ART OF THE POSTMODERN ERA

Also by Irving Sandler

American Art of the 1960s

The New York School: The Painters & Sculptors of the Fifties

The Triumph of American Painting: A History of Abstract Expressionism

ART OF THE POSTMODERN ERA

FROM THE LATE 1960s TO THE EARLY 1990s

IRVING SANDLER

IconEditions

An Imprint of HarperCollinsPublishers

HarperCollins books may be purchased for educational, business, or sales promotional use. For information please write: Special Markets Department, HarperCollins Publishers, Inc., 10 East 53rd Street, New York, NY 10022.

FIRST EDITION

Designed by Nancy Singer

Library of Congress Cataloging-in-Publication Data

Sandler, Irving, 1925–
 Art of the post-modern era : from the late 1960's to the early 1990's / Irving Sandler.—1st ed.
 p. cm.
 Includes bibliographical references and index.
 ISBN 0-06-438509-4 ISBN 0-8133-3433-0 (pbk)
 1. Art, American—Themes, motives. 2. Art, European—Themes, motives.
3. Art, Modern—20th century—United States—Themes, motives.
4. Postmodernism—United States. 5. Art, Modern—20th century—Europe—Themes, motives. 6. Postmodernism—Europe. I. Title.
N6512.S2553 1996
709'.04'5—dc20 95-17096

97 98 99 00 ❖/RRD 10 9 8 7 6 5 4 3

For Lucy

CONTENTS

List of Illustrations ix

Preface xxi

Acknowledgments xxix

Introduction 1

1 Postminimalism 21

2 The Impact of 1968 on European Art 86

3 First-Generation Feminism 114

4 Pattern and Decoration Painting 141

5 Architectural Sculpture 164

6 New Image Painting 194

7 The Art World of the 1970s 214

8 American Neoexpressionism 222

9 The Italian Transavantguardia and German 281
 Neoexpressionism

10 Media Art 319

11 Postmodernist Art Theory 332

12 The Consumer Society and Deconstruction Art 375

13 The Art World in the First Half of the 1980s 425

14 East Village Art 461

15 Commodity Art, Neogeo, and the 482
 East Village Art Scene

16 The "Other": From the Marginal into 523
 the Mainstream

17 Into the 1990s 544

Bibliography 557

Index 617

ILLUSTRATIONS

The number in italics refers to the page number on which the illustration appears.

1. Robert Ryman, *Fix*, 1989, 22⅝″ × 22⅝″, oil on gator board and aluminum. Courtesy PaceWildenstein. Photograph by Jon Abbott. *25*

2. Robert Morris, *Felt*, 1967–68, dimensions variable, felt. Collection of Whitney Museum of American Art, New York. Purchase, with funds from the Howard and Jean Lipman Foundation, Inc. Photograph by Geoffrey Clements, New York. Copyright © 1994 Whitney Museum of American Art. *26*

3. Eva Hesse, *Sans II*, 1968, 38″ × 170¾″ × 6⅛″, fiberglass. Collection of Whitney Museum of American Art, New York. Purchase, with funds from Ethelyn and Lester J. Honig and the Albert A. List Family. Copyright © 1994 Whitney Museum of American Art. *28*

4. Jackie Winsor, *Bound Grid*, 1971–72, 84″ × 84″ × 8″, wood and hemp. Collection of Fonds National d'Art Contemporain, Paris. Courtesy Paula Cooper Gallery, New York. Photograph by eeva-inkeri, New York. *30*

5. Bruce Nauman, *South America Triangle*, 1981. 14′ × 14′ × 14′, steel and cast iron. Collection of Hirshhorn Museum and Sculpture Garden, Smithsonian Institution, Washington, D.C. Courtesy Sperone Westwater Gallery, New York. Photograph by Alan Zindman, New York. *33*

6. Bruce Nauman, *Human/Need/Desire*, 1983, overall 7′ 10⅜″ × 70½″ × 25¾″, neon tubing, transformer, and wires. Museum of Modern Art, New York. Gift of Emily and Jerry Spiegel. Photograph copyright © 1995 Museum of Modern Art, New York. *34*

7. Vito Acconci, *Trademarks*, 1970, photographs/ink prints. Courtesy Barbara Gladstone Gallery, New York. *37*

8. Vito Acconci, *Bad Dream House #2*, 1988, 45′ × 35′ × 12′, each house: 16′ × 10′ × 12′, aluminum, plexiglass, brick concrete, wood. Courtesy Barbara Gladstone Gallery, New York. *39*

9. Chris Burden, *Chris Burden Deluxe Book: 1971–1973*, 1974, overall: 11½″ × 11 ½″ × 2″. Detail: *Shoot*, F Space, Santa Ana, California, November 19, 1971. Looseleaf binder with hand-painted cover, containing fifty-three gelatin silver prints and text documenting twenty-three performance pieces. Collection of Whitney Museum of American Art, New York. Purchase, with funds from Joanne Leonhardt Cassullo. Photograph by Geoffrey Clements, New York. Copyright © 1994 Whitney Museum of American Art. *41*

10. Dennis Oppenheim, *Attempt to Raise Hell*, 1974, 6′ × 4′ × 3′, cast-aluminum figure, bell, felt suit. Timing mechanism forces figure to lunge forward, and the head strikes every sixty seconds. Wooden base, 6′ × 4′ × 3′. Photograph courtesy of the artist. *45*

11. Dennis Oppenheim, *Launching Structure #2, An Armature for Projection (From the Fireworks Series)*, 1982, Bonlow Gallery, New York, approximately 30′ × 80′ × 13′, Butane gas ignition system on mobile towers. Spinning glass rods with rockets and fountains, copper ricochet shields on casters with blue glass windows, galvanized cooling bin, copper recording plates. Hanging diamond platform with suspended black light. Eight-foot-diameter curved glass arcs with rockets, rolling glass ball with fuses. Carbon arc light, revolving wheels with fountains, flares and rockets. Turning steel disc with butane torch. Hanging tambourine with four spinning blades. Mobile kaleidoscope. Photograph courtesy of the artist. *45*

12. Lucas Samaras, *Photo-Transformation 4/19/76*, 1976, 3″ × 3″, SX-70 Polaroid. Photograph courtesy of PaceWildenstein, New York. Photograph by Al Mozell, New York. *46*

13. Gilbert & George, *Underneath the Arches*, 1971, Performance at the Sonnabend Gallery, New York. Photograph courtesy Sonnabend Gallery, New York. *48*

14. Gilbert & George, *Worlds*, 1985, 95″ × 138¼″, hand-dyed black-and-white photographs. Photograph courtesy Sonnabend Gallery, New York. Photograph by Prudence Cuming Assoc. Ltd., London. *49*

15. Nam June Paik, *V-yramid*, 1982, 186¾″ × 85″ × 74″, 40 televisions and videotape. Collection of Whitney Museum of American Art, New York. Purchase, with funds from the Lemberg Foundation, Inc. in honor of Samuel Lemberg. Photograph by Geoffrey Clements, New York. Copyright © 1994 Whitney Museum of American Art. *52*

16. Richard Serra, *Cutting Device: Base Plate Measure*, 1969, overall 12″ × 18″ × 15′ 7¾. Variable lead, wood, stone, and steel. Museum of Modern Art, New York. Gift of Philip Johnson. Photo copyright © Museum of Modern Art, 1995 New York. *55*

17. Richard Serra, *Schunnemunk Fork*, 1991, 4 Plates: 49′1″ × 8′ × 2½″, 35′1″ × 8′ × 2½″, 38′4″ × 8′ × 2½″, 54′4″ × 8′ × 2½″, Cor-ten steel. Courtesy of PaceWildenstein, New York. Photograph by Huger Foote. *57*

18. Richard Serra, *Tilted Arc*, 1981, 12′ × 120′ × 2½″, at Federal Plaza, New York. General Services Administration, Washington, D.C. (destroyed). Photograph by Joan Marter. *57*

19. Robert Smithson, *Spiral Jetty*, April 1971, coil 1,500′ long, approximately 15′ wide, Vesicular black basalt, salt crystals, earth, red water (algae), Great Salt Lake, Utah. Courtesy of John Weber Gallery, New York. *61*

20. Richard Long, *White Marble Circle*, 1982, 14′ in diameter, white marble. Private collection. Courtesy of Sperone Westwater, New York. Photograph by Adam Reich, New York. *63*

21. Tony Cragg, *Some Kind of Group*, 1983, 75½″ × 360″ wall sculpture, found objects. Courtesy Marian Goodman Gallery, New York. *65*

22. Helen Mayer and Newton Harrison, *The Guadalupe Meander, A Refugia for San Jose*, 1982–83, detail of installation. Courtesy of Ronald Feldman Fine Arts., New York. Photograph D. James Dee, New York. *66*

23. Alan Sonfist, *Time Landscape*, New York City, 1965–present, 45′ × 200′. Courtesy C. Johnson. Photograph copyright © 1995 Alan Sonfist. *67*

24. Gordon Matta-Clark, *Humphrey Street Splitting*, 1974, Englewood, New Jersey. Courtesy Estate of Gordon Matta-Clark and Holly Solomon Gallery, New York. *68*

25. Sol LeWitt, Installation at Paula Cooper Gallery, October 10–31, 1981. Photograph courtesy of John Weber Gallery, New York. *71*

26. John Baldessari, *An Artist Is Not Merely a Slavish Announcer*, 1966–68, 59″ × 45″, acrylic plus photograph on canvas. Photograph courtesy of Sonnabend Gallery, New York. Photograph by F. Scruton. *73*

27. Joel Shapiro, *Untitled*, 1974, 7⅛ × 3½″ × 3″, cast iron. Courtesy of PaceWildenstein, New York. Photograph by Geoffrey Clements, New York. *75*

28. Joel Shapiro, *Untitled*, 1980–81, 52⅞″ × 64″ × 45½″, bronze. Courtesy of PaceWildenstein, New York. Photograph by Geoffrey Clements, New York. *76*

29. Nancy Graves, *Cantileve*, 1983, 98″ × 68″ × 54″, bronze with polychrome patina. Copyright 1983 Nancy Graves. Collection of Whitney Museum of American Art, Purchase with funds from the Painting and Sculpture Committee. Photograph by Geoffrey Clements, New York. Also copyright © 1994 Whitney Museum of American Art. *79*

30. Bryan Hunt, *Shift Falls*, 1978, 120″ × 17″ × 11″, bronze. Collection of Vera List. Courtesy of Brian Hunt. *80*

31. Joseph Beuys, *Untitled*, 1974–79, showcase: 35¼″ × 91½″ × 19¾″, stand: 45 ¾″ × 91½″ × 19 ¾″, vitrine made of painted wood with glass windows on welded stool stand with seven double objects: 1. Batteries (2), 2. "Telephone" (2) metal tins, 3. "Celtic Object" (2) records (with copper and hare jaw), 4. "Mirror Pieces" (2 bottles mirrorized inside), 5. "For Washing Feet" (2 washbasins with

soap), 6. "Two Souls" (2) X-ray photographs with Brown Cross, 7. Objects made with peat bricks and butter. Courtesy of Ronald Feldman Fine Arts, New York. Photograph by D. James Dee, New York. *90*

32. Joseph Beuys, *I Like America and America Likes Me*, 1974, performance at René Block Gallery, New York, May 23–25, 1974. Courtesy Ronald Feldman Fine Arts, New York. Photograph by Caroline Tisdall. *91*

33. Marcel Broodthaers, installation view, November 1984. Photograph courtesy of Marian Goodman Gallery, New York. Photograph by Bill Jacobson, New York. *96*

34. Marcel Broodthaers, *Moules Casserole*, 1968, 127 cm. × 96.5 cm., photographic canvas and painting cut out and mounted on card. Photograph courtesy of Marian Goodman Gallery, New York. Photograph by Bill Jacobson, New York. *97*

35. Daniel Buren, *Exit*, installation, John Weber Gallery, December 1980. Photograph courtesy of John Weber Gallery, New York. Photograph by John Abbot. *99*

36. Daniel Buren, *Les Deux Plateaux*, permanent installation at the Palais-Royal, Paris, 1985–86, 260 freestanding columns of various heights; lights; and a sunken artificial stream. Courtesy of John Weber Gallery, New York. *101*

37. Mario Merz, *La casa del giardiniere*, 1983–84, 79″ × 158″ in diameter, metal tubes, wire mesh, oil and acrylic on canvas, beeswax, metal, shells and pine cones. Courtesy of Sperone Westwater, New York. Photograph by Dorothy Zeidman, New York. *106*

38. Mario Merz, *Lizard*, 1978, 110½″ × 92½″, oil and charcoal on canvas, blue neon lance. Private collection. Courtesy of Sperone Westwater, New York. Photograph by Jon Abbott. *107*

39. Jannis Kounellis, *Untitled*, 1983, overall 10′ 11½″ × 17′ 7½ × 16¼ (size variable), steel beam, steel bed frame with propane gas torch, five steel shelves, smoke traces, and steel panel and shelf with wood. Museum of Modern Art, New York. Sid R. Bass, Blanchette Rockefeller, Norman and Rosita Winston Foundation, Inc., funds and purchase. Photograph copyright © 1995 Museum of Modern Art, New York. *109*

40. *The Kitchen* in Womanhouse, 1971–72, Feminist Art Program, California Institute of the Arts, Miriam Schapiro and Judy Chicago, co-directors. Photograph courtesy of Miriam Schapiro, New York. *119*

41. Louise Bourgeois, *Nature Study*, 1984, 30″ × 14½″ × 19″, base: 41″ × 21½″ × 21 ½″, bronze. Collection of Whitney Museum of American Art, New York. Purchase, with funds from the Painting and Sculpture Committee. Copyright © 1994 Whitney Museum of American Art. Photograph courtesy Robert Miller Gallery, New York. Photograph by Allan Finkelman. *122*

42. Louise Bourgeois, *The Destruction of the Father*, detail, 1974, 93⅜″ × 142 ⅝″ × 97 ⅞″, latex, plaster, wood, and fabric. Courtesy of Robert Miller Gallery, New York. Photograph copyright © 1975 by Peter Moore, New York. *123*

43. Faith Wilding, *Waiting*, performance, *Womanhouse*, 1972. Photograph by Lloyd Hamrol. *125*

44. Eleanor Antin, *"My Tour of Duty in the Crimea"* from *The Angel of Mercy*, 1977, 30″ × 22″, photograph. Courtesy Ronald Feldman Fine Arts, Inc., New York. Photograph by Eric Pollitzer, Hempstead, N.Y. *126*

45. Hannah Wilke, *Venus Cushion*, 1972, 63″ × 32″, latex. Courtesy Ronald Feldman Fine Arts, New York. Photograph by eeva-inkeri, New York. *127*

46. Hannah Wilke, *S.O.S. Starification Object Series*, 1974, 6½″ × 4½″, one of thirty-five photographs from Mastication Box. Courtesy Ronald Feldman Fine Arts, New York. *127*

47. Suzanne Lacy and Leslie Labowitz, *In Mourning and in Rage*, 1977, public performance and media event, Los Angeles, California. Photograph by Susan Mogul. *129*

48. Carolee Schneemann, *Eye Body* from thirty-six transformative actions for camera, 1963, 8″ × 10″, photograph. Courtesy Carolee Schneemann. Photograph by Erro. *131*

49. Judy Chicago, *The Dinner Party*, conceived by Judy Chicago and executed by her with a working community of women and men, 1973–79, 48′ × 48′ × 48′, mixed media. Copyright © 1979 Judy Chicago. Photograph copyright © Donald Woodman. *133*

50. Nancy Spero, *"Love to Hanoi"* war series, 1967, 36″ × 24″, gouache and ink on paper. Courtesy of the artist. Photograph by David Reynolds. *135*

51. Nancy Spero, *Torture of Women*, panels 4, 5, 9, 10, 13, 14, 1976, installation, New Museum, 1984, 20″ × 125′, painting and typewriter collage on paper. Collection of the National Gallery of Canada. Courtesy of the artist. Photograph by David Reynolds. *137*

52. George Sugarman, Baltimore Federal, work of art in public place for the U.S. Federal Building in Baltimore (detail), 1975, 100′ overall, painted aluminum. Courtesy of the artist. *144*

53. Frank Stella, *Dove of Tanna* from the *Exotic Bird Series*, 1977, approximately 154″ × 225″ × 36″, mixed media on aluminum. Collection of Whitney Museum of American Art, New York. Copyright © 1994 Whitney Museum of American Art, New York. Gift of the family of Victor W. Ganz in his memory. Photograph by Jerry L. Thompson. *145*

54. Miriam Schapiro, Installation at Lerner-Heller Gallery, *First Fan*, 1976–77, 6′ × 12′, fabric and acrylic on canvas, and *Paisley/Leaf Vestituro*, 1979, 60″ × 50″, acrylic and fabric on canvas. Courtesy of the artist. *147*

55. Robert Rahway Zakanitch, *Song of the Trumpeters*, 1980, 50″ × 88″, acrylic on paper. Courtesy of the artist. *148*

56. Joyce Kozloff, *An Interior Decorated*, installation in the Renwick Gallery of the Smithsonian Institution, Washington, D.C., 1980, height 21′, length 25′, width 18′ 6″, hand-painted glazed ceramic tiles grouted on plywood, silk-screened silk hangings, lithographs on silk laminated onto rice paper. Photograph by Eddie Owen. *149*

57. Cynthia Carlson, *Picture That in Miami*, 1982, temporary installation in room 12′ × 53′ × 27′ in Lowe Art Museum, Coral Gables, Florida, paint on the wall, canvas, and wood. Photograph by Roland I. Unruh. *150*

58. Ned Smyth, *Adoration/Adornment*, installation at Holly Solomon Gallery, New York, detail view, January 1980, 24′ × 60′, cast concrete, sculpted concrete, fabric, and stone-and-glass mosaic. Courtesy Ned Smyth. Photograph by D. James Dee. *151*

59. Valerie Jaudon, *Zama*, 1982, 96″ × 60″, oil on canvas. Courtesy Sidney Janis Gallery, New York. Photograph by Allan Finkelman. *152*

60. Lynda Benglis, *X-Ray*, 1973–74, 35″ × 18″ × 10″, aluminum screen, bunting, sprayed zinc, and aluminum. Private collection. Photograph Paula Cooper Gallery, New York. Photograph by Geoffrey Clements, New York. *153*

61. Robert Kushner, *Lotus*, from *Travelling* (performance), 1983. Courtesy Holly Solomon Gallery, New York. Photograph by Jaye R. Phillips. *154*

62. Robert Kushner, *Spring Love*, 1978, 2 panels each 103¾″ × 43¾″, acrylic on cotton. Private collection. Courtesy Holly Solomon Gallery, New York. Photograph by D. James Dee. *155*

63. Kim MacConnel, *Thunderbomb*, 1981, 102 × 142 ins., acrylic on cotton. Courtesy Holly Solomon Gallery, New York. Photograph by D. James Dee. *156*

64. Thomas Lanigan-Schmidt, *Grace and Original Sin: Saints and Sinners (Two Seconds Before the End of the World)*, 1979, special installation for *Directions* exhibition, June 14–September 3, 1979, Hirshhorn Museum and Sculpture Garden, Smithsonian Institution, Washington, D.C., installation view, overall dimensions of site, approximately 8′ × 10′ × 10′, mixed media. Courtesy Holly Solomon Gallery, New York. Photograph by John Tennant. *158*

65. Judy Pfaff, *3 D*, installation at Holly Solomon Gallery, New York, January 1983, mixed media. Courtesy André Emmerich Gallery, New York. *160*

66. Judy Pfaff, *Es Possible*, 1989, 144″ × 96″ × 48″, enamel on wood and steel. Courtesy André Emmerich Gallery, New York. Photograph by Dennis Cowley. *161*

67. Judith Shea, *Helen's Vest*, 1977, 136″ × 22″, silk organza, ctuna silk. Courtesy Max Protetch Gallery, New York. *165*

68. Christo and Jeanne-Claude, *Valley Curtain, Rifle, Colorado*, 1970–72, 200,000 square feet of nylon polyamide fabric, 110,000 pounds of steel cables. Copyright © Christo 1972. Photograph by Harry Shunk. *166*

69. Christo and Jeanne-Claude, *Running Fence, Sonoma and Marin Counties, California*, 1972–76, 18′ high × 24½ mi. Copyright © Christo 1976. Photograph by Wolfgang Volz. *167*

70. Robert Irwin, *Scrim Veil-Black Rectangle, Whitney Museum of American Art,* 1977, sheet: 27⅛″ × 34″, image: 22″ × 23″¹/₁₆″, ink and press type on paper. Collection of Whitney Museum of American Art, New York. Copyright © 1994 Whitney Museum of American Art. Gift of the artist. Photograph by Geoffrey Clements, New York. *170*

71. James Turrell, *Shanta,* 1967, dimensions variable: projector: 12½″ × 25″ × 10 ½″, transformer: 15″ × 18″ × 12″, transformer base: 2¼ × 24¾″ × 17⅝″, glass plate to act as heat shield for slide: 3″ × 6″, xenon projection. Collection of Whitney Museum of American Art, New York. Copyright © 1994 Whitney Museum of American Art. Gift of Philip Johnson. Photograph by Jerry L. Thompson. *171*

72. Siah Armajani, *The Art of Bridgemaking #3,* 1987–88, 25″ × 70″ × 8″, painted balsa, string, and brick. Courtesy Max Protetch Gallery, New York. Photograph by Dennis Cowley. *172*

73. Siah Armajani, *Reading Garden #3,* installed at State University of New York at Purchase, 1980, 11′ × 57′ × 30′, wood and paint. Courtesy Max Protetch Gallery, New York. *173*

74. Mary Miss, *Perimeters/Pavilions/Decoys,* installation at Nassau County Museum, Roslyn, New York, 1977–78, tallest tower, 18′ high, opening 16′ square; underground 40′ square, wood, earth, steel. Courtesy of Mary Miss. *175*

75. Alice Aycock, *The Machine that Makes the World,* 1979, 12′ wide × 8′ high × 38′ long, wood, steel. Courtesy John Weber Gallery, New York. *176*

76. Donna Dennis, *Deep Station,* 1981–85, 150″ × 240″ × 288″, mixed media (acrylic and enamel paint, wood, plastic pipe, electrical fixtures, glass, rubber, charcoal, pencil, metal, cellulose compound. Courtesy the artist. Photograph copyright © 1987 Peter Mauss/Esto, Mamaroneck, New York. *178*

77. Nancy Holt, *Sun Tunnels,* 1973–76, site: Great Basin Desert in northwest Utah, about four miles southeast of Lucin (population ten) and nine miles east of the Nevada border. The tunnels are aligned with the sun on the horizon (the sunrises and sunsets on the solstices). Total length, 86′; tunnel lengths, 18′, tunnel diameter (outside) 9′ 2½″; tunnel diameter (inside) 8′, wall thickness 7¼; concrete. Courtesy John Weber Gallery, New York. *178*

78. Jackie Ferrara, *198 Castle Clinton Tower and Bridge,* temporary installation, 1979, 12′ 6″ × 23′ 6″ × 13′ 11″, cedar. Courtesy Jackie Ferrara. Photograph by Douglas Hollis. *179*

79. Elyn Zimmerman, *Keystone Island,* 1989, plaza: 50′ diameter, 10′ high from water. Dade County Justice Center, North Miami, Florida. *180*

80. Charles Simonds, *Dwellings,* detail, installation view, 1981, three-part sculpture: 1: 17¾″ × 39 ½″ × 29″; 2: 10⅜″ × 29⅜″ × 7¾″; 3: 8″ × 29″ × 13¾″, clay, sand, sticks, stones, wood, plaster, cloth, and chicken wire. Collection of Whitney Museum of American Art, New York. Copyright © 1994 Whitney Museum of American Art. Purchase, with funds from the Louis and Bessie Adler Foundation, Inc., Seymour M. Klein, President. *181*

81. Charles Simonds, *Dwellings,* detail, installation view. Collection of Whitney Museum of American Art, New York. Copyright © 1994 Whitney Museum of American Art. *182*

82. Scott Burton, *Rock Chair,* 1981–82, 48″ × 40″ × 36″, white lava. Courtesy Max Protetch Gallery, New York. Photograph by Dennis Cowley. *184*

83. Scott Burton, *Two-Cube Table,* 1985–86, 35¾″ × 20″ × 25½″; top 16½″ × 16 ½″ × 16½″; base 11¾″ × 11¾″ × 11¾″, granite. Courtesy Max Protetch Gallery. Photograph by David Allison, New York. *185*

84. Mary Miss, *Untitled,* in collaboration with Stanton Eckstut, architect, and Susan Child, landscape architect, South Cove, Battery Park City, New York, 1988, 2½-acre site. Courtesy of Mary Miss. *191*

85. Philip Guston, *Close-Up,* 1969, 42 × 48 ins., frame: 43 × 49½ ins., Synthetic polymer on canvas. Collection of Whitney Museum of American Art, New York. Copyright © 1994 Whitney Museum of American Art Musa Guston Bequest. Photograph by Geoffrey Clements, New York. *197*

86. Neil Jenney, *Saw and Sawed,* 1969, 58½″ × 70⅜″, including frame, oil on canvas. Collection of Whitney Museum of American Art, New York. Copyright © 1994 Whitney Museum of American Art Gift of Philip Johnson. Photograph by Geoffrey Clements, New York. *200*

87. Susan Rothenberg, *Butterfly,* gift of Perry R. and Nancy Lee Bass, copyright © 1995 Board of Trustees,

National Gallery of Art, Washington, D.C.: 1976, acrylic and matte medium on canvas, 69½″ × 83″ Courtesy of Sperone Westwater Gallery, New York. Photograph by Geoffrey Clements, New York. *201*

88. Robert Moskowitz, *Swimmer*, 1977, 90″ × 73¾″, frame 92½″ × 75¼, oil and pure pigment on canvas. Collection of Whitney Museum of American Art, New York. Copyright © 1994 Whitney Museum of American Art, New York. Gift of Jennifer Bartlett. Photograph by Geoffrey Clements, New York. *202*

89. Nicholas Africano, *An Argument*, 1977, frame: 69″ × 85½″, acrylic, oil, wax on canvas. Collection of Whitney Museum of American Art, New York. Copyright © 1994, Whitney Museum of American Art, New York. Purchase, with funds from Mr. and Mrs. William A. Marsteller. Photograph by Geoffrey Clements, New York. *203*

90. Joe Zucker, *Merlyn's Lab*, 1977, 96″ × 96″, acrylic, cotton and Rhoplex on canvas. Collection of Whitney Museum of American Art, New York. Copyright © 1994 Whitney Museum of American Art, New York Purchase with funds from the Louis and Bessie Adler Foundation, Inc., Seymour M. Klein, President. Photograph by Geoffrey Clements, New York. *204*

91. Robert Colescott, *George Washington Carver Crossing the Delaware: Page from an American History Textbook*, 1975, 84″ × 108″, acrylic on canvas. Collection of Mr. and Mrs. Robert H. Orchard. Courtesy of Phyllis Kind Gallery, New York. *205*

92. Robert Colescott, *Auvers-sur-Oise (Crow in the Wheat Field)*, 1981, 84 × 72 ins., acrylic on canvas. In the collection of the Corcoran Gallery of Art. Gift of the Women's Committee of the Corcoran Gallery of Art. Photograph courtesy of Phyllis Kind Gallery, New York. *207*

93. Jennifer Bartlett, *Rhapsody*, 1975–76, 7′ 6″ × 153′ 9″ over all, 988 plates, each 12″ × 12″. Detail of Installation Paula Cooper Gallery, May 8–June 16, 1976. Private collection, New York. Photograph courtesy Paula Cooper Gallery, New York. Photograph by Geoffrey Clements, New York. *208*

94. Jonathan Borofsky, *I Dreamed I Was Taller than Picasso at 2,047,324*, 1973, 19⅞″ × 15⅞″, oil on canvas. Collection of Martin Sklar, New York. Photograph courtesy Paula Cooper Gallery, New

York. Photograph by Jim Strong, Eric Pollitzer, Hempstead, N.Y. *210*

95. Jonathan Borofsky, installation, Paula Cooper Gallery, October–November 1980. Photograph courtesy Paula Cooper Gallery, New York. Photograph by Geoffrey Clements, New York. *211*

96. Julian Schnabel, *Hamid in Alcheringa*, 1983, 107¾″ × 84″, oil on velvet. Courtesy PaceWildenstein, New York. Photograph by Bill Jacobson, New York. *231*

97. Julian Schnabel, *Mimi*, 1986, 11′ 11″ × 9′, oil on linoleum with horns. Courtesy Pace Gallery. Photograph by Bill Jacobson. *232*

98. Julian Schnabel, *Pope Clement of Rome*, 1987, 132″ × 181″, oil and gesso on tarp-ulin. Courtesy of PaceWildenstein, New York. Photograph by Phillips/Schwab, New York. *234*

99. David Salle, *We'll Shake the Bag*, 1980, 48″ × 72″(2). Collection: Ellen Kern. Photograph by Glenn Steigelman, Inc., New York. *235*

100. David Salle, *Gericault's Arm*, 1985, 6′ 5⅞″ × 8¼′, oil and synthetic polymer paint on canvas. Museum of Modern Art, New York. Gift of the Louise and Bessie Adler Foundation, Inc., Seymour M. Klein, President; Agnes Gund; Jerry I. Speyer Fund; and purchase. Photograph copyright © 1995 Museum of Modern Art, New York. *237*

101. Eric Fischl, *Bad Boy*, 1981, 66″ × 96″, oil on canvas. Courtesy: Mary Boone Gallery, New York. Photograph by Zindman/Fremont, New York. *242*

102. Eric Fischl, *A Visit To/A Visit From/The Island*, 1983, 84″ × 168″, each of two panels: 84″ × 84″, oil on canvas. Collection of Whitney Museum of American Art, New York. Copyright© 1994 Whitney Museum of American Art. Purchase with funds from Louis and Bessie Adler Foundation, Inc., Seymour M. Klein, President. Photograph by Geoffrey Clements, New York. *245*

103. Robert Longo, *Untitled (dead falling man)*, 1982, 84 × 60″, charcoal, graphite, silk-screen ink, on paper. Courtesy of Metro Pictures, New York. Photograph by Pelka/Noble, New York. *246*

104. Robert Longo, *Corporate Wars: Walls of Influence*, 1982, 108″ × 312″ × 48″, cast aluminum bonding, lacquer on wood. Courtesy of Metro

Pictures, New York. Photograph by Pelka/Noble, New York. *247*

105. Elizabeth Murray, *Painters Progress*, 1981, 9'8" × 7' 2½", oil on canvas in 19 parts, overall 9' 8" × 7' 9". Museum of Modern Art, New York. Acquired through the Bernhill Fund and Gift of Agnes Gund Photograph copyright © Museum of Modern Art, New York. *249*

106. Elizabeth Murray, *Tomorrow*, 1988, 111½" × 132¾ × 21½", oil on two canvases. Collection Fukuo Sogo Bank, Ltd., Japan. Photograph courtesy Paula Cooper Gallery, New York. Photograph by Geoffrey Clements, New York. *251*

107. Ida Applebroog, *It Isn't True*, 1979–80, seven panels, each panel: 12" × 9½", overall size: 12 × 75" ink and roplex on vellum Courtesy Ronald Feldman Fine Arts Inc., New York. Photograph by eevainkeri, New York. *252*

108. Ida Applebroog, *God's White Too*, 1985, 86" × 60", two panels, oil on canvas. Courtesy Ronald Feldman Fine Arts Inc., New York. Photograph by Jennifer Kotter, New York. *253*

109. Leon Golub, *Interrogation II*, 1981, 120" × 168", acrylic on canvas. Collection of the Art Institute of Chicago. Photograph by David Reynolds. *255*

110. Leon Golub, *Horsing Around (III)*, 1983, 7' 2" × 7' 2", acrylic on canvas. The Eli and Edythe L. Broad Collection. Photograph by D. James Dee, New York. *257*

111. Malcolm Morley, *Christmas Tree (The Lonely Ranger Lost in the Jungle of Erotic Desires)*, 1979, 72" × 108", oil on canvas. Courtesy Mary Boone Gallery, New York. *259*

112. Malcolm Morley, *Cradle of Civilization with American Woman*, 1982, 80" × 100", oil on canvas. Courtesy Mary Boone Gallery, New York. *259*

113. George McNeil, *Summer Dress*, 1991, 78" × 64", oil on canvas. Courtesy of ACA Galleries and the Estate of George McNeil. *261*

114. Ross Bleckner, *Fallen Object*, 1987, 48" × 40", oil on linen. Collection Courtesy Mary Boone Gallery, New York. Photograph by Zindman/Fremont, New York. *262*

115. Komar & Melamid, *The Origin of Socialist Realism*, 1982–83, 72" × 48", oil on canvas. Courtesy Ronald Feldman Fine Arts, New York City. Photograph by D. James Dee, New York. *264*

116. Komar & Melamid, *Vespers*, 1984–85, six panels, each 13½" × 11", total size: 13½" × 78¾ × 5½", mixed media. Courtesy Ronald Feldman Fine Arts, New York City. Photograph by D. James Dee, New York. *265*

117. Jennifer Bartlett, *Boats*, 1987, painting: oil on canvas, 9' 10" × 14'; sculpture: painted wood, steel support, pine mast, each 66½" × 47½" × 46". Courtesy Paula Cooper Gallery, New York. Photograph by D. James Dee, New York. *266*

118. Susan Rothenberg, *Somebody Else's Hand*, 1979, 20¾" × 36", acrylic and flashe on canvas. Collection Henry S. McNeil, Jr., Philadelphia. Courtesy of Sperone Westwater, New York. Photograph by Roy M. Elkind, New York. *267*

119. Susan Rothenberg, *4 Kinds*, 1990–91, 53" × 88¼", oil on canvas. Private collection. Courtesy of Sperone Westwater, New York. Photograph by Adam Reich, New York. *268*

120. Terry Winters, *Rhyme*, 1985, 68" × 86", oil on linen. Collection of Denver Art Museum. Courtesy of Sonnabend Gallery, New York. Photograph by Jon Abbott. *269*

121. Bill Jensen, *Three Elements (For Ronald Bladen)*, 1987–88, 31 × 41", oil on linen. Courtesy Mary Boone Gallery, New York. *270*

122. April Gornik, *Equator*, 1983, 74" × 116", oil on canvas. Courtesy Edward Thorp Gallery, New York. Photograph by Zindman/Fremont, New York. *271*

123. Sean Scully, *Magdalena*, 1993, 80" × 70", oil on linen. Courtesy Mary Boone Gallery, New York. Photograph copyright© by Dorothy Seidman, New York. *272*

124. William Tucker, *Prometheus (For Franz Kafka)*, 1988, 138½" high × 116" long × 96" wide, plaster for bronze. Courtesy McKee Gallery, New York. *273*

125. Ursula von Rydingsvard, *For Paul* (at the Storm King Art Center, Mountainville, N.Y.), 1990–92, 14' 4" × 9' × 13' 8", cedar, graphite. Photograph courtesy Storm King Art Center. Photograph by Jerry L. Thompson. *274*

126. James Surls, *Dancing on the Bridge*, 1992, 111″ × 78½″ × 43″, red oak, white oak, holly, and steel. Courtesy Marlborough Gallery. *275*

127. Francis Picabia, *Adam and Eve*, 1941–43, 41″ × 29¼″, oil on wood. Collection of Emily and Jerry Spiegel. Photograph courtesy Mary Boone Gallery, New York. Photograph by Zindman/Fremont, New York. *285*

128. Giorgio de Chirico, *La Lettura*, 1926, 36″ × 29″, oil on canvas. Private Collection, New York. Photograph courtesy Robert Miller Gallery, Inc., New York. Photograph by Steven Sloman, New York. *286*

129. Francesco Clemente, *Moon*, 1980, 96¾ × 91″, tempera on 12 sheets of handmade paper mounted on each cloth. Collection of Alan Wanzenberg. Photograph courtesy Sperone Westwater Gallery, New York. Photograph by Zindman/Fremont, New York. *290*

130. Francesco Clemente, *Two Painters*, 1980, 68″ × 94⅛″, gouache on nine sheets of handmade paper with cloth backing. Courtesy Francesco Pellizzi. Photograph courtesy Sperone Westwater Gallery, New York. Photograph by Bevan Davies, New York. *291*

131. Enzo Cucchi, *Vitebsk-Harar*, 1984, overall size approximately 8″ 7″ × 18′ ½″ × 16″, oil on canvas and iron. Museum of Modern Art, New York. Fractional gift of Paine Webber Group Inc. Photograph copyright© 1995 Museum of Modern Art, New York. *292*

132. Sandro Chia, *Idleness of Sisyphus*, 1981, oil on canvas in two parts, overall: 10′ 2″ × 12′ 8¼″; top panel: 6′ 9″ × 12′ 8¼″; bottom panel: 41″ × 12′ 8¼″. Museum of Modern Art, New York. Acquired through the Carter Burden, Barbara Jakobson, and Saidie A. May Funds and purchase. Photograph copyright 1995 Museum of Modern Art, New York. *293*

133. Carlo Maria Mariani, *Composition 3*, 1989, 71″ × 71″, oil on canvas. Courtesy the artist. *295*

134. Sigmar Polke, *Untitled*, 1968. Watercolor, acrylic spray, gouache, 37¾″ × 25″. Museum of Modern Art, New York. Gift of R. L. B. Tobin. Photograph copyright© 1995 Museum of Modern Art, New York. *302*

135. Sigmar Polke, *Mao*, 1972, oil on cloth on cotton fabric, hung from loops around a wooden pole; overall, including pole, 12′ 3″ × 10′ 3½″. Museum of Modern Art, New York. Kay Sage Tanguy Fund. Photograph copyright © 1995 Museum of Modern Art, New York. *304*

136. Gerhard Richter, *Scheune*, 1983, 27½″ × 39½″, oil on canvas. Courtesy Marian Goodman Gallery, New York. Photograph by Bill Jacobson. *306*

137. Gerhard Richter, installation view, 2–24 February 1990, Marian Goodman Gallery, North Gallery. Courtesy Marian Gopodman Gallery, New York. Photograph by Michael Goodman. *307*

138. Georg Baselitz, *Glastrinkerin*, 1981, 63¾″ × 51¼″, oil on canvas. Courtesy Michael Werner Gallery, New York and Cologne. *310*

139. A. R. Penck, *Noon*, 1989, 59″ × 78¾″, acrylic on canvas. Courtesy Michael Werner Gallery, New York and Cologne. *311*

140. Jörg Immendorff, *Cafe Deutschland–III*, 1978, 111″ × 107½″, oil on canvas. Courtesy Michael Werner Gallery, New York and Cologne. *312*

141. Anselm Kiefer, *Adelaide—Ashes of My Heart*, 1990, 85½″ × 89″, chemise, hair, lead airplane, acrylic on canvas. Courtesy Marian Goodman Gallery, New York. Photograph by Jon and Anne Abbott. *313*

142. Anselm Kiefer, *Bruch der Gefässe* (Breaking of the vessels), 1990, 150½″ × 135⅞″ × 59″, lead books in iron bookshelf, iron, lead, copper wire, glass, charcoal, aquatec. Courtesy Marian Goodman Gallery, New York. Photograph by Jon and Anne Abbott. *314*

143. John Baldessari, *Violent Space Series: Nine Feet (of Victim and Crowd) Arranged by Position in Scene*, 1976, 24⅜″ × 36½″, black-and-white photographs on board/ one panel. Courtesy of Sonnabend Gallery, New York. *323*

144. John Baldessari, *The Little Red Cap*, 1982, 84″ × 72″, twelve photographs with text. Courtesy Sonnabend Gallery, New York. Photograph by Zindman/Fremont, New York. *324*

145. Richard Prince, *Untitled (cowboy)*, 1989, 73″ × 108¼″, Ektacolor print. Courtesy Barbara Gladstone Gallery, New York. Photograph by Larry Lame. *327*

146. Richard Prince, *What a Kid I Was,* 1989, 68″ × 48″, acrylic and silk-screen on canvas. Courtesy Barbara Gladstone Gallery, New York. Photograph by Larry Lame. *329*

147. Sherrie Levine, *After Walker Evans: 7,* 1981, 10″ × 8″, photograph. Courtesy of Metropoliton Museum. Photograph courtesy Mary Boone Gallery. Photograph by Zindman/Fremont, New York. *387*

148. Sherrie Levine, *"Untitled" (Lead Checks: 2),* 1987, 20″ × 20″, casein on lead. Courtesy of the artist. Photograph by Zindman/Fremont, New York. *389*

149. Barbara Kruger, *"Untitled" (Buy me I'll change your life),* 1984, 72″ × 48″, photograph. Collection Lisa Phillips, Courtesy Mary Boone Gallery, New York. Photograph by Zindman/Fremont, New York. *392*

150. Barbara Kruger, *"Untitled" (Your gaze hits the side of my face),* 1981, 55″ × 41″, photograph. Courtesy: Mary Boone Gallery, New York. Photograph by Zindman/Fremont, New York. *393*

151. Barbara Kruger, Installation: Mary Boone Gallery, New York, March 1994, dimensions variable, photographic silk-screen/paper. Courtesy Mary Boone Gallery, New York. Photograph copyright © Dorothy Zeidman, New York. *395*

152. Jenny Holzer, *Truisms,* 1982, T-shirt worn by John Ahearn, New York. Courtesy Barbara Gladstone Gallery, New York. Photograph by Lisa Kahane. *396*

153. Jenny Holzer, *Times Square, N.Y.,* spectator board, selections from *The Survival Series,* 1985–86. Sponsored by the Public Art Fund. Courtesy Barbara Gladstone Gallery, New York. *398*

154. Mary Kelly, *Interim,* part 1; Corpus, 1984. Courtesy Postmasters Gallery, New York. *401*

155. Victor Burgin, *Sensation,* 1976, 48″ × 100″, black-and-white photograph mounted on masonite. Courtesy of John Weber Gallery, New York. *402*

156. Hans Haacke, *The Saatchi Collection (Simulations),* 1987, 101″ × 76″, mixed media installation. Edition of two, one in The Eli Broad Family Foundation Collection; the other in Collection of Fonds National d'Art Contemporain, Paris, France. Photograph courtesy John Weber Gallery, New York. Photograph by Fred Scruton, New York. *404*

157. Hans Haacke, *Und Ihr Habt Doch Gesiegt* (And you were victorious after all), 1988, installation in Graz, Austria. Documentation, photograph Hans Haacke. Photograph copyright © Hans Haacke. *405*

158. Hans Haacke, *Helmsboro Country,* 1990, cigarette box: 30½″ × 80″ × 47½″. Twenty cigarettes: each 6½″ × 6½″ × 69¼″, wood, cardboard, paper, photo, silkscreen. Owned by Hans Haacke. Photograph courtesy John Weber Gallery, New York. Photograph by Fred Scruton, New York. *407*

159. Louise Lawler, *Three Women/Three Chairs Arranged By Mr. and Mrs. Burton Tremaine, Sr.,* New York, 1984, 18″ × 23″, image, black-and-white photograph. Courtesy of Metro Pictures, New York. *407*

160. Cindy Sherman, *Untitled Film Still,* 1978, 8″ × 18″, black-and-white photograph. Courtesy of Metro Pictures, New York. *408*

161. Cindy Sherman, *Untitled,* 1989, 45¼″ × 67″, color photograph, edition of six. Courtesy of Metro Pictures, New York. *412*

162. Cindy Sherman, *Untitled,* 1989, 61½″ × 48 ¼″, color photograph. Courtesy of Metro Pictures, New York. *413*

163. Laurie Simmons, *Walking Cake,* 1989, 84″ × 48″, black-and-white photograph. Courtesy of Metro Pictures, New York. *414*

164. William Wegman, *"Untitled" (Man Ray),* 1979, 13¼″ × 10¾″, altered photograph, ink on photograph. Courtesy Holly Solomon Gallery, New York. Photograph by D. James Dee, New York. *415*

165. *The Times Square Show,* 1980. Photograph by Andrea Callard copyright © 1980. *463*

166. Jean-Michel Basquiat, *Hollywood Africans,* 1983, 84″ × 84″ ins., acrylic and mixed media on canvas. Collection of Whitney Museum of American Art, New York. Copyright © 1994 Whitney Museum of American Art. Gift of Douglas S. Cramer. Photograph by Geoffrey Clements, New York. Copyright © 1983 Estate of Jean-Michel Basquiat. Used by permission. *469*

167. Keith Haring, *Untitled*, 1981, 42″ × 46″, sumi ink on rice paper. copyright © 1981 Estate of Keith Haring. *471*

168. Kenny Scharf, *When the Worlds Collide*, 1984, dimensions variable: 122″ × 209¼″, oil acrylic and enamel spray paint on canvas. Collection of Whitney Museum of American Art, New York. Copyright © 1994 Whitney Museum of American Art Purchase with funds from Edward R. Downe, Jr., and Eric Fischl. Photograph by Geoffrey Clements, New York. *472*

169. NOC*167, *Outerspace Painting*, 1984, 73¼″ × 71″, spray paint on canvas. Courtesy Melvin Henry Samuels Junior (NOC*167). Photograph courtesy Sidney Janis Gallery, New York. Photograph by Allan Finkelman. *475*

170. Daze, *Dance Aesea*, 1984, 72¼″ × 120″, spray paint on canvas. Courtesy of Sidney Janis Gallery, New York. *476*

171. Tim Rollins + K.O.S., *Amerika II*, 1986, 90″ × 168″, oil on paper, linen. Courtesy Mary Boone Gallery, New York. *479*

172. Richard Artschwager, *Description of Table*, Variation: *Grey Table*, 26⅛″ × 31⅞″ × 31⅞″, Formica on wood. Collection of Whitney Museum of American Art, New York. Copyright © 1994 Whitney Museum of American Art. Gift of Howard and Jean Lipman Foundation, Inc. Photograph by Geoffrey Clements, New York. *483*

173. Andy Warhol, *Green Coca-Cola Bottles*, 1962, 81½″ × 57″, oil on canvas. Collection of Whitney Museum of American Art, New York. Copyright © 1994 Whitney Museum of American Art. Purchase, with funds from the Friends of the Whitney Museum of American Art. Photograph copyright © 1988 Geoffrey Clements Inc., New York. *485*

174. Ashley Bickerton, *Tormented Self-Portrait (Susie at Arles)*, 1987–88, 7′ 5⅜″ × 68¾″ × 15¾″ synthetic polymer paint, bronze powder, and lacquer on wood, anodized aluminum, rubber, plastic, Formica, leather, chromeplated steel and canvas. Museum of Modern Art, New York. Purchase. Photograph copyright © 1995 Museum of Modern Art, New York. *488*

175. Meyer Vaisman, *The Whole Public Thing*, 1986, 18″ × 70″ × 70″, process ink on canvas, toilet seats. Courtesy Sonnabend Gallery, New York. Photograph by Fred Scruton. *490*

176. Haim Steinbach, *Stay with Friends*, 1986, 33″ × 60″ × 18¼″, mixed media construction. Courtesy of Sonnabend Gallery, New York. Photograph copyright © David Lubarsky 1986. *492*

177. Jeff Koons, *New Hoover Convertible*, 1980, 55½″ × 22″ × 22″, one new Hoover Convertible, plexiglass and fluorescent lights. Courtesy of the artist. *494*

178. Jeff Koons, *Rabbit*, 1986, 41 × 19 × 12 ins., stainless steel. Courtesy of the artist. Photograph by Fred Scruton. *496*

179. Jeff Koons, *Michael Jackson and Bubbles*, 1988, 42″ × 70½″ × 32½″, Porcelain, edition of three. Courtesy of the artist. Photograph by Fred Scruton. *497*

180. Mike Kelley, *Fruit of Thy Loins*, 1990, 39″ × 21″ × 12″, stuffed animals. Courtesy of Metro Pictures, New York. *501*

181. Mike Kelley, *Let's Talk*, 1987, 94½″ × 59″, glued felt. Courtesy of Metro Pictures, New York. Photograph by Andrew Moore. *503*

182. Peter Halley, *Prison with Conduit*, 1981, 36″ × 54″, acrylic, Day-Glo acrylic and Roll-A-Tex on canvas. Courtesy Addison Gallery of American Art, Andover, Mass. Photograph by Fred Scruton, New York. *504*

183. Allan McCollum, *Plaster Surrogates*, 1982–84, installation, Metro Pictures Gallery, New York, 1985, enamel on cast Hydrostone. Courtesy of John Weber Gallery, New York. *506*

184. David Reed, *No. 261*, 1987–88, 26″ × 102″, oil and alkyd on canvas. Private collection. Courtesy Max Protetch Gallery, New York. Photograph by Dennis Cowley. *508*

185. Philip Taaffe, *Untitled*, 1988, 14″ × 15″, enamel, silk-screen collage, acrylic on canvas. Courtesy of Gagosian Gallery, New York. *510*

186. Mike and Doug Starn, *Crucifixion*, 1985–88, 120″ × 180″, toned silver print, Scotch tape, wire ribbons, wood. Courtesy Leo Castelli Gallery, New York. *511*

187. Mary Lucier, *Ohio at Giverny*, 1983, installation at the Whitney Museum of Amreican Art, New

York. Photograph of installation by David Allison, of stills, Mary Lucier. *512*

188. Adrian Piper, *My Calling Card*, 1986, 2″× 3½″, guerrilla performance with calling card (for dinners and parties). Courtesy of John Weber Gallery, New York. *525*

189. Adrian Piper, *Self-Portrait Exaggerating My Negroid Features*, 1981, 8″ × 10″. Pencil drawing. Photograph courtesy of John Weber Gallery, New York. *525*

190. David Hammons, *Untilted*, 1992, height 60″, copper, wire, hair, stone, fabric, and thread. Collection of Whitney Museum of American Art, New York. Copyright © Whitney Museum of American Art. Purchase, with funds from the Mrs. Percy Uris Bequest and the Painting and Sculpture Committee. Photograph by Geoffrey Clements, New York. *527*

191. Mel Edwards, *Whispers*, 1991–92, 16″ × 19″ × 11¾″, welded steel. Courtesy of CDS Gallery, New York. Photograph by Zindman/Fremont, New York. *529*

192. Martin Puryear, *Dumb Luck*, 1990, 70″ × 90″ × 39″, tar, wire mesh, and wood. Private collection, California. Courtesy McKee Gallery, New York. *530*

193. Jimmie Durham, *Self-Portrait*, 1987, 72″ × 36″ × 12″, canvas, wood, mixed media. Courtesy of the artist and the Nicole Klagsbrun Gallery, New York. Photograph by Fred Scruton, New York. *531*

194. Robert Mapplethorpe, *Self-Portrait*, 1985. Copyright © 1985 Estate of Robert Mapplethorpe. *532*

195. David Wojnarowicz, *Untitled (Clocks and Ants)*, 1988–89, 16″ × 20″, silver print. Courtesy P.P.O.W. Inc., New York. Photograph by Adam Reich, New York. *534*

196. John Coplans, *Self-Portrait (Feet, Frontal)*, 1984, 57″ × 37″, silver print. Courtesy Andrea Rosen Gallery, New York. *535*

197. Christian Boltanski, *Monument to Canada*, 1988, 110″ × 70″ × 7″, clothes, fifteen black-and-white photographs, and fifteen lights. Courtesy of Marian Goodman Gallery, New York. Photograph by Jon and Anne Abbott. *537*

198. Ilya Kabakov, *The Man Who Flew into Space from His Apartment*, 1980–88, from *Ten Characters*, Ronald Feldman Gallery, 1988. Collection Centre George Pompidou, Paris. Courtesy Ronald Feldman Fine Arts, New York. Photograph by D. James Dee, New York. *539*

199. Ilya Kabakov, *The Man Who Flew into Space from His Apartment*, another view. *540*

200. Magdalena Abakanowicz, *Anasta: from the series "War Games,"* 1989, 19′ 8″ × 4′ 11″ × 6′ 11″, wood and steel. Courtesy Marlborough Gallery. Photograph by Bob Mates.

COLOR PLATES
(following page 322)

Plate 1. Robert Colescott, *Les Desmoiselles d'Alabama: Vestidas*, 1985, 96″ × 92″, acrylic on canvas. Collection of Professor Hanford Yang. Courtesy Phyllis Kind Gallery, New York.

Plate 2. Judy Pfaff, *N.Y.C.—B.Q.E.*, 1987, 15′ × 35′ × 5′, painted steel, plastic laminates, fiberglass, wood. Courtesy André Emmerich Gallery, New York.

3. Julian Schnabel, *Vita*, 1983, 12½′ × 10′, oil and bondo with plates on wood. Courtesy of PaceWildenstein, New York.

Plate 4. David Salle, *Sextant in Dogtown*, 1987, 96³⁄₁₆″ × 126¼″, frame, 99⅛″ × 129⅜″, oil and acrylic on canvas. Collection of Whitney Museum of American Art, New York. Purchase with funds from the Painting and Sculpture Committee. Photograph by Geoffrey Clements, New York. Copyright © 1994 Whitney Museum of American Art.

Plate 5. Eric Fischl, *Scarsdale*, 1987, 96″ × 93¼″, oil on linen. Courtesy Mary Boone Gallery, New York. Photograph by Zindman/Fremont, New York.

Plate 6. Elizabeth Murray, *More Than You Know*, 1983, 111″ × 108″ × 8″, oil on canvas. The Edward R. Broida Trust. Photograph courtesy Paula Cooper Gallery, New York.

Plate 7. Ida Applebroog, *Church of St. Francis Xavier*, 1987, five panels, overall 86″ × 136″, oil on canvas. Courtesy Ronald Feldman Fine Arts, New York. Photograph by Jennifer Kotter.

Plate 8. Cindy Sherman, *Untitled*, 1987–91, 90″ × 60″, colorprint (MP#210). Courtesy Metro Pictures and the artist.

PREFACE

Art history is not transparent. It is written by individuals, who bring to it their own personal baggage of appetites, psychological makeups, ethnic identities, social positions, political and religious persuasions, and so on. Claims to objectivity notwithstanding, the historian's idiosyncrasies shape art history. Consequently, it would be useful for the historian to present his or her sociopsychoethnic autobiography in the preface to a work. However, given the limitations of space and the reader's patience, it would not be feasible—and, given the workings of the unconscious, not even possible. Still, the question of motivations ought to be dealt with, if only cursorily. Specifically: Why has the historian selected a particular topic and, even more significant, a particular approach?

In my own case I encountered abstract expressionist painting while I was a graduate student in the early 1950s, and it moved me as little else in my life had, certainly infinitely more than the academic American history I was studying at the time. I simply had to know more about it. I found out where the artists met—the Cedar Street Tavern, the Club, the artists' cooperative galleries on Tenth Street—and began to socialize with them. I also painted for a year, and although I was told by artists I respected, Philip Guston, for example, that I had "talent," the intensity for me was not in art making. In the mid-fifties I found that intensity in writing art criticism. But, since I had been trained as a historian, it seemed natural to me to chronicle the art I had come to love and believed to be the most vital, original, and masterly in the world. I started to work on *The Triumph of American Painting: A History of Abstract Expressionism*.[1] At the time the American art-conscious public was still hostile to abstract expressionism. In response I wrote as an embattled partisan, from within the movement, as it were.

I did not rely entirely on my own taste but also paid close attention to the opinions of respected artists, art editors and critics, museum curators and directors, and dealers and collectors. Not surprisingly their views generally paralleled my own. More than that, I sought to formulate a consensus of what these artists and art professionals deemed of great-

est significance and value at any time. This consensus provided me with a kind of "objective" base by which I was guided. The fact that the art-world consensus is ever changing does not minimize its momentary significance, since it reveals which art has made the art world sit up and take notice and has made the strongest impact on culture of its period.

Judging art according to the taste of its moment is as good a way as any other to evaluate it, because, in fact, there are no demonstrable criteria. As Joseph Alsop wrote: "Objectively, there is no such thing as 'good taste' or 'bad taste.' There is only the taste of the particular time and place, as revealed by the surviving data on the works of art that men have loved or scorned." It appears that "differences of epoch and social circumstance have caused men to see works of art . . . differently." And whose taste is one to favor? There is no reason to assume that the taste of one generation is better than that of another. Who "can say that the taste of Titian or Michelangelo was inferior—or superior—to the taste of Matisse or Picasso? Either way, this is a proposition wholly incapable of proof, and downright silly besides. . . . A different, more serious proposition can be solidly proved, however. In brief, the actual *way of seeing* changes with the passage of time."[2] Alsop was thinking of changes in taste over long time periods, but his idea applies in the short range as well.

It may be that the primary value of my work is my closeness to—and, indeed, participation in—the development of American art. I find myself in an ambiguous position between critic and historian. A critic must rely primarily on his or her own taste—with an eye to a loose consensus of peers, of course. A historian takes into account that consensus and succeeding ones as well. Unlike the traditional historian, however, I can take into account only one or at best two or so consensuses, but unlike the critic, I rely very heavily on them. To put it another way, I have experienced art and the art world in the immediate present and within a period too short to provide historic "distance," and yet I have written about both as if they were already in the historic past. In the end my vantage point, within the unfolding of contemporary art, may have enabled me, I hope, not only to chronicle the course of that art but to evoke the sensibility—that most perishable quality—that informed it.

Having dealt with the first generation of the New York School, I found it fitting to survey the artists of the second. They were roughly my own age, and many were friends. Titled *The New York School: Painters and Sculptors of the Fifties*,[3] this book retained some of the partisanship of the first, but less, since the New York School had become sufficiently established so as no longer to need defending. Moreover, I had begun to question why I had been so embattled in the first place. Was abstract expressionism really the "one true art" of our time? Did art stop short with it? I was becoming increasingly impatient with blinkered standard bearers then—as I did subsequently with true believers enlisted in the cause of formalism or neo-Marxism or any other ism. I also became increasingly skeptical of assertions that art had gone into precipitous decline or had even

died—after abstract expressionism or color-field abstraction or minimalism or whatever one's last passion in art was. As I saw it, art was constantly changing, but the best continued to be as vital as ever.

With the emergence of avant-garde artists of the 1960s, such as Frank Stella and Andy Warhol, I must admit that at first I was antagonistic. In time my attitude changed. There was no escaping the relevance of their work. The more I experienced the new art, the more I took my cues from it rather than judging it by criteria handed down from older styles. I was intrigued by the variety, the contradictory pulls, and the diverse "stories," and I decided to map them in *American Art of the 1960s*.[4] As in my earlier studies, I knew most of the artists I wrote about, if not as well as those of my own generation, still well enough to be able to view the development of their art from within the art world.

I thought that my book on 1960s art would be the last of a series. But when it was completed, I was faced with a decision about what to do next. Although several projects interested me, at the beginning of each day's work I found myself thinking about the art of the 1970s and 1980s. In the end I decided to go ahead with another volume. As in my sixties book, I was as concerned with trying to piece things together, to find out how they all fit, as I was with making value judgments or asserting my likes and dislikes. To put it another way, I could see no reason to proselytize for any one style or against any other. The works of certain—relatively few—artists moved me deeply, but I saw no reason to use them as models against which to judge other work. Art can provide a variety of experiences, very few of them extraordinary but many stimulating and therefore meriting consideration. I was convinced that some of the art of the 1970s and 1980s had a sufficient freshness, difference—embodying content that had not previously been conceived, imagined, or experienced—provocation, energy, and quality to be of lasting interest, a conviction reflected in this book.

I continued to gauge the art-world consensus to determine how the period saw itself—but with nagging doubts about its validity, particularly in the 1980s. More than ever before in modern art, taste making depended on the demands of the international art market on the one hand and of political correctness on the other. In influential art circles on both the political left and right, espousing a politically correct ideology was more important than determining aesthetic or other values. Constant pressures were also exerted by art-world power brokers, principally dealers, collectors, auctioneers, and their allies among art professionals, linked in global networks. The international art market had boomed almost beyond belief, and fashionable art was increasingly hyped by the mass media, notably such magazines as *Vogue*, *Interview*, and *Vanity Fair*. In an art world that seemed more and more in thrall to money and fashion—generally intertwined—it was no longer clear not only whether aesthetic values were primary but even how they counted.

As the influential Cologne dealer Paul Maenz, himself significantly responsible for the creation of the new market, lamented:

> Art and the art business have entered today into an alliance that has never before been so complete, [and this] has a negative, perverting influence. Efficient professional handling of every possible practicality from the production of art to the solid affirmation of its market value is so thoroughly taken for granted by all concerned—artists, collectors, critics, dealers, and magazine people—as to make people lose sight of the thing itself, of art itself.[5]

Jeffrey Deitch, an important New York art investment consultant, agreed with Maenz, going so far as to claim that the 1980s might be remembered not so much for "its art as for its art market." The problem was how "to understand the work of art in the age of art investment funds, art as corporate image enhancement, and art as the centerpiece of real estate development schemes." For example, Charles Saatchi used his collection to build his public relations agency's creative reputation, providing "an extraordinary model of how to link advanced art with a perception of business creativity." He later sold much of his collection at substantial profit. Deitch went on to say: "Certainly the most spectacular aspect of the 1980s art boom has been the art-as-investment [phenomenon]. [This] has functioned . . . to dramatically expand the public's consciousness of art." And it attracted a large new audience that accepted auction prices "as a measure not only of monetary value, but of critical esteem."[6]

The growth in size and power of the art market forced me to question whether the art-world consensus could still be used as a credible standard to establish the significance and quality of art? My answer was that it could, but that I had to take into account as never before the workings of the market and of hype, and to discount mercenary attempts to inflate the reputations of artists. I had to ask constantly why the art world focused when it did on certain kinds of art and not on others; why this and not that? In other words, why did certain styles and certain artists monopolize art-world discourse at any moment? More specifically: Who were the individual dealers and collectors as well as artists; art editors, critics, and historians; museum directors, curators, and trustees who shaped the consensus, and how did they manage it?

My own observations and opinions about the art of the 1970s and 1980s were corroborated—and challenged—by an unprecedented amount of art writing in monographs, catalogs, and articles. I also listened closely to many young artists and art professionals, and to a few of my own contemporaries whose work both anticipated and responded to changes in American life and art during the period, notably my close friends Alex Katz and Al Held. Moreover, I kept close tabs on Roy Lichtenstein, who was an acquaintance, and Frank Stella, whose career I had followed closely since 1959.

* * *

Literalist and antiexpressionist avant-garde tendencies commanded most art-world attention during the early and middle 1960s: Pop art, new realism, and photorealism all articulated the objecthood and factuality of the subject; formalist and minimalist abstraction focused on the physical attributes of art—that is, art-as-object. Toward the end of the decade, interest shifted to a variety of postminimal tendencies, among them process art and earth art, which stressed the materiality of art but not its objecthood, and conceptual art, which was antiliteralist or "dematerialized." Other directions were neglected by art professionals. The situation changed around 1970, when tendencies that were neither literalist nor conceptual began to compete for recognition on more or less equal terms. American art seemed to have entered a pluralist era. So it appeared at the time (although less so in retrospect).

In treating a period of seeming pluralism, how does the historian select which styles to feature? I might have given equal time to all tendencies, even a few that had emerged in the forties and fifties, whose practitioners continued to be very active indeed, for example Willem de Kooning and Jasper Johns. Colleagues nostalgic for the openness and democracy of a pluralist situation had urged me to be inclusive, but I decided against this. With the art-world consensus in mind, I chose to identify those tendencies that emerged after 1967 and seemed to be peculiarly of the late sixties, seventies, and eighties—namely art with a fresh content that consciously rejected or deflected formalism and minimalism. Prominent among the new directions in the 1970s, apart from diverse postminimal styles, were pattern and decoration painting and new image painting. The 1980s were marked by two antithetical tendencies: new painting, generally mislabeled neoexpressionism; and media, deconstruction, and commodity art. These two main tendencies were antagonistic, because the one revived painting, much of which turned in on the artists' private visions and experiences, and the other relied on photography and other mechanical media and mass-produced, store-bought commodities to reflect on or convey messages about the pervasive impact on our lives of the mass media and consumerism.

A question that plagued me was how to connect the diverse and contrasting tendencies in the art of the seventies and eighties, when to introduce them, and how to chart them. At first I tried to deal with the entire range of art chronologically. That worked reasonably well for the 1970s. But in treating the art of the 1980s, when competing tendencies developed simultaneously in parallel and crisscrossing tracks, my account became hopelessly fragmented and disjointed. My solution was to treat each tendency—one at a time—as a unit, beginning with what George Kubler called its "entry" into art history, formulating its aesthetics, tracing its course and the development of its leading artists, indicating what its reception in the art world was, when it reached its point of

highest visibility, and how it related to other tendencies. Thus, for the sake of clarity and coherence, I sacrificed a certain sense of chronology.

As a historian of recent art, I must admit to two personal limitations: I believe that conceptual art without a strong visual dimension is failed art. Ideas can contribute substantially to our visual experience, but if there is no compelling image to look at, the ideas are stillborn. To put it bluntly, words have to make me see images. The point of visual art is to be visual, although it can be about anything—even take a position *against* the visual in art. Furthermore, although I am responsive to every visual medium, I do favor painting and sculpture, in the face of repeated attacks on their viability. Consequently I tend to deal with such media as photography and performance art—which were of vital significance in the last two decades—primarily when they refer to issues that were central to the painting and sculpture of the time.

My second limitation is my distanced knowledge of the art world in Europe and the art created there, whose strength and quality were so clearly evident in the 1970s and 1980s. I could not confine my survey to American art as I had in my earlier books in the belief that little else mattered, even though I had included a number of Europeans in my history of the 1960s (but only after their work had been recognized in New York). In this book, however, I felt the need to deal with a considerable number of European artists and tried to present them as fully as I could. My own geographical position, however, could not help but come into play. I could not treat European art, whose development I had not witnessed at firsthand, with the same familiarity as I did American art. Nor could I avoid viewing it from the vantage point of New York. This biased my interpretation since, as Giancarlo Politi, the editor of *Flash Art*, remarked, "Some European art creates less interest in the States, just as in Europe some forms of American art appear less interesting. [It's simply] due to cultural differences."[7]

Finally, as in my earlier books, I paid close attention to the artists' intentions—specifically, those that could be checked against the works of art. I was well aware that this approach had been denigrated as old-fashioned by art theoreticians who, taking their brief from Roland Barthes, had proclaimed "the death of the author" and instead had "privileged" the reader or the viewer, and first among viewers, the art theoretician him- or herself. I favored the ideas of artists, because on the whole I found them to be more provocative and illuminating than those of art professionals. Indeed, I am generally taken aback by the differences between what artists and art professionals profess—between the art I saw in the making and, to quote Brian O'Doherty, "its retrieval on grounds irrelevant to its inception, the unloading of new content upon it, its reinterpretation according to formalist inquisitions, ideological diagnoses, Marxist accusations, quantifications of desire, denial, repression,

power." I get impatient when art is misused to support "contrary positions, dispossessed absolutes, covert moralities, personal kinks, fantasies of history, illusions of gender, all the while accommodating the past to the . . . present. As readings extend to the context of context, you feel you are standing at the edge of a pool where the ripples at your feet have forgotten the dropped stone."[8]

A more significant issue was involved, however. I believed that the fashionable "deconstruction" or, more accurately, demolition, of the artist had distorted the interpretation of art. What was needed was a new reconstruction of creativity—a rebirth of the artist. But artists are not merely self-contained individuals—not the most significant ones. As Joseph Kosuth, a conceptual artist who also wrote art theory, commented in 1982, at the height of the controversy over the role of the artist-as-creator:

> The power of the work we see in museums is exactly this. It is the authenticity of the cultural production of a human being connected to his or her historical moment so concretely that the work is experienced as real; it is the passion of a creative intelligence to the present, which informs both the past and the future. It is not that the meaning of a work of art can transcend its time, but that a work of art describes the maker's relationship to her or his context through the struggle to make meaning, and in so doing we get a glimpse of the life of the people who shared that meaning. [A] work of art must be so singularly the concrete expression of an individual (or individuals) that it is no longer simply about that individual, but rather, is about the culture that made such expression possible.[9]

NOTES

1. Irving Sandler, *The Triumph of American Painting: A History of Abstract Expressionism* (New York: Harper & Row, 1970).
2. Joseph Alsop, *The Rare Art Traditions* (New York: Harper & Row, 1982), p. 4.
3. Irving Sandler, *The New York School: Painters & Sculptors of the Fifties* (New York: Harper & Row, 1978).
4. Irving Sandler, *American Art of the 1960s* (New York: Harper & Row, 1988).
5. Paul Maenz, "Flash Art News 1: The Galleries Talk," *Flash Art* (Nov.–Dec. 1987) supplement, n.p.
6. Jeffrey Deitch, "The Art Industry," *Metropolis*, (New York: Rizzoli, 1991), pp. 39–41.
7. Helena Kontova and Giancarlo Politi, "Two Italians in New York," *Flash Art* (Dec. 1985–Jan. 1986): 38.
8. Brian O'Doherty, "Stella and Hesse: Dispatches from the Sixties," in John Howell, ed., *Breakthroughs: Avant-Garde Artists in Europe and America, 1950–1990* (New York: Rizzoli, 1991), p. 59.
9. Joseph Kosuth, "Portraits . . . Necrophilia Mon Amour," *Artforum*, May 1982, p. 61.

ACKNOWLEDGMENTS

As in my earlier books, I have relied heavily on information and opinions generously provided by artists, above all, but also by critics, historians, museum directors and curators, and dealers and collectors. I would like to thank the artists Vito Acconci, Eleanor Antin, Stephen Antonakos, Ida Applebroog, Graham Ashton, John Baldessari, Jennifer Bartlett, Robert Berlind, Joseph Beuys, Jonathan Borofsky, Louise Bourgeois, Paul Brach, Coosje van Bruggen, Scott Burton, Jane Caplowitz, Cynthia Carlson, Christo and Jeanne-Claude, Chuck Close, Robert Colescott, Russell Connor, John Coplans, Susan Crile, Douglas Davis, Donna Dennis, Stephen Ellis, Eric Fischl, Leon Golub, April Gornick, Nancy Graves, Denise Green, Hans Haacke, Allen Hacklin, Peter Halley, Freya Hansell, Al Held, Eva Hesse, Anthony Hill, Bryan Hunt, Robert Irwin, Alex Katz, Michael Kidner, Komar & Melamid, Joyce Kozloff, Ellen Lanyon, Sol LeWitt, Roy Lichtenstein, Mary Lucier, Mary Miss, Malcolm Morley, Robert Morris, Elizabeth Murray, Graham Nickson, Saul Ostrow, Simon Patterson, Nam June Paik, Philip Pearlstein, Judy Pfaff, Peter Plagens, Archie Rand, David Reed, Walter Robinson, Dorothea Rockburne, Tim Rollins, Stephanie Rose, Ursula von Rydingsvard, Robert Ryman, David Salle, Miriam Schapiro, Randall Schmidt, Carolee Schneemann, Sean Scully, Richard Serra, Joel Shapiro, Cindy Sherman, Harriet Shorr, Robert Smithson, Ned Smyth, Nancy Spero, Frank Stella, Robert Storr, George Sugarman, William Tucker, Andy Warhol, Margorie Welish, Hannah Wilke, Murray Zimiles, and Elyn Zimmerman.

I also wish to express my appreciation to the art editors, critics, and historians Alexandra Anderson, Jonathan Alexander, David Antin, Dore Ashton, Robert Atkins, Elizabeth Baker, Stephen Bann, Jean Baudrillard, Maurice Berger, Avis Berman, Patricia Bickers, Michael Brenson, Coosje van Bruggen, Benjamin Buchloh, Michele Cone, Arthur Danto, Douglas Davis, Edit DeAk, Joshua Decter, William Feaver, Hal Foster, Peter Frank, Peter Fuller, Suzi Gablik, RoseLee Goldberg, Amy Goldin, Adam Gopnik, Clement Greenberg, Andy Grundberg, Eleanor Heartney, Max Kozloff, Hilton Kramer, Rosalind Krauss, Thomas Lawson, Yongwoo Lee, Philip

Leider, Kim Levin, Kate Linker, Lucy Lippard, Carlo McCormick, Thomas McEvilley, Joan Marter, Joseph Masheck, Robert Morgan, Sandy Nairne, Amy Newman, Linda Nochlin, Barbara Novak, Brian O'Doherty, Achille Bonito Oliva, Craig Owens, John Perreault, Peter Plagens, Carter Ratcliff, Pierre Restany, Barbara Rose, Corinne Robins, Robert Rosenblum, John Russell, Jerry Saltz, Meyer Schapiro, Peter Schjeldahl, Ingrid Sichy, Jeanne Siegel, Lowery Sims, Deborah Solomon, Naomi Spector, David Sylvester, Lisa Tickner, Peter Townsend, Judd Tully, Kirk Varnedoe, James Faure Walkner, John Wendler, Karin Wilkin, and John Yau; the museum and artist space professional Richard Armstrong, Robert Buck, Klaus Bussman, Michael Compton, Bonnie Clearwater, Edith Decker, Wolfgang Dreschler, Lucinda Gedeon, Henry Geldzahler, Claudia Gould, John Hanhardt, Barbara Haskell, Alanna Heiss, Wulf Herzogenrath, Christos Joachimides, Ellen Johnson, Thomas Kellein, Klaus Kertess, Kynaston McShine, Richard Marshall, Doreen Mignot, Lisa Phillips, Mark Rosenthal, Nan Rosenthal, Norman Rosenthal, David Ross, Hans Werner Schmidt, Nicholas Serota, Linda Shearer, Elisabeth Sussman, Marcia Tucker, and Connie Wolf; art dealers and their agents Caroline Alexander, Josh Baer, Irving Blum, Mary Boone, Leo Castelli, John Cheim, Tricia Collins, Paula Cooper, Marco Diacono, Jeffrey Deitch, Gilbert Edelson, Andre Emmerich, Ronald Feldman, Barbara Gladstone, Marian Goodman, Joseph Helman, Phyllis Kind, Nicholas Logsdail, Anthony d'Offay, Robert Miller, Holly Solomon, Richard Milazzo, Ileana Sonnabend, Clara Sugo, Leslie Waddington, John Weber, Michale Werner, and Helene Winer.

Among the librarians who have given generously of their time are Krzysztof Cieszkowski, Meg Duff, Angela Ford, Jane Henderson, Beth Houghton, Nicola Hunt, Julia Mathew, Clare Storey, Maria White, and Vajira Wignarajah of the Tate Gallery; Janis Ekdahl, Daniel Fermon, Daniel Starr, Eumie Imm Stroukoff, John J. Trause, Donald Rosen, Tiffany Hampel, and Carol Street of the Museum of Modern Art; and Kayla Stotzky of New York University.

I am also deeply grateful to all those who helped provide photographs to me, notably Anita Duquette of the Whitney Museum of American Art and Mikki Carpenter, Thomas Grischkowsky, and Karen Arch of the Museum of Modern Art.

I am especially indebted to Cass Canfield, Jr., Ashok Chaudhari, and Susan H. Llewellyn of HarperCollins, Cass for his enthusiastic encouragement and useful criticisms; Ashok for his help in preparing the final manuscript; and Susan for her aid in editing the text, as well as to my daughter Catherine and Steve Goss for checking citations and bibliography.

Finally I would like to thank my wife, Lucy, whose help in every stage of this book was invaluable and to whom it is lovingly dedicated.

INTRODUCTION

The world is full of abandoned meanings. In the commonplace I find unexpected themes and intensities.

 —DON DeLILLO, *WHITE NOISE*

And the only intelligence that matters is . . . not to cling to the previous state and to accept a new state. Just to be able to be there for every new challenge.

 —FRANCESCO CLEMENTE

By 1967 the major sixties isms, namely pop art; stained-color-field abstraction, or formalism; and minimalism, had become established in the art world. Their rationales had become familiar, too familiar for them to be thought of as avant-garde. Pop art had been the most notorious of sixties movements up to the end of 1963. After that it no longer generated much art-world discourse. Pop art's innovators—Andy Warhol, Roy Lichtenstein, James Rosenquist, and Tom Wesselmann—continued to command attention. But they had not spawned a second generation; as a result pop art seemed to be on the wane. In actuality it went underground, emerging again, in entirely new guises, only toward the end of the 1970s.

As subjects of art-world discourse, formalist painting and minimal sculpture were longer lived. The premises of color-field abstraction had been formulated by Clement Greenberg in two major articles: "Louis and Noland," 1960, and "After Abstract Expressionism," 1962.[1] The painters he championed—Morris Louis, Kenneth Noland, and Jules Olitski—had achieved considerable art-world recognition by 1964, the year Greenberg organized a show titled *Post-Painterly Abstraction*.[2] Many young painters took up stained-color-field abstraction, soon creating a glut, but none achieved the status of the three leaders. As the sixties progressed, stained-color-field abstraction generated less and less art-world interest outside narrowing formalist circles.[3] But long after the movement and Greenberg's pronouncements on its behalf had ceased to be relevant, his formalist ideology remained current and controversial.

Beginning in 1964 art writers made a strong case in polemical essays for the minimal sculpture of Donald Judd, Robert Morris, Dan Flavin, and Carl Andre. Their work achieved art-world acceptance with the *Primary Structures* show at the Jewish Museum in 1966. Minimalism proved to be more viable than formalism, sprouting a number of postminimal offshoots: eccentric or funky minimalism; process art, composed of piled or scattered fabric and other "antiform" materials; earth art; minimal performance art; and with an insemination of Duchampian cerebration, conceptual art.

Although novel postminimal tendencies had clearly emerged, it took time for art criticism and theory to adapt to them. Formalist and minimal ideologies continued to dominate art criticism well into the 1970s, the disagreements between them notwithstanding. On the side of formalism were Greenberg and his many followers—painter Walter Darby Bannard, and critic-historians Michael Fried, E. C. Goossen, Rosalind Krauss, Barbara Rose, and William Rubin. On the side of minimalism were sculptors Carl Andre, Robert Morris, Donald Judd, and Robert Smithson; friendly critics, such as Lucy Lippard; and again Goossen, Rose, and Krauss, who straddled both formalism and minimalism. This was indeed a formidable array.

The aesthetics of Greenberg, the most important art critic to emerge since World War II, were the fount of both formalist and minimal discourse. Greenberg maintained that in the modern era each of the arts—or the tendency that was modernist in each—had been progressing toward what is autonomous and irreducible in the medium or purely *of* the medium—toward "self-definition," as he put it. Intrinsic to painting are "the flat surface, the [rectangular] shape of the support, [and] the properties of pigment." Most important is flatness, for it alone is "unique and exclusive to pictorial art."[4] Modernist painting defined itself by purging everything that was not of the medium, for example, subject matter, which was in the realm of literature, and "tactile" elements, which were in the realm of sculpture.

Greenberg maintained that modernist art was the avant-garde mainstream within a broader stream, modern art, because it was progressive, verging toward ever-more-autonomous forms. The latest stage of its distinguished history was abstraction, and on the cutting edge was stained-color-field painting. The exemplary current modernist painters then were Louis, Noland, and Olitski.[5]

Greenberg also asserted that the artist's primary goal was to create art of quality, and that the art critic's goal was to recognize quality. As he summed it up in 1980: "Modernist with a capital M" is defined by "the 'simple' aspiration to quality, to aesthetic value and excellence for its own sake, as an end in itself. Art for art's sake. . . . nothing else."[6] Greenberg did not establish any necessary connection between quality and autonomy, or purity. Nor did he specify what constituted quality. But in his opinion the formalist painting of Louis, Noland, and Olitski obviously possessed quality. For him little else in current art did.

Greenberg derived his conception of quality from Immanuel Kant's claim that the aesthetic realm is autonomous, transcending social and moral considerations. He implied that there exists a special human faculty whose sole function is to appreciate art as art and to weigh aesthetic worth. The formalist paradigm holds that aesthetic quality can be determined only through personal experience. That determination can be achieved by putting oneself in a proper frame of mind, focusing exclusively on the formal elements of the work, elements intrinsic to the medium of the work. The perception of quality does not depend on class, race, or gender but on essential human nature.[7] According to this Kantian approach, it follows that art of quality is international, universal, and transcendent.

The antithesis of modernist art was kitsch. Greenberg made this dialectic the subject of his first article on art, "Avant-Garde and Kitsch," published in 1939, and he never changed his mind. Kitsch at its lowest was "popular, commercial art and literature with their chromeotypes, magazine covers, illustrations, ads, slick and pulp fiction, comics, Tin Pan Alley music, tap dancing, Hollywood movies, etc., etc."[8] Low art was bad enough, but even worse was a more "elevated" brand of kitsch, which displayed the trappings of high art without challenging received ideas or taste.

In the struggle between authentic high culture and debased popular culture, there could be no compromise.[9] In order to avoid contamination by kitsch, high art had to withdraw into its own area of competence—and into abstraction. Given Greenberg's bias, the primary enemy was pop art, which had broken down the barriers between high art and kitsch. The appeal of pop art to the art world was disturbing to Greenberg. Also disturbing was the growing infiltration of photography, the principal medium of mass culture, into the realm of high art. Photographs were not necessarily kitsch, but as art they could only be minor. In sum Greenberg maintained that bad taste was on the ascendant. Consequently modernism was increasingly embattled. Its mission had "to be understood as a holding operation, a continuing endeavor to maintain aesthetic standards."[10]

Greenberg's dogmas did not go unchallenged in the 1950s and 1960s.[11] He was often condemned for narrowness and an arrogant refusal to take nonformalist art seriously. But, with the backing of a powerful coterie of artists; dealers; collectors; critics; historians; and museum directors, curators, and trustees, Greenberg managed to outlast all of his detractors. Oddly enough, when the art-critical tide turned against modernism in the 1970s, Greenberg's reputation only grew, for he became the foil—the esteemed foil—of a new breed of antimodernists or postmodernists. Ignoring other interpretations that rooted modernism in dadaism, constructivism, and surrealism—interpretations that stressed social and psychological concerns—they generally accepted Greenberg's definition of modernism as the operative one. Thus postmodernism could be characterized as anti-Greenberg-inspired formalism.

But claims made for the modernism of dadaism, constructivism, or surrealism were just as persuasive as those made for formalism. Consequently it was never clear whether postmodernism constituted a radical break with what came before or was a continuation, a playing out, of modernism, which in any case had always been critical of its own premises.[12] Moreover *modernism* and *postmodernism* were such ambiguous and slippery terms, and had been applied to such a diversity of styles, as to vitiate their usefulness as analytic tools. Nevertheless the aesthetic polemics of the 1980s revolved largely around these labels.

The major problem from the first was that there was no agreed-upon definition of either modernism or postmodernism. This led the poet and critic David Antin to quip that depending on your definition of modernism, you got the postmodernism you deserved. There were, however, two main approaches, contradictory in a number of ways. The first was art-historical, treating postmodernism as a bundle of styles superseding modernist ones. The other was primarily sociological. It posited a radical change—from an industrial society that had generated modernist art to a postindustrial society that gave rise to postmodernist art.

Despite the lack of definitions, the debates went on and on, nearly all of them postmodernist in bias, throwing up enormous amounts of critical and theoretical prose, most of it inflated and obscure. Indeed, the argument over the definition of postmodernism often seemed more significant to the debaters than did its relevance to contemporary culture. (Ironically the discourse in itself could be viewed as constituting postmodernism.[13]) Aware of these problems, I nonetheless continued to use the labels "modernist" and "postmodernist," because I had come to believe that a divide in the visual arts had occurred in the late sixties, and that the labels were in such common use as to be good enough as any to indicate it.

In some measure Greenberg's critics were justified in singling out his modernist paradigm as they did, because it was the basis of the dominant art-critical theory and practice in the 1960s. And if it was to be challenged, a new postmodernist paradigm for considering and evaluating art would have to be formulated. One was.[14]

If the generative terms of the modernist paradigm were "autonomy" and "quality," the competing term was "relevance," attained by confronting social issues or expressing the zeitgeist. Modernists demanded that art be universal and transcendent; postmodernists wanted art to engage its specific social context. Instead of stressing the purely visual, they focused on topical subjects. They also substituted relevance for novelty—the emblem of the avant-garde prized by modernists. As the art critic Edit DeAk put it, postmodernist art produced "the shock of recognition instead of the shock of the new."[15]

Postmodernism called for a different sensibility from modernism, a different attitude toward formal elements and different criteria for judgment. Modernists believed that a work's content inheres in its form and

that subject matter is incidental. Postmodernists emphasized subject matter and disregarded the form-content synthesis. Their different ways of seeing made it difficult for modernists and postmodernists to talk to each other. They were using different languages.

Postmodernists in the visual arts took their cues from their counterparts in architecture, who had earlier launched a sustained attack on the international style. This was initiated by Robert Venturi in his 1967 book, *Complexity and Contradiction in Architecture.*[16] Other critics, such as Charles Jencks, soon added their voices to Venturi's. Jencks identified modernist architecture with the modular, glass-walled, boxlike structures—he called them univalent—exemplified by the buildings of Mies van der Rohe. Such buildings seemed identical wherever they were built and therefore were deemed to be lacking in content—that is, specific references to their function, the locale in which they were to be situated, or the mores of the people and the history of their building. Postmodernist architecture defined itself first of all in terms of what the international style was not. Thus Venturi and his partner, Denise Scott-Brown, looked for inspiration to vernacular building, such as the motel row, with its diverse styles, or Las Vegas, with its myriad signs.[17] As Venturi wrote:

> Architects can no longer afford to be intimidated by the puritanical moral language of orthodox Modern architecture. I like elements which are hybrid rather than "pure," compromising rather than "clean," distorted rather than "straightforward," ambiguous rather than "articulated," perverse as well as impersonal, boring as well as "interesting," conventional rather than "designed," accommodating rather than excluding, redundant rather than simple, vestigial as well as innovating, inconsistent and equivocal rather than direct and clear. I am for messy vitality over obvious unity.[18]

The advocates of postmodernist architecture called for multiplicity or multivalence, inclusiveness, and eclecticism instead of the uniformity and exclusiveness identified with the international style. They repudiated modernism's obsession with the new, which had led to a break with the past, and they rehabilitated motifs, notably decorative, from premodernist styles, combining them with modernist motifs. Indeed, mixing the new and the old was considered "a sign that the architect recognizes the fallacy of seeking one reductive and universal truth, and holds instead to a broader and more tolerant vision of society's—and life's—complexities."[19] Postmodernist architects and theoreticians also rejected the internationalism and utopianism associated with modernist architecture. Because of the clarity of postmodernist polemics in architecture, and because their target was so clearly defined, they played a vital role in discourse in the other arts.

The postmodernist concern for relevance led growing numbers of artists and art professionals to question Greenberg's position on high and low art. Stephen Westfall dismissed Greenberg's "Avant-Garde and

Kitsch" as dated; it had been written in 1939 "at what was perhaps the last moment when the term 'high culture' could be employed with a relative certainty that an audience could agree on what set of standards [was] being applied and feel secure in those standards. It was also a time when the enemies of high culture could easily be fingered: Stalinism, Fascism, Kitsch."[20] In the succeeding half century, the role of pop culture changed. It was so pervasive and powerful as to "become, in every sense, the 'second nature' of modern life," as art historian Kirk Varnedoe and art critic Adam Gopnik claimed, and it also provided "a pool of possibilities that has expanded the language of modern art."[21] Moreover, as curator Lisa Phillips noted, kitsch could be "a potent, edgy form of expression still capable of the kind of shock value that only vanguard art used to have."[22] Westfall found "that kitsch and high culture . . . intermingle with little real damage to, and probably a great deal of reinvigoration of, the latter."[23] Painter, critic, and curator Robert Storr concluded that a significant number of contemporary artists "rightly saw their future—to recast Robert Rauschenberg's remark—in the gap between *Life* and art."[24] In rejecting Greenberg many of these artists and art professionals looked to his bête noire, Duchamp. Duchamp's readymades became a beacon. So did Warhol's pop remades; transient commonplaces appropriated from consumer society, they were the antithesis of the transcendent abstract images Greenberg called for.

Neither Westfall nor Varnedoe, Gopnik, Phillips, or Storr would deny that high art was different from and superior to kitsch. High art depended on acts of discovery while kitsch produced easily consumed effects. Still, kitsch had become a compelling realm of experience that stimulated artistic acts of discovery. Certainly in the 1980s the "impure" works of artists who mixed artistic mediums, embraced diversity, occasionally aspiring to be encyclopedic, and looked for inspiration to vernacular imagery, media, and commodities—whether by Jenny Holzer, Cindy Sherman, Barbara Kruger, Jeff Koons, Mike Kelley, David Hammons, or Elizabeth Murray—seemed much more vital than modernist painting or sculpture.

Formalist criticism was also rejected because increasingly it came to be viewed as specious. Formalist critics would analyze the formal syntax of formalist art and simply assume that formalist art was necessarily of transcendent and universal aesthetic quality without specifying what aesthetic quality was. Their assumption of quality served to give their formal analysis cachet.[25] Postmodernists rejected the formalist idea that quality was universal and transcendent. Greenberg himself maintained that there were no criteria for quality and then acted as if they existed—witness his mandarin dismissal of "critics and journalists who talk 'post-modern.' [There's] nobody among them whose eye I trust."[26] But then Greenberg rejected postmodernist art out of hand.[27] Postmodernists rebutted, asking why, if there were no criteria for judgment, they should accept Greenberg's or anyone else's claims of special insight into quality.

Postmodernists also questioned Greenberg's Kantian belief in a special human faculty for the appreciation of art as art. Was human consciousness actually compartmentalized into separate faculties, each responsible for a particular kind of awareness? Greenberg's critics thought not. Moreover, as Storr wrote, "the cult of 'quality' and the mystique of the 'eye'" absolved formalists "of the responsibility for examining . . . social issues," and other extra-aesthetic but relevant considerations.[28] There was more to the experience of art than the exercise of taste, important though that might be. Postmodernist art professionals insisted that the broader psychological, social, national, and cultural matrix of art could no longer be ignored. And so did leading artists, among them Judy Chicago, Nancy Spero, Sherrie Levine, Kruger, Holzer, and Hammons, who were intent on making social comments, constructive, critical, or iconoclastic.

In asserting that modernist art was progressing toward purity, Greenberg claimed to be empirical, but as he spelled it out, the progress of modernist art seemed to be dictated by historical necessity. That is, there was an implied historical narrative in formalist dogma—a linear mainstream, propelled by an inexorable historical force. The mainstream for Greenberg led to abstraction, which alone had opened up new vistas. All other styles were relegated to the dustbin of art history. Postmodernists rejected this deterministic and exclusivist notion. Instead of a mainstream, postmodernists posited the image of a delta, all styles, even traditional ones, getting a fair share of art-world attention. Indeed, the situation seemed to have become so open that the 1970s was often dubbed the pluralist era. This openness was exemplified in the growing catholicity of art publications, notably *Arts Magazine,* which seemed to feature a different artist in a different style on every other page. But in retrospect the situation was not as democratic as it seemed then: Postminimalist styles received more than their share of attention.

The idea of artistic progress was undermined by a growing belief that the avant-garde was at an end. It appeared to an increasing number of artists and art professionals that the limits of art had been reached, or that if any further limit could be found, there had evolved a tradition of pushing to the limits. Or, to put it directly, carrying art to extremes had become a commonplace in the art world. In 1969 I wrote: "A limit in art is reached when an artist's work comes as close as possible to being non-art," and concluded that conceptual art had ventured as far as art could because it had systematically demolished every notion of what art should be—to the extent that it had eliminated what may be the irreducible conventions in art—the requirements that it be an object and visible.[29] With its 1970 exhibition, *Information,* the Museum of Modern Art put its establishment stamp of approval on conceptual art. Therefore it appeared to me, and I was not alone in this opinion, that the idea of a continuing avant-garde had ceased to be believable. The modernist era was over; it had become history—and had been replaced by a "postmodernist condition."

I also declared the avant-garde dead because "a large and growing public . . . no longer responded in anger to the novel, and when not eager for it is at least permissive."[30] Modernist art, even the part of it that had at first been intentionally iconoclastic and subversive, had become so established and institutionalized as to become "official" on the one hand, and so popular on the other that it could be considered a form of mass culture, another kind of entertainment or decor, color-coded to fit into collectors' living rooms. Millions of dollars were being paid for "Old Master Dadaists, Collectible Nihilists," the prices duly broadcast in the mass media.[31]

The conception of progress had become unbelievable not only in the art world but in the broader social realm as well. At the root of modernist thinking was an exalted conception of universal progress, the optimistic conviction that human society was evolving toward a supranational utopia. Greenberg and his followers generally made no such social claims. Nonetheless the resonance of formalist dogma was augmented by the futuristic vision of a brave new world. Consequently the loss of belief in artistic progress was reinforced by a loss of faith in utopian dreams. Architectural critic Ada Louise Huxtable wrote of the breakdown of modernist "belief systems,"

> . . . those commonly held convictions that guide our acts and aspirations. . . . They were based on an overriding idealism and optimism. . . . These systems of belief were surely extraordinary. [We] believed devoutly in social justice, in the perfectibility of man and his world, in the good life for all. The Bauhaus taught that the machine would put beauty and utility within the reach of everyone. Le Corbusier's "machine to live in" and "radiant cities" would transform human habitation. We believed that the world could be housed and fed; that we could bring order to our cities; that misery and hunger are not eternal verities. . . . We also believed that everyone had a right to beauty, and that aesthetic values equalled moral values. What was useful was beautiful and good, and what was good was good for all of us. . . . The arts, used properly, could bring both pleasure and practical benefits to society. . . . This was the century that equated art, technology, and virtue, and concluded that the better life, and the better world, were finally within our grasp.[32]

Modernism's idealistic vision, its messianic belief that the human condition was improving, became untenable in the wake of the cataclysmic horrors of the twentieth century, from "the irrationalities of World War I . . . to the still incomprehensible irrationality of the Holocaust," as Robert Morris remarked. "It is from this charred source that all post-Enlightenment appeals to Truth and Reason become covered with ashes."[33]

Many young artists who had ceased to believe in futuristic visions began to recycle images and forms from past art and the mass media.

Indeed, appropriation, as this practice came to be known, was the primary sign of postmodernist art. There was also a concomitant denial of originality, experiment, innovation, and invention, valued by modernists. However, what was appropriated had to be provocative. But provocation was no longer equated with newness, as it had been when the idea of the avant-garde was still credible. Questions were soon raised about appropriations. Were they not mannerist and academic? Did the quoted fragments reveal ironically and even perversely that humanism was in tatters? Did this scavenging not prove that art was at an end, dead, in a zero zone? On the other hand, if much of postmodernist art seemed backward looking in style, this might also be forward looking, as art critic Kim Levin suggested: "After nearly a century of Modernism, art in Europe as well as America seemed to have reached a point where the only means left for radical innovation was to be reactionary."[34]

Above all, postmodernist artists and their supporters rejected modernist claims to universality. Indeed, cultural theorist Jean-François Lyotard attributed the emergence of postmodernism to the "suspicion of metanarratives"—that is, universal guiding principles of any kind. Postmodernism dissolved "every kind of totalizing narrative. [It turned] hierarchy into heterarchy [and posited a] centreless universe."[35] The idea of a homogeneous international culture was called into question. Was not this culture really only Western, centered on Europe and the United States? Moveover, was it not the creation of middle-class whites and heterosexual males? Just as they stressed the differences in class and gender, so postmodernist artists stressed local, regional, and national character; race and ethnicity; and history, culture, and current events—in a word, the particular.

The advocates of both formalism and minimalism asserted that art was progressing toward art as art. Formalist painters were focusing on the inherent properties of painting—areas of color and the physical flatness of the canvas—and minimal sculptors, on the inherent properties of sculpture—the literal "objectness" of objects.[36] Both groups claimed to confine themselves to what was unique in each of these arts and to purge their art of anything that was extrinsic to the medium, particularly any element identified with another art. The aspiration of the formalists was to make painting *more* painting, of the minimalists, to make sculpture *more* sculpture. Each camp arrogantly proclaimed that it was *the* authentic avant-garde. Both fought bitterly over which enterprise was the legitimate latest stage of modernism, the formalists accusing the minimalists of impoverishing art and the minimalists going so far as to declare that painting was a dead end.

The minimalists won out. Their claim to be avant-garde was more persuasive than that of the formalists. Their seemingly empty and boring, simple-looking sculpture looked more advanced than color-field abstraction; that is, more difficult, even iconoclastic, more an affront to conven-

tional taste, more like nonart. Consequently, although the audience for advanced art accepted Greenberg's definition of modernist art, it seemed to have in mind minimal art—which Greenberg detested—not his beloved formalist art, which had never looked iconoclastic to begin with.

The growing art-world interest in minimal art led Michael Fried—next to Greenberg, formalism's leading standard bearer—to go on the polemical warpath with renewed urgency in a much-debated 1967 article, "Art and Objecthood." Fried's primary target was the minimalist assertion that the mission of modernist art was to progress toward objecthood; that painting had gone as far as it could go in that direction and was therefore obsolete; and that the "next move" was into sculpture, and minimal sculpture at that, since of all contemporary styles of sculpture it was the most objectlike. In order to become more thinglike, minimal sculpture had eliminated all internal relations, which would call the viewer's attention away from thingness. However, this led the viewer to establish relationships between the unitary minimal sculpture and its surroundings or its "situation," as Robert Morris observed in an influential series of articles, "Notes on Sculpture," in 1966. It followed that changes in the environment, light, and the position of the viewer—indeed, the viewer him- or herself—became components of the work.[37]

Fried focused on the potential contradiction between a self-contained object and the open-ended "situation" it engendered. He maintained that there was no such ambiguity in formalist art, which is dependent only on internal relationships and thus is separate from anything external to itself. It is autonomous, *present* in its entirety, immediately. In contrast, minimal sculpture relies on its external surroundings and is therefore lacking in self-sufficiency. Fried declared that minimalism was irredeemably flawed by its dependence on its changeable environment and its concomitant lack of self-sufficiency. More damning, the viewer is included in the "situation" of minimal sculpture. Consequently the work becomes a kind of stage set and the viewer a kind of actor. Minimal art is essentially therefore, "theatrical," experienced in time. Fried concluded that the "the literal espousal of objecthood amounts to nothing other than a plea for a new genre of theater; and theater is now the negation of art,"[38] not only of modernist art but of all art. As the enemy minimalism had to be defeated.

Updating his thesis in 1982, Fried implied that the theatrical in the visual arts was anything but vanquished; indeed, it "has assumed a host of new guises and has acquired a new name: post-modernism."[39] Fried meant to restore the hegemony of the formalist object, but the effect of his article was to call attention to the modernist claims of both formalism and minimalism at a time when modernism was about to come under attack by postmodernists. If objecthood was the issue, and art-as-object, whatever its nature, was identified with modernism, then objecthood—any work of art-as-object—would be questionable.

Although Fried used the idea of theatricality as a weapon against

minimalism, it is actually more a function of postminimalism—and by extension, of postmodernism. To distinguish modernism from postmodernism, literary theorist Ihab Hassan drew up lists of opposing terms that would serve equally well in distinguishing minimalism from postminimalism. Among the terms were:

Modernism . . .	Postmodernism . . .
Form (conjunctive/closed)	Antiform (disjunctive, open) . . .
Design	Chance . . .
Art Object/Finished Work	Process/Performance/Happening . . .
Creation/Totalization	Decreation/Deconstruction . . .
Centering	Dispersal . . .
Selection	Combination[40]

The postminimalists embraced Fried's idea of theatricality. So did artists in succeeding movements and their supporters, often using it as the point of departure in their discourse. For example, as late as 1979, art theorist Douglas Crimp, in an update on a seminal show titled *Pictures* he had curated in 1977, remarked that the work of the artists included, which incorporated "photographs, film, video, performance, as well as traditional modes of painting, drawing, and sculpture," had been deliberately theatrical in that it was preoccupied with time, or, as Fried had written, "with the *duration of experience.*" Crimp also wrote: "Fried's fears were well founded. For if temporality was implicit in the way minimal sculpture was experienced, then it would be made thoroughly explicit—in fact the only possible manner of experience—for much of the art that followed."[41]

Toward the end of the 1960s, art professionals began to stress the aesthetic qualities of minimal art—rightness of proportion, scale, and surface—rather than its avant-garde claims, indicating that it had become established in the art world. Postminimalism replaced minimalism as *the* radical tendency and would continue in that role in both the United States and Europe during the first half of the 1970s. Postminimalists dematerialized the object (process art); spread it out into its surroundings (process art and earth art); formulated an idea and presented that as a work of art (conceptual art); and employed their own bodies in performance (body art). Ephemeral "situations" in actual space and real time struck the art world as radical because they dispensed with art-as-precious-object. Moreover, in polemical articles and panel discussions, the postmodernists and their supporters branded art-as-object as outmoded, hopelessly retrogressive—in a word, dead. Robert Morris wrote in 1970, for example: "Work that results in a finished product . . . finalized with

respect to either time or space . . . no longer has much relevance."[42]

The advocates of conceptual art were the most extreme in their attacks on art-as-object—and on painting in particular. In his influential 1969 article, "Sentences on Conceptual Art," Sol LeWitt rejected painting and sculpture because they "connote a whole tradition, and imply a consequent acceptance of this tradition, thus placing limitations on the artist who would be reluctant to make art that goes beyond the limitation."[43] Joseph Kosuth agreed that the traditional "languages" of art could no longer be used to say new things. Therefore, he claimed: "Painting itself had to be erased, eclipsed, painted out in order to make art."[44] Douglas Huebler declared: "The world is full of objects, more or less interesting; I do not wish to add any more."[45] John Baldessari went so far as to subtract some: In 1970 he cremated all the works he had executed between May 1953 and March 1966 that were then in his possession.

Not only was art-as-object discredited but also the customary spaces in which works of art were exhibited, namely galleries, collectors' homes, and museums. It was natural for postminimal artists, who moved their art outside gallery spaces, into the world, as it were, to denigrate art-world venues. As Brian O'Doherty pointed out, there was an organic relationship between galleries as "white cubes" and the objects exhibited in them: "The history of modernism is intimately framed by . . . a white, ideal space. . . . The ideal gallery subtracts from the artwork all cues that interfere with the fact that it is 'art.' . . . Some of the sanctity of the church, the formality of the courtroom, the mystique of the experimental laboratory joins with chic design to produce a unique chamber of esthetics."[46]

The postminimalist denial of art-as-object was coupled with a growing revulsion against the commodification of art. Many artists who made what seemed to be unsalable art did so without anticommercial intent; they moved to extremes because they conceived of themselves as avant-garde. Nonetheless considerable numbers were motivated by disgust with the art market to make art that could not be bought or sold. Art critic Barbara Rose asked how else one could account for Walter de Maria's room of dirt or trenches dug into the desert; Robert Morris's process art, which was composed of piles of felt or of dirt, grease, and metal odds and ends, or his "sculpture" made of steam; Joseph Kosuth's and John Baldessari's conceptual art, which consisted only of verbal statements; and Robert Barry's or Douglas Huebler's documentation-as-art of invisible phenomena? Her answer: "A dissatisfaction with the current social and political system results in an unwillingness to produce commodities which gratify and perpetuate that system. Here the spheres of ethics and esthetics merge." She went on to say that artists "who aspire to radicality [try to] take positions so extreme that they will finally be found unacceptable," and thus, by "denying that art is a trading commodity [erode] the very foundation of the art market."[47] Yet the art market did *not* collapse, to say the least. What artists discovered was that there was no art so extreme—neither inaccessible earthworks, photodoc-

umentation, nor even typewritten proposals—for which neophiliac collectors would not pay handsomely.

Rose made her comment in 1969, at the height of the Vietnam War. Artists who despised commodification generally opposed the war. They were appalled by the systematic destruction of a people and their land. As they saw it, rich collectors who thought of art as a commodity were the very ones who were supporting the evil war. The consummate expression of this attitude was a conceptual work by Hans Haacke, exhibited in *Information* at the Museum of Modern Art in 1970. Haacke invited museumgoers to cast ballots on whether they would refuse to vote again for Nelson Rockefeller, governor of New York, a noted collector and power within the museum, because he had not denounced the Vietnam War. It is noteworthy that 68.7 percent of those who participated rejected Rockefeller.

As the Vietnam War intensified in the second half of the 1960s, so did antiwar agitation. In 1968 the Tet offensive raised the temperature to a boiling point at home and abroad. That same year saw the assassinations of Martin Luther King Jr. and Robert Kennedy; the My Lai massacre; the trial and conviction of such dissidents as Philip Berrigan; President Johnson's decision not to seek reelection; and a mass demonstration at the Pentagon. Within the art world, the near-fatal shooting of Andy Warhol inadvertently symbolized the demise of the life-as-a-perpetual-party mentality of the earlier sixties. Moreover, 1968 was the year of the student uprisings in Europe and in our own universities, notably Columbia. There were massive demonstrations in Chicago during the Democratic convention to nominate a presidential candidate. In the streets outside, police clubbed crowds of antiwar demonstrators, who chanted for the benefit of the omnipresent television cameras: "The whole world is watching!" Inside, the delegates nominated Hubert Humphrey, who had earlier proclaimed that the war was a wonderful adventure. The Republicans selected Richard Nixon as their candidate, and he was elected. It was difficult to read the news or watch it on television without a sense of loathing, and this feeling of alienation contributed a great deal to the radicality of much of the art of the time.

The trauma of Vietnam initiated a new generation into the imagination of disaster that marked the twentieth century. Vietnam; the Cold War; the ever-present possibility of atomic destruction; the growing threat of ecological disaster; memories of the Holocaust and of two world wars, Nazism, fascism, and Stalinism. The present looked bleak and the future no better, if there was to be one at all. And artists could not help but respond. What was there to believe in? Art would grow increasingly ironic, even perverse—as if in the throes of a cultural convulsion or malaise.

The alienation felt by many young artists was shared by a large number of their generational peers. In the early 1960s young people gen-

erally had believed in the promise of America. But after 1965, with the escalation of the Vietnam War and with racial confrontations and rioting in the cities, many lost their faith, becoming increasingly contemptuous of conventional society. They improvised a new order of behavior, beliefs, and mores, which Theodore Roszak labeled the counterculture. As he viewed it, this "culture [was] so radically disaffiliated from the mainstream assumptions of our society that it scarcely looks to many as a culture at all, but takes on the alarming appearance of a barbarian intrusion."[48] Literary critic Leslie Fiedler agreed, arguing that the counterculture had repudiated the entire tradition of Western humanism, exemplified "by rationality, work, duty, vocation, maturity and success."[49] The counterculture replaced this attitude with a "peculiar combination of frivolity and despair,"[50] exemplified at its most extreme by the outrageous antics of the yippies and novelist Ken Kesey's Merry Pranksters. Their counterpart in the art world was fluxus, a group that in fact had been formed earlier, in 1962. Its "Purge Manifesto" declared war on "the world of bourgeois sickness, intellectual, professional, and commercialized culture."[51]

A disgust with the past, coupled with a loss of faith in the future, caused disaffected young people to look only to the present. "The meaning of life is here and now, in *this* experience, in *my* head now."[52] Little wonder then that radicalized young artists valued the immediate sensation and did not hesitate to embody it in whatever form seemed appropriate, no matter how ephemeral. It is not surprising either that they denied art-as-object-for-the-ages and instead favored the direct *process* of art making over the *finished* product, using perishable materials or no materials at all. Rejecting traditional art making, they sought to make a new move, a move that would be true to their own experience—their sense of alienation and/or salvation. Their art would be aesthetically radical; and it would end up being anticonventional, antibourgeois, and thus politically radical.

Counterculture groups had diverse interests, but all were engaged in a search for "a new consciousness," variously inspired by Zen Buddhism, Henry Thoreau, and Walt Whitman and often induced by marijuana, LSD, and eardrum-shattering rock music. At the heart of the counterculture, as one of its gurus, Allen Ginsberg, said, were a "return to nature and the revolt against the machine,"[53] and the shared conviction that America was controlled by The Machine, an impersonal and unfeeling monolithic system intent on subjugating human beings to the cycle of production and consumption and holding them in thrall through the manipulations of the mass media.[54] Young people "dropped out" of conventional society, some moving to the countryside and forming communes in which they might attain personal salvation, a feeling of togetherness, and a new life.

To alienated artists the manifestation of the system at hand was the art establishment. To resist its power the Art Workers Coalition (AWC) was founded in 1969.[55] In keeping with the countercultural mentality, the

coalition was kept deliberately loose; no list of members was drawn up, and no officers were elected or appointed. Decisions were made on the basis of "participatory democracy." The coalition's activities were fluid and varied. One group was interested in creating an artists' community; a second, in the living conditions of artists (and workers) and how to improve them; a third, in the "liberation" of women artists (and women generally); a fourth, in the problems of black and Puerto Rican artists; a fifth, in the cultural life of the ghetto and in neighborhood art centers and museums; a sixth, in broader social issues, notably the antiwar movement but also a new society; and the seventh, in protesting the policies of the Museum of Modern Art and restructuring it (and museums in general) in order to gain more decision-making power for artists. Agitation against MoMA soon became the art workers' major activity. Their demands—at first relatively modest and achievable—soon escalated and if met would have altered radically the structure and function of the museum. The rhetoric also escalated at times, as when the critic Gregory Battcock demanded that Bates Lowry, the museum's director, be tried before a "people's tribunal" for "his role in the worldwide imperialist conspiracy."[56]

A number of AWC members questioned whether reforming the Modern was really an issue sufficiently important to monopolize the AWC's attention. Would it not be more important, as Carl Andre suggested, to establish a countercultural artists' community that might replace the existing art market system, which "ha[d] been the curse and corruption of the life of art in America and in the world"?[57] Should not the reformation of capitalist society and/or action against the Vietnam War, which the leaders of that society waged, take precedence? Artists intent on reforming museums countered by insisting that the establishment or the system was monolithic; those who were responsible for the war controlled the museums for their own class interests. MoMA was the cultural arm of American imperialism. A strike at one was a strike at the other. Since the museum discriminated against African-Americans and women, it could be a rallying point for antiracist and antisexist as well as antiwar forces. And, most important, it made a good target because it was highly visible and vulnerable. It was also within the artists' community, and most members of the coalition believed that action for social change ought to begin in one's backyard, as it were. Meetings were held between representatives of MoMA and the AWC, but they were unfruitful.

However, the controversy did raise issues that would continue to engage artists and art professionals. As art critic Hilton Kramer defined it at the time, at issue were

> the artist's moral and economic status vis-à-vis the institutions that now determine his place on the cultural scene, and indeed, his ability to function as a cultural force. Though the Museum of Modern Art was the immediate target of complaint, the issue obviously went beyond the museum and its policies. What was denounced was the

entire social system—not only museums, but galleries, critics, art journals, collectors, the mass media, etc.—that now decisively intervenes between the production of a work of art and its meaningful consumption. What was proposed—albeit incoherently, and with that mixture of naivete, violent rhetoric, and irrationality we have more or less come to expect from such protests—was a way of thinking about the production and consumption of works of art that would radically modify, if not actually displace, currently established practices, with their heavy reliance on big money and false prestige.

In part, then, this was a plea to liberate art from the entanglements of bureaucracy, commerce, and vested critical interests—a plea to rescue the artistic vocation from the squalid politics of careerism, commercialism, and cultural mandarinism. [This is] a moral issue which wiser and more experienced minds have long been content to leave totally unexamined.[58]

The counterculture of the 1960s was short-lived. There were three main causes for its demise. One was the realization that its grandiose political hopes were unattainable. The second was the collapse of the antiwar movement after the invasion of Cambodia in 1970 and the killing of four students at Kent State University. The third comprised commercialism, hype, greed, vulgarization, and—most dramatically—violence, exemplified in the last month of the 1960s by the Rolling Stones concert at Altamont, California, at which a spectator was murdered by Hell's Angels who had been hired as "security guards." Many of the participants in the counterculture became profoundly pessimistic. Despite the corruption of the counterculture, others held fast to its attitudes and values, and they continued to make their alienated yet oddly hopeful voices heard in the 1970s and 1980s. Thus 1968 could be viewed as

the birth of a generalized concept of revolution—a concept that was seemingly endless . . . in terms of what could be incorporated into it. Political emancipation, spiritual regeneration, sexual liberation, . . . alternative lifestyles, grass roots and community democracy, . . . ecologically-based production, holistic therapies, anti-institutional "institutions" could all refer back to one generalized concept.[59]

It would spawn artistic movement after movement in the 1970s and 1980s.

In retrospect the counterculture can also be viewed as a response to a pervasive change that was occurring in Western societies, from an industrial to a postindustrial or consumer society, a change then just being recognized. A group of politically dissident artists in Europe called the situationists were already discussing the new society, on which their leader, Guy Debord, published a book in 1967.[60] Although young people could not be specific, they sensed that the persisting rhetoric of the old society had become outdated and hollow, and its demands on them

meaningless. At the same time they did not like what the new society was turning into. The protests of 1968 in the United States and Europe can even be viewed as a kind of unconscious reaction to this underlying social development.

Postminimal art evolved in part as an alienated and radicalized response to American life in the late 1960s, tempered by the feeling that individuals should be free to "do their own thing," a popular catchphrase at the time. The artists, however, were not moved to make straightforward social comments in their work. To be sure there was a great deal of protest art, but most of it was conventional and banal. This put off postminimalist artists, such as Eva Hesse and Bruce Nauman, and those who followed in their wake.[61] They also found its underlying premise, that the human condition would improve, simplistic—and laughable. Indeed, their response could not help being ironic, at least. Moreover, they had been weaned on avant-garde art and were therefore willing to try anything, no matter how irrational, iconoclastic, anarchic, absurdist, or perverse. Indeed, these negative qualities were prized, if only because they were unconventional, unrestrained, and immoderate, and consequently hated and feared by the middle class, which valued the familiar, restrained, and moderate. But there was a positive side to postminimalism: the artist's direct, free—and potentially elating—involvement with his or her materials and with actual space; that is, with art making as an unalienated activity without market or media pressures.

In the catalog of a major museum show of postminimal art at the height of the Vietnam War, curator Marcia Tucker wrote that the work included "presents itself as disordered, chaotic, or anarchic."[62] Such references to content were relatively rare at the time. Most early interpretations of postminimalism were essentially formal, but a few art professionals did remark that the perishable materials suggested the vulnerable human condition, calling to mind the insignificance, powerlessness, frailty, and impermanence of humankind. And it was noted that the sadomasochistic pain and violence that a Vito Acconci and a Chris Burden embodied in their performance art were appropriate to the time.

The best of postminimal art was genuinely countercultural but knowing. It was only implicitly political, not imparting any specific message, but it did partake of the dark mood of American life. Extreme and eccentric art generated more of the same, until there was a cross-referential density that no longer appeared extreme and eccentric, and if not exactly moderate then at least "normal." However, the internal development of art alone could not account for the evolution of an extremist and eccentric art, nor for the art-world acceptance of it. There were extra-aesthetic reasons—a broader historic context—notably the traumatic events of the late 1960s, which were a continuation of the horrors that marked the twentieth century. These gave rise to a persistent crisis mentality that made the increasingly extreme and eccentric developments in art seem

relevant, indeed natural. However, in time the shock wore off. As the period receded into history, art that initially looked countercultural, even irredeemably perverse, appeared increasingly formal and aestheticized.[63] Such was the fate of all radical art.

Much of the acclaimed art that followed postminimalism in the 1970s and 1980s was explicitly political. After all, the artists of these decades had—unlike their elders—been weaned in a politicized situation.[64] The creation of new socially conscious styles would be spurred in the early 1970s by the upsurge of feminism, which replaced antiwar agitation as the primary social cause in the art world. In the 1980s artists would comment not only on sexism, but on racism, homophobia, and ecological destruction, and would respond with growing concern to the pernicious power of the mass media in a burgeoning consumer society. It is important to stress that the new political art differed from earlier social protest art because it was on the cutting edge rather than being retrogressive.

Art that "deconstructed" social ills generally employed photography and other mechanical media. But at this time there was also an international "renaissance" of painting, some of it political, most not. Painting, often dismissed as dead, seemed more alive than ever. In this situation the advocates of mechanical and traditional media were at constant loggerheads. Indeed, the art of the 1980s became a polemical battleground between their competing claims.

NOTES

1. Clement Greenberg, "Louis and Noland," *Art International*, May 25, 1960; "After Abstract Expressionism," *Art International*, Oct. 25, 1962.

2. Clement Greenberg, introduction to *Post-Painterly Abstraction* (Los Angeles: Los Angeles County Museum of Art, 1964).

3. Greenberg remained true to formalist abstraction. For example, as late as September 1987, in "Vasari Diary" (*Art News*, p. 16), he was quoted as saying: "I think that the best painter alive right now is Jules Olitski. . . . Noland is still a great painter. . . . I think Wyeth is way better than most of the avant-garde stars of this time. Better than Rauschenberg. Better now than Jasper Johns." As the reputations of Olitski and Noland declined, those of Rauschenberg and particularly Johns rose. For Greenberg to state that Wyeth, a middlebrow icon, was superior to Rauschenberg and Johns was unworthy, an art-political ploy to denigrate what he still considered the competition.

4. Clement Greenberg, "Modernist Painting," *Arts Yearbook* 4 (1961): 103–4.

5. Frank Stella, arguably the most influential abstract artist of the sixties, was generally included in the company of Louis, Noland, and Olitski by formalist critics, although Greenberg disliked his work. But, like Greenberg, Stella called for the creation of a self-sufficient art, clear and complete unto itself; witness his famous statement in Bruce Glaser, interviewer, and Lucy R. Lippard, ed., "Questions to Stella and Judd" (*Art News*, Sept. 1966, p. 59): "My painting is based on the fact that only what can be seen there *is* there. It really is an object." What you see is what you see.

6. Clement Greenberg, "Modern and Post-Modern," *Arts Magazine*, Feb. 1980, p. 65.

7. See Paul Richter, "Modernism & After—1," *Art Monthly*, Mar. 1982, p. 3.

8. Clement Greenberg, "Avant-Garde and Kitsch," *Art and Culture: Critical Essays* (Boston: Beacon Press, 1961), p. 9.

9. Prior to 1960 intellectuals generally agreed that pop-

ular culture, or kitsch, was the implacable enemy of high culture. Harold Rosenberg, like Greenberg an art-critical elder statesperson, but of an existentialist frame of mind, was so opposed to kitsch that he asserted in "Pop Culture: Kitsch Criticism," *Tradition of the New* (New York: Horizon Press, 1960, p. 260), that *any* critique, no matter how negative, served "*to add to kitsch an intellectual dimension* [italics in original]" and should be avoided. Rosenberg went on to say: "There is only one way to quarantine kitsch: by being too busy with art. One so occupied is protected by the principle of indifference" (p. 263). But even Rosenberg was ambivalent, since genuine artists, as he also wrote, "like Stuart Davis and Willem de Kooning continue to make good use of billboard type or the lips that sell rouge" (p. 264). Moreover: "Using kitsch is one of art's juiciest devices" (p. 265). But it was dangerous; such art could readily degenerate into kitsch.

10. Greenberg, "Modern and Post-Modern," p. 65.
11. See Sandler, *American Art of the 1960s*, chap. 5.
12. See Johanna Drucker, "Postmodernism," *Art Journal* 49, no. 4 (Winter 1990): 430.
13. Steven Connor, *Postmodernist Culture: An Introduction to Theories of the Contemporary* (Oxford, England: Basil Blackwell, 1989), pp. 7–8, 20.
14. Paul Richter, in "Modernism & After—2" (*Art Monthly*, Apr. 1982, p. 5), defined a paradigm in art as "an interrelated system of beliefs concerning the proper objects of aesthetic experience, the correct way in which these may be perceived.... An aesthetic paradigm functions by informing those who approach art under its influence, as to what to seek in works of art, how to seek this, how to recognize the relative values of those things that claim to produce it, and so on."
15. Edit DeAk, "The Critic Sees Through the Cabbage Patch," *Artforum* Apr. 1984, p. 56.
16. Robert Venturi, *Complexity and Contradiction in Architecture* (New York: Museum of Modern Art, 1966).
17. Postmodern architects continued to use international-style elements, but considered them on a par with borrowings from older styles. Jencks claimed that postmodern architecture double-coded a modernist with a nonmodernist code, adding some different, often older, meaning.
18. Venturi, *Complexity and Contradiction in Architecture*, p. 16.
19. Kirk Varnedoe, *The Poverties of Postmodernism*, Slade Lectures, 1992, Oxford University, typescript, p. 17.
20. Stephen Westfall, "The Greenberg Effect: Comments by Younger Artists, Critics, and Curators," *Arts Magazine*, Dec. 1989, p. 64.
21. Kirk Varnedoe and Adam Gopnik, *High & Low: Modern Art and Popular Culture* (New York: Museum of Modern Art/Harry N. Abrams, 1990), pp. 402, 407.
22. Lisa Phillips, "The Greenberg Effect," p. 62.
23. Westfall, "The Greenberg Effect," p. 64.
24. Robert Storr, "No Joy in Mudville: Greenberg's Modernism Then and Now," in Kirk Varnedoe and Adam Gopnik, eds., *Modern Art & Popular Culture: Readings in High & Low!* (New York: Museum of Modern Art, 1990), p. 179.
25. Henry M. Sayre, *The Object of Performance: The American Avant-Garde since 1970* (Chicago: University of Chicago Press, 1989), p. 45. Norman Bryson deconstructed the connection between explicit formal analysis and the assertion of nonexplicit aesthetic quality in formalist reasoning. He pointed out that there was a gap between the two that had not been bridged.
26. Greenberg, "Modern and Post-Modern," p. 66.
27. Harold Rosenberg also had no interest in postmodernist art. He was reported to have said in the late 1970s that modernism had happened a long time ago and was all over. When asked what had replaced it, he replied: "I don't care."
28. Storr, "No Joy in Mudville," p. 180.
29. Irving Sandler, introduction to *Critic's Choice 1969–70* (New York: New York State Council on the Arts/State University of New York, 1969), n.p.
30. Ibid.
31. Charles Jencks, "The Post-Avant-Garde," *Art & Design* 3, nos. 7–8 (1987): 5.
32. Ada Louise Huxtable, "Is Modern Architecture Dead?" *New York Review of Books*, July 16, 1981, pp. 17–18.
33. Robert Morris, "Three Folds in the Fabric and Four Autobiographical Asides as Allegories (or Interruptions)," *Art in America*, Nov. 1989, p. 150.
34. Kim Levin, *Beyond Modernism: Essays on Art from the '70s and '80s* (New York: Harper & Row, 1988), p. 165.
35. Connor, *Postmodernist Culture*, pp. 8–9.
36. The formalists used different criteria when dealing with sculpture than when dealing with painting. They opted for open welded construction in the vein of Picasso, Gonzales, and David Smith because of its alleged quality. But this sculpture was, as they maintained, "pictorial," a seeming contradiction in the basic formalist premise.
37. Robert Morris, "Notes on Sculpture, Part 2," *Artforum*, Oct. 1966, pp. 20–23.
38. Michael Fried, "Art and Objecthood," *Artforum*, Summer 1967, pp. 15, 19–20.
39. Michael Fried, "How Modernism Works: A Response to T. J. Clark," *Critical Inquiry* 9 (Sept. 1982): 229–30, n. 17.
40. Ihab Hassan, *The Dismemberment of Orpheus: Toward a Postmodern Literature* (New York: Oxford University Press, 1982), pp. 267–68, quoted in Connor, *Postmodernist Culture*, pp. 111–12.
41. Douglas Crimp, "About Pictures," *Flash Art* (Mar.–Apr. 1979): 34, and "Pictures," *October 8* (Spring 1979): 77. Henry M. Sayre, in *The Object of Performance: The American Avant-Garde since 1970*, 1989, used Fried's dialectic as his point of departure. He hailed the new performance art in all its manifestations as *the* avant-garde of the period.

42. Robert Morris, in *Conceptual Art and Conceptual Aspects* (New York: New York Cultural Center, 1970), p. 47.

43. Sol LeWitt, "Sentences on Conceptual Art," *Art and Language*, May 1969, pp. 11–12.

44. Joseph Kosuth, "Joseph Kosuth on Ad Reinhardt," *Cover*, Spring–Summer 1980, p. 10.

45. Douglas Huebler, in *January 5–31, 1969* (New York: Seth Siegelaub, 1969), n.p.

46. Brian O'Doherty, "Inside the White Cube: Notes on the Gallery Space, Part 1," *Artforum*, Mar. 1976, p. 24.

47. Barbara Rose, "Problems of Criticism, VI: The Politics of Art, Part III," *Artforum*, May 1969, pp. 46–48.

48. Theodore Roszak, in Godfrey Hodgson, *America in Our Time* (Garden City, N.Y.: Doubleday, 1976), p. 310.

49. Leslie Fiedler in ibid., p. 311.

50. Hodgson, ibid., p. 321.

51. See Jeff Rian, "Fluxus, Flux On," *Flash Art* (Nov.–Dec. 1992): 53.

52. Hodgson, *America in Our Time*, p. 313.

53. Allen Ginsberg, in ibid., p. 324. Hodgson pointed out (p. 326) that "the actual process of recruitment to the counter culture probably owed more to three factors that had little enough to do with politics except as symbols—to drugs, to rock music, and to the underground media"—its sacrament, liturgy, and gospel.

54. See David Caute, *The Year of the Barricades: A Journey Through 1968* (New York: Harper & Row, 1988), p. 35.

55. For a fuller treatment of the Art Workers Coalition and its activities, see Irving Sandler, "The Artist as Political Activist," in *American Art of the 1960s*, pp. 292–302.

56. Gregory Battcock, in *Open Hearings* (New York: Art Workers Coalition, 1969), p. 8.

57. Carl Andre, in ibid., pp. 30, 34.

58. Hilton Kramer, "Artists and the Problem of 'Relevance,'" *New York Times*, May 4, 1969, sec. D, p. 23.

59. Jonathan Miles, "'68 to '84: What Happened to the Revolution?" *ZG* 11 (Summer 1984): 20.

60. Guy Debord, *La Société du Spectacle* (Paris: Editions Buchet-Chastel, 1967). The first English edition appeared in 1970.

61. Not all political art in the 1960s was clichaic. Works by Leon Golub, Nancy Spero, Peter Saul, Rudolph Baranik, and Edward Kienholz were exceptions. So were *F111* by Rosenquist and *Lipstick* by Oldenburg. The most moving and effective antiwar statement was a poster designed by Irving Petlin, Jon Hendricks, and Fraser Dougherty and issued by the Art Workers Coalition, which used Ronald Haeberle's color photograph of the massacred civilians at My Lai with the text: "Q: And Babies? A: And Babies."

 But on the whole, political art was ordinary. Even Lucy R. Lippard, who organized a major exhibition, *A Different War: Vietnam in Art* (Seattle: Real Comet Press, 1990), wrote: "If Vietnam was a different war, it produced no fundamentally different ways for art to oppose war" (p. 62). The images remained "the basic vocabulary of art against war . . . skeletons, victims, victors, and swords (then guns and bombs) . . . "

62. Marcia Tucker, introduction to *Anti-Illusion: Procedures/Materials* (New York: Whitney Museum of American Art, 1969), p. 25.

63. See Robert Pincus-Witten, "Postminimalism," in *The New Sculpture: 1965–1975* (New York: Whitney Museum of American Art, 1990), pp. 24–25.

64. Irving Petlin wrote of his generation of dissidents, active in the anti–Vietnam War movement, that they did not "know how to live the political life as part of one's regular life" (Sean H. Elwood, *The New York Art Strike of 1970: A History, Assessment, and Speculation* [master's thesis, Hunter College, New York, 1982], p. 38, quoted in Lippard, *A Different War*, p. 34).

1 POSTMINIMALISM

Postminimalism was ushered in by a show titled *Eccentric Abstraction*, curated by Lucy Lippard in the fall of 1966. She decided to organize the show because the rigors of minimalism, of which she had been an early champion, had made her aware of what was precluded, namely "any aberrations toward the exotic." She also recognized that a significant number of artists had "evolved a . . . style that has a good deal in common with the primary [or minimal] structure as well as, surprisingly, with aspects of Surrealism. [These artists] refuse to eschew . . . sensuous experience while they also refuse to sacrifice the solid formal basis demanded of the best in current non-objective art."[1]

Eccentric abstractions were composed of unexpected, often soft materials, arranged in modular or serial structures. The funky materials seemed to refer to the artist's private, frequently erotic experiences. Indeed, eccentric abstraction was also aptly characterized as minimalism with an eccentric, Dada, surrealist, or expressionist edge; or as purist funk; or as sexy, absurdist, or perverse minimalism. On the day of the opening of Lippard's show, and in the same building, there also opened an exhibition of minimal art organized by Ad Reinhardt, with the help of Robert Smithson. Robert Pincus-Witten commented that these two shows "represented the apogee of Minimalism and the beginning of 'post' or 'counter' Minimalism."[2] Lippard soon came to believe that the eccentric abstractionists were intent on the dissolution of the minimal object, as she and John Chandler wrote in a 1968 article titled "The Dematerialization of Art," which was also the subject of a book of hers published in 1973.[3]

Robert Morris, an originator of minimal sculpture, chronicled the transition-in-progress from minimalism to postminimalism. Like Lippard, he had written extensively on minimal art, his "Notes on Sculpture" providing the theoretical underpinning of the "unitary object," as he termed it. But he had turned against the aesthetic of minimal sculpture in two articles, "Anti-Form" (1968) and "Beyond Objects" (1969), in which he formulated a rationale for the postminimal tendency labeled process art.[4]

Morris had come to believe that minimal sculpture was not as phys-ical as art could or should be because the formation and arrangement of its rigid modular or serial units was not inherent in their material. To make a work more physical, the process of the work's "making itself" had to be emphasized. Morris called for a literal art whose focus was on mat-ter—more specifically, on malleable materials—and the action of gravity on matter. Such an art, whose ordering was "casual and imprecise and unemphasized," could not be predetermined. "Random piling, loose stacking, hanging, give passing form to the material."[5] To demonstrate what process art was, Morris organized *9 in a Warehouse* at the begin-ning of 1969. He included not only Americans—Eva Hesse, Richard Serra, and Bruce Nauman—but also Europeans—the Italian arte povera artists Giovanni Anselmo and Gilberto Zorio (and he should have invited Joseph Beuys)—indicating the international character of the new three-dimensional art.

In the essay "Beyond Objects," published soon after *9 in a Warehouse*, Morris asserted that the unitary object, like any object, was connected to its surroundings in a kind of figure-ground relationship. To Morris the equation of the object with the figure revealed that minimal sculpture was "terminally diseased." The cure was to base three-dimen-sional art on "the conditions of the visual field itself." The discrete, homogeneous object had to be replaced by "accumulations of things or stuff, sometimes very heterogenous. . . . In another era, one might have said that the difference was between a figurative and a landscape mode."[6] Morris treated process art in formal terms, but viewed from another perspective, sculpture made of inchoate, mutable "stuff" had an unconventional edge, exemplifying a countercultural attitude to art.

In 1971 Morris again claimed that "the static, portable, indoor art object can do no more than carry a decorative load that becomes increasingly uninteresting." He proposed "a couple of routes away from this studio and factory generated commodity art." One was outdoor earth art, for example, Robert Smithson's *Spiral Jetty* (1970) and Michael Heizer's *Double Negative* (1969–70), which made of landscape the very substance of art. The other was indoor installation, "an art of location," in which artists created "visually pared down" environments, for exam-ple, the dimly lit room of Larry Bell, in which those who entered became acutely aware of the time it took to get used to the darkness and make out what little there was to see. Still, Smithson's *Spiral Jetty* and Heizer's *Double Negative*, which were elementary geometric figures, and the room- and corridorlike installations of a Bell or Bruce Nauman emphati-cally declared their source in minimal art. But their departures were equally significant. Both earth art and installation art depended on real time, requiring the viewer to participate, to "be there and to walk around the work."[7]

Because they involved the viewer as a kind of actor, earth art and

installation art were essentially theatrical. Another form of postminimal art, called body art, carried theatricality to an extreme in "sculpture." Its major practitioners, Vito Acconci and Nauman, used their own bodies as the material of their art, performing elementary movements whose simplicity was inspired by minimal art.

Earth art, installation art, and body art, like minimal art, were based on preconceived ideas. Such artists as Sol LeWitt "abstracted" the ideas themselves and formulated a purely conceptual art. Conceptual art totally "dematerialized" the discrete art object, whose objecthood had been valued above all else by minimal artists. So also in one way or another did earth art, installation art, and body art deny the object. Indeed, all postminimalist tendencies were linked by their urge to avoid objecthood.

In 1969, at roughly the same time as *9 in a Warehouse*, James Monte and Marcia Tucker curated the first museum show of postminimal art, *Anti-Illusion: Procedures/Materials*, at the Whitney Museum. Monte wrote in the exhibition catalog:

> The radical nature of many works in this exhibition depends . . . on the fact that the acts of conceiving and placing the pieces takes precedence over the object quality of the works. [The] very nature of [a] piece may be determined by its location in a particular place. [The location functions] not merely as a site for the work, but as an integral, inextricable armature, necessary for the existence of the work.[8]

In emphasizing the "situation" of artworks, Monte took his cues from Morris, who was included in the show. Indeed, he had in mind the argument over "theatricality," waged by Morris on behalf of minimalism and Michael Fried in the cause of formalism.[9]

Appropriately Tucker and Monte included in their show composers Philip Glass and Steve Reich, and filmmaker Michael Snow, because they conceived of music and film as physical and literal, making viewers acutely aware of "real time"—that is, the passage of time. Tucker wrote that Glass and Reich employ "a deliberate and unrelenting use of repetition [which] focuses attention . . . on the material of sounds and on their performance."[10] In Snow's film *Wave Length*, a camera moves down the length of a room with excruciating slowness; time seemed to have become a palpable substance. The same applied to films by Nauman in which he repeated single physical gestures, such as bouncing a ball.

Monte and Tucker might have included documentation of an earlier conceptual performance by John Latham (1966), which provided a telling commentary on the Fried-Morris argument over theatricality. Latham, an English artist who built assemblages of books sprayed with black paint or partly burnt, and who was an instructor at London's St. Martin's School of Art, a bastion of formalism, took Greenberg's *Art and Culture* from the

school library and used the book as the focus of a conceptual performance piece. He and a group of his students, fellow artists, and critics did not incinerate but chewed a large part of this formalist gospel, and immersed another part in acid, turning it into a liquid. Thus Latham had a modernist object of sorts theatrically transmuted into a postmodernist antiform substance. When the library urgently requested the return of this much-in-demand volume, Latham brought in the jar of liquid. On the following day he was informed that he would not be invited back to teach.

Because postminimal works were not objects, they were generally ephemeral. To preserve their memory or to provide them with an afterlife, and to disseminate information about them, artists recorded them in photographs, films, videos, notes, and other documentation. There were debates over the purpose of such information. Was it simply a nonart record of an artistic event or an artwork in its own right, to be marketed as such? Postminimalists whose sympathies were countercultural believed that the documentation of a work was not art and thus not salable. They had turned to process art, earth art, installation art, body art, and conceptual art because they did not want to create art commodities. Many also believed, as Lucy Lippard observed, that their refusal to produce salable objects would subvert the art market (although she later acknowledged that this attempt had failed). In the end the documentation was accorded the status of art object. Indeed, much of impermanent postminimal art seemed to have been made because of the documentation it yielded: It was made to be photographed. As Nancy Foote wrote: "It's ironic that an art whose generating impulse was the urge to break away from the collectible object (and hence the gallery/collector/artbook syndrome) might through an obsession with the extent and quality of its documentation, have come full circle."[11] Consequently photography assumed a new importance in avant-garde art.

Declaring the radicality of their work, postminimal artists and their supporters announced that painting was not only outmoded but had reached its terminal condition. The issue—Is painting dead?—was seriously debated in the late sixties and remained a topic of contention during the following two decades. Tucker and Monte did include Richard Tuttle and Robert Ryman in *Anti-Illusion: Procedures/Materials*, but in order, it seems, to prove that painting had gone as far as it could. They maintained that in Ryman's all-white pictures, as Tucker wrote, "the application of the pigment [had] become the subject of the work," thus turning it into a kind of process art.[12][1] In reducing painting to a purely manual activity, they suggested that Ryman had carried it to a dead end, ironically resurrecting painting to demonstrate its demise. (It took time for the sensitivity and transcendent quality of Ryman's canvases to be appreciated.) Tuttle's bits of colored cloths were also thought to have carried painting to what seemed to be its terminal stage. Tacked to the wall, they called attention not to themselves but to the "situation" of the wall.

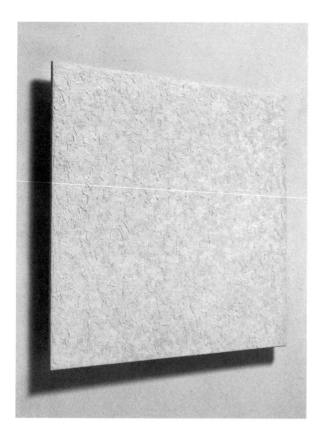

1. Robert Ryman, *Fix*, 1989.
(*Courtesy PaceWildenstein*)

Morris's work exemplified the transition from unitary objects to process, earth, installation, and conceptual art [2]. Minimalist Morris became his own postminimalist, as it were. In his best-known process works, accumulations of soft materials that spilled across the floor into the viewer's space, he set out to explore what he considered the dialectical opposite of *form,* namely *matter.* Instead of fabricating immutable "finished" objects, he manipulated materials that were "formless," whose "form" was changeable and openended. Much as he wanted to emphasize the process of their making, he also wanted to retain a rigorously geometric minimalist component. Consequently he chose to work with gray felt, which was at once malleable and stiff enough to be cut according to a rectilinear pattern. That done, any arrangement shaped by the process of gravity was acceptable. Because the material was floppy, the resulting form had to be indeterminate. It could never be final, and because it could change, the work acknowledged the passage of time—and thus became "theatrical." Later Morris would omit the rectilinear cuts and fill rooms with heaps of amorphous fabrics. He would also make dirt and steam works outdoors.

In 1970 Morris produced a monumental piece at the Whitney Museum in which he summarized his transition from minimal to process

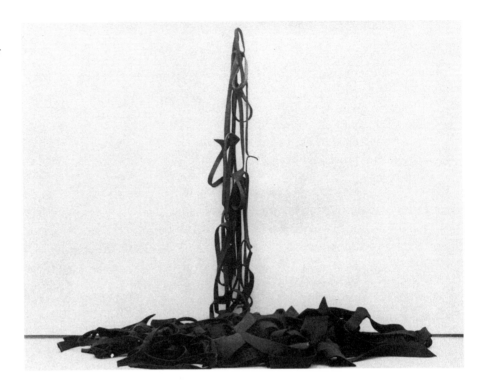

art. In it he scattered, as if at random, huge cubic concrete and timber forms over the vast space of the museum's fourth floor. Morris even wanted to give the piece a theatrical dimension by inviting viewers to watch the process of installation, although for safety reasons this could not be done.

The many statements Morris made about art were primarily formalist, but he did occasionally allow another kind of interpretation, countercultural in tenor, in a kind of upsurge of repressed thought. Observing that our time was "disastrous and unforgiving," Morris went on to say that art in its "irrational games and in its depth of feeling, in its awe and cynicism, its mournings and derisions, its anger and grace [bore] witness to a dark century."[13]

By 1970 the claim that there was still an avant-garde, and that it was postminimalism, ceased to be plausible, but postminimalism retained an aura of radicality nonetheless, in large measure because it continued to yield provocative variants. Consequently postminimalism was promoted by influential neophiliac art professionals both in the United States and Europe. As signs of its radicality, they pointed to the use of unconventional, mainly "poor," materials, such as latex and felt; the emphasis on process and concept rather than on product; the reliance on chance; the seeming formlessness; the use of gravity alone to hold the floor-hugging parts in place; and the way in which the works sprawled into their surroundings.[14] As art critic Max Kozloff wrote of his visit to *9 in a Warehouse:*

[We] are not accustomed to stepping on sculpture, or to avoid step-
ping on sculpture which appears to be some kind of leaving. Nor do
we expect it to seem merely a sullying and spotting of the surfaces
which enclose us. And this is not to speak of the amorphousness of
the substances that for the most part are scattered or dropped about,
and that betray little preconceived notion of orthodox form or even
pattern. It is not that we are irritated by a disdain for permanence,
but we are touched by the knowledge that these works cannot even be
moved without suffering a basic and perhaps irremediable shift in the
way they look.

Kozloff understood that the "attack on the status of the object . . . pro-
vides the show with its major premise and rationale,"[15] but was obviously
taken aback by the countercultural look of sculpture that resembled
chance leavings, droppings, and the like. Few other critics remarked on
postminimal art's bizarre mix of iconoclasm and absurdity or perversity,
presumably because such an interpretation would call into question its
"seriousness"—and theirs. But, much as they ignored it, the countercul-
tural aspect of postminimal art contributed considerably to its appeal.

Postminimal art did not attract a mass audience, to say the least,
but by 1973 there was sufficient public interest to warrant reportage in
the mass media—a sign that whatever radicality it might have had was
past. Douglas Davis, for example, wrote in *Newsweek*:

[Art's] range expanded to unforeseen limits—an artist's work could be
an empty gallery or a 540-mile drawing cut into the Nevada desert. It
could be a videotape event—a closed-circuit telecast of images in a
gallery or a day-long communication with the home audience on a
local TV station. It could be a series of photographs of parking lots, or
a typed-out, IBM-duplicated manifesto hung starkly on a gallery wall.
It could be the artist himself, talking to visitors (or to himself), engag-
ing in sexual activity with a partner (or with himself), or even allow-
ing himself to be shot by a friend.

All were "based on one esthetic premise: that the artist is no longer con-
fined in his expression to objects. . . . American art of the '70s is post-
object art."[16] And so was advanced art in Europe, exemplified by the
works of Joseph Beuys in Germany, arte povera in Italy, and Richard
Long and Gilbert & George in England.

The sculptures made by Eva Hesse between 1965 and her death in
1970 exemplify the eccentric tendency in postminimal art [3]. In most
she retained minimalism's modular grid as well as its literalist treatment
of materials, particularly in 1967, "Minimalism's triumphant year."[17] But
the materials Hesse favored—pliant latex, rubberized cheesecloth, rubber
tubing, and twine—were malleable, subverting minimal rigidity, rational-

ity, and formality. Visceral, yielding, and funky, they seemed to embody her private physiological and psychological experiences, above all, her own sense of the female body and its sexual nature. Loosely hanging soft substances call to mind vaginas; the hemispherical mound suggests a breast; and the string dangling from its center, a stream of milk or an umbilical cord.[18] Hesse often allowed her floppy materials to find their own form. In this she verged on process art. But informality was countered by the way she bandaged wire with cloth or coiled string around cord. In this repetitive binding, Hesse seemed to be "making psychic models," as Robert Smithson observed[19]—that is, searching for the exact embodiment of an interior vision.

Hesse detested the "decorative," which she branded "the only art sin."[20] She favored incongruous juxtapositions and extreme oppositions of materials and forms because she found them ugly and perverse. She was encouraged in this by her close friend, Sol LeWitt. He wrote to her in 1965, when she was having a particularly difficult time with her work: "You must practice being stupid, dumb, unthinking, empty. Then you will able to DO! . . . Try to do some BAD work. The worst you can think of and see what happens."[21] LeWitt's letter struck a chord in Hesse. She later said: "If I can name the content, then . . . it's the total absurdity of life." She added that her "whole life has been absurd. There isn't a thing in my life . . . that hasn't been extreme. [Absurdity] is the key word. . . . It has to do with contradictions and oppositions . . . order versus chaos, stringy versus mass, huge versus small, and I would try to find the most absurd opposites or extreme opposites."[22] Even the systemic, seemingly rational aspect of her work struck her as absurd. "Series, serial, serial art, is another way of repeating absurdity."[23] She later added: "If something is absurd, it's much more exaggerated, more absurd if it's repeated."[24]

Hesse summed up her intentions in a description of *Hang-Up* (1966):

3. Eva Hesse, *Sans II*, 1968. *(Copyright © 1994 Whitney Museum of American Art)*

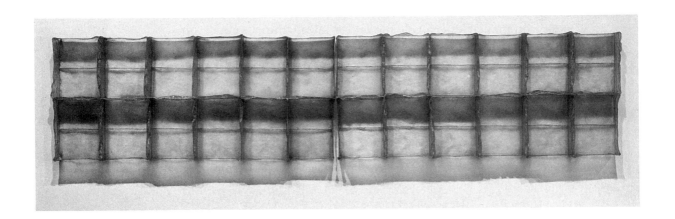

[It was] the most important early statement I made. It was the first time my idea of absurdity or extreme feeling came through. It was a huge piece, six feet by seven feet. . . . It is a frame, ostensibly, and it sits on the wall. . . . The frame is all cord and rope. It's all tied up like a hospital bandage—like if someone broke an arm. The whole thing is absolutely rigid, neat cord around the entire thing. . . . It is extreme and that is why I like it and don't like it. . . . It is the most ridiculous structure that I ever made and that is why it is really good.[25]

Hesse began to use latex in 1967, attracted by its pliability and instability. She knew the works would deteriorate and welcomed that. In the following year, however, she turned to reinforced fiberglass, a lasting substance, indicating a changed attitude; now she was thinking of art for the ages. Hesse's life was tragically short—she became ill in 1969 and died a year later at the age of thirty-four—and her sense of absurdity may well have been heightened by her consciousness of impending death—and perhaps also by the pessimistic mood of the late sixties. Certainly much of the appeal of her work to artists and art professionals of her generation resulted from the way in which the dissociation and dislocation of her forms evoked feelings of malaise. However, the obsessiveness of her binding and other repetitive acts in one way countered the sense of absurdity in her work. Hesse obviously needed to get the form right, to make it feel and look right.

Hesse died before the women's movement emerged in the art world; nonetheless, later commentators have identified components in her work as feminist. Anna C. Chave wrote: "Spinning and weaving, sewing and knitting, wrapping and bandaging: working with fiber is conventionally women's work, and Hesse—like many women of her generation—learned as a matter of course how to sew, knit, and crochet." Moreover her sculpture was layered "with abstract references to female anatomy—with forms suggestive of breasts, clitorises, vaginas, fetuses, uteruses, fallopian tubes, and so forth. . . . Hesse found new and different terms with which to articulate a feminine sexual subjectivity" in other words, from the vantage point of the female, not the male, gaze. Her personal process and imagery would make Hesse a role model for later feminists.[26]

Jackie Winsor, too, retained minimalism's unitary structure and modularity and used unconventional materials, such as tree trunks, bricks, cement, rope, Sheetrock, nails, and lathing, to create eccentric objects, for example, circles made of heavy rope (1968–71). Countercultural in spirit, many of Winsor's sculptures refer to nature. *Bound Square* (1972), for example, is composed of four tree trunks arranged in a square and connected by knobby corners of wrapped cord, like fat knees or elbows. *Bound Grid* (1971–72) [4], consists of saplings bound together, but the trunks are not straight (such is the nature of trees), and one of them forks so that the bottom of the grid has ten arms and the top eleven.

4. Jackie Winsor, *Bound Grid*, 1971–72.
(Courtesy Paula Cooper Gallery, New York)

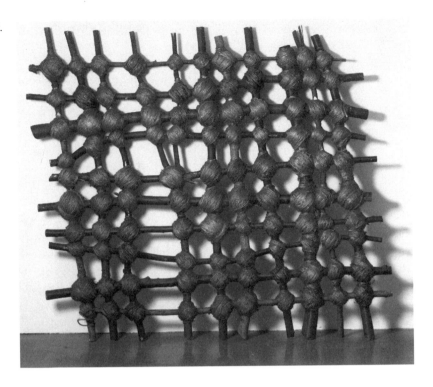

Like Hesse, Winsor was obsessed with seemingly absurdist, labor-intensive, repetitive work, hammering fifty pounds of nails into fifty pounds of wood planks in *Nail Piece* (1970), binding and winding, as in *Four Corners* (1972), and gouging, as in *Laminated Plywood* (1973). In 1974 cubes became the primary structures in Winsor's works, some with slits or windows that conceal secret spaces more than they reveal them. They are related to a series of Hesse's pieces, titled *Accession* (1967–68), each a hollow, open-topped box of grid-perforated aluminum, whose inside is threaded with thousands of small vinyl tubes. Winsor's cubes—as Hesse's do—draw attention to their hidden interiors, exemplifying the central-core or vaginal imagery that feminists of the time characterized as essentially female.

Bruce Nauman was the consummate postminimalist. He not only explored all of postminimalism's different options but most fully expressed its sensibility—a peculiar kind of countercultural black humor, pathos, perversity, aggression, and violence. His early sculptures, such as *Shelf Sinking into the Wall with Copper Painted Casts of the Spaces Underneath* or *Platform Made Up of Spaces Between Two Rectilinear Boxes on the Floor* (both 1966), were funky parodies of minimal art. *Platform Made Up of Spaces . . .* is, as Fidel Danieli wrote appreciatively, "one of the shabbiest pieces of construction to pass as a finished work."[27] Nauman himself said that his work "had to do with trying to make a less

important thing to look at."[28] Thus he diverted minimal art in an eccentric direction, as Hesse and Winsor had.

Asked if he was "deliberately perverse," Nauman replied: "It's an attitude I adopt sometimes to find things out—like turning things inside out to see what they look like. It had to do with doing things that you don't particularly want to do, with putting yourself in unfamiliar situations, following resistances to find out why you're resisting."[29] The countercultural aspects of his work spoke to the Vietnam War generation, whose outlook was exemplified by a graffiti scrawled by a rebellious student on a wall in Paris in 1968: EVERY VIEW OF THINGS WHICH IS NOT STRANGE IS FALSE.[30]

At the core of Nauman's work was an obsession with his own body. His purpose was "to find out what I would look like in a strange situation."[31] He treated his body as a kind of found object, often abject or pathetic. For example, in 1968 Nauman made photographs and holograms of his contorted face, turning flesh into a sculptural substance. He also cast a portion of his body in green wax, *From Hand to Mouth* (1967). In *Feet of Clay* (1966–67), Nauman photographed his feet coated with clay. He said of this piece that "if you can manipulate clay and end up with art, you can manipulate yourself in it as well. It has to do with using the body as a tool, an object to manipulate."[32] Nauman also conceived of his body in unusual ways, using unexpected materials to represent it, as in *Neon Templates of the Left Half of My Body Taken at Ten-Inch Intervals* (1966), an "abstract" sculpture consisting of seven lit neon-tube contours of his body connected by looping dark wires.

In the body art that Nauman began to make in 1965, he conceived and executed simple, repetitive physical gestures, such as pacing, bouncing a ball, clapping, breathing, or whispering. He said he was inspired by Beckett's minimal stories, "for example, Molloy transferring stones from pocket to pocket. . . . They're all human activities; no matter how limited, strange, and pointless, they're worthy of being examined carefully." Nauman performed his elementary gestures in the privacy of his studio and documented them in a variety of mediums. He produced videotapes of himself *Bouncing Two Balls between the Floor and the Ceiling with Changing Rhythms* (1968); slow-motion films of his testicles in motion and being painted black (1969); audiotapes of himself playing the violin— a single note or the notes D-E-A-D repeatedly (1968–69). Presented as art, Nauman's activities seemed outlandish. Indeed, as Coosje van Bruggen observed: "He took events that already verged on the absurd, and pushed them even further into absurdity by recording them photographically."[33]

In 1968 Nauman extended his concerns from manipulating himself to manipulating the viewer, "so that somebody else would have the same experience instead of just having to watch me have that experience." He built a number of "project" works, as he called them, the best known of which are long and narrow passageways. A viewer had to enter each of

these "corridor installations" in order to experience it, becoming as much a performer as a spectator. Nauman's aim was to create a constraining environment that would control the viewer's behavior so as to intensify his or her awareness of the situation.[34] Indeed, the experience of walls pressing in gave rise to physiological feelings of sensory deprivation, disorientation, and being trapped, and psychological feelings of oppression and anxiety.[35]

Nauman also introduced into his corridors video monitors, which functioned as "electronic mirrors."[36] The viewer was called on to respond not only to the unnerving physical space he or she was in but to the media image as a form of self-surveillance. In *Video Corridor* (1970), the screen was placed, as Nauman said, so that as "you walk towards the monitor, towards your own image, your image is yourself from the back. So as you're walking towards your image, you're getting further from the camera. So on the monitor, you're walking away from yourself, and the closer you try to get, the further you get from the camera, the further you're from yourself. It's a very strange kind of situation."[37]

The information provided in *Video Corridor*—and in Nauman's work generally—is deliberately contradictory. "There's the real space and there's the picture of the real space which is something else. . . . What interested me was the experience of putting those two pieces of information together. . . . The experience lies in the tension between the two, of not being able to put them together."[38] Nauman was one of the first artists to juxtapose physical "reality" with its media "representation," testing the experience of each and its relation to the other. Thus he anticipated a growing art-world concern with the impact of the media on American life.

The sense of claustrophobic enclosure and dread experienced in the corridor pieces is most intensely felt in another installation, *Double Steel Cage Piece* (1974). It consists of a cage within a cage, both composed of chain-link fencing, leaving a narrow pathway for viewers to negotiate. Those who chose to enter experienced an aggravated sense of imprisonment that had not only physiological and psychological dimensions but a political one as well. In 1981 Nauman made a number of sculptures that were inspired by accounts of political prisoners in Argentina and South Africa.[39] One, titled *South America Triangle* [5], is composed of a fourteen-foot-wide triangular armature of steel girders at eye level, within which is trapped an upside-down, armless, cast-iron chair—evoking a surrogate figure—hanging from the ceiling. The construction conveys the experience of interrogation and torture—that is, isolation, exposure, pain, and dread.

In 1966 Nauman began, as he said, "to put ideas into the works—mainly to put language into the work."[40] Many of these conceptual works are made of neon tubing, which transforms verbal texts into visual images. The most notorious is a spiral of words that reads: *THE TRUE*

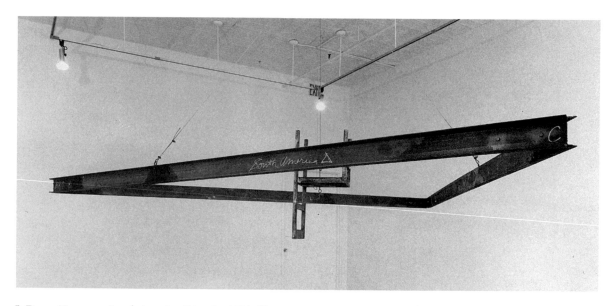

5. Bruce Nauman, *South America Triangle*, 1981. *(Courtesy Sperone Westwater Gallery, New York)*

ARTIST HELPS THE WORLD BY REVEALING MYSTIC TRUTHS (1967). The message is ambiguously profound and nonsensical. It might be taken at face value—as a countercultural slogan—or as a snide comment on a cliché, or as a parody of artistic pretensions, particularly in the time of the Vietnam War. Nauman generally took a few simple words or phrases and used them in different combinations, engaging in witty and disturbing word games with puns, anagrams, and palindromes, as in the anagram *EAT/DEATH* (1972), in which *EAT* is imbedded in *DEATH*, conjuring up a multitude of associations. The texts often refer to political and interpersonal violence: *RAW/WAR* (1971), *SEX AND DEATH BY MURDER AND SUICIDE* (1985), and *WHITE ANGER, RED DANGER, YELLOW PERIL, BLACK DEATH* (1985) [6].[41] These signs are as visual as they are verbal; gaudily colored, they flash on and off and move in and out of phase with one another. Other neons are of figures whose body parts move repetitively: An arm delivers a punch, a leg kicks out, a penis stands erect, a tongue darts in and out.[42]

Language is also central in what was perhaps Nauman's most disturbing installation, of 1972. It consisted of a dark, empty room, a "public" space, into which viewers were invited, only to hear a recorded voice, presumably the artist's, scolding them: "Get out of this room! Get out of my mind!"—get out, that is, of his "private" space. This work raises troubling questions about "the confrontation of private experience and public exposure," as he put it,[43] questions also raised in many of his other works.

In 1989 Nauman began to make colored wax casts of human heads, resembling death masks. Suspended pendulumlike from the ceiling, the

6. Bruce Nauman, *Human/Need/Desire,* 1983.
(Museum of Modern Art, New York)

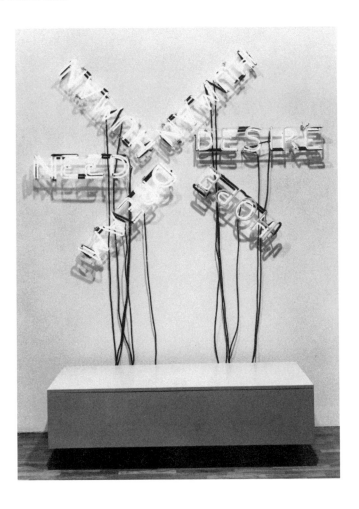

heads often grouped in pairs—faceup or -down, lick each other, stick their tongues in each other's mouths, noses, ears. The ensembles looked like the morbid remains of a guillotine binge. Nauman also dismembered animals, acquired from a taxidermist, and recomposed them, cubistlike, into mismatched creatures. The major work in this surrealist menagerie, *Animal Pyramid* (1989), is a grotesque twelve-foot triple-decker pyramid composed of five mutant caribou, eight deer, and four foxes.

Nauman's funny but degraded view of the vulnerable human condition is exemplified in his video projects of the 1980s in which he used actors. *Clown Taking a Shit* (1987), the clown a stand-in for the artist, epitomizes futility and absurdity. In *Shadow Puppets and Instructed Mime* (1990) four video monitors and four projectors play an interminably recycled tape of a female mime struggling desperately but unsuccessfully to follow the rapid-fire orders of a hectoring male voice, like commands barked at a trained dog—"Lie down, roll over, play dead, put your foot on a chair, put your head on the table." Interspersed is the taped image of a decapitated human head swinging back and forth until

it is smashed by another head that swings in from the side.[44] The content is coercion, frustration, humiliation, stress, threat, and violence.

Nauman was only one of a number of artists in the late 1960s who conceived of the body as a new kind of sculptural substance that did not yield an object. They were drawn to the body because it was "their most readily available [medium] capable of doing exactly what the artist wants, without the obduracy of inanimate matter."[45] Using the body in conjunction with painting, three-dimensional materials, photography, video, and film, they created a new kind of performance art, which was, as Laurie Anderson defined it: "Something live that doesn't look too much like theater."[46]

Body art had multiple roots: Dada performances, detailed in Robert Motherwell's anthology *The Dada Painters and Poets;* Man Ray's well-known photographs of Duchamp and Hans Namuth's film of Jackson Pollock in the act of painting; the happenings of Allan Kaprow, Red Grooms, Claes Oldenburg, Jim Dine, and Robert Whitman between 1959 and 1963; fluxus events beginning in 1961; the Judson Dance Theater performances in the early 1960s; and at the end of the decade, the plays of the Living Theater and Richard Schechner's Performance Group. Theatrical activities outside the interwoven worlds of avant-garde art, dance, and performance were also related to body art and contributed to its art-world appeal. Foremost were spectacles enacted at anti–Vietnam War demonstrations and yippie be-ins, which inspired political groups within the art world, notably the Guerrilla Art Action Group, to stage provocative actions, such as removing a picture from its place on a wall of the Museum of Modern Art or pouring blood on the floor.

Above all, body art developed in the context of other postminimal tendencies. For example, in 1968 Richard Serra filmed a work of process art; the title *Hand Catching Lead* describes the activity. Body art was also conceptual because the artists gave themselves preconceived, elementary tasks to execute, becoming, as Vito Acconci, paraphrasing Sol LeWitt, said, "a kind of dumb copying machine."[47] Like conceptual artists, body artists used photographs, film, video, notes, and other kinds of documentation to record and disseminate information about their ephemeral performances, documentation that itself was generally presented as art. They also made use of a new technology—the portable videotape recorder and player—which could immediately record and play back images. Relatively inexpensive and easy to operate, it lent itself to exploring and recording the artist's body.[48]

With video equipment, artists began to conceive of their performances with the camera in mind, thinking of what was videogenic. As Acconci commented: "The appropriate medium is film/photo (whether or not actual film/photo is utilized): I'm standing in front of a camera—the camera is aiming at me. . . . I can be doing what the camera is doing. I

can be aiming in on myself. Over all, the film frame separates my activity from the outside world."[49]

Acconci had been a poet before turning to body art, but his texts had been visual as much as verbal. He conceived of the page as a field in which to locate words. As he said, he used the words as "props for movement (how to travel from left margin to right / how to make it necessary, or not necessary, to turn from one page to the next)." This led him "to use a larger field (rather than move my hand over the page, I might as well be moving my body outside)."[50]

Like Nauman, Acconci had himself photographed performing minimal bodily motions, as in *Toe-Touch* and *Blinks*, both of 1969. He conceived of these tasks because he needed "reasons to be in a space, reasons to move in space," that took "decisions of time and space . . . out of my hands. . . . I am almost not an 'I' anymore. I put myself in the service of this scheme"—or idea.[51]

In works of 1970 Acconci dealt with himself impersonally as a self-contained physical object. To get more "person-ness into the work," he conceived of tasks that put his body under stress. In one performance he rubbed living cockroaches into his hairy bare belly. In *Trademarks* (1970) [7], he tried "to bite as much of my body as I could reach" and made prints of the bites. Again, like Nauman, he was thinking of Beckett's Molloy: "I was alone with my body, what else can I do but bite myself."[52] And as in Nauman's work, there was a perverse aspect to Acconci's early performances, in his case the element of sadomasochistic physical pain.

In *Conversions* (1970), Acconci used a candle to burn the hair from around one of his nipples and then pulled at it in the vain attempt to develop a woman's breast. He described *Openings* (1970) as "a film . . . which is a shot of my navel and the hairs of my stomach. I pull the hairs out of my navel so that gradually the navel opening is opened further." Both works signaled a change in Acconci's attitude. While remaining sadomasochistic, they introduced, as he said of *Openings*, "all sorts of . . . connotations—sexual, for example. . . . Navel becomes vagina. / I'm using art as a means of changing myself, as a means of breaking out of a category. I am categorized as a male. Now I'm trying to . . . open up the possibility of being a female."[53] *Conversions* and *Openings*, unlike *Toe-Touch* and *Blinks*, which avoided subjectivity, shared "the language of finding yourself [that] was in the air at the end of the '60's."[54]

In 1971 Acconci looked outside himself and began to engage other people in face-to-face encounters. The "pieces started . . . to be more about 'I' meet 'You.'"[55] In one work he proposed to meet viewers at a dangerous location, the end of an abandoned Hudson River pier, at 1:00 A.M. Acconci announced: "To anyone coming to meet me, I will attempt to reveal something I would normally keep concealed."[56] In *Claim* (1971), perhaps his most violent piece, he dealt with his (and by implication,

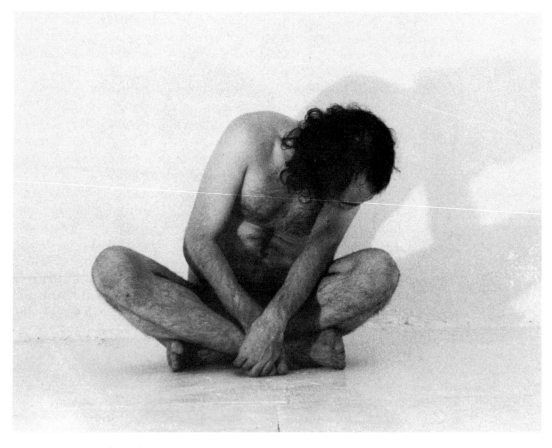

7. Vito Acconci, *Trademarks*, 1970. *(Courtesy Barbara Gladstone Gallery, New York)*

America's) needs to make territorial claims. He blindfolded himself and
positioned himself at the bottom of a flight of cellar stairs. Grasping two
metal pipes and a crowbar, he proposed to "claim" the space against all
comers. His voice on an audiotape threatened: "I'm alone in here in the
basement, and I want to stay alone here . . . I'll keep you away . . . to get
rid of you I'll do anything . . . I'll kill you."[57] In retrospect he thought he
might have, such was the rage that he worked up. Acconci said of his
intentions: "I really don't know how to be interested in any relationship
that doesn't cause trouble for me and potentially for another person."[58]
Although his need to make aggressive, menacing, perverse, and cruel
works was obviously psychological, they were executed at the height of
the Vietnam War and, Acconci believed, were influenced by the trauma
of the war.[59]

Acconci's use of language in *Claim,* the carryover from his earlier
poetry, would remain central in his subsequent work. In descriptions,
commentaries, scripts, and other texts, both written and oral, he docu-
mented, explained, and justified his art. Above all Acconci's rasping voice
became his stylistic signature.[60]

In 1972 Acconci became uncomfortable with the idea that viewers were required go to out-of-the-way, often dangerous places to meet him, and he began to perform in galleries. But rather than trying to command a large space with his body, he now filled the entire space with his amplified voice addressing the viewer. Like Nauman, Acconci introduced private matters into public arenas. Indeed, he increasingly confessed his sexual fantasies and other secrets. In his most confrontational work, *Seedbed* (1972), he secreted himself under a large minimalist ramp at one end of his gallery and masturbated while he audibly fantasized about the gallery goers walking overhead. The sounds of his private activity were broadcast publicly over a loudspeaker, implicating the spectators as unwitting voyeurs. Naturally *Seedbed* created a scandal, but Acconci claimed that *his* intention was poetic: He had positioned himself under a ramp as if under the ground, and masturbated to bridge metaphorically the human and plant processes of germination.

In *Air Time* (1973), Acconci recounted in explicit detail his deteriorating longtime relationship with a woman. He admitted that this, his most autobiographical performance or, more accurately, his autobiography-in-the-making, was "a cruel piece."[61] Works such as *Seedbed* and *Air Time* were perverse, but they had a positive aspect; they were honest in that they "let it all hang out," a popular countercultural phrase. And they could even have a therapeutic effect. In violating social and artistic taboos by making private acts, many of them permissible only in secret and even then shameful—self-mutilation, transsexual urges, masturbation—public, Acconci compelled viewers to face these taboos and consider them afresh.

Having informed the viewer about his private self, in 1974 Acconci proposed to deal with his social self, moving from the psychological to the sociological, as it were. At this time, too, he turned from live performance to installation. In 1976 he created *Where We Are Now (Who Are We Anyway)?* at the Sonnabend Gallery, at the epicenter of the New York art world. Within a room constructed in the gallery he placed a forty-foot-long by two-foot-wide plank that extended lengthwise across a table and out of the window three stories above the pavement, like a diving board or gangplank. Viewers were invited to sit on eight stools on either side of the table. Acconci's voice broadcast over a set of speakers called the meeting to order and announced: "'Now that we know we failed' this is a meeting 'at the edge.'" Then crowd noises were heard and the meeting resumed with the remark: "Now that we're back where we started."[62] In the monologue that followed, Acconci seemed to be asking himself and viewers to jump out of the failed art world into the real world, risking artistic and/or real suicide.

Acconci himself would make that artistic jump in the 1980s, when he began to create only situations that involved other people.[63] Eliminating his presence and his voice from his works, he built house-like structures. *House of Cards* (1983), for example, is a two-story struc-

ture, welded together from gutted automobiles, which is meant to be climbed into. The interior contains realigned car seats, tables, shelves, even a mattress. Acconci used the house as his prototype because it was "the kind of place in which the viewer might feel literally at home." But then he proposed to subvert this conventional attitude by provocatively, even perversely, making the interiors uncomfortable. "If the house makes you cozy, if you can snuggle into it, then you're lost in the past and stabilization; but if the house makes you itch, if you do a double-take, then you snap out of the present, you can have time to think of the future and change."[64] *Bad Dream House #2* (1988) [8], is an upside-down house, and *Face of the Earth* (1984), is both a benign jack-o'-lantern and a threatening skull in which the viewer can either sit passively or slither like a worm in and out of its cavities. Linda Shearer commented that Acconci paradoxically had a "genuine belief in community and [a] fear of conformity a community imposes. . . . Home represents security, shelter, protection, and sanctuary. . . . But it is also restrictive [implying] parental authority . . . which he perceives to be repressive."

Toward the end of the 1980s, Acconci almost entirely eliminated the confrontational elements from his public works. Partaking of a "town-square ideal and the notion of the artwork as a meeting place," they became communal "occasions for interaction"[65]—exemplifying the benign aspect of the counterculture.

Acconci summed up his career as a progression of processes: "a process of exercising 'me,' a process of expanding an 'I': first 'I' with 'me,'

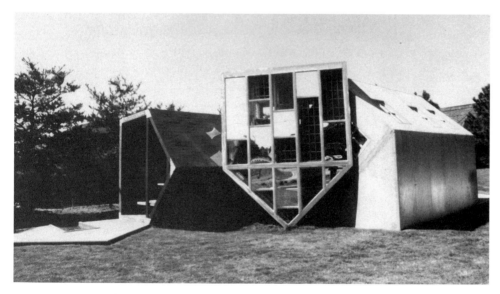

8. Vito Acconci, *Bad Dream House #2*, 1988, 45' × 35' × 12', each house: 16' × 10' × 12', aluminum, plexiglass, brick concrete, wood. (*Courtesy Barbara Gladstone Gallery, New York*)

then 'I' with 'him' or 'her,' then 'I' with 'you,' then a place where my voice can speak to 'them,' then a place where my voice might bring 'you' together, then a place that 'you' could make, and now a place where 'we' might be."[66]

Chris Burden carried masochism to an extreme in his variant of body art. In his notorious first performance of 1971, while he was still an art student, he confined himself for five consecutive days in a metal locker that measured two feet high, two feet wide, and three feet deep—a box reminiscent of Donald Judd's minimal sculptures. "I stopped eating several days prior to entry, thereby eliminating the problem of solid waste. The locker directly above me contained 5 gallons of bottled water; the locker below me contained an empty 5 gallon bottle."[67] The piece seemed iconoclastic, but that may not have been Burden's only intention, since he formulated it following leads in his earlier sculptures. As a student of Robert Irwin, he had built a narrow corridor, eleven feet high and two hundred feet long, composed of black plastic sheeting, propped up by steel pipes and guy wires, into which viewers were invited to enter. What happened next was unexpected. Wind activity created a vacuum, causing the plastic to stick together.

> You couldn't see down it except on rare occasions. If you walked down it, it would engulf you, but if you started running, your body would make an air pocket that would push it open in front of you. It was like magic. The stuff would open in front of you and close behind you. That's when I realized that what I had made was not a piece of sculpture but something that had to be activated. These pieces were about physical activity, about how they manipulated my body.[68]

But the work could still be perceived as traditional sculpture, and this bothered Burden. To avoid any misunderstanding, he began to perform his own work in readymade settings. He commented:

> When I was getting ready for my M.F.A. show, I [went] to look at the space. . . . It was a big converted classroom building and off to one side was a bank of lockers. I kept thinking of making a box and being in a box in the space, and it finally occurred to me that I didn't have to make a box: there were boxes—the lockers—right there. That was a breakthrough for me. . . . I could use a preexisting box and go into it, *be* art by being in it. . . . That's how I started doing performances— it seemed to solve so many problems.[69]

Shortly after he executed *Five-Day Locker Piece*, in a work titled *Shoot* [9], Burden had a friend shoot him in the left arm with a .22-caliber rifle from a distance of fifteen feet. His body art would continue to be of two kinds: single, more or less brief, reckless acts risking or involv-

ing bodily injury, as in *Shoot,* or endurance tests over extended periods of time in which the artist's role was a passive one, as in *Five-Day Locker Piece.* Either way the activity was single, literal, and self-explanatory, much like minimal art. Written expositions—conceptual components—accompanied the pieces and in attitude were much like the pieces themselves, providing facts without comment.

Burden's act of having himself shot was shocking. Why would an artist want to mutilate himself? Why was it significant? Burden answered: "Well, it's something to experience. How can you know what it feels like to be shot if you don't get shot? It seems interesting enough to be worth doing it." When asked by an interviewer, "Why is your work art?" Burden replied, "What else is it?" "Theater?" "No, it's not theater. . . . Getting shot is for real . . . there's no element of pretense or make-believe in it. . . .

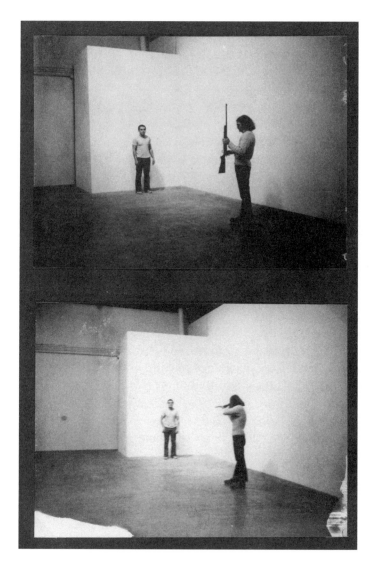

9. Chris Burden, *Chris Burden Deluxe Book: 1971–1973,* 1974. Detail: *Shoot,* F Space, Santa Ana, California, November 19, 1971. *(Copyright © 1994 Whitney Museum of American Art)*

Another reason is that the pieces are visual too."[70] The issue for Burden in *Shoot* was, What is the actual physical and emotional experience of pain? Or in the case of the locker piece, What are the limits of endurance? His self-proclaimed mission was to familiarize himself and his audience with the reality of pain, violence, and vulnerability.

Five-Day Locker Piece and *Shoot* were peculiarly of their time. Their backdrop was daily, candid TV images of the Vietnam War—cages in which prisoners were confined, the Saigon ARVN shooting his revolver into the brain of a bound Viet Cong soldier, the massacre at My Lai—and of innumerable murdered bodies in the news and crime programs. Violence—nonfictitious and fictitious—was ubiquitous.[71] Burden himself commented that "everybody watches [shooting] on TV every day. America is a big shoot-out country. About fifty percent of American folklore is about people getting shot."[72]

Five-Day Locker Piece could also be viewed as a countercultural attack on institutional values, implicitly questioning the relevance of the MFA degree and all it stood for.[73] Moreover, having oneself incarcerated, shot, and, in later performances, electrocuted, drowned, and impaled defied conventional conceptions of what art ought to be—and social taboos, such as the proscription against self-mutilation. Burden alone would be responsible for his body and would not share that power with any other agency.

Art critic Robert Horvitz suggested that there was a mythicoreligious dimension in *Shoot,* likening Burden to Saint Sebastian. In *Transfixed* (1974), Burden even had himself crucified on a Volkswagen, with nails driven through his palms. Thus he "transformed a religious cliché into a diabolically droll, nightmarish masque: jesus, indeed." Horvitz added: "Mortification of the flesh, voluntary seclusion, trial by ordeal, these are the trappings of sainthood."[74]

As gruesome or delinquent gestures, *Shoot* and Burden's other self-endangering works of the early 1970s generated considerable art-world controversy. It was understood that they were in the iconoclastic tradition of modernist art, intent on pushing art, the artist, and the viewer to the limits.[75] But should there not be *some* limits? What were the aesthetic implications of the work? How was its quality to be judged? And equally, if not more important, what were the moral implications? Burden did not editorialize but merely presented situations. Was this acceptable? As Horvitz asked: "To what extent are we justified in suspending our moral judgement when the material being worked is human? To what extent, if any, and under what conditions, does morality have a higher claim on our actions and reactions than esthetics?"[76]

Almost from the first Burden achieved international fame. News of his work spread mostly by word of mouth, but there was also considerable art-world and mass-media coverage. In *Through the Night Softly* (1973), Burden himself contributed to the coverage by using television as a medium. He had his hands tied behind his back and, bare-chested,

crawled on his belly for fifty feet over broken glass on Main Street, Los Angeles. A ten-second videotape of this performance was screened every night for a month on Channel 9 in Los Angeles after the eleven o'clock news. In 1976 Burden ran thirty-second commercials on prime-time TV—Channels 5 and 9 in New York and Channel 3 in Los Angeles—that consisted of a sequence of names: Leonardo da Vinci, Michelangelo, Rembrandt, Vincent van Gogh, and Pablo Picasso, culminating in his own. Much as he sought celebrity, it created problems for him, because people were coming to his work to be titillated. In 1975 he stopped performing and returned to making objects.

At the time, Burden undertook a countercultural analysis of physical and social power, which, as he said, "ultimately shapes the world in which we exist."[77] To embody physical power he began to build machines, such as *The Big Wheel* (1979), in which a motorcycle rear wheel sets in rapid motion a three-ton iron flywheel, whose furious spin lasted about three hours.[78] *A Tale of Two Cities* (1981) is a critique of military power from the vantage point of a boy playing war games—with an eye to adult activities. An installation of several thousand toy soldiers and their war machines, it represents two miniature city-states doing battle.

But Burden was most interested in testing the power of the artist in relation to the art establishment.[79] His purpose was to make art institutions extend themselves in problematic and potentially embarrassing ways—for them—on his behalf—in the name of art. For *Tower of Power* (1985) Burden got the Wadsworth Atheneum to secure the loan of a million dollars' worth of gold bars. Stacked in a pyramid, this "sculpture" was spotlighted and protected around the clock by an armed guard. As a metaphor for the treasures ensconced in museums, gold called attention to the monetary value of the masterpieces around it, to the relation of the museum to the art market, and to the function of the museum as a kind of vault—like a bank vault. Ironically the Wadsworth Atheneum was required to hire additional guards to watch over the gold, which was actually worth considerably less than the paintings and sculptures on display, signifying that our society is much more in awe of gold than of art.[80]

In other work Burden took up the theme of violence in the real world—an extension of his self-inflicted violence—the violence that nations do and threaten to do to one another. His focus was on the arms race. In *The Reason for the Neutron Bomb* (1979), for example, Burden covered the floor of a gallery with fifty thousand nickels, each topped with a matchstick. The nickels-and-matchsticks represented Russian tanks and called attention to the fact that they greatly outnumbered ours. According to the Pentagon, however, our possession of the neutron bomb stopped the Russians from attacking and overwhelming Western Europe. Burden seemed to be asking: Should we be thankful that we had our terror to neutralize theirs?[81] But he did not take a moral stance in this or related pieces. He merely presented symbols for facts. Perhaps the primary effect of viewing fifty thousand nickels-and-matchsticks was to

make the abstraction of the Cold War more "real." After all, how many are fifty thousand tanks and how powerful is the neutron bomb?

At the end of the 1980s Burden made a memorial to some three million South and North Vietnamese who died in the war. He inscribed their names—mostly invented—on giant copper-plated steel sheets arranged like Rolodex cards, hung vertically.[82] It is telling that Burden should circle back to a political situation that had traumatized the United States in the late 1960s and early 1970s—such was the grip of that time on him and his generation.

Sadomasochism and violence were much in the air in the late 1960s and early 1970s. Dennis Oppenheim's performance, titled *Rocked Circle—Fear* (1971), is a case in point. In it he filmed his facial expressions as he was being pelted by rocks.[83] In *Extended Armour* (1970), he tried to ward off an approaching tarantula by tearing out tufts of his hair and blowing them at it. He recalled: "Risk and danger were ingredients in Body Art that just felt right."[84]

In 1974 Oppenheim replaced himself as a performer with puppet proxies. In *Attempt to Raise Hell* [10], a mechanized cast-aluminum puppet, seated Buddha-like, lunges forward and bangs its head, with an unnerving loud gong, once a minute into a hanging bell. In *Lecture #1* (1976) a puppet with a lip-synched soundtrack delivers an art-history talk to an audience of miniature chairs, on one of which a lone puppet is seated. The lecture, which is supposed to be taking place sometime in the 1990s, recounts a successful plot to assassinate all of the advanced artists of Oppenheim's generation. At once funny and paranoid, the lecture predicts the death of the avant-garde and, prophetically, a reactionary return to painting.

From 1979 to 1984, influenced by Marcel Duchamp's mechanical images, Oppenheim built a series of wacky room-size, kinetic, machine-like constructions from industrial materials and commercial artifacts. Conceiving of these *Factories*, as he called them, as "metaphors for a thought process,"[85] he gave them such titles as *Way Station Launching an Obsolete Power. (A Thought Collision Factory in Pursuit of Journey). (A Clip in a Rifle Weapon)* (1979), *A Device for Detecting, Entering, and Converting Past Lies Traveling Underground and in the Air* (1980), and *Accelerator for Evil Thoughts* (1982). Art critic Thomas McEvilley described one such machine for mental processing, part of the *Fireworks* series, studded with firecrackers, rockets, flares, and other combustible substances [11]. Displayed in a SoHo gallery, it was in a sense launched into actual space.

> Mobile towers with tanks of butane gas were used to ignite the different areas; wheels turned, chain reactions occurred, fires swept down swooping ramps as from the sky, and the piece exploded like a house of cards. Some viewers hit the floor, others headed for the door. The

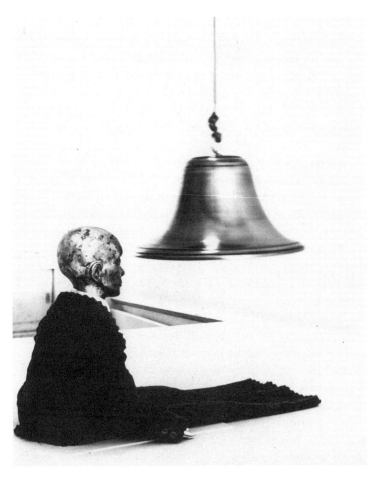

10. Dennis Oppenheim, *Attempt to Raise Hell*, 1974. *(Courtesy of the artist)*

11. Dennis Oppenheim, *Launching Structure #2, An Armature for Projection (From the Fireworks Series)*, 1982. *(Bonlow Gallery, New York)*

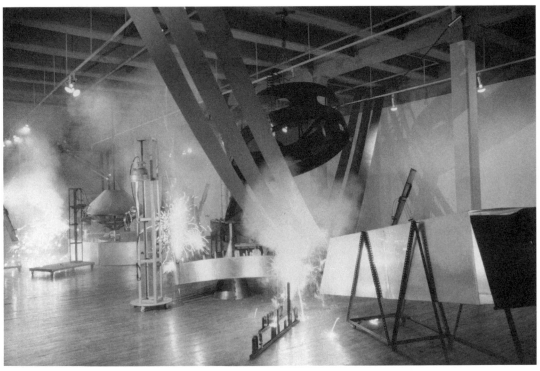

fire department came and broke the windows to clear the smoke. Everyone's clothing had burn marks from flying sparks. The sparking synapses of hysterical mental processes had become a model for a universe out of control and exploding in a kind of terminal orgasm, both big bang and black hole at once.[86]

Thus art ended with a pyrotechnical bang, not a whimper.

Like works by Acconci and Burden, Lucas Samaras's *Auto-Polaroids* (1969–71) and subsequent *Photo-Transformations* [12] of his naked body look sadomasochistic. He manipulated the photographs while they were developing so that the resulting self-images appeared to be distorted and multilated, a grotesque "attack on [his] own flesh," as art critic Carter Ratcliff observed.[87] This reading was reinforced by the knowledge that Samaras's early boxes, objects, and reliefs were studded with pins, razors, knives, and other threatening, pain-inducing artifacts. However, the *Auto-Polaroids* and *Photo Transformations* also exemplify another, more benign aspect of his artistic identity, which was a primary countercultural trait, a narcissistic "finding [of] oneself"—particularly one's psychosexual self.

Samaras's art was autobiographical from the first. For example, his exhibition in 1964 consisted of a reconstruction of the cramped and cluttered room in which he lived and worked. He explained that he "wanted

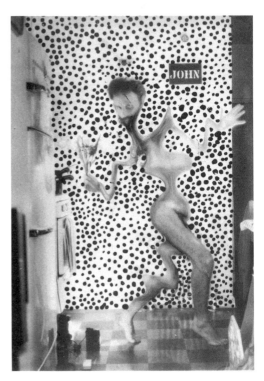

12. Lucas Samaras, *Photo-Transformation 4/19/76*, 1976. *(Courtesy PaceWildenstein, New York)*

to do the most personal thing that any artist could do."[88] He had begun to think of body art as early as 1966, when he wrote: "AUTOEROTIC. Narcissism is making one's body into art."[89] That led him "to photographically explore my body."[90] But in the *Auto-Polaroids* and *Photo-Transformations* Samaras was intent not only on narcissistic self-scrutiny and exhibitionist self-exposure but on investigating the photographic medium, tampering with the developing process in order to create a great variety of inventive, witty, sensual, and decorative abstract effects.

If Acconci and Burden represented the dark side of late-sixties performance art, Gilbert & George seemed to exemplify good humor in their early works. In 1969, when the show *When Attitudes Become Form* opened at the Institute of Contemporary Art in London, Gilbert Proesch and George Passmore were not invited. So, as George said, they "went along as Living Sculpture to the opening and became an extraordinary success. . . . That one evening transformed our whole life." George concluded: "We were the form and the content rolled into one."[91] Changing their names to Gilbert & George, the duo staged their most famous performance, titled *The Singing Sculpture*. Dressed in ill-fitting, outmoded yet dandyish tweed suits, white shirts, and ties, their hands and heads coated with metallic makeup, one carrying a glove, the other a walking stick, they perched atop a table and, for as long as eight hours at a time, rotated like mechanical dolls on a music box and pantomimed the lyrics of *Underneath the Arches* [13], a popular 1920s music hall song, to the tape of an old recording. They took turns rewinding the tape, exchanging the glove and the walking stick each time they did so. The performance piece seemed lighthearted and charming, but it had unnerving edges—in the song, which is about tramps who sleep outdoors, and in the unceasing, repetitive, robotlike gestures.[92]

As "living sculptures," Gilbert & George obliterated the distinction between their "private" selves and the "public" roles they invented—that is, between themselves as persons and personae. Their lives became theater, suggesting that they had no life outside their art, and yet their performance was rooted in their reality. George recalled: "The meaning of the song *Underneath the Arches* was very important. . . . We were very close to being down-and-out ourselves."[93] Gilbert & George considered their work to be social because it "communicated" to people about their life, fictitious though it may have been.

But Gilbert & George had greater ambitions for their art than "autobiography." As they wrote in 1986, "The true function of art is to bring about new understanding, progress and advancement. . . . True art comes from three main life-forces. They are: THE HEAD THE SOUL and THE SEX. . . . The content of mankind is our subject and our inspiration."[94] These, like the other pronouncements Gilbert & George frequently made, were shamelessly grandiose and banal. Did they really mean them? Were they to be taken at face value or were they perverse or

13. Gilbert & George, *Underneath the Arches,* 1971. *(Sonnabend Gallery, New York)*

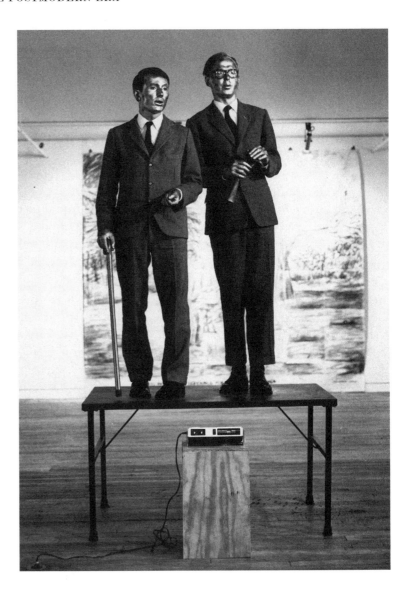

funny or perhaps supersophisticated put-ons or all at once? How, for example, was the following statement to be interpreted? "We want to spill our blood, brains and seed in our life-search for new meanings and purpose to give to life."[95] Carter Ratcliff, who tended to take Gilbert & George's stated intentions seriously, nonetheless wrote: "Few believed in the sincerity of the living sculptures' motto: 'Art for All.' [It] sounded like elitist irony at its most presumptuous—in other words, it sounded just right to art-world ears."[96]

In the early 1970s Gilbert & George transferred the "self"-portraiture in their performance art to multipanel "photo sculptures" [14]. At first they presented themselves as outsiders—miserable drunks in every stage of inebriation or as melancholy recluses isolated in their unfinished house in a squalid part of London's East End. In the best-known of

their photo works, which date from 1977, they pieced together wall-size checkerboard grids from photographs, each framed in black, like minimalist stained glass. The lower right panel contained the stenciled title of the work, the date, and the artists' signatures.

Gilbert & George continued to present their self-portraits in these photo works, but they now began to include the larger world outside their home. Their pieces commented on homosexuality and homosexual sex, AIDS, religion, national identity and nationalism, social class, war, racism, totalitarianism, as well as on youth, lost youth, old age, and death. Their point of view was that of "lower class, uneducated Tories," as George once observed.[97] Gilbert & George assumed the roles of participants, witnesses, and voyeurs. They often appeared coupled with anonymous, vacuous proletarian, presumably homosexual youths in jeans and skintight T-shirts, in decaying urban settings, against a backdrop of new, impersonal office buildings. The figures and their surroundings were interspersed with images, emblems, and signs—crosses, swords, graffiti, flowers, dead branches, heraldic shields, and flags.

Gilbert & George were often praised as authentic social realists, documenting Britain's wretched lower depths, or at least its homosexual subculture. They were also denigrated as self-aggrandizing aesthetes who

14. Gilbert & George, *Worlds*, 1985. *(Sonnabend Gallery, New York)*

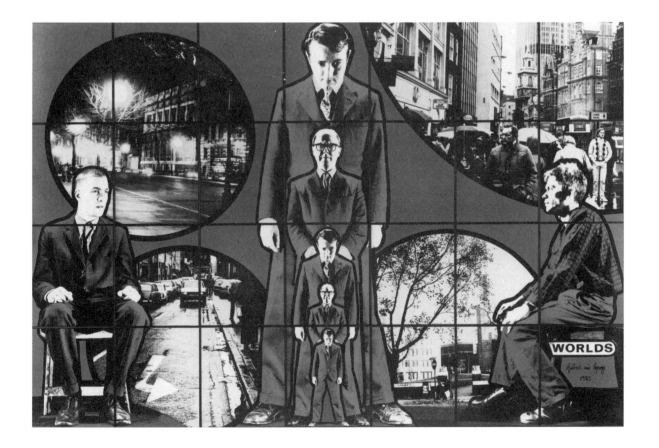

"extract[ed] from real life all the mannerist picturesqueness they could find,"[98] and embellished it with decorative designs and garish "stained-glass" colors. From still another point of view, they were portrayed as romantic bystanders mourning the tragic condition of modern life. As art critic Marjorie Allthorpe-Guyton wrote—unsympathetically: "Forget the toy-boys, the flowers, the fruit, the scatalogical and the porno-graphic; the real subject is Artaud's artist 'suicided by society,' the alien-ated and suffering martyr."[99] However, unlike the great romantics, their martyrdom was a masquerade—mere playacting. Or was it?

Nam June Paik was not generally counted among the postminimal-ists, having achieved art-world recognition several years before they did. However, like the body art of Acconci and Burden, his early performance art was violent, even though it preceded theirs by a decade. In 1958 Paik met John Cage, who aroused his interest in Zen Buddhism, but the young artist seemed to be less taken with Zen's contemplative aspects than with its use of shock tactics, as for example, a teacher beating a dis-ciple as a stimulus to enlightenment. (When Paik spent three days at a monastery in Japan, the head monk struck him repeatedly with a long stick.) Zen's use of physical force was reflected in Paik's performance, *Hommage à John Cage*, 1959, in which he so "fixed" a piano that it top-pled over. In *Étude for Pianoforte* (1960) he jumped off the stage, attacked Cage with a large pair of scissors, cut off his necktie, poured shampoo over his head—and that of pianist David Tudor—pushed his way aggressively through the crowded audience and out of the hall, and then phoned to announce that the performance was at an end. Such works prompted Allan Kaprow to call Paik a "cultural terrorist."[100]

In 1961 George Maciunas organized a performance group named fluxus and enlisted Paik in what would soon become a movement, many of whose members had studied with Cage. Maciunas wrote that fluxus

> forgoes distinction between art and non-art, forgoes artists' indispen-
> sibility, exclusiveness, individuality, ambition, forgoes all pretension
> towards a significance, variety, inspiration, skill, complexity, profun-
> dity, greatness, institutional and commodity value. It strives for non-
> structural, non-theatrical, nonbaroque, impersonal qualities of a sim-
> ple, natural event, an object, a game, a puzzle or a gag. It is a fusion
> of Spike Jones, gags, games, Vaudeville, Cage and Duchamp.[101]

Paik's fluxus performances continued his shock tactics. In *One for Violin*, 1962, he slowly raised a violin over his head and then brought it down with a crash on a table in front of him.

In his subsequent works Paik suppressed violence and embraced the attitudes of the counterculture at its most optimistic and benign, exemplifying its interest in Zen Buddhism, iconoclastic humor, and eroticism. He now adopted Cage's cheerful outlook. In fact, Cage—the

prophet of "joy and revolution"[102] would become a guru of the counter-culture. In 1962 Paik began to work with the medium of television, both with the sets as materials for sculpture and with their electronic trans-missions. He manipulated their innards, distorting the pictures to create new and unprecedented images. As he said: "I buy thirteen secondhand sets. . . . I didn't have any preconceived idea. Nobody had put two fre-quencies into one place, so I do that, horizontal and vertical, and this absolutely new thing comes out."[103] Paik's exhibition of altered TV sets in Wuppertal, Germany, in 1963, was the first video art anywhere.

Paik used Cage's aesthetics to justify his use of television. Cage believed that everyday life and art ought to be fused. If new technologies were central to contemporary life, then they and art should be merged. The purpose of art was to sensitize the public to the radical changes tak-ing place in life. Indeed, as Cage predicted in the catalog of a Paik exhibi-tion, "someday artists will work with capacitors, resistors, and semicon-ductors as they work today with brushes, violins, & junk."[104]

The counterculture despised commercial television as the machine that fueled the commodity-crazed spectacle of consumer society. But if commercial television was an opiate, Paik subverted its mind-drugging programming, turning it against itself. He made this point in 1971, when, in *Waiting for Commercials*, he had a cellist and a pianist play clas-sical music but only a few bars at a time, interspersing them with com-mercial breaks. Paik sought to create an alternative television whose aim was "to humanize technology. My job is to see how establishment is working and to look for little holes where I can get my fingers in and tear away walls. And also, try not to get too corrupt."[105]

Paik moved to New York in 1964 and met cellist Charlotte Moorman, with whom he began to collaborate. Inspired by Moorman, Paik introduced sex into his performances with humor and irreverence. In *Young Penis Symphony*, Moorman played phrases of a Bach cello sonata. On finishing a phrase, she removed a piece of her clothing. She ended up on the floor, completely naked, playing her cello, which lay on top of her.[106] *Opera Sextronique* (1967) led to Moorman's arrest on the charge of indecent exposure. After a notorious trial, she was convicted and received a suspended sentence. In *TV Bra for Living Sculpture* (1969), Moorman wore a "brassiere" of two three-inch television sets and played cello compositions by Paik and other composers. As the tones changed so did the images on the screens.

Paik had Zen in mind in such pieces as *As Boring as Possible* (1966) and *TV Buddha* (1974). In the latter a sculpture of a sitting Buddha views his own image on a closed-circuit television screen. Paradoxically, in the spirit of fluxus iconoclasm and humor, Paik at once mocked spirituality and embraced the religious icon. On the one hand the Buddha appears as a media star and couch potato in a kind of Buddha sitcom. On the other it represents the divine looking at the divine—without interfer-ence? Instantaneous holy feedback; God using electronic media to con-

template himself. The luminous TV image is the perfect medium for contemplating pure contemplation.

In 1970, in collaboration with electronic engineer Shuya Abe, Paik invented a videosynthesizer that enabled him to combine and superimpose images from a number of cameras to produce an infinite variety of images—a kind of painting with electronic light. At the same time he stacked the TV sets to create huge installations and sculptures [15]. The upshot was a novel synthesis of the two-dimensional evanescence of the TV screen and the three-dimensional tangibility of the TV box.

Just as Nauman, Acconci, Burden, and Oppenheim generated their body art by giving themselves preconceived, simple tasks to execute, so

15. Nam June Paik, *V-yramid*, 1982. *(Copyright © 1994 Whitney Museum of American Art)*

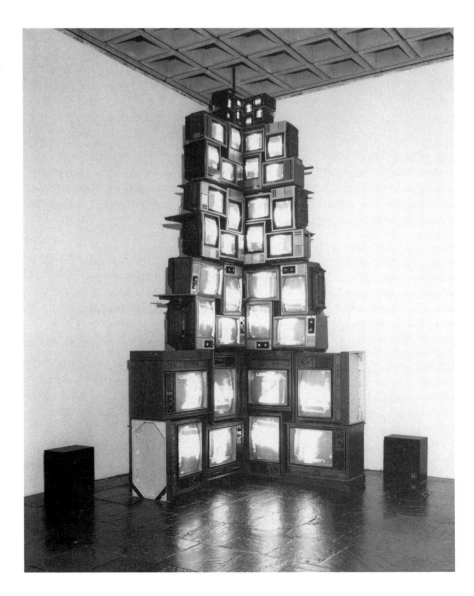

did Richard Serra, except that his bodily movements yielded objects of sorts. His early three-dimensional work derived from a list of verbs he compiled in 1967–68, among them "to splash," "to crease," "to scatter," and "to arrange," and "to disarrange."[107] He referred to them as "actions to relate to oneself, material, place and process."[108] Serra was intent on literalism: on the physical process of making a sculpture, on the physical properties of its materials, and on the actual space it occupied. Scattering, splashing, and propping are exemplified in three pieces that were exhibited in *9 in a Warehouse* (1968), an early show of process art that brought Serra to the attention of the art world. At the time art critic Philip Leider described one work as

> a distribution of strips of latex and rubber on the floor, in an area about twelve feet square. The area is emphatically marked off by a taut diagonal of wire suspended about six or eight inches off the gallery floor [and] tied to two stakes driven into the floor at either end of the area. One has the impression that virtually any arrangement of the formless strips of latex would take on a compositional unity in relation to the diagonal created by the wire.[109]

In this distributional piece the spatial field replaced the traditional object as the primary sculptural concern [16].

The works for which Serra came to be even better known were the thrown-lead pieces and the prop sculptures. *Splashing* (1968) was composed of molten lead hurled at the juncture of the floor and one of the gallery's walls, making the site the mold of the sculpture. It called attention to the artist's theatrical physical gesture, the force of gravity as the forming agent, and the space of the room. Leider observed that "the main point is that the material has assumed no form other than one entirely natural to its own fluid, formless properties." Serra's work was radical because of its "emphasis . . . on the natural formlessness of the materials, and the refusal to force it to correspond to a vocabulary of given, *a priori* forms acceptable to 'art.'"[110] To document this ephemeral piece, he had photographs taken of himself in action, recalling Hans Namuth's film of Pollock pouring paint. This documentation turned Serra into a body artist of sorts. In *Casting* (1969) he turned splashed elements into more substantial and permanent forms, which he then arranged in a gridlike pattern on the floor.

Serra's third sculpture in *9 in a Warehouse* was inspired by the verb "to prop." It consisted of a large square of thinly rolled lead pinned in place on the gallery wall by a heavy steel pipe propped against it. The force of gravity held the piece in place, but the viewer was always aware that it could collapse. A better-known work in this vein was *House of Cards: One Ton Prop* (1969). An open cube composed of four rectangular lead slabs, each weighing about 480 pounds, leaning against one another, it was related to minimal sculpture in modularity, spareness, and literal-

ness, but it differed in massiveness and instability. As Serra remarked: "Lead with its low order of entropy is always under the strain of decaying or deflecting. So what you have is a proposed stable solution which is being undermined every minute of its existence."[111] Indeed, given the size, weight, and pliability of the lead, the parts were destined to overcome the process of gravity that held them in equilibrium, enabling them to stand, and hence to constitute a structure, and cave in—and violently at that. *House of Cards* was perpetually on the verge of disorder and danger; it might tumble on the viewer. The effect was unnerving; spectators kept their distance.

Most of Serra's works executed after the *House of Cards* were also influenced by minimal sculpture except that they were huge in size—monumental, or more accurately, as art critic Elizabeth C. Baker commented with their disequilibrium in mind, a "temporary and tantalizing pseudo-monumentality." Indeed, Serra monumentalized minimal sculpture at the same time that he subverted it, in "a kind of Dada spirit of recklessness."[112] The combination of weighty mass and instability as well as menace and unpredictable violence in Serra's works was in accord with the mood of the Vietnam War period and its aftermath. The aggressiveness of the sculpture seemed aimed both against the society waging the war and against its aesthetic and commercial expectations of what art was supposed to be.

Serra was ambivalent about making extra-aesthetic claims for his sculpture, maintaining that he had no humanistic assumptions that art needs to serve. "I've never felt, and I don't now, that art needs any justification outside of itself."[113] His primary concern was weight.

> Weight is a value for me . . . the balancing of weight, the diminishing of weight, the addition and subtraction of weight, the rigging of weight, the propping of weight, the placement of weight, the locking of weight, the psychological effects of weight, the disorientation of weight, the disequilibrium of weight, the rotation of weight, the movement of weight, the directionality of weight, the shape of weight. I have more to say about the perpetual and meticulous adjustments of weight, more to say about the pleasure derived from the exactitude of the laws of gravity. I have more to say about the processing of the weight of steel, more to say about the forge, the rolling mill and the open-hearth.[114]

And yet Serra himself related his work to social realities; the weight of his materials could be viewed as a metaphor for "the weight of repression, the weight of constriction, the weight of government, . . . the weight of destruction, the weight of suicide," and so on.[115]

16. Richard Serra, *Cutting Device: Base Plate Measure,* 1969. *(Museum of Modern Art, New York)*

During the 1970s Serra's sculpture grew even larger and more aggressive and confrontational. *Sight Point* (1971–75) and *Terminal* (1977) are forty and forty-one feet high respectively. Serra wrote of *Sight Point:*

What's involved are three steel plates 10 feet wide, 40 feet high and 2½ inches thick; the piece weighs about 60 tons. . . . Basically, it's an open truncated pyramid with overlapping planes, forming an equilateral triangle, which can be seen from the inside. When you walk into this space which is about 13 feet across, you look up 40 feet through a triangle that frames the sky.[116]

These towering works seem exalting until the viewer becomes aware that their principle of organization, as in the prop pieces, is the force of gravity. That in itself is disturbing and, more upsetting, the components are "inclined out of vertical," as art critic Clara Weyergraf wrote: "It is not so much the doubt in the stability of the object which is disquieting; the insecurity which *Sight Point* and *Terminal* create emanates rather from a disturbed sense of equilibrium."[117]

Around 1970 Serra began to use sculptural elements to transform and articulate a site or to "capture" it totally.[118] His aim was to affect radically the way in which viewers perceived and physically experienced the space. Despite the objectness of his work, its massiveness and weight, Serra insisted that his primary concern was its "situation," and in this his thinking shared the anti-art-as-object mentality of postminimalism. For example, *Strike* (1970) is a rolled steel plate, eight feet high by twenty-four feet long by one inch thick, wedged into the corner between two walls. It divides the room. The viewer becomes acutely aware of the room—and of its dividers. Having no other means of support, it looks as if it could topple over. The space created is one of persistent physical threat. Interior spaces in *Strike* and related works, for example, *Circuit* (1972), made viewers acutely aware of their bodies—of what might happen to their bodies—perhaps more than the work of any other artist.

In landscape Serra's sculpture is unthreatening [17]. *Shift* (1970–72) is a site-specific arrangement of six walls that zig and zag in some thirteen acres of land. The piece can be experienced only by actually hiking through it, and it changes in appearance as the spectator shifts his or her look from the walls to the landscape and back. The minimal metal elements and nature mutually enhance each other. Nonetheless, if there was something subversive about making sculptural elements of great bulk and weight unstable, it was equally subversive to make them markers of outdoor space.

Serra soon decided that out-of-the-way rural places were not as interesting as urban sites, where there was "a density of traffic flow."[119] His works in city locales were subversive in intent. Instead of embellishing their environment, they challenged and confronted it. This intention was tellingly clear in *Tilted Arc* [18], placed in front of the Federal Court Building in New York, "in the very center of the mechanisms of state power," as Douglas Crimp wrote. A twelve-foot-high, Cor-ten steel, slightly tilted, curved wall, it divided the plaza into two areas. Crimp observed that the building and its plaza "are nightmares of urban development, official, anonymous, overscaled, inhuman."

> The plaza is a bleak, empty area, whose sole function is to shuttle traffic in and out of the buildings. Located at one corner of the plaza is a fountain that cannot be used, since the wind-tunnel effect of the huge office block would drench the entire plaza with water. [Serra's]

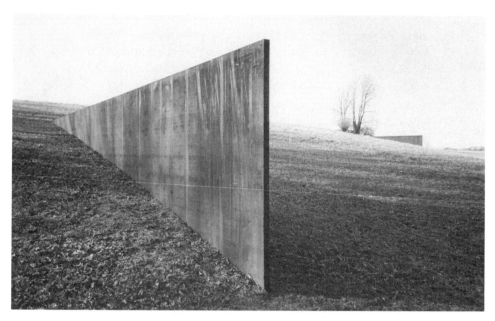

17. Richard Serra, *Schunnemunk Fork*, 1991. *(Courtesy PaceWildenstein, New York)*

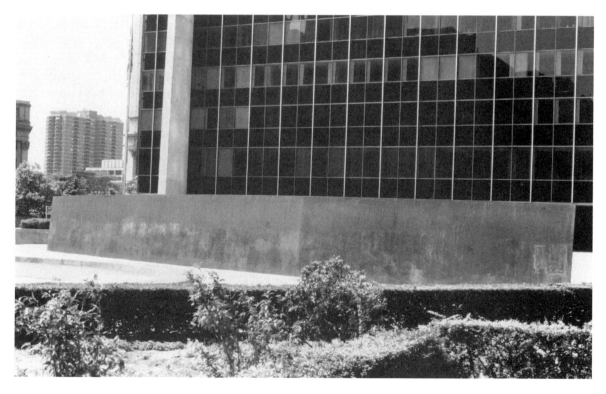

18. Richard Serra, *Tilted Arc*, 1981, at Federal Plaza, New York (destroyed). *(Photograph by Joan Marter)*

sculpture imposes a construction of absolute difference within the conglomorate of civic architecture. It engages the passerby in an entirely new kind of spatial experience that is counterposed against the bland efficiency established by the plaza's architects. . . . Soliciting, even commanding attention, the sculpture asks the office workers and other pedestrians to leave their usual hurried course and follow a different route, gauging the curving planes, volumes, and sight lines that mark this place now as the place of sculpture.[120]

Although Crimp was an ardent admirer of *Tilted Arc*, some thirteen hundred employees who worked in the Federal Building resented the sculpture's demands and petitioned for its removal, generating a lengthy, acrimonious dispute. In the end the work was dismantled, but the controversy over public art continued unabated.

In contrast to Serra's massive slabs, the paintings and sculptures that Richard Tuttle began to make in 1967 were as antimonumental as art could get. Bits of bent wire or small irregular-shaped pieces of cloth dyed in a single color, they were so minimal that they were overwhelmed by the walls to which they were attached, their very near invisibility calling attention to their surroundings. Few sculptures or paintings at the time looked "poorer"—or, with an ironic edge, more poignant.

Like Tuttle, Larry Bell dematerialized the minimal cube—to the point of invisibility. He constructed boxes out of glass treated with different kinds of vaporized metallic and nonmetallic substances, producing luminous tints that seemed to inhere in the material. The tints served to undermine the viewers' "ability to distinguish between what is physically present and what is illusion."[121]

Like so many of his postminimalist colleagues, Robert Smithson was deeply pessimistic. He formulated a theory to account for his attitude and articulated it in lively prose. As he saw it, human destiny depended on the second law of thermodynamics, which held that energy is more easily lost than obtained. The universe would eventually, inevitably, and irreversibly be turned into an all-encompassing sameness, a state of entropy. The future would not be the golden age that humanists dreamed of but an ice age imagined by sci-fi buffs. Progress was taking place *in reverse*. Like it or not, that was the dismal reality, and Smithson accepted it matter-of-factly—with irony, to be sure. So much for modernist visions of a utopian future.

For Smithson entropy was not only the universe's future condition, it was at hand—in our present environment. An "entropic mood" was fostered by the "slurbs, urban sprawl, and the infinite number of housing developments of the post-war boom," consisting of "cold glass boxes, . . . the banal, the empty, the cool, blank after blank," that have

come to dominate American cities.[122] Smithson's bleak cosmology, and the playfulness and black humor with which he wrote about it, found wide appeal at the end of the 1960s.

Smithson's best-known early sculptures were often identified as minimal, but they are open-ended rather than self-contained. Composed of cubic volumes that decrease or increase in size, depending on the side from which the viewer approaches them, the pieces look as if they could extend or recede into infinity. The work's potential extensions beyond the walls of the room led Smithson to think of the physical world outside, notably the entropic industrial and urban landscape of his native New Jersey.

New Jersey was also the location of an automobile ride taken by Tony Smith one night in 1966. Traveling down an unfinished turnpike, he found the experience so moving that its "effect was to liberate me from many of the views I had had about art. It seemed that there had been a reality there which had not had any expression in art." He went on to say that the aesthetic possibilities of an "artificial landscape without cultural precedents began to dawn on me," but there "is no way you can frame it."[123]

Smithson was profoundly impressed by Smith's account and challenged by his speculation about the artistic potential of the American scene lacking in "'function' and 'tradition.'" Smithson was given the opportunity to try to find a "frame" for an amorphous and unbounded landscape in 1966 when he became an artist-consultant to the planners of the Dallas–Fort Worth airport. In the process of investigating the site, auger and core borings were made. These soil samples intrigued him, as did "pavements, holes, trenches, mounds, heaps, paths, ditches, roads, terraces, etc., [all of which] have an aesthetic potential" and are "becoming more and more important to artists." Smithson was attracted to dirt, sand, gravel, and other impermanent, indeterminate, and changeable natural substances—particularly sediment, sludge, and the like—in unarticulated landscapes because they suggested the dissolution of the world. Instead of installing art objects in the airport, he proposed to take the entire site into account, its physical and metaphysical dimensions beneath the earth, on the ground, and from the sky. He envisioned "art forms that would use the actual land as a medium"—in remote places, such as New Jersey's Pine Barrens or even the North and South Poles. "Television could transmit such activity all over the world."[124]

After his Dallas–Forth Worth airport proposal, Smithson began a "dialogue between the indoor and the outdoor . . . what I call site and non-site."[125] In 1968 he collected earth, gravel, and rocks from an outside "site," put it in bins that called to mind his earlier near-minimal sculptures, and brought them into the gallery, the "non-site." In a sense, he brought pieces of the "real" world into the detached realm of art. He also introduced a conceptual component, a topographical map of the site-area that was mounted on the wall near the bins. The site/nonsite juxtapositions had their ironies. Viewers could know the absent site only

through bins, rocks, maps, photographs, captions, and other information provided by Smithson in the nonsite, not through actual sight. But none of the information would enable the viewer to find the site from which he gathered his raw materials. The aspect of the work that was visually most vivid was the contrast between the human-made minimal bins and the natural piles of rocks in them, which call to mind elemental and amorphous geological processes ending in entropy.

In 1968 Smithson organized an *Earthworks* exhibition, consisting of photographs of various projects. At first he was ambivalent about whether the documentation was art, but he soon came to think of both the earthwork and its documentation as art. Indeed, documentation-as-art intrigued Smithson. In *Mirror Displacements* (1969), he placed twelve mirrors, each twelve inches square, in nine different landscape sites in Mexico and took photographs of them, the photographs constituting nonsites. (He favored mirrors in his work because they reflect light and atmosphere in endless and unpredictable ways; as he said, they "evade measure."[126]) He then "exhibited" the documentation, which was all that remained of his activity, as an article in *Artforum,* the dematerialized article presumably becoming the "finished" work.

In 1970 Smithson undertook the creation of monumental earthworks, the largest of which was *Spiral Jetty* [19]. He took a twenty-year lease on ten acres of lakefront land in Utah, hired a contractor, and, using rented earth-moving equipment, shoveled more than six tons of dirt and rock into the red waters of the Great Salt Lake to form a minimal spiral, measuring fifteen feet wide and some fifteen hundred feet from the shore to the end of the coil. Smithson made a thirty-five-minute film (a nonsite) of the work (a site) in which, among other topics, he showed the construction and related modern bulldozers, whose tracks remain visible, to primordial dinosaurs. *Spiral Jetty* was also reminiscent of prehistoric monuments, such as the Serpent Mound in Ohio. Smithson also documented the geological history of the area, and pointed out that the form of the jetty is that of spiral nebulae—and of salt crystals and the microscopic organisms that abound in the lake. He was thinking of the passage of time—in eons—and suggested that in the distant future the work would succumb to entropy and disappear.[127] Ironically *Spiral Jetty* anticipated its fate by vanishing for a number of years, an irony that Smithson would have relished had he lived to see it. Through an unexpected and inexplicable rise of the lake, despite the earthwork's size and mass, it was submerged under water. All that was visible of his monument was the film and other photographic or written documentation.

Toward the end of Smithson's life, his thinking became more positive. He began to think of ecology and the social role that earthworks might play in the rehabilitation of the environment. As he wrote: "Across the country there are many mining areas, disused quarries, and polluted lakes and

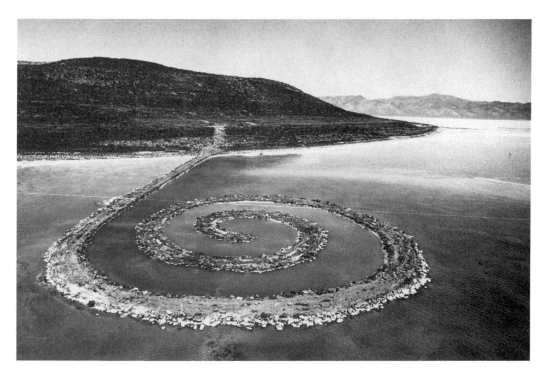

19. Robert Smithson, *Spiral Jetty*, April 1971. *(Courtesy John Weber Gallery, New York)*

rivers. One practical solution for the utilization of such devastated places would be land and water re-cycling in terms of 'Earth Art.'" The artist would mediate between ecologists and industrialists.[128] Smithson proposed both to prettify strip mines, sludge heaps, and other devastated sites and to reveal the ravages of humankind's pollution. He executed one land reclamation project, *Broken Circle/Spiral Hill* (1971), in an abandoned quarry in Emmen, the Netherlands. The work was meant to be temporary, but the Dutch liked it so much that they voted to preserve it as a park. In 1973, Smithson was tragically killed at the age of thirty-four, before he could further realize his land reclamation art.

Smithson was only the first of a number of postminimal artists to create earthworks. All were influenced by the logic of minimal sculptures, which, as Robert Morris observed, lacked internal relationships and articulated their outer limits so emphatically that they pointed to what was beyond, that is their surroundings. Consequently minimal and postminimal sculptors began to take into account how the sculpture's site and "situation" might affect the work or, as Morris remarked, "change the terms."[129] One such change was to make work outdoors.

Earth art was also influenced by process art. Piles or "accumulations of things or stuff" suggested a "landscape mode."[130] Artists who pre-

ferred to work with pliable materials that spread into their surroundings found that nature was the more appropriate site for their work than a contained, four-walled studio or gallery. Smithson and a number of other artists began to think that the more open the space was—the more open to the processes of nature—the better, and they turned to unbounded deserts, salt flats, and the like, working with materials they encountered *in situ*, primarily earth, sand, gravel, and rock. Like the materials used by process artists, most substances found in nature, subject to the elements, were impermanent, indeterminate, and changeable.

Earth artists were in sympathy with the counterculture's glorification of nature, ecological concerns, and back-to-nature rhetoric. Many shared a romantic vision of America's wide-open spaces, whose roots lay in nineteenth-century paintings of the West, such as those of Albert Bierstadt and Thomas Moran. But rather than depict nature, the earth artists worked directly in and with it. Also implicit in earth art was a countercultural loathing of commercialism and a reluctance to create salable art-as-object to be showcased in the gallery-collector's home-museum context.

There were two main types of earth artists, as Alan Sonfist observed. On the one hand were artists who made more or less monumental works, "built to speak of themselves, not of the land they occupy," exemplified by Smithson's *Spiral Jetty*. On the other hand were artists "pursuing the relatively new idea of cooperation with the environment, which they see as necessary because of the threat of its destruction."[131]

Richard Long exemplified the earth-friendly artist. In 1967, while he was a student at the St. Martin's School of Art in London, he rejected pop art and construction sculpture in the vein of Anthony Caro, an influential teacher there. He said: "I wasn't remotely interested in welding metal together or painting coke bottles."[132] Instead he looked to minimal art for his form and the newly emerging process and conceptual art for his method.[133] As he recalled:

> There was a feeling that art need not be a production line of more objects to fill the world. My interest was in a more thoughtful view of art and nature . . . using ideas, walking, stones, tracks, water, time, etc., in a flexible way. I was for art made on common land, by simple means, on a human scale. It was the antithesis of so-called American "Land Art," where the artist needed money to be an artist, to buy real estate to claim possession of the land and to wield machinery. [My aim was] to touch the earth lightly. . . . I prefer to be a custodian of nature, not an exploiter of it.[134]

In his first earthwork, *A Line Made By Walking* (1967), Long formed a single, straight line of flattened grass by walking back and forth across a field. This was his prototypical, perhaps consummate, piece. It had all the components of his later outdoor work: an underlying

concept; a minimal form; a substance found in nature that reverted back to nature after the piece was completed; and photographic and/or other documentation.[135] Subsequently Long trekked in locales all over the world, making ephemeral marks on the earth, and rearranging raw materials found on the site into simple configurations and shapes. For example, using the line as one motif, Long walked without altering the terrain in Peru, 1972; in Canada, 1974, and in Japan, 1976. He formed lines of stones in the Tennessee River, 1970, in Australia, 1977, in the Himalayas, 1975, and on Mount Fuji, 1979. In 1974, he made a 164 mile line by placing a stone at the side of a road to mark every mile. He also made lines of sticks in Canada and England, 1974, and by pouring water on gravel in Ladakh, 1984. He laid bare lines of earth by kicking away stones in Bolivia, 1981, and by brushing away leaves in Nepal, 1983. The straight line became the precursor of other elemental figures: circle, square, spiral, cross, and zigzag.

As for his intention, Long said: "I can't analyze why it is mysterious, why it is beautiful to walk across Dartmoor in a straight line all day, but it is. And because it is beautiful for me to do that, it is good enough for me to make it into art." He added:

> I have taken the simple act of walking, which is common to everyone, ritualized it, and made art out of it. [I] have strong feelings about my

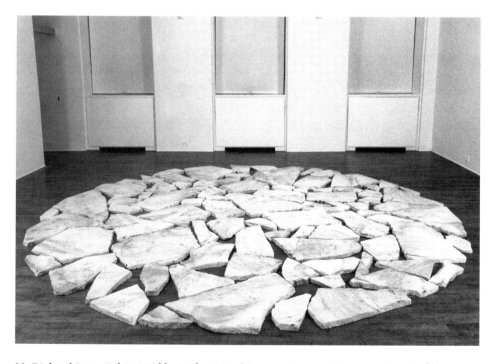

20. Richard Long, *White Marble Circle*, 1982. *(Courtesy Sperone Westwater, New York)*

materials and nature and what I want to do with each work is to make it as powerful and beautiful as possible. The function of art is to invent new ways to deal with the world. . . . I actually think my work is classical. It's about perfect circles or formal geometry—1,000 miles in 1,000 hours or 100 tons in 100 hours. All my work is very simple really.[136]

Long added: "For me simplicity of means is more emotional, potent, and challenging. Art is selection, concentration, ritual; a single vision."[137]

Long brought nature into art-world venues by making sculptures using the same shapes and materials as the works outdoors [20]. He also exhibited photographs of his pieces in landscape as well as maps and diagrams showing the routes and shapes of the walks, all accompanied by titles, captions, and other information. As for the relation between the physical work and its documentation: "I would hope my photographic, text and map works feed the imagination, and my gallery sculptures feed the senses. I believe my works are complementary and all together give an inclusive experience of my art."[138]

What does Long's art signify? It has been related to romantic British landscape painting and/or pictorial diaries and reports of eighteenth- and nineteenth-century British travelers. More often it has been viewed as spiritual or philosophical nomadism.[139] Some critics have written that through his use of geometric form, he has imposed ideal form on formlessness, formal order on anarchic nature. Above all Long's art has been a countercultural dialogue with the earth, bringing humankind close to untamed nature, glorifying it, and pointing up ecological concerns. More mystical writers have considered his work as Zen-like in its "acceptance of the one-ness of man and nature, mystical communion, and a celebration of the natural order."[140] Long himself has been more modest in the claims he has made for his work, relating it to boyhood pleasures of throwing stones, damming streams, or building sandcastles, and his enjoyment of walking in some of nature's wonders.[141]

Long was a major influence on a younger generation of English artists, such as Tony Cragg, Bill Woodrow, Richard Deacon, and Anish Kapoor, all of whom reacted against the glut of Caroesque welded construction and emulated Long's economy of form and direct method of art making. In the case of Cragg, like Long he accumulated readymade materials, but of urban and industrial origin. Cragg's seminal floor piece, *New Stones–Newton's Tones* (1978), is a rectangle composed of small pieces of found polychromed plastic arranged according to the colors of the spectrum. As the title suggests, discarded "stones" of urban origin are given new life through their distribution according to Newton's color theory. Cragg further formed man-made rubbish into human figures stretched out on the floor, as in *Red Skin* (1980), or fixed to the wall, as

in *Some Kind of Group* (1983) [21]—devastated emblems of consumerist gluttony.

Long was only one of a growing number of countercultural artists who looked for inspiration to nature with an eye to an ever-more-urgent need to save the environment. Others were Alan Sonfist and the team of Newton and Helen Harrison, who in the service of ecology produced environmental and/or conceptual works. The art of Newton and Helen Harrison consists primarily of hand-colored maps, charts, photographs, and texts whose purpose is to investigate how humankind impacted ecologically on selected areas, such as the Los Angeles Basin and the Great Lakes, and to formulate feasible solutions to environmental problems. Newton Harrison first came to public attention in 1971, when he exhibited *Portable Fish Farm*, consisting of water-filled tanks containing catfish at various stages of their life cycle. His plan was to kill, prepare, and serve the fish in public, but it generated an acrimonious controversy, which died down only when he agreed to kill them privately.

The following year Newton collaborated with his wife, Helen, on *The Lagoon Cycle*, a project that proposed to transfer edible crabs from lagoons in Sri Lanka to tanks in California and to attempt to breed them in captivity—with the goal of developing an ecologically and commercially viable farming system. Since then the Harrisons' primary enterprise has been reclaiming and restoring polluted sites in the cause of human survival. In the process they developed information about their projects into conceptual art, which they presented in art-world venues [22].

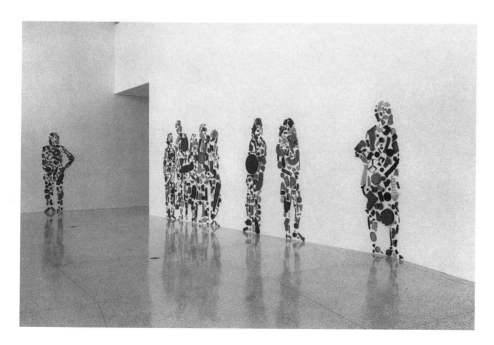

21. Tony Cragg, *Some Kind of Group*, 1983. *(Courtesy Marian Goodman Gallery, New York)*

Alan Sonfist's best-known work, *Time Landscape* [23], begun in 1965, proposed to restore sections of New York City to the way they might have looked in the seventeenth century. He hoped to bring primeval nature—indigenous trees, shrubs, and grasses—back into the city that had destroyed and supplanted it. The primary site was a parcel of land on the northern border of SoHo in Manhattan. To complete the project he had to enter into the political arena, negotiating with community groups, local politicians, real estate corporations, among other interests. It took more than a decade for Sonfist to bring *Time Landscape* into being.[142] He persevered because, as he said: "Our overriding social need is to develop a sensitivity to nature so that we can preserve our planet. My art has always dealt with this."[143]

Gordon Matta-Clark's work was countercultural from the start of his career. *Photo-Fry* (1969) was a performance piece in which he fried photographs in a pan of grease and exhibited the charred remains. *Garbage Wall* (1970) was just that. Taking his work outdoors in 1972, he built *Open House* in a dumpster parked on a SoHo street. Matta-Clark soon adopted derelict buildings as his primary medium. His move was influenced by Smithson and Oppenheim; as a student in 1969, he had helped them make pieces for the first-ever *Earth Art* show at Cornell University.[144] But Matta-Clark, who had studied architecture, devised an urban counterpart to earth art.

In his most famous work, *Splitting* (1974) [24], he "found" a vacant

22. Helen Mayer and Newton Harrison, *The Guadalupe Meander, A Refugia for San Jose,* 1982–83. *(Ronald Feldman Fine Arts, New York)*

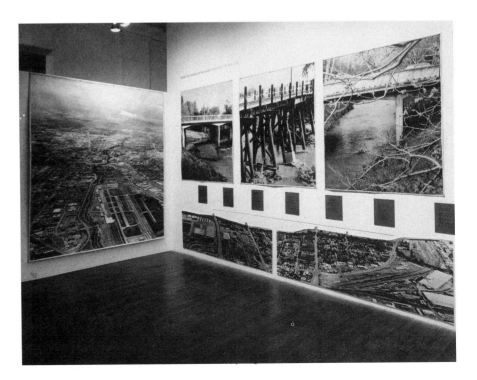

house slated for demolition and cut a one-inch slice through its center, dividing the building in half. He then pared down part of the foundation, lowering the rear half by one foot, opening up a "split," which allowed, as he recalled, "a brilliant wedge of sunlight [to spill] into every room."[145] He also carved out the four corners on the second floor, which he saved as "souvenir" sculptures.

23. Alan Sonfist, *Time Landscape*, New York City, 1965–present. *(Courtesy C. Johnson)*

In *Splitting*, Matta-Clark was intent on creating ever-shifting multiple views that the spectator could experience only by walking through a work. Alice Aycock recalled:

> Starting at the bottom of the stairs where the crack was small, you'd go up, and as you'd go further up, you'd have to keep crossing the crack. It kept widening as you made your way up the stairs to the top so that by the time you got to the top, the crack was one or two feet wide. You really had to jump it. You sensed the abyss in a kinesthetic and psychological way.[146]

Art history–minded viewers related the spaces to baroque art and architecture, for example, Piranesi's imaginary structures. Other viewers found themselves imagining Matta-Clark's daredevil performance of chain-sawing—his choreography, as it were. Still others responded to the

24. Gordon Matta-Clark, *Humphrey Street Splitting*, 1974. *(Courtesy Estate of Gordon Matta-Clark and Holly Solomon Gallery, New York)*

drawing—cutting as drawing—and the dynamic interaction of the rough-hewn volumes, edges, surfaces, and cavities. Robert Kushner commented on the ever-changing outdoor light that illuminated the raw, crumbling building and the interior space now open to the world. The "amazing shaft of light cutting though [the house's] center . . . was sculpture."[147] So was the entire building, an ordinary readymade transformed so as to appear extraordinary. And it was monumental sculpture at that, although Matta-Clark referred to his works as "non-uments."

Much as Matta-Clark asserted his artistic authority and celebrated his individualism, he also meant his excavated buildings—"anarchitecture," as he categorized them[148]—to be a countercultural critique of dehumanized urban renewal and international style architecture. His interventions in the city, as Dan Graham wrote, aimed to set up "a dialogue between art and architecture on architecture's own territory." Graham went on to say: "By making his removals something like a spectacle of a demolition for casual pedestrians, the work could function as a kind of urban 'agit-prop,' something like the acts in 1968 of the Paris Situationists, who had seen their acts as public intrusions or 'cuts' in the seamless urban fabric. The idea was to have their gestures interrupt the induced habits of the urban masses," and make them aware of how urban space was used.[149] Matta-Clark knew of the politically radical situationists' tactic of *détournement*, that is, recycling existing visual works so that they take on new meanings.[150] He said: "By undoing a building, [I open an] enclosure which had been preconditioned not only by physical necessity but by the [exploitative real-estate] industry which profligates suburban and urban boxes as a context for ensuring a passive, isolated consumer—a virtually captive audience."[151]

Matta-Clark despised not only realtors but architects as well. Invited in 1976 to exhibit in a show at the prestigious Institute of Architecture and Urban Studies, he borrowed an airgun and on the evening of the opening blew out the windows of the exhibition space. *Window Blowout*, as he titled his guerrilla action, literally shattered the static, enclosed space of the modernist building, metaphorically shooting down the established architectural discourse. Implicit in Matta-Clark's hostility toward the existing urban environment was the utopian belief that it could be transformed.[152] Or, if not quite that, then his dissection of conventional buildings would reveal to the public different, liberated, and energized spaces and might provoke "speculations about what could be beyond it [existing architecture] and what numbers of directions there could be."[153]

Window Blowout was illegal. So was *Days End* (1975), in which Matta-Clark transformed a turn-of-the-century steel-truss building on a Hudson River pier by making cuts in both, revealing the water below and allowing light to stream through resultant openings, the most spectacular of which was a huge crescent. He succeeded in turning a disused industrial building into a "sun-and-water temple."[154] His dramatic alter-

ation of the pier embarrassed New York bureaucrats who had not noticed him at work and who then issued a warrant for his arrest.[155] That action was welcomed by Matta-Clark who, as Christo remarked, "realized the value of tickling the system, adding a dimension . . . that gave additional energy to [a] piece."[156] (The case was later dropped.)

Despite its positive aspects, Matta-Clark's art was fundamentally negative. His transformation of one kind of urban ruin, soon to be demolished, into another was a "double negation," an exercise in entropy, akin to a Robert Smithson work. Ruining an abandoned ruined building and then abandoning it again was, as Graham wrote, "profoundly pessimistic." "Matta-Clark's 'monument' [will quickly] disappear into the anonymous rubble." It "is something of a useless gesture."[157] John Baldessari concluded: "Gordon's work spotlights and pinpoints one of the crucial ideas of modern art—actually doing and redoing an absurd idea."[158]

All that remains of Matta-Clark's physical projects, apart from a few "souvenirs," are the remnants: drawings, photographs, and collages. But, as conceptual art, they communicate his ideas and perpetuate the memory of the work. Furthermore, much of the photodocumentation was meant to be art. Indeed, Matta-Clark pieced together cubistlike collages and photomontages in "the same way I cut up buildings. I like the idea that the sacred photo-framing process is equally 'violatable.' [The multiple images are] an approximation of [the] kind of ambulatory 'getting to know' what the space is about. Basically it's ways of passing through the space."[159] Still, the camera and scissors could not replace the chain saw and recapture the sensation of being there.

Minimal artists based their works on preconceived ideas that they used to produce the most objectlike of objects. Most postminimal artists also began with an underlying concept, as in Nauman's corridors, Acconci's body art, Smithson's *Spiral Jetty,* or Matta-Clark's "anarchitecture," but their works are not objects in the traditional sense. Moreover, body, earth, and installation artists increasingly exhibited the documentation of their pieces as art. Several postminimalists went further, considering ideas in themselves as autonomous and presenting them in verbal form as works of visual art. Sol LeWitt labeled such texts conceptual art, which he defined as art that "is made to engage the mind of the viewer rather than his eye or emotions."[160] It also meant, as Douglas Huebler said, "making art that doesn't have an object as a residue."[161]

Conceptual art was first viewed as the abstraction or bracketing out of the conceptual component of minimal art. It was also soon perceived as a continuation of the central thrust in Duchamp's art and thinking. Duchamp had said that in introducing mass-produced readymades into an art context, he had added a new idea to the ordinary artifact. Conceptual art, then, can be viewed as the dematerialization (to use Lucy Lippard and John Chandler's word)[162] of a minimal object or a readymade, taking either back to the original idea that generated it.

The shift in thinking from concept as the basis of minimal art to concept-as-art can be traced in the writing of LeWitt, who formulated a rationale for conceptual art in two widely discussed articles, one in 1967 and the other in 1969.[163] He wrote that in conceptual art, the idea was the most important component of the work. It "means that all of the planning and decisions are made beforehand and the execution is a perfunctory affair. The idea becomes a machine that makes the art." This did not mean that conceptual art was rational, "theoretical or illustrative of ideas." Quite the contrary, "it is intuitive . . . and it is purposeless." Conceptual artists "leap to conclusions that logic cannot reach. . . . Irrational judgments lead to new experiences." But: "Irrational thoughts should be followed absolutely and logically," blindly and mechanistically.

According to LeWitt, conceptual art need not yield an object. "The idea itself, even if not made visual, is as much a work of art as any finished product. All intervening steps—scribbles, sketches, drawings, failed works, models, studies, thoughts, conversations—are of interest." Furthermore, "Ideas may also be stated with numbers, photographs, or words or any way the artist chooses, the form being unimportant."[164] Consequently, as LeWitt viewed it in 1967, conceptual art could range from an object generated by an idea to a written or even a spoken idea, or it could exist in the gap between verbalization and visualization [25].

In his 1969 essay, "Sentences on Conceptual Art," LeWitt advanced the idea of concept-as-art more strongly and specifically than he had in

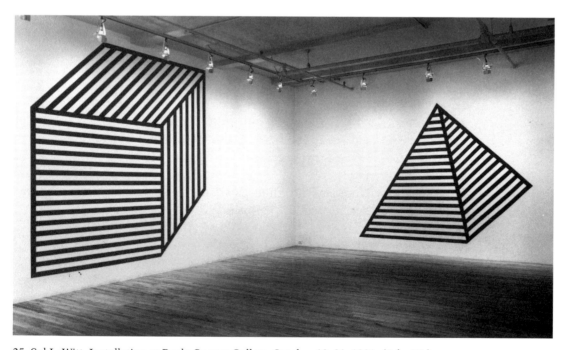

25. Sol LeWitt, Installation at Paula Cooper Gallery, October 10–31, 1981. *(John Weber Gallery, New York)*

his 1967 article. He rejected painting and sculpture because they were meant to appeal to the eye—that is, they were perceptual rather than conceptual. Moreover, they "connote a whole tradition, and imply a consequent acceptance of this tradition, thus placing limitations on the artist who would be reluctant to make art that goes beyond the limitation."[165]

If, as conceptual artists believed, they were advancing beyond the limitation of objects in order to create an art of pure idea, how was their work to be recognized as visual art? LeWitt answered that if the words comprise "ideas about art, then they are art and not literature. . . . All ideas are art if they are concerned with art and fall within the conventions of art." The purpose of conceptual art was to change "our understanding of the conventions of art."[166] Joseph Kosuth went even further, claiming that the sole purpose of art should consist of "presenting new propositions as to art's nature."[167]

Consequently, most early conceptual artists argued that to be art, the "information" they provided had to be about the language of art and its perception. But a growing number thought that ideas from other disciplines should be introduced, that art should become interdisciplinary. This was slow in happening. Lucy Lippard observed in 1972: "Conceptual art has not . . . as yet broken down the real barriers between the art context and those external disciplines—social, scientific, and academic—from which it draws its sustenance (or claims to). [Interactions] between mathematics and art, philosophy and art, literature and art, politics and art, are still at a very primitive level."[168]

But starts were being made. As agitation against the Vietnam War increased, artists began increasingly to deal with political and social issues. In 1970, for example, Adrian Piper exhibited a statement that read in part: THE WORK ORIGINALLY INTENDED FOR THIS SPACE HAS BEEN WITHDRAWN. . . . I SUBMIT ITS ABSENCE AS EVIDENCE OF THE INABILITY OF ART EXPRESSION TO HAVE MEANINGFUL EXISTENCE UNDER CONDITIONS OTHER THAN THOSE OF PEACE, EQUALITY, TRUTH, TRUST AND FREEDOM.[169] With the *Information* exhibition at the Museum of Modern Art in that year, conceptual art became an established tendency—and an option for any artist who wanted to work in this vein.

A painter from 1953 to 1966, John Baldessari then started to make conceptual paintings that questioned the basic premises of painting.[170] Word paintings of 1972 are composed of texts printed in black block letters, for example, PURE BEAUTY. They are related to the printed texts of Joseph Kosuth and Lawrence Weiner, which comment on art but differ in that Baldessari's messages are painted on raw canvas—by hired sign painters, but nonetheless painted—calling attention to—and also subverting with sly wit and humor—the "fundamentals" of easel painting. EVERYTHING IS PURGED FROM THIS PAINTING BUT ART; NO IDEAS HAVE ENTERED THIS WORK confronts formalist aesthetics and parodies them. Such statements reflect Ludwig Wittgenstein's play with language, provoking general ques-

tions as: What is painting? What is art? What is nonart? What are ideas? What is visual, what is verbal, and what is the difference? Could verbal information constitute a visual image? Would the inclusion of texts enlarge the realm of the visual arts, reduced as it had been by formalist dogmas? Where is the art—in the idea or the object? By commissioning sign painters to letter the texts, Baldessari posed a further question: Did artists have to make their works themselves or could other people make them according to the artists' ideas?

Baldessari introduced photographs into another series of pictures, transferring photographs onto canvas and having texts printed beneath them [26]. A number of these photo-word-paintings incorporated art-school textbook commentaries on "good" versus "bad" composition and on the nature of art. Others consisted of deadpan photographs, taken through an automobile window, of ordinary California scenes, coupled with inscriptions identifying their locations, for example, LOOKING EAST ON 4TH AND C/CHULA VISTA, CALIF.

In 1969 Baldessari executed a series titled *Commissioned Paintings*. He began by taking photographs of an anonymous hand pointing to different ordinary objects, and then had fourteen amateur painters each

26. John Baldessari, *An Artist Is Not Merely a Slavish Announcer*, 1966–68. *(Sonnabend Gallery, New York)*

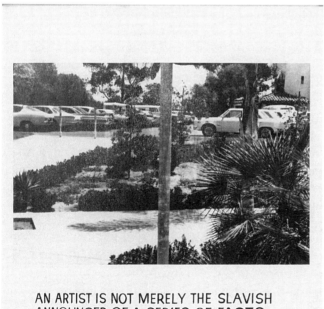

AN ARTIST IS NOT MERELY THE SLAVISH ANNOUNCER OF A SERIES OF FACTS. WHICH IN THIS CASE THE CAMERA HAS HAD TO ACCEPT AND MECHANICALLY RECORD.

paint a faithful picture of the photograph. A professional sign painter was hired to print the caption identifying the amateur painter below each image, such as "A PAINTING BY JANE MOORE." These works raise questions about originality and uniqueness—and quality. Which was the best picture? But they also document the activity of pointing, relating the work to postminimalist process art.

Increasingly employing photography, Baldessari soon purged paint entirely. He no longer felt the need "to be involved with my own hand in any way whatsoever"[171] or to "spend the rest of my life making different combinations of color."[172] Baldessari commemorated his death as a painter and rebirth as a conceptual artist in *Cremation Piece* (1970), in which he had pictures executed before 1966 still in his possession incinerated in a San Diego mortuary (an act reminiscent of the use of napalm in Vietnam), and he later made cookies with the ashes. Invited in 1971 to exhibit at the Nova Scotia College of Art and Design but unable to travel there, he asked students to write voluntarily on the gallery walls: "I will not make any more boring art," as if they were being punished for some school infraction; they covered the walls.

In focusing exclusively on ideas and on their documentation, Baldessari took his "permissions," as he said, from "Duchamp a lot, John Cage a lot. Dada artists. I mean, once you really begin to look at that stuff, then anything's possible. [And] you couldn't have conceptual art without the Fluxus movement."[173] Baldessari also acknowledged a debt to Warhol, who "helped to bring photo-imagery under the umbrella of art, to 'deghettoize' it. I value him for his love of the banal and the ordinary, plus his blurring of high and low culture. I admire his adroitness at balancing idea and execution in the making of his art. At this he was a master."[174]

Like his conceptual paintings, Baldessari's early photographs dealt ironically with aesthetic issues. But he now invented rules, game strategies, and systems, often involving chance. *Choosing: Chocolates* (1972) is a series of twelve color photographs, each of which contains three changing groupings of chocolates placed on graph paper with a finger pointing at different pieces. The work was clearly a parody of formal decision making. What determined taste in the selection of one chocolate over another? Aesthetic quality? An appetite for milk or dark chocolate? Was there a difference between taste and appetite?[175] Was one method of making an artistic choice better than another? But Baldessari's photographs themselves possessed aesthetic quality. He found the edge between an interesting idea and a telling image—the sign of successful conceptual art.[176]

In the early 1970s artists identified with postminimal art had come to think that it was outworn but did not want to reject it wholly, since it provided them with a "mainstream" visual vocabulary. Above all, reacting against postminimalism's antiobject bias, they turned to making traditional objects. In the process minimalism was reevaluated. The sculp-

tor whose work best exemplified this shift was Joel Shapiro. In earlier
work shown in 1970, he had ringed a gallery with small chipboard
shelves, on each of which he placed a 5/8-inch slab of a single sub-
stance—lead, wood, rubber, or clay. In its emphasis on modularity and
the literalness of materials, the work is minimal. But as an installation
whose eye-level shelves are cantilevered from the wall in a theatrical
manner, it is postminimalist. However, the work diverges from both min-
imal and postminimal art in that the shelves suggest the outstretched
palms of human figures.[177]

Then, in 1974, Shapiro continued the dialogue between minimalism
and postminimalism with works that stunned the art world and riveted
its attention, notably a three-inch-high cast-iron "chair" and a five-and-
one-half-inch-high cast-iron "house" placed on the floor of the Paula
Cooper Gallery, which suddenly seemed vast [27]. The house is a mini-
mal sculpture in that it is a triangular volume on a cube, and postmini-
mal because it sits on the floor and is dwarfed by its surroundings,
directing attention dramatically to the real space it is in and its peculiar
relation to the viewer, who towers over it. But no matter how cavernous
the room seems, the miniature sculpture is strikingly physical and com-
mands and activates the space.

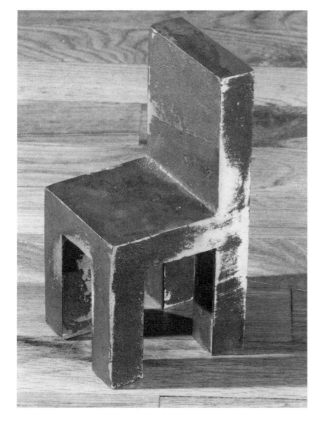

27. Joel Shapiro, *Untitled*, 1974. *(Courtesy PaceWildenstein, New York)*

The house is a potent figurative image that triggers psychological responses. On the one hand, it alludes to intimate home life, for example, childhood experiences of playing with toys. In a sense, then, Shapiro humanized minimal sculpture. On the other hand, the viewer is distanced from the minuscule house, and drawing close does not make it any less remote, giving rise to a strong sense of isolation and strangeness.

By embracing recognizable imagery and employing traditional techniques and materials, namely cast bronze or iron, Shapiro deliberately situated his work in the grand lineage of Western sculpture. Indeed, he kept his images simple in order to emphasize traditional aesthetic qualities, such as rightness of scale and surface nuance.

The "house" was Shapiro's central image in the early 1970s, and he improvised on it in diverse ways, slicing it up, upending it, and turning it every which way. By the middle 1970s its monolithic form was too constraining. He began to project blocky forms into space, turning them into figures [28].[178] At first he made them small, but soon they became larger and raised off the ground. Most of these figures are in motion, limbs flung out in all directions or, when not, are precariously balanced, seeming about to fly or to fall—in marked contrast to minimalist stasis.

28. Joel Shapiro, *Untitled*, 1980–81. *(Courtesy PaceWildenstein, New York)*

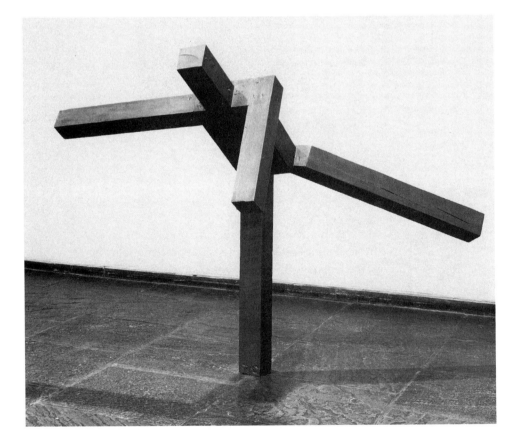

Shapiro's figures are constructed from squared-off planks of raw wood, cast in bronze, the bronze picking up the wood grain, nailheads, and hammer marks. The viewer is always aware of how the forms were pieced together. In fact, Shapiro was intent on revealing the process of sculpture making—as an integral part of what sculpture meant. If the spare bronze "planks" are reminiscent of minimal objects, their composition calls to mind David Smith's late welded constructions, notably the *Cubi*, against which minimal sculptors reacted. In sum, Shapiro synthesized the two major sculptural styles of the last half century—indicating the scope of his ambition.

Shapiro was not the only sculptor of his generation who adopted figuration and employed traditional materials and techniques. There were also Nancy Graves and Bryan Hunt. Indeed, Wade Saunders considered the new traditionalism characteristic of the sculptors born between 1946 and 1955. In speculating about "our commonality," about what "ties us together as a group," he wrote:

> We make things ourselves, instead of jobbing them out. Our scale is generally smaller than that of the preceding generation. Our passion is for the centuries of modeled or carved figures and objects that preceded Minimalism. Installation work is downplayed. . . . For the most part, our sculpture gained its own identity and took flight only at the moment that we scrapped, one by one, the reductivist tenets of Minimalism.
>
> Our work is made in and derives from the studio, where individual attitudes and personal working methods dominate. By all standards of radicalism established in the '60s, our sculpture is conservative—in its modest scale, in its independence from the space in which it is to be exhibited, and in its recourse to bases. . . . Generally we understand ideas through forms, theory through repeated practice. . . . Our sculpture is sensuous and emphasizes touch, shows a resurgent interest in color. . . . Recent sculpture, like current painting, is full of quotation. . . . More than anything else, [it has] an insistent quality of reference. . . . In accepting references, even representations, we've really opened up the language of sculpture for ourselves.[179]

In 1968 Nancy Graves began to make life-size camels from wooden armatures covered with a variety of animal skins and painted to look like camel fur. Like minimal sculptures, the camels are single, literal objects, but they seem to want to roam—in a postminimal space. Exhibited in 1969 and reproduced on the cover of *Artforum*, the camels so resembled the work of taxidermists that they shocked the art world. They looked as if their natural habitat should be a natural history museum. In fact,

Graves was an avid student of paleontology, anatomy, botany, and other natural sciences.

In 1970 Graves turned her camels inside out and began to model anatomically correct bones and compose them into open structures. *Variability of Similar Forms* (1970) was an assemblage of thirty-six isolated leg bones that look like a dance of death or the relics of some ancient religious ritual. Graves then built steel armatures, to which she attached fetishlike painted objects that resembled animal skins, bones, fossils, and feathers, as in *Shaman* (1970).

In 1978, with an eye to her earlier camels, bones, and fetishlike images, Graves began to replicate anything that struck her fancy—fruits, flowers, leaves, pods, bulbs, gourds, crayfish, sardines, potato chips, fans, rope—by casting them directly into bronze, in the process burning away the real things [29]. She then painted these realistic forms in unrealistic high-key colors, bonding the pigment with the metal, and welding them into improvised abstract structures, in the tradition of Picasso, Gonzales, and above all, David Smith. Like Shapiro and Hunt, Graves combined figuration and abstraction, but she carried each to a greater extreme. Indeed, these welded assemblages of bronze casts synthesize opposites: the real and the nonobjective, the natural and the artificial, sculpture and painting, as well as the lightweight images, the weightiness of the metal into which they were cast, and the airiness of their open construction.

In 1973 Bryan Hunt also came to think that postminimalist site-specific works had become outworn. Nonetheless he wanted to refer "conceptually to the problems earthwork artists addressed," but in the form of objects.[180] Hunt began to make scale models of the *Hoover Dam*, the *Wall of China (Nankow Pass)*, and *Phobos* (a moon of Mars), "creating a vision of site-specific sculpture," as he said.[181]

Hoover Dam prompted Hunt to think of water as a sculptural image, and in 1976 he modeled in clay and cast in bronze three-dimensional "lakes"—just the volume of water with its irregular bottom and wavy surface. He recalled: "I wanted to tie together an image and the word 'lake' and an abstract shape of nature."[182] These freestanding works were relatively small and placed directly on the floor, like Shapiro's house and chair. The sculptures of lakes led Hunt in 1978 to model and cast in bronze tall, slender "waterfalls," composed of sinuous ribbons whose surfaces were hand-gouged and scraped like those of Rodin, Giacometti, and de Kooning. The cascading forms suggest draped figures emerging out of falling water [30].

In a sense Shapiro, Graves, and Hunt closed off postminimalism and opened up new possibilities. Painters as well as sculptors became increasingly tradition-minded and worked between figuration and abstraction. Labeled new imagists, they and their work are the subject of chapter 6.

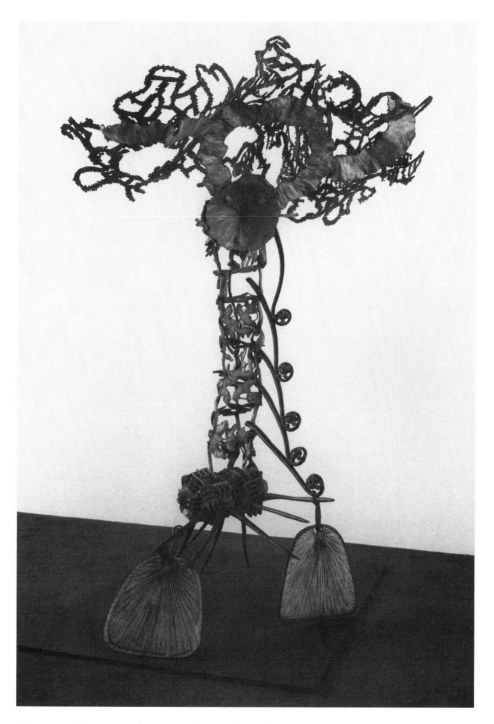

29. Nancy Graves, *Cantileve,* 1983. *(Copyright © 1994 Whitney Museum of American Art, New York; © Estate of Nancy Graves/VAGA, New York, NY)*

30. Bryan Hunt, *Shift Falls*, 1978.
(Collection of Vera G. List. Courtesy Bryan Hunt)

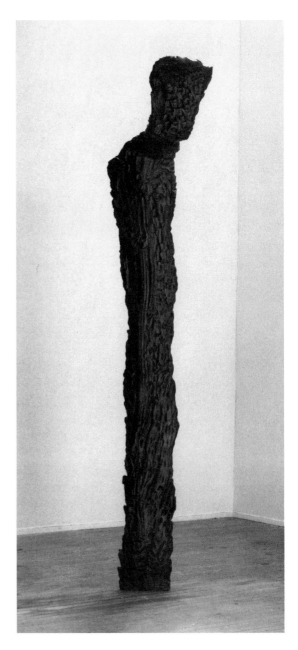

NOTES

1. Lucy R. Lippard, "Eccentric Abstraction," *Art International*, Nov. 1966, p. 28.
2. Lucy R. Lippard, "Intersections," in *Flyktpunkter: Vanishing Points* (Stockholm: Moderna Museet, 1984), p. 14.
3. Lucy R. Lippard and John Chandler, "The Dematerialization of Art," *Art International*, Feb. 1968, pp. 31–36; and Lucy R. Lippard, ed., *Six Years: The Dematerialization of the Art Object from 1966 to 1972 . . .* (New York: Praeger Publishers, 1973).
4. Robert Morris, "Anti-Form," *Artforum*, Apr. 1969, pp. 30–33, and "Notes on Sculpture, Part 4: Beyond Objects," *Artforum*, Apr. 1969, pp. 50–54. The editor of *Artforum* used the label "antiform"; Morris objected to it.

5. Morris, "Anti-Form," p. 35.

6. Morris, "Notes on Sculpture, Part 4," pp. 51, 54.

7. Robert Morris, "The Art of Existence: Three Extra-Visual Artists: Works in Process," *Artforum*, Jan. 1971, p. 28.

8. James Monte, introduction to *Anti-Illusion: Procedures/Materials* (New York: Whitney Museum of American Art, 1969), pp. 4–5. Among the participants in the show were Carl Andre, Linda Benglis, Raphael Ferrer, Philip Glass, Eva Hesse, Neil Jenney, Barry Le Va, Robert Morris, Bruce Nauman, Stephen Reich, Robert Ryman, Richard Serra, Joel Shapiro, Michael Snow, and Richard Tuttle.

9. It is noteworthy that Morris staged performances as a member of the Judson Dance Theater. Neil Jenney, in *Anti-Illusion: Procedures/Materials* (New York: Whitney Museum of American Art, 1969), also seemed to have been thinking about the Fried-Morris discourse, declaring in the catalog: "My sculpture is theatrical. The activity among the physical presences of the items and the events they realize . . . is theatrical. This goes beyond the visual image" (p. 54).

10. Tucker, introduction to *Anti-Illusion*, p. 36.

11. Nancy Foote, "The Anti-Photographers," *Artforum*, Sept. 1976, p. 54.

12. Tucker, introduction to *Anti-Illusion*, p. 28.

13. Morris, "Three Folds in the Fabric," p. 150.

14. In their use of unconventional materials, postminimal sculptors were influenced by Judd's plastics, Flavin's fluorescent fixtures, and Andre's store-bought metal squares. But instead of durable, precise materials, the Postminimalists preferred ephemeral ones.

Among the artists who did not make conventional paintings and sculptures and who achieved international art-world recognition in the 1970s—and it is indeed a formidable roster—were Marina Abramovic, Vito Acconci, Vincenzo Agnetti, Laurie Anderson, Giovanni Anselmo, Eleanor Antin, Art & Language, Michael Asher, David Askevold, John Baldessari, Robert Barry, Lothar Baumgarten, Bernd and Hilla Becher, Bill Beckley, Joseph Beuys, Mel Bochner, Alighiero Boetti, Christian Boltanski, George Brecht, Stanley Brouwn, Marcel Broodthaers, Chris Burden, Daniel Buren, Victor Burgin, James Lee Byers, Pier Paolo Calzolari, Christo and Jeanne-Claude Christo, Hanne Darboven, Jan Dibbets, Luciano Fabro, Terry Fox, Hamish Fulton, Gilbert & George, Dan Graham, Gotthard Graubner, Hans Haacke, Michael Heizer, Dick Higgins, Nancy Holt, Rebecca Horn, Douglas Huebler, Peter Hutchinson, Robert Irwin, Ray Johnson, Allan Kaprow, Edward Kienholz, Joseph Kosuth, Jannis Kounellis, Jean Le Gac, Barry Le Va, Les Levine, Richard Long, Gordon Matta-Clark, Mario Merz, Mary Miss, Robert Morris, Bruce Nauman, NE Thing Co., Dennis Oppenheim, Nam June Paik, Giulio Paolini, Giuseppe Penone, Otto Piene, Michelangelo Pistoletto, Anne and Patrick Poirier, Emilio Prini, Terry Riley, Allen Ruppersberg, Lucas Samaras, Charles Simonds,

Robert Smithson, Michael Snow, James Turrell, Wolf Vostell, William Wegman, Robert Whitman, Laurence Wiener, Roger Welch, and Gilberto Zorio.

15. Max Kozloff, "9 in a Warehouse: An 'Attack on the Status of the Object,'" *Artforum*, Feb. 1969, p. 38.

16. Douglas Davis, "The Arts in America: Art Without Limit," *Newsweek*, Dec. 24, 1973, p. 68.

17. Lucy R. Lippard, *Eva Hesse* (New York: New York University Press, 1976), p. 84.

18. Kim Levin, in "Eva Hesse: Notes on New Beginnings," *Art News*, Feb. 1973, pp. 72–73, wrote that beginning in 1965, Hesse's favorite forms were "the grid, the circle within the grid and the center point of the circle. [They are] pervasive and fundamental to her work. [When] extended into space, the circle may become a hemispherical mound or a cylinder, the grid a series of tray-like partitions and the point a dangling thread, string or rope."

19. Lippard, *Eva Hesse*, p. 6.

20. Cindy Nemser, "An Interview with Eva Hesse," *Artforum*, May 1970, p. 63.

21. Sol LeWitt, letter to Eva Hesse, quoted in Lippard, *Eva Hesse*, p. 35.

22. Nemser, "An Interview with Eva Hesse," p. 60.

23. Lucy R. Lippard, "Eva Hesse: The Circle," *Art in America*, May–June 1971, p. 70.

24. Nemser, "An Interview with Eva Hesse," p. 62.

25. Ibid., p. 60.

26. Anna C. Chave, "Eva Hesse: A 'Girl Being a Sculpture,'" in Helen A. Cooper, ed., *Eva Hesse: A Retrospective* (New Haven: Yale University Press, 1992), pp. 100–101, 108.

27. Fidel A. Danieli, "The Art of Bruce Nauman," *Artforum*, Dec. 1967, p. 19.

28. Bruce Nauman, in *American Sculpture of the Sixties* (Los Angeles: Los Angeles County Museum, 1967), p. 49.

29. Willoughby Sharp, "Nauman Interview," *Arts Magazine*, Mar. 1970, p. 27. Nauman's approach was avant-gardist—an experimental probing of the outer limits of "art." Marcia Tucker, in "pheNAUMANology," *Artforum*, Dec. 1970, wrote that all his works "seem to defy our habitual esthetic expectations" (p. 38). Nauman himself remarked, in Coosje van Bruggen, "Entrance Entrapment Exit," *Artforum*, Summer 1986, that he was not interested in "adding to a collection of things that are art . . . but in investigating the possibilities of what art may be" (p. 89).

30. Caute, *The Year of the Barricades*, p. 225.

31. Coosje van Bruggen, *Bruce Nauman* (New York: Rizzoli, 1988), p. 25.

32. Ibid., p. 109. In Sharp, "Nauman Interview," p. 26, Nauman said that he used his "body as a piece of material."

33. Van Bruggen, "Entrance Entrapment Exit," pp. 93–94.

34. In Jane Livingston, "Bruce Nauman," *Bruce Nauman: Works from 1965 to 1972* (Los Angeles: Los Angeles County Museum of Art, 1972), Nauman remarked: The "project" works "limited the kinds of

things you could do . . . because I don't like the idea of free manipulation, of putting a bunch of stuff out there and letting people do what they want to do with it. I really had more specific kinds of experience in mind" (pp. 22–23).

35. See Tucker, "PheNAUMANology," and Bruce Nauman, in *DISlocations* (New York: Museum of Modern Art, 1991), p. 67.
36. Van Bruggen, *Bruce Nauman*, p. 117.
37. Chris Dercon, "Keep Taking It Apart: A Conversation with Bruce Nauman," *Parkett* 10 (1986): 60.
38. Ibid.
39. For example, Nauman was profoundly moved by Jacobo Timerman's memoir *Prisoner Without a Name, Cell Without a Number,* trans. Tony Talbot (New York: Alfred A. Knopf, 1981).
40. Livingston, "Bruce Nauman." Nauman went on to say: "I would say my interest in Duchamp has to do with his use of objects to stand for ideas" (p. 11).
41. Sex and violence are the subjects of other works in neon of 1985, among them *Sex and Death with Hanging Figures (Double 69)* and *Punch and Judy— Kick in the Groin/Slap in the Face.*
42. See van Bruggen, "Entrance Entrapment Exit," p. 96.
43. Bruce Nauman, in Robert Storr, "Nowhere Man," *Parkett* 10 (1986): 78.
44. See Lois E. Nesbitt, "Lie Down, Roll Over: Bruce Nauman's Body-Conscious Art Reawakens New York," *Artscribe,* Summer 1990, pp. 49–50.
45. Willoughby Sharp, "Body Works," *Avalanche* (Fall 1970): 14.
46. John Howell, *Laurie Anderson* (New York: Thunder's Mouth Press, 1992), p. 35.
47. Martin Kunz, "Interview with Vito Acconci About the Development of His Work Since 1966," in *Vito Acconci* (Lucerne, Switzerland: Kunsthalle, 1978), n.p.
48. John G. Hanhardt, "Beyond Illusion: American Film and Video Art, 1965–75," in Richard Armstrong and Richard Marshall, eds., *The New Sculpture: 1965–75: Between Geometry and Gesture* (New York: Whitney Museum of American Art, 1990), p. 30.
49. Vito Acconci, "Steps into Performance (and Out)," in A. A. Bronson and Peggy Gale, eds., *Performance by Artists* (Toronto: Art Metropole, 1979), quoted in Lynn Zelevansky, "Is There Life After Performance," *Flash Art* (Dec. 1981–Jan. 1982): 38. Acconci conceived of himself as the "target" of his art, using cameras—still, movie, and video—to "shoot" himself, as it were.
50. Vito Acconci, in Judith Russi Kirshner, *Vito Acconci: A Retrospective: 1969 to 1980* (Chicago: Museum of Contemporary Art, 1980), p. 10.
51. Kunz, "Interview with Vito Acconci."
52. Ibid.
53. Cindy Nemser, "An Interview with Vito Acconci," *Arts Magazine,* Mar. 1971, p. 21.
54. Donald H. Harvey, "An Interview with Vito Acconci," *Dialogue,* Jan.–Feb. 1982, p. 54.

55. Kunz, "Interview with Vito Acconci."
56. John Perreault, "Art: Cockroach Art," *Village Voice,* Apr. 8, 1971, p. 23.
57. Marie B. LaCour, *Vito Acconci: Recent Work* (Richmond: Institute of Contemporary Art of the Virginia Museum of Art, 1982), n.p.
58. Linda Shearer, *Vito Acconci: Public Places* (New York: Museum of Modern Art, 1988), p. 5.
59. Ronald J. Onorato, in *Vito Acconci: Domestic Trappings* (La Jolla, Calif.: Museum of Contemporary Art, 1987), p. 23.
60. Judith Russi Kirshner, "Vito Acconci: Language and Space," *Vito Acconci: A Retrospective: 1969 to 1980* (Chicago: Museum of Contemporary Art, 1980), p. 5.
61. Ingrid Wiegand, "Vito Acconci Finally Finds Himself—Through Others," *Village Voice,* Oct. 18, 1976, p. 55. In *Command Performance* (1974) Acconci went even further in inviting the spectator into his work as a participating "actor." John G. Hanhardt, in "Beyond Illusion," wrote that the

viewer encountered a stool lit by a spotlight and recorded by a live video camera; the image of the stool appeared on a monitor located in another part of the exhibition space. Another monitor showed Acconci lying on an examination table, seemingly speaking to the occupant of the stool. The viewer was then encouraged to sit on the stool and be seen on the monitor . . . in relation to his presence—his body—on the monitor . . . Acconci posits the viewer as central to the experience of the piece. (p. 32)

62. Acconci, in Kunz, *Vito Acconci.*
63. See Ellen Schwartz, "Vito Acconci: 'I Want to Put the Viewer on Shaky Ground,'" *Art News,* Summer 1981. Acconci said: "My shift, then, was from a kind of psychological self to a sociological self" (p. 98).
 Acconci anticipated this move in works executed from 1974 to 1979, in which he combined audio- or videotapes with installations or sculptures so that his voice controlled the space. See Onorato, "Vito Acconci: Domestic Trappings," p. 33. Many of these works were executed in Europe, and in them, Acconci, as an American artist, confronted the history, politics, and culture of the place in which the works were made. See Kirshner, *Vito Acconci,* p. 8.
64. Vito Acconci, in *Vito Acconci: The House and Furnishings as Social Metaphor* (Tampa: Fl.: University of South Florida Art Galleries, 1986), p. 8.
65. Shearer, "Vito Acconci: Public Places," pp. 5–6, 13–14.
66. Vito Acconci, in *Vito Acconci: Photographic Works 1969–1970* (New York: Brooke Alexander Gallery, 1988), n.p.
67. Ellen Johnson, *American Artists on Art: From 1940 to 1980* (New York: Harper & Row, 1982), p. 236.
68. Horvitz, "Chris Burden," *Artforum,* May 1976, p. 26.
69. Claudia Gould, "Chris Burden," an interview, in

Breakthroughs: Avant-Garde Artists in Europe and America, 1950–1990 (New York: Rizzoli, 1991), p. 196.

70. Johnson, *American Artists on Art*, pp. 237–38.

71. See Howard Singerman, "Chris Burden's Pragmatism," in *Chris Burden: A Twenty-Year Survey* (Newport Beach, Calif.: Newport Harbor Art Museum, 1988), p. 21, and Kay Larson, "More Proof of Burden," *Village Voice*, Mar. 10, 1980, p. 80, and "Art: Best of Burden," *New York*, Sept. 18, 1989, p. 65.

72. Johnson, *American Artists on Art*, p. 237. See also Paul Schimmel, "Just the Facts," in *Chris Burden: A Twenty-Year Survey*, p. 17.

73. Ibid., p. 16. Another side of Burden's work could also have be considered countercultural, the aim of making the private public, much as Nauman and Acconci had. "Letting it all hang out" was a popular counterculture phrase. For example, in *Natural Habitat* (1976) Burden constructed a full-scale replica of his living quarters in the gallery, and lived there for a week. In *Full Financial Disclosure* (1976) he exhibited his business expenses for that year.

74. Horvitz, "Chris Burden," p. 24.

75. Roberta Smith, "Gallery View: Outrageous Acts Give Way to Eccentric Sculpture," *New York Times*, Sept. 24, 1989, sec. B., pp. 35, 39.

 Burden's risk-taking performances were a gloss of sorts on abstract expressionist rhetoric. He took the idea of risk—so valued by the abstract expressionists but in their case only metaphorical—into real life. He made it *literal.*

76. Horvitz, "Chris Burden," p. 31.

77. Donald Kuspit, "Chris Burden: The Feel of Power," in *Chris Burden: A Twenty-Year Survey*, p. 38.

78. Smith, "Gallery View: Outrageous Acts," p. 39.

79. Burden's critique of the art-world establishment was related to those of Daniel Buren and Marcel Broodthaers, which will be dealt with in chapter 2.

80. Singerman, "Chris Burden's Pragmatism," pp. 24–25. In order to make trouble for art institutions, Burden went so far as to devise a work—*Samson*—that threatened physically to demolish a museum, not to mention its symbolic importance.

81. Larson, "Best of Burden," p. 66.

82. Peter Schjeldahl, "Art: Art Trust," *Village Voice*, Sept. 17, 1991, p. 97.

83. In the late 1960s Oppenheim had been an innovator of earth art. His best-known work was *Time Line* (1968), in which he used chain saws to draw a line in the ice of the St. John River on the U.S. Canadian border. The line also demarcates two time zones, thus crossing space and time.

84. Alanna Heiss, "Another Point of Entry: An Interview with Dennis Oppenheim," in *Dennis Oppenheim: Selected Works 1967–90* (New York: Institute for Contemporary Art, P.S. 1 Museum, 1992), p. 162.

85. Ibid., p. 158.

86. Thomas McEvilley, "The Rightness of Wrongness: Modernism and Its Alter-Ego in the Work of Dennis Oppenheim," in *Dennis Oppenheim: Selected Works 1967–90*, p. 65.

87. Carter Ratcliff, "Modernism Turned Inside Out: Lucas Samaras' 'Reconstructions,'" *Arts Magazine*, Nov. 1979, p. 93.

88. Alan Solomon, "An Interview with Lucas Samaras," *Artforum*, Oct. 1966, p. 43.

89. Lucas Samaras, in *Samaras: Selected Works 1960–1966* (New York: Pace Gallery, 1966), p. 40.

90. Lea Vergine, *Il Corpo Come Linguaggio* (Milan: Giampaolo Praero Editore, 1974), n.p.

91. Daniel Farson, *With Gilbert & George in Moscow* (London: Bloomsbury, 1991), p. 33.

92. See *Gilbert & George: The Complete Pictures 1971–1985* (London: Thames & Hudson, 1986), p. VII.

93. Farson, *With Gilbert & George in Moscow*, p. 33.

94. See Gilbert & George, "What Our Art Means," in *Gilbert & George*, p. vii.

95. Ibid.

96. Carter Ratcliff, in *Gilbert & George*, p. xi.

97. Andrew Wilson, "We Always Say It Is What We 'Say' That Is Important: Gilbert and George Interviewed by Andrew Wilson 5 January 1990," *Art Monthly*, Apr. 1990, p. 10.

98. Peter Plagens, "Gilbert & George: How English Is It?" *Art in America*, Oct. 1984, p. 178.

99. Marjorie Allthorpe-Guyton, "Spotlight: Gilbert & George," *Flash Art* (Nov.–Dec. 1987): 98. Because of their success, she called into question Gilbert & George's self-images as romantic bystanders. "[Unlike] the Great Romantics, Gilbert & George triumph with support from above *and* below: from the cultural elite . . . and from the popular press who love the sex and violence."

100. Calvin Tomkins, *The Scene: Reports on Post-Modern Art* (New York: Viking, 1976), p. 205.

101. Adrian Henri, *Total Art: Environments, Happenings, and Performance* (New York: Praeger, 1974), p. 159.

102. Calvin Tomkins, *The Bride and the Bachelors* (New York: Viking, 1965), p. 137.

103. Ibid., p. 198.

104. Ibid., p. 196.

105. Ibid., p. 226. Paik's countercultural attitude was exemplified in his claim to be "anti ego. . . . Postindustrial society will be a kind of egoless society. . . . Many people now are giving up acquisitiveness in terms of money and material comfort; next stage is to give up acquisitiveness in fame. Of course, Fluxus people, including myself, are vain and *do* have ego. I know that. Is very, very hard" (p. 207).

106. William L. O'Neill, *Coming Apart: An Informal History of America in the 1960s* (New York: Quadrangle Books, 1977), p. 251.

107. Gregoire Müller, *The New Avant-Garde, Issues for the Art of the Seventies* (New York: Praeger, 1972), p. 94.

108. Richard Serra, "Verb List Compilation 1967–68," *Avalanche* (Winter 1971): 20.

109. Philip Leider, "'The Properties of Materials': In the

Shadow of Robert Morris," *New York Times*, Dec. 22, 1968, sec. D, p. 31.

110. Ibid.

111. Liza Baer, "Interview: Richard Serra & Liza Baer: New York City, 30 March 1976," in Richard Serra (with Clara Weyergraf), *Richard Serra: Interviews, Etc., 1970–1980* (Yonkers, N.Y.: Hudson River Museum, 1980), pp. 68, 70.

112. Elizabeth C. Baker, "Critic's Choice: Serra," *Art News*, Feb. 1970, p. 26.

113. Baer, "Richard Serra: 'Sight Point '71–'75/Delineator '74–'76'" radio interview, Feb. 23, 1976, *Art in America*, May–June 1976, p. 86.

114. Richard Serra, in *Richard Serra Sculpture* (New York: Pace Gallery, 1989), n.p.

115. Ibid.

116. Liza Baer, "Richard Serra: 'Sight Point,'" '71–75/Delineator '74–'76,'" a radio interview, Feb. 23, 1976, p. 84.

117. Clara Weyergraf, "From 'Through Pieces' to 'Terminal Study of a Development,'" in *Richard Serra: Arbeiten 66–77* (Tübingen, Germany: Kunsthalle, 1978), p. 213.

118. Carter Ratcliff, "Adversary Spaces," *Artforum*, Oct. 1972, p. 40.

119. Douglas Crimp, "Richard Serra's Urban Sculpture: An Interview," *Arts Magazine*, Nov. 1980, p. 119.

120. Douglas Crimp, "Serra's Public Sculpture: Redefining Site Specificity," *Richard Serra/Sculpture* (New York: Museum of Modern Art, 1986), p. 53.

121. Melinda Wortz, "In Consideration," *Larry Bell: New Work* (Yonkers, N.Y.: Hudson River Museum, 1981), p. 10.

122. Robert Smithson, "Entropy and the New Monuments," *Artforum*, June 1966, p. 26.

123. Samuel Wagstaff Jr., "Talking to Tony Smith," *Artforum*, Dec. 1966, p. 19.

124. Robert Smithson, "Toward the Development of an Air Terminal Site," *Artforum*, Summer 1967, pp. 38, 40. There were other earthworks and related phenomena at the time that shared Smithson's perverse irony but did not receive the attention that his works did, notably Iain Baxter's "aesthetically claimed things," photographs of existing phenomena in the environment, and the "grave" that Claes Oldenburg contributed to *Sculpture in Environment* in New York (1967). A minimal six-by-six-by-three-foot cavity, it was dug by union gravediggers in Central Park behind the Metropolitan Museum and then refilled.

125. Robert Smithson, in *Earth Art* (Ithaca, N.Y.: Cornell University, Andrew Dickson White Museum of Art, 1970), n.p.

126. Lawrence Alloway, "Robert Smithson's Development," *Artforum* (Nov. 1972): 58.

127. In ibid. Alloway wrote: "The sound track [of *Spiral Jetty*] included a quotation from *The Time Stream* [a science fiction story] by John Taine referring to 'a vast spiral nebula of innumerable suns'" (p. 60).

128. Robert Smithson, "Untitled 1971" and "Untitled 1972," in Nancy Holt, ed., *The Writings of Robert Smithson: Essays with Illustrations* (New York: New York University Press, 1979), p. 220.

129. Morris, "Notes on Sculpture, Part 2": 21.

130. Morris, "Notes on Sculpture, Part 4": 51, 54.

131. Alan Sonfist, ed., *Art of the Land: A Critical Anthology of Environmental Art* (New York: E.P. Dutton, 1983), p. xi.

132. Geordie Greig, "Circular Tours in the Name of Art," *Sunday Times Review* (London), June 16, 1991, sec. 5, p. 7.

133. In ibid. Long said: "I like to think my art slides between minimalism and conceptualism," p. 7. He has also spoken of his relationships to Lawrence Weiner, Daniel Buren, and Carl Andre.

134. Richard Long, "Correspondence: Richard Long Replies to a Critic," *Art Monthly*, July–Aug. 1983, p. 20.

135. See R. H. Fuchs, *Richard Long* (London: Thames & Hudson, 1986), p. 46.

136. Greig, "Circular Tours," p. 7.

137. Long, "Correspondence," p. 21.

138. Ibid., pp. 21–22.

139. David Brown, "Some Aspects of British Art Today," in *Europe in the Seventies: Aspects of Recent Art*, (Chicago: Art Institute of Chicago, 1977), p. 18.

140. Lynne Cooke, "Between Image and Object: The 'New British Sculpture,'" in *A Quiet Revolution: British Sculpture Since 1965* (London: Thames & Hudson, 1987), p. 40.

141. Fuchs, *Richard Long*, p. 45.

142. Jeffrey Deitch, "The New Economics of Environmental Art," in Sonfist, *Art in the Land*, p. 89.

143. Nancy Foote, ed., "Situation Esthetics: Impermanent Art and the Seventies Audience," *Artforum*, Jan. 1980, p. 29.

144. A second-generation postminimalist, Gordon Matta-Clark was influenced not only by the form of minimal art but by the desire to decompose the art object that informed process art, earth art, and body art. He was especially impressed by Nauman's and Acconci's investigations into how people behave in various spaces.

145. Gordon Matta-Clark, in an interview conducted in Antwerp, Belgium, in 1977, press release, Oct. 22, 1990, Holly Solomon Gallery, New York.

146. Alice Aycock, in Mary Jane Jacob, ed., *Gordon Matta-Clark: A Retrospective* (Chicago: Museum of Contemporary Art, 1985), p. 33.

147. Robert Kushner, in Mary Jane Jacob, ed., *Gordon Matta-Clark: A Retrospective*, p. 51.

148. Robert Pincus-Witten, in "Jean Highstein and Sensibility Minimalism: A Tissue of Happenstance," *Arts Magazine*, Oct. 1980, wrote of Highstein's alliance with Matta-Clark in which they called Anarchitecture, an amalgam that fused "the notions of anarchy and architecture" (p. 139). Other artists involved were George Trakis, Richard Nones, Suzanne Harris, Richard Landry, Tina Girouard, Jeffry Lew, and somewhat later, Bernard Kirschenbaum, Laurie Anderson, Susan Weil, and

Jean Dupuy. "These artists explored architectural scale, location, or metaphor in their work. Indeed, for nearly a year, they met informally in one another's studios to discuss the nature of their architectural inversions." Later, in "Gordon Matta-Clark: Art in the Interrogative," in Jacob, *Gordon Matta-Clark: A Retrospective*, Robert Pincus-Witten commented that "in its narrowest sense, 'Anarchitecture' really is applicable to Matta-Clark's major structural interventions" (p. 11).

149. Dan Graham, "Gordon Matta-Clark," in *Flyktpunkter*, pp. 90–91.

150. See Christo, in Jacob, *Gordon Matta-Clark: A Retrospective*, p. 41.

151. Donald Wall, "Gordon Matta-Clark's Building Dissections," *Arts Magazine*, May 1976, p. 76.

152. Edward Ball, "The Beautiful Language of My Century," *Arts Magazine*, Jan. 1989, p. 67.

153. Judith Rossi Kirschner, "Non-uments," *Artforum*, Oct. 1985, p. 108.

154. Jacob, *Gordon Matta-Clark: A Retrospective*, p. 78.

155. Joan Simon, "Gordon Matta-Clark, 1943–1978," *Art in America*, Nov.–Dec. 1978, p. 13.

156. Christo, in Jacob, *Gordon Matta-Clark: A Retrospective*, p. 41.

157. Graham, "Gordon Matta-Clark," pp. 97, 101.

158. John Baldessari, in Jacob, *Gordon Matta-Clark: A Retrospective*, p. 19.

159. Kirschner, "Non-uments," p. 108.

160. Sol LeWitt, "Paragraphs on Conceptual Art," *Artforum*, June 1967, p. 83.

161. Lucy R. Lippard, *Six Years: The Dematerialization of the Object from 1966 to 1972* (New York: Praeger Publishers, 1973), p. 129.

162. Lippard and Chandler, "The Dematerialization of Art," pp. 31–36.

163. See LeWitt, "Paragraphs on Conceptual Art," and "Sentences on Conceptual Art," *Art-Language* (England), May 1969.

164. LeWitt, "Paragraphs on Conceptual Art," p. 83.

165. LeWitt, "Sentences on Conceptual Art," pp. 11–12.

166. Ibid., p. 12.

167. Joseph Kosuth, "Art After Philosophy," *Studio International*, Oct. 1969, p. 135.

168. Lippard, *Six Years*, p. 263.

169. Ibid., p. 168.

170. Coosje van Bruggen, *John Baldessari* (New York: Rizzoli, 1990), p. 22.

171. Christopher French, "Blasted Allegories, Fugitive Essays: The Conceptual Images of John Baldessari," *Journal of Art* (Oct. 1990): 12.

172. Nancy Drew, "John Baldessari: An Interview," in *John Baldessari* (New York: New Museum, 1981), p. 64.

173. French, "Blasted Allegories," p. 12.

174. John Baldessari, "A Collective Portrait of Andy Warhol," in Kynaston McShine, ed., *Andy Warhol: A Retrospective* (New York: Museum of Modern Art, 1989), p. 447.

175. Douglas Crimp, "Introduction to 1970s Art," Slide Lecture Anthology—SL XII, Art Information Distribution, New York, 1975, pp. 41–42.

176. James Collins, "Pointing, Hybrids, and Romanticism: John Baldessari," *Artforum*, Oct. 1973,: pp. 53–58.

177. In his earliest minimal sculptures, Shapiro had the body in mind. One piece weighed as much as he did.

178. Roberta Smith, *Joel Shapiro*, exhibition catalog (New York: Whitney Museum of American Art, 1982), pp. 20–22, 25.

179. Wade Saunders, "Talking Objects: Interviews with Ten Younger Sculptors," *Art in America*, Nov. 1985, pp. 110–11.

180. Phyllis Tuchman, "Bryan Hunt's Balancing Act," *Art News*, Oct. 1985, p. 68.

181. Ibid. The first figurative sculpture that Hunt made was an eight-foot-two-inch-high balsa wood and silk-paper replica of the Empire State Building with a dirigible moored to its top (1973). The idea came to him during a two-month illness.

182. Ibid., p. 71.

2 THE IMPACT OF 1968 ON EUROPEAN ART

Just as the United States was traumatized by political events in the late 1960s, so was Europe—by the student uprisings that occurred in 1968 in many of its major cities. And just as the Vietnam War was the catalyst for violent demonstrations in the United States so, too, it was in Europe. There was also widespread alienation—and at a time of unprecedented prosperity and cultural tolerance. As philosopher Jürgen Habermas observed, the student riots constituted "the first bourgeois revolt against the principles of a bourgeois society that is almost successfully functioning according to its own standards."[1]

During the academic year 1967–68, demonstrations and takeovers occurred in twenty-six of Italy's thirty-three universities; in March an estimated half a million students were on strike. On March 17 in London, some twenty-five thousand demonstrated against the Vietnam War at the American embassy. In May the French government was temporarily paralyzed by striking students, joined by millions of workers. The uprising reflected the rise of a counterculture, exemplified in the graffiti scrawled on Parisian walls. THE IMAGINATION TAKES POWER / TAKE YOUR DESIRES FOR REALITY / IT IS FORBIDDEN TO FORBID.

The chronicler of the rebellion, David Caute, asked:

> What were [the students]—courageous visionaries or romantic utopians? Genuine revolutionaries or posturing spoiled brats? An authentic resistance movement or a frivolous carnival by kids who had never known poverty and the fear of unemployment? An idealistic challenge to imperialism or a pantomime of rhetorical gestures? A rebirth of the critical intelligence or a long, drugged "trip" into fashionable incoherence?[2]

If a collective personality could be defined, it would probably encompass all these stances to some degree. But there was no denying that an entire generation was sorely wounded by the events of 1968—and that the wounds would fester. All those involved were gripped by an attitude criti-

cal of established values, an iconoclastic perspective that would continue to shape their outlook on life, society, and, above all, culture. But there was a positive side to this rebellion, as art critic Germano Celant remarked, an "explosive rejection of a philistine culture. . . . People spoke of a revolutionary imagination . . . and a universal renewal. . . . It opened up to multiplicity, no longer categorizing itself as painting or sculpture; it went into the streets. . . . It was a period of feverish experimentation, which liberalized the creative processes."[3]

The leading European artists who emerged at this time—Joseph Beuys in Germany; Mario Merz and Jannis Kounellis of the Arte Povera group in Italy; Marcel Broodthaers in Belgium; and Daniel Buren in France—were profoundly influenced by the student uprising of 1968. They were quickly hailed by the European art world as the equals of the American pop artists, minimalists, and postminimalists. European art, it was alleged, had come into its own.

However, widespread acceptance by art professionals in New York—most of whom persisted in believing that only what happened there was significant—was slow in coming. There were exceptions, for example, Lucy Lippard, who commented as early as 1969 that Europe "may be more fertile for new ideas and new ways of disseminating art than the United States."[4] On the whole, though, as Elizabeth Baker recalled, European art in the seventies was "invisible,"[5] despite occasional sightings, as in Jennifer Licht's *Eight Contemporary Artists* (1974)—five of whom were European—at New York City's Museum of Modern Art.[6]

In 1967 Joseph Beuys, a professor of sculpture at the prestigious Düsseldorf Academy of Art, founded the politically dissident German Student Party and in the following year aligned himself with the rioting students, who strongly influenced his attitudes to art and politics. Beuys, who remained committed to social change to the end of his life, founded (among other organizations) the Organization of Non-Voters/Free Referendum Information Point in 1970 and the Organization for Direct Democracy Through Referendum in 1971. He also waged war against hidebound art education.[7] Beuys summed up his countercultural stance in 1979: "Young people—the hippies in the '60s, the punks today—are struggling to find new ways of defining the culture they live in. They, not money, are the capital of society."[8]

More than any of his contemporaries, Beuys sought to confront the social situation of a physically and psychologically devastated Germany and, by extension, Europe. Facing up to German history and culture—the Nazi period and its antecedents—he said that he would assume the shamanistic role of exorcising past horrors, "indicating the traumas of a time and initiating a healing process."[9] He also believed that the imaginative powers of art could change life and bring about a personal and national rebirth. His ideas appealed to the European art world, because

they seemed peculiarly European and—equally important—because they were expressed in an advanced visual language. Beuys achieved widespread recognition in 1968 and, in the 1970s, became the most important and influential artist in Europe.

Beuys proposed his art as an alternative to contemporary American art—which to him meant pop art, exemplified by Warhol, and minimalism.[10] He overlooked the fact that many American postminimalists were also reacting against pop art and minimalism and were, like him, moving into performance and installation art. And they were as affected by the Vietnam War and America's social evils as he had been by the Nazi horror, the Holocaust, the student uprisings of 1968—and Vietnam. (But he convinced a significant number of European artists and art professionals that his misreading of American and European art was the correct interpretation, in large measure because they wanted to believe it.)

Beuys's artistic roots were in Dada-inspired fluxus, which had been at the center of the German avant-garde in the early 1960s.[11] Attracted by its use of performance to break down barriers between art and life, he joined the group. In February 1963 he hosted an international fluxus festival, *Festum Fluxorum Fluxus* at the Düsseldorf Academy.[12] On that occasion he performed the first of his "actions," as he called his theatrical pieces, titled *Siberian Symphony*. Fluxus artists, who generally favored simple, short, often outrageous and funny sound-producing events, found Beuys's performance too complex and metaphorical for their taste. But much as he diverged aesthetically from the fluxus group, he always maintained his identification with it—and its iconoclastic, antiestablishment image.

Beuys based his mature work on what he claimed was the most consequential event of his life: the alleged shooting down of his fighter plane in the snows of the Crimea during World War II and his miraculous rescue by nomadic Tatars. Claiming that they had resuscitated his frozen body by wrapping him in fat and felt, he later made fat and felt his trademark materials. He also introduced related images and objects: red crosses, medical tubing, ambulance sleds, and the like. The theme of the artist-hero, fallen out of the sky to his painful near death and subsequent resurrection, would be reenacted obsessively in Beuys's work.[13] He then layered this personal myth of wartime survival with references to nature; national consciousness; German history, culture, and mythology; the interaction between East and West; and messianic social prophecy. Finally he formulated a political program and became an activist.

To be effective Beuys had to attract the attention of the media. To this end he fashioned a memorable—a trademark—persona that featured a felt hat (atop his sallow, hollow-cheeked face), an apple green fisherman's vest, jeans, heavy shoes, fur-lined overcoat, and knapsack. In appearance, he was a kind of Teutonic counterpart of the palefaced and silvery-gray-bewigged Warhol.

Performance was central to Beuys's art. For his best-known "action," *How to Explain Pictures to a Dead Hare* (1965), he covered his head with honey and gold leaf and lectured a dead hare cradled in his arms. He said that he took it "to the pictures. . . . I let him touch the pictures with his paws and meanwhile talked to him about them."[14] Animals also appear in Beuys's later performances. In *Iphigenie/Titus Andronicus* (1969) a glowing white stallion pawed while Beuys clashed cymbals and an amplified voice intoned the words "death" and "die." His intention, as he said, was to tie man "from below with the animals, the plants, with nature, and in the same way tie him with the heights with the angels or spirits."[15]

Art-as-action was more important to Beuys than art-as-object. Though his works of art were generally not conceived as autonomous (most were the relics of performances or lectures), they nonetheless manifested a masterful sculptural sensibility. A number of the best-known were conceived as discrete objects. For example, in *Fat Chair* a wedge of fat sits on a chair like a person. Writers have likened the fat to the remains of the millions of people who were melted down in Nazi death camps. References to the Holocaust are also inescapable in *Auschwitz,* which consists of a two-burner hotplate with a chunk of fat on each. But fat was also interpreted as a symbol of life-giving warmth, doubly so because it was insulated by felt. Beuys commented that fat was meant to heat and dissolve the "frozen and rigid forms of the past [so that] future form becomes possible." Its malleability, its ready change from liquid to solid, was a metaphor for change, for the remolding of society.[16] The transitional nature of Beuys's materials, not only fat but the energy that flows through the recurring batteries, transmitters, receivers, insulators, and conductors in his work, also suggested alchemical processes [31].

Reacting against formalist criticism, which they identified as American, European critics and curators often read specific and elaborate symbolic meanings into Beuys's materials and images. But his work seemed to elicit such readings. For example, Troels Andersen reported that in *Eurasia,* 1966, the kneeling Beuys "slowly pushed two small crosses which were lying on the floor towards a blackboard; on each cross was a watch with an adjusted alarm. On the board he drew a cross which he then half erased; underneath he wrote 'Eurasia.'" Then Andersen commented: "The symbols are completely clear and they are all translatable. The division of the cross is the split between East and West, Rome and Byzantium. The half cross is the United Europe and Asia," and so on.[17]

Americans, too, focused on iconography. In writing about *I Like America and America Likes Me* (1974) [32], an "action" in which Beuys lived with a coyote, David Levi Strauss recounted how the coyote emigrated from Eurasia to America, carrying

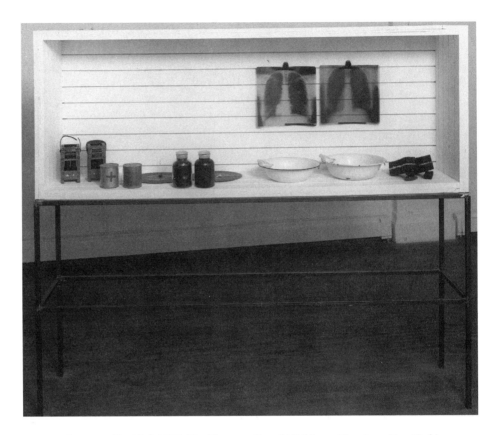

31. Joseph Beuys, *Untitled*, 1974–79. *(Courtesy Ronald Feldman Fine Arts, New York)*

paleo-Asiatic shamanistic knowledge with him, spreading it throughout the North American West and into Mesoamerica. [In the nineteenth century] the coyote became the prime scapegoat in the West. He symbolized the wild and untamed, an unacceptable threat to husbandry, domesticity, and law & order. . . . Like the American Indian, he was the Other in our midst, and we did everything we could to eliminate them both.

When Beuys arrived in the United States, he had himself transported from the airport to the gallery in an ambulance marked with red crosses. Strauss went on:

Wrapped in a felt cocoon inside the ambulance, Beuys recalled his own myth of origin. . . .

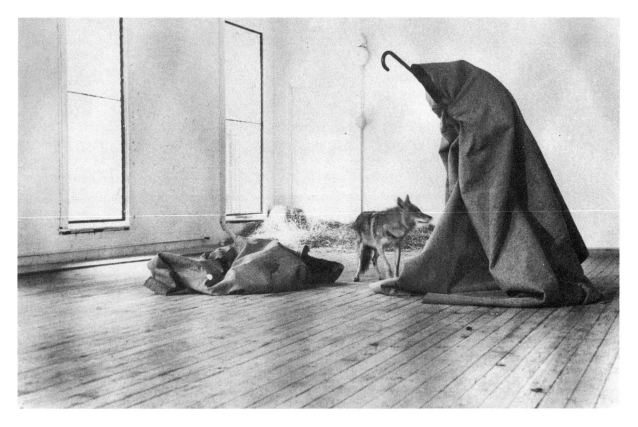

32. Joseph Beuys, *I Like America and America Likes Me,* 1974, performance at René Block Gallery, New York, May 23–25, 1974. (*Courtesy Ronald Feldman Fine Arts, New York; photograph by Caroline Tisdall*)

Upon arrival in the room with the coyote, Beuys began an orchestrated sequence of actions to be repeated over and over in the next three days. [To] begin the sequence [a] triangle that Beuys wears [as a] pendant around his neck . . . the alchemical sign for fire [is struck] three times. [Then] a recording of loud turbine engine noise is played outside the enclosure, signifying "indetermined energy." At this point, Beuys pulls on his gloves, reminiscent of the traditional bear-claw gloves worn by "masters of animals" shamans . . . and gets into his fur pelt/felt, wrapping it around himself so that he disappears into it with the flashlight. He then extends the crook of his staff out from the opening at the top of the felt wrap, as an energy conductor and receptor, antenna or lightning rod. . . .

Beuys . . . follows the movements of the coyote around the room, keeping the receptor/staff pointed in the coyote's direction at all times. . . .

> There is a pile of straw, another piece of felt, and stacks of each day's *Wall Street Journal* in the room. Beuys sleeps on the coyote's straw; the coyote sleeps on Beuys' felt. The copies of the *Wall Street Journal* arrive each day from outside (like the engine noise) and enter into the dialogue as evidence . . . of materialistic thinking.[18]

The American trauma, as Beuys summed it up, was "the Red Man." To cure it "a reckoning has to be made with the coyote, and only then can this trauma be lifted."[19]

Beuys thought of his art, even at its most autobiographical, as political. In his performances he assumed the role of shaman—that is, one who makes a private experience public for the purpose of healing society. In a sense he extended his thinking from his own body in action to the body politic; that is, he moved to sculpting society as his art. With this in mind, Beuys performed an "action" titled *The Silence of Marcel Duchamp Is Overrated* (1964), calling into question Duchamp's detachment from social affairs and his antiart stance.[20]

In 1971 Beuys rented a store in Düsseldorf, in which he invited his fellow citizens to participate in political discussions. From this time on his major activity, which he designated as his "art," became lecturing and talking to people. He often used a blackboard to demonstrate his theories, objects that were preserved as "drawings" and, when assembled, as "sculptures." When art critic Achille Bonito Oliva said to Beuys: "It seems to me that your work is the extending of a kind of 'Socratic space' in which the works are no more than a pretext for dialogue with the individual," Beuys responded: "This is the most important side of my work. The rest—objects, drawings, actions—all take second place. . . . Art interests me only in so far as it gives me the possibility of a dialogue with individuals."[21]

Beuys's message—or his "theory of social sculpture," as he termed it, was that society could be transformed only by art, but first the concept of art would have to be enlarged to include every kind of creativity. From this point of view, everybody was a potential artist.[22] When the people became aware of their creative power, they would join together to reform society, according to their desires.[23] The political process that Beuys advocated was direct democracy through plebiscite on the economy, education, ecology. Free and self-determining people would create communal organizations and rule by "direct action."

Beuys's libertarian antistatist and antibureaucratic politics were much the same as those of the protesting students in 1968. As David Caute wrote:

> The New Left rejected political and economic concentrations of power in favor of a decentralized society with power vested at the local level among producers, community associations, and student unions. . . . This may prove to be the most enduring legacy of the

New Left and the counterculture: the project of an "alternative" society composed of grassroots, "counter institutions" designed both to challenge the bureaucratic structures of official society and to endow common people with an awakening sense of their own capacity.[24]

Just as Beuys believed that humanity had to be regenerated, so he believed that the environment had to be renewed. Consequently he was a cofounder of the ecopolitical Green Party. In 1979 Beuys ran for a seat in the European Community Parliament; he received just 3.5 percent of the vote, but that did not seem to faze him. He said: "Getting elected is not all that matters. . . . Elections are also a time to educate."[25]

Beuys was a controversial figure to the end of his life in 1986.[26] His opponents claimed that his politics were simple-minded and self-serving. Why else did he confer on the artist the leading political role? Furthermore, no matter how fervently he proselytized for individual self-determination and public dialogue, he assumed the egotistical role of the "good" leader, the Christlike savior who transformed his suffering into his art and through it would bind a war-torn society's wounds.[27] In the wake of the Hitler period, his Führer-like stance was worrisome. A charismatic figure, he attracted a considerable number of disciples and acolytes, some of whom dressed in a kind of Beuysian uniform. Critics also viewed Beuys's self-mythification as his primary enterprise. They claimed that, like Warhol, his greatest work was his own dramatization. His pedagogical and political activities were all components of that self-aggrandizing performance.[28] Indeed, so was his life; anything that Beuys did was considered to be part of his art. The props of his "actions," life, and lectures were offered as relics, to be venerated by the faithful.

But Beuys was also esteemed by many artists and others who believed in a social art, and he influenced both performance and installation artists, and painters, such as his students Anselm Kiefer and Jörg Immendorff, as well as Sigmar Polke and Gerhard Richter, who studied at the school in which he taught. His influence was strongest in Europe, but it was also felt in the United States, trying to awake from the nightmare of Vietnam.[29]

In the wake of the 1968 uprisings Marcel Broodthaers undertook a critique of the context of art, focusing on the museum, the institution that most authoritatively establishes art in art history by accumulating and categorizing it. He believed that the museum, more than any other art-world agency, determined the livelihood of artists and the fate of their art and, consequently, was more significant than anything it housed. Indeed, by being put in a museum context, even nonart could be established as art, as in the case of Duchamp's readymades. With an eye to Duchamp, Broodthaers proposed to take the museum-as-frame-of-art and put it within the frame of *his* art, making the deconstruction of the

museum his subject and content—and he did so with a sly and devastating irony.

Broodthaers did not become an artist until 1964, after a long, nonlucrative career as a poet. He had been interested in the visual arts and had occasionally written art criticism. In 1962 he saw an exhibition of Piero Manzoni's work that included cans of the artist's excrement. What impressed Broodthaers was that the cans were for sale, suggesting that art whose idea it was to subvert the art market could be merchandised.[30] In 1963, he was "strongly impressed by the image that the American pop artists had to offer" in shows he saw at the Sonnabend Gallery in Paris.[31] He was also familiar with the French *nouveau réalisme* of Arman, Christo, and Yves Klein.

Broodthaers began to make art by sticking the fifty remaining copies of his most recent volume of poems into plaster, together with two plastic spheres. He exhibited this object and several others that incorporated readymades in a one-person show in Brussels just seven months later. He wrote in the announcement: "I, too, wondered if I couldn't sell something and succeed in life. For quite a while I had been good for nothing. I am forty years old. . . . The idea of inventing something insincere finally crossed my mind, and I set to work at once."[32]

Broodthaers soon began to use kitchen pots and household furniture, and foodstuffs, such as eggshells and Belgium's ubiquitous mussel shells. In 1965 he wrote: "I make Pop. . . . What dreams! What maneuvers! How have I succeeded? Easily, I have just followed the footprints left in the artistic sands by René Magritte and Marcel Duchamp and those new ones of George Segal, Roy Lichtenstein and Claes Oldenburg."[33]

In 1968 there were demonstrations, strikes, and sit-ins in Brussels, as there were in Amsterdam, Berlin, Nanterre, Milan, and Paris, names Broodthaers embossed on a plaque titled *Illimite* (1969). A critical question posed by the radical students was who would control cultural institutions. In Belgium the only major public venue devoted to contemporary art was the Palais des Beaux-Arts. After prolonged debate, artists occupied it. Four of the instigators, including Broodthaers, were chosen to negotiate with the authorities. However, Broodthaers was ambiguous about the protest and his role in it. He had helped to formulate the manifesto, which condemned "the commercialization of all forms of art considered as objects of consumption." But he had also begun to produce art in the first place in order to earn money.

 Broodthaers resigned from the committee and wrote a letter "To my friends," which declared: "A fundamental gesture has been made here that throws a vivid light on culture and on the ambitions of certain people who aspire to control it one way or another: what this means is that culture is an obedient material." He too confessed to a desire "to control the *meaning/direction* . . . of culture," but "I have no material demands to present except that I surfeit myself with cabbage soup." He concluded this sardonic letter with: "My friends, with you I cry for ANDY

WARHOL." And in a 1970 statement, he made it clear why he invoked the name of the exemplary business artist: "The aim of all art is commercial. My aim is equally commercial."[34] Later, as if to prove this statement, he acquired a gold ingot and stamped it with an eagle—his signature sign. He proposed to sell a number of such bars at double the market price of gold, the markup denoting their monetary value as art.

Broodthaers repeatedly called attention to the commodification of art. In 1975 he said: "I doubt, in fact, that it is possible to give a serious definition of Art, unless we examine the question in terms of . . . the transformation of Art into merchandise. This process is accelerated nowadays to the point where artistic and commercial values have become superimposed."[35] He would remain obsessed with the question of who and what defined art and ascribed aesthetic and monetary value to it—and to what end.

The desire to control culture, or at least the cultural context of his own work, and to deconstruct the art-world power structure led Broodthaers to use culture as his material and to invent his own "fictional" museum. In the fall of 1968 he opened his *Museum of Modern Art, Department of Eagles, Section of the Nineteenth Century* on the ground floor of his house. It consisted of empty packing cases for works of art, postcards of famous French paintings, slide projections, and—visible through a window—an empty moving van outside the house. The *Museum* opened, as museums do, with a press conference and a party of art-world dignitaries and friends, at which Broodthaers gave the inaugural speech. In what can be considered a "conceptual performance," he not only usurped the role of museum director and curator but that of press agent and caterer as well. For the next four years, Broodthaers's main activity was curating "museum" shows in which he mixed art objects and commonplace artifacts, calling into question the museum as a realm of transcendent and timeless high culture, spiritual values, and philosophical truths. His art, then, was a parody of artistic packaging.

In 1972 Broodthaers installed in Düsseldorf another "wing" of his *Museum of Modern Art, Department of Eagles*, this one the *Section of Figures (The Eagle from the Oligocene to the Present)*. It included three hundred images of eagles, culled from imperial kitsch, advertisements, comics, and the like, and borrowed from museums in Europe and abroad (including his own)—all of which were treated as equals. Many of the objects were displayed in vitrines like those found in museums of natural history and Beuys's works. Slides of additional representations were projected, and a two-volume catalog was issued. All the objects were carefully labeled and numbered but cataloged not by medium, style, or chronology, as was customary museum practice, but alphabetically, according to the city from which they were borrowed. Both in categorization and presentation, Broodthaers mimicked and spoofed museums' conventional method of classifying art objects, revealing it as arbitrary.[36] Each item bore a label that read "This is not a work of art!" providing a gloss on Magritte's *"Ceci n'est pas une pipe"* and reversing

Duchamp's readymades, withdrawing from—rather than adding to the work—an aesthetic dimension.

Broodthaers closed his *Museum of Modern Art* with two installations in *Documenta 5* (1972). In one, *Section of Modern Art*, he displayed photographs, documents, catalogs, empty frames, and plastic plaques. In the other, *Personal Mythologies*, he stenciled labels on the walls and windows of a room, painted a black square on the floor, printed "private property" on it in white (in three languages), and roped it off with stanchions and chains. This gesture, a satire on the identification of art with private property, also expropriated the artistic power of Harald Szeemann, the director of *Documenta*. Broodthaers's main aim was, as he wrote, "to carry out a subversion of the organizational scheme of [the] exhibition."[37] While the exhibition was in progress, he replaced *Section of Modern Art* with *Museum of Ancient Art, Twentieth Century Gallery*, changing the texts on both floor and walls. That was the final installation of the *Museum of Modern Art*. The reason he gave was that despite his resistance to art officialdom, *Documenta 5* had "established" his *Museum* and subverted its reason for being.

Later Broodthaers began to curate retrospectives of his own work, titled *Décors* [33]. He often repackaged and revised earlier works to show

33. Marcel Broodthaers, installation view, November 1984. *(Marian Goodman Gallery, New York)*

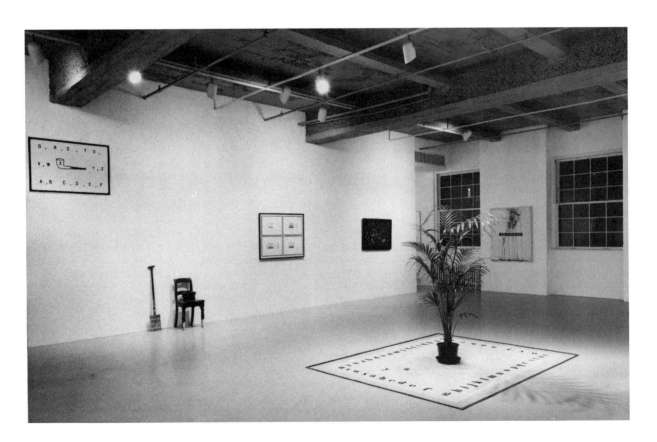

how different contexts altered their meanings. He also increasingly made paintings, but his imagery was frequently printed or stenciled lettering, recalling a comment he had made in 1968: "The language of forms must be reunited with that of words."[38]

Broodthaers's deconstruction of the definition and commodification of art, the role of the museum, and the social interests being served is only one aspect of his work. There are also multiple dimensions, often paradoxical and contradictory, more metaphysical than social—for example, the interfaces between nature and culture; between the verbal and the visual; and between language and reality.[39] A case in point is the complex role played by the simple mussel [34]. Representing the "national" food of Belgium, the shell is at once a metaphor for the museum as a shell of art and an expression of its emptiness, as he said.[40] The mussel (*la moule*) secretes its shell or mold (*le moule*), literally creating itself. Or, as Broodthaers, who dubbed himself "the King of Mussels," wrote in a poem "The Mussel": "This trickster has avoided the mold of society / by casting itself into its own proper mold. / Therefore it is perfect."[41]

The complexity of Broodthaers's work is exemplified in *Sculpture* (1974), a suitcase of bricks with the word "sculpture" painted on it.[42] But what is the sculpture? The contained? The container? The label? All of

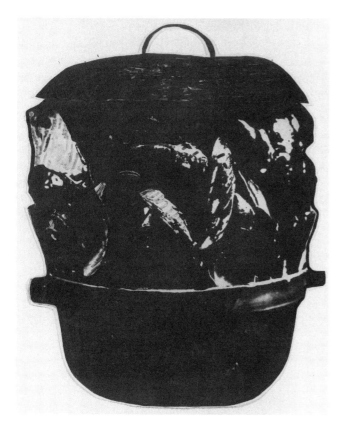

34. Marcel Broodthaers, *Moules Casserole*, 1968. *(Marian Goodman Gallery, New York)*

them? Is the suitcase—like the mussel shell or Duchamp's valise—a metaphor for the museum? What do the bricks represent—the "art," like that of Carl Andre, in the suitcase "museum" and/or their function in the world, as "the rubble of the old society or the raw material with which to build the future"? Moreover, what is their value in monetary terms or aesthetic terms?

Broodthaers and Beuys are often coupled because of their concern with the relations between art and society; their use of common objects and materials, some of them signature substances, such as fat and felt in Beuys's case and mussels, in Broodthaers's, and their theatricality. But there are critical differences. Beuys believed optimistically that art could transform all of life and society; he was utterly lacking in irony. Broodthaers was pessimistic, having no faith in the higher claims of art. Instead he held that art depended on conventions established by art institutions and the market, all of which he set out to deconstruct and undermine with subtle wit and humor.

France, too, had artists like Broodthaers, whose work exposed the alleged gallery-art-magazine-museum nexus. Foremost among them was Daniel Buren.[43] At the beginning of 1967 he collaborated with Olivier Mosset, Parmentier, and Niele Toroni in producing "signature" pictures during the opening of the Salon de la Jeune Peinture. Buren painted vertical stripes; Mosset, a small black circle centered on a white canvas; Parmentier, sprayed horizontal bands; Toroni, brushmarks spaced 30 centimeters apart. They also distributed a tract to the invited guests declaring: WE ARE NOT PAINTERS.[44] It is not surprising that Buren should have participated actively in the student uprising of 1968 or that his sympathies lay with a group on the extreme left, called situationists, who were among its leaders. Like them, he believed that it was not enough to question the forms of art, as the avant-garde traditionally had, because that would only be reformist, not revolutionary. The very "notion of the 'work of art'" had to be destroyed or it would be co-opted by the bourgeois enemy.[45] Buren also said:

> Concretely, the way things are today, the role of the artist is not of great consequence. . . . Consciously or not, he plays the game of the bourgeoisie which is his public, and reciprocally, the bourgeoisie accepts at first glance the product proposed by his artist-producer. It is even especially partial to any art called subversive (mental or political), not only to salve its conscience, but because it relishes the "revolution" when it is hung "on the line" in galleries or nicely disposed in its apartments. . . . The artist, if he wants to work for another society, must begin by fundamentally contesting art and assuming his total rupture with it.[46]

The radical politics of 1968 continued to inform Buren's work.

Buren's signature image consists of vertical stripes, each 8.7 centimeters wide, in white and another color, commercially printed on paper or cloth [35]. These "pictures" were pasted, often surreptitiously, on walls in a variety of environments. He used a stripe format because it constituted the most minimal configuration with which he could vary the size of a work without changing the design. The overall size of the works depended on the sites where they were placed. Having determined this format, Buren refrained from making any other formal decisions. As for color, that was "decided by what they offer me when I buy the cloth. I do not choose. [This] seems to suffice to demonstrate that I personally don't give a damn about . . . color. And the same goes for form. [Anyone] can make it and claim it."[47] What Buren did care about was theories about art, art history, and society. To make his intentions clear, he wrote lengthy texts. These statements, augmented by the exegeses of sympathetic art critics and theoreticians, constituted a web of neo-Marxist ideas that some art writers found more provocative than the work.[48]

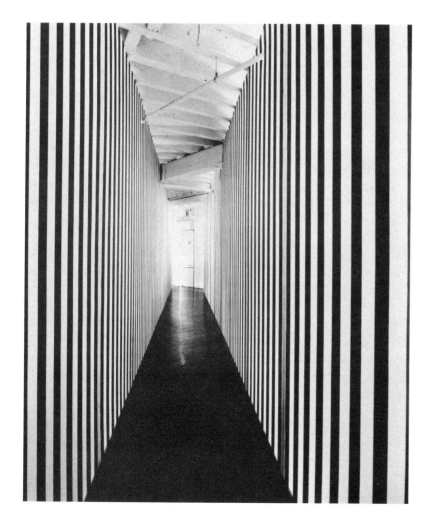

35. Daniel Buren, *Exit. (John Weber Gallery, New York)*

Elizabeth Baker wrote in an early review of Buren's works that in their neutrality, anonymity, and repetitiveness, they stood "against the uniqueness of the art object, against art as expression of personality, [and] against art as a source of exquisite sensations."[49] Nevertheless his striped images, visually uninteresting though they were, could be treated as abstract pictures, another variant of the stripe-painting of the 1960s, related to the canvases of Kenneth Noland and Gene Davis. But what counted for Buren was not his "pictures" in themselves but their interactions with the real world in which he placed them, whether it was the wall of an art gallery, an office building, or a tenement. "Content" would be produced by the relationship of the striped images to the site that "framed" them—and the site would change from work to work.

In sum Buren's intention was to investigate how art acquired meaning and how the context of art—both inside and outside the art world—altered its meaning and shaped the understanding both of art and the environment. When situated outside art-world venues, his work meant to deconstruct its surroundings, causing passersby to view them afresh; the situationists referred to this as *détournement*—that is, deflection. *Within and Beyond the Frame* (1973), a line of nineteen banners extending from inside a SoHo gallery through a window to a building on the other side of the street, lent itself to both an art-institutional critique and situationist practice.

It was vital to Buren to exhibit his pictures in museums, for in order to subvert the institution that most sanctifies art and enhances its monetary value, he had to confront the enemy on its own ground. Moreover, much as his works were conceptual, they had to be objects of sorts, because only with what looked like paintings could he effectively attack conventional painting—and demystify it. Within the hated art system, his pictures "posed" as paintings in order to pose the questions, as Douglas Crimp, one of Buren's champions, wrote: "What makes it possible to see a painting? What makes it possible to see a painting *as a painting?*" And how does a painting's presentation—in an institution, such as a museum or someplace else—affect its status? Buren's aim, as he said, was "nothing less than abolishing the code that until now made art what it is, in its production and in its institutions."[50]

In galleries and museums, Buren's pictures looked like art, and therefore could fulfill their purpose as an art-institutional critique. For art-world insiders, the work looked like art outdoors as well. But how did it look to the man or woman in the street? How were passersby who encountered a work by Buren on a neighborhood wall to determine what it meant or even *was*—that is, would it even be visible to them? Did that matter to Buren? Was his art, then, only for the art-world elite, and if so, how politically effective could it be? Moreover, Buren sold his work. He did insert clauses into the contracts preventing collectors from fully "possessing" the work, but was not the very act of selling a sellout?[51]

Buren claimed to be a political activist. Jeffrey Deitch wrote in 1976:

Buren might prefer to be thought of as a revolutionary Marxist, but his brilliance actually comes from a perfect understanding and manipulation of the capitalist art system. His achievement of over 100 one-man exhibitions since 1968—even while demanding fees, retaining total control of the work . . . is an extraordinary accomplishment, but it may say just as much for the ability of the institutions to absorb political criticism as it does for his ability to enforce his point of view.[52]

On whose behalf was Buren manipulating the culture industry? His own? The working class?

The art system had weapons of its own. It assimilated all manifestations of the avant-garde, thereby domesticating and emasculating them, as it had Duchamp's readymades. The problem remains: How does the artist avoid expropriation? Buren tried by making ephemeral installations. In 1986, however, when he received an offer from the French Ministry of Culture to redo the courtyard of the Palais-Royal, he accepted [36]. The Right made a big fuss, providing the Left with a reason to apologize for Buren's reversal of his earlier radical convictions.[53]

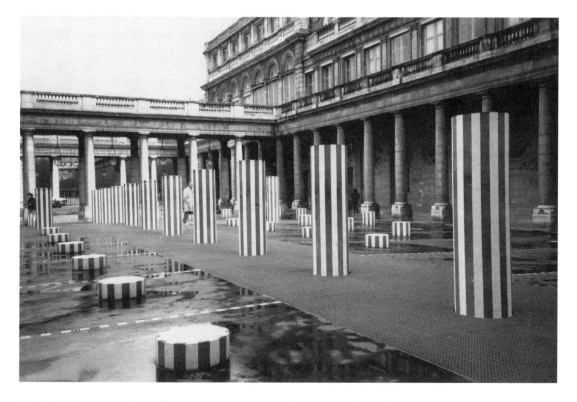

36. Daniel Buren, *Les Deux Plateaux*, permanent installation at the Palais-Royal, Paris, 1985–86. *(John Weber Gallery, New York)*

Rationalizations notwithstanding, he did embellish a monument of La Belle France. The rows of black-and-white, low marble-and-granite columns he installed are complicit with the existing colonnades of the Palais-Royal, stressing the continuity of French culture. The work does not function as situationist *détournement* but as decoration—high-style decoration, to be sure.

In Italy in 1967 a number of artists were grouped together and named by critic Germano Celant arte povera. They were Mario Merz and Jannis Kounellis, its leading artists, and Giovanni Anselmo, Alighiero Boetti, Pier Paolo Calzolari, Luciano Fabro, Marissa Merz, Giulio Paolini, Pino Pascali, Giuseppe Penone, Michelangelo Pistoletto, and Gilberto Zorio. Celant not only identified the artists and gave them a name but also formulated the premises of the group in exhibition catalogs, articles, and a 1969 book, which also included non-Italians, among them Beuys, Jan Dibbets, Hans Haacke, Eva Hesse, Richard Long, Robert Morris, Bruce Nauman, Richard Serra, and Robert Smithson.[54]

Arte povera was strongly influenced by the demonstrations in Italian universities, whose vital center was Turin, where many of the artists lived. They joined with the students, a number of whose leaders were situationists, in a radical critique of rationalism, technocracy, and social institutions and their hierarchies. The arte povera artists used nontraditional materials, often drawn from nature and everyday life—earth, ice, plants, stone—which they pieced together in environmental situations. Indeed, the group was named arte povera because of the "poor" materials its members used.

Arte povera's precursors were Alberto Burri, Lucio Fontana, Yves Klein, Piero Manzoni, Robert Rauschenberg, Emilio Vedova, and Jackson Pollock. In 1949 Fontana began to puncture his canvases, and in 1957 to slash them, in order to reveal the actual space behind them. Rather than represent space—that is, paint illusionary space—he opened the picture up physically—to the world, as it were. He also added pebbles, glass, and ceramic shards, and other unconventional objects to his canvases. Arte povera artists were impressed by the drama of Fontana's slashing gesture, at once simple, or "poor," and grand, and by his use of real materials. They were also influenced by Burri's and Rauschenberg's assemblages— the one composed of ordinary burlap, the other of junk materials.

Manzoni was admired by arte povera for his use of offbeat materials, such as rock-hard bread painted white, and his own breath, blood, and, most provocatively, excrement, which he sealed in metal cans, sold by their weight of gold—a gloss on art-as-commodity. Moreover, Manzoni incorporated "life" into his work, performing (Pollock-like) before cameras, and signing living bodies. In one work he invited viewers to mount a sculptural base with insoles attached, "magically" transforming them into living works of art. In another he stuck a pedestal into the earth and announced that it supported the entire world. Arte povera

was also influenced by Klein, who "painted" with fire and with living naked bodies of models smeared with pigment. Although arte povera rejected painting, it did make exceptions of Vedova's action paintings, which sprawled out into the room, and Pollock's poured configurations, which seemed to expand beyond the picture limits and, because of their large size, became environments. Kounellis spoke enthusiastically of the "epicness" of Pollock's space.[55]

The artists in Turin were also familiar with post-Pollock tendencies in American art. Beginning in 1963 new galleries, such as Gian Enzo Sperone's Galleria Il Punto, introduced Roy Lichtenstein, Robert Rauschenberg, James Rosenquist, and Andy Warhol. Celant wrote: "The triumph of these artists in Italy was due to the Venice Biennale of 1964, which awarded its first prize to Rauschenberg. [Articles] on Minimalism in *Artforum* and *Art News* helped to bring an international context to the Turin art world. [The] Turinese focus shifted from Paris to New York."[56]

Characterizing the aesthetics of arte povera, Mario Merz wrote that it employed

> commercial, technological and manufacturing materials to represent an artistic idea. . . . *Arte Povera* has done away with the frame as a support in order to give value to . . . the floor, . . . the field, or . . . the wall made of bricks, stones or concrete. *Arte Povera* . . . has liberated art from fixed programs. [Objects] very remote from being art . . . gather together in the new art.[57]

Like Merz the Dutch artist Jan Dibbets, who was identified with the Italians, wrote:

> I search consciously for a form of art which is not tied by tradition and in which [a work] is less important than the research. There are so many different situations in which to look at something, that standing right before the painting or walking around a sculpture could well be the most simple kind.
>
> You can fly over something, you can walk along something, drive (by car or train) sail etc. You can "disorientate" the spectator in space, integrate him, you can make him smaller and bigger, you can force upon him space and again deprive him of it. . . .
>
> I'm more involved with the process than the finished work of art. . . . I'm not really interested any longer to make an object.[58]

Summing up Celant's ideas, art critic Carolyn Christov-Bakargiev wrote that arte povera stood for an art free

> from an alienating rationalistic system. . . . a "poor" art as opposed to a complex one, . . . an art that does not add ideas or things to the world but that discovers what's already there; an art interested in the

present, in contingencies and events as a convergence of art and life, [an art] of authenticity and unalienated labor where man is identified with nature, [with] trivial, simple materials which are also natural, such as charcoal, cotton or a live parrot.[59]

Above all arte povera sought to narrow the gap between art and nature. It would be regenerative because its aspiration was "the expansion of creative energy. This energy could be found anywhere—in color and in cactus, in marble and in neon, in leather and in a little nylon shoe." The upshot would be "the aestheticization of reality."[60]

The arte povera artists thought of their work in political terms. For them the elevation of humble materials was a metaphor for the elevation of underprivileged social classes. The artists also related their rejection of oil paint, marble, and bronze—exemplifying an elitist and "repressive" hierarchy of materials—to their rejection of all social stratification and exploitation. Painting was the primary butt because, as Kounellis asserted, it "was associated with a politically oppressive past [and served] the interests of the political status quo."[61] Arte povera not only spurned "high" art materials but the commercial venues that displayed "petrified" art objects marketed to the rich, and the museums that hoarded them. Just as arte povera artists stood against art-as-object and the art system, so they stood against "signature" style, which readily became a commercially viable trademark, although most did develop recognizable styles.

Much as arte povera artists looked to New York, they were, as Celant wrote, "conscious of possessing an inalienable European identity that was irreconcilable with any other."[62] What made European art, culture, and society different was its devastated state. With this in mind the arte povera artists conceived of themselves as alienated, rootless, aesthetic "nomads," who wandered among the fragments of European civilization, using whatever would sustain them. But, Celant went on to say, the shreds had to be "reunited and reassembled [as in] the 'cultural ruins' of Joseph Beuys and Jannis Kounellis, Mario Merz and Anselm Kiefer. Their works perform a therapeutic activity [to exorcise a dark and dismal] past . . . with its wicked and accursed contamination."[63]

Although the arte povera artists were politically radical, their work was rarely exhibited where the poor lived, appearing more often than not in sumptuous palaces and handsome galleries.[64] The materials they favored, though associated more with "life" than with "art," did not look particularly "poor." Moreover, they handled these materials with an elegance that made them look anything but impoverished, an elegance so closely identified with Italian art and design that it is often considered innately Italian. The artists also looked to the omnipresent history of Italian art; for example, Kounellis and Paolini appropriated plaster casts of classical statues in works that seemed as tradition minded as they did avant-garde. Perhaps this, too, was an Italian trait, as Celant suggested;

he concluded his introduction to the massive catalog of *Italian Art in the 20th Century: Painting and Sculpture 1900–1988* at the Royal Academy in London with the observation that the "capacity to 'register' the intersection of the past and the present, of tradition and experiment . . . is unique to the nomadic path of Italian art."[65]

Celant maintained that what distinguished Arte Povera was the union of, as art critic Caroline Tisdall paraphrased it, "culture and nature [in which] the sense of nature [was] an integral part of culture."[66] This was embodied most fully in the installations of Merz. He had begun as a traditional painter, but in 1967, he started to project his canvases into actual space and pierce them with shafts of neon light.[67] He soon introduced common objects—a bottle, a worn raincoat, an umbrella, a chamber pot—integrating them with the neons. Light as a visible force flows through all the material components, no matter how diverse, and unifies—or as Merz viewed it, transforms—them as if alchemically.[68] In 1968 he formed the neons into words, quoting political slogans and catchphrases that Parisian students had written on walls during the student rebellion, such as OBJET CACHE-TOI (object conceal yourself)—an obvious reference to his ambivalence about art-as-object.[69]

Merz's signature image was the igloo, which he constructed from metal pipes and rods and placed directly on the floor or ground in order to create a self-contained space independent of the wall [37]. This work combined references to architecture and art, nature, mathematics, language, and politics. The igloo was a human fabrication in nature.[70] Composed of perishable ice, it was temporary, but it also called to mind permanent and eternal-seeming domes, such as those of the Pantheon and Saint Peter's. As a hemisphere it was a basic geometric form, but Merz also wanted it to be "nongeometrical," so he covered it with chunks of dirt, clay, or wax or with glass shards or twigs. He also attached texts in neon, the first of which quoted the North Vietnamese general Vo Nguyen Giap: "If the enemy masses his forces, he loses ground; if he scatters, he loses strength."[71]

To emphasize transience and temporality, Merz used impermanent, fragile materials found in the various places he made his igloos, because he believed that like the materials and the igloo, art was to be "transitory and ever-changing, yet inexorably bound to the earth, specifically its local environment." The artist, too, like the igloo dweller, was to be a nomad, "constantly in motion, at home everywhere, in touch with both nature and culture."[72] It is significant that Merz had been influenced by the situationists' conception of "drift"—that is, the random movement through one's surroundings in search of "psychogeographical" experience that could be used to construct a new, more livable environment.[73]

In 1972 Merz introduced the Fibonacci number system into his work. Formulated by an Italian monk in the thirteenth century, it is a mathematical sequence that advances by summing up the last two numbers of the

37. Mario Merz, *La casa del giardiniere*, 1983–84. *(Sperone Westwater, New York)*

progression (1-1-2-3-5-8-13 . . .). Both natural and seemingly magical, the Fibonacci formula governs the growth of organic phenomena, such as leaves, lizard scales, pinecones, iguana tails, or snail shells. Merz "wrote" the Fibonacci numbers in neon tubes and attached them to manufactured artifacts, such as the walls of the Guggenheim Museum's spiral ramp. Having investigated housing as one of humankind's basic needs, Merz then turned to life-nourishing food. He piled fruits and vegetables on tables, the mounds often spiral in shape as if unfolding according to the Fibonacci formula. The produce—things with "a smell . . . anguishing and extremely sensual"[74]—also evoked decay and death.

Around 1977 Merz resumed painting, perhaps in response to a general revival in Italian painting, inaugurated by artists who would be labeled the transavantguardia. He painted brushy, high-keyed pictures portraying fantastic or mythic beasts based on lizards, crocodiles, rhinoceroses, buffaloes, and the like [38]. They call to mind primordial times, memories of which, he said, "every man has inside himself."[75]

Like Merz, Jannis Kounellis dealt with the relation of modern human beings to history, society, culture, and nature. Underlying his art was the belief that modern life had lost its meaning and wholeness.

World War II was largely to blame. It had reduced Western civilization to fragments. Kounellis would negotiate the ruins to determine what could be resurrected. He would also suggest tentatively a new humanistic "measure" or "synthesis" on which society might be rebuilt in the face of the dehumanizing distractions of consumerism.[76]

In the installations he began to make in 1967, Kounellis, with an eye to Beuys, incorporated actual artificial and natural "fragments": readymades such as iron bins, burning lamp wicks, and bed frames; natural substances such as wood, burlap, wool, wax, lead, gold, and coal; and living plants, birds, and horses.[77] These works were influenced by the political turmoil of the late 1960s. Kounellis sympathized with the striking students, chalking the names of Marat and Robespierre and the words *"Liberta o morte"* (liberty or death) on a 1969 work. He introduced live birds and animals in order to bring real life into his installations. A 1967 piece consisted of a parrot perched in front of a painted canvas, the

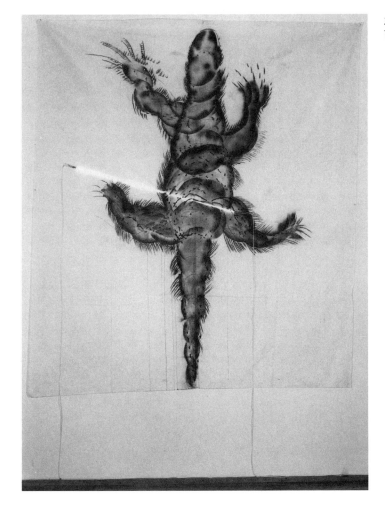

38. Mario Merz, *Lizard,* 1978. *(Sperone Westwater, New York)*

brilliant colors of the feathers eclipsing the artist's pigments, suggesting that life "paints" more vividly than art. In 1969 Kounellis included twelve horses in an installation in a Roman gallery. This and his subsequent work gave rise to elaborate historical, art-historical, sociological, and mythological interpretations, just as Beuys's performances had. For example, Alan Jones wrote:

> Bridled, and hitched facing the walls as if in a stable, the horses had only to stand in place to confirm their stature as an attribute of Europe personified. . . . "The last mythological animal," Basil Bunting called the horse; mindful of the heritage accumulated over great distances of time, and of the urgent need for freedom in the present moment.[78]

Donald Kuspit took another tack, suggesting that Kounellis was mocking art by "treating the exhibition space as if it were a stable," which "brings to mind one of Caligula's most insulting acts: making a horse a member of the Roman Senate."[79] Other critics and curators related Kounellis's horses to classical equestrian statues and the horses in Beuys's "actions."

Kounellis often used propane gas to include fire in his pieces, a comment on "traditional connotations of ritual purification, its cleansing properties" [39].[80] Art writers likened his flames to the sun, holy fire, the alchemist's flame, the spark of life, social transformation, a destructive power, and so on. When fire was combined with other substances or materials, the interpretations became even more complex. As Thomas McEvilley wrote about a number of bed frames to which lighted torches were attached, exhibited in 1969, a "single-bed frame [is] made to the size and proportion of the human frame: metaphorically it is . . . the place where a person is begotten, born, begats, and dies." The metal frame suggests an absent but implied and awaited human figure. "The bed was the measure of the human, but it was subjected to the fire of change. It is the measure itself that is being burnt into change, forced by fire into transformation." Of another work, consisting of two bed frames on one of which were piles of raw cotton and on the other forty small fires, McEvilley wrote: "The two beds balance birth (the cotton bed with its soft invitingness) and death (the fire bed like a torture rack) as two measures of the human, or as pointing to the remaking of the measure, which must be burned up to be reborn again."[81]

As a metaphor for death, fire was also a metaphor for the demise of the utopian hopes of 1968.[82] Smoke smudges—dead fire—represented the ashes of life—*vanitas*. The most grisly image of death by fire was the Holocaust, in art critic Jamey Gambrell's view, the source of many of Kounellis's images:

> What is the 1970 "brick smokestack with smoke on wall and ceiling" (to borrow the detached language of the catalogue caption), if not the

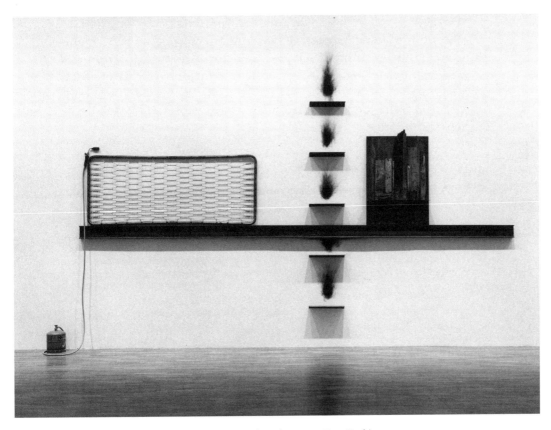

39. Jannis Kounellis, *Untitled*, 1983. *(Museum of Modern Art, New York)*

image of the crematoriums where millions died? What are the bed frames with gas jets, windows covered with lead, doors and passages blocked, if not at least afterimages that the torture, gas chambers and prison cells of our century have left upon the human imagination?[83]

In the 1970s Kounellis produced a nonnarrative theater of tableaux vivants, performances, and installations. He continued to use the kind of components found in his earlier works but added fragments from antiquity, such as classical busts, and modern artifacts, among them toy trains and articles of clothing. For example, in a performance at the Sonnabend Gallery in 1974, he placed a lamp on bright yellow walls, brought in a live horse (which he mounted), and held a mask of Apollo over his face, evoking wide-ranging references not only to images of horses but to Greek gods, the power of the sun, and electric light.[84] In the 1980s Kounellis concentrated on constructing steel reliefs of shelves on which detritus was stored and stacked, again evoking the melancholy fragmentation of modern life—and his continuing effort to achieve a humanistic synthesis.

Unlike the reaction against postminimal art—exemplified by the sculpture of Joel Shapiro, Nancy Graves, and Bryan Hunt—which occurred in the United States in the early 1970s, a reaction against the work of Beuys, Broodthaers, Buren, and arte povera artists did not command art-world attention in Europe until the very end of the decade—with the emergence of the Italian transavantguardia and the German neoexpressionists.

NOTES

1. Caute, *The Year of the Barricades,* p. 34.
2. Ibid., pp. xi, 221.
3. Germano Celant, "The Organic Flow of Art," in *Mario Merz* (New York: Solomon R. Guggenheim Museum, 1989), p. 24.
4. Lippard, *Six Years,* p. 8.
5. Elizabeth C. Baker, "Editorial: The 'Return' of European Art," *Art in America,* Sept. 1982, p. 5.
6. *Eight Contemporary Artists,* (New York: Museum of Modern Art, 1974). Among the artists included were Daniel Buren and Jan Dibbets.
7. In 1972 Beuys became a center of political controversy when as a popular professor at the Academy in Düsseldorf he insisted on admitting anyone who wanted to attend his classes whether he or she was enrolled or not. Fritz Neugass, in "Düsseldorf Artists and Students Rally to Beuys," *Art News,* Feb. 1973, wrote that about

 125 new students applied for his courses, in which 268 were already enrolled. These new applicants were turned down by the administration. Beuys refused to submit, arguing that a limitation of admissions was contrary to the basic law of the German Federal Republic, which guarantees freedom of choice in education. He led a group of 54 students to a sit-in in the Academy's administrative office, demanding admission for the applicants. He was accused of trespassing and of disrupting the enrollment of other students.

 Thereupon, as a disciplinary action, Johannes Rau, Minister of Science and Education of North Rhine–Westphalia, dismissed Beuys and barred him from teaching. Beuys refused to accept his dismissal, pending legal action. In the meantime he is continuing his classes—without salary—since he was not prevented from entering the Academy.

 The incident spurred student organizations to arrange protest meetings and marches through the city. . . . A banner atop the Academy proclaimed: 'Rau out—Beuys stays.' . . . Letters and telegrams bearing the signatures of notables crowded Rau's desk, calling for the reinstatement of Beuys. (p. 77)

 This led Beuys in 1973 to form the Free International University for Creativity and Interdisciplinary Research.
8. Gerald Marzorati, "Beuys Will Be Beuys," *SoHo Weekly News,* Nov. 1, 1979, p. 9.
9. Levin, *Beyond Modernism,* p. 175.
10. Beuys considered Warhol his antithesis but nonetheless a radical artist to be taken seriously because his work was mass-produced and therefore antielitist. Simon Frith and Howard Horne, in *Art into Pop* (London: Methuen, 1987), commented: "Like Warhol, Beuys appeared to obliterate the usual distinctions between life and work, between high and low culture. . . . He too rejected the argument that there could be some transcendent 'high' art, independent of everyday social relations" (p. 120). For Warhol this meant that art was business; for Beuys, that it was creative politics.
11. Beuys was also influenced by the avant-gardist Zero artists in Düsseldorf, among them Otto Piene and Günther Uecker, who joined together in the late fifties. Influenced by Yves Klein and Jean Tinguely, they aimed to break with tradition and create a new art through an extreme simplification of art—to point zero, as it were. They preferred to use basic elements—light, air, water, wind, earth, sand, fire, and smoke. For example, Piene worked with fire and smoke and Uecker hammered nails into boards. See Jan Avgikos, "Point Zero: German Art in the 1950s," *Arts Magazine,* Mar. 1990, p. 59.
12. Beuys's attitude was more political than those of fluxus artists on the whole. Marzorati, in "Beuys Will Be Beuys," wrote that in 1964, Beuys "marked the 20th anniversary of an attempt on Hitler's life by recommending the Berlin Wall be raised five centimeters [for aesthetic reasons]. For his free advice he received one bloody smash in the nose at the hands of a right-wing student" (p. 9).
13. See Levin, *Beyond Modernism,* chapter 3.
14. Ursula Meyer, "How to Explain Pictures to a Dead Hare," *Art News,* Jan. 1970, p. 57.

15. Joseph Beuys, quoted in Filiberto Menna, "Encounter with Beuys," Nov. 1971, handout, Ronald Feldman Gallery, New York, 1971, p. 7.

16. Carter Ratcliff, "People Are Talking About Joseph Beuys," *Vogue,* Mar. 1980, p. 363.

17. Lippard, *Six Years,* p. 18.

18. David Levi Strauss, "*American Beuys:* 'I Like America & America Likes Me,'" *Parkett 26* (1990): 126–28.

19. Ratcliff, "People Are Talking About Joseph Beuys," p. 363.

20. See Caroline Tisdall, *Joseph Beuys* (New York: Solomon R. Guggenheim Museum, 1979), p. 92. Beuys's belief in the power of art to transform life was in a long tradition. Jill Lloyd, in "German Sculpture Since Beuys: Disrupting Consumerist Culture," *Art International,* Spring 1989, wrote that it "harked back to the idealistic aspirations of the early twentieth-century avant-garde, whose last great representative he became" (p. 8). Robert Morris, in "Three Folds in the Fabric," rooted Beuys in "Surrealism's program to liberate man from the bourgeois idea of an autonomous art [formalism] [and] embed art once again in the web of life." This led to the "effort to turn art-making impulses away from the production of estheticized, abstract and autonomous objects" (p. 148).

21. Achille Bonito Oliva, "A Score by Joseph Beuys: We Are the Revolution," interview, Oct. 12, 1971, handout, Ronald Feldman Gallery, New York, 1971, p. 4.

22. Jonathan Price, "Listening to Joseph Beuys: A Parable of Dialogue," *Art News,* Summer 1974, pp. 50–52.

23. Scott Watson, in "The Wound and the Instrument: Joseph Beuys," *Vanguard,* Summer 1988, wrote:

 Beuys . . . lectured on the vast reservoirs of "creativity" which lay latent and unrealized in all people. This creativity was to be the new "capital" for a new economy of the social organism. The political project was thoroughly aestheticized, imagining a "social sculpture" which would consist of "the active mobilization of every individual's latent creativity." His social theories, which called for a new spirituality as the answer to post-war Germany's division into materialist capitalism and totalitarian socialism, owe a great deal to the writings of Rudolph Steiner, who Beuys first read at the end of the war. (p. 20)

24. Caute, *The Year of the Barricades,* pp. 34, 39. See also Walter Grasskamp, "'Give Up Painting' or the Politics of Art: A West German Abstract," in *Breakthroughs: Avant-Garde Artists in Europe and America, 1950–1990* (New York: Rizzoli, 1991), p. 136. A number of Beuys's political actions (or, rather, nonactions) were questionable. For example, in 1971 he refused to sign an international letter of protest when Hans Haacke's exhibition at the Guggenheim was shut down and curator Edward Fry resigned.

25. Marzorati, "Beuys Will Be Beuys," p. 9.

26. Kim Levin, in *Beyond Modernism,* found much in Beuys's art that seemed complicit with, rather than critical of, Nazism.

 His references to Celtic and Nordic mythology recall the idea of Aryan ancestors; his use of Tibetan symbolism relates to the belief that the original Aryans came from Tibet. . . . His *Siberian Symphony* and *Eurasian Staff,* performance pieces referring to the continuous landmass of Europe and Asia, relate to Nazi desires for expansion to the East. . . . The divided crosses and modified crucifixes that he makes carry memories of the hooked cross that was the swastika. (pp. 177–79)

 After listing other "curious connections," Levin concluded:

 Buried somewhere in the depths of Beuys's self-created image are echoes of those Nazi beliefs that the way was being prepared for a higher being, a superior species—a godlike superman. [He] echoes the idea of the *Volk*—the "folk," the essence of the German people—a romanticized concept of the healthy peasant and the native soil that was popular in the 1920s and '30s. Hitler promised Volkswagens to the people, Beuys [exhibits] a Volkswagen bus [and extends] the basic idea of German nationalism to all humankind. (p. 180)

27. See Levin, *Beyond Modernism,* chap. 3.

28. Lois E. Nesbitt, "(Self-) Representation," *Arts Magazine,* Summer 1990, p. 64.

29. Ratcliff, "People Are Talking About Joseph Beuys," p. 364.

30. Michael Compton, "In Praise of the Subject," in *Marcel Broodthaers* (Minneapolis: Walker Art Center, 1989), p. 21.

31. Ludo Bekkers, "Marcel Broodthaers," interview, *Museums Journal* (Amsterdam) 15, no. 4: 66, quoted in Benjamin H. D. Buchloh, "Marcel Broodthaers: Allegories of the Avant-Garde," *Artforum,* May 1980, p. 54.

32. Compton, "In Praise of the Subject," p. 25.

33. Ibid., p. 32.

34. Ibid., pp. 42, 49.

35. Marcel Broodthaers, "Über die Kunst—Im Sinne einer Antwort an Jürgen Harten," *Magazine Kunst* 15, no. 2 (1975): 73–74, quoted in Stefan Germer, "Haacke, Broodthaers, Beuys," *October 45* (Summer 1988): 75.

36. Nesbitt, "(Self-) Representation," p. 65.

37. Marcel Broodthaers, in *Marcel Broodthaers* (New York: Rizzoli, 1989), p. 193.

38. Compton, "In Praise of the Subject," p. 40.

39. See Thomas McEvilley, "Another Alphabet: The Art

of Marcel Broodthaers," *Artforum*, Nov. 1989, p. 109.

40. See Marcel Broodthaers, "Marcel Broodthaers par Marcel Broodthaers," *Journal des Beaux Arts* (Brussels) 1068 (1965): 5.

41. Buchloh, "Marcel Broodthaers: Allegories of the Avant-Garde," p. 55.

42. My analysis of Broodthaers's *Sculpture* is based on McEvilley's interpretation in "Another Alphabet," p. 112.

43. Daniel Buren, in *Five Texts*, trans. Charles Harrison and Peter Townsend (New York: John Weber Gallery, 1973), n.p., commented: "The museum is the inescapable *support* on which the history of art is painted." Patricia Bickers, in "'Cabined, Cribbed, Confined . . .' Daniel Buren's *Cabanes Éclatées*," *Art Monthly*, Mar. 1986, concluded that "Therefore, the museum itself must be the 'subject,' the target of art" (p. 14).

44. Lippard, *Six Years*, p. 24. The BMPT (for Buren, Mosset, Parmentier, and Toroni), group disbanded in 1968.

45. André Parinaud, "Interview with Daniel Buren," *Galérie des Art* 50, Feb. 1968, translated by Lippard, in *Six Years*, p. 42.

46. Daniel Buren, "Is Teaching Art Necessary? (June 1968)," *Galérie des Arts*, Sept. 1968, quoted in Lippard, *Six Years*, pp. 51, 53.

47. Parinaud, "Interview with Daniel Buren," p. 41.

48. See Roberta Smith, "On Daniel Buren," *Artforum*, Sept. 1973, p. 67, and Bickers, "'Cabined, Cribbed, Confined,'" pp. 13–14.

49. Elizabeth C. Baker, "Critics' Choice: Daniel Buren," *Art News*, Mar. 1971, p. 25.

50. Douglas Crimp, "The End of Painting," *October 16* (Fall 1981): 72, 85. (Italics in the original.)

51. See Jeffrey Deitch, "Daniel Buren: Painting Degree Zero," *Arts Magazine*, Oct. 1976, p. 90, and Bickers, "'Cabined, Cribbed, Confined,'" pp. 14–16.

52. Deitch, "Daniel Buren," p. 91.

53. Dore Ashton in "Paris Publicized and Privatized: Daniel Buren in the Palais-Royal," *Arts Magazine*, Sept. 1986, remarked:

Buren boasted in his extreme youth that he and his cohorts were the only moral artists [all of the others were capitalist stooges] because [they] were good, sound materialists who were ready to declare, as Buren once did . . . that "the only thing that one can do after having seen a canvas like ours is total revolution."

Ashton went on to say in apology:

It is apparent that given the magnitude of his commission—both physical and moral—Buren got beyond his juvenilia. This task sobered him. Contrary to what his critics charge, Buren took a firm position of respect for a previous monument [to la Belle France]. . . . Seen in the light of Buren's respect, and of his awareness of the

continuity of history, the addition to Paris was salutary. (p. 20)

54. Germano Celant, *Arte Povera* (Milan: Gabriele Mazzotta Editore, 1969). Celant also included in his book Walter de Maria, Michael Heizer, Douglas Huebler, Lawrence Weiner, Robert Barry, Dennis Oppenheim, and Carl Andre.

55. Thomas McEvilley, "Mute Prophecies: The Art of Jannis Kounellis," *Jannis Kounellis* (Chicago: Museum of Contemporary Art, 1986), pp. 18–20, 24–25.

56. Celant, "The Organic Flow of Art," p. 21.

57. Mario Merz, in Celant, *Mario Merz*, p. 164.

58. Jan Dibbets, in Celant, *Arte Povera*, p. 103.

59. Carolyn Christov-Bakargiev, "Arte Povera 1967–1987," *Flash Art* (Nov.–Dec. 1987): 53.

60. Germano Celant, *The Knot: Arte Povera at P.S. 1* (New York: P.S. 1, 1985), p. 31.

61. Jamey Gambrell, "Industrial Elegies," *Art in America*, Feb. 1988, p. 119.

62. Celant, "The Organic Flow of Art," p. 21. With an eye to American art, arte povera rejected "mass-media icons [and the] images of industrial, reductive and Minimalist perfection."

63. Germano Celant, "EuroAmerica: From Minimal Art to Arte Povera," in John Howell, ed., *Breakthroughs: Avant-Garde Artists in Europe and America, 1950–1990* (New York: Rizzoli, 1991), p. 120.

64. Caroline Tisdall, "'Materia': The Context of Arte Povera," in Norman Rosenthal and Germano Celant, *Italian Art in the 20th Century: Painting and Sculpture 1900–1988* (London: Royal Academy of Arts, 1989), p. 367.

65. Germano Celant, "Art from Italy," in Rosenthal and Celant, *Italian Art in the Twentieth Century*, p. 20.

66. Tisdall, "'Materia': The Context of Arte Povera," p. 368.

67. Germano Celant, "Interview with Mario Merz, Genoa, 1971," in *Mario Merz*, p. 104. Merz said: "The neon light pierced the canvas, emerging from it and then reentering it, coming out again, crossing the empty space between the two paintings, entering the second one—and my idea was that this could continue."

68. Celant, "The Organic Flow of Life," p. 22.

69. Older than most of his fellow artists, Merz had been jailed for his antifascist activities during World War II, and he continued to be active in leftist causes.

70. Merz was also attracted to the hemisphere because "man has an intuitive consciousness of the sphere—a piece of fruit, a ball. It is an age-old intuitive form," as he said in Germano Celant, "Interview with Mario Merz, Bordeaux, 1987," in *Mario Merz*, p. 180.

71. See *Mario Merz*, p. 77; Celant, "Interview with Mario Merz, Genoa, 1971," p. 104.

72. Nancy Spector, "Biography," in *Mario Merz*, p. 282.

73. Celant, "The Organic Flow of Art," p. 18.

74. Celant, "Interview with Mario Merz, Turin, 1983," in *Mario Merz*, p. 52.

75. Celant, "The Organic Flow of Art," p. 35.

76. Dan Cameron, "A Culture Divided: Notes on the Jannis Kounellis Retrospective," *Arts Magazine,* Dec. 1986, p. 65.

77. There were precedents for the use of such materials, and Kounellis seemed to have quoted several deliberately. Gambrell, in "Industrial Elegies," wrote that the "burlap and canvas recall Burri and Fontana; wool, Manzoni; the black painted square that crops up repeatedly stands in for Malevich; wax inevitably reminds us of Beuys" (p. 120); and fire, of Klein. And the juxtapositions of diverse materials call to mind the "combines" of Rauschenberg.

Kounellis had made paintings early in his career, some of which anticipated his installations. In 1960 he exhibited pictures whose images consisted of stenciled letters and numbers, including commonplace words found on store signs—*tabac* and *olio.* An actual street sign was incorporated into one painting. He also draped another canvas around himself and staged a performance in his studio. Kounellis abandoned painting in 1965 and did not resume making art until two years later. By then he had rejected painting, since it was identified with the old "synthesis."

78. Alan Jones, "Carte Blanche: Kounellis Unbound," *Arts Magazine,* Feb. 1990, p. 21.

79. Donald Kuspit, "Alive in the Alchemical Emptiness: Jannis Kounellis' Art," *C Magazine* 17 (Mar. 1988): 45.

80. Gambrell, "Industrial Elegies," p. 127.

81. McEvilley, "Mute Prophecies," p. 70. It is noteworthy that in one bed piece of 1970, Kounellis introduced a live woman covered by a blanket; only one foot protruded, to which was attached a lighted blowtorch.

82. See McEvilley, "Mute Prophecies," pp. 62, 70.

83. Gambrell, "Industrial Elegies," pp. 127–28. There are also evocations of the Holocaust in a number of works dating from 1969 to 1986, in which Kounellis blocked doors with stones, images of imprisonment and entombment.

84. Alan Jones, "Carte Blanche: Kounellis Unbound," p. 22.

3 FIRST-GENERATION FEMINISM

The malaise that gripped the avant-garde in the late 1960s was dispelled for one group of artists, who embraced a new, positive cause, namely feminism. Feminism surfaced in the art world around 1969, when women artists formed consciousness-raising groups in which, as Faith Wilding remarked, "each woman shares and bears witness to her own experience in a non-judgmental atmosphere." Consciousness-raising was also considered "a political tool because it teaches women the commonality of their oppression and leads them to analyze its causes and effects."[1] Women artists had been active in the Art Workers Coalition and other dissident organizations whose leadership was male—and macho—and had come to resent their relegation to "gofer" status, but they did learn how to organize and proselytize,[2] skills they would use on behalf of the women's movement. Feminism soon replaced the protest against the Vietnam War as the most powerful polemical and political force in the art world.

In their discussions women artists discovered that most of them worked on a small scale, in part because they wanted to and in part because they were relegated to kitchens and bedrooms while their male partners took the large studio spaces. Many women found that they preferred to use handicraft materials and techniques historically identified with women's work. Moreover, they were often drawn to subject matter and content that was culled from their own experiences, and they were encouraged to create a personal and subjective art in their consciousness-raising sessions. Feminists believed that their art should be about their lives as women. Art was to begin with the individual, detailing her experiences, emotions, desires, and dreams—who she was and how she got to be that way[3]—but if deeply felt, it would express a sense of the collective experience and consciousness of all women. As Suzanne Lacy recalled, feminist artists believed that art could "influence cultural attitudes and transform stereotypes. Naive as it sounds, change was our goal (though its directions were not clearly articulated)."[4]

Working small, with unorthodox materials and with personal subject matter and content, ran counter to the still-formidable formalist and

minimalist aesthetics, whose advocates dismissed feminist art for not being modernist and mainstream and, consequently, not major. To legitimate their art feminist artists and art professionals, including Miriam Schapiro, Judy Chicago, and Lippard, waged a campaign against formalism and minimalism, attacking these isms for not being about the artist's experience and thus depersonalized. Feminists also rejected the formalist proscription of theatricality in the visual arts. Acting out intimate experiences was a common practice in consciousness-raising sessions, and performance art was a natural outgrowth of this activity. In asserting the relevance of the personal in art, feminists contributed considerably to the death of modernism and to the birth of postmodernism.

The first generation of feminists—that is, the generation of the 1970s—was labeled "essentialist." Its members formulated a new aesthetics based on the premise that women possess a nature inherently different from that of men. As Joan Snyder said, "if your work is about your life, and I can't imagine it being about anything else on some level, then woman's experiences are very different from men's. As we grow up socially, psychologically and every other way, our experiences are just different. Therefore, our art is going to be different."[5] The question of whether women had an essential nature and what that might be was much debated in the 1970s. What was the source of this nature? Was it the issue of social and cultural conditioning or was it biologically and psychologically determined? And if women had an inherent nature, would it not find expression in a "separate" art and be fully apprehended only by women? In defense of the essentialist position, art historian Patricia Mathews maintained: "A whole body of recent research in psychology, literature, art, music, sociology, and education indicates that women perceive reality differently than men, for whatever reasons, and therefore have different expectations from and responses to human experience."[6]

How was a female sensibility to be expressed in art? Through the female body, feminist artists believed. They focused on such subjects as menstruation, the vagina, pregnancy, and female body language. Body images presented from a woman's point of view had a political dimension, at once denying that women were inferior and asserting their power.

The exploration of female sexuality, exemplified in the terms "central core," "central cavity," or "vaginal iconography," engaged feminist artists as well as art critics, historians, and theoreticians.[7] In her description of women's art, art critic Nancy Marmer wrote that there is "a tendency to center the image, a prevalence of vulval forms, erogenous tones and symmetry. . . . A number of the artists explore the uses of floral and other botanical allusions, either in specific references to aspects of female biology, or as more generalized symbols of female identity."

Marmer went on to say that there were precedents in "Surrealism's stockpile of biomorphic subconscious imagery [and] Georgia O'Keeffe's lubricious flowers."[8] Lippard added that more recently, the "erotic power

of Louise Bourgeois' work and Eva Hesse's psychologically open-ended, biomorphic/geometric forms provided important models for the visualization of sexuality. These immensely innovative works deeply affected the art of the coming decade, especially art by women, who were first to recognize their extra-formal radicalism."[9]

Essentialist iconography was only one topic of discussion among feminists. Another was whether certain techniques and materials were better suited than others to express the female sensibility. Should not feminists favor the decorative and utilitarian crafts—sewing, quilting, weaving, appliqué, china painting—because they constituted most of the creative production of women. But the decorative and useful had long been denigrated in the art world. Elitists maintained that if "art" was useful, it could not be free, and if it was decorative, it could not be serious. To rehabilitate the artistic heritage of women, feminists challenged the hierarchical distinction between the "low" crafts and "high" painting and sculpture, introducing the materials and techniques of the one into the other. They also challenged the proscription of the decorative and the functional.

In an important article titled "Quilts: The Great American Art," art historian Patricia Mainardi asserted that quiltmaking had been the exemplary women's art form.[10] She also commented that quilts anticipated certain tendencies in abstract art by more than a century. In 1973 art historian Linda Nochlin observed that the

> patchwork quilt has recently become a burning issue in certain feminist art circles. On the one hand, the existence of these brilliantly stitched creations seems to offer proof of women's ability to create a valid art form apart from the male-dominated institutions of high art. . . . On the other hand, quilts may be viewed more as tokens of women's traditional ability to triumph over adversity, to make the best of things in the face of continual oppression: denied the means of access to historical significance and major stylistic innovation in the art of the past, women fulfilled their aesthetic potentialities within the restricted, safely ahistorical areas of the decorative and the useful.[11]

In their quest for feminist subject matter and content, women also began, as Suzanne Lacy observed, "unearthing scholarship on obscure women artists, . . . critically examining women's artwork for its underlying impulses and premises, and trying to reconcile the rapidly growing body of feminist political theory with our art making." Hence the feminist project was made up not only of personal introspection and activism but of research as well. "Theory grew out of all three."[12]

Feminists favored performance art because it suited their urgent need to voice their concerns as women, because it engaged the public more immediately than painting and sculpture did, and because collaboration was often involved. Indeed, the coming together of women to create art intensified their collective sense of mission. Such cooperative

ventures rejected the modernist glorification of the individual genius and instead privileged "sisterhood."

In sum the aesthetic mission of feminist artists in the 1970s was to distinguish the art of women from that of men and to discover images that represented the essential nature of women. They aspired to "characterize, affirm, or celebrate specifically female attributes [and] reveal the history and the nature of the repressions of woman." Feminists also sought to reveal the discrepancy between the stereotypical images of women they encountered in art and the media and what they actually experienced and felt. They undertook to counter male-invented representations of women and to represent themselves. The purpose of feminist art, as art critic Moira Roth concluded, was "to make art about women from the woman's point of view," and "to teach others about the conditions of women in a way that would lead to changing those conditions."[13]

Women art critics joined the cause of feminist artists. Lippard led the way; having been a spokesperson for minimal and postminimal art, she rejected impersonal formalist analysis and formulated a specifically feminist art criticism, focusing on art made by women, how gender and sexuality shaped it and distinguished it from that made by men, and on the life histories and experiences of women artists—as well as her own.[14] She hoped that feminist art and criticism would raise the consciousness of women about themselves and their role in the art world and society, and move them to act on their own behalf.

Feminist art critics also brought neglected women artists to art-world attention. They were helped by feminist art historians. Nochlin's sociohistorical essay of 1970, "Why Have There Been No Great Women Artists?" was seminal.[15] Rejecting the notion that women were innately inferior as artists, she enumerated the social, psychological, economic, institutional, and cultural barriers that discouraged women from pursuing careers in art and, if they persisted, from succeeding. Art critic Ellen Handy called Nochlin's essay "one of the first blows struck for the serious consideration of the vexed questions of women, art, history, power, denial, repression, and omission."[16] The essay was the primary catalyst in the search for a women's art history. In 1977 Nochlin and Ann Sutherland Harris curated *Women Artists: 1550–1950*, the first major historical survey of paintings by women, at the Los Angeles County Museum of Art. The show then traveled to New York City's Brooklyn Museum.[17]

Women joined together not only to examine their condition in a male-dominated society but also to improve their position within the art world. Discrimination against women artists was widespread, and feminists formed organizations to combat it. The first, Women Artists in Revolution (WAR), was founded in 1970 from within the Art Workers Coalition, in reaction to the organization's sexism. The Whitney Museum of American Art became the major focus of protest. In 1971 WAR sent letters to the museum protesting the underrepresentation of women in its Annual exhibition: of the 143 participants, only 8 were women. The Ad

Hoc Committee of Women Artists, formed in 1970, demanded that fifty percent of the participants in the Whitney Annual be women. They staged a large rally outside the museum and engaged in guerrilla tactics, such as leaving Tampax and raw eggs around the Whitney premises. The museum responded by increasing the representation of women to 22 percent, a step in the right direction, but in the opinion of feminists, only a step.[18]

On the West Coast the exclusion of women from the *Art and Technology* show at the Los Angeles County Museum in 1971 provoked feminist artists into organizing the Los Angeles Council of Women. The council's Museum Action Committee investigated the museum's exhibition record during the previous decade and publicized its appalling findings. As the *Los Angeles Times* reported them: "Over a ten-year period, *one* one-artist show out of fifty-three was devoted to a woman; less than one percent of all work on display at the museum at that moment was by women; only twenty-nine of seven hundred and thirteen artists in group shows had been women."[19]

The first feminist art course on the college level was organized in 1970 by Chicago at Fresno State College. In the following year she and Schapiro formed and codirected a full-fledged Feminist Art Program at the California Institute of the Arts.[20] Its purpose was to help women restructure their lives in keeping with their desire to be artists and "to help them build their artmaking out of their experiences as women."[21] The Program aimed "to provide 'education for women, by women, about women' via consciousness-raising techniques, collaborative projects and the rethinking of art and social history from a feminist perspective."[22]

In 1972 Chicago, Schapiro, twenty-one women students from the program, and three invited artists embarked on an ambitious communal effort called Womanhouse. They converted an abandoned mansion in Hollywood into an environment based on the "age-old female activity of homemaking. . . . Womanhouse became the repository of the daydreams women have as they wash, bake, cook, sew, clean and iron their lives away."[23] The environment became a kind of "*Gesamtkunstwerk* of women's images," shaped by their feminist consciousness [40].[24] Schapiro described how at Womanhouse subject matter evolved from consciousness-raising sessions. Talking to Roth, she said:

> Do you remember the kitchen? Do you remember the motif of breasts covering the walls? [On] the ceiling [forms of] fried eggs [turned] into breasts by stages. Also, do you remember the flat pink skin painted over the refrigerator, stove, sink, etc. and, as a matter of fact, painted over the walls as well? Well, that subject matter came directly out of consciousness-raising sessions we had on the problem of the kitchen and what to do with it. I was very dissatisfied with the ideas that were emerging for the kitchen. So we sat down in an empty room on the hard floor in the cold winter with no heat and no facilities and we began to talk about childhood. As young children, what did the

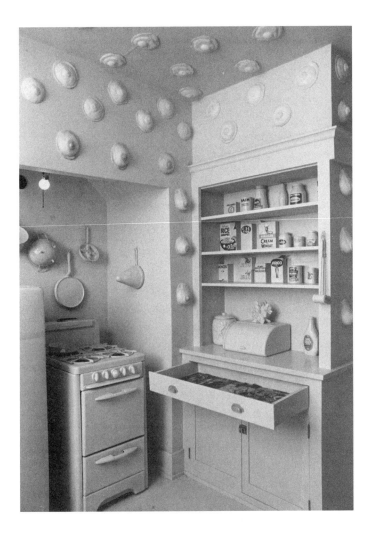

40. *The Kitchen* in Womanhouse, 1971–72.
(Courtesy Miriam Schapiro, New York)

kitchen mean to us? Who was our mother in the kitchen? Who were we? What were the symbols of all of this? I insisted as they spoke to and listened to each other that they develop the habit of visualizing all the information that was being given. This made finding solutions to visual problems much easier.[25]

Participation in Womanhouse was limited to women because, as Chicago reasoned, in the company of men, women had not been, and would not be, able to express and develop a female sensibility in their art. Separatism became the accepted feminist practice in the 1970s, because, as art critic Arlene Raven commented, it provides "a sympathetic environment in which women's art can be seen apart from male preoccupations. . . . 'We are interested in giving women permission to express themselves in ways that have not been accepted or understood by the male-dominated art community.'"[26] Moreover, the coming together of women by themselves facilitated political organization and action in the

service of a "forceful vision of a future without the unwanted baggage of the antifemale mainstream."[27] However, voices were raised against separatism in feminist circles. They questioned its effectiveness in achieving social change in the larger world. Art critic Irene Moss wrote

> that it was the unfairness of discrimination, . . . not male-female competition that was damaging [to women]. "[Since] art is universal and is practiced by both sexes and since excellence is the goal, separating women's art from that of men's is negating the natural order of growth." [Separation] from the art mainstream would only compound the evils of suppression, and [hinder] the struggle for equality.[28]

In 1973 Womanspace was established in Los Angeles. Ruth Iskin described it as

> an attempt at independent self-definition—and control of—women's art, the manner and context of its exhibition, and the criteria for its critical evaluation. . . . Womanspace should give maximum exposure to female artists, and provide special opportunities for visibility to minority groups within the female community. . . . In addition, the feminist cause has to be furthered by exhibitions designed around content issues, which will contribute toward a comprehensive self-definition of women and their art.[29]

Within a year of its formation Womanspace had more than 700 members, of which some five hundred were artists and the rest included filmmakers, art historians, museum personnel, writers, businesswomen, dancers, collectors, art teachers—and twelve men.

Womanspace succumbed to internal dissension. As Wilding remarked:

> There had been political and aesthetic struggles from the beginning, centering on such issues as: What kind of art should be shown, whether "feminist," "political," or just art made by women? Should Womanspace practice censorship of any kind, and if so, on what principles? Should only "professional" artists be shown, and how define professionalism? Was there room for women of all aesthetic and sexual persuasions? Would certain viewpoints be pushed more than others?[30]

Differences among gays and straights, rich patrons and leftists, and radical and less radical feminists split the ranks of feminist organizations and drove members away and made fund-raising difficult—a problem feminist organizations would continue to face.

Feminism needed its heroines and found early ones in Eva Hesse and Louise Bourgeois. Hesse had achieved considerable art-world recog-

nition before feminism emerged, having been given a retrospective at the Guggenheim Museum in 1970, the year after her untimely death. She was esteemed because she had deflected minimal art into a new and viable direction. But her work had a particular appeal to feminists because it issued from her own physiological and psychological experiences as a woman. Bourgeois had had a much longer career than Hesse, having begun to exhibit her work in the middle 1940s. She had always had art-world admirers, but her reputation had been in eclipse in the 1950s and 1960s. Feminist artists and art professionals believed with justification that she was insufficiently recognized because she was a woman artist whose content was autobiographical, and they sought to rehabilitate her. That goal was not achieved until 1982, when the Museum of Modern Art gave her a retrospective exhibition.

Bourgeois was obsessed by memories of a girlhood trauma: Her charming, womanizing father brought into her home a young English teacher who became his mistress, an intruder hated by her mother, who nevertheless accepted the situation in order to keep the family intact. Bourgeois could never resolve her childhood experience of male-female relationships, and they became the primary subject of her subsequent sculpture. As she said, "everything I am interested in is a personal problem. And I have to see my problems in visual shapes before I can deal with them." She also spoke of "flashes of intense experience. . . . I am attacked by so many images. . . . I see images next to each other, or overlapping each other—the whole thing is visual." Bourgeois did not illustrate her memories but strove to recreate how they felt—in a great diversity of images, both figurative and abstract, and in an equally great variety of mediums: wood, marble, bronze, cement, wax, plaster, and latex. She said that while working "there is a mounting tension, arising from my physical encounter with the physical material . . . and out of it grows what I want to say."[31]

Bourgeois's images often refer to the bodily experiences of women—pregnancy, birth, breast-feeding—in the context of the house [41]. Perhaps her most revealing images are found in drawings titled *Femme Maison* (1946–47), each of which is a nude female figure whose upper half is a house. The mood is one of anxiety, loneliness, and vulnerability. A number of her sculptures are of pregnant women whose identity is in their bellies. Most are armless, legless, and headless, in a word, defenseless. But some of Bourgeois's women are aggressive, among them the marble *Knife Woman*—an elongated torso with exposed pudenda that seems to metamorphose into a knife—a mixture of sex and death—and *Fillette* (Little Girl) (1968), a latex-and-plastic penis and testicles hung from a hook—like a hunk of dead meat. *Shredder* (1983) is an image of slicing. Bourgeois once said: "In my art I'm the murderer. . . . The guillotine appears all the time in my work."[32] Her most telling work is a nine-by-eleven-by-nine-foot maw in which the "father"—and, by extension, all authority figures—is devoured, aptly titled *The Destruction of the Father* (1974) [42].

41. Louise Bourgeois, *Nature Study,* 1984.
(Copyright © 1994 Whitney Museum of American Art; © Louise Bourgeois/VAGA, New York, NY)

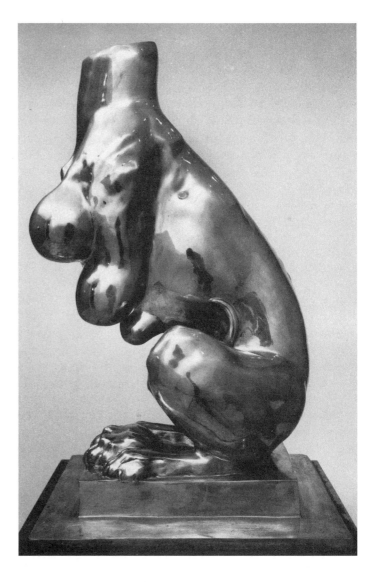

Bourgeois's imagery is too diverse to categorize, but there are recurring motifs, for example, cavities suggestive of caves, lairs, nests, cocoons, and wombs that appear in hanging plaster-and-latex pieces of the early 1960s. Like the house-body images of the 1940s, they both enclose and exclude, providing protective shelter and places in which to nurture or hide, and from which to watch. There are also clusters or gardens or crowds or nests of rounded forms, most prominent in the late 1960s and 1970s. She called these images "phallic breasts, male and female, active and passive."[33] Sprouting from the floor, their arrangement was innovative in sculpture at the time.

Despite their private nature, Bourgeois's often eccentric images are archetypal, as Robert Storr commented, echoing "modern psychology and classical myth, in which gods and demiurges act our their desires

42. Louise Bourgeois, *The Destruction of the Father*, detail, 1974. *(Robert Miller Gallery, New York; photograph copyright © 1975 by Peter Moore, New York; © Louise Bourgeois/VAGA, New York, NY)*

with the paradoxical combination of fickleness, cruelty and powerful constancy we accept as inevitable."[34]

Performance art, often incorporating two- and three-dimensional work, video, film, dance, music, and texts, was an effective medium for feminist artists to communicate urgent messages about their life experiences, emotions, and the condition of women. Not only was there little separation between the performer and her work but between the performer and her audience. This provided the artist with "immediate feedback as well as support for difficult and often painful exposures of experiences and feelings," as Moira Roth commented. She identified three main tendencies in woman's performance art: "the autobiographical/narrative, the mystical/ritualistic and the political."[35] Feminist performance art had been influenced by Bruce Nauman and Vito Acconci, but its introduction of autobiography, myth, and politics added a new dimension to the tendency.

Early manifestations of what might be called feminist autobiographical theater took place in 1972 in Womanhouse. The artists there performed pieces based on such activities associated with women as ironing and scrubbing floors. Faith Wilding exemplified female passivity in a piece titled *Waiting* [43], in which she recited events for which women wait: to wear a bra, to go to a party, to be asked for a dance, for pimples to go away, for Mr. Right, for an orgasm, etc.[36] Chicago commented: "I think that the reason our performances . . . at Womanhouse created so much tension, excitement, and response was that we told the truth about our feelings as women in them, . . . feelings that had simply never been so openly expressed in artmaking."[37]

Eleanor Antin began her "theater of the self," as she called her performances, in the early seventies. These had been preceded in the late 1960s by environments of common objects that constituted "portraits" of friends, and starting in 1971, by *100 Boots*, consisting of fifty-one picture postcards chronicling the adventures of one hundred boots, which she mailed to artists, art professionals, and friends over a two-and-a-half-year period.

In 1972 Antin turned in on herself, producing her first videotape, titled *Representational Painting*. In it she slowly made up her face using the video monitor as a mirror, until finally "I turn out to be some sort of *Vogue* hippie." Thus she represented herself through "painting" as women generally represent themselves to the world.[38] Antin continued to define and portray herself as an artist and a woman by typecasting herself as four characters—surrogate selves: a ballerina, a king, a black movie star, and a nurse, whose roles are "to rule, to star, to help, and to turn one's blackness in a white culture into a Virtue and a Power"[39] She declared: "Since my dialogue is with myself, my method is to use video, still photography, painting, drawings, writing, performing as mediums between me and myself so we can talk to each other."[40]

43. Faith Wilding, *Waiting*, performance, Womanhouse, 1972. *(Photograph by Lloyd Hamrol)*

As the king Antin asked the question: "If I were a man, what sort of man would I be?"[41] Her answer was to wage a losing war on behalf of the have-nots against the haves, who are destroying the earth. As a nurse she assumed the persona of Florence Nightingale [44]. *The Angel of Mercy* was a Victorian costume drama that consisted of photographs of Nurse "Eleanora's" life and activities in the Crimean War as well as live performances involving the artist, family members and friends, musicians, and forty life-size painted cutout masonite figures of nineteenth-century hussars, lancers, common soldiers, ladies and gentlemen, and Queen Victoria. The work examined the contest between healing and killing in war. Antin as the ballerina "Eleanora Antinova" read from her memoirs, *Recollections of My Life with Diaghilev,* recalling her celebrated roles in the Ballets Russes.[42] Summing up her work, Antin commented that although she was "interested in defining the limits of myself . . . the four selves soon began to lead their own lives . . . that I am hardly in a position to stop or control."[43]

Hannah Wilke was primarily a performance artist who used her own naked body as her medium, but she also made portable wall works, such as a series (1971–77) in which latex was shaped into erotic, flowerlike and

fleshy labial images in sensuous pinks [45]. In her performances, begun in 1970, Wilke undressed in order to examine her body and sexuality from the viewpoint of the "female gaze." Her purpose was at once to expose and challenge stereotypes of women and to celebrate eroticism.

In a number of her performances, Wilke turned her own naked body into living sculptures to whose erotic surface she attached other erotic objects. In the *Starification Object Series (S.O.S)* (1974–75) [46], she and bystanders chewed gum, which she folded into vaginal shapes and then stuck onto herself. These "signature" images read as vulva and scar, denoting both pleasure and pain, reflecting, as she said, "the ambiguity and complexity of emotions."[44] In the title Wilke turned "scar" into "star," an allusion perhaps to her pose as a beauty queen. On the other hand, the scar coupled with S.O.S. suggests a plea for help as if from a battered woman.[45] In her punning titles and use of readymades, vaginal images, and of herself as the subject of photographs, Wilke was influenced by Duchamp, with whose work she had a kind of love-hate relationship throughout her mature career.

Wilke's self-exposure raised questions in feminist circles. Did her striptease and cheesecake poses make her complicit with the "male gaze," particularly because she was beautiful? Many feminists thought so. For example, Muriel Dimen wrote that since women have traditionally been seen as sex objects, feminist artists must downplay erotic attributes and

44. Eleanor Antin, *"My Tour of Duty in the Crimea"* from *The Angel of Mercy*, 1977. *(Ronald Feldman Fine Arts, Inc., New York)*

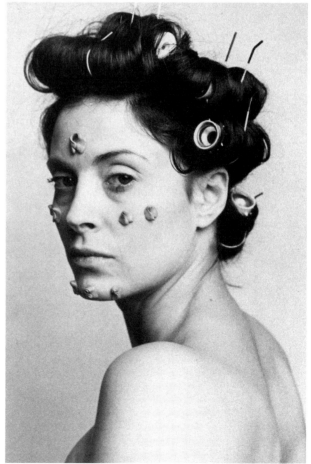

45. Hannah Wilke, *Venus Cushion,* 1972. *(Ronald Feldman Fine Arts, New York)*

46. Hannah Wilke, *S.O.S. Starification Object Series,*
1974. *(Ronald Feldman Fine Arts, New York)*

not "engage in any stereotypically feminine behavior, such as putting on make-up, [or] wearing high heels,"[46] both of which Wilke did. Other feminists allowed that her images were ambiguous but that they criticized and subverted the sexist image of women as passive and validated the female body.[47] Lippard wrote: "When women use their own bodies in their art work, they are using their *selves;* a significant psychological factor converts these bodies or faces from object to subject."[48] Wilke said that her "interest in developing a specifically female iconography" aimed to create a positive image toward female sexuality and "wipe out . . . prejudices, aggression, and fear."[49] She viewed herself as a "sugargiver" one who offers sweetness—of chewing gum, for example—and by implication bodily pleasure.[50] Wilke concluded that "women must take control of and have pride in the sensuality of their own bodies and create a sexuality in their own terms, without deferring to concepts degenerated by culture."[51]

A consideration of feminist performance art must take into account Lynda Benglis's notoriously controversial photographs of herself naked, one of which she ran as an advertisement in *Artforum* in 1974. Posed as a pinup girl, her body greased and shining, she wore only dark glasses and held a giant double-ended dildo. Five of the magazine's editors published a letter condemning it as "an object of extreme vulgarity" and "a shabby mockery of the aims" of feminism.[52] Other art professionals considered it a feminist statement, as Lippard commented: "In a put-on (or take-off) of media stereotypes and role-playing in the art world, she offered a view of herself as a woman with everything—everything needed to Make It (talent either being taken for granted or minimized): a seductive woman's body and the obligatory big prick. (She remarked that 'men are more involved with penis envy than women.')"[53]

Moira Roth remarked that as the 1970s progressed, feminist autobiographical performance art became increasingly "threadbare." There was little attempt on the part of feminists to evaluate the quality of performances. Indeed, how could a critic *dare* to "judge the life (as opposed to the art) of the performer? How does one weigh admirable politics against dull art? What is the audience's stake in personal performances which seem created exclusively to satisfy the therapeutic needs of the artist?" Sensitive to these matters, a number of feminist artists began to deal with broader feminist issues, notably violence toward women, particularly rape, which Suzanne Lacy viewed as "a current condition of every woman's life."[54]

Ablutions (1972) was an hour-and-a-half collaborative performance created by Chicago, Aviva Rahmani, Sandra Orgel, and Lacy herself.

> The performance took place in an area strewn with egg shells, piles of rope and fresh meat. A tape of women describing their experiences of being raped played, while a naked woman was slowly and methodically

bound with white gauze from her feet upward to her head. At the same time, a clothed woman nailed beef kidneys into the rear wall of the space . . . while two nude women bathed themselves in a center stage series of tubs containing first eggs, then blood, and finally clay. Finally, two clothed women bound the performance set and two other performers into immobility with string and rope. As they left the space, the tape repeated, "and I felt so helpless all I could do was just lie there."[55]

In 1977, at the time of a series of brutal rapes and murders by the so-called Hillside Strangler in Los Angeles, Lacy, in collaboration with Leslie Labowitz, a former student of Joseph Beuys, and in conjunction with a number of women's organizations, staged *Mourning and Rage* [47]:

> They directed this event toward a twofold audience: media reporters (and by extension, a media audience) and the women's community of Los Angeles. The performance began with participating women driving to the [Los Angeles City Hall] in a hearse and accompanying motorcade. On the steps . . . ten giant mourning figures, flanked by some sixty women also in black, confronted the media—who had

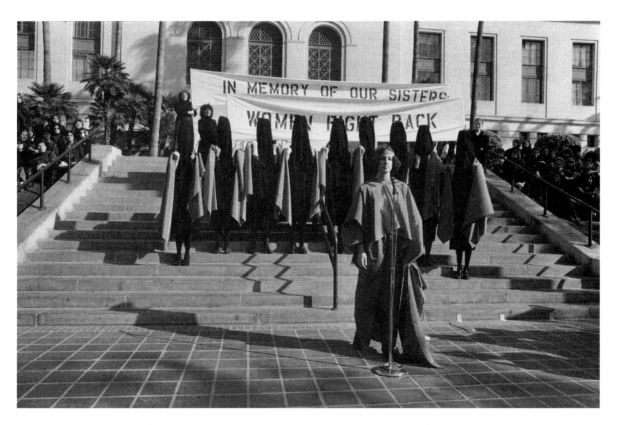

47. Suzanne Lacy and Leslie Labowitz, *In Mourning and in Rage*, 1977. *(Photograph by Susan Mogul)*

appeared en masse [including six television stations]—and read short statements linking the Hillside Strangler murders to a myriad of other expressions of nationwide violence against women [including the role of the media in fostering such violence].

Rape was of particular concern to Lacy because it was "a galvanizing issue, and any political organizer uses the conditions which can bring different people together." Indeed, the primary purpose of her art was to organize women in order to protest violence and to strengthen the community of women. After 1975 Lacy focused her performance activities on the conditions of prostitutes, old women, and Third World women.[56]

Much of feminist performance art, like that of Beuys, sought to effect social change or at least to dramatize the problems facing women. As art critic Kristine Stiles wrote: "Performance art has [placed] the individual body in a discourse with the social body. Without a clear understanding of this political subtext of performative art, its most challenging and revolutionary dimension will be missed and lost."[57]

Another major category of feminist performance art aimed to commemorate great female figures of history and prehistory. Roth recalled that as part of the feminist enterprise, women artists—and art professionals—

> combed through history . . . searching out and reinterpreting women's roles in it. . . . Women explored art history for sites of sacred female rites, for images of goddesses and fertility figures—prehistoric, Indian and Cretan—as well as for forgotten, or insufficiently acclaimed, Western women artists in historical time. A spate of literature came out arguing for the existence of women's dominance (often symbolized by the worship of the Great Goddess) in mythic and prehistoric times, and of women's unique relationship to nature.

The Great Goddess was the consummate image of female power, and feminist performers tried to imagine what she might have been, each creating her own private—and in this sense, autobiographical—ritual. Among the artists who celebrated the Great Goddess were Carolee Schneemann, Meredith Monk, Mary Beth Edelson, Joan Jonas, and Ana Mendieta.[58]

Schneemann was the pioneer. She had been associated with Allan Kaprow, Claes Oldenburg, and other creators of happenings in the early 1960s.[59] In a performance titled *Eye Body* (1963) [48], whose "impetus came from a combination of the writings of Wilhelm Reich, Antonin Artaud, and Simone de Beauvoir's *Second Sex*," she transformed her New York loft, as she explained,

> into an "environment"—with 4 × 9-foot panels, broken mirrors and glass, lights, photographs and motorized umbrellas. Then in a kind of

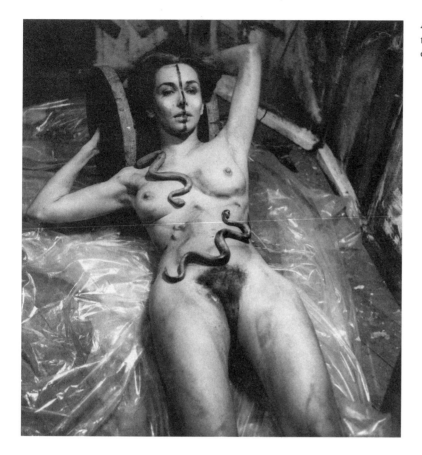

48. Carolee Schneemann, *Eye Body,* from thirty-six transformative actions for camera, 1963. *(Courtesy of the artist)*

shamanistic ritual I incorporated my own naked body into the con-
structions—putting paint, grease and chalk on myself. At one point I
had live snakes crawling over my body! Only later did I realize the
affinity of this to the famous statue of a Cretan goddess whose body is
decorated with serpents.[60]

Schneemann would fully understand the meaning of her body images only
in the early 1970s, after she had studied prehistoric goddess artifacts and
the history of women during three thousand years of patriarchal society.[61]

 Meat Joy, performed in 1964 by the Kinetic Theater founded by
Schneemann, featured a mélange of naked bodies in orgiastic celebration.
It had, as she wrote, "the character of an erotic rite: excessive, indulgent, a
celebration of flesh as a material: raw fish, chickens, sausages, wet paint,
transparent plastic, rope, brushes, paper scrap," at once "ecstatic . . . sen-
sual, comic, joyous, repellent."[62] *Fuses,* 1965, was even more provocative
than *Meat Joy;* in it Schneemann and her longtime lover had sex; among
the images was a penis metamorphosed into a vagina and stained with
menstrual blood.[63] *Meat Joy* and *Fuses* were denigrated by the art world as
titillating and degraded. Schneemann said that she did not intend to create
a scandal, although "you do get an instinct for *where the repression is* and

you go for it. I always thought that my culture would be gratified that I was putting it out, but instead they want to punish you."[64] This work also led Schneemann to consider whether she was dreaming the dream of women or the dream of men dreaming women. It provoked her to think that an important issue for women artists was how to divest themselves of male structures and build new ones while still remaining in the art world.

In 1976 Schneemann created *Interior Scroll*, her best-known work and the most notorious of feminist performances. She stood naked in a dim light and read from a paper scroll that she extracted slowly and rhythmically from her vagina, which she had long thought of "as a sculptural form, an architectural referent, the source of sacred knowledge, ecstasy, birth passage, transformation."[65] The text was inspired by a snub from a female art critic but was about a male poststructuralist filmmaker who refused to look at Schneemann's films, much as he found her personally charming. He simply could not abide *the personal clutter / the persistence of feelings / . . .* the diaristic indulgence / the painterly mess / . . . the primitive techniques." The filmmaker concluded by informing Schneemann that she was not "a film-makeress. . . . We think of you as a dancer."[66]

Interior Scroll was about rage and pulling it out of her body, ridding her body of it. But it was also about pleasure—pleasure in her own body. More often than not Schneemann celebrated the female body in erotic rituals that intended to disturb and change America's guilt-ridden culture. Some feminists found her work lacking in feminist art-theoretical grounding. She responded by asserting that these cerebral critics bury the body—its sensual, ecstatic, and orgasmic dimensions—beneath linguistic structures. They ignore lived experience and, as she said, "stuff their vaginas with their theories."[67]

Feminist installation artists also celebrated the Great Goddess. Indeed, apart from the performances of Schneemann, the most successful homages were the works by Chicago and Nancy Spero. Chicago's room-size *The Dinner Party* [49], begun in 1973 and completed in 1979, is a table in the form of an equilateral triangle with an open center, each wing of which is forty-six and a half feet long, The table is set with thirty-nine individual place settings, each of which consists of an elaborately shaped ceramic or painted china plate, a needlework runner, a ceramic chalice, and a knife, fork, and spoon. Each plate and runner is the symbolic "portrait" of a mythological or historically significant woman. Among the embroidered runners are, for example, a turn-of-the-century "memory quilt" for Susan B. Anthony; a leather and beadwork piece for Sacagawea, made by an American Indian artist; and an old lace-and-ribbonwork pattern for Emily Dickinson.[68] The most striking features of the table settings, indeed of the entire work, are the plates in the form of vaginas, which also resemble butterflies. The floor of the installation is composed of more than 2,300 white porcelain tiles across which are written the

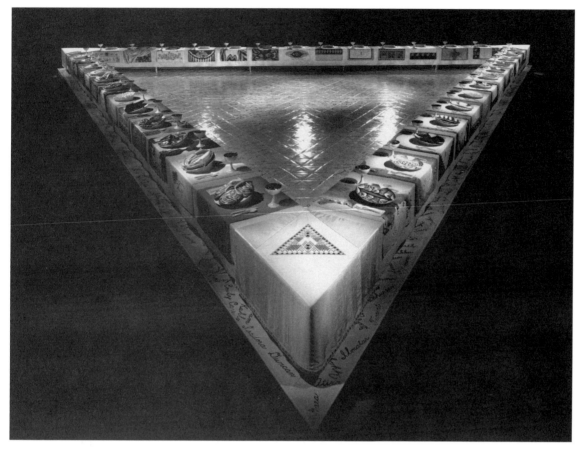

49. Judy Chicago, *The Dinner Party,* 1973–1979. *(Copyright © 1979 Judy Chicago)*

names of 999 additional women notables in Western history. At the entrance of the work banners with slogans commemorate the Great Goddess. A project as ambitious and complex as *The Dinner Party* could not have been realized by one person. Indeed, some four hundred women participated in its production, although Chicago retained aesthetic control and was generally identified as its creator.

The Dinner Party encompassed the prehistory and history of women, celebrating their worldly, spiritual, and cultural achievements on a monumental scale; emphasized the biological distinctiveness of women; and employed crafts historically associated with women. Above all, in bringing together representations of great women of past and present in one piece, *The Dinner Party* presented them as an exalted sisterhood in a kind of mythicopoetical communion—a sisterhood emulated in the collaborative nature of the project.

The Dinner Party generated acrimonious controversy, primarily because of the provocative vaginal imagery of the plates.[69] Could labia stand for women—and symbolize their historic roles? Maureen Mullarkey asserted that they could not: "Chicago's decision to represent

the stature and variety of women's accomplishments by genitals only—as if women's achievements had more to do with the organic, instinctual make-up of women than with the ability of certain women at certain times, and for highly contingent reasons, to transcend the cultural limitations of gender."[70] Lucy Lippard defended Chicago:

> Women's bodies, for better or worse, are still the core of much feminist art, entangled as they are with our exploitation on the economic, domestic, and media fronts, central as they are to our campaigns for reproductive rights and against discriminatory "protective" laws. Chicago realized this early on and has since been struggling to make the butterfly (the "witch's messenger") a suitably powerful, flexible and evocative symbol for the breadth of women's history.[71]

There were other questions. Had Chicago expropriated the work of her hundreds of collaborators and projected herself as the latest great woman, emulating the macho "genius"? Was the installation underscored "by a proselytizing self-righteousness that replaces art with cultism and offers literalism in the guise of education"? Did Chicago underestimate the viewer's intellectual capacities?[72] Or was *The Dinner Party* an epic, pioneering, and profound feminist monument that had, as she believed, the power to change consciousness?[73] Whatever the verdict, it did attract crowds wherever it was shown and focused attention on feminist issues and art—which was after all Chicago's underlying purpose.[74]

Like Chicago's *The Dinner Party*, Nancy Spero's work exemplifies the essentialist position of first-generation feminists. Indeed, it is the consummate statement in social, cultural, and above all aesthetic terms. Her aim was "to find a 'voice' for woman, intelligible, yet separate from the patriarchal voice, and to reclaim the image of woman from the representations of others."[75] Anticipating Spero's feminist works was a series of *War Drawings* made between 1966 and 1969, at the height of the Vietnam War, in which ferocious phallic images ejaculate, defecate, vomit, and spit bombs and bodies from the sky [50]. As she said: "I couldn't think of any other way of showing the obscenity of the bomb, except through this expression of sexual obscenity."[76]

Spero would soon depict only women: "Woman as protagonist, the woman on stage." But she continued to link power, violence, and sex. In keeping with the urgency of her message, she limited her medium to paper in order to be more direct and to simulate bulletin boards or wall posters. But she was also reacting against painting as "an 'establishment' product" and therefore criticizing not only the politics of war but of the art world as well.

Spero introduced words into the *War Drawings*, such as "pacification" and "search and destroy." In her subsequent works, she used typewritten quotations, fracturing and overlapping them in visually stimulat-

50. Nancy Spero, *"Love to Hanoi"* war series, 1967. *(Courtesy of the artist)*

ing rhythms, but surrounding them with expanses of empty white so that most are legible. The images and the texts are, as Spero commented, "set in tension with one another and are not illustrative in any way."[77] As she explained: "The format of the work, extended linear panels of paper, both horizontal and vertical, enables me to disperse images, text, leave blank stretches of paper—silences, in direct or layered messages. The work is a visual manuscript laid out on the wall. In this way I can deal with multiple contents."[78]

Many of Spero's images were borrowed, anticipating a practice common in the art of the 1980s: "I ransack art history and photographic sources. I usually change the images in some way. But I do unashamedly appropriate from found images. I feel that I can take something that's in the public domain, either text or image." These images were often transferred onto zinc plates and rubber stamps and printed on the picture surfaces. By 1987 Spero had made approximately a hundred stamps depicting women in "many different sizes, shapes, historical periods, old, young, black, Vietnamese, white, etc.—all in what I would consider natural poses for their roles. A 'pose' is how one carries oneself, identifies oneself— how one confronts the world and the gaze of the viewer, male or female."[79]

In the *War Drawings* Spero raged against the helplessness of Vietnamese bombing victims. In her subsequent works, as Lucy Lippard observed, she extended her fury against "the powerlessness of the . . . artist, the woman herself"—the woman-artist in the art world without a voice.[80] For Spero the writing of Antonin Artaud exemplified her own anger and frustration and inspired her to create the *Codex Artaud* (1971–72), a series of scroll-like, collaged works ranging in length from eight to twenty-five feet, in which Artaud texts were quoted.

> Artaud is exceptional for having uttered the most extreme expressions of dislocation and alienation in the 20th century. He represents himself as the victim par excellence. While violent in gesture and language, he is masochistic and passive [which is] the part of the female victim. . . .
>
> I identified with Artaud's sense of victimage—using his language to exemplify my loss of tongue—fracturing his already fractured texts, because I felt a victim as regards to both being a woman and an artist.[81]

In 1974 Spero turned her attention "to real events, to real victims in real prisons, tortured for political reasons" [51].[82] Moved by case histories in Amnesty International newsletters, she made *Torture in Chile* (1974), a work approximately 23 by 122 inches long. Part of the text read: "live mice and insects introduced into vaginas . . . nipples blown off or burnt genitals destroyed by electricity." In other works she "began to explore other aspects of women's experience, not only torture, but war and rape, birth, aging, work, [and] dance." She also dealt with the lives of women in different cultures and time periods even projecting into the future, when she envisaged "the utopian possibilities of women taking charge of their own bodies."[83] In expanding the range of her work, Spero incorporated "images from the prehistoric, contemporary, black, Asian, white, Greek goddesses, rollerskaters, etc.—a cinematic splicing of female figures from all kinds of cultures and times. . . . A simultaneity of images without a continuous narrative."[84] The images are often sexual—a classical Venus holding an oversize dildo, the Celtic goddess Sheela-na-gig with an enormous vagina—images she selected because they are potent forces. As art critic Rosetta Brooks observed, Spero negotiated the "separated worlds of the sacred and the profane, the personal and the social, the archetypal and the stereotypical and the ancient and contemporary."[85] Together all of her images evoke the "generic female."[86]

Spero acknowledged that she made "woman's art," but recognized that she would need

> to defend herself against the charge of being overspecialized in regard to women's choices and subject matter, style. Male artists never have to defend themselves since male specialization is never challenged. It is taken for granted as universal. Women artists will

51. Nancy Spero, *Torture of Women*, panels 4, 5, 9, 10, 13, 14, 1976. *(National Gallery of Canada; courtesy of the artist)*

know when they arrive at equal status—that utopian day—when the art world takes for granted that our subjects are no more illogical or overspecialized than those of male artists. It's the problem of finding—inventing if necessary—nonmale points of view, of not using language and body language that are inherited from male priorities. Which is what I have gone and done.[87]

Feminists opened up new aesthetic options to women—and men. Moreover, they made the art world "look hard at whatever was formerly considered 'marginal' in art," as Robert Storr commented. "Under the pressure of their conviction and research, diaristic imagery, emotionally charged eclecticism, new materials and previously unacceptable attitudes toward craft were all admitted as serious points of departure for looking at old art and making the new."[88]

Feminism also engendered a new sense of community. Indeed, there was a proliferation of feminist art organizations; in 1977 eighty-five of them, with a combined membership of 75,000, formed the Coalition of Women's Art Organizations to coordinate their activities. But although the

feminist movement struggled to gain recognition for women artists, equality with male artists was not achieved. In the mid-1970s approximately 66 percent of bachelor's degrees in studio disciplines and art history were awarded to women, and 50 percent of the professional artists in the United States were women. Yet only 15 percent of the one-person shows in New York's prestige galleries were devoted to women, an increase of just 1.5 percent over 1970. Men still got most of the museum shows; the ratio at the Museum of Modern Art from 1980 through 1985 was roughly thirteen to one; at the Guggenheim, fifteen to one; at the Whitney, twenty-two to four. Articles about male artists in *Artforum* and *Art in America* greatly outnumbered those about women.[89] Art-world discrimination against women artists would remain a major issue for feminists.

However, by the late 1970s there was a decline in feminist commitment. In 1976 Barbara Zucker noted:

> A kind of lethargy seems to have settled over feminism, not just in the arts but in all phases of its development. Predictably, there has been a media backlash, a female backlash (witness the defeat of the ERA [Equal Rights Amendment]), an exhaustion about the subject that comes with too much exposure of any vital issue. But worse, there is a kind of settling in, an acceptance of the feminine "institutions" which have developed since the late '60s; and those who seem the most quiescent, and the least able to ask questions about where to move next, are the feminists who are part of these collective oases. In effect, a lot of women seem to be scratching each other's backs.[90]

Joyce Kozloff agreed with Zucker "that the currently practiced approaches to talking about and showing women's work have become tired and unimaginative."[91] There would be a next move in feminism, in the 1980s, but by another group, more theoretically inclined and with a different agenda.

NOTES

1. Faith Wilding, *By Our Own Hands: The Women Artist's Movement: Southern California: 1970–1976* (Santa Monica, Calif.: Double X, 1977), p. 10.
2. See Cindy Nemser, "The Women Artists' Movement," *Feminist Art Journal* (Winter 1973–74): 8–10.
3. Peter Frank, "Auto-art. Self-indulgent? And How!" *Art News*, Sept. 1976, p. 43.
4. Suzanne Lacy, "The Name of the Game," *Art Journal* 50, no. 2 (Summer 1991): 65.
5. Joan Snyder, in "The Woman's Movement in Art, 1986," *Arts Magazine*, Sept. 1986, p. 54.
6. Patricia Mathews, "Feminist Art Criticism: Multiple Voices and Changing Paradigms," *Art Criticism* 5, no. 2 (1989): 3.
7. See Thalia Gouma-Peterson and Patricia Mathews, "The Feminist Critique of Art History," *Art Bulletin* 69, no. 3 (Sept. 1987): 326–57.
8. Nancy Marmer, "Womanspace, A Creative Battle for Equality in the Art World," *Art News*, Summer 1973, p. 39.
9. Lucy R. Lippard, "Intruders: Lynda Benglis and Adrian Piper," in John Howell, ed., *Breakthroughs: Avant-Garde Artists in Europe and America, 1950–1990* (New York: Rizzoli, 1991), pp. 126–27.
10. See Patricia Mainardi, "Quilts: The Great American Art," *Feminist Art Journal* (Winter 1973): 1, 18–23. See also Rachel Maines in "Fancywork: The Archaeology of Lives," *Feminist Art Journal* (Winter 1974–75): 1, 3.
11. Linda Nochlin, "Introductory Essay: The Recent Work of Miriam Schapiro," in *Miriam Schapiro: The*

Shrine, the Computer and the Dollhouse (San Diego–La Jolla, Calif.: University of California, Mandeville Art Gallery, 1975), p. 5.

12. Lacy, "The Name of the Game": 64.

13. Mathews, "Feminist Art Criticism": 2, 6. (The Moira Roth quote is in "Vision and Re-Visions: Rosa Luxemburg and the Artist's Mother," *Artforum*, Nov. 1980, pp. 36–38).

14. See Roberta Smith, "Two Critics Collected," *Art in America*, Nov.–Dec. 1976, pp. 36–37 (a review of Lucy R. Lippard, *From the Center: Feminist Essays on Women's Art* [New York: Dutton, 1976]).

15. Linda Nochlin, "Why Have There Been No Great Women Artists?" *Art News*, Jan. 1971, pp. 22–39.

16. Ellen Handy, "Readings: Women, Art, Feminism," *Arts Magazine*, May 1989, p. 31.

17. Judy Chicago, *Through the Flower: My Struggle as a Woman Artist* (Garden City, N.Y.: Doubleday & Co., 1973), was also important.

18. Feminist artists also picketed the Museum of Modern Art in 1972.

19. Lippard, *From the Center*, p. 98.

20. Chicago and Schapiro directed the program from 1971 to 1973; Schapiro alone, from 1973 to 1975.

21. Nochlin, "Introductory Essay: The Recent Work of Miriam Schapiro," p. 5.

22. Grace Glueck, "Women Artists '80," *Art News*, Oct. 1980, p. 61.

23. Wilding, *By Our Own Hands*, pp. 25–26. Other important feminist organizations were the Woman's Caucus for Art, with chapters around the country, formed in 1972; and the Feminist Art Institute, founded in 1979 in New York by Miriam Schapiro with Nancy Azara and others.

24. Gouma-Peterson and Mathews, "The Feminist Critique of Art History," p. 330.

25. Moira Roth, "Interview with Miriam Schapiro," in *Miriam Schapiro: The Shrine, the Computer and the Dollhouse* (LaJolla, Calif.: University of California, Mandeville Art Gallery, San Diego, 1975), pp. 13–14.

26. Marmer, "Womanspace, a Creative Battle for Equality in the Art World," *Art News*, Summer 1973, p. 39.

27. Arlene Raven, "Cinderella's Sisters' Feet," *Village Voice Art Supplement*, Oct. 6, 1987, p. 8.

28. Christine C. Rom, "One View: The *Feminist Art Journal*," *Woman's Art Journal* (Fall 1981–Winter 1982): 23. The *Feminist Art Journal*, edited by Cindy Nemser, opposed Chicago's biological determinism as too narrow and opted for a broader approach to the female sensibility. See Martha Rosler, "The Private and the Public: Feminist Art in California," *Artforum*, Sept. 1977.

29. Ruth Iskin, *Womanspace Journal* 1, no. 1 (Feb.–Mar. 1973): 8–9, quoted in Wilding, *By Our Own Hands*, p. 49.

30. Wilding, *By Our Own Hands*, p. 53. In 1971 Sheila de Bretteville started the Women's Design Program, and in 1973, Judy Chicago, de Bretteville, and Arlene Raven founded the Feminist Studio Workshop, an art and design school for women. The Woman's Building was opened in Los Angeles in 1973. It housed a number of women's organizations, including the Feminist Studio Workshop, Womanspace, the Grandview Galleries, and Gallery 707, Sisterhood Bookstore, Associated Women's Press, Los Angeles Feminist Theater, Women's Improvisation, and a coffee shop, a photo gallery, and a feminist travel bureau.

31. Donald Kuspit, "An Interview with Louise Bourgeois," *Bourgeois* (New York: Vintage Books, 1988), pp. 30–31.

32. Pat Steir, "Mortal Elements: Pat Steir Talks with Louise Bourgeois," *Artforum*, Summer 1993, 127.

33. Louise Bourgeois, in Dorothy Seiberling, "The Female View of Erotica," *New York Magazine*, Feb. 11, 1974, p. 56, quoted in Deborah Wye, "Louise Bourgeois: 'One and Others,'" *Louise Bourgeois* (New York: Museum of Modern Art, 1982), p. 27.

34. Robert Storr, "Louise Bourgeois: Gender & Possession," *Art in America*, Apr. 1983, p. 136.

35. Moira Roth, Preface and "The Amazing Decade: Women and Performance Art in America," in Moira Roth, ed., *The Amazing Decade: Women and Performance Art in America 1970–1980* (Los Angeles: Astro Artz, 1983), pp. 8, 18, 21.

36. See Judy Chicago, *Through the Flower: My Struggle as a Woman Artist* (New York: Anchor Books, 1982), p. 122.

37. Ibid., pp. 128–29.

38. Roth, "The Amazing Decade," p. 19.

39. Eleanor Antin, in *The Amazing Decade*, p. 76.

40. Eleanor Antin, "Dialogue with a Medium," *Art-Rite* 7 (Autumn 1974): 23.

41. Roth, "The Amazing Decade," p. 19. The Antin quotes come from Dinah Portner, "Interview with Eleanor Antin," *LAICA Journal* (Feb.–Mar. 1980): 35.

42. "Eleanor Antin," p. 76.

43. Eleanor Antin, in Colin Naylor and Genesis P-Orridge, eds., *Contemporary Artists* (London: St. James Press, 1977), p. 33.

44. Joanna Frueh, "Hannah Wilke," and Hannah Wilke, "Intercourse with . . . ," in *Hannah Wilke: A Retrospective* (Columbia: University of Missouri Press, 1989), pp. 41, 138. Other vaginal images that Wilke used were fortune cookies and shaped latex. She also incorporated other eccentric materials, such as laundry lint, erasers, and chocolate.

45. "Hannah Wilke," in *The Amazing Decade*, p. 146.

46. Muriel Dimen, "Politically Correct? Politically Incorrect?" in Carole S. Vance, *Pleasure and Danger: Exploring Female Sexuality* (Boston: Routledge & Kegan Paul, 1984), p. 140, quoted in Frueh, "Hannah Wilke," p. 45.

47. Mathews, "Feminist Art Criticism," p. 4.

48. Lucy R. Lippard, "The Pains and Pleasures of Rebirth: European and American Women's Body Art," in *From the Center*, p. 124.

49. Wilke, "Intercourse with . . . ," in Frueh, *Hannah Wilke: A Retrospective*, p. 139.

50. Hannah Wilke, "I OBJECT Memoirs of a Sugargiver (Edition Coup de Couteau)," in *Hannah Wilke: A Retrospective* (Columbia: University of Missouri Press, 1989), p. 143.

51. Hannah Wilke, "Visual Prejudice," in *Hannah Wilke: A Retrospective*, p. 141.

52. "Letters," *Artforum*, Dec. 1974,: p. 9. In rebuttal Robert Rosenblum, in "Letters," *Artform*, Mar. 1975: p. 8, gave "three dildos and a Pandora's Box" to Benglis for bringing "out of the closet . . . the Artforum Committee on Public Decency and Ladies' Etiquette."

53. Lippard, "Intruders," Howell, *Breakthroughs*, p. 127.

54. Roth, "The Amazing Decade," pp. 21, 30.

55. Mary Jane Jacob et al., "Essays," in *The Amazing Decade*, p. 86.

56. Roth, "The Amazing Decade," pp. 30–32.

57. Kristine Stiles, "Readings: Performance and Its Objects," *Arts Magazine*, Nov. 1990, p. 41.

58. Roth, "The Amazing Decade," pp. 22–27. Other Performance artists singled out by Roth were Pauline Oliveros, Linda Montano, Donna Henes, Betsy Damon, and Barbara Smith.

59. Schneemann has not received as much credit as she deserves. She entered the art world in the ambience of the happenings group but too late to be included among its leading practitioners. When feminism emerged around 1970, she was in London, returning only in 1973, again too late to be included among its innovating artists.

60. Andrea Juno, "Carolee Schneemann," in Andrea Juno and V. Vale, eds., *Angry Women* (San Francisco: RE/search Publications, 1991), pp. 68–69.

61. Roth, "The Amazing Decade," p. 22.

62. Carolee Schneemann, *More Than Meat Joy: Complete Performance Works & Selected Writings* (New York: McPherson/Documentext, 1979), p. 63.

63. During the Vietnam War, Schneemann made antiwar films: *Snows* and *Viet-Flakes*, as well as exploring her body.

64. Juno, "Carolee Schneemann," p. 67. (Italics in original.)

65. Schneemann, *More Than Meat Joy*, p. 234.

66. Roth, "The Amazing Decade," p. 14. (Italics in original.)

67. Interview with Carolee Schneemann, New York, Dec. 18, 1992.

68. Thomas Albright, "Guess Who's Coming to Judy Chicago's Dinner," *Art News*, Jan. 1979, pp. 60–62: "The number of participants were arrived at because 'there were 13 at the Last Supper and there are also traditionally 13 people in a coven of witches,' Chicago explains. 'I found it intriguing that the same number is associated with male holiness and feminine evil.'"

69. See Gouma-Peterson and Mathews, "The Feminist Critique of Art History," p. 342.

70. Maureen Mullarkey, "Dishing it Out: Judy Chicago's 'Dinner Party,'" *Commonweal*, Apr. 10, 1981, p. 211.

71. Lucy R. Lippard, "Judy Chicago's 'Dinner Party,'" *Art in America*, Apr. 1980, p. 118.

72. Ronald J. Onorato, "Review: San Francisco: Judy Chicago," *Artforum* (Summer 1979): 76.

73. Lippard, "Judy Chicago's 'Dinner Party,'" p. 125.

74. Gouma-Peterson and Mathews, "The Feminist Critique of Art History," p. 342.

75. Jo-Anna Isaak, "Nancy Spero: A Work in Comic Courage," in Dominique Nahas, *Nancy Spero: Works Since 1950* (Syracuse, N.Y.: Everson Museum of Art, 1987), p. 27. See Lisa Tickner, "Images of Women and *la peinture feminine*," in *Nancy Spero*, (London: ICA, 1987), p. 5.

76. Kate Horsfield, "On Art and Artists: Nancy Spero," *Profile* 3, no. 1 (Jan. 1983): 8

77. Jeanne Siegel, ed., *Artworks 2: Discourse on the Early 80s* (Ann Arbor, Mich.: UMI Research Press, 1988), p. 261.

78. Dena Shottenkirk and Nancy Spero, "Dialogue: An Exchange of Ideas Between Dena Shottenkirk and Nancy Spero," *Arts Magazine*, May 1987, p. 34.

79. Jeanne Siegel, "Nancy Spero: Woman as Protagonist," *Arts Magazine*, Sept. 1987, p. 13.

80. Lucy Lippard, *A Different War: Vietnam in Art* (Seattle: Real Comet Press, 1990), p. 42.

81. Nancy Spero, in Lenore Malen, ed., "Symbolism: Contemporary Manifestations," *M/E/A/N/I/N/G*, 8 (Nov. 1990): 8.

82. Ibid.

83. Ibid.

84. Shottenkirk and Spero, "Dialogue," p. 34.

85. Rosetta Brooks, *Nancy Spero* (Philadelphia: Lawrence Oliver Gallery, 1987), n.p.

86. Lynne Cooke, "Neo-Primitivism," *Artscribe International*, Mar.–Apr. 1985, p. 22.

87. Shottenkirk and Spero, "Dialogue," p. 35.

88. Storr, "Louise Bourgeois," p. 129.

89. Henry M. Sayre, *The Object of Performance: The American Avant-Garde since 1970* (Chicago: University of Chicago Press, 1989), pp. 86–87.

90. Barbara Zucker, in "The Women's Movement: Still a 'Source of Strength' Or 'One Big Bore'?" *Art News*, Apr. 1976, p. 48.

91. Joyce Kozloff, in "The Woman's Movement: Still a 'Source of Strength' Or 'One Big Bore'?" *Art News*, Apr. 1976, p. 49.

4 PATTERN AND DECORATION PAINTING

In their search for new form and content, artists turned to the crafts and decoration. Feminists led the way because handicrafted decoration had historically been women's work—or, as feminists insisted, art—and they sought, as Miriam Schapiro commented, to have their "art speak as a woman speaks."[1] But should handicrafted objects, denigrated as "low" by art-world "elitists," be considered art? Or only that work in which craft materials and techniques were employed with the clear intention of being "high" art? Chicago mixed "high" and "low," using craftspersons in collaborative works. Schapiro and most art-world feminists had only "high" art in mind. They created new decorative styles, collectively labeled pattern and decoration painting.

Pattern and decoration painting looked fresh, even somewhat shocking, because it announced itself as decoration, and the modernist artists in the New York School considered any art that was decorative and—worse—incorporated sewing, weaving, embroidering, and any other functional craft as little better than kitsch or, at best, minor. In contrast, painting was supposed to be disinterested and occupied with "serious" matters. Abstract artists in particular were hostile to decoration because their own art was often characterized as *merely* decorative, implying that it was lacking in higher or deeper meaning.

Like modernists, many pattern and decoration painters, notably feminists, did make extra-aesthetic claims for their work, but other colleagues, generally male, dismissed all such rationales. Art critic Amy Goldin declared boldly that "decoration is typically . . . contentless," and art critic Jeff Perrone added that it is "cant" to pretend that it is "something other than decorative. Decorative art doesn't need to be written about much—it should simply provide a feeling of its beauty. Why have all these pumped-up theories about an art that, fundamentally, is supposed to be directly attractive to the eye?"[2]

Pattern and decoration painters not only had to rebut the attack on their work because it was decorative but also because it was painting. Minimal and postminimal artists and their advocates had waged a

polemical war against painting, with considerable success. As late as 1975, the editors of *Artforum*, in a special issue devoted to the current state of painting, claimed that a large segment of the art world—including the editors themselves—had come to believe "that painting has ceased to be the dominant artistic medium at the moment. [Artists] understood to be making 'the inevitable next step' now work with any material but paint."[3] As Tom Lawson remarked: "Put simply, [*Artforum's*] editors were of the opinion that . . . as a means of making advanced, ambitious art [painting] had been finally overtaken and rendered obsolete by the vast array of alternate media made respectable during the Sixties and early Seventies."[4]

But who had decided what art was ambitious and viable? In the opinion of Max Kozloff, an editor of *Artforum*, it was "Conceptualists [who] have monopolized *theory*, and it is quite enough for them to stick painting with the label *dépassé*." He went on to say that "brush wielders were [accused of being] afflicted by a creative halitosis."[5] But the very success of the attack on painting gave rise to a backlash. Important art-world professionals had come to view painting as antiestablishment and thus cutting edge. Even within minimal art there had emerged a new reductive painting—that of Robert Ryman, Brice Marden, and Robert Mangold—which was receiving growing art-world attention. However, many conventional painters and their advocates rejected pattern and decoration painting because it incorporated fabric, which, as Robert Kushner maintained, they were unable "to see . . . as equivalent to a painted surface."[6] But such criticisms only helped pattern and decoration painters to avoid the stigma of academicism.

If painting in itself was problematic in the 1970s, it was doubly so when it contained recognizable images, and much of pattern and decoration painting did. Robert Zakanitch recounted his confusion when he first painted "a flower, a pattern." He had been steeped in formalism, which had proscribed referential motifs. And now, his "paintings were about . . . things that looked irretrievably decorative [and that] was very scary because decorative elements were an anathema to be shunned and avoided at all cost. . . . Here was the beginning of something new and I really wasn't sure of where it fit into what I knew about painting but it felt like . . . it was mine."[7] Coupling figuration and abstract patterning, Zakanitch's pictures—and pattern and decoration painting generally—looked different enough from what art was supposed to look like that Joyce Kozloff could credibly suggest that it constituted "a third category of art . . . which is neither representational nor abstract."[8] But as such it was also related to the sculpture of Joel Shapiro, Bryan Hunt, and Nancy Graves and to new image, or "bad," painting (discussed in chapter 6), all of which seemed peculiarly *of* the middle 1970s.

Even as late as 1976, when Zakanitch wrote his statement, decorative painters felt the need to come to terms with the by then well-established formalism and particularly minimalism. Pattern and decoration

painting had been influenced by minimal art; as museum director Janet Kardon wrote: "The ubiquitous grid lies at the heart of decoration as it does at the heart of minimalism."[9] And both were repetitive and nonhierarchical, modular, or serial. But pattern and decoration painting differed from minimal art because its designs were drawn from past and existing decorative styles. Moreover, in reaction against the puritanical austerity and aloofness of minimal art, it was hedonistically opulent and accessible. Schapiro recalled that she, Kozloff, and Zakanitch, among others, "wanted to revitalize the sensuousness of painting. . . . It was really a pendulum swing away from reductivism, and we talked about that."[10] In sum, pattern and decoration painting was antiminimalist in its employment of rich color, personal handwriting, and sumptuous texture. As Valerie Jaudon remarked, "It is an attitude which is inclusive rather than exclusive."[11] Still the decorative painters felt embattled. Intimidated by formalist and minimalist rhetoric, they felt called upon to repudiate it. Joyce Kozloff, in a polemic titled "Negating the Negative (An Answer to Ad Reinhardt's 'On Negation')," called for an art of affirmation: additive, personal, decorative, lyrical, rococo, eclectic, exotic, complex, ornamented, and warm.[12] Decorative painters who equated formalism and minimalism with modernism identified themselves as anti- or postmodernist. They related pattern and decoration painting to postmodern architecture, which, in reaction against the international style, had incorporated decoration, much of it appropriated from premodernist styles.

Decorative artists met to discuss what their art signified. Should not art aspire to break down barriers between "high," or "elitist," art and "popular," and/or folk, art? Should it not be close to "life," a "populist" art that would "communicate"? Above all, as Schapiro remarked, they "talked about our relation to decorative objects and artifacts"[13] generally neglected in the art world, not only quilts and other works traditionally made by Western women but non-Western art, notably, Islamic decoration and architecture, Japanese kimonos, Mayan weavings, Mexican tiles, and Moroccan ceramics. Pattern and decoration painters were inspired by a growing number of museum shows devoted to the decorative arts, among them an exhibition of Persian manuscripts, *A King's Book of Kings: The Shah-nameh of Shah Tahmasp*, at the Metropolitan Museum of Art (1972), and a show of kimonos, *Tagasode = Whose Sleeves . . . Kimonos from the Kanebo Collection*, at the Japan Society in New York City (1976).

The new decorative painters also looked to the fabrics, kitchen utensils, clothing, and architecture designed by the Russian constructivists and suprematists. They were influenced by extravagant stage and ballet decor—for example, Leon Bakst's sets and costumes for the Ballets Russes de Monte Carlo—not surprising given the central role of theatricality in the sensibility of the 1970s. It is significant that Kushner should have begun his career with performance pieces.

"High" art also interested pattern and decoration painters, notably

that of Matisse and of two of their contemporaries, George Sugarman and Frank Stella. In the early 1970s Sugarman had constructed a series of sheet-metal reliefs whose profuse forms and exuberant color stunned decoration-minded painters [52]. He became a kind of father figure to younger painters and exhibited with them, even though his attitude toward decoration in art was ambivalent. Stella's 1967 protractor canvases, comprising high-keyed, interlaced circular and semicircular bands and the inner shapes they formed, were openly decorative. He said: "My main interest has been to make what is popularly called decorative painting truly viable in unequivocal abstract terms [and] so strongly involved with pictorial problems and pictorial concerns that they're not conventionally decorative in any way."[14] Later reliefs, composed of garishly painted sheet aluminum, which Stella called "pictures," owe much to Sugarman's sculpture and are even more decorative. Stella's rationale for this work was formalist [53]. As he saw it, painting had become debilitated, and in order to be revitalized had to extend physically into

52. George Sugarman, *Baltimore Federal* (detail), 1975. *(Courtesy of the artist)*

53. Frank Stella, *Dove of Tanna* from the *Exotic Bird Series*, 1977. *(Copyright © 1994 Whitney Museum of American Art, New York)*

actual space. Pattern and decorative painters rejected his formalist rhetoric but were very taken with what they saw in the work.

Finally, pattern and decoration painters and their supporters theorized about the universality of decoration and whether there was an inherent human disposition for it—perhaps even a psychic structure, like that for language. Speculation about the universality of decoration was in the air; the publication in 1978 of *The Sense of Order: A Study in the Psychology of Decorative Art,* by the eminent English art historian Ernst Gombrich, was taken as a sign, even though he had no connection with the pattern and decoration movement. Gombrich proposed the existence of an underlying order in the universe, whose cardinal features are pattern and symmetry. Just as human anatomy is symmetrical, so there is a psychological disposition to order, hence the presence of pattern and symmetry in the arts of all peoples.[15]

Schapiro and Chicago were among the first artists of their generation to experiment with decorative painting. In the feminist art programs they founded in the early 1970s, decoration and the handicrafts as both intellectual issues and artistic strategies were major topics of discussion. At roughly the same time, Amy Goldin, a visiting professor at the University of California at San Diego during the 1970–71 academic year, began to assess the artistic potential of decoration, especially Oriental artifacts and Islamic architecture. Her teaching was particularly influential on her students Kushner and Kim MacConnel. In 1972 the two young artists mounted a joint show of their work, *Decorations.* In articles published between 1975 and 1978, Goldin established a rationale for dec-

orative art, based on pattern and sensuous color, whose aim was to provide pleasure.

Goldin was also a catalyst in bringing together the artists inclined to the decorative. In 1974 they began to meet in New York to discuss aesthetic issues. In February 1975 the first public discussion took place at Artists Talk on Art, at my suggestion. "The Pattern in Painting" included Martin Bressler, Rosalind Hodgkin, Valerie Jaudon, Tony Robbin, and Mario Yrissary. Holly and Horace Solomon also invited pattern and decoration painters to meet at their "alternative space" at 98 Greene Street in SoHo and, when they opened a gallery on West Broadway in 1975, to exhibit there. But, the shared outlook of pattern and decoration painters notwithstanding, they created individual styles.

Miriam Schapiro first came to art-world attention in the 1950s as a second-generation abstract expressionist. In the early 1960s she turned to painting hard-edge abstractions, several of which contained central-core images, anticipating a feminist concern with an essentially female subject matter. Schapiro's activities in the feminist art movement began to influence her painting in 1972. As her contribution to Womanhouse, in collaboration with Sherry Brody she constructed a miniature *Dollhouse*, in which they incorporated a variety of decorative fabrics. She later recalled having been "overwhelmed by seeing *The King's Book of Kings* in the Metropolitan [Museum]. . . . I was struck by the miniature aspect [and] by the relationship between the geometrizing of the page; the flora and fauna inside, moving out into the borders. I could not get over that."[16]

Dollhouse was a turning point in Schapiro's art. In her subsequent "femmages" she overlayed "patterns" with "paint, fabric, photography, tea towel, ribbon, lace, and glue," in order to create "an opulent, multilayered, eccentric and hopeful abstract art. [54]"[17] Thus, she combined geometric design, recalling her hard-edge abstraction, with an exuberant patchwork, reminiscent of her abstract expressionist painting—using the one as a foil against the other.

Paraphrasing Schapiro, art critic Carrie Rickey wrote that her "passion for needlework, quilts and clothing by anonymous American women inspires her to create works of art in their image."[18] Each "substance in the collage [was to] be a reminder of a woman's dreams."[19] Moreover, she shaped her pictures into kimonos, houses, fans, and valentines. About a collage that contained a handkerchief Schapiro said:

> Sentimentality for me is a very powerful idea. . . . I crunch the handkerchief on a grid. . . . The grid is there to indicate that this is about order, this is about form, but the [handkerchief is] there so you can cry when you remember all the tears which soaked all the handkerchiefs from time gone by. My curious esthetic sense counts on the merger of the grid and the handkerchief.[20]

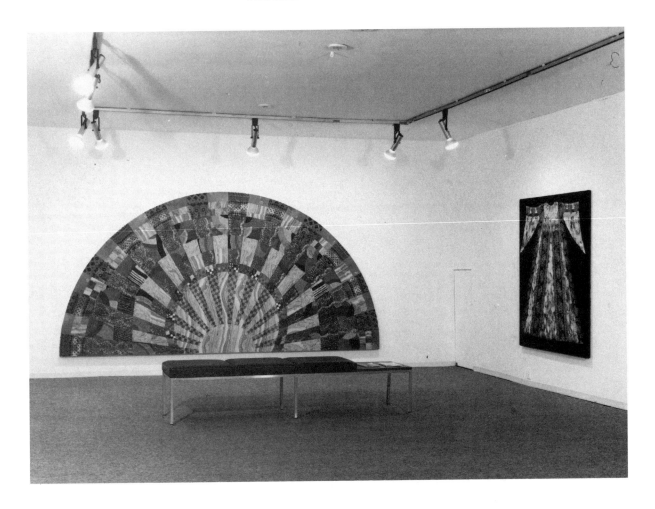

The grid was also important to Schapiro because it signified "high" art. So did paint, which she combined with diverse materials. The "big" size of her pictures was a sign of ambitious painting—at a time when the art world equated small with minor. But size had another function. Schapiro said that "the fan is a trivial, insignificant aspect of women's culture. I heroicize it. I make the fan twelve feet long."[21]

54. Miriam Schapiro, Installation at Lerner-Heller Gallery, *First Fan*, 1976–77 and *Paisley/Leaf Vestituro*, 1979. *(Courtesy of the artist)*

Zakanitch had been a color-field painter until around 1974, when he met Schapiro in California. He recalled that "at the time, 'decorative' was a very bad word."[22] Nonetheless he began to paint flowers, fruits, and vegetables, while retaining his formalist concern with "flatness, overallness, and large scale." Zakanitch integrated the figurative motifs into an abstract grid or lattice infrastructure and painted them energetically in rich colors. He wanted, as he said, "to create paintings of exotic, joyful expansiveness."[23] Because the gestural quality of his facture calls to mind abstract expressionism, Zakanitch can be considered *the* expressionist pattern and decoration painter [55].

* * *

Joyce Kozloff's first New York show in 1970 consisted of paintings based on architectural motifs in Greek temples she had seen in Sicily two years earlier. Traveling in Mexico in 1973, she was struck by the patterns in native pottery, textiles, and architecture, particularly the brick- and tilework on eighteenth-century Churrigueresque church facades, and she based a series of paintings on them.[24] Kozloff became convinced that decoration "humanizes our living and working spaces"[25] and provides ways in which "men and women have always transformed the banal into the extraordinary."[26] She also began to question whether such work created by anonymous groups of women and Third World craftspersons was inferior to Western "high" art, and concluded that it was not.

In 1974 Kozloff became interested in Islamic patterns and in the following year took a trip to Morocco, where she studied mosque architecture and ornament, paying particular attention to how the two were integrated. This encouraged a move beyond the limits of painting into environmental art. She said: "I had begun to think of my paintings as walls, but they weren't walls. . . . I decided to move onto the walls and to decorate a room—that is, an environment in which the ornament would be literal and palpable." To do this she began to make ceramic tiles and print fabric. The upshot was *An Interior Decorated* (1979–81) [56], an environment made up of ceramic tile mosaics, silk hangings, and lithographs. Kozloff remarked that it was a "personal anthology of the decorative arts." Her catalog of worldwide motifs included

> American Indian pottery, Moroccan ceramics, Viennese Art Nouveau
> book ornament, American quilts, Berber carpets, Caucasian kilims,
> Egyptian wall paintings, Iznik and Catalan tiles, Islamic calligraphy,
> Art Deco design, Sumerian and Romanesque carvings, Pennsylvania

Dutch signs, Chinese painted porcelains, French lace patterns, Celtic illuminations, Turkish woven and brocaded silks, Seljuk brickwork, Persian miniatures and Coptic textiles.[27]

In 1979 Kozloff was given the opportunity to move her room-size works into public spaces.[28] She paid particular attention to the decorative styles, popular culture, and history associated with each site, devising schematized figurative motifs that would be recognized by the average passerby. She said that she "made cultural portraits of the cities in which the pieces are situated." For example: "The [work in the] Buffalo subway station is about Buffalo. It's a combination of decorative forms taken from Seneca Indian jewelry, from Art Deco buildings in the city, and

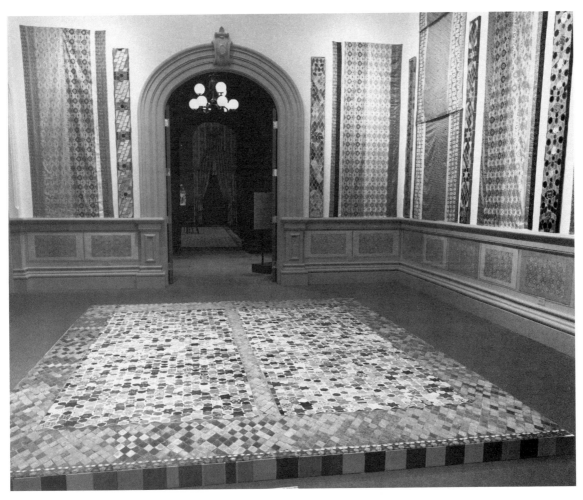

56. Joyce Kozloff, *An Interior Decorated*, installation in the Renwick Gallery of the Smithsonian Institution, Washington, D.C., 1980.

from local Louis Sullivan and Frank Lloyd Wright landmarks."[29] In this and her other public installations, Kozloff achieved a "coming together of painting, sculpture, architecture and the applied arts."[30]

In 1976 Cynthia Carlson began to make "works only using pieces of thick paint glued directly to the wall itself as installations, titled, with tongue in cheek, 'wallpaper pieces.'" Carlson soon embellished entire rooms with all-over patterns of brushstrokes in relief, breaking down distinctions between "previously separated categories 'decoration' and 'art'"[31] and between painting, sculpture, and architecture [57].[32]

Like Kozloff, Ned Smyth was inspired by architecture. In his first show in 1974, he exhibited sculptures of buildings composed of modular cast concrete blocks and curved archlike elements. Like the "houses" and "chairs" of Joel Shapiro, they were balanced on the edge between minimalist abstraction and recognizable imagery, calling to mind toys—more specifically, building blocks—and at the same time, the history of architecture. Smyth's work soon became more complex and elaborate; the columns and capitals, resembling schematized palm trees, were arranged to suggest Egyptian, Roman, and Gothic arcades.

57. Cynthia Carlson, *Picture That in Miami*, 1982. *(Lowe Art Museum, Coral Gables, Florida)*

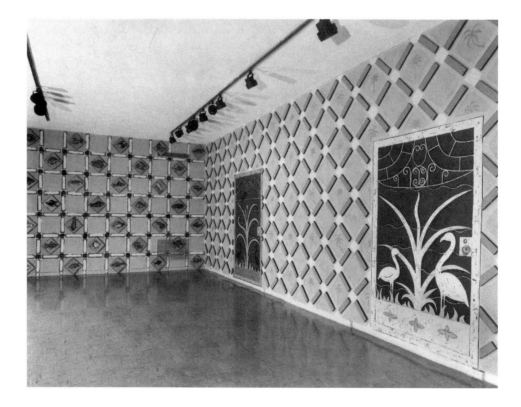

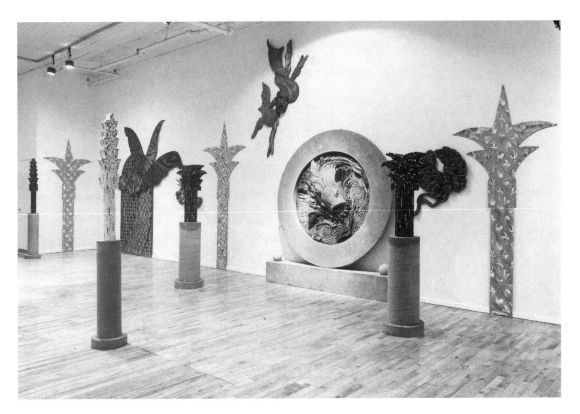

58. Ned Smyth, *Adoration/Adornment,* installation at Holly Solomon Gallery, New York, detail view, January 1980. *(Courtesy Ned Smyth)*

Smyth then decorated the columns and capitals with mosaic tile and other materials, and introduced figurative motifs, which he interspersed with the abstract [58]. Like Kozloff, he was commissioned to create works for public places.[33] In 1979 he wrote: "Decoration represents a move . . . towards humanism. I want to seduce, excite and move people by amassing decorative, physical, historical and archetypal images and objects. . . . Each of the disciplines—architecture, painting, stained glass—becomes a detail in a larger pattern."[34]

More than any other decorative painter, Valerie Jaudon focused on abstract patterning. Her pictures of the 1970s, composed of allover designs of interwoven ribbonlike bands, call to mind ancient Celtic interlace as well as Stella's monochromatic stripe paintings. In the 1980s Jaudon's painting became increasingly complex [59]. Design became asymmetrical, overlapping linear configurations generated illusionistic space, perspectives became multiple, monochrome gave way to color, and surfaces became richly textured. Her imagery also changed, becoming recognizable, reminiscent of cathedral vaults, arches, and windows.

59. Valerie Jaudon, *Zama,* 1982. *(Sidney Janis Gallery, New York; © Valerie Jaudon/VAGA, New York, NY)*

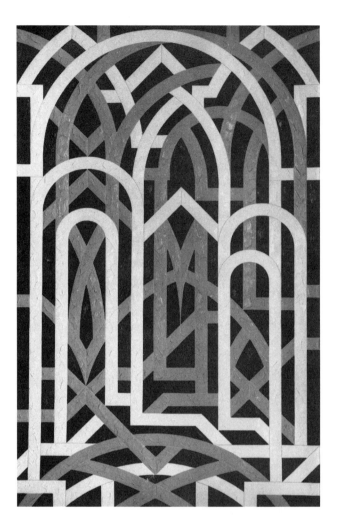

Lynda Benglis first came to art-world attention as a process artist who worked in the area between painting and sculpture. In 1970, inspired by the poured paintings of Pollock, the stained canvases of Helen Frankenthaler and Morris Louis, the poured sculpture of Richard Serra, and the scatter sculptures of Barry Le Va, she puddled cosmetic-colored latex directly onto the floor, the solidified paint becoming a lava-like sculptural form.

In 1972 Benglis began to make a series of relief sculptures that look like drapes that are knotted in the middle and fan out, this shape becoming her signature image. These pleated and fluted bowlike forms, at times sprinkled with glitter, are rich in associations—for example, to women's jewelry and clothing, and the human torso [60].

A seminar that Robert Kushner took with Amy Goldin at the University of California at San Diego in 1969 led him to consider the

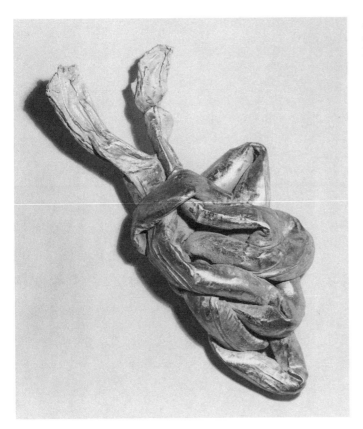

60. Lynda Benglis, *X-Ray*, 1973–74. *(Paula Cooper Gallery, New York; © Lynda Benglis/VAGA, New York, NY)*

possibilities of decoration in art. In 1971 he began staging performances featuring extravagant costumes that he designed and made. Three years later he traveled to Afghanistan, Iran, and Turkey with Goldin. "That really cemented a lot of feelings about decoration which I had been toying with. . . . Islamic culture is a decorative culture."[35] In *Persian Line*, at the Kitchen, a performance space in New York City, in 1975, the audience was presented with a row of outlandish hats, Iranian women's face coverings, and capes. Several male and female models in everyday clothes walked on, undressed, put on the costumes, and sashayed about, while Kushner made satiric comments in the manner of a fashion-show host. After the performance the capes and hats were put on display [61].[36]

Holly Solomon, Kushner's dealer, recalled that he "told her that he wanted to elevate decoration and fashion to a higher aesthetic status. Decoration and fashion were the most derogatory categories in art, he said, and what interested him was trying to lift them up, just as the Pop artists had elevated commercial art."[37] Kushner incorporated a broad variety of textiles and dress trimmings, such as sequins and glitter, in his paintings. He also introduced images, appropriated, as he said, from "the Burpee Seed Catalogue, Paul Poiret, Matisse, Busby Berkeley and the Watts Towers,"[38] as well as Leon Bakst's decor, Chinese scrolls, wallpaper,

61. Robert Kushner, *Lotus,* from *Travelling* (performance), 1983. *(Holly Solomon Gallery, New York)*

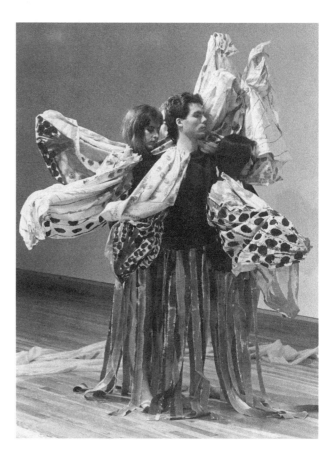

plastic trays, and what have you. His gaze was indeed "promiscuous," as Janet Kardon commented [62].[39]

Above all Kushner was "obsessed by Matisse," and not only because his work was decorative:

> My drawing sensibility really comes very directly from Matisse and the way he, I think, reconceived the issue of drawing in the twentieth century. . . . If I am drawing a figure, I really want the figure to feel like it has weight to it, which I think was Matisse's great contribution to modernist draftsmanship—simplifying it to the ultimate, but always maintaining volume, even if it was only a line. And that's what I think about.

As for the content of his work, Kushner believed that it was "'about happiness.' [with] intelligence. [There's] a commonly held misconception that if you make things that are about happiness or joy, it's mindless and dumb. And that certainly couldn't be further from the truth. Witness Matisse; witness, at his best, Dufy; at his most optimistic, Gauguin; many, many, many Islamic artists and many Oriental artists."[40]

* * *

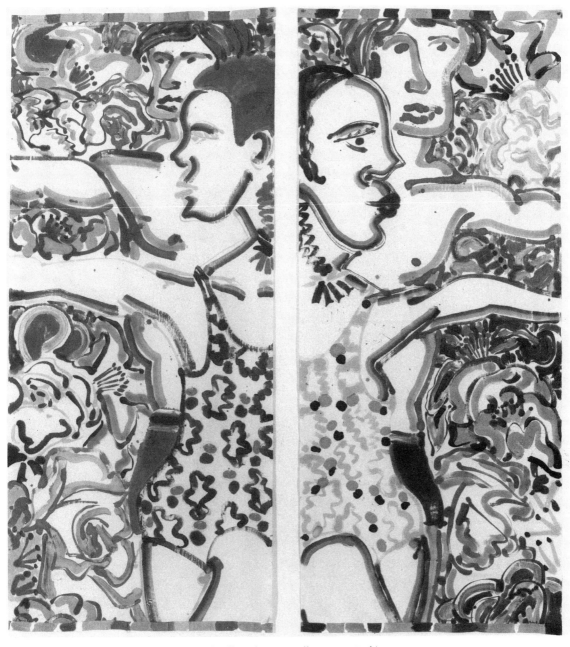

62. Robert Kushner, *Spring Love*, 1978. *(Holly Solomon Gallery, New York)*

Like his fellow student Kushner, Kim MacConnel was inspired by Goldin's teaching about the values of decoration. In the pictures for which he is best known, he cut strips from garish, mass-produced fabrics, for example, Hawaiian shirts, sewed them together, and overpainted them with patterns culled from the decorative arts as well as his own cartoonlike representations of anything that struck his fancy [63]. These

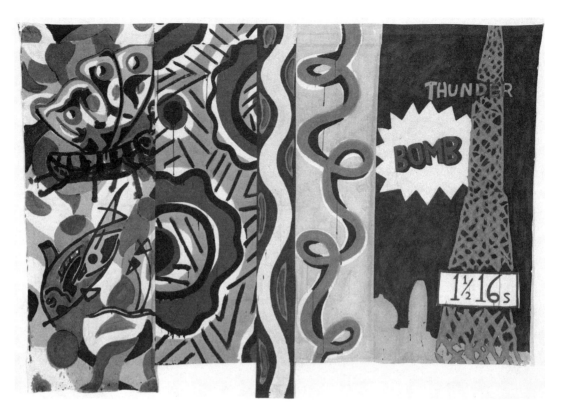

63. Kim MacConnel, *Thunderbomb*, 1981. (*Holly Solomon Gallery, New York*)

tacky textiles and crude pop images exemplified America's vulgar yet vital mass culture. They were also related to the newly emerging new image, or "bad," painting. MacConnel also moved decoration off the wall, acquiring used furniture and covering it with a cacaphonous mélange of kitsch images.

 In 1990 MacConnel traveled to West Africa. After his return he painted "abstract" pictures of vividly colored triangles and circles, based on African motifs from the outer walls of dwellings (decoration traditionally painted by women). He affixed to the surfaces of these works postcards and photographs of African daily life. Thomas McEvilley considered MacConnel's compositions postmodern because they looked like modernist abstractions but are in fact "representations of found visual elements from another culture. By this strategy MacConnel focuses attention on Modernism's originative root in African art." In a reversal of Western artists' appropriation of Third World art, he turned "Modernist abstraction back into African design." Moreover, unlike modernists who pirated "primitive" art without acknowledging its original context, MacConnel tried to document the living culture from which the imagery derived. He "thus weaves together a series of issues that constitute the

post-Modern agenda: women's issues, historicist issues, multicultural issues, intermedia issues."[41]

Thomas Lanigan-Schmidt and Judy Pfaff were often identified with the pattern and decoration painters because of the gaudiness of their vividly colored, profuse assemblages. Like most pattern and decoration artists, they were represented by the Holly Solomon Gallery. However, neither Lanigan-Schmidt nor Pfaff was primarily interested in art as decoration.

Lanigan-Schmidt pieced together found bits of tinfoil, colored cellophane, Saran Wrap, old postcards and greeting cards, holy pictures tarted up with glitter, sequins, dime-store gems, and other glitzy urban detritus into religious objects—altars, icons, chalices, and crowns [64]. Their tackiness was intentional; Lanigan-Schmidt's vision was that of a Catholic, ethnic, working-class child, very conscious of his background and the kind of extravagant religious kitsch-"art" he grew up with—and proud of it.[42] He remembered winning a thrift-shop "mother-of-pearl crucifix with a gold plastic Jesus on it which still hangs in my parents' bathroom. It's a nice crucifix, it held up over time, and the gold plastic Jesus has a bit of patina to it now."[43] Lanigan-Schmidt embraced the poor and inexpensive materials of consumer society because they were identified with his family and the class they were part of. He cultivated—with dignity—their bad taste, precious sentimentality, and wonder in order to define the way they expressed themselves, their religious conviction, and their "self-worth in a society that considers them almost worthless."[44]

Museum curator Roger S. Wieck described the first major piece that Lanigan-Schmidt exhibited, in his own downtown New York City apartment in 1969:

> *The Sacristy of the Hamptons* [was] a kind of medieval treasury [consisting of] vestments such as miters, chasubles, stoles, and a bishop's ring; relics of the True Cross, the Crown of Thorns, a hair of Christ, and the Virgin Mary's veil, as well as sand and grass from the Holy Land; crosses, books, chalices, and chalice palls; a crown of the Infant King; regal paraphernalia such as crowns and an orb; and the Thirty Pieces of Silver (two sets).[45]

Lanigan-Schmidt's works do not embody only a beatific vision. They also represent and condemn evil, exemplified by the rat-ridden *The Preying Hands: In a Little Corner Chapel to Mammon in the Cathedral of Moloch Greed Makes Human Sacrifice Expedient Upon the Altar of Racism, Displacement and Gentrification* (1982–83). Moreover, they contain autobiographical imagery, mainly from childhood and often shockingly self-revealing. For example, *A Rite of Passage* (1985), is composed of 125 pictures, framed by lasagna pans, which recount a boy's coming-of-age in the oppressive environment of a New Jersey refinery town.[46]

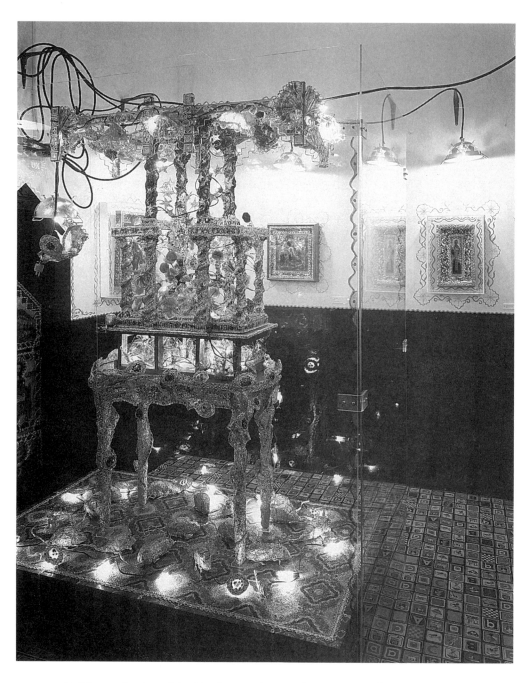

64. Thomas Lanigan-Schmidt, *Grace and Original Sin: Saints and Sinners (Two Seconds Before the End of the World)*, 1979. *(Holly Solomon Gallery, New York)*

Lanigan-Schmidt's seriousness was frequently called into question. In its seeming artlessness his work was thought to relate more to folk and outsider art than to high art. Viewers were often made uncomfortable, even embarrassed, by the seeming perversity of the "ersatz opulence of the worthless trash [that he] fetishized."[47] Indeed, his brand of "bad" art *did* have an element of parody and even camp, defined by Susan Sontag as the "love for the unnatural, for artifice and exaggeration."[48] Nonetheless Lanigan-Schmidt succeeded in transubstantiating tawdry materials into authentic sacramental works of art.[49] One critic actually saw in his "redemption of junk . . . a metaphor for Christ's salvation of man."[50]

Judy Pfaff, like Lanigan-Schmidt, used a mélange of diverse materials, though hers were not found but new, purchased from lumberyards, hardware stores on Canal Street, and novelty shops. Compared to Lanigan-Schmidt's works, which emphasize their source in real life, Pfaff's are abstract. She pieced together colored plastics of all kinds, wires, contact paper, sheet metal, wood, screening, paint, and so on, into wall-to-wall, floor-to-ceiling assemblages of three-dimensional construction and sculpture, and two-dimensional collage and painting [65].[51]

These theatrical environments are related to postminimal works that spread into their surroundings, such as those of Richard Tuttle, Barry Le Va, Lynda Benglis, Alan Saret, Richard Serra, Bruce Nauman, and Alan Shields, all of which "looked very good to me and very smart." She also said: "I share a lot of turf with [Stella] as I obviously did with Graves, Calder, Sugarman and many others."[52] But above all, in its complexity and ambiguity, Pfaff's work is related to that of her teacher and friend Al Held.

Stunned by the profuse and seemingly formless quality of Pfaff's walk-in, room-size installation titled *Deepwater* (1980), Linda Nochlin wrote:

> Thin, flexible, stick-like forms cantilevered from the walls, wavered like elongated stalks of coral—pink, pale lemon, yellow, and red. A tangled deep-sea mesh of the same unidentifiable material dangled mid-air; other clusters and hazy raffia spokes—blond and pale blue and scarlet—spurted up from the floor, rippling in non-existent currents, or zigzagged from the ceiling. [The walls of the gallery were] smeared and streaked with enormous brush strokes of red, blue and more aggressive black paint. [The upshot] was a kind of three-dimensional *déreglement des senses* . . . daring, risky, on the brink of chaos, if not completely overboard, yet in some sense paradigmatic of a new and inventive kind of ordering.[53]

Although Pfaff's abstract configurations initially look disordered, random, and unfocused, they contain "paths" of related motifs that bring them into focus. She was fundamentally a formalist in that she aspired to

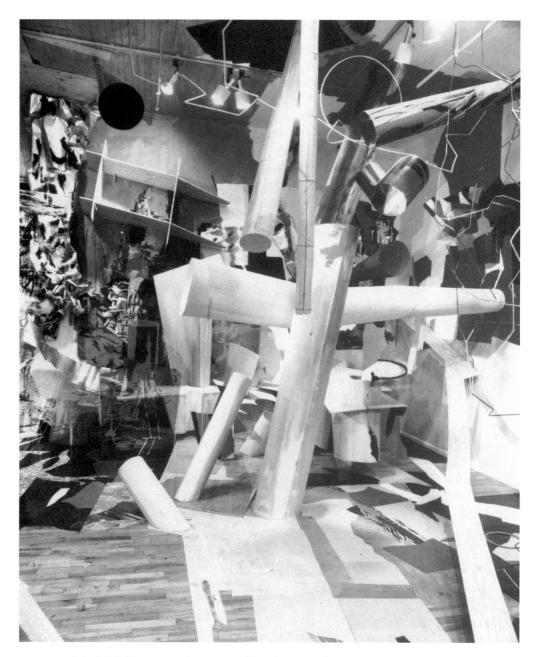

65. Judy Pfaff, *3 D,* installation at Holly Solomon Gallery, New York, January 1983. *(André Emmerich Gallery, New York)*

expand the language of abstract art and was concerned with formal rela-
tionships. As she said: "Formal concerns . . . color, form, light, time,
space . . . dominate the decisions in the work. What appears to be the
subject of the work is undisciplined energy. Ironically, what keeps me
involved with the work is the juggling of formal complexities."[54] The

seeming randomness and lack of focus notwithstanding, the viewer can make out and track the abstract configurations. A circle, for example, permutates from a simple line drawn on the wall or formed in wire into elaborate geometric or meshlike structures into solid columnar or hollow, megaphonelike cones. Nonetheless, Pfaff carried form to the edge of chaos, and this was her original contribution to formalist construction-sculpture.

In 1982 Pfaff began to build portable wall reliefs that looked like fragments of her installations [66]. She introduced into them common objects and images, commenting that "because of a fascination with the urban, I have used commercial signs, letters, still life, even figuration to conjure specific results."[55] In the reliefs, structure became clearer, underlining her concern with formal qualities. Her command of form is most evident in the intricate wire constructions she used to project her works off the wall—inventive, spiderlike armatures that function as "bases," aesthetic tours de force where one would least expect them.

In her dizzying profusion of often unrelated components, whether environmental or studio, Pfaff succeeded in conveying "freneticism, nervousness and visual demand . . . and a kind of hysteria that feels as if it could only exist under the conditions we're living in."[56] The world, in her view, was "unsettled, unstable. It is raucous and staccato. The nerve centers are constantly changing. And an installation, with its total openness, allows me to plunge into that spacy void and edit the chaos into a dramatic and sensual environment."[57]

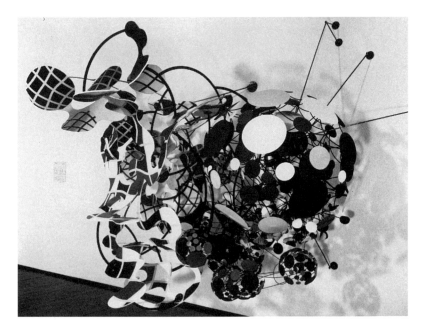

66. Judy Pfaff, *Es Possible*, 1989. *(André Emmerich Gallery, New York)*

NOTES

1. Miriam Schapiro, "Process and Ideology in an Opulent, Multilayered, Eccentric and Hopeful Abstract Art," in *Ten Approaches to the Decorative*, Sept. 1976, Alessandra Gallery (N.Y.), mimeographed typescript, n.p.
2. Jeff Perrone, "Fore-, Four, For, Etc.," *Arts Magazine*, Mar. 1980, pp. 84, 87.
3. Editors, "Painters Reply," *Artforum*, Sept. 1975,: p. 26.
4. Thomas Lawson, "Painting in New York: An Illustrated Guide," *Flash Art* (Oct.–Nov. 1979): 4.
5. Max Kozloff, "Painting and Anti-Painting: A Family Quarrel," *Artforum*, Sept. 1975,: p. 41.
6. Robert Becker, "Robert Kushner," *Flash Art* (Nov. 1984): 37.
7. Robert S. Zakanitch, in *Ten Approaches to the Decorative*.
8. Patricia Johnston, "Joyce Kozloff: Visionary Ornament. An Overview," *Joyce Kozloff: Visionary Ornament* (Boston: Boston University Art Gallery, 1986), p. 6.
9. Janet Kardon, "The Decorative Impulse," in *The Decorative Impulse*, (Philadelphia: University of Pennsylvania, Institute of Contemporary Art, 1979), p. 4. John Perreault made the same point in "Issues in Pattern Painting," *Artforum*, Nov. 1977, pp. 32–36.
10. Jan Avgikos, "The Decorative Politic: An Interview with Miriam Schapiro," *Art Papers*, Nov.–Dec. 1982, p. 8.
11. Valerie Jaudon, accompanying Carrie Rickey, in "Decoration, Ornament, Pattern and Utility: Four Tendencies in Search of a Movement," *Flash Art* (June–July 1979): 23.
12. Joyce Kozloff, in *Ten Approaches to the Decorative*.
13. Avgikos, "The Decorative Politic," p. 8.
14. William S. Rubin, in *Frank Stella* (New York: Museum of Modern Art, 1970), p. 149.
15. See Suzi Gablik, "The Psychology of Decoration," *New York Times Book Review*, May 27, 1979, p. 7. A review of E. H. Gombrich, *The Sense of Order: A Study in the Psychology of Decorative Art* (Ithaca, N.Y.: Cornell University Press, 1979).
16. Ruth A. Appelhof, "Interview (May 1978 and February 1979)," in *Miriam Schapiro: A Retrospective: 1953–1980* (Wooster, Ohio: College of Wooster Art Museum, 1980), p. 48.
17. Schapiro, "Process and Ideology."
18. Miriam Schapiro, accompanying Rickey, in "Decoration, Ornament, Pattern and Utility," p. 23. In *The Decorative Impulse* Schapiro wrote that she wanted her art to be "an homage to anonymous decorators of the past, artist/makers from all over the world and throughout time who used repetitive motifs to embellish handmade utilitarian objects" (p. 31).
19. Schapiro, "Process and Ideology."
20. Paula Bradley, "Interview (November 1977)," *Miriam Schapiro: A Retrospective: 1953–1980*, p. 45.
21. Appelhof, "Interview (May 1978 and February 1979)," p. 48.
22. Kay Larson, "For the First Time Women Are Leading, Not Following," *Art News*, Oct. 1980, p. 68.
23. Zakanitch, accompanying Rickey, in "Decoration, Ornament, Pattern and Utility," p. 23.
24. Patricia Johnston, "Joyce Kozloff: Visionary Ornament: An Overview," pp. 1–2.
25. Joyce Kozloff, accompanying Rickey, in "Decoration, Ornament, Pattern and Utility," p. 23.
26. Joyce Kozloff, in *The Decorative Impulse*, p. 21.
27. Joyce Kozloff, in *Joyce Kozloff: An Interior Decorated* (New York: Tibor de Nagy Gallery, 1979), n.p.
28. Among Kozloff's major commissions between 1979 and 1985 were the Harvard Square Subway Station; the Wilmington, Delaware, Amtrak Station; the San Francisco airport; the Humbolt–Hospital Subway Station, Buffalo, New York; and the 1 Penn Center at Suburban Station, Philadelphia, Pennsylvania.
29. Hayden Herrera, "A Conversation with the Artist," in *Joyce Kozloff: Visionary Ornament*, p. 28.
30. Kozloff, accompanying Rickey, "Decoration, Ornament, Pattern and Utility," p. 23.
31. Cynthia Carlson, accompanying Rickey, in "Decoration, Ornament, Pattern and Utility," p. 23.
32. See David S. Rubin, "Cynthia Carlson: From the Decorative to the Commemorative," *Cynthia Carlson: Installations 1979–1989 (A Decade, More or Less)* (Reading: Pa.: Albright College, Freedman Gallery, 1989), p. 4.
33. Among Smyth's major public commissions were *Reverent Grove* for the Federal Building and U.S. Courthouse in St. Thomas, Virgin Islands, 1978; *A Part of the Whole* for the Prudential Insurance Company, Thousand Oaks, California, 1982; *Two Trees* for the Veterans Administration Hospital, Gainsville, Florida, 1983; *Plaza Lavoro* and *Mythic Source* for Pittsburgh, Pennsylvania, 1984; and *Upper Room* for Battery Park City, New York, 1986.
34. Ned Smyth, accompanying Rickey, in "Decoration, Ornament, Pattern and Utility," p. 23.
35. Robert Becker, "Robert Kushner," *Flash Art* (Nov. 1984): p. 38.
36. Janet Kardon, "Opulent Subversions," *Robert Kushner* (Philadelphia: University of Pennsylvania, Institute of Contemporary Art, 1987), p. 11.
37. Calvin Tomkins, "The Art World: Matisse's Armchair," *The New Yorker*, Feb. 25, 1980, p. 111.
38. Robert Kushner, accompanying Rickey, in "Decoration, Ornament, Pattern and Utility," p. 23.
39. Kardon, "Opulent Subversions," p. 12.
40. Becker, "Robert Kushner," pp. 35, 37–38.
41. Thomas McEvilley, "Kim MacConnel: The Irony of the Decorative," *Kim MacConnel: Hotel Beauregarde* (New York: Holly Solomon Gallery, 1991), n.p. See also Kim MacConnel, "Artist's Statement," in *Kim MacConnel: Decoc Terrae Africano* (Aspen, Colo.: Aspen Art Museum, 1990), p. 5.
42. Lanigan-Schmidt first experienced art in church and

learned about it from nuns in parochial school, who encouraged him to make art his mission. It was natural for him to create sacramental objects.

43. Thomas Lanigan-Schmidt, "Thomas Lanigan-Schmidt: Incarnation and Art," in Peter Occhiogrosso, *Once a Catholic* (Boston: Houghton Mifflin, 1987), p. 25.

44. Martin James Boyce, "Thomas Lanigan Schmidt: Joy of Life, Predestinationism and Class-Clash Realism," *Flash Art* (Nov. 1983): 60.

45. Roger S. Wieck, "Thomas Lanigan Schmidt: The Art of Transubstantiation," *Thomas Lanigan Schmidt: Halfway to Paradise* (New York: Holly Solomon Gallery, 1988), p. 11.

46. Paul A. Harris, "Art Review: Lanigan-Schmidt Exhibit Primitive, But Profound," *West County Journal*, Dec. 21, 1988 clipping in file of Holly Solomon Gallery, New York.

47. Aimee Rankin, "The Parameters of 'Precious,'" *Art in America*, Sept. 1985, p. 111.

48. Susan Sontag, "Notes on Camp," *Partisan Review*, (Fall 1964): 515, 526–27.

49. See Wieck, "Thomas Lanigan-Schmidt: The Art of Transubstantiation," pp. 10–19.

50. Howard N. Fox, introduction to *Directions*, (Washington, D.C.: Hirshhorn Museum and Sculpture Garden, Smithsonian Institution Press, 1979), p. 34.

51. Roberta Smith, "Art: Judy Pfaff: Undone and Done," *Village Voice*, Feb. 1, 1983, p. 93.

52. Helaine Posner, "A Conversation with Judy Pfaff," in *Judy Pfaff* (New York: Holly Solomon Gallery, 1988; and Washington, D.C.: National Museum of Women in the Arts, 1989), pp. 14–15, 20.

53. Linda Nochlin, "Judy Pfaff, or the Persistence of Chaos," in *Judy Pfaff*, pp. 6–7.

54. Posner, "A Conversation with Judy Pfaff," p. 16.

55. Ibid.

56. Judy Pfaff, interviewed by Sarah McFadden in "Expressionism Today: An Artists' Symposium," *Art in America*, Dec. 1982, p. 70.

57. Paul Gardner, "Blissful Havoc," *Art News*, Summer 1983, p. 74.

5 ARCHITECTURAL SCULPTURE

Pattern and decoration painting anticipated and in many cases influenced a number of artists who looked to architecture and furniture for inspiration, although their work was not particularly decorative. One of them, Scott Burton, was even included in a 1977 show titled *Patterning and Decoration*, and in 1979 he wrote a statement, "Decoration, Ornament, Pattern and Utility."[1] He commented that he was not interested in the painting aspect of the new decorative art, which he rejected as "nothing but one more conservative attempt to hold onto painting."[2] But he spoke glowingly of the "screens, curtains and hangings of Robert Kushner, Jane Kaufman and Kim MacConnel; the walls, floors and ceilings of Joyce Kozloff and Valerie Jaudon. . . . And there is an important related artist who has appeared at this time, too—Judith Shea, the clearest, most advanced artist who produces wearable objects [67]. Her work is clothing, not costume; she is rethinking the structure of Western garments."[3] Burton concluded: "New decoration . . . is leading back to the real social world of multi-class culture, and thus into the history of our time."[4]

Burton characterized utilitarian decoration as one of "two mutations [which] come out of sculpture and painting but leave them behind." The other was "the landscape architecture of George Trakas and the interior architecture of Siah Armajani." The "new building art," as Burton called it, consisted of site-specific works that refer to architecture.[5] Hence the label architectural sculpture, coined by Siah Armajani, is fitting.

Architectural sculpture was informed by a countercultural urge to carry art outside the precincts of the art world. It was also influenced by feminism. Many of the artists were women: Alice Aycock, Donna Dennis, Jackie Ferrara, Nancy Holt, Mary Miss, and Elyn Zimmerman. With this in mind feminists claimed that it was natural for women sculptors to be attracted to images of shelter. Lucy Lippard suggested that the biological and sexual roots of "shelter sculpture," as she labeled it, were in the female body.[6] Like Lippard, Donna Dennis believed that women sculptors were inherently inclined to build something around an interior space, a central core pregnant with meaning. She also pointed out that a

favorite girlhood activity was playing house—and the importance of childhood experiences in consciousness-raising. But architectural sculpture had other sources. All of its practitioners had been influenced by minimal and postminimal art, and when they felt the need of introducing something "more," as Dennis put it, one way was to place a triangular solid on a cube,[7] as Joel Shapiro had done in his "houses," and move the form out into the environment.

By 1980 a number of articles had appeared on architectural sculpture, the most important of which were by Lippard and Rosalind Krauss.[8] Lippard characterized traditional sculpture as "an autonomous object standing . . . in isolation from its environment." Modernist sculpture had become so autonomous that it was "totally deracinated"—like modern man. However, deracination had given rise to a counter-reactive "need to belong somewhere. . . . It is this need which is being answered by an increasing amount of . . . body-related 'architectural' sculpture sited in nature."[9] Lippard's attitude was countercultural. In contrast Krauss was formalist. She also defined modernist sculpture as the self-referential object detached from its surroundings, whether they comprised unbuilt landscape or built architecture. She then defined what she considered a new kind of postminimal or postmodern sculpture between landscape and architecture, characterizing it as "sculpture in the expanded field." As antecedents of architectural sculpture, Krauss offered labyrinths and mazes.[10]

Other sources were Robert Smithson's huge earthworks, which moved art out of an art-world context and took into account the nature of the landscape; Claes Oldenburg's proposals for monuments; Bruce Nauman's corridors; Gordon Matta-Clark's "anarchitecture"; Christo and

67. Judith Shea, *Helen's Vest*, 1977. *(Courtesy Max Protetch Gallery, New York)*

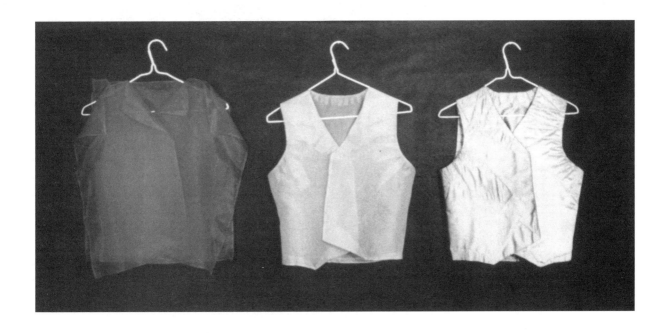

Jeanne-Claude's wrapped buildings; Robert Irwin's and James Turrell's installations; and Maya Lin's Vietnam War Memorial in Washington.[11]

The work of Christo and Jeanne-Claude was of particular interest to architectural sculptors because it was closer in size to architecture than to conventional art; impacted on the environment, if only temporarily, as architecture did; and was made of nonart materials. As early as 1962 the Christos built a pointedly political *Iron Curtain,* which was a barrier of used metal oil barrels stacked so as to block a Paris street. From 1964 to 1968, in a more poetic vein, they constructed storefronts whose windows were curtained so that the interiors were veiled in enigma. In 1968 they began to make use of existing architecture by wrapping actual buildings with fabric, contrasting the solidity of the structure with the fragility of the material; the first of these works was the Kunsthalle, in Bern, Switzerland, which they concealed under 27,000 feet of polyethylene.[12]

68. Christo and Jeanne-Claude, *Valley Curtain, Rifle, Colorado,* 1970–72. *(Copyright © 1972 Christo)*

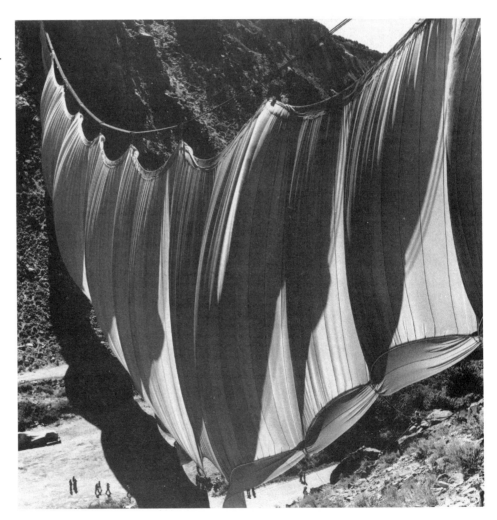

Christo and Jeanne-Claude took their wrapping out into nature in 1969, when they draped a cliff-lined Australian shore approximately 1½ miles long and 85 feet high with one million square feet of synthetic, woven straw-colored fabric and 36 miles of brick-colored polypropylene rope. *Valley Curtain* (1970–72) [68], an orange nylon curtain weighing 8,000 pounds, spanned a valley 1,250–1,368 feet wide in Rifle, Colorado. *Running Fence* (1972–76) [69], 24½ miles long and 18 feet high, consisting of 2,150,000 square feet of white nylon suspended from 2,050 metal posts, snaked through the fields of Sonoma and Marin Counties, California, plunging into the Pacific Ocean.

To realize these and other vast projects—"almost on the edge of the impossible, but that is the exciting part"[13]—Christo and Jeanne-Claude raised large sums of money, primarily through the sale of drawings, collages, original lithographs, and early works. (The cost of *Running Fence* was $3,250,000.) The enterprises involved retaining lawyers, ecologists,

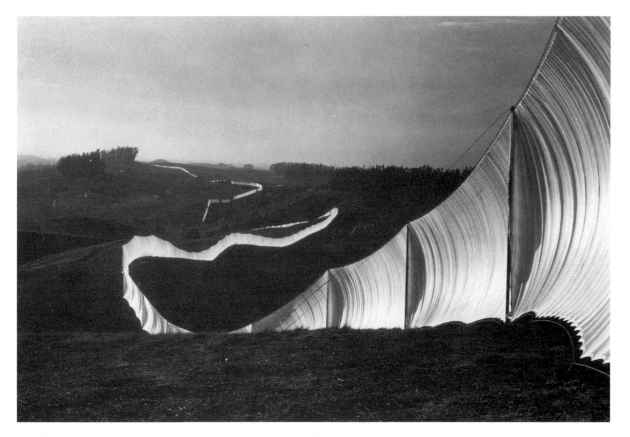

69. Christo and Jeanne-Claude, *Running Fence, Sonoma and Marin Counties, California,* 1972–76. *(Copyright © 1976 Christo)*

and laborers and enlisting judges and community leaders. In a sense the Christos were process artists who worked with people, negotiating with and persuading them—molding public opinion. They considered all of the diversified social interactions required to realize a work part of the work. Christo said that their "colours are the farmers, the politicians, the variety of governmental agencies, the people who own the land. [We] need to mix these colours to get the chemistry right. If [we] fail, [we'll] never realize [our] project."[14] Christo and Jeanne-Claude's proposals often met with opposition from community constituencies, but the artists were rarely deterred and waged generally successful public-relations campaigns. They declared that all efforts pro and con enriched their work.[15]

The Christos likened their art making to that of the city planner or architect building new highways, airports, or bridges. Indeed, their art involved borrowing "the space of architecture, urban planning and urban design, and [making] them become an intricate part of the art experience." As a consequence they could not help challenging conventional assumptions about art. They had, as Christo said, "to enlarge and continually pose the fundamental question: What is art?" Christo and Jeanne-Claude's projects were also problematic as art because they were temporary; the artists insisted on leaving the land as they found it. They welcomed transience, viewing it as a countercultural challenge to "our notion of the immortality of art, of our arrogance to believe that we are immortal." Moreover, the transitory was not salable; "nobody can purchase or control it [a project], or sell tickets to see it." However, after the projects disappeared, they take on "some kind of legendary character. Their presence, because they are not here, is much more than if they were."[16] The documentation—film, video, books, photographs, preparatory mock-ups and drawings, and the like—remained.

The discourse on Christo and Jeanne-Claude's work tended to focus on its social dimension, great cost, and transience, more often than not neglecting the poetry both of the works themselves and of their documentation. Yet their shrouded phenomena evoke a sense of mystery. And the fabric itself, as Christo commented, "is almost like an extension of our skin" and also calls to mind the large tents which nomads pitch and collapse and move away, and nothing remains.[17] Christo and Jeanne-Claude themselves were nomads of a kind, realizing projects all over the world. It is significant that the image of the artist-as-nomad should be the self-image of Beuys, Merz, Kounellis, and Long, suggesting that it has a peculiar contemporary relevance.

In 1970 Robert Irwin anticipated architectural sculpture by basing his works on the specific nature of their surroundings. He took his first step toward a site-determined art in the late 1950s, when, as an abstract expressionist painter in Los Angeles, he began to question the relationship between the imagery *in* and physicality *of* painting. As he said, "The moment a painting took on any kind of image, [it] went flat. . . . Imagery

[was] a second order of reality, whereas I was after a first order of presence. . . . And basically, that's what I'm still after today." Irwin also posed the question: "How do I paint a painting that doesn't begin and end at the edge [and that] starts to take in and become involved with the space or environment around it?"[18]

At first Irwin gradually reduced his imagery until all that remained was an allover vibrating field of tiny dots of contrasting colors on slightly curved canvases. The paintings had become so spare that as discrete objects containing discernible images, they were barely visible; they had painted themselves out of existence, as he commented.[19] Then, in 1968, Irwin spray-painted a bowed aluminum or Plexiglas disc white and suspended it about eighteen inches from a white wall and lit it so that it cast a rosette of shadows. The disc seemed to dematerialize and the shadows to become palpable. It became difficult to distinguish the object from the environment into which it was dissolved. The "picture" had turned into its shadows. The final step was to dispense with the art object and to deal just with the actual environment.

In 1968 the Los Angeles County Museum of Art initiated an *Art and Technology* show, which put artists in manufacturing establishments. Invited to participate, Irwin asked James Turrell and the psychologist Ed Wortz, an employee of a California aerospace research company, to join with him in investigating the effects of sensory deprivation on human perception. They set up a ganzfield, defined by Wortz as a visual field in which "there are no objects you can take hold of with your eye" and which is "entirely homogeneous in color." Irwin commented that in an echo-free, totally light-blackened chamber, "you had no visual or audio input at all, other than what you might do yourself. You might begin to have some retinal replay or hear your own body, hear the electrical energy of your brain, the beat of your heart, all that sort of thing." Participants ended up perceiving themselves perceiving.[20] Irwin's experiments with ganzfields led him to think that visual art—and only visual art—could examine the process of seeing. That was its special role. His mission would be to create situations in which viewers would become aware of how they *see*. As he saw it, "nonobjective art now meant 'nonobject,' and . . . perception itself, independent of any object, was the true art act."[21]

But viewers were also in the world, and Irwin wanted to make them *see* their environment. He began to alter existing sites, aiming to express the particular presence of each. Attentive viewers were made aware not only of all of its components, no matter how incidental, but the way in which ever-changing light and their own movements changed the environment. The alterations Irwin made were so subtle that they verged on invisibility. Indeed, he seemed to want to "achieve the maximum transformation with the minimum alterations," as writer Lawrence Weschler commented. "Or, at any rate, it was on that basis that Irwin often came to gauge the success of his installations."[22]

One of Irwin's favorite materials—a kind of signature material—was

a translucent scrim, which was difficult to focus on. He used it to defocus space most effectively in a perceptual environment he created at the Whitney Museum in 1977 [70]. Given the entire fourth floor, he removed all the dividing walls to make one vast empty space. He then stretched a single white nylon scrim across the entire length of the space, its lower edge, a black beam at the viewer's eye level. Finally he ran a thin continuous black tape around the walls at the same level as the black beam. The museum space was completely transformed. On the one hand viewers became acutely disoriented; nothing was at the distance it appeared to be. On the other they became acutely aware of the room, its architectural details, and changing light. Not only did they become aware of the "empty" space but of an utter "silence" that pervaded it, a silence that served to heighten sounds from both outside—traffic noise—and inside—air-conditioning. The effect was at once dizzying, elating, and oddly serene. The experience of the situation was what Irwin defined as his "art."

Turrell was often coupled with Irwin because of their mutual interest in perception, but the differences in their work are pronounced. Turrell commented that even when they collaborated in 1968, "Bob would take something and dematerialize it with light. I came from the other end, taking light and trying to make it physically present."[23] For example, in *Afrum* Turrell aimed a quartz-halogen projector at a corner of his studio and created what seemed to be a solid cube of light, "an ethereal form of trompe-l'oeil minimalism."[24] In this and other *Projection Pieces*, as he called them, light became palpable [71]. His experience

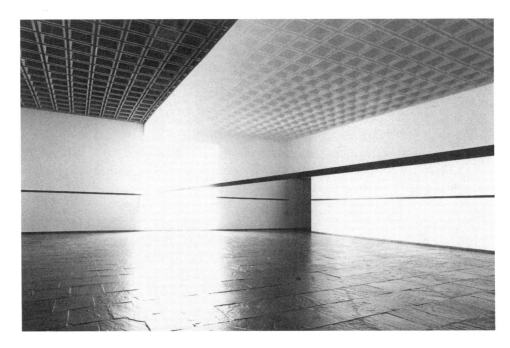

70. Robert Irwin, *Scrim Veil-Black Rectangle, Whitney Museum of American Art*, 1977. *(Copyright © 1994 Whitney Museum of American Art)*

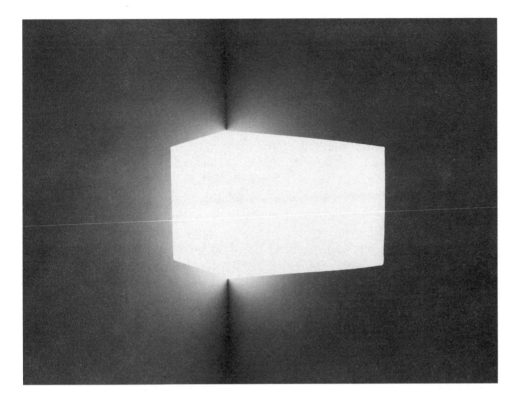

71. James Turrell, *Shanta*, 1967. *(Copyright © 1994 Whitney Museum of American Art)*

with a ganzfield in 1968 also revealed to him that light could have substance. Like Irwin he decided to create situations in which viewers could perceive their own perceptions, in his case by employing actual light—argon, daylight, quartz, tungsten, xenon, and so on.

From 1967 to 1980, Turrell's work was known in New York primarily by word of mouth. That changed with his retrospective at the Whitney Museum in 1980. The most startling piece, *Laar* (1980), was a large, vacant dimly lit gallery, which viewers entered. They could see on the far wall what seemed to be a mural-size monochromatic gray picture, but when they approached, its opaque surface dissolved into a rectangular opening in a partition, through which appeared another unexpected empty room, a "sensing space," as Turrell called it, which seemed to be inhabited by a tangible greenish or bluish gray mist. There was no mist, however; the "atmosphere" was created by light reflected from outside the room. When viewers stepped back, the opaque surface reappeared. Turrell explained: "This is like looking behind the stage to find the mirrors, . . . only to discover there are none."[25] But viewers were never clear about what they were seeing, confronted as they moved about by spatial ambiguities, illusions, deceptions, and enigmas, which heightened their awareness of their own seeing.

In the early 1970s Turrell began to make *Skyspaces* by cutting apertures into ceilings or roofs to expose the sky, turning each into a moving "picture" of changeable weather and light, at different times of day, flat

or deep, opaque or transparent. Further to experience the sky, Turrell in 1977 purchased an extinct volcano that rises eight hundred feet above the Painted Desert. Since then he has been reshaping its crater into an even-sided dish that can be used as a kind of observatory, somewhat like Stonehenge, to track the equinoxes and contemplate the sky as a great dome or celestial vault. Within the volcano he has been gouging out a series of interconnected chambers, which are aligned and illuminated according to astronomical occurrences.[26]

Adam Gopnik considered Turrell's art of actual light to be an extension of a tradition that extends from Hudson River landscape painting to Rothko's color-field abstractions. Turrell then was "an heir to American luminism, with its transcendentalist impulses and its deification of nature." On the other hand his work, in an equally American way, seems to reject transcendentalism, because the light he produced is "real and . . . open to investigation."[27] Turrell himself preferred the second interpretation. "My art deals with light itself. It's not the bearer of revelation—it is the revelation. . . . The light draws attention only to what it is."[28]

Siah Armajani began to make architectural sculpture out of a desire to understand American national identity, what it was, how it developed, and what it had become. He looked for knowledge and inspiration toward vernacular building, which "by its very nature is social"[29]: Early American log cabins, barns, covered bridges, and meeting halls, as well as more recent shingle-style and Shaker buildings, Main Street facades, and urban newsstands [72].[30] The structures that attracted him were built from ordinary lumber, corrugated sheet metal, screening, and other plain materials in a straightforward, commonsense, rough-and-ready manner—the carpentry handcrafted, the joints and fastening devices left exposed.

72. Siah Armajani, *The Art of Bridgemaking #3*, 1987–88. *(Max Protetch Gallery, New York; Dennis Cowley)*

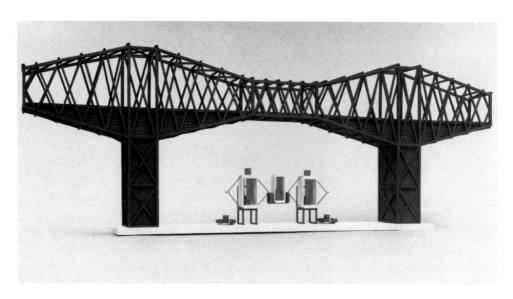

Armajani reasoned that before he could build complex structures, he would need to learn the vocabulary of indigenous building forms and practices. With this in mind, in 1974 he began to construct a series of small-scale cardboard sculptures—of doors, windows, stairs, tables, chairs, etc.—which he called his *Dictionary for Building.* "What I was trying to do was put together an index of art and architectural possibilities."[31] In 1978 Armajani began to enlarge his constructions and build them from more permanent materials. Invited to participate in a new talent show at the Guggenheim Museum in that year, he constructed a sprawling wood sculpture on the entire ground floor. *Lissitsky's Neighborhood, Center House,* was a compilation of five houses, each one representing a vernacular style of American architecture. It also incorporated motifs, colors, and techniques favored by the Russian constructivists, who had tried to invent a modern architectural language to represent, as Naum Gabo wrote, "the whole edifice of our everyday existence."[32] Moreover, in its complexity and contradiction the work referred to postmodern architecture.[33]

At this time Armajani began to design and construct a series of public "reading rooms" and "reading gardens" [73]. He had in mind the town meeting as the exemplar of American democracy.[34] The structures are generally open to their surroundings and consist of disjointed, often incongruous parts. Each "room" is experienced as a separate space, pro-

73. Siah Armajani, *Reading Garden #3,* installed at State University of New York at Purchase, 1980. *(Max Protetch Gallery)*

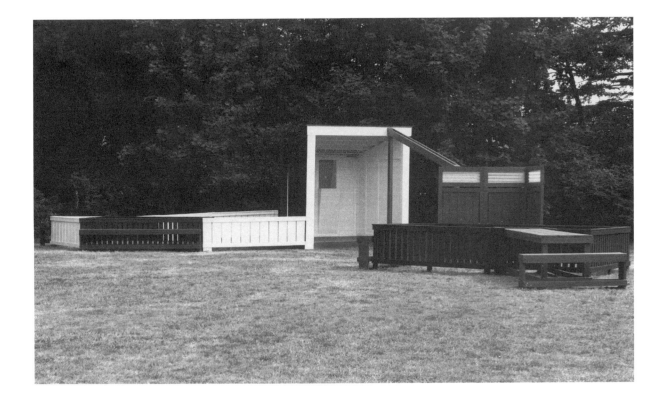

viding few if any clues as to what the other spaces might be. There is rarely an identifiable front or back; facades are dissimilar—roomlike spaces, eccentric in shape. A passageway might unexpectedly veer off or end in a blank wall. Despite the dissociation of the components in an Armajani installation, it all coheres, calling to mind both the unity and the decentralization and antihieratic egalitarianism of American society at its most ideal. Indeed, the work prompts countercultural ideas about American democracy, its institutions—reading rooms and red school-houses—and the shapers of its thought and spirit. With this in mind Armajani introduced a verbal component into his constructions of the 1980s—stenciled or inlaid printed aphorisms, much as they were inscribed on the walls of public buildings. His texts were culled from the writings of Ralph Waldo Emerson, Walt Whitman, Robert Frost, and Frank O'Hara, among others. The most telling quote was from John Dewey's *Art as Experience:* AS LONG AS ART IS THE BEAUTY PARLOR OF CIVI-LIZATION, NEITHER ART NOR CIVILIZATION IS SECURE.

In 1973 Mary Miss installed a temporary work on the Battery Park landfill, overlooking the water. It consisted of a row of five fencelike wood modules spaced fifty feet apart, each with a cut-out circle placed progressively lower from element to element. On a line with the setting sun the circles seemed to sink—like it—into the ground. The work derived the modularity of its forms and the seriality of the descending circles from minimal sculpture, which Miss had encountered in 1968, the year she moved to New York. Moreover, minimal sculpture "put a focus on space, and that was important to me." Because the piece was placed outdoors and spread out, viewers could not help becoming "engaged in a more extended way which I really liked. They couldn't just stand around and look—they had to walk around."[35]

In 1974 Miss began to build large wooden structures that alluded to scaffolds, fences, storage bins, mine shafts, towers, gateways, barns, and other vernacular American buildings, much as Armajani's works did. In *Perimeters/Pavilion/Decoys* [74], completed in 1978 on the grounds of the Nassau County Museum of Art in Long Island, New York, Miss mixed sculpture, architecture, and landscape design. Laid out on a four-acre enclosed field, the work consisted of one underground structure, two earth mounds, and three wood-and-screen towers. The towers were the prominent features, but the subterranean complex was the center of attraction, although from the ground it was indicated only by the top of a ladder that stuck out. Viewers climbed down some seven feet into an open courtyard and found themselves in the central core of a series of diverse spaces laid out on a rectangular plan. The viewers then moved from the brightly lit atrium in and out of colonnades and dark corridors and rooms with wooden or dirt walls, some punctuated by even darker windows. *Perimeters/Pavilions/Decoys* was influenced by Mesopotamian brick complexes, Mexican and Pompeiian courtyards, and Pueblo Indian

buildings.[36] The installation's essential content was the extended sequence of physical—and psychological—sensations experienced while exploring it. The experience was of space as a physical reality, of "inside/outside, above/below, light/dark, open/closed, nature/artifice."[37]

Alice Aycock's first major architectural sculpture was *Maze* (1972), which was inspired by the circular tombs she had seen in Mycenae two years earlier. A circular structure six feet high and thirty-two feet in diameter, it consisted of five concentric rings entered through one of three openings in the outer wall. Viewers had to move through its interior maze in order to experience its "psycho-physical space," as Aycock termed it, in this case, the space of entrapment.

Aycock was not particularly identified with feminism, but the "vagi-

74. Mary Miss, *Perimeters/Pavilions/Decoys*, installation at Nassau County Museum, Roslyn, New York, 1977–78. *(Courtesy Mary Miss)*

75. Alice Aycock, *The Machine that Makes the World*, 1979. *(John Weber Gallery, New York)*

nal iconography" and house imagery that recur in her work exemplify the essentialist aesthetic prevalent in the 1970s. For example, her best-known work, *Project Entitled Studies for a Town* (1977), in the collection of the Museum of Modern Art, is a wooden cylinder circled by steps rising to a dead end but offering views of an inner ampitheaterlike space. The work also resembles the Native American kivas of the Southwest, with which Aycock was familiar, and indeed looks like some kind of a ceremonial structure.[38]

In 1978 Aycock began to construct fantastic machine-like sculptures related to those of Dennis Oppenheim with whom she was in close contact at the time. She had in mind the mechanistic images of Francis Picabia, Marcel Duchamp, and Jean Tinguely, but unlike them, hers were ritualistic like her earlier architectural sculpture. The machine works—accompanied by mystical texts—were given such titles as *The Machine that Makes the World* (1979) [75]; *How to Catch and Manufacture Ghosts* (1979); and *A Theory of Universal Causality (Time/Creation Machine)*(1983). Howard Risatti suggested that the key to her sculpture was the paradoxical mix of a belief in rationality associated with the machine and a belief in ghosts and magic, associated with the transrational world.[39]

Like Armajani, Donna Dennis looked to vernacular architecture for inspiration. In 1972 she began to construct from memory or from 1930s photographs the false fronts of mom-and-pop hotels. These mundane buildings were meticulously detailed but looked strange because they were diminutive, roughly the height of viewers, not of buildings; theatrically lit from within; and installed amid paper palm trees in stagelike settings from which taped birdcalls trilled.

From 1976 to 1978 Dennis built ordinary domestic shelters, among them a series of rural tourist cabins. A later work, *Tunnel Tower* (1979–80), topped by a neon sign, is based on a small building at the entrance to the Holland Tunnel in New York. Subsequent sculptures are drawn from melancholy New York City subway stations and feature shadowy stairways that lead into dark depths [76]. Dennis's architectural sculptures on the whole are peculiarly American "dream spaces"[40] whose mood is enigmatic and nostalgic.

The work for which Nancy Holt is best known, titled *Sun Tunnels* (1973–76) [77], was built in the Great Basin Desert, Utah. It consists of four larger-than-life-size concrete cylinders that form a cross. Each tunnel is punctuated with holes corresponding to different constellations—Capricorn, Columba, Draco, and Perseus—through which the sun casts light. This and other of Holt's architectural sculptures are among the twentieth-century progeny of Stonehenge and other ancient astronomical monuments.

76. Donna Dennis, *Deep Station*, 1981–85. *(Courtesy of the artist. Photograph copyright © 1987 Peter Mauss/Esto, Mamaroneck, New York)*

77. Nancy Holt, *Sun Tunnels*, 1973–76. *site: Great Basin (Courtesy John Weber Gallery, New York)*

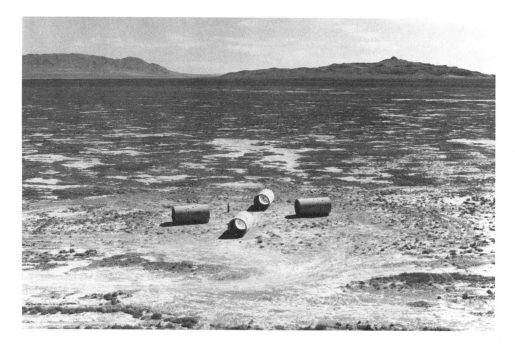

* * *

In 1974 Jackie Ferrara began to make works with wood planks (one by two, two by three, and two by four inches) in modular and serial stepped arrangements that call to mind step pyramids, ziggurats, and mastabas [78].[41] Her architectural sculpture had its source in the minimal art of Carl Andre, Robert Smithson, and Sol LeWitt, but it tended to be more complex. The walls are rarely identical, and the massive components are pierced with irregular gaps, slits, and niches. Many have interior courtyard- and shaftlike openings. In 1981 Ferrara began to make models for outdoor "places." She said, "as I continued to make objects I became more and more ambitious, and I wanted to make larger works relating to specific sites. [My] notion of site has grown to encompass its surroundings, its neighborhoods, and its physical environs."[42]

In 1968 Elyn Zimmerman assisted Robert Irwin and James Turrell on their project for the *Art and Technology* show at the Los Angeles County Museum, and like them created her own indoor installations in which she explored perception. In 1977 she traveled to Ellora in India and was struck by the sixth- and seventh-century cave temples cut into rock. She wrote about this and other ancient sites she visited:

> Juxtaposed building fragments; odd fenestrations in crumbling walls, water collected where there had been none, doors and stairs that lead

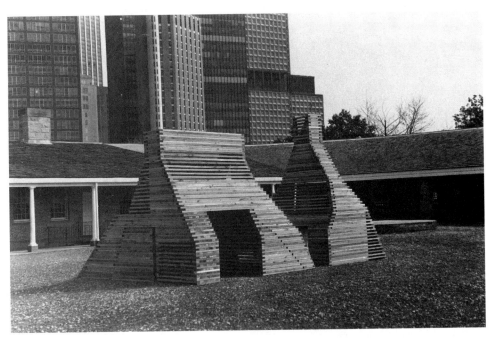

78. Jackie Ferrara, *198 Castle Clinton Tower and Bridge,* temporary installation, 1979. *(Courtesy Jackie Ferrara)*

nowhere—these anomalies are visually and conceptually stimulating. . . .

There are also geological sites, especially in deserts and on seacoasts, that share the exposed quality of ruins. There, too, the rock formations have been shaped and worn by the elements.[43]

Zimmerman's feeling for such sites as Ellora led her to use stone in conjunction with water and greenery to create installations in landscape. For example, in *Marabar*, completed in 1984, a trapezoidal pool of water is flanked by three large stones, each with a rough outer side and a polished side facing the water. This complex is the central feature of a garden dotted with rough-hewn granite boulders. Zimmerman wanted her works to change people's relationships to their immediate surroundings in order to foster their interest in larger environmental issues.[44] *Keystone Island* (1989) [79] in Miami is her most ecologically minded piece. In it she related a courthouse to a surrounding mangrove swamp by installing an artificial island of coral rock some fifty feet in diameter, which is reached by a bridge from the building. The focus is on the mangroves, the lagoon, and the marine life that inhabits it, indeed, on the ecosystem of the area.[45]

79. Elyn Zimmerman,
Keystone Island, 1989.
(Courtesy of the artist)

* * *

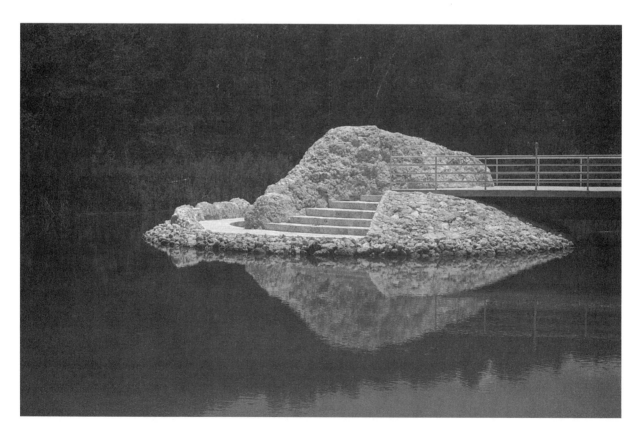

Although all architectural sculpture referred to architecture or build-
ing, it was varied in form and content. Most of it was large in size but not
the inches-high work of Charles Simonds [80][81]. Countercultural in atti-
tude, Simonds in 1971 took to the city streets, where he constructed
impermanent dwellings and their ruins out of tiny clay bricks, walking
away when he was finished. By 1982 he had built some three hundred of

80. Charles Simonds,
Dwellings, detail,
installation view,
1981. *(Copyright ©
1994 Whitney Museum
of American Art)*

81. Charles Simonds, *Dwellings,*
detail, installation view. *(Copyright
© 1994 Whitney Museum of
American Art)*

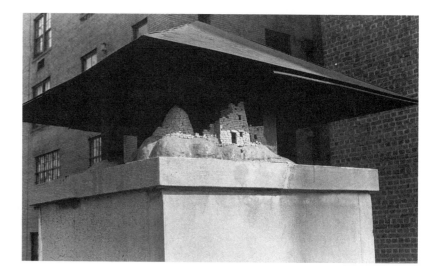

them all over the world, but mainly in an economically depressed section of New York City's East Side. His structures housed a vanished race of little people, about whom he invented a history, ethnography, anthropology, sociology, and religion. Although they were once to be found throughout the urban environment, all that remained of their civilization were ghost towns in niches in tenement walls, cracks in sidewalks and street curbs, on window sills, and in vacant lots.

Simonds began the narrative of the little people by making his own body the site of their origin. In *Birth* (1970) and *Landscape/Body/Dwelling* (1971) he enacted—and had filmed—his own "mythic" birth ritual, rising naked from "primordial" clay in which he had buried himself and using it to build the first fantasy dwellings on his chest. In these performances Simonds metaphorically connected his body to the earth and to the world of the little people, who came into being just after he did.[46]

Transferring his private scenario into the public arena outside the confines of the art world, Simonds came into contact with neighborhood people, and particularly children, who stopped to watch and chat about his work and its relevance to their own environment and its destiny. In the process Simonds learned of the need for recreational space in the Lower East Side. He began to work with local community groups in planning and building a park-playlot for children—another kind of little people—on a derelict piece of city property and participated in the required seemingly endless political action. The project was realized in 1974.

In the late 1970s Scott Burton began to make sculptures that resembled pieces of furniture and thus were related to architectural sculpture. They evolved from the props of postminimal performances—"sculpture-theater," as he called them[47]—that he had staged in the early and middle 1970s. One piece was composed of short scenes punctuated by blackouts and played fifty feet from the audience.[48] The actors, inter-

acting with a few pieces of furniture, moved robotlike, at an exaggerat-edly slow rhythmic pace, in intricately choreographed movements. Burton had studied behavioral psychology, and the body language of the distanced characters represented states of mind, such as "threat-aggres-siveness," "appeasement," and "disengagement."[49] At the same time the performers seemed utterly impersonal and impassive, resembling models in Philip Pearlstein's new realist paintings—and it is significant that Burton had written perceptively about them.

Burton's use of furniture in his performances led him in 1972 to exhibit an actual ordinary chair, which he titled "Grand Rapids Queen Anne." It was the descendant of realist painting, the readymades of Duchamp, and, cast in bronze in 1975, the remades of Johns and Warhol. In *Pastoral Chair Tableau* (1975) Burton omitted live performers and staged props as "furniture tableaux"; six scavenged chairs placed on a carpet of artificial grass against a blue backdrop looked like surrogate actors engaged in a dialogue.

In 1977 Burton concentrated on turning chairs into sculptures that were meant to be sat in.[50] He had come to believe that artists had a respon-sibility to the public at large to make sculpture that was useful. As he said, his art would "place itself not in front of but around, behind, underneath (literally) the audience in an *operational* capacity."[51] Transforming art "into some kind of design," making it functional so that it could be used by a nonart audience, would "get some social meaning back into art."[52]

At first Burton used readymade chairs—as well as tables—but he soon began to design and fabricate his own furniture-sculpture—follow-ing the example of Richard Artschwager, except that Burton's furniture was functional. He appropriated or invented different chair-and-table sculptures for different situations, depending on whether a piece was meant, for example, for a library, a restaurant, or a public park [83]. Burton's most original works, *Rock Chairs* [82], were influenced by Brancusi's juxtaposition of classically polished and primitively rough sur-faces. They are natural boulders—of gneiss, lava, marble, and so on—with three smooth cuts, to fashion a base, a seat, and a back.[53] His work was also diverse because he took as models a variety of furniture styles of the past. Furthermore, he used unusual materials in surprising juxtaposi-tions: galvanized steel with inlaid mother-of-pearl; or a blue Bahia gran-ite tabletop with steel legs lacquered in blue Metalflake paint. Later pieces were more abstract—referring to Russian constructivist, German Bauhaus, Dutch de Stijl, and American minimalist art. [3]

As early as 1969 Burton had written, with Rauschenberg in mind, that the "only large esthetic distinction remaining is that between art and life; [and that] distinction is fading."[54] He also wrote admiringly about artists who tried to create utilitarian objects of aesthetic value, consider-ing them the equals of Picasso and Matisse. "[Gerrit] Rietveld is not only the first of the great 20th-century furniture designers, he is one of the great 20th-century object makers, whatever the category of the

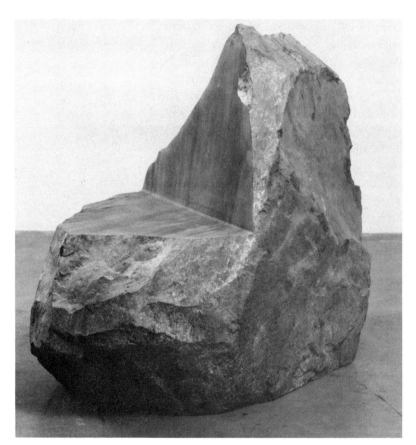

82. Scott Burton, *Rock Chair*, 1981–82. *(Max Protetch Gallery, New York)*

object. . . . His furniture-approaching-sculpture (together with Brancusi's few pieces . . . that are sculpture-approaching-furniture) is the major precedent for any contemporary art object seeking to extend itself toward environmental and architectural design."[55] However, much as Burton was inspired by constructivist, Bauhaus, and de Stijl associates, he refused to accept their utopian rhetoric. Kirk Varnedoe recalled that Burton said: "I have no sense of transcendence that the early modernists had, but I'm very big on the ordinary."[56]

Above all Brancusi inspired Burton, as he acknowledged: "My excitement over Brancusi focuses . . . on the architectural elements and works of furniture he created. The various kinds of seats and tables he made are especially fascinating." He went on to say that they

are not merely applied art but autonomous sculptures of objects. . . . Brancusi's enlargement of the definition of the art object is as original as Duchamp's new kind of object, the readymade, or Tatlin's utilitarian Constructivist works. And in today's artistic climate Brancusi's embrace of functional objects seems as absolutely contemporary as his invention for our century . . . of sculpture as *place* [as in the complex that sums up his life's work in Tirgu-Jiu, Rumania].[57]

Burton not only believed that art should be utilitarian but that it should be accessible and improve the environment. Consequently he had his furniture-sculpture integrated into architectural settings. Spread out over public spaces, these installations of seats and tables are the fullest realization of his art.[58]

Architectural sculpture was ideally exhibited in public places, engaging an audience that rarely if ever visited art museums or galleries. This led its makers, as Miss commented, to examine the "possibility of integrating art with society, of artists going out and affecting the environment, of having a role in the real world, whether it's in a county park or an urban plaza—that's what's most exciting to me."[59] Two groups of artists would agree with Miss, but their approaches were different, indeed contradictory. The first created works of art in public places, and the second public art.

In the 1970s there was an upsurge in the commissioning of works of art for public places, initiated by the National Endowment for the Arts (NEA) and the General Services Administration (GSA), both agencies of

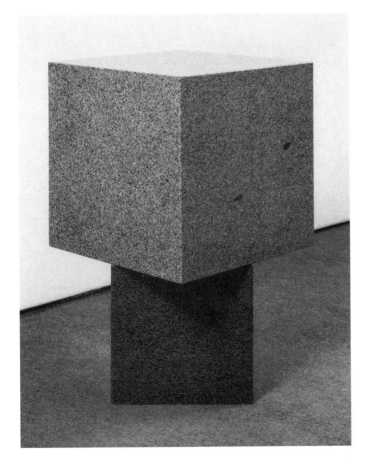

83. Scott Burton, *Two-Cube Table*, 1985–86. (*Max Protetch Gallery*)

the federal government. The justification for federal sponsorship was outlined in a position paper Brian O'Doherty, head of the NEA's Visual Arts Program, asked me to write in 1972. I began by declaring that the program was necessary because it affirmed U.S. cultural awareness and humanity. Then I asked: But how is a democratic society to achieve a valid public art? Not by governmental dictation to artists, as has been the practice of totalitarian regimes, but by making it possible for a variety of artists, each according to his or her individual vision, to create for public places, in the conviction that together their work would embody the highest aspirations of American society. I also pointed out that citizens' groups and governmental agencies concerned with urban renewal had recognized that art could play a role in enriching the environment. City planners were agreed that one way to provide a neighborhood with an identity was through the introduction of a landmark, and art could serve that purpose.

The time seemed ripe for federal support of public art. Around 1960 public attitudes toward advanced art began to change from indifference or hostility to interest and sympathy. In response to the public's growing openness, an emerging generation of artists tended to feel less alienated and to visualize itself as integrated into society, in marked contrast to the older generation, the abstract expressionist vanguard of the 1940s and 1950s. Moreover, the young artists lost interest in the abstract expressionist ambition of expressing subjective private experiences and visions. Their concerns were more objective and often took the existing environment into account. To put it simply, there was a convergence of good will on the part of both artists and the public, stimulating thinking in the direction of public art.

As significant as the change in artists' attitudes and styles was a change in the size of their works, a change brought about by the internal evolution of sculpture. Artists had come to possess what might be called an environmental vision—that is, to view a thing in its context. This way of seeing led many sculptors to question the customary use of the pedestal, that is, as a base just to hold an art work. But the pedestal was also a form, a sculpturally meaningless form, frequently larger than the sculpture it was meant to support. Consequently sculptors either made sculptures of their bases or eliminated them altogether and placed works directly on the floor. But in order to enable a sculpture sitting on the floor to be seen, it was enlarged, often to a monumental size more suitable for exhibition in public places than in private homes, galleries, and even museums.

Artists came to believe that a move into public art might generate a new content. That is, if they were to consider the cultural, social, political, and economic conditions of the people in whose environment they would work, fresh forms and meanings might emerge, infusing new life into contemporary art. In turn, works of art in public places, by altering the environment, might affect the outlook of the inhabitants. The artists'

interest in how art influenced the quality of people's lives did not, however, have to lead artists to produce for a public with its expectations. Artists could carry studio ideas out into architecture or into the environment. The autonomy of art would not be sacrificed thereby, although their conceptions would probably alter in the process. If enough artists were enabled to work in public places, a new aesthetic tradition might develop, a tradition of a contemporary public art with its own criteria of suitability, quality, and the like, different from that of studio art. The process had to be trial and error and would entail numerous failures, but the alternative to a slow, improvisational evolution was a public art based on preconceived ideas, presumably those of bureaucrats. In my report to the NEA I stressed that in order for any program of public art to succeed, there was a need for dialogue between the community and the artists. On every level possible the community had to clarify and articulate its needs, educate itself, and participate in the choice of public art.[60]

Some works of art in public places were successful, notably Alexander Calder's sculpture in Grand Rapids. O'Doherty called it

> a model of the successful assimilation of a work of advanced art by a community which eagerly prepared itself for its reception. Matching funds were raised locally on a wide base. . . . The success of the Calder is due to the fact that different groups within the city found that it fulfilled *their* necessities. The art community was, of course, enthusiastic; the city's cultural leaders saw the Calder as a focus for various other kinds of cultural events—open-air concerts, etc.; and the public was proud of the national attention the city received. Others saw the art work as a socially useful device for improving the "quality of life." [Some] citizens concerned with urban renewal welcomed the Calder primarily as a major impetus towards renovating a downtown area. . . . It is also possible to see the Calder as a model of the way in which a successful work of art can exercise those elusive moral energies we like to think attach themselves to the idea of quality, and so prepare the way, through practical education, for community participation in more advanced art.[61]

So successful was the Calder that it became the logo of Grand Rapids, stenciled everywhere, most visibly on city vehicles.

From 1967 to 1981 the federal government subsidized more than three hundred works of art in public places nationally. Despite its auspicious beginning, in time this program lost its luster. The art increasingly came to be viewed as "plaza plop." Moreover, a controversy provoked by a Richard Serra sculpture called the entire enterprise into question. In 1981 Serra was commissioned by the GSA to create a work in the plaza of a federal building in downtown Manhattan. He had installed a 12-foot-high, 120-foot-long, corten-steel *Tilted Arc*, as the piece was called.

Some thirteen hundred federal employees petitioned for the removal of the sculpture, because they claimed that it was an "ugly" barrier that cut the plaza in two. At a three-day public hearing in 1985, the following questions were raised: What was the function of works of art in public places, and for whom were they created? Should they enhance, humanize, or decorate their surroundings, as it was generally assumed? If so, what if they did not? What if a work, as Douglas Crimp wrote of *Tilted Arc*, "aggressively occupies public space, openly confronts its public"?[62] Did the public then have to accept it? The underlying question was: Should tax money—$175,000 in the case of *Tilted Arc*—be spent on public art at all?

One of the opponents of *Tilted Arc* who worked in the federal building offered four reasons for its relocation: "Number one, it destroys the previously open plaza by obstructing free passage across the plaza and blocking an open view of the fountain; number two, it constitutes a scar on the plaza and creates a fortress-like effect; number three, it's a target for graffiti; number four, it is too large for its present site and it violates the very spirit and concept of the plaza."[63] Peter Schjeldahl wrote on behalf of the workers.

> What have they got to complain about? Plenty. They can complain of this oppressive symbol that their government is on anybody's side but theirs. They can complain that everything that is right about *Tilted Arc*, on its own terms, is wrong in terms of what they humanly want and need. They can complain that the condescending, self-flattering establishment doesn't have to live with this grim thing, and they do have to.[64]

The majority of art professionals supported *Tilted Arc* because of its aesthetic merit. They also accepted Serra's claim that to remove the site-specific sculpture would be to destroy it, and they defended Serra's freedom of expression. Crimp wrote that in

> reorienting the use of Federal Plaza from a place of traffic control to one of sculptural place, Serra . . . uses sculpture to hold its site hostage. [Serra insists] upon the necessity for art to fulfill its own functions rather than those relegated to it by its governing institutions and discourses. For this reason, *Tilted Arc* is considered an aggressive and egotistical work, with which Serra places his own aesthetic assumptions above the needs and desires of the people who must live with his work.[65]

And the work did exactly that. As Robert Storr wrote: "*Tilted Arc* demands attention, insisting that its presence is not an adjunct or adornment of the space it occupies. [The work is meant to subvert] the tyranny of architects and the bland conventions of most of public art. . . . It is

that physical polemic, aside from the arguable beauty of the piece itself, which is the work's principal virtue." However, the piece was placed "directly in the path of people largely ignorant of and for the most part alienated by modern art."[66]

Serra himself insisted that his freedom of expression had priority over the desires and comfort of his audience. As he said: "Trying to attract a bigger audience has nothing to do with the making of art. It has to do with making yourself into a product, only to be consumed by people. Working this way allows society to determine the terms and the concept of art; the artist must then fulfill those terms. I find the idea of populism art-defeating."[67] Then why take taxpayers' money to work in public, and the argument went around and around? In the end, after eight years of controversy, the GSA ordered *Tilted Arc* removed. Serra fought the decision in the courts but lost, and the piece was dismantled in 1989.

The controversy over *Tilted Arc* raised serious questions. What was the artist's responsibility to the public? Should commissions be awarded to artists who worked in styles acceptable to a small art-conscious constituency but incomprehensible to a general public? What voice should the public have in commissioning a work of public art? And under what conditions might it be removed?

Because of what appeared to be the deficiencies in the works-of-art-in-public-places program, there emerged a new approach—as exemplified by the thinking of Armajani, Miss, Burton, Holt, Ferrara, and others—an approach that would yield a public art. As Armajani commented: "Our work is not meant to enhance architecture, or to alter it, but to be one in the other, like water in a glass. The public place engulfs us both."[68] Moreover: "Public art should not intimidate or assault or control the public. It should be neighborly. It should enhance a given place."[69]

Miss added that "there are archetypal needs that are met regularly in different cultures . . . for protected spaces, places for reflection, places of distraction. I am . . . trying to find ways of creating equivalents within our own context."[70] The particular context that Miss had in mind was the psychologically and physically distressed urban environment.

> Think about building structures that can be integrated into this context—physically and visually integrated, not just an afterthought. Alter the context by introducing transition zones from street to building (human scale); construct spaces where slow motion is possible. Give people the luxury of engagement, not confrontation. . . . Priorities: breathing space, human scale, first-hand experience, focusing on the strong visual elements of the city.[71]

But, Miss was quick to add, "For a work in a public space to be successful, it's absolutely necessary for it to maintain its strength and integrity."[72]

Accordingly, as Burton declared, public art would move "away from the hermetic, the hieratic, the self-directed; toward more civic, more

outer-directed, less self-important relations with social history." Its "content [would be] more than the private history of its maker."[73] Burton attacked the claims of self-expression on the part of autonomous studio artists. "I feel the world is now in such bad shape that the interior liberty of the artist is a pretty trivial area. . . . Communal and social values are now more important. What office workers do in their lunch hour is more important than my pushing the limits of my self-expression."[74] As Armajani said: "The public artist is a citizen first."[75]

Artists who sought to design or redesign parks, playgrounds, gardens, indoor and outdoor plazas, bus stops, and other public sites would have to rethink their artistic roles. If "art is, or should be, a public matter . . . and [if] the artist should have an integral connection to society, [then] the concept of heroic individualism that has attached itself to artists throughout the modern period" would have to be ruled out.[76] Public artists would no longer create an isolated object in a public space, no matter how well they integrated it into the site. Instead they would have to submit their vision to the requirements of others and collaborate with architects, landscape architects, city planners, real estate developers, engineers, city officials, and community leaders. That interaction would not be an easy one. As Miss remarked, they would have to face "the difficulty of stepping into the extremely complex and highly pressured system of architecture, building, and contracting. How does one get through the maze of committees, codes, safety regulations, and big budgets and end up with a work that is really moving?"[77] Moreover, public artists would also have to pay attention to the needs of the community and earn its trust.

Collaboration could compromise the artists' vision, but that risk had to be taken. And it could succeed only if each "promoted a conception that subordinates personal artistic style to the functional requirements of particular sites." But there was an advantage in that it made it "possible to do work where the form and content are less confined: there are greater variety of locations, richer cross-references to existing structures, an extended viewer experience."[78]

Public art found its fullest expression in the three-and-one-half-acre plaza of Battery Park City in Lower Manhattan, not far from the site of Serra's *Tilted Arc*. Involving architects Stanton Eckstut and Cesar Pelli, landscape architects Susan Child and M. Paul Friedberg, artists Armajani, Burton, Miss, and Ned Smyth, among others, as Miss recalled: "From the beginning, it was really a collaboration".[79] The team proposed to provide "the place with a strong emotional content." They created a carefully planned environment that, with its plaza, park, garden, fountains, outdoor cafés, works of art, and other amenities, was itself a work of art. For example, Miss sought to provide inhabitants with the experience of moving "from the density of Midtown to the open waterfront of Manhattan," to create "a visual transition between the land and the water," and to synthesize "the built and the natural." With this in mind she built a pier out into the harbor at the South Cove that echoed the

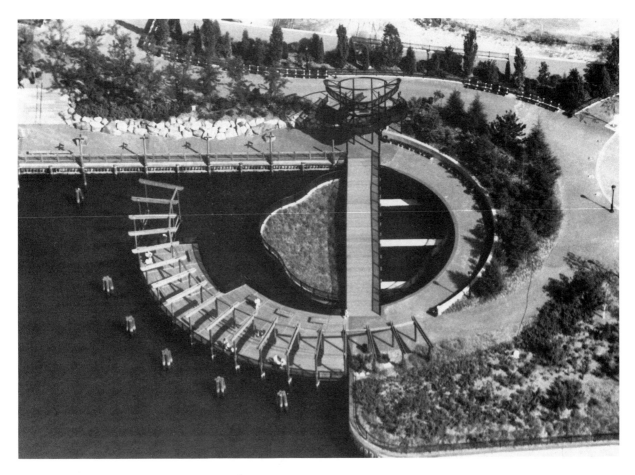

84. Mary Miss, *Untitled*, in collaboration with Stanton Eckstut, architect, and Susan Child, landscape architect, South Cove, Battery Park City, New York, 1988. *(Courtesy Mary Miss)*

existing pilings in the water and functioned as a kind of island against the background of skyscrapers, which brought the viewers as close to water and sky as one could get in New York City [84]. This work was successful as public art because it gave "people more than they ever expected, something they didn't know how to ask for."[80]

NOTES

1. Scott Burton, in *Patterning and Decoration* (Miami, Fla.: Museum for the American Foundation for the Arts, 1977), and accompanying Carrie Rickey, "Decoration, Ornament, Pattern and Utility: Four Tendencies in Search of a Movement," *Flash Art* (June–July 1979) :23.
2. Scott Burton, accompanying Rickey, in "Decoration, Ornament, Pattern and Utility," p. 23.
3. Scott Burton, in Foote, "Situation Esthetics," p. 23.
4. Burton, accompanying Rickey, in "Decoration, Ornament, Pattern and Utility," p. 23.
5. Foote, "Situation Esthetics," p. 23.
6. Lucy R. Lippard, "Complexes: Architectural Sculpture in Nature," *Art in America*, Jan.–Feb. 1979, p. 88.
7. Donna Dennis, conversation with the author, New York City, Mar. 10, 1994.
8. See Rosalind Krauss, "John Mason and Post-Modernist Sculpture: New Experiences, New Words," *Art in America*, May–June 1979; and "Sculpture in

the Expanded Field," *October*, Spring 1979; and Lucy R. Lippard, *Dwellings* (Philadelphia: University of Pennsylvania, Institute of Contemporary Art, 1978), and "Complexes: Architectural Sculpture in Nature," p. 88.

9. Lucy R. Lippard, "Complexes: Architectural Sculpture in Nature," pp. 86–87. See also Kate Linker, "An Anti-Architectural Analogue," *Flash Art* (Jan.–Feb. 1980): 20–21.

10. Krauss, "John Mason and Post-Modernist Sculpture," pp. 120–25.

11. See Mary Miss, "On a Redefinition of Public Sculpture," *Perspecta 21* (1884): 68. Other works were related to architecture by older contemporary artists, notably Isamu Noguchi's garden for the UNESCO building in Paris.

12. In 1958 Christo began to wrap tables, chairs, a bicycle, a baby carriage, an automobile, and the like in fabric and secure them with rope—transforming everyday artifacts into enigmatic packages.

13. Ellen H. Johnson, *American Artists on Art: From 1940 to 1980* (New York: Harper & Row, 1982), p. 198.

14. Robert Enright, "Now You See It, Now You Don't: The Legendary Art of Christo," *Border Crossings* (Jan. 1992): 35.

15. See Douglas Davis, "The Size of Non-Size," *Artforum*, Dec. 1976, pp. 46–51.

16. Enright, "Now You See It, Now You Don't," pp. 32–33, 37.

17. Barbaralee Diamonstein, *Inside New York's Art World* (New York: Rizzoli, 1979), p. 94.

18. Lawrence Weschler, *Seeing Is Forgetting the Name of the Thing One Sees: A Life of Contemporary Artist Robert Irwin* (Berkeley: University of California Press, 1982), p. 61.

19. Robert Irwin, Talk to the Independent Curators Incorporated at the Pace Gallery, New York, Sept. 22, 1992.

20. Nancy Marmer, "James Turrell: The Art of Deception," *Art in America*, May 1981, pp. 96–97. See also Weschler, *Seeing is Forgetting*, p. 128.

21. Ibid., p. 81. In 1966 Robert Morris had written that minimal sculpture had become so reduced that it focused attention on its surroundings and on the spectator, the perceiving spectator, in its ambience. In a sense Irwin took this idea to an extreme and focused exclusively on the perception of the viewer.

22. Weschler, *Seeing Is Forgetting*, p. 172.

23. Patricia Failing, "James Turrell's New Light on the Universe," *Art News*, Apr. 1985, p. 76.

24. Craig Adcock, "Anticipating 19,084: James Turrell's *Roden Crater Project*," *Arts Magazine*, May 1984, p. 77.

25. Rosalind Krauss, "Overcoming the Limits of Matter: On Revising Minimalism," *Studies in Modern Art 1: American Art of the 1960s* (New York: Museum of Modern Art, 1991), pp. 133–34.

26. Adcock, "Anticipating 19,084: James Turrell's *Roden Crater Project*," p. 76.

27. Adam Gopnik, "The Art World: Blue Skies," *The New Yorker*, July 30, 1990, pp. 75, 77.

28. Pamela Hammond, "James Turrell: Light Itself," *Images & Issues*, Summer 1982, p. 53.

29. Calvin Tomkins, "Profiles: Open, Available, Useful," *The New Yorker*, Mar. 19, 1990, p. 55.

30. Armajani was also influenced by Jefferson's red-brick house in Monticello because it adapted European architectural modes, such as Palladian proportions, to American architectural requirements. See Patricia C. Phillips, "Siah Armajani's Constitution," *Artforum*, Dec. 1985, p. 74.

31. Tomkins, "Profiles: Open, Available, Useful," p. 62.

32. Naum Gabo, "Sculpture: Carving and Construction in Space," in J. L. Martin, Ben Nicholson, and Naum Gabo, eds., *Circle International Survey of Constructive Art* (London: Faber & Faber, 1937), p. 111.

33. Siah Armajani, in Linda Shearer, *Young American Artists: 1978: Exxon National Exhibition* (New York: Solomon R. Guggenheim Museum, 1978), said that he was influenced by Robert Venturi's postmodernist architecture and writing, especially his book *Complexity and Contradiction in Architecture* (p. 14).

34. Armajani, in ibid., called himself a "midwestern populist."

35. Avis Berman, "Space Exploration," *Art News*, Nov. 1989, p. 132.

36. Kate Linker, "Mary Miss," *Mary Miss* (London: Institute of Contemporary Art, 1983), n.p.

37. Ronald J. Onorato, "Illusive Spaces: The Art of Mary Miss," *Artforum*, Dec. 1978, p. 32.

38. Howard Risatti, "The Sculpture of Alice Aycock and Some Observations on Her Work," *Woman's Art Journal* (Spring–Summer 1985): 28–29.

39. Ibid., p. 37.

40. Howard N. Fox, *Directions* (Washington, D.C.: Hirshhorn Museum and Sculpture Garden/Smithsonian Institution Press, 1979), pp. 32–33.

41. David Bourdon, in "Jackie Ferrara's Incremental Journey," *Jackie Ferrara's Sculpture: A Retrospective* (Sarasota, Fla.: John and Mable Ringling Museum of Art, 1992), commented that in earlier works, made of cotton batting, glue, wood, and cardboard, "virtually all the elements and motifs of Ferrara's art were already in place: the staircases, the penchant for stacked and layered structures with incremental proportions, the pyramid and tower forms, as well as the progressively stepped profiles that appear to curve" (p. 37).

42. Ileen Sheppard-Gallagher, "Interview with Jackie Ferrara," in *Jackie Ferrara Sculpture: A Retrospective* (Sarasota, Fla.: The John and Mable Ringling Museum of Art, 1992), p. 14.

43. Elyn Zimmerman, "Artist's Statement," in *Elyn Zimmerman* (Tampa, Fla.: University of South Florida, Contemporary Art Museum, 1991), p. 25.

44. See Elyn Zimmerman, *Public Art Review 2*, vol. 3, no. 1 (Spring–Summer 1990).

45. See John Beardsley, "Hallowed Ground," in *Elyn Zimmerman*, p. 15.

46. Phil Patton, "The Lost Worlds of the 'Little People,'" *Art News*, Feb. 1983, pp. 86, 89. Rudy Burckhardt made a film of *Landscape/Body/Dwelling*, 1973.

47. Richard Francis, "Non Solum . . . Sed Etiam," *Scott Burton* (London: Tate Gallery, 1985), p. 9.

48. Elizabeth C. Baker, "Scott Burton, 1939–1989," *Art in America*, Feb. 1990, p. 163.

49. Linda Shearer, "Scott Burton: *Behavior Tableaux*" (New York: Solomon R. Guggenheim Museum, 1976), n.p.

50. Scott Burton said in Kim Levin, "Scott Burton, 1939–89," *Village Voice*, Jan. 16, 1990: "My chairs and tables are not just sculptures, but also real furniture for actual use." Levin concluded: "His work isn't furniture aspiring to be art; it's art in the form of furniture. It lays claim to the world of function" (p. 95).

51. Burton, in Foote, "Situation Esthetics," p. 23.

52. Robert Campbell and Jeffrey Cruikshank, "Interview: Scott Burton," in *Artists and Architects Collaborate: Designing the Wiesner Building* (Cambridge: MIT Press, 1985), pp. 62, 66.

53. Charles F. Stuckey, in "Scott Burton Chairs," *Scott Burton Chairs* (Cincinnati: Contemporary Arts Center, 1983). Reprinted in Jiri Svetka, ed., *Scott Burton Sculptures 1980–89*, (Düsseldorf: Kunstverein für die Rheinlände und Westfalen, 1989), has pointed out that the *Rock Chairs* "have no direct precedent in the history of furniture or in the history of sculpture" (p. 61).

54. Scott Burton, "Notes on the New," *When Attitude Becomes Form* (Berne: Kunsthalle Bern, 1969), n.p.

55. Scott Burton, "Furniture Journal: Rietveld," *Art in America*, Nov. 1980, p. 103. In 1989 Burton was permitted to rearrange the sculptures by Brancusi at the Museum of Modern Art. He exhibited the "bases" as sculptures, that is, with the "sculptures" removed. In 1982 Burton exhibited his own work with that of modernist architects Marcel Breuer, Mies van der Rohe, Mart Stam, and Werner Moser. See Peter Schjeldahl, "Art: Scott Burton Chairs the Discussion," *Village Voice*, June 1, 1982, p. 86.

56. Kirk Varnedoe, "Scott Burton: A Memorial Tribute," talk given at the Museum of Modern Art, New York, Mar. 28, 1990.

57. Scott Burton, "My Brancusi," *Art in America*, Mar. 1990, pp. 149–50, 153.

58. Among Burton's public works are those commissioned by the National Oceanic and Atmospheric Administration in Seattle (1983), Pearlstone Park, Baltimore, Md. (1985), the Massachussetts Institute of Technology in Cambridge (1985), and the Equitable Life Assurance Company in New York City (1988).

59. Berman, "Space Exploration," p. 134.

60. Irving Sandler, *Report to Nancy Hanks on Works of Art in Public Places*, National Endowment for the Arts, Washington, D.C., 1973.

61. Brian O'Doherty, "Public Art and the Government: A Progress Report," *Art in America*, May 1974, pp. 44–45.

62. Douglas Crimp, "Richard Serra: Sculpture Exceeded," *October 18* (Fall 1981): 78.

63. William Toby, in Clara Weyergraf-Serra and Martha Buskirk, eds., *Richard Serra's "Tilted Arc"* (Eindhoven, the Netherlands: Van Abbemuseum, 1988), p. 18.

64. Peter Schjeldahl, "Artistic Control," *Village Voice*, Oct. 14, 1981, p. 100.

65. Crimp, "Serra's Public Sculpture," p. 53.

66. Robert Storr, "'Tilted Arc': Enemy of the People?" *Art in America*, Sept. 1985, p. 92.

67. Harriet Senie, "The Right Stuff," *Art News*, Mar. 1984, p. 55.

68. Calvin Tomkins, "The Art World: Like Water in a Glass," *The New Yorker*, Mar. 21, 1983, p. 92.

69. Siah Armajani, in "Ideas and Trends: Shaping the New Sculpture of the Streets," *New York Times*, Sept. 22, 1885, sec. 4, p. 1.

70. Claudia Gould, "Mary Miss Covers the Waterfront," *Stroll*, Oct. 1987, p. 54.

71. Mary Miss, "On a Redefinition of Public Sculpture," *Perspecta 21* (1984): 60.

72. Berman, "Space Exploration," p. 134.

73. Foote, "Situation Esthetics," p. 23.

74. Scott Burton, in Douglas C. McGill, "Sculpture Goes Public," *The New York Times Magazine*, Apr. 27, 1986, p. 67. Quoted in Brenda Richardson, *Scott Burton* (Baltimore, Md.: Baltimore Museum of Art, 1985), p. 10. There is a psychological dimension in Burton's work. When John Romine, in "Scott Burton: Interview," *Upstart*, May 1981, asked Burton "What toys interested you as a child?" he replied, "A tiny table and chair which were, in fact, not mine but only loaned to me." Then he added: "In some way all my furniture is an attempt to repossess—to possess—those pieces. [They] were my favorite objects and they were never really mine" (p. 7). Quoted in Lynne Cooke, in *Scott Burton: Early Work* (New York: Max Protetch Gallery, 1990), n.p.

75. Armajani, in "Ideas and Trends," p. 1.

76. Calvin Tomkins, "Profiles: Open, Available, Useful," p. 49.

77. Gould, "Mary Miss Covers the Waterfront," p. 54.

78. Foote, "Situation Esthetics," p. 27.

79. Mary Miss, in "Artists and Designers on Collaboration," *Arts Review* 3, no. 1 (Fall 1985): n.p.

80. Gould, "Mary Miss Covers the Waterfront," pp. 54, 55–57.

6 NEW IMAGE PAINTING

Much of pattern and decoration painting, for instance, that of Robert Kushner, Kim MacConnel, and Robert Zakanitch, contained simple recognizable subjects. Little attention was paid to them at the time; they were thought of as just another decorative component, like the flat repetitive designs. In retrospect, however, the imagery can be considered a variation of *"Bad" Painting*, the title of a show at the New Museum and *New Image Painting*, at the Whitney Museum, both in 1978.

In a 1979 review of current figurative art, David Salle remarked:

> One senses imagery creeping into the arena of New York painting and sculpture at a time when the formalist hegemony, with its concerns for "pure" perception, is breaking up. People seem to want to look at pictures of things again. But for a generation of artists weaned on the primacy of abstraction and the over-valued presence of "idea" in works of art, the inclusion of imagery into painterly format . . . can be problematic.

Among the artists Salle had in mind were Neil Jenney, Robert Moskowitz, and Susan Rothenberg, all of whom made painterly paintings of simple, single subjects against single-colored grounds. Salle concluded that these artists conceived their imagery in relation "to the most recent abstract picture-making concerns."[1] So did Roberta Smith, who commented in a lengthy review of *New Image Painting* that the artists' concerns were often derived from minimal, postminimal, and conceptual art, and that absorbing "various tactics from anti- or non-painting modes . . . give[s] narration and/or figuration new, more radical sanction."[2]

The new image painters looked for inspiration to the seemingly crude painterly figuration of Philip Guston with an eye to the gestural imagery of Willem de Kooning and Jackson Pollock and the color fields of Barnett Newman, Mark Rothko, and Clyfford Still. In a sense the new image painters combined the two main tendencies in abstract expressionism. They were also influenced by the minimal furniture of Joel

Shapiro and Richard Artschwager as well as the single-color canvases of Robert Ryman, Brice Marden, and Robert Mangold. Indeed, as Carter Ratcliff observed: "Take away the figurative element, and the result is monochrome painting."[3]

Working in the interface between abstraction and figuration, the new image painters rejected recently established realist styles, notably the new perceptual realism of Philip Pearlstein and the photorealism of Chuck Close and Richard Estes. They scrupulously avoided literalist rendering and the artful look of "good" drawing and painting, the kind taught in art schools, a look that in their opinion had become banal and academic. Instead they cultivated the appearance of crudity and ineptness. Their painting was not bad, of course, but "bad," meaning "good."

Jenney said that he began to make new image paintings in 1969 in reaction against photorealism. Its brushstrokes were hidden; he let his show. He wanted his images to have "impact," to be "demonstrative and straightforward" and therefore he avoided refined techniques.[4] Elsewhere he remarked that in making his new image paintings, he had a revelation, that even if he "produced the worst paintings possible, they would not be good enough."[5] Robert Colescott said that he became a "bad" painter because he wanted to work in "a more personal form."[6]

Because of the seeming "badness" of their painting, the new image painters were attacked by traditionalists for betraying "good" painting, on the one hand and, on the other hand, by avant-gardists for employing a medium as backward-looking and therefore dead as painting. In rebuttal new image painters and their advocates dismissed conventional painting as academic but maintained that painting was a proven medium of sensuous expression, and there seemed to be an urgent need for such expression. Because of the attacks on their work, new image painters could think of themselves as radical—and embattled, just as pattern and decoration painters had. To be sure, their pictures were figurative, and therefore easy to understand. But in the quirkiness and awkwardness of the images and the "badness" of the execution, new image painting was *provocative* enough to look unconventional, if not new.

Why was there an urge for crudely executed rudimentary and childish-looking images? How relevant was this kind of seeming infantilism, this *sophisticated* infantilism? Why the regression? Was it the counterculture in a new guise? Was it a genuine upsurge of the repressed? Anarchic or mock anarchic? Or was it a faux innocence or "Naïf Nouveau," as Carrie Rickey called it? She wrote that she was "repelled by [its] anti-intellectual character. . . . By emulating the naturalness of authentic primitives, Naïf Nouveau's pretend that ignorance is bliss and suggest they know better. It's their way of being intellectual about anti-intellectualism."[7] Kim Levin agreed that the "desire for innocence is a by-product of its loss." But she concluded that the retrogressive, regressive, and unrepressed "are often the most fertile source material. The trite, the degraded, the simplistic, and the debased now have a perverse allure."[8]

* * *

New image painting did not achieve art-world recognition until the end of the 1970s, but it was ushered in by Philip Guston's 1969 show of figurative paintings. A first-generation abstract expressionist, Guston in the middle 1960s had moved from abstraction, which was the basis of his considerable reputation, to a seemingly crudely painted cartoon-like imagery. He had come to consider abstraction as "an escape from the true feelings we have, from the 'raw,' primitive feelings about the world—and us in it." The Vietnam War was

> what was happening in America, the brutality of the world. What kind of man am I, sitting at home, reading magazines, going into a frustrated fury about everything—and then going into my studio *to adjust a red to a blue*. I thought there must be some way I could do something about it. I knew ahead of me a road was laying. A very crude, inchoate road. I wanted to be complete again, as I was when I was a kid.

Guston concluded: "There is nothing to do now but paint my life. . . . My dreams, surroundings, predicament, desperation, Musa [his wife]—love, need. Keep destroying any attempt to paint pictures, or think about art. If someone bursts out laughing in front of my painting, that is exactly what I want and expect."

Consequently Guston chose his subjects from his everyday life: old shoes, rusty nails, brick walls, drawn blinds, rags, cigarette butts, and empty whiskey bottles, as well as brushes, tubes of paint, easels, and other studio paraphernalia. The earlier pictures featured hooded Ku Klux Klansmen—in desert landscapes, inspired by George Herriman's comic strip *Krazy Kat*, in dreary rooms lit by naked light bulbs, and in the city, sometimes riding in cars [85]. Guston recalled: "The KKK has haunted me since I was a boy in L.A. In those days they were there mostly to break strikes, and I drew and painted pictures of conspiracies and floggings, cruelty and evil." But the new pictures were "self-por-traits. . . . I perceive myself behind the hood. . . . In this new dream of violence, I feel . . . as if I were living with the Klan. What do they do afterwards? Or before? Smoke, drink, sit around their rooms (light bulbs, furniture, wooden floors), patrol empty streets; dumb, melan-choly, guilty, fearful, remorseful, reassuring one another? Why couldn't some be artists and paint one another." The Klansmen pictures are funny, but they possess a strong element of self-loathing. Guston's father, a Russian immigrant ragpicker, had committed suicide by hanging when Guston was ten years old—it was the boy who found him—a traumatic experience, which he most likely identified with the lynchings perpe-trated by the KKK.

After 1972 Guston's work grew even more autobiographical. Then, as his daughter recalled: "He painted his first *Painter's Forms*, a strange,

85. Philip Guston, *Close-Up*, 1969. *(Copyright © 1994 Whitney Museum of American Art)*

self-referential work, a lexicon of coughed-up objects—shoes, bottle, stretcher, bricks—emanating from the open mouth of the painter, whose rather calm self-portrait appears, in profile, in the painting's upper left."[9] Guston defined himself not only through a recurring lima-bean head with one swollen eye but through a mélange of everyday artifacts and detritus—"junk for the junkman's son."[10] Many of his images appear to refer not only to his own life—his memories of his father's death or that of his brother from gangrene after an automobile accident in which his leg was crushed—but to world events—the Holocaust. Piles of severed emaciated limbs, shoes, and decapitated heads are reminders both of his brother's leg and of the remains of Nazi death camps.

Guston's new imagery shocked and appalled his abstract expressionist contemporaries because it called to mind pop culture. De Kooning's and Pollock's figurative pictures were acceptable to their colleagues, but not Guston's, because kitsch references were taboo.

However, young artists, searching for an alternative to minimalism, post-minimalism, and literalist realism, embraced his figurative painting. Some found it too cultured for their taste, too much in the grand tradition of painting, preferring the work of more subversive artists like the late Picabia and de Chirico (also admired by Guston). But all recognized that his mixture of recognizable images and seemingly crude painterly handling opened up new possibilities. Indeed, he became so influential that, as Peter Schjeldahl reported, "'Gustonesque' now recommends itself, like 'Kafkaesque,' as a term in the lexicon of perversely poetic 20th-century feelings."[11] Indeed, Guston was the only abstract expressionist to seem relevant to young painters who emerged in the 1970s and 1980s.

New image painting reached its apogee in 1978 with *"Bad" Painting* and *New Image Painting*. Marcia Tucker, the curator of *"Bad" Painting*, defined it as "figurative work that defies either deliberately or by virtue of disinterest, the classic canons of good taste, draftsmanship, acceptable source material, rendering, or illusionistic representation. In other words, this is work that avoids the conventions of high art, either in terms of traditional art history or very recent taste or fashion."

Accordingly, bad painters looked for inspiration to "low" art, as Tucker wrote, "commercial and popular art, children's book illustrations, high-school paraphernalia, calendars, comic books, and thrift shop and flea market objects collected by many of the artists." She insisted that the artists in her exhibition were not "modern primitives," and, indeed, ten had MFAs and two BFAs. However, there was an affinity between bad painting and folk art; in both "emotional content, subject matter and idealistic commitment to a personal vision were of vital importance."

Tucker claimed that bad painting was iconoclastic in its challenge "to the conventions of Minimalism [and] traditional figurative painting as well as those of Photo-Realism. Thus, it is possible that the work of many of the artists in the exhibition is functioning in an avant-garde manner."[12] This claim was not convincing—not as late as 1978—but the fact that a curator as astute as Tucker could make it indicates that the work did look provocative at the time.

"Bad" Painting was memorable more for the title of the show, the ideas presented in the catalog by Tucker, and their timely entry into art discourse than for the work of the fourteen artists exhibited. Of the nine under the age of forty, only Jenney, age thirty-three, and William Wegman, age thirty-five, merited and would receive considerable art-world recognition, and Wegman more as a photographer and a video artist than as a painter.[13]

Curated by Richard Marshall, *New Image Painting* included Nicholas Africano, Jennifer Bartlett, Denise Green, Michael Hurson, Neil Jenney, Lois Lane, Robert Moskowitz, Susan Rothenberg, David True, and Joe Zucker. Unlike Tucker, Marshall emphasized the abstract compo-

nent in the recent figurative painting and its references to minimal art. Indeed, as he saw it, what related the diverse images in his show was that they "fluctuate between abstract and real. They clearly represent things that are recognizable and familiar, yet they are presented as isolated and removed from associative backgrounds and environments. [The subjects are] drastically abbreviated or exaggerated, retaining only [their] most basic identifying qualities." The images are further altered through arbitrary shifts of scale, handling of paint matter and color, and placement in the picture. Thus the meanings of new image paintings are rendered ambiguous. Any narrative is only implied, not specified. It "is non-linear and non-sequential, and therefore does not readily lend itself to simple, obvious explanation."[14]

Roberta Smith divided the new image painters into two groups: one, image–color field, the other, conceptual. Such artists as Africano, Moskowitz, and Rothenberg "mainly silhouette a simple shape or figure (or two) against a monochrome background, mixing a beguiling simplicity and awkwardness with highly personal symbolism." Bartlett, Jenney, and Zucker "have more or less dissected painting and put it back together again, reassembling the components of their work in ways that give each aspect its own conceptual point and separateness." Smith concluded prophetically that the *New Image Painting* show was "the first step toward a fuller understanding of a change in esthetic climate, the first, not the last word."[15]

In 1968 Neil Jenney reasoned that "realism was going to return," but he did not know to "what degree." He decided to present simple cause-and-effect narratives in which people's actions are related to objects, as he said, "for instance, a crying girl and a broken vase . . . or trees and lumber" [86]. His primary concern was the immediate presentation of a clear image, but he was also aware that whatever he painted was "always going to be paint,"[16] hence, he revealed the process of painting.

In the two or three years before this development, Jenney had worked in a variety of postminimal styles. "I explored all kinds of materials and sculpture. . . . I went through 'styles' faster than anyone else on the art scene. [Then,] I moved into realism with a tremendous rush of energy." Jenney began to draw childlike images loosely with the brush, a stroke at a time, as if finger-painting, cultivating a child's awkwardness. His narrative was as naive and elementary as his "fingerprint expressionism." He said of *Girl and Doll* (1969), "A little girl is weeping because her doll is broken. . . . We know this isn't really serious, but it is traumatic for *her*."[17]

Jenney's sketchy images were placed against a horizonless monochromatic painterly field. Each picture was enclosed by a prominent black frame whose physicality emphasized both the flatness of the panel and the illusionistic depth of the image and field. He then printed the simple titles of the pictures, for example, *Trees and Lumber,* on the

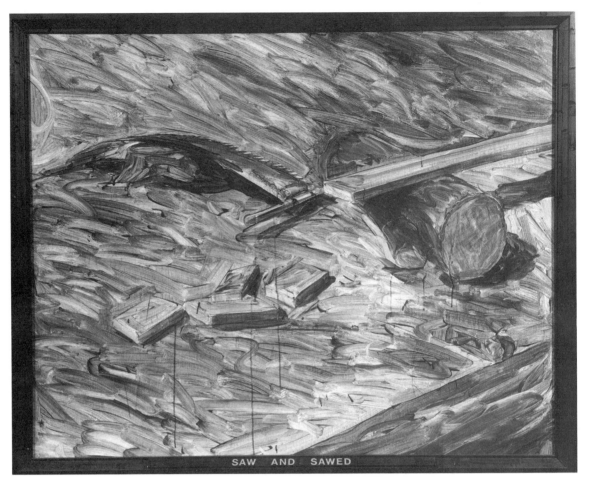

SAW AND SAWED

86. Neil Jenney, *Saw and Sawed*, 1969. *(Copyright © 1994 Whitney Museum of American Art)*

frames. Image, brushwork, frame, and text are at once a sophisticated commentary on painting and artlessly expressive, like a child's painting.

In the early 1970s Jenney gave up his bad painting style and began to render landscapes meticulously with an eye to such nineteenth-century American realists as the Hudson River painters, William Harnett and John Peto. He also made his frames and the lettering of his titles more elaborate and assertive, often larger than the painted image. Many of these "good" paintings deal with the destruction of the environment. In *Meltdown Morning* (1975) the heavy frame resembles a slitlike window—in a bomb shelter, perhaps—that looks onto a landscape whose central third is filled with a closeup section of a tree trunk. In the distance a nuclear mushroom cloud is juxtaposed against an ordinary rain cloud. Art critic Mark Stevens commented: "Whereas the nineteenth-century Americans viewed the landscape as a place of sublime promise, Jenney's view is one of impending loss."[18]

* * *

In 1974 Rothenberg took as her subject the silhouette of a horse, locating it in a single-color ground and pinioning it with simple design elements such as vertical bands or crosses—all painted in a loose manner with expressionist urgency [87]. Critics commented that the horse image had a psychological charge, prompting thoughts about the relationship between girls—herself as a child, her daughter—and horses. But Rothenberg herself claimed that "the horse held no particular private significance for her," except that it was appealing as a "big, soft, heavy, strong, powerful form."[19]

Rothenberg preferred to stress the nonillusionistic abstract components in her paintings. She said: "I just thought about wholes and parts, figures and space."[20] She remarked elsewhere:

> The geometrics in the painting—the center line and other divisions—
> are the main fascinators. They were there before the horse. . . . First I
> do the lines and then the horse may have to push, stretch, and modify
> its contours to suit the ordered space; the space, in turn, may have to
> shift to accommodate a leg, or split a head, until a balance is
> achieved. . . .
> The lines and bars are intended to flatten and clarify what is
> happening with the image.[21]

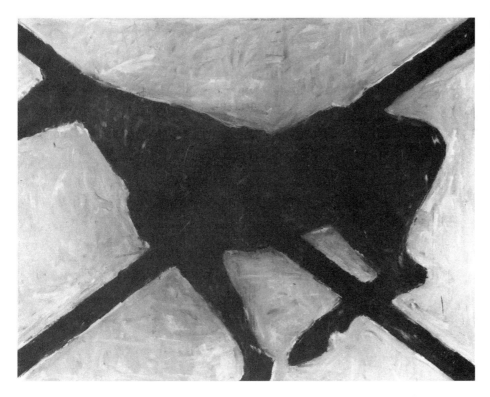

87. Susan Rothenberg, *Butterfly*, 1976. *(Copyright © 1995 Board of Trustees, National Gallery of Art, Washington, D.C.)*

Rothenberg's painting strongly impressed the art world in the 1970s because it was perceived as "felt" yet sufficiently spare and restrained to avoid self-indulgence and sentimentality.

In pictures such as *Cadillac/Chopsticks* (1975), *Swimmer* [88], and in subsequent paintings of architectural motifs—the World Trade Towers, the Empire State Building—Robert Moskowitz simplified the subjects to their silhouettes, thereby calling attention to contour drawing, interaction of color, and subtly inflected brushing. In later works of the 1980s, he appropriated the images of modern masters—Rodin's *The Thinker*, Brancusi's *Bird in Space*—transforming each into a single-colored plane on a single-colored ground. These pictures are monumental and haunting—homages to earlier art in the idiom of new image painting.

In tableaulike pictures of the middle and late 1970s, Nicholas Africano painted miniature figures in profile [89]. They are built up of

88. Robert Moskowitz, *Swimmer,* 1977, *(Copyright © 1994 Whitney Museum of American Art)*

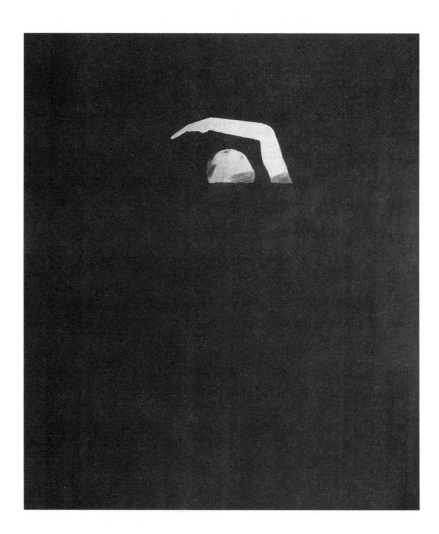

89. Nicholas Africano,
An Argument, 1977,
*(Copyright © 1994
Whitney Museum of
American Art, New
York)*

crudely modeled pigment and are centered on relatively large, mono-chromatic fields. The figures are participants in emotionally charged, unresolved domestic melodramas. *The Scream* (1978), a series of three pictures, was accompanied by an inscription on the wall: "This man went crazy because of a woman. He was my close friend. I tried to comfort him but I didn't know what to do. It was stupid, trying to figure it out, so I just tried to hold him. He screamed. It was terrible. I hate people who go crazy."

Unlike most new image painters, Africano emphasized narrative content. Indeed, he came to painting via the study of literature. "As an English student, I wrote short stories and they kept getting shorter. They required an immediacy of image. I started substituting small drawings and ideograms for words."[22] Moreover, in many pictures a caption—a conceptual component, as in Jenney's work—is printed on the surface, emphasizing the story line.

Many of Africano's works are autobiographical. Indeed, the bearded artist himself appears as a character in situations of "emotional paralysis that I have experienced, an inability to make contact, to confront people or situations directly. . . . They are about moments when you are called upon to feel a certain thing and you find yourself incapable of feeling what you ought to."[23] The feelings of malaise are embodied in the way the figures are

swamped by their single-color backdrops which also serve to draw the spectators' attention to the psychological tensions in the narrative.[24]

In 1971 Joe Zucker began to "paint" storybooklike illustrations of plantation life, windmills, ferris wheels, sailing ships, and Mississippi riverboats—using cotton balls, soaked in paint and rhoplex and attached to the canvas [90]. The technique called attention to both the clunky imagery it yielded and to the abstract, impasto-like surface. In his best-known paintings—the *Land of Cotton* series, 1976—in which the subject of making cotton refers to the material whereof the images are made— Zucker mixed irony and sentimentality.[25]

Robert Colescott introduced social commentary on racism in Western art and society into new image painting. In his works of the 1970s he appropriated famous pictures and parodied them by painting "badly" and by replacing white characters with crude caricatures of African-Americans or Africans. Van Gogh's poverty-stricken *Potato Eaters* were turned into "happy darkies" in *Eat Them Taters* (1975), and the head of de Kooning's *Woman* was replaced by Aunt Jemima in *I Still Get a Thrill When I See de Koo* (1978) (with an eye to Mel Ramos's pinup-girl

90. Joe Zucker, *Merlyn's Lab,* 1977. *(Copyright © 1994 Whitney Museum of American Art)*

takeoff of the de Kooning). In *George Washington Carver Crossing the Delaware* (1975) [91], a spoof of Emanuel Leutze's academic painting of 1851, the celebrated botanist replaces the Father of Our Country and leads a boatload of rowdy black down-home types—a mooning mammy, cooks, banjo player, corn-liquor-swilling roustabout, sporting life, and so on.[26] Thus Colescott satirized the exclusion of blacks from history texts and ridiculed popular racist stereotypes.

Much as African-American history and culture was in Colescott's mind, he did not look to African art for inspiration. He commented that his pictures could be made only in the United States, and that his primary artistic influences were Western:

> Even though I'm an Afro-American artist that studied in France and loves German Expressionism, I don't think the final product could be

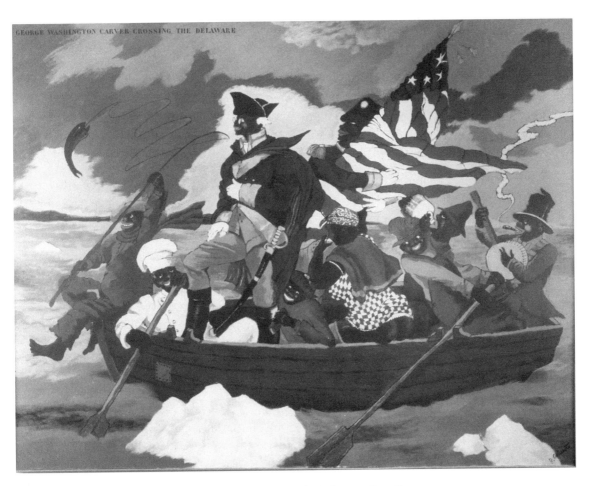

91. Robert Colescott, *George Washington Carver Crossing the Delaware: Page from an American History Textbook*, 1975. *(Phyllis Kind Gallery, New York)*

done in Germany or France or Africa, and I know more about German Expressionism than I know about African masks, but I think my paintings reflect a unique character that I draw from this culture and speak about this culture.

More specifically Colescott was a new image painter. He said that the "more idiosyncratic, the more deviant the work becomes [the] 'badder' it becomes in terms of standards that had been applied all along . . . and less like work that's been done before"—and more personal and intimate.[27]

In the late 1970s Colescott's work changed. The figures became more rounded, in their appearance as well as in what they signify. The satire was often aimed not only at the situation of blacks but of humankind as a whole. For example, he confronted sexual stereotypes and taboos and the complexities of sexual relations between black and white men and women. In *Beauty Is in the Eye of the Beholder* (1979), his self-image as a male African-Americn artist paints Matisse's *The Dance* while looking back and giving the eye to a half-dressed full-bodied white woman—model? mistress? whore? fantasy figure? He also portrayed himself as Van Gogh at work flanked by two skeletons in *Auvers-sur-Oise: Crow in the Wheatfield* (1981) [92], stereophonic earphones covering the cut-off ear while Van Gogh himself, ear bandaged, surveys the scene. In a series of paintings, *At the Bathers' Pool* (1984–85), he examined white and black body types, juxtaposing female nudes in order to demonstrate the "competition between standards of beauty, both physical and artistic. You can't separate the two. The competition has been going on since the first white face met the first black face, in antiquity, somewhere up the Nile."[28]

Colescott faced a critical problem for African-American artists, namely, how to depict African-Americans. His tongue-in-cheek interpretation of racist and sexist stereotypes raised hackles in African-American and feminist circles. Was he demeaning African-Americans when he should be representing them in the best light possible, as some spokespersons for the African-American community would like? Cultural critic Cornel West maintained that there was no agreement as "to what the 'real Black community' is and what 'positive images' are." Thus the demands for positive images "presuppose the very phenomena to be interrogated, and thereby foreclose the very issues . . . to be investigated."[29] Colescott himself refused any attempts to limit his expression in the name of "community standards."

Colescott's satires were problematic because it was not always clear just how they were meant to be taken. In causing viewers to laugh at stereotypes was he perpetuating them or making viewers aware of their prejudices? There was no question in curator Lowery Sims's mind. "Colescott flouts taboos in art, sex, race, money, power, and politics. [He] wreaks havoc with the accepted social and sexual order in a manner

92. Robert Colescott, *Auvers-sur-Oise (Crow in the Wheat Field)*, 1981. *(Corcoran Gallery of Art, Washington, D.C.)*

more cogent—and perhaps in the long run more effective—than more overtly destructive social protest."[30]

More than any other new image painter, Jennifer Bartlett rigorously dissected the "language" of painting, slicing it up into "some of [its] basic elements": four rudimentary figurative motifs—a tree, a house, a mountain, and the ocean—and three equally elementary abstract elements—the square, the circle, and the triangle—in three sizes—large, medium, or small. "I decided that you can have lines in a painting, and they can be of four sorts—horizontal, vertical, curved, and diagonal—and they can be of different colors and different lengths. There are three possible ways of making a mark on a two-dimensional surface—dotted, freehand, or measured."[31]

In her major early work, *Rhapsody* (1975–76) [93], consisting of 988 baked enameled steel plates, each a foot square, arranged in a grid 7½ feet high and 153 feet long, wrapped around the walls of New York City's

Paula Cooper Gallery, Bartlett put these minimal motifs through an exhaustive series of combinations and permutations, as if heeding Sol LeWitt, who, in "Sentences on Conceptual Art," wrote that the artist's proposal should be subjective in its inception, but once formulated should be executed methodically.[32]

Jonathan Borofsky can be included among the new image painters because he was of their generation and because critical aspects of his work resembled theirs, but only aspects since he created the *Gesamtkunstwerk* of the 1970s. In 1969 he began to record sequential numbers—1, 2, 3, 4, etc.—on 8½-by-11-inch sheets of paper, a conceptual activity but also reminiscent of minimal serialism. He then piled 9,350 of these papers into a minimal-looking 3½-foot-high rectangular stack, which he titled *Counting from 1 to Infinity* and exhibited in 1973. *Counting* was influenced by Sol LeWitt's proposals for wall drawings, but unlike the latter, which were mechanically executed by the artist's assistants, Borofsky drew the numbers by hand in what seemed to be an introspective and contemplative manner.

93. Jennifer Bartlett, *Rhapsody,* 1975–76, detail of installation, Paula Cooper Gallery, May 8–June 16, 1976. *(Private collection, New York)*

Borofsky's incessant and ongoing counting was like saying a mantra, a meditative activity that had a source in the 1960s counterculture. In 1971 he began to use the process of counting in a kind of free-associational manner to generate subjective images. In sum Borofsky used the "rational" process of counting to create "irrational" products,

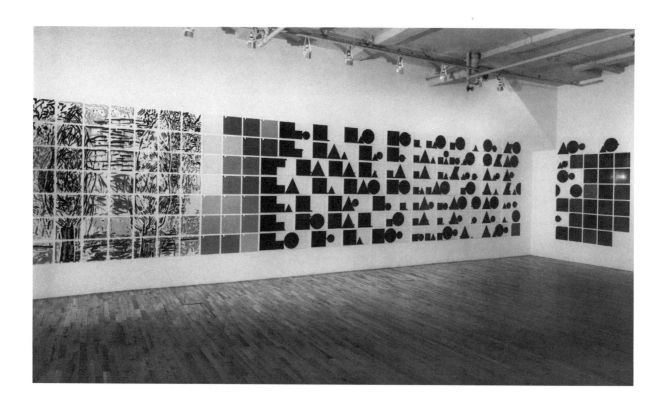

deflecting minimal and conceptual art into a new direction.[33] As he said, he wanted to "get rid of *cool* art, open up feeling and show ourselves."[34] Elsewhere he commented: "I always reach into myself for information, for material that I might use for my art."[35]

The hundreds of doodles on Borofsky's sheets of numbers, and the hundreds he made subsequently, were the source of images he began to render in a "maximalist" variety of styles—ranging from realism to expressionism—and mediums—painted canvases attached to the wall or propped up like sculptures; monolithic three-dimensional and relief sculptures or constructions in space; drawings on paper, canvas, wall, and ceiling; video, light, and sound pieces. He then combined these elements into room-size installations, recalling postminimal theatrical environments. Nonetheless the components were discrete objects, which he continued to number individually, each number becoming a kind of signature. Borofsky introduced into his work whatever came to mind as he counted, no matter how foolish or simplistic or banal or embarrassing. Or, as Lynne Cooke wrote about his "nakedness": "What is crucial is his willingness to appear vulnerable; to be openly mawkish, ingenuous, trivial, awestruck, earnest, funny, self-congratulatory, vulgar and so forth."[36] Borofsky himself commented: "I knew I was doing something innovative for the time, because I was just talking about my mother and father, death and very personal things, in such a way that people could easily say, Oh, how embarrassing—you know, he's not very cool."[37]

In a 1975 show Borofsky transported all the work in his studio into the Paula Cooper Gallery. This multimedia ensemble of finished and unfinished drawings, paintings, and sculptures was a psychic stage set. Entering it—and subsequent installations—was like plunging into Borofsky's stream of consciousness. Although his art in its entirety presented itself as an autobiography in perpetual progress, much of it was an invention. For example, in *Age Piece* (1972), he imagined what a series of thirteen of his works, made at different intervals in his career, from age eight to age forty, might look like, and executed them.

In many of his works Borofsky included an imagined self-image in a variety of guises,[38] ranging from the far-fetched, self-aggrandizing guru of cosmic consciousness to the equally far-fetched, self-indulgent child or self-deprecating buffoon. The pieces were often funny, such as, *I dreamed I was taller than Picasso at 2,047,324* (1973) [94], in which the printed title is juxtaposed against a "bad" drawing. Or, *I dreamed that Salvador Dali wrote me a letter. Dear Jon, There is very little difference between the commonplace and the avant-garde. Yours truely* [sic]*, Salvador Dali."* But the lighthearted mood was dissipated as the spectator became aware that the individual components in Borofsky's chaotic-looking mélanges were often conflicted, anxiety provoking, and disturbing.

Large sculptures that Borofsky began to make in the 1970s are surrogate self-portraits. A hammering man whose motorized arm is in perpetual motion calls to mind the artist as an archetypal worker. An end-

94. Jonathan Borofsky, *I Dreamed I Was Taller than Picasso at 2,047,324*, 1973. *(Collection of Martin Sklar, New York)*

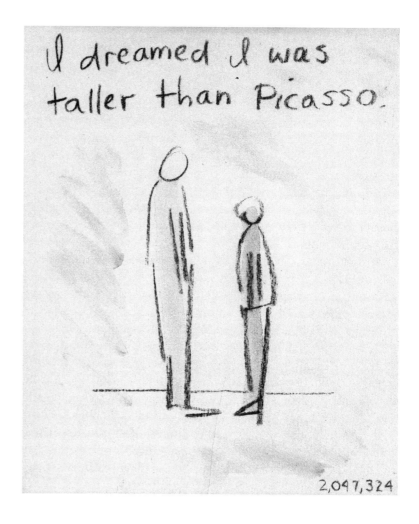

lessly chattering man with a built-in tape recorder exemplifies the workings of his mind. A running man was Borofsky, running from danger to freedom. The artist was also a man in a hat carrying a briefcase presumably containing his drawings—"a metaphor for my brain"[39]—which called to mind Duchamp's valise; transporting his drawings was also the artist. And he was also the eleven-foot-high sculpture, half clown–half ballerina, with a sad expression, one foot rotating dancelike to the tune of "I Did It My Way"—the artist as pathetic entertainer.[40] It is noteworthy that all these mechanized images are in motion. Indeed, movement in time is central to Borofsky's body of work, beginning with his ongoing counting, and culminating in kinetic sculpture and film, video, slide, and sound pieces.

In the 1980s Borofsky increasingly presented his private view of public issues. For example, as his contribution to the *Zeitgeist* show in Berlin (1982), he hung outside the building a life-size carved and painted Styrofoam self-portrait that looked as if it had been catapulted out of the window in the direction of East Berlin. He also drew his *Running Man* on the Berlin Wall.[41] Other works made disturbing references to world

affairs, such as the arms race. One of his installations included a real Ping-Pong table, whose camouflaged top had the American defense budget stenciled on one side of the net, and the Soviet on the other [95].

His 1990 installation at the Paula Cooper Gallery was, as he said, at "the intersection of the personal space and the global space."[42] Rocks and seeds represented earth and a gravity-defying spinning boulder in outer space. A freestanding ten-foot book by Jean Robert, titled *The Individual and the Nature of Mass Events*, was open to part 4, "The Practicing Idealist," chapter 10, pages 276–77, "The Good, the Better and the Best: Value Fulfillment vs. Competition." Life-size figures in textured gray cement with disks of inner lights shining from their foreheads were either everyman or extraterrestrial humanoids. A spiral organ emitted computer-generated music of the spheres. When added up these disparate components became a space-age vision of enlightenment.

Much as Borofsky's works are theatrical installations, they are composed of discrete objects. "Whenever I do an installation, I think of it as one whole work made up of individual parts, which ultimately break off

95. Jonathan Borofsky, installation, Paula Cooper Gallery, October–November 1980. *(Paula Cooper Gallery, New York)*

and become their own smaller works that are usually either sold or stowed away somewhere."[43] Thus they partook of the "return to the object" prevalent in the 1970s. And in the seeming artlessness of the painted components, they were akin to new image painting, which was just beginning to command art-world attention.

New Image Painting, more than any other 1970s painting show, rehabilitated painting. But a number of other shows at the time contributed to this development. The first was *A Painting Show,* a mélange of forty-one artists, at New York City's fashionable P.S. 1 in 1977. It was followed in 1978 by Linda Cathcart's *American Painting of the 1970's* at the Albright-Knox Art Gallery in Buffalo, New York, whose purpose it was to proclaim the viability of current painting. She challenged "art historians and critics [who] have put forth the notion that painting has become repetitive, redundant, self-obsessed, stale, and stalled. They conclude that it is not worth examination and some feel that perhaps other forms of artistic activity have superseded, in terms of visual validity, the function once fulfilled by painting."[44] In her opinion it was alive and well. Painting had become much too varied to generalize about as if it were one thing, and critics who did missed the essential point, namely its pluralism.

The following year Barbara Rose also took up the standard of painting, in a show she curated at the Grey Art Gallery in New York City titled *American Painting: The Eighties.* In the introduction to the catalog she asserted that there was a "great hunger for images," painted images. She defended painting and attacked its enemies, notably the advocates of photography as well as the medium of photography itself. Her polemic was flawed because it was too shrill; there was no need to attack other media in order to make a case for painting. Her show also missed the mark because of the number of inferior artists she had selected; there were better ones, but she had been away from the art world too long to be able to identify them. Nevertheless Rose's show and catalog were important because of the publicity they received and the controversy they generated—all of which called attention to painting.

New image painting would move in two directions, toward an anarchic badness, badder than ever before, or toward "bad" painting that clearly aspired to be "good" or—to put it simply—toward painting.

NOTES

1. David Salle, "New Image Painting." *Flash Art* (Apr.–May 1979): 40.
2. Roberta Smith, "The Abstract Image," *Art in America,* Mar.–Apr. 1979, p. 102.
3. Carter Ratcliff, "Contemporary American Art," *Flash Art* (Summer 1982): 32.
4. In Paul Gardner, "Portrait of Jenney," *Art News,* Dec. 1983, Jenney said: "But I had to distance myself from the Photo-Realist crowd. They tried to be perfect, to hide the brushstrokes. I chose to be imperfect, to show the brushstrokes" (p. 73).

5. Neil Jenney, in *"Bad" Painting* (New York: New Museum, 1978), n.p.
6. Robert Colescott, "The New Figuration" (typescript of panel discussion organized by the New Museum, New York, May 24, 1982), p. 11.
7. Carrie Rickey, "Naive Nouveau and Its Malcontents," *Flash Art* (Summer 1980): 36, 38. Rickey included Africano, Jenney, Longo, Fischl, Lawson, and Levine.
8. Kim Levin, "The Agony and the Anomie," *Arts Magazine*, Apr. 1986, p. 63.
9. Musa Mayer, *Night Studio: A Memoir of Philip Guston* (New York: Alfred A. Knopf, 1988), pp. 149–50, 158–59, 170–71, 173.
10. Peter Schjeldahl, *The 7 Days Art Columns: 1988–1990* (Great Barrington, Mass.: The Figures, 1990), p. 55.
11. Ibid., p. 51.
12. Marcia Tucker, in *"Bad" Painting*, n.p.
13. Older artists Joan Brown and Cply were well known in New York. The other artists in *"Bad" Painting* were James Albertson, Eduardo Carillo, James Chatelain, Charles Garabedian, Robert Chambless Henden, Joseph Hilton, Judith Linhares, P. Walter Siler, Earl Staley, and Shari Urquhart.
14. Richard Marshall, in *New Image Painting* (New York: Whitney Museum of American Art, 1978), p. 7. The new imagists were influenced by the works of several artists who emerged in the 1950s and early 1960s, notably Jasper Johns's painterly renditions of flags, targets, numbers, and letters, and Jim Dine's pictures of shoes and neckties.
15. Smith, "The Abstract Image," pp. 102–4.
16. Neil Jenney, in *New Image Painting* (New York: Whitney Museum of American Art, 1978), p. 38.
17. Paul Gardner, "Portrait of Jenney," *Art News*, Dec. 1983, pp. 73–74.
18. Mark Stevens, "Master of 'Dumb Art,'" *Newsweek*, July 20, 1981, p. 67.
19. Lisbet Nilson, "Susan Rothenberg: 'Every Brushstroke Is a Surprise,'" *Art News*, Feb. 1984, p. 51. See also Joan Simon, *Susan Rothenberg* (New York: Harry N. Abrams, 1991), p. 29.
20. Rothenberg, in "Expressionism Today: An Artists' Symposium," *Art in America*, Dec. 1982, p. 65.
21. Susan Rothenberg, in *New Image Painting* (New York: Whitney Museum of American Art, 1978), p. 56.
22. Michael Bonesteel, "Moments of Conviction: The Story Paintings of Nicholas Africano," *New Art Examiner*, July 1980, pp. 10–11.
23. Sandra Hytken, "Nicholas Africano's Acrylic Autobiographical Angst," *Chicago Weekly Reader*, Jan. 14, 1977, sec. 1, p. 26, quoted in Dupuy Warrick Reed, "Nicholas Africano: Responsible Relevance," *Arts Magazine*, June 1979, p. 158.
24. Alfred Jan, "Reviews: San Francisco: Nicholas Africano, Fuller Goldeen," *Flash Art* (Summer 1985):
57. Many of Africano's pictures are nonautobiographical, such as the *Battered Woman* series (1978) and a thirty-painting sequence based on Puccini's opera *The Girl of the Golden West* (1910).
25. See Joe Zucker, in Corinne Robins, *The Pluralist Era: American Art, 1968–1981* (New York: Harper & Row, 1984), p. 174, and Joe Zucker, in *New Image Painting* (New York: Whitney Museum of American Art, 1978), p. 68.
26. See Lowery S. Sims, "Bob Colescott Ain't Just Misbehavin'," *Artforum*, Mar. 1984,: p. 59.
27. Colescott, "The New Figuration," p. 11.
28. Robert Colescott, quoted in Susanne Arnold, "The Eye of the Beholder: Robert Colescott," in *The Eye of the Beholder: Recent Work by Robert Colescott*, (Richmond, Va.: University of Richmond, Marsh Gallery, 1988), pp. 12–13.
29. Cornel West, "The New Cultural Politics of Difference," *October 53* (Summer 1990): 104.
30. Sims, "Bob Colescott Ain't Just Misbehavin'," p. 59.
31. Jennifer Bartlett, in *New Image Painting*, (New York: Whitney Museum of American Art, 1979), p. 20.
32. Sol Lewitt, "Sentences on Conceptual Art," *0–9*, no. 5 (January 1969): 3–5.
33. Borofsky was selected by Sol LeWitt to have a one-person show at Artists Space in 1973. He exhibited *Counting*.
34. Lucy R. Lippard, "Jonathan Borofsky at 2,096,974," *Artforum*, Nov. 1974, p. 63.
35. Antonella Soldaini and Vincent Todoli, "Borofsky," *Flash Art* (Mar. 1985): p. 18. Jonathan Borofsky, in Mark Rosenthal and Richard Marshall, *Jonathan Borofsky*, (Philadelphia: Philadelphia Museum of Art, 1984), p. 148, said that his "deepest inner source is . . . my dreams."
36. Lynne Cooke, "Jonathan Borofsky at the Whitney, New York," *Artscribe International*, Mar–Apr. 1985, pp. 54–55.
37. Soldaini and Todoli, "Borofsky," p. 18.
38. See Mark Rosenthal, "Jonathan Borofsky's Modes of Working," in Rosenthal and Marshall, *Jonathan Borofsky*, p. 14.
39. Borofsky, in Rosenthal and Marshall, *Jonathan Borofsky*, p. 176.
40. See Cooke, "Jonathan Borofsky at the Whitney, New York," p. 54.
41. Joan Simon, "Report from Berlin: 'Zeitgeist': The Times & the Place," *Art in America*, Mar. 1983, p. 37.
42. Soldaini and Todoli, "Borofsky," p. 18.
43. Katherine Howe, "'I can never quite get too direct . . .' Jon Borofsky, An Interview," *Images and Issues*, May–June 1984, p. 20.
44. Linda Cathcart, *American Painting of the 1970s* (Buffalo, N.Y.: Albright-Knox Art Gallery, 1978), p. 1.

7 THE ART WORLD OF THE 1970s

The question of how and why artists achieve or do not achieve recognition at any moment has long fascinated the art world. In the modern era, or at least since World War II, success or lack of it has been determined through a consensus of key artists and art professionals—dealers and collectors; art editors, critics, and historians; and museum directors, curators, and trustees. They established what has been of significance and value in the visual arts. In *American Art of the 1960s*, I detailed how this consensus was formulated.[1] Just as in that survey, I chose to be guided by the art-world consensus in this book, with confidence in its integrity for the art of the 1970s and, with reservations, for the art of the following decade.

Minimal sculpture was established with the *Primary Structures* show, curated by Kynaston McShine at the Jewish Museum in New York City in 1966. Leading minimalists were also included in *Sculpture of the Sixties*, organized by Maurice Tuchman in 1967 at the Los Angeles County Museum of Art and accompanied by a catalog, which fairly accurately reflected the art-world consensus about American sculpture at the time. Postminimal art became "established" in 1969 in two shows: *9 in a Warehouse* at the Leo Castelli Gallery Annex, which included Eva Hesse, Bruce Nauman, and Richard Serra, and *Anti-Illusion: Procedures/Materials* at the Whitney Museum.[2] Curated by Marcia Tucker and James Monte, the *Anti-Illusion* show included Lynda Benglis, Hesse, Neil Jenney, Nauman, Robert Ryman, Serra, Joel Shapiro, and Richard Tuttle.[3] Artists in *9 in a Warehouse* and *Anti-Illusion* were featured in *Artforum*, the leading journal of avant-garde art, whose editor, Philip Leider, was a champion of postminimal art.

Castelli's support of postminimal art was critical. In the late fifties he had launched the careers of Jasper Johns and Robert Rauschenberg, and in the sixties he represented major pop artists, minimal artists, and postminimalists Serra and Nauman.[4] He had built up a network of "friendly" galleries at home and abroad, establishing international visibility and a market for his artists. By 1964, the year Rauschenberg won the first prize at the Venice Biennale, Castelli had become the most pres-

tigious dealer in the Western world. He was an adviser to important collectors, such as Count Giuseppe Panza di Biumo, who had accumulated the world's largest collection of art produced in the United States—more than six hundred works by 1980, including a considerable number of postminimal works.[5]

In 1969 American postminimalists and their European counterparts, among them Joseph Beuys and arte povera, were surveyed in two major shows in European museums: *Live in Your Head: When Attitudes Become Form: Works-Concepts-Processes-Situations-Information*, curated by Harald Szeemann at the Kunsthalle, Bern, and *Square Pegs in Round Holes*, curated by Wim Beeren at the Stedelijk Museum, Amsterdam. In 1970 Kynaston McShine organized *Information* at the Museum of Modern Art, placing the museum's imprimatur on conceptual art, performance art, and site-specific works.[6]

In Europe, postminimal art, arte povera and related tendencies were promoted primarily by a network of young museum professionals and art dealers.[7] Their taste was exemplified by Szeemann's selection of artists in *Documenta 5*, 1972. Included were Vito Acconci, John Baldessari, Beuys, Marcel Broodthaers, Daniel Buren, Christo, Gilbert & George, Hesse, Jenney, Jannis Kounellis, Sol LeWitt, Richard Long, Mario Merz, Nauman, Dennis Oppenheim, Ryman, Serra, Robert Smithson, and Richard Tuttle. Throughout much of the 1970s postminimal tendencies continued to be considered the most advanced in international art, and received a considerable amount of art-critical and museum support. For example, in 1974, the most important European museum show was *Projekt 74: Kunst bleibt Kunst*—accompanied by a 480-page catalog—at the Wallraf-Richartz Museum in Cologne. Curated by Evelyn Weiss, the exhibition was subtitled *Aspects of International Art from the Early Seventies* and set out to define the sensibility of the art of the decade. Painting was deliberately downgraded. Of the approximately eighty artists included, only six were painters, four of them photorealists. Some thirty artists were commissioned to make special projects, among them Acconci, Beuys, Christian Boltanski, Broodthaers, Buren, Gilbert & George, Long, Merz, Robert Morris, Nauman, Serra, and Alan Sonfist. *Documenta 6*, 1977, directed by Manfred Schneckenberger, also included leading postminimal and arte povera artists. But by the end of the 1970s there was a European consensus that the three major European artists to have emerged in the late sixties were Beuys, Merz, and Kounellis.

Feminist artists achieved growing recognition, primarily through their own efforts. Confronted with art-world discrimination, they organized their own galleries in New York City: the Women's Interart Center, which opened in 1971; the A.I.R. Gallery, in 1972; and Soho 20, in 1973. They also curated their own shows. Women in the Arts (WIA) mounted *Women Choose Women* at the New York Cultural Center in 1973. Including works by 109 contemporary women artists, selected by feminist artists and art professionals, it was the first such show in a major big-city

museumlike setting, and the harbinger of many more to come. In 1972, feminist art publications began to appear. The more important were *Feminist Art Journal* (1972–77) and *Women Artists Newsletter*, founded in 1975 (retitled *Women Artist News* in 1978). From 1977 to 1980 the Los Angeles Woman's Building published *Chrysalis: A Magazine of Woman's Culture*. Other important feminist magazines were *Heresies*, founded in 1977; *Helicon Nine, A Journal of Women's Art and Letters* and *Women and Performance*, both begun in 1979; and in 1980, the *Women's Art Journal*.

Pattern and decoration painting began to attract art-world interest in 1975 with the opening of the Holly Solomon Gallery. For some half dozen years previously Holly and her husband Horace had run a "salon" in a SoHo loft at 98 Greene Street, in which they presented poetry readings, dance recitals, performances by artists, video and film programs, and shows of new art. The gallery's *Opening Group Exhibition* included Brad Davis, Tina Girouard, Robert Kushner, Kim MacConnel, and Ned Smyth. These artists as well as Robert Zakanitch, Valerie Jaudon, Thomas Lanigan-Schmidt, and Judy Pfaff were given one-person shows at the gallery.[8]

Museums also began to exhibit pattern and decoration painting. Marcia Tucker included the work of Kushner and MacConnel in the 1975 Biennial at the Whitney Museum. Amy Goldin singled them out in her review of the show in *Art in America*. She would become the major critical champion of pattern and decoration painting, publishing a series of articles on the decorative between 1975 and 1978.[9]

In 1977 Goldin organized *Patterning and Decoration* at the Museum of the American Foundation for the Arts in Miami, Florida. In an attempt to broaden the perception of the new decorative art, she included work by Stella and Sugarman.[10] In that same year John Perreault surveyed *Pattern Painting* at P.S. 1 in New York, a show that comprised works by twenty-six artists. In 1978 Ruth K. Meyer mounted *Arabesque* at the Center of Contemporary Art in Cincinnati, Ohio, and in 1979, Janet Kardon curated *The Decorative Impulse* at the Institute of Contemporary Art, University of Pennsylvania, in Philadelphia.[11]

In 1977 Solomon introduced the artists she represented at the Basel Art Fair under the heading "Pattern and Decoration." She commented that a

> Swiss private dealer, Thomas Ammann . . . bought several pattern works, and the rush was on. So far, the major buyers have been European. Dr. Peter Ludwig, the West German chocolate manufacturer . . . has bought in depth. A group exhibition of Herr Ludwig's holdings in this line is currently [1980] on view at the Neue Galerie–Ludwig Collection in Aix-la-Chapelle, under the title "The New Fauves." Other dealers have lost no time catching the decorative wave: James Mayor in London, Daniel Templon in Paris, Bruno Bischofberger in Zurich, Rudolph Zwirner in Cologne, and Robert Miller, Tibor de Nagy, and the Lerner-Heller Gallery in New York.[12]

Willi Bongard, who published *Art Aktuell*, Cologne, a newsletter whose subscribers were largely collectors, also promoted pattern and decoration painting.

The first major European museum survey, *Patterning Painting*, was mounted at the Palais des Beaux-Arts de Bruxelles, Brussels, Belgium, in 1979. It was followed by *Pattern: Kushner, MacConnel, Ripps, Zakanitch* at the Musée d'Art Moderne et d'Art Contemporain, Nice, France; *Les Nouveau Fauves—Die Neuen Wilden* at the Ludwig Collection, Aachen, West Germany; *Dekor* at the Mannheimer Kunstverein, Mannheim, West Germany (and thereafter at Amerika Haus in West Berlin and the Museum of Modern Art in Oxford, England); and *Pattern Painting/Decoration Art* at the Museum Moderner Kunst Stiftung Ludwig, Vienna.

Architectural sculptors began to achieve art-world recognition with the Whitney Biennial of 1978. Pincus-Witten wrote at the time that "these 'constructionists' represent the cutting edge of the art of the late seventies; they are its most seriously progressive group, the one least marked by petty M.F.A. amalgams, the least soft-centered trend."[13] Important museum shows of architectural art were *Dwellings* at the Institute of Contemporary Art, University of Pennsylvania (1978); *Architectural Analogues* at the downtown branch of the Whitney Museum (1978); and *Architectural Sculpture* at the Institute of Contemporary Art, Los Angeles (1980). The Whitney Biennial of 1981 included Alice Aycock, Nancy Holt, Mary Miss, and Dennis Oppenheim, among others. Functional sculpture was featured in *Improbable Furniture* at the Institute of Contemporary Art, University of Pennsylvania, 1977. By 1980 a number of articles had appeared on the tendency and on individual artists, the most important of which were Rosalind Krauss, "John Mason and Post-Modernist Sculpture, New Experiences, New Words," *Art in America* (May–June 1979), and "Sculpture in the Expanded Field," *October* (Spring 1979); and Lucy R. Lippard, "Complexes: Architectural Sculpture in Nature," *Art in America* (Jan.–Feb. 1979).

The new image painters found their first advocates in the underground art magazine *Artrite*, whose editors Edit DeAk and Walter Robinson had their fingers on the pulse of what was liveliest in New York. New image painters began to achieve recognition in 1976, the year that Susan Rothenberg and Jennifer Bartlett had important shows, the former of her images of horses at the Willard Gallery; the other, of her *Rhapsody* at the Paula Cooper Gallery. The new image painters were soon included in shows of paintings that commanded attention in the New York art world, notably *A Painting Show* in 1977 at P.S. 1, a prestigious and fashionable venue. Among a formidable roster of forty-one artists were new image painters Africano, Jenney, Moskowitz, and Rothenberg.

The *New Image Painting* exhibition at the Whitney Museum in 1979 established its participants, among them Africano, Bartlett, Jenney, Moskowitz, Rothenberg, and Joe Zucker. More than any other show of painting in the 1970s, it announced the rehabilitation of painting. Linda

Cathcart's *American Painting of the 1970's* at the Albright-Knox Art Gallery in Buffalo, New York (1978), consisted of works by fifty artists, among them Jenney, Moskowitz, and Rothenberg, but it was not the purpose of the exhibition to feature the new imagists but instead to proclaim the viability of current painting generally. The following year Barbara Rose also took up the standard of painting, in a show she organized at the Grey Art Gallery, New York City, titled *American Painting: The Eighties*, comprising forty-one artists, including new imagists Moskowitz and Rothenberg, and others, among them Nancy Graves, Bill Jensen, and Elizabeth Murray.

The economy in the 1970s was in recession, causing galleries to migrate from Fifty-seventh Street and its environs downtown to the SoHo (the acronym for "south of Houston [Street]") where rents were lower and spaces larger. Paula Cooper was the first to open a gallery there—in 1968—followed in 1969 by Ivan Karp and Max Hutchinson, and in 1970 by Leo Castelli. It took some time for SoHo to attract the uptown art-world clientele, but they came, particularly when the economy began to recover and the neighborhood was gentrified through an influx of boutiques and restaurants. By 1980 SoHo had expanded south into Tribeca ("triangle below Canal [Street]") and was approaching Wall Street—fittingly, given the romance of art and money that was soon to blossom.

The recession was a primary cause of the establishment of not-for-profit alternative galleries—that is, galleries alternative to commercial galleries, or artist spaces, as they are also called—which were often directed by artists and/or boards on which artists made up the majority. They were formed because of a lack of commercial outlets for artists who deserved to be shown. Moreover, much interesting art was being made that did not fit into commercial galleries or was not marketable in the conventional way. Artists also looked to alternative galleries because of a desire to control the display and distribution of their art. Just at the moment when there was a need for new venues for art, public money was made available for their formation by the National Endowment for the Arts and state councils for the arts.

Not-for-profit spaces took many forms. Some featured exhibitions devoted to object art or video or performance. Others embraced causes, dedicating themselves to feminism or realism, and so on. Among the more prominent in New York were 112 Greene Street, founded in 1971; the Kitchen, 1971; the Institute of Art and Urban Resources (which administered the Clocktower and P.S. 1 in New York City), 1972; and Artists Space, 1972. Outside New York there were the Los Angeles Institute of Contemporary Art, established in 1972; N.A.M.E. in Chicago, 1973; and and/or in Seattle, 1974.

Many of the artists and art professionals who participated in the creation of alternative galleries had been influenced by the counterculture. As Kay Larson commented, they continued to believe

that individuals acting in concert could actually have an impact on "the system." Could the attitudes and skills learned by a generation of politically sensitized artists have an effect outside the political arena? Alternative spaces were formed around artists' determination to take matters into their own hands, to fill a need that other institutions were too unresponsive to fill. The very notion that an "alternative" was possible may have been a product of the subjective realities of the war years.[14]

Despite the countercultural attitude of many participants in alternative spaces, government funding was essential to their success, and they vied for it.[15] The National Endowment for the Arts not only contributed from a third to a half of their budgets but also provided a stamp of approval that helped in their other fund-raising efforts. Fostered by the NEA, alternative spaces soon mushroomed throughout the nation—in Seattle, Portland, Los Angeles, and San Francisco on the West Coast; in Minneapolis, Chicago, Kansas City, and Cleveland; and in New York, Washington, and Boston on the East Coast. In 1977 the NEA received more than a hundred applications from alternative spaces and funded fifty-nine of them.

Initially alternative spaces aspired to provide an alternative to commercial galleries—"a neutral, nonjudgmental, nonauthenticating, openly experimental and sympathetic place to house new ideas, a place unconcerned with traditional amenities like engraved invitations and plaques on the walls, or trustees with connections to IBM and Xerox."[16] By the midseventies such alternative spaces as P.S. 1, the Kitchen, Franklin Furnace, Creative Time, the Clocktower, and Artists Space had moved into the artworld mainstream. They became established, with professional administrators who developed expanded exhibition programs and sought general audiences. Rather than remaining alternative to the commercial galleries, they ended up feeding them, like farm teams in big-league baseball. As a kind of upscale counterpart of the alternative galleries, the New Museum of Contemporary Art was founded in 1977 by Marcia Tucker, whose purpose it was to feature recent art in a museum setting.

The link of alternative spaces to commercial galleries, even if it was inadvertent, disturbed radical artists, who organized other kinds of alternative spaces, such as Colab and Group Material. Colab's motto was "collaboration, collective, cooperative, communal projects only." It managed the ABC No Rio gallery, on Rivington Street on Manhattan's Lower East Side, which mounted such shows as *Income & Wealth*, *Manifesto*, and the *Real Estate Show*. Colab also organized *The Times Square Show* in 1980. Later shows were *Suicide, Murder & Junk*, *Animals Living in Cities*, *Crime Show*, *Erotic Psyche*, *Extemist Show*, and *Island of Negative Utopia*. Group Material was organized in 1980. As Tim Rollins, one of its founders, recalled:

Our headquarters were at a storefront gallery in the East Village. We began as a group of socially-minded art students disgruntled at the time by the so-called "alternative spaces" in the city. Group Material was far more interested in the social processes that gave art objects their meaning. We created exhibitions for the largely Hispanic neighborhood around us and the art world as well. It was like a workshop.[17]

On the whole the art market of the 1970s was relatively quiet, compared to that of the 1960s and 1980s. The recession of 1973–74 was debilitating, but the art world did the best it could. Artists did not have to take vows of poverty as they did in the 1940s and 1950s, but their expectations were relatively low. The newer ones, and even many of their elders, as Mary Jane Jacobs wrote, "knew it would be years, if ever, before they could live off sales on their art, but alternative spaces and an occasional grant [from the National Endowment for the Arts and the New York State Council on the Arts] and teaching jobs helped them to make it along the way."[18] Sympathetic curators, among them Marcia Tucker, Patterson Sims, and Barbara Haskell of the Whitney Museum of American Art, and Linda Shearer of the Guggenheim Museum, also did what they could to be of assistance.[19] In particular the Whitney Biennials provided encouragement to and recognition for new artists. They were often the first to show young artists in a museum setting.[20] But as Carter Ratcliff wrote in 1978: "Art stardom sixties-style brought with it fame, significant money, a place in the history books. . . . But not once in this decade has it happened—that volatile mix of culture shock, heavy sales, and critical attention which explodes and then, when the smoke clears away, reveals a brand-new art star."[21]

Still, signs of a future boom were present early on, notably the landmark auction of fifty contemporary American works, mostly pop, from the collection of Robert and Ethel Scull, at Sotheby Parke-Bernet in the fall of 1973. The sale earned $2,242,900. Jasper Johns's *Double White Map,* which the Sculls had purchased for $10,200 some eight years earlier, fetched $240,000. The staying power of the art of the last generation of consensus-supported artists was confirmed, and that bolstered art-market confidence. Moreover, never before had so large and rapidly acquired a collection been so quickly and profitably dispersed, and the fact that it was made a strong impression. More than that, it indicated that selling contemporary art at auction could be a viable marketing strategy, although it took roughly a decade before this became a common practice. Collectors did continue to buy art, and the price level did rise steadily, if slowly. But the art market had to wait until the 1980s to skyrocket.

NOTES

1. Sandler, *American Art of the 1960s,* chaps. 5–6.

2. The first show that included postminimalist art to command art-world attention was *Eccentric Abstraction,* curated by Lucy R. Lippard at the Fischbach Gallery in New York City in 1966. It included Eva Hesse and Louise Bourgeois.

3. Recognition of postminimalists was furthered through

prestigious museum shows, such as the Whitney Annuals, from 1968 to 1970, and the Whitney Biennials, which began in 1973. Other important museum group shows to feature postminimalists were *Art in Process*, at the Finch College Museum of Art (1969); *Here and Now* (1969); at the Steinberg Art Gallery of Washington University, which included Serra and Tuttle; and *Nine Young Artists: Theodoron Awards* (1969), at the Guggenheim Museum, which included Nauman and Serra. Also in 1969, the first major show of *Earth Art* was mounted by the Andrew Dickson White Museum at Cornell University. Curated by Willoughby Sharp, it included Long, Morris, Oppenheim, and Smithson.

4. The Sonnabend and newer New York galleries, such as Paula Cooper, Dwan, John Weber, Jon Gibson, and Bykert, also promoted the new art. *Anti-Form* (1968) at the Jon Gibson Gallery, New York (Hesse, Nauman, Serra, and Tuttle) was an important show of postminimal art.

5. See Milton Gendel, "'If One Hasn't Visited Count Panza's Villa, One Doesn't Really Know What Collecting Is All About,'" *Art News*, Dec. 1979, pp. 44–49.

6. *When Attitudes Become Form* included the Americans Hesse, Morris, Nauman, Oppenheim, Serra, Smithson, and Tuttle, and the Europeans Beuys, Kounellis, Long, and Merz. *Square Pegs in Round Holes* included the Americans Hesse, Jenney, Morris, Nauman, Oppenheim, Ryman, Serra, and Smithson, and the Europeans Beuys, Kounellis, Long, and Merz. *Information* included the Americans Acconci, Baldessari, Morris, Nauman, Oppenheim, and Smithson, and the Europeans Beuys and Long. In 1970, Donald Karshan curated *Conceptual Art and Conceptual Aspects* at the New York Cultural Center, which included the Americans Nauman, Oppenheim, and Piper, and the European Buren.

7. Among the leading European museum professionals who supported the new art were Wim Beeren and Edy de Wilde of the Stedelijk Museum in Amsterdam; Enno Develing of Gemeentemuseum in The Hague; John Leering and Rudi Fuchs of the Stedelijk van Abbe Museum in Eindhoven; Franz Meyer of the Basel Kunstmuseum; Johannes Cladders of the Städtisches Museum in Mönchengladbach; Carl Ruhrberg of the Kunsthalle in Düsseldorf; Nicholas Serota of the Museum of Modern Art in Oxford; Harald Szeemann of the Kunsthalle in Bern; art critics Germano Celant, Barbara Reise, and Seth Siegelaub; dealers Gian Enzo Sperone in Turin and later in Rome, Annie de Dekker (Wide White Space) in Antwerp, Adrian van Ravesteijn) of Art and Project in Amsterdam; Gary Schum and Konrad Fischer in Düsseldorf; and Ileana Sonnabend, Yvonne Lambert, and Jack Wendler in Paris. Count Giuseppe Panza di Biumo was prominent among collectors.

8. Richard Armstrong, "A Short History of Holly Solomon Gallery," in *Holly Solomon Gallery* (New York: Holly Solomon Gallery, 1983), p. 8.

"9. Pattern and decoration painting was also championed by art critics John Perreault, Carrie Rickey, and Jeff Perone.

10. In 1976, the year before Goldin's show, Jane Kaufman curated the first show of the new decorative art, titled *Ten Approaches to the Decorative*, at the Alessandra Gallery in New York City. It included Valerie Jaudon, Joyce Kozloff, Tony Robbin, Miriam Schapiro, Arlene Slavin, George Sugarman, John Torreano, Robert Zakanitch, Barbara Zucker, and herself.

11. *The Decorative Impulse* traveled to the Mandeville Art Gallery, University of California at San Diego, La Jolla; Minneapolis College of Art and Design, Minneapolis; and the Museum of Contemporary Art, Chicago. Other shows of the new decorative art in the 1970s were *Pattern and Decoration* at the Sewall Art Gallery, Rice University, Houston, Texas (1978); and *Patterns*, Albright-Knox Art Gallery, Buffalo, New York (1979).

12. Calvin Tomkins, "The Art World: Matisse's Armchair," *The New Yorker*, Feb. 25, 1980, p. 112.

13. Robert Pincus-Witten, "Entries: Cutting Edges," *Arts Magazine*, June 1979, p. 104.

14. Larson, "Rooms with a Point of View," *Art News*, Oct. 1977, p. 34.

15. Brian O'Doherty of the NEA remarked: "It was a happy historical accident that the endowment was there when all this started." Quoted in ibid., p. 35.

16. Ibid., p. 33.

17. Tim Rollins + K.O.S. (Kids of Survival), interviewed by Trevor Fairbrother, in *The BiNational American Art of the Late 80's* (Boston: Institute of Contemporary Art, 1988), p. 168.

18. Mary Jane Jacob, "Art in the Age of Reagan: 1980–1988," in *A Forest of Signs: Art in the Crisis of Representation* (Cambridge, Mass.: MIT Press, 1989), p. 15.

19. In 1979 Michael Blackwood Productions, Inc., released a film titled *14 American Artists*, chosen by Rosalind Krauss, Robert Pincus-Witten, and Roberta Smith, including Mary Miss, Peter Campus, Chuck Close, Dennis Oppenheim, Elizabeth Murray, Nancy Graves, Joseph Kosuth, Gordon Matta-Clark, Alice Aycock, Scott Burton, Dorothea Rockburne, Laurie Anderson, Vito Acconci, and Joel Shapiro.

20. The 1981 Whitney Biennial summed up the 1970s, featuring pattern and decoration painters Kushner, MacConnel, and Zakanitch; architectural sculptors Armajani, Aycock, Burton, Holt, and Miss; new image painters Bartlett, Jenney, and Moskowitz; as well as Acconci, Borofsky, Hunt, Pfaff, Shapiro, Shea, Wegman, and the newly emerged Murray and Julian Schnabel.

21. Carter Ratcliff, "The Art Establishment: Rising Stars vs. the Machine," *New York*, Nov. 27, 1978, p. 53.

8 AMERICAN NEOEXPRESSIONISM

Around 1980, within a year of the *New Image Painting* show at the Whitney Museum, a new group of painters, the most celebrated of whom were Julian Schnabel, David Salle, and Eric Fischl, suddenly became the center of art-world attention. Commonly labeled—or, more accurately, mislabeled—neoexpressionists—to distinguish them from their predecessors—they were acclaimed as the inaugurators of a renaissance of American painting.[1] The Americans were soon linked by art professionals to a number of European painters: the Italians Sandro Chia, Francesco Clemente, and Enzo Cucchi; and the Germans Sigmar Polke, Gerhard Richter, Georg Baselitz, Jörg Immendorff, Anselm Kiefer, Markus Lüpertz, and A. R. Penck. Indeed, the Americans achieved their spectacular success in part because they were coupled with their European counterparts.[2]

The advocates of neoexpressionism considered it to be significantly different from new image painting. In actuality the two tendencies were related, the one building on the other, and Rothenberg and Murray were generally counted in both groups. Edit DeAk observed that in new image painting "the language was rudimentary; just one prop . . . a me-phrase, a character symbol, appearing on the stage of painting. Then the thingies multiplied, [becoming] historically frenzied, embellished, [and] romanticized."[3] The work of Schnabel and Salle, for example, in comparison to that of such artists as Jenney, was more multidimensional, incorporating more references to art history and the mass media and employing more complex pictorial means, such as overlapping images and multiple canvases. The neoexpressionists on the whole were more audacious, daring to do more, more boldly, on a bigger scale. They cultivated and paraded their individuality, feeling free to paint their fantasies, memories, fears, hang-ups, and whatever else they desired—and this in the face of growing art-theoretical polemics against painting and the painter-as-protean-genius, whose exemplar was Schnabel.

What was the growing appeal of painting, and figurative painting at that? On the most elementary level, artists and viewers yearned for

"image and color," as independent curator Diego Cortez remarked.[4]
There seemed to be too much conceptually based art in the galleries, and
not enough work that was handmade or meant to be *looked* at. After all,
the visual arts were supposed to be visual. As early as 1981 Hilton
Kramer wrote that the turn to painting was a

> genuine change in taste. . . . Its roots lie in something deeper and
> more mysterious than mere fashion. At the heart of every genuine
> change in taste there is, I suppose, a keen feeling of loss, an existen-
> tial ache, a sense that something absolutely essential to the life of art
> has been allowed to fall into a state of unendurable atrophy. It is to
> the immediate repair of this perceived void that taste at its profound-
> est level addresses itself.[5]

What had been lost above all was the sensuous—and emotional—dimen-
sion in art. As Kay Larson commented: "Artists are desperate to recon-
nect with feeling. . . . There is a compulsion to *make contact*—whether
with materials, or with the heroic possibilities of painting, or with the
myth of the artist-creator, dormant during twenty-odd years of irony and
intellectual distance in art."[6] So profound was the "feeling of loss" that
the "ache" Kramer spoke of was even felt by a number of postminimal
artists who "returned" to figurative painting and other traditional media.
The fact that neoexpressionism was an international phenomenon also
appeared to confirm Kramer's claim that the art world was experiencing
a profound hunger for painting.

The neoexpressionists wanted to paint directly—even instinctively—
thereby continuing the tradition of historic expressionism. But, some sev-
enty years after its inception, they knew that they could not do so in quite
the same way: A new kind of consciousness was required. Consequently,
they employed available images and techniques with premeditation and
erudition. For example, they looked to past art for cues, especially to
neglected figures of twentieth-century art, artists who were modernist early
in their careers and then turned against it, like Giorgio de Chirico and
Francis Picabia. Modernist historians who had hailed their earlier painting
condemned their later work as a perverse and cynical betrayal of modernist
ideals. But to the young neoexpressionists, the late de Chirico and Picabia
were models to be emulated. Indeed, their alleged perversity was admired.
That de Chirico copied his own work was regarded as a virtue by artists
who themselves had become appropriators, and who seemed to face the
future by looking to the past. Picabia's crude renderings of kitsch subjects
were lauded as worthy precursors of their own "bad" images.

Artists embraced all of Western painting, but they tended to pay
particular attention to their own heritage. As Fischl said: "I think what's
going on in painting now is coming out of national identities. People
have withdrawn into their own histories to try to find meanings. . . .
When Italians and Germans go back into their history, they're going back

to their strengths. A lot of American art is going back to sources, too."[7]

But neoexpressionism had formidable antagonists, among them Rosalind Krauss, Douglas Crimp, Hal Foster, Annette Michelson, Craig Owens, and Benjamin Buchloh, all of whom were associated with *October* magazine. They claimed vociferously that painting as an art form had nothing new or relevant to say and was therefore hopelessly retrogressive, no longer viable or believable—in a word, dead. Just as earlier painting styles had been denigrated by postminimalists, so were new image and neoexpressionist painting, but on different grounds—art-theoretical and political.

Summing up the art-theoretical attack on painting—it is be dealt with in full in chapter 11—in a 1981 article in *October,* Crimp announced "The End of Painting." He used as his butt a statement by Barbara Rose defending painting in the name of humanism. According to her, painting was "a high art, a universal art, a liberal art, an art through which we can achieve transcendence and catharsis. Painting has ... the capacity to materialize images rendered up by the boundless human imagination. Painting is a great unbroken tradition that encompasses the entire known history of man. Painting is, above all, human."[8] Crimp branded Rose's "rhetoric ... reactionary." It was "in direct opposition to that art of the sixties and seventies ... which sought to contest the myths of high art, to declare art, like all other forms of endeavor, to be contingent upon the real, historical world." Crimp was contemptuous of "the myth of man and the ideology of humanism which it supports." But why destroy the humanist conception of man and the art that exemplified it? Because they "are all notions that sustain the dominant bourgeois culture. They are the very hallmarks of bourgeois ideology."[9] And bourgeois ideology in the Reagan eighties was in the ascendant as never before in living memory. Indeed, painting and, particularly, neoexpressionist painting, had to be purged because it was the aesthetic counterpart of political neoconservatism.

The champions of painting rebutted by pointing proudly to its long and distinguished tradition, arguing that the authority of its history legitimated current practice. Moreover, they asserted that it was the exemplary vehicle with which to express consciousness. What counted most was that painters had never stopped painting and that a sizable public had accepted their pictures and had welcomed the new manifestations without any qualms. Both painters and spectators continued to believe, as Harold Bloom commented, "in the reality of the self, and so ... also in authorship, in originality, and in aesthetic values independent of societal concerns."[10] Indeed, painting in the 1980s appeared to be in a renaissance—anything but dead (as if it could ever die). Painting's adversaries were declared to be puritans possessed of "a nearly paranoid resentment of aesthetic pleasure, as if this were a form of corruption or perhaps mental retardation."[11] Moreover, they were ideologues whose ideas were not derived from their experience of art but from dogma-bound preconceptions, above all that it

was the function of art to struggle against capitalism and modernist culture. The partisans of painting brushed aside such claims as being beside the point of painting. As painter and art critic Peter Plagens wrote, art "cannot be made to jump through theoretical hoops by either a philosopher-ringmaster or by artist-acrobats themselves. Once or twice, maybe, but then the recalcitrant audience begins to hunger again for something that'll *stick*."[12] And that "something" could only be expressed in painting and was therefore its true concern.

Salle turned the tables on the art theoreticians by somewhat perversely claiming that it was "because painting is so charged, so weighted down by history, so lumbering, so *bourgeois,* so *spiritual*—all these things that had made them so 'incorrect'—I came to see this is what gave painting such potential."[13]

The enemies of painting declared that it was disreputable because its revival was caused by an enormous growth of the art market, or what Owens called "the studio-gallery-museum power nexus."[14] They alleged that paintings were valued by the bourgeoisie primarily because they were portable objects that could be bought and sold. The affluent middle class was encouraged to buy by dealers who were adept at marketing and using the media. They promoted painting—and made it fashionable—often with the media-savvy cooperation of the artists themselves. And what was worse, artists in the privacy of their studios were succumbing to market pressures. That is, they had capitulated to the vulgar and uneducated taste of new-rich collectors. Instead of formulating "difficult" abstract or conceptual art, market-oriented artists contrived "easy" figurative and narrative paintings. It was implied that if art did not have a politically radical edge, it was *only* a commodity. The advocates of painting countered by pointing out that genuine works of art had meanings which have nothing to do with commerce or politics and are unaffected by either. Such works do become commodities, of course, but that is not why they were created. Still, knowledgeable observers of the art world sympathetic to neoexpressionism were also troubled by the possible influence on the new painting of the market, hype, fashion, and the glamour that fashion conferred.[15] On the other hand the market had its enthusiasts. For example, Cortez wrote that despite

> its layers of materialism, opportunism, and ambition, [the market supports] the most significant art of this time. To the critics who feel that this new painting is mere marketing strategy, let me say that they are only partially correct. It is good marketing in bed with the best art. It is, I maintain, a strategy of the soul.
>
> My admiration and respect for the new dealers who have supposedly "manipulated" and "packaged" this new art (Werner, Boone, Bischofberger, Westwater, D'Offay, etc.) is at least equal to that of the artists and their work.[16]

The critics of painting concentrated their assault on neoexpression-ism, because of its enormous acclaim. They asserted that it was merely "neo," a rehash of outmoded styles. Thus it differed from historic expres-sionism, which was immediate, antirational, and free. Issuing from what Kandinsky called "inner necessity," expressionism had been primal, authen-tic, and styleless. In contrast neoexpressionism exploited a received lan-guage and cultivated style. Historic expressionism was innocent; neoexpres-sionism, self-conscious. Consequently the latter was decayed expression-ism, as Howard Singerman asserted:

> Re-presented, the acid colors and the thick clotted paint [associated with expressionism] become representations—pictures, memories, frayed and familiar, of expressionism. Unlike its ancestor, the new expressionism is not meant to free the painter from language and style, from history, and to let him speak directly, and even more, feel directly; that is not its function. Rather, the new expressionism is meant to unite him with a painting that once did feel and speak directly, or thought it could.[17]

Neoexpressionism was expressionism in quotes. Hal Foster asserted that its practitioners "consciously or not, play at expression. Neo-Expressionism: the very term signals that Expressionism is a 'gestuary' of largely self-aware acts." The upshot was *simulations* of authenticity and originality.[18]

The adversaries of neoexpressionism pointed out that they were not the first to reject the specious rhetoric of expressionism. Major contem-porary artists had already done so in their art. As early as 1957 Robert Rauschenberg painted *Factum 1*, a seemingly expressionist picture, and then copied it. The question he posed was whether the second version was as authentic as the original. How could the spectator tell? Jasper Johns also called inner necessity into question when he filled in his flags and targets with "expressionist" brushwork contrived by applying molten wax drop by drop. Beginning in 1962 the pop artists parodied expres-sionist brushstrokes. Roy Lichtenstein rendered them in comic-book style, and Andy Warhol used them to embellish his trendy *Portraits* of the 1970s in a deliberately cosmetic and insincere fashion. Warhol's *Oxidation Paintings* (1978), produced by urinating on canvases coated with metallic pigment, constituted the most corrosive critique of expres-sionism's credibility.

Newer artists, such as Gretchen Bender, also debunked expression-ist painting. She pieced together works from tin squares on which she reproduced a variety of images culled from art and the mass media, for example, a detail from a Schnabel painting, juxtaposed against a Lichtenstein pop motif and a photograph from an advertisement.[19] Her purpose was to show that none of these images issued from "inner neces-sity." But from another, generally overlooked, point of view, it appeared

that Rauschenberg, Johns, Warhol, and even Bender had opened up new possibilities for "expressionist" painting.

The enemies of the new painting also called into question the viability of primitivistic references frequently found in neoexpressionist pictures. Earlier twentieth-century artists could believably seek primal content. That was no longer possible since images culled from primitive art had been thoroughly assimilated by the mass media, becoming mere items in its vast image bank. As Lynne Cooke remarked, primitivistic images "have become so familiar as to be virtually mass-cultural." It was not possible to tell whether artists were engaging freshly with primitive culture or responding to "Sunday supplements, television documentaries, advertising campaigns and the like, all of which employ [primitivistic] imagery as commonplace matter."[20]

In rebuttal the supporters of neoexpressionism maintained that its validity did not depend on the emulation of historic expressionism. To insist that neoexpressionism could be nothing more than imitative was a rhetorical trick. It could yield authentic images in other ways. Accepting that they could no longer be innocent, artists could identify with the tradition of expressionism and self-consciously cultivate its effects. They could use painterly painting with deliberation and even artifice to embody genuine feelings and intuitions. As Carter Ratcliff pointed out, "The entranced, distracted naiveté of Expressionism [could be] a starting point on the way toward [the] sophistication . . . ironies . . . fictions of unmitigated consciousness." The search for expressive forms could not be abandoned. Expressionism had to be confronted. It had its traps, to be sure, but its riddles remained to be solved.[21]

Artists generally understood the pitfalls of painting in an expressionist manner. Mike Glier spoke disdainfully of "designer Expressionism that takes the look of Expressionism—wild color, agitated surface—it's got all the earmarks, but I don't think it means much. It's a packaged look of wildness." Still, Glier went on to say that expressionist art can contain "the residue of the individual," and there seemed to be a need for it at the moment. "People really want to be touched," and "mark-making does that. It has a very tactile sense that is appealing right now—a reaction against the too-slick, modernized, alienating society we're all so familiar with."[22] Judy Pfaff asked: "If the paint is fast and sloppy, is that feeling? I don't know. It could be quite rote, quite unfelt, systemic. Using the grid—is that intelligence? Maybe." Pfaff questioned the "way in which everything has been coded. . . . Elizabeth Murray is a very expressive painter. She just doesn't put the paint on with . . . speed. . . . As fast as Frank Stella paints, I doubt if he's an Expressionist."[23] Either way there was an unmeasurable unconscious and intuitive component in the most conscious painterly painting.[24] As David Salle put it: "I've never understood the tendency to run a critical geiger counter over someone's work, measuring the degree of Expressionism. . . . It seems besides the point."[25] The point was

that neoexpressionist artists could be "honest." The proof was in the paintings of such artists as Murray and Kiefer, which appeared to possess the conviction and range and depth of expressive content of older expressionist works. And there seemed to be an urgent need for the emotional charge, aura, and resonance of their pictures. But, as Peter Schjeldahl asked, Why did painterly painting have to express "the direct, sincere communication of primary emotion that we associate with orthodox Expressionism"? What was wrong with "irony, convolution, 'deconstruction,' and/or hot and cold running humor"?[26] Schjeldahl pointed to a countercultural provocative, even perverse, edge in much of the new painting, even the most heroic—a continuation of the "badness" of new image painting—exemplified by Schnabel's broken crockery, Salle's softcore pornography, and Fischl's masturbatory adolescents.

The defense of neoexpressionist styles as valid alternatives to historic expressionism was argued most cogently by Peter Halley. He maintained that to think of the new expressionism as an unimaginative reprise of the old was to miss the point: The new was different from the old. Historic expressionist theory presupposed a more or less fixed self—a natural or centered, innocent, or unmediated self that artists could express through spontaneous painting, the sign of authenticity. Instead Halley posited a self that was decentered, multiple and shifting, mediated by social and cultural pressures. Thus "Today there is not one expressionism but many expressionisms." Moreover, "The emotions expressed may not necessarily be the same as those expressed in previous expressionistic art." Indeed, they may be "different and even contradictory." In much of neoexpressionist work, Halley continued:

> A strange new emotion is emerging in response to the particular conditions of these times, an emotion that would not have been recognizable as an emotion before. With their understanding of self in shambles, their senses numbed by the reverberating phrases, sounds, and images of the mass media, their ability to react curtailed by a lifetime of nuclear false alarms, ecological booby traps, sporadic global warfare, and political and economic turmoil, these artists are capable of neither the clearly defined anger nor the orgasmic release characteristic of earlier expressionisms. They have attended art schools and universities with unprecedented facilities for gathering art historical information. They have been exposed to a contemporary explosion of exhibitions, museums, catalogues, and color reproductions.

Consequently the neoexpressionists "are expressing an emotion that is based on some other part of the psyche than the ego, for typically these artists are deprived of any traditional sense of self." Neoexpressionists needed to be hyperconscious. This made their painting different from that of their predecessors but no less genuine.[27]

Elizabeth Baker also called attention to the diversity of the neoexpressionists:

> Some of them may qualify as "hard core" Expressionists—their work conveys a direct emotionalism through an agitated "personal" application of paint. Others, however, adopt an expressionist "look" for ends that range from the conceptual to the satirical. [Young artists] have reclaimed a central position for vigorous painterly execution, coupled with something more overtly taboo in self-respecting modernist usage: literary subject matter. Whether religious, pop-cultural, mythological, psycho-sexual, or even political, the imagery of these artists is of a highly evocative nature, if not explicitly narrative.

Baker had in mind such young artists as Schnabel, Salle, and Fischl, but she also included related older artists, among them Leon Golub, Philip Guston, and Malcolm Morley. The middle generation—Jensen, Pfaff, Rothenberg—painted "from the heart." Finally there were the painterly conceptualists, such as Jennifer Bartlett, who "integrate[s] the paintstroke-as-sign with a resilient intellectual scaffolding which usually defuses any incipient emotional content." Baker concluded that for most of the neoexpressionists "tradition is no longer a burden, but a newly discovered resource. [They seek] reentry into the realm of allegory, history and myth that the dominant styles of the modern period so decisively discarded."[28]

A significant number of the artists singled out by Baker shared other pictorial attributes. For example, Schnabel and Salle chose to depict images appropriated from existing art and the mass media, underlining the consciousness of their art making. Moreover, they attached real objects to their canvases, evincing a desire to make their paintings sculptural, perhaps a hangover of minimal dogma and a need to depict reality. Murray painstakingly shaped canvases and stacked them in low reliefs, moving her pictures into actual space, and also painted images from her everyday life. In sum Schnabel, Salle, and Murray, among other artists of their generation, seemed to want painting to make contact with the outer world, by introducing real things, moving into real space, and/or painting real subjects rather than or as well as expressing their inner worlds.

But why did certain neoexpressionists achieve art-world recognition and others little or none? With the exception of Bartlett and Rothenberg, the successful new artists painted pictures with a seemingly perverse edge (Schnabel, Salle, Fischl, Robert Longo, Malcolm Morley, and Komar & Melamid); a feminist dimension (Murray and Ida Applebroog); references to the AIDS crisis (Ross Bleckner); and political oppression (Golub).

Julian Schnabel's enormous pictures, composed of bulky supports whose surfaces are encrusted with smashed plates and energetically overpainted with heavy pigment, created a sensation when they were

exhibited in 1979 at the Mary Boone Gallery in SoHo. Indeed, the jagged shards of crockery provoked the kind of shock that Pollock's "drips" and Rauschenberg's paint-smeared bed and stuffed goat had. Schnabel's later paintings on black and red velvet were equally shocking, since velvet was a material associated with kitsch in gift shops and street art shows.

Like the new image painters, Schnabel reacted against formalist, minimal, and postminimal art. He strongly rejected the oft-repeated claim that painting was at an end.[29] Like the new image painters, he was influenced by Guston's imagery and facture. But Schnabel differed from the new image painters in the scale of his ambition—to paint the "big picture," like Pollock or Newman, and to tackle weighty themes—life and death, earthly suffering, martyrdom, and spiritual transcendence, as in *Portrait of God* (1981).

Schnabel also stood apart from new image painters because of the complexity of his work. He had been influenced by Robert Rauschenberg's combine-paintings with an eye to James Rosenquist's juxtaposition of disparate images on the one hand, and on the other by the new German painting, notably that of Sigmar Polke. "There is a craziness, a nonchalance that I call the texture of poverty in his painting. [It] is subversive."[30] Indeed, Schnabel's painting was more closely related to the new German painting than to the painting of his American contemporaries of the late seventies and early eighties.

The canvases that Schnabel painted before the plate pictures had already been distinguished by the assertiveness of their material substance. He had built up their surfaces, scooped out shallow craters, and projected ledgelike forms. These pictures also contain images that would recur in the later works: truncated figures, cone shapes, and linear networks like veins, scars, roots, the branches of trees in winter, or cracks on sidewalks.[31]

Schnabel conceived his plate paintings in 1978 after having seen the broken glazed tiles in buildings and parks of the architect Antonio Gaudí in Barcelona [96]. He recalled: "It was that radical moment that an artist waits for."[32] Plates attracted him because they provided a strongly physical surface on which to paint.[33] So did the velvet, pony hides, old tarpaulins, and Kabuki theater backdrops that he later used. Schnabel also attached deer antlers (reminiscent of Joseph Beuys, whom he revered), planks of weatherbeaten wood, and other unusual weighty substances to the surfaces (like Rauschenberg). But the broken crockery was special because it functioned as a counterpart to his impetuous brushwork. Not only did it provide a material and disruptive surface on which to paint, but it had metaphorical signification as well, suggesting violence, rage, chaos, and decay.[34] These qualities were inherent in many of Schnabel's subjects—writhing, dismembered, bandaged—and mummified torsos, crucifixions, and the like.

Almost as provocative as Schnabel's use of smashed chinaware and velvet was his quotation from past masters—such as Caravaggio and

96. Julian Schnabel, *Vita,* 1983. *(PaceWildenstein, New York)*

Oskar Kokoschka—children's books, artists' manuals, and the mass media, all of which might be combined in one work. The images were all of equal value to him, as he said: "I really don't make hierarchical judgments about something that would be from art history or something that would be from a psychological drawing text, or something that would be a shape, that would not have a name on it at all, or something that would be a letter."[35] But all the images and materials that he selected had a personal appeal. Schnabel claimed that what he "expressed is a feeling of love for something that had already existed, a response to something already felt." Consequently he denied that he was an expressionist, neo or any other kind, because that would imply that his art was about self-expression [97].

97. Julian Schnabel, *Mimi,* 1986.
(PaceWildenstein, New York)

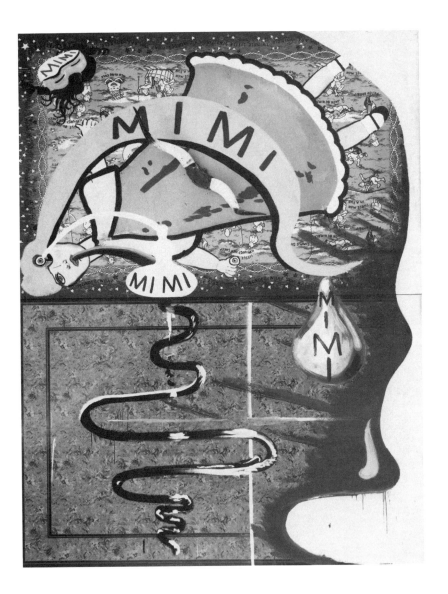

Using used things, things we all recognize, is in direct conflict with the idea of building your own specific original signature that will isolate the image you make from all others. Using already existing materials . . . brings a real place and time into aesthetic reality. [It] goes beyond the style of the signature of the artist. It is an anti-heroic art.

The specialness of art [is] the power to take ordinary things, and . . . to produce a kind of transcendence of their ordinariness.[36]

Despite Schnabel's regard for the imagery he recycled, and his disavowal of self-expression, his work, as Thomas Lawson remarked, "has a sort of romance of the ego and creativity, [an] unquestioning individualism, an unquestioning free will. . . . He represents this operatic, Wagnerian . . . power."[37] Indeed, Schnabel's images, whether art historical or religious or kitschy, were often viewed as signs of self-love, self-aggrandizement, and self-importance.

The claims Schnabel made for his paintings were repeatedly questioned in the art world. Were his pictures genuinely felt or "felt" in quotes? Was their size a sign of grandeur or grandiosity? Were they, as Schjeldahl quipped, in "the spirit of van Gogh" or "Kirk Douglas as van Gogh in *Lust for Life*"?[38] Art critic Stuart Morgan singled out Schnabel's

scaled-up version of a self-portrait Antonin Artaud drew in his last years. . . . The archetypal *poète maudit*, Artaud embodies agony. . . . To his death Artaud remained superbly unacceptable to the bourgeoisie he so despised. How interesting that Schnabel should pay homage to an outcast—the same Schnabel who announced to the press, "I have a very good life," and, as early as 1980, "I always knew it could be like this."

Morgan disdained Schnabel's "coopting the ignored and rejected" and "selling tokens of his anti-bourgeois sentiments."[39]

To Schnabel's credit he refused to be trapped by a style no matter how much recognition it received. By 1981 he was making pictures that had no broken plates and was using a greater variety of images, even explicit portraiture. In 1983 he began to create monumental sculpture that called to mind primitive funerary paraphernalia and ancient weapons. Some three years later he began to incorporate words into his paintings—like concrete poetry—the words taking the place of figurative motifs in earlier works. In many pictures the only image was a word. In one sense this use of language can be viewed as a response to graffiti art and to the growing number of artists who mixed image and text. Schnabel's verbal message was not always clear, but in works from about 1987 the words, often names—Pope Pius IV, Saint Ignatius of Loyola— clearly have religious reverberations and also suggest that he identified himself with spiritual heroes [98].

98. Julian Schnabel, *Pope Clement of Rome*, 1987. (PaceWildenstein, New York)

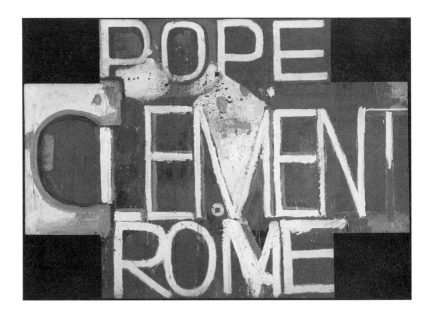

At the end of 1989 Schnabel exhibited paintings on blood red velvet, each containing a single sentence in bone white pigment—"There is No Place on this Planet More Horrible than a Fox Farm during Pelting Season," a sentence he found handwritten on a ten-dollar bill. The crude lettering owed much to Jean-Michel Basquiat's text-covered works and even more to Robert Motherwell's canvases, inscribed "Je t'aime." Schnabel's social consciousness was called into question by art professionals, just as his earlier attitudes had been. Was the declaration merely rhetorical, exploiting art-world social consciousness?[40]

Schjeldahl, one of Schnabel's early supporters, concluded that he is "a great poet of material surfaces."[41] To which I would add, a master of scale. However one responds to Schnabel's painting, it was *for* the eighties. No other body of work riveted art-world attention as his did.

Salle achieved celebrity soon after Schnabel, and their names were often coupled. They had met in the late 1970s and had become friends. However, Salle said that Schnabel's "work was probably about as far from mine as anybody I was close with at the time, his concerns were largely material, mythological, heroic, mine just weren't."[42] There was nothing epic in Salle's potpourri of images appropriated from popular culture—a Donald Duck, a soft-core pornographic nude—and high art—a Caravaggio male figure. They were rendered in a variety of styles ranging from sketchy drawing to old-masterish finish [99]. He also affixed onto the canvas commonplace three-dimensional objects—a piece of furniture or, in one picture, a brassiere.

Salle's interests were close to those of conceptual artists with whom he was friendly, such as Sherrie Levine, Tom Lawson, and Barbara Kruger, all of whom used photography in their art. Indeed, the images

Salle painted were more often than not appropriated from photographic sources. He chose to paint them in order to work on a large scale. Moreover, painting "has a very different physical presence than a photograph, and I think one loses the heavy-handed sense of photography as being a referent point in the world. Painting becomes its own referent." To put it another way, all of Salle's images, including those taken from the world via photography, took on new meaning in the autonomous world of the painting.[43] It is significant that he painted photographic images at a time when painting was under attack by influential art theoreticians who were promoting photography as the relevant art of the time. His linking of painting and photography when both were in a polemical combat contributed to both his work's relevance and its controversial nature.

Salle's mélanges of juxtaposed and multilayered images were also pertinent because of their complexity—at a time when new image painting as a tendency had come to seem wanting in this characteristic. He had been influenced by the incongruous combination and layering of images in Picabia's *Transparencies,* and in the pictures of Sigmar Polke, himself influenced by Picabia; by Rauschenberg's and Rosenquist's mixtures of unrelated images and styles; and above all, by Johns's multidi-

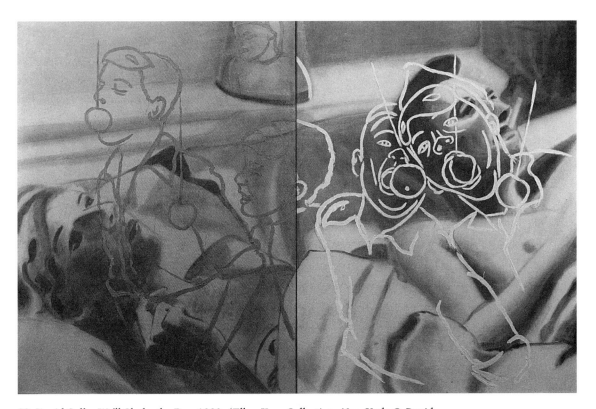

99. David Salle, *We'll Shake the Bag,* 1980. *(Ellen Kern Collection, New York; © David Salle/VAGA, New York, NY)*

mensional conceptual painting. As a kind of homage Salle often incorpo-rated images and objects found in Johns's work, including body parts and the name "Tennyson."[44] Schnabel and Eric Fischl, Salle's former classmate at the California Institute of the Arts, had also mixed and superimposed images, but it was Salle, more than his contemporaries, who showed the way to a new complexity in painting.

What was Salle's intention? He began a painting by identifying with a certain image, then intuitively reacting to it by putting something next to it or adding something, and so forth, until the picture "reaches a point of fullness and complication."[45] Critics often wrote that the number of images he could choose from was infinite. He denied that, claiming that the "critical cliché that everything is in the paintings, including the kitchen sink, is just a misconception." In actuality, he had "a very nar-row, specific range of images. . . . There are very few things that I use and I tend to use them over and over again. . . . The point is that I can't really think of how to use any other thing. . . . There are whole ranges of experience that I just can't even imagine using."[46] He also said that there was an "internal logic holding . . . disparate images together."[47] They "are not logically or hierarchically organized, but they are cross-referenced. It's like cross-referencing without an index."[48] The picture, then, had no story line. As he insisted: "There's no narrative. There really is none, there isn't one."[49]

Salle believed that his choice of what to depict was the source of his originality. Commenting on "the current debate over 'the end of original-ity,'" which he considered to be "sophistic," he said: "Originality is still the only thing that matters in the end. [It] has to be located outside the question of personal 'style.' . . . Put simply, the originality is in what you choose. What you choose and how you choose to present it."[50] How the images were juxtaposed was critical. In sum Salle appropriated images because he was attracted to them—that is, because he empathized with them. Moreover, the way in which he related them was subjective. Consequently he was not so aesthetically removed from Schnabel as he believed.

Intent on self-expression, Salle did not care to comment on paint-ing or popular culture in his pictures. His denial notwithstanding, motifs culled from the mass media do appear in his work, such as the Santa Claus head in *Wild Locusts Ride* (1985). A recurring image is the female nude that seems to have been lifted from pornographic magazines, pub-lications that most flagrantly exemplify America's sex-obsessed popular culture or its underbelly, as it were—a kind of doubly debased culture, the kitsch side of kitsch [100]. Pornographic subjects were important to him not "as a comment on the society that produces them" but for their personal meanings. He actually took his own photographs of hired mod-els, according to his own tastes.

Salle was also deeply involved with movies, making frequent refer-ences to their significance to him. He said, for example:

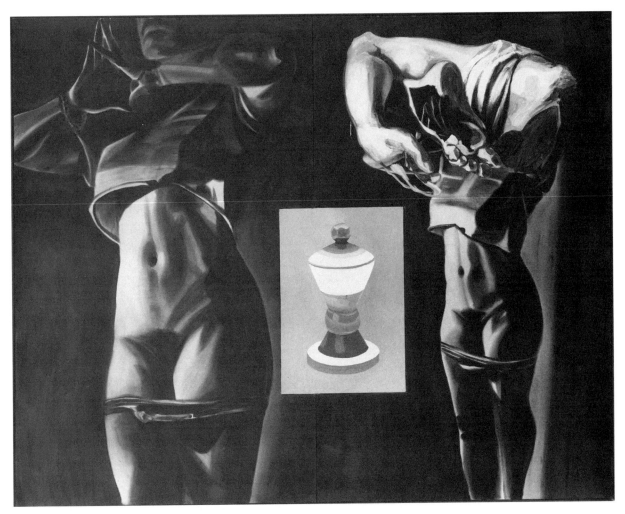

100. David Salle, *Gericault's Arm*, 1985. *(Museum of Modern Art, New York; photograph copyright © 1995 Museum of Modern Art, New York; © David Salle/VAGA, New York, NY)*

> Remember the scene in *Apocalypse Now* where Martin Sheen's head is in the corner of the screen and superimposed over that is a ceiling fan in the room that he's having hallucinations in? The fan turns into helicopter blades and the soundtrack is the Doors' "This Is the End." It's a great moment in the history of cinema, I think. . . . That was 1979. It was not the actual concrete source for . . . paintings but it made me feel so clearly that I was on the right track.[51]

Salle seems to have been struck by the mood of the scene rather than by any specific image—and it was mood that he was after in his own painting. He also seems to have been influenced by the devices used in movies, such as the split screen, jump-cut, slice, zoom, and dissolve.

Salle may have been less notorious than Schnabel, but his painting

was more problematic—indeed, the most problematic painting of the time. Kim Levin remarked as late as 1987 that his work "certainly generates irrational responses, both rapturously pro and rabidly con."[52] Roberta Smith wrote: "For American art of the 1980's, Salle's painting stands out as one of its great and most paradigmatic achievements."[53] In contrast Arthur Danto wrote that he found it "exceedingly depressing. . . . I was grateful to leave."[54] And Robert Hughes commented: "With so many contenders for the title of Most Overrated Young American Artist, it is hard to award the palm. But one of the strongest candidates would certainly be David Salle."[55]

Unsympathetic critics were unnerved by what they maintained was the incoherence of Salle's work. Despite his claims to the contrary, a significant number believed that he chose his subjects indiscriminately and that therefore there was no relation among them. It did look that way. Superimposed on each other and painted on different panels, his images, disjunctive to begin with, were difficult to read and link. What was the connection between light bulbs, shoes, musical instruments, clowns, and naked women in grisaille, all of them recurring images?[56] Danto, for example, wrote that Salle's pictures "present themselves as puzzles to be solved, and part of the tension they arouse comes from the viewer's quest for a coherent solution, which the work persists in frustrating." Danto went on to say that the paintings end up conveying a teasing "sense of purposiveness with no specific purpose."[57] (It is curious that the 1950s did not expect a story line or "meaning" from Rauschenberg, but that the 1980s did from Salle.)

Other hostile critics maintained that Salle's images canceled one another out, and this was true in some measure. However, as a friendly critic, Robert Storr, pointed out, he "created a kind of graphic double-exposure, making it impossible to see the work whole. The effect is a pictorial, not to say conceptual and emotional, dyslexia. When the decorative patterning of the [picture] coalesces, the images become diffuse; when the images emerge distinctly, they separate, and with that separation the unity of the [picture] dissolves." Storr concluded that addition became subtraction, more or less.[58] He was intrigued by this kaleidoscopic effect. So were postmodern writers. They considered Salle's mixture of images as a random play of signifiers, fragments culled from preexisting visual phenomena. Its openness to a variety of interpretations, a seeming infinity of interpretations, struck them as postmodern. Indeed, it appeared to deconstruct the modernist demand for a unified work, a totality.[59] Salle's alleged antimodernism was most pointed in *Fooling with Your Hair* (1985), in which he lined up two sculptures by Giacometti and two "moderne" lamps above three semipornographic nudes, making all of them equal, thus suggesting that high modernist culture was just another kind of kitsch.[60] As Roberta Smith summed up, Salle's fragmentary imagery was unfixed, a word much favored by postmodernists. She observed that it exemplified "a quality that runs through the look and

feel of our art and through our criticism, as it does through our times."[61]

Critics were particularly provoked by Salle's repeated depiction of naked or scantily clothed female figures in sexually explicit poses, and he meant to provoke.[62] His representations of women on their backs with legs apart, bending over, or on their knees were viewed by some critics as interesting examples of "bad boy" voyeurism. But many feminists condemned Salle's images as being blatantly offensive. Mira Schor claimed that they seem "to be a continuation of a male conversation which is centuries old, to which women are irrelevant except as depersonalized projections of man's fears and fantasies."[63] Barbara Kruger, as strong a feminist as Schor, disagreed. She acknowledged the sexism of Salle's images, but added:

> David is an important, generative artist whose work has foregrounded . . . the rotting stuff of sentiment that leaks out of every cliché and every "feeling." Soppy humanism becomes a joke. . . . I *don't* subscribe to the riff that naked bodies constitute just another phylum in the perpetual parade of "empty signifiers," but I certainly won't fall in line with a kind of censorious, rampaging, self-righteousness which wants to excise sexuality from the representation realm.[64]

Salle himself understood the feminist argument that his presentation of naked women might help "to promote a fiction about who women are and what they do and think and feel. And this is helping to prolong their oppression in the culture. . . . It might be true, in which case it would be unfortunate." But in defense of his voyeuristic nature, he explained: "I've done what I can to make the work emotionally honest. If the transgressional aspect is still the only thing that one can feel from it, then I probably haven't done a good job."[65]

Salle's work may be pornographic, but as he said, it is not "particularly erotic."[66] Many critics concurred. Smith wrote that his sexualized images "approach the pornographic without ever quite getting there. Rather, they float behind Salle's veils of stained color shrouded in a mysterious half light and in their own kind of privacy."[67] Indeed, his grayed and often fuzzy nudes are distanced, faded, and drained, denuded of the erotic.

A number of critics, some favorable to Salle, believed that his mélange of images was illuminating because it emulated our experience of television. Salle himself recognized that the "most common critical description of my work is that it's like watching television and flipping through channels." But he rejected that interpretation as "totally inappropriate. A simple, objective analysis shows that the work is a very specific orchestration of a handful of imagistic themes." Still, his dissociated mode of presentation was not very different from television's—a segment of a soap opera, commercials, another segment, commercials, a segment of news, commercials, another program, on and on.[68]

If Salle's fragmented imagery did not seem to add up to a cohesive whole, was there some underlying sensibility or mood of which the disconnected fragments partook? Was not his presentation of them melancholy and perhaps even misanthropic? Salle's own words may hold a key.

> I think we are getting to a point in the culture where the notion that something happened that wasn't supposed to happen—the notion of humor or the absurd, the unexpected, the irrational—that these notions of how to see one's life, and how to be involved with one's own life, conjoin to make a sensibility which is more accepting than the sensibility of previous generations. I'm thinking of an art that functions as an accidental trigger rather than a logical one. And that does have to do probably with certain things everyone has pointed out, like media glut, things like that. Like, ho ho, maybe we really are morally bankrupt. And maybe it's fun.[69]

Salle's statement would account for the sexual provocation in his work, the occasional violence, and degraded imagery. It might also account for the deliberate "badness" of his drawing, invariably pointed to by hostile critics. Danto wrote that "its badness seems willed even where there is no clear sign that the artist could do better if he wished to."[70] Hughes complained that Salle "can hardly draw at all. His line is slack and weak." Hughes went on to say that "Salle's graphic ineptitude is praised by his fans as a kind of fallen representation, as though it were a critique of affectlessness."[71]

And so it was. Levin wrote: "Of course Salle's stew of vacuous images and styles is coarse, crude, vulgar, and American in the worst way. . . . Would we want it to be anything else?" She concluded: "With more breadth than anyone else, Salle seems to address the pressing philosophical issues of our day: disjunction, disaffection, meaninglessness, vacuity, loss of authenticity and memory."[72] Indeed, his purpose appeared to be to accommodate himself—with some anger and irony, to be sure—to incoherence, disorder, and incongruity as the unfortunate state of contemporary life. Literary critic Alan Wilde commented that the postmodernist, and he could have had Salle in mind, matched "an indecision about the meanings or relations of things [with] a willingness to live with uncertainty, to tolerate, and, in some cases, to welcome a world seen as random and multiple, even, at times, absurd."[73]

Eric Fischl's paintings are related to those of Schnabel and Salle in that they are improvised from fragments, and like Salle's, appropriated from photographs. They differ because the fragments are pieced together into recognizable scenes—familiar-looking bedrooms, patios, and above all, swimming pools and beaches—peopled by ordinary American types engaged in everyday activities. It took Fischl a decade of experimentation to evolve his American scene imagery. While a student at Cal Arts

(1970–72), he painted abstractions. Then, influenced by Jonathan Borofsky and Joel Shapiro, as well as Elizabeth Murray, Susan Rothenberg, and other new imagists, he tried to combine figuration and abstraction, using cutout forms, as in *House/Shield/Mask/Ladder*, the title of a 1975 work. Subsequently Fischl invented a family of fishermen and used cutout figures to illustrate stories about them. But the images struck him as too abstract, and he increasingly felt the need to create "a believable experience. . . . It took a long time for me to finally say, 'These are real people and this is a room and they have this kind of chair instead of just a chair.'"[74] He did not want viewers to say: "I like the weight of this or that, or the way one color pushes off another." Instead they would say, "Why is that person doing that to that person?" or, "What's happening here?"[75] This led him to return to painting on canvas because he felt it was only in that medium that he could construct a moment of intense drama.[76]

Fischl's new "stories" had their source in his own discomforting life experiences and fantasies, but these experiences and fantasies were also those of the social class to which he belonged, namely the surburban middle class in a consumer society.[77] His content was the psychosocial, or more specifically psychoclass, psychosexual, and psychoracial behavior of its members. His aim was to reveal, as he said, "how people act when they think they are alone or not observed"[78]—that is, as they really are. Fischl's focus was on the family in its diverse interactions, central to which, as Robert Storr pointed out, was "the experience of one's own physical and psychic nakedness, and the uneasy fascination one has with the nakedness of others."[79] Indeed, Fischl's cast of characters was exposed "in all its nakedness (both symbolic and real)."[80]

In order to capture idiosyncratic poses and gestures that distinguish suburban Americans—their body language, as it were—Fischl relied on photographs from advertisements and pictures in books and magazines. He also took many of his own snapshots, often of nude sunbathers. Moreover, his imagery was informed by film, what art critic Bruce Ferguson termed his "cinematic consciousness."[81] Fischl's images were not illustrations of other images but improvised, constructed in the free-associational, additive, direct process of painting. His feeling out, his groping, gave his paintings an awkward and clumsy edge that avoided the look of academic rendering.

Fischl was very conscious of the nudgy "badness" of his work.[82] "One thing I love about people like Dove and O'Keeffe and Hartley is that there is this kind of dumbness to their work, a directness. . . . I respond to that. I understand it. I find that those qualities are in my own work, that there is an awkwardness to the forms or to the narrative moment."[83] There was a sense in Fischl's painting that he would have liked to have been a perceptual realist, to have achieved the "perfection" of a Philip Pearlstein, had not psychic pressures and anxieties distorted his representation.

In Fischl's best-known pictures, painted after 1979, the protagonists

are self-absorbed, voyeuristic boys who have just reached puberty and are trying to negotiate the sex-obsessed adult world while coping with their own newly urgent sex drives. His consummate image is *Bad Boy* (1981) [101], in which an adolescent boy contemplates the crotch of a naked woman sprawled seductively on a bed while he reaches behind him into her purse. Fischl described the process of developing his narrative:

How I make a painting; picture it. . . .

A bowl of fruit. Yes fruit! Apple and oranges but especially bananas. I love to paint bananas; big bananas. Pan across the bowl of fruit. . . .

Where is it? A bedroom? Ah! a bedroom. Put in the bed. Put in a window. Pull the blinds. Light streaming through the bamboo curtains. Southern light, feel the heat. Border town. Borderline behavior. Put in table. Install the phone. What if someone calls? Take the phone off the hook.

Anyone home? A couple's on the bed. What've they been doing? Feel the heat!

No. He's not right. He has to go. She rolls over. Hot, idle, a little

101. Eric Fischl, *Bad Boy*, 1981. *(Mary Boone Gallery, New York)*

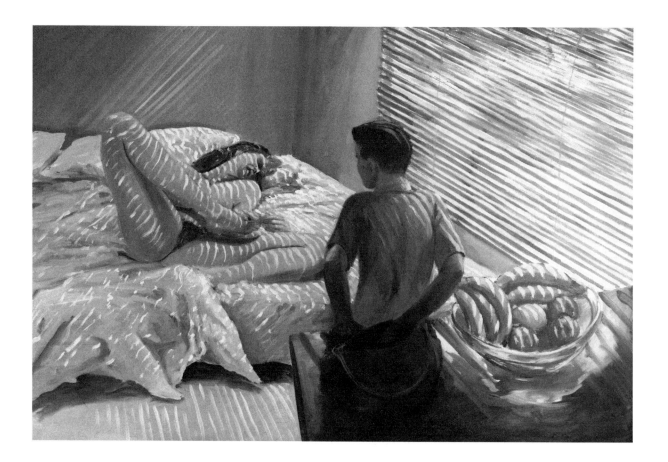

bored, she's picking at her toenail. Look what she's showing us! A real looker. Eyeful. She's not alone.

There is a child on the bed looking out the window.

Who are these people? She's old enough to be his mother. She is his mother! Feel the heat. Feel the edge.

He gets off the bed; goes to the table. He can't take his eyes off her. What's he doing now? Reaching back behind him.

He's reaching into her purse. Change the telephone to a purse. He's going through her purse. He's stealing her wallet! Bad boy.[84]

Bad Boy tells the story of a boy-coming-of-age stealing from his mother—stealing a look at her vagina and money from her bag (surrogate vagina), the vagina and bag echoed by the basket of fruit, the traditional art-historical image of a woman offering herself. Robert Pincus-Witten remarked of *Bad Boy* in 1981: "Freud lives. Two forbidden acts: theft/the view of the genitals. The hand slipping into the purse signifies Oedipal fornication that psychologically precedes all others. The linguistic pivot is snatch and snatching."[85] *Bad Boy* was shocking—and Fischl meant it to be. It was also compelling because of its authenticity and intensity and because it dealt with sex and money, both American obsessions.

Bad Boy confronted the incest taboo. So did *Birthday Boy* (1983), but more directly. A voluptuous naked woman lies on a bed; legs wantonly open, she entices a pubescent naked boy who sits beside her, but she looks away inattentively, seemingly bored, as if the seduction does not interest her very much. Not sure of what to do, the boy, equally diffident, glances past her and tentatively touches her leg. The sense of sex as commonplace was even more evident in *Inside Out* (1982), in which a woman, while copulating, changes a television station. In *Daddy's Girl* (1984), a naked man hugs a naked child in what may be tender cuddling or incest and child molestation. As Fischl said, "Nobody was watching them, therefore something could happen."[86] These pictures were unsentimental, often perverse and provocative. By making private acts public, they made viewers uncomfortable, causing them to consider sexuality and sexual taboos in American life generally and in their own lives—their hidden desires and secret shame.

Fischl's paintings were socially as well as psychologically disturbing. His affluent types appear to have realized the American dream but have repressed the darker primal realities in life and have failed to develop public rituals to deal with them.[87] In 1982 he commented that "central to my work is the feeling of awkwardness and self-consciousness that one experiences in the face of profound emotional events in one's life . . . such as death, or loss, or sexuality. . . . One truly does not know how to act! Each new event is a crisis, and each crisis . . . fills us with much the same anxiety that we feel when, in a dream, we discover ourselves naked in public."[88]

In another sense the American dream that still seemed realizable in the 1960s had failed. Fischl asserted that "the way America has grown and acted . . . doesn't match the ideal. I mean, America's not Disneyland

and we can't deny it any longer. Things smell, things have edges, people can get hurt."[89] The age of innocence was over. As art critic Avis Berman remarked, "Fischl's archetypal theme is trouble in paradise."[90] For example, *Scarsdale* (1987) exposes the sadness and isolation of a tired elderly woman in pursuit of pleasure—the tragedy of aging in America. The content is trite, but it is, to use Fischl's words, "supercharged banality."[91]

Scarsdale is one of many of Fischl's images that call to mind Edward Hopper's paintings. Indeed, Fischl can be considered the Hopper of the 1980s. But he had mixed feelings about Hopper, calling him "a crummy figure painter. His figures are so leaden. . . . Yet [that leadenness] gave his work psychological importance. You really feel the anxiety of the people in it, the loneliness."[92] Of the artists of his own generation, Fischl was closest to performance artists Eric Bogosian and Spalding Gray and moviemaker David Lynch. Fischl greatly admired Lynch's *Blue Velvet* and *Wild at Heart.* Lynch, too, found what is "right next door . . . *very* interesting." Beneath the familiar and banal surface of appearances, he discovered unnerving abnormalities, perversions, and corruption. In a comment that might have been made by Fischl, Lynch said: "It's a possible world. I look at locations and ask myself: what could happen here? It's like life, like somebody's life. . . . But it's definitely once removed and in a film world." However, as critic Bryan Appleyard wrote, Lynch had the knack of "staying just close enough to the utterly ordinary to make the strangeness all the more disorienting."[93]

After 1983 race and class began to figure in Fischl's work as well as sex. *A Visit To/A Visit From/The Island* [102] is a two-panel painting; in the right panel, a group of drowned blacks have washed ashore; in the left panel, a group of whites vacation on a luxurious beach. The work refers to the tragic attempt of Haitians to escape to the United States. The stark contrast of rich white and poor black is pointed, but the picture has a subtler, more telling moral content. It "presents the two halves of his social equation as if the people in them, absorbed by their own realities, were totally unaware of each other."[94] Regarding his turn from adolescent themes to adult relationships and social issues, Fischl commented: "At some point you grow up. I just happen to be doing it at 38."[95]

Robert Longo was another young painter who emerged in the early 1980s. In 1979 he began a series of outsize black-and-white drawings, titled *Men in the Cities,* because, as he said, minimal and conceptual art had made "drawing and painting [look] very traditional and . . . outmoded and dead, [so it] seemed really radical to draw, to paint." The first of the drawings was of a man whose body arches backward while his left hand clutches at his back. The image was appropriated from "a [Rainer Werner] Fassbinder film still from *An American Soldier* . . . from the scene at the end of the movie where two gangsters get shot." It appealed to Longo because it had a "high-impact kind of bang; at the same time it has this incredibly fluid grace."[96]

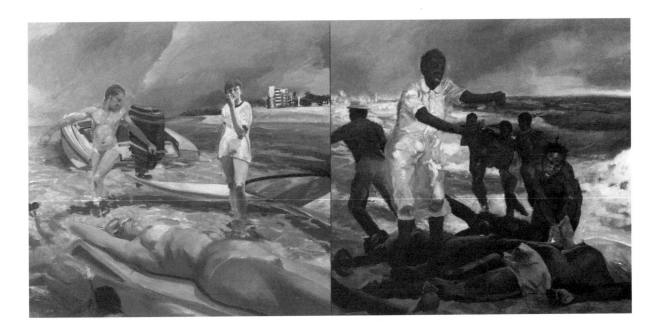

Longo found other subjects to draw in newspaper photos and film stills [103]. Later he photographed friends on the roof of his building as they twisted and turned in order to avoid tennis balls and stones thrown at them. He then made slides of the photographs, projected them onto white paper, and rendered the images in charcoal and graphite. Hovering between photography and photorealist drawing, Longo's work, like Salle's, entered into the polemical art-world battles of the 1980s.

Larger than life and meticulously rendered, Longo's isolated figures are frozen melodramatically in contorted positions that suggest falling as if shot, or dancing—the dance of death.[97] Their "stories" are ambiguous since they are anonymous and removed from any context. They are nonetheless familiar, hovering between "real" life and "simulated" cinematic or television life. Indeed, each figure in an arrested moment resembles a single stop-action frame from a movie or TV show—some imagined violent climax perhaps. Longo projected his stock mass-media subjects on an epic scale, as tall as nine feet; he said: "My work basically exists somewhere between movies and monuments."[98] Richard Prince summed up Longo's pictures:

> The violence seemed Hollywood; pin-striped John Wayne in an executive suite punching out his vice president; . . . Joey Dee Peppermint Lounge skintight early sixties late seventies rockers doing a who-can-die-the-best type dance. . . . The whole experience was a sexual/intellectual Disneyland for the post-war baby boom weaned on TV and the *New York Post*.[99]

102. Eric Fischl, *A Visit To/A Visit From/The Island*, 1983. *(Copyright © 1994 Whitney Museum of American Art)*

103. Robert Longo, *Untitled (dead falling man)*,
1982. *(Courtesy of Metro Pictures, New York)*

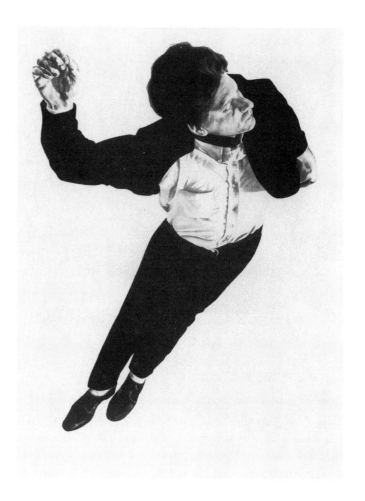

Longo soon expanded his artistic means to include sculpture, photographs, and relief and painted elements.[100] The works became more aggressive—like Schnabel's pictures—and larger—the size of billboards and wide-screen movies. Like Schnabel, too, Longo tackled big themes: power, love, war, and death.[101] *Corporate Wars: Walls of Influence* (1982) [104], a work twenty-six feet long, contains a central cast-aluminum relief that depicts the endless struggle for business success, exemplified by eighteen young Wall Street types pummeling each other with their fists. This section is flanked by two projecting black-lacquered wood skyscrapers, whose perspective is tilted and distorted so as to accent their oppressive mass and height.

In *Pressure* (1982–83), a close-up dejected clown, his face painted white (Everyman) is squashed by a cropped gray, anonymous modernist office block (the world of business and finance). *Now Everybody (For R. W. Fassbinder)* (1982–83) includes bombed-out buildings in front of which a life-size contorted figure cast in bronze seems to have been shot. As Longo said:

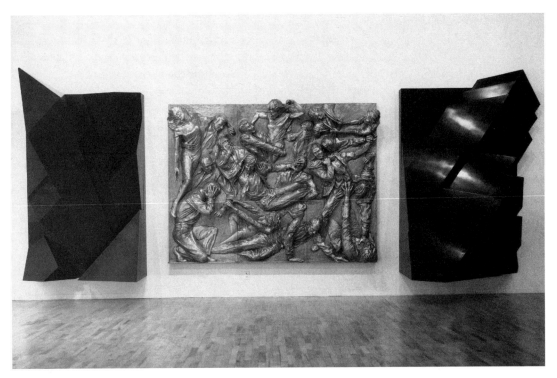

104. Robert Longo, *Corporate Wars: Walls of Influence*, 1982. *(Courtesy of Metro Pictures, New York)*

I mean, look at *Time* and *Newsweek,* man. The media. For the first time, Americans are being confronted with this reality they've never seen before. Like, you look at a picture from Beirut on the cover of this magazine, and it's like, "Wow, man, look at this guy with his head blown off!" That city especially has shown America what it could be like here.[102]

Critics favorable to Longo claimed that his work conveyed the tension, anxiety, and alienation—the dehumanization, in a word—of urban corporate society and deconstructed it in a cold and impersonal manner. Other critics were not convinced. For example, Roberta Smith was troubled by the "fat corporate look" of Longo's work. "It's not hard to think . . . that their mesmerizing mix of violence, power, formal drama and material glamour is a little too perfectly compatible with the industrial-military complex"[103]—or from the pop culture from which they were derived.

Elizabeth Murray moved to New York in 1967. She recalled: "I didn't know many people . . . except for Jennifer Bartlett, who was very supportive, and . . . Joel Shapiro. At first I felt quite out of it. Pop was so campy,

and Minimalism . . . was equally off-putting. The word being spread was, 'Haven't you heard? Painting is dead!' I thought, 'Oh, really? Well, to hell with *that*. I'm painting.'"[104] Murray felt the need to experience the "miracle involved with paint. It's just this stuff in a tube which you squeeze out . . . yet you use it as a transforming agent."[105]

Murray was taken not only with the materiality of paint but with the physicality of the stretched canvas as well. She shaped canvases into irregular units and then composed and stacked them into low reliefs. Her move into actual space owed much to Frank Stella, but unlike Stella, who constructed his "pictures" so that they resembled high reliefs, Murray used canvases as flat surfaces to paint on, but she countered the physicality of the canvas—and the projecting canvases—with expressionist painting that produced an illusion of depth. At the same time, the painterly painting was a foil to the hard edges of the superimposed canvases. Although improvisational, Murray's brushwork was not impulsive. Like the canvases she shaped, which were obviously carefully considered and built, the painting seemed deliberate but no less urgent for that; it was, in a word, felt.

Murray was related to Schnabel, Salle, Fischl, Longo, Bartlett, and Rothenberg in that her imagery had figurative elements, but it was more abstract than theirs. Nonetheless, it was often narrative, her stories rooted in her life as a woman. Like other neoexpressionists, Murray cultivated complexity. In sum, she synthesized such disparate elements as the two-dimensional surface and three-dimensional relief, figuration and abstraction, gestural painting and hard edges. She also combined diverse approaches and images culled from earlier twentieth-century styles: cubist-inspired fragmentation and construction in space, surrealist biomorphism, expressionist facture, and pop art motifs. As she said, her "art comes from other art." At the same time she introduced elements from "low" art, especially cartoon drawing, of which she wrote: "The simplification, the universality, the diagrammatic quality of the marks, the breakdown of reality, its blatant, symbolic quality—have been an enormous influence on my work."[106]

Beginner (1976) was a key picture in Murray's development. Its image recalls the cartoon character "Tweety Bird," an Arp-like biomorph, and a pretzel-like embryo with a kind of umbilical cord—all at once. she said that the image "evolved from combining two commas."[107] The "comma" was suggestive of the punctuation mark and organic form: sperm, uterus, and pregnant belly. It would become a recurrent shape. Significantly commas entered Murray's vocabulary of forms when her first child was born and thus had a private meaning. But their meaning was also suprapersonal; used in pairs, the commas resembled the yin-yang sign—the symbols of the harmonic coupling of male and female.[108]

In 1980 Murray began to compose pictures from stretched-canvas fragments. *Painters' Progress* (1981) [105] consists of nineteen individual

105. Elizabeth Murray, *Painters Progress*, 1981. *(Museum of Modern Art, New York; photograph copyright © Museum of Modern Art)*

jagged-shaped canvases. The segments are unified, but barely, by the image of a single palette with fat brushes-phalluses[109] sticking out of the thumbhole. Murray commented: "With *Painters' Progress* I wanted to talk about the tools of the trade. . . . I wanted to turn art back in on itself. The palette is the head and the brushes are coming out of the eyehole."[110] She soon moved from the studio into the kitchen and living room. In *Yikes!* (1982) the central image is a steaming cup—a recurring subject. She said: "The cup is an extremely female symbol. It can be seen as an encasement for the female genitals. It is a male symbol too: the winner of an athletic event gets a cup. I also find the cup—as an object—a beautiful image. Handle, saucer, cup—three circular shapes."[111] Murray also represented tables, chairs, spoons, and other commonplace objects found around the home. "I paint about the things that surround me—things that I pick up and handle every day. . . . Art is an epiphany in a coffee cup."[112] But this intimate paraphernalia is projected dramatically on a large scale—emulating the ambitious "big picture" identified with the New York School.

The furniture and kitchenware in some of Murray's pictures look anthropomorphic, becoming surrogates for people engaged in domestic psychodramas. In *More Than You Know* (1983), composed of nine overlapping canvases, the central image is a green table superimposed on a splayed, heart-shaped red bed. On the tabletop is a piece of paper, presumably a letter, and next to it, a ghostly image of the haggard face in Edvard Munch's *The Scream*. The table, its legs flung out like human limbs, also seems to scream. The news contained in the letter is clearly tragic. In fact, Murray conceived of the picture after a visit to her dying mother. "The Munch head is supposed to be her face, and also her footprint." The red form was "a bed, with a headboard. . . . The table is going over the bed. The table is her body, too, flying out of the room."[113]

The works Murray made at the end of the 1980s are single shapes in high relief. The most striking image is that of shoes [106].[114] She said: "I was thinking of the old nursery rhyme about the old lady who lived in a shoe. I had been looking at the Van Gogh shoes because I thought he had transformed crumby old work shoes into beautiful objects. A shoe has all kind of connotations. . . . The idea of a work shoe or a very heavy lady's walking shoe appealed to me. I'm amazed by how the exaggeration of the shoe works; as it twists and turns up, it becomes so many different things—even a figure."[115] Murray's shoes were also borrowed from the comics, derived from the shoes Dagwood wears in "Blondie." At the same time she had in mind the thick-soled shoes her unemployed father wore as he looked for a job in the depression thirties.[116]

Murray's multivalent work appealed to a variety of art-world constituencies: feminists, taken with her domestic imagery and the way she employed abstraction from a feminist point of view; fans of pop culture, because of her references to cartoons; and lovers of painting, because of

106. Elizabeth Murray, *Tomorrow*, 1988. *(Collection Fukuo Sogo Bank, Ltd., Japan)*

her intensity. Moreover, as Deborah Solomon commented: "Because Murray's work is both abstract and representational, it appeals at once to people who love abstract painting in the name of modernism and people who hate it in the name of post-modernism."[117]

Ida Applebroog's cartoonlike wall works were not included in the *"Bad" Painting* or *New Image Painting* shows, but they should have been [107]. They are composed of rows of panels, each with the same simple image heavily outlined in Rhoplex on translucent vellum, accompanied by a one-line caption. The backgrounds are cut out and the images projected so that shadows are cast on the walls.[118] Applebroog's "frozen theater" or *Performances,* as she titled them, are reminiscent of comic strips, storyboards, or film strips.

Applebroog's characters reveal themselves and their banal but jarring and often sinister interpersonal relationships in minute but telling gestures and in a few words of text. Everything looks "normal" and benign, but nothing is quite what it seems to be.[119] Some scenarios exemplify extreme loneliness: one character says pathetically: HAPPY BIRTHDAY TO ME. In another sequence of two teenage girls, the caption reads "He says abortion is murder," followed a few frames later by "So?" The final frame is of three business-suited men talking. The punch line is: WHY

107. Ida Applebroog, *It Isn't True,* 1979–80. *(Ronald Feldman Fine Arts, New York)*

ELSE DID GOD GIVE US THE BOMB? Still another strip, of a couple dancing cosily, is captioned: HURRY UP AND DIE. Applebroog commented that the "underlying theme is the condition of being human, the inertia of interpersonal relationships. . . . The cast of characters [is] prone to glibness and frozen gestures, evoking alienation, isolation and a sense of the impossibility of articulate thought."[120] The images often have tie-back curtains or half-drawn shades, calling to mind windows—putting the viewers in the disturbing role of voyeurs, eavesdropping on a peepshow Applebroog has staged.

During the 1980s, with an eye to Philip Guston and Leon Golub, Applebroog turned to painting in what seemed to be a need for more space in which to stage her dramas and a desire to articulate a greater range of emotions and to project them more strongly. The works continue to deal with the intimate lives of ordinary people in contemporary society, in particular women and children. However, whereas the earlier works are simple storyboard sequences, the later works are disjointed and complex, composed of differently scaled and rendered images in multipartite large and small canvases, attached to one another or inset, in a manner reminiscent of Salle's pictures. The characters in the early works are passive and innocuous; after 1985 they grow assertive—often violent and grotesque. But the content remains the same: the apathy, cruelty, and aggression that people experience in everyday life; the absurd lies, deceptions, and vanities that veil them; and the pain and guilt they cause.

Applebroog's painting is at once "ugly" and seductive. Mira Schor pointed out in 1987 that her palette consists of the reds, browns, and yellows of body fluids and excretions and that the textures were often gelatinous, looking like "gleaming sludge."[121] And yet the painting is pleasurable, making Applebroog's horrific subjects and their gruesome narratives palatable and at the same time adding to their expressive power.

Applebroog's psychosocial concerns include sexism, *It's a Girl, Send It Back* (1985), racism, *God's White Too* (1985) [108], the victimization of

108. Ida Applebroog, *God's White Too,* 1985. *(Ronald Feldman Fine Arts, New York)*

women and children, *K-Mart IV* (1985–90), and the misuse of power, notably by doctors and hospital personnel.[122] The text, repeated several times, in *Emetic Fields* (1989), reads: "You are the patient, I am the real person." Applebroog's pictures of the aged, with their sagging and lumpy bodies, the infirm, the maimed, and the destitute are her most pathetic. In *Beulahland (for Marilyn Monroe)* (1987) the sex goddess is depicted as a frumpy sixty-one-year-old (the age she would have been had she lived), whose bulging flesh is barely contained by a bikini, in the seductive pose of a photograph of her at thirty-four. Floating around the figure are disk-like age spots.[123] In repetitive frames, a man at the wheel of a car appears through a windshield, associating the blond bombshell with another object of male desire—the automobile.

Applebroog wrote that certain American scenes

> cause one to feel nauseated—"Emetic Fields." These usually have two core elements: endless consumption and violence. In fact, [American life] is characterized by the endless consumption of acts of violence, as can be verified by watching television news every evening and reading the tabloids every morning.
>
> Concern with violence, together with the notion of people not caring, is basic to my work—violence committed out of cruelty, out of stupidity, out of a desensitization to violence.[124]

Applebroog's painting was about the world, but hers was not a distanced or ironic view. She confessed her inner torments, anxieties, and fears while projecting what she witnessed and experienced—with an authenticity that demolished the art-theoretical assertion that painting could no longer be genuine.

Most of the neoexpressionists were little known at the beginning of the 1980s. Not so Leon Golub, whose career stretched back into the late 1940s and who had achieved a considerable reputation in the 1950s as the foremost member of a group of artists in Chicago known as the "Monster Roster." He was established as a leading artist of the 1980s—an old master of the new painting—in 1982 with his exhibition of huge pictures of mercenaries, interrogators, and assassins.[125] These canvases had been anticipated by his pictures of the 1960s, titled *Gigantomachies*, in which colossal ravaged heroes—based on late Roman statuary—heroes that barely survived Dachau and Hiroshima—were engaged in violent combat. Humanist man was further battered in more realistic pictures of the Vietnam War. Working from news photos, Golub viewed himself as "simply a reporter," but he was also an interpreter of these painful events. How did one visualize slaughter? "You can't do it by painting pretty pictures about it. You have to create those kinds of stylized forms which are so brutal that they jump beyond the stylization."[126] The harsh-

ness of Golub's subject matter was emphasized by oppressive blacks, browns, reds, and grays, and rough facture interspersed with areas of heavy, brown, raw canvas.

Humankind descended even lower in the pictures of paid torturers and killers at their cruel work [109]. As in the Vietnam paintings, Golub's images were culled from newspapers and magazines. The unstretched backdrops were a uniform raw red oxide, projecting the outsize figures aggressively at the viewer. The gargantuan size of the canvases added to their assertiveness. Golub described his method:

> The figures are outlined and partially shaded in black paint. Then a coat of white paint is put on for highlights and lighter areas. I then apply layers of local colors to define skin, metal, wood, cloth, etc. The painting is then laid on the floor. Areas are partially dissolved with solvents and scraped with sculpture tools, more recently, a meat cleaver, to erode the paint skin.

Golub then repeatedly reconstructed and eroded the painting until "the different figures, their gestures, grins and leers, etc., are in some sort of achieved tension [and] retain a raw, brute look."[127]

On one level Golub's group portraits of thugs had an unequivocal political purpose: to expose the shadowy peripheries of tyranny where power was exercised most nakedly and violently—out of sight, where the

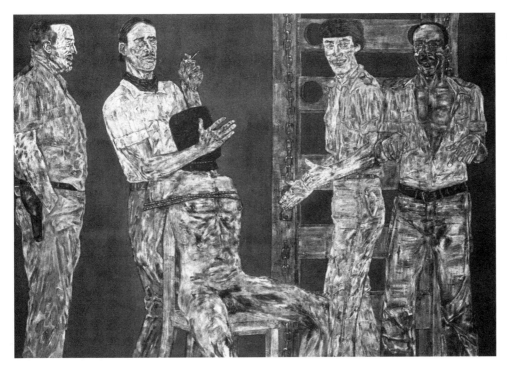

109. Leon Golub, *Interrogation II*, 1981. *(Art Institute of Chicago)*

camera did not go.[128] And he wanted to convey this imagery, as he said of George Grosz's pictures, in "so ferocious [a] style that it couldn't be brushed away, dismissed as mere art" or "assimilated to a comfortable point of view."[129]

On another level Golub's content was ambiguous. In his depiction of interrogations, his focus was on the victimizers, not on their mute, naked, trussed, and strung-up victims. The viewer could empathize with them, isolated in their hoods and disoriented, in pain and terror, and in every way dehumanized, reduced to mere flesh, but could not identify with them. On the other hand, much as the torturers were pawns of some larger malevolent power, symbols of oppression and the banality of evil, they were individuals with idiosyncratic physical and psychological characteristics, which were subtly detailed. But Golub portrayed them just doing their jobs, occasionally conversing, joking, arguing, or taking a breather. He even imagined them at play—cavorting with their girl- or boy-in-drag friends, as in the Horsing Around series (1983) [110].

In recognizing the thugs as singular people while dehumanizing their victims, Golub reversed the usual bias of political art: identification with the oppressor rather than the oppressed. To further make his brutes accessible to the audience, he had them confront the viewers directly, eyeballing us, drawing us into their world, implicating us, making us complicit—as it were making us all torturers and murderers. As Robert Storr commented, "No one is blameless, just as no one who comes to [these paintings] looking for contemplative solace or confirmation of his or her prior convictions gets away without abrasions or emotional bruises."[130]

Nonetheless Golub's "message" remained ambiguous. We, as "good" people, might be outraged by the torturers and murderers, but "maybe at some level [we were] identifying with those guys, deriving a vicarious imaginative kind of pleasure in viewing these kinds of macho figures— physical, gestural, sadistic."[131] This led Rosetta Brooks to ask whether Golub was "an undercover agent or secret fetishist." Perhaps both, conflating "documentary truth and sexual fantasy," and giving both added dimension. She found this "chilling intrusion of the pleasure principle into the world of information retrieval" a kind of voyeuristic sexual deviance, as socially transgressive as the depiction of pornographic torture.[132] Be that as it may, Golub bore witness to inhumanity and suffering, thus revealing democratic society's unfinished business.

Golub showed that political art need not be mere propaganda. Indeed, he made human acts that violate the human body and murder disturbingly real in a way that even news reports could not. Living flesh was turned into a political arena, intimate but projected on an epic scale, making the kind of impact to which propaganda art aspired but rarely achieved. Golub's work was acclaimed in the 1980s art world because of its social significance and because it was central in an ongoing debate over the role of politics in art. But there were other reasons for its recog-

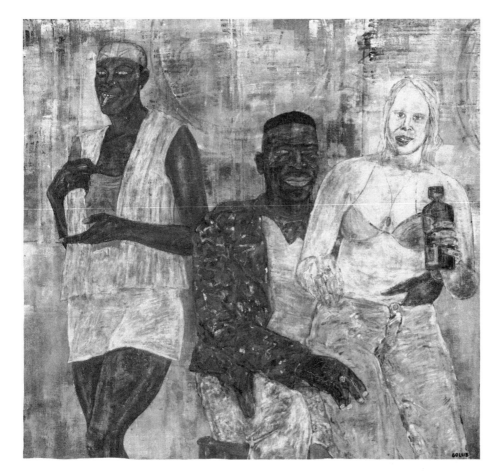

110. Leon Golub, *Horsing Around (III)*, 1983. *(Eli and Edythe L. Broad Collection)*

nition. One was the ambition and authority of his giant canvases—the antiheroic successors of nineteenth-century heroic history painting.[133] Another was the quality of Golub's fierce drawing and harsh painting or, in Carter Ratcliff's words, "the battered gorgeousness of his paint surfaces."[134]

Like Golub, Malcolm Morley was an old master of the new painting. In 1965 he had been the innovator of photorealism. In 1971, with van Gogh in mind, he introduced expressionist facture into his photograph-inspired painting, anticipating the neoexpressionism of the 1980s. Looking back on his development, he characterized his photorealism as "my perfect period, and what followed an imperfect period—a tearing down of perfection. I would actually start knifing and shattering the so-called fidelity of the image . . . with paint. I'd collage objects on the surface, like a rifle, for instance." He added: "There'd always be a cynical, wise-guy angle to it."[135] And yet van Gogh was a kind of hero, and Morley painted homages to him—or were they? In *The Last Painting of Vincent van Gogh* (1972) he repainted van Gogh's *Cornfield with Crows*, placing it on an easel and beneath it, a paintbox, palette, and old-fashioned pistol

of the sort that van Gogh might have used to commit suicide.

Morley not only cultivated a seemingly inward-directed expressionist facture but invented a personal iconography, based on "what I've actually seen and experienced in one way or another."[136] His central subject matter was inspired by childhood experiences in England during World War II. As a boy he had made models of famous warships; one was on a windowsill of his house in London when it was bombed. Evacuated to Devon, he was taken on a school trip to the beach to see the lifeboat of a torpedoed tanker, an experience that strongly impressed him.[137] Morley used images of war toys—soldiers, model planes, ships, and trains—to represent his obsessions, anxieties, and fears—as in *Train Wreck* (1975) and *Age of Catastrophe* (1976), whose central image is an air crash.

The Ultimate Anxiety (1978) is based on a postcard reproduction of Francesco Guardi's *The Embarkation of the Doge on the Bucintoro*. In Morley's version the Doge's boat is on the Grand Canal, but a train crashes into the picture. The past and present collide with each other—the ultimate anxiety.[138] *Christmas Tree (The Lonely Ranger Lost in the Jungle of Erotic Desires)* (1979) [111] is a psychosexual drama that takes place in an imaginary jungle. Built from disconnected images, it contains a macho cowboy on his horse who points a dildo, in place of his revolver, at an Indian. They are surrounded by a variety of sexual symbols—phallic cobras, a wrecked train, dancing female legs, brightly plumed birds, and so on. Morley said that the "painting is very personal. It sums up 20 years of work."[139] In a number of pictures from the 1980s, he juxtaposed scenes from modern life with those of classical antiquity—contrasting the shallowness of the one with the mythic resonance of the other [112]. In *The Palms of Vai* (1982) the bottom is a beach scene of bathers; the top a headless torso above which stands a sculpture of a bull with a bloodlike stain dripping from its mouth, based on an ancient Minoan sculpture.

In pictures from the late 1970s and 1980s, Morley made small watercolors, using "a lot of splashing and dribbling and all kinds of watery incidents that go to make up 'watercoloury-ness'—as in 'painterliness.'" He then imposed grids on them and translated them meticulously into oil on canvas, one square of the grid at a time, reverting to the tight technique of his photorealist paintings. The illusionistic image emerged from abstract bits. At one and the same time Morley wanted freely to express his subjects and himself, and to suppress his personal inclinations by inventing a new method for "original seeing" that avoided what he had been conditioned to see and to associate with the imagery. He went on to say: "The mood then is the mood of the watercolour but amplified in a much more intense medium. Oil paint intensifies the watercolour aspects."[140]

In using a distanced and impersonal process to render painterly images, Morley raised questions about the nature of expressionism in

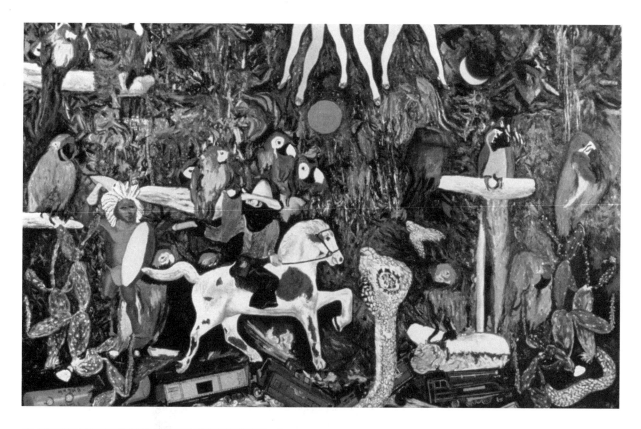

111. Malcolm Morley, *Christmas Tree (The Lonely Ranger Lost in the Jungle of Erotic Desires)*, 1979. *(Mary Boone Gallery, New York)*

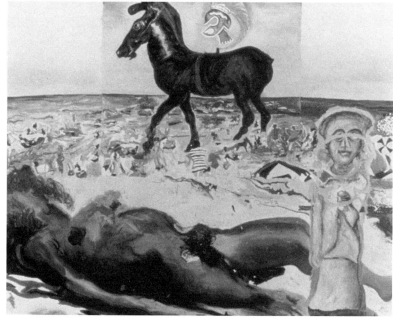

112. Malcolm Morley, *Cradle of Civilization with American Woman*, 1982. *(Mary Boone Gallery, New York)*

general, entering into the art-theoretical discourse of the time. How improvisational or spontaneous did painting have to be to be "authentic"? Could an expressionist-looking picture that was the issue of careful copying be genuine? Was Morley an expressionist? Not in the traditional sense, perhaps, but as curator and critic Klaus Kertess wrote, his painting possesses "a kind of mythopoetic, disjunctive visual delirium."[141]

Kertess's characterization of Morley's work would apply just as well to George McNeil's expressionist figuration, except that McNeil arrived at his images directly in the process of painting [113]. The wildness of his painting was informed by consummate artistry he had cultivated since 1932 as a student of Hans Hofmann. In fact McNeil, like Philip Guston, was a first-generation abstract expressionist who turned to figuration. However, unlike Guston's figurative work, his did not achieve considerable art-world recognition until the late 1970s, at about the same time as new image painting and neoexpressionism.

McNeil's images are in the tradition of German expressionism but more distorted, garishly colored, and gesturally energetic than those of any of his predecessors, particularly in his paintings from the 1980s. The subjects were culled from past art and mythology but with an eye to popular culture, specifically television. Indeed, McNeil seemed to imagine the frenzied inner life of boob-tube characters and convey it in hectic painting. He wrote in 1984 that his "human images . . . increasingly expressed negative states such as absurdity and anxiety."[142] But they are also funny. Carter Ratcliff caught the spirit of McNeil's pictures when he wrote that they are "a place where traditional figures like the Pierrot of the *commedia dell'arte* take on the manic presence of punk rockers."[143]

Like Schnabel and Salle, Ross Bleckner appropriated images, which he exhibited in 1981. Unlike Schnabel's and Salle's, his were abstract, not figurative. Composed of vertical stripes, they looked as if they were pirated from op art, but they differed in that they were referential, recalling ribbons, wrapping paper designs, and bars of cages. Moreover they were soft-edged and backlit, shrouded in a neoromantic atmosphere. Peter Halley hailed Bleckner's stripe paintings as postmodern because they recycled a modernist style.[144] He soon made them even more postmodern by turning the abstract images into birdcages with tiny birds, as in *Cage,* or candy boxes, as in *Infatuation* (both 1986).

Much as Bleckner subverted modernism, he had another motive: "In my stripe paintings [as] in all my different kinds of paintings [what I was looking for was an] almost continual light that comes from the inside. That's why I always work from dark to light. . . . The main thing to me is how the image is disembodied, almost vaporized, into this continuous pulsating glow." The glow became increasingly melancholic, evoking, as he said, "remembrance and loss . . . a shared vulnerability." [114][145] His painting meant to "encounter mortality, . . . the fact that

113. George McNeil, *Summer Dress*, 1991. *(ACA Galleries and the Estate of George McNeil)*

114. Ross Bleckner, *Fallen Object*, 1987. *(Mary Boone Gallery, New York)*

nothing is certain and nothing is unalterable."[146] In a time of an **AIDS** epidemic, references to the loss of friends were unmistakable if, in Bleckner's words, "elliptical or poetic." There are also, as art critic Lisa Liebman wrote, "allusions or tributes to other kinds of losses—of love, youth, innocence."[147]

Contributing to the mood of mourning was an inventory of subjects that included commemorative urns, loving cups, and other memento mori: funeral bouquets of decaying flowers, wreaths, and ribbons; hovering hummingbirds, the symbols of lost souls; spectral chandeliers; and abstract white points of flickering light like heavenly stars, which are also Kaposi's sarcomas, one of the manifestations of **AIDS**. This doleful iconography was self-consciously sentimental and campy—a kind of ironic twitting of death—which added to rather than detracted from Bleckner's tragic content.

Bleckner was the elegiast of neoexpressionism, his pictures about "departure," as he suggested.[148] In *Remember Me* (1988) the words of the title are inlaid in the painting, like a whisper. Pat Steir wrote that the picture "may reflect a desire for permanence, a desire to make something about oneself remain present when one is absent, but it also of necessity reveals a knowledge of the fact that one may become absent, and thus . . . an awareness of the fragility of human relationships and of human beings."[149]

Vitaly Komar and Alexander Melamid—a team—stood apart from other new New York painters because of their extreme rootlessness. Trained as academic artists in the Soviet Union, they had mastered socialist realism. Then, in 1972, they rejected the official style and invented "Sots Art"—an amalgam of Communist propaganda "art" and American pop art. In pictures, banners, and performances they appropriated and subverted Soviet political slogans, with a wit both devastating and devious enough to confuse the censors. For example, in *Double Self-Portrait* (1972), a painting that mimics the official mosaics that were ubiquitous in the Soviet Union, Komar & Melamid replaced the stereotypical profile portraits of Lenin and Stalin with their own faces. Explaining their Sots art, Komar commented: "In capitalist life, in America, you have an overproduction of things, of consumer goods. Here we have an overproduction of ideology. So your Pop art puts a tomato soup can in a painting . . . and our Sots art puts our mass poster art into a frame for examination."[150]

When Komar & Melamid emigrated to the United States, they began to paint again in a socialist-realist style because, as they explained with mock seriousness, they had loved Stalin when they were kids: "No one changes from childhood. . . . Deep down, we are real Stalinists." And yet their art is a hilarious satire of the stereotypical Communist-dictated style in all of its idiocy, banality, pretentiousness, and futility. In *The Origins of Socialist Realism* [115], a muse in classical dress holds up the head of Stalin with one hand and with the other traces its shadow on the wall.

Much as they spoofed socialist realist art, Komar & Melamid also meant their academic technique to mock what they considered the shoddiness of modernist art. Consequently they incorporated every modernist style in a series of mixed-panel pictures, parodying them all [116]. Their mélange of images was a kind of postmodern burlesque, but they claimed to be playing it straight. "We appreciate freedom deeper than others do. . . . We need to make thousands of pictures—any subject, any style, any size, completely free. The idea of 'the masterpiece' has disappeared."[151]

In 1988 Komar & Melamid moved into a studio next to a brass foundry in the manufacturing city of Bayonne, New Jersey, across the bay from New York City. Claiming to escape from the art-crazed public, they

115. Komar & Melamid, *The Origin of Socialist Realism*, 1982–83. *(Ronald Feldman Fine Arts, New York)*

shed the dishonorable for the honorable, indifference for passion, the mercenary for the selfless, the banal for the original. [In] the promised land: Bayonne.

At last, beauty assails our eyes from every vantage. The Bergen Point Brass Foundry, for example. . . .

By day, we tread Bayonne's gallery-free streets . . . passing the ancient ruins: abandoned factories, junked cars, industrial dumps, the wretched refuse of a dying culture's teeming shores, all as poignant in their decaying beauty as the crumbling Colosseum of Rome. . . .

116. Komar & Melamid, *Vespers,* 1984–85. *(Ronald Feldman Fine Arts, New York)*

> Ah wormwood [growing in the empty lots], eternal grass of industrial dumps! We ourselves loved you in our Moscow childhoods.[152]

Having found their "home," in the "real" America—but one reminiscent of Stalinist Russia—Komar & Melamid painted paeans to the American proletariat, but ironically, since heavy industry in the United States was in decline. The duo also made small sculptures, titled *Bayonne Rock Gardens,* which were assemblages of detritus and weeds plucked from vacant lots.

In exile wherever they lived—whether in the Soviet Union, Israel, or the United States—Komar & Melamid were the most deracinated of 1980s artists.

If Komar & Melamid were at one extreme of the new painting, Jennifer Bartlett and Susan Rothenberg were at the other. Where Komar & Melamid were nihilist or at least tongue-in-cheek, the latter were utterly serious and positive, both in their obvious regard for painting and their subject matter. Bartlett and Rothenberg were first recognized as new image painters and then as neoexpressionists. Bartlett's works, composed of pigment baked onto enamel metal squares, were not painted in a conventional manner, but they soon would be. In 1979 she began to introduce freehand brushwork, often like that of Monet, into her conceptual "alphabet" of forms. Increasingly the painting took over. In *Swimmer Atlanta* (1979) she turned to nature, notably the surface of water, for subject matter. The Up the Creek and To the Mountain series (1981–82) are based on scenes she had seen or photographed. In 1984 Bartlett conceptualized nature by building three-dimensional objects— houses, rowboats, tables, and chairs—which she used as subjects, more accurately "models," for painting and exhibited with the pictures, mixing "sculpture" and painting [117].

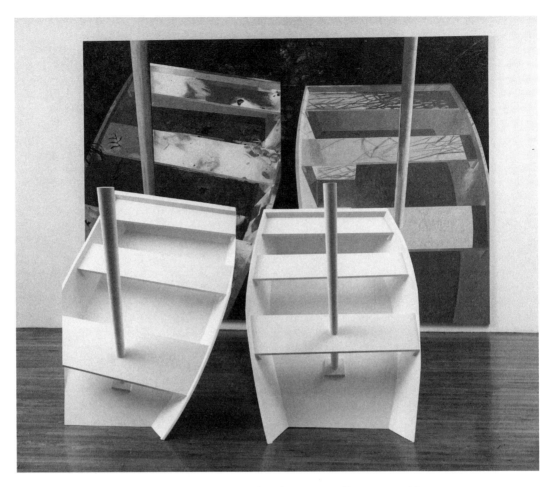

117. Jennifer Bartlett, *Boats*, 1987. *(Paula Cooper Gallery, New York)*

* * *

By the time of the *New Image Painting* show in 1978, Rothenberg
had tired of depicting profile horses locked onto the picture plane by ver-
tical and diagonal bands, the subject that had brought her to the atten-
tion of the art world.[153] Instead she began to paint the horse in frontal
view, eliminating the geometry. She then dismembered the horse into
bones and body fragments.

> One of the big elements that the geometry gave the painting was ten-
> sion. . . . And at one point I found that a bone could create the same
> feeling. [There] were the soft contours of the horse, the sharp lines of
> the stretcher and the bones, which also were more integrated with
> the subject matter. Then . . . I began to wing it with the bones. And
> the work certainly got more psychologically intense, since bones have
> so many connotations.[154]

In 1980 Rothenberg painted a series of disembodied human faces and hands—surrogate self-portraits of a kind [118].[155] She wrote that she was "trying to invent new forms to stand in for the body since I don't want to make a realist painting. . . . I'm very aware of my body in space—shoulders, frontal positions." She went on to say that much of her work was about body language.[156] In 1982 Rothenberg tackled the full human figure. One of her most explicit subjects was *Mondrian* (1984). She said that as she was drawing, an image of a solitary man "just reminded me of him. I had seen some photographs of him. . . . And then I started to play with the idea of making paintings of Mondrian [as a] kind of imaginary dialogue with him."[157] She also commented: "I really have a tremendous feeling about who he must have been, both about how screwed up he probably was, and also how pure and wonderful and disciplined."[158]

In 1985 Rothenberg began to paint figures in continuous movement—bikers, dancers, spinners, vaulters, and jugglers. The repetitive elements—suggestive both of futurist lines of force—and feathery brushstrokes created a sense of perpetual motion. Toward the end of the decade she used the human body as the occasion for invention, painting figures in impossible positions, such as a *U* in *Blue U-Turn* (1989), imagining new anatomies, such as the Giacometti-like body with a head at either end in *Bone Heads* (1989–90). Rothenberg's images were arrived at improvisationally and, as she said, aimed to express "a personal viewpoint about reality." [119][159] "Its complexities involve perceptual and psy-

118. Susan Rothenberg, *Somebody Else's Hand*, 1979. *(Collection Henry S. McNeil, Jr., Philadelphia)*

chological memories based on real and imagined experiences. . . . which are things that seem close to unpaintable, which is why I love painting."[160] The criticism of neoexpressionism for being "neo," signifying inauthentic, was belied by Rothenberg's painting.

Like much of Bartlett's and Rothenberg's work, the paintings of Terry Winters, Bill Jensen, and April Gornik are based on nature. Winters was reared as an artist on abstract expressionist "action" painting. Using the canvas as a kind of sketchbook, he improvised elemental cellular, pod- and shell-like, microscopic organisms—evoking the beginnings of life [120]. His biomorphic abstraction is in the tradition of Georgia O'Keeffe and Arthur Dove, but more specifically, of Arshile Gorky, William Baziotes, and the early Mark Rothko, but painted with a eye to the late Philip Guston. Indeed, as art critic Michael Kimmelman observed, Winters's work "is as much about different ways of putting paint to canvas—with its blend of washed, impastoed, scumbled, erased, slathered and crisply drawn—as it is a chart of rudimentary organic forms."[161]

Like Winters, Bill Jensen looked for inspiration to the more abstract of early-twentieth-century American modernists, notably Dove

119. Susan Rothenberg, *4 Kinds*, 1990–91. *(Private collection)*

120. Terry Winters, *Rhyme*, 1985. *(Denver Art Museum)*

and Marsden Hartley, and above all Albert Pinkham Ryder [121]. However, Jensen's pictures have none of the sketchy quality of Winters's; indeed, like Ryder's paintings, they tend to be small in scale and seem obsessively worked and reworked. Moreover, unlike Winters's images, Jensen's verge on recognizable landscapes and figures. These are authentic visionary paintings, in the American tradition that extends back in time to the Hudson River School.

Like Jensen's more figurative images, April Gornik's landscapes are imagined but more "realist" [122]. She said: "I remember being surprised when I realized there was a big, untaught, relatively uncelebrated history of American landscape painting lurking in my art historical background." Nonetheless, she added: "I get exasperated with the superficial reading of mine and all old landscape painting as being first and foremost 'Romantic.'"[162] And with good reason. Unlike her predecessors who looked to the American scene for transcendental visions, Gornik's painting expresses her private experience. It is, as she once said, "an emotional landscape"—a strange and disturbing one.

"Expressionists" who achieved art-world recognition in the 1980s tended to be figurative. The major exception was Sean Scully, an unre-

121. Bill Jensen, *Three Elements (For Ronald Bladen)*, 1987–88. *(Mary Boone Gallery, New York)*

generative modernist, whose paintings combine expressionism and geometric abstraction [123]. They are composed of allover complexes of vertical and horizontal broad stripes of vigorously brushed strokes that follow the direction of the stripes. He said that "the subject in my paintings is the way the stripe is painted, and that is no different to me than Cézanne's apple or his bottle, which he painted over and over again. The stripe is neutral and boring and that makes the stripe receptive to interpretation."[163] The physicality of the painting led Scully in the early 1980s to inset separate panels of stretched canvas of various sizes and thicknesses into his pictures. He also varied the abstract elements in his paintings—repetitive and contrasting stripes, their facture and colors.[164]

Scully said about his intention: "What I'm trying to do is to use a deliberately elemental structure and set it up so that the paintings have very different rhythms, very different personalities—one may have a kind

of intimacy, another a sort of wildness, or a brutality, an ugliness, a lyricism, a brightness, a darkness, a claustrophobic feeling, a powerfully aggressive feeling. In that sense my painting is like figurative art."[165]

122. April Gornik, *Equator,* 1983. *(Edward Thorp Gallery, New York)*

Although the new painting took the limelight in the 1980s, a number of remarkable sculptors whose work was in a sense neoexpressionist commanded art-world attention.

William Tucker's sculpture, composed of hand-gouged boulder- or lumplike forms, hark back to Rodin's works, at the beginning of modernism, and prehistoric monuments, at the beginning of sculpture [124]. The bulges in Tucker's monoliths often evoke parts of the human figure, a bent knee or elbow, for example. As art critic Jed Perl summed them up, they are "about beginnings—about the Birth of Sculpture."[166]

Ursula von Rydingsvard's constructions are composed of massive laminated and carved cedar beams that refer to minimal sculpture but are obviously arrived at in the improvisational process of sawing, grinding, chopping, gouging, and gluing wood fragments [125]. Her work is abstract but has figural references—hollowed-out and/or bulbous vessels

123. Sean Scully, *Magdalena,* 1993. *(Mary Boone Gallery, New York)*

124. William Tucker, *Prometheus (For Franz Kafka)*, 1988. *(McKee Gallery, New York)*

that are also reminiscent of human figures. Her works frequently allude to her girlhood experiences as a member of an intensely religious Polish farming family. Art critic Michael Brenson wrote of *Zakopane* (1987), a piece eleven and a half feet high and twenty-two feet long: "At the top of a wall-sized row of almost 70 thin, vertical, two-inch boards, 22 horizontal beams hover over the viewer like a gallows. At knee level is a row of

125. Ursula von Rydingsvard, *For Paul*,
1990–92. *(Storm King Art Center)*

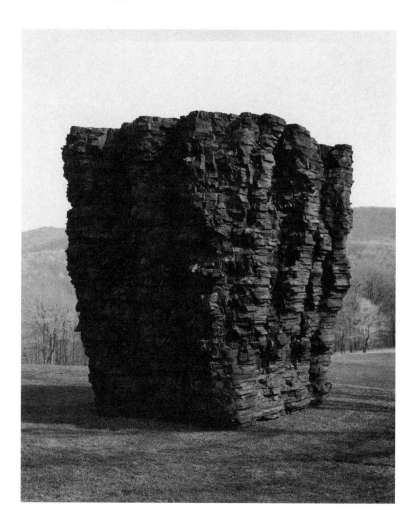

22 rounded skin-like protuberances as rapt as the faces of those ker-
chiefed women at prayer. Those forms also suggest purses, or sacks of
oats in a stable. They remind the artist of udders and containers for holy
water in rural churches."[167] It was apt for Brenson to make references to
religion, for the work looks like a detail of a primitive Gothic choir stall
or chapter room.

James Surls matured as an artist in the agrarian South and looked
to its imagery for inspiration [126]. His sculpture, much of it constructed
from burnt wood, consists of spirit figures, staring eyes in the dark (call-
ing to mind Jackson Pollock's *Eyes in the Heat*), evil eyes, snake eyes,
swamp flowers, rural churches, and leaves that turn into knives. Surls is
an authentic regional surrealist who expresses both the enigma and vio-
lence of the southern scene. Although he has been the kind of artist
whom the New York art world has rarely taken kindly to, his work has
had the sculptural power to make its presence strongly felt there.

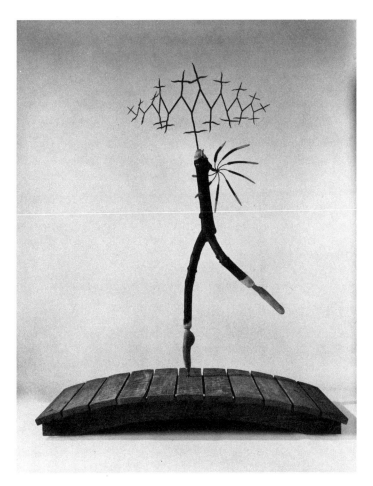

126. James Surls, *Dancing on the Bridge*, 1992.
(Marlborough Gallery, New York)

NOTES

1. The precipitousness of the recognition of neoexpressionism is indicated by the change of heart of Robert Pincus-Witten, who became an early champion of the tendency. In "Entries: Two Voices," *Arts Magazine*, Apr. 1979, he had written of "the inescapable tiredness of painting today, its soft-core character." Painting had become "insufficiently compelling or . . . interesting. I think this denotes the possibility, at least, that painting can't 'do it' anymore. . . . Painting seems so much less than sculpture today" (p. 118).

2. A number of the new European and American painters were shown together in the memorable *A New Spirit of Painting* display in London in 1981. Many of these and related painters were shown the following year in a show titled *The Pressure to Paint*, organized by Diego Cortez. See Diego Cortez, *The Pressure to Paint* (New York: Marlborough Gallery, 1982). The artists included were Georg Baselitz, Jean-Michel Basquiat, Sandro Chia, Francesco Clemente, Enzo Cucchi, Martin Disler, Rainer Fetting, Keith Haring, Jörg Immendorff, Anselm Kiefer, Per Kirkeby, Markus Lüpertz, Michael McClard, A. R. Penck, David Salle, Julian Schnabel, and Robin Winters.

3. DeAk, "The Critic Sees Through the Cabbage Patch," 53.

4. Cortez, *The Pressure to Paint*, p. 5.

5. Hilton Kramer, "The Art Scene of the '80s," *New Art Examiner*, Oct. 1985, pp. 24–25.

6. Kay Larson, "Art: Pressure Points," *New York*, June 28, 1982, p. 59.

7. Eric Fischl, interviewed by Carter Ratcliff, in "Expressionism Today: An Artists' Symposium," *Art in America*, Dec. 1982, p. 60.

8. Crimp, "The End of Painting," 74–75. Crimp took this passage from Barbara Rose, *American Painting: The Eighties: A Critical Interpretation* (New York: Vista Press, 1979), n.p.

9. Ibid.

10. Harold Bloom, "The American Sublime: Gregory Botts: Painting as Icon," *Gregory Botts Paintings* (New York: Anne Plumb Gallery, 1990), p. 1.

11. Peter Schjeldahl, "Notes for Eight Columns I'm Not Writing This Week," *Village Voice*, Oct. 26, 1981, p. 80.

12. Peter Plagens, "I Just Dropped in to See What Condition My Condition Was In," *Artscribe International*, Feb.–Mar. 1986, p. 24.

13. Gerald Marzorati, "The Artful Dodger," *Art News*, Summer 1984, p. 55.

14. Craig Owens, "Back to the Studio," *Art in America*, Jan. 1982, p. 107.

15. See Carter Ratcliff, "Issues & Commentary: Dramatic Personae, Part V: Rulers of Sensibility," *Art in America*, May 1986, p. 173.

16. Cortez, *The Pressure to Paint*, p. 5.

17. Howard Singerman, "Paragraphs Toward an Essay Entitled Restoration Comedies," *Journal: A Contemporary Art Magazine* (Summer 1982): 50.

18. Hal Foster, "The Expressive Fallacy," *Art in America*, Jan. 1983, pp. 80, 83, 137. In the same issue of *Art in America*, Craig Owens, in "Issues & Commentary: Honor, Power and the Love of Women," pp. 9, 11, seconded Foster's position. "In 'Neo-Expressionism' . . . Expressionism is reduced to convention, to a standard repertoire of abstract, strictly codified signs for expression. . . . The pseudo-Expressionists [simulate] passion; they create illusions of spontaneity and immediacy, or rather expose the spontaneity and immediacy sought by the Expressionists as illusions, as a construct of preexisting forms." See also Thomas Lawson, "Or, The Snake Pit," *Artforum*, Mar. 1986, p. 102.

19. Foster, "The Expressive Fallacy," pp. 82–83.

20. Cooke, "Neo-Primitivism," p. 20.

21. Carter Ratcliff, "The Short Life of the Sincere Stroke," *Art in America*, Jan. 1983, p. 137.

22. Mike Glier, interviewed by Sarah McFadden, in "Expressionism Today: An Artists' Symposium," *Art in America*, Dec. 1982, p. 70.

23. Judy Pfaff, interviewed by Sarah McFadden, in ibid.

24. See Donald B. Kuspit, "Rejoinder: Tired Criticism, Tired 'Radicalism,'" *Art in America*, Apr. 1983, p. 15.

25. David Salle, interviewed by Carter Ratcliff, in "Expressionism Today: An Artists' Symposium," p. 58.

26. Schjeldahl, "Notes for Eight Columns," p. 80.

27. Peter Halley, "A Note on the 'New Expressionism' Phenomenon," *Arts Magazine*, Mar. 1983, pp. 88–89. Halley found most intriguing "the persistent inclusion in the new expressionism movement of certain artists whose work does not conform to any of the existing expressionist norms, [in particular] David Salle, Cindy Sherman, Richard Bosman, and Eric Fischl." Indeed, their work seems "too ironic, too reluctant about the assertion of any clearly defined ego to be counted as expressionism." But it was precisely this digression from the norms that makes it different and interesting as expressionism.

28. E.C.B. [Elizabeth C. Baker], "Editorial: How Expressionist Is It?" *Art in America*, Dec. 1982, p. 5.

29. See Julian Schnabel, *C.V.J.: Nicknames of Maitre d's & Other Excerpts from Life* (New York: Random House, 1987), p. 32.

30. Ibid., p. 32. Julian Schnabel, in Matthew Collings, "Modern Art: Julian Schnabel Interviewed by Matthew Collings," in *Artscribe International*, Sept.–Oct. 1986, said: "Beuys has been a great inspiration to me. He was Polke's and Kiefer's teacher. . . . Beuys presented an alternative. . . . He was able to make an art that was outside the formal realm—he put it on a generic, humanistic level. So things like theatricality, illustration . . . things alluding to life . . . became part of the possibility of art through Beuys" (pp. 26–27).

31. See Cathleen McGuigan, "Julian Schnabel: 'I Always Knew It Would Be Like This,'" *Art News*, Summer 1982, pp. 90–91, and Gerald Marzorati, "Julian Schnabel: Plate It as It Lays," *Art News*, Apr. 1985, p. 64.

32. Schnabel, *C.V.J.*, p. 149.

33. Julian Schnabel, in "Post-Modernism," *Real Life* 6 (Summer 1981): 6, said of the broken plates, "Basically I just treat them like stuff."

34. Schnabel, in *C.V.J.*, wrote that the "sound of glass breaking or plates breaking" called to mind "parents fighting, or . . . screaming on *Kristallnacht*. . . . The plates seemed to have a sound, the sound of every violent human tragedy. . . . I wanted to make something that was exploding as much as I wanted to make something that was cohesive" (p. 149).

35. Giancarlo Politi, "Julian Schnabel," *Flash Art* (Oct.–Nov. 1986): 53.

36. Julian Schnabel, "Writings by Julian Schnabel," in *Julian Schnabel: Paintings 1975–1986* (London: Whitechapel Art Gallery, 1986), p. 97. The excerpt is from July 11, 1986. See also Schnabel, *C.V.J.*, p. 205.

37. D. A. Robbins, "An Interview with Thomas Lawson," *Arts Magazine*, Sept. 1983, p. 116.

38. Peter Schjeldahl, "Art: The Ardor of Ambition," *Village Voice*, Feb. 23, 1982, p. 79.

39. Stuart Morgan, "Misunderstanding Schnabel," *Artscribe International*, Aug. 1982, p. 45.

40. See Kim Levin, "Art Walk," *Village Voice*, Dec. 19, 1989, p. 112.

41. Peter Schjeldahl, "Art: Meaning Nothing," *Village Voice*, Oct. 2, 1990, p. 107.

42. John Roberts, "An Interview with David Salle," *Art Monthly*, Mar. 1983, p. 4.

43. Salle was not always convinced about the viability of painting. He had been a student at Cal Arts, where there was "clearly intellectual opposition to painting" from conceptual artists, as he said in Peter Schjeldahl, "David Salle Interview," *LAICA Journal* (Sept.–Oct. 1981): "Truly, the exciting people were not painting. That's not to say there were no good painters, but the interesting people were not painting." Salle himself stopped painting for a while and instead did performances and videotapes. When he resumed he made pictures which were "quite cerebral—for instance . . . a gray painting next to a pho-

tograph of someone taking a knife and slashing it. . . . They were didactic and they were also kind of pernicious and aggressive. [They] had [a] kind of unresolved anger" (pp. 15–16). But the *art* of painting became increasingly important to him.

44. Robert Pincus-Witten, in "Entries: I-Know-That-You-Know-That-I-Know," *Arts Magazine*, Feb. 1984, wrote:

Of course, Salle . . . views Johns—as does his whole generation—as an emblem, quite in the same way and he (and it) views Rauschenberg. Indeed, Johns and Rauschenberg are now seen to represent an emblematic dichotomy. . . . Thus, in that sense, Salle's embrace of Johns must be viewed as a conscious "device" . . . by way of dissociating himself from Schnabel whose work is in many respects understood as a morphological extension of the Rauschenberg combine-paintings. (p. 129)

45. Editors, "Complicities: A Conversation Between David Salle and John Hawkes," *Border Crossings*, vol. 9, no. 4 (Fall 1990): 34.

46. Ibid.: 37. Salle stressed again and again that his subjects, particularly those that alluded to pornography and comedy, are important to him. See Robert Pincus-Witten, "Interview with David Salle," *Flash Art* (Summer 1985): 35.

47. Editors, "Complicities": 31.

48. Schjeldahl, "David Salle Interview," p. 22.

49. Robert Pincus-Witten, "Pure Painter: An Interview with David Salle," *Arts Magazine*, Nov. 1985, p. 79.

50. David Salle, in Dan Cameron, ed., *Art and Its Double: A New York Perspective* (Barcelona: Centre Cultural de la Fundacio Caixa de Pensions, 1986–87), p. 24.

51. Georgia Marsh, "David Salle (II)," in Jeanne Siegel, ed., *Artwords 2: Discourse on the Early 80s* (Ann Arbor, Mich.: UMI Research Press, 1988), pp. 174–75. David Salle, in Joseph Kosuth, "Portraits . . . Necrophilia Mon Amour," *Artforum*, May 1982: "I had an idea that I wanted to make this painting that looked like a painting that you'd see in a movie, a kind of hip movie where the decor was from the '60s or the late '50s. That really was the starting point" (p. 60).

52. Kim Levin, "The Salle Question," *Village Voice*, Feb. 3, 1987, p. 81.

53. Roberta Smith, "Art: David Salle's Works Shown at the Whitney," *New York Times*, Jan. 23, 1987, sec. C, p. 20.

54. Arthur Danto, "Art: David Salle," *The Nation*, Mar. 7, 1987, p. 304.

55. Robert Hughes, "Art: Random Bits from the Image Haze," *Time*, Feb. 9, 1987, p. 67.

56. See Lisa Phillips, "His Equivocal Touch in the Vicinity of History," in *David Salle* (Philadelphia: Institute of Contemporary Art, 1986), p. 24.

57. Danto, "Art: David Salle," pp. 302–3. Eleanor Heartney, in "David Salle: Impersonal Effects," *Art in America*, June 1988, p. 121, questioned the morality of "an ostensible refusal to embrace legible meaning." So did Jeff Perrone, in "The Salon of 1985," *Arts Magazine*, Summer 1985, who wrote that Salle

makes a shambles of the pact artists have with audiences . . . to invest Art with meaning, with a purpose. There is, in his art, no attempt to pretend Art has "higher," "inner," or "intentional" meaning; his contempt for all sincerity lays waste to . . . the disguises of "personal expression," "spiritual fulfillment," "pictorial logic," "social consciousness," and all the other mystifications [of art]. . . . Salle shows exactly how meaningless [making art] is, how absurd the charade of personal struggle, the efforts to hide impotence. [For] him, the jig is up, the charade is over. [He] confirms what many people have always suspected about Modern Art: it doesn't mean anything. To the sophisticated audience he says, "I'm corrupt, because I don't believe any of this rot; you're corrupt, because you really don't either; we must be meant for each other." (p. 73)

58. Robert Storr, "Salle's Gender Machine," *Art in America*, June 1988, p. 25.

59. See Merope Lolis, "Twin Desires: The Art of Troy Brauntuch, David Salle, Jack Goldstein," *ZG*, no. 9 (*Breakdown*): n.p.

60. Levin, "The Salle Question," p. 81.

61. Roberta Smith, "Endless Meaning at the Hirshhorn," *Artforum*, Apr. 1985, p. 85.

62. Editors, "Complicities": 32.

63. Mira Schor, "Appropriating Sexuality," *M/E/A/N/I/N/G* 1 (Dec. 1986): 14.

64. Anders Stephanson, "Barbara Kruger," *Flash Art* (Oct. 1987): 55–56.

65. Editors, "Complicities": 33. Salle speculated as to why the sexuality in his work should elicit a different response from that of Eric Fischl. The reason perhaps was that his was "loaded in a mostly personal way . . . and that's probably what people find baffling. . . . Eric's work has never been attacked because the sexuality depicted in the paintings is exactly congruent with the sexuality in society. The codes of sexuality are the social codes" (p. 38).

66. Ibid.: 31, 39.

67. Smith, "Art: David Salle's Works Shown."

68. Moreover, as Varnedoe and Gopnik wrote in *High & Low*: Salle "was the first artist to paint T.V. experience in T.V. light—the life of the deep blue bedroom lit by the light of the dark blue box" (p. 372).

69. Schjeldahl, "David Salle Interview," p. 19.

70. Danto, "Art: David Salle," p. 302.

71. Hughes, "Random Bites from the Image Haze," p. 68.

72. Levin, "The Salle Question," pp. 81–82.

73. Alan Wilde, in Connor, *Postmodernist Culture*, pp. 115–16.

74. Nancy Grimes, "Eric Fischl's Naked Truths," *Art News,* Sept. 1986, p. 75.

75. Kevin Robbins, "Eric Fischl," *Upstart Magazine* (Jan. 1984): 6.

76. In "Corrupting Realism: Four Probes into a Body of Work," *Eric Fischl Paintings* (Saskatoon, Sask.: Mendel Art Gallery, 1985), Bruce Ferguson wrote that Fischl

 considered seriously the (then) underrated works of the blatantly imagistic Philip Guston, Malcolm Morley, Paterson Ewen or Richard Artschwager, as well as the psychodynamic narrative performances of Laurie Anderson or Vito Acconci. Simultaneously, he responded in an integral way to the music and lyrics of a popular cult figure such as Patti Smith or to the vignettes quintessential to a Robert Altman film. (p. 20)

 Ferguson also pointed to Fischl's reading of a book such as Joseph Heller's *Something Happened,* the story of an American father's tragedy, with its discussions of potential incest or family malfunction. Fischl was also influenced by Manet, Homer, Munch, Beckmann, Balthus, and Hopper.

77. Eric Fischl, in "Fischl Talks," in Peter Schjeldahl, "Bad Boy of Brilliance," *Vanity Fair,* May 1984, said: "My mother was alcoholic. . . . The thing about having a sick parent is that you think it's your problem. You feel like a failure because you can't save her. None of my paintings are strictly autobiographical, but the tone of the work has everything to do with my childhood" (p. 72).

78. Avis Berman, "Artist's Dialogue: Eric Fischl," *Architectural Digest,* Dec. 1985, p. 76.

79. Robert Storr, "Desperate Pleasures," *Art in America,* Nov. 1984, pp. 124–25.

80. Linda Milrod, Foreword to *Eric Fischl Paintings,* p. 5.

81. Ferguson, "Corrupting Realism," p. 24.

82. Grimes, "Eric Fischl's Naked Truths," remarked that Fischl's "vision has no room for precious painterly passages and complex manipulations of color and structure. 'I found from my experience that I could make a convincing statement even though the language was unconvincing. The paintings were poorly painted but compelling.'" (p. 78).

83. Fischl, interviewed by Ratcliff, "Expressionism Today: An Artists' Symposium," p. 60.

84. Peter Schjeldahl, *Eric Fischl* (New York: Stewart, Tabori & Chang, 1988), pp. 22–23.

85. Robert Pincus-Witten, "Entries: Snatch and Snatching," *Arts Magazine,* Sept. 1981, p. 90.

86. Eric Fischl, "Fischl about Fischl," *Border Crossings* (Fall 1985): p. 86.

87. Participating on a panel discussion, *The New Figuration* (New Museum, New York, May 17, 1982, typescript), Eric Fischl said:

 I'd like to read . . . an observation by Louis Mumford on suburbia, when he says that when leisure generally increased, play became the serious business of life. Thus, in reaction against disadvantages of the crowded city, the suburb itself became an overspecialized community more and more committed to relaxation and play as an end in itself. This is not merely a child-centered environment; it's an environment based on a childish view of the world, in which reality is sacrificed for the pleasure principle. Thus the suburb served as an asylum for the preservation of illusion." (pp. 8–10)

88. Eric Fischl, press release, Edward Thorpe Gallery, New York, February 1982. Fischl also said: "I want people to feel they're present at a scene they shouldn't be at, and don't want to be at." (Donald Kuspit, "An Interview with Eric Fischl," *Fischl* [New York: Elizabeth Avedon Editions Vintage Contemporary Artists, 1987], p. 36.)

89. Robbins, "Eric Fischl," p. 46.

90. Berman, "Artist's Dialogue: Eric Fischl," p. 72.

91. Robert Enright, "Missing and Mastering the Erotic: The Painting of Eric Fischl," *Border Crossings* (Fall 1985): 82.

92. Grimes, "Eric Fischl's Naked Truths," p. 77.

93. Bryan Appleyard, "Lynch Pinned," *Sunday Times Magazine* (London), Aug. 12, 1990, pp. 18–19.

94. Robert Storr, "Desperate Pleasures," p. 130. At the end of the 1980s, Fischl left America for foreign locales, such as India. There he observed the people from the vantage point of a tourist, conscious that he was a stranger. Thus he found new subject matter in which to express his curiosity and alienation, but without the psychic urgency of his American scenes. In compensation his painting also became more sensuous and accomplished—and grand, as Fischl seemed to have his eye on nineteenth-century history painting.

95. Grimes, "Eric Fischl's Naked Truths," p. 78.

96. Richard Prince, *Robert Longo: Men in the Cities, 1979–1982* (New York: Harry N. Abrams, 1986), pp. 88, 97. Longo made a small aluminum cast of the gangster. A study for this relief was reproduced in the catalog of *Pictures* (New York: Artists Space, 1977), p. 27.

97. Longo gave various sources for the *Men in the Cities.* Among contemporary artists were Rosenquist and Borofsky, and photorealism generally. In Prince, *Robert Longo,* Longo—a rock guitarist—was impressed by the way "bands like the Talking Heads [or] the Contortions, fronted by James Chance, when he's jumping around on the stage in new ways, moving hot and fast" (p. 88). Longo went on to say that he was also influenced by "Greek and Roman sculpture, like the *Dying Gaul* or the friezes of Pergamum [as well as] Edward Hopper and Egon Schiele. . . . Then there are the movies, like those of Peckinpah,

[such as] *The Wild Bunch* or Arthur Penn with *Bonnie and Clyde*. [*Men in the Cities*] became [a] balancing act between classical influences and contemporary influences" (p. 97).

98. Robert Longo, in *"Tracking," "Tracing," "Marking," "Pacing"* (New York: Pratt Institute Gallery, 1982), n.p.

99. Prince, introduction to *Robert Longo*, p. 87.

100. Longo was also a performance artist, video artist, choreographer, and rock guitarist.

101. Paul Gardner, "Longo: Making Art for Brave Eyes," *Art News*, May 1985, p. 64.

102. Michael Welzenbach, "The Ups and Downs of Art Stardom: An Interview with Robert Longo," *New Art Examiner*, Dec. 1984, p. 43.

103. Roberta Smith, "Art: Material Concerns," *Village Voice*, May 29, 1984, p. 85.

104. Paul Gardner, "Elizabeth Murray Shapes Up," *Art News*, Sept. 1984, p. 51.

105. Sue Graze and Kathy Halbreich, "Interview," in Graze and Halbreich, eds., *Elizabeth Murray: Paintings and Drawings* (New York: Harry N. Abrams, 1987), p. 126.

106. Ibid., pp. 122, 125.

107. Elizabeth Murray, "Artist's Commentary," in *Elizabeth Murray*, p. 26.

108. Joan Simon, "Mixing Metaphors: Elizabeth Murray," *Art in America*, Apr. 1984, p. 144.

109. Roberta Smith, "Motion Pictures," in *Elizabeth Murray, Paintings and Drawings* (New York: Harry N, Abrams, 1987), p. 8.

110. Murray, "Artist's Commentary," p. 46.

111. Gardner, "Elizabeth Murray Shapes Up," p. 55.

112. Deborah Solomon, "Celebrating Paint: What's in a Murray: More Than You Know, and Then Some," *New York Times Magazine*, Mar. 31, 1991, p. 40.

113. Ibid., p. 22.

114. Murray used boots as early as 1981, in *Walk Drawing*.

115. Murray, "Artist's Commentary," p. 98. It is noteworthy that as early as 1965 Murray "made things like a huge armchair with a figure in it which I called *Daddy Reading the Newspaper*. I did an enormous pair of pants with huge shoes" (Graze and Halbreich, "Interview," p. 126).

116. Varnedoe and Gopnik, *High & Low*, p. 385.

117. Solomon, "Celebrating Paint," p. 40.

118. Applebroog also photographed the panels, shadows and all, and turned them into printed booklets.

119. Ruth Bass, "Ordinary People," *Art News*, May 1988, p. 152.

120. Ida Applebroog, in *Supershow*, educational supplement (New York: Independent Curators Incorporated, 1979), n.p.

121. Mira Schor, "Medusa Redux: Ida Applebroog and the Spaces of Post-Modernity," *Artforum*, Mar. 1990, p. 121.

122. Marilyn A. Zeitlin, "Happy Families," in *Ida Applebroog: Happy Families* (Houston: Contemporary Arts Museum, 1990), p. 13.

123. Lowery S. Sims, *"Beulahland (for Marilyn Monroe): An Icon for America,"* in ibid., pp. 23, 27.

124. Ida Applebroog, "Studies for 'Emetic Fields,'" in *Ida Applebroog: Bilder* (Ulm, Germany: Ulmer Museum, 1991), p. 40.

125. Joseph Dreiss, in "Leon Golub," *Arts Magazine*, Jan. 1982, wrote: "If critical attention is any gauge of artistic significance, then Leon Golub must be considered a major voice in contemporary art. Donald Kuspit, Lawrence Alloway, Max Kozloff, Matthew Baigell, Irving Sandler, Corinne Robins, and others have explored his art through interviews and major articles, some of them writing two or more pieces on his work" (p. 10).

126. Leon Golub, *Profile* 2, no. 2 (Mar. 1982): 10, 13.

127. Matthew Baigell, "'The Mercenaries': An Interview with Leon Golub," *Arts Magazine*, May 1981, p. 169.

128. Gerald Marzorati, *A Painter of Darkness: Leon Golub and Our Times* (New York: Viking, 1990), p. 34.

129. Leon Golub, interviewed by Ratcliff, in "Expressionism Today: An Artists' Symposium," p. 64.

130. Robert Storr, "Review of Books: Monograph," *Art in America*, Dec. 1990, p. 55.

131. Michael Newman, "Interview with Leon Golub," *Leon Golub: Mercenaries and Interrogations* (London: Institute of Contemporary Art, 1982), p. 7.

132. Rosetta Brooks, "Leon Golub: Undercover Agent," *Artforum* (Jan. 1990): 117–19.

133. Storr, "Review of Books: Monograph," p. 57.

134. Carter Ratcliff, "Contemporary American Art," *Flash Art* (Summer 1982): p. 34.

135. Malcolm Morley, interviewed by McFadden, in "Expressionism Today: An Artists' Symposium," p. 68.

136. Ibid.

137. Later Morley had attended a naval school, and had worked as a seaman on a cargo ship.

138. Michael R. Klein, "Traveling in Styles," *Art News*, Mar. 1983, p. 97.

139. Klaus Kertess, "Malcolm Morley: Talking About Seeing," *Artforum*, Summer 1980, p. 51.

140. Matthew Collings, "The Happy Return: Malcolm Morley," an interview, *Artscribe International*, Jan.–Feb. 1985, pp. 17–18.

141. Klaus Kertess, "On the High Sea and Seeing a Painting," *Malcolm Morley* (Paris: Editions ARPAP, 1993), p. 224.

142. George McNeil, "One Painter's Expressionism," in *George McNeil: Expressionism: 1954–1984* (New York: Artists' Choice Museum, 1984), p. 9.

143. Carter Ratcliff, "George McNeil," *George McNeil: The Past Twenty Years* (Fort Lauderdale, Fla.: Museum of Art, 1982), p. 5.

144. See Peter Halley, "Ross Bleckner: Painting at the End of History," *Arts Magazine*, May 1982, pp. 132–33.

145. Lawrence Chua, "Ross Bleckner," *Flash Art* (Nov.–Dec. 1989): 122–25.

146. Stuart Morgan, "Strange Days," an interview with Ross Bleckner, *Artscribe International*, Mar.–Apr. 1988, p. 51.

147. Lisa Liebman, "Ross Bleckner: Mood Indigo," *Art News*, May 1988, pp. 131–33.

148. See Ross Bleckner, interviewed by Trevor Fairbrother and David Ross, in *American Art of the Late 80's* (Boston: Institute of Contemporary Art, 1988), p. 59.

149. Pat Steir, "Where the Birds Fly, What the Lines Whisper," *Artforum*, May 1987, p. 110.

150. Amy Newman, "'The Celebrated Artists of the End of the Second Millennium A.D.,'" *Art News*, Apr. 1976, p. 45.

151. Peter Schjeldahl, "Komar/Melamid," *Flash Art* (Dec. 1985–Jan. 1986): 65.

152. Komar & Melamid, "We Love NJ," *Artforum*, Apr. 1989, pp. 133–34.

153. Rothenberg was included in prestigious international shows, beginning with *A New Spirit in Painting*, 1981, at the Royal Academy in London, along with Julian Schnabel, leading German neoexpressionists, and Italian transavantguardia painters.

154. Lisbet Nilson, "Susan Rothenberg: 'Every Brushstroke Is a Surprise,'" *Art News*, Feb. 1984, p. 51.

155. Rothenberg, in Nilson, "Rothenberg," said: "I guess it was about me. What I had was a head and hand. Do I need this?" (pp. 51–52).

156. Susan Rothenberg, interviewed by Hayden Herrera, in "Expressionism Today: An Artists' Symposium," p. 139.

157. Joan Simon, *Susan Rothenberg* (New York: Harry N. Abrams, 1991), pp. 89, 123.

158. Grace Glueck, "Susan Rothenberg: New Outlook for a Visionary Artist," *New York Times Magazine*, July 22, 1984, p. 16.

159. Rothenberg, in "Expressionism Today: An Artists' Symposium," p. 65.

160. Susan Rothenberg, in Richard Marshall, *50 New York Artists: A Critical Selection of Painters and Sculptors Working in New York* (San Francisco: Chronicle Books, 1986), p. 94. Quoted in Simon, *Rothenberg*, p. 137.

161. Michael Kimmelman, "Art View: Cells, Crystals, Bugs and Shells, Rendered in Paint," *New York Times*, Sunday, Mar. 8, 1992, sec. 2, p. 35.

162. "Three Painters: Susan Rothenberg, April Gornik, Freya Hansell," *Bomb* 23 (Spring 1988): 19.

163. Sean Scully, "Berkeley Lecture," typescript, October 1987, p. 8, quoted in Carter Ratcliff, "Sean Scully: The Constitutive Stripe," *Sean Scully: The Catherine Paintings* (Fort Worth, Tex.: Modern Museum of Fort Worth, 1993), p. 9.

164. Judith Higgins, "Sean Scully and the Metamorphosis of the Stripe," *Art News*, Nov. 1985, pp. 108–9.

165. Ibid., pp. 109–10.

166. Jed Perl, "From September to December," *The New Criterion*, Feb. 1988, p. 45.

167. Michael Brenson, "Ursula von Rydingsvard's Sculptural Theater," *Ursula von Rydingsvard Sculpture* (Mountainville, N.Y.: Storm King Center, 1992), p. 28.

9 THE ITALIAN TRANSAVANTGUARDIA AND GERMAN NEOEXPRESSIONISM

The figurative painting of Julian Schnabel, in particular, but also the work of Susan Rothenberg, David Salle, and other Americans began to attract international art-world attention around 1981, paralleling the recognition of two groups of European painters, the Italians—Francesco Clemente, Sandro Chia, and Enzo Cucchi—and the Germans—Georg Baselitz, Jörg Immendorff, Anselm Kiefer, Markus Lüpertz, A. R. Penck, Sigmar Polke, and Gerhard Richter. Their painting was welcomed as a reaction against American minimalism and postminimalism, Italian arte povera, and fluxus art in Germany, which had dominated avant-garde art of the 1970s. Most of the impresarios of the new painting had earlier championed nonpainting tendencies and continued to support certain "masters," notably Joseph Beuys, even though he rejected painting as reactionary and bourgeois.[1] However, by 1980, they had come to believe that of all artistic tendencies the new painting had the greatest potential, and that it had introduced into art a much needed fresh humanist content.

This was the thesis of Norman Rosenthal, Christos Joachimides, and Nicholas Serota, who in 1981 curated *A New Spirit in Painting* at London's Royal Academy, the first major international show to feature the new painting. In the preface of the catalog they wrote: "We are in a period when it seems to many people that painting has lost its relevance. . . . It is argued that it has become academic and repetitive."[2] But in their opinion, minimal and conceptual art had become hidebound and outworn; the latter, Rosenthal quipped, seemed to be talking itself out of existence.[3] In contrast, painting "is in fact flourishing. Great painting is being produced today." Nonetheless, in the face of "Minimalism and its offshoots," contemporary painters still felt embattled; their painting seemed an act of "resistance within the context of art."[4] Therefore, they said, this exhibition "is meant both as a manifesto and as a reflection on the state of painting now."

Rosenthal, Joachimides, and Serota then asserted that the new painting was intent on representing "human experiences, in other words

people and their emotions, landscapes and still-lives."[5] In his essay Joachimides wrote: "We are confronted with an art that tells us about [the artists'] personal relationships and personal worlds. . . . It is the need to talk about oneself, to express one's own desires and fears, to react to daily life, indeed to reactivate areas of experience that have long lain dormant."[6] Joachimides wanted to rehabilitate not only daily life as subject matter but "subjectivity, the Visionary, Myth, Suffering, and Grace."[7] In sum the curators of *A New Spirit in Painting* called for a reconsideration of the possibilities of painting and of figuration in painting, of subjectivity, of sensuousness, of expressionism, and of the grand tradition of Western painting. Rosenthal and Joachimides stated their case for painting even more strongly a year later in the catalog of a show they organized, titled *Zeitgeist* ("the spirit of the times"). As the name implied, the painters they selected had allegedly expressed what it meant to be alive and what felt relevant in the 1980s.

A New Spirit in Painting included a broad cross section of international contemporary painting, but it promoted the new European painting, especially German, at the same time pointedly downplaying the new American painting; only Schnabel's work was included, presumably because of its relationship to that of the Germans. Roberta Smith condemned the show's "hidden agenda—showcasing the new German figurative expressionism at the expense of both American and Italian painters."[8] *Zeitgeist* openly zeroed in on newly emerged German painters, suggesting that their painting was the most significant of contemporary art. Ten of the forty-five participants were Americans, but only four were new painters—Jonathan Borofsky, Susan Rothenberg, Julian Schnabel, and David Salle.

German neoexpressionism and to a lesser degree the Italian transavantguardia were promoted not only by Rosenthal, Joachimides, and Serota but by other leading European art professionals, among them Jean-Christophe Ammann, Thomas Ammann, Bruno Bischofberger, Rudi Fuchs, Johannes Gachnang, Peter and Irene Ludwig, Paul Maenz, Achille Bonito Oliva, Giancarlo Politi, Charles Saatchi, Gian Enzo Sperone, Michael Werner, and Edy de Wilde. They presented these tendencies as peculiarly European, supposing that the new European painting had been developed in opposition to American art, which they declared was exemplified by pop and minimal art. Such comparisons sounded good, at least to Europeans, but in actuality they were specious. They conveniently ignored the fact that pop and minimal art had emerged in the 1960s and that the new American painters had reacted against them just as the Europeans had. The European advocates of European painting promoted it by inventing stereotypes of both American and European art and pitting them against one another.

Attempts to distinguish European from American art had begun before the international recognition of the new painting. In 1976, for example, Achille Bonito Oliva, who was to be a champion of the transa-

vantguardia, claimed that European art embodied an idealistic vision whereas American art was fixed on facts "that are never intended to refer to any general more enlarged and historical vision of life." Referring only to itself it was formalist art as art. American art also resembled advanced U.S. technology; in contrast European art remained occupied with "traditional craftsmanship." The former, as the issue of a new society, strove for the new; the latter, rooted in its long history, notably earlier-twentieth-century avant-garde art, aspired to come to terms with its past.[9] Oliva went on to say that American artists approved of capitalism whereas European artists were critical of existing society and wanted to transform it, and thus were ideological.

Oliva singled out Beuys as the exemplary European artist, an artist-hero who has "a scheme for transforming the world," who "sets out, through art, spiritually to reconstitute man's unity, to give him back energy and the urge to transform his dealings with the world, both political and cultural." Oliva claimed that Beuys's American counterpart was Andy Warhol (a claim Beuys himself made).[10] Warhol was *the* American capitalist realist, the consummate consumer, who, moreover, "systematically catalogues the data of reality." After all, "American reality rests upon technology and its attendant mentality." American "reality" is based on the "*module*" and the "representation of *geometrical infinity.*" Just as Warhol was interested in modular design, so were minimal artists, and they too were peculiarly American.[11] (It is not surprising that Beuys and Warhol were featured and coupled. Despite their differences, they had much in common. Both had signature costumes, were adept at attracting the media and had achieved celebrityhood, and were charismatic and attracted cultlike entourages: Beuys his disciples and Warhol his superstars).

Oliva claimed that the aggressiveness of the American art market, its "imperialist [invasion of] the whole world with its art merchandize," had created the perception that American art was of "higher quality [than] European art. [Thus] economic power . . . compels European collectors to soak up American art." Economic hegemony determined art-critical hegemony. Insisting that both American and European avant-garde art was self-sufficient and of equal quality, Oliva called for resistance to American influence.[12]

Like Oliva other leading European art professionals engaged in what art critic Pierre Restany called an "anti-American Kulturkampf."[13] For example, Johannes Gachnang, a champion of the new German painting, wrote that after World War II, American civilization appealed to Europeans because it represented "progress and freedom, whether in the political, economic or cultural sphere." In time, however: "The tremendous American challenge of the fifties and sixties was afflicted with all the signs of a juvenile attack, emanating from a land without a real history and directed against the bastions of a largely shattered occidental culture in the old European centers."[14] Now that Europe was rebuilt, the

time had come for its art to find its own identity, rooted in the history and indigenous culture of its various constituencies.

Gachnang's sentiments were echoed by his younger colleague Rudi Fuchs. While organizing the influential *Documenta 7* show in 1982, he was reputed to have said that American art was formalistic and therefore no longer fulfilled Europe's need for humanistic art that addressed the problems of its rich culture. *Documenta 7* would meet this need.[15] Later Fuchs reiterated that European artists "like A. R. Penck, Jannis Kounellis, and, of course, Joseph Beuys . . . delved into their own Italian, German, and Mediterranean traditions."[16]

In the 1980s European art professionals would continue to embellish their image of a peculiarly American art, adding that it was preoccupied with the mass media and consumer society and employed mechanical or nonpainting techniques associated with the mass media. For example, art critic Wolfgang Max Faust said: "The background for today's New York direction is a combination of Pop and Conceptual art, which reflects the pivotal role of the media in postwar American society. Anselm Kiefer once said: 'Europe has the history, America had the media.'"[17] Serota agreed: "Particularly in New York, there is now a natural tendency to be concerned exclusively with contemporary culture. We have a more elliptical relationship with history and culture in a broader sense. In the best European art, there's an awareness of the ebb and flow of history, of culture and politics. Much American art is object-oriented . . . concerned solely with consumer interests."[18]

European art professionals and artists, especially in Germany and Italy, would repeat again and again—with variations, to be sure—Oliva's, Gachnang's, and Fuchs's formulation of the contrasting models of American and European art—the one reflecting an inhuman society of mass men, the other humanist and individual. They would strive to reestablish the hegemony of European art and the institutional and market support that they felt was needed to sustain it. They would repudiate the "orthodoxies [that] aggressively proclaimed [that work] produced in and around New York [was] virtually the only universally acceptable art—everything else was at best provincial," as Rosenthal, Joachimides, and Serota asserted.[19] It helped that no new American art with a high international profile had emerged in the 1970s. Consequently the claim that European art was equal in quality and interest to American art became increasingly believable, and European art professionals reiterated it with growing conviction. By the end of the 1970s museum director Dieter Honisch observed that the art world in Western Europe was focusing increasingly on current European art: "More is said about the Centre Pompidou than about the Museum of Modern Art."[20]

Self-consciously and confidently intent on developing an independent art, the new European painters repudiated modernism's preoccupation with the future and reexamined their past history, traditions, mythology, and above all, art. They looked for inspiration to pre–World

War II figurative painting, reevaluating and rehabilitating late Picabia, late de Chirico, and late Picasso, as well as Chagall, Mario Sironi, and Max Beckmann, whose paintings had been excluded from the canon of modern art and, in fact, were ridiculed by modernists. In particular the late work of de Chirico and Picabia appealed to the new painters because it denied formal values and because its "badness," though reactionary, looked iconoclastic and, more important, appeared to open up new possibilities for painting.

In his late painting Picabia was the baddest of the bad, snubbing his nose arrogantly and contemptuously at modernist dogmas [127]. He cultivated vulgarity, sordidness, sentimentality, and triviality, pressing, as André Breton observed, "further than anyone else into the bad taste of his epoch."[21] But the jokey badness of his painting looked good to eighties artists such as Polke, Schnabel, and Salle. Picabia taught them how to use kitsch "realism" to reinvigorate painting without bothering with formal innovation. His pictures, which looked as if they were made to be sold in tourist traps, anticipated Polke's use of trashy images and materi-

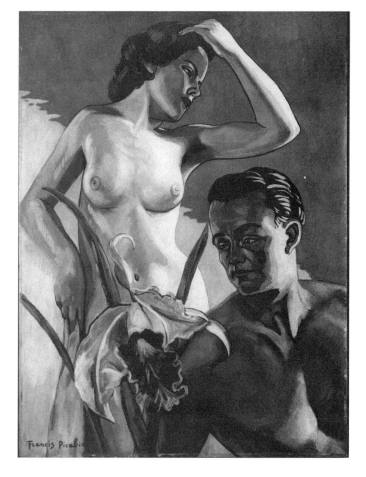

127. Francis Picabia, *Adam and Eve,* 1941–43. *(Collection of Emily and Jerry Spiegel)*

als and Schnabel's use of black velvet. Moreover, Polke, Schnabel, and Salle were influenced by Picabia's method of layering incongruous images. Eighties painters were not as intransigently perverse as Picabia, who remained a nihilistic dadaist to the end. It is significant that he should have been relocated from art's backwater to its mainstream, and that he and his fellow dadaist Duchamp should have been hailed as heroes by leading eighties artists.

De Chirico's "bad" late work, like Picabia's, was rehabilitated by a new generation of artists in the late 1970s [128]. It had long been an embarrassment to modernists; William Rubin virtually ignored it in the de Chirico retrospective he curated at the Museum of Modern Art in 1982.[22] De Chirico had a few admirers and even influenced an artist or two; Philip Guston was one, and he was eagerly embraced by young European painters who thought of him as a kind of European artist who happened to live in the United States. De Chirico's copying of his own earlier works, which he had begun in 1924 and continued until his death in 1953, was particularly admired because it denied originality and was thus a slap at modernism, and because it was a precursor of the younger painters' appropriation of past images and styles.

In reassessing their history and past culture, European artists and

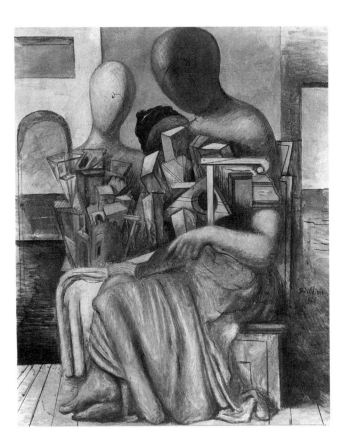

128. Giorgio de Chirico, *La Lettura,* 1926. *(Private collection, New York; © Foundation Giorgio de Chirico/Licensed by VAGA, New York, NY)*

art professionals recognized that, as Joachimides had written, the new German and Italian painters shared "common underlying concerns," but "regional singularities" were not to be neglected.[23] Neither were national and even "local" differences. The "age of internationalism" had ended, as Giancarlo Politi, the editor of *Flash Art,* announced; "artists of interest" were reverting to "national particularities [and] are the typifications of their national culture."[24] Promoters of the new national art were quick to point out that neither they nor the art they supported were nationalistic. As Faust averred: "Nationalistic would be that you see your tradition as superior or more valuable. That was the experience of nationalism we had in the Third Reich. But there are specific aspects that make German art German."[25] Whether those aspects were inherent or acquired, the German neoexpressionists looked to German romanticism and expressionism; the Italian transavantguardia, to Italian painting of the twenties and thirties, notably late de Chirico and Sironi. No wonder then that the Germans ended up looking like Germans, and the Italians like Italians. Ironically, the growing interest in national identity had become so international that a national "look" helped an artist's chances for global recognition.

In 1979 Achille Bonito Oliva, who had until then supported arte povera, began to promote the painting of Sandro Chia, Francesco Clemente, Enzo Cucchi, Nicola de Maria, and Mimmo Paladino, which he labeled the transavantguardia. He organized a show in Sicily and published an article on the movement in *Flash Art* (which continued to feature it), and in the following year, a book.[26] The new Italian painting soon commanded international art-world attention. Robert Pincus-Witten reported that at the Venice Biennale of 1980, "the real issue [was] what to make of [Chia, Clemente, Paladino, and Cucchi, who] in a way may be thought of as offering a parallel to . . . Schnabel, Salle, [Gary] Stephan. This [tendency] emerges as the strongest trend both there and here."[27]

Oliva's thesis was that Italian art had been dominated by the non-painters of arte povera. With the transavantguardia, painting, which had developed in part in reaction against arte povera, had become the most vital Italian medium. Arte povera and the transavantguardia were different in most respects. The arte povera artists favored installations of readymades and found materials that denied the art object and the artist's hand as the sign of subjectivity; the transavantguardia artists embraced painting, emphasizing their idiosyncratic touch.

Arte povera was avant-gardist; the transavantguardia, revivalist, favoring a return to traditional painting. Oliva wrote that instead of thinking of modernist art's development as an inexorable linear progression into the new, as it were, the transavantguardia opted "to pick and choose from [past styles] in the conviction that, in a society in transition toward an undefinable end, the only option is that offered by a nomadic and transitory mentality."[28] A catchword for arte povera, "nomadism"

remained one for the transavantguardia painters, who used it to replace "avant-garde." Mimmo Paladino defined it as "crossing the various territories of art, both in a geographical and a temporal sense, and with maximum technical and creative freedom. So if, on the one hand, I feel close to Giotto and Piero della Francesca, on the other I pay attention to Byzantine and Russian icons. . . . I believe that the superficial glance is very much in keeping with the fast moving times we live in."[29]

Until the middle of 1979, arte povera and transavantguardia artists were friendly. Chia, Cucchi, Clemente, and de Maria had themselves made installations and been influenced by conceptual art. But antagonisms developed over aesthetics and art-world politics. Art professionals, such as Sperone, embraced both groups, treating each as the best of its generation. However, a struggle for art-critical hegemony developed between Oliva and Germano Celant, the champion of arte povera. Oliva won, but Celant remained a powerful figure, promoting arte povera, as well as earth art, minimalist performance, and conceptual art, and ignoring or attacking the transavantguardia. For example, in 1981 Celant curated a show at the Centre Pompidou in Paris, *Italian Identity: Art in Italy since 1939*, whose eighteen participants included only one painter of the transavantguardia. Giancarlo Politi condemned the survey for distorting the situation of Italian art:

> A glaring example of Celant's intellectual partisanship is the attempt to cancel the most exciting and successful moment in recent Italian art history, namely, the Italian trans-avantgarde . . . and its offshoots, which have been totally omitted from this show (apart from the inclusion of De Maria). Despite the vast amount of information that goes along with this review, there is no mention of Bonito Oliva's book *The Italian Trans-avantgarde*, which certainly represents the most felicitous critical insight of the past few years.[30]

As late as 1989, Celant condemned the revival of painting in Italy and Germany, although by then he had accepted a few painters, for example, Cucchi, Clemente, and Kiefer. He branded the new painting a reactionary and fear-ridden "leap into the past," by artists who quoted the fascist styles of the thirties, which glorified Italy's Roman past, and either regressed into the nationalistic and patriotic mentality of that dark period in European history or were apolitical. They downplayed "political commitment and . . . conceptualism in favor of a bombastic style and a populist fauvism . . . preferring to surprise the spectator with bizarre personal images." These new painters "beefed up the role of the artist by exalting . . . the wonders of beautiful painting [which are] recognizable to the mass media public as 'real art.'" In sum the new painting was backward looking, nationalistic, nostalgic, romanticist, showy, pandering, and superficial.[31]

Oliva counterattacked by claiming that the transavantguardia's

return to painting signaled that the "ideology of Italian 'poverismo' [has been] bypassed [replaced] by a new attitude which [rediscovers a picture's] pleasure of showing itself off, of its own texture, of the substance of the painting unencumbered by ideologies and purely intellectual worries. Art rediscovers the surprise of an activity infinitely creative, open [to] thousands of possibilities."[32]

Moreover, according to Oliva, the transavantguardia was nationalist in outlook, in contrast to arte povera, which was internationalist, "thereby losing and alienating the deepest cultural and anthropological roots."[33] Oliva recognized that arte povera did have an Italian "look" but, unlike the transavantguardia, did not make specific references to past Italian art. The new painting "addresses itself to a typically European and Italian history of painting which developed out of Mannerism from the sixteenth century onward.... Trans Avant Garde Art is Neo Mannerist."[34] Italian artists had denied their national identity for some thirty-five years. With the transavantguardia: "The idea of investigating the Italianness of Italian art, long discredited by its association with fascist cultural politics, was rehabilitated as the birthright of young painters."[35]

Still, the dissociation of national consciousness from fascism and chauvinism was a problem. The new painters solved it by using borrowings from historic Italian art—generally classical and even fascist inspired—in an ironic, even perverse, and above all idiosyncratic (or "original") manner. Anticlassical classicism had long been a practice in Italian art; in the twentieth century, it was most commonly identified with de Chirico—one reason he had become a favorite of the young painters.[36] Like de Chirico the transavantguardia cleverly put references to "Italianness" in figurative quotation marks. Nonetheless, the effect was peculiarly Italian. As Chia summed up, the special role of the artist was "to perceive what is given as a cultural tradition [in an] unconventional, outrageous way. It is his task and also his social duty . . . to start a new creation from an existing creation."[37]

The transavantguardia developed out of a growing hunger for painting and figuration—art for the ages—following a decade dominated by "poor," often transient, installation art. At the same time Italy had become a consumer society, its economy booming—its gross national product surpassing even those of France and Great Britain, and its art market flourishing.[38] Dealers and collectors demanded salable art, and the transavantguardia painters provided it.

Francesco Clemente's primary subject was his "signature" face—close-cropped head, almond-shaped eyes, high cheekbones, full lips—staring out pensively and passively. He also portrayed his own—or a surrogate's—body, its diverse orifices, and what appears to be every imaginable bodily function. His "self-portrait"—ever-changing, often androgynous—decapitates itself, gets devoured by fishes, lays an egg, gives birth

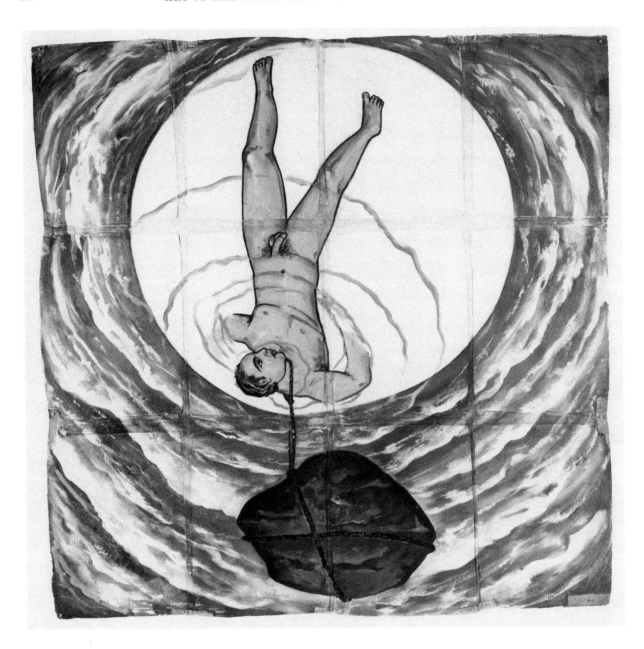

129. Francesco Clemente, *Moon*, 1980. *(Collection of Alan Wanzenberg)*

from its mouth or penis, and is combined with signs and symbols culled from art and heraldry, and from fragments of his diverse and disconnected experiences. Whether his paintings included his self-image or were just composed of fragments, as Clemente said: "Most . . . grow out of phrases, of things I hear or read. Coincidences; say, the fact that in a week I read or hear the same phrase in twenty different situations. I open four books and they say the same thing. I talk to three people and they tell me the same thing" [129].[39] In keeping with this casual approach, Clemente's images are generally floating and fragile. His touch

is light and cool, in contrast to the "hot," ponderous facture of the German neoexpressionists.

If Clemente's painting was self-obsessed, it was not particularly self-revealing; introspective and intimate but mannered and distanced, the artist seemed to stand off, observe himself, and report playfully, mockingly, often perversely, in a "secret and confidential manner," as Edit DeAk remarked [130]. In its "kinkiness, whimsicality, [and] unruliness," Clemente's work had "the allure of taboo" and a "charming licentiousness."[40] Above all Clemente explored polymorphous sexuality, often auto-erotic and occasionally aberrant. But his obsession with carnality also had a spiritual dimension. As Robert Storr commented, Clemente had a "mystical fascination with the body as a 'communicating vessel'"—of sublime as well as mundane knowledge.[41]

Clemente, then, can be characterized as a sexual nomad. He was also a "geographic nomad," as Storr commented,[42] a way of life aspired to by both the transavantguardia and arte povera. Spending part of every year in New York, Rome, Naples, and India, Clemente was able to cross-reference the cultures of the Old World and the New, of West and East. But, much as he was constantly on the move, he remained quintessentially Italian. Indeed, as he remarked, artists who passed through World War II, "from Enzo Cucchi to Anselm Kiefer [have each] succeeded in

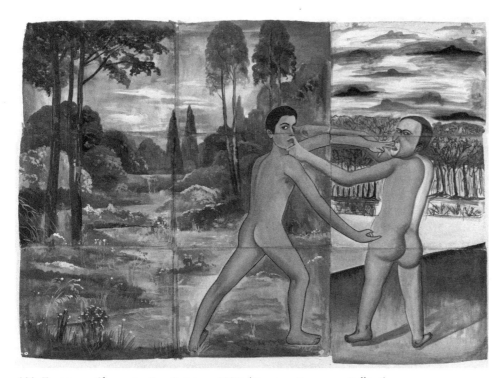

130. Francesco Clemente, *Two Painters*, 1980. *(Courtesy Francesco Pellizzi)*

sinking his roots into the soil of his own birthplace." Moreover, Clemente looked for inspiration to Italian art, notably that of the late de Chirico, the Italian academicians of the 1920s and 1930s, and "those faces painted on wood by the Romans in Egypt, the mummies of the Romans at the Metropolitan."[43] It is fitting that in *Perseverance* (1982) Clemente painted himself cradling the Pantheon.

Enzo Cucchi was the neoexpressionist of the transavantguardia, closer to Anselm Kiefer than to Clemente [131]. Moreover, unlike Clemente, whose primary content was polymorphous sex, Cucchi's was life-destroying natural forces. Skulls populate desolate landscapes heavily pigmented in somber colors. Images of death are leavened by an occasional living motif, for example, a crowing rooster in *Paesaggio Barbaro* (1983). Earthquakes are recurring subjects in Cucchi's paintings of the 1980s, both as representations of natural disasters and metaphors for some apocalypse to come: "I think that now there'll be a huge, general catastrophe, like nothing that's ever happened before."[44]

131. Enzo Cucchi,
Vitebsk-Harar, 1984.
(Museum of Modern Art,
New York)

Through most of the 1970s Sandro Chia made installations in the manner of arte povera. Then, toward the end of the decade, he turned to painting, depicting pneumatic figures, the offspring of de Chirico, Alberto Savinio, Leger, the presuprematist Malevich, Chagall, and the late Picasso. Marzorati commented on Chia's obvious borrowings:

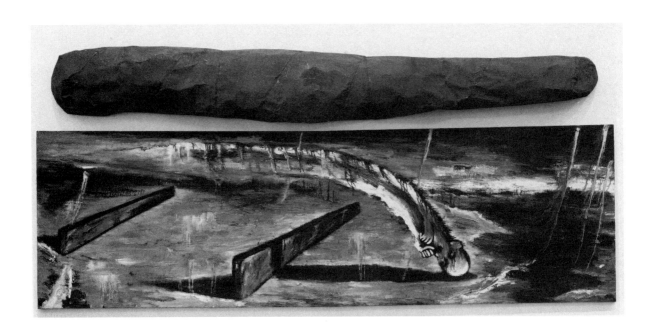

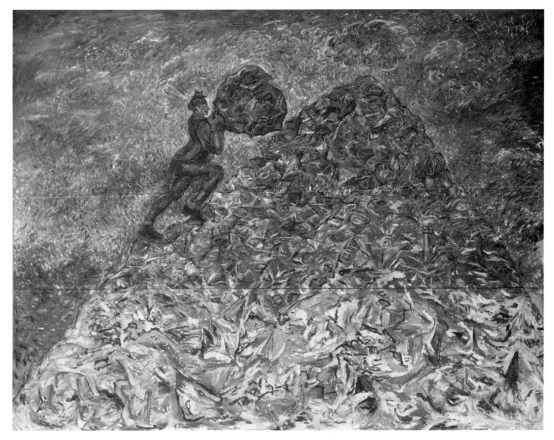

132. Sandro Chia, *Idleness of Sisyphus*, 1981. *(Museum of Modern Art, New York, photograph copyright ©
1995 Museum of Modern Art, New York; © Sandro Chia/Licensed by VAGA, New York, NY)*

Filtered through Chia's memory and blended by his hand, these lift-
ings and borrowings are altered, to be sure. But then, Chia isn't trying
to hide anything—quite the opposite. He quotes, expecting his audi-
ence, if not to know the specific artist quoted, then at least to sense
that it is the history of art that is providing the source material. . . .
Chia has said . . . "In my opinion, we should work . . . upon this accu-
mulation, this labyrinth of styles. I don't see why I should refuse these
riches, this humus."[45]

However, Chia's relationship with tradition was a love-hate one.
Indeed, he created an anticlassical classicism, exemplified by farting fig-
ures that spoof their classical prototypes. His ambivalence is clear in his
The Idleness of Sisyphus (1981) [132]. According to Marzaroti, Chia's
"Sisyphus, modern down to the fedora he wears, . . . is a man resigned to
covering old ground, but happy to have something to push against. Here,

in effect, is Chia."[46] In Craig Owens's view, "Chia debunks the (modernist) belief in progress in art. [His] painting is a joke, then, at the modernist painter's expense."[47]

The classical tradition in Italian art was a vital factor in transavant-guardia painting but not as central as it was in Carlo Mariani's. He quoted directly from the neoclassical style of the last decade of the eighteenth century and the early years of the nineteenth. Why would an artist living in the 1970s and 1980s want to appropriate a premodern style—and one that was a rehash of earlier classical art, identified with academicism, and favored by fascist, Nazi, and Communist regimes—at that? Mariani explained:

> My interest in this period isn't purely artistic, but also social and political, and it is something very private and specific to me, this great admiration, this great love I have for the time. . . .
>
> Above all, the artistic production that came out of this period: the retrieval, the recovery of beauty, the sense of nostalgia for a past which could be reclaimed, and the melancholic nature of this nostalgia—the great poetry, shall we say, the great style and elegance of this period. I am aware of this as also being the time of the birth of modern artistic thought. . . .
>
> Maybe it is because we seem to have lost our sense of values and that somehow by going backwards, if only mentally, I think I can regain them. I suppose it is an escape.

Mariani wanted to start anew, at the beginning of modernism. But he allowed that his neoneoclassical work possessed "a subtle unconscious irony [which has to do] with wishing, dreaming for something which you know could never be possible."[48]

Despite the affinities of Mariani's painting to neoclassical art, his is different. The characters in some of his pictures are contemporary—portraits of fellow artists and art-world personalities. More often the figures are exaggeratedly classical—hypermannerist, as if Mariani had wished to abstract their classical essence. In work made at the end of the 1980s, he interspersed his neoclassical borrowings with modernist ones—for example, *Headrack* (1990), which mixes classical sculpture and Duchamp's readymades—setting up an ironic dialogue between the two types [133]. Mariani's recycling of a premodern style seemed curiously relevant in the postmodernist era.

In 1980 the German painters Baselitz, Immendorff, Kiefer, Lüpertz, Penck, Polke, and Richter achieved international recognition. Each had developed an individual artistic identity, but because they were German and had emerged to world notice about the same time, they were frequently grouped together.[49] In actuality, they constituted two aestheti-

cally different and antagonistic groups, one consisting of Baselitz, Immendorff, Kiefer, Lüpertz, and Penck, who were labeled neoexpressionists; the other of Richter and Polke, who were not given a name but might have been called faux expressionists.[50] Richter and Polke used painting to deconstruct painting, particularly expressionist painting. They called into question received ideas about painting, notably those held by Baselitz, Lüpertz, Penck, Kiefer, and Immendorff.

Richter and Polke made no claims for the German identity of their art,[51] but the neoexpressionist painters and their supporters did. The leading advocates of a national art were dealer Michael Werner, Johannes Gachnang, director of the Kunsthalle in Bern, and his younger colleague Rudi Fuchs, director of the Van Abbe Museum in Eindhoven. The chief theoretician of neoexpressionism, Gachnang claimed that works of art were shaped decisively by the "cultural landscape" in which they were made. This belief led him to examine the differences between contemporary European and American art and between local, national,

133. Carlo Maria Mariani, *Composition 3*, 1989. *(Courtesy the artist; © Carlo Maria Mariani/VAGA, New York, NY)*

and regional subcultures in Europe, for example, the Nordic and the Mediterranean.[52]

Gachnang maintained that the exploration of national identity in German art since 1945 had been inhibited by "the trauma of national socialism," which had created "a feeling of isolation and a lack of points of reference."[53] Postwar West German artists naturally rejected the official pseudoclassical art of the catastrophic Nazi era—and the related socialist realism dictated by the Communist bureacracy in East Germany—and, by extension, all realism. But where were artists to look for points of departure? They were unfamiliar with modernist art, condemned as *entartete Kunst* ("degenerate art") by Adolf Hitler and banned in 1937. Consequently they looked first to the abstract art of Paris and then to that of New York, which had eclipsed it. The tachist and abstract expressionist styles, originating in Paris and New York, were appealing because they were advanced and international and therefore antidotes to discredited retrogressive and xenophobic Nazi art. More than that, abstract art seemed as far as art could get from Nazi- and Communist-imposed realist styles.

Instrumental in introducing Germany to international modernist art were the early *Documenta* shows in Kassel. Indeed, as Dieter Honisch, director of the National Museum in West Berlin, wrote: "If there is an art scene in Germany open to the world, we have the Documenta to thank."[54] The first, in 1955, curated by Arnold Bode, reviewed developments from 1905 to 1945. *Documenta 2* (1959), organized by Werner Haftmann, surveyed art since 1945, with particular emphasis on American art.[55] In 1958 *The New American Painting*, a major survey of abstract expressionism and a retrospective of Pollock's work, both organized by New York City's Museum of Modern Art, were shown in Berlin. Information about contemporary art, notably pop and minimal art, was also provided by shows in mushrooming private galleries, private collections—such as those of Peter and Irene Ludwig—which were circulated in German museums, and mammoth museum shows, such as *Prospekt* in Düsseldorf in 1974. Through these exhibitions German artists were able to assimilate the history of twentieth-century modernist art and were in a position to take their own path.

Joseph Beuys showed the way to a new German art in the late 1960s and 1970s. He had been the first artist to face up to Hitlerism and the Holocaust and to make of this confrontation the subject of avant-garde art. Moreover, he was deeply rooted in European culture and had a political program for the present and a vision of the future. His attitude, as Fuchs remarked, was crucial "in restoring self-confidence to the German art scene"; in revealing that artists could once again root themselves in German history and culture—without disgust or despair; and in declaring "faith in the possibility of constructing the world, and history, once again."[56] As a professor at the Academy of Arts in Düsseldorf, he influenced a large number of students, among them Polke and Richter in the

early 1960s, and Kiefer and Immendorff in the early 1970s. His proselytiz-
ing led Richter and Polke to question the enterprise of painting, although
unlike him, they did not abandon it. Beuys's example inspired Kiefer and
Immendorff to investigate German history, culture, and identity.

Baselitz, Lüpertz, and Penck had been exhibiting their work since
the early 1960s. But as figurative painting it was unfashionable and had
been omitted from important shows—until the *Prospekt* exhibition, in
which pictures by Lüpertz and Penck were included. Their works trig-
gered a controversy about the viability of painting and, more specifically,
figurative painting. Were not Lüpertz and Penck using outmoded pictor-
ial means to embody a disreputable content? What was most at issue was
whether the new painting was essentially different from Nazi- and
Communist-inspired art. Growing numbers of German art professionals
came to believe that it was, and their opinion was bolstered by the fact
that most of the leading new painters—Richter, Polke, Baselitz, Lüpertz,
and Penck—had escaped from East Germany to the Federal Republic.
They became refugees because the Communist commissars had censored
and repressed their work, precisely because of its divergence from social-
ist realism.

Another hotly debated issue was whether the new German painting
was *the* genuine German art. But there was a prior question: Was there a
German national identity? After all, Germany was fragmented into more
or less independent states, or *Länder*. Did provincialism take precedence
over and counter nationality? Or possibly contribute to it? Max Faust
pointed out that an interest in regionalism, "which reaches back to tradi-
tion," was growing in Germany:

> the state and the nation are (again) coming apart, [therefore] national-
> ism is pure fiction, beyond any possibility of realization. [Paradoxical]
> as it sounds, it makes "Germanness" an exemplary international atti-
> tude. Only in fragmentation . . . is it possible today to accept the idea
> of nationalism, i.e., only in its connection to self-questioning, dissolu-
> tion, and dispersal.[57]

But if art in Germany seemed to the Germans to be dependent on local-
ity, when presented abroad it was promoted as German—without any
reservations.

However, if there was a German national identity, where was its
expression in art to be found? Fuchs insisted that the romantic tradition
and its twentieth-century development, expressionism, was the true
German art. He argued that Hitler had suppressed expressionism, thus
rupturing the continuity of German art.[58] The neoexpressionists "would
rebridge *Die Brücke*," as Robert Pincus-Witten wrote.[59] But what was
inherently German about expressionism? Many German artists and art
professionals were convinced that the special—even exclusive—mission
of German culture was to plumb the psychic depths for images that were

at once primitivistic and spiritual. Fuchs, for example, claimed that German painting was characteristically "raw" and "uncooked." Traditionally, it had "a wildness and brutality."[60] Indeed, the German neo-expressionists were often called the "Heftige," or "wild ones."

A few critics rejected the notion that the expressionist tradition was peculiarly German, more German than other German art. They pointed out that German artists had been very varied in their artistic approaches. For example, art critic Annelie Pohlen condemned what she considered the uncritical and distorted prejudice that any art lacking "an irrational, mythic, anarchic, violent, sentimental cast cannot be German. . . . Not only Expressionism but also the Bauhaus, smithy of international Modernism, is German. Which of these is more in tune with the German soul?"[61] But critics like Pohlen were in the minority and their opinions tended to go unheeded.

Fuchs attributed the violence of neoexpressionist painting not only to the German character but to the cleavage of Germany into East and West. He then claimed that the new German painting had achieved inter-national prominence in the early eighties in part because of Germany's geographical position. The wall, which tragically severed Germany, was also the "painful borderline [which] cuts, like a wound, through the heart of Europe. . . . The German artists have reacted with violence to this violent situation."[62]

Other art professionals also used the centrality of Germany in the Cold War to make claims for a special relevance of German neoexpres-sionism in global art. This was the subtext of the *Zeitgeist* show, orga-nized by Norman Rosenthal and Christos Joachimides in Berlin in 1982. The very site of the show, Berlin—and even more pointedly, the renowned Martin-Gropius-Bau, some thirty feet from the Berlin Wall—possessed inner affinities to the art. Even more, across the way was the site of the former Gestapo headquarters, with a sign in four languages: "You are standing on the ground of the former torture chamber of the Gestapo."[63] More than any other city, then, Berlin mirrored Cold War anxieties and was "an environment of horror, made up of the German past and present." It exemplified the "*ZEITGEIST:* the place, *this* place, *these* artists, at *this* moment."[64] Thus, at the same time that the neoex-pressionists and their champions asserted the national identity of German art, they proclaimed its international pertinence.

The idea that expressionism was peculiarly German had a long his-tory, reaching back to some of its early-twentieth-century innovators. For example, Emil Nolde had claimed that his painting issued from his German genes, blood, and soil. He had urged his compatriots to purge from their work all foreign—and inherently inferior—influences, notably French. To him typically Nordic painting was aggressive and heavily spiritual, executed in overwrought colors and crude forms. Hitler dis-agreed and prohibited Nolde from painting. Nevertheless, Nolde, who

was an early member of the Nazi party, fervently believed that his kind of art should be the approved art of the Third Reich. Was Nolde right? Was neoexpressionism, then, neo-Nazi? How did the neoexpressionists view the Nazi period? Did their painting attempt to face critically the atrocities of Nazism and the history and culture that spawned them? Or was it complicit with the totalitarian, nationalistic, and racist bombast associated with Nazism? Might it even be a whitewash of the unspeakable past? At the very least, was not an art that continued to invent and sentimentalize, as Pohlen wrote, "an archaic community of kindred souls—a collective of rough, insane dream-dancers [and] stinging monsters in art," politically dangerous?[65]

There were, of course, diverse opinions. Donald Kuspit, the most passionate American art-critical champion of German neoexpressionism, found in Kiefer's painting a "direct engagement with the idea of a heroic German past [and] a peculiar kind of affirmation of . . . heroic German culture."[66] Art critic Craig Owens considered that kind of affirmation "proto-fascist." Neoexpressionism aimed to recycle "the entire German Romantic reserve of folklore, symbolism, myth and cultural heroics . . . that was appropriated by National Socialist propaganda as evidence of a German national character."[67] Other critics argued that neoexpressionism was too ambiguous to be damned as fascistic. But could ambiguity about such issues as the Holocaust be condoned?

What, for example, was one to make of the following remark by Gachnang? "I am forced to ask myself . . . to what extent [Germany] was really shaped by ideas of the Jewish tent and the Greek temple; whether the little known, passionate forces of the Nordic landscape haven't in reality had a greater influence on our thoughts and actions, and on the *gestalt* we have yet to develop, than we are generally inclined to admit."[68] Were these the forces that led to Nazism, racism, war and genocide? Was neoexpressionism glorifying them as typically German? Did Gachnang approve? Moreover, what was the social role and, by implication, the mission of German neoexpressionism? Kuspit claimed that the "new German painters perform an extraordinary service for the German people. They lay to rest the ghosts—profound as only the monstrous can be—of German style, culture, and history, so that the people can be authentically new. . . . They can be freed of a past identity by artistically reliving it."[69] Could "mere" painting really atone for the Holocaust?

Fuchs rebutted assertions that neoexpressionism was complicit with Nazism by pointing out that in rehabilitating German expressionism—and accepting the label neoexpressionism—the painters declared their anti-Nazism. Was not the very "wildness" of their painting antiauthoritarian? But then Fuchs compromised his position by inviting Hans-Jürgen Syberberg to screen the premiere of his four-hour film of Wagner's *Parsifal* at *Documenta 7*. While not a neo-Nazi, Syberberg professed a romanticist love of the *Volk*, as Ian Buruma wrote. He railed

against [the] vacuous idiocy of contemporary (West) German culture, corrupted by America, by rootless "Jewish leftists," by democracy. Syberberg also believes [in a] German identity that was rooted in the German soil, in Wagner's music, in the poetry of Hölderlin and the literature of Kleist, in the folk songs of Thuringia and the noble history of Prussian kings—a *Kultur*, in short, transmitted from generation to generation, through the unbroken bloodlines of the German people. [He possesses a] Wagnerian intoxication with deep Germanness. . . . Syberberg does not separate his political, social, and aesthetic opinions from his art. Indeed, they are at the core of his creative work. . . . Syberberg believes in Germany as a *Naturgemeinschaft*, an organic community whose art grows from the native soil.[70]

Owens coupled Syberberg and the neoexpressionists. "Syberberg's apologists, like some of the more astute defenders of neo-expressionist painting, claim that he is ultimately ambivalent about—simultaneously fascinated by and critical of—the German Romantic heritage." Owens disagreed, asserting that instead of being ambiguous, the director possessed "an undisguised nostalgia for the time when Germans were Germans: 'Germany,' Syberberg writes in a special number of *Cahiers du Cinéma* devoted to his work, 'was never more German than under Hitler. . . . When were the German people more beautiful, more fierce, more true, more dignified, more representative of Germany?'"[71]

Reviewing *Documenta 7*, Carter Ratcliff attacked Fuchs's motives.

There is something dreadful—and dreadfully familiar—in Fuchs's desire to celebrate "the dark irrationalism . . . the complex, illogical, impassioned character [of] the culture of Central Europe." . . .

Fuchs has labored under the compulsion to single out a certain strain of Central European irrationality and privilege it above the rest. This is, to put it mildly, indefensible. [This charge] finds support in his own comments. Rarely has anyone supplied so willingly, even lavishly, the evidence needed to render a judgment on his dubious instincts. Doesn't Fuchs know how he sounds? If not, we must conclude that he is naive; an authoritarian crypto-fascist monster so unknown to himself that he reveals his innermost nature with every move he makes. Or perhaps he does know how he sounds and doesn't care, in which case we have to see him as a monster driven by some "deep dark passion" that puts him beyond the control of his own knowledge.[72]

The advocates of neoexpressionism stressed that the quest of the German painters was for national identity not nationalism, but their rhetoric was frequently xenophobic, particularly when dealing with American art. Gachnang, for example, was often accused of anti-Americanism. He denied it, maintaining that rather than being chauvin-

istic, he was investigating "cultural origins. . . . Artistic and cultural things had happened in Europe, but for many years no one cared to perceive them, so long as American culture eclipsed everything else and appeared so promising for the future."[73] But he also decried the "unfortunate fifties mentality and the formalist way of looking, which [German artists] took from the Americans."[74] As late as 1989 Gachnang commented: "I still believe in old Europe, in the last tango of the white race. [When] art is just determined by America, then Good Night."[75]

The promotion of German neoexpressionism and the concomitant downgrading of the new American painting had a political dimension. Art critic Nancy Marmer pointed out in 1981 that a

> disconcerting new mood of nationalism . . . seems to be sweeping [Germany]. At the same time, antagonism towards American culture and the American presence (especially the American military presence) had spread far beyond its former narrow base among the extreme left . . . fueled by the fear of . . . Germany as an atomic battlefield in a war between East and West. . . . On the German art scene, the appeal to seemingly archaic nationalist sentiments has been part of the disquieting background of recent aggressive efforts to launch neo-Expressionist painting on the international art market.[76]

In opposition to the neoexpressionists, Sigmar Polke and Gerhard Richter, like Joseph Beuys, believed that painting was in crisis, probably used up, but unlike him, they did not abandon it. Instead they used painting to investigate its own nature and purpose, probing its various subjects, styles, and possible meanings. They refused to establish a single style and instead insisted on working in a variety of modes, ranging from realism to abstraction, and with a variety of techniques and materials, committing themselves to none and calling them all into question. The single "signature" style, prized by the neoexpressionists, could be taken as the sign of "authentic" artistic identity and could also become a kind of trademark that would help market the work. Polke and Richter spurned this kind of self-promotion. They appeared to reject, often sarcastically, what seemed outworn, pretentious, and meretricious, while cultivating what seemed viable—but provisionally, so that it was not clear whether they were neutral, negative, or positive, nihilist or idealist.

Polke came to international prominence in the 1980s, but he had already achieved some notoriety while still a student in Düsseldorf in 1963. A year or so after the emergence of pop art in the United States, Polke, together with Richter and Konrad Fischer (an artist who went on to become a well-known dealer), held a now-legendary show, titled *A Demonstration for Capitalist Realism*, in a furniture store in Düsseldorf. Polke exhibited pictures of chocolates, buns, and chains of sausages—

134. Sigmar Polke, *Untitled*, 1968. *(Museum of Modern Art, New York; photograph copyright © 1995 Museum of Modern Art, New York)*

appropriated from newspapers and magazines—poking fun at the materialistic striving of postwar Germany, both in the impoverished Communist East and the affluent West. Crudely painted, the work was an ironic gloss on American pop art, notably Warhol's and Lichtenstein's slick icons of commodities, and East European socialist realist "machines." In their deliberate "badness," Polke's pictures anticipated new image painting [134]. Indeed, at first glance they look ham-fisted and inept—and were meant to, in order to deny good taste and craft. But further viewing revealed their subtle artistry.

At the same time that he was painting his pop pictures, Polke, following the example of Robert Rauschenberg and Warhol, made a series of pictures (1963–69) in which he crudely enlarged halftone photographs of banal events, such as might appear in cheap tabloids. He borrowed Lichtenstein's use of little dots of paint (appropriated from benday printing) but painted the dots off-register so that they almost obliterated the image. Thus, tongue-in-cheek, Polke fashioned his own brand of "optical" photorealism. Again, concurrently with his pop and photorealist pic-

tures, he made fabric pictures (1964–71). Palimpsests of trashy images on cheap, ready-made, preprinted fabric, they were influenced by Rauschenberg's works and, even more, by Francis Picabia's layered kitschy images of the 1920s. As his contribution to the São Paulo Bienal in 1975, Polke, in collaboration with Achim Duchow, issued a broadside in which he reproduced two of his own works and as an homage, one of Picabia's.[77]

The best-known of the fabric pictures, *The Picture Painted According to the Commands of Higher Beings* (1966), consisted of flamingos in front of a sunset. Next to this painting was posted a photostat that read: I STOOD IN FRONT OF THE CANVAS AND TRIED TO PAINT A BUNCH OF FLOWERS. THEN I RECEIVED FROM HIGHER BEINGS THE COMMAND: NO BUNCHES OF FLOWERS! PAINT FLAMINGOS! AT FIRST I TRIED TO CONTINUE PAINTING. BUT THEN I REALIZED THAT THEY MEANT THIS SERIOUSLY. The irony was clear. Polke was using the avant-garde mode of conceptual art as a pretext for clumsily painting what art critic Claude Gintz called "a flea market orientalism— moonlit pools, tropical palms, pink flamingos—as if the bourgeois 'dream' were taking up where the triviality of his sausages and chocolate bars had left off."[78] In a sense Polke's tacky images parodied the new consumerist stage of capitalist society. They also ridiculed the art world in which modernist art had been reduced to decor. *The Picture Painted According to the Commands of Higher Beings* was a spoof on the pretensions of modernism. *Moderne Kunst* (1968), consisting of abstract gestures, signs, and symbols, which exposed the stereotypical character of modernist art, was even more of a lampoon.

In the 1970s and 1980s Polke introduced sociopolitical and historical subjects, for example, the French Revolution and Nazism, into his painting [135]. In *The Day of Glory Has Come . . .* and *Liberté, Égalité, Fraternité* (1988), he commented on how rationalism turned into terror. *Camp* (1982), with its images of barbed-wire fences and a string of electric lights, and the *Watchtower* series (1984–88), depict concentration camps, but their meaning is ambiguous. Other, more abstract pictures, the *Transparents* (1987–89), are composed of see-through polyester sheets on both sides of which were painted layers of signs, symbols, and figures, whose content—seemingly alchemical or shamanistic—would increasingly preoccupy Polke.

In the early 1980s Polke began to experiment with unconventional techniques and materials, including aluminum, arsenic, barium, iron, magnesium, potassium, silver, and zinc—as well as lacquers, shellac, pure pigments, staining liquids, sealing wax, alcohol, methanol, butanol, depilatories, and on occasion rat poison. He scattered these materials onto resin-coated canvases to create translucent clouds of changeable color. Transformed as they are acted upon by temperature, humidity, and the decomposition and recomposition of the chemicals, these abstract paintings seem to have a life of their own. From one point of view the metamorphosis of one substance into another is suggestive of perpetual

135. Sigmar Polke, *Mao*, 1972. *(Museum of Modern Art, New York; photograph copyright © 1995 Museum of Modern Art, New York.)*

"becoming" as a condition of contemporary reality; from another, of the action of nature outside the artist's control; and from still another, of alchemy, stirring up, as Polke said, "a longing for the unknown mystery."[79]

As in his historical and sociological pictures, Polke's intention in his abstractions of the 1980s was unclear. They look ghostly, enigmatic, even mystical, and transcendental claims were made for them. Storr, for one,

would not accept such claims for "a character as slippery as Polke" and concluded that he was "an incorrigible Merry Prankster."[80] Groot tried to have it both ways, labeling him "a dadaist mystic."[81] Whatever Polke's intention, the abstract paintings are distinguished by their grace and elegance. If Polke meant to subvert painting, he also managed to affirm it. It may be because of the double edge in his work that it became a powerful influence on a younger generation of painters, including Salle, Schnabel, and Richard Prince. Indeed, as Storr wrote, "it is hard not to recognize Polke's direct or indirect influence on all that disassembles, distends, recodes and, by successive overlay, obscures the picture in front of you."[82]

Gerhard Richter avoided working in any one style in order to be free of any associated ideology. It is significant that he grew up in the dogma-surfeited and regimented Communist East Germany and in 1961 escaped to West Germany. As he wrote: "I do not pursue any particular intentions, system, or direction. I do not have a programme, a style, a course to follow. . . . I shy away from all restrictions. I do not know what I want, I am inconsistent, indifferent, passive; I like things that are indeterminate and boundless, and I like persistent uncertainty."[83]

In the early 1960s Richter, like Polke, made paintings of ready-made photographs lifted from the mass media or taken by himself. These works raised a number of specific questions. What did the photographs Richter chose to copy signify to him—most had no personal connection—and what did it mean that he painted them? And what of those photographs that did touch him personally—for example, those dealing with sex and death? Moreover, how did a painter reconcile the mechanically induced veracity of a photograph with the artist's allegedly subjective painterly touch, a touch that obscures the alleged objectivity of the photograph? Might the pictures signify something other than factuality or subjectivity? Finally, what was the relationship of the photograph to the painting? Was it the painting's purpose to "express" the photograph—as a thing-in-itself or as a catalyst for subjective responses? Or was it the purpose of the photograph to be a pretext for painting, and was that painting necessarily "expressive"? In his *Townscapes* (1968) Richter emphasized the *process* of painting, while in his *Portraits* (1966–72) he focused more on the photorealist *image*.

In general Richter questioned the nature of representation. What do painting and photography represent? What does abstraction represent? How is it different from figuration? The issue could become very complicated. For example, in 1966 Richter made a series of paintings of commercial color charts. At first glance these gridlike pictures look like geometric abstractions, but they are actually representations. In another style, a series of *Gray Paintings* (1973) consist of amorphous, monochromatic fields that may be abstractions or skyscapes. Richter wrote that he painted them because

I did not know what I should paint or what there might be to paint. . . .

Grey is the epitome of non-statement, it does not trigger off feelings or associations. [It is] an illusion, like a photograph. And like no other colour, it is suitable for illustrating "nothing."

For me grey is the . . . only possible equivalent for indifference, for the refusal to make a statement, for lack of opinion, lack of form.[84]

Subsequently Richter painted pictures in both figurative and abstract styles. At one extreme are small, photorealist still lifes and landscapes that from a distance resemble photographs but are painted in blurry fashion, so that close up they verge on painterly abstractions [136]. At the other extreme are large painterly abstractions that have the look of photographs [137]. Much as they seem opposite, the styles are linked in their reference to photography, prompting art critic Bernard Blistène—with Walter Benjamin in mind—to dub him "a painter in the age of reproduction."[85]

Richter's painterly abstractions, begun in 1977, pose difficult questions about the viability of historic expressionist, abstract expressionist, and neoexpressionist painting and the romantic tradition that was often identified as peculiarly German—a tradition he spurned. In his first

136. Gerhard Richter, *Scheune*, 1983. *(Marian Goodman Gallery, New York)*

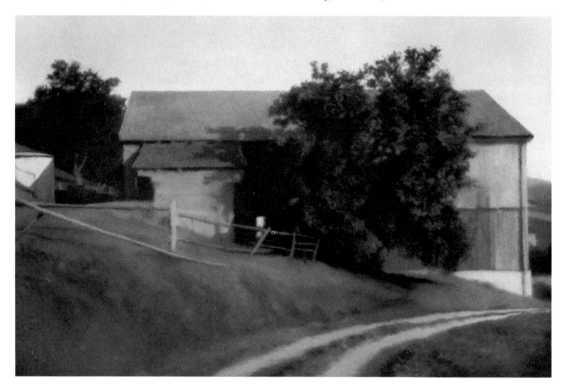

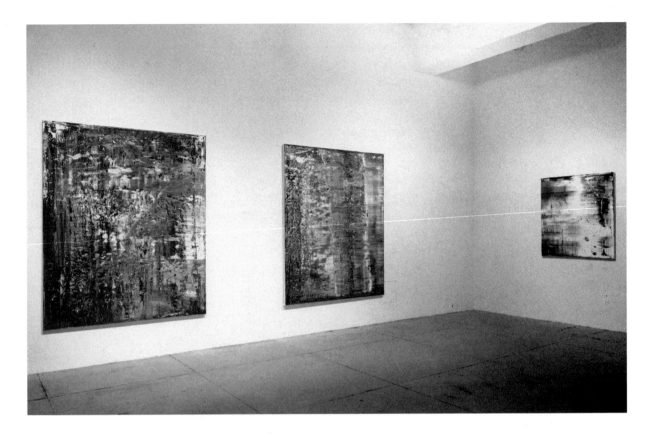

Abstract Paintings, photographs of small-scale sketches were transposed onto large-scale canvases by dragging paint across the surface with boards, and later with spatulas of different sizes, simulating a "hot" look. Subsequent pictures did not have their source in photographs but retained a "cool" photographic look. Richter did make subjective and formal decisions in the process of painting—accepting, revising, or destroying the emerging image. Consequently the abstractions are expressionist in some degree. But they were produced in a decidedly nonexpressionistic mechanistic, distanced, and arbitrary manner. Thus the painting was not "authentic" but, as Stephen Ellis commented, "a rhetoric, a device to be employed rather than a drama to be enacted. [The] painterly gesture . . . as a sign of subjectivity and spontaneity is recoded to signify objectivity and self-consciousness. . . . Abstract Expressionism [is turned] away from its inward-looking, mythopoeic and psychological concerns, and forced . . . to look outward at 'things in the world' [such as] photography."[86] In sum, Richter made expressionism-in-quotes the subject of his painting.[87] He dispassionately contrived a representation of passionate expressionist abstraction, just as he simulated a representation of a photograph. This point is crucial. As art critic Kenneth Baker put it: "Clearly the old sense of abstraction as the negation of representation is anachronistic."[88]

Was Richter a cynic or a nihilist bent on the subversion of painting

137. Gerhard Richter, installation view, 2–24 February 1990. *(Marian Goodman Gallery, New York)*

or the revelation of its alleged bankruptcy? Craig Owens wrote that he used expressionist brushwork against itself, emptying it of "every residue of subjectivity and spirituality. All of his canvases, whether representational or abstract, aspire to the anonymity and neutrality of the photographic image."[89] Or was it Richter's intention to preserve painting, to assess what in painting could be credibly conserved and cultivate it? Could his critique of expressionism, based on encountering the image while painting in the throes of inner necessity, lead to another kind of expressionism, based on self-aware predetermined procedures? Put another way the question that Richter posed in his painting was whether it was possible to make a believable expressive painting when all the moves were known. Could emotion be *represented*, which is different—or is it?—from *expressing* it in the direct act of painting?

Richter implied that his aim was to salvage painting. He saw himself "as the heir to an enormous, great, rich culture of painting, and of art in general, which we have lost, but which nevertheless obligates us. In such a situation, it is difficult not to want to restore that culture, or what would be just as bad, simply to give up."[90] He not only did not give up painting but, as Baker suggested, opened up "a future for what might seem a vitiated mode of painting." Richter—and Polke—show optimistically "that the self-consciousness that burdens painters today need not be paralyzing. [Their paintings] detail new, fecund ambiguities in the making and understanding of art where they might be least expected."[91] In the end it was the result that counted. The *Abstract Paintings* are in fact beautiful. Richter himself doubted whether beauty mattered, claiming that it "is a mere projection which we can shut off at will, leaving only the reality of nature's inhuman ugliness"—and humankind's, whose "crime which fills the world is so absolute that we can lose our senses out of sheer dispair," as he wrote in his diary.[92]

In 1988 Richter painted fifteen photorealist grisaille pictures on the controversial theme of the Baader-Meinhof gang, which had been responsible for a series of bombings, assassinations, and bank robberies that triggered retaliations by the police and the courts. The gangleaders, Andreas Baader and Ulrike Meinhof, were found dead in jail, but it was never determined how they died. There were many theories, none of which could be proved. The activities of the gang, the government reprisals, and the circumstances of their death gave rise to an ongoing controversy that traumatized West German society. The terrorists' funeral took place on October 18, 1977, a date that Richter took as the title of his series. The paintings were based on police and press photographs, but only those in which fragments of bodies, dead or alive, are presented. These images, represented in black and gray, are brushed and smeared so as to appear blurred and, at times, indecipherable. Shrouded in a mournful, depressing, and pathetic aura, the pictures seem to embody death itself.

Richter was obviously troubled by the Baader-Meinhof affair, writing that "the death of the terrorists and all the connected events before and afterwards amounted to a monstrosity which made an impact on me ever since, even when I repress it, like a piece of unfinished business."[93] As he saw it, they were "not victims of a specific ideology on the left or the right but of ideological behavior per se." And every extreme ideological faith was "superfluous and life threatening."[94] The terrorists had fought and died "for ideas, for nothing."[95] Although Richter's attitude toward the terrorists and their jailers was not clear, nevertheless, in the context of the ongoing controversy, the pictures could not help being provocative and keeping the issue alive.

The *October 18, 1977* pictures make obvious references to earlier paintings, such as Goya's *The Third of May* and Mantegna's *Dead Christ*. Consequently, as art critic Maja Damjanovic commented, they can be viewed as a continuation of Richter's critique of painting, questioning whether it was possible to make a valid contemporary history painting.[96] Moreover, he engaged, as Buchloh wrote, in a critique "of Warhol's rendering death anonymous [as in the *Disasters* (1962–66)] and . . . of Kiefer's work, a critique of the idea predominant in Germany, that history is easy subject-matter for painting."[97]

Damjanovic's interpretation of *October 18, 1977* is persuasive. She commented that its

> hazy surfaces play an active role in distancing the viewer from the fascination of a direct, close-up examination that could lead to clinical voyeurism or a sensationalist aggrandizement of events and victims. Like vestigial remains barely existing in memory, the subjects are articulated in grey paint not only to produce a generalized somber mood, but also to emphasize a detached and objective documentary position—thus limiting idealization and romanticization. . . . While Richter's canvases are too deliberately impressionistic to wave the banner of a political issue, there is a genuine attempt to stir up collective memory and responsibility without allowing sentimentality or ideology to enter the narrative of history.[98]

Unlike Polke and Richter, the neoexpressionists Georg Baselitz, A. R. Penck, Jörg Immendorff, and Anselm Kiefer never doubted painting's expressive capability. To varying degrees all four confronted the situation of Germany after World War II.

In 1964 Baselitz began to paint hulking, loutish peasants, herdsmen, and hunters with their genitals exposed, all roaming the smoldering rubble of Germany. These "heroes," some equipped with paintbrushes or a palette, were to revive German society and culture and make it whole again. In 1969 Baselitz started to upend his subjects, perhaps as a metaphor for humankind in a topsy-turvy world [138]. He himself pre-

138. Georg Baselitz,
Glastrinkerin, 1981. *(Michael
Werner Gallery, New York and
Cologne)*

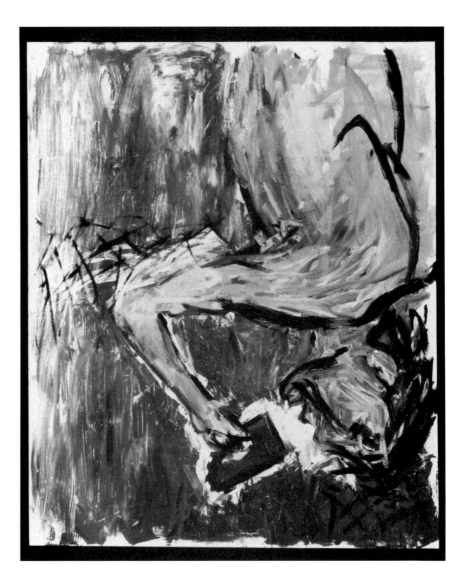

ferred to call attention to his thick and sensuous paint application. "An object painted upside-down is of use for painting because it's of no use as an object."[99]

Looking back to the German expressionists' love of primitive art, A. R. Penck revived ideograms, hieroglyphics, and calligraphy reminiscent of cave, ancient Egyptian, Mayan, and African art [139]. He believed that the mentality of primitive man was akin to that of modern man, and that primitivistic imagery was equally comprehensible to both. Moreover Penck maintained that this subject matter conveyed the experience of terror and alienation in the Cold War era, particularly in a Germany rent in two. Thus his painting exemplified the crisis mentality shared by his neoexpressionist colleagues.

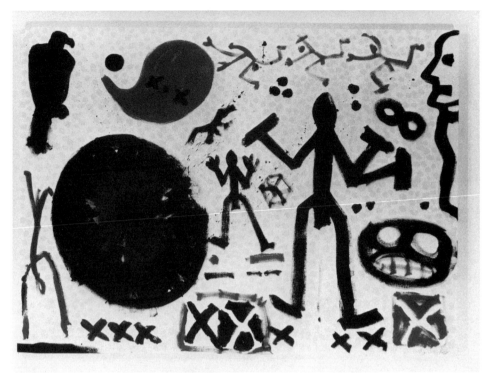

139. A. R. Penck, *Noon*, 1989. *(Courtesy Michael Werner Gallery, New York and Cologne.)*

* * *

Jörg Immendorff, a student of Joseph Beuys, was the social realist of neoexpressionism, as Roberta Smith wrote, "a master of the political cartoon as painting."[100] His outlook was decisively shaped by the student uprisings in 1968. Despite doubts as to whether painting was a politically relevant activity or had been fatally tainted by "bourgeois aestheticism," Immendorff would not abandon painting. He did seek to put it in the service of revolution, however (in his case, Maoism), although he did not curb an ironic attitude rooted in dadaism. His primary themes were political and cultural events in recent German history, notably Nazism, the economic revival of Germany, and the schism between Communist East and capitalist West. Above all, the division of Germany into two states obsessed him and became the subject of a series of apocalyptic pictures, titled *Café Deutschland*, which be began in 1978 and for which he is best known [140].

Like Immendorff, Anselm Kiefer was a student of Beuys who took up painting [141]. And like his teacher, he aimed to confront the horrors of the Nazi period and the German history, culture, and myth that led up to it, and hoped to heal the wounds and revitalize German idealism. Indeed, Kiefer had enormous ambitions for painting, aspiring to use it to redefine the entire development of German history and culture, from its prehistory through Wagner, Nietzsche, and Hitler to the present day. Like Beuys,

140. Jörg Immendorff, *Cafe Deutschland–III*, 1978. *(Courtesy Michael Werner Gallery, New York and Cologne.)*

Kiefer was often viewed as an "archaeologist of German guilt"[101] and "as a kind of Pied Piper leading away the demons of the Third Reich," but unlike his mentor, he avoided topical social issues and had no political ambitions.

Before he became a painter, Kiefer had done a stint as performance artist. In 1969 he had himself photographed in a Nazi uniform giving the *Sieg Heil*—an illegal act—in a number of European cities. When these photographs were published in Germany, they gave rise to a controversy over whether Kiefer was a Nazi sympathizer. His subsequent works also call attention to the Nazi past. A number are of ruined monumental buildings of the Hitler era or of ravaged fields—the bombed-out and smoldering remains of the Nazi vision of "a one thousand-year Reich." Kiefer's very surfaces looks devastated—a muck of thick oil and acrylic

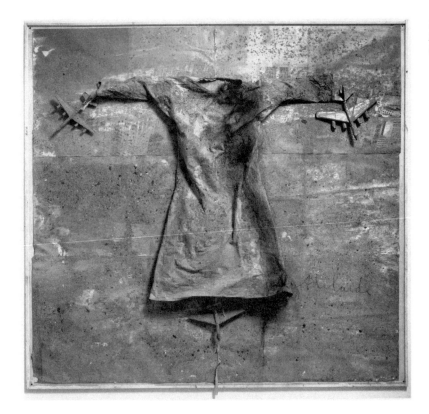

141. Anselm Kiefer, *Adelaide—Ashes of My Heart*, 1990. *(Marian Goodman Gallery, New York)*

paint, straw, sand, emulsion, shellac, junk metal, photographs, and assorted "gunk." But the images of incinerated earth also allude to the burning of fields before plowing—the anticipation of new growth. Moreover, his earth is German, the earth from which the *Volk* and its romanticist culture originate. Words written on the surface of the pictures complicate the content. The field in *Nuremberg* (1982), for example, is inscribed with the words *Nürnberg—Festspiel—Wiese* (Nuremberg—festival performance—field). Art critic Jack Flam noted: "These words evoke, independently of the pictorial image in which they are inscribed, a stream of related associations, such as the medieval mastersingers of Nuremberg and Richard Wagner's opera about them (a favorite of Hitler's), as well as the city's Nazi convocations and anti-Jewish laws before the Second World War, and the war crimes trials that were [held there] after it."[102]

Like his photographs of himself in a Nazi uniform, Kiefer's repeated allusions to the Nazi period, the German soil, and ancient Teutonic heroes, bards, and kings raise questions about his intentions. Did the winged palette in *Resumptio* (1974) signify that the painter was "a guardian-angel, carrying the palette in blessing over the world," as Rudi Fuchs claimed?[103] Or did Kiefer reinvoke, as Adam Gopnik wrote, "the forbidden rhetoric of German romanticism—Nordic meadows and Nordic myths—in order to redeem it"?[104] What was the significance of his inclusion of historic figures,

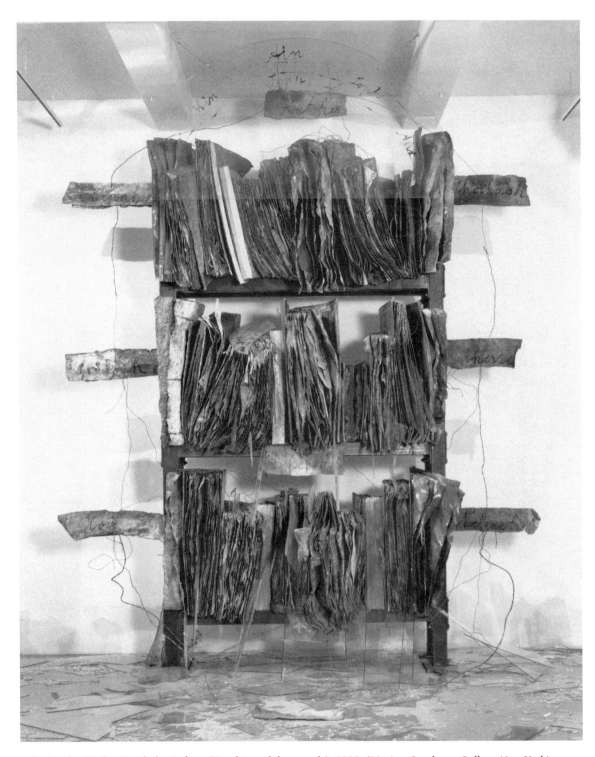

142. Anselm Kiefer, *Bruch der Gefässe* (Breaking of the vessels), 1990. *(Marian Goodman Gallery, New York)*

such as Barbarossa, the twelfth-century Holy Roman Emperor who bolstered the power of Germany and who, myth had it, would one day rise from the dead to save Germany; Heinrich von Kleist and Christian Dietrich Grabbe, both of them nineteenth-century playwrights who wrote nationalistic plays; Horst Wessel, the twentieth-century composer of the chauvinistic German hymn; and Albert Leo Schlageter, a World War I hero.[105] Were these historically loaded portraits a neo-Nazi paean to a nationalistic and militaristic Germany, or did they confront and expose Teutonic and Nazi myths?

Whether one believes that Kiefer was critical of or complicit with Nazism, it was generally acknowledged that he was a powerful artist [142]. Flam wrote that in his pictures "beauty is of a difficult and wild sort, ugly and disturbing. His pictures are at once somber and lyrical, and evoke terror as well as ecstasy."[106]

NOTES

1. Wolfgang Max Faust, in "The Appearance of Zeitgeist," *Artforum*, Jan. 1983, viewed the development from nonpainting to painting as a kind of progression, a view that allowed European art professionals who had embraced American minimalism and postminimalism, arte povera, fluxus, and the like now to support both nonpainting and painting. "Just as art had to 'go through' language (conceptual art), nature (land art), technical media (photography, film, video), the artist's body (body art), and physical action (happenings, performances), presently much of its development seems to need to 'go through' images" p. 87.

2. Christos M. Joachimides, Norman Rosenthal, and Nicholas Serota, preface to *A New Spirit in Painting* (London: Royal Academy of Arts, 1981), p. 11.

3. Interview with Norman Rosenthal, London, Aug. 2, 1989.

4. Joachimides, "A New Spirit in Painting," in *A New Spirit in Painting*, p. 15.

5. Joachimides, Rosenthal, and Serota, preface to *A New Spirit in Painting*, pp. 11–12.

6. Joachimides, "A New Spirit in Painting," p. 14.

7. Christos M. Joachimides, "Achilles and Hector before the Walls of Troy," *Zeitgeist* (Berlin: Martin-Gropius-Bau: Verlag Frölich & Kaufmann, 1982), pp. 9–10.

8. Roberta Smith, "Fresh Paint," *Art in America*, Summer 1981, pp. 71, 73.

9. Jean-Christophe Ammann, who curated an early major show of *Europe in the Seventies: Aspects of Recent Art* (Chicago: Art Institute of Chicago, 1977), wrote in the catalog that "European artists . . . in comparison to their American counterparts, work from an entirely different cultural and social tradition. [Many European] artists' conception of self is grounded on tradition [and on] social self-awareness." This is illustrated in the work of "Joseph Beuys, and even more stringently in the work of Victor Burgin, Mario Merz, Gilberto Zorio, A. R. Penck, Sigmar Polke, Jannis Kounellis. . . . The social self-awareness of European artists is crystallized in an exemplary way in the work of Joseph Beuys. I should like to generally maintain: whoever finds access to Joseph Beuys can also experience and understand contemporary European art" (p. 8).

10. In "Situations: Beuys, Cucchi, Kiefer, Kounellis," *Galeries Magazine*, June–July 1986, pp. iv–v, Beuys defended Warhol: "Andy Warhol has fully identified with Americanism. But that doesn't mean being uncritical. . . . Warhol has done great things. He once said he would like to be a machine. With that he brings himself to a boundary which is very interesting. . . . Moreover, Andy Warhol is one of the few artists—and that unites me with him—who has taken up the notion of economics in art. He works in a firm, a collective—the Factory."

David Galloway, "Beuys and Warhol: Aftershocks," *Art in America*, July 1988, remarked that Beuys and Warhol shared "deep-seated philosophical affinities. Both had waged war on the time-honored and gallery-bound concept of originality." Moreover "Beuys and Warhol seemed to symbolize to the press that alchemical ability of artists to transform everyday objects into great value and wealth. . . . Beuys also understood the fundamentally conceptual nature of Warhol's art" (pp. 121–22).

Both Warhol and Beuys fashioned themselves into cult figures. Trevor Fairbrother, in *Beuys and Warhol: The Artist as Shaman and Star* (Boston: Museum of Fine Arts, 1992), wrote: "They projected both the ceremonious aura of the shaman (the tribal healer, priest, and leader) and the brand-name allure of the star (the commercialized fame-driven performer). [They] underscored their new personas in self-portraits" (n.p.).

11. Achille Bonito Oliva, *Europe/America: The Different Avant-gardes* (Milan: Deco Press, 1976), pp. 7–13.

Oliva also compared American conceptual artists with their European counterparts. The Americans investigated the nature of art with the idea of advancing art as art; the Europeans examined the social role of art and art institutions.

12. Oliva, *Europe/America*, p. 8.

13. Pierre Restany, in "Some Opinions on Documenta 7," *Flash Art* (Nov. 1982): 42.

14. Johannes Gachnang, "German Paintings: Manifestos of a New Self-Confidence," in *The European Iceberg: Creativity in Germany and Italy* (Toronto: Art Gallery of Ontario, 1985), p. 63.

15. See Willi Bongard, *Art Aktuell* 12, nos. 3–4 (Feb. 1982): 110. Anti-Americanism was particularly in evidence in *Documenta 7* (1982), curated by Rudi Fuchs, one of whose advisers was Gachnang. Giancarlo Politi, in "Documenta," *Flash Art* (Nov. 1982) reported that Germano Celant had declared "at a press conference that Documenta VII confirmed Europe's cultural supremacy over the USA! Only three months earlier he had been doing his best to demonstrate the exact opposite" (p. 34). Politi questioned the relatively large number of Europeans included in *Documenta 7* compared to the small number of Americans, the poor installation of the Americans' works—"in the attic or under the stairs"—and the exclusion of significant Americans, such as Julian Schnabel.

16. Brigid Grauman, "Inside Europe: The Temperature Is Lower," *Art News*, Apr. 1988, p. 118.

17. Mina Roustayi, "Crossover Tendencies: An Interview with Wolfgang Max Faust," *Arts Magazine*, Feb. 1988, p. 64.

18. Grauman, "Inside Europe: The Temperature Is Lower," p. 115.

19. Joachimides, Rosenthal, and Serota, preface to *A New Spirit in Painting*, p. 12.

20. Dieter Honisch, "What Is Admired in Cologne May Not Be Accepted in Munich," *Art News*, Oct. 1978, p. 64.

21. Bernard Blistène, "Francis Picabia: In Praise of the Contemptible," *Flash Art* (Summer 1983): 27.

22. William Rubin also neglected the late Picasso in the monumental retrospective that he curated at the Museum of Modern Art in 1989.

23. Joachimides, "A New Spirit in Painting," p. 15.

24. Nicholas Bourriaud, "Giancarlo Politi, Helen Kontova: 20 Years of Flash-Art," *Galeries Magazine*, Dec.–Jan. 1988, p. 138.

25. Roustayi, "Crossover Tendencies," p. 65.

26. The show, titled "Opere Fatte ad Arte," took place at the Palazzo di Città, Acireale. Achille Bonito Oliva, "The Italian Trans-Avantgarde," *Flash Art* (Oct.–Nov. 1979): 18–19, and *The Italian Trans-avantgarde* (Milan: Giancarlo Politi Editore, 1980).

27. Robert Pincus-Witten, "Entries: If Even in Fractions," *Arts Magazine*, Sept. 1980, p. 119.

28. Eleanor Heartney, "Apocalyptic Visions, Arcadian Dreams," *Art News*, Jan. 1986, pp. 86–87.

29. Angela Vettese, "Mimmo Paladino," *Flash Art* (May 1987): 99.

30. Giancarlo Politi, "Italian Identity," *Flash Art* (Oct.–Nov. 1981): 61.

31. Germano Celant, *The Knot* (New York: P.S. 1, Institute for Art and Urban Resources, 1985), pp. 42–45. Celant, in "The Organic Flow of Art," in *Mario Merz* (New York: Solomon R. Guggenheim Museum, 1989), pp. 37–38, restated his position.

32. Oliva, "The Italian Trans-Avantgarde," p. 18.

33. Oliva, *The Italian Trans-avantgarde*, p. 10.

34. Matthew Collings, "More and Less Passion: Achille Bonito Oliva: Interviewed by Matthew Collings," *Artscribe International*, Feb.–Mar. 1986, p. 42.

35. Marcia E. Vetrocq, "Utopias, Nomads, Critics: From Arte Povera to the Transavantguardia," *Arts Magazine*, Apr. 1989, p. 53.

36. See Achille Bonito Oliva, "Giorgio de Chirico and the Trans-avantgarde," *Flash Art* (Mar. 1983): 21, 23–24. In the field of art Italian fascism was not so repressive as German Nazism. Therefore certain artists could be rehabilitated, notably those in a movement labeled the Novecento, which was, as Henry Martin wrote in "Italy," *Art News*, Feb. 1985: "the Fascist regime's middle-brow reply to the excesses of the Futurists. Rather than a true movement, it was essentially a curatorial attempt to create a sense of some cohesive Italian culture [but was] sufficiently inconsistent as to include such artists as Giorgio Morandi, Massimo Campigli and Marino Marini" (p. 62).

37. Edward Lucie-Smith, *Art in the Eighties* (Oxford, England: Phaidon, 1990), p. 28.

38. Alberto Asor Rosa, "Contemporary Italy," in Norman Rosenthal and Germano Celant, eds., *Italian Art in the 20th Century* (London: Royal Academy of Art, 1989), p. 360.

39. Giancarlo Politi, "Francesco Clemente," *Flash Art* (Apr.–May 1984): 17.

40. Edit DeAk, "A Chameleon in a State of Grace," *Artforum* (Feb. 1981): 40.

41. Robert Storr, "Realm of the Senses," *Art in America*, Nov. 1987, p. 139.

42. Storr, "Realm of the Senses," p. 134.

43. Politi, "Francesco Clemente," p. 18. Clemente commented on the influences on his work. "I think that Fuseli . . . has a lot to do with that whole aspect of my work which is tied to bad taste. [Picabia and the late de Chirico] have claimed to be dilettantes in order to maintain the integrity of their inquiry, and they have shown that eroticism and humor aren't held hostage by an age" (p. 15). Clemente, in Sarah Kent, "Turtles All the Way: Francesco Clemente Interviewed by Sarah Kent," *Artscribe International*, Sept.–Oct. 1989, p. 58 said that some of the artists he admired at various times were Luca Giordano, William Blake, Fuseli, late Picasso, de Chirico, Picabia, Cy Twombly, Warhol, and Julian Schnabel." It is noteworthy that Clemente has resurrected the technique of fresco, a technique peculiarly associated with Italian art.

44. Giancarlo Politi and Helena Kontova, "Interview with Enzo Cucchi," *Flash Art* (Nov. 1983): 21.

45. Gerald Marzorati, "The Last Hero," *Art News*, Apr. 1983, p. 60.

46. Ibid., p. 61.

47. Craig Owens, "Issues and Commentary: Honor, Power and the Love of Women," *Art in America*, Jan. 1983, p. 9.

48. Sandy Nairn, in collaboration with Geoff Dunlop and John Wyver, *State of the Art: Ideas & Images in the 1980s* (London: Chatto & Windus, 1987), pp. 29–30.

49. These seven artists were among the dozen or so of their generation who were included in the prestigious *German Art of the 20th Century: Painting and Sculpture 1905–1985*, held at the Royal Academy of Arts in London, 1985.

50. The two groups were also separated geographically. Richter and Polke were based in Düsseldorf; Baselitz, Lupertz, and Penck in Berlin. The somewhat younger Kiefer and Immendorff lived in Düsseldorf. Richter and Polke were established first, Richter in the Venice Biennale (1972) and Polke, in the XIII São Paulo Bienal (1975).

51. Richter observed in Deborah Solomon, "The Cologne Challenge: Is New York's Art Monopoly Kaput?" *New York Times Magazine*, Sept. 6, 1992, "I'm not interested in a German style and I don't know what it is. But whenever I see my work in another country I think, ah, it looks a bit German. It has to do with Germany" (p. 30).

52. Rudolph Schmitz, "Keeping the Whole Thing in Motion: A Conversation Between Johannes Gachnang and Rudolph Schmitz," *Tema Celeste* (Apr.–June 1989): 42–43. Gachnang claimed that one of his goals was to explore two opposing worlds, the Mediterranean and the Nordic. "Mediterranean culture gives priority to outer appearances, to elegance and beauty, with everything else falling into line accordingly; the Germans, on the other hand, worked from the inside out, and the outside then came of its own accord," a very questionable hypothesis indeed.

 Taking his cues from Gachnang, Fuchs, in Paul Groot, "The Spirit of Documenta 7: Rudi Fuchs Talks about the Forthcoming Exhibition," *Flash Art* (Summer 1982), said that he wanted "to offer artists an opportunity to speak their own language. 'Dialect' could be said to be the motto of this exhibition. Earlier editions of Documenta sought an international language. Number 7 attempts to provide a fluid framework for autonomous and authentic cultural expressions, a context for the varying dialects" (pp. 20–21, 25).

53. Johannes Gachnang, "New German Painting," *Flash Art* (Feb.–Mar. 1982): 34.

54. Honisch, "What Is Admired in Cologne," p. 67.

55. Phyllis Tuchman, in "American Art in Germany: The History of a Phenomenon," *Artforum*, Nov. 1970, p. 58–61, 68–69, reported that examples of American pop, minimal, and postminimal art in large numbers had become available in Germany in the 1960s, through the efforts of such dealers as Rudolf Zwirner, Konrad Fischer, and Heiner Friedrich; collectors, such as Karl Ströher and Ludwig; Rudi Fuchs and organizers of *Documenta* and other exhibitions; and curators in Aachen, Cologne, Darmstadt, and Krefeld. By 1970 museums in these four cities had acquired sculptures by Carl Andre (four); Dan Flavin (two); Donald Judd (four); Robert Morris (four); and Claes Oldenburg (eighteen, plus one bedroom environment); and paintings by Jasper Johns (five); Roy Lichtenstein (twenty-six); Robert Rauschenberg (nine); James Rosenquist (five); Frank Stella (three); and Andy Warhol (thirty-one), as well as works by Eva Hesse, Bruce Nauman, Richard Serra, and Robert Smithson.

56. R. H. Fuchs, "Chicago Lecture," *Tema Celeste* (Jan.–Mar. 1989): 54.

57. Faust, "The Appearance of the Zeitgeist": 92.

58. Günther Gercken, in "Figurative Painting after 1960," in Christos M. Joachimides, Norman Rosenthal, and Wieland Schmied, eds., *German Art in the 20th Century: Painting and Sculpture 1905–1985* (London: Royal Academy of Arts, 1985), reported that Baselitz, who had been a child during World War II, spoke of his generation of artists as fatherless (p. 473).

59. Robert Pincus-Witten, "Entries: Rebridging the Bridge: Hödicke, Joachimides, and Berlin in the Early '80s," *Arts Magazine*, Mar. 1990, p. 76.

60. Fuchs, "Chicago Lecture": 54, 59. Fuchs tended to undervalue the contribution of American abstract expressionism to German neoexpressionism.

61. Annelie Pohlen, "Obsessive Pictures or Opposition to the Norm: Noteworthy Aspects of the Engaged Imagination in the New German Art," *Artforum*, May 1984, p. 44.

62. Fuchs, "Chicago Lecture": 49, 53. Donald B. Kuspit, in "Acts of Aggression: German Painting Today," *Art in America*, Sept. 1982, claimed that the major figures were Baselitz, Lüpertz, Penck, Immendorff, Polke, and Kiefer. Kuspit listed other artists: The Berlin group (K. H. Hödicke, Bernd Koberling, Salomé, Helmut Middendorf, Rainer Fetting, Bernd Zimmer, and Elvira Bach), the Mülheimer Freiheit Group, Cologne (Walter Dahn, Georg Jiři Dokoupil, Peter Bömmels, Hans Peter Adamski, Gerard Kever, and Gerhard Naschberger), and the Hamburg artists Werner Büttner and Albert Oehlen. Though known in the United States, they did not make anywhere near the impression that Baselitz, Immendorff, Kiefer, Lüpertz, Penck, Polke, and Richter did (p. 144).

63. Joan Simon, "Report from Berlin: 'Zeitgeist': The Times & the Place," *Art in America*, Mar. 1983, p. 33.

64. Joachimides, "Achilles and Hector," pp. 10–11.

65. Annelie Pohlen, "Climbing Up a Ramp to Discover German Art," *Artforum*, Dec. 1984, p. 54.

66. Donald B. Kuspit, "Acts of Aggression: German Painting Today, Part II," *Art in America*, Jan. 1983, pp. 99–100.

67. Craig Owens, "Bayreuth '82," *Art in America*, Sept. 1982, p. 134.

68. Gachnang, "German Paintings: Manifestos of a New Self-Confidence," p. 65.

69. Donald B. Kuspit, "Flak from the 'Radicals': The

American Case Against Current German Painting," in *Expressions: New Art from Germany* (St. Louis: St. Louis Art Museum, 1983), p. 46.

70. Ian Buruma, "There's No Place Like Heimat," *New York Review of Books*, Dec. 20, 1990, pp. 34, 36.

71. Owens, "Bayreuth '82," pp. 135–36. Ian Buruma, in "From Hirohito to Heimat," *New York Review of Books*, Oct. 26, 1989, p. 42, also attacked Syberberg for "his nostalgia for the former glory of his native hearth," a return to which, Buruma believed, could not be achieved.

72. Carter Ratcliff, "Further Opinions on Documenta 7," *Flash Art* (Jan. 1983): 24.

73. Schmitz, "Keeping the Whole Thing in Motion," p. 42.

74. Gachnang, "New German Painting," p. 34. Gachnang and others who shared his views tend to undervalue the Zero and Fluxus groups and their activities in the late 1950s and 1960s, particularly in Düsseldorf, then the center of German art.

75. Peter Razceck, "Cologne: *Bilderstreit:* The Power Struggle of Post-War Art. An Interview with Exhibition's Curator Johannes Gachnang," *Journal of Art* (June–July 1989): 17.

76. Nancy Marmer, "Isms on the Rhine," *Art in America*, Nov. 1981, pp. 122–23.

77. Claude Gintz, "Polke's Slow Dissolve," *Art in America*, Dec. 1985, p. 107.

78. Ibid., p. 106.

79. Paul Groot, "Sigmar Polke," *Flash Art* (May–June 1988): 67.

80. Storr, "Polke's Mind Tattoos," *Art in America*, Dec. 1992, pp. 72, 134.

81. Groot, "Sigmar Polke," p. 68.

82. Storr, "Polke's Mind Tattoos," p. 69.

83. Gerhard Richter, "Notes 1966–1990," in *Gerhard Richter*, (London: Tate Gallery, 1991), p. 109. This passage was written in 1966.

84. Ibid., p. 112. This is from a letter to E. de Wilde, February 23, 1975.

85. Bernard Blistene, "Artistes: Mechanique et Manuel dans l'art de Gerhard Richter," *Galeries Magazine*, Apr.–May 1988, pp. 91–92.

86. Stephen Ellis, "After the Fall," *Tema Celeste* 34 (Jan.–Mar. 1992): 59.

87. There are precedents for Richter's distanced approach to expressionist facture, for example, Johns's filling in of American flags with painterly painting in the 1950s; Rauschenberg's duplication of an "action painting" in *Factum 1* and *Factum 2* (1957); and Lichtenstein's pop rendition of a brushstroke in *Little Big Picture* (1965).

88. Kenneth Baker, "Abstract Jestures," *Artforum*, Sept. 1989), p. 137.

89. Owens, "Bayreuth '82," p. 191.

90. Baker, "Abstract Jestures," p. 136. The quote comes from Roald Nasgaard, *Gerhard Richter Paintings* (New York: Thames & Hudson, 1988), p. 21.

91. Baker, "Abstract Jestures," p. 138.

92. Neal Ascherson, "Revolution and Restoration: Conflicts in the Making of Modern Germany," in *Gerhard Richter*, p. 39. In "Notes 1966–1990" Richter wrote: "Art is the highest form of hope" (p. 113).

93. Ascherson, "Revolution and Restoration," p. 38.

94. Michael Brenson, "A Concern with Painting the Unpaintable," *New York Times*, Mar. 25, 1990, sec. H, p. 39.

95. Kim Levin, "'Belief is Dangerous,'" *Village Voice*, Apr. 3, 1990, p. 98.

96. Maja Damjanovic, "Gerhard Richter," *Tema Celeste* (July–Oct. 1990): 65. Richter's *October 18, 1977* also harks back to his *Eight Student Nurses* (1966), who were murdered by Richard Speck in Chicago.

97. Isabelle Graw, "Gerhard Richter: '18 October 1977,'" *Artscribe International*, Sept.–Oct. 1989, pp. 8–9.

98. Damjanovic, "Gerhard Richter," p. 65.

99. Groot, "The Spirit of Documenta 7," p. 23.

100. Roberta Smith, "Art in Review: Jörg Immendorff," *New York Times*, Apr. 3, 1992, section C, p. 30.

101. Bernard Marcadé, "This Never-Ending End . . ." *Flash Art* (Oct.–Nov. 1985): 39.

102. Flam, "The Alchemist," *New York Review of Books*, Feb. 13, 1992, p. 31. The photographs of Kiefer in a Nazi uniform were not widely shown until 1975.

103. Groot, "The Spirit of Documenta 7," pp. 20–21.

104. Adam Gopnik, "The Art World: Alchemist," *The New Yorker*, Nov. 21, 1988, p. 138.

105. It is difficult to understand Kiefer's pictures fully without a knowledge of his iconography and quotations. Mark Rosenthal provides useful information in his detailed catalog, *Anselm Kiefer* (Chicago: Art Institute of Chicago, 1987).

106. Flam, "The Alchemist," p. 36.

10 MEDIA ART

An exhibition titled *Pictures,* curated by Douglas Crimp at Artists Space in 1977, would have a considerable impact on the art discourse—and a good deal of the significant art—of the 1980s, although this was not perceived at the time. He selected Troy Brauntuch, Jack Goldstein, Sherrie Levine, Robert Longo, and Phillip Smith because their pictures consisted of pictures whose images were appropriated from pictures.[1] Crimp was struck by pictures of pictures because, as he wrote in the introduction of the *Pictures* catalogue: "To an ever greater extent our experience is governed by pictures, pictures in newspapers and magazines, on television and in the cinema. Next to these pictures firsthand experience begins to retreat, to seem more and more trivial. While it once seemed that pictures had the function of interpreting reality, it now seems that they have usurped it." Thus "we only experience reality through the pictures we make of it." They have become our reality. "It therefore becomes imperative to understand the picture itself." Using photomechanical media as a storehouse of images and taking appropriated, secondary or simulated images as subjects, the *Pictures* artists had produced "a new kind of representation."[2]

In 1979 Crimp elaborated on what the new representation signified. The intention of the works was not to transcribe the real; they do "not achieve signification in relation to what is represented ['reality'], but only in relation to other representations ['simulations' of 'reality'].... What these pictures . . . picture is only what is always already another picture. [These] artists are, for the most part, picture-users rather than picture-makers. Their activity involves the selection and presentation of images from the culture at large."[3] (Crimp's interest in pictures of pictures was influenced by the deconstructionist idea of French philosopher Jacques Derrida that everything was a text, that there was nothing outside texts, and that texts could have significance only in relation to other texts.)

In 1980 Craig Owens added to Crimp's formulation another idea, that the *Pictures* artists were motivated by "the allegorical impulse." He wrote: "Allegorical imagery is appropriated imagery. It adds another

meaning to the image." Owens went on to say: "Troy Brauntuch, Sherrie Levine, Robert Longo [are] artists who generate images through the reproduction of other images, [each] often itself already a reproduction."4 For Owens the "allegorical impulse" was central to postmodernism, an art-theoretical formulation that provided cachet for some of the same artists that Crimp featured.

In his early essays Crimp did not spell out just how ubiquitous media imagery was. The curators of *Image World: Art and Media Culture* at the Whitney Museum in 1989 did. At the entrance of the show, a message in bold print informed American viewers that every day they were bombarded with sixteen hundred commercial messages. The catalog enumerated:

> This morning, 260,000 billboards will line the roads to work. This afternoon, 11,520 newspapers and 11,556 periodicals will be available for sale. And when the sun sets again, 21,689 theaters and 1,548 drive-ins will project movies; 27,000 video outlets will rent tapes; 162 million television sets will each play for 7 hours; and 41 million photographs will have been taken. Tomorrow, there will be more.[5]

The overwhelming number of Americans born after 1945 had been weaned on the mass media, particularly television. They had sat for hours on end every day in front of the tube, their consciousness permeated by its programming—and its commercials. So prevalent had the mass media become that many artists felt that they had come to constitute their essential experience, if not reality itself. The media had also become their formative culture. As one anonymous artist scrawled on a wall in the notorious *Times Square* show (1980), "Publicity is the culture of the consumer society."

Thomas Lawson personalized the pervasive influence of the media, asserting that

> the insistent penetration of the mass media into every facet of our daily lives has made the possibility of authentic experience difficult, if not impossible. Our daily encounters with one another, and with nature, our gestures, our speech are so thoroughly impregnated with a rhetoric absorbed through the airwaves that we have no certain claim to the originality of any one of our actions. Every cigarette, every drink, every love affair echoes down a never-ending passageway of references—to advertisements, to television shows, to movies—to the point where we no longer know if we mimic or are mimicked. We flicker around the flame of our desire, loving the comfort of repeating a well-worn language and its well-worn sentiments, fearful of losing all control to that language and the society it represents. We are trapped firmly within the terms of a fatal attraction, unable to say "no" with any conviction.[6]

Marvin Hieferman, one of the curators of *Image World*, commented that confronted with this image overload, artists dealt with the issues: "what it is like to perceive human experience through commercial images. [How do] artists respond to, deconstruct or reconstruct the material that makes up this environment. Artists have the same responses as everyone else. It's about being critical, ambivalent and awestruck."[7] Most artists who were impelled to investigate and interpret the ubiquitous mass media and their experience of it appropriated mass-media techniques and images as their artistic language.

If the art of the 1980s could be characterized by any one technique, it would be appropriation. Indeed, it was thought by art professionals to mark the watershed between modernism and postmodernism. But appropriation was not new, having had a long history in twentieth-century art. It began with Marcel Duchamp, who chose his first readymade, the mass-produced metal bottle rack, in 1913. This work called into question the definition of art, the creative action of the artist, and the value of the art work's uniqueness and originality. Since Duchamp claimed to have chosen the readymade with indifference, its very expressiveness was problematic. Despite Duchamp's intention, however, the readymade glorified the mass-produced object; it was transformed both into "art" and into an icon of industrialization. But in his choice of readymades, Duchamp played down the fact that they were commodities.

Appropriation was continued in the work of Jasper Johns. His images, such as the painted bronze ale cans, differed from Duchamp's readymades because they were remades on which Johns had lavished artistry, turning them into objects of high art. But, like Duchamp's readymades, they did not call attention to their function as commodities. Pop artists, the most extreme of whom was Warhol, also "plagiarized" their images. Unlike Duchamp and Johns, Warhol chose to portray images of commodities because of his interest in them as commodities—as icons of consumerism. He emphasized their nature as commodities by employing the technique of commercial art to duplicate them. Whereas Duchamp's artifacts referred to industrial mass production, Warhol's commodities exemplified consumption—and advertising.

If appropriation had such a long-established history, why did it become so central in the art of the 1980s? As painter and art critic Peter Plagens asked, why, "with such antecedents as Duchamp's bottle rack almost 75 years old, and with a whole generation of pseudo-deadpan Pop depictions of commercial flotsam behind us [is] this work catching on now"?[8] One extremely negative answer was given by Victor Burgin; the new appropriation was "based on the most stupid protestations of amnesia. 'I have no memory, I never knew this had been done before.'"[9] There was another, positive answer to Plagens's question. Artists of the 1980s used appropriation to interpret consumer society. As they saw it, Warhol had only broached the subject. There was much more to say—negatively, positively, and imaginatively—all of which was relevant to the time.

* * *

John Baldessari and Richard Prince were the first to make pictures from mass-media pictures. Baldessari showed the way from conceptual art of the late 1960s, which focused on aesthetic issues, to what might be called media art. In 1972 he began to use B-movie stills, combining them into composite photoworks. He did not appropriate the stills because he had any particular feeling about Hollywood, but, as he remarked: "Well, I don't go with anything in mind. I find these places that have random assortments of film stills, and I'll know it when I see it. When an image jumps out at me, then something is going on, and the job is to find out what that's about. Once I've found an image, I'll often return to it. I'll go back over it years later and notice something I had completely ignored."[10] Or, as he put it elsewhere, winnowing movie stills "gives me an idea of what's on my mind: it's a way of bringing that intuitive stuff up from below, giving it shape and finding out what it is."[11] However, Baldessari was also aware that what he chose subjectively would interest others. "I think I'm well enough attuned to culture to know what will trigger people's minds. On the other hand, I don't want to spell it out for them. . . . I like to confound people with something completely simple, artful, and on the other hand create a very complex murky troublesome piece."[12]

In recycling movie imagery, Baldessari was not interested in commenting on mass culture. Inspired by the theories of the Swiss linguist Ferdinand de Saussure about the arbitrary nature of signs, he treated texts and images—different codes or languages, as it were—as open-ended signifiers.[13] *Concerning Diachronic/Synchronic Time: Above/On/ Under (with Mermaid)* (1976) is composed of six film stills, the top two, an airplane and a bird, soaring above two shots of a motorboat, entering on the left and departing on the right, and at the bottom, a one-man submarine and a mermaid. "I wanted the work to be so layered and rich that you would have trouble synthesizing it. . . . I am asking you to believe the airplane has turned into a seagull and the sub into a mermaid during the time the motorboat is crossing. I am constantly playing the game of changing this or that, visually or verbally."[14] However, Baldessari also seemed to have some kind of narrative in mind involving pilot, bird, motorboater, submariner, and mermaid, but leaving viewers free to invent their own scenarios.[15]

Above all Baldessari investigated the verbal and visual nature of narrative. In one group of composite photoworks, *Blasted Allegories* (1978), he flip-flopped words and pictures so that any number of readings was possible. He photographed images selected at random from a television screen, using different color filters, because as he said, "The world constructed by the media seems to me a reasonable surrogate for 'real life,' whatever that is."[16] Then with the help of friends, he assigned an associative word to each image. The photographs were filed alphabetically according to the words. Each *Blasted Allegory* consisted of a series

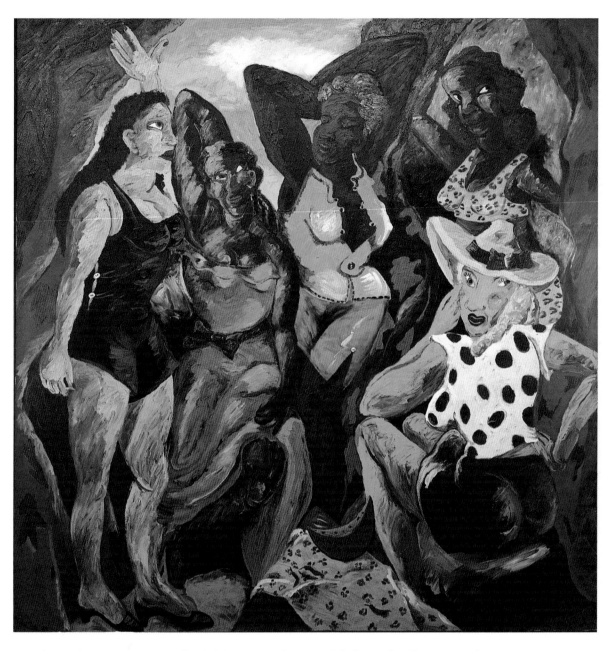

1. Robert Colescott, *Les Desmoiselles d'Alabama: Vestidas*, 1985. (*Phyllis Kind Gallery, New York*)

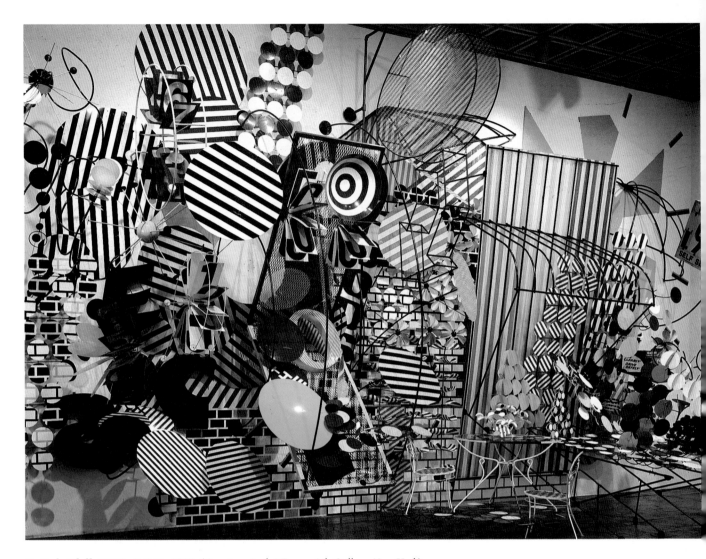

2. Judy Pfaff, *N.Y.C.–B.Q.E.*, 1987. (*Courtesy André Emmerich Gallery, New York*)

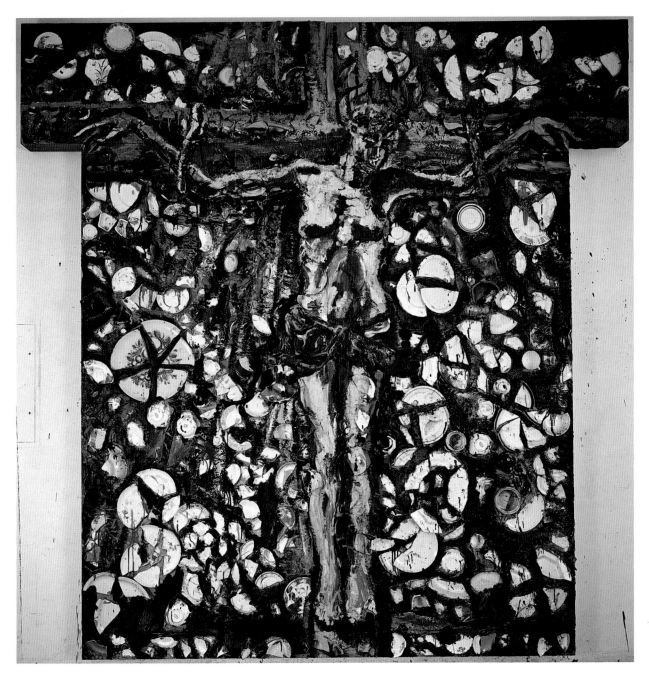

3. Julian Schnabel, *Vita*, 1983. (*Courtesy PaceWildenstein, New York*)

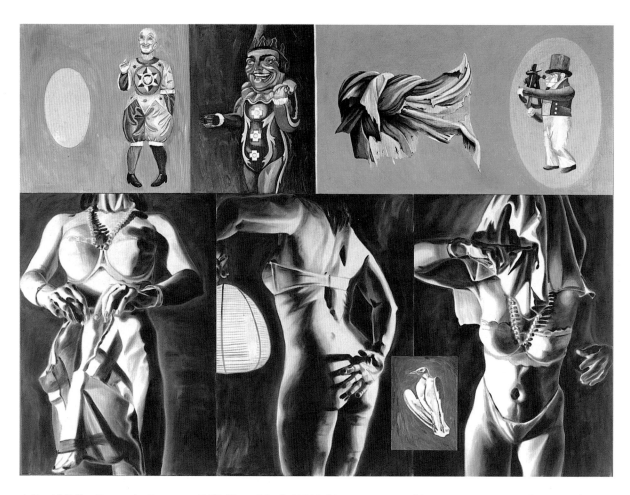

4. David Salle, *Sextant in Dogtown*, 1987. (*Copyright © 1996 Whitney Museum of American Art, New York; © David Salle/VAGA, New York, NY*)

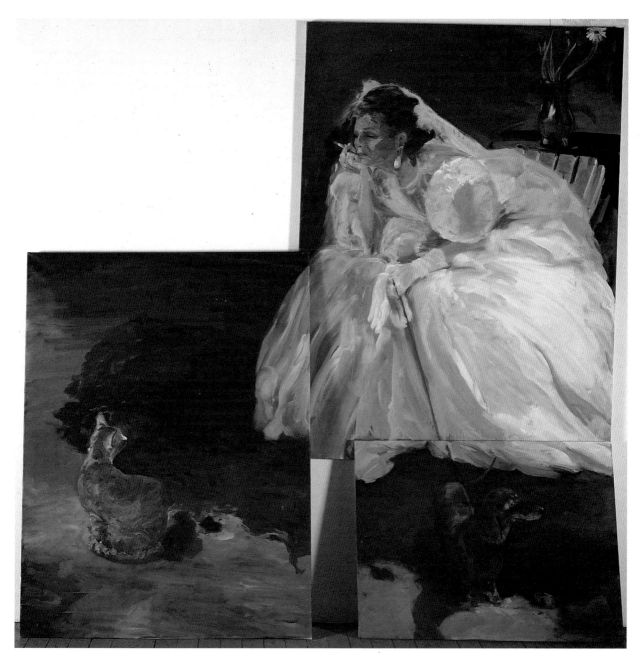

5. Eric Fischl, *Scarsdale*, 1987. (*Mary Boone Gallery, New York*)

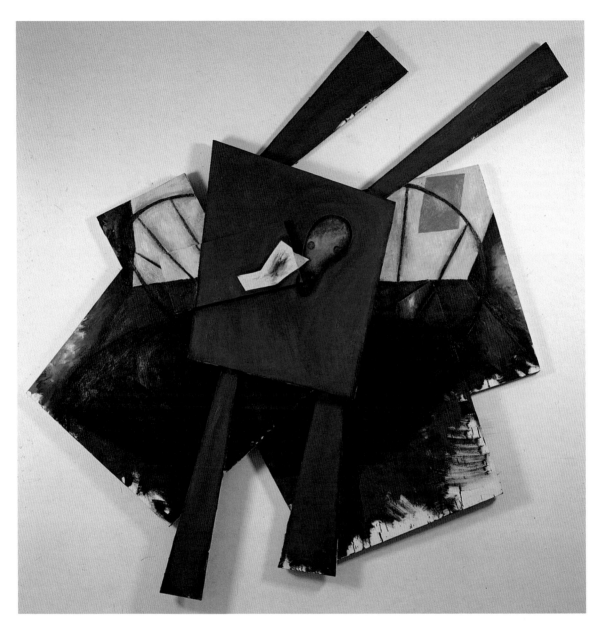

6. Elizabeth Murray, *More than You Know*, 1983. (*Paula Cooper Gallery, New York*)

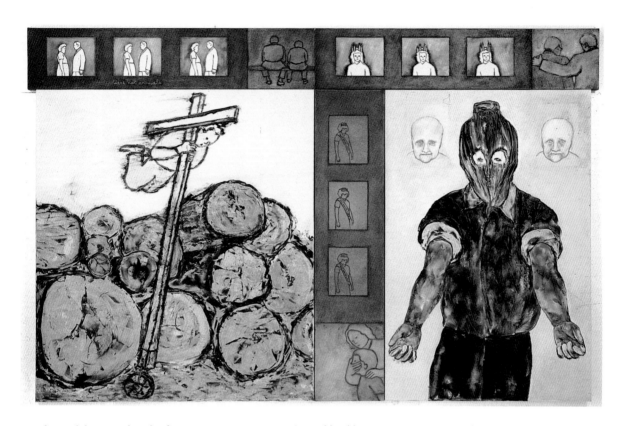

7. Ida Applebroog, *Church of St. Francis Xavier*, 1987. (*Ronald Feldman Fine Arts, New York*)

8. Cindy Sherman, *Untitled*, 1987–91. (*Courtesy Metro Pictures and the artist*)

of these photographs—like a film storyboard—selected according to an arbitrary game plan. In one sequence, for example, the images were grouped because their words had the same first letter; in another the photographs were of the same color. Baldessari had no specific narrative in mind, yet the sequence, no matter how arbitrary, suggested a story line, one that was indeterminate and open to any interpretation.

The stories in other composite photoworks were more decipherable. Composed of disjunctive fragments, they were not linear but disconnected—and unexpected. In *Violent Space: Nine Feet (of Victims and Crowd) Arranged by Position in Scene* (1976)[143], only feet appear, isolated in circles; the viewers are invited to reconstruct the event—a murder? an accident? a suicide?—from these fragments as they imagine it, to fill in the gaps in information, as it were. In *Violent Space Series: Two Stares Making a Point but Blocked by a Plane (For Malevich)* (1976), two men stand on a flat roof and gaze (presumably) at Kasimir Malevich's white square. In this work Baldessari turned purist abstraction into a narrative. Why Malevich's square? What is it hiding, if anything? What are the men in the picture looking at? Why are they looking at it in the way they are?

In the late 1970s Baldessari's narratives became more social and psychological. He said: "I try to get my work to resonate with my understanding of the world. It's paradoxical, full of ambiguities."[17] *Little Red Cap* (1982) [144] consists of a grid of cropped black-and-white movie stills and one climactic color photograph of a torn red cloth caught in the underbrush. Baldessari chose an archetypal fairy tale because it could be followed more or less easily, but he fragmented it in order to suggest deeper meanings and feelings—seduction, sex, violence, bestial-

143. John Baldessari, *Violent Space Series: Nine Feet (of Victim and Crowd) Arranged by Position in Scene,* 1976. *(Sonnabend Gallery, New York)*

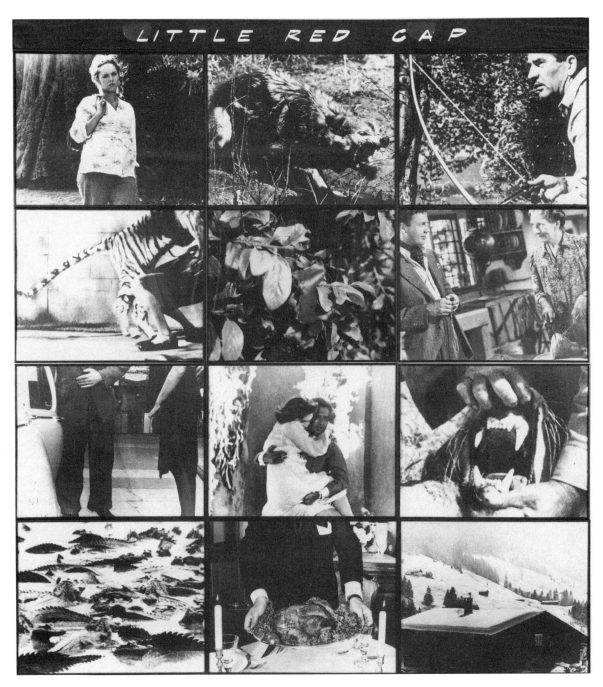

144. John Baldessari, *The Little Red Cap*, 1982. *(Sonnabend Gallery, New York)*

ity, and entrapment. In 1986 he began to mask the faces of people in his photographs with white, black, and colored circles, ascribing to each color a symbolic value: "Green, safe; red, dangerous; blue, aspirational; yellow, chaotic." In so doing he shifted the narrative from individuals to social types, notably nameless authorities: the businessman, the police chief, and so on.

Baldessari was not the first to introduce photographic images into the realm of painting and sculpture and thereby to command art-world attention. The photosilkscreen paintings of Warhol and Rauschenberg of the early 1960s, the photographs of Edward Ruscha and Wegman, the conceptual art of Kosuth, and the photo documentation of Nauman and Acconci, all provided precedents. However, because of the way in which he used mass-media imagery, Baldessari was of greater influence on leading media-minded photographers and painters of the 1980s, such as Richard Prince, David Salle, Sherrie Levine, and Barbara Kruger. Moreover, Baldessari had been an influential teacher at the California Institute of the Arts, whose students included Eric Fischl, Mike Kelley, and Salle. It is noteworthy, too, that Helene Winer, the director of Artists Space, who had proposed the *Pictures* show, was a friend.

In 1977 Richard Prince began to rephotograph captionless photographs from advertisements: expensive watches, perfumes, and other commodities and fashionable male and female models. Prince represented media images because they were "the closest thing to the real thing,"[18] as he said. Or, "What it looks like is what it is."[19] His photoworks had been anticipated by an exhibition titled *From the Picture Press* at the Museum of Modern Art in 1973. Its curator, John Szarkowski, assisted by Diane Arbus and Carole Kismaric, selected photographs published in the *New York Daily News* and displayed them without their accompanying captions or news stories. Szarkowski commented that as images without texts, "the photographs are shockingly direct, and at the same time mysterious, elliptical and fragmentary, reproducing the texture and flavor of experience without explaining its meaning."[20]

By separating images from their media context—that is, from their intended significations—Prince enabled them to take on other meanings. This led art theoreticians to claim that he dissociated motifs from their familiar frames of reference in advertising in order to deconstruct it. For example, by grouping similar images—models looking in the same direction—it was said that Prince revealed how their stereotypical poses were used for exploitative purposes in a consumer society. Put another way, through isolating bits of information, changing their sizes, cropping, repeating, and juxtaposing them, he made viewers aware of what the underlying messages in advertising were, how they functioned, and how they affected perception. Viewers were led to understand how images could be manipulated in order to seduce and deceive the public.[21] From

this point of view, Prince was treated as a social commentator whose aim was to critique commodification.

Although art theoreticians contributed considerably to Prince's success, their interpretation of his work was limited. Prince himself said that his rephotography "shouldn't be mistaken for something that's exclusively theoretical or for that matter programmatic."[22] As art critic Rosetta Brooks remarked, such words as "simulation," "dissimulation," and "appropriation" were used by the critical establishment of the 1980s "almost to the point of overkill, in attempting to contextualize Prince's art activity. And, though such terms are not at all inaccurate, they don't seem to do justice to either the art or to its context. The words are somehow too clinical, too coldly theoretical."[23] As curator Lisa Phillips observed, they overlook "expressions of fear, desires, and obsessions, not to mention the experience of visual pleasure."[24]

The images that attracted Prince were social and cultural stereotypes, but he believed that they issued from deep sources in the American psyche. In one of his essays, titled "The Perfect Tense," he described a fictional character—it could well have been himself:

> Magazines, movies, TV, and records. It wasn't everybody's condition but to him it sometimes seemed like it was, and if it really wasn't, that was alright, but it was going to be hard for him to connect with someone who passed himself off as an example or a version of life put together from unmediated matters.
>
> He had already accepted all these conditions and built out of their givens, and to him what was given was anything public and what was public was always real. He transported these givens to a reality more real than the condition he first accepted. He was never too clever, too assertive, too intellectual . . . essentially too decorative. He had a spirit that made it easier to receive than to censor.
>
> His own desires had very little to do with what came from himself because what he put out (at least in part) had already been out. His way to make it new was *make it again*, and making it again was enough for him and certainly, personally speaking, *almost* him.[25]

But Prince's "public" imagery had a "private" subjective dimension. As he wrote, "The pictures I went after, STOLE, were too good to be true. They were about wishful thinking,"[26] secret desires and dreams, not only the public's but his own.

Prince's best-known series of rephotographed photographs was pirated from Marlboro cigarette advertisements, which featured stereotypical American cowboys [145]. The image in advertisements was meant to capitalize on the cowboy's archetypal exemplification of rugged individualism. Prince did reveal the Marlboro man as a fiction, a Madison Avenue invention, but at the same time he identified with the mythic macho cowboy. Indeed, all of the figures in his pictures can be

considered "surrogate self-portraits," as Phillips commented, "all of them roles that examine masculine identity."[27]

In 1984 Prince began to use the "gang format," a term applied by photolab technicians to multi-images printed on one page. As if in keeping with the technique, he took as his subjects gangs—motorcyclists and their girlfriends, heavy-metal bands, or surfboarders—whose images he appropriated from magazines that appeal to those specialized American subcultures. Phillips remarked that the pictures are identified with "teen delinquency, and anti-social behavior—but of people living on their own terms."[28] As he said, "My 'girlfriend' gangs weren't like the Hollywood-Playboy-girl-next-door thing. The girl in my gang *is* the girl next door."[29] Prince portrayed the underbelly of American life, but just as he seemed to identify with the Marlboro man, so he identified with the bikers—in their sexual desire for half-naked "chicks" mounted in provocative poses on powerful customized motorcycles.[30]

In 1987 Prince turned from his erotic romance with the motorcycle to the equally macho automobile. He purchased "muscle-car" hoods, repainted them, and hung them on the wall as reliefs.

There are advertisements for these hoods in the backs of car magazines. You send away for them. I get them through the mail. . . . I

145. Richard Prince, *Untitled (cowboy)*, 1989. *(Barbara Gladstone Gallery, New York)*

paint them specific car colors. Tor-red. Panther pink. Grass green. Lemon twist. Plum crazy. Vitamin-C. Hugger orange. I order certain models. Shelbys, Challengers. Chargers.

There's a lot of extended adolescence in the work. Some of these cars like that Challenger and Charger were in movies like *Vanishing Point* and *Bullitt*. I don't think it was an accident that Dennis Hopper was driving a '69 Charger in *Blue Velvet*.[31]

But the hoods also made shrewd references to pop art, minimal sculpture, and hard-edge and color-field abstraction.[32]

In 1985, while working on the "gangs," Prince had begun to redraw cartoons. Redrawing existing drawings was related to rephotographing photographs and repainting hoods, but it enabled him to introduce his "hand" into his works, and—with an eye toward Twombly's "graffiti"—to make them more personal, as it were. He said: "The jokes came out of drawing the cartoons. I wanted to draw and I liked the way certain cartoons were drawn. So I decided to redraw the ones I liked. . . . I drew a lot of Whitney Darrow cartoons." But Prince also drew the punch lines without the cartoons. "I started calling these cartoon drawings 'jokes' and realized I was calling them wrong. So I started to forget about the cartoon image and just think about the text or punch line. I checked out joke telling books. I picked out about a dozen jokes . . . ones that were familiar, the ones that get retold, and wrote them out, by hand, on small pieces of paper. Paper and pencil. Pencil on paper."[33] One recurring joke read: "I went to see a psychiatrist. He said: 'Tell me everything.' I did, and now he's doing my act." In a series of pictures of 1993, Prince silkscreened single jokes in sans-serif typeface on monochromatic fields. They were clearly influenced by pop art; Baldessari's late 1960s conceptual paintings, in which he had printed texts spoofing formalist art; and Edward Ruscha's word-pictures. Like Prince's hood reliefs, however, they also referred to minimal art and color-field and hard-edge abstraction.

As for his intention, he said:

I live here. I live in New York. I live in America. I live in the world. I live in 1988. It comes from doing cartoons. It comes from wanting to put out a fact. There's nothing to interpret. There's nothing to appreciate. There's nothing to speculate about. I wanted to point to it and say what it was. It's a joke. . . .

I work with about fifteen jokes. . . . A lot of jokes have to do with the relationships between men and women, men and men, and women and women.[34]

The word-images looked simple, as simple as Prince claimed they were, but they—and the cartoons—lent themselves to a variety of complex interpretations. His jokes came not only from the media but from

146. Richard Prince, *What a Kid I Was*, 1989. *(Barbara Gladstone Gallery, New York)*

American "folk" humor and bantering, and perhaps from some deeper stratum in the national unconscious. They often dealt with cuckoldry—dirty old boss chasing young buxom secretary interrupted by wife—an archetypal theme in Western culture, certainly going as far back as medieval fabliaux. Art critic Jerry Saltz thought that there was a deeper meaning to Prince's pictures of jokes and cartoons: "Prince ironically observes society malevolently laughing at itself and others—how it makes fun of women, homosexuals, and politics in particular, but also the drunk, the stupid, and the unfortunate in general. . . . Prince has succeeded in revealing the true emotional content of the jokes—malevolence and anger."[35]

After 1985 Prince mixed and layered cartoons and their captions in a growing profusion of shuffled images and punchlines [146]. In a series of *White Paintings*, begun in 1990, he recombined his earlier images in seemingly endless permutations, in a process, as he said, analogous to

"sampling" employed by rap musicians. The resulting mélange, as Phillips observed, seemed "diaristic," the issue of "a stream of consciousness."[36] Paradoxically, the more profuse Prince's imagery became, the more fragmented, disjunctive, and illegible—and consequently abstract—the more it called attention to the felicities of formal arrangements and drawing.

The rephotography that Prince introduced became a popular technique in the 1980s, but that was only one reason for his influence. As collectors B. Z. and Michael Schwartz, in an interview with Peter Halley, said: "Prince is the absolute seminal figure. [His] work functions on so many different levels and has so much to do with the traditions of modernism, photography, Conceptual Art and Pop Art. Yet it branches out into a whole new way of seeing."[37]

NOTES

1. Helene Winer, in an interview with Irving Sandler, New York, Oct. 11, 1991, reported that David Salle would also have been in the show, but he had recently shown at Artists Space, and a gallery rule disqualified him. John Baldessari was missing because he was too established to show at Artists Space, but he was dealt with in the catalog as an influential figure. Winer could not recall why Richard Prince was not included, but he should have been. There may have been one or two more artists working with media imagery, but no more.

2. Douglas Crimp, "Pictures," *Pictures* (New York: Artists Space, 1977), pp. 1–2.

3. Douglas Crimp, "About Pictures," *Flash Art* (Apr.–May 1979): 34.

4. Craig Owens, "The Allegorical Impulse: Toward a Theory of Postmodernism," *October 12* (Spring 1980): 69.

5. Marvin Heiferman, "Everywhere, All the Time, for Everybody," in *Image World: Art and Media Culture* (New York: Whitney Museum of American Art, 1989), p. 17.

6. Thomas Lawson, "A Fatal Attraction," *A Fatal Attraction: Art and the Media* (Chicago: Renaissance Society at the University of Chicago, 1982), p. 3.

7. Saul Ostrow, "Marvin Heiferman," *Bomb* (Fall 1989): 48, 52.

8. Peter Plagens, "Issues & Commentary: The Emperor's New Cherokee Limited 4 × 4," *Art in America*, June 1988, p. 24.

9. Gregorio Magnani, "Victor Burgin," *Flash Art* (Nov.–Dec. 1989): 121.

10. Christopher French, "Blasted Allegories, Fugitive Essays: The Conceptual Images of John Baldessari," *Journal of Art* (Oct. 1990): 12.

11. Hunter Drohojowska, "No More Boring Art," *Art News*, Jan. 1986, p. 65.

12. Marc Selwyn, "John Baldessari," *Flash Art* (Summer 1987): 64. Selwyn suggested a parallel between Baldessari's work and David Lynch's movies, and Baldessari strongly agreed.

13. See Craig Owens, "Telling Stories," *Art in America*, May 1981, pp. 132, 134.

14. Drohojowska, "No More Boring Art," pp. 63–64.

15. Baldessari's work was often classified as story art. Other artists so labeled were David Askevold, Bill Beckley, Robert Cummings, Peter Hutchinson, William Wegman, and Roger Welsh.

16. Drohojowska, "No More Boring Art," p. 65.

17. "Guide to Room 6": *John Baldessari Exhibition*, Whitney Museum of American Art, New York, 1991.

18. Rosetta Brooks, "Spiritual America: No Holds Barred," *Richard Prince* (New York: Whitney Museum of American Art, 1992), p. 85.

19. Roberta Smith, "Review/Art: Richard Prince, Questioning the Definition of Originality," *New York Times*, May 8, 1992, sec. C, p. 32.

20. John Szarkowski, introduction to *From the Picture Press* (New York: Museum of Modern Art, 1973), pp. 5–6. Szarkowski was equally interested in the formal dimension of photography, which is emphasized when the image is shorn of any accompanying text.

21. Jerry Saltz, "Notes on a Drawing: Sleight/Sight of Hand: Richard Prince's *What a Business*, 1988," *Arts Magazine*, Jan. 1990, p. 13.

22. Richard Prince, *The Velvet Well*, 1982, manuscript, quoted in Lisa Phillips, "People Keep Asking: An Introduction," *Richard Prince* (New York: Whitney Museum of American Art, 1992), p. 33.

23. Brooks, "Spiritual America: No Holds Barred," p. 85.

24. Phillips, "People Keep Asking: An Introduction," p. 33.

25. Richard Prince, "The Perfect Tense," in Brian Wallis,

ed., *Blasted Allegories: An Anthology of Writings by Contemporary Artists* (New York: New Museum of Contemporary Art, 1987), p. 414. (Italics in original.)

26. Brooks, "Spiritual America: No Holds Barred," p. 85.

27. Phillips, "People Keep Asking: An Introduction," p. 35.

28. Ibid., p. 38.

29. Larry Clark, "Interview," *Richard Prince* (New York: Whitney Museum of American Art, 1992), p. 130.

30. See Majorie Welish, "Who's Afraid of Verbs, Nouns, and Adjectives?" *Arts Magazine*, Apr. 1990, pp. 80–81.

31. Clark, "Interview," p. 135.

32. Tiffany Bell, "Reviews: Richard Prince," *Art News*, Apr. 1990, p. 162.

33. Clark, "Interview," p. 131.

34. Richard Prince, interviewed by Elisabeth Sussman and David Ross, in *The BiNational American Art of the Late 80's* (Boston: Institute of Contemporary Art and Museum of Fine Arts, 1988), p. 164.

35. Saltz, "Notes on a Drawing," pp. 13–14.

36. Phillips, "People Keep Asking: An Introduction," p. 45.

37. Peter Halley, "B. Z. & Michael Schwartz," *Galeries Magazine*, Feb.–Mar. 1989, p. 121.

11 POSTMODERNIST ART THEORY

The way in which John Baldessari, Richard Prince, and the artists in the *Pictures* show made pictures of pictures interested not only Douglas Crimp and Craig Owens but other art critics who wrote for a new quarterly art-theoretical journal named *October*, founded in 1976. It promoted the *Pictures* aesthetic as part of a campaign it waged against formalism and modernism using as its weapons postmodernist ideas and approaches culled from the writings of Roland Barthes, Jacques Derrida, Michel Foucault, Jean Baudrillard, Jacques Lacan, and other French intellectuals.[1]

Formalism had had powerful enemies in the sixties, when it dominated art discourse. But in the following decade it came under even more intense and sustained attack by a new generation of artists, critics, historians, and other art professionals. This was signaled as early as 1970, when a group of radical art historians and critics who formed a New Art Association, in opposition to the College Art Association, issued a newsletter declaring:

> We are against the myth of the neutrality of art.
>
> We deny that esthetic experiences flow only into further esthetic experiences, for we believe there is a firm tie between the artistic imagination and social imagination.
>
> We object to the study of art as an activity separated from other human concerns. . . .
>
> We are against the reduction of art to an object of speculation and an ornament for exploiters. . . .
>
> We are against the artificial segregation of the study of art from other disciplines—anthropology, history, etc.—and its careful protection from social issues. We are against the fragmentation of knowledge which suppresses the real implication of our cultural heritage by providing an ideology which upholds the racist, patriarchal and class structure of our society.[2]

The New Art Association's manifesto was formulated at the height of the Vietnam War, and it reflected the politicization of the generation of young scholars that questioned the basic assumptions of every intellectual discipline. This questioning, or critical theory, as it came to be called, can be viewed as the legacy of sixties radicalism—but in retreat from political activism into academic discourse. The issues raised by critical theoreticians would dominate the art-critical and art-historical agenda for the next decade and a half.

Formalist critics, led by Clement Greenberg and his dwindling coterie, rebutted, to be sure. They continued to claim that the artwork was an autonomous object and that critics ought to focus on its formal properties and ignore extraformal issues. Art should not be relegated to the illustration of social history or critical theory. The focus ought to be on detailing the aesthetic components of individual works, and their quality, even if the latter could not be specified. Formalists denigrated art critics who subjected art to theory by claiming that they lacked the sensibility to experience the visual and sensuous dimensions of art, and therefore imposed an arbitrary extra-aesthetic order and limit on art, both distancing themselves from it and falsifying it. There was, after all, *painting* in painting. How could it be ignored? As a letter writer to the *New York Times* maintained, "It's like hearing that a convocation of eunuchs has declared that there's no such thing as sexual pleasure."[3]

Many formalists acknowledged that expectations and preferences in art were conditioned in part by social circumstances and ought to be examined, but required that art be viewed primarily as art. Some formalists even granted that aesthetic quality issued in part from a specific culture and its history and assumptions about what was worthwhile. But all insisted that aesthetic quality did exist, that it could be appreciated beyond the culture in which the art was produced, that it could transcend the politics and class interests of any particular place and time, and that, at its best, it could even have universal appeal.

But fewer and fewer young critics, scholars, and intellectuals seemed to be listening to formalists of any persuasion. Instead, they saw an unbridgeable rift between art critics, who paid close attention to what was *within* the frame of the work of art, that is, its formal components, and art theorists, who looked *beyond* the frame to the social, economic, and political context within which art came into being and whose institutions it served. Art theorists paid particular attention to class and gender, which they claimed shaped art. They shifted critical attention away from the particular work of art to its social context, claiming that art could be understood only by investigating the extra-aesthetic circumstances within which it was produced and exhibited. Above all, they insisted that what counted most in art was what it represented. Representation was defined as the complex of images and texts through which a society represents itself—images and texts that have become so ingrained as to be

accepted without question. The work of art was treated as a kind of "text" leading to a discourse on representation. Instead of focusing on the singleness of the art object, art theoreticians dealt with its multiple contexts, with the polyvalence of meaning, with intertextuality—more specifically, with the patronage of art, the class interests served by it, and its relation to popular culture. This resulted in a considerable diversity of approaches among art theorists. They analyzed the content of art from the often conflicting perspectives of Marxism, feminism, history (rather than art history), sociology, psychoanalysis, semiology, and linguistics. But they all agreed that art was essentially about representation, not formal issues.[4]

Attacks on conventional art history and criticism intensified as the 1970s progressed, particularly as feminist art theory developed in scope and persuasiveness. But established thinking was not easily subverted, or so dissident art professionals believed. For example, in 1975 Amy Goldin wrote: "American art history [has been] called elitist, racist and sexist. The charges stick." She also commented: "Taste and artistic quality are presented to students as inalienable attributes of persons and things respectively. But the social and theoretical basis of that usage is not questioned. . . . Surely art can be considered a matter of social practice. Objects can be seen in terms other than what historians recognize as their artistic value." Surveys purporting to be general and universal are in actuality "histories of Western European art . . . specialized and parochial, devoting little or no space to Islamic, African or pre-Columbian art"[5]—not to mention art made by women, African-Americans, Latinos, and other minorities.

The transformation of art criticism was dramatically highlighted at the end of 1975 when leading contributors to *Artforum,* the bastion of Greenbergian criticism, rejected formalism and embraced a sociological approach to art. Max Kozloff, its new editor, with the support of John Coplans, its executive editor, introduced a series of articles dealing with the issue of who controls "visual statements, and for what purposes?" Kozloff concluded: "There is no escape from ideology, either in the creating or the interpreting of art."[6] Hilton Kramer went on the attack in the *New York Times,* accusing *Artforum* of "a muddled and strident Marxism, insistent upon a tendentious sociopolitical analysis of all artistic events and deeply suspicious of all esthetic claims."[7] David Bourdon seconded Kramer, declaring that *Artforum* "is now less interested in art than in its sociological framework."[8]

In a rejoinder to Kramer, Coplans and Kozloff defended their "critical attempt to link art with the historical and political realities of its viewers." They attacked Nazi, Stalinist, and Maoist suppression of the "free imagination" and then criticized the Western "myth of unlimited artistic freedom. . . . This false state of mind engendered a dehydrated formalism that attributes an immaculate autonomy to art. Such a doc-

trine effectively proscribed psychic input, ethnic and sexual nourish-
ment, narrative interest, and the political dissent upon which a work
might be founded." If art criticism did not confront such issues, "it
merely support[ed] the market,"[9] and ended up being either naive or cyn-
ical. In a later article titled "Art Is a Political Act," the two editors of
Artforum reaffirmed its "move toward sociopolitical analysis," and partic-
ularly its critical treatment of "the market system and institutional struc-
tures of the art world [and its] complacent, decaying agencies and shop-
worn myths."[10]

Kozloff and Coplans were not permitted to pursue their editorial
policy for long. Charles Cowles, the publisher, pressured by advertisers
and aware of considerable art-world concern about a decrease in the
number of articles on current art, did not renew Coplans's contract after
December 1976. Kozloff resigned the following month and was replaced
by Joseph Masheck. In a letter to *Artforum* in March 1977, more than
one hundred artists and art professionals protested the "dismissal and/or
provoked resignation of John Coplans and Max Kozloff."[11] Although they
lost their jobs, their editorial position anticipated a general reorientation
of art criticism.

When Kozloff and Coplans took over *Artforum*, Rosalind Krauss
and Annette Michelson resigned as editors.[12] In the spring of 1976 they
and Jeremy Gilbert-Rolfe founded *October*. With their contributions and
those of Douglas Crimp (who became the editorial associate and then
managing editor), Craig Owens, Benjamin Buchloh, and others, *October*
became the major art-theoretical journal in the United States. Its intel-
lectual concerns were also echoed in articles in *Art in America* by Owens
and Hal Foster, who began to write for the magazine in December 1981
and January 1982 respectively.

October was named in "celebration" of the Russian Revolution of
October 1917, which, as its editors announced, was "that moment in our
century when revolutionary practice, theoretical inquiry and artistic
innovation were joined in a manner exemplary and unique." The name
was also meant to commemorate Sergei Eisenstein's film *October*
(1927–28), which memorialized the revolution.[13] Moreover, the title was
chosen to suggest that film was to be a major area of inquiry in *October*.
The editors hoped that their journal would emulate the Bolshevist artists'
attempt to fuse avant-garde art and Marxist ideology and practice.
Indeed, *October*'s credo, which appeared on the cover of every issue, was
"Art/Theory/Criticism/Politics." The journal did not espouse any specific
political program; implicitly it stood opposed to the existing capitalist
social order, "within a time of growing reaction."[14] *October* also aimed to
challenge art institutions and their aesthetic canons. But underlying its
oppositional stance was disgust at what Charles Jencks once termed
(sympathetically) "the image of the bourgeoisie triumphant and enjoying
itself."[15] Explicitly *October* featured artists whose content was "political"
and who worked in mechanical media. The journal's policy recalled that

of the Russian constructivists and more specifically, its productivist members, who undertook a pervasive critique of existing culture. Finding traditional handmade media, particularly painting, tainted by bourgeois appetites and expectations and inadequate as revolutionary tools, the productivists rejected them in favor of photography, film, typography, and poster design, all of which lent themselves to propaganda and its wide dissemination. The constructivists embraced abstraction, but to their dismay, they found that the masses did not understand, much less appreciate, their nonobjective art. Nor, when Stalin took power, did the state allow it, and they were suppressed.

Like the productivists, the writers for *October* called for an art of "radical" content and rejected painting in favor of photography and other mechanical media. But the Americans recognized that they were "members of a middle-class intelligentsia with no illusion of a revolutionary mission," as Michelson remarked,[16] and no vision of a future utopia. Neither were they threatened with Stalinist censorship and persecution, as the Russian avant-garde and their supporters had been. Moreover, the contributors to *October* understood that their chosen constituency was not the masses but left-leaning colleagues. The *October* coterie was not composed of revolutionists without a revolution, as Floyd Dell characterized Greenwich Village bohemians in the earlier part of the century, but bourgeois liberals who embraced a radical rhetoric.[17] However, the contributors to *October* had lived through the turbulent Vietnam War protests, the student uprisings of 1968, and Watergate, and were deeply affected by these traumatic events. Consequently, they were suspicious of, if not hostile to, all established institutions and their received canons, justifications, and representations.

Above all the *October* critics rejected formalism, which had been the established art theory and which, they believed, had become so overworked that it could contribute only minor glosses to art discourse. Krauss was especially sensitive to this since she had been a disciple of Greenberg. But she and Michelson had discovered alternative ideologies with the intellectual cachet that formalism had once had, namely the new and increasingly fashionable postmodernism and poststructualism.[18] In place of Greenberg, they ensconced the French theoreticians, especially Derrida and Barthes, who had analyzed the ideological assumptions and implications of signs and language, literature, and literary criticism.

For literary critics who turned to theory, "assumptions that were once agreed on . . . became controversial. [We] no longer share the tacit agreement we once did about basic words—'literature,' 'culture,' 'meaning,' 'value,' 'tradition,' 'author,' 'reader,' 'text,' you name it."[19] In the debate over fundamental literary assumptions and definitions, as cultural critic Edward W. Said observed, "old categories . . . have lost their intellectual authority. The notion of literature itself has been eroded, so that film, media, popular culture, music, and the visual arts have entered

the once sacrosanct field of literary text. Literature has admitted Third World, Afro-American, feminist writing in contrast to Eurocentric texts."[20]

The editors of *October* felt that they were in the same situation as the literary theorists. In a 1981 editorial, Michelson wrote that the "journal was taking shape [in] a difficult transitional moment in which the modernist canon, the forms and categories which had defined it, the practices for which it provided a framework of intelligibility, were everywhere in question." Basic aesthetic terms, such as "quality," "originality," "authenticity," and "transcendence" had become problematic as never before. Michelson called for the critical analysis of postmodernism and the support of theoretically significant contemporary art.[21]

The primary goal of critical theorists was decentering, that is, getting rid of anything that implied a center or hierarchy. They disputed the idea of a mainstream in modernist art and in Western culture generally, and the primacy of Western culture in world culture. They also denied the central role of any patriarchal figure, such as the genius. The focus, then, was on the margins, on marginality, on what was repressed, on the "other," as it were. The favorite method of achieving decentering was deconstruction.

Derrida, who first formulated deconstruction, argued that self and society are constructs of, and circumscribed by, language. Everything is a text, and there is nothing outside the text. But language is unstable at its very core because, as Ferdinand de Saussure had pointed out, there is no single, inherent, or "privileged" match between any signifier (for example, the word "tree") and what it signifies (for example, any particular tree or idea about a tree).[22] The possible interpretations of a signifier are unlimited. Consequently Derrida conceived of language as an endless play of signifiers that could not yield any coherent sequence or objective truth. It lacks ultimate meaning, or to put it another way, its meanings are perpetually deferred.

Moreover, texts were unstable not only because language was unstable, but because they contained discrepancies. The primary purpose of deconstruction was to probe a text for its conflicting assumptions, premises, and self-deceptions with the intention of revealing that the text does not necessarily mean what it claims to. Indeed, its hidden or repressed meanings are more often than not in opposition to its overt intentions. Deconstructionists were intent on unearthing and recovering these marginal meanings. In the past, students of literature were trained to disregard and explain away "contradictions, obscurities, ambiguities, incoherences, discontinuities, ellipses, interruptions, repetitions, and plays of the signifier," as David Lehman wrote. Not any more. Deconstruction would expose these "hidden" contradictions and call the text to account.[23]

The device deconstructivists most often used to disclose dubious assumptions was to identify a key, primary, or "privileged" term in a text

and pit it against a secondary, binary, or "marginal" term, with the aim of inverting—and decentering—the terms. The purpose was to prove that the binary or marginal term is more significant, or at least to establish an unstable relationship between one term and the other. In transposing "the marginal to the center," the claim was made "that the work itself meant the opposite of (or at least 'called into question') the very manifest meaning it appeared to convey."[24] For example, "originality" and "copying" (or repetition, or employing received codes and conventions) are binary terms. If originality was deemed central to modernist art, then deconstructionists would claim that copying was equally if not more important. If originality was identified with painting and copying with photography, an art of mechanical reproduction, and if painting was generally considered the premier art, then deconstructionists, by an act of inversion, would replace painting with photography as the premier art. All established assumptions could be inverted; for example, that in the visual arts the visual took precedence over the verbal, or the spatial over the temporal. Art theorists proclaimed the primacy of the verbal in the visual arts, and thus provided a rationale for conceptual art. They also asserted the primacy of the temporal over the spatial, establishing a rationale for "theatricality" in the visual arts.

In a radically new conception of literary creation, Barthes proclaimed the death of the author (or artist). He attacked "the image of literature to be found in contemporary culture [because it] is tyrannically centered on the author, his person, his history, his tastes, his passions. [The] *explanation* of the work is always sought in the man who has produced it, as if . . . it was always finally the voice of one and the same person, the *author*, which delivered his 'confidence.'" Barthes conceived of literature as a body of texts, "a multi-dimensional space in which a variety of writings, none of them original, blend and clash."[25] The function of the writer was to enter that space, appropriate what had already been written, and provide glosses on it. Instead of being original and unique creations by individuals, works of art became texts that comment on texts. In this sense the author becomes "the creature of writing, rather than its creator."[26] Thus Barthes replaced the creative imagination of the individual with language.

As novelist David Lodge summed it up, from a deconstructionist point of view "there is no such thing as an author, that is to say, one who originates a work of fiction *ab nihilo*. Every text is a product of intertextuality, a tissue of allusions to and citations of other texts. There are no origins, there is only production, and we produce our 'selves' in language. Not '*you are what you eat*' but '*you are what you speak*' or, rather '*you are what speaks you.*'"[27] Other theorists would soon substitute for language history, or society. Art critic Brian Wallis summed it up by saying that the issue was no longer "'What do I, as a creative individual think? What am I feeling? And how do I construct the world?' but rather and conversely, 'How does the world construct me?'"[28] Theorists would

also substitute for Barthes's author the male patriarch or macho male, the capitalist entrepreneur, God, or any authoritative figure, and proclaim the death of all of them.

Criticism's function was no longer to decipher "the Author . . . beneath the work" but to interpret the text. If the author's (or artist's) intention no longer counted, and if a text's meaning could never be fixed and was open to endless interpretations, how was a text to be interpreted and, equally important, by whom, and whose intepretation counted? The answer was the reader (or viewer). As Barthes put it: "The birth of the reader must be at the cost of the death of the Author."[29] Meaning was therefore to be found not in the work of art but in the interpretations of its readers, whatever they were. Any interpretation a reader offered was as true or significant as any other. In theory—but not in practice—there was no "privileged" interpretation. This elevated the creative function of the reader at the expense of the author. Indeed, deconstructionists proclaimed that the reader had replaced the author as "creator," as it were.

Literary critic Morris Dickstein characterized the first phase of deconstruction as one of a "pervasive skepticism, sometimes bordering on nihilism."

> With Derrida's dictum that everything was a text, that "nothing is outside-the-text," both self and society became simply constructs of language, arbitrary verbal categories, dim referents in a ghostly allegory of texts about texts, language about language. Since there was no criterion of truth in interpretation, only the assurance of a multiplicity of readings, all meaning was rendered unstable and all reading became a form of misreading.

The pervasive skepticism of deconstruction had its value. As Dickstein pointed out, "It has made us more aware of the contingent and subjective nature of all interpretation, the degree to which our categories of understanding, grounded in language, conditioned all our reading." But deconstruction also had its pitfalls. It often led to a self-indulgent and frivolous if imaginative play with signifiers for the sake of play—play that bore little relationship to a literary work.

At first deconstruction was apolitical, but as Dickstein pointed out, to a politicized generation "it is but one step from the deconstruction of language to the critique of ideology. Thus deconstruction has helped engender . . . a resurgence of social and cultural criticism, including Marxism [and] feminism, all flirting dangerously with the idea that there is a world *outside* the text that is nevertheless inscribed *in* the text."[30]

Deconstruction was also central to postmodern theory. To recapitulate, the discourse on postmodernism had begun in architecture, but it soon assumed literary, sociological, and psychoanalytical dimensions. On the one hand postmodern criticism incorporated poststructuralist literary theory. On the other hand, it encompassed social theories about the

evolution of capitalist society from an industrial to a postindustrial stage and the concomitant progression of culture from modernism to postmodernism. It did not take long for the literary and sociological approaches to be linked—as they were in *October*.[31]

Critical theorists sought to unmask representation, which cultural critic Jacob Bercovitch defined as "the system of interlinked ideas, symbols, and beliefs by which a culture . . . seeks to justify and perpetuate itself; the web of rhetoric, ritual, and assumptions through which society coerces, persuades, and coheres."[32] These ideas—and images—among them conceptions of class, gender, and race, are fictions constructed by social agencies such as the mass media, whose purpose it is to safeguard the status quo. Such fictions are assumed to be the natural order, or if not quite that, then images of social consensus. Put another way, representation consists of our ideological assumptions about family, society, nation, race, gender, law, culture, and religion, which we simply accept without question. The public is conditioned to accept a certain kind of representation, which is reinforced by the schools, the churches, the courts, and other social agencies as well as by the mass media. In the 1970s a significant number of artists and their art-theoretical supporters aimed to deconstruct—that is, unmask and demystify—the ways in which the existing social order represented itself. Their purpose was to expose it not as natural but as an artificial construction formulated and perpetuated by the ruling class through its control of social agencies and the means of communication.

The radical turn in the thinking of young intellectuals was provoked by the Vietnam War protests and the student uprisings of 1968. Dickstein observed that these events "provided much of the impetus as well as the footsoldiers for the explosion of literary theory in the 1970s. Now the strategies of confrontation that had failed in the streets succeeded on the page."[33] Literary critic Terry Eagleton agreed: "Post-structuralism was a product of that blend of euphoria and disillusionment, liberation and dissipation, carnival and catastrophe, which was 1968. . . . Unable to break the structures of state power, post-structuralism found it possible instead to subvert the structures of language. Nobody, at least, was likely to beat you over the head for doing so."[34] Deconstruction came naturally to young academics: During the Vietnam War and the Watergate affair, they had been deceived so often by official rhetoric that they habitually looked for an alternative reading.

Poststructuralism in both literary and art criticism was also attractive to young scholars because it provided fresh—and trendy—approaches that opened up vast new areas of investigation and speculation. The unexpected meanings yielded by the deconstructive reversals of binary terms, namely the elevation of the "marginalized" secondary term over the primary one, could be exhilarating. Moreover, deconstruction theory elevated the enterprise of young academics-as-readers over that of

authors or artists, since they could reveal "repressed" material of which authors or artists themselves were allegedly unaware. Although according to deconstruction theory no interpretation was superior to any other, in practice it did not work out that way. Art theorists established themselves as privileged readers.

Poststructuralism provided theories and methods with which to challenge established and presumably old-fashioned thinking—approaches used by young academics to bid for intellectual leadership and tenure. Moreover, deconstruction's occupation with marginality was appealing to young scholars who were marginalized in academe. Those on the political left, and most were, also empathized with other marginalized groups—women, people of color, gays—in a word, the "other."

The editors of *October* used art theory to gain art-world power, and they were expert at playing art and academic politics. Much as Krauss rejected formalism, she had learned from Greenberg how to acquire tastemaking power: Assume an identifiable aesthetic position with a relatively few identifiable premises, repeat them again and again until they seem "natural," and apply them to a relatively few privileged artists, whose work, with some exceptions, seems closely related to and even illustrates the art-critical premises. At the same time identify an opposing aesthetic and attack it vehemently or dismiss it as beneath serious consideration.

Krauss's strategy was to embrace postmodernism, denounce modernism as the enemy, and use a deconstructive method to repudiate it. She also promoted aggressively artists who employed mechanical media, especially photography, as opposed to artists who produced handmade objects—above all, paintings.[35] The sixties artists featured by Krauss in *October* were the postminimalists she had embraced when she rejected formalist criticism—Robert Smithson, Robert Morris, Carl Andre, Richard Serra, Sol LeWitt, Vito Acconci, Hans Haacke, and Daniel Buren. In her choice of eighties artists Krauss favored those who employed photography—Sherrie Levine, Robert Longo, Cindy Sherman, and Louise Lawler. Their work could readily be justified as the fulfillment of art theory.

Having established her art-theoretical premises and identified the artists who fulfilled them, Krauss dismissed most other art as retrograde—the revival of traditional tendencies—or venal—"the production of luxury objects for consumption and investment, often . . . by multinational corporations."[36] Craig Owens, an *October* insider, inadvertently revealed how Krauss's tactics worked. She claimed membership in the critical avant-garde "on the basis of her embrace of the structuralist contention that cultural production is primarily a matter of codes and conventions, rather than of such discredited concepts as 'intentionality,' 'originality,' 'subjectivity,' etc." But more than that, she claimed to represent "a generation of American critics, although I must add, not for the most part critics concerned with the visual arts."[37]

Owens went on to discuss Krauss's treatment of critics who did not agree with her approach. They were dispatched in a special issue of *October* edited by Krauss, titled "Art World Follies, 1981" and "dedicated (according to an editorial preface) 'to knaves and fools, with an emphasis on the latter.' [She claimed] that 'foolishness has become the medium through which almost every transaction in the art world is conducted.'" Owens then asked: "What is the reader to do . . . with the implausible suggestion that the entire art world (with the exception of a few enclaves, such as that occupied by *October*) had suddenly succumbed to an epidemic of 'foolishness'?"[38] Used this way, art discourse became an instrument of intimidation and exclusion.

Owens also asked what the reader was to do with the bad faith of those who, in something of a deconstructionist inversion, speak "from a position of authority" while at the same time repudiating it.[39] (Owens himself was accused of doing just that.) Ratcliff targeted this aura of authority assumed by art theoreticians, particularly those who denied that art theory was secondary to art making and claimed it to be equal, if not superior. He commented that in order to deny the significance of the artist-as-creator, or, as he put it,

> the creative essence and absolute power of the Romantic ego and its modernist descendants. . . . Hal Foster, Benjamin Buchloh, Craig Owens and other art theorists displace the creative ego's functions to the structures of language, ideology, history—themes over which these writers exercise impressive rhetorical control. Shaping and reshaping definitions of their times, they take (imaginary) possession. . . . The art theorists would like to become the intellectual proprietors of the postmodern era.[40]

While rejecting the conception of the artist as creative genius, *October* made the art theorist an interpretive genius, at the same time denying the existence of genius. It often seemed that preening art theorists had become power-hungry self-servers. Eric Fischl thought so; as a participant in a panel discussion in 1983, he claimed that fellow panelist Owens "would love nothing more than to replace the word 'artist' with the word 'critic.' We won't play, Craig."[41] Fischl might have added that art theorists had little if any understanding of what artists actually did.[42] The pathological arrogance, not to say silliness, of elevating theory over art was clear if only one asked which theorist was the equal of or superior to an Elizabeth Murray or a Cindy Sherman.

The contributors to *October* came under attack for other reasons. Their practice of promoting artists because they were theoretically minded (or "correct") was condemned for confining the experience of art to impersonal ideologies imposed on it. Art theorists were also criticized for favoring text over the physical properties of art. As Robert Pincus-Witten commented:

The reduction to text marginalizes the literally physical properties of facture, process, texture, image, color, and so on, while it enshrines scholasticism as the means of access to the work of art; it is as if the literal work now claimed but scant incarnation, while the sifting of preferred critical opinion, of commentary upon commentary, becomes alpha and omega. [What had occurred was] a miraculous transfer of the work of art from a set of tangible, visual facts . . . to a brief of legalistic appeals to authority.[43]

Robert Storr also attacked art theory for drawing attention away from art and to the discourse about it—and for the murkiness of its language. "At its best and worst it is a form of play. And, like other ingeniously designed games it can become an all-consuming activity. Keeping track of new authors as their tomes crowd onto bookstore shelves, correlating their hypnotically digressive arguments or following the subtle one-upsmanship of their footnotes is a 'thinking person's' *Trivial Pursuit*." Storr concluded that along "with the 'nouveau-riche' artist, we now have the 'nouveau-smart' one," and the one could be as career-minded as the other.[44] In fact it often seemed that eighties artists who used mechanical media and texts had formulated their art with art theory in mind or, if not quite that, had internalized art theory and assimilated it into their own art making. Aware of the advantages of being written about in *October*, a few became willing collaborators—if not hostages—of its critics. Indeed, their art was often referred to as deconstructionist.

Despite *October*'s limitations and faults, it was to its credit that it was seriously intellectual and dealt with contemporary art as intellectually important. Unfortunately much of its prose was impenetrable—a speaking in art-theoretical tongues—the heritage of second-generation formalist criticism of the 1960s and arcane French theoretical writing, plus a desire to appear profound, together with shoddy thinking and an insensitivity to language, shocking in writers who claimed to value the text. It was all too common for art writing in *October* to have lost all reference even to the art it purported to illuminate.[45]

The *October* clique used deconstruction systematically to dismantle or demystify modernism, its canon, and every one of its values—originality, uniqueness, authenticity, autonomy, completeness, transcendence, and aesthetic quality. But the demolition of modernism took time. Its progress from 1977 to 1981 can be traced in a series of key articles that marked the innovational period of *October*: Krauss, "Notes on the Index: Seventies Art in America" (1977), and "Sculpture in the Expanded Field" (1979); Crimp, "Pictures" (1979); Owens, "Allegorical Impulse: Toward a Theory of the Postmodern" (1980); Buchloh, "Figures of Authority, Ciphers of Regression" (1981); Michelson, "The Prospect Before Us" (1981); and Krauss, "The Originality of the Avant Garde: A Postmodernist Repetition" (1981).

In "Sculpture in an Expanded Field," Krauss posited an art-theoretical rationale for postminimal sculpture, noting: "Over the last ten years surprising things have come to be called sculpture: narrow corridors with TV monitors at the end; large photographs documenting country hikes; mirrors placed at strange angles in ordinary rooms; temporary lines cut into the floor of the desert." How was this work to be defined as sculpture? Was it not-sculpture? Did not the definition of sculpture have to be expanded? To answer the question, Krauss used binary oppositions to build a kind of mathematical model. She defined traditional sculpture as the monument built for a specific purpose in a specific space. Modernist sculpture, in contrast, was portable and "largely self-referential." It had been exhausted in her opinion by 1950, and it could be viewed only negatively, as "absence"; that is, as "not-architecture" and "not-landscape." But these very terms of exclusion began to interest sculptors at the end of the sixties, as did, by inversion, the terms "architecture" and "landscape," or "the built and the not-built, the cultural and the natural." Sculptors began to probe the "outer limits" of sculpture at which the medium becomes "almost infinitely malleable" and "suspended" in an "expanded field."

Krauss then formulated other binary pairs, for example, "site-construction" (the combination of landscape and architecture, as in Smithson's *Partially Buried Woodshed* at Kent State University) and "marked site" (the combination of landscape and not-landscape, as in Smithson's *Spiral Jetty*). Among the artists who "[thought] the expanded field," Krauss listed Robert Morris, Robert Smithson, Michael Heizer, Richard Serra, Walter de Maria, Robert Irwin, Sol LeWitt, Bruce Nauman, Alice Aycock, John Mason, Mary Miss, Charles Simonds, Dennis Oppenheim, Nancy Holt, George Trakis, Richard Long, Hamish Fulton, Christo, and Joel Shapiro.

In a sense Krauss added her art-theoretical gloss to the argument between Robert Morris and Michael Fried, a dozen years earlier, as to whether modernist sculpture should be self-contained or refer to its environmental situation. She came down on the side of Morris but allowed, as Fried had insisted, that postminimal sculpture should no longer be defined as modernist. Consequently she concluded that work in the "expanded field" constituted a "rupture" with modernist sculpture and was in "the domain of postmodernism."[46]

Because a great deal of postminimal art was inaccessible or ephemeral, artists photographed it to show what it looked like and to preserve its memory. The photodocumentation soon came to be thought of as integral to the work itself—a kind of trace of the real thing or event and a real work of art in its own right. This encouraged the *October* group to investigate the nature of photography and to provide it with an art-theoretical rationale. More than that, Krauss declared that photography had replaced painting as the relevant art.[47]

In "Notes on the Index: Seventies Art in America," she characterized the photograph as an "index," an actual imprint of something tangi-

ble in the world. In her words, indexes are "marks or traces [of that] to which they refer, the object they signify. Into the category of the index, we would place physical traces (like footprints), medical symptoms. . . . Cast shadows could also serve as the indexical signs of objects"—and above all photographs.[48]

Krauss went on to say that to be understood, the photograph required a caption. "A meaninglessness surrounds [the photograph] which can only be filled in by the addition of a text." The supplemental caption related the index to conceptual art, or it was conceptual art. Not only did the captioned photograph incorporate verbal texts into visual art more than ever before, but captioning so linked the visual with the verbal that the visual was turned into a text. In this way Krauss solved— or seemed to—a problem that had troubled deconstructionists: Could visual images be dealt with as texts?[49] Although the issue was never resolved, art theoreticians treated visual imagery as if it were a verbal text—and thus a fitting subject for deconstruction. At one and the same time they embraced the literal photograph and the literary caption.

Photography was also of critical importance to Krauss because in her view it was central to the advanced art of the 1970s, namely art that used

> the photograph as a means of representation. It is not only there in the obvious case of photo-realism but in all those forms which depend on documentation—earthworks, particularly as they have evolved in the last several years, body art, story art—and of course in video. But it is not just the heightened presence of the photograph itself that is significant. Rather it is the photograph combined with the explicit terms of the index. For, everywhere one looks in '80s art, one finds instances of this connection.[50]

Krauss herself considered the index and her article on it to be so important that she reprinted the first part in an anthology of essays marking the first decade of *October*. She and the other editors wrote in the introduction:

> Almost from the outset the index . . . appeared to us [to be] a particularly useful tool. [It] could work against the grain of familiar unities of thought, critical categories such as medium, historical categories, . . . style, categories that contemporary practices had rendered suspect, useless, irrelevant. In its status as trace or imprint, the index cut across the rigidly separate artistic disciplines, linking painting with photography, sculpture with performance and cinematography.

Photography or, rather, "the photographic . . . had come to affect all the arts";[51] Krauss actually considered photography to be *the* medium of postmodernism. Owens concluded that in "Notes on the Index," she "unifies postmodernist art according to the signifying conditions of a single medium, photography."[52]

Photography was viewed as central not only to advanced art but to society as well. Photography critic Abigail Solomon-Godeau wrote: "As photography has historically come to mediate, if not wholly represent, the empirical world for most of the inhabitants of industrialized societies (indeed, the production and consumption of images serves as one of the distinguishing characteristics of advanced societies), it has become a principal agent and conduit of culture and ideology."[53]

Krauss believed that photography had been consigned to a "cultural limbo . . . for a century and a half," presumably by modernism. In a special issue on photography in *October*, she and Michelson proclaimed: "Only now . . . is Photography truly 'discovered,' and now it is that we must set to work, establishing an archaeology, uncovering a tradition, constituting an aesthetic." In good deconstructivist fashion, the editors termed the redemption of photography "'the return of the repressed.'" They would confer on photography the persuasive cachet of art theory. They were taken aback, however, by the enormous growth of a market for photographs—and their potential, if unintended, complicity with the market, but announced that the market also required critical study and that they would undertake it.[54]

In their thinking about photography and film, the contributors to *October* were greatly influenced by a 1936 essay, "Photography in the Age of Mechanical Reproduction," by Walter Benjamin. As Crimp stated, his "classic essay on mechanical reproduction has become central to critical theories of contemporary visual culture."[55] So important was Benjamin's thinking to the editors of *October* that they devoted the winter 1985 issue to an English translation of his "Moscow Diary."

Benjamin believed that the modern age was distinguished by two developments: the rise of mass society and a technological revolution, namely photomechanical reproduction. Both would radically affect the perception of art. He began with the premise that an original work had a "presence in time and space, [a] unique existence at the place where it happens to be." Its place and the "touch" of the maker conferred on it an "aura," a singular authenticity, and because of that, its authority. Reproduction made a work available at any place in any time and no matter how perfect could not confer an aura. Moreover, when there came into being a large—potentially infinite—number of copies—as in the age of mechanical reproduction—the aura of the original withered.[56] The proliferation of reproductions had depreciated and demystified the original work of art and deflated its aura. If art could no longer be original, it followed, as Benjamin saw it, that the idea of the artist as an individual genius who makes singular works of art was obsolete. He concluded that such ideas as "creativity and genius, eternal value and mystery" had become "outmoded."[57]

Benjamin's ideas did not go unchallenged. His critics asserted that a reproduction was not the original and the original continued to exist. His supporters tried to rebut this argument. For example, art critic

Howard Singerman asserted: "What is important is not that the work *is*—the original, authentic body—but that it is *seen*—the image, public and multiple. And seen with this familiarity, seen again and again, even the original becomes only another instance, another copy of its image."[58] In actuality the opposite seemed to be the case. Reproductions of the Mona Lisa did not dissipate the aura of the original. Instead they caused masses of people to yearn for the real thing and crowd to view it. Rather than devalue the original, reproductions enhanced its aura, and the more reproductions there were, the more the aura was enhanced.[59]

Benjamin extended his reasoning on reproductions to photographs, arguing that because a photograph was mechanically reproduced and could yield multiple copies, none of them could be considered the original or the unique or the authentic work. After all, Benjamin maintained, if one could make an infinite number of prints from a photographic negative, it made no sense to ask for the "authentic" print. *All* lacked the aura—that is, the handmade mark of the creator. This idea too was questioned. Benjamin's critics admitted that there is no single original or authentic print—nor did it even need to be printed by its photographer; still, all prints possess the aura of an original.[60] A Walker Evans *is* a Walker Evans, and it is different from a photographic copy of it, such as one by Sherrie Levine—and the difference is critical. Moreover, as Kirk Varnedoe pointed out, a reproduction is a thing in its own right and permits new things to be done to it, as Duchamp did when he penciled a mustache on a reproduction of the Mona Lisa. Or the processes of reproduction can be used to make new images, as Warhol did in his sloppy silk-screening.[61]

The flaws in Benjamin's thinking notwithstanding, he became a cult figure to the *October* group. His influence is clear in a 1984 article by Krauss; she wrote that photography had made a

> travesty of the ideas of originality, or subjective expressiveness, or formal singularity. . . . By exposing the multiplicity, the facticity, the repetition and stereotype at the heart of *every* aesthetic gesture, photography deconstructs the possibility of differentiating between the original and the copy, the first idea and its slavish imitators.
>
> [It calls] into question the whole concept of the uniqueness of the art object, the originality of its author, the coherence of the oeuvre within which it was made, and the individuality of so-called self-expression.[62]

What made Benjamin attractive to *October*'s editors was the fact that he had focused on photography because it was an art of mechanical reproduction and hence the fitting medium of contemporary culture. As such it had replaced easel painting, which he denigrated as bourgeois. After all, the Russian revolutionary artists had relegated it to the dustbin of history. Sidney Tillim commented, with *October* editors (among other

theorists) in mind, on their "discomfort with art as a purely self-involved activity," exemplified by Greenbergian formalism they equated with modernism. Their thinking had become increasingly political. They had inaugurated *October* largely in order to provide a response to growing reactionary forces within both the political and cultural spheres. "Benjamin was among the first to criticize Modernism in sociopolitical terms that linked photography to artistic reform, providing meanwhile a theory of mechanical reproduction that justified for many the repudiation of esthetic self-consciousness."[63] Benjamin himself had seen the world in crisis—between fascism and Communism—and this colored everything he wrote. Mechanical reproduction took art out of the realm of "tradition" and placed it in the arena of "politics"—a change Benjamin welcomed. Art could now become a weapon in the service of Communism.[64] Photography lent itself to such a mission because it could be widely and cheaply disseminated to the masses. According to Benjamin film was an even more powerful propaganda weapon than still photography, and it was fitting that film criticism was featured in *October*.

The *October* group did not support all photography, certainly not that which aspired to be "pure" or "high," or that which was "impure" because it emulated the look of painting and evoked originality, uniqueness, and subjectivity. Pure photography focused on what made photography different from any of the other arts—its "truth" to appearances and its peculiar physical and formal qualities. It was, in a word, formalist—or modernist. The champion of pure photography was John Szarkowski, the director of photography at the Museum of Modern Art, who more than any other individual established photography as a high art, defined its terms of discourse, and created its canon—at least until the 1980s.[65] In a sense Szarkowski had been to photography what Greenberg had been to painting. Szarkowski's thesis was that photography is a unique medium, which, as it evolved, progressed self-consciously toward its own essence. He sought to identify photography's "values, traditions, masters and masterworks," as Solomon-Godeau put it. Photography was "purified of its worldly entanglements, distilled into a discrete ensemble of 'photographic pictures,'" treated with reference to itself only. As Szarkowki said: "One might say that the picture was formed by the edges."[66] Summing up his own contribution, he commented: "I think I took the risk of allowing photography to be itself and show itself without being couched in the rubric of philosophical or moral positions."[67] *October* challenged not only Szarkowski's formalism but his dismissal of the provocative directions photography took in the 1970s and 1980s.

October also rejected impure photographers who emulated the look of painting (with the exception of Cindy Sherman). In contrast to pure photographers, impure photographers minimized photography's traditional or "straight" role as a veristic window on the world. They expanded and loosened up technique, cultivating grainy images, blurred

focus, cropping, wide-angle distortions, and color.[68] Impure photographers then began to manipulate the surface, emulating the idiosyncratic "touch" of the painter; and to enlarge the formats—rejecting the conventional eight-by-ten-inch size—so that their photographs could compete with wall-size canvases.[69] Pure and impure photographers were generally unsympathetic to each other. Pure photographers unfairly denigrated impure photographers for their alleged disregard of the craft of photography. Impure photographers unfairly accused pure photographers of being old hat. They also existed in different worlds—pure photographers in a photography world, impure photographers in the art world.

The editors of *October* had no use for either kind of photography. They were particularly dismissive of claims made for the impure variant—that is, "notions of value, of presence or aura, of authenticity currently revived and adapted for photography," as Krauss and Michelson wrote, "notions" that abetted the marketing of the work.[70] *October* maintained that the commercial appeal of impure photography was the major reason that it came into being. Questionable as this interpretation was, an increasingly active market had indeed developed, beginning in the 1960s with Rauschenberg's and Warhol's introduction of photography into painting and into the context of art-world exhibition venues. Moreover the mass of documentation—of conceptual art, earth art, performance art, and the like—that appeared in galleries in the late 1960s and 1970s made its habitués accustomed to seeing photographs and then to buying them. Thus a new market developed, one whose prices were geared more to high-priced painting than to traditional photography.

The editors of *October* would not accept subjectivity, uniqueness, and authenticity in photography. But their main butt was painting, the medium that most exemplified originality, subjectivity, uniqueness, and authenticity. They insisted that painting had to be purged. But painting was on the upswing. In 1979 the Whitney Museum mounted *New Image Painting* and the Grey Art Gallery in New York City, *American Painting: The Eighties*. And the partisans of painting, notably Barbara Rose, the curator of the Grey Art Gallery show, went on the polemical offensive. A prolific critic identified with formalist and minimal art, Rose had become disillusioned with succeeding styles because in her view they had reached two dead ends. One was a backward-looking "return to realism." The other was a "tradition-smashing revolution" that aimed to purge art of "drawing, illusionism, brushwork, scale, metaphor and compositional relationships." Reductive tendencies were bad enough but, what was worse, they led to "conceptual art, performance, video."

Rose was so dispirited by these developments that she had ceased writing about current art or even paying attention to the art criticism about it. In 1977, however, she sensed that young artists once again felt a "great hunger" for painting, and she began to visit studios. She found that artists had been inspired by four shows—*Cézanne: The Late Works*,

Monet at Giverny, the Jasper Johns retrospective, and *Abstract Expressionism: The Formative Years*—and were returning to "hand painting with brush on canvas." They were again interested in the creation of personal images, in quality, and in tradition, not radicality. Rose predicted that the 1980s would be marked by a revival of painting.[71]

With the art theory of *October* in mind, Rose identified photography as the enemy of painting. Referring to an article by Richard Hennessy in *Artforum*, "What's All This About Photography?" Rose claimed that photography could not be "other than a minor art because of its intrinsic inability to transcend reality, no matter what its degree of abstraction. . . . According to Hennessy, photography, and by inference, painting styles derived from it [for example, photorealism], lacks surface qualities, alienating it from sensuous experience."[72]

Hennessy's article not only detailed how the "expressive possibilities" of photography are "hopelessly handicapped" but was also a paean to painting. Pointing to the process of painting, "to the strokes with which it is built up," he commented: "At no point are we looking at something remote from human endeavor. Everything is choice, delectation, effort and construction. The hand, eye and mind make themselves felt everywhere. The surface of a photograph cannot provide gratifications of this range or depth." In summation Hennessy wrote: "Things of the spirit and mind, thought to be so unseizable, so nebulous, so other, find expression *through the hand*, taking up a material existence in the world. . . . Painting proclaims the true incarnation, the union of matter and spirit, in the act of painting—of body and soul."[73]

Rose concluded that the forty-one painters she selected were

> dedicated to the preservation of painting as . . . an art of universal as opposed to local or topical significance. Their aesthetic . . . defines itself in conscious opposition to photography and all forms of mechanical reproduction which seek to deprive the art work of its unique "aura." [They] are equally committed to a distinctively humanistic art . . . the product exclusively of the individual imagination. . . . Not innovation, but originality, individuality and synthesis are the marks of quality in art today, as they have always been. [The] capacity of painting [is] to evoke, imply and conjure up magical illusions that exist in an imaginative mental space [and] achieve transcendence.

Finally genuine painting had a political dimension, because it was a "moral example of mature responsibility and judicious reflection."[74]

Rose's brief for painting was criticized by many of its supporters, who argued that it had not suddenly come to life, as she claimed. Rose may have had a revelation, but there were many artists and art professionals who had never lost the faith. Thus Roberta Smith maintained that the revival of painting was

an important aspect of the art of [the 1970s] . . . and this has as much to do with Rose's villains, the anti-painting mediums, as with a renewed attention to painting itself. Painting has shown itself to be perversely resilient, able to absorb from every quarter, even those which seemed—or claimed—to threaten its very existence. It has learned from Minimalism's emphasis on the literal . . . and from Conceptual and performance art's emphasis on subject matter, auto-biography, narrative and allusive imagery. The totality and vehemence of Rose's denunciation of the '60s and '70s has nothing to do with the facts and realities of historical progression.[75]

For *October* contributors there was no justification for painting of any kind. A 1979 editorial condemned recent

> proclamations of renewed faith in the permanence and transcendent powers of the aesthetic impulse [and in] the cleansing properties of linseed and turpentine. . . . American artists of the eighties will, we are told, again emerge paint-spattered from their studios. A new academy claims the walls of our galleries and museums: artists whose works have been consigned to deserved oblivion during the sixties have reemerged to claim the "legacy of Abstract Expressionism." And the black-and-white specter, photography, is once again to be exor-cized. . . .
>
> Attempts to . . . reerect the toppled statue of the Artist at the center are, in fact, symptomatic of a desire to reverse history.

The editorial concluded that "art is not a timeless manifestation of human spirit, but the product of a specific set of temporal and topical, social and political conditions. The investigations of these conditions defines for us the activity of postmodernism."[76] In "The End of Painting" (1981), Crimp wrote: "The rhetoric which accompanies this resurrection of painting is almost exclusively reac-tionary: it reacts specifically against all those art practices of the sixties and seventies which abandoned painting and coherently placed in ques-tion the ideological supports of painting, and the ideology which paint-ing, in turn supports."[77] (The ideology was bourgeois humanism, which repeatedly became *October*'s whipping boy.) In the same issue of *October* in which Crimp's article appeared, Clara Weyergraf wrote that "'human-ist aesthetics' . . . appeals to 'man' as the center of the aesthetic experi-ence, as the pretext of the art's making, the subtext of its meaning, the context of its reception. We are moved by this description of ourselves as the audience of the work of art as we are consoled by its implicit sense of the universal status of our *humanity*. But this de-historicized audience is in fact a fiction."[78] According to Crimp the *coup de grace* to humanist painting was delivered by Daniel Buren's readymade "stripes." When they

"are seen as painting, painting will be understood as the 'pure idiocy' that it is. [The] code of painting will have been abolished and Buren's repetitions can stop; the end of painting will have finally been acknowledged."[79]

The heaviest attack on painting, however, was mounted by Benjamin Buchloh in "Figures of Authority, Ciphers of Regression" (1981). Buchloh's agenda was the most rigorously political of *October*'s contributors. He required art to be an ideological weapon in the struggle against "the ruling bourgeoisie." Its primary function was to counter or "transgress" the bourgeois taste for painting by adopting mechanical means of production, such as photography, film, and printed text. Buchloh condemned the neoexpressionists (in Europe and, by implication, the United States) for disregarding the radical aesthetic developments of the first two decades of the twentieth century and instead repeatedly embracing "obsolete representational and expressive pictorial practices." Buchloh asked whether "modes of figurative representation in present-day European painting . . . indulge and reap the benefits of [growing authoritarianism]; or worse yet . . . cynically generate a cultural climate of authoritarianism."[80]

Buchloh continued his attack on painting in a 1982 review of *Documenta 7*. He condemned the show as "a desperate attempt to reestablish the hegemony of esoteric, elitist, modernist high culture. [*Documenta 7*] emphasizes the hegemony of painting and sculpture [and] also reestablishes the supremacy of the museum as the social institution within which the discourse of high culture originates and must remain. Documenta 7 proclaimed the individuality of the artist and the autonomy of artistic practice." Buchloh did like one series of paintings—Warhol's *Oxidation Paintings*—canvases prepared with copper emulsion, on which Warhol or an assistant had urinated.[81]

Buchloh's neo-Marxist argument did not go unchallenged. In direct rebuttal, Richard Hertz wrote in *Real Life:* "Calling certain pictorial practices (i.e., easel painting) *obsolete* [is an assertion of] Buchloh's historical determinism, one which is never argued, never even acknowledged, but which is a recurrent motif throughout his article and is the basis for his entire argument." Hertz also accused Buchloh of "cultural authoritarianism" because of his intolerance of any art that did not contribute to social progress.[82] Buchloh's opponents questioned his assertion that the primary and proper function of art was to help overthrow capitalism. Moreover, it was not clear whether capitalism was nearing its end, as Buchloh believed; or whether, as Peter Halley suggested, it was rather in "the middle of an ongoing and unpredictable 'bourgeois experiment.' [If so,] then perhaps one must grant that this bourgeois notion—the temporal expression of the individual—is not about to go away as quickly as might otherwise have been expected." Still, Halley observed, "Expressionism and the problem underlying it, the nature of emotionality," had seriously to be assessed.[83]

In 1981 there occurred a direct confrontation between an *October* writer, a photographer favored by the magazine, and two new painters. Owens invited David Salle and Julian Schnabel to participate in a panel discussion with himself and Sherrie Levine. In his introductory remarks he asserted that the mission of contemporary art was to deconstruct postindustrial or information society. "The artist no longer makes an object, but rather is involved in the transfer and processing of information. This aspect accounts for the absolutely central role of photography in Post-Modernism—photos which were always excluded from the Modernist hierarchy." Owens went on to say that photographs were not made but taken. Referring to fellow panelist Levine, he added, "By appropriating information [she] addresses this issue of ownership, and therefore of power." Owens also commented that the new art of mechanical means is antagonistic to painting, which had become "academic." As a means of production, painting was technologically outdated, "moribund," and attempts to revive it were futile. Photography was "the next move." Owens concluded that the "situation right now [between photography and painting] is polarized."

Salle rebutted Owens by defending what he ironically called his "production," claiming that "Sherrie's work is as much produced as mine or Julian's. [My] work is as much about the resonance of information. We might as well all start cutting up newspapers. I mean, what you're describing, Craig, is just pure Conceptual Art, which is extremely academic." Salle concluded: "I just don't think it's fruitful to say that information has replaced production as a measure of art because of some Marxist critique of the evolution of industrial society." Owens countered: "I'm arguing for an art that is culturally relevant,"[84] as if Salle were not.

The attack on painting became a kind of politically correct ideological tic. As late as 1990 art critic Laura Cottingham would write:

> Like other impressive relics from the past, painting's essential meaning is always tied to its pastness. Calling out from its place on the wall, the first thing a painting says, like an anxious member of a fallen aristocracy mumbling to guests, is, "I am a painting." As if that alone is enough. But, for the likes of corporate walls, it usually is. [The] market consistently supports reactionary art practices—that is, art that still fulfills the humanist spirit and formalist tenets of modernism. The seventies, after all, brought forth conceptualism and the beginnings of feminism, and that is what got lost in the leap from 1969 to 1980. It is an enormous loss, but not one that we can expect to see addressed when the flashing dollar sign is the guiding light of curating.[85]

Most defenses of painting disregarded theory. But one defender was interested in combating *October* on its own terms: Thomas Lawson, a painter, publisher of the art magazine *Real Life*, and contributor to

Artforum. Paradoxically he wanted to see the demise of painting, because as a means of expression it was dead, just as Buchloh, Crimp, Foster, and Owens believed. And he shared their radical political aims. But he believed that painting, not photography or the conceptually based work John Baldessari had dubbed poststudio art, was the most effective current means of criticizing society, and Lawson's primary commitment was to social change.

Lawson branded poststudio styles as repetitive, predictable, sentimental, regressive, and academic. No wonder painting had revived.[86] In his most widely discussed article, "Last Exit: Painting" (1981), Lawson identified *October* as his primary antagonist and attacked it for publishing "jeremiads condemning, at least by implication, all art produced since the late '60s, save [that which] owes a clear and demonstrable debt to the handful of Minimal and Conceptual artists they lionize as the true guardians of the faith. From a position of high moral superiority these elitists . . . condemn the practice of 'incorrect' art altogether, as an irredeemably bourgeois activity that remains largely beneath their notice."[87] Lawson stressed that the art *October* promoted had "marginalized itself in the culture. . . . The creation of deliberately obscure work, in deliberately obscure places, caused a public to be lost, and one of the benefits of the resurgence of painting in the Eighties has been that this audience has been regained."[88] Thus the major weakness of poststudio art—its Achilles' heel, as it were—was that it was invisible and therefore politically ineffective. As an example Lawson singled out Buren's work, because Crimp had claimed that it best served the revolution, but added that it was invisible to all but a few.[89]

In contrast to photography, Lawson maintained, painting possessed visibility and authority and therefore could command attention. That is, it was understood in the culture as being significant,[90] and consequently possessed the presence that made it a useful medium for political art. Consequently, as Lawson viewed it, painting seemed the best critical tool with which to confront and subvert the existing social order. Painting could by stealth discreetly "unsettle conventional thought," and destabilize appearances. The radical painter could be "the infiltrator, the undercover agent who can make himself acceptable to society while all the while representing disorder."[91] Lawson concluded: "The appropriation of painting as a subversive method allows one to place critical esthetic activity at the center of the marketplace where it can cause the most trouble."[92]

But which artists were fulfilling Lawson's goal? In his opinion: "Salle occupies a central position in this polemic. . . . Salle makes tremendously stylish paintings [that have a] look of high fashion. And yet the images he presents this way are emotionally and intellectually disturbing." His paintings are "dead, inert representations" and therefore "take the most compelling sign for personal authenticity that our culture can provide and . . . reveal its falseness. . . . insinuating a crippling doubt

into the faith that supports and binds our ideological institutions."[93] Above all Salle's work was subversive because of its antihumanist tendencies.[94]

Owens would have none of this.[95] He dismissed Lawson's reasoning as sheer rhetoric. Salle's "return" to painting was a sellout.[96] Rather than calling into question the authority of painting, Salle was interested in making art, claims to the contrary notwithstanding. Lawson agreed with Owens that art, its institutions, and the art market could co-opt the dissident artist; indeed, as early as 1981, Lawson was sure that this would happen in the end, pessimistically allowing that "the seducer [would find] himself in love with the intended victim." Nevertheless Salle's paintings remain significant pointers indicating the last exit for the radical artist.[97] To put it another way, Lawson hoped that painting would finally reveal itself to be dead. Until it did, he would "dress up the putrefying remains . . . for the wake."[98] He asked "So what is a radical artist to do in the current situation if he or she wants to avoid instant cooptation or enforced inactivity?" His answer was, To paint.[99]

Toward the end of the 1980s, Lawson admitted that he had gotten painting wrong. His attitude had mellowed. Reviewing his history, Lawson remarked that he and other young artists in the late seventies were connected by

> an interest in the mass media. We felt that TV and the movies and advertising presented a problem and a challenge to visual artists. . . . What we did, first of all, was to perversely deny originality of any kind—and this denial runs the gamut of all young artists working today. Even artists who are not directly involved in appropriating mass-media imagery—Julian Schnabel, for instance—refuse to accept the idea that you have to invent. There is something melancholy about our work. If Pop Art represented a kind of optimistic acceptance of mass culture, ours is a kind of melancholic acceptance. . . . This all took place after "the death of painting." We had all been schooled in the idea that painting was finished, and the second perverse thing that we did was to decide to paint. Since there's a deadness to mass-media imagery, there was a fittingness in our decision to work in a medium that we didn't have all that much conviction about. But interestingly, once you start working in it you become more and more convinced by it. All these years later, painting actually seems interesting in itself, rather than a mere perverse challenge.[100]

So painting had not died. Nor was photography as "invisible" as Lawson made it out to be. New photographers, such as Cindy Sherman and Barbara Kruger, produced work that competed with painting in size, sensuousness, and authority—and commanded art-world, media, and public attention.

<p style="text-align:center">* * *</p>

Unlike Lawson the art theoreticians who published in *October* would not relent in their campaign against painting—and modernism, which they identified with it. The widest-ranging polemic against modernism was Krauss's "The Originality of the Avant-Garde: A Postmodernist Repetition" (1981), which would be a seminal text in the art-theoretical canon. In it she advocated "a demythologizing criticism and a truly postmodernist art, both of them acting now to void the basic propositions of modernism, to liquidate them by exposing their fictitious condition."[101] Krauss deconstructed modernism by taking what she considered its key term—originality or creation—and attempting to show that its "repressed" opposite—the copy or repetition or appropriation—was actually more to the point of modernist practice, modernist rhetoric notwithstanding. While modernists—she used Rodin as her example—were celebrated for their originality, they actually copied themselves by repeating images and by making multiples. In this manner Krauss tried to undermine a basic premise of modernism. However, much of her argument was problematic.[102] A Rodin—whether or not it exists as one of a series of multiples—remains a Rodin; all the casts are "original," even those that were cast after his death, although they should be considered somewhat "unfinished."

But that was only one of Krauss's questionable arguments. She went on to say that if there were to be modernist originality, then it would have to be "more than just the kind of revolt against tradition that echoes in Ezra Pound's 'Make it new!' or sounds in the futurists' promise to destroy the museums. [I conceive it] as a literal origin, a beginning from ground zero, a birth."[103] But why was it necessary to go to extremes? Was not Pound's and the futurists' definition of modernism sufficient? Krauss's argument became a kind of special pleading for her antimodernist thesis. In support of it, she pointed out that grids were an emblem of modernist art and asserted that no one could claim to have been the originator, again pitting originality against repetition. It is true that there may be no specifiable originator or "first idea" of the grid, but it was "new" in the context of modernist art and had great potential for fresh development. Modernist artists, such as Mondrian and Stella, used the grid so distinctively as to make it "original" enough.[104]

My reservations about the way in which Krauss conceived of the roles of the modernist and postmodernist artist notwithstanding, the issue she posed was relevant at the time. Distanced from the polemics of the New York art world, Ilya Kabakov, a Russian émigré artist, offered what is perhaps the most cogent interpretation:

> Modernism has to do with an extraordinary confidence on the part of the individual artists in their own genius, a confidence that they are revealing some profound truth and that they are doing it for the first time. The postmodern consciousness arises in a society that doesn't need new discoveries, a society that exchanges information, that cor-

relates all possible languages [all of which have already been worked out] and establishes interrelationships between them. You could say that modernism juxtaposes itself to all that has preceded it in the past, while postmodernism means primarily participation in one unified field or network of artistic life.

Kabakov went on the say that modernists admired Cézanne because he was authentic and had discovered a new language for art. Postmodernists prefer Duchamp, "who worked with readymade materials. Today's postmodernist artist works not only with readymade things but also with readymade artistic languages."[105]

At the end of her article Krauss speculated on what an art of appropriation might look like. She concluded that "it would look like a certain kind of play with the notions of photographic reproduction"—like the work of Sherrie Levine:

> Levine's medium is the pirated print, as in the series of photographs she made by taking images by Edward Weston of his young son Neil. [But] Weston's "originals" . . . are already taken from models provided by others; they are given in that long series of Greek kouroi. . . . Levine's act of theft . . . opens the print from behind to a series of models from which it, in turn, has stolen, of which it is itself the reproduction.

Was not Levine's piracy "original" and "new"—and thus modernist? Krauss claimed not: "Insofar as Levine's work explicitly deconstructs the modernist notion of origin, her effort cannot be seen as an *extension* of modernism. It is, like the discourse of the copy, postmodernist. Which means that it cannot be seen as avant-garde either."[106] But art theorists' repeated assertions that Levine was not original ironically turned her into an original. As Victor Burgin commented: "In making her the exemplary-postmodern-authorial-deconstructive artist, they have promoted her precisely to the position of authorship."[107]

Levine was also the exemplary artist for Craig Owens. In an important two-part article in *October* titled "The Allegorical Impulse: Toward a Theory of Postmodernism," he distinguished between the "deconstructive impulse" characteristic of postmodernist art and the "self-critical tendency of modernism. . . . When the postmodernist work speaks of itself, it is no longer to proclaim its autonomy, its self-sufficiency, its transcendence: rather, it is to narrate its own contingency, insufficiency, lack of transcendence. [Its] thrust is aimed . . . against the symbolic, totalizing impulse which characterizes modernist art."[108] The binary term of symbol was allegory. One was modernist, the other postmodernist. "Allegorical imagery is appropriated imagery. [The allegorist] adds another meaning to the image." Owens added that "allegory occurs whenever one text is doubled by another; [that is] is *read through* another. [The] paradigm for

the allegorical work is thus the palimpsest." Beneath every reading of every text there was always something hidden or repressed, something that had to be unearthed. Thus the double could be doubled—into infinity. In Owens's view, Levine was the consummate appropriator.[109]

October's assault on the idea of the artist-as-creator with a unique vision and style as a modernist fiction was two-pronged. One, first articulated by Roland Barthes, aimed at the privileged role of "the Author," substituting for the *intention* of the Rodin-like genius the *intepretation* of the text by the viewer. The second denied the existence of the artist-as-creator's self as a unified entity and, by extension, the individual human being as a centered, coherent ego. This was replaced with a new conception of self as an ever-shifting construction shaped by social institutions and forces, especially the media.

Decentering the self was not new in twentieth-century thought. Art critic Thomas McEvilley had observed that there was a "sceptical, positivistic, and critical" thrust in modernism. Because of it "the self fell prey to various dissections and analyses. Marx broke it down into byproducts of impersonal socio-economic conditions. For Darwin it was the result of biological forces. Freud saw it as a bag of disconnected and warring energies. For behaviorists it was a machine to be programmed."[110] But postmodernists went even further and dismissed the self as a fiction. In an article titled "Postmodernism and the Consumer Society," cultural theorist Fredric Jameson wrote:

> The great modernisms were . . . predicated on the invention of a personal, private style, as unmistakable as your fingerprint. . . . But this means that the modernist aesthetic is in some way organically linked to a conception of a unique self and private identity, a unique personality and individuality, which can be expected to generate its own unique vision of the world and to forge its own unmistakable style.

Jameson went on to say:

> Yet today, from any number of distinct perspectives, [theorists] are all exploring the notion that that kind of individualism and personal identity is a thing of the past; that the old individual or individualist subject is "dead." . . . There are in fact two positions on all this, one of which is more radical than the other. The first one is content to say: yes, once upon a time, in the classic age of competitive capitalism, . . . there was such a thing as individualism, as individual subjects. But today, in the age of corporate capitalism . . . that older bourgeois individual subject no longer exists.
>
> Then there is a second position, the more radical of the two, what one might call the poststructuralist position. It adds [that] the bourgeois individual subject *never* really existed in the first place;

there have never been autonomous subjects of that type. Rather, this construct is merely a philosophical and cultural mystification which sought to persuade people that they "had" individual subjects and possessed this unique personal identity.[111]

According to postmodernists, what replaced the individual as a self-aware and controlling ego was the self as an arena of shifting psychosociocultural identifications—multiple selves, as it were, in an infinite network of discourses. The self was viewed as an imaginary construct whose form is ever-changing, pulled this way and that by language, social ideology, class, gender, family, race, physical and psychological desires, and memory.

The conception of a splintered self was easily rebutted. It was enough to assert that a sense of a unified self exists, and everyone—except the psychotic—knows that it does. Certainly the self is socially determined to a degree—with regard to gender roles, for example—but everyone in the real world—outside of what theoreticians imagine—recognizes his or her self, that is, what makes a person what he or she is, in a word, singular. And certain selves throughout history have had special creative talents.

The conception of the self as a social and cultural construction was central to the art theory of a second generation of feminists that emerged around 1980 and challenged the essentialist thinking of the first generation. Earlier feminists, such as Miriam Schapiro, Judy Chicago, Nancy Spero, and Lucy Lippard, believed that women had an innate or "natural" female nature. They dealt with that nature *From the Center*, as Lucy Lippard titled an important book on feminist art published in 1976. Second-generation feminists maintained that human beings exist wholly in language rather than in biology. Language determines how they perceive themselves, both unconsciously and consciously, and therefore how they identify themselves as male and female. Employing poststructuralism, semiotics, social philosophies, such as Marxism, and the psychoanalytic theories of Jacques Lacan, feminists asserted that "representation [is the] way of reflecting the culture's vision of itself. Representation thus legitimizes culture's dominant ideology, and is therefore inevitably politically motivated," as art critic Patricia Mathews commented. Through representation, male-dominated society constructs different male and female identities and imposes them on the public through repeated indoctrination in the schools, the courts, the mass media, and so on. But resistance to this representation was possible. Second-generation feminists conceived of women as an unfixed category, constantly in the process of change, change that women themselves could bring about through the deconstruction of partriarchal codes and mechanisms of domination.[112]

Feminist deconstructionists believed that images of women, especially of the female body, created by essentialists reinforced the stereotype of women invented by "phallocrats." They accused the essentialists of diverting attention from the ways in which patriarchal society and culture constructed the image of women as different from or "other" than and inferior to the male image. The primary task of feminist art was not to investigate what was fixed as female, but to analyze how male authority marginalized women.

Both first- and second-generation feminist theory had flaws, as Mathews pointed out. She criticized the essentialists for mystifying the nature of women and the deconstructionists for their "continual repetition of demystification" because it is only negative and has nothing positive to offer. On the other hand the essentialists "provide a positive identity, one that deconstruction needs and may incorporate in the midst of [its] very attempts to deny it." She continued:

> Both represent certain realities.... Spero grounds her work in the condition of being female, in what woman is in relation to herself, and to other women, [Mary] Kelly to how that self is constructed in relation to social, ideological and psychological structures. They are mutually exclusive concepts, yet both are operative. One reveals the continuities between, the other exposes the discontinuities and disjunctions without. Instead of legitimizing the study of only one or the other, instead of discarding the one for the other, an investigation of the positioning of one within the other would better reveal both.[113]

This attempt to bridge the conceptions of the feminine as a fixed entity and as an unfixed social and historical gender construction became the enterprise of feminist theory at the end of the 1980s.

Both first- and second-generation feminists agreed that the struggle against the discriminatory practices of art institutions was far from won. Gains had been made since the early 1970s, sufficient to prompt an exhibition in 1989, *Making Their Mark: Women Artists Move into the Mainstream: 1970–85,* and the publication of a lavish catalog featuring dozens of women who had achieved art-world recognition, among them, Laurie Anderson, Ida Applebroog, Jennifer Bartlett, Lynda Benglis, Louise Bourgeois, Judy Chicago, Nancy Graves, Eva Hesse, Jenny Holzer, Joyce Kozloff, Barbara Kruger, Sherrie Levine, Mary Miss, Elizabeth Murray, Judy Pfaff, Adrian Piper, Susan Rothenberg, Miriam Schapiro, Cindy Sherman, Nancy Spero, and Jackie Winsor. Curator Randy Rosen wrote that the show

> chronicles a breakthrough period in which traditional attitudes and perceptions about the role of women artists began to shift within the art world and in the public's view as well. Between 1970 and 1985,

more women than ever before achieved visibility in galleries, museums and art criticism. Although there have always been exceptional women artists, for the first time women exerted a widespread influence on mainstream art, becoming a central force in shaping it.[114]

Still the gains were insufficient. The proof was the Museum of Modern Art's *International Survey of Recent Painting and Sculpture* (1984); of the 169 artists in the show, only 19 were women. An outraged group of feminists reacted by organizing the Guerrilla Girls. Its members decided to be anonymous and wore large gorilla heads in public to avoid accusations of using feminism to further their careers. Moreover, "no one woman need fear having to pay the price for insulting a dealer, curator, or critic the group may have miffed along the way. . . . Without any personalities or careers to gossip about, their audience is left with only the facts and the issues to ponder and debate."[115] The gorilla disguise also got the Guerrilla Girls media attention—including items in *Vogue* and spots on nighttime TV.[116] The main activity of the Guerrilla Girls was making posters, plastering SoHo with them, and running them as advertisements in art magazines. The first poster (1985) signed "the conscience of the art world," listed the names of forty-two well-known male artists and posed the question: "What do these artists have in common?" The answer was that they all "allow their work to be shown in galleries that show no more than 10 percent women or none at all." The onus was put on the artists, which made art-political sense, since the implication was that they might be shamed enough to use their power with their dealers to change the situation. Other posters followed, as well as stickers, videotapes, and Christmas cards.[117] At first the Guerrilla Girls thought their agitation would be of short duration, but this turned out not to be the case. (It has continued into the 1990s.) Questions were raised over whether the Guerrilla Girls' posters were art and, if so, good art. Art critic Susan Tallman treated the posters in traditional art-critical terms: "Most have the studiedly undesigned look of 1970s conceptual art: black and white and set in that most generic of typefaces, Helvetica." She went on to say that collectors wanted to buy them, a sign of sorts of aesthetic quality.[118]

The examination of the situation of women in a male-dominated society was only one aspect of the art-theoretical deconstruction of society. As Hal Foster wrote in the introduction of *The Anti-Aesthetic: Essays on Postmodern Culture*, the contributions to this book "take for granted that we are never outside representation—or rather, never outside its politics," and that "in the face of a culture of reaction on all sides, a practice of resistance is needed."[119] This "resistance" took two major forms. One aimed at the way in which the established social order represented

itself—primarily through the media. The other targeted the art institutions that helped maintain the status quo.

Derrida had asserted that people are controlled by language; Baudrillard added a gloss, saying that people are mediated by the language of the media. Political artists and their art-critical supporters deconstructed the stereotypical texts and images of the mass media—texts and images presented as true. As Owens wrote in 1982, the *"critique of* representation [would aim] to challenge its [the media's] authority, its claim to possess some truth." It would unearth "the link between representation and power in our culture. . . . to expose the particular interests which all representations serve, their affiliations with classes, offices, institutions." Owens went on to say:

> Much of the best current work deals with images, transmitted through the media, that exploit the documentary status of photographic or cinematic modes of representation. . . . Artists who deal with such images work to expose them as instruments of power. Not only do they investigate the ideological messages encoded therein, but, more importantly, the strategies and tactics whereby such images secure their authoritative status in our culture. . . . Through appropriation, manipulation and parody, these artists work to render visible the invisible mechanisms whereby these images secure their putative transparency.[120]

The second group of political artists who aimed to resist representation undertook to deconstruct the art institutions that promoted modernist art. This became the central political issue for the *October* group in 1984, and remained so through the end of the decade. In fact, most of the articles on the visual arts in the *October* anthology published in 1987 appear under the heading "Critique of Institutions." On the one hand political art theorists promoted political artists whose intention it was to deconstruct art institutions, such as Marcel Broodthaers, Daniel Buren, and Hans Haacke. On the other they attacked what they considered the establishment interpretation and support of modernist art, especially painting. Buchloh spearheaded the attack. For him modernist art had two phases. The first had been genuinely revolutionary; its innovators undertook a pervasive critique of politics and art. During the second—and more influential—phase, art institutions, notably New York City's Museum of Modern Art, under the directorship of Alfred Barr, aestheticized, canonized, and popularized avant-garde art, dissipating its political and artistic radicalism. Crimp added:

> At MOMA, both in its earlier period and still more today, the works of the Soviet avant-garde, of Duchamp, and of the German dada artists have been tamed. They are presented, insofar as is possible, as if they were conventional masterpieces of fine art. The radical implications of the work have been distorted by the institution. . . .

[MOMA] intended to present not merely individual objects of modern art but rather a *history* of those objects. [It is] clear that the justification for the false construction of that history is connoisseurship.

Crimp also attacked art institutions, corporations, and the marketplace for neglecting political art and for promoting in a concerted fashion painting and sculpture.[121] (But political art was hardly marginalized, thanks to *October*. The artists *October* promoted, such as Buren and Levine, became art stars.)

October's hatred of painting seemed to have no bounds. In an article titled "The Fine Art of Gentrification" (1984), Rosalyn Deutsche and Cara Gendel Ryan not only condemned neoexpressionism and the art world that supported it but went even further in asserting that both painting and the art world were complicit with real estate interests engaged in the gentrification of the East Village. Deutsche and Ryan began by describing the East Village art community—in derogatory terms. They went on to say that it "conceals a brutal reality. For the site of this brave new art scene is also a strategic urban arena where the city, financed by big capital, wages its war of position against an impoverished and increasingly isolated local population." The aim of the city was to rid the East Village of its poor inhabitants and turn it over to real estate developers, so that they could build housing for the professional white middle class.

Deutsche and Ryan urged artists who had moved into the East Village to move out and stay out, disregarding the fact that most of the artists had moved there in the first place and had to remain there because they were poor. But the authors thought that artists would not leave because they (and the art world) believed themselves exempt from social responsibility. Deutsche and Ryan reserved their most scathing abuse for neoexpressionist painting whose "ideology [of] subjective expression obfuscates concrete social reality." In contrast to radical "art practices [of the 1960s and 1970s] that intervened directly in their institutional and social environments," neoexpressionism was "an unapologetic embrace of commercialism, opportunism. . . . The art establishment has resurrected the doctrine that aestheticism and self-expression are the proper concerns of art and that they constitute realms of experience divorced from the social. . . . The participants in the East Village scene serve this triumphant reaction."[122] Deutsche and Ryan had much to say about the greed of real estate powers, their collusion with city government, and the indifference of artists, but it seemed that it was the new painting as much as gentrification that angered the authors. No wonder this article was singled out for republication by the editors of *October* in their tenth-year anniversary book of essays.

The leftist politics of *October* and the agit-prop of the Guerrilla Girls and other activist groups were strongly resisted in the art world by the

New Criterion, founded by Hilton Kramer and Samuel Lipman in the fall of 1982. Politically Kramer, its editor, was an implacable anti-Communist, pro-American neoconservative. It was hardly surprising that *October,* named after the Russian Revolution, made him see red. Aesthetically Kramer was an unregenerate champion of modernism, in despair over its decline. In a no-holds-barred fashion, he categorically condemned any semblance of popular culture in "high" art. In the name of the established modernist canon and transcendent aesthetic quality, Kramer stood opposed to postmodernist art, art history, art criticism, and especially art theory.

Kramer rooted the thinking of the *October* group in the turbulent anti–Vietnam War protests and the counterculture of the late 1960s. He held the perpetuation of dissident attitudes responsible for what he considered the sorry condition of American culture. In his introductory statement to the first issue of the *New Criterion,* he wrote:

> [Culture] has almost everywhere degenerated into one or another form of ideology or publicity or some pernicious combination of the two. As a result, the very notion of an independent high culture and the distinctions that separate it from popular culture and commercial entertainment have been radically eroded. . . .
>
> A very large part of the reason for this sad state of affairs is, frankly, political. We are still living in the aftermath of the insidious assault on mind that was one of the most repulsive features of the radical movement of the Sixties. The cultural consequences of this leftward turn in our political life have been far graver than is commonly supposed. In everything from the writing of textbooks to the reviewing of trade books, from the introduction of kitsch into the museums to the decline of literacy in the schools to the corruption of scholarly research, the effect on the life of culture has been ongoing and catastrophic.[123]

Kramer was correct in pointing to the counterculture of the late 1960s as the source of much of what followed, and this made his discourse relevant. He could not be dismissed simply as a reactionary whose opinion did not count. Nor did his opponents want to. Ironically his writing allowed some of them to make believe that they were still in the avant-garde, or at least, on the "cutting edge," although most knew better.

Kramer claimed that the left's rejection of modernism arose "out of a sense of bitter disappointment and betrayal. [The left's] view may be summed up as follows: Modernism claimed to be revolutionary, it claimed to be anti-bourgeois, it promised us a brave new world, but it turned out to be a coefficient of bourgeois capitalist culture, after all, and we therefore reject it as . . . reactionary." Consequently, as Kramer viewed it, the contributors to *October* and their allies rejected modernism's

claims of high culture and [dedicated themselves to the destruction of] the privileged status it enjoys in the cultural life of bourgeois democracies. [Finally, although] there has been from the beginning of the modernist movement a *révolte* element. . . , it was the aesthetic component—not the politics—which proved to be enduring, and which came to play a role in shaping the sensibility of high culture in bourgeois society."

For the left, then, it was the aesthetic dimension in art that had to be challenged. Kramer allowed that by the end of the 1960s, modernism had achieved "mainstream status in the academy, in the marketplace, in the media, and in our institutions generally,"[124] and had become the new establishment. But it was nonetheless embattled, and he would be its champion in opposition to renegade artists and critics bent on its destruction.

Kramer also castigated the postmodernists, who were "excavating the ruins of the very civilization [modernism] had buried." He pointed to the "revival of nineteenth-century Salon painting and Beaux-Arts architecture . . . the elevation of Victorian and Pre-Raphaelite art [as] symptoms of a craving that is central to the whole aesthetic outlook of postmodernist art." He went on to say that this craving "brought with it not only certain changes in contemporary style—the most important of which was the emergence of Pop art—but a decisive shift away from the attitude of high seriousness that had long been a fundamental component of the modernist outlook." Postmodernism substituted for seriousness

> amplitude and flamboyance . . . grand gestures and a showy sociability . . . mediocrity and frivolity. . . . In a period that saw Andy Warhol emerge as the very model of the new artist-celebrity . . . sheer corniness was no longer looked upon as a failure of sensibility, nor was superficiality—or even vulgarity—regarded as a fault. Bad taste might even be taken as a sign of energy and vitality, and "stupid art"—as its champions cheerfully characterized some of the newer styles that began to flourish in the late Seventies and early Eighties—could be cherished for its happy repudiation of cerebration, profundity, and critical stringency.

The main culprits responsible for "the facetious, which has proved to have a far more insidious power to shape the course of culture than anyone has yet acknowledged [are] Warhol . . . John Cage in music, John Ashbery in poetry, and Donald Barthelme in prose fiction. The later work of Philip Johnson is the most celebrated example in architecture." Thus Kramer identified those who betrayed "the high purposes and moral grandeur of modernism." In Kramer's opinion modernism remained "the only really vital tradition that the art of our time can claim as its own."[125] And the *New Criterion* would foster this tradition, although it would

devote far more of its pages to traducing the traducers of modernism than to identifying and promoting its contemporary adherents.

The *New Criterion* stood opposed to all the new critical approaches—poststructuralist, deconstructionist, feminist, gay, multicultural. Roger Kimball, a frequent contributor to the magazine, objected to the "teaching of literature primarily as a species of ideological activism." He noted

> that the precise components of that activism will vary depending on the nature of the politics involved. [However,] they are in many ways united. All reject the ideal of scholarly disinterestedness; all exhibit a pervasive animus against the achievements and values of Western culture; all systematically subjugate the teaching and study of literature to political imperatives; and all are extraordinarily intolerant of dissent. [The] rise of multiculturalism as an omnibus term for the new academic orthodoxy has provided common cause and something of a common vocabulary for a profession otherwise riven by an allegiance to competing radicalisms.

Above all, Kimball maintained, leftists, no matter what their disagreements, agreed that a preference for "Western culture and its heritage [is] ethnocentric and racist [and] that our differences—of race, class, sexuality, and ethnic heritage—must be given priority over our common humanity."[126]

In a rebuttal of Kimball in the London *Times Literary Supplement*, literary critic Peter Brooks pointed out that the "authority" of the humanities was based on a "consensus on the place and meaning of culture, including the place and significance of Greek and Roman Antiquity within it." This old cultural consensus was eroding because "America is increasingly an ethnically and culturally diverse—even fragmented—society. . . . Increasingly, the watchword of the student left is 'diversity': student bodies, faculties and the curriculum should reflect the new 'multiculturalism' of the society at large." Brooks concluded "that the theoretical and methodological battles waged within the humanities over the past two decades, despite obvious excesses and certain terroristic uses of 'theory,' represent a great renewal, indeed one that has brought us back to fundamental questions about the place of literature and culture in human life and society." Brooks did grant that pluralism had its problems, namely to determine what was significant and of value, to "construct and reconstruct traditions," to establish a new canon, but the situation "is infinitely preferable to the intolerance of such as Kimball."[127]

But the *New Criterion* would have none of Brooks's kind of reasoning. In a 1990 article cultural critic Richard Vine summed up all that the magazine stood against, in the shrill tone of much of its prose. He castigated

> our radicals [because they] "privilege," yea even "fetishize," the egregiously second-rate. Television, Disneyland, B movies, pop music, French philo-babble, cutely uninhabitable architecture, and, of

course, great swaths of pretentious junk art—all these are easy to talk about. Indeed, they invite talk to take precedence. "Dallas" may be nothing but good-natured pap, but the things one can say about it as "a vehicle of cultural imperialism" have a power exceeding that of their putative subject. The theory becomes immeasurably more interesting and creative than the art, which shrivels to, at best, an excuse for or illustration of current "critical" doctrine.[128]

At the end of the 1980s Kramer summed up his position:

> Art . . . —and this includes scholarship, too—must be defended and pursued and relished not for any political program it might be thought to serve but for what it *is,* in and of itself, as a mode of knowledge, as a source of spiritual and intellectual enlightenment, as a special form of pleasure and moral elevation, and as a spur to the highest reaches of human aspiration. . . .
>
> The defense of art must not . . . be looked upon as a luxury of civilization—to be indulged in and supported when all else is serene and unchallenged—but as the very essence of our civilization.

In this cause references to popular culture had to be purged from high culture and its discourse and, above all, banned from college courses in the arts and the humanities. Moreover

> we must make an effort . . . to rescue the study of the arts and humanities from the baleful influence [of] the social sciences It is the tendency of the social sciences to reduce the arts and the humanities to a level of materialist culture where distinctions between high art and popular culture and between art and politics are meaningless—and at that level what art is itself can no longer be discussed, for it is seen to consist of nothing but the sum of its social and economic attributes.

As for Kramer's remedy:

> I am advocating . . . a return to the very disciplines that have been so much under attack in recent years. . . . In art history, it means the revival of training in connoisseurship—the close, comparative study of art objects with a view to determining their relative levels of aesthetic quality. . . .
>
> Our task . . . is to try to expel the politicization of the arts and the humanities in order to allow them enough free intellectual air in which to breathe and grow.[129]

Thomas Lawson countered Kramer's arguments in *Artforum* by questioning "his repeated advocacy of 'quality' and 'standards.' What pre-

cisely he means by these terms is never made clear."[130] Lawson was right to question Kramer's use of the idea of quality as a weapon with which to condemn art he did not like for other reasons. Quality is in any case indefinable. Equally questionable was Kramer's conviction that aesthetic quality could not be compatible with political commitment.

Kramer refused to consider seriously most of the art of interest to the art world. This left him in a marginal position, made still more marginal because he refused even to entertain any position different from his own. His criticism was marked, as Annette Michelson pointed out, by a "sense of closure, the premature atrophy of the inquiring, speculative impulse. The contemptuous and personalized dismissal of those artists and critics who have responded, however awkwardly, to that impulse is a form of philistinism, embarrassing in this case."[131] She did not mention that critics on the left were equally contemptuous and dismissive of Kramer. Nor did she indicate that *October* was no more open than the *New Criterion*. If Kramer did not have much support in the art world (although he was widely and closely read), he did have the ear of the National Endowment for the Arts. Much as he presented himself as an embattled outsider, he was the cultural voice of neoconservatism and thus a power to be reckoned with.[132]

The confrontation of critics on the right and the left over the artistic legacy of the Vietnam War, the student uprisings of 1968, the counterculture, and Watergate was still unresolved in the 1990s. Questions remained. Was the art, no matter how perverse, established by the art-world consensus the true expression of how it really felt to be alive at that time? Or was it a nihilist assault on more than twenty-five centuries of Western civilization in the name of marginalized "others"—women, gays, people of color, and other minorities? If one valued Western civilization, were the barbarians at the gate? Or had the world, succumbing to rampant tribalism and nationalism, ethnic cleansing, population explosion, and ecological devastation, degenerated into barbarism?

NOTES

1. Jeremy Gilbert-Rolfe resigned after the publication of three issues.
2. *New Art Association Newsletter*, Sept. 1970, in "Politics," *Artforum*, Nov. 1970, p. 39.
3. L. S. Klepp, "Letters to the Editor: The M.L.A. Convention," *New York Times Magazine*, Mar. 10, 1991, p. 16.
4. See Sara Day, "Art History: Crisis or New Horizons: Art History's New Warrior Breed," *Art International*, Spring 1989, pp. 78–89.
5. Amy Goldin, "'American Art History Has Been Called Elitist, Racist and Sexist. The Charges Stick,'" *Art News*, Apr. 1975, pp. 48, 49–50.
6. M.K. [Max Kozloff], editorial in *Artforum*, Dec. 1975, p. 7.
7. Hilton Kramer, "Muddled Marxism Replaces Criticism at Artforum," *New York Times*, Dec. 21, 1975, sec. D, p. 40.
8. David Bourdon, "Art: Artforum Goes Political,"

Village Voice, Jan. 5, 1976, p. 68.

9. John Coplans and Max Kozloff, "Letters: Artforum Versus Kramer," *New York Times*, Jan. 4, 1976, sec. D, p. 2. Kozloff elaborated on these ideas in a talk, "Art Criticism: What Is to be Done?" held at the Pratt Institute, New York, Mar. 4, 1977.

10. Max Kozloff and John Coplans, "Art Is a Political Act," *Village Voice*, Jan. 12, 1976, p. 71.

11. "Letters," *Artforum*, Mar. 1977, p. 8.

12. For an analysis of the inner workings of *Artforum* in the early and middle 1970s, see Robert Pincus-Witten, "Naked Lunches," *October 3* (Spring 1977): 102–18, and Jack Burnham, "Ten Years Before the Artforum Masthead," *New Art Examiner*, Apr. 1978, pp. 1, 6–7.

13. Editors, "About *October*," *October 1* (Spring 1976): 3.

14. Annette Michelson, "The Prospect Before Us," *October 16* (Spring 1981): 119.

15. "Interview with Charles Jencks," in Charles Jencks, ed., *The Post Avant-Garde: Painting in the Eighties* (London: Academy Editions, 1987), p. 17.

16. Michelson, "The Prospect Before Us," p. 119.

17. There is in some of the writing in *October* the implication that art and art theory and criticism could or ought to lead to "revolutionary change." For example, see Clara Weyergraf, "The Holy Alliance: Populism and Feminism," *October 16* (Spring 1981): 29.

18. Joseph Masheck, in "Editing *Artforum*," *Art Monthly*, Dec. 1977–Jan. 1978, recalled that even during the editorial turmoil at *Artforum* in 1975, "the ideological interests of several . . . editors had become their main preoccupations rather than motivations for subjecting works of art to critical scrutiny" (p. 11).

19. Gerald Graff, "Where Do We Go from Here? 17 Critics Read Between the Lines: Vital Signs," *Village Voice Literary Supplement*, Oct. 1988. Graff went on to say: "Setting out with the best intentions to talk about a literary work 'in itself,' we found that we could not assume agreement in our premises about the nature of poetry, how it communicates, and its social and cultural functions. Consequently, our attention was diverted from the poem to the terms in which we talk about poems" (p. 21).

20. Edward W. Said, in ibid., p. 14.

21. Michelson, "The Prospect Before Us," p. 119.

22. As a tendency within poststructuralism, deconstruction had its roots in structuralism. Jean-Michel Roy, in "Opinion: The French Invasion of American Art Criticism," *Journal of Art* (Nov. 1989) wrote that the "main idea behind structuralism was that cultural phenomena as different as myth, fashion, literature, cinema or painting may all be understood as a manipulation of signs governed by an underlying sign-system. Thus, the task of the critic became to uncover these underlying systems and to unveil their internal organization, i.e., their structure" (20). Poststructuralists were weaned on structuralism, but they also criticized some of its basic tenets. The structuralists dealt with language as if it were a sta-

ble system; for the poststructuralists, language was an ever-shifting discourse. To put it another way, the structuralists conceived of language as a natural, inevitable human function, the poststructuralists, as an *artificial* construction, therefore contingent and changeable.

23. David Lehman, *Signs of the Times: Deconstruction and the Fall of Paul de Man* (New York: Poseidon Press, 1991), pp. 66–67.

24. James W. Tuttleton, "Books: Quisling Criticism: The Case of Paul de Man," *New Criterion*, Apr. 1991, p. 50.

25. Roland Barthes, "The Death of the Author," in Brian O'Doherty, ed., *Aspen 5 + 6* (Fall-Winter 1967): sec. 3, n.p.

26. Lehman, *Signs of the Times*, p. 35.

27. David Lodge, *Nice Work: A Novel* (London: Secker & Warburg, 1988), p. 40.

28. Brian Wallis, "Modernism, Postmodernism, and Beyond," in *Beyond the Frame: American Art 1960–1990* (Tokyo: Setagaya Museum, 1991), p. 194.

29. Barthes, "The Death of the Author," sec. *3*, n.p.

30. Morris Dickstein, "Where Do We Go from Here?" *Village Voice*, pp. 19–20. (A similar development occurred in conceptual art; beginning as a critique of the "language" of art, it ended up deconstructing society.)

31. I am indebted to my discussions with Luke Murphy, a graduate student of mine at the State University of New York at Purchase, for my formulation of poststructuralism.

32. Frederick Crews, "Whose American Renaissance," *New York Review of Books*, Oct. 27, 1988, p. 68.

33. Dickstein, "Where Do We Go from Here?" p. 19.

34. Terry Eagleton, *Literary Theory: An Introduction* (Minneapolis: University of Minnesota Press, 1983), p. 142. Quoted in Lehman, *Signs of the Times*, p. 73.

35. Krauss maintained that deconstruction and photography, respectively, were "the next" intellectual and artistic moves and was therefore laudatory. Much as it was natural for her to employ the formalist tactic of "the next move," it was also ironic, since she was using a discredited—in her view—avant-gardist tactic to demolish formalism.

36. Annette Michelson, Rosalind Krauss, Douglas Crimp, and Joan Copjec, eds., "Introduction," *October: The First Decade, 1976–1986* (Cambridge, Mass.: MIT Press, 1987), p. xi.

37. Craig Owens, "Review of Books: Analysis Logical and Ideological," *Art in America*, May 1985, p. 25. This is a review of Rosalind E. Krauss, *The Originality of the Avant-Garde and Other Modernist Myths* (Cambridge, Mass.: MIT Press, 1985). Krauss's quote is from p. 2.

38. Owens, "Review of Books: Analysis Logical and Ideological," p. 26.

39. Connor, *Postmodernist Culture*, p. 240.

40. Carter Ratcliff, "Issues & Commentary: Dramatis Personae, Part IV: Proprietary Selves," *Art in America*, Feb. 1986, p. 13.

41. Andy Stark, "Notebook: Talking Politics, Talking Art," *New Criterion*, Jan. 1984, p. 80.

42. In Jed Perls, "Robert Hughes with Jed Perls," *Modern Painters* 3, no. 3 (Autumn 1990), Hughes said that he was "impatient with the overwhelming academic orthodoxy of poststructuralism, with its disrespect for the writer's voice, its complete incomprehension of what writers actually do. The idea that it is the language that generates the text! That dreadful pretentious lingo of intertextuality! [All] they really mean is that writers read other writers. What news!" (33).

43. Robert Pincus-Witten, "Postminimalism," in *The New Sculpture: 1965–75*, (New York: Whitney Museum of American Art, 1990), p. 24.

44. Robert Storr, "Other 'Others,'" *Village Voice Art Supplement*, Oct. 6, 1987, pp. 16–17.

45. Arthur C. Danto, in "Books & the Arts: What Happened to Beauty?" *The Nation*, Mar. 30, 1992, related the art theory inspired by Baudrillard, Benjamin, Barthes, Foucault, Derrida, Lacan, et al., to the art it extolled. Both "are marked by radical discontinuity, fragmentariness, obscurity, mock technicality. The writings belong together with the art they were used to interpret [in their] indignant incoherence" (p. 421). Storr, in "Other Others," p. 16, also attacked art theory for its "hermeticism and deliberate ambiguity."

46. Krauss, "Sculpture in the Expanded Field": 41–42. For the influence of Fried's formulations in "Art and Objecthood," see Howard Singerman, "In the TEXT," *A Forest of Signs: Art in the Crisis of Representation* (Los Angeles: Museum of Contemporary Art, 1989), p. 159.

47. In declaring painting obsolete, Krauss reaffirmed the thinking of the minimalists and postminimalists, who had also rejected painting.

48. What made the index so important to Krauss was its literalness, an attribute prized by the minimalists and postminimalists. It is noteworthy that touch in painting is also an index but one that is subjective and illusionistic, and therefore, unacceptable to Krauss.

49. Rosalind Krauss, "Notes on the Index: Seventies Art in America, Part 2," *October 3* (Fall 1977): 66.

50. Rosalind Krauss, "Notes on the Index: Seventies Art in America," *October 3* (Spring 1977): 77. It is noteworthy that even before *October* there was growing art-world interest in photography as an art form. *Artforum*, under the editorship of Max Kozloff, began to feature it.

51. Michelson, Krauss, Crimp, and Copjec, "Introduction," p. x.

52. Owens, "Review of Books: Analysis Logical and Ideological," p. 29.

53. Abigail Solomon-Godeau, "Photography After Art Photography," in Brian Wallis, ed., *Art After Modernism: Rethinking Representation* (New York: New Museum of Contemporary Art, 1984), p. 76.

Solomon-Godeau summed up the appeal of photography to art theoreticians: "Virtually every critical and theoretical issue with which postmodernist art may be said to engage in one sense or another can be located within photography. Issues having to do with authorship, subjectivity, and uniqueness are built into the very nature of the photographic process itself: issues devolving on the simulacrum, the stereotype, and the social and sexual positioning of the viewing subject are central to the production and functioning of advertising and other mass-media forms of photography" (p. 80).

54. Editors, introduction to "Photography: A Special Issue," *October 5* (Summer 1978): 3–5.

55. Douglas Crimp, "The Art of Exhibition," *October 30* (Fall 1984): 56.

56. Howard Singerman, "In the TEXT," pp. 162–63.

57. Patrick Frank, "Recasting Benjamin's Aura," *New Art Examiner*, Mar. 1989, p. 30.

58. Singerman, "In the TEXT," pp. 162–63.

59. See Frank, "Recasting Benjamin's Aura," pp. 30–31.

60. The editors of *October*, in the introduction to "Photography: A Special Issue": 5, made much of the impossibility of distinguishing one photographic print from another, and hence the questionability of authenticity.

61. Kirk Varnedoe, "The Poverties of Postmodernism," lecture at the Museum of Modern Art, New York City, Oct. 23, 1990, author's notes.

62. Rosalind Krauss, "A Note on Photography and the Simulacral," *October 31* (Winter 1984): 59, 63.

63. Sidney Tillim, "Since the Late 18th Century the Function of Art as a Form of Value, and How That Value Was to Be Defined, Has Been Anything But Clear," *Artforum*, May 1983, p. 67.

64. Varnedoe, lecture at the Museum of Modern Art.

65. Abigail Solomon-Godeau, "Mandarin Modernism: 'Photography Until Now,'" *Art in America*, Dec. 1990, p. 141. She also wrote that Szarkowski's

unrivaled influence within the art-photography world—a world embracing museums, collectors, galleries and private dealers, publishers of photography books and periodicals as well as art photographers themselves—is not solely attributable to the reputation of the department he heads nor the power of the institution that houses it. Indeed, Szarkowski's prestige derives equally from his widely admired exhibitions and from his writings, which have served, since his arrival at the museum in 1962, to revise and refurbish the art-photography tradition, to prune and rework its canon and to establish a modern (although hardly contemporary) pantheon.

Richard B. Woodward, in "It's Art, But Is It Photography?" *New York Times Magazine*, Oct. 9, 1988, wrote that Szarkowski "is one of the great fig-

ures of American art; and MOMA has shown a longer, deeper regard for the art of photography than any institution in the world. But in the opinion of many critics, the museum has lost its edge by ignoring these artists-who-use-photography" (pp. 31, 42).

66. Solomon-Godeau, "Mandarin Modernism," pp. 143, 183. The John Szarkowski quote comes from his *Photography Until Now* (New York: Museum of Modern Art), p. 219.

67. John Gruen, "The Reasonably Risky Life of John Szarkowski," *Art News,* Apr. 1978, p. 67.

68. Woodward, "It's Art, But Is It Photography?" p. 44.

69. Susan Weiley, in "The Darling of the Decade," *Art News,* Apr. 1989, wrote: "Photography has been divided along esthetic lines, but some feel the more accurate distinction lies between photographers whose work invites intimate viewing, as in a book, and those who intend the work for a wall. . . . Work has shifted from the intimacy of being held in the hand toward something that has to be seen on the wall, at a distance. It's a major difference" (p. 149).

70. Editors, introduction to "Photography: A Special Issue": 4.

71. Barbara Rose, *American Painting: The Eighties: A Critical Interpretation* (New York: Vista, 1979), n.p.

72. Ibid.

73. Richard Hennessy, "What's All This About Photography?" *Artforum,* May 1979, pp. 22–23. Italics are in original text.

74. Rose, *American Painting: The Eighties,* n.p.

75. Roberta Smith, "Review of Exhibitions: New York: 'American Painting: The Eighties,' at the Grey Gallery, N.Y.U.," *Art in America,* Oct. 1979, p. 122.

76. Rosalind Krauss and Annette Michelson, "Editorial," *October 10* (Fall 1979): 3–4. Hal Foster, in "A Tournament of Roses," *Artforum,* Nov. 1979, agreed: "To Rose and Hennessy photography is important only as a scapegoat; they deem its influence on painting a bad one, and so blame photography for painting's debility. Then (as if this were not enough) they subject photography to painterly criteria and condemn it in general: one can only conclude, yes photography is not painting" (64).

 Not all champions of photography opposed painting. John Szarkowski, in Gruen, "The Reasonably Risky Life of John Szarkowki," when asked whether photography might one day replace painting, replied: "Heavens, no! Why on earth would people want to live without painting? What conceivable reason could there be for people of their own free wills to decide that life would be as good without painting? [A] world without painting! That would be madness!" (p. 70).

77. Crimp, "The End of Painting": 74.

78. Clara Weyergraf, "The Holy Alliance: Populism and Feminism," *October 16* (Spring 1991): 23.

79. Crimp, "The End of Painting," pp. 85–86.

80. Benjamin H. D. Buchloh, "Figures of Authority, Ciphers of Regression: Notes On the Return of Representation in European Painting," *October 16* (Spring 1981). He went on to condemn the new painting in every way that he could. For example, in contrast to the political radicalism of Berlin Dada, the "apolitical humanitarian stance of the expressionist artists, their devotion to spiritual regeneration, their critique of technology, and their romanticism of exotic and primal experience perfectly accorded with the desire for an art that would provide spiritual salvation from the daily experience of alienation resulting from the dynamic reconstitution of postwar capitalism." Buchloh equated the current "guise of irrationality and the ideology of individual expression" with "proto-Fascist libertarianism [which] prepares the way for the seizure of state power." At the same time neoexpressionism signaled "the end of a class" by generating "apocalyptic and necrophiliac visions." Buchloh concluded: "The mock avant-garde of contemporary European painters now benefits from the ignorance and arrogance of a racket of cultural parvenus who perceive it as their mission to reaffirm the politics of a rigid conservatism through cultural legitimation" (40, 62, 66–68).

81. Benjamin H. D. Buchloh, "Documenta 7: A Dictionary of Received Ideas," *October 22* (Fall 1982): 105, 109.

 Douglas Crimp, in "Pictures," *October 8* (Spring 1979), with *The New Image* show in mind, wrote that its purpose was "to preserve the integrity of *painting.*" The Whitney was complicit "with that art which strains to preserve the modernist aesthetic categories which museums themselves have institutionalized; it is not, after all, by chance that the era of modernism coincides with the era of the museum" (88). Thus Crimp by inference identified painting with the institution of the museum and modernism, both of them disreputable, in his opinion.

82. Richard Hertz, "A Critique of Authoritarian Rhetoric," *Real Life* 8 (Spring–Summer 1982): 16–18.

83. Peter Halley, "A Note on the 'New Expressionism' Phenomenon," *Arts Magazine,* Mar. 1983, pp. 88–89.

84. "Post-Modernism," *Real Life* (Summer 1981): 8–10. The notion of a "next move" had its source in Marxist historical determinism *and* modernist formalism, much as Owens repudiated it.

85. Laura Cottingham, "Review: The Last Decade: Eighties Artists," *Contemporanea* 23 (Dec. 1990): 89.

86. Lawson elaborated, in "Last Exit: Painting," *Artforum,* Oct. 1981: "Much activity that was once considered potentially subversive, mostly because it held out the promise of an art that could not be made into a commodity, is now as thoroughly academic as painting and sculpture, as a visit to any art school in North America will quickly reveal. And not only academic, but marketable, with 'documentation' serving as the token of exchange" p. 43.

87. Ibid., p. 40.

88. Critical Art Ensemble, "Interview: Thomas Lawson," *Art Papers,* Jan.–Feb. 1989, pp. 20–21.

89. Douglas Crimp had maintained in "The End of

Painting" that the coup de grace to painting was delivered by conceptual art, notably that of Daniel Buren.

90. Critical Art Ensemble, "Interview: Thomas Lawson," pp. 20–21.

91. Thomas Lawson, "Spies and Watchmen," *Cover 1* (Spring–Summer 1980): 17. In "Last Exit: Painting," he was hostile to what he considered reactionary styles of painting, "from New Abstraction to Pattern and Decoration, [which] proved to be little more than the last gasps of a long overworked idiom, modernist painting" (40). He was also especially contemptuous of the historicist and self-advertising neoexpressionism of a Schnabel or Clemente, artists motivated by "a nostalgic desire to recover an undifferentiated past. . . . These young painters ingratiate themselves by pretending to be in awe of history. Their enterprise is distinguished by an homage to the past" (41).

92. Lawson, "Last Exit: Painting": 45.

93. Ibid.: 45.

94. Thomas Lawson, "Nostalgia as Resistance," *Modern Dreams: The Rise and Fall and Rise of Pop* (Philadelphia: Institute of Contemporary Art, 1988), p. 159. Hal Foster accepted this interpretation of Lawson. He wrote of the paintings of Salle and Lawson in "Between Modernism and the Media," *Art in America*, Summer 1982, "Leery of the false freedoms of our culture (including much of contemporary art), they pose an art that would reveal how our representation subject us. They thus contrive a 'dead' painting, a painting that undermines its own claim to truth or representative status" (p. 17).

95. See Craig Owens, "Back to the Studio," *Art in America*, Jan. 1982, pp. 99–107.

96. Craig Owens, "Letters," *Art in America*, Apr. 1982, p. 7.

97. Lawson, "Last Exit: Painting," p. 45.

98. Thomas Lawson, "Or, The Snake Pit," *Artforum*, Mar. 1986, p. 101.

99. Lawson, "Last Exit: Painting," p. 45.

100. Janet Malcolm, "Profiles: A Girl of the Zeitgeist—Part II," *The New Yorker*, Oct. 27, 1986, pp. 57–58.

101. Rosalind E. Krauss, "The Originality of the Avant-Garde: A Postmodernist Repetition," *October 18* (Fall 1981): 66.

102. Much of Krauss's argument is not convincing. She attacks originality and authenticity by pointing out that Rodin had not finished the *Gates of Hell* at the time of his death and that it was cast later. Thus she writes in "The Originality of the Avant-Garde," that the copies of the *Gates of Hell* "exist in the absence of an original" (48). But the *Gates of Hell* is merely an unfinished Rodin; there is no problem of originality or authenticity. Krauss is bothered by the fact that Rodin made copies of some of his sculptures. She comments: "Now nothing in the myth of Rodin as a prodigious form giver prepares us for the . . . multiple clones. For the form giver is the maker of originals, exultant in his own originality" (51). But the multiples are only a part of Rodin's prodigious production and do not really make a myth of him as a form giver. Moreover, multiple casts are of his forms, and they are all original and what he did with them is original.

103. Krauss, "The Originality of the Avant-Garde": 53.

104. The grid in modernist art was used in a variety of ways, all of which looked new, particularly when compared to older forms. There is no need to require any single original source or to denigrate artists because they were not the inventor of the grid. Krauss concluded that the grid can only be repeated, and pitted originality against repetition in a deconstructionist manner, implying that modernist art is repetitive rather than original. But do Mondrian, LeWitt, Stella, or Andre really only repeat? To use the fact that Blanc and Thiers liked the work of Delacroix and copies of Old Masters is to condemn Delacroix with a kind of guilt by association. Krauss also attacked spontaneity in painting by pointing to Monet, who contrived the look of spontaneity, concluding in "The Originality of the Avant-Garde," that the "sense of spontaneity was the most fakable of signifieds" (63). But what of Pollock? Did he fake spontaneity? And so forth.

105. Robert Storr, "An Interview with Ilya Kabakov," *Art in America*, Jan. 1995, p. 67.

106. Krauss, "The Originality of the Avant-Garde": 64, 66. (Italics in original.)

Krauss's dilemma was best characterized by Roger Scruton. In "In Inverted Commas: The Faint Sarcastic Smile on the Face of the Postmodernist," *Times Literary Supplement*, Dec. 18, 1992, he commented that "the determination to be new, and to define oneself as new, belongs to the old project of modernity" (p. 4). The postmodernist was "therefore quite happy to be old hat. [But] if the hat is too old, he becomes a pre-modernist, . . . and so falls off the map of cultural history altogether. [The] postmodernist has to be extremely careful neither to fall into the pit of the modernists, by believing in what Harold Rosenberg called 'the tradition of the new,' nor to collapse onto the dust heap of history, by believing in the tradition of the old."

107. Gregorio Magnani, "Victor Burgin," *Flash Art* (Nov.–Dec. 1989): 121.

108. Craig Owens, "The Allegorical Impulse, Part 2," *October 13* (Summer 1980): pp. 79–80.

109. Craig Owens, "The Allegorical Impulse: Toward a Theory of Postmodernism" (part 1), *October 12* (Spring 1980): 68–69.

110. Thomas McEvilley, "The Case of Julian Schnabel," *Julian Schnabel: Paintings 1975–1987* (London: Whitechapel, 1986), p. 11.

111. Fredric Jameson, "Postmodernism and Consumer Society," in Hal Foster, ed., *The Anti-Aesthetic: Essays on Postmodern Culture* (Port Townsend, Wash.: Bay Press, 1983), pp. 114–15. It is noteworthy that Jameson was a contributor to *October*.

112. Mathews, "Feminist Art Criticism," pp. 11–12. Influential in formulating feminist deconstructionist theory was a group of London-based critics and theoreticians, many of whom wrote for *Screen*. Foremost among these was Laura Mulvey, who in a seminal article titled "Visual Pleasure and Narrative Cinema" (1975), examined how Hollywood movies mold the way in which society views gender differences.

113. Mathews, "Feminist Art Criticism," pp. 13, 22. Thomas McEvilley, in "Redirecting the Gaze," in Randy Rosen and Catherine C. Brawer, eds., *Making their Mark: Women Artists Move into the Mainstream 1970–85* (New York: Abbeville, 1989), p. 195, took a tack similar to Mathews's. He pointed out that deconstructionist feminists asserted that the "emphasis on the depiction of the female body, may be complicit with the male gaze and with the long tradition of patriarchal exploitation of the female image." On the other hand, the essentialists "have expressed the misgivings that the deconstructivists, with their emphasis on language, analysis, and French philosophy, may be complicit with the male emphasis on intellectual mediation of experience." He concluded:

Yet it can be argued that both these strategies are necessary and that their difference is more complementary than contradictory. The goddess-reviving artists are reacting to the fact that for millennia the female body has been culturally colonized by the patriarchal order; they are trying, in effect, to take their bodies back. The deconstructivists are reacting to the equally long and thorough patriarchal colonization of the female mind; they are trying, in effect, to take their minds back.

In providing knowledge, much of it in verbal form, about how society forms or "constructs" women, Spero anticipated the main tendency in second-generation feminist art of the 1980s. However, as a feminist essentialist Spero was out of sympathy with later, more conceptually oriented feminist thinking. In one of her works, a physically liberated dancer leaps exultantly over a quote of Derrida's: "There is no essence of women."

114. Press release for *Making Their Mark: Women Artists Move into the Mainstream 1970–85*, Philippa Polskin/Betsy Ennis: Art & Communication Counselors, New York City, p. 3.

115. John Loughery, "Mrs. Holladay and the Guerrilla Girls," *Arts Magazine*, Oct. 1987, p. 63.

116. Susan Tallman, "Prints and Editions: Guerrilla Girls," *Arts Magazine*, Apr. 1991, p. 22.

117. Mira Schor, in an article on the Guerrilla Girls, "Girls Will Be Girls," *Artforum*, Sept. 1990, p. 125, wrote: "The naming of institutions and individuals contin-ued into 1986: 'ONLY 4 OF THE 42 ARTISTS IN THE CARNEGIE INTERNATIONAL ARE WOMEN,' 'THE GUGGENHEIM TRANSFORMED 4 DECADES OF SCULPTURE BY EXCLUDING WOMEN ARTISTS. Only 5 of the 58 artists chosen by Diane Waldman for "Transformations in Sculpture: 4 Decades of European and American Art"' are women." And the agitation continues to this day.

118. Tallman, "Prints and Editions: Guerrilla Girls," p. 22. In response to art-market demand, the Guerrilla Girls "made available a complete set of the 30 posters produced between 1985 and 1990, in a limited edition of 50."

119. Foster, "A Preface," *The Anti-Aesthetic*, pp. xv–xvi.

120. Craig Owens, "Issues & Commentary: Representation, Appropriation & Power," *Art in America*, May 1982. Owens also called for the deconstruction of and resistance to the traditional visual arts. "In the visual arts, the postmodernist critique of representation proceeds by a similar attempt to undermine [the claim] of visual imagery . . . to represent reality as it really is, whether this be the surface appearance of things (realism) or some ideal order lying behind or beyond appearance (abstraction). Postmodernist artists demonstrate that this 'reality,' whether concrete or abstract, is a fiction" (pp. 9–10, 21).(Italics in original.)

121. Crimp, "The Art of Exhibition": 68. The culprits in the revival of painting were Rudi Fuchs, the artistic director of *Documenta 7;* Norman Rosenthal and Cristos Joachimides, the organizers of *Zeitgeist;* Kynaston McShine, the curator of *An International Survey of Recent Painting and Sculpture* at the Museum of Modern Art; and Hilton Kramer, editor of the *New Criterion*.

122. Rosalyn Deutsche and Cara Gendel Ryan, "The Fine Art of Gentrification," *October 31* (Winter 1984): 93, 105–6. Crimp, in "The Art of Exhibition," castigated "a new breed of entrepreneurial artists, utterly cynical in their disregard of both recent art history and present political reality. These newly heralded 'geniuses' work for a parvenu class of collectors who want art with an insured resale value, which will at the same time fulfill their desire for mildly pornographic titillation, romantic cliché, easy reference to past 'masterpieces,' and good decor" (76).

123. Hilton Kramer, "A Note on *The New Criterion*," *New Criterion*, Sept. 1982, pp. 1–2.

124. Hilton Kramer, "Modernism and Its Enemies," *New Criterion*, Mar. 1986, pp. 4, 6–7.

125. Hilton Kramer, "Postmodern: Art and Culture in the 1980s," *New Criterion*, Sept. 1982, pp. 36–40, 42.

126. Roger Kimball, "The Periphery vs. the Center: The MLA in Chicago," *New Criterion*, Feb. 1991, p. 9.

127. Peter Brooks, "Western Civ at Bay," *Times Literary Supplement*, Jan. 25, 1991, p. 6.

128. Richard Vine, "The Beatification of Walter Benjamin," *New Criterion*, June 1990, p. 48.

129. Hilton Kramer, "Studying the Arts and the Humanities: What Can Be Done?" *New Criterion*, Feb. 1989, pp. 3–6.

130. Thomas Lawson, "Hilton Kramer: An Appreciation," *Artforum*, Nov. 1987, p. 91.

131. Annette Michelson, "Contemporary Art and the Plight of the Public," *Artforum*, Sept. 1974, p. 70.

132. Lawson, "Hilton Kramer: An Appreciation," p. 91. Kramer's copublisher, Samuel Lipman, sat on President Reagan's National Council on the Arts, which oversees the National Endowment for the Arts.

12 THE CONSUMER SOCIETY AND DECONSTRUCTION ART

Underlying the conflict between *October* and the *New Criterion* were opposing political attitudes toward capitalist society—the one critical, the other supportive. However, the expression of these positions in art was one-sided. Few recognized artists on the political right introduced social concerns into art—Gilbert & George stand out as exceptions. In contrast a considerable number on the left made political art whose targets were the art world, capitalism, and the mass media that was so vital to its functioning.

Left-leaning artists were naturally concerned with the role that the burgeoning art market played in their lives. As I commented in the Introduction, this concern was not new; in the late 1960s many postminimalists had become so disgusted with the growing commercialization of art that they had attempted to produce unsalable works. Others—Marcel Broodthaers, Daniel Buren, and Hans Haacke, for example—made art that attacked art institutions. Since then artists had become aware that the commodification of art was part of a larger social development in the so-called First World: the emergence of a consumer society or, as it has also been called, consumer capitalism, media society, information society, postindustrial society, and multinational capitalism. Indeed, this new social order had become so pervasive and compelling that artists could not help reacting. Emerging after World War II and reaching its apogee in the 1980s, consumer society was defined by the abundance of goods produced by computer technology. An ever-increasing cornucopia of commodities was made available to growing masses of affluent consumers. They were urged to buy these products by advertisements in the proliferating mass media (notably television), subsidized by the publicity industry. Indeed, the continued growth of the economy depended on the mass media's ability to maintain a constantly burgeoning demand for commodities and services.

Artists had been among the first to call attention to and attempt to define the consumer society. In the 1960s an international group of Marxist bohemians, called the situationists, targeted the new stage of

capitalism. Although they numbered only some six dozen during their fifteen-year history, they made their views felt in leftist circles, playing an important role, for example, in fueling the students' revolt in Paris in 1968. The primary situationist text was Guy Debord's book, *Society of the Spectacle*, published in French in 1967 and in English in 1970. A decade before it was fashionable to do so, Debord had come to believe that the critical issue in the new stage of capitalist development was not the means of production but the means of consumption. As he viewed it, capitalism had evolved and instituted such powerful mechanisms for manipulating consciousness that the masses had been transformed into passive consumers, in thrall to an all-embracing "spectacle" of advertising and the media. The spectacle was mind drugging and curbed the quest for challenging and meaningful activities that might provide genuine fulfillment and an authentic sense of self. Advertising caused the masses to develop and internalize needs and aspirations that they did not actually have—that did not issue from their true selves. It followed that in succumbing to media-induced desires, the masses developed false selves.[1] The fulfillment of these fictitious cravings generated a sense of well-being, but that was only an illusion concealing a profound condition of alienation—and boredom. A favorite situationist slogan was: Boredom Is Always Counterrevolutionary.

The artistic purpose of the situationists was to confront the "spectacle." They would inspire and provoke the passive masses into rejecting false desires and regaining their true selves. Revitalized, the masses would become active participants in a creative transformation of everyday life. One of the artistic practices of the situationists was to "drift" through an urban space in order to experience its "geopsychology," with the idea of making the environment more livable. Another practice was *détournement,* or deflection. This meant appropriating preexisting images and texts from art or the mass media and, in a kind of cultural sabotage, deflecting them from their previous function so that they took on new subversive meanings. For example, situationists changed the captions of comic strips to turn them into political allegories. The situationists generally revised existing texts, images, or situations rather than create original works.

Although the situationists wanted to use art as a means of social and cultural regeneration—and avoid having it co-opted by the consumer society—they came to believe that this was impossible. Art always ended up being assimilated into the "spectacle," transformed into a commodity. Consequently they chose to abandon art and engage in direct political action, creating transitory "situations" aimed at disrupting the debilitating passivity engendered by the media in order to arouse hopes for a new life.

The situationists disbanded in 1972, but their ideas had influenced and continued to influence artists, among them Buren and Haacke, both of whom aimed to deconstruct art institutions. The situationist method

of appropriating media images for political purposes became common in the 1980s. Situationist practices also informed bad painting and its counterpart, punk music, whose leading impresario, Malcolm McLaren, had been schooled in situationist techniques. Later, associations of political artists, such as Group Material and Act Up, used situationist tactics, although without always knowing their source. Situationist ideology was also a catalyst for the theories of Jean Baudrillard and Jacques Derrida, which were much discussed in the art world in the 1980s.

In American academic circles the idea that capitalism had entered a consumerist phase was formulated by Daniel Bell in *The Coming of Post-Industrial Society* (1973) and *The Cultural Contradictions of Capitalism* (1976). The latter was reviewed in *Artforum*, an indication of its interest to artists and art professionals, particularly those sensitive to the commodification of art.[2] In 1981, Craig Owens, using ideas culled from Bell, presented an analysis of the social and cultural evolution of consumer capitalism in *Real Life* (founded by Thomas Lawson in 1978 to examine the relationship of the mass media to art). According to Owens, Bell saw

> the development of modern society in terms of three historical phases; pre-industrial, industrial, and post-industrial. The first is based upon extraction; its primary economic activities are hunting, farming, mining, and so on. In industrial society [which flourished in the nineteenth century], these extractive activities are replaced by productive ones. [All] human activities are realigned according to the schema of production.

Power is in the hands of those who control the means of production. The aesthetic expression of industrial society is modernism.[3] In his review of Bell's book in *Artforum*, Tim Yohn wrote that the modernist economy, politics, and culture "have shared the assumption of the autonomy of the individual human being. Indeed, this ideal, the equation of self-determination and freedom, [as well as] the ability . . . 'to make of oneself what one can, and even—to remake one's self altogether,' is the basis of what Bell calls 'modernism.' [One could observe] the parallel emergence of the bourgeois entrepreneur and the independent artist."[4]

Succeeding industrial society was postindustrial society. It was, according to Bell, as interpreted by Owens, "the society of information," whose primary purpose was marketing, inducing consumers to buy. "Power now resides with those who control the networks for the processing, retrieval, and transmission of information."[5] The culture of postindustrial or consumer society was postmodernism. On the whole postmodernists maintained that the individual in society and culture had ceased to be autonomous and had become a cog in a social mechanism, whether it was a multinational corporation or the international art world. Individuals were no longer inner-directed but outer-directed, as it were, in thrall to social institutions and their representations in the

media. The individual fashioned him- or herself by what he or she appropriated—in life, through shopping; in art, through copying the art of others and media imagery.

In *Society of the Spectacle*, Debord claimed that reality had been replaced by its images, particularly those produced by the advertising industry, images which had come to control the thinking of the masses. He used as the epigraph of his book a remark made some 150 years earlier by Ludwig Feuerbach, that our "age prefers the sign to the thing signified, the copy to the original, representation to reality."[6] If that was true in Feuerbach's time, our own had taken a qualitative leap in the number of signs it was incessantly subject to.

Translated into economic terms, Debord's claim that images had replaced reality meant that the signs of commodities had replaced the commodities. Whatever was marketed in consumer society, whether a widget or a president of the United States, was an image, a sign, or a signifier. Debord cited Clark Kerr, who forecast that commerce in such images would replace the railway and the automobile as "the driving force in the development of the economy in the second half of the twentieth century.[7] And this seemed to have occurred. In a society of mass affluence, where the supply of commodities was taken for granted, marketing took precedence over production. Advertising images not only functioned to promote commodities, but they themselves became commodities, more important than the commodities they promoted. As Jeffrey Deitch put it, "The maxim of the former production-oriented economy was that you could 'build a better mousetrap and the world would beat a path to your door.' . . . In our current economy of mass affluence where upscale consumers already possess almost every product they really need, marketing rather than pure production has become the key to business success."[8]

Amidst the plethora of me-too products in the affluent society, it was not the function of a commodity, but the image—or rather the minor difference in image—that counted, and it was this difference that was marketed. Advertising in the mass media created the desire for the difference. Rather than provide information about a product, the publicity industry appealed to the consumer's emotions—making him or her wonder how using the product might feel—cultivating identification with the product, creating a dream of the commodity, and selling that dream. In this sense the image of an imaginary commodity replaced the real thing.

Growing numbers of artists began to deconstruct consumerism and the mass media and their relation to art and the art world. They were influenced by the theories of Jean Baudrillard, published in English in a paperback, *Simulations*, in 1983. He maintained that in an age of consumer capitalism, all of reality was totally mediated by the mass media— by what the situationists had termed "the spectacle." With the emergence of mass culture and mass reproduction, there had been an explosion of

"signs"—simulations of reality that had replaced reality. All "of contemporary life had been dismantled and reproduced in scrupulous facsimile."[9] Simulacra had become more real than reality itself; they had become, in Baudrillard's term, "hyperreal." He also observed that new mass-media industries had emerged to process signs in order to sell commodities, pop stars, or political figures and to mold public opinion. Baudrillard concluded pessimistically that nothing could counter or resist the seduction of the media.

Lawson assimilated and summarized Baudrillard's message:

> The modern world, like the empires of the ancient world, has been ruled by spectacle. But a tremendous change has overtaken the relation of the people to that spectacle. . . . The spectacle is no longer simply a staged event, a coronation or rally invented to provide the legitimacy of tradition and pomp; it is now a pervasive non-event whose consumption is made so easy its rejection is almost impossible.

Lawson went on the say that the spectacle has moved from the public realm to the private, "right into the living room." It has become a

> narcotic [that] turns us into somnambulent consumers subsiding toward an easeful, over-sated death. As we allow this spectacle to hypnotize us it infiltrates more than our critical faculties, it insinuates itself into the dream world, the unconscious realm that shapes our relations to others and the world. Growing from an imitation of life it becomes so pervasive that life imitates it.[10]

What was the function of works of art in this new phase of capitalism? According to Baudrillard they were consumer products, nothing more. Such an opinion was obviously questionable—and, moreover, philistine. Baudrillard had little conception of art other than as an art-market counter and no sensitivity at all to its aesthetic quality. Nor did he recognize that aesthetic worth largely determines commercial value.[11]

Baudrillard's views on the role of the mass media in consumer society were widely read and discussed in the art world. Many artists found them persuasive but rejected his claim that it was impossible to resist the mass media. Even if the media were as all powerful as he said they were, which was questionable, many politically minded artists felt that they had to resist and show others the way to resist. They had no other choice. To this end they would have to appropriate media images, texts, and techniques and turn them against the media—becoming double agents of a kind.

In his original essay in the *Pictures* catalog (1977), Crimp had not attributed explicit political content to the work in the show. But in a 1979 article he revised his thinking and suggested that the photographs appropriated by the artists had once had specific meanings, indicated by

their captions or other commentaries, meanings established by those in power. The artists in *Pictures* had subverted these readings—dissociating the signifiers from the signifieds, as Derrida might say—and had provided the possibility of alternative interpretations. In this way the work in *Pictures* had decoded the hidden and repressed social meanings originally attributed to images. To put it another way, as Crimp saw it, *Pictures* had undertaken a critical analysis of representation—that is, the role of images and texts in consumer society and the interests and institutions they serve. Appropriation had yielded a new socially conscious art—a deconstruction art.

Dan Graham agreed with Crimp. In 1980 he wrote that deconstruction art recognized that "television, film, advertising, and photography *are* the dominant modes of discourse in American culture." Combining "entertainment *and* political analysis," deconstruction art "wants to enter the media directly, utilizing media's existing genres—documentary, drama, popular music, comedy, discussion, etc.—without trying to create novel, innovative forms for their own sake. In place of esthetic innovation, it will employ textual deconstruction, narrative and distancing devices as strategies for dealing with ideologically loaded content."[12] Deconstruction artists at their most optimistic seemed to think that by using the techniques of mass culture in their art, they could channel "the power and effectiveness of the mass media to positive ends. Art would be freed from its marginal, elitist position, become engaged in the cultural mainstream, and the way would be cleared for a raising of the mass consciousness—effected by the artist."[13]

Struck by the impact of photography, motion pictures, and television on contemporary life and culture, deconstruction artists asked with growing urgency the questions that appeared in a wall text in the *Image World* show at the Whitney Museum: "But how are these images created and whom do they speak for? Whose needs do they serve, whose goals and values do they advance? Why are media images so powerful and persuasive? How do they infiltrate our conscious thoughts and desires? Have media fictions become a reality?"[14] Above all, how do artists call into question the objectivity of photographs, because they were in fact not truthful but manipulative? How could art "deprogram [people] from simply accepting pictures as documents of reality, and to examine the ways images shape [people]."[15]

A major problem that deconstruction artists faced was how best to get their messages across to the public. Earlier social protest artists had wanted their art to reach the masses. They believed that it ought to be simple and clear, didactic and exhortative—in a word, propagandistic. Was this approach still effective? Had it ever been effective? Robert Storr thought not, and he reflected the opinions of most deconstruction artists:

> The traditional imperative of political art is to "say" something.
> Outrage, hope, solidarity—these emotions demand expression and

the presumed audience . . . would require that what is said is said without equivocation. Thus, "sincerity" disallows ambiguity or ambivalence, "urgency" prohibits complexity. So goes the logic and therein lies its flaw. . . . Meaning for the public is reduced to reflex identification—"Which side are you on?"—while the essential structures of thought remain intact.[16]

Political art that sought to change structures of thought was acceptable in the art world; propagandistic art was not. But the question remained: Could this new kind of political art be effective? Could it bring about social change? Lawson maintained that people could be changed by art that confronted them "with information and [made] them think about that information. In some long-term way, art is a moral force. . . . I don't mean that art's moral in any didactic sense of telling you how to behave. Its seriousness and the steadiness with which you have to work it through and deal with it are exemplary in some way."[17]

But many other political artists had their doubts. Haacke wrote: "Eventually [my own art] becomes academic . . . I don't have delusions about immediate and demonstrable effects. If my stuff has repercussions, they remain largely immeasurable." Then why bother making it? Because "there is a chance that, together with many other people, one may have an influence on the social climate, both within the art world as well as beyond its assumed parochial boundaries."[18]

Storr did not believe that political effectiveness was the issue:

Good political art doesn't address a stereotypical person, it addresses conflicts inherent in given definitions of the social reality—conflicts among, but also within, individuals and groups. It makes these disparate viewers see something about their world that in turn makes them aware of the unresolved or unsatisfactory dimensions of their own lives or environment. Such art is basically a series of leading questions looking not so much for answers as for responses that complicate their initial statement. . . .

I don't think political art has accomplished any large social purpose other than to excite people to think about how they live and what is possible. In that sense political art is [not] burdened by its mission or efficacy. . . . Political art has no special need to justify its existence in terms of its proven utility or power over events. Like any art, the value of political art resides in the imaginative scope, resonance, and detail.[19]

The opponents of political art insisted that it was generally banal, made in the hope that because it was virtuous its banality would be overlooked or forgiven. And it was often forgiven, because as Peter Plagens pointed out, dealing with "tough political issues, like arms control, . . . the worsening plight of the poor, violence against women, and so on [can

be considered] an improvement on . . . decorating bank lobbies with big, clean abstractions and letting the world go on its self-destructive way." However, Plagens added: "But then the turf gets tricky. To begin with, there's a hegemony of the tepid left in the art world. When you say 'political art' . . . it's assumed you're talking about anti-Reagan, pro-Sandinista, pro-freeze, anti-domestic-budget-cut art." The art ends up preaching to the converted,[20] at least when it was exhibited in art-world venues. And was it really worth the effort to "*épater le collectionneur* through glorified *tchotkes*"?[21]

Political art became, as Jeremy Gilbert-Rolfe reportedly said, "a species of self-righteous moralizing whose chief function is to congratulate the audience on sentiments they already share."[22] Political works were primarily "rituals [that] make the participants feel good, . . . secure in the knowledge that they are nice people who have their priorities straight, unlike those hypothetical people, presumably the majority, [who are] uncaring victims of that manipulation through spectacle which is Capitalism." Gilbert-Rolfe went on to attack the complacency of the faithful who will not confront artistic problems, who are certain "that historical relevance means artistic significance and that the way toward that relevance is through a ritualised form of the idea of social intervention. This comes down to putting various kinds of overt nagging on the wall, and getting paid for it." To "people who consume anticonsumerism, [this] stuff just encourages us to . . . be complacent rather than critical."[23]

John Miller also noted that an influential leftist group of artists and critics rarely considered the quality of political art. He wrote that as the 1980s progressed, it took "whatever so-called politicized practice says at face value." What that meant was that the "critic stands aside to let the obvious righteousness of properly politicized artworks speak for itself," no matter how impoverished the art was in every other way. Criticism had been compromised by an "unbridled reductivism" and authoritarianism, and Miller found this abnegation of critical responsibility alarming. But even more alarming was the presumption "that when self-appointed political activists claim to speak for the masses, their self-interest need not be examined."[24]

Questions were raised about what kind of audience political artists ought to be trying to reach. The general public or the art world? Was deconstruction art too subtle and abstract to be understood by the person in the street? As art critic Patrick Frank asked: "How can this art, which can be understood by so few people, hope to achieve any kind of transformation of consciousness on a wide scale?"[25] Moreover, if political art was to be effective, where should it be exhibited? In elitist private galleries and museums or in the real world, installed in public places, for example, as murals or on billboards? Many political artists made works of art for public venues but these were primarily gestures; most of their art was shown in galleries and museums—and was meant to be. Carter

Ratcliff reflected the attitude of most deconstruction artists when he wrote that the primary mission of their work was to overcome the art world's "blindness to the image-bombardment to which everyone in the culture is subjected by the agents of consumerism. . . . [Deconstruction artists] can do a great deal to cure the art world's blindness to the larger world, and to liven up the earnest respectability, the deadly tastefulness, of American art institutions."[26] Haacke added that many gallery goers were "working in the consciousness industry, where opinions are made and promoted. That is the arena where my stuff could perhaps be of some use."[27] And it was likely to be seen by collectors Charles and Doris Saatchi and S. I. Newhouse, the head of a great media empire. But questions of venue and audience remained troublesome and much debated.

But did not the very act of exhibiting in a commercial gallery compromise political art? Did not political art lose its transgressive edge and become complicit with the system it set out to destroy when it was introduced into the art market? David Carrier remarked that Jenny Holzer's works, which allegedly deconstructed consumer society, are themselves "commodities, and so a part of the system she aims to criticize. Indeed, what else could they be since they are sold and displayed by collectors and museums?" Carrier then asked: "Is it really possible for Haacke fundamentally to challenge the art world in which his work is prominently displayed, collected and written about?"[28] Or, as Plagens asked more bluntly, did not "a supremely marketable kind of art [render that art] 'critically impotent'"? Did it become not only "an 'art of complicity' but an 'art of embarrassment'"?[29] When the establishment embraced political art, was it not transformed into nostalgia for rebellion? Did it not become entertainment, as the case of the *Image World* at the Whitney Museum in 1989, which, as one critic remarked, might be taken for an amusement park,[30] or "museum art."

The problem of where to exhibit his work concerned Haacke:

> As to selling the works, let's not forget that we are not living in an ideal society. One has to make adjustments to the world as it is. In order to reach a public, in order to insert one's ideas into the public discourse, one has to enter the institutions where this discourse takes place. . . . As you know, more often than not it is by way of commercial galleries that one eventually gets invited to shows that attract larger audiences. Documenta, museum exhibitions, and so forth rarely present works that have not been, at least marginally, sanctioned by the art trading posts. . . . So, all in all, it is a messy situation, full of compromises. . . . If I had not made adjustments, by now I would be consumed by bitterness and nothing would have been achieved.[31]

Nancy Marmer had her doubts about Haacke's reasoning, writing:

Most political artists (as well as non-political artists) prefer to behave with selective blindness about the contradictions of the market system within which they have to function. In order to survive within the art world, they must behave as if art which favors social change does not, by its participation in the art market, also affirm that system and thus support the status quo. Political artists need to ignore the fact that the current acceptance and legitimation of socially concerned art within art world institutions (whether major commercial galleries, private collections, museums or international exhibitions like Documenta) indicates that the political genre itself now satisfies consumer society's familiar demand for periodic style change.[32]

Marmer's point that artists who deconstructed commodification ended up its accomplices was well taken. But more telling was her observation that deconstruction artists tended not to deconstruct their own art works when they became costly commodities. They simply continued to produce more.

And might not deconstruction artists be careerist? Might not subversive gestures be merely rhetorical, executed because political art had become chic? And it *had* become fashionable. The "entry," as George Kubler would say, of deconstruction art into the art world was perfectly timed. It proposed to deconstruct the mass media at a moment when deconstruction theory and concern with the power of the media were becoming intellectually fashionable. Deconstruction art was also timely because it was figurative, like trendy new image painting and neoexpressionism. By wedding figural imagery with conceptual art, deconstruction art became a kind of figuration for intellectuals. It was at once new, representational, and full of meaning. Equally important, deconstruction artworks were generally portable objects and therefore commercially viable. Thus they combined market savvy with politically and aesthetically radical rhetoric. To put it bluntly, whatever else they aspired to, deconstruction artists knew the art world and made strategic moves that paid off.

It is also likely that a number of artists identified as deconstructionist by art theoreticians may have had other things in mind. They were inspired by sitcoms and crime busters and other "dramas" witnessed on television and in movies, and decided to take their subjects from them. They were also influenced by performance art. Many artists who emerged in the late 1970s and early 1980s frequented clubs, such as the Limbo Lounge and the Mudd Club in New York City, where they felt the punk-rock spectacles were more exciting than what was exhibited in the galleries. Performances by artists were common in these night spots. The music itself—by David Byrne or Patti Smith, for example—was half performance. Artists who used their bodies in performance art moved easily to representing their bodies or the bodies of others in works of art. The theorizing of a Crimp or Owens drew attention away from the fact that

the roots of a great deal of deconstruction art lay in performance art, popular music, television, and movies while conferring intellectual and political cachet on it.

In the end anticonsumerist art was consumed by those it was aimed against. Just as antiart manifestations had been assimilated by the art market, so were anticonsumerist manifestations. Money filled the cultural cracks in consumer society. But why did collectors buy art aimed against them? Perhaps as Haacke said, it was because the "art world . . . has been so saturated by the products of a phony individualism and coy rebellion that for no better reason than out of boredom the audience wants something different."[33] On the other hand, Ratcliff pointed out that emblems of individuality were so prized that there was a growing art-world demand "for images that insist, sometimes belligerently, that they don't want to be consumed. That makes them irresistibly consumable." Ratcliff likened deconstruction art to Marxism, which also had

> currency among Western critics not because it shows a way beyond the mechanics of capitalism but because, with their challenges to that market machinery, certain Marxist critiques take on a particularly salable aura of courageous individuality. Each new Marxist challenge, no less than the most off-putting innovations of Carl Andre or Hans Haacke, is an alluring image of an entrepreneurial self. When we learn to see this not as an ironic peculiarity but as a straightforward fact, we will have begun to get a clear view of our culture and its art.[34]

And collectors paid handsomely for art that abused them. Douglas Davis reported:

> Collector Gilbert Silverman of Detroit bid $90,000 for Hans Haacke's *On Social Grease* last year at Christie's without the slightest hesitation, though the work directly mocks six major corporate and political figures (including David Rockefeller, Douglas Dillon and Richard Nixon) by quoting each of them on a separate metal plaque advocating support of the arts as a "social lubricant."[35]

Much as it meant to criticize the "culture industry," deconstruction art validated its benevolence.

In all the debates, political artists had the last word. They simply had to do what they had to do. Did it matter whether it was effective? Of course, but who could predict? Even if there was only the remotest chance that their art would have an effect on society, the artists had to make the effort. It was their social and moral responsibility. But deconstruction art had another purpose: to reveal American life as it was experienced by the artist. Thus it served a traditional artistic function. Indeed, it was this function, not the virtuousness of its political messages or its effectiveness in generating social change, that commanded—and

continues to command—attention. As Ratcliff remarked, "We don't care about art because it is morally good or promises to make us better or the world perfect. We care about art for other reasons, among them our unconscious pleasure in watching it reflect our gestures of simultaneous revelation and concealment, challenge and accommodation."[36] In the end what counted was the artistry of the work, not making a well-meaning, "politically correct" statement about life but bringing art to life.[37] The art world embraced political art, even that which set out to subvert it, because of its value as art.

In 1977, with an eye to Marcel Duchamp, Sherrie Levine exhibited in an offbeat storefront gallery in SoHo seventy-five ready-made pairs of shoes purchased from a job lot, which she sold at a slight markup in a single day. The shoes were miniature, sized for children but designed for adults, providing a kind of surrealist gloss on consumerism.[38] The following year she met Richard Prince and was taken with his "economy of means. If Richard wanted an image, he took it, just like that."[39] This encounter led her to photograph reproductions of the photographs of Walker Evans, Edward Weston, and other modern masters, whose works were prized for their originality. Levine became an appropriator of images because she had come to believe that conventional aesthetic ideas, such as originality—ideas advanced by the newly fashionable neo-expressionists—were fictions that needed to be demystified [147].[40]

Like Duchamp's readymades, Levine's works were essentially conceptual rather than visual. She added a new thought to the photographs she copied—not anything new to see. But her critique of the "myth" of the original genius, which was central to her art, separated her appropriations from the readymades of Duchamp and the remades of Warhol. In 1980 she said, echoing Roland Barthes and Jacques Derrida:

> We know that a picture is but a space in which a variety of images, none of them original, blend and clash. A picture is a tissue of quotations drawn from innumerable centers of culture. . . . We can only imitate a gesture that is . . . never original. . . . A painting's meaning lies not in its origin, but in its destination. The birth of the viewer must be at the cost of the painter.[41]

Crimp wrote approvingly of Levine's reproductions of Edward Weston's photographs of his son that they contained

> no combinations, no transformations, no additions, no synthesis. . . . In such an undisguised theft of already existing images, Levine lays no claim to conventional notions of artistic creativity. She makes use of the images, but not to constitute a style of her own. Her appropriations have only functional value for the particular historical discourses into which they are inserted.[42]

147. Sherrie Levine, *After Walker Evans: 7*, 1981. *(Metropolitan Museum)*

Crimp observed that Weston's photographs of his son themselves referred to the classical nude, and if Levine was a pirate, then so had Weston been—and, by implication, all of his progenitors.

Crimp treated Levine's appropriation primarily as a trigger of art-theoretical discourse. Viewers may have been moved by the Weston photograph, but in order to appreciate Levine's gloss, they had to have read the writings of Douglas Crimp, Rosalind Krauss, Craig Owens, and Hal Foster. She herself may have been influenced by their ideas, although she denied that "theory precedes the work." "I look for theory that I think is going to help me in a different kind of language."[43] Be that as it may, the *October* group followed her work closely, interpreting and supporting it, and repeatedly hailing her attack on modernist originality as the exem-

plary postmodernist gesture. Ironically Levine's piracy could also be viewed as modernist because it had never been done before. Her "originality" then stemmed from her total rejection of originality. As Thomas Lawson pointed out, the extremism of Levine's rephotography infects "her work with an almost romantic poignancy," oddly reminiscent of neoexpressionism,[44] much as she reviled it.

In re-presenting another artist's work and presenting it as her own, Levine also aimed to deconstruct and undermine the art market, in which value depended on originality, authenticity, and uniqueness. Her print of an Edward Weston or a Walker Evans photograph posed the question of what it was worth in dollars compared to an "original." How was the monetary value of art to be determined in Walter Benjamin's "Age of Mechanical Reproduction"? Moreover, how were the escalating prices of Evans's photographs arrived at in the first place? As in the case of her critique of originality, Levine's critique of art-as-commodity differentiated her work from that of Duchamp and Warhol, which did not specifically call attention to the art market.

Levine's rephotographed photographs could be interpreted in ways different from those of deconstructionists. Her rephotographs looked "slightly washed-out," compared to their originals, and the difference was clear to those who knew the sources.[45] Allegations of art theorists notwithstanding, the originals possessed an "aura" that Levine's photographs lacked. Her prints looked "bad," ironically—and shrewdly—calling to mind the bad painting in vogue at the time.[46]

Following her appropriation of master photographs, Levine made watercolor reproductions of the work of Joan Miró, Henri Matisse, Arthur Dove, Stuart Davis, Ernst-Ludwig Kirchner, Fernand Léger, Egon Schiele, and others, which she found in books. Into these pictures "after" modern masters, she reintroduced her personal "touch" but could not help subordinating it to the idiosyncratic style of the artists she replicated. As for her intention, she remarked:

> In the late '70s and early '80s, the art world only wanted images of male desire. So I guess I had a sort of bad girl attitude: you want it, I'll give it to you. But of course, because I'm a woman, those images became a woman's work. . . .
>
> Schiele always seemed to be the ultimate male expressionist, the ultimate bohemian, so I thought it would be amusing to try on his clothes, as it were.[47]

The ambiguity of these watercolors raised provocative questions. On the one hand the miniature scale—they were the same size as the book illustrations—and delicate hand were stereotypically identified with woman's art. Consequently Levine seemed to be complicit with sexist attitudes. On the other her diminutive watercolors could be a gloss on the role of the macho master and his gaze and desires—and by extension, neoex-

pressionist "geniuses"—and the art market that fostered their work.

Levine's handmade watercolors were a step in the direction of traditional painting. Another step was a series of "pictures" called *Gold Knots* (1987), consisting of readymade rectangles of unpainted plywood in which the plugs that lumberyards use to replace knots had been coated with gold leaf. However, the abstract wood-grain patterns call to mind painterly textures as well as the shattered glass in Duchamp's *Large Glass*.

Levine then began to paint "real" paintings, even though she had asserted (in 1981) that "basically painting is pure idiocy [offering no] true respite from a ruthlessly inequitable and self-destructive society" [148].[48] Her pictures, which she called "generic" abstractions, are composed of stripes or checkerboards painted on wood or lead mounted on wood. Levine turned to abstraction because she was "very bored with figurative imagery. And I suspected that a lot of other people were too."[49] She said that she thought of the "generic" paintings as "distillations of formalist, late modernist paintings [for example, Kenneth Noland's]." Thus they continued her critique of originality but in an indirect manner, appropriating the look of abstract painting rather than any specific image. As she said: "I don't think that [the generic abstractions] will give you [the] kind of satisfaction—the closure, balance, harmony . . . that

148. Sherrie Levine, *"Untitled" (Lead Checks: 2)*, 1987. *(Courtesy of the artist)*

you get from classic formalist painting. I wanted the ones I was making to be uneasy. They are about death in a way: the death of modernism."[50]

After Levine's polemics against painting, her return in the generic abstractions was widely considered to be a cynical attempt to find a salable product for her earlier ideas. The new pictures were exhibited in SoHo's Mary Boone Gallery, the most commercially successful and fashionable of the newer galleries. Given Levine's stance against the commodification of art, the move was a shock to many of her supporters, who believed that she had capitulated to the market[51] Others, John Baldessari, for example, suggested that she might be "fighting from within the system."[52]

Shortly after her move to the Mary Boone Gallery, Levine's attitude toward her work began to change. At first she tried to hold on to the idea that painting was finished, asserting that she was involved in "endgame art," and "that endgame art is a field that I can move around in."[53] Later she asked that her works be evaluated as paintings and "enjoyed on a visceral level. . . . Actually, I can imagine someone writing about these paintings *as* formalist paintings—comparing them with the stripe paintings from the early 1970s, for example." By 1986 she had repudiated the early art-theoretical reading of her work "that expunged all poetry from it," going on to say: "Almost all the critical support for my work was coming from a leftist, academic reading of it. . . . I was very appreciative, even collaborative. But at one point I began to feel boxed in. It has gotten to the point where people couldn't see the work for the rhetoric." She now wanted her generic abstractions read as paintings not "position papers." She even "wanted to stress some things that I thought the rhetoric around my work had prevented people from getting: originality, pleasure."[54] Her intention notwithstanding, the paintings as paintings continued to work best as triggers for art-theoretical discourse.

In 1989 Levine exhibited sculptures consisting of elegant Beuys-like cherrywood-and-glass cases, each containing a single, frosted cast-glass abstract object dramatically spotlighted in a darkened gallery. Appropriated from Duchamp's malic molds, representing the frustrated bachelors in the *Large Glass*, the three-dimensional shapes were fabricated with a pristine purity reminiscent of Brancusi and Arp. But it was the specter of Duchamp that dominated the show—and indeed Levine's work as a whole, or so it seems in retrospect. At the very beginning of her career, she had exhibited readymade shoes; then she had appropriated the works of other artists—artists who were her male persona as Rrose Selavy had been Duchamp's female complement. Levine's checkerboard abstractions alluded to Duchamp's obsession with chess—and to art gamesmanship. In the end her dialogue with Duchamp turned out to be the most engaging aspect of her work.

Barbara Kruger selected photographs from magazines, photographic annuals, and how-to handbooks; enlarged, cropped, and spliced them;

combined them with brief texts in the typeface of advertisements; and photographed the whole and framed it with bright-red-enameled strips. Her works call to mind Alexander Rodchenko's and John Heartfield's photomontages and Rodchenko's framing. However, she herself stressed non-art sources: "My work was informed on a *formal* level by my work as a magazine designer [for Condé-Nast Publications]. The actual arrangements were shaped by that"[55]—that is, the laying out and pasting up of images and texts. Enlargement was done by commercial printers.

In her mock ads Kruger probed "the relationship between commercial design and the way a culture designs people's lives."[56] Her intention was to analyze the way in which images function in society. Kruger was influenced by art theory, and she allowed that "theory has intermittently become a source of both pleasure and rigour for me, but I have *never* illustrated it."[57]

Much of Kruger's work is a feminist critique of representation, namely images of women as they are constructed by the male-dominated media—images that shape the way women view themselves. She aimed to expose "stereotypes that perpetuate the prevailing power balance between women and men."[58] Her intention was to counteract the active male gaze and empower the hitherto passive female gaze. Kruger also deconstructed the psychopolitical pressures of consumerism on women in texts that read: "Buy Me I'll Change Your Life" (1984) [149] and "I Shop Therefore I Am" (1987). More often her message was ambiguous. The text in "Your Gaze Hits the Side of My Face" (1981) [150] is juxtaposed against the image of a stone classical head. It asks, Whose "gaze"? The viewer's? The male gaze? Against whom is the violence of "hits" directed? Women? The image of woman? The male construction of an idealized woman, as exemplified in Western culture? The words in themselves and in conjunction with the image raise questions that give rise to more questions—all directed at "You" or declared by "I." Writing about "I Am the Real Thing," art critic Henry Sayre asked whether Kruger as the "I" was declaring the subject's "personal self-worth . . . and/or artistic prowess and authority" or commenting on herself as a sexual object? "But finally, with the recognition of the context of these words—that is, *in a photograph,* a pseudoreality, a black-and-white simulacrum of the real thing—it reveals itself to be a pathetic posture, a self emptied of meaning."[59]

Kruger wanted her photographs to emulate the seductiveness as well as the "maximum graphic impact" of commercial advertising in order to command the attention it did.[60] But they were often attacked for looking too much like advertising to be politically transgressive. Did they serve as a critique of the spectacle of consumerism or were they part of the spectacle? However, Kruger's works differed from advertisements in that their visual and verbal components were not clearly related. She explained: "In most design work, received images and words are arranged and aligned to produce assigned meanings. I am engaged in

149. Barbara Kruger, *"Untitled"* (*Buy me I'll change your life*), 1984. (*Collection of Lisa Phillips*)

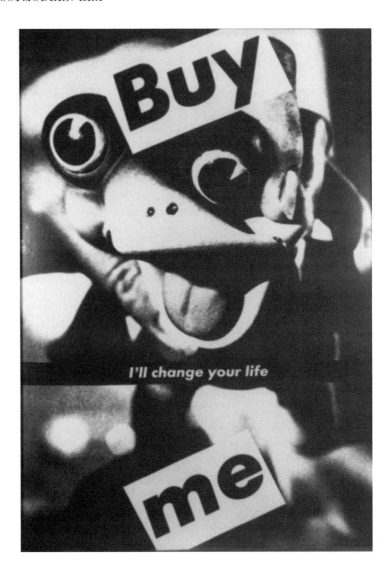

rearranging and realigning these dominant assignments."[61] Her purpose was to use mass-media stereotypes to demystify them. "I'm just trying to ask questions or make suggestions . . . to change people's minds, to make them think a little bit."[62] Indeed, Kruger's 1980s work are polemical but do not preach.

In Kruger's best work image and text are so balanced that both are maximized, a fact that contributed considerably to their aesthetic quality. Many art theoreticians were uneasy with the artful quality of her work, claiming that it distracted attention from her messages. They also found her "stylistic signifiers" problematic, because, as Douglas Crimp commented, they tended "to reduce the work to a generalized political statement, rather than one of real specificity. This may be one of the reasons that Barbara's work has been so well received, this and the fact that the work's graphic beauty is its most obvious characteristic."[63] Kruger

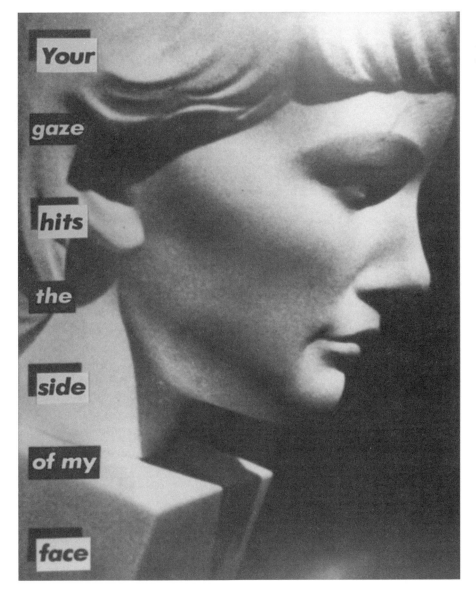

150. Barbara Kruger, *"Untitled" (Your gaze hits the side of my face)*, 1981. *(Mary Boone Gallery, New York)*

was also criticized for making salable pictures and selling them. Her reply was: "These were *objects*. I wasn't going to stick them on the walls with pushpins. I wanted them to enter the marketplace because I began to understand that outside the market there is nothing—not a piece of lint, a cardigan, a coffee table, a human being. That's what the frames were about: how to commodify them. It was the most effective packaging device. Signed, sealed and delivered."[64]

The criticism of Kruger's seriousness as a political artist escalated when she, like Levine, joined the Mary Boone Gallery in 1987. Roberta Smith maintained that Kruger's "feminist messages looked out of place in a gallery known for its devotion to macho Neo-Expressionist painting,

its shortage of female artists and its glossy high profile."[65] Robert Storr also asked whether

> it is excessive to be asked repeatedly to overlook the contradictions of showing work critical of "late Capitalism" in the galleries that owe most to the "simulated" prosperity of the '80s. Likewise, the irony of women being given the celebrity treatment of their brush-wielding male adversaries by notoriously chauvinist promoters is a phenomenon not easily explained away by postmodernist casuistry.[66]

In defense of her move to Mary Boone, Kruger said that she showed her work in a number of sites, from billboards to art galleries to matchbooks. "I think my work can be effective [in questioning gender and sexual representations] within the symbolic site of Mary's gallery, given its position in the discourses of contemporary picture-making and aesthetic practices."[67] "The question is how I can be more effective in generating change. I'm not interested in repeating the notion of the great artist, of being the Queen of the Hop. I want to let go of that competitiveness."[68] But if an art-world audience was the one Kruger wanted to reach, then the Mary Boone Gallery was the best venue in which to deliver her message. In the early 1990s Kruger's stylistic "look" was reappropriated by the advertising industry, notably in Smirnoff Vodka advertisements. An art that aimed to criticize consumerism was ripped off for consumerist purposes. But she accepted the pirating of her style by Madison Avenue, since it called attention to *her* message, if indirectly.

The works Kruger exhibited in 1989 focus on the body. She commented that they "came at a time when, here in New York, there was this apex of trials and public spectacles having to do with the battering of the body and the battering of women's bodies. The works . . . were very much about the body: the body of sex, the body of illness, the body of vanity, the body of humiliation . . . the vulnerability and finiteness of our bodies. We have to be aware of the fact that we're living in a time of epidemic."[69]

In her show at the beginning of 1991, Kruger tipped the balance of her work toward the verbal, verging on the direction of Jenny Holzer, possibly in response to the criticism that her photographs were too aestheticized [151]. She transformed the Mary Boone Gallery into a spectacular floor-to-ceiling, wall-to-wall environment of eye-jarring billboard-size white-on-red and black-on-white texts and halftone images on every available surface. The viewer was bombarded with angry messages indicting censorship; intolerance; violence against women, sexism, racism, homelessness; and other social evils. When the gallery was closed, passersby were confronted by a lowered metal door painted with an American flag whose white stripes consisted of texts asking: "Who is free to choose? Who is beyond the law? Who is healed? Who is housed? Who speaks? . . . "

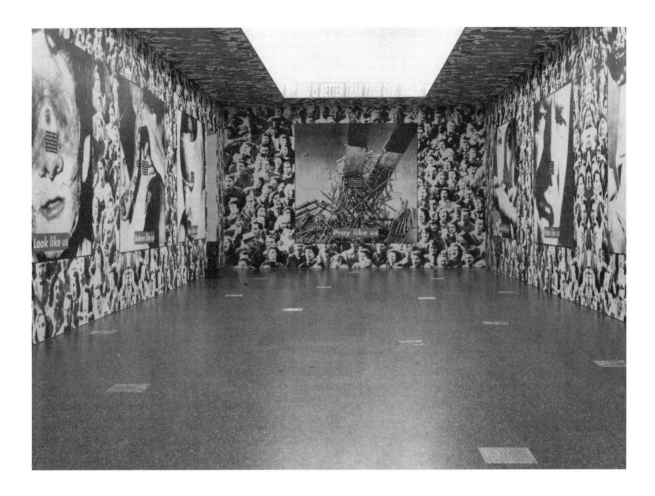

151. Barbara Kruger, installation, Mary Boone Gallery, New York, March 1994. *(Mary Boone Gallery, New York; photograph copyright © Dorothy Zeidman, New York)*

Despite their mechanistic and commercial look and didactic intent, Kruger's works on the whole were not lacking in subjectivity. Her work requires that the viewer "take the work first of all as a clue to how we live, how we have been living, how we have been led to imagine ourselves, how our language has trapped as well as liberated us, how the very act of naming has been till now a male prerogative and how we can begin to see and name—and therefore live—afresh," as Adrienne Rich said of feminist literature.[70] Kruger's works convey how women—herself and women collectively—and other socially repressed groups *felt*. The primary feelings expressed—highlighted by the Mary Boone installation—are rage and pain at the situation of women and marginalized groups generally, and give her work its intensity—and, oddly, relate it to contemporary expressionist styles.

Jenny Holzer's works consist primarily of texts, the first of which were titled *Truisms* [152]. In 1976, while a painting student at the Rhode Island School of Design, she was influenced by the conceptual art of Lawrence Weiner, Robert Barry, and Joseph Kosuth; Bruce Nauman's

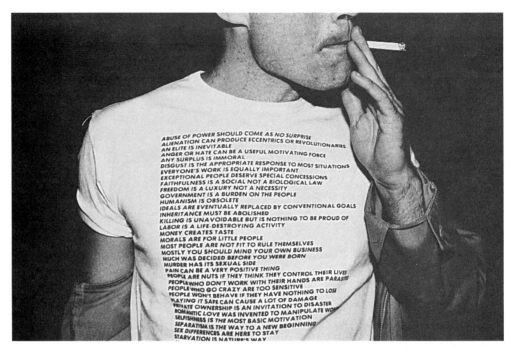

152. Jenny Holzer, *Truisms*, 1982. *(Barbara Gladstone Gallery, New York)*

neon words; and the soundtracks of Vito Acconci's performances. As she said, she was "trying to respond to the place of language in art."[71] She began to invent aphorisms that summarized her "version of everything that could be right or wrong with the world."[72] Even though Holzer's *Truisms* were her own, they seemed to be culled from America's collective unconscious.[73] They spoke in multiple voices and often contradicted each other, for example, a few on the subject of work, EVERYONE'S WORK IS EQUALLY IMPORTANT, EXCEPTIONAL PEOPLE DESERVE SPECIAL CONCESSIONS, LABOR IS A LIFE-DESTROYING EXPERIENCE, and PEOPLE WHO DON'T WORK WITH THEIR HANDS ARE PARASITES. Despite the multiplicity of Holzer's messages, certain themes, such as survival, recurred, and more often than not the voice was that of a woman and her message about the condition of women.

After Holzer had written "a couple of hundred [*Truisms*] I had to think about what to do with them. And then I thought that by their very nature, they were public—even though individually they were private attitudes, they were common knowledge—and they should be placed into the public sphere."[74] So she made page-size posters, each containing forty or so of her sayings arranged in alphabetical order, and distributed them over Lower Manhattan. She said:

> I got the idea partly from someone . . . who went around plastering Times Square with posters that warned other men to stay away from the area, warning them that they would get leprosy and tuberculosis. . . .

I was amazed at how the word "leprosy" on a poster would stop you short, and at how effective these posters were. . . . I would see that other people were amazed by them, too. . . . So it gradually dawned on me that the short texts I was writing would look good on posters and that I could put them up anywhere.[75]

Holzer turned conceptual art from art-as-art in usual art-world venues to art-as-human relations in the public arena.[76]

Holzer's messages were intentionally ambiguous, perhaps in order to avoid hammering people with propaganda and to make them think for themselves. But it was never clear what her statements added up to. Certainly critics did not agree. From a poststructuralist point of view, Sayre wrote that because Holzer's "truths" contradicted one another, their "thrust is not toward closure but openness. They emphasize the conflicts that lie at the heart of all discourse."[77] Kim Levin and Thomas Lawson were social minded in their approach. Levin found the *Truisms* "sensible sounding and out of control. . . . But embedded in the rigid imperatives and inchoate sentiments is an awareness that behavior is programmable, and codes of ethics can be manipulated."[78] Lawson commented that Holzer's anarchic overload of information that defied all logic was in "the various tongues that the authorities adopt," and served to render the "voice of authority . . . unbelievable."[79]

After the *Truisms* Holzer made the *Inflammatory Essays* (1979–80) and the *Living* (1980) and the *Survival Series* (1983). The text in each series had a different purpose, as she said: "The *Truisms* were . . . as close as I could make them . . . genuine clichés. . . . With the *Living* and *Survival* series, the messages were pretty straightforward." Moreover, the

> *Inflammatory Essays* are very different from, say, the *Survival* Series. In *Survival* the language was flat, matter-of-fact. . . . The *Inflammatory Essays* were indeed flaming; the language was kind of baroque and they were "hot" all the way through. [In] the *Truisms*, like the *Inflammatory Essays*, there were many different voices. . . . In *Living* and *Survival*, it was just one point of view, basically, on a number of different topics.[80]

In 1982 a number of Holzer's sayings—PRIVATE PROPERTY CREATES CRIME, MONEY CREATES TASTE, YOUR OLDEST FEARS ARE THE WORST ONES—were flashed on the Spectacolor Board in Times Square as if they were advertisements or news reports [153]. As a medium of mass communication, electronic signage (LED) enabled Holzer

> to present work to a large public. . . . Because signs are so flashy, when you put them in a public situation you might have thousands of people watching. So I was interested in the efficiency of signs as well as in the kind of shock value the signs have when programmed with

153. Jenny Holzer, *Times Square, N.Y.,* selections from *The Survival Series,* 1985–86. *(Barbara Gladstone Gallery, New York).*

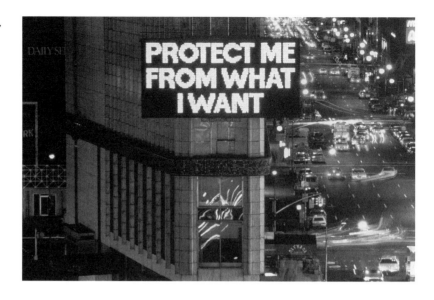

my particular material. These signs are used in advertising and they are used in banks. I thought it would be interesting to put different subjects . . . in this format.[81]

Electronic signs appealed to Holzer because of their visual power and "their capacity to move, which I love because it's so much like the spoken word: you can emphasize things; you can roll and pause, which is the kinetic equivalent to inflection in the voice. . . . I write my things by saying them or I write and then say them, to test them. Having them move is an extension of that. . . . It almost gets musical."[82] Sayre related the pacing of Holzer's texts to the tempo of television's two- to three-second shot and ten-second commercial message. He also suggested that the contradictions in her texts were related to the disjunctive programming of TV. "Furthermore, her messages embody something of the same terse *authority* as the commercial—'The night belongs to Michelob' . . . 'Promise her anything but give her Arpege.'"[83]

In 1987 Holzer created *Laments,* a huge installation of LED signs and stone sarcophagi at the Dia Foundation in New York City. The texts were the last testaments of thirteen fictitious dead people. She explained: "Anybody born since 1945 has probably realized that it could be over in a *second.* Add to that AIDS, the greenhouse effect and everything else, and it's not too hard to come up with death as a subject matter."[84] *Laments* was also inspired by Holzer's fear about the death of her recently born baby. Kirk Varnedoe and Adam Gopnik wrote: "What makes Holzer's art moving is its connection to the larger river of American confession. [The] dark intimations of violation, loss, and entrapment expressed in an environment of bright public spectacle—is a poetic reduction of the imagery of urban melancholia that has always been part of the inheritance of American art."[85]

In *Laments* Holzer made full use of the visual dimension of LED signage. She punctuated a vast interior space with multiple columns of words in different typefaces, in different colors, flashing on and off and moving up and down at different speeds. The overload of information and the visual display were dizzying. However, the same texts, carved into sculptural sacrophagilike blocks in a nearby room, could be read by the viewers at leisure. At the end of 1989 Holzer installed a single work in the Guggenheim Museum. The program, which ran for 105 minutes, consisted of some 330 messages, including 239 from the *Truisms*, 8 from the *Inflammatory Essays*, 34 from the *Living Series*, 46 from the *Survival Series*, and 4 from *Laments*. Taking the entire space into consideration, Holzer coiled a 535-foot-long electronic ribbon around the inner spiral wall of the museum's ramp. On the floor in the middle of the rotunda she placed a circle of seventeen red granite benches with inscribed texts. As in the *Laments* at Dia, the messages—in varied formats and colors, expanding and contracting, moving in different directions and doubling up—flashed by in rapid-fire succession. The Guggenheim's interior well is vast, but Holzer took command of it and turned it into a visually spectacular kind of monumental "brain."[86]

More than any other deconstruction artist, Mary Kelly rooted her art in critical theory and focused on the condition of women. Her best-known work was *Post-Partum Document* (1973–79), a six-section, 135-frame work, which as she wrote,

> describes particular events in my own relationship with my son, from birth until age five. Events such as weaning from the breast, learning to speak, starting school, writing; but *Post-Partum Document* is not simply about child development. It is an effort to articulate the mother's fantasies, her desire, her stake in that project called "motherhood." . . .
>
> Although the mother's story is my story, *Post-Partum Document* is not an autobiography. . . . It suggests an interplay of voices—the mother's experience, feminist analysis, academic discussion, political debate.[87]

The work consists of personal items—the son's stained diapers, scribblings—accompanied by the mother's written comments.

Kelly maintained that femininity was not "natural" but "constructed," and therefore she rejected the essentialist approach of first-generation feminists. "I think that what's discovered in working through the *Post-Partum Document* is that there is no pre-existing sexuality, no *essential* femininity." By examining the processes of their construction, one could see the possibility of deconstructing representations that justify the subordination of women in society.[88]

Kelly did not use images of women because they had been overrep-

resented, objectified, fetishized, and exploited—that is, turned into "a necessary component in the libidinal economy of men as it has developed in our culture, which is distinct from the libidinal economy of women as it has been repressed in our culture."[89] Essentialists rebutted by claiming that in eliminating female figuration, Kelly had sacrificed the visual and sensual dimension that art—and, above all, feminist art—ought to have. However, she insisted on the importance of the visual component in her works, even though her practice was primarily conceptual.

Kelly was also criticized for depending too much on written material, raising the question of "how much the emphasis on the verbal constitutes a denial of *visual* language, an admission of the failure of purely visual practice except as a hook into the content," as Lucy Lippard observed. Moreover, much of her text was highly theoretical, referring to the psychoanalytic theory of Jacques Lacan, Marxism, semiotics, linguistics, and feminist film studies, and therefore was difficult to grasp. This did not bother Lippard, who wrote: "Like the best feminist art of any style, **PPD** [*Post-Partum Document*] cannot be fully understood outside of the feminist social structures that nurtured it. Its seeds lay in consciousness-raising." But what of a broader audience? Lippard remarked that "Kelly answers such criticisms by intentionally targeting, or limiting, her audience to 'the Women's Movement, other women artists and people generally interested in the issue of patriarchy.'"[90] Despite the criticisms leveled against it, *Post-Partum Document* was a monument of second-generation feminist art much as Judy Chicago's *The Dinner Party* was a landmark of the first.

In her next monumental work, *Interim* (1984–89) [154], a mixture of texts and images in photographs and prints projected in two and three dimensions, Kelly moved from investigating motherhood to the aging of women and their growing invisibility and powerlessness in a male-dominated world. As Marcia Tucker commented: "Because power accrues to a woman in a patriarchy by virtue of her body's procreative capacities and its potential for fetishization, the aging or aged female body becomes a relic, a site of loss."[91] Based on more than one hundred conversations with women, *Interim* is divided into four categories, each of which, as Kelly said, "engages with a particular institutional discourse: fiction, fashion, and medicine in *Corpus* [body]; the family in *Pecunia* [money]; the media in *Historia* [history]; and social science in *Potesta* [power]."[92] The work is less autobiographical than *Post-Partum Document* and deals more with collective memories of women. Its object is to specify "the discourses and institutions" that define and regulate feminine identities.[93]

Like Kelly, Victor Burgin made works in the early 1980s that combine texts and photographs, are rooted in art theory, and deal with the construction of the feminine, but from a masculine point of view [155]. Taking as his subjects images of women by men, such as Manet's

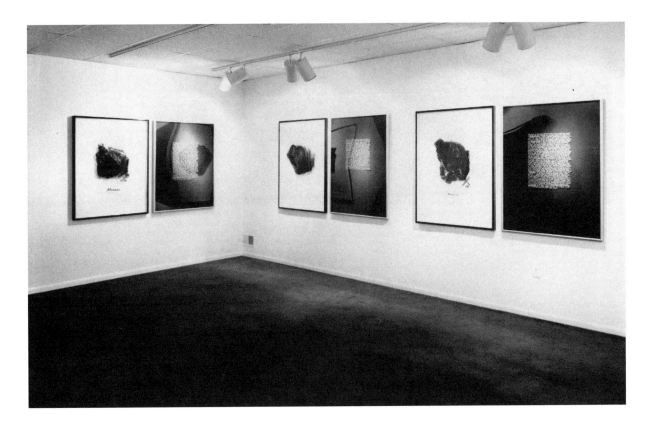

154. Mary Kelly, *Interim,*
part 1; *Corpus,* 1984.
Courtesy Postmasters
Gallery, New York.

Olympia and Shakespeare's Portia, he deconstructed the way in which men consciously and unconsciously make fetishes of women and invent, as Paul Smith commented, a "whole 'mystery of femininity' which has always been the object of masculine curiosity and scorn."[94]

Hans Haacke was the most explicitly political of the deconstruction artists. Before turning to socially committed conceptual art, he made three-dimensional works that interacted with their environments, revealing the interdependent processes of nature. In 1968 he was profoundly affected by the student uprising in Paris. At that time he encountered the situationists, who denounced the dependency of art on the market and the mystification of the artist and his or her art.[95] He also became aware of the institutional critique of Broodthaers and Buren.

Haacke recalled:

I became politicized, like a lot of people. As I had been dealing with what I considered, at the time, to be physical and biological "systems," it appeared to be only logical, from the point of view of general systems theory, and particularly in view of what was happening in the social arena, also to address social issues. That seemed to require a shift in medium. . . . That led me to the incorporation of words. Our social relations are structured and largely intelligible through verbal

Sensation

Create a little sensation
Feel the difference that everyone can see
Something you can touch
Property
There's nothing to touch it

ContraDiction

You've got it
You want to keep it
Naturally. That's conservation
It conserves those who can't have it
They don't want to be conserved
Logically, that's contradiction

Logic

Everything you buy says something about you
Some things you buy say more than you realise
One thing you buy says everything
Property
Either you have it or you don't

155. Victor Burgin, *Sensation*, 1976. *(John Weber Gallery, New York)*

constructs. This development in my work coincided with the influx of words into the art scene of the period.[96]

As his entry in the *Information* show at the Museum of Modern Art in 1970, Haacke took a poll of viewers asking them whether they would vote for Nelson Rockefeller, whose family was closely identified with the museum and who had himself been a president of the museum as well as the governor of New York State, because he had not denounced the Vietnam War. Of those polled 68.7 percent said they would reject him. In 1971 Haacke included as part of his retrospective at the Guggenheim Museum a work titled *Shapolsky et al Manhattan Real Estate Holdings, A Real-Time Social System, as of May 1, 1971*, which became the center of controversy. In it he presented documentation—photographs of 142 properties, many slum buildings, in New York City, and printed text detailing the Shapolsky property holdings. All Haacke did was provide without comment facts that he had scrupulously researched, the information on public record, culled from files in the county clerk's office. As he said: "I do not want to practice agitation which appeals or accuses. I am satisfied if I can provoke a consciousness of a general context and mutual dependence by *facts* alone. *Facts* are probably stronger and often less comfortable than even the best intended opinions. . . . I would like to make the *processes themselves* appear."[97] The Guggenheim Museum canceled the show, because as Thomas Messer, its director, explained in a letter to Haacke, although "art may have social and political *consequences* . . . these, we believe, are furthered by indirection and by the generalized, exemplary force that works of art may exert upon the environment, not, as you proposed, by using political means to achieve political ends, no matter how desirable these may appear to be in themselves."[98] Haacke, of course, did not propose to take action against real estate interests but

wished to make viewers draw their own conclusions. He succeeded at least in suggesting that the Guggenheim was complicit with real estate interests or if not quite that, in fear of their power. The museum's censorship generated a great deal of discourse and publicity, raising consciousness, as it were, which could be taken as proof of the work's political effectiveness.

The Guggenheim controversy revealed to Haacke just how connected the museum was with social and economic powers in the society, and he decided to make the capitalist "system" the subject of his art. Above all he would expose the self-serving reasons corporations used their profits to sponsor art, notably the favorable publicity value of their patronage as well as the evils this publicity was meant to counteract. He wrote that business executives

> recognized that a company's association with art could yield benefits far out of proportion to a specific financial investment. Not only could such a policy attract sophisticated personnel, but it also projected an image of the company as a good corporate citizen and advertised its products—all things which impress investors. . . .
>
> A public relations executive of Mobil in New York aptly called the company's arts support a "goodwill umbrella," and his colleague from Exxon referred to it as a "social lubricant." . . .
>
> Corporate public relations officers know that the greatest publicity benefits can be derived from high-visibility events, shows that draw crowds and are covered extensively by the popular media . . . in short, blockbusters.[99]

Haacke also believed that museums conceived of shows with corporate needs in mind and tailored their programs to meet these requirements, practices he considered pernicious.

Haacke wrote that the artistic means he employed "are as political as the subject matter, that is to say, they play an equally signifying and interventionist role."[100] Hence he not only appropriated material from corporate sources but the particular kind of presentation—in logos, typeface, advertising, and the like—identified with a company. For example, *Tiffany Cares* (1977–78) consisted of an expensive-looking "presentation case"—such as one might see in Tiffany's—which contained a silver-plated copper plate engraved with a Tiffany advertisement containing a statement by Walter Hoving, the chairman of the company, suggesting that the investments of the rich help the poor. Haacke included his own response to Hoving in a statement on the inner cover of the case: "The 9,240,000 Unemployed in the United States of America Demand the Immediate Creation of More Millionaires."

In 1974 Haacke was commissioned by the Wallraf-Richartz Museum in Cologne to create a piece for a show celebrating the museum's 150th anniversary. Titled *Projekt '74: Kunst bleibt Kunst*, the

show would be the most important of the year in Europe. In his entry he traced the history of who bought and sold a single work by Manet, the *Asparagus Still Life* (1880), owned by the Wallraf-Richartz. His purpose was to call attention to an issue generally repressed in the history of art—the economics of art. Included in the documentation he exhibited was a listing of the membership of the museum's Kuratorium (a friends-of-the-museum organization) and their economic affiliations. The museum rejected the work, because it might embarrass Josef Abs, a prominent banker who belonged to the Kuratorium and had worked for Hitler's Third Reich. In reaction Daniel Buren pasted onto his own work a reduced version of the Haacke work, which he proclaimed his own. The museum responded by pasting paper over the Haacke component in the Buren. All this, of course, gave rise to controversy—and publicity in

156. Hans Haacke, *The Saatchi Collection (Simulations)*, 1987. *(Eli Broad Family Foundation Collection; collection of Fonds National d'Art Contemporain, Paris, France)*

European newspapers and magazines—much more than if the museum had kept its hands off—and therefore raised social consciousness, which was Haacke's intention.

In treating the art world as part of the capitalist system, Haacke repeatedly stressed the connections between corporate patrons of the visual arts and their alleged unsavory economic and political practices, notably in the Third World. In *The Saatchi Collections (Simulations)* [156], he included the statement of Lenin's, "Everything is connected to everything else," which he found quoted in the Saatchi & Saatchi PLC 1985 *Annual Report*. In this work he linked the Saatchis' activities in South Africa with parodies of fashionable works Saatchi had collected.

In 1988 Haacke was invited by the city of Graz, Austria, to participate in an exhibition of works of art in public places on the theme *Guilt and Innocence of Art,* with particular reference to the annexation of Austria by the Nazis in 1938 [157]. He chose to rebuild a replica of the monument the Nazis erected over a seventeenth-century statue of the Virgin Mary. It was from the base of this obelisk that Hitler had hailed Graz as the "city of the people's insurrection." A banner on the monument was inscribed with the words "Und Ihr Habt Doch Gesiegt" (And you were victorious after all). Haacke added an inscription at its base listing "The Vanquished of Styria," among them 300 Gypsies, 2,500 Jews, 8,000 political prisoners, and 9,000 other civilians. His re-creation raised the issue of Austria's support of Nazi Germany, which most Austrians

157. Hans Haacke, *Und Ihr Habt Doch Gesiegt* (And you were victorious after all), installation in Graz, Austria, 1988. (*Photograph copyright © Hans Haacke*)

had tried to forget, and was fire-bombed by neo-Nazis, damaging the Virgin. Not surprisingly Haacke's message and the violent attempt to censor it made major news. In the end the perpetrators were apprehended, tried, and imprisoned.

In 1990 Haacke exhibited *Helmsboro Country* [158], in which a large replica of a pack of cigarettes spills out onto the floor. The work incorporates the image of North Carolina Senator Jesse Helms and the Philip Morris logo, quotes from him and executives of the tobacco company, and silkscreen copies of the Bill of Rights. Haacke's intention was to deconstruct the policy of a corporation that supported lavishly both the arts and a senator who would cut governmental support of the arts in general and in particular any art that might be homoerotic, proabortion, feminist, and anticapitalist.

On the whole Haacke's approach was ironic, because as he wrote: "Irony leaves things in abeyance and invites the viewer to fill in the gaps. In other words, it is an appeal to the viewer's intelligence. I want to have some fun, and so should the audience have: fun—by using their heads."[101]

In 1981 Louise Lawler, with an eye to the Institutional Critique of Haacke, Buren, and Broodthaers, began to deconstruct the locus of art: museum and commercial galleries, corporate venues, and rich collectors' living rooms [159]. Photographing artworks in settings in which they were customarily installed, she pointed to the meanings conferred on art by their contexts. To put it another way, her pictures dealt with the relationship between what exists within the frame of art and what exists without, or how the work functions in the world and how that affects its content.

By showing modernist masterpieces ensconced amid comfortable furniture, decorative knickknacks, and a television set in a collector's living room or next to elevator doors or an exit sign in a museum, Lawler called into question the autonomy of art and the transcendental claims made on its behalf. She also twitted the radical rhetoric of modernist art, whose destiny it was to end up domesticated in rich collectors' homes. In this sense her photographs are elegies to the avant-garde.

In other works by Lawler ordinary objects are accompanied by texts, focusing on the relation between art and artifact. In 1989 she addressed the issue of AIDS by ringing a gallery with ninety-four identical photographs of plastic drinking cups of a kind used by AIDS patients, representing the senators who voted for Senator Helms's motion to limit federal funds allocated to education about AIDS and its prevention.

Lawler's work dealt with issues deemed important by art theorists, and it is noteworthy that her photographs were published in *October* in 1983 and republished in the anthology commemorating the first decade of its existence.

* * *

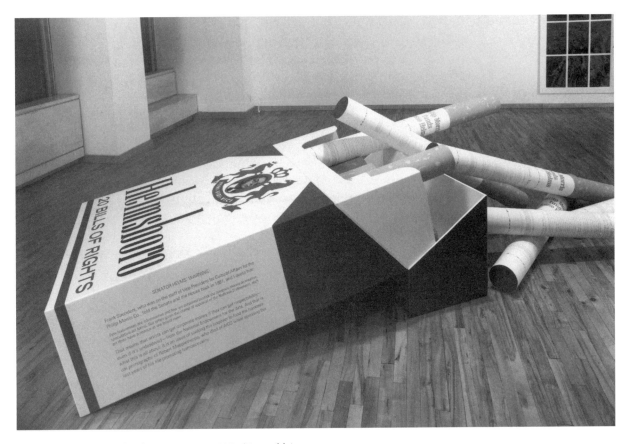

158. Hans Haacke, *Helmsboro Country,* 1990. *(Owned by Hans Haacke)*

159. Louise Lawler, *Three Women/Three Chairs Arranged By Mr. and Mrs. Burton Tremaine, Sr.,* New York, 1984. *(Metro Pictures, New York)*

In 1977 Cindy Sherman began to photograph herself disguised as popular female stereotypes who might have appeared in 1950s B-movies [160]. She invented the characters—"the career girl," "the model," "the actress" or "the star"—styled them and their sets, acted or simulated them, and directed and photographed them. These *Untitled Film Stills* quickly attracted the attention of art theoreticians because they were photographs, not paintings, and appeared to embody the deconstructionist conception of the self as perpetually shifting, if not a fiction.[102] Indeed, Sherman's self-representation seemed unfixed to such a degree that it was impossible to determine what was real, that is, her "true" self, and what was imagined, fantasized, or appropriated.

Sherman's images also appealed to art theoreticians because, as Hal Foster remarked, they are "types presented by the media *as* women. In her work we see that to express a self is largely to replicate a model."[103] The self that Sherman portrayed was one that she as a woman was called upon to emulate in a male-dominated society, that is, models con-

160. Cindy Sherman, *Untitled Film Still*, 1978. (Metro Pictures, New York)

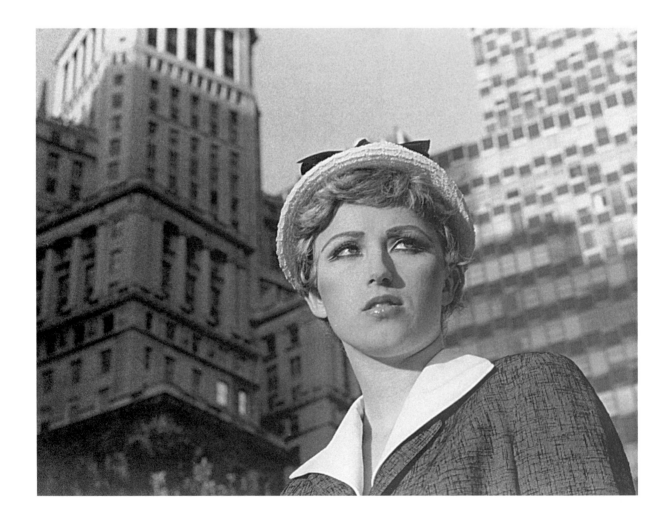

structed by the media with which women were encouraged to identify, as Craig Owens observed.[104]

As Ingrid Sischy wrote in *The New Yorker*: "Right from the start, Sherman has been held up as a paradigm of feminist photography, and as a 'postmodern' example of artists who appropriate images already in the world and redo them in a way that somehow throws the spotlight on their meta-meaning in our culture." Sischy went on to to say that Sherman "has come to embody all this," but added, "I don't believe it's how she began. . . . When you ask her about her work, she's noticeably untheoretical and tentative." Indeed, at their core, Sherman's self-portraits are about dressing up, an activity that preoccupied her as a girl. Sischy wrote that it was "one of the few things in life in which women have traditionally been granted more opportunity for self-expression than men." But dressing up had another kind of meaning to women, as Sischy went on to say: "from the minute they're out of diapers, women have had to deal with the world of appearances in a more inexorably pressured way than men do. That's what makes this a subject on which women are expert witnesses: all women."[105]

Sherman recalled that when she was a child, "I would spend a lot of hours at the mirror, fooling with makeup and dressing up. . . . I would dress up as an old lady and walk around the block and fool the neighbors, things like that."[106] Sherman continued this game of pretending while a student at SUNY Buffalo. There it occurred to her: "It was like painting in a way: staring at my face in a mirror, trying to figure out how to do something to this part of my face, how to shade another part." At one point she was assigned to do a serial piece and her friend Robert Longo suggested: "'You have all this makeup, why don't you do a series of photographs of yourself putting it on?' So I did this transitional series—from no makeup at all to me looking like a completely different person. The piece got all this feedback. It dawned on me that I'd hit on something."[107]

In 1975 Sherman began making *Cutouts*. She invented a scenario, cast herself in all the roles, dressed up, photographed the characters in various scenes, cut them out, pasted them down on pieces of paper, and exhibited them like storyboards. The *Cutouts* were influenced by pop art and performance art and its documentation but even more by movies. Sherman recalled: "I think I identified more with what was going on in film when I was in college than with what was going on in the art world at that time. Of course, that was the mid-70's, so it was a kind of a boring time. [Film] was much more interesting."[108]

Sherman came to New York in 1977. At an evening at David Salle's loft, she saw pornographic photographs that he had brought back from the magazine for which he worked. This documentation of X-rated performances, as it were, inspired her to make her black-and-white *Untitled Film Stills*—some seventy-five from 1977 to 1980—the most famous of which is the runaway teenager, facing away from the viewer, in white

shirt, checked skirt, and bobby socks, holding her suitcase, waiting on a highway for a hitch, presumably to the big city. Other roles Sherman performed were the anxious lover, fallen woman, lonely girl, and rich girl.[109] These stop-action shots hover between photography and film, each suggesting the climax of a story. Despite their emulation of kitschy Hollywood publicity stills, Sherman photographs exude feelings of anxiety and dread lacking in their prototypes, feelings "coaxed . . . from some deep place in her memory," as Gerald Marzorati observed.

In 1980 Sherman began to take color photographs that employed backscreen projection. She no longer acted out media stereotypes but portrayed herself in the guise of ordinary contemporary women. "What I wanted . . . was to begin making characters that were more real-looking."[110] Despite the change in subject matter, the new self-portraits were as anxious as the *Untitled Film Stills*. The works that she exhibited in 1981 were two by four feet, large for photographs, but by 1983 they had grown to eight by four feet, emulating the "big pictures" of the neo-expressionists. Her color on this scale also made her photographs look "painterly."

In the face of proliferating art-theoretical interpretations of her work, Sherman herself emphasized her playacting. "I wonder how it is that I am fooling so many people. I'm doing one of the most stupid things in the world . . . and people seem to be falling for it."[111] Sischy, however, found her innocence a virtue. "Sherman found her voice as an artist, precisely because she didn't try anything fancy; she simply started recording what she was already up to—getting dressed up as somebody else—and that's why this work is so authentic and convincing."[112] From this "simple" point of view, the elaborateness and intricacy of the art-theoretical rhetoric seemed excessive. Nevertheless it was relevant. Sherman did address a number of social issues her contemporaries believed were critical.

Chameleonlike, Sherman seemed to turn herself into a blank screen on which she projected not her "true" self but diverse artfully constructed personae culled from popular cultural stereotypes of femininity. Whatever self-reality she projected was filtered through the mass media; thus her images point outward rather than inward—toward social representations. Feminists were taken with the way in which Sherman negotiated the discrepancy between how women are defined socially and what they actually experience, an issue that was vital in the lives of women. As Suzanne Lacy observed: "I muse over Cindy Sherman's self-portraits of Everywoman, and I can't rid myself of the disturbing feeling that I am witnessing in more sophisticated form an originating impulse toward feminism, one that I have seen repeatedly in art students when they first encounter the discrepancy between interior and exterior definitions of women."[113]

Sherman acted roles dictated by male desires and fantasies, which frame women as passive objects on display. From this vantage point her

stereotypical role-playing could be viewed as "entertainment," presumably for the pleasure of men. Hugo Williams maintained that her work succeeded because its "projection of a powerfully coquettish sexuality, an old-fashioned come-hitherishness" that is mildly pornographic and has sexist and sex-exploitative overtones that feminists preferred to overlook.[114] In opposition to this interpretation, Sherman could be said to exhibit "to-be-looked-at-ness" in order to subvert it.[115] That is, she gazed critically at the male gaze. At the same time, she turned her gaze on herself, revealing what she desired. In the end hers was the active gaze of a woman who, as the photographer, constructed her own image, making herself more than just the object of male fantasy.

Sherman's imagery gains from a reading as social commentary. But the self-expressive or neoexpressionist dimension of her photography was equally or more significant. There was a real "interior" Cindy Sherman hidden in the "exterior" types; even art theoretician Owens allowed that, much as he claimed that her primary aim was to deconstruct the mass media. He pointed to "the uncanny precision" of her representations and "the very perfection of her impersonations." She had identified herself with her painstaking *re*constructions "so thoroughly, that artist and role appear to have merged into a seamless whole."[116] Her images transcend media stereotypes, cultural clichés, and both stock and deconstructive readings and evoke authentic psychological states, emotions, desires, and fantasies—what it really feels like to be woman as victim, woman as sex object. And what it really feels like to be Cindy Sherman. That indeed was the source of their expressive power.

After inventing medialike images of "beautiful" women, Sherman turned against "beauty" with a ferocity rarely found in the history of art [161]. In 1985 she substituted for her self-image a hideous mélange of dolls, teddy bears, and toy monsters submerged in a stew of slime, vomit, pus, and glop that look as if they had oozed out of horror movies.[117] Sherman appears to have thought of herself as garbage, and in this sense her images are existential. They are also psychological in that they seem to represent "the nightmares of her subconscious,"[118] and social, representing, as art critic Elaine Equi wrote, "the bulimic excess of consumerism and its corresponding cycles of binging and purging. [What's] left is the disgust that follows overindulgence."[119] In a more profound sense, Sherman's repellant and depressing pictures exemplify the "the abject" in life and in art, that which is cast off, dirty, degraded, grotesque, and pathetic. As Williams remarked, her "imagination extends . . . into a cyborg world of freaks and monsters," which violates the border between the human and the nonhuman.[120]

In 1989 Sherman exhibited self-portraits based on Old Master paintings with an eye to Hollywood costume sagas [162]. Not only did she dress up as actresses might but altered her very body, attaching prosthetic breasts, noses, bald pates, and the like. Instead of idealizing the sitters as portrait painters traditionally did, Sherman made them disgust-

161. Cindy Sherman, *Untitled*, 1989. *(Metro Pictures, New York)*

ing or farcical, paroding the tradition of portraiture both in the history of art and "historical" movies. Her subsequent works were even more grotesque. Consisting of "images of eroticized and aestheticized medical dummies . . . all tit bibs and red-foam vaginas," they are dehumanized to the extreme. The body is turned into a polluted vessel and sex is equated with defilement. David Levi Strauss wrote that in a time of conflicts over AIDS, censorship of alleged pornography, and who controls a woman's body, "the body has become a site of social, sexual, and political conflict." Sherman did not "anaesthetize these conflicts [but has] aestheticized them; that is, [she has] *transformed* them into art."[121]

Sherman's photographs commanded art-world attention, not only because of their references to art theory, feminism, the mass media, consumer society, and, in her later works, to the abject in human nature, but also because of their reference to painting, namely their size and scale, and high-keyed color—which made problematic the boundary between photography and painting. Moreover, they were related to other kinds of art—notably performance art, body art, conceptual art, media art, and deconstruction art—all of which seemed peculiarly relevant in the 1970s and 1980s.

Like Sherman's photographs, Laurie Simmons's Cibachrome prints feature images of women appropriated from the mass media. Her most

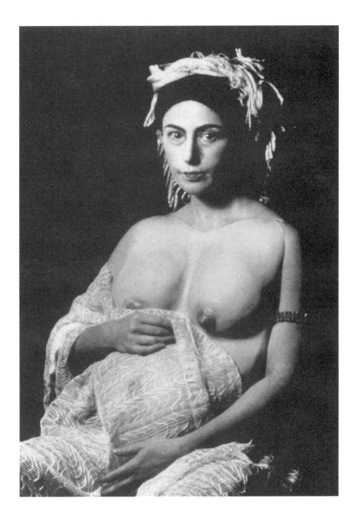

162. Cindy Sherman, *Untitled*, 1989. *(Metro Pictures, New York)*

provocative pictures are of female dolls in banal suburban settings enacting trite TV-commercial and sitcom scenarios, executed in the slick manner of fashion photography. In another series, *Tourism*, the dolls are posed as if in snapshots, in tourist centers around the world, the favorite playpens of the consumer society. On the one hand these images exist in the spaces between the realms of childhood and adulthood, fantasy and reality. On the other they deconstruct gender stereotyping, as well as consumer culture and suburban life, and the glossy fashion in which they are presented.

Simmons's photographs at the end of the 1980s depict a variety of ordinary artifacts standing on legs, for example, *Walking Cake* [163] and *Walking Toilet*. Photography critic Andy Grundberg wrote: "Headless and absurd, the objects look like figures culled from 1950's cigarette advertising. But Simmons makes them seem at once humanoid and endearing. She contrasts the overscaled objects with the human proportions of their legs and mixes animate and inanimate qualities in unexpected [and theatrical] ways."[122] Richard Kalina's interpretation was more psychosocial:

163. Laurie Simmons, *Walking Cake,* 1989. *(Metro Pictures, New York)*

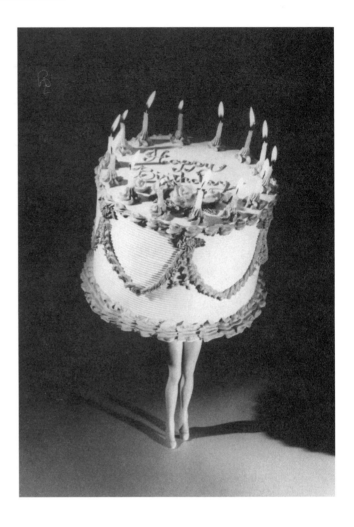

"Simmons's unsettling hybrids indicate the extent to which women have been diminished by the mindless, ritualistic identification with possessions and property. They are literally upholders of middle-class propriety and are humans only from the waist down. . . . These object-women seem passive and pathetically anxious to please."[123]

William Wegman's videos and photographs of his dog Man Ray, taken from 1970 to 1982, are self-portraits of sorts, and consequently related to Sherman's [164]. The Weimaraner seemed to be a kind of collaborator, playing straight-"Man" to Wegman the comedian, but above all he was a surrogate for the artist, as Henry M. Sayre put it, "an alter ego putting on Wegman's many faces, a Charlie McCarthy to Wegman's Edgar Bergen."[124] Man Ray was a great character as a dog, but he was only a dog. As an actor he had no "personality" except the one constructed for him by Wegman, who dressed him and posed him in ridicu-

lous situations, for example, wrapped in yarn (1981), wearing an Indian bonnet (1981) or a sombrero (1982), or dusted in flour (1982).

What was Wegman's identity in all of this? As Sayre wrote, his self was "a kind of theater, an ongoing transference of identity, an endless 'acting out.' . . . an arena of free play."[125] But what was the nature of this acting out? As Wegman said, he liked things that were "wrong and dumb" to the extent of being embarrassing.[126] But rather than submit himself to that, he made Man Ray his stand-in.

The photographs of Man Ray are funny. So are the "bad" drawings with written captions that Wegman began to make in 1975. At first he doodled on unsuccessful photographs, for example, in *Ray Cat* (1979) sketching cat's ears and whiskers on a photograph of the dog. This led

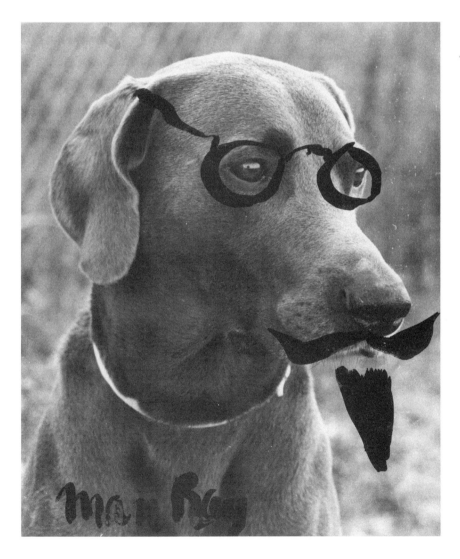

164. William Wegman, *"Untitled" (Man Ray)*, 1979. *(Holly Solomon Gallery, New York)*

Wegman to draw with pencil on typewriting paper—visual jokes, one idea per page. He kept the drawings small and "poor" because he wanted them to be subversive and funny, not powerful and beautiful. Because they are "dumb," there is a "pathetic" or "abject" quality about them that turned out to be very influential, particularly in the late 1980s.

The theatricality in Sherman's, Simmons's, and Wegman's photographs is a sign of its centrality in the sensibility of the 1970s. It found its fullest expression in the performance art of Laurie Anderson, Eric Bogosian, and Spalding Gray. Performances by artists were staged in growing numbers in downtown late-night clubs and alternative spaces, notably Artists Space and the Kitchen. Art theoreticians quickly embraced performance art as one of the tendencies that was not created in the isolation of the studio, and therefore, unlike painting, did not become an emblem of the artist's originality, as Craig Owens commented. Indeed, "Performance . . . is the post-studio art par excellence."[127]

In 1974 Laurie Anderson was selected by Vito Acconci to have her first one-person show at Artists Space as part of its Artists Choose Artists Program. She exhibited conceptual art but the following year staged her first performance at Artists Space. In her theatrical pieces of the 1970s, Anderson told stories interspersed with short films and tape recordings. She also accompanied herself on the violin, which she had studied as a child. Her narratives drew upon her own life, for example, childhood experiences or a "dream series which came out of falling asleep in art history classes and mixing those dreams with what was on the screen."[128] "As an artist I wanted to create an atmosphere that the audience could enter with a lot of images and sounds. . . . I make pictures out of images and sound."[129]

Anderson was influenced by Acconci's confessional performances. They "made me laugh a lot. . . . Nobody else was acting like that. . . . He was and is a great poet. I love just listening to him speak [in his] amazing, gravelly, deep, intoxicating voices."[130] She also admired comedian Andy Kaufman's ability to "actually shrink a room. He seemed to understand space in a way I had never considered. . . . I learned a lot about space from Andy."[131] Anderson was also inspired by rock and punk music featured in downtown clubs. She commented: "I think the energy infusion brought to the art scene by the music is the most exciting thing that's happened in art for years."[132]

Anderson embraced performance art because, as she said:

I have the advantage of being able to see who I'm talking to. And this contact has been extremely important in the development of my work. As a member of the avant-garde, I was of course committed to making work that was as vivid, surprising and inventive as I could make it. . . .

And the avant-garde is a safe place for artists to work out ideas that seem a bit peculiar to the general public (whoever they are).[133]

At one point Anderson wondered whether she could reach an audience outside the art world, to "cross over," as it came to be called. Then, in 1978,

I was scheduled to do a performance in Houston and since the museum wasn't really set up for this sort of thing—no stage, no chairs, no sound system—the performance was booked into a local country-and-western bar. The advertisements suggested some kind of country fiddling, so a lot of regulars came. . . . About halfway through the concert, I realized that the regulars were really getting it. What I was doing—telling stories and playing the violin—didn't seem bizarre to them. The stories were a little weird but so are Texan stories. I remember that I felt a great relief. The art world was after all quite tiny and I'd been doing concerts for the same hundred people. This was a whole new world.[134]

In 1980 Anderson elaborated on her "crossover" role:

I have received and continue to receive psychological and intellectual support from the art world and believe that the structure and intentions of my work are best understood by other artists. However, in the past two years I have found myself doing as many things for nonart audiences as for art audiences. I don't change the work according to the audience. As a result, it is now possible for me to think of American art as something that can enter culture in other ways unescorted by institutional art intermediaries. Radio, T.V. and a variety of spaces—old movie houses, rock clubs, bars, V.F.Ws and amphitheatres—have become more accessible to artists who work in live situations. Using these channels makes it possible as well as necessary continually to revise my ideas about the flexibility of space—physical, electronic and psychological—and finally to learn to look at people. The audience appears to be expanding and . . . there's so much enthusiasm. . . .

I'm also interested in wider audiences because it takes performance art out of slightly ingrown situations (twice a year for the same three hundred people) and because it pays better to do things sponsored by Schlitz than the Museum of Modern Art.[135]

Then, in 1981, her record *O Superman* became a bestseller, grossing over a million dollars. Warner Bros. put her under contract, which gave her the wherewithal to mount ever more ambitious works. Taking her cues from the Philip Glass/Robert Wilson opera *Einstein on the Beach*

(1976), she expanded "sketchy, small-scale performance pieces to epic proportions."[136] She combined "film, music, electronics, story telling, dancing, social commentary, impersonation, animation, and anything else I come up with. What I do has been described as high-tech opera, live art, electronic stand-up comedy, avant rock, and that clumsy label, performance art. . . . Fortunately, nobody knows what performance art refers to."[137] Anderson also began to introduce pop elements into her performances. She said: "Granted, American pop culture is designed for the average twelve-year-old, and art looks pretty strange sometimes when it tries to wedge itself into pop music charts, television, and Broadway. But I love this kind of clash; I thrive on not fulfilling people's expectations."[138]

The stories that Anderson told about her life felt peculiarly American, and she intended them to. "I try to pick things that would make people say, 'I was just thinking that a couple of days ago; I didn't say it exactly like that but I had that idea.'" In a seven-hour performance, *United States I-IV* (1983), she unfolded her vision of the American experience, "examining America by talking about herself."[139] As she described it: "The first part is transportation, the second part is money, the third is a kind of psycho-social situation, and the fourth is, ah, love."[140] *United States I-IV* consists of "talking songs" in the American vernacular both in language and in music which quotes jazz, rock and roll, reggae, and the like. The recitation is accompanied by a violin, slide and film projections, and voice-altering technology, the voice altering becoming Anderson's stylistic signature. But much as she utilized impersonal electronic media, both her scenarios and their staging remained intimate and personal.

Anderson's recurring theme is the American on the move over today's open road, with an eye to Walt Whitman, in a post–Vietnam War odyssey. At the beginning of *United States,* perhaps with the saga of the American pioneer in the wilderness in mind, she imagines driving on a rainy night and getting lost; when it starts to get light, "you realize / you have absolutely no idea where you are."[141] In the concluding number, "Lighting Out for the Territories," Anderson recites: "You've been on this road before. / You can read the signs. / You can feel the way. / You can do this / in your sleep."[142]

In the late 1980s Anderson's work grew increasingly political. She said:

> As America gets more conservative, I find my own reactions to this are driving me further into the politics of pop culture. I want to know what the motor is, what is driving this culture further and further to the right. Consequently, much of my work has become political and engaged. . . . The art that I like the most and the art that I aspire to make helps people live this life as well as possible. . . . Maybe it's because I consider this a crisis situation for the arts in this country. At the moment I just don't feel I have the leisure to make art about art. . . .

For me, at this time, art must address the issues—sensually, emotionally, vividly, spiritually. This means being involved with the aspirations, lies, and dreams of what is so snobbishly called low culture.[143]

Empty Places (1989), in which she appeared alone on the stage telling stories and singing songs, was inspired by the Reagan eighties. She said: "It's an unadorned story about pain. I'm angrier now than I was."[144]

Anderson said: "One of my greatest hopes was that American artists could actually find ways to finally enter their own culture and I had hoped that other artists could share this goal."[145] Other artists made the cross-over, among them Eric Bogosian. He began performing at the Mudd Club and other downtown clubs using the name "Ricky Paul." Although there was little that was visual in his solo appearances and plays, his monologues were related to media and deconstruction art in that they took pop clichés and "détourned" them, in his case, in often angry, insulting, and perverse ways.

Bogosian recalled: "When I was a teenager, a normal day could include listening to the Beatles, watching *The Mod Squad* or *The Beverly Hillbillies* on TV, performing in *Romeo and Juliet* at school, reading *Mad* magazine, and, in my spare time, reading Kafka or Dickens. I never thought there was anything inconsistent about what I was doing." In time Bogosian came to believe that the "mass media . . . feeds us the mental equivalent of a carcinogenic diet of salt and sugar and fat. Fed solely on what the mass media feeds us, our minds and souls become sick." As an antidote, the

fine arts set up a posture of reflexion, a looking-at-myself-looking-at-the-world stance. What I saw scared me and this has become the basis of my work. . . .

I address the desires that move me through my life, fueled by years of listening and watching TV, movies, and recorded music. . . . And I seek a higher ground. Not a higher ground in the sense of a higher, snobbier, I'm-bored-I-need-something-stronger higher ground, but a higher ground that helps me reconcile my life with the world around me.

So my work seems to be both high and low at the same time. It is high in that it is reflexive; it is low in that it is bluntly entertaining.[146]

Like Anderson and Bogosian, Spalding Gray emerged as a storyteller in an art-world context, beginning in 1977 when he and Elizabeth Le Compte founded the Wooster Group in SoHo. Like Bogosian's, his work lacks a strong visual dimension but chronicles the American experience from his autobiographical point of view. Gray's monologues "epito-

mise the complex and repressed WASP mentality," chronicling its obsessions and hangups. They are an "adventure into guilt and neurosis. . . . In each monologue, Gray is involved in a constant battle with his id, which throws tantrums and threatens to ruin his career, love life and finances. After a number of skirmishes, each book concludes with a sort of triumph of superego that saves the day."[147]

As the 1980s progressed, Crimp's *Pictures* took on a mythical stature as a pathfinding exhibition, although, as he commented, when it was on view in Artists Space it had hardly been noticed. *Pictures* generated a plethora of me-too shows, adding to its historic stature. Crimp said:

> Versions of the show, using something of the vocabulary of my trying to theorize an attitude about representation, appeared all over the place. To the point where by now [as late as 1989] MOCA [the Museum of Contemporary Art in Los Angeles] can do [an] exhibition "A Forest of Signs" which is basically the "Pictures" show twelve years later. Obviously filled out with different artists and theorized in different ways but fundamentally that.[148]

By 1985 deconstruction art had become familiar enough to the general public to warrant coverage in the mass media. As summed up by Douglas Davis in *Newsweek*, it represented "a significant new trend in photography. . . . Museum and gallery walls are beginning to be filled with images that either mock or deny the candid realism long associated with the camera. Though the photographers behind them vary widely in style, they all share one central premise: photography lies as often as it tells the truth." Despite their skepticism about photography's claim to truth, the new photographers "believe that media overkill is constructing a wholly independent reality, as vivid, as 'true' as the world outside. To rephotograph a photograph seems to them as natural—as much a true representation of life—as taking snapshots at a family picnic." Davis went on to say: "Where early photographers lusted to reproduce the world, the new breed lusts to reproduce, manipulate and criticize the medium itself."[149]

NOTES

1. Myriam D. Maayan, "From Aesthetic to Political Vanguard: The Situationist International, 1957–1968," *Arts Magazine*, Jan. 1989, p. 51.
2. See Tim Yohn, "Books," *Artforum*, Dec. 1976, pp. 60–62. (A review of Daniel Bell, *The Cultural Contradictions of Capitalism* [New York: Basic Books, 1976].)
3. Craig Owens, in "Post-Modernism," *Real Life* (Summer 1981): 8.
4. Yohn, "Books," p. 60.
5. Owens in "Post-Modernism": 8.
6. Guy Debord, *Society of the Spectacle* (Exeter, England: Rebel Press Aim Publications, 1987), epigraph.
7. Debord, *Society of the Spectacle*, para. 193.
8. Jeffrey Deitch, "Cultural Geometry," *Cultural Geometry* (Athens, Greece: Deste Foundation for Contemporary Art, 1988), pp. 31, 33.

9. Jean Baudrillard, *Simulations*, translated by Paul Foss, Paul Patton, and Philip Beitchman (New York: Semiotext(e), 1983), pp. 10, 13.

10. Thomas Lawson, in "The 1983 Mountain Lake Symposium," *New Art Examiner*, Jan. 1984, sect. 3, p. 2.

11. See David Carrier, "Baudrillard as Philosopher or, The End of Abstract Painting," *Arts Magazine*, Sept. 1988.

12. Dan Graham, in Nancy Foote, ed., "Situation Esthetics: Impermanent Art and the Seventies Audience," *Artforum*, Jan. 1980, pp. 25–26. See also Peter Plagens, who in "International Shows: Under Western Eyes," *Art in America*, Jan. 1989, put this idea negatively. He characterized deconstruction art as "rebellious advertising art, as if the creative department of Saatchi & Saatchi were infiltrated after hours by guerrillas bent on revenge" (p. 36).

13. Stephen Ellis, "The Boys in the Bande," *Art in America*, Dec. 1988, p. 125.

14. *Image World: Art and Media Culture* (New York: Whitney Museum of American Art, 1989).

15. Susan Weiley, "The Darling of the Decade," *Art News*, Apr. 1989, p. 145.

16. Robert Storr, "Nancy Spero: Central Issues—Peripheral Visions," in Dominique Nahas, ed., *Nancy Spero: Works Since 1950*, p. 45.

17. D. A. Robbins, "An Interview with Thomas Lawson," *Arts Magazine*, Sept. 1983, pp. 116–17. Lawson added: "Art is a public discourse. What I go through to make it is not important. The dialogue should be kept public and not be confused with my personal life. What is important is the end result and what happens when the end result goes public."

18. Connie Samaras, "Sponsorship or Censorship?" *New Art Examiner*, Nov. 1985, p. 25.

19. Eleanor Heartney, "The Politics of Protest," *New Art Examiner*, Sept. 1992, p. 16.

20. Peter Plagens, "Bee-Bop Da Reebok in L.A.," *Art in America*, Apr. 1985, p. 145.

21. Peter Plagens, "Issues & Commentary: The Emperor's New Cherokee Limited 4 × 4," *Art in America*, June 1988, p. 23.

22. Roger Kimball, "Notebook: Sundays in the Dark with the Whitney," *New Criterion*, Jan. 1987, p. 85.

23. Jeremy Gilbert-Rolfe, "The Price of Goodness," *Artscribe International*, Nov.–Dec. 1989, pp. 50–52.

24. John Miller, "When Activism Becomes Quietism," *Acme Journal* 1, no. 1 (Spring 1992): 51–52.

25. Patrick Frank, "A Great Debate: Criticism in the '80s," *New Art Examiner*, Nov. 1985, p. 39.

26. Carter Ratcliff, "Contemporary American Art," *Flash Art* (Summer 1982): 33.

27. Paul Taylor, "Interview with Hans Haacke," *Flash Art* (Feb.–Mar. 1986): 40.

28. David Carrier wrote in "Reviewing the Eighties: Art Criticism and Its Beguiling Fictions," *Art International*, Winter 1989, p. 37, that deconstructive critics were also complicit. "Despite [their] attempts to challenge the dominant ideologies of the eighties, the tangible result of their rhetoric is to promote the art they discuss." See also Thomas Lawson, "The Dark Side of the Bright Light," *Artforum*, Nov. 1983, p. 62.

29. Plagens, "Issues & Commentary: The Emperor's New Cherokee," p. 24.

30. J. Hoberman, "Brave New Image World: The Whitney Looks at Art in the Light of TV," *Village Voice*, Nov. 28, 1989, p. 41.

31. Yve-Alain Bois, Douglas Crimp, and Rosalind Krauss, "A Conversation with Hans Haacke," *October 30* (Fall 1984): 42–43.

32. Nancy Marmer, "Documenta 8: The Social Dimension?" *Art in America*, Sept. 1987, p. 136.

33. Taylor, "Interview with Hans Haacke," p. 40.

34. Carter Ratcliff, "The Marriage of Art and Money," *Art in America*, July 1988, p. 145.

35. Douglas Davis, "The Billion Dollar Picture?" *Art in America*, July 1988, p. 23.

36. Carter Ratcliff, "Issues & Commentary: Dramatis Personae, Part IV, Proprietary Selves," *Art in America*, Feb. 1986, p. 13.

37. Reisman, "Looking Forward," p. 62.

38. See Crimp, *Pictures*, p. 16.

 In 1977 Levine was included in the *Pictures* show, curated by Crimp, in which she exhibited *Sons and Lovers*, a series of thirty-six drawings of silhouetted heads of different sizes and combinations of Washington, Lincoln, John Kennedy (appropriated from coins), and an anonymous woman and a couple (pirated from wig advertisements). In *Pictures*, pp. 16–17, Douglas Crimp wrote that in their diverse juxtapositions, these trite images constituted an ambiguous "scenario that moves from assassination to adultery." Levine was bothered by the element of "hand" in her drawn silhouettes and began using photographs cut from magazines. See Thomas Lawson, in "Nostalgia as Resistance," *Modern Dreams* (New York: Institute of Contemporary Art, Clocktower Gallery 1988), p. 159.

39. Gerald Marzorati, "Art in the (Re)making," *Art News*, May 1986, p. 96.

40. Sherrie Levine said in "Post-Modernism," *Real Life* 6 (Summer 1981): "I take umbrage with the institutions that have made art what it is; the expression of brutish, but brilliant shepherd boys discovered and patronized by sensitive landholders" (6).

41. Sherrie Levine, "Five Comments," in Brian Wallis, ed. *Blasted Allegories* (New York: Museum of Contemporary Art, 1987), p. 92.

42. Douglas Crimp, "Appropriating Appropriation," in *Image Scavengers: Photography* (Philadelphia: Institute of Contemporary Art, 1982), p. 30.

43. Paul Taylor, "Sherrie Levine Plays with Paul Taylor," *Flash Art* (Summer 1987): 55. Levine claimed that her art-theoretical bent was different from that of the *October* group. In Janet Malcolm, "Profiles: A Girl of the Zeitgeist," p. 61, she said:

 When I first started doing the appropriative

work, a lot of the criticism written about it—much of it in *October*—was based on ideas of the Frankfurt school of philosophy, but somehow I felt that these sociological explanations coming out of Marx were insufficient. I had the intuition that if I started reading psychoanalytic theory I might find more satisfying explanations. Appropriating art is not all that different from wanting to appropriate your father's wife or your mother's husband. It's all the same psychological mechanism: the Freudian idea that desire is triangular—you desire what the other desires.

44. Lawson, "Last Exit: Painting," p. 45.
45. Carter Ratcliff, "Issues & Commentary: Art & Resentment," *Art in America*, Summer 1982, p. 11.
46. At the same time Levine's rephotographs were related to photorealist painting of the 1970s, except she took photographs of photographs rather than make paintings of them.
47. Taylor, "Sherrie Levine Plays With Paul Taylor," p. 55, 57. Elsewhere, in Janet Malcolm, "Profiles: A Girl of the Zeitgeist, Part II," *The New Yorker*, Oct. 27, 1986, p. 61, Levine said:

> Ultimately . . . all my work is a feminist statement. It deals with the difficulty of being a woman who is trying to create images that are not a product of the expectations of male desire, in a culture that is primarily a celebration of male desire. What I do is to come at the problem through the back door; I appropriate images of male desire as a way of not being coopted by that desire. I appropriate only the great modern male masters, and I choose only works that I love and value.

48. Levine, in "Post-Modernism," p. 6.
49. Taylor, "Sherrie Levine Plays with Paul Taylor," p. 57.
50. Marzorati, "Art in the (Re)Making," p. 96.
51. Not all of Levine's advocates condemned her. Rosalind Krauss wrote the introduction to the catalog of her show at the Mary Boone Gallery in 1989.
52. Marc Selwyn, "John Baldessari," *Flash Art* (Summer 1987): 63.
53. Taylor, "Sherrie Levine Plays with Paul Taylor," p. 58.
54. Marzorati, "Art in the (Re)Making," pp. 92–93, 96. To put it another way, Levine had grown dissatisfied with art theory. Reflecting her uneasiness, Marzorati wrote: "Increasingly, these theoretical critics were writing less about new art (which of it was important and why) and more about the art world—about art's role in a late capitalist, consumer society. Their critiques were drawing now on Marx or, more accurately, on contemporary Marxist writing, as much as on Barthes and Derrida. And this showed in their readings of Levine's work. What mattered most it seemed was how her appropriations commented on the gallery system; that she was an artist making

decisions about making pictures seemed to matter hardly at all" (p. 97).
55. Kate Linker, "Barbara Kruger: An Interview," *Flash Art* (March 1985): 36.
56. Michael Brenson, *New York Times*, May 15, 1987, sec. C, p. 26.
57. Anders Stephanson, "Barbara Kruger," *Flash Art* (Oct. 1987): 58.
58. Michael Brenson, "Art: Barbara Kruger," *New York Times*, Apr. 6, 1984, sec. C, p. 29.
59. Henry M. Sayre, *The Object of Performance: The American Avant-Garde Since 1970* (Chicago: University of Chicago Press, 1989). (Italics in original.) Sayre also remarked: "Consider the phrase 'You are not yourself.' On the one hand, it is a common enough equivalent for 'You are out of sorts today.' On the other hand, it is a four-word treatise on the social construction of male—or female—identity in contemporary society" (p. 196).
60. Paula Marincola, "Stock Situations/Reasonable Facsimiles," *Image Scavengers: Photography* (Philadelphia: Institute of Contemporary Art, 1982), p. 24.
61. Stephanson, "Barbara Kruger," pp. 58–59.
62. Sarah Rogers-Lafferty, "Barbara Kruger," an interview, in *Breakthroughs: Avant-Garde Artists in Europe and America, 1950–1990* (New York: Rizzoli, 1991), p. 228.
63. Bois, Crimp, and Krauss, "A Conversation with Hans Haacke": 47.
64. Carol Squires, "Diversionary (Syn)tatics," *Art News*, Feb. 1987, p. 84.
65. Roberta Smith, "Art: Barbara Kruger's Large-Scale Self-Expressions," *New York Times*, Jan. 11, 1991, sec. C, p. 12.
66. Robert Storr, "Other 'Others,'" *Village Voice Art Supplement*, Oct. 6, 1987, p. 17.
67. Stephanson, "Barbara Kruger," p. 55.
68. Eleanor Heartney, "How Wide Is the Gender Gap?" *Art News*, Summer 1987, p. 144.
69. Rogers-Lafferty, "Barbara Kruger," pp. 228–29.
70. Adrienne Rich, "When We Dead Awaken: Writing as Revision," *On Lies, Secrets and Silence: Selected Prose 1966–1978* (New York: Norton 1979), p. 35, quoted in Thalia Gouma-Peterson and Patricia Mathews, "The Feminist Critique of Art History," *Art Bulletin* (Sept. 1987): 336.
71. Rex Reason, "Democratism," *Real Life* 8 (Spring–Summer 1982): 11.
72. Bruce Ferguson, "Wordsmith: An Interview with Jenny Holzer," *Art in America*, Dec. 1986, p. 111.
73. Jenny Holzer, in Jeanne Siegel, ed., *Artwords 2: Discourse on the Early 80s* (Ann Arbor, Mich.: UMI Research Press, 1988), p. 292, said: "To write a quality cliché you have to come up with something new."
74. Reason, "Democratism," p. 9. In Bruce Ferguson, "Wordsmith: An Interview with Jenny Holzer by Bruce Ferguson," *Jenny Holzer: Signs* (Des Moines, Iowa: Des Moines Art Center, 1986), p. 67. Holzer also commented that her *Truisms* were partially inspired by her experience at the Whitney Museum's

Independent Study Program in early 1977, during which she was assigned "numberless books, all of which were heavies," on Marxism, feminism, and art theory. "I thought maybe I could translate these things into a language that was accessible."

75. Ferguson, "Wordsmith," p. 67.

76. Holzer considered herself part of a movement of "public artists," including Barbara Kruger, Keith Haring, John Ahearn, Justin Ladda, John Fekner, Tim Rollins + KOS, and Lee Quinones. Their work was so diverse in medium and style as to defy categorization. Yet, they all were "united by a desire to make something that's meaningful to a lot of different people, that's presented in a nonart location, that's about issues that are important to anyone." Jenny Holzer, from my notes of a lecture at the Solomon R. Guggenheim Museum, Jan. 16, 1990.

77. Sayre, *The Object of Performance*, p. 198.

78. Kim Levin, "Lumière et Son," *Village Voice*, Jan. 8, 1990, p. 89.

79. Thomas Lawson, "Nostalgia as Resistance," *Modern Dreams: The Rise and Fall and Rise of Pop* (New York: Institute of Contemporary Art, 1988), p. 160.

80. Steven Evans, "Not All About Death: Jenny Holzer Interviewed by Steven Evans," *Artscribe International*, Summer 1989, p. 58.

81. Siegel, "Holzer's Language Games," pp. 291, 65. Holzer's cacophony of texts appeared in public and art world venues not only on electronic signs but on large photostats in windows, adhesive stickers pasted in public phone booths, and what have you. In public they were presented anonymously, so that they would be perceived not as art but as just messages.

82. Ibid., p. 294.

83. Sayre, *The Object of Performance*, p. 201.

84. Evans, "Not All About Death," p. 58.

85. Varnedoe and Gopnik, *High & Low*, p. 405.

86. Levin, "Lumière et Son," p. 89.

87. Mary Kelly, "Preface," *Post-Partum Document* (London: Routledge & Kegan Paul, 1983), pp. xvii–xviii.

88. Mary Kelly, "No Essential Femininity: A Conversation Between Mary Kelly and Paul Smith," *Parachute* 26 (Spring 1982): 35.

89. Jo-Anna Isaak, "Our Mother Tongue, *The Post-Partum Document*," *Vanguard*, Apr. 1982, p. 16.

90. Lucy R. Lippard, "Foreword," in Kelly, *Post-Partum Document*, pp. x, xii, xiii.

91. Marcia Tucker, "Picture This: An Introduction to Interim," in *Mary Kelly Interim* (New York: New Museum of Contemporary Art, 1990), p. 18.

92. Hal Foster, "That Obscure Subject of Desire," in ibid., p. 61.

93. Griselda Pollock, "Interventions in History: On the Historical, the Subjective, and the Textual," in ibid., p. 40.

94. Paul Smith, "Difference in America," *Art in America*, Apr. 1985, p. 197.

95. David Craven, "Hans Haacke and the Aesthetics of Dependency Theory," *Arts Magazine*, Mar. 1987, p. 57.

96. Paul Taylor, "Interview with Hans Haacke," *Flash Art* (Feb.–Mar. 1986): 39.

97. Benjamin H. D. Buchloh, "Hans Haacke: Memory and Instrumental Reason," *Art in America*, Feb. 1988, p. 159, n. 13.

98. See Thomas M. Messer's letter to Hans Haacke, Mar. 19, 1971, in "Gurgles around the Guggenheim," *Studio International*, June 1971, p. 249.

99. Hans Haacke, "Issues & Commentary: Museums, Managers of Consciousness," *Art in America*, Feb. 1984, p. 15.

100. Taylor, "Interview with Hans Haacke," p. 40.

101. Ibid.

102. Douglas Crimp, "The Photographic Activity of Postmodernism," *October 15* (Winter 1980): 99.

103. Hal Foster, *Re-codings: Art, Spectacle, Cultural Politics* (Seattle: Bay Press, 1985), pp. 66–67.

104. Craig Owens, "The Allegorical Impulse: Toward a Theory of Postmodernism, Part 2," *October 13* (Summer 1980): 77.

105. Ingrid Sischy, "Photography: Let's Pretend," *The New Yorker*, May 6, 1991, pp. 87, 90, 96.

106. Peter Schjeldahl, "Portrait: She Is a Camera," *7 Days*, Mar. 28, 1990, p. 17.

107. Gerald Marzorati, "Imitation of Life," *Art News*, Sept. 1983, pp. 84–85.

108. Bronwyn C., "A Conversation with Cindy Sherman about Radio, Art, Reality and Other Things," *WFMU Music/Art Convergence* (New York: Germans van Eck Gallery, 1992), p. 6. In this interview Sherman also commented on her "childhood obsessions with watching old movies on TV."

109. Sischy, "Photography: Let's Pretend," p. 89.

110. Marzorati, "Imitation of Life," p. 86.

111. Cindy Sherman, *Documenta 7*, quoted in Marzorati, "Imitation of Life," p. 83.

112. Sischy, "Photography: Let's Pretend," p. 88.

113. Suzanne Lacy, "The Name of the Game," *Art Journal* 50, no. 2 (Summer 1991): 67.

114. Hugo Williams, "Commentary: Her Dazzling Career," *Times Literary Supplement*, Jan. 11, 1991, p. 10.

115. See Mathews, "Feminist Art Criticism": 20.

116. Owens, "The Allegorical Impulse . . . Part 2," pp. 77–78. Owens did conclude that a distinction had to be made, that in the end Sherman's self was an "Imaginary construct" which implicates the mass media as "the false mirror which promotes . . . alienating identifications." Sherman found it necessary to be complicit with the media, to participate "in the very activity that is being denounced *precisely in order to denounce it*."

117. Elaine Equi, "Cindy Sherman," *Arts Magazine*, Sept. 1989, p. 72.

118. Laura Cottingham, "Spotlight: Cindy Sherman," *Flash Art* (Oct. 1987): 97.

119. Equi, "Cindy Sherman," p. 72.

120. Williams, "Commentary: Her Dazzling Career," p. 10.

121. David Levi Strauss, "Aesthetics and *An*aesthetics," *Art Issues*, Mar.–Apr. 1993, p. 22.

122. Andy Grundberg, "Photographic View: The Mellow-

ing of the Post-Modernists," *New York Times*, Dec. 17, 1989, sec. 2, p. 43.

123. Richard Kalina, "Review of Exhibitions; New York: Laurie Simmons at Metro Pictures," *Art in America*, Feb. 1974, p. 174.

124. Henry M. Sayre, *The Object of Desire: The American Avant-Garde since 1970* (Chicago: University of Chicago Press, 1989), p. 56.

125. Ibid., pp. 56–57.

126. William Wegman, talk at a Whitney Museum seminar, New York, Feb. 4, 1992.

127. Craig Owens, "Back to the Studio," *Art in America*, Jan. 1982, p. 100.

128. "Laurie Anderson," in Roth, *The Amazing Decade*, p. 74.

129. John Howell, *Laurie Anderson* (New York: Thunder's Mouth Press, 1992), p. 17.

130. Ibid., pp. 96–97.

131. Nancy Foote, ed., "Situation Esthetics: Impermanent Art and the Seventies Audience," *Artforum*, Jan. 1980, pp. 22–23.

132. Michael Shore, "How Does It Look? Punk Rocks the Art World," *Art News*, Nov. 1980, p. 83.

133. Laurie Anderson, in *High & Low: Modern Art and Popular Culture; Six Evenings of Performance* (New York: Museum of Modern Art, 1990), n.p. Curated by RoseLee Goldberg.

134. Ibid.

135. Foote, "Situation Esthetics," p. 23.

136. Howell, *Laurie Anderson*, p. 22.

137. Statement read by Russell Connor at an evening with Laurie Anderson at the Whitney Museum of American Art, New York, Jan. 18, 1990.

138. Anderson, in *High & Low: Modern Art and Popular Culture*.

139. Howell, *Laurie Anderson*, pp. 14, 75.

140. Laurie Anderson, interviewed by Robin White, in *View* 2, no. 8 (Jan. 1980): 7.

141. Laurie Anderson, *United States* (New York: Harper & Row, 1984), p. 12.

142. Ibid., p. 220.

143. Anderson, in *High & Low: Modern Art and Contemporary Culture*.

144. Howell, *Laurie Anderson*, p. 27.

145. Anderson, in *High & Low: Modern Art and Popular Culture*.

146. Eric Bogosian, in ibid.

147. Ameena Meer, "Nuts in Bali," *Frieze* 9 (Apr. 1993): 30.

148. Timothy Druckery, "Douglas Crimp," *Flash Art* (Mar.–Apr. 1990): 171–72. Crimp had meant his show to be a critique of consumer society, but it had a reverse effect in the market-conscious 1980s, which paradoxically contributed to its historic position. He remarked that "the clarity of the position allowed for what ultimately became a kind of marketing strategy. Therefore some of those artists and other artists who were included with the later versions of the 'Pictures' show became extremely successful." Their images became sought-after commodities.

149. Douglas Davis, "Seeing Isn't Believing," *Newsweek*, June 3, 1985, pp. 69–70.

13 THE ART WORLD IN THE FIRST HALF OF THE 1980s

"The America that the Reagan administration inherited was an America still in shock from a decade of humiliation," cultural historian Nicolaus Mills wrote. The country had not recovered from the humiliating defeat in Vietnam and the disgrace of Watergate. The sense of shame was exacerbated by Jimmy Carter's inability to negotiate the release of American hostages held in Iran for 444 days. The economy had witnessed the worst recession since the Great Depression of the 1930s. But the newly elected Reagan had pledged "to make America proud again," and this appealed strongly to a nation that had "an insatiable need to proclaim its triumphs."[1]

The economy revived in the 1980s, and the booming real estate and stock market, celebrated for its junk bonds and corporate takeovers, was one such triumph. One of its heroes was Donald Trump who trumpeted his success in Trump Tower, Trump Shuttle, and Trump Princess. Other triumphs were

> the private extravaganzas of the superrich. . . . In the summer of 1989, Wall Street financier Saul Steinberg's $1 million fiftieth birthday party was not even the event of the season. That honor went to publisher Malcolm Forbes for a $2 million seventieth birthday party in Morocco. There he and eight hundred guests, flown from the United States on three jet planes, were entertained by six hundred acrobats, jugglers, and belly dancers, had an honor guard of three hundred Berber horsemen, and consumed 216 magnums of champagne in toasts.[2]

Matching the economy, the art world had its own great successes. For example, from 1979 to 1989, Sotheby's did more than $10 billion in business. Auction prices—$53.4 million for Van Gogh's *Irises* and $20.7 million for Willem de Kooning's *Interchange*—were front-page, prime-time news; chief auctioneer John Marion became a celebrity. And Sotheby's was only one part of a burgeoning global art market, whose estimated gross ranged as high as $40 billion.[3]

The art-market buildup in America had begun after the recession of 1974–75. Exacerbated by an oil crisis and the tremendous inflation it triggered, the slump gave rise to a new kind of thinking about investment in art. Many Americans panicked as they saw their cash reserves dwindle. This caused them to acquire solid assets, such as real estate, precious gems—and art. People began to think of works of art not just as luxury items but as tangible properties. The conception of art as a sensible, economically rational investment was fostered by the financial press and by increased coverage in the mass media and art magazines such as *Art News*. Banks and investment and insurance companies established art-market departments, and corporations began to acquire art as never before. Stockbrokers and economic advisers recommended that investors put a percentage of their holdings in art, enlarging and fueling the market. Stuart Greenspan reported in *Art & Auction:*

> In the '80s, financial institutions, which have always looked upon art and collectibles as non-liquid assets not to be taken seriously, began to appreciate the fact that such property is easily convertible, at least holds its value, and, in time of declining returns in other areas, is producing short-term as well as long-term profits. The spectacular growth of the industry, moreover, is impelling major financial institutions to stop dragging their feet and to involve themselves with art investment. Investment, which used to be a dirty word in this context, obviously is no longer.[4]

Indeed, the art investment program of Citibank, inaugurated in 1979 and directed by Patrick Cooney with the advice of Jeffrey Deitch, became a powerful force in the art world.

Unprecedented numbers of new collectors, Japanese and Europeans as well as American, entered the art world. Diana Brooks of Sotheby's reported that from 1983 to 1985 the number of serious private clients bidding at auction had quadrupled—to approximately one hundred thousand in the United States alone. By the end of the 1980s, Michael Ainslie, also of Sotheby's, estimated that worldwide the number of collectors who spent at least ten thousand dollars a year on art was roughly four hundred thousand. Peter Watson reported that for the 250 to 350 top collectors, "collecting contemporary art is twice as popular as collecting modern—that is, twentieth-century—art; three times as popular as collecting Impressionists and four times as popular as collecting Old Masters."[5]

As the economy revived, investment in art continued to increase. Contributing to the growth was art's increasing chic. New York was not only the primary American art market but it had assumed the role of *the* international city—in both finance and culture. Magazines such as *New York* and *Architectural Digest* began to feature—or, more accurately, to hype—a new urban lifestyle that revolved around trendy boutiques,

restaurants, clubs—and galleries. The glamour of it all attracted the European jet set as well as many fashion-minded members of a college-educated and increasingly affluent generation of Americans born during and after the late 1940s—the so-called baby boomers.[6]

In 1982 the international stock market began to boom, and by 1984 it began to influence the art market strongly. Growing numbers of new collectors frequented galleries and auction houses. According to lists in *Art News* and *Art & Antiques* just over 60 percent were Americans, followed by Japanese and Germans, almost half of whom preferred contemporary art.[7] The appearance of *Art & Auction* in 1979 was a sign of the times. In the early years of its existence the magazine catered to collectors for whom buying art was a private pursuit. An editor reported that "the art market was a minor league game, a diversion for the wealthy . . . a place of traditional values, of discretion, somewhat closed and hermetic. If one collected, one tended to do so in a private way, for one's own pleasure."[8]

This changed when auctions began to play a major role in the marketing of contemporary art, becoming the darling of the mass media. Auction houses had been reluctant to enter the market for contemporary art. But then Sotheby's auctioned a painting by Julian Schnabel for $93,500 in 1983—it had been priced at $3,000 four years earlier. Responding to what the *Washington Post* dubbed "a triumphant auction debut,"[9] they all jumped in. Sotheby's and Christie's brought their vast resources to bear, advertising lavishly, using direct mail, and publishing glossy catalogs. As part of their aggressive marketing campaigns, according to *Newsweek,* they used traveling exhibitions to lure buyers, arranging special events and parties at each stop. In 1984 Sotheby's began lending money to collectors who put up their art as equity.[10] Auction houses also gave sellers advances against sales and encouraged collectors to market their works through them by guaranteeing sales, thereby acquiring art and becoming dealers.

In their competition with private galleries, the auction houses had the advantage. They made the buying of art public and the prices of artworks known to all, validating the prices, as it were. Artworks increasingly resembled stocks and bonds, becoming liquid commodities, and their liquidity encouraged speculation. Auctions were turned into spectacular events, enhanced by new record prices that seemed to be set almost daily. Growing numbers of multimillionaires began to buy recent art not only to satisfy their aesthetic requirements but to publicize and glorify their financial clout. Their competitive bidding inflated prices, and the inflation validated the art as a commodity. Art seemed to be escalating endlessly in value. Young artists shared in the spoils; for example, Anselm Kiefer's paintings, which sold from $7,000 to $15,000 in 1981, rose to between $500,000 and $1,000,000 at the end of the decade.

The boom changed discourse in the art world. Matters of money and

careerism entered into art talk as never before. Leo Castelli said: "Everybody has become infinitely more money conscious. . . . First and foremost, it's the artists."[11] In this artists were not different than their generational contemporaries. The end of the Vietnam War saw the collapse of mass political activities in the United States. In Europe the utopian dreams generated by the "revolution" in Paris in May 1968 turned into a nightmare in August, when Russian tanks rolled into Prague, crushing Czechoslovakia's tentative liberalization of Communism. Many young American antiwar activists, exhausted by their seemingly interminable agitation and disillusioned by their inability to transform society, abandoned politics. They turned from social to personal concerns, adopting middle-class career goals—most succeeding quite handsomely. But a considerable number retained their dissident values. As social critic Michael Lerner pointed out, for many "who *had* been activists or who *had* participated in the consciousness revolution of the sixties, the legitimate desire to build a family, own a home, develop a career, and even enjoy good food or attractive clothing was not counterposed to remaining true to the social justice values that they held in the sixties."[12]

Large numbers found jobs in colleges and universities—and were soon tenured. There they undertook a radical critique of both consumer capitalism and the basic assumptions of every intellectual discipline. Political activism in the streets turned into academic dissent. Feminist studies emerged from this critique, and growing numbers of women turned inward, participating in consciousness-raising, and outward, engaging in political action on behalf of feminist causes. Others undertook a critique of consumer society and the mass media.

But if considerable numbers of young people remained committed to countercultural values, others in great numbers embraced consumerism. For many, with the decrease of political commitment and the concomitant increase of purchasing power, Woodstock gave way to Club Med, yippies (members of the countercultural Youth International Party) to yuppies (young upwardly mobile professionals). Exemplifying the change was the conversion of Jerry Rubin from prototypical yippie to a Wall Street stockbroker and organizer of networking parties for fellow yuppies.[13] In 1977, Norman Podhoretz, a fashionable neoconservative intellectual who had traversed the political spectrum from left to right, hailed the bitch goddess: "Everywhere one looks today there are signs of a new tendency to accept the ambition for success as a healthy impulse rather than a disreputable weakness, and to treat the achievement of success as something to take pride in rather than something to be sheepish about."[14]

Indeed, a new breed of artists embraced the cult of success. "Downtown and uptown in the world of contemporary art, one is as likely to catch an artist, dealer or collector talking about 'double shows,' 'waiting lists,' 'the pressures of the fast track,' 'career structuring' and

'market positioning' as about such topical critical issues as 'image scavenging' and 'the return of the heroic.'"[15] Careerism even entered into art schools. They began to offer courses in the mechanics of the art world, preparing students for "an MBA (master of the business of art)."[16] *Newsweek* reported: "At the Art Institute of Chicago, students are now taught elementary bookkeeping, the ins and outs of contracts, ways to promote their work, how the business side of galleries functions and ways to sell art directly to such nontraditional buyers as architects or other professionals for use in their offices."[17]

The change in the art world often has been dated to February 1979, when Julian Schnabel, then a twenty-nine-year-old, had his first one-person exhibition at the new Mary Boone Gallery and achieved instant success. All of his paintings were sold before the show even opened.[18] Castelli soon joined Boone in representing Schnabel, the first painter he had taken on in twelve years. Schnabel's dual show at the Boone and Castelli Galleries in 1981 was the most talked-about event of the season. To hype Schnabel's marketability labels bearing the names of prestigious buyers were affixed next to the pictures they bought instead of the customary red dots. He was also the only young American to be included in *A New Spirit in Painting* show at the Royal Academy in London in 1981; and a year later was given a retrospective of four years work at the Stedelijk Museum of Amsterdam, followed by a one-person show at the Tate Gallery in London.[19] All in all in 1982 Schnabel had eight one-person exhibitions and was included in twenty-two group shows. Suzi Gablik commented: "It became impossible in certain circles to attend a dinner party where Schnabel was not the center of conversation. Everybody, it seemed, was asking everybody, in an effort to get at the heart of the matter, 'What do *you* think about Julian Schnabel?'"[20]

Schnabel's obvious painterly gifts and the heroic aspect of his work—the sense that a new Jackson Pollock may have emerged on the scene—contributed to his instant stardom. But self-promotion played a critical role. Schnabel assumed the melodramatic postures of artist-as-genius-lusting-for-life-and-transcendence and savior of painting.[21] Both the art world and the mass media responded eagerly to his pronouncements, such as: "I wanted to have a feeling of God in [the paintings in his 1982 show. They] are the view from the bridge between life and death. I think about death all the time. . . . My presumption is that if the viewer becomes conscious of these realizations about life and death in my paintings, the world might be a better place. It's as fundamental as that."[22] As his most grandiose act of self-aggrandizement, Schnabel at age thirty-six wrote his autobiography, which he titled *C.V.J.*, allegedly after the nicknames of maître d's in his favorite restaurants. The writing was shockingly banal, and Schnabel either did not know or care—if the latter, such was the enormity of his arrogance—just how trite it was. Indeed, he revealed it all; for example, he cautioned:

For any artist, no matter how generous or normal they try to be, their companion will always be left out in some way. The most difficult thing to understand is that the work that is being made for the love of them is the very thing that is robbing them of the love they need from you. . . . The thing for the partner to remember is the absolute necessity of their presence in order to help the artist to be free enough to behave in this loathsome manner.[23]

Schnabel became an ego monster—a kind of Donald Trump of art or the artist laureate of the Reagan era. Robert Pincus-Witten, an ardent admirer, felt called upon to twit him: "Even Schnabel, I suspect, must find his megalo-romantic theatricalized *Kunstwollen* [will toward art] a trifle ridiculous."[24] But it did impress an influential sector of the art world. Peter Schjeldahl summed it up: "To understand the Schnabel phenomenon, it is crucial to see the value of shamelessness. . . . Like Warhol and Salvador Dalí before him, Schnabel appears not to have an embarrassable bone in his body. This plus talent and timing made for one of the luckiest hands an ambitious artist was ever dealt." Schjeldahl went on to say that "through the breach made by Schnabel's broad shoulders has come the torrent.[25]

Schnabel and a select number of his contemporaries became celebrities, even beyond the confines of the art world. To a sizable public their looks and lives became better known than their art. The *New York Times* reported that at the heavily publicized opening of the Palladium discotheque in 1985, "The newest stars of the evening were the artists and their entourages . . . Francesco Clemente, Julian Schnabel and Keith Haring among them." The Palladium "incorporates large-scale murals, environmental installations and set designs by some of the city's hottest young artists [mounted by] Henry Geldzahler, former Metropolitan Museum curator and New York City cultural commissioner." Steve Rubell, the Palladium's co-owner and former co-owner of Studio 54, *the* "in-club" of the 1970s, said that he featured artists because they "are the focal point of the '80s. . . . They're the celebrities now in the same way fashion designers were in the '70s and rock stars in the '60s.'"[26]

Contributing to the celebrity of the art stars and the collectors, dealers, curators, and critics associated with them was the coverage in mass magazines—not only *Time* and *Newsweek* but *Vanity Fair, Vogue,* and the like. Such magazines became interested in art because art had grown increasingly chic, and as magazines of fashion, they made it even more fashionable or, to put it more accurately, they made a select number of artists fashionable. The coverage, augmented by manipulative publicity on the part of dealers and agents and also collectors, became so excessive as to constitute hype.

Hype breathlessly featured the artists' lifestyles: where and with whom they lived and played; what they wore and ate. The focus was on their expensive indulgences and social successes rather than on their art

and its aspirations. An article on Schnabel in *Vogue* contained not only photographs of his stylish Tribeca loft but also his wife's high-fashion clothing, including her favorite black cocktail dress.[27] Even the *New York Times* joined in this vulgar practice. For instance:

> When Jean Michel Basquiat walks into Mr. Chow's on East 57th Street in Manhattan, the waiters all greet him as a favorite regular. . . . He goes to the restaurant a lot. One night, for example, he was having a quiet dinner near the bar with a small group of people. While Andy Warhol chatted with Nick Rhodes, the British Rock star from Duran Duran, on one side of the table, Basquiat sat across from them, talking to the artist Keith Haring.
>
> "He'll run in here in an $800 suit and paint all night," says his friend Shenge. "In the morning, he'll be standing in front of a picture with his suit just covered in paint."[28]

Hype had become so prevalent that, as Jeffrey Deitch remarked: "There is certainly a perception that hype itself is perhaps the most important new medium in the corporate world as well as in the art world. The process of promotion, the selling, the culturalization of art ideas and images has become an art form itself."[29]

Schnabel's dealer, Mary Boone, was generally considered the most triumphant purveyor of art-world hype. Her emergence in Schnabel's wake was as sudden and spectacular as his.[30] Indeed, she became so notorious that Thomas Lawson could declare (with some exaggeration, to be sure) that she had "deconstructed" "capitalist manipulation."

> Boone has moved beyond hyping her artists, beyond hyping herself, to hyping the idea of hype, thus making its operation totally clear. [She appeared] in magazine after magazine, from *Life* to *Savvy* to *Metropolitan Home*, heavily touted as the rising star of SoHo, the most successful dealer since Leo Castelli. She exhibited her success by displaying the evidence of her newly earned wealth—a splendid loft apartment, and stunning collections of clothes and shoes, in company with the art in question.[31]

To her credit, however, Boone was the first dealer to recognize and represent a number of the most gifted and provocative artists of the 1980s. And that was the primary reason for her success. Moreover, she was a first-rate business person. Not only did she enlist Castelli on behalf of Schnabel, but also Bruno Bischofberger in Zurich, Dan Weinberg in San Francisco, Anthony D'Offay in London, Margo Leavin in Los Angeles, and above all Michael Werner, Europe's most powerful dealer, with whom Boone established a partnership in 1983 and whom she married in 1986. Moreover Boone chose her collectors carefully, placing the works of her artists in the most prestigious private and public collections.[32]

Boone may have had more than her share of art-world and media attention, but she was only one of a number of important dealers. Apart from Castelli, others were Ileana Sonnabend, by now a legend; Paula Cooper, Arne Glimcher (of the Pace Gallery, now PaceWildenstein), Irving Blum and Joe Helman (of the Blum-Helman Gallery), Helene Winer and Janelle Reiring (of Metro Pictures), Angela Westwater (of the Sperone-Westwater Gallery), Barbara Gladstone, Marion Goodman, Holly Solomon, and toward the end of the decade, Larry Gagosian. These dealers enhanced their power as tastemakers when they mounted simultaneous shows, as Castelli did with Boone (Schnabel and Salle), with Sperone-Westwater (Sandro Chia), and with Metro Pictures (Longo).

The Schnabel phenomenon was made even more spectacular by the wholesale accumulation of his work by Charles and Doris Saatchi, widely recognized as *the* collectors of the 1980s. He was the head of one of the world's leading advertising and public relations agencies, whose publicity campaign helped elect Margaret Thatcher prime minister of Great Britain. His huge business success gave his collecting activities both resources and cachet: His budget for art was reported to be two million dollars a year.

The Saatchis began to buy art in 1969; by 1985 they owned more than five hundred works, comprising the greatest collection of art from the 1960s to the present. Unlike other major collectors, they acquired multiple works by the artists they favored, for example, more than twenty each by Schnabel, Kiefer, and Clemente. The Saatchis seemed intent on bringing their art to the public, whether out of public mindedness or self-aggrandizement, or to acquire tastemaking power, or to increase the value of their holdings, or perhaps a mixture of all these motives. They were unstinting in lending their works to museums for exhibitions, contributing to the renown of their collection and the artists in it. In 1982, for example, they were the lenders of nine of the eleven canvases in Schnabel's one-person show at the Tate Gallery, the first in a series arranged by the patrons of the New Art Group, of which Charles Saatchi was a founder.[33] He and his wife also opened their own museum in London in 1985, some thirty thousand square feet of exhibition space in a former paint warehouse, to showcase their collection. At the time of the opening, they published a lavishly illustrated four-volume catalog, *Art of Our Time,* devoted to their holdings. Contributing to their tastemaking power were Doris Saatchi's writings on art in *Artscribe International Architectural Review, The World of Interiors,* and *House & Garden.*

The Saatchis were joined by growing numbers of American, European, and Japanese collectors prepared to spend huge sums for art.[34] The Japanese were particularly active since they were able to take advantage of the devalued American dollar to buy art—along with Rockefeller Center, Columbia Pictures, and other formerly American enterprises.[35] To the new collectors as to the old, art was attractive as a

badge of culture and conspicuous consumption. As Adam Smith observed, for most rich people the chief enjoyment of their wealth among others consists in parading it. But the new collectors far outdid the old. As Robert Hughes wrote, "for a crushing but tasteful display of economic power, . . . the rawest junk-bond trillionaire knows that art is the best way." Or as collector Asher Edelman said: "The auction is a hog-pen environment. . . . People are coming to auctions to show how rich and important they are. I think it's wonderful. It creates a great form of patronage. So I welcome the hogs to the hog pen."[36] And it made news, too, as Schjeldahl observed: "The eating of art by the rich this year [1989] is a bigger story than anything that might conceivably be happening in studios, galleries, or museums. It is a big tail wagging a little dog."[37]

There was another crucial difference between old-rich and new-rich collectors. Old collectors generally did not think of collecting art as a way of making money. Many new millionaires did, viewing their art as a speculative investment, like stocks and bonds, and as a safe place to store money. As Greenspan summed up in *Art & Auction*, "investment, no matter how much people will deny it, is one of the most important factors in the growth of today's market."[38] Art did seem to be a moneymaking machine with prices climbing ever higher, partly because of the number of collectors competing for the same art and partly because of inflation.

Moreover new collectors, in contrast to old, seemed to think they ought to be able to sell their art at a profit whenever they pleased:

> Fifteen years ago, people didn't expect that there was always going to be a secondary market, even for works by a great artist. If you bought a Carl Andre work you had to buy it just because you believed in it. You couldn't buy it because you thought you could resell it for a profit, or even because you thought you could get your money out of it. Very few collectors thought that way. Now there's this expectation among the art collectors that you deserve to get your money back out of everything you buy—at least.[39]

Artists, dealers, consultants, and other art professionals certainly influenced collectors. Indeed, some collectors spent more time listening to art experts than they did looking at art—and art experts grew in number. But most of all, collectors listened to other collectors. Consequently collectors constituted the most influential force in the market of the 1980s, and they dominated the art-world consensus. In the Reagan eighties money talked, as the saying goes. It seemed fitting that in a consumer society, the consumer should have the greatest say.[40] Art critic Dan Cameron summed it up in 1986:

> If the art world five years ago seemed to be dominated by the galleries—an adjustment that contrasted, for example, to the central role

of critics during the 1960's—it now appears that patronage itself is becoming the all-important factor in determining the type of international impact an artist is going to have. Whereas until recently artists and dealers talked about the number of works sold from an exhibition, now the emphasis is clearly on who bought them.[41]

Collectors watched what trendsetting collectors were buying and followed suit.[42] Follow-the-leader collecting generated, as Mary Jane Jacob observed, "the sense that everyone has the *same* collection."[43] As a result the number of "hot" artists tended to be relatively limited. Waiting lists for their works became common. Deitch spoke of an "international top-40 . . . known by every art collector and curator and writer, and then we have everybody else." The art stars could be recognized by simply following the resale of their works at auction. But numbers of "everybody else" began to sell, too. Increasingly collectors looked for guidance to the market. As Jeffrey Deitch remarked: "The market place has become so dynamic, and the media coverage of the market place is now getting so good, that the market place itself is creating the critical consensus. . . . You have now ten thousand people following these auction results very closely, even artists. The market place is now communicating in a broader, more specific way than art magazines and art critics."[44] Deitch was thinking of the market as an informal communications system that provided information to its serious participants. How it worked was hard to specify—much depended on rumor and gossip—but it did work. And auction prices became the primary source of information and the basis of art's validation.

Collectors naturally injected matters of commerce into art talk. Indeed, it became respectable to couple art and money. As early as 1979 Robert Hughes commented on the way money altered the experience of works of art:

> It may well be that my generation—the people born between 1935 and 1940—will be the last to remember what a truly disinterested museum visit was like. Quite simply, it is now difficult and, for many people, impossible to walk into a gallery and look at a work of art without its "value"—which means simply price, real or hypothetical— intruding on their reflections. [It] makes the price part of the subject of the work.[45]

Roy Lichtenstein, whose own works were priced in the millions of dollars, commented regretfully that "people now see money when they see art."[46]

The art world as a whole had been monetarized. Art that was shown in a dozen or so commercial galleries and was acquired by a few dozen or so trendsetting collectors monopolized art discourse, even that of art professionals who tried to remain aloof from the market and often doubted that much of fashionable art was worthy of discussion. Art mag-

azines, especially *Art News,* grew more market conscious, increasing their reportage on the activities of collectors, dealers, and auction houses. Critics, in the pay of private galleries, began to write catalog introductions. This became a major source of income, particularly because dealers paid considerably more than magazines did. And it was worth it to galleries, because, as Roberta Smith reported, they did not have "to wait for a negative review in an art magazine (or for no review at all), or wait for museum shows and their accompanying catalogues. [They] get the ball rolling by simply hiring a critic and doing the job inhouse—which guarantees a positive treatment."[47] And they also improved their relationships with the critics.

Art critic Allan Schwartzman maintained that critics had become vulnerable to compromise by writing for galleries.[48] They simply could not be critical in such publications. Smith wrote that the "gallery-published catalogue automatically changes the role of the critic from adversary to advocate—a role all critics assume some of the time—but a choice which should be made within the writing itself rather than imposed by the context."[49] Indeed, most of this commentary was no longer independent or disinterested but had become a glorified kind of publicity or advertising.

The very look of the catalog—the sheer elegance of most—proclaimed that their true purpose was promotional, even if the essay was intellectually "honest." In that case the catalog became even more persuasive as publicity. Smith concluded that "critics who exploit their own credibility tend to lose it."[50] And they did, but so did art writing generally. Art criticism was further debased because many of its practitioners entered into the art market in other ways, buying and selling art, even works given to them by artists, and writing about work they themselves owned. Critics also advised collectors and even worked for galleries. Voices were rarely raised against such practices but they did diminish the status of critics as arbiters of art.

The tastemaking power of critics may have been diminished, but not that of art editors, such as Elizabeth Baker of *Art in America* and Ingrid Sischy of *Artforum.* Appointed in February 1980, Sischy was closest in age to the young artists of the decade and made *Artforum* into their organ. Art critic Jerry Saltz commented that she was "to the magazines what Boone was to galleries—a powerful catalytic *eminence grise,* an enthusiast and a supporter of 'the new art.'" She cultivated the global art world, adding the word "international" to *Artforum*'s masthead by 1982. She had the

> ability to get out of something at just the right moment. Thus "Artforum" stayed up to date and "hip." She had a great sense of timing which saved the magazine from ever being inextricably linked to any one set of artists, or too intent on seeing the success of any one movement. No—"Artforum" just wanted to be where the action was

and maybe lead the pack—and it did. The January 1980 issue of "Artforum" had 94 pages—by the end of 1989 it had increased to 180 pages.[51]

Museums had been the most important agencies in the validation of art, because they were (or were commonly thought to be) shrines elevated above commercial interests and concerned primarily with quality or standards of taste. Museums historically let time elapse before showing contemporary art, but beginning in the 1960s that practice changed. This was exemplified in the Metropolitan Museum's decision in 1969 to celebrate its centennial with a major show of New York painting and sculpture from 1940 to 1970. Composed of 410 works in fifty thousand square feet of space, it was one of the biggest shows ever put on by the Metropolitan and attracted a quarter of a million viewers (the third-largest in its history). Many museum directors and curators not only entered the field of contemporary art but, like dealers, collectors, and critics, vied to be first in recognizing and exhibiting new art and being acknowledged as pacemakers by other art professionals. This led them to participate actively in the art world, assuming its values—and its momentary opinions—rather than distancing themselves in order to evaluate and revise them. In the process, however, museums lost much of their tastemaking cachet.

The museum practice of featuring artists represented by fashionable galleries grew in the 1970s. For example, of the forty-five artists in the 1987 Whitney Biennial, a third came from only four galleries. There was no collusion, of course; the best artists had long gravitated to a few galleries. But the suspicion that the curators were overly influenced by the art marketplace was hard to allay. This suspicion was fueled by retrospectives given to young art stars, which seemed to boost their reputations and the prices of their works prematurely. Among the artists who were awarded major shows were Julian Schnable, age thirty-six, at Amsterdam's Stedelijk Museum and London's Tate Gallery (in 1982); David Salle, age thirty-four, at Philadelphia's Institute of Contemporary Art (in 1986), which traveled to the Whitney Museum; Cindy Sherman, age thirty-three, at the Akron Art Museum (in 1984), which traveled to the Whitney Museum; Robert Longo, age thirty-five, at the Los Angeles County Museum of Art (in 1989); and Eric Fischl, age thirty-eight, at the Whitney Museum (in 1986). *Art News* reported: "Never before has an entire generation of artists moved into the museums so quickly, and never before have the individual shows been so large, the tour so long, the praise heaped upon the artists in catalogue essays so thick."[52]

Museum directors also became increasingly suspect because they seemed more money- than art-minded. There was good reason for this. Museum operations were growing and costs were rising precipitously.[53] The expense of loans, insurance, and catalogs made it increasingly difficult to mount ambitious shows. Corporations stepped in to help

(enhancing their own images, of course). But they began to shape museum policies, encouraging blockbuster shows with box office appeal. Beginning with *King Tut* at the Metropolitan Museum, they turned museum going into mass entertainment. Indeed, this seemed to be the goal of the museum's director, Thomas Hoving, and he showed the way to museums generally. Robert Hughes reported that they "adopted the strategies of other mass media: the emphasis on spectacle, the cult of celebrity, the whole masterpiece-and-treasure syndrome."[54]

The fiscal crisis of museums caused them to expand their in-house income-raising enterprises, such as gift shops, bookstores, and restaurants. Consequently their trustees hired a new breed of directors whose background was as much or more in business as in art. In turn the young directors enlisted new-rich collectors and corporate executives in large numbers as trustees. The new entrepreneurial directors had ambitions and agendas of their own. Their exemplar was Thomas Krens, who in 1988 was appointed director of the Guggenheim Museum in New York and the Guggenheim Foundation, which manages the Peggy Guggenheim Collection in Venice. He then began to put into effect a master plan he had devised. He would network the Guggenheim Museum and the Peggy Guggenheim Collection with a new museum of contemporary art, the world's largest, that he was organizing in North Adams, Massachusetts, which he proposed to fill with the great contemporary collection of Count Giuseppe Panza di Biumo and his wife, Giovanna, to which he would add museums in Salzburg, Austria, and Bilbao, Spain. Krens would then become the art-world counterpart of the merger princes of the business world.

Deborah Weisgall described an interview with Krens:

> He talks about art as a commodity and museums as an industry.
>
> [He] does not once mention a work of art, but analyzes the problems besetting the museum "industry" and outlines solutions. The "industry" is in crisis. With one or two exceptions, museums are priced out of the art market, and new tax laws do not encourage gifts. . . .
>
> In the "shakeout" Krens predicts museums will undergo during the next decade, they will have to explore "mergers and acquisitions." They are overcapitalized and must understand, like other businesses, "asset management." A museum's assets are its collections. Its exhibitions and program are its "product."

Weisgall concluded: "Krens wants to transform the museum industry— how institutions operate, how they acquire art, how they show it, how they think about it."[55]

The 1980s saw the emergence of a new kind of independent curator who hired his or her services out to galleries and bought and sold the works he or she featured in shows and in catalogs. These curators also

managed to have their shows placed in museums, thus maintaining a semblance of respectability—so blurred had the line between the private and public sectors in the art world become.

The art world of the 1980s was too large and complex to be dominated by any single person or institution, even the art market. Countervailing pressures were always at work. Consequently there was strong opposition to the tastemaking hegemony of big collectors, auction houses, dealers, and the market mentality they generated.

Auction houses were accused of being most responsible for the commodification of art—far beyond the galleries. Carter Ratcliff held them to be the major cause of the

> inflationary mischief that divorces esthetic merit from any reasonable assessment of market value. . . . The circus atmosphere of an auction encourages decimal points to leap about like wayward acrobats. [Moreover] auctions narrow the art world's focus to the sort of objects that go well off the block. Much art is ignored, while a few varieties begin to glitter like financial instruments of a new kind—bearer bonds made of oil on canvas or sculpted metal. This is the weightiest charge: more effectively than gallery sales, bidding scrimmages on the auction floors don't simply taint art with a commercial flavor; they turn paintings and sculpture into a kind of money.[56]

The Saatchis' actions and motives were also frequently questioned. In making their collection available to the public, were they really being generous or were they self-serving, enhancing the worth of their holdings and their image in both the advertising and art worlds. Their loan of all but two of the eleven pictures in Schnabel's show at the Tate Gallery in 1982 "became a rallying point for critics of the artist, the collector and the institution," art critic Kenneth Baker wrote. "Speculation flared that Saatchi was exercising undue influence on the Tate's administration of exhibitions, and that the covert intent of his loans was to put the stamp of a great museum's approval on Schnabel's dubious achievements to help ensure their future marketability. For its part, the Tate was suspected of yielding to Saatchi's wishes on the dim promise of future donations of otherwise unobtainable (read: unaffordable) work."[57] In the face of the art-world outcry, Saatchi withdrew from the board of trustees of the Whitechapel Art Gallery in 1983 and the Tate in the following year.

Art professionals often criticized their colleagues' practices. For example, Roberta Smith in the *New York Times* challenged the relationship of Robert Pincus-Witten with the dealer Larry Gagosian. Singling out a remark of Pincus-Witten in a Shafrazi gallery catalog, she asked:

> Why must Robert Pincus-Witten, a critic of some achievement, deliver what seems to be a thinly disguised bouquet to his current

employer, Larry Gagosian, in the catalogue's opening essay? He writes about dealers "who shine in the secondary market" and who "transformed their galleries into virtually disinterested exhibition spaces." It's fine to admire the historical exhibitions Mr. Gagosian has sponsored, but it stretches credibility to call them "disinterested."[58]

Hype was repeatedly condemned by art professionals. For example Richard Martin asserted that hype was pernicious rhetoric because it packaged art for easy consumption, simplifying and vulgarizing it. "'Hype' isn't just a happy enthusiasm, for that would be acceptable to me; it is a false attribution of style and aesthetic leadership; it is a denial of critical judgment and distance; it is an evasion of the critical process in favor of the media process. [It] betrays art in favor of the artist. Hype requires the figure of the artist, whether on the cover of a vulgarizing art magazine or represented in the popular press and in the related media. The artist becomes the paramount figure, not the art." Martin concluded: "Hype is a cheerleading, money-making, deceiving, magnifying, name-giving, movement-making process as applied to art."[59]

But Andy Grundberg cautioned that all adulatory writing was not necessarily hype. Some praise might be deserved. In the case of the phenomenally swift success of the Starn Twins, age twenty-seven, he wrote: "Were it not for the obvious vigor, ambition and virtuosity of the work . . . one might wonder whether the forces of hype had triumphed at last." He concluded that allegations of hype were not yet warranted. If the Starn Twins "can keep getting better . . . then all the attention they are receiving now will seem not only prescient but also well deserved."[60] Schjeldahl added: "I think we're sophisticated enough to discern what has real value and what is merely promotion."[61]

But a number of prominent art critics, among them Robert Hughes, Hilton Kramer, Suzi Gablik, and Barbara Rose, disagreed with Schjeldahl. They condemned as corrupt both the art world and the art it prized. Hughes, the art critic of *Time*, characterized the 1980s as "probably . . . the worst decade in the history of American art. [The] scale of cultural feeding became gross, and its ailment coarse; bulimia, the neurotic cycle of gorge and puke, the driven consumption and regurgitation of images and reputations, became our main cultural metaphor. Never had there been so many artists, so much art, so many collectors, so many inflated claims, so little sense of measure." Hughes also castigated the "inflation of the market, the victory of promotion over connoisseurship, the manufacture of art-related glamour, the poverty of art training, [and] the embattled state of museums."[62]

Hughes's most notorious jeremiad was a long poem, published in March 1984, in the *New York Review of Books*, titled "The SoHoiad: or, The Masque of Art, A Satire in Heroic Couplets Drawn from Life," and modeled on Alexander Pope's *The Dunciad*. Using the pseudonym Junius Secundus, Hughes savaged artists—"Julian Snorkel," "Jean-Michel

Basketcase," "David Silly," and "Keith Boring," among others—as well as art professionals. He lambasted the art world as a cesspool of greed, hype, fakery, and pretension. Schnabel came in for the most abuse: "And now the hybrid child of *Hubris* comes— / JULIAN SNORKEL, with his ten fat thumbs! / *Ad nauseam,* he babbles, honks, and prates / Of Death and Life, Careers and Broken Plates" and "Poor SoHo's cynosure, the dealer's dream, / Much wind, slight talent, and vast self-esteem."[63]

Carter Ratcliff dubbed Hughes, Kramer, Gablik, and Rose "art-world Cassandras, who "with outrage, sorrow and superior detachment" and occasionally, as in the case of Hughes, with a mocking wit that explodes pretentiousness, pomposity and cant, deplored "know-nothing eclecticism; careerist maneuvering and a market quickening to reward it; the ascendancy of naive and opportunistic collectors; a slackness that leaves art-world borders open to the encroachment of mere fashion; and, permeating all else these writers dislike, hype." The Cassandras felt little need to be precise in documenting their accusations. Paradoxically their persistent raging turned out to have an effect opposite of what they intended, abetting "the institutions of the art world [which] require critics willing to play the angry, threatening, even spookily prophetic Cassandra-role. . . . Overall, such attacks encourage the belief that, good or bad, art-world developments have immense importance—a belief useful to the centers of art-world power."[64]

Dan Cameron too rejected the "censuring or pessimistic messages" of Robert Hughes, Suzi Gablik, and Barbara Rose. They "are so consumed by their frustration . . . that they have lost the ability to differentiate artist from artist, good from bad from so-so. To many, Schnabel-Salle-Longo-Haring-and-the-others has become a composite entity," the hated emblem of a new "art world that will never be the way it used to be." Cameron concluded: "Is Mary Boone really a witch, or are a lot of these critics starting to lose their marbles?"[65]

Most artists and art professionals were not as negative as the Cassandras, but they believed that the art market exerted growing pressures on every aspect of art. This became a topic of continual discussion. Richard Armstrong, Richard Marshall, and Lisa Phillips, the Whitney Museum curators who organized the Biennial of 1989, wrote despairingly in the catalog: "We have moved into a situation where wealth is the only agreed upon arbiter of value. Capitalism has overtaken contemporary art, quantifying and reducing it to the status of a commodity. Ours is a system adrift in mortgaged goods and obsessed with accumulation, where the spectacle of art consumption has been played out in a public forum geared to journalistic hyperbole."[66] It is notable that this comment was made by the organizers of the most fashionable show of current art in America, themselves often accused of following market dictates.[67]

Two critical questions remain. Did the collector consensus lower taste, and did it affect art making? Many art professionals claimed that

artistic standards declined as the tastemaking power of new collectors, who entered the art world in the 1980s, grew. It was allowed that they valued quality, if only for commercial reasons, but it was alleged that they lacked the taste of artists and art professionals who previously had been most influential in establishing the art-world consensus. However, no proof of this could be provided, naturally, because in questions of taste, there are no objective criteria, only opinions.

The new collectors had little use for the likes of difficult postminimalist earth, performance, and conceptual art, and instead desired portable and salable paintings that could hang on their walls. As Mary Boone commented: "The new art has a much broader appeal. It has images in it, it's colorful—and you can see something in it without a doctoral degree."[68] The requirements of collectors did create a demand for collectible figurative painting and thus seemed to contribute to its upsurge. But the reverse was also true. As usual in modern art, artists created works for their own reasons, and collectors bought them after the fact. As Salle said: "They deal with whatever there is to deal with."[69]

The second question, the one that matters most, is whether the expectations of collectors influenced what artists produced in their studios. Had artists singled out by the art-world consensus accommodated their art to the demands of the burgeoning art market? The problem, as Thomas McEvilley posed it, was not whether artworks would end up as commodities, but whether they would start out that way.[70] It was generally assumed in the art world that if artists aped fashionable images, forms, and styles, that is, created with the market in mind, they cynically betrayed their artistic visions. There were always such artists, the followers who climbed onto bandwagons after they had became trendy. But what about the innovators, the ones that counted?

Did these artists shape their work to attract the market? Could they? Most art professionals believed they could, but few were specific as to how. Eric Fischl did not think it was possible; he said that if artists tried to anticipate what collectors desired, they would get it wrong. Arthur Danto thought otherwise. He believed that he had discovered the recipe for success in the 1980s; presumably with Schnabel in mind, he wrote that successful art

> must look as if it is preemptively important. . . .
>
> As a style, Importance Art possesses certain unmistakable features. It must, in the first instance, be extremely big. It must exhibit as well a certain incoherence, as though the images it juxtaposes reflect the dynamics of what psychoanalysts term Primary Process—implying that the work emerged uncontaminated by deliberation from the artist's creative unconscious. There must in addition be a certain flaunting of taste, and hence of traditional artistic skills: drawing must be slack, the application of paint desultory and tacky,

the choice of colors rebarbative. Ideally, Importance Art rejects the sorts of materials to be found in art-supply stores, to show that boundaries are being challenged.

The art world played a role in establishing art as important. It

> helps that there should be some negative critical writing, for that confers controversiality on the art, and it is an axiom that all Important Art is controversial when it first appears. This in turn serves as a sign that the collector has gotten in on the ground floor. . . .
>
> The period between art school and art market cannot be too short, for youth and novelty, combined with the stylistic attributes of Importance, connote the potential for growth—in the stock-market sense of the term.[71]

With the possible exception of Jeff Koons, all artists believed that they were immune from the pressures and temptations of the art market. Sandro Chia, for example, claimed that "economic systems and economic values rule the art world," yet he exempted himself. It had been alleged that the Saatchis had hurt his market position by "dumping" his work, but nonetheless, "Now, I am outside the system. . . . I don't have dealers. . . . I have made more money in these last years than I did when I had dealers. . . . I found myself at 40 with factories, horses, more houses than I need, wives, children, child support, alimony, taxes—I pay ten times more in taxes each year than my father made in his entire life."[72] Given the fact that nearly every other artist believed sincerely that he or she was unaffected by or outside of the system, it may be that the presumed influence of the art market was largely imaginary. Or was it?

The question of whether collectors influenced artists or vice versa may have been beside the point. Perhaps they were united in a kind of symbiosis. As Edit DeAk remarked: "The audience essentially knows and thinks the same stuff as the professional artist. The artist is just the one who decides to spend the time executing it. There's really nothing this type of artist can say that everybody else hasn't already thought or even dreamt eight times."[73] Did artists and dealers then share some kind of collective unconscious? And if so, what were its expectations? "That worried me," said John Baldessari: "What will the hope of money and acclamation prompt you to do unconsciously?"[74]

But artists had to make money, given the exorbitant cost of living in New York, and this created pressures on their art making that did not affect earlier generations as much. Rents, the greatest expense, were spiraling. In the 1950s a decent-size loft could be rented for as little as thirty dollars a month. At a dollar an hour, which was the average part-

time pay then, it would take thirty hours to pay the rent. Artists could subsist on odd jobs. By the 1970s this was no longer possible. As Carter Ratcliff reported in 1978:

> A medium-size loft has 2,500 square feet of floor space. Ten years ago, that much space in the heart of SoHo could be had for well under $200 a month, plus $1,200 for any fixtures the previous tenant might have installed. Now the same loft could easily bring $500 per month—or $650. And the fixtures . . . would run $10,000 to $20,000—while resales of co-op lofts with certificates of occupancy range from $100,000 to $125,000 and above.[75]

In the eighties, these rents doubled. To survive in the center of the New York art world, young artists had to have a market for their art, a full-time job, or an independent income.

In 1983 Michael Brenson pointed out that a painting by David Salle sold for as much as $35,000; a Robert Longo, $40,000; and a Julian Schnabel, $60,000. But of the forty to ninety thousand artists in New York, "only a handful, probably less than 20, meet with dramatic critical and financial success. . . . Given the rewards, the limited number of places at the top and the cost of living in New York City, it is not surprising that Mr. Longo should say: 'One of the strange things about this generation is that it's so involved with competition.'"[76] Brenson went on to say: "The pressure to succeed increases the temptation to force the pace, to create a persona [or to strike an attitude], to do what is necessary to sell." But did this pressure affect art-making? David Reed thought so: "I see too many things that are unfinished, works that make me say to myself, 'If only they had taken more time.' There is this pressure now to be surer, quicker, more confident." And once an artist was successful, there was enormous pressure to produce "material," as it was called in the art market, for shows in an expanding international art world.

The question of how art-world rewards, pressures, and distractions affected art making would remain a nagging one. Brenson asked whether they had "weakened the resolve of artists and therefore narrowed the scope or limited the depth of their work"?[77] Armstrong, Marshall, and Phillips suggested that the

> market-driven backdrop of the late eighties [made it difficult for artists] to find the time and space for reflection and the testing of ideas in the face of relentless pressure to produce, to persist despite the spurious authority of a collectors' consensus; to resist the temptation of becoming cynical, to seek and discover a sense of purpose and value that overrides the greed and impotent theorizing that has choked so much contemporary art.[78]

Smith agreed:

> I think it's harder and harder for young artists to get started in a good and healthy way in New York. They get too much too soon, they know how the system works, and the system is so greedy for young artists that a lot of them are getting burned out. There are so many artists who get taken up so fast. People have been saying this for twenty years, I know, but there is such a hotbed of activity right now. It's almost like there's not enough oxygen for artists to stabilize their careers in.[79]

But artists on the whole recognized their situation and adapted to it. Peter Plagens commented that many believed that it was possible to sell enough work to have a successful career; certainly the odds were very long, but it was possible. Artists were willing to give it a shot for a period of time, say five years. They tried to see if something could be floated that would interest the art world and if it did not, they abandoned art.[80] Eric Bogosian almost came to this point in 1980. He "became frightened by the squalor and the poverty. . . . I didn't want to live in a slum the rest of my life. I had rats in my apartment. How would you like to be in an apartment with a rat trying to chew his way out of your bathroom every night?" Bogosian added: "Then the roll of the dice changed and suddenly I was able to make a very good living."[81] Baldessari remarked: "These days a lot of artists say, 'By this age, I should have had this many shows, sold this much, gotten a color reproduction into this magazine and a review in that one'—that's how you're judged and that's how you judge yourself. It distresses me, but given the current climate, what else can you do?"[82] But did that affect what artists did in their studios? Les Levine thought not, suggesting that they recognized that "the savviest marketing approach won't work unless the art is worthwhile."[83] "In the end," Baldessari concluded, "it's just you and the art."[84]

The art-world consensus in the 1960s could be gauged by retrospective shows in museums. But the late 1970s and 1980s, there were too many such shows to count for much. Moreover, as I commented above, the role that museums played in validating art was less important than in earlier decades because of the seeming complicity with the art market and the increased tastemaking power of collectors and dealers. Nonetheless fair indicators of the consensus were certain group shows in museums, notably the Whitney Museum of American Art and to a lesser degree the Hirshhorn Museum and Sculpture Garden in Washington, D.C.

The role of the Whitney was vital since it was the only New York museum repeatedly to feature new art, until 1983, when the Brooklyn Museum, under the directorship of Robert Buck, joined it. Other New York museums took a backseat position. The Museum of Modern Art had played a crucial role in formulating the art-world consensus prior to 1967, when William Rubin succeeded Alfred H. Barr as director of paint-

ing and sculpture. Under Rubin's leadership it no longer did, although to his credit, he built the historic component of the museum's collection and arranged a number of magnificent historical shows.

Inaugurated in 1977, the Whitney Biennials aimed to present an overview of current art executed during the preceding two years and chosen by the curators. These curators—Patterson Sims, Barbara Haskell, Richard Marshall, Richard Armstrong, Lisa Phillips, and John Hanhardt—were relatively young and frequented studios of new as well as established artists. Extremely knowledgeable about current art, their selections could be taken to represent the art-world consensus of the liveliest and most provocative American art at the moment—but at the point where it would be of interest to a more general public. It was difficult to negotiate the expectations of both constituencies, and the curators were often criticized for being both too art world oriented and not enough. The biennials were more often than not attacked, indeed, becoming the shows the art world loved to hate in what grew into a ritual of biennial bashing, as Eleanor Heartney wrote. Critics of the 1989 show charged that it was "too New York-based, too myopic, too trend-conscious, too subservient to the major galleries to serve as a genuine measure of the art world's condition."[85] All this was debatable. What was not was the fact that the Whitney Museum, using four or five young curators, took the risk of dealing with contemporary art—with new art— and it was the only major museum in New York to do so.

The 1983 Biennial showcased the major tendencies of eighties art: neoexpressionist figurative painting (Schnabel, Salle, Longo, Fischl, Rothenberg),[86] as well as media and deconstruction art (Baldessari, Holzer, Kruger, Sherman) and a few artists identified with the graffiti movement (Basquiat, Haring). Feminist agitation had had some success; roughly one-third of the artists—fourteen out of forty-six—included were women. It is noteworthy that many of the artists included in the Whitney Biennial of 1983 were also in *Directions 1983*, curated by Phyllis Rosenzweig at the Hirshhorn Museum. She subdivided the participants into four categories: "Melodrama (Sherman, Applebroog, Salle, and Longo)," "Expressionisms (Borofsky, Murray, and Schnabel)," "From the Model (Scott Burton, Siah Armajani)," and "Real Space/Illusion (Elyn Zimmerman)."

In the following year the Hirshhorn mounted *Content: A Contemporary Focus, 1974–1984*, which consisted of 150 artists. Roberta Smith reported that it was "built on a core of the same roster of international art stars who have been supplying shows around the world for the past several years. To this it added an even bigger group of American and European conceptual, process, story, installation, and *arte povera* artists, some 'New Image' painters," among others.[87] The thesis of the show was in keeping with fashionable postmodernist thinking, featuring "art that involves itself with the 'life-world' in which it evolves" instead of art conceived of as a self-contained object that deals primarily with formal

issues. "Referentiality has replaced innovation as the primary concern of many artists in the last ten years."[88]

Also in 1984 Kynaston McShine curated *An International Survey of Recent Painting and Sculpture* at the Museum of Modern Art, which inaugurated a new museum wing. It consisted of 165 artists, only fourteen of whom were women, provoking feminists to picket the museum. The protest was the most interest the show generated, since it was little more than a potpourri of most current international styles. Still, it did cover European art more extensively than any other American museum had.

The new European painting came into international prominence in the Venice Biennale of 1980. The German pavilion featured the pictures of Anselm Kiefer and Georg Baselitz, and the *Open '80* show in the International Pavilion, curated by Harald Szeemann and Achille Bonito Oliva, included the Italian artists Enzo Cucchi, Francesco Clemente, and Sandro Chia. New York dealers, who soon took on European painters, said that for them the show was "the turning point." Mary Boone recounted: "The significance of the Biennale was really quite staggering." Holly Solomon added: "After Venice, it was clear that something was going on in Europe."[89] In the following year *Art News* reported that New York galleries had exhibited European artists in such numbers that collectively they were perceived to "represent the first major groundswell of artistic activity in Europe since the end of World War II—and the first substantial challenge in 40 years to the international predominance of American art. . . . This foreign onslaught has, for the most part, been enthusiastically welcomed by the city's art community and by the press."[90]

The international recognition of the new European painting had been a number of years in the making. In the case of Italy, art dealer Gian Enzo Sperone was the first major impresario of the young Italians, mounting repeated group and one-person shows. Chia recalled: "Sperone grouped us together—Chia, Cucchi, Clemente—and professionally it was good for us. . . . It was clear to us just watching each other that we were probably the best painters [in] Italy at that moment. . . . We wanted to show paintings at the very core of the art world, not in some marginal gallery somewhere."[91] A leading Cologne dealer, Paul Maenz, joined in the promotion of the Italians. In 1978 he exhibited them alongside the well-known arte povera artists in a series of exhibitions, and in 1979 he mounted an important show of the young painters titled *Arte Cifra*. He then arranged exhibitions in small museums in Mannheim, Bonn, Wolfsburg, and Groningen in the Netherlands. The Italians also made a strong impression in *Perspective '79* at the Basel Art Fair.[92]

In 1979 Achille Bonito Oliva gave the group a label, in a major article, titled "The Italian Trans-Avantgarde," in the newly bilingual Italian/English magazine, *Flash Art*. It was followed a year later by a lavishly illustrated book, published by Giancarlo Politi, which was translated into nine lan-

guages. Politi, who was also the publisher and editor of *Flash Art,* continued to feature the transavantguardia in his increasingly influential magazine, influential in part because of the success of the young Italians. In 1980 Jean-Christophe Ammann, the director of the Kunsthalle in Basel, organized a seven-person exhibition, titled *Contemporary Italian Artists,* which traveled to the Museum Folkwang in Essen and the Stedelijk Museum in Amsterdam. The support of Edy de Wilde, the director of the Stedelijk, was especially important, since he not only took Ammann's show but made a number of purchases, bolstering international art-world confidence in the young Italians.

In 1981, after their exhibition at the Venice Biennale, "The Three Cs," as they came to be called, were showcased at the Sperone-Westwater-Fischer Gallery in New York—at the propitious moment of the emergence of local neoexpressionism. And in 1982 the Solomon R. Guggenheim Museum mounted *Italian Art Now: An American Perspective.* Among the seven artists represented in that show were Chia and Cucchi. And this was only the beginning of the success of the Three Cs. Chia and Cucchi would remain important artists, but as Paul Taylor wrote, it was Clemente who ended up staking "the strongest claim on the American art world's heart, and its wallet."[93]

Two groups of new German painters achieved international prominence at the start of the 1980s. They were Sigmar Polke and Gerhard Richter, on the one hand, and, on the other hand, the neoexpressionists Georg Baselitz, A. R. Penck, Markus Lüpertz, Jörg Immendorff, and Anselm Kiefer. Baselitz, Lüpertz, Penck, Polke, and Richter had been exhibiting since the early 1960s, but Polke and Richter came to prominence in Europe earlier than the others. Polke was given museum shows in Lucerne in 1968; Munster, 1973; Bonn, 1974; Kiel, 1975; Tübingen, Düsseldorf, and Eindhoven, 1976; Kassel, 1977, and Cologne, 1979, and Richter, in Essen, 1970; Düsseldorf, 1971, Munich, 1973; Mönchengladbach, 1974; Bremen, 1975; Krefeld and Paris, 1977; Eindhoven, 1978; London, 1979; and Essen again, 1980.

The most influential promoter of the neoexpressionists was Michael Werner. Johannes Gachnang, the director of the Kunsthalle in Bern, Switzerland, who was himself an early supporter of the new German painting, called Werner the "broker and intermediary, an excellent friend of these artists and a marvelous interlocutor."[94] Werner, in collaboration with Mary Boone, was responsible for introducing Baselitz, Penck, Lüpertz, and Immendorff in New York. Gachnang organized a number of important shows of the new German painting. His friend and younger colleague, Rudi Fuchs, the director of the Van Abbe Museum in Eindhoven, also became an advocate. Indeed, the Gachnang-Fuchs collaboration came to be called the Eindhoven-Bern axis. They cultivated a network of museums, which circulated shows from one to another.

In the fall of 1979, three important Dutch museums—in Eindhoven, Amsterdam, and Rotterdam—featured major newly acquired paintings

by Baselitz, Immendorff, Kiefer, Lüpertz, and Penck. European art professionals wondered whether there was in the making an ambitious attempt to upgrade expressionism and regain European leadership in painting in the face of new image painting, then emerging in New York.[95] Then, in 1980, Baselitz and Kiefer represented Germany at the Venice Biennale.

The leading Werner artists joined in their own promotion, presenting themselves in public as exotic dandies. They "all had the same look and aura, elegant and privileged. Their hair was close-cropped, and they wore very studied designer clothes—some of it leather, all of it black. They had sculptural rings on their fingers and beautiful women on their arms. Waiters knew what each one drank."[96] "Together they are seen as a gang, making public appearances at openings and at restaurants and bars. . . . The cult of the artist's image which the Werner group has developed is powerful, even if such posturing has contributed to their being regarded, in some circles, as caricatures."[97]

Major museum and special institutional shows contributed greatly to the success of the new German painting. In London *A New Spirit in Painting* (1981), organized by Norman Rosenthal, Christos Joachimides, and Nicholas Serota, included both Europeans and Americans, but the European representation was disproportionately large, and within it, the German representation, particularly of young painters, was even more unbalanced in their favor. Indeed, it was the conviction of the curators that a number of the Germans were the best painters of their generation anywhere and consequently ought to have international recognition, and it was this conviction that prompted them to organize the show in the first place.

In 1981 Kasper Koenig mounted *Westkunst,* a survey of art since 1939, in Cologne. The show did not promote any one aesthetic position but did include the neoexpressionists and transavantguardia in its section of new art, titled *Heute* (Today).[98] The presentation of young painters in the context of a historical survey conferred "legitimacy and stature on the new art."[99] Even France recognized that something significantly new was happening in Germany. In 1981 Suzanne Page and René Block curated a large exhibition titled *Art allemagne aujourd'hui* at the Musée d'Art Moderne de la Ville de Paris, which included Polke, Richter, Baselitz, Kiefer, and Immendorff.

Rosenthal and Joachimides did not rest on their laurels with *A New Spirit in Painting.* In 1982 they curated a large show titled *Zeitgeist* in Berlin. It was narrower in scope than *A New Spirit,* that is, more focused on neoexpressionism, what Rosenthal called the baroque expression of *A New Spirit.* Indeed, *Zeitgeist* abstracted what the organizers really believed to be *the* new spirit of *A New Spirit.* Of the forty-five participants three-quarters could be characterized as neoexpressionists, and almost half were Germans. The only young Americans included were Borofsky, Salle, Schnabel, and Rothenberg (the lone woman in the show). William Feaver viewed *Zeitgeist* as both a European counteroffen-

sive against American art and the fulfillment of German and indeed European aesthetic aspirations. Thus: "The Americans in 'Zeitgeist' were very much the overseas visitors, there to lend support. . . . 'Ich bin ein Berliner,' as President Kennedy said. Schnabel could pass for one of the boys." And, with the number of Italians restricted to six, "the Germans triumphed. They were, after all, on home ground."[100]

Documenta 7 (1982), organized by Fuchs in Kassel, was widely considered at the time to be the most important international show of contemporary art. Although broad in its coverage, it confirmed the hegemony of painting, and was widely perceived as promoting the new German painting.[101] Roberta Smith found "a real sense of resentment toward American art. . . . Documenta seemed to me to be an effort to make painting a specifically European activity. I think that's why the exhibition stressed the sort of American art that is derived from a Minimal and conceptual background. A painter like Julian Schnabel, for example, was excluded, while young artists doing photograph-based work were invited to exhibit."[102]

The recognition of German art was furthered by the exhibition *Von Hier Aus* (Starting now), organized by Koenig in 1984 at the Düsseldorf fairgrounds with a grant from the city of almost $1,000,000. It consisted of some sixty artists, most of them from Germany and a few international artists who had been influential in Germany. Internal art-world politics, namely the rivalry for artistic hegemony between Düsseldorf and Cologne, the two most important German art centers, was the catalyst.[103] Fearful of being eclipsed by Cologne, the powers that be in Düsseldorf made funds available for mounting *Von Hier Aus,* which featured German artists who had achieved international recognition and would attract an international audience.

The promotion of a German neoexpressionist pantheon was continued by Rosenthal and Joachimides in *German Art of the 20th Century: Painting and Sculpture 1905–85* at the Royal Academy in London (1985). Ostensibly a historical survey, it served to establish Richter, Polke, Baselitz, Kiefer, Penck, and Lüpertz, and a few of their neoexpressionist colleagues, as the legitimate heirs of historic German modern art, centered on the expressionism of Der Blaue Reiter and Die Brücke.[104] In the United States, the first major museum survey, titled *Expressions: New Art from Germany,* was mounted by Jack Cowart in 1983 at the St. Louis Museum of Art and went from there to P.S. 1 in New York City. It consisted of the five artists: Baselitz, Immendorff, Kiefer, Lüpertz, and Penck.

West German governments on the national and local levels were active in the promotion of German painting at home and abroad, providing subsidies for exhibitions. For example, *A New Spirit in Painting* and *German Art of the 20th Century* in London, and *Expressionism: New Art from Germany* in the United States were generously funded. The city of Cologne contributed $3,000,000 for *Westkunst.* The commitment of

Germany to art—and to its own art—was also manifest in the boom of museum building, notably the new state gallery in Stuttgart, museums in Darmstadt, Frankfurt, and Mönchengladbach, and the expansion of the Folkwang in Essen.

The emergence of European art in the 1980s fostered the growth of the European art market, which in turn contributed to the success of European art. As Jeffrey Deitch said in 1990: "In the early 80s there was a disproportionate amount of activity in the American market place. Now [from 1985 to 1990] Europe is perhaps even more active than America in the contemporary art market."[105] German collectors were particularly active, and they bought recent German art. As Donald Kuspit summed it up, the German art world is marked by

> a pushiness, a militant determination to get the art across, to convince us of its value, to declare its uniqueness. The whole cheering squad of German intellectuals, journalists, museum directors, collectors and sundry fellow travellers seems to be rooting for the German team of artists in concerted, carefully orchestrated effort.
>
> The art world is being subjected to a publicity and propaganda barrage about German art that has the look of a first step of a campaign of conquest.[106]

By the middle 1980s a pantheon of new German painters had been established by international art-world consensus. They were Polke, Richter, Baselitz, Immendorff, Kiefer, Lüpertz, and Penck, with Polke, Richter, and to a lesser degree, Kiefer having the edge over the rest. Other groups of German painters received some international art-world recognition: Karl Horst Hödicke, Bernd Koberling, Rainer Fetting, Salomé, Dieter Hacker, and Helmut Middendorf in Berlin; Werner Büttner and Albert Oehlen in Hamburg; the Mülheimer Freiheit group in Cologne, whose leading artists were Jiři Georg Dokoupil and Walter Dahn and a younger member, Peter Bömmels. Peter Schjeldahl, looking back on the 1980s, remarked that it was "a decade in which German art did to American art what the Mercedes did to the Cadillac—outclassed it. . . . The four absolutely best artists, by my own and many other people's lights, to have emerged internationally since the '70s—Sigmar Polke, Gerhard Richter, and Anselm Kiefer, along with the late Joseph Beuys—are German."[107]

By 1986 it was clear that the new painting had been established, as Michael Brenson wrote in an article in the *New York Times* asking, "Is Neo-Expressionism an Idea Whose Time Has Passed?" His answer was yes. The leading neoexpressionists "are now represented in just about every important institution involved with contemporary art in the United States and Europe, and the number of these institutions is growing."[108] In Germany there was even a backlash as interest in the new painting declined.[109] For example, in 1988 Harald Szeemann organized *Zeitlos*

(Timeless), a major summer-long show at the Hamburger Bahnhof near the Berlin wall in West Berlin. With *Zeitgeist*'s promotion of neoexpressionist painting in mind, he presented minimal art as an ongoing, viable alternative. Manfred Schneckenberger, who organized *Documenta 8* (1987), also minimized painting. Inspired by Beuys, who was the only nonliving artist in the show, he chose as the theme "art and society." Proclaiming the need for social commitment, he favored site-specific, multimedia installations.

In the late 1980s, the new German painting had become so familiar and had come to include so many patently mediocre followers that the promotion on its behalf backfired. The New York art world was taken aback by the quantity of mannerist German painting in the *BerlinArt*, curated by Kynaston McShine at the Museum of Modern Art in 1987. This glut was even more fully exposed in the *Refigured Painting* at the Guggenheim Museum in 1989, curated by Krens. Karen Wilkin reported:

> Critical reaction to "Refigured Painting" has been almost uniformly negative. Descriptions have ranged from "ghastly" to "near disaster" to "I can't remember a worse museum show." Critics have taken exception to the after-the-factness of doing such a show in the first place and to the *"arrogant* badness" of the result. Krens has been faulted . . . for failing to add any fresh insight to what we already know about the artists in the exhibition who, by this time, are familiar to most informed viewers.[110]

The same criticism was leveled at a huge exhibition titled *Bilderstreit* (Picture strife) in Cologne (1989). As described by David Galloway: it

> was touted with predictable superlatives: the most important exhibition of 1989 would present no fewer than 1,000 works by 129 artists who have, presumably, staked out the esthetic terrain since 1960. Given such epic dimensions, Lufthansa and Deutsche Bank joined the city of Cologne and the state of North Rhine–Westphalia to guarantee the seven-digit budget. Organization of the three-month extravaganza was entrusted to Siegfried Gohr, director of Cologne's Ludwig Museum and the Swiss publisher-curator Johannes Gachnang.[111]

Given the familiarity of the participating artists, art-critical focus was on the art politics of the show. The purpose of *Bilderstreit*, according to Christian Bernard, was to ensure the artistic supremacy of West Germany and its aesthetic satellites, Austria, the Netherlands, and Italy. Bernard concluded: "*Bilderstreit* is a celebration of nationalistic bids to control art and the art market."[112] The show was also condemned for its relationship to the art market, primarily in its favored treatment of a few German artists.[113] Increasingly, art professionals sought to present the

German art world, both in itself and as part of the international art world, as enormously complex, fragmented into competing factions, dissociated not only by aesthetics, politics, friendships, competing cities, but by galleries as well.

Media and deconstruction artists achieved art-world recognition shortly after the neoexpressionists. A significant number were graduates of the California Institute of the Arts (CalArts), which had replaced Yale as the leading art school in America. On the cutting edge of the latest developments in art, CalArts produced more than its share of interesting artists who emerged in the late 1970s and 1980s. Like the students at Yale, they networked and looked out for each other, which contributed to their success.

CalArts became prominent because of the talent of its students and the mix of its faculty. The staff included conceptual or "poststudio" artists, of whom John Baldessari was the most influential; painters, foremost of whom were Paul Brach and Allan Hacklin; happening and fluxus artists, such as Allan Kaprow; and women artists Miriam Schapiro and Judy Chicago, who organized a feminist art program. Despite their diverse approaches the various "camps" remained friendly. Students were able to negotiate among them; for example, while at CalArts, David Salle and Eric Fischl began as conceptual artists and then turned to painting.

The focus at CalArts was on content, not formal issues, specifically, how art might be socially useful and the role of the artist in society. Consequently the school attracted students engaged in issues of class, gender, race, and the education of the artist in a consumer or media society. Students were constantly challenged to account for why they wanted to be artists, why they were at CalArts, who established social and cultural meaning, and why it was established. John Miller remarked that the faculty "forced their students to rethink what becoming an artist might be all about, rather than training them to 'ply their craft' quietly and patiently in wait of some obscure personal revelation."[114]

Despite the variety of aesthetic approaches at CalArts, the leading tendency was conceptual art. Baldessari was the key figure. He recalled: "I was hired as a painter [but] I wasn't much interested in painting as I was into something else. . . . I called it 'Post-Studio Art' because I didn't want to call it conceptual art; that was too specific, too constraining. I wanted the course to be a catchall to anyone who wasn't doing straight painting or straight sculpture."[115] Conceptual artists at CalArts engaged in an assault on formalism. Art had to "involve more than a continuing investigation of its own history, forms and practices." This entailed an "examination of art's potential social and political engagement. Related to this general concern is the use of forms, means of production and presentation strategies culled from disciplines strictly outside the traditional

confines of fine art," such as commercial photography and the mass media.[116]

Like CalArts, the Independent Studies Program of the Whitney Museum was the seedbed of a considerable number of media and deconstruction artists. Under the direction of Ron Clark, the program was heavily oriented toward art theory, or as its twenty-fifth anniversary publication put it, "alternative methodologies committed to the critical examination of the social and psychological factors that condition cultural production and reception."[117] Many of its instructors and visiting artists were leading media and deconstruction artists and writers who supported them, among them Mary Kelly and Benjamin Buchloh.

Much as teachers and students at CalArts questioned the purpose of art, particularly art-as-object, most made conventional, gallery-type works that could be marketed, even when of a conceptual nature. Moreover, much as they questioned the function of the artist, CalArts engendered "a belief in individual creative genius," as Catherine Lord observed.[118] The school prepared its students for careers in New York or, as one wit put it, to fight the Battle of West Broadway. In fact CalArts was oriented more to New York than to California. A constant stream of New York artists was brought in to lecture and give critiques. They made students aware of how the New York art world functioned and how to navigate it. Baldessari remarked: "Not very many schools could offer that so [students] came out with I would say a good two-year edge on the students from other schools." Moreover he urged his students to "get to New York right away and usually they did."[119]

The emigration of CalArts graduates was partly responsible for the first show of media art in New York, *Pictures,* at Artists Space in 1977. It was curated by Douglas Crimp at the invitation of the director, Helene Winer. Winer had been the director of the museum in Pomona, where she had become friendly with the CalArts teachers and students. She wrote enthusiastically of the appeal of "an art school where students read Wittgenstein and Levi-Strauss and were . . . attracted, in many instances, by an apparent emphasis on art as an intellectual rather than an exclusively physical-technical or creative-expressive pursuit."[120]

As the director of Artists Space, Winer gave shows to a number of CalArts graduates. She would have liked to have sold their work but was unable to do so since collectors were apparently unwilling to buy in not-for-profit galleries. As a result, Winer left Artists Space in 1980 and with Janelle Reiring opened a commercial gallery named Metro Pictures. Winer said that the gallery's "primary aesthetic commitment" was to art that reflects "concerns emanating from the culture as represented in the popular media." The gallery's artists "appropriate and re-use images from pre-existing sources, and often work in more than one medium of presentation that render traditional art categories obsolete."[121] Among the artists shown at Metro Pictures were Thomas Lawson, Sherrie Levine,

Robert Longo, Richard Prince, Cindy Sherman, Laurie Simmons, and Louise Lawler. Dan Cameron wrote: "Here was a gallery that had taken the unparalleled step of focusing exclusively on figurative (or representational) art derived from media-based sources, or which used strategies borrowed from the post-Conceptual movements of video and performance."[122] Cameron went on the say that Metro Pictures and its artists

> represented a highly intellectual flank of art world opinion, one whose theories were well-grounded in the work of such key European philosophers as Barthes, Derrida, Foucault and Lacan. [Ideas] of this caliber had always been associated with the Neo-Marxist fringe of the art world—a sector that had habitually spurned (or, at best, ignored) the machinations of the highly competitive art market. Yet Metro Pictures' slick graphics and professional installations left little doubt that they were aiming for nothing less than full acceptance of this work within New York's art mainstream—curators, collectors, European dealers, monthly "trade" periodicals, and museums.[123]

Metro Pictures artists also arranged to be shown in leading East Village galleries, for example, Nature Morte, during the short period when the East Village was fashionable.

Many of the artists exhibited in Metro Pictures were also featured by *October* magazine and written about by Rosalind Krauss, Douglas Crimp, Craig Owens, and others. Media and deconstruction art were also dealt with in *Real Life*, published by Thomas Lawson—who was represented by Metro Pictures. Unlike *October*, however, *Real Life* promoted painting, but painting that subverted painting. Beginning in 1981, *Art in America* ran a series of articles on media and deconstruction art by Hal Foster and Owens. In 1982 *Artforum* proposed, according to an editorial by its editor, Ingrid Sischy, in collaboration with Germano Celant, to "confront artmaking that retains its autonomy as it enters mass culture at the blurred boundary of art and commerce, and partakes . . . of the body of popular art."[124] Thus *Artforum* dealt with much of the same art as *October* and *Real Life*.

The *Pictures* show at Artists Space was only the first of many exhibitions featuring media and deconstruction artists. In 1980 Barbara Kruger curated a show titled *Pictures and Promises* at the Kitchen. It included Holzer, Levine, Prince, Sherman, and Simmons. In 1982 the Institute of Contemporary Art at the University of Pennsylvania in Philadelphia mounted *Scavengers: Photography* and *Image Scavengers: Painting.* This show included works by Kruger, Lawson, Levine, Longo, Prince, Salle, Sherman, and Simmons. That same year Lawson curated *A Fatal Attraction: Art and the Media* at the Renaissance Society, University of Chicago, consisting of twenty artists, among them Jeff Koons, Kruger, Longo, Prince, and Sherman. Other shows that featured

media and deconstruction art were *Art and Social Change, U.S.A.* at the Allen Memorial Art Museum of Oberlin College (1983); *Content: A Contemporary Focus 1974–1984* at the Hirshhorn Museum and Sculpture Garden; *Difference: On Representation and Sexuality* at the New Museum of Contemporary Art (1984); *Media World* at the Whitney Museum (1989); and *A Forest of Signs: Art in the Crisis of Representation* at the Los Angeles Museum of Contemporary Art (1989).

NOTES

1. Nicolaus Mills, "The Culture of Triumph and the Spirit of the Times," in Nicolaus Mills, ed., *Culture in an Age of Money: The Legacy of the 1980s in America* (Chicago: Ivan R. Dee, 1990), pp. 12–13.
2. Ibid., p. 20.
3. Richard W. Walker, "Inside the Art Market," *Art News*, Nov. 1988, p. 130.
4. Stuart Greenspan, "Bright Lights, Big Bucks," *Art & Auction*, May 1989, p. 221.
5. Peter Watson, *From Manet to Manhattan: The Rise of the Modern Art Market* (New York: Random House, 1992), p. 419.
6. My ideas on the economy and art were formulated with the help of Jeffrey Deitch in an interview, New York, Apr. 17, 1992.
7. Watson, *From Manet to Manhattan*, p. 388.
8. Greenspan, "Bright Lights, Big Bucks," p. 220.
9. Lisbet Nilson, "Making it Neo," *Art News*, Sept. 1983, p. 62.
10. Katrine Ames with Maggie Malone and Donna Foote, "Sold! The Art Auction Boom," *Newsweek*, Apr. 18, 1988, p. 72.
11. Nilson, "Making it Neo," p. 64.
12. Michael Lerner, "Looking Forward to the Nineties," *Tikkun* Nov.–Dec. 1989, p. 37.
13. Jerry Rubin, *Growing (Up) at 37* (New York: M. Evans, 1976), chronicled the transformation of a sixties radical into a seventies guru. As Tom Hayden, a sixties radical himself, viewed the seventies in Peter Goldman and Gerald Lubenow, "Where the Flowers Have Gone," *Newsweek*, Sept. 5, 1977: "It's a very selfish decade. . . . It's all me. People who experienced profound disappointment trying to change the system are jogging and growing vegetables and concentrating on brightening their own corners of the world" (pp. 24–25).
14. Norman Podhoretz, "The Return of Success," *Newsweek*, Aug. 29, 1977, p. 11.
15. Nilson, "Making it Neo," pp. 64, 69.
16. Mary Jane Jacob, "Art in the Age of Reagan: 1980–1988," *A Forest of Signs: Art in the Crisis of Representation* (Cambridge, Mass.: MIT Press, 1989), p. 15.
17. Kim Foltz and Maggie Malone, "Golden Paintbrushes: Artists Are Developing a Fine Eye for the Bottom Line," *Newsweek*, Oct. 15, 1984, p. 82.
18. There were precedents for Schnabel's success, notably that of Jasper Johns, whose first show in 1958 was almost as successful, but he did not receive the kind of hype that Schnabel and other artists of his generation did.
19. When the European art world began to feature new European painters, it seems to have needed at least one American counterpart. Schnabel was chosen. As for press coverage, in 1981, McGuigan reported: "Schnabel was covered not only by the usual New York critics but by the *New Yorker* and *Newsweek*. Even *Rolling Stone* assigned an article on him. When the now-defunct *Soho News* did a story on emerging New York artists, Schnabel's picture graced the cover" (p. 88).
20. Suzi Gablik, "Julian Schnabel Paints a Portrait of God," *New Criterion*, Jan. 1984, p. 10.
21. Stuart Morgan, "Misunderstanding Schnabel," *Artscribe International*, Aug. 1982, p. 45. See Doris Saatchi, "Artists and Heroes," *Artscribe*, Oct. 1982: "More than any other artist of recent years, Julian Schnabel epitomizes the artist as heroic figure. His outsized, muscle-bound pictures—in case there's someone who hasn't already heard—have taken the international art world by storm. With ham-fisted ferocity, he roughs esoteric figures and images onto cheap velvet and canvas encrusted with broken crockery, rude truths in a junky world" (p. 18).
22. Julian Schnabel, in "Expressionism Today: An Artists' Symposium," *Art in America*, Dec. 1982, pp. 139, 141. Schnabel also remarked: "All my paintings have a function so they're real things in the way that primitive objects might have been real, usable or magical things to the Indians in Mexico. My paintings allude to some kind of power. But they're really not primitive at all. They're pretty sophisticated. They are solar-powered energy generators. They seem to be alive in some way."
23. Schnabel, *C.V.J.: Nicknames of Maître d's*, p. 81.
24. Robert Pincus-Witten, "Entries: Sheer Grunge," *Arts Magazine*, May 1981, p. 97.
25. Peter Schjeldahl, "Falling in Style: The New Art and Our Discontents," *Vanity Fair*, Mar. 1983, p. 116.
26. Deborah Phillips, "Bright Lights, Big City," *Art News*, Sept. 1985, p. 82.

27. Ibid.

28. Cathleen McGuigan, "New Art, New Money," *New York Times Magazine,* Feb. 10, 1985, pp. 23, 20, 74. Quoted in Thomas Lawson, "Or, The Snake Pit," *Artforum,* Mar. 1986, p. 97.

29. Jeffrey Deitch and Martin Guttmann, "Art and Corporations," *Flash Art* (Mar.–Apr. 1988): 79.

30. Schjeldahl, "Falling in Style," p. 116. Cathleen McGuigan, in "Julian Schnabel: 'I Always Knew It Would Be Like This,'" *Art News,* Summer 1982, reported that "in tandem with Schnabel's well-publicized rise, a lot of attention has been focused on Boone and *her* success. She was recently featured on the cover of *New York* magazine and interviewed by *Esquire.* She is being profiled for *Savvy* and the *Saturday Review* and has been covered by *Life* and *People.* . . . 'Basically, she is known because of me,' Schnabel says. 'I think Mary is famous because I'm famous and I'm famous because Leo is famous. But what artist is really famous, say, compared to Burt Reynolds?'" (pp. 93–94).

31. Thomas Lawson, "The Dark Side of the Bright Light," *Artforum,* Nov. 1982, p. 66.

32. McGuigan, "Julian Schnabel: 'I Always Knew It Would Be Like This.'" Boone dealt "with 'less than 30 collectors,' who include, besides the [Eugene and Barbara] Schwartzes and the Saatchis, Barry Lowen of Los Angeles, Sydney and Frances Lewis of Richmond, Morton Neumann of Chicago, Charles and Valerie Diker of New York, Al Ordover, who was an early collector of Pop art, and Frederick Roos of Stockholm" (p. 93).

33. Sanford Schwartz, "The Saatchi Collection, Or a Generation Comes Into Focus," *New Criterion,* Mar. 1966, pp. 22–23.

34. McGuigan, in "Julian Schnabel: 'I Always Knew It Would Be Like This,'" wrote that in 1982, *Art News* canvassed two leading dealers: "'It's a very different art world than it was five years ago,' says [Janelle] Reiring of the current market. 'There are a lot of new collectors and so much money around,' concurs [Paula] Cooper. In the last year or so, at least half a dozen new galleries devoted to serious contemporary art have opened in SoHo, and the demand for new work is great. Many of the new—not necessarily young—collectors share an enthusiasm for the younger artists. Their art is accessible, both esthetically and, for the moment, financially" (p. 93). Modern and contemporary art was particularly attractive to new collectors in part because they were more available than old masters and in part, because their authenticity was easier to establish.
 Among the leading collectors were Edye and Eli Broad, Douglas Cramer, Elaine and Werner Dannheisser, Edward R. Downe Jr., Asher Edelman, Arthur and Carol Goldberg, Barbara Jakobson, Raymond Learsy, Catherine and Donald B. Marron, Adrian and Robert Mnuchin, S. I. Newhouse, Eugene and Barbara Schwartz, and Jerry and Emily Spiegel.

Among the corporations and investment and insurance firms that collected art and entered the market as never before were Chase Manhattan Bank, Prudential Life, Philip Morris, and Exxon.

35. Watson, in *From Manet to Manhattan,* wrote:

> Between 1973 and [the insurance company] Yasuda's purchase of [van Gogh's] *Sunflowers* in 1987 [for a then record price of $39.9 million], some *five hundred* museums were built in Japan. Every perfectural district, every borough, built one, and many corporations did so as well. [The] International Plaza Agreement . . . effectively revalued the yen, which rose by 45 percent over the next twelve months, and by nearly 100 percent against the dollar by 1987. This huge increase in Japanese wealth showed up in the art market almost immediately. . . . By the end of 1986, the value of paintings imported by Japan had almost doubled over the previous year, from . . . $212 million [to over] $391 million. This rate of increase was maintained in 1987. . . . As 1987 wore on, the Japanese presence made itself felt more and more. (pp. 393–95)

36. Dinitia Smith, "Art Fever: The Passion and Frenzy of the Ultimate Rich Man's Sport," *New York,* Apr. 20, 1987, pp. 37, 39.

37. Peter Schjeldahl, "Arts: Thok!" *7 Days,* Jan. 4, 1989, pp. 50–51.

38. Greenspan, "Bright Lights, Big Bucks," p. 221.

39. Gilda Williams, "Interviews Jeffrey Deitch," *Flash Art* (Summer 1990): 169.

40. Jacob, in "Art in the Age of Reagan," wrote that the collector has "replaced the critic of the 1960s [as] someone to whom a certain segment of the art world looks. [The] 80s is the era of 'Marketism'" (p. 16).

41. Dan Cameron, *Art and Its Double* (Barcelona: Fundacio Caixa de Pension, 1986), p. 30.

42. Saatchi was the leading trendsetter. Singlehandedly, he could boost a market for an artist or depress it, as in the case of Sandro Chia. See Jacob, "Art in the Age of Reagan," p. 16; Don Hawthorne, in "Saatchi & Saatchi Go Public," *Art News,* May 1985, p. 79; and Richard W. Walker, "The Saatchi Factor," *Art News,* Jan. 1987, p. 118. Buying fashionable new art could also provide entry into the world of fashion, and being fashionable validated the acquisition of fashionable art.

43. Jacob, "Art in the Age of Reagan," p. 16.

44. Williams, "Interviews Jeffrey Deitch," pp. 168–69. Deitch was one to know the art market, for, as Nilson in "Making it Neo," reported, he was "an exemplar of the recent transformations in the New York art world: he left his job in an austerely intellectual SoHo gallery in the mid-'70s to earn an MBA at the Harvard School of Business Administration before resuming his involvement with the contemporary scene" (p. 64).

45. Robert Hughes, "Time Essay: Confusing Art with Bullion," *Time*, Dec. 31, 1979, p. 57.

46. Paul Taylor, "Roy Lichtenstein," *Flash Art* (Oct. 1989): 91.

47. Roberta Smith, "Art: Critical Dealings," *Village Voice*, Sept. 13, 1983, p. 71.

48. Allan Schwartzman, "The Business of Art: Catalog Culture," *Arts Magazine*, June 1988, p. 8.

49. Smith, "Art: Critical Dealings," p. 71.

50. Ibid.

51. Jerry Saltz, "Snapshot American Art 1980–1989," in *American Art of the 80's* (Milan: Electa, 1991), p. 214.

52. Crocker Coulson, "Too Much Too Soon?" *Art News*, Sept. 1987, p. 115.

53. Alexander Stille, in "Wanted: Art Scholar, M.B.A. Required," *New York Times*, Jan. 13, 1991, sec. 4, p. 35, commented on how museums had grown in size and complexity. For example, J. Carter Brown, director of the National Gallery in Washington, reported: "When I became director in 1970, . . . we had 350 employees. Now [1991] we have 1,000. Back then the museum was all in one building; we have doubled the space. Our budget was $5.9 million in 1970; today it's $53.9 million."

54. Brigid Grauman, "Inside Europe: The Temperature is Lower," *Art News*, Apr. 1988, p. 117.

Mills, in "The Culture of Triumph," wrote that the ultimate link between consumerism and high art was exemplified by

the Bloomingdale's–Metropolitan Museum alliance. In 1980 both turned their attention to aristocratic China and to what the Bloomingdale's ads called "forty years of opulence." But the link did not end here. As art historian Debora Silverman pointed out, what Bloomingdale's was packaging as fashion, the Met was packaging as art. Robes from the Met's "Costume of China" exhibit were first shown to the public at Bloomingdale's along with the reproductions for sale in the store. Then, on being returned to the Met, the robes were displayed on mannequins dressed by Met curator and former *Harper's Bazaar* fashion editor Diana Vreeland. The problem, as critics were quick to point out, was that the Met mannequins were not dressed according to Chinese custom. Their clothes should have shown their bearers' places in the caste system. . . . Instead what dictated their layered look in the museum was what had dictated their look at Bloomingdale's: the illusion of fashionable luxury they could be meant to convey. (p. 22)

55. Deborah Weisgall, "A Megamuseum in a Milltown: The Guggenheim in Massachusetts?" *New York Times Magazine*, Mar. 5, 1989, pp. 54–55.

56. Carter Ratcliff, "The Marriage of Art and Money," *Art in America*, July 1988, p. 81.

57. Kenneth Baker, "Report From London: The Saatchi Museum Opens," *Art in America*, July 1985, p. 23.

Paul Overy, in "What Makes Saatchi Run?" *Journal of Art* (Oct. 1990), questioned the Saatchis' motives in publishing a lavish catalog of their holdings: "The catalogue encouraged the idea of the Saatchi collection as something fixed and permanent, despite the fact that substantial numbers of works included in the catalogue were no longer in the collection upon publication" (26). Much of the art-world antipathy to Saatchi derived from his agency's management of Margaret Thatcher's successful election campaigns in 1979 and 1983, and its alleged link to South African affiliate company's promotional activities for constitutional change, although the Saatchis themselves were apparently not involved. Hans Haacke wrote in Bois, Crimp, and Krauss, "A Conversation with Hans Haacke," "Foes of apartheid think that this change, in effect, cemented the system which reserves political power in South Africa *exclusively* for the white minority, which constitutes sixteen percent of the population" (25). Baker, in "Report from London," reported that the left also attacked the Saatchi Museum for promoting autonomous art that could take the form of commodities and calling attention away from the adversarial art the left promoted, which aimed "to incite critical thinking that will dispel the illusions by which people are taught to live—critical thinking that will frame a better world." What made the left even angrier was the thought that the Saatchi Museum was "the latest effort to prevent art from becoming a vehicle of critical thought that might ultimately threaten the order of things from which Saatchi himself has so far benefited enormously" (pp. 25, 27). Indeed, the Saatchis became so repugnant to the left that Hans Haacke repeatedly made them a subject in his art.

Perhaps the Tate was unduly influenced by the Saatchis. Nevertheless in 1984 the museum mounted a Hans Haacke exhibition with works highly critical of Saatchi, one disclosing that a major client of his firm was the South African Nationalist Party.

58. Roberta Smith, "Art: Works From the 80's With a Certain Optimism," *New York Times*, Sept. 21, 1990, sec. C, p 30.

59. Richard Martin, "Dan Cameron and the Contras, Or, Contra Dan Cameron," *Arts Magazine*, Feb. 1988, pp. 88–89.

60. Andy Grundberg, "A Pair of Shows for a Pair of Trendy Twins," *New York Times*, Oct. 2, 1988, sec. 4, pp. 33, 41.

61. Nilson, "Making it Neo," p. 68.

62. Robert Hughes, "Art, Money, the 1980s: A Jeremiad. The Decline of the City of Mahagonny," *New Republic*, June 25, 1990, p. 28.

63. Junius Secundus [Robert Hughes], "The SoHoiad: or, The Masque of Art: A Satire in Heroic Couplets Drawn from Life," *New York Review of Books*, Mar. 29, 1984, pp. 17–18. See Janet Malcolm, "Profiles: Ingrid Sischy, Part II," *The New Yorker*, Oct. 27, 1986,

p. 64. In fairness to Hughes, however, he did admire contemporary artists, among them Elizabeth Murray, Susan Rothenberg, Sean Scully, and Joel Shapiro.

64. Carter Ratcliff, "Issues & Commentary: Dramatis Personae, Part 1: Dim Views, Dire Warnings, Art-World Cassandras," *Art in America*, Sept. 1985, pp. 9, 13, 15.

65. Dan Cameron, "Mary Boone and the Sandanistas [*sic*]," *Arts Magazine*, May 1984, p. 97.

66. Richard Armstrong, Richard Marshall, and Lisa Phillips, *Whitney Biennial Exhibition, Invitational Survey of Contemporary American Art*, (New York: Whitney Museum of American Art, 1989), p. 10.

67. See Kay Larson, "The Art of the Newest: Big Money, Superstar Painters Fuel the Fantasy Machine," *New York*, Dec. 25, 1989, p. 78. There were few dissenting voices to these negative opinions. Mary Jane Jacob was one. In "A Goal Fulfilled: Renaissance or Deluge?" *Art News*, Apr. 1988, she asked: Was not the art world of the 1980s "what we asked for? Isn't this the effect of our 'success'? Central to the liberal ideology of the late 1960s and early '70s was a desire to bring art to the people.... The radically increased number of people now participating in every aspect of the art world is a goal fulfilled. In the 1970s, we felt there weren't enough places giving exposure to art; now there are so many it's impossible to keep up. We complained that corporations were not doing anything for the arts; now they support exhibitions, at least some, and have built many collections. There was scant representation of women, artists of color, and those from non-Western parts of the world—or even those living outside New York. If their enfranchisement is not yet fully realized, there is, at the very least, an increased consciousness of the lines that have been drawn around art. [Moreover,] now art sells for more than ever before, and many more artists can make a living from their work [instead of teaching or doing unrelated jobs]. So finally, what are we complaining about?" (p. 123).

68. Nilson, "Making it Neo," p. 67.

69. Michael Brenson, "Artists Grapple With New Realities," *New York Times*, May 15, 1983, sec. 2, p. 30.

70. Thomas McEvilley, "Forum," *Artforum*, Apr. 1984, p. 71.

71. Arthur C. Danto, "Renaissance or Deluge: The Age of Importance Art," *Art News*, Apr. 1988, p. 121. Kim Levin, in "The Agony and the Anomie," *Arts Magazine*, Apr. 1986, p. 63, had a similar idea. Characterizing the sensibility of 1980s painting, probably with Schnabel in mind, she wrote: "Sensation and sensationalism [are its] hallmarks.... Overblown metaphor, sensuous color, material pleasure, and the ridiculous romance of the making of art.... Grandiose technique often accompanies crude or banal imagery, grandiose subjects and crude execution go together, too."

72. Sandro Chia, "Making Art, Making Money: 13 Artists Comment," *Art in America*, July 1990, pp. 138–39. The artist was interviewed by Lilly Wei.

73. DeAk, "The Critic Sees Through the Cabbage Patch," 56.

74. John Baldessari, in "Making Art, Making Money," p. 133.

75. Carter Ratcliff, "The Art Establishment: Rising Stars vs. the Machine," *New York*, Nov. 27, 1978, p. 56.

76. Brenson, "Artists Grapple with New Realities," pp. 1, 30.

77. Ibid., p. 30.

78. Armstrong, Marshall, and Phillips, *1989 Whitney Biennial Exhibition*, p. 10.

79. Robert Mahony, "Interviews: Roberta Smith," *Flash Art* (May–June 1990): 180.

80. Conversation with Peter Plagens, New York, Jan. 19, 1990.

81. Eric Bogosian, in "Making Art, Making Money," p. 135.

82. Baldessari, in ibid., p. 134.

83. Les Levine, in ibid., p. 141.

84. Baldessari, in ibid., p. 134.

85. Eleanor Heartney, "Who's Afraid of the Whitney Biennial?" *Art News*, Summer 1989, p. 171.

86. By 1982 neoexpressionism had become established. *Art in America* devoted a special issue to it, featuring the statements of nineteen artists. Its editor, Elizabeth C. Baker, in E. C. B., "Editorial: How Expressionist Is It?" *Art in America*, Dec. 1982, noted: "'Neo-Expressionism' is emerging as a broad phenomenon. [It] is already being embraced by the mass media. Gallery activity on its behalf has been hectic; museum attention has not been lacking. It is said to sell well in an otherwise uncertain market; examples hang prominently—never modestly or shy—in numerous New York living rooms" (p. 5).

87. Roberta Smith, "Endless Meaning at the Hirshhorn," *Artforum*, Apr. 1985, p. 81.

88. Miranda McClintic, "Content: Making Meaning and Referentiality," *Content: A Contemporary Focus, 1974–1984* (Washington, D.C.: Hirshhorn Museum and Sculpture Garden, 1984), p. 25.

89. Deborah C. Phillips, "No Island Is an Island: New York Discovers the Europeans," *Art News*, Oct. 1982, p. 69.

90. Ibid., p. 66.

91. Gerald Marzorati, "The Last Hero," *Art News*, Apr. 1983, p. 65.

92. Paul Taylor, "How Europe Sold the Idea of Postmodern Art," *Village Voice*, Sept. 22, 1987, pp. 99–100, 102.

93. Ibid.

94. Gachnang, "New German Painting," p. 35.

95. See Willi Bongard, *Art Aktuell* 9, no. 16–17 (Sept. 1979): 360–61.

96. Gabriella de Ferrari, "The Art of Discord," *Mirabella*, May 1992, p. 61.

97. Lucie Beyer and Karen Marta, "Report from Germany: Why Cologne?" *Art in America*, Dec. 1988, p. 47.

98. The selection of *Heute* was seriously compromised. The problem was that Koenig had run out of money

and therefore invited dealers to choose and subsidize the work, which was featured in a separate catalog that typographically matched that of the show. Nancy Marmer, "Isms in the Rhine," *Art in America*, Nov. 1981, p. 116. Marmer remarked: "'Heute' included such stars of last season's gallery circuit as the Italian New Wave—Cucchi, Clemente, Chia, Paladino, Nicola de Maria; the New York, German, Swiss and Viennese neo-Expressionists—Schnabel, Salle, Borofsky, Kiefer, Castelli, Salome, Luthi, Schmalix; the Pattern and Decorationists—Kushner, MacConnel, Pfaff; and 'Pictures' artists—Brauntuch, Goldstein, Longo."

99. Phillips, "No Island Is an Island," p. 68.
100. William Feaver, "Dispirit of the Times," *Art News*, Feb. 1983, pp. 80–83.
101. See David Galloway, "Report from West Germany: A Season of Artistic Detente," *Art in America*, Mar. 1983, p. 26.
102. Phillips, "No Island Is an Island," p. 68.
103. Dieter Honisch, the director of the National Gallery in West Berlin, in "What Is Admired in Cologne," observed:

 The newest, best-known and perhaps the most important of German art centers is the complex in Cologne-Düsseldorf. The cities have a very different history—and a hearty mutual dislike. . . . The art dealers have settled in Cologne, the artists in Düsseldorf. Cologne, possessing the more intelligent cultural administration, also has the richer museums, built up by the citizens themselves. Düsseldorf, as the seat of the *Land* government, has the new modern collection of North Rhine–Westphalia. Werner Schmalenbach, with a very handsome budget, has built it up from almost nothing to one of the leading collections of its kind, but contemporary German art has largely been ignored.

 Düsseldorf has added importance through its academy, with its brilliant teachers and artists.

 However, the Cologne museum acquired the Ludwig Collection, first as a loan and then as a gift. "In quantity and quality this collection set new standards for Germany. Suddenly it was necessary for devotees of modern art to visit Cologne, as it had previously been obligatory to go to Düsseldorf." (pp. 62–67)

 Rivaling the Saatchis as collectors of contemporary art were Peter and Irene Ludwig from Aachen, Germany, the husband an industrialist, art historian, and professor, and the wife an art historian. In 1966 the Ludwigs began to buy large numbers of American paintings and sculptures, notably pop art, op art, minimalism, and photorealism. Peter Ludwig himself explained in Barbara Catoir, "The New German Collectors," *Art News*, Apr. 1986, that he and

other "'German collectors played an important role in the success of American art. They played a similar role when it came to German art at the end of the '70s and the beginning of the '80s. I think that the unfolding of German art would not have been quite so strong without the broad backing of the collectors and of the great number of museums all over this country that show these artists again and again'" (p. 79). As early as 1976 Ludwig donated German neo-expressionist paintings to the city of Cologne. Before then only Joseph Beuys had been represented in its collection.
104. Karen Wilkin, "Refiguring the Guggenheim," *New Criterion*, June 1989, p. 53. Other important shows of German art were *Neue Wilde* (New savages) in Aachen and *Heftige* (Angry painters) in Berlin, both held in 1980, and in the following year, the *Mülheimer Freiheit*, in Cologne.
105. Williams, "Interviews Jeffrey Deitch," p. 168.
106. Kuspit, "Acts of Aggression," p. 141.
107. Peter Schjeldahl, "Art: Bully Boys," *7 Days*, Apr. 11, 1990, p. 63.
108. Michael Brenson, "Art View: Is Neo-Expressionism an Idea Whose Time Has Passed?" *New York Times*, Jan. 5, 1986, sec. 2, p. 12.
109. "West German Art Today: Neo-Expressionism and After," *Art News*, Apr. 1986, reported: "Neo-Expressionism is still triumphant . . . but there are signs that its ascendency . . . is ending" (p. 67).
110. Wilkin, "Refiguring the Guggenheim," p. 55.
111. David Galloway, "Report From Germany: Elephant-Walk Follies," *Art in America*, Sept. 1989, pp. 69–70.
112. Christian Bernard, "Business-Streit," *Galeries Magazine*, June–July 1989, p. 141.
113. However, many German art dealers hated the show. As Galloway, in "Report from Germany: Elephant-Walk Follies," reported, thirty-three dealers charged "the curators with commercial manipulation and pseudo-art-historical ambitions [and] have issued a declaration that they will, in the future, deny the Ludwig Museum any and all cooperation. They also publicly demanded that Gohr's contract not be extended when it expires in 1991" (p. 72).
114. John Miller, "Please Pass the Orb," in *CalArts: Skeptical Belief(s)* (Chicago: Renaissance Society at the University of Chicago, 1987), p. 12.
115. Nancy Drew, "John Baldessari: An Interview," *John Baldessari* (New York: New Museum of Contemporary Art, 1981), p. 64.
116. Mark Stahl, "Towards an Appreciation," in *CalArts: Skeptical Belief(s)*, p. 12.
117. Scott Gutterman, "A Brief History of ISP," *Independent Study Program: 25 Years (1968–1993)* (New York: Whitney Museum of American Art, 1993), p. 16.
118. Catherine Lord, "History and History," in *CalArts: Skeptical Belief(s)*, p. 6.
119. Jeanne Siegel, "John Baldessari: Recalling Ideas," in

Jeanne Siegel, ed., *Artwords 2: Discourse on the Early 80s* (Ann Arbor, Mich.: UMI Research Press, 1988), p. 48.

 Helene Winer, in an interview, New York, Oct. 11, 1991, said that Baldessari was a great consumer of up-to-date information, collecting artists' books, magazines, catalogs, and the like, which he made available to students.

120. Kay Larson, "How Should Artists Be Educated?" *Art News*, Nov. 1983, p. 89.

121. Helene Winer, "Metro Pictures," in *For Love and Money: Dealers Choose* (New York: Pratt Manhattan Art Center, 1981), n.p.

122. Cameron, "Art and Its Double," p. 22.

123. Ibid.

124. Ingrid Sischy and Germano Celant, "Editorial," *Artforum*, Feb. 1982, p. 34.

14 EAST VILLAGE ART

New image painting, as I observed in chapter 6, pointed in two directions. One was toward "fine" art, the culmination of which was neoexpressionism. The other was toward an extreme "bad" painting, an art based more than ever before on anarchic and infantile impulses, an anyone-can-do-it aesthetic, and the trivialities of mass culture. Neo-"bad" painting was identified with a generation of artists who lived and worked in Manhattan's Lower East Side, soon given the catchier name East Village. East Village art was accompanied by another cultural manifestation that emerged in 1976, punk rock or new wave.[1] Young artists began to frequent punk rock clubs and bars because they found the music more stimulating than the art shown in galleries. Responding to artist interest, in 1978 Artists Space featured the new bands in a two-week run.

There evolved a "punk aesthetic," which "blurred the boundaries between visual art, performance art and rock concerts, between high and low culture, and between who is 'qualified' to be an artist, a musician—or both," as Michael Shore reported in 1980.[2] "Artists and art students have been forming rock bands, rock musicians are making underground films, performance artists have been appearing in rock clubs and making records and punk-oriented fashion designers are also exhibiting sculpture, to mention a few of the manifestations of this new spirit."[3]

Thomas Lawson recalled that young New York artists recognized that the

> fast, psychotically repetitive rock music [of the *Ramones* or Patti Smith] could provide a successful way to reinject life into the moribund idea of "performance art.". . . Since so many of us had grown up with John Lennon, Mick Jagger, or Ray Davies as our idea of a living artist, it seemed natural. Suddenly everybody was in a band, mostly fairly transitory groupings confined to the art world. . . . The music that came out of this activity tended to be fast and rough, betraying a studied carelessness. . . . There was little regard for musical skill, or

for originality per se. Anything could be lifted and reused as necessary, and could be done as badly as seemed appropriate.

Lawson went on to say that inspired by the punk aesthetic,

> a great many people [such as Beth and Scott B and Eric Mitchell] became interested in cheap film production, using Super-8, the technology of home movies. The aesthetic here was as rough and ready as that of the music scene—production values were deliberately amateur, acting was for the most part desultory, story lines were left incomplete. . . . The look was usually derived from *film noir,* as were the story lines and characterization, so there [was] a ready-made style suitable for representing the self-image of the downtown scene. [The art was marked by a] deliberate poverty of production—the inclusion of over-exposed film, jumpy editing, poor sound quality. . . .
>
> What this work had in common was an attitude of familiarity towards popular culture, a mixture of love and contempt for the omnipresent images of capitalist consumerism.[4]

Recognizing the prevalence of the punk aesthetic, local nightclubs found that it was good business to allow artists to perform.[5] Shore reported that the

> Mudd Club in Tribeca, a favorite haunt of young artists and new wave musicians, . . . instituted a policy of presenting performance art and underground films in the early evening to augment the regular late-night rock concerts and disco-style dancing to the latest new wave records. Artists like Lawrence Weiner, Michael Oblowitz and Chris Burden have recently shown films or given performances there. . . .
>
> Eric Bogosian has lately been performing at the Mudd Club and other downtown rock clubs as "Ricky Paul," a perverse, Lenny Bruce–like master-of-ceremonies who tries to incite audiences through insult and intimidation.[6]

Jeffrey Deitch described a performance at the Mudd Club prompted by the refusal of the Russians to withdraw from Afghanistan in 1980.

> Artist/musician Steve Pollack [gathered] a group of artists to respond to the revved up Cold War. . . .
>
> Advertised with an unsettling poster by Lynne Augeri, rich in Nazified imagery, *Cold War Zeitgeist,* as the production was called, was a lively and actually somewhat frightening evening of music, multimedia performance, live transcontinental communications, and "military briefings."
>
> [A] smorgasbord of offerings in typical New Wave style [included] a continuous slide show, juxtaposing Richard van Buren's

"Parrot Jungle" snapshots with real news photos fresh from Afghanistan supplied by Jim Sheldon, a *Time* photographer just back from the war zone.

Cold War Zeitgeist built to a climax with a lip-synched performance by Steve Pollack's band, The Untouchables, which featured a growling transvestite flanked by two gun-toting chorus girls in jackboots.

[Upstairs, there took place] a multi-media performance titled *Last War III*, directed by Judy Rifka and Matthew Geller [which included the] baton twirling of Ann Singer [and] two of Dara Birnbaum's extraordinary video tapes, constructed from the ridiculous but sublimely significant vocabulary of junky TV shows and disco hits.[7]

East Village Art began to command widespread art-world attention in 1980 with *The Times Square Show* [165], organized by an artists group called Collaborative Projects, Inc., or Colab. It consisted of the work of some one hundred artists installed in an abandoned building that had housed a bus depot and a massage parlor. Kim Levin recounted that the show

radiated genuine energy. [It] was irreverent, raw, rebellious, messy, and had a makeshift, casual, carefree air of an amateur endeavor, as if nothing were at stake. The spirit of anarchy, exuberance, and celebration announced itself from the street: tinny carnival music blared from a loudspeaker on Seventh Avenue, setting a tone of fun-house

165. *The Times Square Show,* 1980. *(Photograph copyright © 1980 by Andrea Callard)*

bedlam. . . . "Four jam-packed floors!: More than you bargained for," proclaimed a little blue Xeroxed leaflet, mimicking the media and the merchants, and mocking the art world. . . .

Like Schwitters' *Merzbau*, the building was a total environment, but it was inner city art, an art of plastic and rags, broken glass and garbage, celebrating squalor and urban decay.[8]

Robert Pincus-Witten was more specific about the

incredible raunch of the Times Square Art Show [with its] acrid stories of social alienation, graffitists galore, plaster casters, vague terrains reached by stairs strewn with broken beer bottles, feminists of all stamp questioning pornography of all manner, [photographs] showing calisthenic feats of scatalogical s-&-m, quaint hand fans waved against the summer heat, illustrating vaginal penetration, painful sexploitation tales, and social critical anecdotes of all kinds; in short, the opposite of any refrigerated notion of formalist values.[9]

Most of the works in *The Times Square Show* were in bad taste and artless. Yet they "exuded knowing references to art history and recent art," as Levin commented.[10] They were less radical than the rhetoric about them. Indeed, they were too conventional to interest the art world for long. Moreover the communal spirit of *The Times Square Show* could not be sustained. Ida Applebroog recalled that at first the show was "very democratic. People came in and did work from top to bottom, everyone just sort of grabbed a space. And there were no labels and no names; no one was identified. It was tremendously exciting. Something new was happening. Here were very, very young artists who were very political, and the work was about sex and violence and the things that were very important to them at that point."[11] Nonetheless the show was compromised from the start. The participants could not sustain "a cry of rage against current artworldiness."[12] Applebroog commented that

suddenly somewhere along the line someone decided to send out an invitation. And it was embossed, very elegant, and it was sent to dealers and collectors: 6:00 to 8:00 p.m., black tie optional. And what happened was that not all, but a great number of the artists suddenly came rushing in to identify their works, put labels on, and be there as part of the establishment. That show has always been an important one, yet no one really talks about this one little piece of it that sort of rushed us into the 80s.[13]

Artists fought each other for optimum spaces and for the attention of the media. It even got nasty as artists infringed on each other's space. Moreover, the show had a "gifte shoppe" which was meant to be "a microcosmic strike for economic independence and control of their products,"

but was also in the business of selling "unsalable" works—cheap.[14]

The commercialization of art was resisted by members of Colab and other dissident groups.[15] They argued over whether artists should stay on the fringe or have careers. Many created socially conscious art devoted to community problems and social change.[16] For example, Group Material, a collaborative formed in 1979, was committed, as its members wrote, "to the creation, organization and promotion of an art dedicated to social communication and political change." Operating out of a storefront on the Lower East Side, Group Material arranged shows in galleries and alternative spaces on such themes as housing, education, gender, and the U.S. Constitution. Group Material also invited 103 artists and groups to design advertising display cards, exhibited in New York subways and buses, and arranged for a twelve-page supplement in the Sunday *New York Times*.

Group Material was included in the Whitney Biennial of 1985. Given a room, it created an installation, titled *Americana,* composed of pictures by anonymous and well-known artists—Norman Rockwell and LeRoy Neiman (who otherwise would never have been invited to show at the Whitney), as well as Andy Warhol, Leon Golub, and Eric Fischl—the works hung edge to edge, floor to ceiling. The installation also included a washer-and-dryer set, packaged foodstuffs and other supermarket items, open magazines, book jackets, posters, photographs, and "vernacular music to accompany America's dirty laundry," as art critic Lisa Liebmann commented.[17] In accepting invitations to exhibit in art-world institutions, Group Material intended to criticize them but they also opened themselves up to accusations of having "sold out." The issue remained unresolved: Was Group Material's "institutional critique" transgressive, or did the institutional venue within which the critique took place defang it?[18]

Much as many of the artists in *The Times Square Show* and their associates who crowded into the East Village tried to hold on to their iconoclasm, most ended up packaging it. *New York/New Wave* (1981), curated by Diego Cortez at P.S. 1, brought punk art into a fashionable art-world venue. The next move for careerist artists was to make salable works and market them in commercial galleries, dozens of which they themselves organized in the East Village. Impresarios and promoters of punk culture took command, the most notorious and influential of whom was Malcolm McLaren.

An early sympathizer of the situationists, McLaren used their seditious tactics not to undermine consumer culture but to capitalize on it.[19] While still an art student in England, with an eye to Andy Warhol, he had come to believe that he no longer had to think of making art. "I just had to consider the idea of selling. And selling things became an art in itself." With the clothes designer Vivienne Woodward, McLaren opened a series of shops on London's King's Road, featuring punk clothing and accessories. He demonstrated that situationist subversion could be marketed; his motto was, as he said, Cash from Chaos.[20] He then formed an anarchic rock band, called the Sex Pistols, consisting of four punks utterly

devoid of musical skills, to help promote the new look he was merchandizing. Their insulting antiestablishment music was an immediate hit. *God Save the Queen*—"she ain't no human being"—issued in 1977 at the time of the queen's Silver Jubilee—jumped to number one in the hit parade. They were "a welcome breath of foul air. Ugly, abusive, and unprofessional, they were perhaps the first truly rebellious commodities. It's what made them so marketable."[21]

McLaren later became an "artist" in his own right, appropriating and combining bits of the music from a variety of sources, from African drumming to *Carmen*—at a time when appropriation was in vogue both in art and in black ghetto rap music. He would continue to perpetrate—or try to perpetrate—scandals, for example illustrating a record jacket for the Bow Wow Wow, a band he managed, with a pedophiliac photograph of four figures who simulated Manet's *Déjeuner sur L'Herbe,* one of whom was the band's fourteen-year-old lead singer, naked. A true heir of Warhol, McLaren became the consummate business artist, cynically, flamboyantly, and successfully wedding commerce and culture. In recognition of his historic significance and as a sign of the times, he was given a retrospective at the New Museum in 1988. It consisted of punk bric-a-brac he merchandized—ripped T-shirts and posters with subversive messages, record jackets, bondage pants—mementos of his self-aggrandizing career as an entrepreneur, entertainer, and tastemaker in both London and New York.

The punk attitude became so pervasive in the early and middle 1980s that art professionals vied to discover the "baddest." The Los Angeles Institute of Contemporary Art was the winner, when in 1982, it exhibited LeRoy Neiman in tandem with Andy Warhol, although neither was punk. Neiman was allegedly the most famous, richest, and popular artist in the world. A "Chicago illustrator, who came to national prominence via *Playboy* Magazine," as Peter Plagens wrote, he "believes that his sleek, superficial drawing, flung chroma, and heartfelt homages to the likes of . . . Sylvester Stallone, as a doe-eyed Rocky make him an heroic amalgam of an old master and visionary modernist." The institute may have been ironic in exhibiting Neiman. Whatever its intention, it presented the "titillatingly vulgar . . . as demonstrative of originality."[22] The very end of the decade would witness the emergence of an art so "bad" that it came to be dubbed pathetic or abject art.

East Village art took two directions, one the sophisticated primitivism of a Jean-Michel Basquiat; the other, the sophisticated infantilism of a Keith Haring or Kenny Scharf. Basquiat began his career in the late 1970s as part of a two-person team that used the pseudonym SAMO. They scrawled cryptic messages on urban walls, such as, SAMO AS AN ALTERNATIVE TO GOD. Many ridiculed the "boozh-wha-zee"—SAMO AS AN END TO PLAYING ART, RIDING AROUND IN DADDY'S CONVERTIBLE WITH TRUST FUND MONEY. Although these "ghetto haikus"[23] appeared all over Manhattan, SAMO had the art world in mind, often hitting walls near

SoHo galleries. Indeed, Basquiat became part of the East Village art scene, frequenting the many art galleries there and late-night spots. He formed a "noise" band called Gray, which played at CBGB, Hurrah, and the Mudd Club.

At the same time Basquiat was painting, inspired by Rauschenberg's combine-paintings, Twombly's scribbled canvases, and Dubuffet's *art brut*.[24] His pictures consist of images and texts that refer to his life, to black history, and to popular culture. Early paintings, from 1980 to late 1982, include crude skeletal figures, primitivistic masklike faces, graffiti, and city street images, some suggestive of children's sidewalk games. Pictures executed from late 1982 to 1985, many with exposed, crudely homemade stretchers, tend to be packed with written words, signs, and symbols referring to his African and Hispanic identity, historical events, and contemporary black figures with whom he identified [166]. Believing himself to be exploited by his dealers, Basquiat portrayed world-champion heavyweight boxer *St. Joe Louis Surrounded by Snakes,* his rapacious white promoters. In the two years before his death in 1988, Basquiat's style changed somewhat, as he focused increasingly on painterly figuration.

Basquiat's images and texts tend to be extremely diverse in sources, references, and concerns. He appropriated images from African, Aztec, Egyptian, Greek, and Roman art and the paintings of Manet, Degas, Rodin, Matisse, Ingres, and Leonardo. Richard Marshall drew up a list of his subjects derived from words in his pictures:

> money (ONE CENT, DOLLAR BILL, ANDREW JACKSON, TAX FREE); value, authenticity, and ownership (PESO NETO, @, ESTIMATED VALUE, 100%, NOTARY, REGISTERED TRADEMARK); commodities of trade, commerce, and monetary manipulation (PETROLEUM, GOLD, PLATINUM, COTTON, SALT, TOBACCO, ALCOHOL, HEROIN); . . . identification with historical black figures (MALCOLM X, LANGSTON HUGHES, MARCUS GARVEY); black athletes, boxers, and musicians (HANK AARON, JESSE OWENS, SUGAR RAY ROBINSON, JERSEY JOE WALCOTT, MILES DAVIS, DIZZY GILLESPIE, CHARLIE PARKER); . . . references to racism (SLAVES, SLAVE SHIPS, DARK CONTINENT, NEGROES, MISSISSIPPI, HARLEM, GHETTO, HOLLYWOOD AFRICANS, AMOS AND ANDY); . . . cartoons and comic books (ACTION COMICS, MAD, MARVEL, DISNEY, WARNER BROTHERS, A.A.P.); cartoon and comic characters (PORKY PIG and ELMER FUDD, SUPERMAN and JIMMY OLSEN, BATMAN and ROBIN, DICK TRACY and PRUNEFACE, POPEYE and OLIVE OYL, ROCKY and BULLWINKLE, GUMBY and POKEY); . . . and junk foods (PEZ, JIFFY POP, CORN PUFFS, BLACK CHERRY SODA).[25]

Basquiat's script was never in the flamboyant wild style of the ghetto spray-paint writers who covered New York's subway cars. His let-

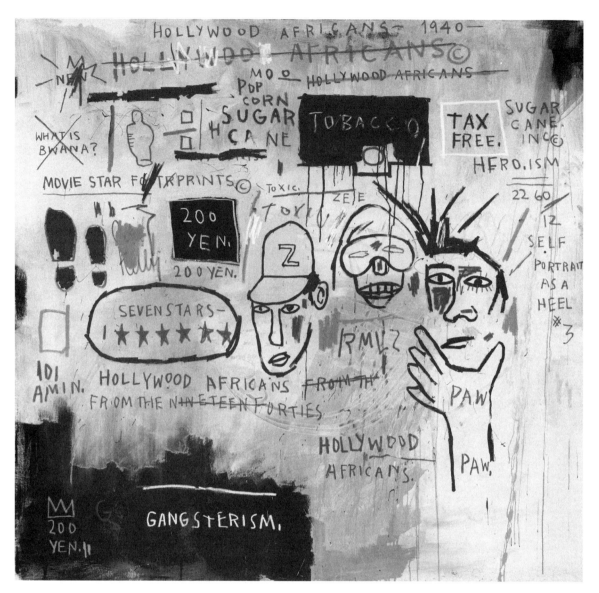

166. Jean-Michel Basquiat, *Hollywood Africans*, 1983. *(Copyright © 1994 Whitney Museum of American Art and copyright © 1983 Estate of Jean-Michel Basquiat. Used by permission)*

tering, whether in the early **SAMO** graffiti or in the later texts on canvas, is comparatively small and legible. However, he shared the graffiti artists' urge to self-aggrandizement: the three-pointed crown that recurs in Basquiat's work is kind of a signature image proclaiming "I Am King." His repetitive autobiographical and self-promoting texts were related to the lyrics of rap music. The syncopated repetition of images and words was also inspired by jazz of the 1940s, namely that of Dizzy Gillespie and Charlie Parker, in memory of whom Basquiat painted *Charles the First*, and *Bird of Paradise* and *Ornithology*, titles of Parker's albums. The play with words—many are invented—is also reminiscent of jazz improvisation. Indeed, Basquiat's painting was the visual counterpart of rap and jazz, and that constituted his original contribution to visual art.

Basquiat should be linked with the neoexpressionists rather than the wild style spray-painters because his painting was influenced by historic expressionism. He was *the* primitivistic new painter. But was his primitivism "authentic" or "neo"? There were conflicting opinions. Adam Gopnik denigrated the work as anachronistic, academic, and rhetorical—

> dutiful schoolboy inventories of every received idea of "raw" or "primitive" utterance that had been circulating in modern art since before the First World War. . . . The "African" masks, the coarse, zappy line, the scarifications, the scribbling intensity [are] just . . . primitive clichés. . . . It was corny in 1918, and it was still corny in 1988. . . .
>
> Basquiat offered the art world [an] immediately recognizable inventory of instant "primitive" clichés that he had picked up by looking at art books.[26]

In opposition to Gopnik, other critics claimed that whatever the references in Basquiat's paintings—to *Gray's Anatomy*, the art of Twombly, Dubuffet, or Matisse, illustrations in African history books—he was making art out of himself, his own experience. He had a ranging and inquisitive mind, as Robert Storr observed: "Everything about his work is knowing, and much is *about* knowing."[27] Robert Farris Thompson wrote: "The texts in his paintings are, among many things, brave essays in cultural self-definition. They reflect not only the books that he read and the worlds he lived in—middle-class Haitian Brooklyn, The Brooklyn Museum, the graffitero streets, the music of his own 'noise-band,' and the Soho art scene; more critically, they reflect how he made sense of all those realms."[28] What Basquiat chose to paint was felt, and that is the source of the strength and uniqueness of his pictures. His art was genuine.

However, the art world was divided on this issue between bashers and boosters, as Adam Gopnik remarked, and the controversy was complicated by Basquiat's behavior in the art world. Discovered in 1980, he quickly achieved success and notoriety.[29] Indeed, he came to be viewed as the exemplary artist of the East Village, on the one hand, the romantic genius soon to become mythic—black, beautiful, rebellious, hip, and

wild, a prodigy suicided by drugs at the age of twenty-seven, and on the other hand, the careerist, avid for celebrity and money, as his surrogate father, Andy Warhol, had been. Indeed, Basquiat became the last of Warhol's superstars, and the two were inseparable until Warhol's death.

With this in mind, as Gopnik commented,

> the bashers maintain that Basquiat was a barely sentient graffiti marker who was picked up by the downtown art world, which, with its special mixture of condescension and solemn cultishness, gave him paints and brushes, fed him cocaine, and told him he was an artist.... The boosters ... take the position that Basquiat was a natural genius who summoned into his paintings the previously taboo energy and vitality of the streets and got martyred for his troubles.... Even by art-world standards, it is a bad-tempered dispute, with each side accusing the other of at least latent racism. The bashers say that Basquiat was taken up by the art world because he conformed to an inherently stereotyped notion of the black artist as an instinctual, rhythmic innocent; the boosters insist that the bashers cannot bear any young black man's entrance into the pantheon.[30]

In the end what counted was the work. And as Julian Schnabel wrote: "There's a moment in his work that was very powerful and very succinct about his time.... When he was on he was on, and that's a lot."[31]

Keith Haring came out of the studio into the subways after he had seen "graffiti and ... fabulous trains. You could go down to Times Square, just stand there 15 minutes, and see better art than you could see all day in Soho."[32] He then began to draw cartoonlike images in white chalk on the sheets of black paper that covered empty advertising spaces in subways, creating a kind of public art. Haring's first subjects were crawling babies that emanated radiating rays, which became his symbol-signature, to which he added an array of other images, such as barking dogs, animated appliances, and dancing and copulating figures [167].

Haring's drawing was related to "bad" painting, but that connection was rarely made. Instead he was identified with the graffiti painters though his image was not his signature and did not appear on trains. Still, there were affinities between the two kinds of mark making. Both were "immediately recorded and immediately on view," as Haring said, "There are no 'mistakes' because nothing can be erased. [The] image comes directly from the mind to the hand. The expression exists only in that moment." He elaborated elsewhere: "My drawings are never pre-planned. I never sketch a plan for a drawing, even for huge wall murals. My early drawings [are] like automatic writing or gestural abstraction."[33]

Haring said that his imagery was influenced by ghetto break dancing that he had seen in 1983 and 1984 in which some dancers bent over

167. Keith Haring, *Untitled,* 1981. *(Copyright ©
1981 Estate of Keith Haring)*

backward to the floor and other dancers went underneath them in moves
called the bridge and the spider. His imagery was also related to rap
music, as Jeffrey Deitch commented: "Like a master rapper who can
rhyme line after line in a never ending cadence, Haring keeps unfolding
his images with a visual syncopation."[34]

Haring said: "I grew up with Walt Disney cartoons. So I'm a perfect
product of the contemporary age, because I'm only twenty-four and I
grew up in America. And my images . . . deal with very everyday, elemen-
tary human words and ideas. [The] main thing is that they are part of
common experience."[35] His images were at once appealingly childlike
and grown-up, tackling big issues, such as life and death—his "radiant
child" exudes both nuclear poisons and the life force—and condemning
drugs, racism, and homophobia, and warning against **AIDS**, but always
tempered by the humor and sentiment of his cartoonlike style.[36] He
wanted to be both "serious" and populist, but never quite got the mix
right. His drawing, though distinctive and lively, did not succeed in being
more than sentimental and one-dimensional. But it was crowd-pleasing,
like a Disney animation.

As an extension of his populism, Haring mass-produced his reper-
tory in thousands of drawings, prints, paintings, sculptures, murals,
T-shirts, buttons, and banners. He even opened a store—the Pop Shop—
which marketed inexpensive items decorated by him—and his style lent
itself to the enterprise. Taking Warhol as his model, Haring turned him-
self into a fashionable celebrity and successful entrepreneur while retain-
ing his standing in the art world.

* * *

Like Haring, Kenny Scharf had been an art student who had been inspired by the sprayed graffiti he saw in the subways. "I couldn't read it at first; I just thought, wow, this is weird, it's neat. I was just hypnotized by it, you know, being in art, and then I met all these guys . . . and it was really exciting. [I] just started doing it."[37] Just as graffiti painters looked to comic strips for imagery, Scharf took as his subjects cartoon characters on TV [168].

> I'd always been doing the Jetsons at school: I made a Jetson city from old stuff like TV dials and TV tubes—I loved those buildings. At the time of the Fun Gallery show, a friend of mine had a Jetsons comic book, and he showed it to me, and I just thought: I'm going to make paintings of them. And that's what I did [beginning in 1981]. They were small, airbrushed—I put the Jetsons in scenes.
>
> [After] the Jetson paintings, I did the Flintstone paintings, and then there was this kind of metamorphosis—Flintjet, Jetstone. And then there was Felix the Cat. . . . George and Wilma [Jetson] had a baby they called El Fredix. And then there were other offspring.[38]

168. Kenny Scharf, *When the Worlds Collide*, 1984. *(Copyright © 1994 Whitney Museum of American Art)*

Scharf explained how he came to redo cartoon characters. "I chose them because they came out of my unconscious, but I'd seen them on TV." But he also had high culture and modernist art in mind. "I don't think there are big substantial differences between Oedipus and

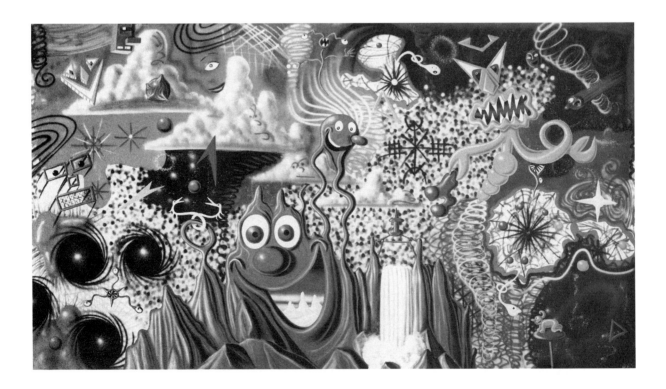

Flintstones or between Tanguy's nuclear forms and the Jetsons. Oedipus and space amoebas are now a part of mass culture because they are symbols everyone is familiar with." Scharf went on to say that in his paintings he combined "serious and comic subjects. The Jetsons and Flintstones exist alongside Oedipus and let themselves be caught up in the tentacles of Tanguy-like amoebas. In any case, the way I paint is still just as *funny*. My characters take part in ridiculous stories, and the colors are unreal, fantastic, artificial, crazy."[39] Indeed, having fun while painting was Scharf's intention. "And I want people to have fun looking at the paintings. When I think, What should I do next?, I think: more, newer, better, nower, funnier."[40]

Depicting the jokey mass-media figures that peopled Scharf's psyche made his biomorphism different from that of Tanguy, Miró, and other surrealists from whom he borrowed motifs. Moreover, his imagery has none of their "still-spooky dread [or] sexual terror." As Marzorati commented, "It is surrealism without the dark edge of night, surrealism for the fun of it." Marzorati also wrote that Scharf's pictures express "a youthful longing for childhood, one shaped by the TV set. It is the creation—in the real world—of a TV version of the '60s as remembered by those who saw the shows every night. It is the product of a *mentalité*—a mindset, a kind of common subjectivity—that is the first to be shaped, at one remove, by records, movies and especially TV."[41] Indeed, Scharf's painting recalls his childhood experience of the canned "art" the media programmed for children—and celebrates it.

The Times Square Show included not only "professional" artists who portrayed life on New York's mean streets but graffiti writers who grew up and continued to live on those streets. They were given a wall outside the building for a mural.[42] Ghetto based, they used spray paint to "hit" neighborhood walls with their own names or "tags," as they called them, plus the numbers of the streets on which they lived. Their aim was to put their personal stamp on the urban environment, and in order to make their work stand out, they developed distinctive, eye-catching signature styles. But the "tags" were also territorial signs of affiliation with a youth subculture. Graffiti writing was often thought to be the authentic art of the ghetto world,[43] although even many ghetto dwellers viewed it as vandalism and visual pollution.

The ghetto artists constituted an art world, following one another's styles. They formulated their own code of ethics. For example, as Edit DeAk reported: "You don't tag over somebody else's tag because it's like defacing someone's identity."[44] The graffiti artists also established their own pantheon. As Kirk Varnedoe and Adam Gopnik wrote: "The names of the first writers to make an advance were—and still are—recalled and honored by the writers who came after them: Hondo, who made the first top-to-bottom; the Fabulous Five, led by Lee, who made the first 'whole train.'"[45] At first the names of the artists were spare and legible but soon

many were so embellished as to be unreadable except by the initiated. At the end of the 1970s, graffiti writers added to their "tags" improvised figurative images inspired by comic books, Disney cartoons, video games, sci-fi, and other popular illustrations. The resulting decorative mélanges came to be known as wild style. To reach a wider public, graffiti artists moved their art from ghetto walls to subway trains, often covering every exterior inch of a sixty-foot-long car.

By 1962 stylistic differences among graffiti painters could be identified. As Kim Levin wrote somewhat patronizingly, Crash was their pop artist,

> whose canvases really do look like free-style, soft-focus variations on early Lichtenstein, right down to the black outlines, comic book blonde, and zappy words. They've got their David Salle: Daze, whose "City of Dreams" is an effective combination of disjunctive urban images. They've even got their Georgia O'Keeffe: Lady Pink, whose contribution is a painting of one very large pink rose. . . .
>
> A-One's huge wall-size (or train-size) canvas called "Train Art" is crammed with dense jostling shapes, images, writing, and a riot of color [reminiscent] of abstract expressionism. Toxic, NOC, and the Arbitrator Koor also share that same macho style—pure aggression and chaotic energy. Ramm-ell-zee's painting, however, . . . is ethereal and sparse.[46]

Wild style painting emerged at roughly the same time as break dancing and rapping, the dance and music of the ghetto. Together their practitioners constituted a subculture generally labeled hip-hop. Just as graffiti artists sprayed their "tags" all over subway cars, assaulting millions of riders with their egos, so rappers with portable sound systems blaring at deafening volume took to streets, parks, and playgrounds. Like graffiti painting, rapping is "an exuberant, stylized form of bragging, with the MC's name repeated like an incantation," as Mary Herron wrote. Break dancers too invented difficult acrobatic movements in the attempt to outdo each other. Herron went on to say: "One of rap's starting points was in the breaking competitions in the local parks (between dancers, sound systems and DJ's) and rap has the same spirit of competitive play: the battle over who is the baddest and the best."[47]

Graffiti artists generally stole the spray paint they used, often in quantities large enough to paint entire subway trains. That and their vandalism made them criminals, according to the law. If above the age of eighteen they could, if caught, go to jail, particularly after the Transit Authority began a serious crackdown. Their vandalism was condemned as anarchic by its detractors. But that was part of its appeal both to the artists themselves and their law-abiding supporters, who either tolerated, or were titillated by, lawbreaking they considered relatively insignificant.

The Times Square Show brought graffiti artists from the South Bronx into the art world. Their wild style quickly commanded growing

attention because its crude drawing and garish fluorescent colors were
thought to be the latest manifestation of primitivism in modern art and
because they were related to bad painting [169, 170]. Edit DeAk, a sup-
porter of graffiti art, was attracted by the urban "information" it pro-
vided. It might look "primitive, infantile, badly done, crumpled, rumpled,
tacky, raunchy, crappy, unconscious, whatever. But the . . . messages and
even the look itself is what none of the artworld artists I know have been
able to come up with."[48]

The ghetto artists were welcomed into the East Village art scene, its
galleries and clubs. And they were only too happy to enter, seduced by
the lure of money and fearful of the growing risk of jail in their losing
guerrilla war against the Transit Authority. But the art world outside the
East Village did not entertain its new "primitives" for long. When the
novelty of their work wore off, they were abandoned as suddenly as they
had been embraced. The art world took to heart only Basquiat and
Haring and Scharf; the latter two were white and had been "tamed" by
art school, in their cases, the School of Visual Arts. As Haring recalled:

> The only people who survived it were those who weren't really a part
> of it. People like me, Jean Michel Basquiat, and Kenny Scharf, who
> were always peripheral to the movement. . . . It was complicated

169. NOC*167, *Outerspace Painting,*
1984. *(Courtesy Melvin Henry Samuels
Junior (NOC*167)).*

170. Daze, *Dance Aesea,* 1984.
(Sidney Janis Gallery, New York)

because Jean Michel and I didn't want to disassociate ourselves from the graffiti artists, because we appreciated them on a certain level and didn't want to discredit what they were doing. At the same time our inclusion in the movement was a limitation for us. Jean Michel hated being called a graffiti artist even though he also did work on the street in the beginning and was instrumental in inspiring me to do work on the street. We had respect for the graffiti world but we were working differently and didn't let ourselves become engulfed in the whole thing.[49]

One reason graffiti art was dropped by the art world was the naive attitude of the genuine ghetto artists; they thought of themselves as pop stars and were exploitative.[50] But more important, their primitivism lacked dimension, and this became clear when their street culture began to vie for a place in the realm of high art. It was then viewed as a kind of urban "outsider" art that lacked the cultural underpinning to speak to an art world audience. After a short while it was dismissed as a fad. The graffiti artists tried to emphasize the aesthetic quality of their work, as Futura 2000 (Leonard McGurr) said, the "bottom line is that we're doing . . . art and culture."[51] But that only raised eyebrows. Even Rene Ricard, a champion of graffiti art, suggested in an early article that its Achilles' heel was that its culture was limited. Therefore he suggested that it belonged in the world of commercial art because it was essentially about "packaging," about "trademarks," like designer jeans. It certainly had "the look of the times, this is what packaging should look like: kids would buy it. These guys should get themselves design jobs, before they get ripped off. Several have already worked their way into the applied arts, where they belong: on record covers, doing the art direction for movies, slides behind Rappers, backdrops for Breakers. Sitting by yourself on a wall is different."[52] But just as graffiti art was not taken up for long by the art world, it was not

taken up by the commercial art world, not in the way rap music was assimilated by the pop music industry. Indeed, rap music transformed popular music, becoming increasingly sophisticated as rap musicians learned to use samplers—that is, computers that could appropriate and reproduce existing sounds and mix them in every conceivable way.

The art-world consensus was that graffiti art was inferior, even the best of it. A few art professionals thought otherwise, however. For example, Adam Gopnik wrote from the vantage point of 1992 that wild-style graffiti "was one of the few genuinely original and inspired decorative looks to have appeared in the past twenty years; the gaudy, maniacally congested gleaming letters overlapping and intertwined in patterns as hypnotically dazzling as any Hibernian illumination—part Gaudí and part Walt Disney. It was an authentic vernacular expression." But Gopnik added: "Wildstyle, though, never found a real home in the art world proper. The good stuff was too big, and too ephemeral: once the style was reduced to conventional canvas style, it looked thin."[53] Josh Baer, director of White Columns in New York City, who invited the graffiti artists to show in the gallery, had come to this same conclusion as early as 1982. "The meaning definitely changes as it goes from the street to the gallery. . . . Over the last year, it became much milder."[54] Graffiti painting had lost its brash and raw edge. It may be, as Fab 5 Freddy said, that "graffiti dies when it's legalized."[55]

There were other reasons for the decline of graffiti art. One was a subtle brand of racism. White sophisticates viewed graffiti as the product of black instinctual innocents and dabbled in it for the sake of temporary kicks—a kind of *nostalgie de la boue*. Some rich collectors were so titillated that they even invited ghetto blacks into their homes, but once or twice, not more, because their "guests" lacked the requisite sophistication and manners. In any case collectors felt more comfortable with middle-class white artists, like Haring and Scharf.

Like the graffiti artists, the Kids of Survival (K.O.S.) were ghetto dwellers, but there the similarity ended. They were organized into an art-making group by Tim Rollins, a white artist who had a fine arts degree, had studied with Joseph Kosuth and had been his studio assistant, and had helped found Group Material, an organization of Beuys-inspired, socially committed artists. As a teacher in a South Bronx junior high school, Rollins turned his "classroom [into] a sort of refugee camp for students with learning problems who were not doing well at all in their other classes. Yet many of these 'unteachable' kids had extraordinary artistic talent. . . . The classroom became a working studio."[56]

Rollins recognized that a lack of culture had limited the graffiti spray painters and had been responsible for the art-world's rejection of them. But he also believed that their particular life experiences could contribute a rich subject matter and content to art. He would bring together a group of underprivileged young people, teach them, and with

them create art. The resulting works would be made *with* and not merely *about* the "people." The purpose was to make art. With Beuys in mind, Rollins attacked as "dangerous" the "idea that the world is a social sculpture . . . because who's doing the molding? Society is not an artwork. Art is a construct of society."[57]

Rollins then founded Tim Rollins + K.O.S.—a collaborative of some fifteen local teenagers. In forming an art-making group, he challenged the traditional conception of the individual creator. He did not want to be a guru but to engage in a genuine collaboration. Nonetheless, as he said: "I have authority, I'm the conductor because I'm older and more experienced, but on the other hand I haven't had *their* experiences, so all of us together are better than any one of us separately."[58]

Rollins had the K.O.S. read books he assigned and "draw what came to their minds—not illustrating the text but relating the meaning of it to their everyday life."[59] At one point an eleven-year-old drew directly on the pages of the book, and it clicked. The page now "had two layers of meaning and history." Then books were taken apart, the pages affixed to linen in a minimalist gridlike fashion and painted on. The visual and the verbal were organically integrated. The texts underneath were not meant to be read but were the basis of the imagery. The images did not illustrate the texts but interpreted them.

Rollins recalled:

> The first paintings were from what I call the "blood and guts" tradition of political art [aiming] to indict and hopefully to transform . . . society. . . . These works presented a white outsider's view of the South Bronx . . . with references to drugs, shoot-outs, misery, fires, lurid colors, and cartoonish characters. . . . As we all worked deeper, the images had more to do with fantasy, eroticism, religion and beauty.[60]

The *Amerika* series (1984–89) [171], Tim Rollins + K.O.S.'s best-known work, was based on the last chapter of Franz Kafka's book, in which the protagonist sees hundreds of women dressed as angels playing horns. The pictures contain multiple images of mutant golden horns of all biomorphic shapes and sizes. They were improvisational but knowingly alluded to the works of Bosch, Redon, Klee, and Miró and also to Dr. Seuss illustrations, and Marvel Comics. Other books interpreted by Tim Rollins + K.O.S. were Melville's *Moby-Dick*, Crane's *Red Badge of Courage*, Carroll's *Alice in Wonderland*, Orwell's *1984*, Flaubert's *Temptation of St. Anthony*, and Malcolm X's *Autobiography*.[61] Each called for different treatment. For example, Tim Rollins + K.O.S.'s version of the *Red Badge of Courage*, a novel about the Civil War, featured jewel-like wounds inspired, as Grace Glueck reported, "by actual scars on two of the youths' bodies; by the stigmata of Jesus in the Isenheim Alterpiece . . . , and stark photographs by Peter Magubane of South African blacks who were injured in demonstrations against apartheid."[62]

Rollins + K.O.S. was taken on by commercial galleries, and its work achieved considerable art-critical acclaim.[63] Art critic Jerry Saltz commented that Rollins went *"outside* the system in order to get *in.* And he brought these young artists with him—not as freaks (as was the case of some of the early 80s attempts to institutionalize subway Graffiti artists) but with dignity and respect."[64] But Rollins did not forget the roots of the group in the ghetto, its genesis in public education, or his desire for social change. Much of the money Rollins + K.O.S. earned was put aside for the creation of a tuition-free South Bronx Academy of the Fine Arts whose curriculum would be modeled on their collaboration.

171. Tim Rollins + K.O.S., *Amerika II,* 1986. *(Mary Boone Gallery, New York)*

NOTES

1. Michael Shore, in "Punk Rocks the Art World: How Does It Look? How Does It Sound?" *Art News,* Nov. 1980, recounted the history of the music.

 Punk Rock began concurrently in England and New York as a violently revisionist reaction against what young musicians and fans saw as a monolithic, overly sophisticated, irrelevant rock music establishment. Punk was originally performed by young, untrained musicians who deliberately flaunted their inexperience, simultaneously revering and radically reworking rock's musical roots: their songs were generally brief in duration, basic to the point of crudity, rhythmically fast and emphatic, sonically abrasive and assaultive, with provocative, even vicious, lyrics. (pp. 79–81)

2. Ibid., p. 79.
3. Ibid.
4. Thomas Lawson, "Nostalgia as Resistance," *Modern Dreams* (New York: Institute of Contemporary Art: Clocktower Gallery, 1988), pp. 153–54. Other filmmakers in the New York Underground Cinema were Charles Ahearn, Becky Johnston, Jim Jarmusch, and James Nares. See Fred Brathwaite, a.k.a. Fab 5 Freddy, "Jean-Michel Basquiat," *Interview,* Oct. 1992, p. 119.

 Lawson also wrote: "Musicians like Rhys Chatham and Glenn Branca could claim to be continuing the traditions of serial music, but at the same time, enjoyed playing with the urgency and glamour provided by the rock format" (p. 153).

5. Jeffrey Deitch, in "'Cold War Zeitgeist' at the Mudd Club," *Art in America,* Apr. 1980, wrote that the Mudd Club catered to artists in order to "draw the 'right kind' of art crowd; in return, the artists have the run of the place from 9:00 to 11:00 before the regulars arrive" (p. 134).

6. Shore, "Punk Rocks the Art World," p. 84.

7. Deitch, "'Cold War Zeitgeist' at the Mudd Club," pp. 134–35.

8. Kim Levin, "The Times Square Show," *Arts Magazine*, Sept. 1980, pp. 87–88.

9. Robert Pincus-Witten, "Entries: If Even in Fractions," *Arts Magazine*, Sept. 1980, p. 117.

10. Levin, "The Times Square Show," p. 88.

11. "The Woman's Movement in Art, 1986," *Arts Magazine*, Sept. 1986, p. 57.

12. Anne Ominous [Lucy R. Lippard], "Sex and Death and Shock and Schlock: A Long Review of the Times Square Show," *Artforum*, Oct. 1980, p. 51.

13. "The Woman's Movement in Art, 1986," *Arts Magazine*, Sept. 1986, p. 57.

14. Ominous, "Sex and Death and Shock and Schlock," p. 53.

15. Despite Colab's countercultural program, it solicited and received grants for *The Times Square Show* and other shows from the New York State Council on the Arts, the National Endowment for the Arts, the New York City Department of Cultural Affairs, National Video Industries, and a half dozen or so corporate and private sponsors.

14. Ominous "Sex and Death and Shock and Schlock": 53.

16. Colab's purpose was to raise funds, organize exhibitions, share equipment, and somewhat later, to run the ABC No Rio Gallery in Manhattan's impoverished Lower East Side.

17. Lisa Liebmann, "At the Whitney Biennial: Almost Home," *Artforum*, Summer 1985, p. 59.

18. In 1988 Group Material mounted an ambitious four-part show, titled *DEMOCRACY*, at the richly endowed Dia Art Foundation in New York, an official art-world venue. The parts were "Politics and Election," "Education and Democracy," "Cultural Participation," and "AIDS and Democracy: A Case Study." The exhibition contained the works of established artists and schoolchildren, grade-school clock and desks, a TV set, bags of snack foods, and bric-a-brac of all sorts. Group Material held a series of panels and town meetings to discuss issues raised by the exhibitions. See David Reisman, "Looking Forward: Activist Postmodern Art," *Tema Celeste* 29 (Jan.–Feb. 1991): 60.

19. Simon Frith and Howard Horne, in *Pop into Art* (London: Methuen, 1987), pp. 131–32, characterized McLaren's artifacts as "*subversive* Pop art" and as "pop situationism."

20. Michael Boodro, "Radical Cheek," *Art News*, Jan. 1989, pp. 115–16.

21. C. Carr, "Never Mind the Bollocks, Here's the Impresario," *Village Voice*, Sept. 27, 1988, p. 40.

22. Peter Plagens, "Issues & Commentary: Mixed Doubles," *Art in America*, March 1982, p. 13.

23. Klaus Kertess, "Brushes with Beatitude," in Richard Marshall, ed., *Jean-Michel Basquiat* (New York: Whitney Museum of American Art, 1992), p. 50.

24. Josh Baer, interviewed by Irving Sandler, New York, Apr. 13, 1992, recalled that Diego Cortez, an early champion and friend of Basquiat, proposed to White Columns that he mount a show of Basquiat, Twombly, and Dubuffet. Marco Livingston, in *Pop Art: A Continuing History* (New York: Abrams, 1990), p. 229, wrote that Basquiat was also influenced by Larry Rivers's pictures, "such as *Cedar Bar Menu* (1959) in its casual approximation of a found object, complete with hand-scrawled texts and images of ostentatious crudeness and simplicity."

25. Richard Marshall, "Repelling Ghosts," in Marshall, *Jean-Michel Basquiat*, p. 23. In many of his pictures, Basquiat obsessively incorporated anatomical diagrams and their annotations, culled from *Gray's Anatomy*, which had been given to him by his mother when he was a boy after a stay in the hospital.

26. Adam Gopnik, "Madison Avenue Primitive," *The New Yorker*, Nov. 9, 1992, p. 138.

27. Robert Storr, "Two Hundred Beats Per Min.," in John Cheim, ed., *Jean-Michel Basquiat Drawings* (New York: Robert Miller Gallery, 1990), n.p.

28. Robert Farris Thompson, "Royalty, Heroism, and the Streets: The Art of Jean-Michel Basquiat," in Marshall, *Jean-Michel Basquiat*, p. 28.

29. Basquiat's pictures came to art-world attention in *The Times Square Show* of 1980, praised by Jeffrey Deitch in *Art in America* as "a knockout combination of de Kooning and subway spray-paint scribbles." He received even more critical attention the following year when he was included in Diego Cortez's *New York/New Wave* show at P.S. 1. And there was a great deal more to come.

30. Gopnik, "Madison Avenue Primitive," p. 137.

31. Andrew Decker, "The Price of Fame," *Art News*, Jan. 1989, p. 101.

32. Nicolas A. Moufarrege, "Lightning Strikes (Not Once But Twice): An Interview with Graffiti Artists," *Arts Magazine*, Nov. 1982, p. 88.

33. Keith Haring, "Keith Haring," *Flash Art* (Mar. 1984): 22.

34. Jeffrey Deitch, "The Radioactive Child," *Keith Haring* (Amsterdam: Stedelijk Museum, 1986), p. 11.

35. Francesca Alinovi, "Interviews with the Artists: Keith Haring," *Flash Art* (Nov. 1983): 29–30.

36. Livingston, *Pop Art: A Continuing History* , p. 228.

37. Moufarrege, "Lightning Strikes," p. 88.

38. Gerald Marzorati, "Kenny Scharf's Fun-House Big Bang," *Art News*, Sept. 1985, p. 81.

39. Alinovi, "Interview with Kenny Scharf," pp. 30–31.

40. Marzorati, "Kenny Scharf's Fun-House Big Bang," pp. 77–78.

41. Ibid., pp. 75, 77.

42. A first generation of graffiti writers had emerged around 1970. A few early attempts were made to introduce some of them into the art world, in SoHo shows at the Razor Gallery in 1973 and Artists Space in 1975, with a catalog introduced by Peter Schjeldahl. But they had not been successful despite being featured in

the mass media; for example, a major article in *New York* in 1973, and an essay by Norman Mailer in *The Faith of Graffiti* (New York: Praeger Publishers, 1974), documentation by Mervyn Kurlansky and Jon Naar. See Joan Wallace and Geralyn Donohue, "Edit DeAk," an interview, *Real Life* 8 (Spring–Summer 1982): 4.

43. In Moufarrege, "Lightning Strikes," Kano, a graffiti writer, said: "Graffiti is the culture of the ghetto world" (p. 89).

Some of the graffiti artists did not come from disadvantaged homes. Grace Glueck, in "Gallery View: On Canvas, Yes, but Still Eyesores," *New York Times*, Dec. 25, 1983, sec. 2, p. 22, reported that "Blade's father, for example, owns two Yellow Cabs, one of which Blade drives; Toxic's father is a retired policeman; Seen's father owns a construction business, and Noc 167's mother . . . is a journalist. And some have even had art training."

44. Wallace and Donohue, "Edit DeAk," p. 3.
45. Varnedoe and Gopnik, *High & Low*, pp. 376–77, 382.
46. Levin, "Art: The 57th Street Stop," p. 119.
47. Mary Harron, "Rapping: A Postcard from the Ghetto to the City," *ZG* 6 (1982): n.p. Jon Pareles, in "How Rap Moves to Television's Beat," *New York Times*, Jan. 14, 1990, sec. 2, p. 28, observed that rapping was influenced by

the cadences of gospel preachers and comedians, the percussive improvisations of jazz drummers and tap dancers. It also looks to Jamaican "toasting" (improvising rhymes over records), to troubadour traditions of social comment and historical remembrance that stretch back to West African griots, and to a game called "the dozens," a ritualized exchange of cleverly phrased insults. And of course, rap wouldn't exist without the 1960's and 1970's funk records—especially James Brown songs—that supply beats, bass lines and interjections

for innumerable rap recordings.

48. Wallace and Donohue, "Edit DeAk," p. 4.
49. Shaun Caley, "Keith Haring," *Flash Art* (Summer 1990): 125–26.
50. Suzi Gablik, in "Report from New York: The Graffiti Question," *Art in America*, Oct. 1982, p. 35, anticipated the fall of the graffiti artists by asking whether they have "sauntered out onto a limb that ultimately will not support them but only breed new expectations, false hopes and disappointments."
51. Moufarrege, "Lightning Strikes," p. 89.
52. René Ricard, "The Radiant Child," *Artforum*, Dec. 1981, p. 40.
53. Gopnik, "Madison Avenue Primitive," p. 138.
54. Josh Baer, "Space Invaders," *ZG* 6 (1982): n.p.
55. Richard Goldstein, "In Praise of Graffiti: The Fire Down Below," *Village Voice*, Dec. 24, 1980, p. 58.
56. Tim Rollins, in *The BiNational: American Art of the Late 80's* (Boston: Institute of Contemporary Art and Museum of Arts, 1988), p. 168.
57. Ibid., p. 171.
58. Tim Rollins, in "Making Art, Making Money," p. 178.
59. Rollins, in *The BiNational: American Art of the Late 80's*, p. 170.
60. Ibid.
61. Because Rollins focused on the classics of Western literature he was accused of cultural imperialism, that is foisting an alien culture on his ghetto associates.
62. Grace Glueck, "'Survival Kids' Transform Classics to Murals," *New York Times*, Nov. 13, 1988, sec. 2, p. 42.
63. Rollins + K.O.S. were paid for making art by the Art and Knowledge Workshop, a nonprofit organization founded by Rollins in 1982. Rollins was accused of exploiting K.O.S. for his own fame and fortune. See Mark Lasswell, "True Colors: Tim Rollins's Odd Life With the Kids of Survival," *New York*, July 29, 1991, pp. 30–38.
64. Jerry Saltz, "Snapshot American Art 1980–1989," *American Art of the 80's* (Milan: Electa, 1991), p. 217.

15 COMMODITY ART, NEOGEO, AND THE EAST VILLAGE ART SCENE

Neogeo was a label given a group of artists who emerged in the East Village and became the focus of art-world attention in 1986. They were Ashley Bickerton, Peter Halley, Jeff Koons, and Meyer Vaisman, as well as Haim Steinbach and Allan McCollum, who were soon associated with them. They were linked in part because they had rejected neoexpressionism on the grounds that it had become familiar and established. Shortly before their sudden emergence, Michael Brenson asked in a Sunday *New York Times* article: "Is Neo-Expressionism an Idea Whose Time Has Passed?" His answer was that it had.

> An artistic moment has passed. It is not that the phenomenon known as Neo-Expressionism is dead, or that the artists identified with it are no longer the subject of intense interest and debate. But the fire that was lighted by those European and American artists whose bold, large-scale, usually painted, figurative work burst into prominence around 1980 with a flair and sweep that seemed to make everything possible is now down to a glow. Together, it is unlikely that they will receive the same kind of attention again.
>
> [There] is now a sense of saturation . . . a widespread feeling of "enough!"[1]

The time seemed ripe for a new move, and the neogeos made it.

The neogeos are best treated as two closely-connected groups. One, consisting of Bickerton, Koons, Steinbach, and Vaisman, appropriated commodities and their labels from consumer culture. They were influenced by Duchamp's readymades; pop art, notably Warhol's pictures of Campbell's soup cans and sculptures of Brillo boxes; and the deconstruction art of Barbara Kruger. But they were equally inspired by minimal sculpture, the high style that had recently been avant-garde but was now established enough to be considered the newest classicism. It provided the model for the shelves on which Steinbach placed his commodities, the vitrines in which Koons encased his, and the boxes on which

172. Richard Artschwager, *Description of Table*, Variation: *Grey Table*, 1964. *(Copyright © 1994 Whitney Museum of American Art)*

Bickerton affixed his labels. Another important predecessor was Richard Artschwager, whose Formica "furniture" combined pop and minimal art [172].[2] Bickerton, Koons, Steinbach, and Vaisman contrived a shrewd amalgam of conceptual art, pop art, and minimal art, which added up to a novel variant of media and deconstruction art. Consequently their art is more accurately labeled commodity art than neogeo.

The second group, consisting of Halley and McCollum, were neogeo, because they simulated modernist geometric painting. Ross Bleckner's recycling of op art was a major influence. Halley related Bleckner's appropriation to that of such postmodernist photographers as Sherrie Levine and Cindy Sherman, except that Bleckner transplanted appropriation into the traditional medium of painting. Thus he enabled geometric abstraction to challenge the hegemony of neoexpressionist figuration.[3] Neogeo work was related to commodity art because it used appropriation and treated historic geometric abstraction as a kind of commodity, whose value had been established by the museums, academia, and above all, the art market.

Both the neogeos and commodity artists—for whom Halley was the main spokesperson—considered consumer society and the mass-media

that fueled it as "spectacle." They were influenced by fashionable post-structuralist and neo-Marxist theory, particularly that of Jean Baudrillard, who became a kind of cult figure. Baudrillard believed that the mass media had replaced reality with an all-encompassing web of images or simulacra. Simulations had become more real than reality—or "hyperreal"—and had come to refer to nothing outside of themselves. Baudrillard concluded that there was no escape from this "spectacle."

The commodity artists seemed to accept that they were trapped in consumer society and could make art only by "shopping" for existing artifacts and images; their art was often called simulationism.[4] But their attitude toward these subjects and consumer society at large was ambiguous. It was not clear whether their art was complicit or transgressive or complicit *and* transgressive? Did the artists fetishize commodities, as Warhol had; deconstruct them, as Kruger had; or give rein to fantasy, as Artschwager had? On the one hand their work was visually appealing, as if the mass-produced commodities they chose to showcase were icons. On the other the products were just that—gross products. Were they implying a critique of consumerism? The issue was much debated in the late 1980s—without being resolved.

Although commodity artists were influenced by Artschwager, they did not distort everyday objects imaginatively, as he did. Fantasy did not seem to be a goal. Neither was social commentary, or if it was, it was too ambiguous—far more than in Kruger's work—to be recognizable. More likely, the commodity artists were complicit with consumerism, closer to Warhol than to Artschwager or Kruger. As Meyer Vaisman said: "The best art in any given era absolutely mirrors that era and its physical parameters. I don't believe that art is a particularly effective medium to pass judgments or propose solutions."[5]

Warhol was indeed much admired by the commodity artists. He had created *the* exemplary art of the consumer society—paintings and sculptures that represent mass-produced commodities and were fabricated much as they were [173]. They were meant to signify that the United States was the best of all possible worlds—the neo–New World. As Warhol said:

> What's great about this country is that America started the tradition where the richest consumers buy essentially the same things as the poorest. You can be watching TV and see Coca-Cola and you know that the President drinks Coke, Liz Taylor drinks Coke, and just think, you can drink Coke, too. A Coke is a Coke and no amount of money can get you a better Coke than the one the bum on the corner is drinking. All the Cokes are the same and all the Cokes are good. Liz Taylor knows it, the President knows it, the bum knows it, and you know it.[6]

As for culture: "Everybody was part of the same culture now. Pop references let people know that *they* were what was happening, that they didn't

173. Andy Warhol, *Green Coca-Cola Bottles,* 1962. *(Copyright © 1994 Whitney Museum of American Art; photograph copyright © 1988 Geoffrey Clements Inc., New York)*

have to *read* a book to be part of culture—all they had to do was to *buy* it (or a record or a TV set or a movie ticket)."[7] Shopping had become culture.

The progeny of Warhol would identify themselves through their purchases, and the brand names—Gucci, Rolex, Vuitton—blazoned on these products. Thus they would fashion their individual lifestyles. The consummate items of individuality were works of art, and they could be considered the ultimate consumer products. Artists too chose to identify themselves in their art by "shopping" for images and commodities from the consumer society and collectors, by shopping for art.

Warhol aspired to be a business artist. Consequently, he fashioned commodities for the art market. To better merchandise them, he sought and attained celebrityhood. He also showed that commodities touched by a celebrated artist could be transformed into art and command high prices. The anointed objects did not even have to be called art. A shopping junkie himself, Warhol had accumulated a mountain of kitsch, most

of which he never looked at again, much less used. After his death some ten thousand items, including nineteenth-century academic paintings, Art Deco furniture, cookie jars, Fiesta ware, toys, and a vast assortment of flea-market bric-a-brac, were put up for auction with the kind of excessive hype that Warhol would have loved. Sotheby's estimated that the sale would bring up to fifteen million dollars. It brought almost twice that. Art critic Gary Indiana concluded: "The success of the Warhol Auction marks the highest recognition of shopping as a way of life."[8] The consummate business artist, he achieved the American dream of riches and fame. As a skillful social climber and self promoter, he had become a household name during his life. After his death he became the holy ghost of commodification.

Warhol was a role model to the neogeos and commodity artists who were avid careerists. But their careerism could be rationalized as an ironic commentary on careerism, or even, as a *détournement*—to use the situationist term—a deflection and thus a subversion of careerism—and commodification. Kirk Varnedoe and Adam Gopnik wrote that if, as Baudrillard maintained, there was no escape from capitalism's "spectacle," then there was "no possibility of rebellion." Consequently "all that one could hope to do was to retreat into deep cover, taking up a position of frozen equanimity within the society which one despised, and participating in its evils so fully and wholeheartedly that in retrospect one's actions could only be understood as a form of irony."[9] Warhol could also be viewed in this manner, his images not icons of consumer society but subversive portraits of society which mirror its emptiness, conformity, and superficiality. At the same time he was supposed to have manipulated the media and the foibles of the fashionable rich, cashing in at their expense. Rather than being the Peter Pan of the consumer society, he was, as Henry M. Sayre wrote, "the exploiter of exploiters, the poor kid from a working-class, immigrant background who turned the tables on the rich."[10]

Pop art had blurred the line between a work of art as a commodity and any other commodity. It followed that a commodity could be a work of art. *Artforum* accepted that it could—as early as 1982—and consequently paved the way for commodity art. In an editorial Ingrid Sischy and Germano Celant wrote that the magazine would embrace "an artistic pantheism affecting all aspects of the merchandising of culture and the culturalizing of merchandise. Art becomes capable of appearing anywhere, not necessarily where one expects it, and crossing over and occupying spaces in all systems." Sischy and Celant even featured a fashion designer, Issey Miyake, illustrating his work for the editorial. They also likened art to fashion, both of which depend "on the manipulation of preceding 'models' (neoclassicism, new wave, neoexpressionism, neorealism, neoromanticism, neofauvism, neolook). Such hyperconsciousness of historical styles, such facility with their renderings, recall the Mannerist attitude, which today is based not on originals, but on reproductions that transforms art into legend—Pop icons."[11]

* * *

How did Ashley Bickerton arrive at commodity art? As a student at CalArts, he had been a painter but was heavily influenced by its conceptual art orientation. He based his images on words—SUSIE, BOB, GOD—but he embellished them extravagantly. Subsequently he reduced the words to primitive utterances, such as UGH, GUG, or phonetic babble, but lettering remained central to his work. Bickerton also began a dialogue with formalism, posing the question: What is a painting? What is it *literally?* His answer was to exaggerate the physical elements of paintings—to the point of parody. In order to accentuate the picture plane, he projected it into actual space so that it became the surface of a minimal-like metal box.[12] He also emphasized Ryman-like brackets that attached a "picture" to the wall by enlarging them. He provided screws with which to hang the work; pockets to hold them; packing materials, neatly rolled and tied; the handles needed to transport the work; and occasionally suspension wires to secure the box to the wall. The works became, as he said, "'hyperrealizations' or caricatures of the conventional art object. . . . These are paradigms of paintings."[13] Bickerton would make their overstated components the elements of his style.

On the surfaces of his reliefs Bickerton meticulously painted installation instructions and a list of all the materials of which the works were composed, presumably for the purpose of conservation. He then began to incorporate information about the function of the work in the art world and the larger world—warnings about the toxic effects and environmental hazards of the materials, and the name SUSIE, which he said would serve as an "Index/Name Brand/Artistic Signature" facilitating the cataloging and archiving of his work.[14] To indicate that a painting was a commodity, he incorporated a digital meter that recorded its minute-by-minute increase in price. Bickerton remarked: "I wanted to look at the entire art scene from a holistic point of view, objects as utilitarian things that [were] lifted, shipped, stored, hung." The work displayed "on the wall of the gallery is only one minute fraction of that object's existence and total meaning."

Above all Bickerton's works are a commentary on commodification—or, as he put it, the colonization of America and art by advertising. He was particularly inspired by surfboards, as he said, "massively smeared with corporate sponsorship decals. The logos became a form of expression, about the relationship to corporate culture."[15] With this in mind Bickerton invented his own logo, CULTURE-LUX (culture-luxury)—to accompany SUSIE—and the motto THE BEST IN SENSORY AND INTELLECTUAL EXPERIENCES.

Bickerton's consummate statements on consumerism were one piece in which he put the surface up for sale to advertisers who had to pay to become part of a work of art, and two *Self-Portraits* [174]. He had seen a self-portrait of Van Gogh at the Metropolitan Museum of Art and was inspired to paint his own, but consisting of an assortment of corpo-

rate logos and decals—Bayer aspirin, CalArts, *Surfer* magazine, *Village Voice*, Citibank, Marlboro cigarettes, Integral Yoga Natural Foods, etc., products he himself used or consumed, constructing an "idea" of himself from the brandnames. Thus Bickerton defined himself through commodities and institutions. Like public advertising these "private" works

174. Ashley Bickerton, *Tormented Self-Portrait (Susie at Arles),* 1987–88. *(Museum of Modern Art, New York; photograph copyright © 1995 Museum of Modern Art, New York)*

had a slick machine-made look, although they were painted painstakingly by hand.

Critics differed as to whether Bickerton was being straightforward—this is my life—and thus a new kind of expressionist, or ironic? Ronald Jones wrote: "From the first, Bickerton's paintings centered on the struggle to recover the first person, uncover the obliterated self."[16] In contrast Eleanor Heartney maintained, with *Tormented Self-Portrait (Susie at Arles)* in mind, that the "overriding spirit seems to be one of self-mockery, as Bickerton illustrates the enormous distance between today's upwardly mobile, entrepreneurial young artist and the tragic hero of modernist myth."[17]

Bickerton believed that his reliefs mirrored the reality of our time, namely that "every space has been marked, touched, charted and catalogued. . . . It's all been circumscribed and prepackaged and inscribed in the form of kitsch." This had given rise to a sense of loss, but "we can reinvent ourselves in kitsch, like a dog can get excited about going out for a walk on a chain."[18] Indeed, "We must mythopoeticize it."[19] From this vantage point, art critic Christian Leigh viewed Bickerton as a kind of latter-day bad-boy Huck Finn and his works as "rafts," voyaging into a hyperconsumerist future. "It's not hard to imagine that they conceal built-in stereo systems, ashtrays, portable TVs, solar-energy panels, satellite dishes, clock radios, full bars, microwave units, fishing rods, radar and telegraph devices, and a running supply of water—everything we need to make it in a future existence somewhere between wild paradise and grand apocalypse."[20]

At the end of the 1980s Bickerton began to build conceptual "landscape pieces." If all of reality had been circumscribed by man, the only way nature could be understood was through human-made artifacts. Hence he employed commodities that people use to go into nature—camping, mountain climbing, and sailing equipment. Responding to work like that of Bickerton, Jeffrey Deitch wrote that a "new kind of artificial nature [is replacing] natural nature, that we used to take for granted. . . . Nature is maybe a trip to a national park where you have to stand in line and take a bus tour, or a trip to Tahiti in a Club Med village. More likely than not, because art is completely immersed in the electronic media, nature is something that we absorb over TV. Now nature is as artificial and re-created as the works of art themselves."[21]

Bickerton soon found another, ecological, rationale for his landscape pieces. Mixtures of agricultural substances and industrial waste, encased in anodized aluminum, black leather and glass, they called attention to humankind's devastation of the environment. In *Landscape #1* (1988) Bickerton affixed a warning label that read: "ATTENTION! THIS ARTWORK'S PHYSICAL EXISTENCE AND ATTENDANT VALUE STATUS IS INDIVISIBLE FROM THE MASSIVE ONGOING DEGRADATION, IMPOVERISHMENT, AND DESTRUCTION OF THIS PLANET!" In *Still Life (The Artist's Studio After Braque)* (1988) Bickerton wittily alluded to the poisonous effects both of ecological cont-

amination and consumerism. Composed of toxic materials—and a warning label against exposure to them—it contained a digital meter that displayed the work's price, beginning at $25,000 and rising at the rate of two cents a minute.[22] The more time spent contemplating the piece, the more life-threatening and expensive it became. It killed the collector as it provided pleasure and made money.

Like Bickerton, Meyer Vaisman parodied the dogmas of formalism by exaggerating the physical components of painting, in his case magnified canvas weave, photomechanically reproduced onto actual canvas. The fabric pattern, which became a kind of signature image, poked fun at the formalist requirement that a painting must refer only to itself. Vaisman further asserted the painting's "objecthood" by projecting his pictures into the room, using thick stretchers and/or stacking canvases one on top of the other on the floor or wall. The canvas-weave motif also called into question another formalist dictum, that only abstract art was valid. The pattern looked nonobjective but was actually the representation of a real thing.

Furthermore, taking his cues from Warhol, as Bickerton had, Vaisman professed to "mirror" society.[23] His view of American life was perverse, to say the least, exemplified by excrement, money, debased sex, fraudulent art, and the artist—Vaisman himself—as faker. In *The Whole Public Thing* (1986) [175] four canvases, piled on the floor, are crowned with four toilet seats whose tops are covered with his printed canvas-

175. Meyer Vaisman, *The Whole Public Thing*, 1986. *(Sonnabend Gallery, New York)*

weave canvas, inviting viewers to defecate on art. Sex came off no better than art. *Painting of Depth* (1986) contains three waist-high holes lubricated with grease, which refers to Dutch Wives, masturbatory devices for sailors. Sex is reduced to carnality.

Vaisman introduced his own image as a motif in a number of his works. In *The Uffizi Portrait* (1986) his portrait was a cartoon drawn by a street artist in front of the Uffizi Gallery in Florence. The sketch seemed to ask to be compared with the masterworks in the museum. He viewed the portrait "as a caricature of our civilization"[24]—the decline and fall of Western man—and of art—art reduced to kitsch. At the same time, his gesture aimed to reveal—and nihilistically—art's inherent fraudulence. As Vaisman commented, "In a sense all culture is fake, and in that sense this art, being consciously fake, is more real than the other kind."[25] *The Morgue Slab* (1987) contained silk-screened profiles of portraits on ancient and modern coins juxtaposed with his signature, signature canvas weave, and self-caricature, suggesting that they were all of a kind. As Vaisman pictured it, money, art, and the artist's self were equally debased.

In 1990 Vaisman showed mass-produced copies of historic tapestries, the kind that appealed to middlebrow taste, on which he had superimposed hand-embroidered cartoon images. Dan Cameron wrote that the wall hangings were a spoof on contemporary art-making.

> [Vaisman] looks the best-intentioned spectator straight in the eye and says, "Look, Bud, you and me both know the game's over, so why bother keeping up the pretense anymore?"
>
> Even the ads for this show were, in such a context, particularly revealing, with Vaisman's now-signature organ-grinder's monkey in top-hat and tails, biting into a coin and fixing us with a lean, jungle-primate stare. It is the artist himself, playing inter-species, cross-dresser.

Cameron concluded that Vaisman reveled in proclaiming that the emperor had no clothes and profiting from it as well.[26]

In the early eighties Haim Steinbach created his signature style—arrangements of mass-produced, consumer goods displayed on wedge-shaped shelves constructed from wood laminated with Formica [176]. These sculptures call to mind Duchamp's readymades, Warhol's Brillo boxes, Artschwager's Formica "furniture," and Judd's minimal reliefs. As Steinbach commented: "My work . . . plays on Pop and minimal references."[27]

The minimal shelves "bracketed" commodities Steinbach selected, abstracting them from their usual surroundings and establishing for them an aesthetic frame, a context of art that enables them to be perceived as art. They become stages of sorts for tableaux in which products

become inanimate actors. At the same time, the shelves resemble com-
mercial display racks, turning minimal sculpture into consumerist
props. Thus both the merchandise and the shelves hovered in between
being art-objects-as-commodities and commodities-as-art-objects.

Steinbach reduced the creative process to appraising, choosing,
purchasing, arranging, and displaying—representing the major activities
in consumer society. In sum, his art making was a kind of shopping.
Consequently socially minded critics viewed Steinbach's work as a cri-
tique of consumer society, conflating advertising, shopping, and art.[28]
But there was no agreement as to whether he was critical or complicit.
On the one hand his work was viewed as an art of "resistance," taking a
familiar form and giving it a new, and provocative, meaning, detouring
its meaning, as it were.[29] Edward Ball offered this interpretation, com-
menting that Steinbach's "repetitive mantel-set pieces . . . emulate the
narcotic rhythms of the marketplace. [They] cite the shelves of the dis-
count department store and its warehouses, with their stockpiles of con-
sumer products no one wants, in which case the planned obsolescence of
capitalism becomes a central subject of Steinbach's constructions."[30] On
the other hand the works were viewed as trophies or icons of con-
sumerism. More likely, as art critic Holland Cotter observed, the sculp-
ture was both; it "does not answer to a programmatic either/or, [but
exists] precisely on that thin line of 'extreme ambivalence' between criti-
cism and celebration: a state of fascination, you might say, both with the
enticement of the objects and with the values they create and preserve."[31]

Steinbach himself considered the artifacts he collected as objects of

desire, visually attractive rather than distasteful. He culled his artifacts from flea markets and antique shops as well as from the supermarkets, treating them all on a par. As Germano Celant wrote, "Steinbach risked losing himself among things, opening himself to their seduction, their enchantment, their meaning."[32] In transplanting consumer items that appealed to him from the marketplace into the art gallery, he presented them solely for whatever expressive or aesthetic value they might have individually and in concert. As he said:

> What I do with objects is what anyone can do, what anyone does anyway with objects, which is to talk and communicate through a socially shared ritual of moving, placing and arranging them. . . .
>
> People communicate with objects, indicating their attitudes towards them, by the way they use, present and gesture with them. Everyone collects, arranges and presents objects. Presenting one's objects is most often a self-conscious activity, a living room especially is a display case.[33]

Indeed, Steinbach's wares, as John Miller remarked, "are juxtaposed according to an acute formal sense—not unlike flower arranging."[34]

In 1980 Jeff Koons began to produce off-the-shelf vacuum cleaners, stacked or paired and showcased in pristine, fluorescent-lit, airtight, Plexiglas vitrines [177]. They were accompanied by light boxes containing advertisements for cigarettes or automobiles that featured the word "new." Koons was obviously influenced by Duchamp and Warhol; still his appropriations were critically different from theirs. Duchamp had claimed indifference in the choice of his readymades. Warhol presented consumer products as icons, but in an utterly deadpan fashion. In contrast Koons highlighted and glamorized his vacuum-packed everyday appliances, with all the lust for commodities that characterized the consumerist 1980s. He probed the edge where commodity fetishism and art fetishism interfaced and revealed how commodities can function as works of art and how works of art function as commodities. What made Koons's objects look novel in a way that Duchamp's and Warhol's no longer did, and made them seductive to sophisticated spectators, was their encasement in electrically lit minimal containers that quoted Judd's Plexiglas-sided modular boxes and Flavin's fluorescent tubes. Thus Koons, like Steinbach, shrewdly joined lowly consumer items with a high-art style.

 The "state-of-being-new" was the theme of the vacuum-cleaner pieces, as Koons commented.[35] Perfect brand-newness was equated with cleanliness and purity, goodness and immortality, with what he called "the eternal virgin."[36] From this point of view, dirt and decay represented death, and it is significant that vacuum cleaners are dirt-removing machines. They also had sexual attributes, both male and female, as

177. Jeff Koons, *New Hoover Convertible*, 1980. *(Courtesy of the artist)*

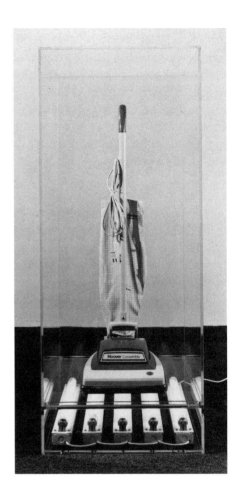

Koons remarked, sucking machines with phallic attachments.[37] But their sexuality was immaculate, their slick look negating any sense of the sweaty physicality associated with sex. Koons spun a web of words around his vacuum cleaner—and all of his subsequent—works, explicating them in an utterly serious and seemingly candid manner in frequent public appearances. Like Warhol, he can be considered as much a performance artist as a producer of art objects.

Koons recognized that at a time when neoexpressionism was monopolizing art-world attention, his commodity art would be ignored. So he abandoned the art world and became a commodity broker on Wall Street. In 1985 he felt that his moment had come and arranged for a one-person show at the International with Monument Gallery in the East Village. He used money he had made on Wall Street to fabricate new work. Titled *Equilibrium*, the show consisted of three kinds of bizarre objects: first, "equilibrium tanks," which were aquariums containing identical basketballs filled either with mercury or water so that they sank or floated incongruously at different levels in the tank; second, objects, such as a raft or an aqualung, cast in bronze, which would make them

life threatening if they were used—symbols of death; and third, framed ads for Nike footwear, mostly depicting African-American sports stars in the poses of businessmen or mythic heroes. As in the vacuum cleaner pieces, Koons formulated an elaborate rationale for his *Equilibrium* series, saying, for example: "The basketballs denote social mobility particularly for urban blacks. . . . The accompanying Nike ads are the sirens of 'go for it,' they are the great deceivers who tell you 'I've achieved the state of equilibrium. You can do it too. You'll be a star.'"[38]

The *Equilibrium* sculptures are remades, not readymades, signaling a change in Koons's procedure, and all of his subsequent work would be fabricated by skilled craftspersons. His next works were exhibited in the infamous show at the Sonnabend Gallery, which marked the sudden emergence of neogeo and commodity art in 1986. Titled *Luxury and Degradation*, the series consisted of stainless-steel castings of consumer products, the best-known of which was a bourbon-filled train marketed by the Jim Beam company. Koons said: "I emptied decanters of their bourbon, cast them in stainless steel, sent them back to Jim Beam to have them be refilled, and had the government reapply its tax stamp to them."[39] This icon of middle-class kitsch was an allegory of "society's relentless pressures to get ahead and acquire the look, accoutrements and habits of luxury." But that luxury was false, like stainless steel masquerading as a luxurious metal[40] signifying "an underlying degradation."[41] Still, rendering imperishable a commodity meant to be perishable, Koons made it "immortal."[42]

To emphasize the theme of the show, Koons displayed advertisements for alcohol, intended to encourage people to drink. He had these posters reproduced in oil paint, much as Lichtenstein before him had stenciled bendaylike dots in paint.

> I had to speak to every company to get permission. First of all, I had to know how to present my idea to them, and then to work with their lawyers and to work with the printers. These paintings aren't appropriated, they are reprinted, but they had to be reprinted off the original plates. The original full-size negatives were sent out from every company. The only thing that was transformed was the image from paper onto canvas, and then onto stretchers. So they're intellectual paintings. They're not handmade. They were made by a machine, and presented as paintings.[43]

Koons had transformed cheap ads into seductive luxury items.

Koons then cast into "new" stainless steel "old" figurines, dolls, and portrait busts, one of Louis XIV, in a series titled *Statuary*. The consummate work was a once-inflatable-plastic *Rabbit* [178] with a carrot. To Koons the rabbit was a symbol of fantasy, the great masturbator, the playboy, and the Easter bunny. Once cast, it also alluded to the polished sculptures of Brancusi and Arp. Kitsch and "high" modernist art were wittily united.

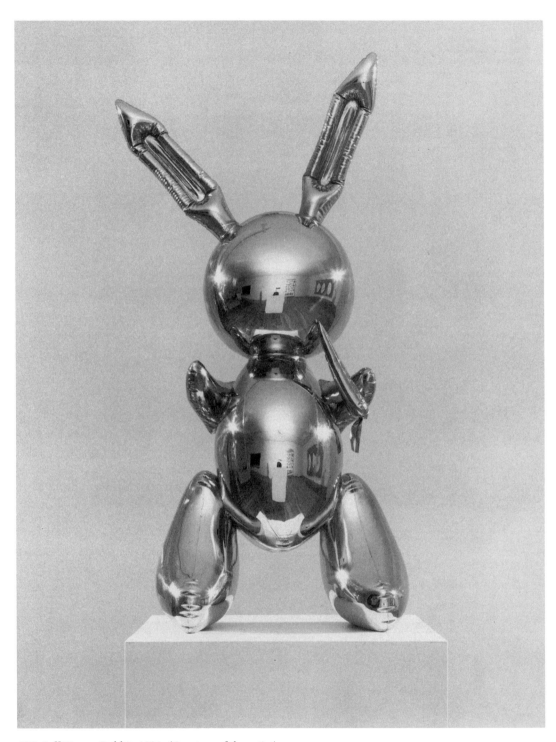

178. Jeff Koons, *Rabbit*, 1986. *(Courtesy of the artist)*

In 1989 Koons mounted *The Banality Show*, consisting of lifesize porcelain and polychromed wood sculptures fabricated by skilled craftspersons. One was a blown-up version of a girlie-magazine center-fold nude hugging a pink panther; another, a nude encountering a sub-marine periscope in her bath. The most outrageous image was of Michael Jackson in white porcelain cuddling his pet chimpanzee, Bubbles [179]. Again Koons's sculptures were clearly in the vein of Duchamp's readymades and Warhol's remades, but they were so blatantly "baptized in banality"[44] as to be metamorphosed into hyperkitsch. That apparently could and did shock many in the art-world audience who "claimed not to have been shocked by anything at all since the early six-ties."[45]

Koons's objects were often denigrated as vulgar camp. But he insisted: "I don't see a Hummel figure as tasteless. I see it as beautiful and respond to it. I truly love the sentimentality in the work. I love the finish."[46] He believed that most other people did too but were ashamed to admit it. He declared that his mission—and he thought of it as a kind of

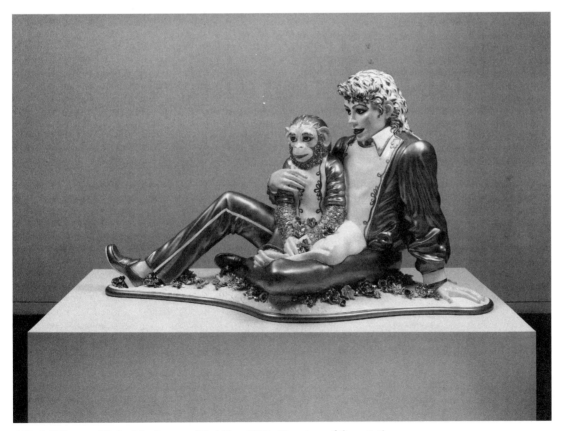

179. Jeff Koons, *Michael Jackson and Bubbles*, 1988. *(Courtesy of the artist)*

public service—would be to convince the public to accept its superficial habits and tastes. "I was trying to remove guilt and shame of the bourgeois class [to] things that they respond to, in . . . an aesthetic manner,"[47] and induce them "to listen to their environment . . . and find beauty in the most simple of things."[48]

This was the message Koons had to "sell." As he said: "The only thing I'm trying to accomplish is to have my work communicate. . . . I just want to make art be as strong a vehicle as possible for manipulation, seduction and propaganda. . . . Why don't we use the entertainment industry; why aren't we using Hollywood more? I know that sexuality is effective. I'm going to use sexuality." And "If fame is part of that, then it's a necessary requirement for me, as a professional. . . . My work will use absolutely anything. It cares only for the end."[49]

To educate the middle class, Koons had to seduce it. Appealing to its love of kitsch was one way. It is noteworthy that of the two main varieties of kitsch—that which is so low that it cannot be taken for art (mass cult), and that which can (midcult)—Koons chose mass cult. Why? Perhaps not to confuse his potential audience or perhaps because he believed that its taste was that low. Or was he appealing to a more sophisticated desire to "get down and dirty"? Perhaps all of the above. The larger-than-life scale of Koons's sculptures and their costly and exquisite materials and fabrication were also seductive. So were the sculptures' clever allusions to "high" art. The work managed to look sophisticated, pricey, cuddly, and monumental. By giving kitsch an interesting edge, Koons became the dandy of consumer culture, charming both a popular and an elite audience with his cleverness, whatever else he conveyed.

Koons's works naturally were often viewed as a commentary on consumerism in art. Gopnik wrote of them "as demonstrations . . . that in our culture *all* art aspires to the condition of chotchkes."[50] Artistic making became commodity production. Keith Haring, who opened a boutique to market his art, considered Koons's work subversive, remarking: "It's an interesting phenomenon to see artists like Jeff Koons exposing the commodification of the [art] object and the ridiculous point it's come to in such an unashamedly brash, upfront, and callous way. It's as though the collectors are paying to be made fun of."[51]

Most critics viewed Koons as *the* child of the consumer society, the legitimate heir of Warhol. Roberta Smith wrote: "Koons delves into the peculiarly intense relationships people have with consumer objects—the simple attraction we can feel for them, the way they come to represent goals or achievements, the way they enhance or inhibit our lives."[52] Indeed, he was utterly accepting of commodification. His own statements contributed to this reading. "I believe in advertisement and media completely. My art and my personal life are based in it." He elaborated that advertisement

defines people's perceptions of the world, of life itself, how to interact with others. The media defines reality.

Just yesterday we met some friends. We were celebrating, and I stated to them: "Here's to good friends!" It was like living in an ad. It was wonderful, a wonderful moment. We were right there living in the reality of our media.[53]

In keeping with his belief in the media, Koons hyped his 1988 show with full-page advertisements in art magazines and huge pictures on billboards, featuring the artist surrounded by female models in exotic settings, pictures that seem to have been intended as works of art in their own right. An avid self-promoter, Koons like Warhol had the knack of commanding art-world and mass-media attention.

There was still another reading of Koons's *Banality* series, namely that Koons was an expressionist of sorts who chose his subjects because they genuinely moved him. Gopnik wrote:

They are relentlessly *invented* objects, which derive their imagery and iconography from a narrow, specific, archaic band of American popular culture. They come from the empty interregnum of pop culture in the seventies (when, as it happens, Koons was an adolescent)—the world of limited animation, Sid and Marty Krofft's Christmas specials, "Charlie's Angels," the Pink Panther. . . .

Koons is the *poète maudit* of American adolescence. His work summons up the world of the thirteen-year-old boy's bedroom. . . . It is an art of sniggering sexuality and of a weird, premature nostalgia—at once self-caressing and deliberately provocative.[54]

Varnedoe and Gopnik summed up Koons's adolescent vision as "me, sexy babes, and my stuff." It was puerile but it had "the look of the cold luxury item."[55]

Michael Jackson, who was roughly the same age as Koons, was his idol—and with good reason, for there were significant similarities between the two. Critic Richard Goldstein wrote of Jackson that he was "a superstar who emerges from the structures of advertising and merchandising that generate banality. . . . In his latest production, Michael banalizes the very notion of 'bad,' turning the leather and chains of the hard-X world, and even the youngblood ritual of grabbing one's crotch into teddy-bear semiotics."[56]

In 1989 Koons enlisted Ilona Stoller, better known as La Cicciolina (the pinchable one), an Italian porn star, deputy of the Italian parliament, and soon to be his wife, to collaborate on a film documenting their lovemaking. It was to be titled *Made in Heaven*. In 1990 he exhibited at the Venice Biennale larger-than-life-size sculpture as well as epic colored silk-screen photographs of himself and his wife having sex (in the pic-

tures, against sentimental landscapes). (In his 1991 show the copulating couple was surrounded by carved wood, Disney-like hummingbirds, puppies with their tongues hanging out, and flowers.) Koons had carried pornography in visual art to a sensationalist extreme.[57] But as he saw it: "I was using sexuality as the most direct reference to guilt and shame."[58] His intention was to liberate people by revealing the beauty in erotic love and showing them that the only way to participate in the spiritual and eternal is through the biological. But Koons was also in love: "Ilona and I are really a contemporary Adam and Eve." It was indeed a match made in heaven (at the time). After all, as he said, Ilona "is a media person, she is a media personality, she survives by the media. . . . We are one."[59] Koons's embrace of pornography was another move along the road of banality. Ilona replaced his beloved knickknacks. In advertising commonplace sex acts, he mock-mythicized them. Indeed, he made hyper kitsch of pornographic imagery, itself kitsch. But he also transubstantiated smut into art.

In the *Made in Heaven* series Koons incorporated key ideas and images found in his earlier works. Like the vacuum cleaners, Ilona was a kind of dirt-sucking persona, who cleansed the unclean through the redeeming act of love—the mythical metamorphosis of the whore into a virgin, the whore made new, as it were. Both sides of her male-fantasized role are manifest in the halo of flowers on her blond hair and her sluttish boots, garters, and bustiers.[60] Did Koons mean it? Gopnik thought so. He maintained that Koons had no sense of irony and unquestionably believed in himself. What he did was no spoof: "Koons is out there passionately expressing himself, as full of feeling as Kirk Douglas in 'Lust for Life.'"[61]

With commodity art in mind, Mike Kelley composed the works for which he is best known from secondhand stuffed dolls and animals, some of which sat on ratty afghans or blankets spread on the floor.

> I was thinking a lot about Haim Steinbach when I did them. Except I was trying to put all the things into them that I felt Haim left out of his. What I saw Haim Steinbach doing was working with the ideal—art about the commodity in terms of a classical notion of perfection. To do that you have to separate the objects from the world, put them on a stage or in a frame, like theatre or a movie. They are out of this world, that's how his shelves function. Then the objects never change, they're fetishized as being perpetually brand new. They're not allowed to wear out. What I wanted was to have something that was worn yet not nostalgic.[62]

Kelley insisted that "there's nothing I hate more than romantic, nostalgic art . . . artists who use decay and age to tug this heartstring for nostalgia and they think, 'oh, the past,' 'oh, the loss,' 'oh, death,' you

know all this romantic stuff. My work [is] not about idealization."[63] Indeed, there is nothing sentimental about stuffed animals sewed together at the crotch, seemingly engaged in nasty sexual activities, or just sitting alone, as if in solitary confinement [180]. Kelley's purpose

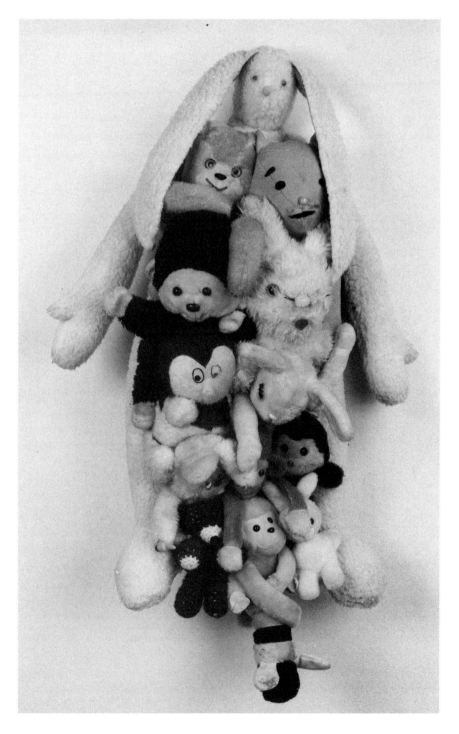

180. Mike Kelley, *Fruit of Thy Loins*, 1990. *(Metro Pictures, New York.)*

was to debunk the mawkish mythology of childhood, which he believed was the unconscious projection of toymakers and adults generally.[64]

In a sense Kelley's thrift-shop dolls and animals are actors in perverse—and funny—pantomimes. As such, they are the progeny of his earlier equally perverse performances. Art critic Christopher Knight described one such work, PLATO'S CAVE/ROTHKO'S CHAPEL/LINCOLN'S PROFILE, as a parody of the artist-as-hero and the spectator as the lowest-of-the-low:

> The entrance to Kelley's cave-chapel is covered over with a painting, underneath which the hapless viewer must wriggle to gain access to the mystic truths within. ("Crawl Worm!" declares the legend on the painting, neatly forcing the audience into the posture of a supplicant.) The interior of this shadowy space is hung with monochromatic canvases, in the manner of the Rothko chapel, although their colors here derive from such mundane sources as bodily fluids and decorator color charts. Likewise, the space is dimly lit with fake fireplaces—artificial illumination in the inner sanctum. And suspended from the ceiling are painted bedsheets—"Rothko's Blood Stain (Artist's Conception)" [alluding to Rothko's suicide] and "Body Print (Self-Portrait as the Shroud of Turin)"—images that suggest everything from "psychologically revealing" Rorschach blots to the "spiritual" paintings of Yves Klein.[65]

Kelley was raised in a repressive working-class Catholic family in Detroit. In rebellion he embraced the nihilistic side of rock-and-roll culture. Remaining a "blue-collar anarchist," as he called himself,[66] he used his art to subvert conventional notions of taste, morality, citizenship, and art's elitist claims [181]. He said: "I'm not interested in things that rise above, but rather things that sink below. Anything that people don't like."[67] Kelley zeroed in on "repressed things in this culture—embarrassing things, like sexual dysfunction and the scatological"[68]—and above all, the infantile. And he favored the trashiest of materials, which he related to the tactics of the counterculture. A tacky felt banner made in 1987, modeled on the feel-good work of (Sister Mary) Corita Kent, a former nun, read: "Pants Shitter & Proud / P.S. Jerk-Off Too (And I Wear Glasses)." In 1988 Kelley produced seventy-four drawings of garbage copied from the backgrounds of Sad Sack cartoons, whose pathetic World War II protagonist was at the bottom of the military establishment. Derived from popular culture, these drawings were also telling commentaries on consumerism and ecology.

In *Pay for Your Pleasure* (1988), an installation, Kelley presented quotes of celebrated writers and artists glorifying the iconoclastic role of the artist, for example, Goethe on imagination: "Naturally raw, and enamoured of absurdity, it breaks out against all civilizing restraints"; Rimbaud: "I have no moral sense. I am a brute"; the Dada poet Tristan

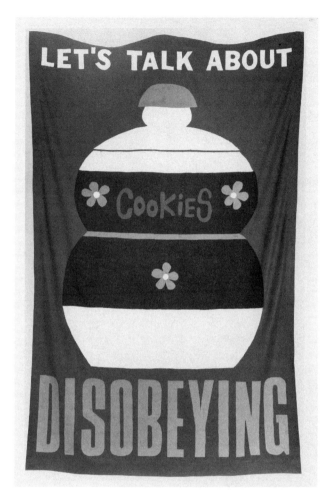

181. Mike Kelley, *Let's Talk*, 1987. *(Metro Pictures, New York)*

Tzara: "We are a furious wind . . . preparing the great spectacle of disaster, fire, decomposition"; and Mondrian: "I think the destructive element is too much neglected in art." One would have thought that Kelley agreed, except that he made them lead up to an "art"-work by serial killer John Wayne Gacy, the gesture turning the statements to his end.[69]

Peter Schjeldahl characterized Kelley as "a master at giving offense . . . with finely calibrated eruptions in art of stuff *so* low" as to constitute "The New Low."[70]

Just as commodity artists appropriated consumer items, the neogeos Peter Halley and Allan McCollum copied motifs from past nonobjective art. Their works were also related to commodity art because the modernist paintings they simulated seemed increasingly like costly commodities.

The geometric abstractions Halley exhibited in 1985 appeared to continue the tradition of twentieth-century abstract art [182]. But they were different in that their forms suggested images: windows, often barred, and conduits, which resemble "microchips, battery cells, semi-

182. Peter Halley, *Prison with Conduit,* 1981. *(Addison Gallery of American Art, Andover, Mass.)*

conductors and digital relays." Consequently Halley's geometric forms *represent* specific subjects, although reduced to simple diagrams. In making abstract art figurative, he called into question the rationale of modernism: "the transcendental rhetoric that accompanied the 'old' abstraction of the suprematists and Mondrian, of the Bauhaus and constructivists."[71] Instead his neogeo would be "a meditation on culture" and society.[72] Halley would emulate Frank Stella, who "act[ed] out the role of modernist artist for a postmodern audience."[73]

Halley recalled that around 1980, "I wanted to start to work with what I thought was the quintessential idealist form, the square, which had both a general, intellectual history and a specific history within modernism. . . . I wanted to make the square something no longer ideal, because I imagined it as a space of confinement, and so I put bars on it and it became a prison."[74] Halley painted with Roll-A-Tex, a stuccolike material used to decorate suburban homes, and Day-Glo pigments, thus introducing a pop element into his work. But he also preferred Day-Glo

because it yielded "a kind of light that was technological light and not a natural light."[75] Influenced by the poststructuralist theories of Michel Foucault, Halley said that his isolated squares symbolized industrial society—the alienating "hard geometries of hospital, prison, and factory"[76]—and by inference its modernist culture.

In the next phase of his work Halley connected the isolated cells with conduits, which represented "interlocking communications network of broadcast media, computers, and telecommunications systems."[77] If the prison cells stood for alienating "hard geometries," the network of conduits signified "the soft geometries" of the new technology, which was, as Halley saw it, "a succinct way of expressing the space of our culture"[78]—the postindustrial or postmodern culture about which Baudrillard theorized.[79]

Halley's vision was essentially pessimistic. He refused to believe the utopian rationale underlying geometric abstraction in the visual arts and the international style in architecture. Ironically, modernist art and architecture had come to signify, in the words of Jeffrey Deitch, an admirer of Halley, "representations of corporate consciousness . . . symbols of abstract bureaucratic power,"[80] and "the logo-type[s] of the multinational corporation."[81] Nor would Halley accept the vision of postindustrial society, asserting that "the computer now mediates so much thought, [that] I think we're stuck with something that limits thought or that controls thought in a way that's rather troubling."[82] Halley's pessimism may have led him to suppress the "connectedness and interrelatedness" of the conduit images in his subsequent work. "[Issues] of alienation have re-emerged for me. The spaces have become emptier, the conduits tend not to make connection with the cells."[83]

Toward the end of the 1980s, Halley's paintings became increasingly nonreferential. They looked less like a critique of modernist geometric abstraction and more like an "authentic" continuation—the formalist progeny of Joseph Albers, Frank Stella, and Ellsworth Kelly. They were distinguished by their formal design and above all by their hyperactive Day-Glo color. But creating a new link in the chain of modernist abstraction may have been Halley's intention early on, the Baudrillardian rhetoric a way to make it seem more relevant.[84]

Like Halley's paintings, Allan McCollum's best-known works simulate modernist abstractions. Titled *Plaster Surrogates* [183], they are solid plaster objects of different sizes that *represent* paintings (colored frame, white mat, and black picture) but are rather "false pictures," as he called them.[85] From 1982 to 1990, McCollum produced more than two thousand of these substitute works of art, signed, dated, and numbered, which he hung in groups on the wall.[86] In a sense they are mass-produced unique objects. In fact, it was his intention to compare what is singular with what is not, maintaining that the one could not be understood without the other.

But could the *Plaster Surrogates* be considered paintings? McCollum had begun with the formalist "notion of reducing painting to a simple set of

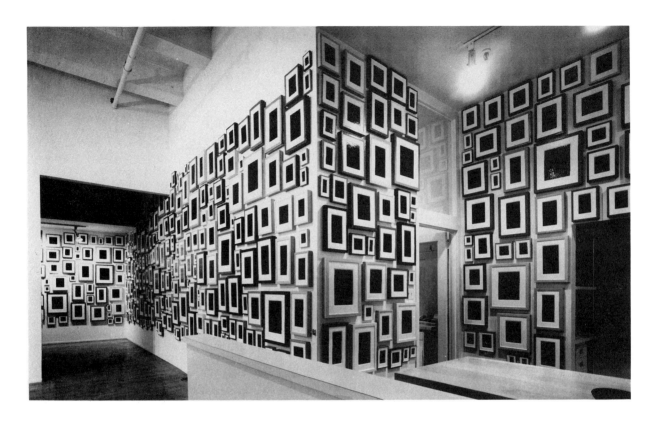

183. Allan McCollum,
Plaster Surrogates,
1982–84. *(Courtesy of
John Weber Gallery,
New York)*

essential terms. . . . That was what a lot of painters seemed to be thinking about in the late Sixties and early Seventies."[87] He came to the conclusion that on the most fundamental level, "a work of Fine Art needs only to function as a *signal,* a signal directing one to lapse into a particular state of mind, a state which one reserves especially for one's aesthetic adventures." McCollum would "isolate this signal, and reproduce it with the sparest of means. . . . Then my objects could exist as pure potential, with no superficial meaning than that which may accrue in relation to our aesthetic pleasures." He would then repeat this minimal signal "like a flashing beacon."[88]

McCollum's *Plaster Surrogates* fit within a tradition of monochrome abstraction that stems from the works of Kasimir Malevich, Ad Reinhardt, and Yves Klein. But his pictures poked fun at their aspirations. After all, each was only a "sign-for-a-painting,"[89] in which his creative *investment* was almost nil. He himself said that he was "doing just the minimum that is expected of an artist and no more."[90] Indeed, the black-centered *Plaster Surrogates* look so mute that each has been viewed as the end of art—"a kind of blank-eyed *vanitas.*"[91]

McCollum came to believe that the formalist enterprise was absurd because

every conceivable description of a painting that one might offer to define its "essence" or its "terms" could always be found to also

define some other, similar object which was *not* a painting—except for one: a painting always has the *identity* of a painting: a painting is what it is . . . precisely because the culture makes a place for it.

It followed that "the 'terms' of painting are the terms of the world-at-large! [The] meaning of an artwork resides in the role the artwork plays in the culture, before anything else." As McCollum saw it, people imagined that they had an emotional need for painting. But its true meaning was as an item of exchange in the real social world.[92] It was the artwork's function as a commodity that accounted for "the powerful grip of all those emotions which go into making, showing, buying, selling, and looking at art."[93] That was the fate of art in a consumer society in which people discover themselves "through perpetually repeated acts of *buying* things."[94] In producing "a particular type of commodity . . . that the single individual can mass-produce,"[95] McCollum commented on the nature of consumer society in which almost identical—or me-too—products create an illusion of choice. In a sense he bridged neogeo and commodity art. As in the case of Steinbach and Bickerton, it was not clear whether his work served to undermine or contribute to the consumerist "spectacle." Moreover, did it preserve what it could of art or make a spectacle of the end of art?

In exhibiting the *Plaster Surrogates* in salon-type hangings, McCollum minimized the importance of an individual unit and emphasized the ensemble spread over gallery walls, calling attention to the environment. Thus, in dealing with the definition and commodification of art, he took the role of the gallery into account, since the artwork is partly defined by its gallery or museum context. Within the gallery setting, McCollum's works functioned like stage props of sorts. They served, as he said, to turn "the gallery into a quasi-theatrical space which seemed to 'stand for' a gallery; and by extension, this rendered me into a sort of caricature of an artist, and the viewers became performers, and so forth. In trying to objectify the conventions of art production, I theatricalized the whole situation without exactly intending to."[96] As a component of an installation at the American Fine Arts gallery in New York in 1991, McCollum hired a surrogate staff, actors who performed as gallery attendents, accosting viewers and delivering a set sales pitch about the transcendent aesthetic values of the "pictures" on display.

In 1982 McCollum began to wonder whether his *Plaster Surrogates* existed in the real world. It occurred to him that they resembled the indistinct, or monochromatic framed pictures that are stage props hanging on the walls of living-room sets in television shows. This prompted him to take photographs directly from television—pictures of pictures of pictures—somewhat as Richard Prince and Sherrie Levine had. McCollum remarked that these *Perpetual Photos*, as he called them, like "artworks everywhere, are just a kind of prop." They provided "a kind of facetious 'proof' that my works were an accurate rendering of a real-life phenomenon. . . . When I enlarge these little meaningless smudges up to life-size—

the size of a picture we might hang in our own home—there's nothing there, just the ghost of an artwork, the ghost of content. There's something parodic in this gesture of mine, I think, and something pathetic."[97]

In 1985, McCollum extended the idea of the *Plaster Surrogates* and the TV prop pictures into sculpture. Inspired by ginger jars commonly seen on television, he produced large solid-cast vaselike plaster objects—substitute sculptures or signs for sculptures—which he titled *Perfect Vehicles*.

In 1983 McCollum produced *Individual Works*, composed of an alleged ten thousand palm-size, greenish, hand-grenade-like Hydrocal objects massed on a long, narrow, velvet-covered table. As a wall label noted, no two are identical. Generated by a computer, each is composed of up to eight parts chosen from 150 separate elements derived from ordinary objects like bottle caps, drawer pulls, and candy molds. Even more than with the *Plaster Surrogates*, the differences are minimal and the effect is of endless repetition. Indeed, it is difficult to imagine a huge number of pieces whose uniqueness was imperceptible. Still, the viewer had to trust McCollum's word that each was singular. But did it matter morally, aesthetically, or commercially or was it a joke? And what was the aesthetic quality of each component of *Individual Works* or *Plaster Surrogates* or *Perfect Vehicles*, and did *that* matter? Perhaps not, but the ensembles were another matter, since they were artfully composed. As McCollum recognized, he had become "something of an installation artist."[98]

Like Halley, other abstract artists, among them David Reed and Philip Taaffe, seemed intent on creating what might be labeled conceptual abstraction, self-conscious abstraction, or third-person abstraction. Stephen Ellis distinguished the new abstraction from its modernist antecedents, terming it a "formal rhetoric." The older idioms

> have become equally and simultaneously available. Such availability allows meaning to emerge from a grammar of connection and juxtaposition. . . . For the moderns the direction of march was clear: forward. For those working in the present, there is no single imperative direction, only a web of connections. . . .
>
> The ambition to create absolutely new form, in the modernist sense, has come to seem superfluous. . . . As a result, the nature of innovation has mutated to the invention of new relationships between forms. . . . fragments of previously existing units (historical idioms originally conceived as complete in themselves). Whether historical references are directly quoted . . . or only alluded to . . . the reliance on chains of fragmentary reference is the same. Of course the meaning of these chains, the reconstitutions of history they imply, may differ violently from artist to artist, but these common tropes

indicate a shared sense of the plight and possibility of contemporary art [for the] generation of artists between 35 and 45.[99]

In the early 1980s, with an eye to Gerhard Richter, David Reed began to scrape large palette knives through wet paint with sweeping gestures [184]. His abstraction recalls the work of gesture painters of the late 1940s and 1950s and, like theirs, is expressive, but it avoids "old fashioned" and stale expressionist mannerisms that are comfortably humanist, nostalgic, and sentimental. At the same time, the surface is polished and depersonalized, distancing the painterly activity and denying the substance of the paint. Indeed, the look of the machine-made subverts the look of the handmade and ironically calls into question its expressive potential.

Reed aspired to coolness and artificiality. He fashioned flat planes that look tactile but are not; motile gestures whose action is stopped; high-gloss painting that looks like a photograph—a mechanical reproduction of a painterly painting—the ambiguity between the two creating a sense of "uncanniness," of strangeness, which Reed prized.

Reed emulated the light of photographs, television, and the movies, "a technological light . . . which is directionless—homogeneous across the screen—and increases the intensity of every color. . . . Technological light can be suggested in an abstract painting, but made more sensual and material than it is on a screen or in a photograph." At the same time he wanted to connect to the tradition of painting, evoking, as he said, "the billowing cloaks that cover the figures in Baroque painting,"[100] much as he arrested the sweeping flow of draperylike folds with disjunctive rectangles of contrasting colors.

Reed's painting is essentially decorative. But it raises many of the same questions that Richter's does and opens up fresh possibilities for abstract art. Moreover, by cultivating the look of mechanical reproduction prized by the *October* group but realizing it in painting, Reed addressed many of the art-theoretical issues that dominated art dis-

184. David Reed, *No. 261*, 1987–88. *(Private collection)*

185. Philip Taaffe, *Untitled*, 1988.
(Gagosian Gallery, New York)

course in the late seventies and eighties, making his work particularly
relevant at the time.

Like Halley, Philip Taaffe represented modernist painting [185]. In
1983 he began to appropriate imagery from Bridget Riley, Myron Stout,
Barnett Newman, Ellsworth Kelly, and other well-known abstract
painters. He said that their pictures were "loaded spaces. . . . I can iden-
tify as an artist with the thinking and the work," but "within my own
view of what should exist in painting . . . grounding my own work in
theirs and seeing how that can create another phase of what painting
can mean."[101] Taaffe personalized his borrowings through an intricate
process of picture making. He used silk-screen and linocut to print frag-
ments of images on paper, which he then pieced together and pasted
onto canvas and overpainted. That is, he painstakingly fabricated col-
lages that end up looking like paintings, paintings that did not resemble
those of any of his sources. In his subsequent works Taaffe introduced
patterning, borrowed from Islamic and other decorative styles. This
move was fitting since his painting, like Reed's, was essentially decora-
tive. Indeed, it can be considered a fresh variant of pattern and decora-
tion painting.

* * *

Taaffe was not the only artist who appropriated the imagery of other artists because of his "infatuation" with it.[102] Mike and Doug Starn (the Starn twins) did so too, but in a shrewd twist they used the camera to appropriate painting, for example, the Mona Lisa or a seventeenth-century picture of the dead Christ by Philippe de Champaigne. Moreover, they made their photographs simulate handmade paintings, composing them of separate papers, often crumpled, bent, and scratched, pasted together with Scotch tape or push-pinned to the wall in a seemingly slapdash manner [186]. Other composite photoworks were elaborately framed, the frames simulating relief sculptures.

Mike and Doug Starn insisted that the emulation of painting stemmed from their needs as photographers. They had been

frustrated by the scale of photographs—20″ × 24″ was the largest you could go in a normal darkroom situation. We wanted to make things bigger, so we decided to tape the paper together. The folding and wrinkling of the paper is to bring out what the photo is printed on—paper.

186. Mike and Doug Starn, *Crucifixion*, 1985–88. *(Leo Castelli Gallery, New York)*

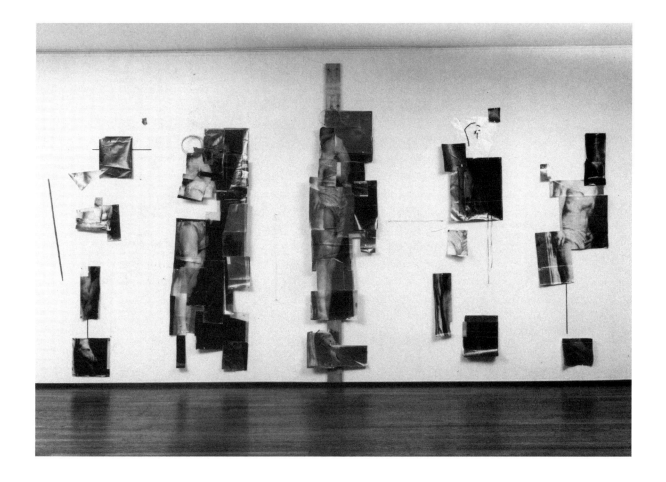

We think a beautiful frame is exciting.... There's nothing wrong in dressing up art.[103]

The Starn twins used art-historical masterpieces as readymades (and it is noteworthy that one of their favorite subjects, the Mona Lisa, had also been appropriated by both Duchamp and Warhol). But the Starn twins altered their borrowed images and shrouded them in a dreamlike nostalgic and sentimental aura, neoromantic in feeling—akin to that in Ross Bleckner's painting. Indeed, as Robert Pincus-Witten pointed out, their subjects are "fetishized and eroticized." They laid out a photograph of Champaigne's dead Christ in "elaborate framed and boxed enlargements . . . and placed [him] before the public's gaze as if he were a huge relic of adoration." Pincus-Witten also remarked on the Starn twins' choice of the rose as subject, its "pink and puckered sequence of labial membrane essentializes the perfumed secret of the female genitals."[104]

Despite Mike and Doug Starn's insistence that their works be considered in the context of photography, it was the way in which it verged toward painting that generated immediate art-world interest. Their works were big, one-of-a-kind, and revealed the artist's hand. The hand-made frames contributed a sculptural dimension.[105] Because the pieces were unique, they were potentially expensive and indeed soon attracted collectors and commanded high prices.[106] Moreover, by emphasizing "touch," the Starn twins denied Walter Benjamin's conception of photography as devoid of "aura" and uniqueness and thus their work entered into art-theoretical discourse.

Mary Lucier was another artist with a manifest nostalgia for painting in a nonpainting medium, namely video. In *Ohio at Giverny* (1983) [187] a row of seven screens of varying sizes showed moving images of

187. Mary Lucier, *Ohio at Giverny,* 1983. *(Copyright © 1994 Whitney Museum of American Art, New York)*

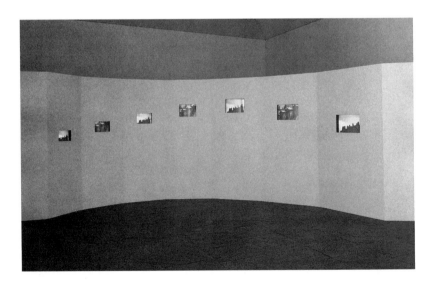

the landscape Monet painted—his garden and lily pond as well as country roads and fields and skies dotted with clouds. Lucier chronicled a journey from her birthplace in Ohio to Monet's house and grounds in Giverny to monuments of the Père-Lachaise Cemetery in Paris as emblems of finality. The juxtaposition of Lucier's childhood home and Monet's restored gardens was, as Lucier commented, "one of confrontation and reconciliation between the 'new' and 'old' worlds, youth and age, art and life, representation and abstraction, technology and nature."[107]

The East Village is a neighborhood in Lower Manhattan extending from Fourteenth Street into the Lower East Side and from Second Avenue to the East River. Because it was a cheap-rent area, it had, beginning in the 1950s, attracted artists. Those who settled there in the 1970s and early 1980s shared a sense of community and a zeitgeist, which, as David Rimanelli wrote, meant "living on the edge, derangement of the senses, illicit drugs, casual sex, steamy nightclubs, renegade artists, rock and roll bands, underground fashion, roach-infested walk-ups, drag queens, maniacs, poets."[108]

The East Village state of mind originated in its art bars and clubs, among which were Club 57, 8 B.C., Limbo Lounge, Pyramid Club, and the Red Bar. Each had its own clientele. For example, Club 57, in the basement of a church on St. Marks Place, was the hangout of Keith Haring, Kenny Scharf, and their friends. Gerald Marzorati wrote that it consisted of

> a bar, a few tables and a jukebox with a mix of old '60s garage-band singles. . . . There was a Monster Movie club, and theme parties and special nights like ladies' wrestling night. . . . Ann Magnuson, the performance artist and actress . . . pretty much set the tone of the place. She organized many of the events, especially the talent shows, which were more like re-creations (half ironic, half sentimental) of old TV variety shows. [In] almost every way, in every undertaking, Club 57's skits and shows were devoted to realizing live, with kid-fun warmth, what had only been seen on TV.[109]

A few clubs soon appealed to a broader clientele. The Mudd Club, which opened in October 1978, was, according to Peter Frank,

> a laboratory for the bizarre and the creative . . . a place where, as Andy Warhol observed, "they call mistakes experiments." . . .
>
> Two months after its opening, Mudd had been transformed from a one-floor, out-of-the-way bar to a multileveled, multimedia talk-of-the-town art-and-performance club. Eventually the fourth floor of the TriBeCa loft building became a makeshift gallery. . . . Several young art dealers started scouting the scene—including Tony Shafrazi, Annina Nosei, Mary Boone, and Gracie Mansion.[110]

Whatever the orientation of the clubs, Carlo McCormick, one of *the* two leading in-house critics spawned by the East Village—the other was Walter Robinson—reported that the "scene rages on seven nights a week from as early as eight to as late as four in the morning and is continued by some even later in the after-hours clubs or all-night restaurants. It has been commented upon more than once that the best attribute and worst problem of the East Village is that it is too much fun."

The club owners welcomed artists because, as McCormick commented, they "acknowledge that art is a big draw. Besides the interested audience, in a large group show all the artists will come and bring their friends, which can amount to a lot of drinking customers." In turn, artists found the clubs useful.

> With the enormous success that artists like Haring, Kenny Scharf and Jean-Michel Basquiat have had since their early club shows, young unknown artists have continued to use clubs as a vital chance for exposure. . . . With the intense emphasis today on the market as the art world's ruling concern, artists needing a competitive edge in the overflowing ranks of the undiscovered have used clubs to exhibit as well as an invaluable meeting ground.[111]

Critic Maureen Dowd agreed that the clubs "have become more than places to take a break from work, have a drink and talk. They are art galleries and experimental theaters and fashion runways. They host book parties, photo exhibits and jazz concerts. Clubs are a place to do business, to make contacts."[112]

The club owners asked artists and their associates to mount exhibitions, some lasting only one night. This led artists to open galleries in the neighborhood, as Allan Schwartzman wrote, "with no more than cheap spaces, a few months rent, some friends, and Mickey-and-Judy drive."

> Initially, just about all the East Vallage galleries were begun by artists: Gracie Mansion, Nature Morte, Civilian Warfare, 51X, Mo David, Cash Newhouse, International with Monument. Gracie Mansion began her gallery as a spoof of a gallery . . . in her railroad flat loo. "It wasn't in actuality a serious gallery," she recalls. "It was very much a statement about the art world and an excuse for having a party." Nature Morte was begun by Alan Belcher and Peter Nagy as a studio, a place to hang their friends' art, and a way to meet people. . . .
>
> But the spirit that was the East Village caught on, generated colossal quantities of hype, transformed an impoverished neighborhood into a real estate war zone, and is largely responsible for . . . shifts in the attentions of the market.[113]

Consequently the "bohemianism" of the East Village was only a

veneer on its commercialism, ironically even contributing to it. Moreover, as McCormick maintained, commercialism influenced art making. He wrote that the artists were "responsive, if not overly acquiescent, to the art market and its capitalistic formula of success." The East Village was "the locus of . . . the most truly capitalistic art ever produced. [It] cannily transforms inspiration to commodity and willfully avoids the hypocrisy of denying its materialistic value."[114]

By 1984 the East Village scene had become established. As Robert Pincus-Witten wrote, it "became tag, handle, and lever—a tag of easy appeal," whose purpose was "commodification." The proof of its arrival was two museum shows mounted in 1984: *The East Village Scene* at Philadelphia's Institute of Contemporary Art at the University of Pennsylvania, and *Neo York* at the Santa Barbara Museum in California. Pincus-Witten concluded that "all the dates are there, the firsts, the bios, the bibliography."[115]

East Village activities were broadcast as part of popular culture. In 1985 the *New York Times*'s Sunday magazine ran a cover story titled "Youth. Art. Hype. A Different Bohemia":

> The fascination has been fanned by the success of three movies set downtown and made by directors who live there: Susan Seidelman's "Desperately Seeking Susan," Jim Jarmusch's "Stranger than Paradise" and Martin Scorsese's "After Hours"; by the popularity of the Jay McInerney novel that is set amid chic downtown clubs and restaurants, "Bright Lights, Big City"; by the influence of rock in Talking Heads and in the music and fashion of Madonna and Cyndi Lauper, all of whom got their start downtown, and by the art explosion in the East Village that has given young artists who were unknown a few years ago the sort of celebrity and wealth previously reserved for rock stars.[116]

The clubs changed from makeshift to superchic, exemplified by the Palladium. Its owners hired

> Henry Geldzahler as its art curator. The club commissioned top young artists to help decorate; Scharf designed a black-lit corridor with floors covered in a rainbow of shag carpet and walls swaddled in Day-Glo fake fur. He plastered the pay phone booths with fun-house mirrors, bubbles of liquid foam and plastic toys—dinosaurs, airplanes and soldiers. Haring painted a backdrop for the dance floor, Jean-Michel Basquiat did a mural over one of the bars, Francesco Clemente did a fresco at the top of the stairs, and David Salle and Eric Fischl designed video art. . . .
>
> By decorating the Palladium, the art stars helped to insure its success and encourage the swarm of pretties and poseurs into their bohemia. With the ubiquitous Warhol in their midst, groups of artists

and downtown dealers also pose in publicity shots for the Palladium.[117]

However, the East Village art scene went into a sudden eclipse. Rising rents and small spaces were partly responsible. But what really finished it off was the opening up of many new galleries in the large buildings on Broadway and Prince Street in SoHo. A number of East Village galleries also moved into this section. Equally important, major established galleries, such as Leo Castelli, Sonnabend, and Mary Boone, took on East Village artists. Most responsible for the demise of the East Village was the inferiority of the art generally shown there.

Within the mélange of East Village art there emerged two broad tendencies, one whose roots were in graffiti art, the other neogeo and commodity art. Graffiti-based art was centered on Haring, Basquiat, and Kenny Scharf, and ghetto artists, such as Lee Quinones, NOC*167, and Futura 2000. *The Times Square Show* in 1980 introduced graffiti-based art into the art world. The following year Diego Cortez featured it in an important exhibition, titled *New York/New Wave*, which he curated at P.S. 1. At the same time White Columns, a not-for-profit gallery, invited ghetto artists to work there with the proviso that the paint be purchased for them—not stolen. For the most part they painted directly on the wall, but a few used canvas and sheet metal. They kept and later exhibited these portable pictures at Fashion Moda, a South Bronx storefront gallery that exhibited neighborhood artists. In 1981, Fashion Moda organized a show at the New Museum, which included both graffiti and East Village artists.[118]

In 1983 the prestigious Sidney Janis Gallery featured *Post-Graffiti*, its label for art that came off the subways and onto commercial gallery walls. Among the artists included were Basquiat, Haring, and Scharf, as well as A-One, Bear, Crash, Daze, Futura 2000, Lady Pink, Lee Quinones, Noc*167, Ramm-ell-zee, the Arbitrator Koor, Toxic, and Zephyr. The gallery aimed to validate the graffiti movement and establish itself as a major promoter, much as it had for pop art in 1962. There was also interest in Europe; for example, Rudi Fuchs included Haring, Basquiat, and Quinones in the 1982 *Documenta*, and the Boymans–van Beuningen Museum in Rotterdam exhibited ten of the graffiti artists in 1983 and acquired some of their works.

Commodity and neogeo artists, who mixed pop, minimal, media, and conceptual art, constituted the other prominent group in the East Village. The most important venue was International with Monument, opened in 1984, which represented Ashley Bickerton, Peter Halley, and Jeff Koons. Neogeo and commodity art were also promoted by Jay Gorney and Estelle Schwartz, and by Tricia Collins and Richard Milazzo.

The work of Bickerton, Halley, Koons, and Vaisman came into public prominence in 1986 with a group show at the important Ileana Sonnabend Gallery and an article by Paul Taylor in *New York*, which served to hype the tendency as it described it.

The moment was right because by the mid-eighties European and American painting had become too familiar to generate much art-world discourse, and attention was shifting to media and deconstruction art, of which commodity art and neogeo were the offspring. The new art was appealing because it was "distant and calculated . . . anonymous and thinky and often strives for the look of industrial manufacture," as Taylor commented. [119]

In 1984 Michael Schwartz, a securities trader on the American Stock Exchange, who in his middle twenties was roughly the same age as the neogeos and commodity artists, bought a work by Bickerton at the White Columns Gallery, a thirty-two-foot-long section of a wall piece that was too large for him to display in his apartment. He "became friendly with Ashley, who suggested I go to an opening with him. The opening was at International with Monument Gallery. There I saw a whole new crowd, a different set of artists, collectors, critics. . . . It took a while for my eye to catch on to it."[120] But, "here was something very undiscovered and very exciting, and I could be at the center of it." Schwartz then purchased major works by Halley, Koons, Vaisman, and other young artists. He interested his parents, Barbara and Eugene Schwartz, who were major collectors of contemporary art, in the new art, and they encouraged their friends to buy. According to Jeffrey Deitch, himself a strong supporter of neogeo and commodity art, "The role of key collectors in putting this together as a package, of identifying it as a recognizable new esthetic, was crucial. . . . They gave it the momentum that made it much more than a small dialogue based in the East Village. They turned it into an international phenomenon."[121]

The artists themselves were avid self-promoters. Robert Pincus-Witten commented on their "projection of a hardnosed front." "What is so impressive about the Neo-Conceptualists is how much they stick together, sustain one another stylistically—elbows crooked out. . . . They strike one as resolved to be closed to other syntheses, though their carapace may be thickened through the bravado of youth."[122] Before arranging to show with Sonnabend, as Taylor commented, "they turned down the prestigious Marlborough Gallery and the fashionable Mary Boone Gallery—or so they say. Some people are appalled by the way their business was conducted. Even Mary Boone has been heard to joke that their tactics are 'like a cliché of my worst publicity.'"[123] The neogeo and commodity art show at the Sonnabend Gallery, according to its director, Antonio Homem, "was one of the best attended in the gallery's history, quickly sold out, with pieces bought by collectors from the United States, Europe and South America. The prices ranged from $10,000 to $50,000, surprisingly large figures for little-known artists."[124]

The success of the neogeos and commodity artists seemed to have provided a model for even younger artists at the end of the 1980s. As Allan Schwartzman described the route of success, with more than a touch of irony:

It's the summer of 1986. You've been studio assistant to David Salle or Sandro Chia or Robert Longo. You've written reviews for *Art in America,* an article for *Flash Art,* and your best buddy has just become review editor of *Artforum.* It's September of 1986. Your work is included in a large group show at White Columns which will travel . . . to a soon-to-be-hot young gallery in London or Cologne or somewhere in Switzerland. It's November of 1986. You've just completed your first "mature" paintings. A few discrete, yet strategically placed comments from your artist/critic/marketing-whiz friends, and Pat Hearn, Brooke Alexander, Annina Nosei, and Stefan Stux visit your studio. . . . It's May of 1987. You have an exhibition at International with Monument or Massimo Audiello or Postmasters. The gallery invites Estelle Schwartz to see the work before anyone else does and with special discounts she sells half-a-dozen of your paintings to her collectors. She even buys one for herself. Jeffrey Deitch places a few, and before you know it you have a waiting list.

Schwartzman went on to say:

It's September of 1987. You have a show at Nature Morte of a collaborative project with Sherrie Levine or Alan [*sic*] McCollum or Haim Steinbach. Your show gets blasted by the critics. . . . Battle lines are drawn. Your fans become your defenders. You are a contender. You decide that you need a proper gallery. A gallery with influence in Europe, with museum clout, and with the kind of collectors who don't know from Avenue B. It's November of 1987. You've just completed your second "mature" body of work and practically every significant gallery in town wants you.[125]

The Whitney Museum Biennials were a good measure of artists on the rise. The 1985 Biennial featured media art and deconstruction art—Prince, Levine, Simmons. It also introduced East Village artists; out of the fifty-four participants, twelve had shows in the East Village galleries, among them Kenny Scharf and David Wojnarowicz. Gerald Marzorati called the Biennial "one of the best (accurate, timely, pleasurable) museum shows to date having to do with the new American art of the '80s."[126] Cameron agreed, characterizing it as "far and away the most exciting, most interesting, and most accurate portrayal of the current moment in art history that we have seen in years, and are likely to see before (knock on wood) 1987."[127]

After the upsurge of neogeo and commodity art, no new tendencies emerged in the 1980s. Instead a series of individual artists who used appropriation in one way or another attracted art-world attention and received a great deal of publicity. The Starn twins achieved recognition in the Whitney Biennial of 1987; Jeff Koons with his *Banality* show at the Sonnabend Gallery in 1988; Mike Kelley with his exhibition of stuffed found animals at Metro Pictures in 1990; and David Hammons with his

retrospective at P.S. 1 in 1990. Indicating that no new "ism" monopolized art-world attention, the Whitney Biennial of 1987 became more pluralistic. As Kim Levin remarked, the three curators—Armstrong, Marshall, and Phillips—have "come up with a sedate, sober, and generally unassailable presentation of safe art,"[128] safe to the art world but not necessarily to the broader public. The Whitney Biennial of 1989 was much the same as that of 1987. Eleanor Heartney wrote that what is most striking about it "is how little it has to offer that seems really new." The show reflected "an art market that has unearthed no single new trend to replace . . . Neo-Geo."[129]

Art-world attention in the late 1980s was focused on the burgeoning art market. If it seemed to be mushrooming in the early and middle years of the decade, that was nothing compared with the boom that began in 1987. In 1979–80, only fourteen postwar paintings sold for $1 million or more at Christie's and Sotheby's; in 1987–88, the figure rocketed to 121. In the same season, the two auction houses together sold over $3 billion worth of art.[130] Even before the art market boomed, *Time,* in a 1979, cover story on auctions marveled at the mind-boggling audiences, publicity, prices, and profits.[131] And Robert Hughes cautioned that art prices had gotten so high that the market could easily go bust.[132] It did anything but, of course. Auction prices soared. In 1987 van Gogh's *Irises* was knocked down at $53.4 million at Sotheby's. *Newsweek* reported: "International media converged on the sale as if it were the Olympics, and indeed, splashy art auctions have suddenly become a thrilling sporting event."[133]

And then on November 9, 1988, the market for contemporary art took off with the the sale of thirty-two works from the Burton and Emily Tremaine collection. Jasper Johns's *White Flag* fetched $7 million. The next day, Johns's *False Start* in the collection of Mr. and Mrs. Victor W. Ganz sold for $17 million. "The binge (there can be no other word) began on October 18, 1989. [During the single month of November,] 58 works sold [at auction internationally] for more than $5 million and 305 for more than a million. [Everybody] agreed that it had been a record season and would remain unbeaten for some time. Maybe for all time."[134]

Also in November 1989 the art market collapsed.

NOTES

1. Michael Brenson, "Art View: Is Neo-Expressionism an Idea Whose Time Has Passed," *New York Times,* Jan. 5, 1986, sec. 2, p. 1. See Marco Livingston, *Pop Art: A Continuing History* (New York: Abrams, 1990), p. 222. Eschewing the subjective art-making process, the neogeos embraced conceptual art, and consequently were sometimes labeled neoconceptualists or smart artists.

2. Meyer Vaisman remarked, in Steven Henry Madoff, "Richard Artschwager's Sleight of Mind," *Art News,* Jan. 1988, that Artschwager's "work has been floating through the art world, offering possibilities." He also commented: "All of the art having to do with furniture—by myself, Koons, Haim Steinbach, Ashley Bickerton, John Armleder—it definitely touches on Artschwager. He's become like a classical artist, and he's turned Formica into a classical material for us. [What] he's done is apply his obsessions to the world . . . to world objects instead of just art objects" (p. 121).

3. Peter Halley, "Ross Bleckner: Painting at the End of History," *Arts Magazine,* May 1982, pp. 132–33.

4. Eleanor Heartney, "Simulationism: The Hot New Cool Art," *Art News,* Jan. 1987. Baudrillard had no use for simulationist art. In Catherine Francblin, "Interview

with Jean Baudrillard," *Flash Art* (Oct.–Nov. 1986): 55, he said: "Generally speaking, the play on quotations is boring for me. . . . the play of second and third degree quotes. I think that is a pathological form of the end of art, a sentimental form. . . . If only art could accomplish the magic act of its own disappearance! But it continues to make believe it is disappearing when it is already gone" (p. 132).

5. Meyer Vaisman, *The BiNational: American Art of the Late 80's* (Boston: Institute of Contemporary Art and Museum of Fine Arts, 1988), p. 206.

6. Andy Warhol, *The Philosophy of Andy Warhol (From A to B and Back Again)* (New York: Harcourt Brace Jovanovich, 1975), pp. 100–101. Warhol's vision of consumer capitalism as a cornucopia of goods in which all could share sounded more like consumer communism.

7. Andy Warhol and Pat Hackett, *Popism: The Warhol '60s* (New York: Harcourt Brace Jovanovich, 1980), p. 221. As Warhol saw it in Andy Warhol, *America* (New York: Harper & Row, 1985), America was a simulation: "Everybody has their own America, . . . a fantasy that they think is out there [but it is] pieced . . . together from scenes in movies and music and lines from books. And you live in your dream America that you've custom-made from art and schmaltz and emotions as much as you live in your real one" (p. 8). No wonder Baudrillard admired Warhol above all.

8. Gary Indiana, "The Auctions," *Village Voice*, May 17, 1988, p. 42.

9. Varnedoe and Gopnik, *High & Low*, pp. 389, 392.

10. Sayre, *The Object of Performance*, p. 33.

11. Ingrid Sischy and Germano Celant, "Editorial": 34–35.

12. Ashley Bickerton, in a talk to the Independent Curators, Incorporated, New York, Apr. 4, 1991, said that his interest in pictorial flatness led him to introduce "abstract" stonelike forms that he saw on the wall of a house on a trip to Mexico. He was taken with the idea of using the simulation of a substance that makes up a wall—on which a picture could hang—in the pictures, a wall on top of a wall, as it were.

13. Paul Taylor, "The Hot Four: Get Ready for the Next Art Stars," *New York*, Oct. 27, 1986, p. 52.

14. Christian Leigh, "It's the End of the World and I Feel Fine," *Artforum*, Summer 1988, p. 119.

15. Richard Phillips. "Ashley Bickerton," *Journal of Contemporary Art* 2, no. 1 (Spring–Summer 1989): 81–82.

16. Ronald Jones, "Protective Custody," *Artscribe International*, Sept.–Oct. 1988, p. 51.

17. Eleanor Heartney, "Reviews of Exhibitions: New York: Ashley Bickerton at Sonnabend," *Art in America*, June 1988, p. 155.

18. Phillips, "Ashley Bickerton," pp. 80–81.

19. Ashley Bickerton and Aimee Rankin, "Fluid Mechanics: A Conversation Between Ashley Bickerton and Aimee Rankin," *Arts Magazine*, Dec. 1987, p. 85.

20. Leigh, "It's the End of the World and I Feel Fine," p. 119.

21. Gilda Williams, "Interviews Jeffrey Deitch," *Flash Art* (Summer 1990). Deitch related the artificial landscape to people who remake themselves: "Public figures like Michael Jackson who recreated himself through plastic surgery, exercise programs, and of course, what Jeff Koons is doing. . . . This is a whole new kind of consciousness, this is a whole new definition of what we are as a people and what we can make of ourselves":168.

22. Jones, "Protective Custody," p. 53.

23. Vaisman, in *BiNational: American Art of the Late 80's*, p. 206.

24. Ibid., p. 207.

25. Heartney, "Simulationism," p. 135.

26. Dan Cameron, "Spotlight: Meyer Vaisman: A Comedy of Ethics," *Flash Art* (Summer 1990): p 137.

27. Haim Steinbach, in *BiNational: American Art of the Late 80's*. In 1979 Steinbach produced an installation at Artists Space in which, as he said on p. 190, he "partially covered the walls with alternating vertical strips of a single color and designer's wallpaper. I mounted simple, bracketed, wooden plank shelves against the walls, and set common household objects on them" (p. 193). In an installation the following year at Fashion Moda, Steinbach filled the gallery with cast-off items picked up on the neighboring South Bronx streets, featuring those that particularly interested him.

28. Holland Cotter, "Haim Steinbach: Shelf Life," *Art in America*, May 1988, p. 159.

29. See David Joselit, "Investigating the Ordinary," *Art in America*, May 1988, p. 154. Joselit took his cues from the situationist strategy of *détournement*.

30. Edward Ball, "The Beautiful Language of My Century," *Arts Magazine*, Jan. 1988, p. 70.

31. Cotter, "Haim Steinbach: Shelf Life," p. 160.

32. Germano Celant, "Haim Steinbach's Wild, Wild, Wild West," *Artforum*, Dec. 1987, p. 76.

33. Tricia Collins and Richard Milazzo, "McDonald's in Moscow and the Shadow of Batman's Cape: Haim Steinbach," *Tema Celeste* (Apr.–June 1990): 36. See also Steinbach, *BiNational: American Art of the Late 80's*, p. 191.

34. John Miller, "The Consumption of Everyday Life," *Artscribe International*, Jan.–Feb. 1988, p. 49.

35. Daniela Salvioni, "Interview with McCollum and Koons," *Flash Art* (Dec. 1986–Jan. 1987): 68.

36. Robert Enright, "The Material Boy and the Femme Fidèle," an interview, *Border Crossings* 10, number 1 (Jan. 1991): 43.

37. Jeff Koons, talk given at the Institute of Fine Arts, New York University, Apr. 3, 1991.

38. Salvioni, "McCollum and Koons," p. 67.

39. Ibid., pp. 67–68.

40. Roberta Smith, "Rituals of Consumption," *Art in America*, May 1988, p. 168.

41. Giancarlo Politi, "Luxury and Desire: An Interview

with Jeff Koons," *Flash Art* (Feb.–Mar. 1987): 74.

42. Jeff Koons, *BiNational: American Art of the Late 80's*, p. 121.
43. Taylor, "The Hot Four," p. 53.
44. Koons, talk at the Institute of Fine Arts, Apr. 3, 1991.
45. Adam Gopnik, "The Art World: Lost and Found," *The New Yorker*, Feb. 20, 1989, p. 107.
46. Enright, "The Material Boy and the Femme Fidèle," p. 40.
47. Andrew Renton, "Jeff Koons: I Have My Finger on the Eternal," *Flash Art* (Summer 1990): 110.
48. Enright, "The Material Boy and the Femme Fidèle," p. 42.
49. Ibid., pp. 38, 40–41.
50. Gopnik, "The Art World: Lost and Found," p. 107.
51. Caley, "Keith Haring," p. 127.
52. Smith, "Rituals of Consumption," p. 164.
53. Klaus Ottman, "Jeff Koons," *Journal of Contemporary Art* 1, no. 1 (Spring 1988): 20–21.
54. Gopnik, "The Art World: Lost and Found," pp. 107–8.
55. Varnedoe and Gopnik, *High & Low*, p. 398.
56. Richard Goldstein, "Just Say Noh. The Esthetics of Banality," *Artforum*, Jan. 1988, p. 82.
57. A number of pieces in the *Banality* series, such as *Woman in Tub* (1986), *Naked* (1988), and *Pink Panther* (1988), made explicit references to sex and anticipated the *Made in Heaven* series.
58. Enright, "The Material Boy and the Femme Fidèle," p. 43.
59. Renton, "Jeff Koons: I Have My Finger on the Eternal," pp. 110, 112.
60. The computer-generated oil paintings recall the oil-printed posters in the *Luxury and Degradation* show. The glass and wood sculptures of a variety of sex acts, cute dogs with their tongues hanging out, flowers, and cherubs are the progeny of the *Banality* series. They and the backgrounds of the pictures sentimentalize hard-core pornography.
61. Adam Gopnik, "The Art World: Lust for Life," *The New Yorker*, May 18, 1992, p. 78.
62. John Miller, "Mike Kelley," in *Mike Kelley* (New York: A.R.T. Press, 1991), p. 19.
63. Paul Taylor, "Mike Kelley: Toying With Second-Hand Souvenirs," *Flash Art* (Oct. 1990): 141.
64. Miller, "Mike Kelley," pp. 19, 30. When asked whether his stuffed animals related to pop art, Kelley replied in Taylor, "Mike Kelley: Toying With Second-Hand Souvenirs," p. 143: "Not too much because Pop art, as far as I see it, was pretty formal. It was like hard edge painting in disguise.... I'm more interested in subject matter."
65. Dan Cameron, "Mike Kelley's Art of Violation," *Arts Magazine*, Summer 1986, p. 17. The quote is from Christopher Knight, "Season Opening Shows May Presage Great Art Year," *Los Angeles Herald Examiner*, Oct. 5, 1985.
66. Elizabeth Sussman, introduction to *Mike Kelley Catholic Tastes* (New York: Whitney Museum of American Art, 1993), p. 16.
67. Mike Kelley, *BiNational: American Art in the Late 80's*, p. 117.
68. Miller, "Mike Kelley," p. 15.
69. Michael Kimmelman, "Art View: Mike Kelley's Toys Play Nasty Games," *New York Times*, Apr. 7, 1991, sec. H, p. 33.
70. Peter Scheldahl, "Art: The New Low," *Village Voice*, Nov. 13, 1990, p. 97.
71. Ball, "The Beautiful Language of My Century," p. 71.
72. Peter Halley, *BiNational: American Art of the Late 80's*, p. 96.
73. Peter Halley, "Frank Stella and the Simulacrum," *Flash Art* (Feb.–Mar. 1986). Stella's abstractions interested Halley because, as he wrote: "Honeycomb aluminum and etched magnesium remind us of the postindustrial world of ultralight metals and printed circuits. The illusionistic 'cones and pillars' of the newest work are reminiscent of the spatial simulations of computer graphics": 35.
74. Giancarlo Politi, "Peter Halley," *Flash Art* (Jan.–Feb. 1990): 86.
75. Ibid., p. 84.
76. Peter Halley, "The Crisis in Geometry," *Arts Magazine*, Summer 1984, p. 113.
77. Ball, "The Beautiful Language of My Century," p. 71.
78. Politi, "Peter Halley," p. 86.
79. Halley, "The Crisis in Geometry," p. 113. Deitch organized an exhibition titled *Cultural Geometry*, in which Halley was the central artist, as he said in Williams, "Interviews Jeffrey Deitch," to "demonstrate that this work [included] wasn't just abstraction without any reference to life, that we could really understand a lot about the cultures that the work came from" (p. 168).
80. Jeffrey Deitch, "The Modern World," *Artscribe International*, Jan.–Feb. 1987, p. 37.
81. Jeffrey Deitch and Martin Guttmann, "Art and Corporations," *Flash Art* (Mar.–Apr. 1988): 78.
82. Politi, "Peter Halley," p. 82.
83. Halley, *BiNational American Art of the Late 80's*, p. 97.
84. See Kenneth Baker, "Abstract Jestures," *Artforum*, Sept. 1989, p. 138.
85. Craig Owens, "Allan McCollum: Repetition & Difference," *Art in America*, Sept. 1983, p. 130.
86. D. A. Robbins, "An Interview with Allan McCollum," *Arts Magazine*, Oct. 1985, p. 41.
87. Ibid., p. 41.
88. Allan McCollum, "Perfect Vehicles," in *Damaged Goods* (New York: New Museum, 1986), p. 11.
89. Robbins, "An Interview with Allan McCollum," p. 40.
90. Gary Watson, "Allan McCollum, Interviewed by Gary Watson," *Artscribe International*, Dec.–Jan. 1985–86, p. 67.
91. Cotter, "Haim Steinbach: Shelf Life," p. 156.
92. Robbins, "An Interview with Allan McCollum," p. 41.
93. Ibid., pp. 40–43.
94. Ibid. p. 43.
95. Salvioni, "Interview with McCollum and Koons," p. 66.

96. Robbins, "An Interview with Allan McCollum," p. 41.

97. Ibid., p. 44. McCollum said: "I was surprised to see how often images which looked exactly like my surrogates appeared in the backgrounds of television dramas, old movies, and so forth."

98. Ibid., p. 41.

99. Stephen Ellis, "After the Fall," *Tema Celeste* 34, (Jan.–Mar. 1992): 56, 58.

100. Stephen Ellis, "Talking Pictures: David Reed Interviewed by Stephen Ellis," *Art Papers* (Los Angeles: A.R.T. Press, 1990), pp. 4, 19.

101. Philip Taaffe, *BiNational: American Art of the Late 80's*, p. 199.

102. Philip Taaffe, talk given at the Whitney Museum of American Art, New York, Dec. 2, 1992.

103. Doug and Mike Starn, in *BiNational: American Art of the Late 80's*, p. 183.

104. Robert Pincus-Witten, "Being Twins: The Art of Doug and Mike Starn," *Arts Magazine*, Oct. 1988, pp. 73, 75.

105. In the late 1890s the Starn twins created fully sculptural scaffolds in which they inset their photographs.

106. For example, Charles Saatchi acquired twenty works.

107. Mary Lucier, "Light and Death," in Doug Hall and Sally Jo Fifer, eds., *Illuminating Video: An Essential Guide to Video Art* (New York: Aperture, 1990), pp. 460–61.

108. David Rimanelli, "Cumulus from America: Déjà Vu," *Parkett* 24 (1990): 146.

109. Gerald Marzorati, "Kenny Scharf's Fun-House Big Bang," *Art News*, Sept. 1985, p. 80.

110. Peter Frank and Michael McKenzie, *New, Used & Improved: Art for the 80's* (New York: Abbeville, 1987), pp. 64–65.

111. Carlo McCormick, "Supplement: Guide to East Village Artists," in Phyllis Plous, curator, *Neo York: Report on a Phenomenon* (Santa Barbara, Calif.: University Art Museum, 1984), pp. 4–5.

112. Maureen Dowd, "Youth. Art. Hype. A Different Bohemia," *New York Times Magazine*, Nov. 17, 1985, sec. 6, p. 40.

113. Allan Schwartzman, "Art and Business: The End of an Alternative," *Arts Magazine*, Sept. 1988, p. 12.

114. McCormick, "Supplement: Guide to East Village Artists," p. 1.

115. Robert Pincus-Witten, "The New Irascibles," *Arts Magazine*, Sept. 1985, p. 102.

116. Dowd, "Youth. Art. Hype. A Different Bohemia," p. 33.

117. Ibid., pp. 42, 88.

118. The major critics of graffiti-based art were Edit DeAk and René Ricard. Its dealers were Patti Astor of the Fun Gallery and then Shafrazi. The major collector was Dolores Neuman.

119. Taylor, "The Hot Four," p. 63.

120. Michele Cone, "Conversations with Art Collectors: Michael Schwartz," *Flash Art* (Dec. 1985–Jan. 1986): 63.

121. Eleanor Heartney, "Simulationism: The Hot New Cool Art," *Art News*, Jan. 1987, p. 134.

122. Robert Pincus-Witten, "Entries: First Nights," *Arts Magazine*, Jan. 1987, p. 45.

123. Taylor, "The Hot Four," pp. 51–52.

124. Heartney, "Simulationism," p. 132.

125. Allan Schwartzman, "The Business of Art: Catalog Culture," *Arts Magazine*, June 1988, p. 7.

126. Gerald Marzorati, "Picture Puzzles: The Whitney Biennial," *Art News*, Summer 1985, p. 75.

127. Dan Cameron, "A Whitney Wonderland," *Arts Magazine*, Summer 1985, p. 66.

128. Kim Levin, "Minimalisn't," *Village Voice*, Apr. 28, 1987, p. 87.

129. Heartney, "Who's Afraid of the Whitney Biennial?" p. 171.

130. James Servin, "SoHo Stares at Hard Times," *New York Times Magazine*, Jan. 20, 1991, p. 27.

131. Michael Demarest, "Living: Going . . . Going . . . Gone!" *Time*, Dec. 31, 1979, p. 46.

132. Robert Hughes, "Time Essay: Confusing Art with Bullion," *Time*, Dec. 31, 1979, pp. 56–57.

133. Katrine Ames, et al., "Sold! The Art Auction Boom," *Newsweek*, Apr. 18, 1988, p. 65.

134. Peter Watson, *From Manet to Manhattan: The Rise of the Modern Art Market* (New York: Random House, 1992), pp. 447, 455.

16 THE "OTHER": FROM THE MARGINAL INTO THE MAINSTREAM

The last years of the 1980s saw a significant number of artists who were "other"—that is, members of marginalized groups—African-Americans, Native Americans, homosexuals—achieve considerable art-world recognition with work that referred to their culture, emerging into the mainstream. In a sense the upsurge of the marginal was a late manifestation of the counterculture, the establishment redefined as the white, heterosexual, Western male, and alleged to be the fount of racism, sexism, and imperialism. Art theoreticians soon provided a rationale for a "multicultural" art, using a deconstructionist methodology that focused, as Hal Foster suggested, on "difference and discontinuity [in order to] rightly challenge ideas of totality and continuity." The neo-Marxists in this group, increasingly unsure of the validity of the idea of the class struggle in the face of the collapse of Communism, substituted the Other for the working class. The struggle of the marginal against the mainstream replaced the struggle of the proletariat against the bourgeoisie. As Foster put it,

> new social forces—women, blacks, other "minorities," gay movements, ecological groups, students . . . have made clear the unique importance of questions of gender and sexual difference, race and the Third World . . . in such a way that the concept of class, if it is to be retained as such, must be articulated in relation to these new terms. In response, theoretical focus has shifted from . . . economic identity to social difference. . . .
>
> In a similar way, political art is now conceived less in terms of the representation of a class subject (à la Social Realism) than of a critique of social representation (gender positioning, ethnic stereotyping, etc.). Such a change entails a shift too in the position and function of the political artist.
>
> [Now,] the site of struggle . . . is as much the cultural code of representation as the means of production.

The goal of the struggle was no longer the revolutionary overthrow of capitalism and the establishment of socialism but a kind of ameliorating "resistance" within the existing social order—without any utopian vision in mind.[1] Actually, it was sufficient to *present* the art of the Other in a fashionable art-world venue to make politically correct claims for the work.[2]

From the early 1970s on Adrian Piper's primary content was the experience of an African-American woman in white society. As a black woman who could pass for white and was often ostracized by both whites and blacks, she was well positioned to experience the unguarded attitudes of both races toward each other and to comment on them. More specifically, as a Ph.D. with a Harvard degree who moved easily in white elitist circles, Piper could be a "silent witness to the discreet racism of the bourgeoisie."[3]

Piper examined her own estranged experience as the locus of psychosocial tensions and traumas about race. Her autobiographical self became a metaphor for America's "self." In her search for identity, she made the personal political, fulfilling the essential requirement of feminism. She said: "For me, the concept of the consciousness-raising group is essential and we need to see precisely that model invoked to deal with racism."[4] As Lucy R. Lippard summed up, Piper's continuing themes are "alienation and manipulation, failures of communication, ostracism, rejection, the ways in which the self is formed by society, the relationship between self and other."[5]

Piper's art focused on what she believed was the fear of white Americans that they might be part black. Of mixed race, she exemplified in person "the racist's nightmare, the obscenity of miscegenation. . . . I represent the loathsome possibility that everyone is 'tainted' by black ancestry: If someone can look and sound like me and still be black, who is unimpeachably white?" In 1975 she made a poster piece that read: "I embody everything you most hate and fear."[6] In 1981 Piper drew her *Self-Portrait: Exaggerating My Negroid Features* [189], both exploring and asserting her racial identity and calling attention to the African component in the Euro-American being.

Piper's intention was to confront white viewers directly with their prejudices and compel them to acknowledge their racist—and sexist—attitudes, their fears and hatreds and the myths and stereotypes they give rise to. Her message is exemplified by two calling cards she had printed in 1986 [188]. She would present one to anyone unaware of her race who had made a racist remark in her presence. It stated: "Dear Friend, I am black. I am sure you did not realize this when you made/laughed at/agreed with that racist remark." It went on to regret the discomfort her presence was causing just as she regretted the discomfort racism was causing her. Piper presented another card to any male who accosted her. It began with "Dear Friend," and went on to say: "I am not here to pick

Dear Friend,
I am black.
I am sure you did not realize this when you made/laughed at/agreed with that racist remark. In the past, I have attempted to alert white people to my racial identity in advance. Unfortunately, this invariably causes them to react to me as pushy, manipulative, or socially inappropriate. Therefore, my policy is to assume that white people do not make these remarks, even when they believe there are no black people present, and to distribute this card when they do.
I regret any discomfort my presence is causing you, just as I am sure you regret the discomfort your racism is causing me.
Sincerely yours,
Adrian Margaret Smith Piper

188. Adrian Piper, *My Calling Card,* 1986. *(John Weber Gallery, New York)*

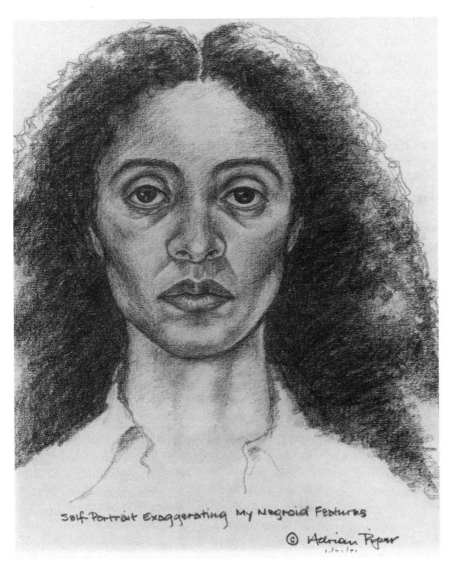

Self-Portrait Exaggerating My Negroid Features
© Adrian Piper

189. Adrian Piper, *Self-Portrait Exaggerating My Negroid Features,* 1981. *(John Weber Gallery, New York)*

anyone up, or to be picked up. I am here because I want to be here, ALONE." She ended it with "Thank you for respecting my privacy."

In an earlier work, *Four Intruders Plus Alarm System* (1980), the images of four black men appear on silk-screened light boxes. But the accompanying audiotape represents four common white voices, of the well-meaning liberal, the know-nothing, the black impersonator, and the racist. "I'm antagonized by the hostility of this piece. Not all blacks are like that. . . . I can understand black anger because I'm angry too. . . . It's not my responsibility, it's not my fault. . . . To be quite honest, I don't like blacks. . . . If they're having a bad time, it's a basic defect in character."[7] Any white viewer could recognize these stereotypical attitudes.

Piper used conceptual art in order to call attention to her message.[8] However, she feared that her work, consisting primarily of photographic documentation and printed texts, would be dismissed as nonart. She broached this issue directly in *Four Intruders Plus Alarm System*, in which one character objects to her work by saying: "What I expect is an art experi-ence, and that's not what I'm getting." In an installation in the *DISlocations* show at the Museum of Modern Art (1991), she made the art reference absolutely clear by building an all-white room that referred unequivocally to minimal art as an art of pure artness. Within this lily-white room, she placed a minimal box in which were encased four television sets on whose screens appeared a single African-American, who declared all the things he was not, among them: "I'm not scary," "I'm not shiftless," "I'm not stupid," "I'm not dirty." Piper wanted to maintain two terms at their extremes: the "white cube" identified with elitist gallery and museum spaces, and politi-cal commentary that spoke of common American reality. She would not reconcile these terms, nor would she give either up.[9]

Like Piper, David Hammons was included in the *DISlocations* show, but unlike her he brought the clutter of the black ghetto into the museum. Beginning in the 1970s, he took the African-American urban experience as his subject, executing performances and street works in black neighborhoods because he felt that was where living culture was to be encountered, employing materials found there.[10] For example, he built gardens of wine bottles in vacant lots. On one occasion, he stood with other vendors on a crowded street selling snowballs of different sizes signed by himself. They sold out.

Hammons's permanent works are pieced together from hair from barbershop floors [190], plastic milk crates, barbecued ribs, fried chicken wings, greasy paper bags, grease, rusted bottle caps, used wine bottles—each bearing the memory of a black person's lips, as he once said. Hammons spoke of the funky objects he uses as having a history readily recognizable to African-Americans. The works he composed from them are compassionate, funny, and angry metaphors for the poverty and racism experienced by ghetto dwellers.

Toward the end of the 1980s, Hammons began to show increasingly

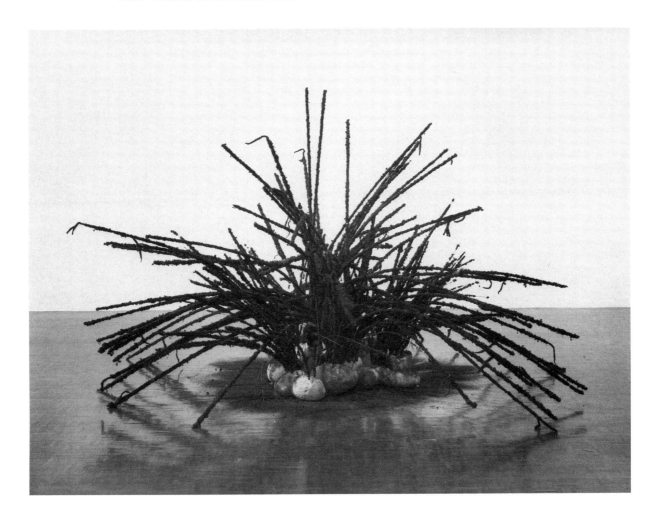

190. David Hammons, *Untitled*, 1992. *(Copyright © 1994 Whitney Museum of American Art)*

in art-world venues, for example, Exit Art in 1989 and P.S. 1 in 1990. In the large room of Exit Art, he introduced a toy train painted blue, which trailed in and around upended baby-grand-piano lids and through a tunnel under a mound of blue-dusted coal. Music was piped in from four speakers, two playing John Coltrane, one Thelonius Monk, and one James Brown's "Night Train," accompanied by Hammons's own voice repeating "All aboard the night train." In the gallery's small room, he installed two spiraling glass constructions, one standing, one lying, from empty bottles of Night Train wine. The piece cross-referenced the role of the train in African-American history and culture—the underground railroad, the freedom train, the A train to Harlem, Coltrane's *Blue 'Trane* album, and even Night Train wine.[11] And the blues: "what did I do to be so black and blue?"[12]

Hammons's major work at P.S. 1 was titled *Higher Goals*. Taking as his subjects jazz and basketball, both pivotal in ghetto life, he ringed a large room with seven twenty- to thirty-foot-high hoops: one a bottomless garbage can; another, a red plastic milk crate; and still another—and

its backdrop—embellished with bottle caps. At the opening of his show, Hammons staged a pickup basketball game in the gallery, accompanied by the raucous jazz of the Jemeel Moondoc and Jus Grew Orchestra, set on a stage ringed with chain-link fencing. Art critic Calvin Reid commented:

> *Higher Goals* acknowledged the genius brought to the game by African-American athletes while decrying the excessive influence the game has over black youngsters. Yet clearly Hammons is beguiled by the game's jazz-like mixture of speed, improvisation, shifting structure, physicality, and mythic community stature. The performance produced an impressive cross-fertilization between two disciplines, music and sports, utterly distinct in execution and sensibility.[13]

Much as Hammons's work is rooted in the ghetto, it also refers to art, as he said, situated "somewhere between Marcel Duchamp, Outsider art, and Arte Povera."[14] It also calls to mind the actions and objects of Joseph Beuys.[15] Moreover, his work is related to commodity art. However, Hammons is closer in sensibility and intention to Mike Kelley and Ilya Kabakov than to Haim Steinbach or Jeff Koons.

In 1963, the year of the historic civil rights march on Washington, Melvin Edwards began to weld steel reliefs he titled *Lynch Fragments* [191]. Made in three periods—1963–67, 1973, and 1978 to the present—they number more than 150. Composed primarily of hooks, knife blades, handcuffs, hammers, saws, and railroad spikes, they are roughly the size of a human head or an African mask and are hung confrontationally at eye level. The *Lynch Fragments* call to mind manual labor and, more strongly, slavery and torture. Indeed, clenched like a fist about to strike, they embody Edwards's anger over the situation of African-Americans.

Like Edwards, Martin Puryear created abstract sculptures with imagistic references [192]. He was influenced by minimalist sculpture, which he first saw at the Venice Biennale in 1968, but diverged from it in that his work is extraordinarily varied, often biomorphic, hand-made, and suggestive of things in the world. The imagery ranges from circle reliefs to open buildinglike structures to bulky monoliths. Puryear's pluralism resulted in part from his nomadic existence: He was a teacher for the Peace Corps in West Africa, an art student in Sweden and later at Yale, where he earned an M.F.A., and a Guggenheim Fellow in Japan.

Puryear cross-bred the diverse cultures that he experienced at first-hand and their histories, for example, the story of Jim Beckwourth. Born in the late eighteenth century, the son of an African-American slave woman and a white man who lived as a frontiersman became a chief of

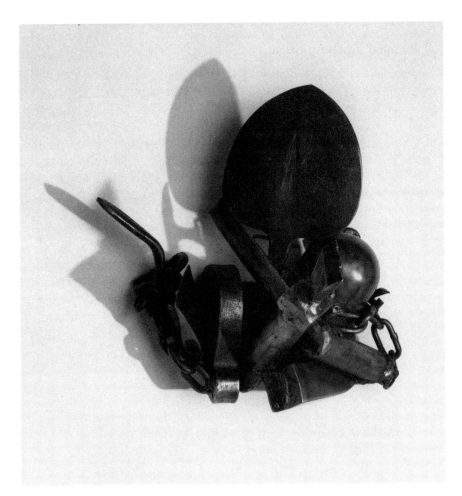

191. Mel Edwards, *Whispers*, 1991–92. *(CDS Gallery, New York)*

the Crow Indians, panned for gold in California, and was a guide and translator for the U.S. Army in the Cheyenne Wars.

Puryear's forms often refer to the African and African-American experience; for example, the bronze chair in *Bodark Arc* (1982) resembles a Liberian chieftain's chair. But he was most interested in First and Third World crafts—the work of the woodworker, basketweaver, quillworker, joiner, cooper, and wheelwright. Storr wrote that while living in Africa, Puryear "understood implicitly that although an African-American, he, as much as anyone of European extraction, was an outsider to the customs of the people among whom he lived." Consequently he "dedicated himself to learning the 'trade secrets' of the local builders, which raised no . . . problems of cultural expropriation or improper pastiche." His aim was "to recover the creative possibilities offered by highly refined crafts that have been marginalized by industrial society, or simply lost to it."[16] He used these techniques to make abstract constructions with modernist sculpture in mind.

192. Martin Puryear, *Dumb Luck,* 1990.
(Private collection, California)

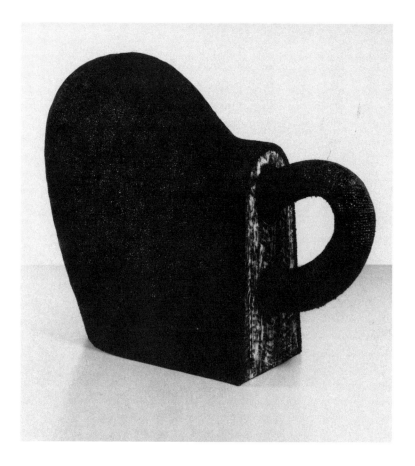

* * *

Jimmie Durham believed that thinking about Native Americans had been contaminated by Euro-American interpretations—abiding images of the "Indian" as "Edenic innocent, uncivilizable savage, noble savage, infantilized adult."[17] Through performances and site-specific as well as portable works incorporating texts, he set out to deconstruct the stereotypical representations of Native Americans invented by a dominant white society, and he did so with telling wit.

> Don't worry—I'm a good Indian. I'm from the West, love nature, and have a special intimate connection with the environment. (And if you want me to, I'm perfectly willing to say it's a connection white people will never understand.) I can speak with my animal cousins, and believe it or not, I'm appropriately spiritual. (Even smoke the pipe.)[18]

Durham's relief sculpture *Self-Portrait* (1987) [193], a prototypical work, is a flayed skin overlaid with inscriptions referring to his situation as a "redskin," both an *object* of white oppression and a proud Cherokee *person.*[19] It is at once a hunting trophy, a crucifix, and a museum piece.[20]

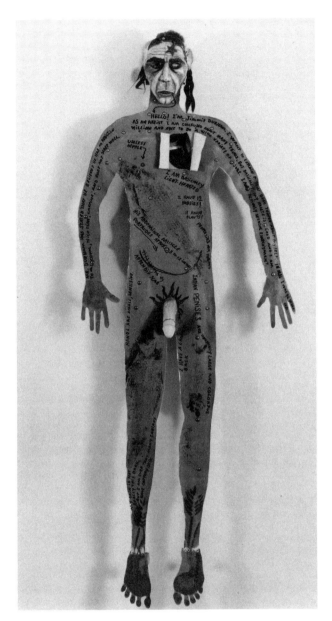

193. Jimmie Durham, *Self-Portrait*, 1987. *(Courtesy of the artist and Nicole Klagsbrun Gallery, New York)*

In such depictions of the Native American, he entered into "the current discourse about primitivism and the collection of primitivism . . . and how it operates in society. What is primitive? Who are the primitives? Why do people like primitivism? Why is there neo-primitivism?"[21] But seriousness is leavened with humor, even though it is never clear whom the joke is on. *Pocahantas's Panties*, encrusted with feathers and beads and purportedly "On Loan from the Museum of the American Indian," prompted Luis Cammitzer to question whether Durham's purpose was "to laugh at himself or to bite the viewer's head off."[22] Most likely both.

* * *

In the 1970s and 1980s homosexual artists began to use their lives, their subculture, and the AIDS plague that devastated their community as subject matter. There had been precedents, in the work of Gilbert & George and David Hockney, but homosexual imagery became more open and direct in the 1970s, making the private public as never before, and entering the mainstream. In the middle of that decade, Robert Mapplethorpe began to photo-document the New York gay scene. Central to his body of work was a series of self-portraits in which, like Cindy Sherman, he presented himself in a variety of roles—as a horned devil, drag queen, gangster, terrorist with a machine gun, man-about-town in black tie, and so on [194]. He commented: "Most of the things I've photographed I've been involved in directly in one way or another. . . . I was experimenting with my own sensibilities. I was finding out about myself."[23]

Mapplethorpe's most notorious models were naked males engaged in homoerotic practices. They were inspired by his own desire, but he also distanced his subjects, dehumanizing them with an icy formality and the stylishness and finish of high-fashion photography, with an eye to the "fine art" photography of such historic figures as Man Ray and

194. Robert Mapplethorpe, *Self-Portrait*, 1985. *(Copyright © 1985 Estate of Robert Mapplethorpe)*

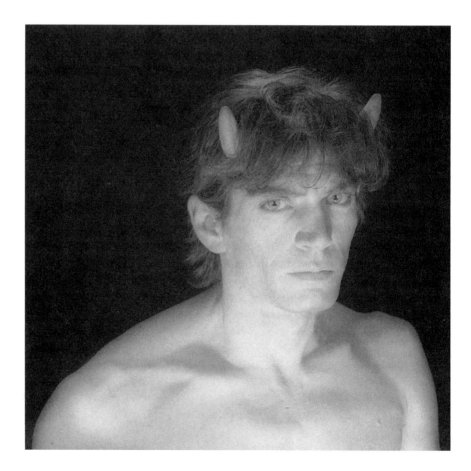

George Russell Lynes. Indeed, part of the attraction of his pictures is the way in which often repellent subjects, for example, sadomasochistic sexual acts, such as a fist or whip shoved up the rectum, are aestheticized.

Ingrid Sischy wrote that Mapplethorpe courted controversy:

> [He] leaped on the sex taboo in art as though it were the last frontier to explore. Instead of circling around homosexuality, Mapplethorpe made it an unavoidable subject for anyone looking at or talking about his pictures. Instead of being afraid that homosexuality would ruin his career, Mapplethorpe used it to forward his reputation. . . .
>
> He was a photographer who took advantage of all the taboos and mysteries surrounding sex and homosexuality. They were his keys to doing something that would be noticed.[24]

And noticed he was. His provocative photographs were even condemned in the U.S. Congress and gave rise to calls for censorship and a controversy over federal funding of the National Endowment for the Arts. The art world supported Mapplethorpe's right to photograph what he pleased. Nevertheless questions were raised about the morality of his more salacious works and whether their subjects distracted so much from his artistry as to be unsuitable in art.

During the 1980s Mapplethorpe played down explicit homosexuality and instead focused on conventional portraits; flowers, which are erotic in much the same way that Georgia O'Keeffe's flowers are; and nude black men, who though fetishized are treated more as sculptures than as sex objects. But as Sischy concluded: "Of all his subjects, sex is the one that most clearly reveals his intuition and his cleverness. In fact, only a small proportion of his work is on this topic, but this is where his contribution to photography stands out."[25]

David Wojnarowicz confronted AIDS both as a victim of the disease, an elegist of dead lovers and friends, and a gay activist [195]. Commemorating Peter Hujar, who died of AIDS, Wojnarowicz made a collage painting, which included nine photographs of Hujar on his deathbed, a twenty-dollar bill, germ/sperm images, and an anguished typewritten text about the causes of AIDS, having the disease, homophobia, and political neglect of the epidemic.[26] An untitled 1984 construction consists of an animal skull covered with maps, whose mouth is clamped with barbed wire and between whose teeth is a globe covered with dollar bills. The symbolism was clear. The AIDS dead are worldwide, and the living cannot get the dollars needed to fight the disease because their advocates are gagged.

Homosexuality, homophobia, and AIDS were not Wojnarowicz's only subjects. He had what Lucy Lippard called a "cinematic memory." As he remarked:

195. David Wojnarowicz, *Untilted (Clocks and Ants)*, 1988–89. *(P.P.O.W. Inc., New York)*

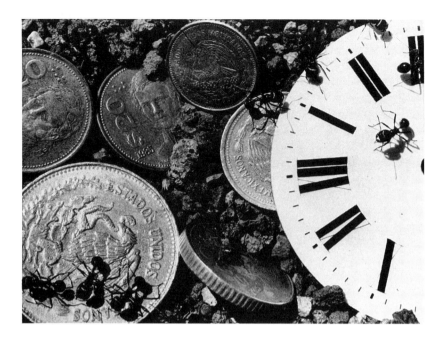

> Inside my head behind the eyes are lengthy films running on multiple projectors; the films are images made up from information from media . . . childhood memories of the forest I lay down in; the surfaces of the earth I scrutinized and some are made up of dreams. Sometimes the projectors run simultaneously sometimes they stop and start but the end result is thousands of feet of multiple films crisscrossing in front of each other thereby creating endless juxtapositions and associations.[27]

Indeed, Wojnarowicz evolved a private store of images culled from dreams, most of them nightmares, which he juxtaposed in what seemed to be a free-associational manner; this repertoire included animals and reptiles, tornadoes and volcanoes, brains and bones, a horror mask, maps, wrecked trains, sex acts, money, and blood cells.[28] Whether it referred to death or dreams, Wojnarowicz's vision was unhinged and full of menace.

Mapplethorpe died of AIDS in 1989, Wojnarowicz, in 1992.

John Coplans took as his subject himself as aged "other," commenting, as he put it, on "a culture that hates old people."[29] In Polaroids that he began to take in 1984 and first exhibited in 1987, his subject was his own vulnerable and deteriorating naked body. He recorded the ravages of time—his sagging chest, fat belly, misshapen feet—with a clinical eye to detail and a self-deprecatory and sardonic wit [196]. His perception of his body is at an opposite pole from Mapplethorpe's cold vision of per-

fect physique. Indeed, Coplans's photography "is the stuff of Mapplethorpe's worst nightmares."[30]

To achieve greater immediacy, Coplans enlarged close-up photographs of his body and/or its parts, segmenting them in multipanel sequences to make them gargantuan. Much as the decrepit body is the source of his discomfort—and fears—he takes comfort in its image and embraces it. Moreover, there is something tragic but grand about it, in a King Lear sense—and not only because of its monumental size.

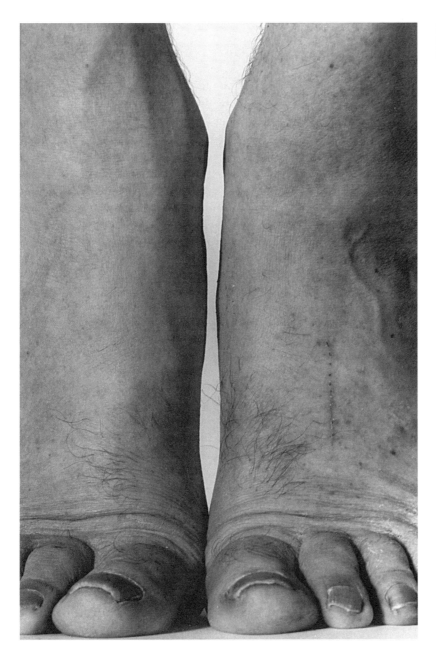

196. John Coplans, *Self-Portrait (Feet, Frontal)*, 1984. *(Andrea Rosen Gallery, New York)*

* * *

The growing concern with social issues—the AIDS crisis, censorship, sexism, and racism—led to increased art-world interest in installation and performance art. The most notorious performance artists were feminists, such as Karen Finley, Holly Hughes, and Annie Sprinkle, whose sexually explicit tirades against the abuse and exploitation of women gave rise to controversies over their alleged pornography. But the art-world reception of these and other performances was mixed; none of the artists received the general approval that Laurie Anderson, Eric Bogosian, and Spalding Gray had.

Installation art fared better, as David Hammons began to work in art-world venues and the work of Christian Boltanski, Ilya Kabakov, and Magdalena Abakanowicz was widely shown. Although these artists were often considered "political," they rarely dealt with topical issues, certainly not in their best work. Rather thay began with their own experience of a social nature, in the case of Hammons, life in the African-American ghetto; Kabakov, communal living in the Soviet Union; and Boltanski and Abakanowicz, the experience of World War II and the Holocaust.

Christian Boltanski's primary subject matter was fleeting childhood, made even more fleeting by intimations of death. In 1972 he began to make large photoworks—the most moving of which are room-size installations—of nameless children, for example, Jewish high school students in 1931. He rephotographed photographs, enlarged and cropped them so as to blur them, and mounted them in cheap tin frames. He then highlighted each with an inexpensive gooseneck lamp from which electric cords dangled [197]. The lamp both illuminates and obscures the close-up images in a manner that evokes interrogation and torture. In some works Boltanski juxtaposed the photographs with beat-up tin biscuit boxes. The children in these out-of-focus, fugitive-looking images are assumed to be dead, and the boxes suggest that they contain the last documents and remaining personal possessions of the deceased.[31] The awareness of death is also felt in other of Boltanski's works, consisting of piles of used clothes, like those collected in the concentration camps.

Boltanski evidently had both the Holocaust and his own lost childhood, which he sought to recover, in mind. In an autobiographical narrative, possibly fictional, he claimed that during World War II his Jewish father was hidden by his Catholic mother in the cellar of their house while she publicly decried his "desertion" of his family. His wartime mythmaking calls to mind that of Beuys, as does his use of "nonart" relics allegedly from his past and their presentation in display cases, and his allusions to genocide. Boltanski's works are effective not only because they evoke the Holocaust movingly but because their references are oblique, which is the only way a subject so horrific can be creditably dealt with. More generally, they are visual requiems for all innocent victims.

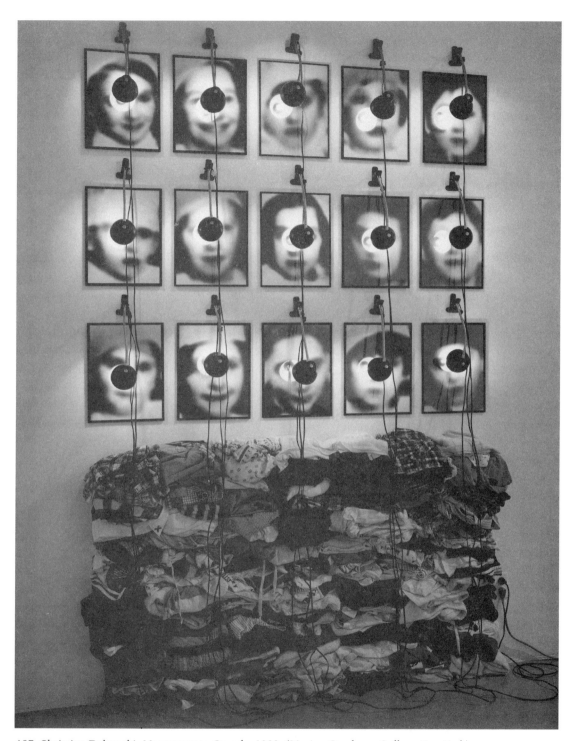

197. Christian Boltanski, *Monument to Canada*, 1988. *(Marian Goodman Gallery, New York)*

* * *

Ilya Kabakov took as the subject of his installations squalid and tragicomic life in Soviet Russia, focusing on the communal apartment, or *kommunalka*. Entire families from disparate social, ethnic, and cultural backgrounds were forced by the Stalinist regime to inhabit crowded and dreary spaces, sharing bathrooms and kitchens. Kabakov commented: "Life as we live it here is dominated by a . . . feeling of extremely closed spaces. . . . It is an unpleasant feeling." It results in an "individual who is always closed up within himself. . . . The deeper you sink into yourself, the quicker you discover yourself projected into this enormous void, if you can think of the sky as a void."[32]

Kabakov's best-known work is titled *Ten Characters* (1988), which "touch all the problems of my own self."[33] Each individual—*The Untalented Artist, The Man Who Flew into His Picture, The Man Who Never Threw Anything Away*—or rather his pathetic story—is represented by his room. They all try to forget or escape their dismal reality. *The Man Who Flew into Space from His Apartment* built a rubber-and-wire catapult and shot himself into outer space, the evidence of which is a gaping hole in the ceiling and official documentation reporting his disappearance [198][199].

Kabakov himself escaped to the West, "discharge[d] from the madhouse." Nevertheless, he continued to be a resident of a remembered dreary and claustrophobic *kommunalka*. "I know no other self."[34] In interviews he has despaired of being understood by anyone who had not lived in the Soviet Union. He need not have worried; the *atmosphere* of his installations conforms increasingly to that of today's world in strife among hostile racial, tribal, and ethnic groups.

As a Pole, Magdalena Abakanowicz said: "My whole life has been formed and deformed by wars and revolutions of various kinds, mass hatred and mass worship."[35]. Her installations of nearly identical, anonymous, hollow figures in burlap, the cousins of Giacometti's elongated personages, call to mind inmates in concentration camps. The works in the *War Games* series, begun in 1987, consist of fallen massive tree trunks carved with chainsaw, ax, and chisel [200]. Their severed limbs, whose stumps are bandaged with burlap or encased in steel, are metaphors for dismembered yet still armored soldiers fallen in battle. Michael Brenson wrote: "They lie broken yet indestructible, impotent yet endowed with imposing phallic power. Wounded and immobilized, these survivors of human and environmental devastation are blessed with an infinite capacity for resistance and regeneration."[36]

The installations of Boltanski, Kabakov, and Abakanowicz (Hammons should be added to this list) are rooted in personal experience that suggests broader national and human concerns. Their content is oppression and pain but not hopelessness. The underlying message is that humankind is indomitable.

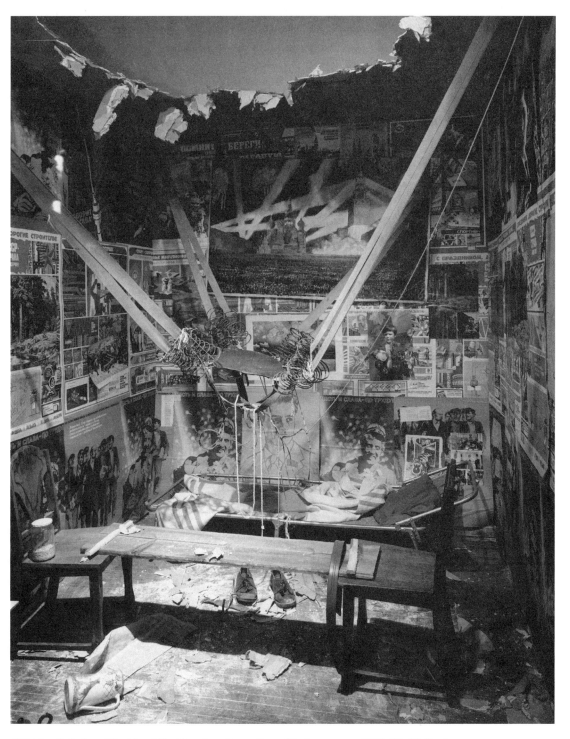

198. Ilya Kabakov, *The Man Who Flew into Space from His Apartment*, 1980–88. *(Collection Centre George Pompidou, Paris)*

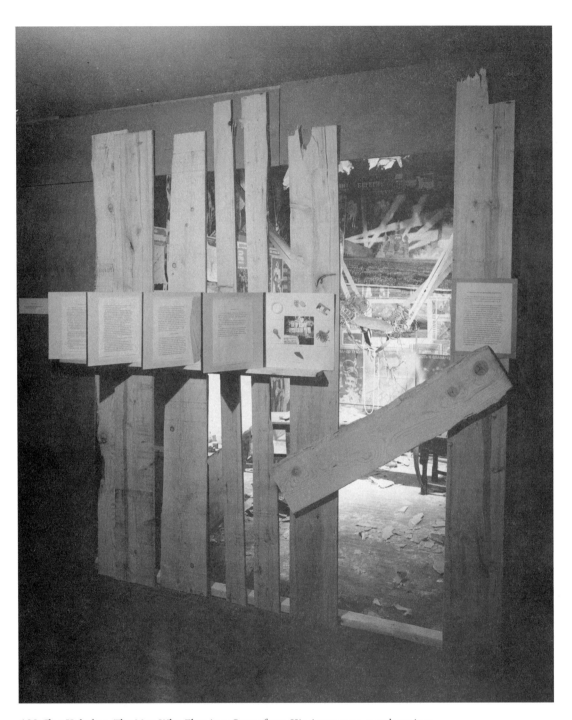

199. Ilya Kabakov, *The Man Who Flew into Space from His Apartment,* another view.

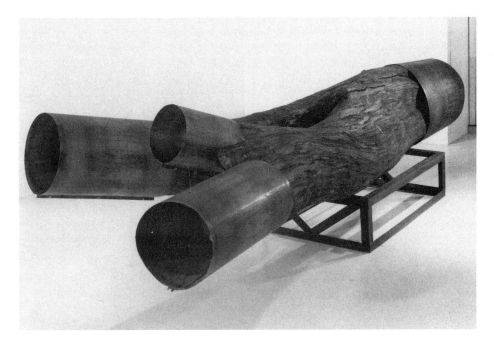

200. Magdalena Abakanowicz, *Anasta: from the series "War Games,"* 1989. *(Marlborough Gallery)*

* * *

Just as marginalized groups within the Western art world achieved growing recognition, so did Third World artists, whose painting referred to their indigenous cultures. Recognition was difficult for them to achieve in the face of the claim by "conservative" advocates of Eurocentric culture that it was man's greatest achievement and thus had superseded all other cultures. "Liberals" whose bias was anticapitalist, anticolonialist, and anti-Western pointed out that Western culture was created primarily by white heterosexual males and did not necessarily transcend nation, race, and gender, as "conservatives" supposed. Challenging what they believed to be the narrow Eurocentric interpretation of the "conservatives," "liberals" stressed the role that economic and military power played in the hegemony of Western culture. They also rejected the assumption of its universality and superiority and instead "privileged" Third World artists along with homosexuals and Western people of color.

In 1984 a show titled *"Primitivism" in 20th Century Art: Affinity of the Tribal and the Modern* at the Museum of Modern Art coupled primitive and Western modern works. The show presented primitive art merely as the source of Western modern art and did not consider it in its own context and right as art. Thomas McEvilley challenged the premise of the exhibition in *Artforum,* writing that it "shows Western egotism still as unbridled as in the centuries of colonialism and souvenirism." William Rubin, the curator of *Primitivism,* rebutted, and an acrimonious argument ensued.[37]

With this controversy in mind, Jean-Hubert Martin mounted *The Magicians of the Earth* in Paris (1989). In it the works of one hundred

artists, fifty Western, fifty non-Western, were juxtaposed "with no implications of hierarchy or centrality—or with a conscious attempt to have no such implications."[38] One of the show's organizers, Mark Francis, said: "We wondered, what would it mean to show the avant-garde from China? What should art from Australia consist of? Would you show art by white postmodernists, or contemporary aboriginal art, or both? The same questions had to be asked in India, Haiti, Brazil, and dozens of other places."[39] The show surveyed Third World art as it has never been before, called Western art-world attention to it, and indicated that a number of the participants merited serious consideration.[40]

NOTES

1. Hal Foster, "For a Concept of the Political in Art," *Art in America*, Apr. 1984, pp. 17–19.

2. Those interested in the art of the "other" often took conflicting positions. For example, feminists, often middle class, had little interest in the class struggle or anti-imperialism.

3. Clive Philpot, "Adrian Piper: Talking to Us," in *Adrian Piper: Reflections 1967–1987* (New York: Alternative Museum, 1987), p. 9.

4. Nicola Upsom, "Adrian Piper: Smiling at Strangers," *Second Shift* (Spring 1993): 9.

5. Lucy Lippard, "Intruders: Lynda Benglis and Adrian Piper," in John Howell, ed., *Breakthroughs: Avant-Garde Artists in Europe and America, 1950–1990* (New York, Rizzoli, 1991), p. 130.

6. Ibid.

7. Ibid.

8. Adrian Piper had been active as a conceptual artist in the New York art world since 1967.

9. Robert Storr pointed this out in a talk at New York University, Dec. 12, 1991.

10. Calvin Reid, "Chasing the Blue Train," *Art in America*, Sept. 1989, p. 196.

 Hammons had a one-person show in 1975 at Just Above Midtown, a gallery devoted mostly to showing minority artists, in which he exhibited works made of greasy bags and barbecue bones.

11. Reid, "Chasing the Blue Train," p. 197.

12. Kellie Jones, "David Hammons: Exit Art Installation, 1989."

13. Calvin Reid, "Kinky Black Hair and Barbecue Bones: Street Life, Social History, and David Hammons," *Arts Magazine*, Apr. 1991, pp. 61–62. Hammons's most notorious work was a 14-by-16-foot portrait of a blond, blue-eyed, and white-skinned Jesse Jackson, with the title inscribed on the surface: "How Ya Like Me Now?" While the portrait was being installed in a parking lot in Washington, D.C., a group of ten blacks vandalized it. They regarded the picture as racist, attacking it with sledgehammers and partially destroying it. Hammons had it rebuilt but installed in an art-world venue.

14. Elizabeth Hess, "Getting His Due," *Village Voice*, Jan. 1, 1991, p. 81.

15. Reid, in "Kinky Black Hair," wrote: "The use of fat, felt, pianos, and animals so associated with Beuys have their parallel in the hair, chicken wings, barbecue bones, and paper bags of Hammons; materials used and reused, thick with traces of the artist's life or with essentialist experience from the world beyond the gallery's door" (p. 63).

16. Robert Storr, "Martin Puryear: The Hand's Proportion," in *Martin Puryear* (New York: Thames & Hudson, 1991), pp. 132–33.

17. Jimmie Durham and Jean Fisher, "The Ground Has Been Covered," *Artforum* "Summer 1988" p 101.

18. Lucy R. Lippard, "Little Red Lies," in *Jimmie Durham: The Bishop's Moose and the Pinkerton Men* (New York: Exit Art, 1989), p. 22.

19. Rushing, "Strategic Interentions."

20. Lippard, "Little Red Lies," p. 24.

21. "Conversation between Jimmie Durham and Jeanette Ingberman," in *Jimmie Durham: The Bishop's Moose,* p. 30.

22. Luis Camnitzer, "Jimmie Durham: Dancing Serious Dances," in ibid., p. 8.

23. Susan Weiley, "Prince of Darkness, Angel of Light," *Art News*, Dec. 1988, p. 108.

24. Ingrid Sischy, "Photography: White and Black," *The New Yorker*, Nov. 13, 1989, p. 136. Mapplethorpe did not only take shocking photographs of naked males and their body parts. One series was focused on the naked body of Lisa Lyon, a bodybuilding champion. He photographed her in a variety of stereotypical female roles, among them sex kitten, high fashion model, and sadomasochistic dominatrix. It is significant that Mapplethorpe should have selected for his

subject a woman who made her muscular body look masculine.

25. Ibid., p. 137.

26. See Jerry Saltz, "Notes on a Painting: Not Going Gentle," *Arts Magazine*, Feb. 1989, pp. 13–14.

27. David Wojnarowicz, *In the Shadow of Forward Motion* (New York: PPOW Gallery, 1989), n.p., quoted in Lippard, "Out of the Safety Zone," *Art in America*, Dec. 1990, p. 134.

28. Lippard, "Out of the Safety Zone," p. 132.

29. Vince Aletti, "Body Language: John Coplans Takes It Off," *Village Voice*, Mar. 26, 1991, p. 80.

30. Elizabeth A. Fraiberg, "John Coplans: The Aboriginal Man," *Q: A Journal of Art* (May 1990): 28.

31. See Nancy Marmer, "Boltanski: The Uses of Contradiction," *Art in America*, Oct. 1989, pp. 169–80, 233.

32. Claudia Jolles and Viktor Misiano, "Eric Bulatov and Ilya Kabakov in Conversation with Claudia Jones and Viktor Misiano," *Flash Art* (Nov.–Dec. 1987): 81.

33. Robin Cembalest, "The Man Who Flew Into Space," *Art News*, May 1990, p. 179.

34. Victor Tupitsyn, "From a Communal Kitchen: A Conversation with Ilya Kabakov," *Arts Magazine*, Oct. 1991, p. 54.

35. Alanna Heiss, *Magdalena Abakanowicz: War Games* (New York: Institute of Contemporary Art, P.S. 1, 1993), p. 2.

36. Michael Brenson, "Magdalena Abakanowicz's 'War Games': Monumental Horizontality," in ibid., p. 9.

37. See *Artforum*, Nov. 1984, Feb. 1985, May 1985, and Mar. 1990.

38. Thomas McEvilley, "Overheard: Former Beaubourg Director Jean-Hubert Martin Talks with Thomas McEvilley," *Contemporanea* 23 (Dec. 1990): 110.

39. Edward Ball, "Interviews: Mark Francis," *Flash Art* (Jan.–Feb. 1990): 157.

40. One painter, Cheri Samba from Zaire, was singled out and exhibited widely in the West. He employed the technique of sign painting to comment in image and text with wit and sympathy on the aspirations, foibles, and problems of his people.

17 INTO THE 1990S

By the end of the 1980s the question of whether painting was dead or alive ceased to be debated in the art world, except by the *October* coterie. Painting was simply accepted as a viable artistic option. After all, it had been around since cave days, and on the evidence of the current interest, it looked as if it would just keep going on and on. Even many of its previous detractors came to view it as capable of certain kinds of expression that no other art form could deliver. Painters, both those established early in the eighties, such as Francesco Clemente, Eric Fischl, Anselm Kiefer, Elizabeth Murray, Sigmar Polke, Gerhard Richter, Susan Rothenberg, David Salle, and Julian Schnabel, and, later in the decade, Peter Halley, Philip Taaffe and David Reed, continued to command art-world attention.

So did the work of media and deconstruction artists, notably John Baldessari, Richard Prince, Cindy Sherman, Jenny Holzer, Barbara Kruger, and Hans Haacke, but not their younger contemporaries, since images appropriated from the mass media, captioned photographs, advertisinglike layouts, and so on, had become all too common. A huge survey, titled *Image World: Art and Media*, held at the Whitney Museum in the late fall of 1989, met with art-world indifference. So did a related show, *A Forest of Signs: Art in the Crisis of Representation* at the Museum of Contemporary Art in Los Angeles. Peter Plagens of *Newsweek* wrote of *Image World:* "The news that artists, as curator Lisa Phillips writes [in the catalog], 'have had to confront the fact that this new visual mass communication system has in some way surpassed art's power to communicate' is hardly heartstopping."[1] Commenting on a wall label in the show, which read, "Why are media images so powerful and persuasive?" Peter Schjeldahl remarked: "It's funny. I had just been wondering why media images (including verbal ones on wall labels) are so weak and unpersuasive. Maybe it's because like most people, I've spent my life in intimate, daily, love-hate combat with such images, acquiring a certain immunity in the process." Schjeldahl concluded: "The sophisticated groan, a vernacular locution that most Americans pick up around the age of 8, is a defense against the mental and spiritual depredations of

media. . . . The [show's] effort to reproduce the media's supposedly soul-shattering glut is almost touching, it's so resistible."[2] The *New Yorker* critic reported that the *Image World*'s premise "'that the overpowering presence of the media has produced an 'image world'—is about as sprightly today as the Oldest Living Confederate Widow could expect to be. Come *on*, kids! Screw your thinking caps on a little tighter."[3] As Andy Grundberg summed it up, *Image World* and *A Forest of Signs* exuded "a valedictory air. One felt not that they were describing current events in the art world but rather that they were encapsulating an era and transforming it into art history. This effect was heightened by their appearing in 1989, the decade's last year."[4] Even middlebrow and lowbrow periodicals dismissed it as old hat.

The deconstructionist rationale that supported the work of such artists as Levine, Kruger, and Haacke seemed equally old hat. Moreover their work had been embraced by the art market and consequently had lost much of its polemical edge. Its own commodification called into question its critique of commodification. And what was more damning, it could be co-opted by consumer society, as Kruger's "look" was in Smirnoff Vodka advertisements. Above all Baudrillard's neo-Marxist idea that people were unable to distinguish between reality and media imagery and that they were seduced by the "spectacle" of consumer society and reduced to passiveness struck growing numbers of art professionals as humdrum and/or unbelievable. This idea had been popularized by deconstruction, commodity, and neogeo artists to the extent that it had become "the critical lingua franca," as David Rimanelli observed. By 1990 it had gone "out of fashion. . . . Few knowing people in the art world still speak of simulacra, the hyperreal, or the ecstasy of communication."[5]

Events in Eastern Europe revealed just how resistible propaganda was, no matter how massive. After the Russian Revolution in 1917, the Soviet Union had inaugurated a "great experiment," namely to produce a "new Communist man." For seventy years the Leninist and Stalinist dictatorships had monopolized public discourse and had engaged in the most exhaustive indoctrination supported by unspeakable terror. Then, in a matter of weeks in August 1989, the masses overthrew Communism and tore down the Iron Curtain. If totalitarian societies could not control thought, how much less likely was it in the democratic West.

Art theory in general seemed exhausted by the end of the 1980s. The names of the intellectual gurus of that decade—Derrida, Barthes, Foucault, Lacan—were referred to with decreasing frequency, and when their ideas did come up, they were more often than not challenged. With the demise of Communism, Marxism lost much of its cachet. In retrospect a great deal of what had been published in *October* appeared to be specious. Schjeldahl quipped: "Amid the clatter of toppling Lenin statues, the plight of . . . *October* becomes touching. Will they change the name to *August?*"[6] The idea promoted by the left that capitalism had

entered the stage of "late capitalism," and was on its last legs, now seemed to be the hangover of obsolete wishful thinking more than the present reality. As Robert Storr pointed out,

> We are in fact in a period of *high* capitalism. And, for all its structural debility and all the misery and fraud it propagates, capitalism has no rivals, only economic cycles and internal competition. In fact, rather than collapsing of its own weight—although partial collapses always threaten—capitalism is about to reabsorb the still weaker socialist systems that have so long been its political adversaries.[7]

The proof of how tired *October* had become was a symposium organized by Rosalind Krauss at the Dia Foundation in the fall of 1990. The topic was the *High & Low: Modern Art and Popular Culture* show at the Museum of Modern Art. The show's purpose was to reveal that "high" artists had borrowed freely not only from the mass media but from every kind of "low" art and that this practice had become an established part of the tradition of modern art. This premise appealed to the general public but had become too familiar to be of interest to the art world, except as the inaugural show of Kirk Varnedoe, the museum's new director of painting and sculpture. Krauss and the other speakers announced that they would provide theoretical alternatives to the methodology of Varnedoe and his associate Adam Gopnik, but they did little more than deliver short talks on historical subjects, most of them concerning Duchamp, talks no different from those common at the annual meetings of the College Art Association. Art theory had become, in a word, academic, and indeed, it remained influential only in graduate art history programs, in which unregenerate tenured ideologues taught that scholarship meant choosing and mastering a dogma; poking through works of art for evidence supporting it; and evaluating the work on the basis of the dogma.[8]

Deconstruction artists who had been promoted by art theorists began to repudiate art theory because they felt that it limited the interpretation of their art, confining the discourse and closing it off. Such artists as Sarah Charlesworth and Laurie Simmons began to voice their objections publicly.[9] Commenting on Charlesworth's statement that she was sick of deconstruction, Robert Pincus-Witten said: "She was, as Suzanne Joelson whispered into my ear, Theory Weary. . . . Or, as Jerry Saltz rhymed later, Theory Leery, to which I could not help but affix the final couplet, Theory Bleary."[10]

Many deconstruction artists turned from unmasking the media to new subjects, as Andy Grundberg observed. "Levine's last show . . . consisted of sculptured glass objects that took their cue from Duchamp. Prince's current shows . . . consist of paintings and sculptures that in appearance seem eager to evoke Minimalist styles of the late 1960's. Sherman's next show . . . will include portraits redolent of Old Master

painting. [These artists'] images now seem less mediated than personal, and they are tinged with no small measure of nostalgia. Today, memory seems a more potent subject than the media." Grundberg concluded that these artists as well as Laurie Simmons and Louise Lawler "have broadened their focus beyond the media to address how contemporary consciousness is shaped by images of all sorts."[11]

Commodity artists and the neogeos achieved art-world recognition in 1986. They were the last *group* of artists to command art-world attention in the eighties. But if no new "ism" emerged at the end of the 1980s, certain individuals dominated art discourse, for example, the Starn twins in 1987, Koons in 1988, Mike Kelley and David Hammons in 1990. All were neo-Duchampian appropriation artists, but the art world did not link them together; instead it focused on the distinctive qualities of each, in the case of the Starn twins, the postmodernist nostalgia for the past; Koons, the apotheosis of consumer society—and of Warhol;[12] Kelley, the psychological and social underbelly of consumer society; and Hammons, the growing consciousness of the African-American experience, and by extension, of a multicultural America.

Art of the end of the 1980s took three diverse directions. The first extended available twentieth-century styles in personal ways, disregarding social issues. The second—which commanded the most art-world attention—dealt directly with newly urgent social problems, and the third was aptly labeled abject or pathetic art. Extending available styles had become too traditional and expected an approach to generate much comment in the art world, although a number of individual artists did. On the other hand, abject and socially conscious tendencies were much discussed.

Abject art was surveyed in a show titled *Just Pathetic* (1990) that included Mike Kelley, William Wegman, and David Hammons. As a whole the work was the end product of a countercultural tendency toward "badness" in art prevalent since the late 1960s. Ralph Rugoff wrote in the catalog that "pathetic art settles for an undignified ridiculousness. Constructed with preterite materials, this work often seems laughably awkward; its gawkiness, both conceptually and physically, frequently gives it an adolescent appearance. . . . A typical characteristic of pathetic art is its low-grade construction." Pathetic art is so pathetic that it even lacks irony:

> Bereft of irony's protective distance, pathetic art invites you to identify with the artist as someone [not] in control of his or her culture. . . .
>
> So no tongue-in-cheek critiques. No policing actions. No devastating salvoes hurled at the art establishment. Pathetic art knows it doesn't have the strength; its position of articulation is already disabled and impaired. . . .
>
> Pathetic art is sad but also funny, and the sadder it gets, the funnier it seems.

Rugoff concluded that pathetic art was a reflection of a society and a culture that were disfunctional and out-of-gas and whose future did not seem to offer any improvement. The essay ended with a paradox—that many of the pathetic artists in the show had achieved success. But "there's no failure like success."[13]

Arthur Danto was also struck by the prevalence of what he called "demotic art," characterized by a "zero degree of draftsmanship. [Its drawing is] the kind that finds its way into tattoo parlors, prison wall graffiti, leaflets advertising garage sales." It is "derisive, sullen, hostile, punk . . . charmless, expressionless, flat, mechanical, smeared, logogrammatic." Responsible was what he termed "a convulsion in culture." "We are not dealing with the work of marginal figures but with mainstream art; . . . massively mainstream," at that. Danto concluded that works of art that are "antiaesthetic, palimpsestic, fragmented, chaotic, layered, hybridized" may be "a mirror of our times."[14] By 1990 the major practitioners of pathetic art were established. Although they attracted dozens of followers who presented ludicrous readymades, cartoonlike parodies, and the like, the tendency had gotten stale.

Danto's suggestion that pathetic art was influenced by the sorry state of the world was well-taken. But there was much to celebrate in the 1990s. The Cold War had ended and with it the threat of nuclear holocaust. Western liberalism had triumphed—its emblem, the heady news photograph of Germans tearing down the hated Berlin wall. Still, there was much to be pessimistic about: the AIDS epidemic; rampant nationalism and genocide; famine and the oncoming environmental catastrophe generated by the excesses of the consumer society and the population explosion; and in addition the deterioration of the inner cities and accompanying homelessness, increasing racial tensions, and drug and crime problems; the poor condition of education; the antiabortion movement; growing homophobia; and censorship.[15] The problems that beset Americans were omnipresent. As Laurie Anderson commented: "I just walk out my door and there it is. Every night there are four men trying to sleep in 30-degree weather in a new loading dock dormitory. . . . Old women are rifling through garbage bags hunting for scraps. Delivery boys ring all 10 doorbells at once, which was really irritating until one day I realized: they can't read."[16]

If pathetic artists seemed caught up in a fin-de-siècle gloom, socially conscious artists were hardly less pessimistic. Those on the political left asserted "that the Western liberal democracies are repressive and imperialistic and maintain their hegemony [by] convincing the majority . . . to live their own domination as freedom"[17]—a highy questionable hypothesis. But whether socially minded artists believed this or not, they recognized that capitalism was here to stay. Lacking a vision of a future good society, they understood that they could only hope to ameliorate existing society, not revolutionize it. All that art could be was, as Storr wrote with as much optimism as he could muster:

[for] worse and for better . . . a fever graph of the enthusiasms, dis-
contents, bad conscience, and bad faith of its patrons' and practition-
ers' class. . . . Its contradictions are ours, from which no revolution
has saved us in the past and none seems likely to do so in the future.
Resistance of any meaningful kind to the constraints and crimes of
bourgeois society must therefore begin with the admission and con-
stantly updated appraisal of our compromised position within it. For
if, in its crisis-ridden and frequently brutal unfolding, that reality
seems intolerable, nevertheless we cannot stand apart from it and tell
the truth.

 The prospect before us is to reenter [existing society] in the full-
ness of its enduring ambiguity, magnificence, and corruption. To that
end we must acknowledge and surrender to the complete if some-
times tragic fascination with contemporary life.[18]

If the art market was any indication, capitalism was hardly on its
last legs. Indeed, the market reigned over all of the art activities of the
1980s. As Schjeldahl observed: "Money and contemporary art got mar-
ried in the '80s. The couple was obnoxious and happy."[19] And Robert
Pincus-Witten wrote in the last months of the decade: "The talk of art
and money is ceaseless; however much one says No to the subject, it
asserts itself."[20] In November, 1989, a billion dollars' worth of art was
sold at auction. And in May two records were broken; $82.5 million was
paid for van Gogh's *Portrait of Dr. Gachet* and $78.1 million for Renoir's
Au Moulin de la Galette. But that month marked the end of the binge.[21]
Confidence in the market was shaken by shocking revelations that much
of Japanese buying that fueled the boom had to do not with appreciation
of art and aesthetic values but with moving money around unlawfully for
the benefit of organized crime and corrupt politicians.[22] Another shock
was the report in October that trendsetter Charles Saatchi was selling
large numbers of works from his collection. Most important, the art
world was finally convinced that art was overpriced, most of all contem-
porary art. In November the bottom of the art market dropped out.[23]
 Contemplating the precipitous fall in auction prices, Schjeldahl
wrote: "For almost everything of the '80s, it was strictly from bloodbath."
Still, "no one was going to jump out a window on account of an
unbought Julian Schnabel. . . . Here was a market, still vastly lusher than
that of a decade ago." But, the "long feeding frenzy whose insults to com-
mon sense could seem to traumatize even some of its beneficiaries" was
over. Schjeldahl concluded: "The recession ahead should foster a desper-
ately needed rethinking of what art is and what art is good for."[24]
 Socially committed artists were appalled by the excesses of the bur-
geoning art market. Its collapse added to their belief that boom-and-bust
capitalism was evil. Nevertheless whether they acknowledged it or not,
they accepted Storr's assumption that capitalism would persevere. Still,
gripped by a sense of social urgency and anxiety, they would deal with

social issues in their art. And the best faced perpetually nagging problems: If art was to have social content, how to avoid the reduction of issues to simplistic one-dimensional propagandizing or abstract illustration of theoretical premises, and instead embody the complexities of being and existence, its joys, miseries, and challenges, on the one hand and on the other hand, to do so in an aesthetically compelling manner.

Socially committed art was hardly new at the end of the 1980s. Indeed, that decade had had a plethora of such artists ranging from Golub to Haacke to Kruger and Holzer. But a new group of artists with a multicultural message had come to the fore: African-Americans, Latino- and Chicano-Americans, Asian-Americans, and Native Americans. In the summer of 1990 *The Decade Show* was mounted at the New Museum, the Studio Museum in Harlem, and the Museum of Contemporary Hispanic Art. In a lengthy review in *New York*, Kay Larson wrote that the exhibition "means to enlist the peripheries—the people who feel 'marginalized' and who are often very angry about it." She emphasized the efforts of the three museum directors who organized the show: Marcia Tucker, Kinshasha Holman Conwill, and Nilda Peraza,

> ambitious and socially conscious women who have all experienced marginalism in their own lives and whose allegiances point [to] the emerging identity of the nineties. . . .
>
> "The Decade Show" describes the growing consciousness of "otherness" in American society. . . . Multiculturalism is the buzzword among groups trying to position themselves for the day when whites of European derivation become a minority in America.[25]

Roughly one-third of the artists in *The Decade Show* had achieved art-world recognition in that they had been shown in prestigious galleries, had received art critical and, in many cases, museum attention. (Some twenty-five of the ninety-three artists in the show have been dealt with in this survey.) Tucker, herself, realized this; she suggested in the catalog that rather than viewing the show in terms of "oppositional thinking," "*branch* thinking" might be more appropriate, "because it's not about 'us versus the mainstream.'"[26] The year 1990 saw the publication of Lucy Lippard's book, *Mixed Blessings: New Art in a Multicultural America*, one of a growing number of books on the subject.[27]

Art theoreticians on the left embraced multiculturalism, but they had to do some ideological flip-flops. In the 1980s they had proclaimed the death of the author, exemplified by the white, Western, heterosexual male. Multiculturalism required the rebirth of the author since the marginalized artist had to be identified as African-American, Latino-American, and so on, and as a genuine representative of his or her culture. Authenticity made a comeback. Multiculturalism raised serious social questions. Would it lead to the empowerment of marginalized peo-

ple and hence to a more just society, or to a new tribalism that would fragment society?

Multiculturalism was only one of the social issues that engaged growing numbers of artists, both in their art and their activities as citizens. The terrible toll of the AIDS epidemic on the art community made it an issue of the first priority. The concern over AIDS intensified an interest in the theme of the body, an issue long raised by feminists and growing in urgency because of the controversy over abortion or, to put it more generally, who controlled a woman's body. The question raised by the work of such artists as Kiki Smith and David Wojnarowicz was how do we apprehend the body, and in whose image? The media's? Ours? And whose body is it: male, female, gay, straight, white, colored, aged, working class, middle class? What is private; what is public?

Art about the naked body was often branded pornography and censored. The cause célèbre was the cancellation in 1989 of the Robert Mapplethorpe retrospective of photographs at the Corcoran Gallery of Art in Washington, D.C., some of naked people, children with their genitals exposed, and homoerotic practices. The show had been funded in part by the National Endowment for the Arts, and that was used as a pretext by Senator Jesse Helms to introduce an amendment to an appropriations bill, which the Senate approved by voice vote, prohibiting use of public money to "promote, disseminate, or produce obscene or indecent materials." Helms's primary target was the NEA, which he hoped to eliminate entirely, and with reauthorization coming up in 1990, he was preparing the ground. In the 1990s he would achieve his goal.

The threat to freedom of artistic expression was serious. The most worrisome incident was the indictment in 1990 of Dennis Barrie, the director of the Cincinnati Art Center, for mounting the Mapplethorpe retrospective. The charge was pandering obscenity and exhibiting naked minors. Barrie stood trial before an unsympathetic judge and a jury whose members were selected primarily because they knew nothing about art. He was saved from jail only by the ineptness of the prosecution's case.

It was not only the Mapplethorpe controversy but the growing agitation of gays for increased governmental attention to the AIDS crisis and on behalf of themselves as a discriminated-against minority that intensified homophobia and attacks on the NEA in Congress. The butt was a NEA-funded show titled *Witnesses: Against Our Vanishing,* scheduled to open at Artists Space in New York, in November 1989. Curated by Nan Goldin, the exhibition was meant to be a "collective memorial" in which twenty-three artists would represent "their personal responses to AIDS."[28] Susan Wyatt, the director of Artists Space, was fearful that the catalog of the show, which contained an essay by Wojnarowicz attacking Helms, California Representative William Dannemeyer, and New York's Cardinal John O'Connor, might embarrass the agency. She alerted the

NEA so that it might be prepared for any adverse criticism. Believing that Helms was his main problem, Chairman John Frohnmeyer asked Artists Space to return the ten thousand dollar grant it had been awarded. Artists Space refused, and the grant was canceled. The art world was outraged by the NEA's stance, and it rallied in support of Artists Space. Within days unsolicited contributions of more than eighty thousand dollars arrived in the mail, including checks of ten thousand dollars each from Roy Lichtenstein and the Pace Gallery. Accompanying a contribution of ten thousand dollars from the Art Dealers Association of America was a statement by R. Frederick Woolworth and Gilbert S. Edelson on behalf of its board of directors, pointing out that

> of the approximately 85,000 grants made by the NEA since [its inception in] 1965, only some twenty odd (one-quarter of one percent) have generated public controversy. This is a small price to pay for the freedom of expression that is essential to creativity and a core value of a democratic society. . . .
>
> The issue is not whether the nation's tax dollars should go to fund "pornography" or art that is "offensive" to a minority or even a majority of its citizenry. The issue is whether we, as a nation, have the courage to seek out the best and to leave for posterity the richest cultural patrimony that contemporary society can produce. To do so, we must rely upon a system of judgment by experts in the various fields of artistic endeavor.[29]

Stunned by the art-world response, Frohnmeyer traveled to New York to meet leaders of the artists' community at Artists Space. Aware that the loss of his artist constituency would be more damaging than the antipathy of Helms, Frohnmeyer restored the grant to Artists Space—one battle won in the war for freedom of expression, but not the last by any means.

Activist organizations, such as Act-Up (AIDS Coalition to Unleash Power) and Gran Fury created works condemning homophobia and the public neglect of the AIDS epidemic. For example, at the Venice Biennale of 1990, Gran Fury mounted billboardlike works in which a portrait of the Pope was paired with a quote by Cardinal O'Connor from the Vatican's Conference on AIDS: "The truth is not in condoms or clean needles. These are lies. . . . Good morality is good medicine." An accompanying text read in part: "By holding medicine hostage to Catholic morality and withholding information which allows people to protect themselves and each other from acquiring the Human Immunodeficiency Virus, the church seeks to punish all who do not share in its peculiar vision of human experience and makes clear its preference for living saints and dead sinners." On another wall an image of an erect penis was paired with the sentences "Men Use Condoms Or Beat It," "AIDS Kills Women," and "Sexism Rears Its Unprotected Head." The Gran Fury work created a furor over whether it violated Italian obscenity laws and should be cen-

sored. After a brief shutdown, the venue was allowed to remain open.[30]

In keeping with the social concerns of artists, there was a growing interest in installation and performance art, particularly of a political nature. Such works lent themselves to a direct presentation of topical political issues, not only the AIDS epidemic but freedom of artistic expression, violence against women, abortion rights, racism, homelessness, and the protection of the environment.

Peter Schjeldahl, as good a prognosticator as any, sized up the situation in 1991 and predicted "a major shift" caused, if by no other factors, by boredom.

> We are bored with auctions. We are bored with dealers as celebrities and collectors as celebrities. We are bored also with celebrated theories. Politically corrective critique bores us with its forever unexamined Utopian fatuities. . . .
>
> What we want this season . . . is shakedown simplification of the art culture, reduced as much as possible to communions of artists and newly self-conscious audiences. As a practical matter, the favored mode of the art will be installational. . . . We want to walk into spaces temporarily transformed by particular artists to trigger particular thoughts, feelings, and reflections bearing on who they are and who we are.[31]

Robert Storr's *DISlocations* at the Museum of Modern Art and Lynne Cooke's and Mark Francis's Carnegie International in Pittsburgh, both in 1991, exemplified this attitude. In their anti-art-as-object attitude, installation and performance art at the beginning of the 1990s seemed to resume postminimalism of the late sixties. Thus, ironically, much of the art with which I end this book circles back to the countercultural art that began it.

Socially oriented art was anointed in the Whitney Biennial of 1993, curated by Elisabeth Sussman. The introductory wall text stated that the works of the eighty-two artists selected, of whom only eight were painters, "confront critical issues that are altering the fabric of American life." It continued:

> In particular, the artists raise important questions about the changing role of the artist in society; the politics of representing racial and sexual difference; the boundaries between art and pornography; the function of art as a sociopolitical critique; the interrelationships of self, family, and community; and the influence of new technologies.[32]

Most of the critical responses to the show were negative, a sign of the waning interest in socially oriented art. Elizabeth Hess, who generally supported social art, wrote a mildly favorable review, finding the work "uneven" but containing enough "smashing objects" to make the

show "worthwhile."[33] Roberta Smith damned it as "a pious, often arid show that frequently substitutes didactic moralizing for genuine visual communications" but went on to say that "this Biennial is a watershed. In some ways it is actually a better show than usual because it sticks its neck out." However, Smith concluded: "While the exhibition dwells at length on the problems that face fin de siecle America, it does not often demonstrate their conversion into convincing works of art."[34] Peter Schjeldahl wrote that the show was "the most coherent biennial ever" which "accurately reflect[s] the dominant trend of the last two years in American art culture." But he found it baleful and concluded: "The episode will last until a generation emerges that is tired of it or until universal justice occurs on Earth, whichever comes first. Neither can come too quickly for me."[35] Kay Larson singled out works by Gary Hill, Glenn Ligon, Sue Williams, and Robert Gober, and commented that on the whole the "work—even when grim—is at least passionately energized," but she was taken aback by works whose political correctness "pushed you past endurance."[36] Robert Hughes branded the show "A Fiesta of Whining: Preachy and political, [it] celebrates sodden cant and cliché."[37] Peter Plagens agreed that the show was "mostly preachy and glum . . . a Salon of the Other . . . which ends up more a dyspeptically sad show than a radically feisty one."[38]

With the decline of art-world interest in socially oriented art as a tendency, and with no "new" tendency in evidence, art entered into a pluralist condition. In 1995 the Whitney mounted "A Polite Biennial," as Mark Stevens dubbed it. "The assorted currents of contemporary art are invariably presented in their most polite and handsome forms." Its politics was of politesse. Stevens concluded "no commanding style or attitude now rules the art world."[39] Although the 1970s is commonly thought to be the pluralist era, the label more accurately applies to the 1990s, or at least so it seems at mid-decade.

NOTES

1. Peter Plagens, "Art: MassComm 101: the Media vs. Modernism," *Newsweek*, Nov. 27, 1989, p. 88.
2. Peter Schjeldahl, "Art: Tomorrowland," *7 Days*, Nov. 29, 1989, p. 63. Kirk Varnedoe and Adam Gopnik, *High & Low*, agreed that a large public had "a hardened knowingness about the value-emptied amorality of media culture. [Far] from being the preserve of a small cadre of vanguard thinkers, [it was] the sour, commonplace cynicism of the whole commercial culture" (p. 375).
3. "Art," *The New Yorker*, Nov. 27, 1989, p. 16.
4. Andy Grundberg, "As It Must to All, Death Comes to Postmodernism," *New York Times*, Sept. 16, 1990, sec. 2, p. 47. Marzorati, in "Picture Puzzles: The Whitney Biennial," *Art News*, Summer 1985, recognized as early as 1985 that "the moment, one in which art has been about pictures, is nearly played out. [A] certain edge has been rubbed smooth" (p. 77).
5. Rimanelli, "Cumulus from America": 146–47.
6. Peter Schjeldahl, "Art: Art Trust," *Village Voice*, Sept. 17, 1991, p. 97.
7. Storr, "No Joy In Mudville," p. 182.
8. See Michael Brenson, "Art View: A Concern With Painting the Unpaintable," *New York Times*, Mar. 25, 1990, sec. 2, p. 35.
9. Sarah Charlesworth openly condemned deconstruction at a panel at the School of Visual Arts, New York, Mar. 1990.
10. Robert Pincus-Witten, "Theory Weary," in Collins and Milazzo, *The Last Decade: American Artists of the 80's* (New York: Tony Shafrazi Gallery, 1990), p. 46.

11. Andy Grundberg, "Photographic View: The Mellowing of the Post-Modernists," *New York Times*, Dec. 17, 1989, sec. 2, p. 43.

12. Warhol's name was ubiquitous, heralded in a vast retrospective (second in size only to the Picasso) at the Museum of Modern Art in 1989, the huge catalog, the publication of many books, and on and on. Brian Wallis, in "Review of Books: Absolute Warhol," *Art in America*, Mar. 1989, wrote that "two years after his death, Andy Warhol continues to loom over the contemporary art scene like a silver specter. Everywhere his influence is evident: in the kitschy readymades that critique consumerism; in the easy passage between art-making and fashion, rock music, entertainment or films; in the celebration of artists as celebrities or stars; and in the endless fascination of the mass media with the art world as a rather bizarre and freewheeling sideshow" (p. 25).

13. Ralph Rugoff, "Just Pathetic," *Just Pathetic* (Los Angeles: Rosamund Felsen Gallery, 1990), pp. 3–4, 19.

14. Arthur C. Danto, "Books & The Arts. What Happened to Beauty?" *The Nation*, Mar. 30, 1992, pp. 418, 420–21.

15. Dan Cameron, "Changing Priorities in American Art," *Art International*, Spring 1990, p. 89.

16. Laurie Anderson, "1980–1989, R.I.P.: Strange Angels: Flying Into the Next Century," *Village Voice*, Jan. 2, 1990, p. 44.

17. Louis Menand, "Articles of Oppositional Faith," *Times Literary Supplement*, July 21–27, 1989, p. 796.

18. Storr, "No Joy In Mudville," p. 182.

Arthur C. Danto, in "Are We Cracking Under the Strain," *New York Times Book Review*, Dec. 23, 1990, wrote that we live in a time in which God, democracy, socialism, art, sex, the family, and economic growth have become problematic as never before. Change is occurring with such rapidity that "the world is . . . so different from what it was only recently that there are no useful lessons to be drawn from the past—except that lesson. [We] have to learn to live without solutions and make do instead with a few human values and some tentative norms" (p. 22).

19. Peter Schjeldahl, "Art: Art Gavel Comes Down Hard," *Village Voice*, Nov. 27, 1990, p. 123.

20. Robert Pincus-Witten, "Entries: Geist, Zeitgeist & Breaking the Zero Barrier," *Arts Magazine*, Oct. 1989, p. 60.

21. Peter Watson, in *From Manet to Manhattan, The Rise of the Modern Art Market* (New York: Random House, 1992), wrote:

At the beginning of May in New York the contemporary auction at Christie's fell $10 million below the firm's worst expectations ($50 million), and twenty-six of the seventy-seven pictures failed to sell. At the Sotheby's sale two nights later, thirty-three out of eighty-seven works did not meet their reserve, and the total of $55.9 million was well short of the expected $87–113 million. . . .

At the sales of contemporary art that autumn [1990], works by Dubuffet, Warhol, Schnabel and Stella all went unsold. . . . By the end of the year, David Nash, Sotheby's head of Impressionists in New York, was talking about a return to 1988 levels. By the middle of 1991, a return to 1986 levels was being contemplated. (pp. 457–59)

22. Art was used to circumvent the law in Japan in the following manner. As Watson reported in *From Manet to Manhattan*, pp. 443, 459, to buy a property whose price was controlled by law, the buyer would "sell" a painting to the seller for one price and buy it back in a few months at an agreed-upon price many times higher. Every time this was done, the price of art rose. Then major Japanese companies dealing in art went bankrupt. If the thousands of paintings they acquired were put up for sale, the art market would collapse. They were held back, but confidence in the market was shattered.

23. Speculation was nothing new in American economic life. In Alexis Gregory, "Economics: Art as Money: An Interview with John Kenneth Galbraith," *Journal of Art* (Oct. 1990), Galbraith said:

Some part of the art market, perhaps a large part, is now a manifestation of the classical character of inflation on the speculative level. That is to say, prices have gone up for whatever reason. This causes other people to think they're going up more, and so they buy on that expectation and that sends the prices up. That, in turn, attracts other people to buy and the price goes up even more. This is the pure speculative situation that occurs most often in the securities markets, but it also occurs in real estate and is now manifesting itself in the art market. (p. 59)

But what went up came down.

24. Schjeldahl, "Art: Art Gavel Comes Down, Hard," p. 123. Judd Tully reported, in "Passed!" *Journal of Art* (Dec. 1990):

The spectulative boom in contemporary art that triggered an artbreak of auction fever in the salesrooms of Christie's and Sotheby's in the late '80s passed away in early November, leaving behind a long list of high-priced casualties. The bad news began at Sotheby's evening sale of November 6, realizing a puny $19.8 million with 43 of the 77 lots failing to find buyers. The shocking buy-in rate of 56%, and a sales total that was exactly half of the lowest pre-sale estimate, constituted an outright disaster" (1).

James Servin, in "SoHo Stares at Hard Times," *New York Times Magazine*, Jan. 20, 1991, wrote:

The most glaring sign of an overinflated art boom came in November 1989, when two paintings at

Sotheby's, a Jasper Johns and a Willem de Kooning, netted a total of $38 million, $5.6 million more than Sotheby's total contemporary sales in all of 1986. As the spring of 1990 approached, the financial world turned its attention to the S&L crisis, the falling dollar and an uneven Japanese stock market, all of which contributed to pull the rug from under the art world. With the erosion of confidence of those in the financial world, the art market unraveled with astonishing speed. Around the time of the May 1990 contemporary art auctions, Christie's and Sotheby's brought in only half of an expected $100 million. Six months later, the gloom persisted. Of 554 art works expected to sell at the two auction houses, only 332 did, at $49.6 million below their combined lowest estimate. At Sotheby's, a Julian Schnabel canvas failed to elicit a single bid. After some silence, cynical laughter and a round of applause followed. (p. 27)

25. Kay Larson, "Art: Three's Company," *New York*, June 11, 1990, p. 84. In the last week of 1990, in an issue, titled "Age of Anxiety," devoted to predictions for the 1990s, *Newsweek* featured Marcia Tucker in a sidebar because of her "vision of a politically engaged, multicultural art." (Editors, "People for the 90s: Marcia Tucker," *Newsweek*, Dec. 31, 1990, p. 39.)

Among the better-known artists in the show were Hans Haacke, Leon Golub, Robert Colescott, Jenny Holzer, Komar & Melamid, Martin Puryear, Mel Edwards, Eric Fischl, Barbara Kruger, Cindy Sherman, Richard Prince, and Bruce Nauman.

26. Nilda Peraza, Marcia Tucker, and Kinshasha Holman Conwill, "Directors' Introduction: A Conversation," *The Decade Show* (New York: Museum of Contemporary Hispanic Art, New Museum of Contemporary Art, Studio Museum in Harlem, 1990), p. 12. The artists in the show who are dealt with in this book are Applebroog, Basquiat, Colescott, Coplans, Durham, Edwards, Fischl, Golub, Haacke, Hammons, Holzer, Kelly, Komar & Melamid, Kruger, Lawler, Nauman, Prince, Puryear, Rollins & K.O.S., Sherman, Simmons, Spero, Steinbach, and Wojnarowicz.

27. Lucy R. Lippard, *Mixed Blessings: New Art in a Multicultural America* (New York: Pantheon Books, 1990).

28. Nan Goldin, "In the Valley of the Shadow," *Witnesses: Against Our Vanishing* (New York: Artists Space, 1989), p. 5.

29. Art Dealers Association of America, press release, Nov. 13, 1989, p. 3.

30. Robert Nickas, "That Sinking Feeling," *Flash Art* (Oct. 1990): 139.

31. Peter Schjeldahl, "Art: Art Trust," *Village Voice*, Sept. 17, 1991, p. 97.

32. *1993 Biennial Exhibition Introductory Wall Text* (New York: Whitney Museum of American Art, 1993), mimeographed sheet.

33. Elizabeth Hess, "Art + Politics = Biennial: Up Against the Wall," *Village Voice*, Mar. 16, 1993, p. 35.

34. Roberta Smith, "At the Whitney, a Biennial with a Social Conscience," *New York Times*, Mar. 5, 1993, sec. C, pp. 1, 27.

35. Peter Schjeldahl, "Art + Politics = Biennial: Missing the Pleasure Principle," *Village Voice*, Mar. 16, 1993, p. 34.

36. Kay Larson, "Art: What a Long Strange Trip," *New York*, Mar. 22, 1993, p. 72.

37. Robert Hughes, "A Fiesta of Whining," *Time*, Mar. 22, 1993, p. 68.

38. Peter Plagens, "Fade from White: The Whitney Biennial Gives Center Stage to Women, Gays, and Artists of Color," *Newsweek*, Mar. 15, 1993, pp. 72–73.

39. Mark Stevens, "Art: A Polite Biennial," *New York*, Apr. 3, 1995, p. 56.

BIBLIOGRAPHY

BOOKS

Albright, Thomas. *Art in the San Francisco Bay Area: 1945–1980*. Berkeley: University of California Press, 1985.

Alloway, Lawrence. *Topics in American Art Since 1945*. New York: W.W. Norton, 1975.

Anderson, Wayne. *American Sculpture in Process*. New York: New York Graphic Society, 1975.

Art Workers Coalition, *Documents 1*. New York: Art Workers Coalition, 1969.

_____. *Open Hearing*. New York: Art Workers Coalition, 1969.

Ashbery, John. *Reported Sightings, Art Chronicles*. New York: Alfred A. Knopf, 1989.

Ashton, Dore. *American Art Since 1945*. New York: Oxford University Press, 1983.

Atkins, Robert. *ArtSpeak: A Guide to Contemporary Ideas, Movements, and Buzzwords*. New York: Abbeville Press, 1990.

Baker, Kenneth. *Minimalism*. New York: Abbeville Press, 1981.

Bann, Stephen, and William Allen, eds. *Interpreting Contemporary Art*. London: Reaktion Books, 1991.

Barber, Bruce, ed. *Performance Text(e)s & Documents*. Montreal: Boulanger, 1981.

Battcock, Gregory, ed. *The Art of Performance*. New York: E.P. Dutton, 1984.

_____, ed. *New Artists Video: A Critical Anthology*. New York: E.P. Dutton, 1978.

_____, ed. *Why Art?* New York, E.P. Dutton, 1977.

_____, ed. *Idea Art: A Critical Anthology*. New York: E.P. Dutton, 1973.

_____, ed. *The New Art: A Critical Anthology*. New York: E.P. Dutton, 1966.

Baudrillard, Jean. *Simulations*, trans. Paul Foss, Paul Patton, and Philip Beitchman. New York: Semiotext[e], 1983.

Beardsley, John. *Art in Public Places*. Washington, D.C.: Partners for Livable Places, 1981.

_____. *Earthworks and Beyond: Contemporary Art in the Landscape*. New York: Abbeville Press, 1984.

Beeren, Wim A. L. *Century in Sculpture*. Amsterdam: Stedelijk Museum, 1992.

Berger, Maurice. *Labyrinths: Robert Morris, Minimalism and the 1960s*. New York: Harper & Row, 1989.

Brentano, Robyn, with Mark Savitt, eds. *112 Workshop/112 Greene Street*. New York: New York University Press, 1981.

Bronson, A. A., and Peggy Gale, eds. *Performances by Artists*. Toronto: Metropole, 1979.

Broude, Norma, and Mary D. Garrard, eds. *Feminism and Art History*. New York: Harper & Row, 1982.

Brown, Betty Ann, and Arlene Raven, *Exposures: Women & Their Art*. Pasadena, Calif.: New Sage Press, 1989.

Burgin, Victor. *The End of Art Theory: Criticism and Postmodernity*. London: Macmillan, 1986.

Burnham, Jack. *Great Western Salt Works: Essay on the Meaning of Post-Formalist Art*. New York: George Braziller, 1974.

_____. *The Structure of Art*. New York: George Braziller, 1971.

_____. *Beyond Modern Sculpture*. New York: George Braziller, 1968.

Cameron, Dan. *New York Now: Saatchi Collection*. Milan: Giancarlo Politi Editore, 1987.

Carrier, David. *The Aesthete in the City: The Philosophy and Practice of American Abstract Painting in the 80's*. University Park: Pennsylvania State University Press, 1994.

Castleman, Riva. *American Impressions: Prints Since Pollock*. New York: Alfred A. Knopf, 1985.

Caute, David. *The Year of the Barricades: A Journey Through 1968*. New York: Harper & Row, 1988.

Celant, Germano. *Unexpressionism*. New York: Rizzoli, 1988.

_____. *Arte Povera*. Milan: Gabriele Mazzotta Editore, 1969.

Chadwick, Whitney. *Women, Art, and Society*. New York: Thames and Hudson, 1990.

Chicago, Judy, and Miriam Schapiro. *Anonymous Was a Woman*. Valencia, Calif.: Feminist Art Program, California Institute of the Arts, 1974.

Connor, Steven. *Postmodernist Culture*. Oxford, England: Basil Blackwell, 1989.

Crimp, Douglas. *On the Museum's Ruins*. London: MIT Press, 1993, with photographs by Louise Lawler.

Cummings, Paul. *Artists in Their Own Words: Interviews by Paul Cummings*. New York: St. Martin's Press, 1979.

Davis, Douglas. *Artculture: Essays on the Post-Modern*. New York: Harper & Row, 1977.

_____. *Art and the Future*. New York: Praeger Publishers, 1973.

Diamondstein, Barbaralee, ed. *Artists and Architects Collaboration*. New York: Watson-Guptill, 1981.

_____. *Inside New York's Art World*. New York: Rizzoli, 1979.

Dienst, Rolf-Gunter. *Deutsche Kunst: Eine Neue Generation*. Cologne: M. Dumont Schauberg, 1970.

Faust, Wolfgang Max. *Hunger Nach Bildern*. Cologne: M. Dumont Schauberg, 1982.

Fleshin, Nina, ed. *But Is It Art? The Spirit of Art as Activism*. Seattle: Bay Press, 1995.

Fine, Elsa Honig. *Women and Art*. Montclair, N.J.: Allanheld, Osmun & Co., 1978.

Fineberg, Jonathan. *Art Since 1940: Strategies of Being*. London: Laurence King, 1995.

Foster, Hal, ed. *Recodings: Art, Spectacle, Cultural Politics*. Port Townsend, Wash.: Bay Press, 1985.

_____, ed. *The Anti-Aesthetic: Essays on Post-Modern Culture*. Port Townsend, Wash: Bay Press, 1983.

Frank, Peter, and Michael McKenzie. *New, Used and Improved: Art for the 80's*. New York: Abbeville Press, 1987.

Frascina, Francis, ed. *Pollock and After: The Critical Debate*. New York: Harper & Row, 1985.

Freeman, Phyllis, Eric Himmel, Edith Pavese, and Anne Yarowsky, eds. *New Art*. New York: Harry N. Abrams, 1984.

Frith, Simon, and Howard Horne, *Pop into Art*. London: Methuen, 1987.

Fuller, Patricia. *Five Artists at NOAA: A Case Book on Art in Public Places*. Seattle: Real Comet Press, 1985.

Fuller, Peter. *Beyond the Crisis in Art*. London: Writers and Readers Publishing Cooperative, 1980.

Gablik, Suzi. *The Reenchantment of Art*. New York: Thames and Hudson, 1991.

_____. *Has Modernism Failed?* New York: Thames and Hudson, 1984.

_____. *Progress in Art*. New York: Rizzoli, 1977.

Gardner, James. *Culture or Trash?* New York: Carol Publishing Group, 1993.

Gilmour, John C. *Picturing the World*. Albany: State University of New York Press, 1986.

Godfrey, Tony. *The New Image: Painting in the 1980s*. New York: McGraw-Hill, 1986.

Goldberg, RoseLee. *Performance Art from Futurism to the Present*. New York: Harry N. Abrams, 1988.

Goodman, Cynthia. *Digital Visions: Computers and Art*. New York: Harry N. Abrams, 1987.

Gorgoni, Gian Franco. *Beyond the Canvas: Artists of the Seventies and Eighties*. New York: Rizzoli, 1985. Introduction by Leo Castelli.

Greenberg, Clement. *Art and Culture: Critical Essays*. Boston: Beacon, 1961.

Grundberg, Andy. *Crisis of the Real: Writings in Photography 1974–1989*. New York: Aperture Foundation, 1990.

Hall, Doug, and Sally Jo Fifer, *Illuminating Video: An Essential Guide to Video Art*. New York: Aperture Foundation, 1990.

Harris, Ann Sutherland, and Linda Nochlin. *Women Artists 1550–1950*. New York: Alfred A. Knopf, 1977.

Hager, Steven. *Art After Midnight: The East Village Scene*. New York: St. Martin's Press, 1986.

_____. *Hip Hop: The Illustrated History of Break Dancing, Rap Music, and Graffiti*. New York: St. Martin's Press, 1984.

Hedges, Elaine, and Ingrid Wendt. *In Her Own Image: Women Working in the Arts*. New York: McGraw-Hill, 1980.

Henri, Adrian. *Total Art: Environments, Happenings, and Performances*. New York: Praeger Publishers, 1974.

Hertz, Richard. *Theories of Contemporary Art*. Englewood Cliffs, N.J.: Prentice-Hall, 1985.

Hess, Thomas, and Linda Nochlin. *Woman as Sex Object: Studies in Erotic Art, 1730–1970*. New York: Newsweek, 1972.

Hess, Thomas, and Elizabeth Baker. *Art and Sexual Politics: Women's Liberation, Women Artists and Art History*. New York: Art News Series, Macmillan, 1973.

Hins, Berthold. *Art in the Third Reich*, trans. Robert Kimber and Rita Kimber. Oxford, England: Basil Blackwell, 1979.

Hodgson, Godfrey. *America in Our Time: From World War II to Nixon, What Happened and Why*. Garden City, N.Y.: Doubleday, 1976.

Honnef, Klaus. *Contemporary Art*. Cologne: Taschen Verlag, 1988.

_____. *Concept Art*. New York: Phaidon Publishers, 1971.

Howell, John, ed. *Breakthroughs: Avant-Garde Artists in Europe and America, 1950–1990*. New York: Rizzoli, 1991.

Hoy, Anne H. *Fabrications: Staged, Altered, and Appropriated Photographs*. New York: Abbeville Press, 1987.

Hughes, Robert. *The Shock of the New*. New York: Alfred A. Knopf, 1981.

Hunter, Sam. *American Art of the 20th Century*. New York: Harry N. Abrams, 1975.

_____, ed. *An American Renaissance: Painting and Sculpture Since 1940*. New York: Abbeville Press, 1986.

Jencks, Charles. *Post-Modernism—The New Classicism in Art and Architecture*. New York: Rizzoli, 1987.

Jensen, Robert, and Patricia Conway, *Ornamentalism: The New Decorativeness in Architecture and Design*. New York: Clarkson N. Potter, 1982.

Joachimides, Christos, and Norman Rosenthal, eds. *American Art in the 20th Century*. Munich: Prestel Verlag, 1993.

_____, eds. *Metropolis*. New York: Rizzoli, 1991.

Johnson, Ellen H. *American Artists on Art: From 1940 to 1980*. New York: Harper & Row, 1982.

_____. *Modern Art and the Object*. New York: Harper & Row, 1976.

Knight, Christopher. *Art of the Sixties and Seventies: The Panza Collection*. New York: Rizzoli, 1988.

Krauss, Rosalind E. *The Originality of the Avant-Garde and Other Modernist Myths*. Cambridge, Mass.: MIT Press, 1985.

_____. *Passages in Modern Sculpture*. New York: Viking Press, 1977.

Kurlansky, Mervyn, and John Naar. *The Faith of Graffiti*. New York: Praeger Publishers, 1974. Text by Norman Mailer.

Kurtz, Bruce D., ed. *Keith Haring, Andy Warhol, and Walt Disney*. Munich: Prestel Verlag, 1992.

Kuspit, Donald. *The New Subjectivism: Art in the 1980s*. Ann Arbor, Mich.: UMI Research Press, 1988.

_____. *The Critic as Artist: The Intentionality of Art*. Ann Arbor, Mich.: UMI Research Press, 1984.

Lacy, Suzanne. *Mapping the Terrain: New Genre Public Art*. Seattle: Bay Press, 1995.

Lippard, Lucy R. *Mixed Blessings: New Art in a Multicultural America*. New York: Pantheon Books, 1990.

_____. *A Different War: Vietnam in Art*. Seattle: Real Comet Press, 1990.

_____. *Get the Message? A Decade of Art for Social Change*. New York: E.P. Dutton, 1984.

_____. *Overlay: Contemporary Art and the Art of Prehistory*. New York: Pantheon Books, 1983.

_____. *Six Years: The Dematerialization of the Art*

Object from 1966 to 1972. New York: Praeger Publishers, 1973.

_____. *From the Center: Feminist Essays on Women's Art*. New York: E.P. Dutton, 1974.

_____. *Changing: Essays in Art Criticism*. New York: E.P. Dutton, 1971.

Livingston, Marco. *Pop Art: A Continuing History*. New York: Harry N. Abrams, 1990.

Loeffler, Carl, ed. *Performance Anthology: A Source Book for a Decade of California Performance Art*. San Francisco: Contemporary Art Press, La Mamelle, Inc., 1979.

Lucie-Smith, Edward. *Art in the Eighties*. New York: Phaidon Universe, 1990.

_____. *American Art Now*. New York: William Morrow, 1985.

_____. *Art in the Seventies*. Ithaca, N.Y.: Phaidon Books/Cornell University, 1980.

_____. *Art New*. New York: William Morrow, 1977.

Lyotard, Jean-Francois. *The Postmodern Condition: A Report on Knowledge*, trans. Geoff Bennington and Brian Massumi. Manchester, England: Manchester University Press, 1984.

Marshall, Lee. *Art at Work: The Chase Manhattan Collection*. New York: E.P. Dutton, 1984.

Marshall, Richard, and Robert Mapplethorpe. *50 New York Artists: A Critical Selection of Painters and Sculptors Working in New York*. San Francisco: Chronicle Books, 1986.

Masheck, Joseph. *Smart Art*. New York: Willis, Locker and Owens, 1984.

_____. *Modernities, Art-Matters in the Present*. University Park: Pennsylvania State University Press, 1993.

Meyer, Ursula, ed. *Conceptual Art*. New York: E.P. Dutton, 1971.

Michelson, Annette, Rosalind Krauss, Douglas Crimp, and Joan Copjec, eds. *October: The First Decade, 1976–1986*. Cambridge, Mass.: MIT Press, 1987.

Miller, Lynne F., and Sally S. Swenson. *Lives and Works: Talks with Women Artists*. Metuchen, N.J., and London: Scarecrow Press, 1981.

Mitchell, W.J.T., ed. *Art and the Public Sphere*. Chicago: University of Chicago Press, 1992.

Muller, Gregoire. *The New Avant-Garde: Issues for the Art of the Seventies*. New York: Praeger Publishers, 1972.

Munro, Eleanor. *Originals: American Women Artists*. New York: Simon and Schuster, 1979.

Munsterberg, Hugo. *A History of Women Artists*. New York: Clarkson N. Potter, 1975.

Naef, Weston J. *Counterparts: Form and Emotion in Photography*. New York: E.P. Dutton, 1982.

Nairne, Sandy, in collaboration with Geoff Dunlop and John Wyver. *The State of the Art: Ideas & Images in the 1980s*. London: Chatto & Windus, 1987.

Naylor, Colin, and Genesis P-Orridge. *Contemporary Artists*. London: St. James Press, 1977.

Neff, Terry A., ed. *A Quiet Revolution: British Sculpture Since 1945*. London: Thames and Hudson, 1987.

New Art. London: Academy Editions, 1991.

Nemser, Cindy. *Art Talk: Conversations with Twelve Women Artists*. New York: Charles Scribner's Sons, 1975.

Nochlin, Linda. *Women, Art, and Power and Other Essays*. New York: Harper & Row, 1989.

Oliva, Achille Bonito. *Avantguardia/Transavantguardia*. Milan: Gruppo Editorale Electra, 1982.

_____. *The Italian Trans-avantgarde*. Milan: Giancarlo Politi Editore, 1980.

_____. *Europe/America: The Different Avant-gardes*. Milan: Deco Press, 1976.

Oliveira, Nicolas de, Nicola Oxley, and Michael Petry. *Installation Art*. London: Thames and Hudson, 1994.

O'Neill, William L. *Coming Apart: An Informal History of America in the 1960s*. New York: Quadrangle Books, 1977.

Parker, Roszika, and Griselda Pollock. *Old Mistresses: Women, Art and Ideology*. New York: Pantheon Books, 1981.

Peterson, Karen, and J.J. Wilson, *Women Artists*. New York: Harper & Row, 1976.

Phillipson, Michael. *Painting, Language, and Modernity*. London: Routledge and Kegan Paul, 1985.

Pincus-Witten, Robert. *Post-Minimalism into Maximalism*. Ann Arbor: UMI Research Press, 1987.

_____. *Entries: Maximalism*. London: Out of London Press, 1983.

_____. *Postminimalism*. New York: Out of London Press, 1977.

Plagens, Peter. *Sunshine Muse: Contemporary Art on the West Coast*. New York: Praeger Publishers, 1974.

Griselda Pollock, *Visions and Difference: Femininity, Feminism and the Histories of Art*. London: Routledge and Kegan Paul, 1988.

Pradel, Jean-Louis, ed. *World Art Trends 1983/4*. New York: Harry N. Abrams, 1984.

Jonathan Price, *Video Visions: A Medium Discovers Itself*. New York: New American Library, 1977.

Quintavalle, Arturo Carlo, and Vittorio Corna. *Italian Art 1960/80*, trans. Howard Roger MacLean. New York: Banca Commercialle Italiana, 1984. Preface by Thomas M. Messer.

Raven, Arlene. *Crossing Over: Feminism and Art of Social Concern*. Ann Arbor, Mich.: UMI Research Press, 1988.

Raven, Arlene, Cassandra Langer, and Joanna Frueh, eds., *Feminist Art Criticism: An Anthology*. Ann Arbor, Mich.: UMI Research Press, 1990.

Reinhardt, Ad. *Art as Art: The Selected Writings of Ad Reinhardt*, edited by Barbara Rose. New York: Viking Press, Documents of 20th-Century Art, 1975.

Robins, Corinne. *The Pluralist Era: American Art 1968–1981*. New York: Harper & Row, 1984.

Robinson, Hilary, ed. *Visibly Female: Feminism and Art Today*. London: Camden Press, 1987.

Rockwell, John. *All American Music: Composition in the Late Twentieth Century*. New York: Alfred A. Knopf, 1983.

Rose, Barbara. *American Art Since 1900*. New York: Praeger Publishers, 1975.

Rose, Margaret A. *The Post-modern and the Post-industrial: A Critical Analysis*. Cambridge, England: Cambridge University Press, 1991.

Rosen, Randy, and Catherine C. Brawer, eds. *Making Their Mark: Women Artists Move into the Mainstream, 1970–85*. New York: Abbeville Press, 1989.

Rosenberg, Harold. *Art on the Edge: Creators and Situations*. New York: Macmillan, 1971.

Rosenblum, Robert. *The Dog in Art from Rococo to Post-Modernism*. New York: Harry N. Abrams, 1988.

Roth, Moira, ed. *The Amazing Decade: Women and Performance Art in America 1970–1980*. Los Angeles: Astro Artz, 1983.

Ruhrberg, Karl. *Twentieth-Century Art: Painting and Sculpture in the Ludwig Museum*. New York: Rizzoli, 1986.

Russell, John. *The Meanings of Modern Art*. New York: Museum of Modern Art and Harper & Row, 1981.

Schneider, Ira, and Beryl Korot, eds. *Video Art: An Anthology*. New York: Harcourt Brace Jovanovich, 1976.

Rubinstein, Charlotte Streifer. *American Women Artists*. Boston: G.K. Hall & Co., 1982.

Saltz, Jerry. "Snapshot American Art 1980–1989," in *American Art of the 80's*. Milan: Electa, 1991.

Sayre, Henry M. *The Object of Performance: The American Avant-garde Since 1970*. Chicago: University of Chicago Press, 1989.

Schneider, Ira, and Beryl Korot, eds., *Video Art, An Anthology*. New York: Harcourt Brace Jovanovich, 1976.

Schwartz, Sanford. *The Art Presence: Painters, Writers, Photographers, and Sculptors*. New York: Horizon Press, 1982.

Selz, Peter. *Art in Our Time*. New York: Harry N. Abrams/Harcourt Brace Jovanovich, 1981.

Senie, Harriet F. *Contemporary Public Sculpture: Tradition, Transformation, and Controversy*. Oxford, England: Oxford University Press, 1983.

Siegel, Jeanne. *Art Talk: The Early 80s*. New York: Da Capo Press, 1988.

Smagula, Howard. *Currents: Contemporary Directions in the Visual Arts*. Englewood Cliffs, N.J.: Prentice-Hall, 1989.

Solomon-Godeau, Abigail. *Photography at the Dock*. Minneapolis: University of Minnesota Press, 1991.

Sondheim, Alan, ed. *Individuals: Post-Movement Art in America*. New York: E.P. Dutton, 1977.

Sonfist, Alan, ed. *Art in the Land: A Critical Anthology of Environmental Art*. New York: E.P. Dutton, 1983.

Stein, Harvey. *Artists Observed*. New York: Harry N. Abrams, 1986.

Steinberg, Leo. *Other Criteria: Confrontation with Twentieth-Century Art*. New York: Oxford University Press, 1972.

Taylor, Brandon. *Avant-Garde and After: Rethinking Art Now*. New York: Harry N. Abrams, 1995.

Tomkins, Calvin. *The Scene: Reports on Post-Modern Art*. New York: Viking Press, 1976.

Tuchman, Maurice, and Jane Livingston, *A & T: A Report on the Art and Technology Program of the Los Angeles County Museum of Art 1967–1971*. Los Angeles: Los Angeles County Museum, 1971.

Tufts, Eleanor. *Our Hidden Heritage: Five Centuries of Women Artists*. New York: Paddington Press, 1974.

Varnedoe, Kirk, and Adam Gopnik, eds., *Modern Art and Popular Culture: Readings in High & Low!* New York: Museum of Modern Art, 1990.

Venturi, Robert. *Complexity and Contradiction in Architecture*. New York: Museum of Modern Art, 1966.

Vergine, Lea. *Il Corpo Come Linguaggio: La 'Body-art' e Storie Simili*. Milan: Giampaolo Prearo Editore, 1974.

Waldman, Diane. *Collage, Assemblage, and the Found Object*. New York: Harry N. Abrams, 1992.

Wallis, Brian, ed. *Blasted Allegories: An Anthology of Writings by Contemporary Artists*. Cambridge, Mass.: MIT Press, 1987.

_____, ed. *Art After Modernism: Rethinking Representation*. New York: New Museum of Contemporary Art, 1984.

Warhol, Andy. *America*. New York: Harper & Row, 1985.

Watson, Peter. *From Manet to Manhattan: The Rise of the Modern Art Market*. New York: Random House, 1992.

Wheeler, Daniel. *Art Since Mid-Century: 1945 to the Present*. New York: Vendome, 1991.

Wilding, Faith. *By Our Own Hands: The Women Artists' Movement: Southern California: 1970–1976*. Santa Monica, Calif.: Double X, 1977.

Wrede, Stuart, and William Howard Adams, *Denatured Visions: Landscape and Culture in the Twentieth Century*. New York: Harry N. Abrams, 1991.

CATALOGS

Amherst, Mass. Hampshire College Gallery. *Images of the Self*, 1979. Text by Irving Sandler.

Amherst, Mass. Fine Art Center Gallery, University of Massachusetts. *Critical Perspectives in American Art*, 1976. Text by Rosalind Krauss.

Amsterdam. Stedelijk Museum. *'60s '80s: Attitudes/Concepts/Images*, 1982. Texts by Wim Beeren, Cor Blok, Edy de Wilde, Ad Peterson, Gijs van Tuyl, Antje von Gravenitz, and George Weissman.

_____. *Op Losse Schroeven: Situates en Crypostructuren*, 1969. Texts by Wim Beeren, Piero Gilardi, and Harald Szeemann.

Athens. Deste Foundation for Contemporary Art. *Artificial Nature*, 1990. Text by Jeffrey Deitch.

_____. *Cultural Geometry*, 1988. Texts by Jeffrey Deitch and Peter Halley.

Barcelona. Centre Cultural de la Fundacio Caixa de Pensions. *Art and Its Double*, 1987. Text by Dan Cameron.

Basel, Switzerland. Kunsthalle. *7 junge Kunstler aus Italien: Sandro Chia, Francesco Clemente, Enzo Cucchi, Nicola de Maria, Luigi Ontani, Mimmo Paladino, Ernesto Tatafiori*, 1980. Texts by Jean-Christophe Ammann, Achille Bonito Oliva, and Germano Celant.

Berlin. Hamburger Bahnhof. *Zeitlos*, 1988. Text by Harald Szeemann.

Berlin. Martin-Gropius-Bau. *Metropolis—International Art Exhibition Berlin*, 1991. Texts by Christos M. Joachimides and Norman Rosenthal.

Bern, Switzerland. Kunsthalle. *Fabro, Kounellis, Merz, Paolini: Materialien zu einer Ausstellung*, 1980. Texts by Johannes Gachnang, Per Kirkeby, Jannis Kounellis, and Mario Merz.

_____. *Live in Your Head: When Attitudes Become Form—Works, Concepts, Processes, Situations, Information*, 1969. Texts by Scott Burton, Gregoire Muller, Harald Szeemann, and Tommaso Trini.

Bielefeld. Kunsthalle. *Chia, Clemente, Cucchi*, 1983. Text by Wolfgang Max Faust.

Boston, Institute of Contemporary Art and the Museum of Fine Arts, and Düsseldorf, Germany, Kunsthalle. *The Bi-National: American Art of the Late 80's*, 1988. Texts by Trevor Fairbrother, David Joselit, Elisabeth Sussman, and Thomas Crow.

Boston. Institute of Contemporary Art. *Endgame: Reference and Simulation in Recent Painting and Sculpture*, 1986. Texts by Yve-Alain Bois, Thomas Crow, and Hal Foster.

Boston. Museum of Fine Arts. *Beuys and Warhol*, 1991–92. Text by Trevor Fairbrother.

Buffalo, N.Y. Albright-Knox Art Gallery, *American Painting of the 1970s*, 1978. Text by Linda Cathcart.

Charlotte, N.C. Knight Gallery. *Holzer, Kruger, Prince*, 1984. Text by William Olander.

Chicago. Art Institute of Chicago. *Europe in the Seventies: Aspects of Recent Art*, 1977. Texts by Jean-Christophe Ammann, David Brown, B.H.D. Buchloh, and Rudi Fuchs.

Chicago. Museum of Contemporary Art. *A View of a Decade: 1966–1976/Ten Years*, 1977. Text by Martin Friedman, Robert Pincus-Witten, and Peter Gay.

_____. *Bodyworks*, 1975. Text by Ira Licht.

Chicago. Renaissance Society at the University of Chicago. *A Fatal Attraction: Art and the Media*, 1982. Text by Thomas Lawson.

Cincinnati. Cincinnati Art Museum. *Making Their Mark: Women Artists Move into the Mainstream: 1970–1985*, 1989. Texts by Catherine C. Brawer, Ellen G. Landau, Thomas McEvilley, Ferris Olin, Randy Rosen, Calvin Tomkins, Marcia Tucker, and Ann-Sargent Wooster.

Cincinnati. Contemporary Arts Center. *Arabesque*, 1979. Text by Ruth K. Meyer.

Cologne. Museum Ludwig. *Bilderstreit. Widerspruch, Einhalt und Fragment in der Kunst seit 1960*, 1989. Texts by Siegfried Gohr, Johannes Gachnang, Hans Belting, and Michael Compton.

Cologne. Museen der Stadt. *Westkunst: Zeitgenossische Kunst seit 1939*, 1981. Texts by Hugo Borger, Laszlo Glazer, Kasper König, and Karl Ruhrberg.

Düsseldorf, Germany. Stadtische Kunsthalle. *Prospect Retrospect. Europe 1946–1976*, 1976. Texts by Jürgen Harten, Konrad Fischer, John Matheson, Hans Strelow, Benjamin Buchloh, and Rudi H. Fuchs.

Fort Lauderdale, Fla. Museum of Art. *An American Renaissance: Painting and Sculpture Since 1940*, 1986. Texts by Sam Hunter, Malcolm R. Daniel, Harry F. Gaugh, Karen Koehler, Kim Levin, Robert C. Morgan, and Richard Sarnoff.

Houston. Contemporary Art Museum. *American Narrative/Story Art: 1967–1977*, 1977. Text by Paul Schimmel.

Indianapolis. Indianapolis Museum of Art. *Power: Its Myths and Mores in American Art, 1961–1991*, 1991. Texts by Holliday T. Day, Anna C. Chave, George E. Marcus, and Brian Wallis.

Ithaca, N.Y. Andrew Dickson White Museum. *Earth*, 1969. Texts by Willoughby Sharp and William C. Lipke.

Jacksonville, Fla. Art Sources Inc. *Patterned Space*, 1979. Text by Tony Robbin.

Jerusalem. Israel Museum. *Life-Size: A Sense of the Real in Recent Art*, 1990. Texts by Suzanne Landau, Douglas Crimp, Carolyn Christov-Bakargiev, Germano Celant, Robert Storr, and Christian Leigh.

Kassel, Germany. *Documenta 9*, 1992. Texts by Jan Hoet, Denys Zacheropoulos, Bart de Baere, Pier Luigi Tazzi, and Claudia Herstatt.

_____. *Documenta 8*, 1987. Texts by Bazon Brock, Vittorio Fagone, Edward F. Fry, Michael Grauer, Wenzel Jacob, Wulf Herzogenrath, Georg Jappe, Pierre Restany, Lothar Romain, and Manfred Beilharz.

_____. *Documenta 7*, 1982. Texts by Saskia Bos, Coosje van Bruggen, Germano Celant, Hans Eichel, Rudi H. Fuchs, Johannes Gachnang, Walter Nikkels, and Gerhard Storck.

_____. *Documenta 6*, 1977. Texts by Karl Oscar Blase, Bazon Brock, Joachim Diederichs, Ulrich Gregor, Birgit Hein, Wulf Herzogenrath, Klaus Honnef, Peter W. Janson, Lothar Long, Günter Metkin, Lothar Romain, David A. Ross, Vieland Schmeid, Manfred Schneckenburger, and Evelyn Weiss.

_____. *Documenta 5*, 1972. Texts by Ingolf Bauer, Reiner Diederich, Richard Grubling, Hans Heinz Holz, Ebherd Roters, Willy Rotzler, Klaus Staeck, Pierre Versins, and Charles Wilp.

La Jolla, Calif. Museum of Contemporary Art. *Sitings*, 1986. Texts by Hugh M. Davies and Ronald J. Onorato.

Lausanne, Switzerland. Musée d'Art Contemporain. *Post Human*, 1992. Text by Jeffrey Deitch.

Lewisburg, Pa. Center Gallery, Bucknell University. *Contemporary Perspectives*, 1984. Text by Thomas Lawson.

London. Hayward Gallery. *Falls the Shadow*, 1986. Texts by Barry Barker, Joanna Drew, Susan Ferleger, and Jon Thompson.

_____. *The Condition of Sculpture*, 1975. Text by William Tucker.

London. Hayward Gallery and Serpentine Gallery. *The Sculpture Show*, 1983. Texts by Kate Blacker, Fenella Crichton, Paul de Monchaux, Nena Dimitrijevic, Stuart Morgan, Dianna Petherbridge, Bryan Robertson, and Nicholas Wadley.

London. Institute of Contemporary Art. *Comic Iconoclasm*, 1987. Text by Sheena Wagstaff.

London. Institute of Contemporary Art and Hayward Gallery. *Arte Italiana*, 1982. Texts by Guido Ballo, Renato Barilli, Flavio Caroli, Vittorio Fagone, Luciano Giaccari, Loredano Parmesani, Roberto Sanesi, and Caroline Tisdall.

London. Royal Academy of Arts. *American Art in the Twentieth Century: Paintings and Sculpture 1913–1993*, 1993. Texts by Barbara Moore, Brooks Adams, Neal Benezra, Richard Armstrong, John Beardsley, Wolfgang Max Faust, Donald Kuspit, Gail Savitsky, Mary Lublin, Carter Ratcliff, Karel Ann Marling, Peter Selz, Thomas Kellein, Achille Bonito Oliva, and others.

_____. *Italian Art in the Twentieth Century*, 1989. Texts by Norman Rosenthal, Germano Celant, Alberto Asor Rosa, and Caroline Tisdall.

_____. *German Art in the 20th Century: Painting and Sculpture 1905–1985*, 1985. Texts by Christos M. Joachimides, Norman Rosenthal, Wieland Schmied, Irit Rogoff, Walter Grasskamp, Siegfried Gohr, Franz Meyer, and Gunther Gercken.

_____. *ZEITGEIST*, 1982. Texts by Walter Bachauer, Thomas Bernhard, Karl-Heinz Bohrer, Paul Feyarbend, Christos M. Joachimides, Hilton Kramer, Vittorio Magnano Lampugnani, Robert Rosenblum, and Norman Rosenthal.

_____. *A New Spirit in Painting*, 1981. Texts by Hugh Casson, Christos M. Joachimides, Norman Rosenthal, and Nicholas Serota.

London. Tate Gallery. *New Art at the Tate Gallery*, 1983. Texts by Alan Bowness and Michael Compton.

Los Angeles. California Afro-American Museum. *Introspectives: Contemporary Art by Americans and Brazilians of African Descent*, 1989. Texts by Henry J. Drewe and David C. Driscoll.

Los Angeles. Institute of Contemporary Art. *Architectural Sculpture*, 1980. Texts by Debra Burchett, Susan C. Larsen, Lucy R. Lippard, and Melinda Wortz.

Los Angeles. Los Angeles County Museum of Art. *Avant-Garde Art in the Eighties*, 1987. Text by Howard N. Fox.

_____. *Photography and Art: Interactions Since 1946*, 1987. Texts by Andy Grunsberg and Kathleen McCarthy Gauss.

_____. *Individuals: A Selected History of Contemporary Art*, 1986. Texts by Kate Linker, Donald Kuspit, Hal Foster, Ronald J. Onorato, Germano Celant, Achille Bonito Oliva, John C. Welchman, and Thomas Lawson.

_____. *American Sculpture of the Sixties*, 1967. Texts by Maurice Tuchman, Lawrence Alloway, Wayne V. Andersen, Dore Ashton, John Coplans, Clement Greenberg, Max Kozloff, Lucy R. Lippard, James Monte, Barbara Rose, and Irving Sandler.

Los Angeles. Museum of Contemporary Art. *Helter Skelter. LA Art in the Nineties*, 1992. Texts by Paul Schimmel, Norman M. Klein, Lane Relyea, Charles Bukowski, and others.

_____. *A Forest of Signs: Art in the Crisis of Representation*, 1989. Texts by Ann Goldstein, Mary Jane Jacob, Ann Rorimer, and Howard Singerman.

Los Angeles. Rosamund Felsen Gallery. *Just Pathetic*, 1990. Text by Ralph Rugoff.

Milwaukee. Milwaukee Art Museum. *Word as Image: American Art 1960–1990*, 1990. Texts by Gerry Biller, Russell Bowman, and Dean Sobel.

_____. *The World of Art Today*, 1988. Text by Russell Bowman.

New Haven, Conn. Yale University Art Gallery. *Twenty Artists: Yale School of Art, 1950–1970*, 1981. Text by Irving Sandler.

New York. American Fine Arts. *Just Pathetic*, 1992.

New York. Artists Space. *Pictures*, 1977. Text by Douglas Crimp.

New York. Bronx Museum of the Arts. *Traditions and Transformations: Contemporary Afro-American Sculpture*, 1989. Text by Philip Verre.

New York. Fischbach Gallery. *Eccentric Abstraction*, 1966. Text by Lucy R. Lippard.

New York. Grey Art Gallery and Study Center, New York University. *American Painting: The Eighties: A Critical Interpretation*, 1979. Text by Barbara Rose.

New York. Solomon R. Guggenheim Museum. *Refigured Painting: The German Image 1960–88*, 1989. Texts by Heinz Ruhnau, Michael Govan, Heinrich Klotz, and Thomas Krens, Hans Albert Peters, Jürgen Schilling, and Joseph Thompson.

_____. *Italian Art Now: An American Perspective*, 1982. Texts by Lisa Dennison and Diane Waldman.

New York. Independent Curators, Inc. *Critiques of Pure Abstraction*, 1995. Text by Mark Rosenthal.

_____. *From Media to Metaphor: Art About AIDS*, 1992. Texts by Robert Atkins and Thomas W. Sokolowski.

_____. *Team Spirit*, 1989. Texts by James Hillman, Irit Rogoff, Susan Sollins, and Nina Sundell.

New York. Institute of Art and Urban Resources, P.S. 1 Museum. *The Knot Arte Povera*, 1985. Text by Germano Celant, Alanna Heiss, and the participating artists.

_____. *Rooms*, 1977. Texts by Alanna Heiss and Linda Blumberg.

New York. Institute of Contemporary Art and Clocktower Gallery. *Modern Dreams: The Rise and Fall of Pop*, 1988. Texts by Edward Leffingwell, Karen Marta, and others.

New York. International Center of Photography. *The Indomitable Spirit*, 1990. Texts by Marvin Heifferman and Andy Grundberg.

New York. Lehman College Art Gallery. *Landscape in the Age of Anxiety*, 1986. Text by Nina Sundell.

New York. Marlborough Gallery, *Pressure to Paint*, 1982. Text by Diego Cortez.

New York. Museum of Modern Art. *Dislocations*, 1992. Text by Robert Storr.

_____. *Allegories of Modernism*, 1992. Text by Bernice Rose.

_____. *High & Low: Modern Art and Popular Culture*, 1990. Texts by Kirk Varnedoe and Adam Gopnik.

_____. *Modern Art and Popular Culture: Readings in High & Low*, 1990. Texts by Kirk Varnedoe, Adam Gopnik, John Bowlt, Lynne Cooke, Lorenz Eitner, Irving Lavin, Peter Plagens, Robert Rosenblum, Roger Shattuck, Robert Storr, and Jeffrey Weiss.

_____. *High & Low: Modern Art and Popular Culture: Six Evenings of Performance*, 1990. Texts by RoseLee Goldberg, Laurie Anderson, Eric Bogosian, Bongwater

(Ann Magnuson & Kramer), David Cale, Brian Eno, and Spalding Gray.

_____. *Committed to Print: Social and Political Themes in Recent American Printed Art*, 1988. Text by Deborah Wye.

_____. *1961 Berlinart 1987*, 1987. Texts by Rene Block, Lawrence Kardish, Kynaston McShine.

_____. *Primitivism in 20th Century Art: Affinity of the Tribal and the Modern*, 1984. Texts by William Rubin, Kirk Varnedoe, et al.

_____. *An International Survey of Recent Painting and Sculpture*, 1984. Texts by Richard E. Oldenburg and Kynaston McShine.

_____. *New Work on Paper*, 1982. Text by Bernice Rose.

_____. *Information*, 1970. Text by Kynaston L. McShine.

New York. New Museum of Contemporary Art. *The Decade Show, Frameworks of Identity in the 1980s*, 1990. Texts by Kinshasha Holman-Conwill, Nilda Peraza, Marcia Tucker, C. Carr, David Deitcher, Jimmie Durham, Guillermo Gomez-Pena, Julia P. Herzberg, Susana Toruella Leval, Eunice Lipton, Margo Machida, Micki McGee, Sharon P. Patton, Lowery Stokes Sims, Laura Trippe and Gary Sangster, and Judith Wilson.

_____. *The Other Man: Representations of Masculinity*, 1987. Text by Marcia Tucker.

_____. *Fake: A Meditation on Authenticity*, 1987. Text by William Olander.

_____. *Damaged Goods: Desire and the Economy of the Object*, 1986. Texts by Hal Foster, Brian Wallis, Deborah Bershad, and Marcia Tucker, and artists' statements.

_____. *The Art of Memory: The Loss of History*, 1985. Text by William Olander.

_____. *"Bad" Painting*, 1978. Text by Marcia Tucker.

New York. New York Cultural Center. *Conceptual Art and Conceptual Aspects*, 1970. Text by Donald Karshan.

New York. Queens Museum. *The Real Big Picture*, 1986. Text by Marvin Heifferman.

New York. Tony Shafrazi Gallery. *The Last Decade: American Artists of the 80s*, 1990. Texts by Robert Pincus-Witten, Diego Cortez, and Collins & Milazzo.

New York. Holly Solomon Gallery. *Holly Solomon Gallery*, 1983. Texts by Richard Armstrong and Robert Rosenblum, and Holly and Horace Solomon interview with Neil Printz.

New York. Whitney Museum of American Art. *Black Male*, 1994. Text by Thelma Golden.

_____. *1991 Biennial*, 1991. Texts by Richard Armstrong, John G. Hanhardt, and Lisa Phillips.

_____. *The New Sculpture 1965–75: Between Geometry and Gesture*, 1990. Texts by Richard Armstrong, John G. Hanhardt, and Robert Pincus-Witten.

_____. *Image World: Art and Media Culture*, 1989. Texts by Marvin Heifferman, Lisa Phillips, and John G. Hanhardt.

_____. *1989 Biennial Exhibition*, 1989. Texts by Richard Armstrong, John G. Hanhardt, Richard Marshall, and Lisa Phillips.

_____. *1987 Biennial Exhibition*, 1987. Texts by Richard Armstrong, John G. Hanhardt, Richard Marshall, and Lisa Phillips.

_____. *1985 Biennial Exhibition*, 1985. Texts by Richard Armstrong, John G. Hanhardt, Barbara Haskell, Richard Marshall, Lisa Phillips, and Patterson Sims. Includes *Americana*, curated by Group Material.

_____. *Focus on the Figure: Twenty Years*, 1982. Text by Barbara Haskell.

_____. *1981 Biennial Exhibition*, 1981. Texts by John G. Hanhardt, Barbara Haskell, Richard Marshall, Mark Segal, and Patterson Sims.

_____. *1979 Biennial Exhibition*, 1979. Texts by John G. Hanhardt, Barbara Haskell, Richard Marshall, Mark Segal, and Patterson Sims.

_____. *New Image Painting*, 1978. Text by Richard Marshall.

_____. *Art About Art*, 1978. Texts by Leo Steinberg, Jean Lipman, and Richard Marshall.

_____. *1977 Biennial Exhibition*, 1977. Texts by Barbara Haskell, Marcia Tucker, Patterson Sims, John G. Hanhardt, and Mark Segal.

_____. *Two Hundred Years of American Sculpture*. 1976. Texts by Tom Armstrong, Wayne Craven, Norman Feder, Barbara Haskell, Rosalind E. Krauss, Daniel Robbins, and Marcia Tucker.

_____. *Anti-Illusion: Procedures/Materials*, 1969. Texts by Marcia Tucker and James Monte.

Newport Beach, Calif. Newport Harbor Art Museum. *Cal Arts: Skeptical Belief(s)*, 1987. Text by Susanne Ghez.

Omaha. Joslyn Art Museum. *New Art of Italy*, 1985. Text by Holliday T. Day.

Philadelphia. Institute of Contemporary Art, University of Pennsylvania. *Devil on the Stairs: Looking Back on the Eighties*, 1991. Texts by Robert Storr and Judith Tannenbaum.

_____. *Modern Dreams*, 1988. Text by Thomas Lawson.

_____. *1967: At the Crossroads*, 1987. Texts by Janet Kardon, Hal Foster, and Irving Sandler.

_____. *The East Village Scene*, 1984. Texts by Janet Kardon and Irving Sandler.

_____. *Image Scavengers: Painting* and *Image Scavengers: Photography*, 1982. Texts by Janet Kardon, Paula Marincola, and Douglas Crimp.

_____. *Drawings: The Pluralist Decade*, 1980. Texts by Janet Kardon, John Hallmark Neff, Rosalind Krauss, Richard Lorber, Edit deAk, John Perreault, Howard N. Fox, and Nancy Foote.

_____. *The Decorative Impulse*, 1979. Text by Janet Kardon.

_____. *Dwellings*, 1978. Text by Lucy Lippard.

_____. *Improbable Furniture*, 1977. Texts by Robert Pincus-Witten and Suzanne Delehanty.

_____. *Against Order: Chance and Art*, 1970. Text by Robert Pincus-Witten.

Pittsfield, Mass. Berkshire Museum. *New Decorative Art*, 1983. Text by Debra Bricker Balken.

Pittsburgh. Carnegie Mellon Art Gallery. *Abstraction/ Abstraction*, 1986. Texts by David Carrier and Elaine A. King.

Pittsburgh. Museum of Art, Carnegie Institute. *1991 Carnegie International*, 1991. Texts by Lynne Dooke, Mark Francis, Fumio Nanjo, and Zinovy Zinik.

_____. *1988 Carnegie International*, 1988. Texts by John Caldwell, Vicky A. Clark, Thomas McEvilley, Lynn Cooke, Milena Kalinovska, Jole de Sanna, Marjorie Welish, Dan Cameron, Lothar Baumgarten, Jamey Gambrell, Stephen Schmidt-Wulffen, Barbara London, Kellie Jones, Michael Newman, Sarah McFadden, Linda Norden, and Nancy Princenthal.

_____. *1985 Carnegie International*, 1985. Texts by Achille Bonito Oliva, Bazon Broch, Benjamin H.D. Buchloh, John Caldwell, Germano Celant, Hal Foster, Rudi H. Fuchs, Johannes Gachnang, Per Kirkeby, Jannis Kounellis, Hilton Kramer, Donald B. Kuspit, John R. Lane, Thomas McEvilley, Mark Rosenthal, Peter Schjeldahl, and Nicholas Serota.

Princeton, N.J. Squibb Gallery. *Aspects of Post-Modernism: Decorative and Narrative Art*, 1981. Text by Sam Hunter.

Purchase, N.Y. Neuberger Museum of Art. *Soundings*, 1981. Texts by Dore Ashton, Germano Celant, Suzanne Delehanty, and Lucy Fischer.

Regina, Alberta. Norman Mackenzie Art Gallery. *Space Invaders*, 1985. Texts by Bruce Ferguson and Sandy Nairne.

St. Louis. St. Louis Art Museum. *Expressionism: New Art from Germany*, 1983. Text by Jack Cowart.

Santa Barbara, Calif. University Art Museum, University of California. *Neo-York*, 1984. Text by Phyllis Plous.

Sarasota, Fla. John and Mable Ringling Museum of Art. *This Is Not a Photograph: Twenty Years of Large-Scale Photography*, 1987. Texts by Joseph Jacobs and Marvin Heifferman.

Seattle. Henry Art Gallery, University of Washington. *The Idea of the Post-Modern: Who Is Teaching It?*, 1981. Texts by Lawrence Alloway, Donald B. Kuspit, Martha Rosler, and Jan van der Marck.

Stockholm. Moderna Museet. *Flyktpunkter: Vanishing Points*, 1984. Text by Lucy Lippard.

Tokyo. Setagaya Art Museum. *Beyond the Frame: American Art 1960–1990*, 1991. Texts by Lynn Gumpert and Brian Wallis.

Toronto. Art Gallery of Ontario. *The European Iceberg: Creativity in Germany and Italy Today*, 1985. Texts by Germano Celant, Roald Nasgaard, Tilmann Buddensieg, Francesco Dal Co, Bruno Cora, Johannes Gachnang, Arturo Carlo Quintavalle, and others.

Turin, Italy. Galleria Civica d'Arte Moderna, *Conceptual Art, Arte Povera, Land Art*, 1970. Texts by Germano Celant, Lucy Lippard, Luigi Malle, and Aldo Passoni.

Washington, D.C.: Hirshhorn Museum and Sculpture Garden, *Content: A Contemporary Focus, 1974–1984*, 1984. Texts by Howard F. Fox, Miranda McClintic, and Phyllis D. Rosenzweig.

_____. *Directions '83*, 1983. Text by Phyllis D. Rosenzweig.

_____. *Directions*, 1979. Text by Howard H. Fox.

Winnipeg, Manitoba. Winnipeg Art Gallery. *The Impossible Self*, 1988. Texts by Bruce Ferguson and Sandy Nairne.

GENERAL ARTICLES

Alexander, Max. "Now on View, New Work by Freelance Curators." *New York Times*, February 19, 1989, sec. 2, pp. 35, 40.

Alinovi, Francesca. "Twenty-first Century Slang." *Flash Art* (November 1983): 23–27.

Alloway, Lawrence. "Site Inspection." *Artforum*, October 1976, pp. 49–55.

Ames, Katrine, with Maggie Malone and Donna Foote, "Sold! The Art Auction Boom." *Newsweek*, April 18, 1988, pp. 65–72.

Ammann, Jean-Christophe. "A Plea for New Art in Public Places." *Parkett* (July 1984): 7–35.

_____. "Documenta: Reality and Desire." *Flash Art* (November 1982): 37–39.

_____. "Westkunst in Cologne." *Flash Art* (October-November 1981): 51.

_____. "Schweizer Brief: 'Live in Your Head—When Attitudes Become Form.'" *Art International*, May 1969, pp. 47–50.

Anderson, Alexandra. "The New Bronze Age." *Portfolio*, March-April 1983, pp. 78–83.

_____. "When Artists Make Furniture." *Art News*, February 1981, pp. 93–98.

Andre, Carl, and Jeremy Gilbert-Rolfe, "Commodity and Contradiction, or, Contradiction as Commodity." *October* 2 (Summer 1966): 100–104.

Antin, David. "Television: Video's Frightful Parent: Part I." *Artforum*, December 1975, pp. 36–45.

_____. "Talking at Pomona." *Artforum*, September 1972, pp. 39–47.

_____. "Art and Corporations." *Art News*, September 1971, pp. 23–26, 52–56.

_____. "Lead, Kindly Blight: Ecological Year for Artists, *Art News*, November 1970, pp. 36–39, 87–90.

Apple, R.W., Jr. "Portrait of the 80's: Shall We Dance?: As Two Worlds Warm, A Post-Postwar Order Awaits." *New York Times, The Weekly Review*, December 24, 1989, sec. 4, p. 1.

Appleyard, Bryan. "Lynch Pinned." *Sunday Times Magazine* (London), August 12, 1990, pp. 17–23.

Avgikos, Jan. "Point Zero: German Art in the 1950s." *Arts Magazine*, March 1990, pp. 52–59.

Baker, Elizabeth C. "Editorial: How Expressionist Is It?" *Art in America*, December 1982, p. 5.

_____. "The 'Return' of European Art." *Art in America*, September 1982, p. 5.

_____. "Artworks on the Land." *Art in America*, January-February 1976, pp. 92–96.

Baker, Kenneth. "Abstract Jestures." *Artforum*, September 1989, pp. 135–38.

_____. "Report from London: The Saatchi Museum Opens." *Art in America*, July 1985, pp. 23–27.

Edward Ball. "Interviews: Mark Francis." *Flash Art* (January-February 1990): 156–57, 176.

_____. "'The Beautiful Language of My Century': From the Situationists to the Simulationists." *Arts Magazine*, January 1989, pp. 65–72.

Bann, Stephen. "Mobilizing Memories: Italian Art in the 20th Century at the Royal Academy, London." *Arts Magazine*, April 1989, pp. 37–39.

Baudrillard, Jean. "What Are You Doing After the Orgy." *Artforum*, October 1983, pp. 42–46.

Bell, Jane. "What Is German About the New German Art?" *Art News*, March 1984, pp. 96–101.

_____. "Biennial Directions: The 1983 Whitney Biennial." *Art News*, Summer 1983, pp. 76–79.

Benezra, Neal. "Overstated Means/Understated Meaning: Social Content in the Art of the 1980s." *Smithsonian Studies in American Art*, Winter 1988, pp. 19–31.

Berman, Avis. "Public Sculpture's New Look." *Art News*, September 1991, pp. 102–109.

Berman, Marshall. "Can These Ruins Live?" *Parkett*, no. 20 (1989): 42–55.

Bernard, Christian. "Business-Streit." *Galeries Magazine*, June-July 1989, pp. 94–99, 141.

Bleckner, Ross. "Transcendent Anti-fetishism." *Artforum*, March 1979, pp. 50–55.

Bernard Blistène, "Francis Picabia: In Praise of the Contemptible." *Flash Art* (Summer 1983): 24–31.

Borum, Jenifer Penrose. "Robert Pincus-Witten: The Critic as Dandy." *Art Criticism* 5, no. 2 (1989): 49–60.

Beyer, Lucie, and Karen Marta. "Report from Germany: Why Cologne?" *Art in America*, December 1988, pp. 45–51.

Bourdon, David. "Art: Artforum Goes PolitiCalif." *Village Voice*, January 5, 1976, pp. 64–68.

Bourriaud, Nicolas. "Giancarlo Politi, Helena: 20 Years of Flash Art," an interview. *Galeries Magazine*, December-January 1988, pp. 50–51, 138.

Bowman, Russell. "Words and Images: A Persistent Paradox." *Art Journal* (Winter 1985): 335–43.

Bradbury, Malcolm. "The Scholars Who Misread History." *New York Times Book Review*, February 24, 1991, p. 9. A review of David Lehman, *Signs of the Times: Deconstruction and the Fall and Decline of Paul de Man*. New York: Poseidon Press, 1991.

Brenson, Michael. "Art View: Is Neo-Expressionism an Idea Whose Time Has Passed?" *New York Times*, January 5, 1986, sec. 2, pp. 1, 12.

_____. "New Painting Phenomenon." *Brutus*, February 1984, pp. 26–66.

_____. "Artists Grapple with New Realities." *New York Times*, May 15, 1983, sec. 2, pp. 1, 30.

Brewster, Todd. "Boone Means Business." *Life Magazine*, May 1982, pp. 30–37.

Bryson, Norman, and Elizabeth Cowie, "Invisible Bodies." *New Formations*, Summer 1987, pp. 20–28, 29–36.

Brighton, Andrew. "Bad History." *Artscribe*, February-March 1986, pp. 30–33.

Brock, Bazon. "The End of the Avant-Garde? And So the End of Tradition." *Artforum*, Summer 1981, pp. 62–67.

Bromberg, Craig. "Spotlight: Thomas Krens: Gunslinger for the Guggenheim." *Art News*, May 1988, pp. 73–74.

Brooks, Peter. "Western Civ at Bay." *Times Literary Supplement*, January 25, 1991, pp. 5–6.

_____. "Space Fictions." *Flash Art* (December 1986-January 1987): 78–80.

_____. "From the Night of Consumerism to the Dawn of Simulation." *Artforum*, February 1985, pp. 76–81.

Benjamin H. D. Buchloh, "Documenta 7: A Dictionary of Received Ideas." *October* 22 (Fall 1982): 104–26.

_____. "Allegorical Procedures: Appropriation and Montage in Contemporary Art." *Artforum*, September 1982, pp. 43–56.

_____. "Parody and Appropriation in Francis Picabia, Pop, and Sigmar Polke." *Artforum*, March 1982, pp. 28–34.

_____. "Figures of Authority, Ciphers of Regression: Notes on the Return of Representation in European Art." *October* 16 (Spring 1981): 39–68.

Burgin, Victor. "Photographic Practice and Art Theory." *Studio International*, July-August 1975, pp. 39–51.

Burnham, Jack. "Ten Years Before the Artforum Masthead." *New Art Examiner*, April 1978, pp. 1, 6–7.

_____. "Alice's Head: Reflections on Conceptual Art." *Artforum*, February 1970, pp. 37–43.

_____. "Real Time Systems." *Artforum*, September 1969, pp. 49–55.

Buruma, Ian. "There's No Place Like Heimat." *New York Review of Books*, December 20, 1990, pp. 34–43.

Buskirk, Martha. "Interviews with Sherrie Levine, Louise Lawler, and Fred Wilson." *October* 70 (1994): 104–108.

Cameron, Dan. "Changing Priorities in American Art." *Art International*, Spring 1990, pp. 86–90.

_____. "Pop 'n' Rock." *Art Issues*, November 1989, pp. 9–17.

_____. "Think Piece." *Arts Magazine*, April 1987, pp. 25–29.

_____. "Documenta 8 Kassel." *Flash Art* (October 1987): 61–68.

_____. "The Whitney Biennial." *Flash Art* (Summer 1987): 86–87.

_____. "Art and Its Double: A New York Perspective." *Flash Art*, special supplement (May 1987): 57–71.

_____. "Post-Feminism." *Flash Art* (February-March 1987): 80–83.

_____. "Report from the Front." *Arts Magazine*, Summer 1986, pp. 86–93.

_____. "Pretty as a Product." *Arts Magazine*, May 1986, pp. 22–25.

_____. "Transparencies." *Art Criticism* 3, no. 1 (1986): 1–10.

_____. "Illustration Is Back in the Picture." *Art News*, November 1985, pp. 114–20.

_____. "A Whitney Wonderland." *Arts Magazine*, Summer 1985, pp. 66–69.

_____. "Mary Boone and the Sandinistas." *Arts Magazine*, May 1984, pp. 96–99.

_____. "Biennial Cycle." *Arts Magazine*, June 1983, pp. 64–68.

Carr, C. "Money Changes Everything: The East Village Art Mart." *Village Voice Literary Supplement*, September 1985, pp. 6–7.

Carrier, David. "Art Criticism and Its Beguiling Fictions." *Art International*, Winter 1989, pp. 36–41.

_____. "Baudrillard as Philosopher or, The End of Abstract Painting." *Arts Magazine*, September 1988, pp. 52–60.

_____. "Suspicious Art, Unsuspecting Texts." *Arts Magazine*, November 1985, pp. 32–35.

Catoir, Barbara. "The New German Collectors." *Art News*, April 1986, pp. 77–82.

Celant, Germano. "Art Spaces." *Studio International*, September-October 1975, pp. 115–23.

Chandler, John Noel. "Notes Toward a New Aesthetic." *Artscanada*, October-November, pp. 16–41.

Christov-Bakargiev, Carolyn. "Arte Povera 1967–1987." *Flash Art* (November-December 1987): 52–69.

Clair, Jean. "Giorgio de Chirico: The Terror of History." *Flash Art* (March 1983): 12–20.

Clarke, John R. "Up Against the Wall, Transavantguardia!" *Arts Magazine*, December 1982, pp. 76–81.

_____. "The Decorative Revisited: 'Five on Fabric.'" *Arts Magazine*, May 1982, pp. 142–43.

Cohen, Ronny H. "Energism: An Attitude." *Artforum*, September 1980, pp. 16–23.

Collings, Matthew. "Mythologies: Art and the Market: Jeffrey Deitch Interviewed by Matthew Collings." *Artscribe*, April-May 1986, pp. 22–26.

_____. "More or Less: Achille Bonito Oliva: Interviewed by Matthew Collings." *Artscribe International*, February-March 1986, pp. 42–43.

Collins, James. "Love and Loathing in Europe." *Flash Art* (March 1985): 62–69.

_____. "The Rise of Europe." *Flash Art* (October-November 1981): 64–67.

Collins, Tricia, and Richard Milazzo. "Sinking to the Bottom of Discourse. Rene Ricard." *Tema Celeste*, July-October 1990, pp. 50–55.

Colpitt, Frances. "Report from Los Angeles: Space Commanders." *Art in America*, January 1990, pp. 67–71.

Compton, Michael. "Art and Responsibility." *Flash Art* (Summer 1980): 10–11.

Cone, Michele. "Conversations with Art Collectors: Michael Schwartz." *Flash Art* (December 1985-January 1986): 63.

Cooke, Lynne. "Minimalism Reviewed." *Burlington Magazine*, September 1989, pp. 641–45.

_____. "Object Lessons." *Artscribe International*, September–October 1987, pp. 55–59.

_____. "Neo-Primitivism: A Regression to the Domain of the 'Night-Mind' or Adolescent Persiflage?" *Artscribe*, March-April 1985, pp. 16–24.

Cotter, Holland. "Dislocating the Modern." *Art in America*, January 1992, pp. 100–107.

_____. "Black Artists: Three Shows." *Art in America*, March 1990, pp. 164–71, 217.

_____. "Report from New York: A Bland Biennial." *Art in America*, September 1989, pp. 81–87.

_____. "Import/Export: Art from the Exiled City." *Art in America*, October 1987, pp. 43–51.

Cottingham, Laura. "Reviews: The Last Decade: Eighties Artists." *Contemporanea*, December 1990, pp. 88–89.

Coulson, Crocker. "Too Much Too Soon?" *Art News*, September 1987, pp. 115–19.

Coxhead, David. "Growing Up: Lucy Lippard," an interview. *Art Monthly*, December 1979-January 1980, pp. 4–9.

Craven, David. "Science Fiction and the Future of Art." *Arts Magazine*, May 1984, pp. 125–29.

Crimp, Douglas. "The End of Painting." *October* 16 (Spring 1981): 69–86.

_____. "The Photographic Activity of Postmodernism." *October* 15 (Winter 1980): 91–101.

_____. "Pictures." *October* 8 (Spring 1979): 75–88.

Critical Art Ensemble, "Interview Thomas Lawson." *Art Papers*, January-February 1989, pp. 20–26.

Danto, Arthur C. "What Happened to Beauty?" *Nation*, March 30, 1992, pp. 418–21.

_____. "Art: Spoleto Festival U.S.A." *Nation*, July 29–August 5, 1991, pp. 168–72.

_____. "Art for Activism's Sake." *Nation*, June 3, 1991, pp. 743–47.

_____. "Bad Aesthetic Times in the USA?" *Modern Painters*, Summer 1989, pp. 55–59.

Davis, Douglas. "Issues and Commentary: 57th Street: A Neomodern Melodrama." *Art in America*, March 1984, pp. 9–17.

_____. "Issues and Commentary: The Avant Garde Is Dead! Long Live the Avant Garde." *Art in America*, April 1982, pp. 11–19.

_____. "Architecture: Design for Living." *Newsweek*, November 6, 1978, pp. 82–91.

_____. "The Size of Non-Size." *Artforum*, December 1976, pp. 46–51.

_____. "The Arts in America: Art Without Limits." *Newsweek*, December 24, 1973, pp. 68–74.

DeAk, Edit. "The Critic Sees Through the Cabbage Patch." *Artforum*, April 1984, pp. 53–60.

_____. "Stalling Art." *Artforum*, September 1982, pp. 71–75.

_____. "A Chameleon in a State of Grace." *Artforum*, February 1981, pp. 36–41.

DeAk, Edit, and Diego Cortez. "Baby Talk." *Flash Art* (May 1982): 34–38.

DeAk, Edit, and Ingrid Sischy. "A Light of Opportunity: An Editorial." *Artforum*, January 1985, p. 48.

Decter, Joshua. "Allegories of Cultural Criticism." *Flash Art* (May-June 1993): 118–19, 128.

Deecke, Thomas. "'Art Is No Luxury—Art Has Its Social Uses.'" *Art News*, October 1978, pp. 88–91.

Deitch, Jeffrey. "The Modern World." *Artscribe International*, January-February 1987, pp. 37–39.

_____. "'Cold War Zeitgeist' at the Mudd Club." *Art in America*, April 1980, pp. 134–35.

Deitch, Jeffrey, and Martin Guttmann, "Art and Corporations." *Flash Art* (March-April 1988): 77–79.

_____. "Report from Times Square." *Art in America*, September 1980, pp. 58–63.

Deitcher, David. "When Worlds Collide." *Art in America*, February 1990, pp. 120–27, 189–91.

Deliss, Clementine. "Conjuring Tricks." *Artscribe International*, September-October 1989, pp. 48–53. (On the *Magicians of the Earth* exhibition.)

Demarest, Michael. "Going . . . Going … Gone!" *Time Magazine*, December 31, 1979, pp. 46–55.

Dery, Mark. "The Merry Pranksters and the Art of the Hoax." *New York Times*, December 23, 1990, sec. 2, pp. 1, 36.

Dimitrijevic, Nena. "Sculpture After Evolution." *Flash Art* (April-May 1984): 21–31.

Dobie, Elizabeth Ann. "Interweaving Feminist Frameworks." *Journal of Aesthetics and Art Criticism* (Fall 1990): 381–94.

Dowd, Maureen. "Youth. Art. Hype. A Different Bohemia." *New York Times Magazine*, November 17, 1985, pp. 26–42, 87–89, 100.

Drohojowska, Hunter. "The '80s: Stop Making Sense." *Art News*, October 1989, pp. 146–51.

Drucker, Johanna. "Book Reviews: Postmodernism." *Art Journal* (Winter 1990): 429–31.

Druckrey, Timothy. "Douglas Crimp," an interview. *Flash Art* (March-April 1990): 171–74, 184.

Duncan, Carol. "When Greatness Is a Box of Wheaties." *Artforum*, October 1975, pp. 60–64.

Duve, Thierry de. "Marcel Duchamp, or The *Phynancier* of Modern Life." *October* 52 (Spring 1990): 61–75.

Edenbaum, Seth. "Parody and Privacy." *Arts Magazine*, October 1987, pp. 44–45.

Ellis, Bret Easton. "The Twentysomethings: Adrift in a Pop Landscape." *New York Times*, December 2, 1990, sec. 2, pp. 1, 37.

Ellis, Stephen. "After the Fall." *Tema Celeste*, January-March 1992, pp. 56–59.

_____. "The Boys in the Bande." *Art in America*, December 1988, pp. 110–25, 167–69.

Esterow, Milton. "The Second Time Around." *Art News*, Summer 1993, pp. 148–53.

Evans-Clark, Phillip. "Neo-Surrealism, or the Archetype of the Artist as an Ostrich." *Arts Magazine*, December 1985, pp. 26–31.

"Expressionism Today: An Artists' Symposium." *Art in America*, December 1982, pp. 58–75, 139–41. Statements by Robert Beauchamp, Richard Bosman, Charles Clough, Peter Dean, Rafael Ferrer, Eric Fischl, Louise Fishman, Mike Glier, Leon Golub, Bill Jensen, Malcolm Morley, Judy Pfaff, Katherine Porter, Susan Rothenberg, David Salle, Julian Schnabel, Joan Snyder, Pat Steir, Frank Young.

Failing, Patricia. "Black Artists Today: A Case of Exclusion." *Art News*, March 1989, pp. 124–31.

Fairbrother, Trevor. "We Make the Future Tense." *Parkett*, no. 20 (Summer 1989): 74–89.

Faust, Wolfgang Max. "Notes on German Art in the 20th Century: Written 6th August 1985." *Artscribe*, September-October 1985, pp. 20–25.

_____. "German Artists: How German Are They?" *New Art Examiner*, December 1984, pp. 28–34.

_____. "The Appearance of the Zeitgeist." *Artforum*, January 1983, pp. 87–93.

Feaver, William. "Italian Art in the 20th Century: Chauvinism and Chic." *Art News*, May 1989, pp. 138–45.

_____. "Dispirit of the Times." *Art News*, February 1983, pp. 80–83.

_____. "A 'New Spirit'—or Just a Tired Ghost?" *Art News*, May 1981, pp. 114–18.

_____. "The Splashes, Slow Dawns and Guiding Lights of British Art." *Art News*, May 1981, pp. 119–21.

Felice, Attanasio di. "Painting with a Past: New Art from Italy." *Portfolio*, March-April 1982, pp. 94–99.

Fenton, Julia A. "Interview: Marcia Tucker." *Art Papers*, January-February 1982, pp. 10–12.

"A Feminist Art Program," interviews with Judy Chicago and Miriam Schapiro. *Art Journal* (Fall 1971): 48–49.

Finch, Christopher. "Process and Imagination." *Design Quarterly*, nos. 74–75 (1969): 22–30.

Filler, Martin. "The Shock of the Hughes." *Vanity Fair*, November 1990, pp. 188–90, 222–26.

Fineberg, Jonathan. "Tracking the Avant-Garde." *Harvard Magazine*, January-February 1984, pp. 24–35.

Fleming, Lee. "Issues Are the Issue." *Art News*, January 1985, pp. 84–89.

_____. "Biennial Directions: *Directions 1983*." *Art News*, Summer 1983, pp. 79–82.

Flood, Richard. "Skied and Grounded in Queens: 'New York/New Wave' at P.S. 1." *Artforum*, Summer 1981, pp. 84–87.

Foltz, Kim, and Maggie Malone, "Golden Paintbrushes: Artists Are Developing a Fine Eye for the Bottom Line." *Newsweek*, October 15, 1984, pp. 82–83.

Foote, Nancy, ed. "Situation Esthetics: Impermanent Art and the Seventies Audience." *Artforum*, January 1980, pp. 22–29. Interviews with Vito Acconci, Laurie Anderson, Scott Burton, Cecile Abish, Peter Campus, Richard Fleischner, Dan Graham, Nancy Holt, Peter Hutchinson, Patrick Ireland, Mary Miss, Max Neuhaus, Lucio Pozzi, Charles Simonds, Alan Sonfist, and Eve Sonneman.

Foote, Nancy. "Monument—Sculpture—Earthwork." *Artforum*, October 1979, pp. 32–37.

_____. "The Anti-Photographers." *Artforum*, September 1976, pp. 46–54.

Forge, Andrew. "Painting and the Struggle for the Whole Self." *Artforum*, September 1975, pp. 44–49.

Foster, Hal. "Signs Taken for Wonders." *Art in America*, June 1986, pp. 80–91.

_____. "The 'Primitive' Unconscious of Modern Art." *October* 34 (Fall 1985): 45–70.

_____. "For a Concept of the Political in Art." *Art in America*, April 1984, pp. 17–25.

_____. "The Expressionist Fallacy." *Art in America*, January 1983, pp. 80–83, 137.

_____. "Subversive Signs." *Art in America*, November 1982, pp. 88–92.

_____. "Between Modernism and the Media." *Art in America*, Summer 1982, pp. 13–17.

_____. "Critical Spaces." *Art in America*, March 1982, pp. 115–19.

_____. "A Note to Painting." *Arts Magazine*, May 1981, pp. 100–101.

_____. "A Tournament of Roses." *Artforum*, November 1979, pp. 62–67.

_____. "The Apotheosis of a Crummy Space." *Artforum*, October 1976, pp. 28–37.

Frackman, Noel, and Ruth Kaufman, "Documenta 7: The Dialogue and a Few Asides." *Arts Magazine*, October 1982, pp. 91–97.

Francblin, Catherine. "Jean Baudrillard," an interview. *Flash Art* (October-November 1986): 54–55.

Frank, Patrick. "Recasting Benjamin's Aura." *New Art Examiner*, March 1989, pp. 29–31.

_____. "A Great Debate: Criticism in the '80s." *New Art Examiner*, November 1985, pp. 38–41.

Frank, Peter. "Artists Go on Record . . . The Next Song You Hear on the Radio Might Well Be Art." *Art News*, December 1981, pp. 74–76.

_____. "Where Is New York?" *Art News*, November 1979, pp. 58–65.

_____. "Auto-Art: Self-Indulgent? And How!" *Art News*, September 1976, pp. 43–48.

Freedman, Samuel G. "Vietnam in America: The War and the Arts." *New York Times Magazine*, March 21, 1985, pp. 50–56.

Fried, Michael. "Art and Objecthood." *Artforum*, June 1967, pp. 12–23.

Frueh, Joanna. "Towards a Feminist Theory of Art Criticism." *New Art Examiner*, January 1985, pp. 41–44.

Fuchs, R. H. "Chicago Lecture." *Tema Celeste*, January-March 1989, pp. 49–59.

Gablik, Suzi. "Dancing with Baudrillard." *Art in America*, June 1988, pp. 27, 28.

_____. "Report from New York: The Graffiti Question." *Art in America*, October 1982, pp. 33–39.

Gachnang, Johannes. "New German Painting." *Flash Art* (February-March 1982): 33–37.

Galligan, Gregory. "Is There Life Beyond Neo-Geo? New New York Painters." *Art International*, Spring 1989, pp. 32–38.

Galloway, David. "Report from Germany: Elephant-Walk Follies." *Art in America*, September 1989, pp. 69–75.

_____. "Beuys and Warhol: Aftershocks." *Art in America*, July 1988, pp. 112–23.

_____. "Report from Germany: Taking Stock." *Art in America*, May 1986, pp. 29–39.

_____. "Report from Germany: Totems Without Taboos." *Art in America*, October 1984, pp. 29–37.

_____. "Report from West Germany: A Season of Artistic Detente." *Art in America*, March 1983, pp. 25–29.

Gambrell, Jamey. "All the News That's Fit to Print: A Parallel of Social Concern of the 1930s and 1980s." *Print Collector's Newsletter*, May–June 1987, pp. 52–55.

Gardner, Paul. "How to Succeed (by Really Trying)." *Art News*, February 1990, pp. 134–37.

_____. "SoHo: Downtown Boomtown." *Art News*, March 1987, pp. 129–33.

_____. "When Is a Painting Finished?" *Art News*, November 1985, pp. 89–99.

_____. "The Electronic Palette." *Art News*, February 1985, pp. 66–73.

Gendel, Milton. "'If One Hasn't Visited Count Panza's Villa, One Doesn't Really Know What Collecting Art Is All About.'" *Art News*, December 1979, pp. 44–49.

Germer, Stefan. "Haacke, Broodthaers, Beuys." *October* 45 (Summer 1988): 63–75.

Gibson, Eric. "Thinking About the Seventies." *New Criterion*, May 1985, pp. 45–48.

_____. "Art: Spring Exhibitions." *New Criterion*, June 1984, pp. 69–73. (On Picabia.)

Giebel, Victoria. "The Art of Engagement: Architects Join Forces with Artists." *Metropolis*, July–August 1986, pp. 32–36.

Gilbert-Rolfe, Jeremy. "The Price of Goodness." *Artscribe International*, November–December 1989, pp. 48–53.

_____. "From Reading to Unreading: Barthes's Challenge, Derrida's Truth." *Arts Magazine*, April 1989, p. 25.

_____. "Beyond Absence: Mary Boochever and Moira Dryer Return a Notion of Being to Abstraction." *Arts Magazine*, October 1988, pp. 53–61.

_____. "The Impressionist Revolution and Duchamp's Myopia." *Arts Magazine*, September 1988, pp. 61–67.

_____. "Nonrepresentation in 1988: Meaning Production Beyond the Scope of the Pious." *Arts Magazine*, May 1988, pp. 30–39.

_____. "The Politics of Art." *Arts Magazine*, September 1986, pp. 21–27.

Gimelson, Deborah. "Elaine & Werner Dannheisser." *Galeries Magazine*, April-May 1991, pp. 120–29, 141.

Gintz, Claude. "The Good, the Bad, the Ugly: Late de Chirico." *Art in America*, Summer 1983, pp. 104–109.

Glueck, Grace. "The Artists' Artists." *Art News*, November 1982, pp. 90–100.

_____. "Women Artists '80." *Art News*, October 1980, pp. 58–63.

Godfrey, Tony. "Report from London: Decline and Fall." *Art in America*, February 1990, pp. 63–65. (On the Saatchi Collection.)

_____. "Report from Germany: A Tale of Four Cities." *Art in America*, November 1988, pp. 33–41.

Gohr, Siegfried. "The Situation and the Artists [in Twentieth Century Germany]." *Flash Art* (February-March 1982): 38–46.

Goldberg, Rosalee. "What Happened to Performance?" *Flash Art* (March 1984): 28–29.

_____. "Post-TV Art." *Portfolio*, August 1982, pp. 76–79.

_____. "Space as Praxis." *Studio International*, September-October 1975, pp. 130–35.

Goldin, Amy. "Patterns Grids and Painting." *Artforum*, September 1975, pp. 50–54.

_____. "American Art History Has Been Called Elitist, Racist and Sexist. The Charges Stick." *Art News*, April 1975, pp. 48–51.

Goldsmith, Barbara. "The Meaning of Celebrity." *New York Times Magazine*, December 4, 1983, pp. 75–82, 120.

Goldstein, Richard. "In Praise of Graffiti: The Fire Down Below." *Village Voice*, December 24, 1980, pp. 55–58.

Gomez, Edward M. "Art: Quarreling over Quality: A Feminist Critique Blasts Old Assumptions About How We Judge an Artist's Works." *Time Magazine*, Fall 1990, pp. 61–62.

Gopnik, Adam. "The Art World: Empty Frames." *New Yorker*, November 25, 1991, pp. 110–20.

_____. "The Art World: Lost and Found." *New Yorker*, February 20, 1989, pp. 107–11. (On Jeff Koons and Christian Boltanski.)

Gouma-Peterson, Thalia, and Patricia Mathews. "The Feminist Critique of Art History." *Art Bulletin*, September 1987, pp. 326–57.

Graham, Dan. "Signs." *Artforum*, April 1981, pp. 38–43.

Grauman, Brigid. "Inside Europe: The Temperature Is Lower." *Art News*, April 1988, pp. 115–18.

_____. "Shaping the '80s: Europe's Hottest Curators." *Art News*, March 1988, pp. 172–77.

Graw, Isabelle. "Reworking History." *Flash Art* (November-December 1989): 107–109. (On post–World War II German art.)

Greenberg, Clement. "Modern and Post-Modern." *Arts Magazine*, February 1980, pp. 64–66.

"The Greenberg Effect: Comments by Younger Artists, Critics, and Curators." *Arts Magazine*, December 1989, pp. 58–64. Statements by Joshua Decter, Peter Halley, Pat McCoy, John Miller, Lisa Phillips, David Reed, Florence Rubenfeld, Kenneth Wahl, and Stephen Westfall.

Greenspan, Stuart. "The Art Market 1979–1989: Bright Lights, Big Bucks." *Art and Auction*, May 1989, pp. 220–21.

Gregory, Alexis. "Art as Money: An Interview with John Kenneth Galbraith." *Journal of Art* (October 1990): 58–59.

Groot, Paul. "The Spirit of Documenta 7: Rudi Fuchs Talks About the Forthcoming Exhibition." *Flash Art* (Summer 1982): 20–25.

_____. "Further Opinions on Documenta 7." *Flash Art* (January 1983): 24.

Gruen, John. "The Reasonably Risky Life of John Szarkowski." *Art News*, April 1978, pp. 66–70.

Grundberg, Andy. "Photography View: The Mellowing of the Post-Modernists." *New York Times*, December 17, 1989, sec. 2, p. 43.

Haacke, Hans. "Working Conditions." *Artforum*, Summer 1981, pp. 56–61.

Haden-Guest, Anthony. "Art or Commerce." *Vanity Fair*, November 1991, pp. 200–205, 251.

Hall, James. "Neo-Geo's Bachelor Artists." *Art International*, December 1989, pp. 30–45.

Halley, Peter. "B.Z. & Michael Schwartz," an interview. *Galeries Magazine*, February-March 1989, pp. 118–28, 139–40.

_____. "Frank Stella and the Simulacrum." *Flash Art* (February-March 1986): 32–35.

_____. "The Crisis in Geometry." *Arts Magazine*, Summer 1984, pp. 111–15.

_____. "A Note on the 'New Expressionism' Phenomenon." *Arts Magazine*, March 1983, pp. 88–89.

Handy, Ellen. "Readings: Women, Art, Feminism." *Arts Magazine*, May 1989, pp. 25–31.

_____. "Notes on Criticism: Art and Transactionalism." *Arts Magazine*, October 1986, pp. 48–52.

Hapgood, Susan. "Irrationality in the Age of Technology." *Flash Art* (January 1983): 41–43. (On A.R. Penck and Keith Haring.)

Hawthorne, Don. "Saatchi & Saatchi Go Public." *Art News*, May 1985, pp. 72–81.

Heartney, Eleanor. "The Politics of Protest," a conversation with Robert Storr. *New Art Examiner*, September 1992, pp. 14–17.

_____. "Eco-Logic." *Sculpture*, March-April, 1990, pp. 36–41.

_____. "Social Responsibility and Censorship." *Sculpture*, January-February 1990, pp. 16–20.

_____. "Combined Operations." *Art in America*, June 1989, pp. 140–47.

_____. "How Wide Is the Gender Gap?" *Art News*, Summer 1987, pp. 139–45.

_____. "Simulationism: The Hot New Cool Art." *Art News*, January 1987, pp. 130–37.

_____. "Neo-Geo Storms New York." *New Art Examiner*, September 1986, pp. 26–29.

Herrera, Hayden. "Manhattan Seven, *Art in America*, July-August 1977, pp. 50–63.

Hershkovits, David. "Art in Alphabetland." *Art News*, September 1983, pp. 88–92.

Hertz, Richard. "A Critique of Authoritarian Rhetoric." *Real Life Magazine*, Spring-Summer 1982, pp. 16–18.

Hess, Elizabeth. "Success! A Boone for Feminists?" *Village Voice Art Supplement*, October 6, 1987, pp. 4–5.

Higgins, Dick. "Five Myths of Post Modernism." *Art Papers*, January-February 1989, pp. 11–19.

Hobbs, Robert, ed. "Earthworks: Past and Present." *Art Journal*, special issue (Fall 1982): 191–233. (Includes nine essays.)

Hochfield, Sylvia. "The Rubin Years." *Art News*, February 1990, pp. 130–33.

Honisch, Dieter. "What Is Admired in Cologne May Not Be Accepted in Munich." *Art News*, October 1978, pp. 62–67.

Howell, C. "New Directions in Environmental Art." *Landscape Architecture*, January 1977, pp. 38–46.

Howell, John. "Paula Cooper: Quite Contrary." *Art News*, March 1989, pp. 153–57.

Hughes, Robert. "Art, Money, New York, the 1980s: A Jeremiad. The Decline of the City of Mahagonny." *New Republic*, June 25, 1990, pp. 27–38.

_____. "Careerism and Hype Amidst the Image Haze." *Time Magazine*, June 17, 1985, pp. 78–83.

_____. "On Art and Money." *New York Review of Books*, December 6, 1984, pp. 20–27.

_____. "There's No Geist Like Zeitgeist." *New York Review of Books*, October 27 1983, pp. 63–68.

_____. "Time Essay: Confusing Art with Bullion." *Time Magazine*, December 31, 1979, pp. 56–57.

Hunter, Sam. "Post-Modernist Painting." *Portfolio*, January-February 1982, pp. 46–53.

Hutchinson, Peter. "Earth in Upheaval." *Arts Magazine*, November 1968, pp. 19–21.

Isaak, Jo Anna. "Women: The Ruin of Representation." *Afterimage*, April 1985, pp. 6–8.

Iversen, Margaret. "Fashioning Feminine Identity." *Art International*, Spring 1988, pp. 52–57.

_____. "Difference: On Representation and Sexuality." *M/F*, nos. 11–12 (1986): 78–99.

Jappe, Georg. "Young Artists in Germany." *Studio International*, February 1972, pp. 69–70.

Jensen, Robert. "Damaged Speech. On Recent Political Art." *M/E/A/N/I/N/G* 9, May 1991, pp. 27–34.

Joachimides, Christos. "Zeitgeist." *Flash Art* (November 1982): 26–31.

Johnson, Ellen H. "Appropriation: Are These All Originals?" *Dialogue*, March 1988, pp. 23–27.

Johnson, Ken. "Poetry & Public Service." *Art in America*, March 1990, pp. 161–63, 219.

_____. "Being and Politics." *Art in America*, September 1990, pp. 154–61.

Johnston, John. "Jean Baudrillard Interview." *Art Papers*, January-February 1989, pp. 4–7.

Jolles, Claudia, and Viktor Misiano. "In Conversation with Eric Bulatov and Ilya Kabakov." *Flash Art* (November-December 1987): 81–83.

Jones, Alan. "Paravision: An Interview with Tricia Collins and Richard Milazzo." *Galeries Magazine*, August-September 1986, pp. 106–108.

Jones, Bill. "Graven Images: Art After Iconoclasm." *Arts Magazine*, May 1989, pp. 73–77.

Jones, Ronald. "Hover Culture: The View from Alexandria." *Artscribe International*, Summer 1988, pp. 46–51.

_____. "Six Artists at the End of the Line: Gretchen Bender, Ashley Bickerton, Peter Halley, Louise Lawler, Allan McCollum, and Peter Nagy." *Arts Magazine*, May 1986, pp. 49–50.

Joselit, David. "Investigating the Ordinary." *Art in America*, May 1988, pp. 148–55.

Kalil, Susie. "American Collage Since 1950." *Artweek*, September 18, 1982, pp. 1–26.

Kaprow, Allan. "Video Art: Old Wine, New Bottles." *Artforum*, June 1974, pp. 46–49.

_____. "The Education of the Un-Artist," parts 1 and 2. *Art News*, February 1971, pp. 28–31, 66–68; May 1972, pp. 34–39, 62–63.

Karmel, Pepe. "Photography: Looking at the Big Picture." *Art in America*, September 1983, pp. 35–39.

Karson, Robin. "South Cove Battery Park City." *Landscape Architecture*, May-June 1986, pp. 48–53.

Kerber, Bernhard. "Zeitgeist." *Art International*, April-June 1983, pp. 34–43.

Kimball, Roger. "The Periphery vs. the Center: The MLA in Chicago." *New Criterion*, February 1991, pp. 8–17.

_____. "Is MoMA Attempting Suicide?" *New Criterion*, April 1988, pp. 30–38.

_____. "Notebook: Sundays in the Dark with the Whitney." *New Criterion*, January 1987, pp. 83–88.

Kimmelman, Michael. "The Case of Vanishing Art." *New York Times*, May 14, 1989, sec. 2, pp. 1, 43.

Kingsley, April. "Six Women at Work in the Landscape." *Arts Magazine*, April 1978, pp. 108–12.

Kontova, Helena. "From Performance to Painting." *Flash Art* (February-March 1982): 16–21.

Kontova, Helena, and Giancarlo Politi, "Two Italians in New York." *Flash Art* (December 1985-January 1986): 38–40.

_____. "Paris Biennale and Turin's New Museum." *Flash Art* (April-May 1985): 36–37.

_____. "An Interview with Achille Bonito Oliva." *Flash Art* (Summer 1980): 8–9.

Kosuth, Joseph. "Portraits . . . Necrophilia Mon Amour." *Artforum*, May 1982, pp. 58–63.

Kozloff, Joyce. "The Women's Movement: Still a 'Source of Strength' or 'One Big Bore.'" *Art News*, April 1976, p. 49.

Kozloff, Max. "Pygmalion Reversed." *Artforum*, November 1975, pp. 30–37.

_____. "Painting and Anti-Painting: A Family Quarrel." *Artforum*, September 1975, pp. 37–43.

_____. "Traversing the Field . . . Eight Contemporary Artists at MoMA." *Artforum*, December 1974, pp. 44–49.

_____. "9 in a Warehouse." *Artforum*, February 1969, pp. 38–42.

Kozloff, Max, and John Coplans, "Art Is a Political Act." *Village Voice*, January 12, 1976, p. 71.

Kramer, Hilton. "Studying the Arts and the Humanities: What Can Be Done?" *New Criterion*, February 1989, pp. 1–6.

_____. "Modernism and Its Enemies." *New Criterion*, March 1986, pp. 1–7.

_____. "The Art Scene of the '80s." *New Art Examiner*, October 1985, pp. 24–29.

_____. "Art: Turning Back the Clock: Art and Politics in 1984." *New Criterion*, April 1984, pp. 68–73.

_____. "Today's Avant-Garde Artists Have Lost the Power to Shock." *New York Times*, November 16, 1989, sec. 2, pp. 1, 27.

_____. "Signs of Passion: The New Expressionism." *New Criterion*, November 1982, pp. 40–45.

_____. "A Note on *The New Criterion*, *New Criterion*, September 1982, pp. 1–5.

_____. "Postmodern: Art and Culture in the 1980s." *New Criterion*, September 1982, pp. 36–42.

Krauss, Rosalind. "Overcoming the Limits of Matter: On Revising Minimalism," in *Studies in Modern Art 1: American Art of the 1960s*. New York: Museum of Modern Art, 1991, pp. 122–141.

_____. "A Note on Photography and the Simulacral." *October* 31 (Winter 1984): 49–68.

_____. "The Originality of the Avant-Garde: A Postmodernist Repetition." *October* 18 (Fall 1981): 44–66.

_____. "John Mason and Post-Modernist Sculpture: New Experiences, New Words." *Art in America*, May-June 1979, pp. 120–25.

_____. "Notes on the Index: Seventies Art in America," parts 1 and 2. *October* 3 (Spring 1977): 69–81; 4 (Fall 1977): 58–67.

_____. "Video: The Aesthetics of Narcissism." *October* (Spring 1976): 50–64.

_____. "Sense and Sensibility: Reflections on Post '60s Sculpture." *Artforum*, November 1973, pp. 43–53.

_____. "A View of Modernism." *Artforum*, September 1972, pp. 48–51.

Kultermann, Udo. "'We Continue the Evolution Through Art': Reflections on Fontana, Manzoni, and Pascali." *Arts Magazine*, April 1989, pp. 44–48.

Kurtz, Bruce. "Documenta 5: A Critical Preview." *Arts Magazine*, Summer 1972, pp. 30–43.

Kuspit, Donald B. "Sincere Cynicism: The Decadence of the 1980s." *Arts Magazine*, November 1990, pp. 60–65.

_____. "Two Exhibitions: Morbid Manners . . ." *Artforum*, March 1989, pp. 121–24.

_____. "The Opera Is Over: A Critique of Eighties Sensibility." *Artscribe International*, September-October 1988, pp. 44–49.

_____. "Against All Odds: The Triumph of German Vision in an Age of No Vision." *Artscribe*, February-March 1986, pp. 34–35.

_____. "Rejoinder: Tired Criticism, Tired 'Radicalism.'" *Art in America*, April 1983, pp. 11–17.

_____. "Acts of Aggression: German Painting Today," parts 1 and 2. *Art in America*, September 1982, pp. 140–51; January 1983, pp. 90–101, 131–36.

_____. "The New (?) Expressionism: Art as Damaged Goods." *Artforum*, November 1981, pp. 47–55.

Lacy, Suzanne. "The Name of the Game." *Art Journal* (Summer 1991): 64–68.

Langer, Cassandra L. "Feminist Art Criticism: Turning Points and Sticking Places." *Art Journal* (Summer 1991): 21–28.

Larson, Kay. "The Art of the Newest: Big Money, Superstar Painters Fuel the Fantasy Machine." *New York*, December 25, 1989, pp. 77–78.

_____. "The Whitney Biennial." *Galeries Magazine*, June-July 1989, pp. 64–67.

_____. "The Dictatorship of Greenberg." *Artforum*, Summer 1987, pp. 76–78.

_____. "Art: Masters of Hype." *New York*, November 10, 1986, pp. 100–103.

_____. "How Should Artists Be Educated." *Art News*, November 1983, pp. 85–90.

_____. "Art: Pressure Points." *New York*, June 28, 1982, pp. 58–59.

_____. "The Expulsion from the Garden: Environmental Sculpture at the Winter Olympics." *Artforum*, April 1980, pp. 3645.

_____. "For the First Time Women Are Leading Not Following." *Art News*, October 1980, pp. 64–72.

_____. "Rooms with a Point of View." *Art News*, October 1977, pp. 32–38. (On alternative or artists' spaces.)

Lawson, Thomas. "Toward Another Laocoon or, The Snake Pit." *Artforum*, March 1986, pp. 97–106.

_____. "Last Exit: Painting." *Artforum*, October 1981, pp. 40–47.

_____. "Spies and Watchmen." *Cover* 1 (Spring-Summer 1980): 17.

_____. "Painting in New York: An Illustrated Guide." *Flash Art* (October-November 1979): 4–11.

Leider, Philip. "How I Spent My Summer Vacation, or, Art and Politics in Nevada, Berkeley, San Francisco and Utah." *Artforum*, September 1970, pp. 40–49.

Leigh, Christian. "The Art Market 1979–1989: Into the Blue." *Art and Auction*, May 1989, pp. 262–69.

Kim Levin, "The Agony and the Anomie." *Arts Magazine*, April 1986, pp. 62–63.

_____. "The Times Square Show." *Arts Magazine*, September 1980, pp. 87–89.

_____. "Farewell to Modernism." *Arts Magazine*, October 1979, pp. 90–92.

LeWitt, Sol. "Sentences on Conceptual Art." *0–9*, no. 5, January 1969, pp. 25–26.

_____. "Paragraphs on Conceptual Art." *Artforum*, Summer 1967, pp. 79–83.

Liebmann, Lisa. "At the Whitney Biennial: Almost Home." *Artforum*, Summer 1985, pp. 57–61.

Lifson, Ben, and Abigail Solomon-Godeau, "Photophilia: A Conversation About the Photography Scene." *October* 16 (Spring 1981): 103–18.

Linker, Kate. "Eluding Definition." *Artforum*, December 1984, pp. 61–67.

_____. "Public Sculpture II." *Artforum*, Summer 1981, pp. 37–42.

_____. "Public Sculpture." *Artforum*, March 1991, pp. 64–73.

_____. "An Anti-Architectural Analogue." *Flash Art* (January-February 1980): 19–25.

Lippard, Lucy R. [Anne Ominous]. "Sex and Death and Shock and Schlock: A Long Review of the Times Square Show." *Artforum*, October 1980, pp. 50–55.

_____. "Complexes: Architectural Sculpture in Nature." *Art in America*, January-February 1979, pp. 87–88, 93.

_____. "Caring: Five Political Artists." *Studio International*, Summer 1978, pp. 197–207.

_____. "Public Sculpture II: Provisions for the Paradise." *Artforum*, June 1981, pp. 64–42.

_____. "Public Sculpture: The Pursuit of the Pleasurable and Profitable Paradise." *Artforum*, March 1981, pp. 64–73.

_____. "Art Outdoors: In and Out of the Public Domain." *Studio International*, March-April 1977, pp. 83–90.

_____. "Women's Body Art: The Pains and Pleasures of Rebirth." *Art in America*, June 1976, pp. 78–82.

_____. "The Art Workers Coalition: Not a History." *Studio International*, November 1970, pp. 171–74.

_____. "Eccentric Abstraction." *Art International*, November 1966, pp. 34–40.

Livingston, Jane. "Some Thoughts on 'Art and Technology.'" *Studio International*, June 1971, pp. 258–63.

Lloyd, Jill. "German Sculpture Since Beuys: Disrupting Consumerist Culture." *Art International*, Spring 1989, pp. 8–16.

Lotringer, Sylvere. "Third Wave: Art and the Commodification of Theory." *Flash Art* (May-June 1991): 89–93.

Loughery, John. "Mrs. Holladay and the Guerrilla Girls." *Arts Magazine*, October 1987, pp. 61–65.

Lurie, David R. "Consumer and Connoisseur: On the New Museum's *Damaged Goods: Desire and the Economy of the Object*." *Arts Magazine*, November 1986, pp. 16–18.

McClintic, Miranda. "Sculpture Today." *Art and Auction*, May 1988, pp. 160–67.

McCormick, Carlo. "Poptometry." *Artforum*, November 1985, pp. 87–91.

Thomas McEvilley, "Overheard: Former Beaubourg Director Jean-Hubert Martin Talks with Thomas McEvilley." *Contemporanea*, December 1990, pp. 110–11.

————. "Marginalia: Son of Sublime." *Artforum*, May 1988, pp. 11–12.

————. "I Think Therefore I Art." *Artforum*, Summer 1985, pp. 74–84.

————. "Art in the Dark." *Artforum*, Summer 1983, pp. 62–71.

McEwen, John. "How They Got It Together: 'A New Spirit in Painting,'" interview with Norman Rosenthal and Christos Joachimides. *Art Monthly*, February 1981, pp. 3–4.

McFadden, Sarah. "Report from Lake Placid: The Big Secret: Art at the Olympics." *Art in America*, April 1980, pp. 53–63.

McGill, Douglas C. "Sculpture Goes Public." *New York Times Magazine*, April 27, 1986, pp. 42–47, 63, 66–67, 85, 87.

McGuigan, Cathleen. "The New Art, New Money. The Marketing of an American Artist." *New York Times Magazine*, February 10, 1985, pp. 20–35.

Madoff, Steven Henry. "Sculpture Unbound." *Art News*, November 1986, pp. 103–109.

————. "What Is Postmodern About Painting: The Scandinavia Lectures," parts 1 and 2. *Arts Magazine*, September 1985, pp. 116–21; October 1985, pp. 59–64.

————. "A New Generation of Abstract Painters." *Art News*, November 1983, pp. 78–84.

"Making Art, Making Money: 13 Artists Comment." *Art in America*, July 1990, pp. 133–41, 178–79. The artists were John Baldessari, Mary Miss, Eric Bogosian, Martha Rosler, Tim Rollins, Maren Hassinger, Sandro Chia, Jessica Diamond, Doug Hollis, Mary Weatherford, Carrie Mae Weems, Christopher Brown, and Les Levine. The interviewers were Lilly Wei, Cecile Nelkin McCann, and Carrie Mae Weems.

Malcolm, Janet. "Profiles (Ingrid Sischy—Part II)," *New Yorker*, October 27, 1986, pp. 47–66.

Marcadé, Bernard. "This Never-Ending End." *Flash Art* (October-November 1985): 36–39.

Margolis, Joseph. "Reinterpreting Interpretation." *Journal of Aesthetics and Art Criticism* (Summer 1989): 237–51.

————. "Postscript on Modernism and Postmodernism, Both." *Theory, Culture and Society*, February 1989, pp. 5–30.

Marck, Jan van der. "Inside Europe Outside Europe." *Artforum*, January 1978, pp. 49–55.

Marmer, Nancy. "Documenta: The Social Dimension?" *Art in America*, September 1987, pp. 128–38, 197–99.

————. "Isms on the Rhine." *Art in America*, November 1981, pp. 113–23.

————. "Womanspace, A Creative Battle for Equality in the Art World." *Art News*, Summer 1973, pp. 38–41.

Martin, Henry. "A Letter from Italy." *Art International*, March-April 1982, pp. 135–42.

————. "The Italian Art Scene, Dynamic and Highly Charged." *Art News*, March 1981, pp. 70–77.

Martin, Richard. "Dan Cameron and the Contras, or, Contra Dan Cameron." *Arts Magazine*, February 1988, pp. 88–89.

Marzorati, Gerald. "Picture Puzzles: The Whitney Biennial." *Art News*, Summer 1985, pp. 74–78.

————. "Your Show of Shows." *Art News*, September 1984, pp. 62–65.

Masheck, Joseph. "Iconicity." *Artforum*, January 1979, pp. 26–36.

————. "Editing *Artforum*." *Art Monthly*, December 1977-January 1978, pp. 11–12.

Mathews, Tom. "The Arts: Fine Art or Foul?" *Newsweek*, July 2, 1990, pp. 46–52.

Mayer, Rosemary. "Performance and Experience." *Arts Magazine*, December-January 1973, pp. 33–36.

Meisel, Perry. "Review of Books: How Postmodern Is It?" *Art in America*, December 1990, pp. 53–55.

Melville, Stephen. "The Temptation of New Perspectives." *October* 52 (Spring 1990): 3–15.

————. "Notes on the Reemergence of Allegory, the Forgetting of Modernism, the Necessity of Rhetoric, and the Conditions of Publicity in Art Criticism." *October* 19 (Winter 1981): 55–92.

Michelson, Annette. "Contemporary Art and the Plight of the Public." *Artforum*, September 1974, pp. 68–70.

Miller, John. "The Consumption of Everyday Life." *Artscribe International*, January-February 1988, pp. 46–52.

Marcus, Greil. "Pop Culture: The Style of the Seventies." *New York Times Book Review*, June 5, 1977, pp. 9, 44–45.

Patricia Mathews, "Feminist Art Criticism: Multiple Voices and Changing Paradigms." *Art Criticism* 5, no. 2 (1989): 1–34.

Morgan, Stuart. "Past Present Future: Count Giuseppe Panza di Biumo Interviewed by Stuart Morgan." *Artscribe*, Summer 1989, pp. 53–56.

Morgan, Stuart, Jon Bird, and Adrian Forty. "The Saatchi Museum." *Artscribe*, September-October 1985, pp. 45–50.

Morris, Robert. "Three Folds in the Fabric and Four Autobiographical Asides as Allegories (or Interruptions)." *Art in America*, November 1989, pp. 143–50.

————. "American Quartet." *Art in America*, December 1981, pp. 91–105.

————. "The Present Tense of Space." *Art in America*, January-February 1978, pp. 70–81.

————. "Aligned with Nazca." *Artforum*, October 1975, pp. 26–39.

————. "The Art of Existence: Three Extra-Visual Artists: Works in Process." *Artforum*, January 1971, pp. 28–33.

Moufarrege, Nicolas A. "Lightning Strikes (Not Once but Twice): An Interview with Graffiti Artists." *Arts Magazine*, November 1982, pp. 87–93.

_____. "Lavender: On Homosexuality and Art." *Arts Magazine*, October 1982, pp. 78–87.

_____. "Another Wave, Still More Savagely Than the First: Lower East Side, 1982." *Arts Magazine*, September 1982, pp. 69–73.

Mulvey, Laura. "Kruger and Burgin." *Creative Camera*, May 1984, pp. 1377–1382, 1387.

Nadelman, Cynthia. "A Star-Struck Carnegie International." *Art News*, March 1986, pp. 115–18.

_____. "'Graffiti Is a Thing That's Kind of Hard to Explain.'" *Art News*, October 1982, pp. 76–78.

Nagy, Peter. "From Criticism to Complicity: Sherrie Levine, Peter Halley, Jeff Koons, Haim Steinbach, Ashley Bickerton, Philip Taaffe." *Flash Art* (June 1986): 46–49.

Nemser, Cindy. "Subject-Object: Body Art." *Arts Magazine*, September 1971, pp. 38–42.

Nesbitt, Lois E. "(Self-)Representation." *Arts Magazine*, Summer 1990, pp. 61–67.

_____. "Readings: Culture, Style, History." *Arts Magazine*, November 1989, pp. 33–39.

Amy Newman, ed. "Who Needs Art Critics," a panel discussion of Grace Glueck, Kay Larson, and Mark Stevens moderated by Amy Newman. *Art News*, September 1982, pp. 55–60.

New Art Association, newsletter, no. 3, reprinted in "Politics." *Artforum*, November 1970, pp. 39–40.

Nilson, Lisbet. "Making It Neo." *Art News*, September 1983, pp. 63–70.

Nochlin, Linda. "Learning from 'Black Male.'" *Art in America*, March 1995, pp. 86–91.

O'Doherty, Brian. "Books." *Artforum*, May 1986, pp. 18–19. (Afterword of "Inside the White Cube.")

_____. "Inside the White Cube: Part II: The Eye and the Spectator." *Artforum*, April 1976, pp. 26–33.

_____. "Inside the White Cube: Notes on the Gallery Space: Part I." *Artforum*, March 1976, pp. 24–30.

Olander, William. "Material World." *Art in America*, January 1989, pp. 122–28, 167.

_____. "Art and Politics of Arms and the Artist." *Art in America*, June 1985, pp. 59–63.

Oliva, Achille Bonito. "Neo-America." *Flash Art* (January-February 1988): 62–66.

_____. "Giorgio de Chirico and the Trans-avant-garde." *Flash Art* (March 1983): 21–24.

_____. "The International Trans-Avantgarde." *Flash Art* (October-November 1981): 36–43.

_____. "The Bewildered Image." *Flash Art* (March-April 1980): 32–41.

_____. "The Italian Trans-Avantgarde." *Flash Art* (November-December 1979): 17–20.

_____. "Process, Concept and Behavior in Italian Art." *Studio International*, January-February 1976, pp. 3–10.

Ostrow, Saul. "Strategies for a New Abstraction." *Tema Celeste*, Autumn 1991, pp. 66–71.

_____. "Marvin Heifferman." *Bomb*, Fall 1989, pp. 48, 52.

_____. "Refigured Painting." *Arts Magazine*, Summer 1989, p. 80.

Ottmann, Klaus. "True Pictures." *Flash Art* (February-March 1987): 90–91.

_____. "Artists in Exile." *Flash Art* (April-May 1985): 26–69.

Overy, Paul. "What Makes Saatchi Run?" *Journal of Art* (October 1990): 26.

Owens, Craig. "Review of Books: Analysis Logical and IllogiCalif." *Art in America*, May 1985, pp. 25–31. A review of Rosalind E. Krauss, *The Originality of the Avant-Garde and Other Modernist Myths*. Cambridge, Mass.: MIT Press, 1985.

_____. "Issues and Commentary: Honor, Power and the Love of Women." *Art in America*, January 1983, pp. 7–13.

_____. "Issues & Commentary: Representation, Appropriation & Power." *Art in America*, May 1982, pp. 9–21.

_____. "Phantasmagoria of the Media." *Art in America*, May 1982, pp. 98–100.

_____. "Back to the Studio." *Art in America*, January 1982, pp. 99–107.

_____. "The Allegorical Impulse: Toward a Theory of Postmodernism," parts 1 and 2. *October* 12 (Spring 1980): 58–80; 13 (Summer 1980): 67–86.

Pacheco, Patrick. "Art Gets Serious with a New Set of Stars." *New York Times*, March 3, 1991, sec. 2, pp. 1, 25.

Paparoni, Demetrio. "When the Market Becomes the Best Critic." *Galeries Magazine*, August-September 1986, pp. 109–11.

Pardee, Hearne. "The New American Landscape." *Arts Magazine*, April 1984, pp. 116–17.

Pareles, Jon. "How Rap Moves to Television's Beat." *New York Times*, January 14, 1990, sec. 2, pp. 1, 28.

Parks, Addison. "One Graffito, Two Graffito." *Arts Magazine*, September 1982, p. 73.

Perls, Jed. "Robert Hughes with Jed Perls." *Modern Painters*, Autumn 1990, pp. 29–33.

_____. "Art: From September to December." *New Criterion*, February 1988, pp. 43–54.

_____. "Art: Storytellers." *New Criterion*, May 1986, pp. 57–63.

Perreault, John. "Usable Art." *Portfolio*, July-August 1981, pp. 60–63.

_____. "The New Decorativeness." *Portfolio*, June-July 1979, pp. 46–50.

_____. "False Objects: Duplicates, Replicas and Types." *Artforum*, February 1978.

_____. "Issues in Pattern Painting." *Artforum*, November 1977, pp. 32–36.

Perrone, Jeff. "The Salon of 1985." *Arts Magazine*, Summer 1985, pp. 70–73.

_____. "Entrees: Diaretics: Entreaties: Bowing (Wowing) Out." *Arts Magazine*, April 1985, pp. 78–83.

_____. "The Fresh and Not-So-Fresh." *Arts Magazine*, December 1984, pp. 104–107.

_____. "Signs and Design, *Arts Magazine*, February 1982, pp. 132–40.

_____. "Fore-, Four, For, Etc." *Arts Magazine*, March 1980, pp. 84–89.

_____. "Excess—A Disseminar." *Arts Magazine*, October 1979, pp. 98–117.

Phillips, Deborah C. "Bright Lights, Big City." *Art News*, September 1985, pp. 82–91.

_____. "No Island Is an Island: New York Discovers the Europeans." *Art News*, October 1982, pp. 66–71.

_____. "Definitely Not Suitable for Framing." *Art News*, December 1981, pp. 62–67.

_____. "New Faces in Alternative Spaces." *Art News*, November 1981, pp. 90–100.

Phillips, Gifford. "Issues and Commentary, a Vote for the Highbrow Museum." *Art in America*, January 1981, pp. 9–11.

Phillips, Lisa. "'High' Art: The Thrill of Pain Caused by Modern Art Is Like an Addiction." *Art and Text* 22 (1986): 19–26.

Pincus-Witten, Robert. "Entries: Rebridging the Bridge: Hodicke, Joachimides, and Berlin in the Early '80s." *Arts Magazine*, March 1990, pp. 72–77.

_____. "Entries: Geist, Zeitgeist & Breaking the Zero Barrier." *Arts Magazine*, October 1989, pp. 59–61.

_____. "Entries: Concentrated Juice & Kitschy Kitschy Koons." *Arts Magazine*, February 1989, pp. 34–39.

_____. "The New Irascibles." *Arts Magazine*, September 1985, pp. 102–109. Portfolio of six portraits by Timothy Greenfield-Sanders and drawings by Mark Kostabi.

_____. "Entries: I: Baselitzmus; II: Borstal Boy Goes Mystic." *Arts Magazine*, Summer 1984, pp. 96–98.

_____. "Entries: I-Know-That-You-Know-That-I-Know." *Arts Magazine*, February 1984, pp. 126–29.

_____. "Entries: Post-Epistemic Dilemma." *Arts Magazine*, September 1983, pp. 110–13.

_____. "Defenestrations: Robert Longo and Ross Bleckner." *Arts Magazine*, November 1982, pp. 94–95.

_____. "Entries: Snatch and Snatching." *Arts Magazine*, September 1981, pp. 88–91.

_____. "Entries: If Even in Fractions." *Arts Magazine*, September 1980, pp. 116–19.

_____. "Entries: Cutting Edges." *Arts Magazine*, June 1979, pp. 104–109.

_____. "Entries: Two Voices." *Arts Magazine*, April 1979, pp. 118–19.

_____. "Entries: Gluck, Stephan, Acconci." *Arts Magazine*, March 1978, pp. 92–93.

_____. "Naked Lunches." *October* 3 (Spring 1977): 102–17.

_____. "Theater of the Conceptual: Autobiography and Myth." *Artforum*, October 1973, pp. 40–46.

Plagens, Peter. "Art: MediaComm 101: The Media vs. Modernism." *Newsweek*, November 27, 1989, pp. 88–89.

_____. "International Shows: Under Western Eyes." *Art in America*, January 1989, pp. 33–41.

_____. "Issues & Commentary: The Emperor's New Cherokee 4x4." *Art in America*, June 1988, pp. 23–24.

_____. "I Just Dropped In to See What Condition My Condition Was In." *Artscribe*, February-March 1986, pp. 22–29.

_____. "Nine Biennial Notes." *Art in America*, July 1985, pp. 114–19.

_____. "Issues & Commentary: Mixed Doubles." *Art in America*, March 1982, pp. 9–15.

_____. "Site Wars." *Art in America*, January 1982, pp. 90–98.

_____. "Issues & Commentary: The Academy of the Bad." *Art in America*, November 1981, pp. 11–17.

_____. "Peter and the Pressure Cooker." *Artforum*, June 1974, pp. 28–33.

Podhoretz, Norman. "The Return of Success." *Newsweek*, August 29, 1977, p. 11.

Pohlen, Annelie. "Cosmic Visions from North and South." *Artforum*, March 1985, pp. 76–81.

_____. "Climbing Up a Ramp to Discover German Art." *Artforum*, December 1984, pp. 52–57.

_____. "Obsessive Pictures or Opposition to the Norm: Noteworthy Aspects of the Engaged Imagination in the New German Art." *Artforum*, May 1984, pp. 44–49.

_____. "The Beautiful and Ugly Pictures. Some Aspects of German Art." *Art and Text* 12–13 (1984): 60–73.

Politi, Giancarlo. "Conversations with Art Dealers: Joe Helman." *Flash Art* (December 1986-January 1987): 86–87.

_____. "Documenta." *Flash Art* (November 1982): 34–36.

_____. "Venice Biennale." *Flash Art* (November 1982): 46–48.

_____. "Italian Identity." *Flash Art* (October-November 1981): 61.

_____. "Venice Biennale: An Interview with Harald Szeemann." *Flash Art* (Summer 1980): 5–7.

Pollock, Griselda. "Critical Reflections." *Artforum*, February 1990, pp. 126–27.

_____. "Women, Art and Ideology: Questions for Feminist Art Historians." *Woman's Art Journal* (Spring-Summer 1983): 39–47.

"Post-Modernism." *Real Life Magazine*, Summer 1981, pp. 4–10. Participants: Christian Hubert, Sherrie Levine, Craig Owens, David Salle, and Julian Schnabel.

Price, Jonathan. "Listening to Joseph Beuys: A Parable of Dialogue." *Art News*, Summer 1974, pp. 50–52.

Rajchman, John. "Postmodernism in a Nominalist Frame." *Flash Art* (November-December 1987): 49–51.

Ratcliff, Carter. "I Like the Free World." *New Art Examiner*, September 1986, pp. 26–29.

_____. "Issues & Commentary: Dramatis Personae, Part V: Rulers of Sensibility." *Art in America*, May 1986, pp. 9–15, 170–73.

_____. "Issues & Commentary: Dramatis Personae, Part IV: Proprietary Selves." *Art in America*, February 1986, pp. 9–13.

_____. "Issues & Commentary: Dramatis Personae, Part III: Criticism and the Lucretian Prospect." *Art in America*, November 1985, pp. 11–15.

_____. "Issues & Commentary: Dramatis Personae, Part II: The Scheherazade Tactic." *Art in America*, October 1985, pp. 9–13.

_____. "Issues & Commentary: Dramatis Personae, Part I: Dim Views, Dire Warnings, Art-world Cassandras." *Art in America*, September 1985, pp. 9–15.

_____. "The Short Life of the Sincere Stroke." *Art in America*, January 1983, pp. 73–79, 137.

_____. "Further Opinions on Documenta 7." *Flash Art* (January 1983): 24–25.

_____. "Contemporary American Art." *Flash Art* (Summer 1982): 32–35.

_____. "On Iconography and Some Italians." *Art in America*, September 1982, pp. 152–59.

_____. "Issues & Commentary: Art & Resentment." *Art in America*, Summer 1982, pp. 9–13.

_____. "Modernism and Melodrama." *Art in America*, February 1981, pp. 105–109.

_____. "Art Stars for the Eighties." *Saturday Review*, February 1981, pp. 12–20.

_____. "People Are Talking About Joseph Beuys." *Vogue*, March 1980, pp. 321, 362–63, 364.

_____. "The Art Establishment: Rising Stars vs. the Machine." *New York*, November 27, 1978, pp. 53–71.

_____. "Making It in the Art World: A Climber's Guide" and "A Prejudiced Guide to the Art World." *New York*, June 1978, pp. 61–71.

_____. "Notes on Small Sculpture." *Artforum*, April 1976, pp. 35–42.

_____. "On Contemporary Primitivism." *Artforum*, November 1975, pp. 57–65.

Raven, Arlene. "Cinderella's Sisters' Feet." *Village Voice Art Supplement*, October 6, 1987, pp. 6–9.

Razceck, Peter. "Cologne: *Bilderstreit*: The Power Struggle of Post-War Art. An Interview with Exhibition's Curator Johannes Gachnang." *Journal of Art* (June–July 1989): 16–17.

Reason, Rex. "Democratism or, I Went to See the *Chelsea Girls* and Ended Up Thinking About Jenny Holzer." *Real Life Magazine*, Spring-Summer 1982, pp. 5–13.

Reec, Christopher. "Off the Wall and Onto the Couch! Sofa Art and the Avant-Garde Analyzed." *American Art*, Winter 1989, pp. 33–43.

Reed, Susan. "The Meteoric Rise of Mary Boone." *Saturday Review*, May 1982, pp. 36–42.

Reid, Calvin. "Kind of Blue." *Arts Magazine*, February 1990, pp. 54–56.

"Renaissance or Deluge," statements by Mark Stevens, Arthur C. Danto, Roger Kimball, and Mary Jane Jacobs. *Art News*, April 1988, pp. 119–21.

Rian, Jeffrey. "Past Sense, Present Sense." *Artscribe International*, January-February 1989, pp. 60–65.

Reisman, David. "Looking Forward. Activist Postmodern Art." *Tema Celeste*, January-February 1991, pp. 58–62.

Richard, Nellie. "Notes Toward a (Critical) Re-Evaluation of the Critique of the Avant-Garde." *Art and Text* (March 1985): 15–19.

Richardson, John. "Go Go Guggenheim." *New York Review of Books*, July 16, 1992, pp. 18–22.

Richter, Paul. "Modernism & After–2." *Art Monthly*, April 1982, pp. 5–8.

_____. "Modernism & After–1." *Art Monthly*, March 1982, pp. 3–8.

Rickey, Carrie. "Art Attack." *Art in America*, May 1981, pp. 54–57.

_____. "Naive Nouveau and Its Malcontents, *Flash Art* (Summer 1980): 36–39.

_____. "Art of Whole Cloth." *Art in America*, November 1979, pp. 72–83.

_____. "Decoration, Ornament, Pattern and Utility: Four Tendencies in Search of a Movement." *Flash Art* (June-July 1979): 19–23. Accompanied by statements by Scott Burton, Cynthia Carlson, Brad Davis, Mary Grigiordis, Valerie Jaudon, Richard Kalina, Joyce Kozloff, Robert Kushner, Robin Lehrer, Kim MacConnel, Tony Robbin, Miriam Schapiro, Ned Smyth, Robert Zakanitch, and Barbara Zucker.

Rimanelli, David. "Cumulus from New York: Deja Vu." *Parkett*, no. 24 (1990): 146–47.

Robbins, D.A. "The 'Meaning' of 'New'—The '70s/'80s Axis: An Interview with Diego Cortez." *Arts Magazine*, January 1983, pp. 116–21.

Roberts, John. "Hyping Hype." *Art Monthly*, June 1983, pp. 3–4.

_____. "Psycho-Pop." *Artscribe*, October 1981, pp. 37–41.

Robins, Corinne. "Ten Months of Rush-Hour Figuration." *Arts Magazine*, September 1982, pp. 100–103.

_____. "Nationalism, Art, Morality, and Money: Which Side Are We/They or You On?" *Arts Magazine*, January 1982, pp. 107–11.

Robinson, Walter, and Carlo McCormick, "Slouching Toward Avenue D: Report from the East Village." *Art in America*, Summer 1984, pp. 134–61.

Rom, Christine C. "One View: *The Feminist Art Journal.*" *Woman's Art Journal* (Fall 1981-Winter 1982): 19–24.

Rose, Barbara. "Ugly? The Good, the Bad, and the Ugly: Neo-Expressionism Challenges Abstract Art." *Vogue*, March 1982, pp. 372–74, 425.

_____. "Portfolio: Abstract Art in America." *Dialogue*, no. 4, 1980, pp. 46–55.

Rose, Frank. "Exploring the Art-Rock Nexus (Part 1)." *Art Express*, September-October 1981, pp. 30–35.

Rosen, Carol. "Sites and Installations: Outdoor Sculpture Revisited." *Arts Magazine*, February 1990, pp. 65–70.

Rosenthal, Mark. "From Primary Structures to Primary Imagery." *Arts Magazine*, October 1978, pp. 106–107.

Rosler, Martha. "The Private and the Public: Feminist Art in California." *Artforum*, September 1977, pp. 66–74.

Roth, Moira. "Toward a History of California Performance," parts 1 and 2. *Arts Magazine*, February 1978, pp. 94-103; June 1978, pp. 114–23.

Roy, Jean-Michel. "The French Invasion of American Art Criticism." *Journal of Art* (November 1989): 20–21.

Russell, John. "The Modern Charts Its Course Step by Step." *New York Times*, May 13, 1990, sec. 2, pp. 35, 46.

_____. "The New European Painters." *New York Times Magazine*, April 24, 1983, pp. 28–33, 36, 40–42, 71–76.

_____. "The Arts in the 70's: New Tastemakers on Stage." *New York Times*, January 23, 1977, sec. 2, pp. 1, 20.

Saatchi, Doris. "Artists and Heroes." *Artscribe*, October 1982, pp. 16–19.

Salle, David. "New Image Painting." *Flash Art* (April-May 1979): 40–41.

Salvioni, Daniela. "McCollum and Koons," an interview. *Flash Art* (December 1986-January 1987): 66–68.

Saunders, Wade. "Making Art Making Artists." *Art in America*, January 1993, pp. 70–94.

_____. "Talking Objects: Interviews with Ten Sculptors." *Art in America*, November 1985, pp. 110–36. Tom Butter, R.M. Fischer, Joel Fisher, Roni Horn, Mel Kendrick, Donald Lipski, John Newman, Judy Pfaff, Judith Shea, Robert Therrien.

_____. "Hot Metal." *Art in America*, Summer 1980, pp. 86–95.

Schapiro, Michael Edward. "Four Sculptors on Bronze Casting: Nancy Graves, Bryan Hunt, Joel Shapiro, Herk Can Tongeren." *Arts Magazine*, December 1983, pp. 111–17.

Schjeldahl, Peter. "The Documenta of the Dog." *Art in America*, September 1992, pp. 88–97.

_____. "Junk Heaven." *Village Voice*, October 1, 1991, p. 98.

_____. "Art: Art Trust." *Village Voice*, September 17, 1991, p. 97.

_____. "Art: Art Gavel Comes Down, Hard." *Village Voice*, November 27, 1990, p. 123.

_____. "Art: Bully Boys." *7 Days*, April 11, 1990, pp. 63–64.

_____. "Art: Earthy But Housebroken." *7 Days*, April 19, 1989, pp. 64–65.

_____. "Art: Thok!" *7 Days*, January 4, 1989, pp. 49–51.

_____. "Art in Defense of Artistic Fashion." *Vanity Fair*, April 1984, p. 97.

_____. "Up Against the Wall: A Berlin Story." *Vanity Fair*, April 1983, pp. 93–96, 162.

_____. "Falling in Style: The New Art and Our Discontents." *Vanity Fair*, March 1983, pp. 115–16, 252–54.

_____. "Art: Notes for Eight Columns I'm Not Writing This Week." *Village Voice*, October 28, 1981, p. 80.

Schmidt-Wulffen, Stephen. "Conversations with Art Dealers: Michael Werner." *Flash Art* (December 1985-January 1986): 61–62.

Schmitz, Rudolph. "Keeping the Whole Thing in Motion; A Conversation Between Johannes Gachnang and Rudolph Schmitz." *Tema Celeste*, April-June 1989, pp. 39–47.

Schor, Mira. "You Can't Leave Home Without It." *Artforum*, October 1991, pp. 114–19.

_____. "Girls Will Be Girls." *Artforum*, September 1990, pp. 124–29.

_____. "From Liberty to Lack." *Heresies* (1989): 15–21.

Schulze, Franz. "'Extravagant Multiplicity' at Documenta 7." *Art News*, September 1982, pp. 89–91.

_____. "The '70s: A Bedeviling Complexity Marked by Noisy Extremes of Taste." *Art News*, January 1980, pp. 36–41.

Schwabsky, Barry. "Exits: Unbuilding the Wall: From Berlin Looking East." *Arts Magazine*, March 1990, pp. 72–77.

Schwartz, Ellen. "At the Whitney and the Guggenheim: It's the Gospel According to Their Organizers, Not 'The Word.'" *Art News*, April 1981, pp. 122–27.

Schwartz, Estelle. "Advertising, Advertising." *Artscribe International*, September-October 1988, pp. 70–74.

Schwartz, Sanford. "The Saatchi Collection, or A Generation Comes into Focus." *New Criterion*, March 1986, pp. 22–37.

_____. "Anselm Kiefer, Joseph Beuys, and the Ghosts of the Fatherland." *New Criterion*, March 1986, pp. 22–37.

Schwartz, Therese. "The Politicalization of the Avant-Garde," parts 1–3. *Art in America*, November-December 1971, pp. 96–105; March-April 1972, pp. 70–79; March-April 1973, pp. 67–71.

Schwartzman, Allan. "Who's Up and Who's Down?" *Art and Auction*, September 1992, pp. 94–97, 132.

_____. "Art and Business: The End of an Alternative." *Arts Magazine*, September 1988, pp. 11–12.

_____. "The Business of Art: Catalog Culture." *Arts Magazine*, June 1988, pp. 7–8.

Secrest, Meryle. "Leo Castelli: Dealing in Myth." *Art News*, June 1982, pp. 66–72.

Servin, James. "SoHo Stares at Hard Times." *New York Times Magazine*, January 20, 1991, pp. 24–29.

Sharp, Willoughby. "Body Works." *Avalanche*, Fall 1970, pp. 14–17.

_____. "Discussions with Heizer, Oppenheim, and Smithson." *Avalanche*, Fall 1970, pp. 48–71.

Sharp, Willoughby, and Lisa Bear, "A Discussion with Acconci, Fox and Oppenheim, *Avalanche*, Winter 1971, pp. 96–99.

Shore, Michael. "Punk Rocks the Art World: How Does It Look? How Does It Sound?" *Art News*, November 1980, pp. 78–85.

Siegel, Jeanne. "Suits, Suitcases and Other Look-Alikes." *Arts Magazine*, April 1989, pp. 70–75.

_____. "Geometry Desurfacing: Ross Bleckner, Alan Belcher, Ellen Carey, Peter Halley, Sherrie Levine, Philip Taaffe, James Welling." *Arts Magazine*, March 1986, pp. 26–32.

_____. "Leon Golub/Hans Haacke: What Makes Art Political?" *Arts Magazine*, April 1984, pp. 107–13.

_____. "The New Reliefs." *Arts Magazine*, April 1982, pp. 140–44.

Silverthorne, Jeannie. "The Knot: Arte Povera at P.S. 1." *Artforum*, January 1986, pp. 90–91.

_____. "The Pressure to Paint." *Artforum*, October 1982, pp. 67–68.

Simon, Joan. "Report from Berlin, 'Zeitgeist': The Time & the Place." *Art in America*, March 1983, pp. 33–37.

_____. "Double Takes." *Art in America*, October 1980, pp. 113–17.

Simpson, Catharine R. "Multiculturalism: A Big Word at the Presses." *New York Times Book Review*, September 22, 1991, pp. 1, 28–29.

Sims, Lowery Stokes. "The Mirror the Other: The Politics of Esthetics." *Artforum*, March 1990, pp. 111–15.

Sischy, Ingrid. "Photography: Let's Pretend." *New Yorker*, May 6, 1991, pp. 86–96.

_____. "Photography: White and Black." *New Yorker*, November 13, 1989, pp. 124–46.

_____. "East Sets West Sets East." *Artforum*, January 1985, pp. 59–75.

Sischy, Ingrid, and Germano Celant. "Editorial." *Artforum*, February 1982, pp. 34–35.

Simmen, Jeannot L. "New Painting in Germany." *Flash Art* (November 1982): 54–58.

"Situations: Beuys, Cucchi, Kiefer, Kounellis," a conversation. *Galeries Magazine*, June-July 1986, pp. ii–v.

Smith, Dinitia. "Art Fever." *New York*, April 20, 1987, pp. 34–43.

Smith, Paul. "Import/Export: Terminal Culture? 'The British Edge.'" *Art in America*, September 1987, pp. 37–41.

_____. "Difference in America." *Art in America*, April 1985, pp. 190–99.

Smith, Roberta. "Art: 4 Young East Villagers at Sonnabend Gallery." *New York Times*, October 24, 1986, sec. C, p. 30.

_____. "Endless Meaning at the Hirshhorn." *Artforum*, April 1985, pp. 81–85.

_____. "Art: German Fever." *Village Voice*, October 1, 1983, p. 78.

_____. "Art: Critical Dealings." *Village Voice*, September 13, 1983, p. 71.

_____. "Fresh Paint." *Art in America*, Summer 1981, pp. 70–79. (On *A New Spirit of Painting*.)

_____. "Biennial Blues." *Art in America*, April 1981, pp. 92–101.

_____. "'American Painting: The Eighties,' at the Grey Gallery, N.Y.U." *Art in America*, October 1979, pp. 122–23.

_____. "The Abstract Image." *Art in America*, March–April 1979, pp. 102–105.

Solomon, Deborah. "The Cologne Challenge: Is New York's Art Monopoly Kaput?" *New York Times Magazine*, September 6, 1992, pp. 21–23, 30, 45, 49.

Solomon-Godeau, Abigail. "'The Label Show': Contemporary Art and the Museum." *Art in America*, October 1994, pp. 51–55.

_____. "Mandarin Modernism: 'Photography Until Now.'" *Art in America*, December 1990, pp. 140–49, 183.

_____. "Playing in the Field of the Image." *Afterimage*, Summer 1982, pp. 10–13.

"Some Opinions on Documenta 7." *Flash Art* (November 1982): 41–42. Statements by Willi Bongard, Gunter Brus, Sandro Chia, Jorge Glusberg, Lucius Grisebach, Helena Kontova, Paul Maenz, Giuseppe Panza di Biumo, Pierre Restany, Salome, Holly Solomon, and Daniel Templon.

"Some Opinions on Venice Biennale." *Flash Art* (November 1982): 49–50. Statements by Jean-Michel Alberola, Giulio Carlo Argan, Amnon Barzel, Willi Bongard, Georges Boudaille, Lucrezia de Domizio, Mario Diacono, Piero Dorazio, Giorgio Marconi, Matz B., Filiberto Menna, Pierre Restany, Holly Solomon, Daniel Templon, and Ben Vautier.

Spear, Athena. "Some Thoughts on Contemporary Art." *Allen Memorial Art Museum Bulletin*, Spring 1973, pp. 90–98.

Staniszewski, Mary Anne. "Conceptual Art." *Flash Art* (November-December 1987): 88–96.

Starenko, Michael. "Review of Books: Contemporary Photography." *Art in America*, April 1988, pp. 21–23.

Stark, Andy. "Notebook: Talking Politics, Talking Art." *New Criterion*, January 1984, pp. 79–81.

Stephanson, Anders. "Fredric Jameson," an interview. *Flash Art* (December 1986-January 1987): 69–73.

Stepan, Peter. "Germany." *Art News*, February 1985, pp. 52–56.

Stevens, Mark. "Man of the MOMA." *Vanity Fair*, November 1990, pp. 96–108. (On Kirk Varnedoe.)

_____. "The Dizzy Decade." *Newsweek*, March 26, 1979, pp. 88–91, 94.

Stille, Alexander. "Wanted Art Scholar, M.B.A. Required." *New York Times*, January 13, 1991, sec. 4, pp. 35–36.

Storr, Robert. "Other 'Others.'" *Village Voice Art Supplement*, October 6, 1987, pp. 15–17.

Strauss, David Levi. "Aesthetics and Anaesthetics." *Art Issues*, March-April 1993, pp. 21–23.

Stretch, Bonnie Barrett. "Contemporary Photography." *Art & Auction*, May 1987, pp. 140–47.

Tacha, Athena. "Complexity and Contradiction in Contemporary Sculpture." *Gamut*, Winter 1982, pp. 67–77.

Tallman, Susan. "Prints and Editions: Guerrilla Girls." *Arts Magazine*, April 1991, pp. 21–22.

Taylor, Paul. "How Europe Sold the Idea of Postmodern Art." *Village Voice*, September 22, 1987, pp. 99–100, 102.

_____. "The Hot Four: Get Ready for the Next Art Stars." *New York*, October 27, 1986, pp. 50–56. (On Ashley Bickerton, Peter Halley, Jeff Koons, and Meyer Vaisman.)

_____. "Cafe Deutschland." *Art News*, April 1986, pp. 68–76.

_____. "Conversations with Artists: Nature Morte," a conversation with Peter Nagy and Alan Belcher. *Flash Art* (February-March 1986): 64–65.

Thwaites, John Anthony. "Germany: Prophets Without Honor." *Art in America*, December 1985, pp. 110–15.

Tillim, Sidney. "Criticism and Culture, or Greenberg's Doubt." *Art in America*, May 1987, pp. 122–27, 201.

_____. "The View from Past 50." *Artforum*, April 1984, pp. 66–69.

_____. "Since the Late 18th Century the Function of Art as a Form of Value, and How That Value Was to Be Defined, Has Been Anything but Clear." *Artforum*, May 1983, pp. 67–73.

_____. "Earthworks and the New Picturesque." *Artforum*, December 1968, pp. 42–45.

Tisdall, Caroline. "Performance Art in Italy." *Studio International*, January-February 1976, pp. 42–45.

Tomkins, Calvin. "The Art World: Like Water in a Glass." *New Yorker*, March 21, 1982, pp. 92–97.

_____. "The Art World: Matisse's Armchair." *New Yorker*, February 25, 1980, pp. 108–13.

Trini, Tommasi. "The Sixties in Italy." *Studio International*, November 1972, pp. 165–70.

Tuchman, Phyllis. "American Art in Germany: The History of a Phenomenon." *Artforum*, November 1970, pp. 58–69.

Tucker, Marcia. "An Iconography of Recent Figurative Painting: Sex, Death, Violence, and the Apocalypse." *Artforum*, Summer 1982, pp. 70–75.

Tully, Judd. "The East Village: Is the Party Over Now?" *New Art Examiner*, March 1986, pp. 20–23.

_____. "A New Expressionism." *Horizon*, January-February 1984, pp. 38–47.

Tupitsyn, Margarita. "From Sots Art to Sov Art: A Story of the Moscow Vanguard." *Flash Art* (November-December 1987): 75–80.

Vetrocq, Marcia E. "Utopias, Nomads, Critics: From Arte Povera to Transavantguardia." *Arts Magazine*, April 1989, pp. 49–54.

Vettese, Angela. "Mimmo Paladino," an interview. *Flash Art* (May 1987): 98–99.

Vine, Richard. "The 'Ecstasy' of Jean Baudrillard." *New Criterion*, May 1989, pp. 39–48.

Virshup, Amy. "The Great Art Explosion." *Art News*, April 1988, pp. 103–109.

Volpi, Marisa. "Italian Art Today." *Art News*, March 1981, pp. 86–91.

Walker, James Faure. "Awkward Moments." *Artscribe* 27, February 1981, pp. 12–14.

Walker, Richard W. "The Passionate Possessors." *Art News*, January 1990, pp. 123–39.

_____. "The Saatchi Factor." *Art News*, January 1987, pp. 117–21.

Wallace, Joan, and Geralyn Donohue, "Edit DeAk," an interview. *Real Life Magazine*, Spring-Summer 1982, pp. 3–4.

Wei, Lilly, ed. "Talking Abstract." *Art in America*, July 1987, pp. 80–97. Interviews with Gregory Amenoff, Jake Berthot, Ross Bleckner, Marcia Hafif, Mary Heilmann, Brice Marden, Elizabeth Murray, and George Peck.

Weiley, Susan. "The Darling of the Decade." *Art News*, April 1989, pp. 143–50.

_____. "Prince of Darkness, Angel of Light." *Art News*, December 1988, p. 108.

Weinstock, Jane. "Issues & Commentary: A Lass, a Laugh and a Lad." *Art in America*, Summer 1983, pp. 7–10.

Weisgall, Deborah. "A Megamuseum in a Mill Town: The Guggenheim in Massachusetts." *New York Times Magazine*, March 5, 1989, pp. 32–84.

Welish, Marjorie. "Who's Afraid of Verbs, Nouns, and Adjectives?" *Arts Magazine*, April 1990, pp. 79–84.

West, Cornel. "The New Cultural Politics of Difference." *October* 53 (Summer 1990): 93–109.

Westfall, Stephen. "Surrealist Modes Among Contemporary New York Painters." *Art Journal* (Winter 1985): 315–18.

Weyergraf, Clara. "The Holy Alliance: Populism and Feminism." *October* 16 (Spring 1981): 23–34.

Whelen, Richard. "The 1979 Biennials: Discerning Trends at the Whitney." *Art News*, April 1979, pp. 84–87.

Wilkin, Karen. "Refiguring the Guggenheim." *New Criterion*, June 1989, pp. 51–55.

Williams, Gilda. "Jeffrey Deitch," an interview. *Flash Art* (Summer 1990): 168–69, 186.

Winter, Simon Vaughan. "Nicholas Logsdail," an interview. *Artscribe*, January-February 1985, pp. 33–36.

Wolf, Deborah. "Mary Boone." *Avenue*, October 1982, pp. 40–47.

Wolfe, Tom. "The 'Me' Decade and the Third Great Awakening." *New York*, August 23, 1976, pp. 26–40.

"The Women's Movement in Art, 1986." *Arts Magazine*, September 1986, pp. 54–57. A panel discussion with Ida Applebroog, Josely Carvalho, Susan Gill, Chris Heindl, Fran Hodes, Bea Kreloff, Ora Lerman, Sabra Moore, Joan Semmel, Joan Snyder, and Nancy Spero.

Wong, Stella. "East Village Art." *Art and Auction*, November 1985, pp. 112–21.

Woodward, Richard B. "It's Art, but Is It Photography?" *New York Times Magazine*, October 9, 1988, pp. 28–31, 42, 44, 46, 54–55, 57.

Yard, Sally. "The Shadow of the Bomb." *Arts Magazine*, April 1984, pp. 73–82.

Yau, John. "Official Policy: Toward the 1990s with the Whitney Annual." *Arts Magazine*, September 1989, pp. 50–54.

"Zeitgeist: An Interview with Christos Joachimides." *Flash Art* (November 1982): 26–31.

Zelevansky, Lynn. "Documenta: Art for Art's Sake." *Flash Art* (November 1982): 39–40.

_____. "Is There Life After Performance." *Flash Art* (December 1981-January 1982): 38–42.

Zimmer, William. "Still Funky But Oh So Chic SoHo." *Art News*, November 1980, pp. 90–93.

Zucker, Barbara. "The Women's Movement: Still a 'Source of Strength' or 'One Big Bore,'" *Art News*, April 1976, p. 48.

WORKS ON ARTISTS

Magdalena Abakanowicz

Rose, Barbara. *Magdalena Abakanowicz*. New York: Harry N. Abrams, 1994.

Chicago. Museum of Contemporary Art. New York. Abbeville Press. *Magdalena Abakanowicz*, 1982. Texts by Mary Jane Jacob, Magdalena Abakanowicz, and Jasia Reichardt.

Minneapolis. Walker Art Center. *Magdalena Abakanowicz—An Installation in the Minneapolis Sculpture Garden Organized by the Walker Art Center, Minneapolis*, 1994. Texts by Martin Friedman and Magdalena Abakanowicz.

New York. Institute for Contemporary Art, P.S. 1 Museum. *Magdalena Abakanowicz—War Games*, 1993. Texts by Michael Brenson, Alanna Heiss, and Magdalena Abakanowicz.

Vito Acconci

Linker, Kate. *Vito Acconci*. New York: Rizzoli, 1994.

Chicago. Museum of Contemporary Art. *Vito Acconci: A Retrospective: 1969 to 1980*, 1980. Text by Judith Russi Kirshner.

La Jolla, Calif. La Jolla Museum of Contemporary Art. *Vito Acconci: Domestic Trappings*, 1987. Texts by Ronald J. Onorato and Vito Acconci.

Lucerne, Switzerland. Kunsthalle. *Vito Acconci*, 1978. Acconci interview with Martin Kunz.

New York. Museum of Modern Art. *Vito Acconci: Public Places*, 1988. Texts by Linda Shearer and Vito Acconci.

White, Robin. "Vito Acconci," an interview. *View*. Oakland, Calif.: Crown Point Press, 1979.

Acconci, Vito. "Notes on Work, *Avalanche*, no. 5, 1971, pp. 2, 4, 6, 8, 30, 43, 53, 62.

Burnham, Jack. "Acconci in a Tight Spot." *New Art Examiner*, May 1980, pp. 1, 8–11.

Celant, Germano. "Dirty Acconci." *Artforum*, November 1980, pp. 76–83.

Gilbard, F. "An Interview with Vito Acconci." *Afterimage*, November 1984, pp. 9–15.

Levine, Ed. "In Pursuit of Acconci." *Artforum*, April 1977, pp. 38–41.

Melville, Stephen. "How Should Acconci Count for Us?: Notes on a Retrospect." *October* 18 (Fall 1981): 78–89.

Rickey, Carrie. "Vito Acconci: The Body Impolitic." *Art in America*, October 1980, pp. 118–23.

Schwartz, Ellen. "Vito Acconci: 'I Want to Put the Viewer on Shaky Ground,'" *Art News*, June 1981, pp. 93–99.

Nicholas Africano

Raleigh, N.C. North Carolina Museum of Art. *Nicholas Africano: Paintings 1976–1983*, 1983. Text by Nicholas Africano.

Bonesteel, Michael. "Moments of Conviction: The Story Paintings of Nicholas Africano." *New Art Examiner*, Summer 1980, pp. 10–11.

Hugo, Joan. "Nicholas Africano's Parables." *Art Week*, May 16, 1981, pp. 5–6.

Reed, Dupuy W. "Nicholas Africano: Responsible Relevance." *Arts Magazine*, June 1979, pp. 158–60.

Laurie Anderson

Anderson, Laurie. *United States*. New York: Harper & Row, 1984.

Howell, John. *Laurie Anderson*. New York: Thunder's Mouth Press, 1992.

White, Robin. "Laurie Anderson," an interview. *View*. Oakland, Calif.: Crown Point Press, 1979.

Philadelphia. Institute of Contemporary Art, University of Pennsylvania. *Laurie Anderson: Works from 1969 to 1983*, 1983. Texts by Janet Kardon, Ben Lifson, Craig Owens, and John Rockwell.

Gordon, Mel. "Laurie Anderson: Performance Artist." *Drama Review*, June 1980, pp. 51–64.

Lifson, Ben. "Laurie Anderson: Dark Dogs, American Dreams." *Aperture* 86 (1982), pp. 44–49.

Owens, Craig. "Amplifications: Laurie Anderson." *Art in America*, March 1981, pp. 120–23.

Rockwell, John. "Laurie Anderson: American Music Unbound." *Esquire*, December 1982, pp. 136–39.

Shewey, Don. "The Performing Artistry of Laurie Anderson." *New York Times Magazine*, February 6, 1983, pp. 27–28, 55, 59.

Stewart, Patricia. "Laurie Anderson: With a Song in My Art." *Art in America*, March-April 1979, pp. 110–13.

Eleanor Antin

La Jolla, Calif. La Jolla Museum of Contemporary Art. *Eleanor Antin*, 1977. Texts by Jonathan Crary, Kim Levin, and Eleanor Antin.

Cadet, Nancy. "Eleanor Antin." *High Performance* (Fall 1989): 62–63.

Durland, Steven. "Help! I'm in Seattle." *High Performance* 9, no. 2 (1986): 72–73.

Hicks, E. "Eleanor Antin: Narrative Juxtapositions." *Artweek*, January 1981, pp. 5–6.

Johnson, Ken. "Eleanor Antin at Ronald Feldman." *Art in America*, April 1995, pp. 107–108.

Kissin, Eva H. "The Man Without a World." *Films in Review*, November-December 1992, pp. 415–16.

Martin, Carol. "Loves of a Ballerina." *High Performance* 10, no. 1 (1987): 89–90.

Skoller, Jeffrey. "The Man Without a World." *Film Quarterly*, Fall, 1995, pp. 107–108.

Ida Applebroog

Atlanta. High Museum of Art. *Art at the Edge: Ida Applebroog*, 1989. Text by Susan Krane.

Houston. Contemporary Arts Museum. *Ida Applebroog: Happy Families: A Fifteen-Year Survey*, 1990. Texts by Lowery S. Sims, Thomas W. Sokolowski, and Marilyn A. Zeitlin.

New York. Ronald Feldman Gallery. *Ida Applebroog*, 1989. Text by Carlo McCormick.

_____. *Ida Applebroog*, 1987. Texts by Ronald Feldman, Carrie Rickey, Lucy R. Lippard, Linda F. McGreevy, and Carter Ratcliff.

Bass, Ruth. "Ordinary People." *Art News*, May 1988, pp. 151–54.

McGreevy, Linda F. "Ida Applebroog's Latest Paradox: DeadEnds=New Beginnings." *Arts Magazine*, April 1986, pp. 29–31.

_____. "Under Current Events: Ida Applebroog's *Intimates and Others*." *Arts Magazine*, October 1984, pp. 128–31.

Schor, Mira. "Medusa Redux: Ida Applebroog and the Spaces of Post-Modernity." *Artforum*, March 1990, pp. 116–22.

Schwendenwein, Jude. "Social Surrender: An Interview with Ida Applebroog." *Real Life Magazine*, Winter 1987, pp. 40–44.

Siah Armajani

Basel, Switzerland. Kunsthalle Basel. *Siah Armajani*, 1987. Text by Jean-Christophe Ammann.

Nice, France. Via Arson. Centre National d'Art Contemporain. *Siah Armajani*, 1994. Texts by Nancy Princenthal, Siah Armajani, Jean-Philippe Vienne, Jean-Christophe Ammann, Patricia C. Phillips, and Christopher Knight.

New York. Max Protetch Gallery. *Siah Armajani*, 1991. Text by Nancy Princenthal.

Philadelphia. Institute of Contemporary Art, University of Pennsylvania. *Siah Armajani: Bridges, Houses, Communal Spaces, Dictionary for Building*, 1985. Texts by Janet Kardon and Kate Linker.

Antonelli, Paola di. "Siah Armajani." *Domus*, February 1990, pp. 48–57.

Armajani, Siah. "Site: The Meaning of Place in Art and Architecture." *Design Quarterly*, no. 122 (1983): 6–9.

Berlind, Robert. "Armajani's Open-Ended Structures." *Art in America*, October 1979, pp. 82–85.

Phillips, Patricia C. "Siah Armajani's Constitution." *Artforum*, December 1985, pp. 70–74.

Princenthal, Nancy. "Master Builder." *Art in America*, March 1986, pp. 127–32.

Shermeta, Margo. "An American Dictionary in the Vernacular: Utilitarian Ideas and Structures in the Sculpture of Siah Armajani." *Arts Magazine*, January 1987, pp. 38–41.

Tomkins, Calvin. "Profiles: Open, Available, Useful." *New Yorker*, March 19, 1990, pp. 48–72.

Richard Artschwager

Buffalo, N.Y. Albright-Knox Art Gallery. *Richard Artschwager's Theme(s)*, 1979. Texts by Richard Armstrong, Linda L. Cathcart, and Suzanne Delehanty.

New York. Whitney Museum of American Art. *Richard Artschwager*, 1988. Text by Richard Armstrong.

Baker, Elizabeth C. "Artschwager's Mental Furniture." *Art News*, January 1968, pp. 48–49, 58–61.

Bankowsky, Jack. "Richard Artschwager." *Flash Art* (March-April 1988): 80–83.

Bruggen, Coosje van. "Richard Artschwager." *Artforum*, September 1983, pp. 44–51.

Lubell, Ellen. "Richard Artschwager." *Arts Magazine*, May 1972, pp. 67–70.

Madoff, Steven Henry. "Richard Artschwager's Sleight of Mind." *Art News*, January 1988, pp. 114–21.

Smith, Roberta. "The Artschwager Enigma." *Art in America*, October 1979, pp. 93–95.

Stitelman, Paul. "Richard Artschwager." *Arts Magazine*, January 1974, pp. 70–74.

Welish, Marjorie. "The Elastic Vision of Richard Artschwager." *Art in America*, May-June 1978, pp. 85–87.

Zimmer, William. "Richard Artschwager." *Arts Magazine*, June 1975, pp. 7–10.

Alice Aycock

Tampa, Fla. University of South Florida Art Galleries. *Alice Aycock Projects 1979–1981*, 1981. Text by Edward F. Fry.

Aycock, Alice. "Alice Aycock, Project for Five Wells Descending a Hillside." *Tracks, a Journal of Artists' Writings* (Spring 1976): 23–26.

Fry, Edward. "The Poetic Machines of Alice Aycock." *Portfolio*, November-December 1981, pp. 60–65.

Kuspit, Donald. "Aycock's Dream Houses." *Art in America*, September 1980, pp. 84–87.

Morgan, Stuart. "Alice Aycock: Structures, Stories and the History of Man—Powered Flight." *Artscribe*, December 1978, pp. 12–17.

Poirier, Maurice. "The Ghost in the Machine." *Art News*, October 1986, pp. 78–85.

Price, Aimee Brown. "A Conversation with Alice Aycock." *Architectural Digest*, April 1980, pp. 54–60.

Risatti, Howard. "The Sculpture of Alice Aycock and Some Observations on Her Work." *Woman's Art Journal* (Spring-Summer 1985): 28–38.

Russell, John. "Alice Aycock: The Game of Fliers." *Presentense* (San Jose Institute of Contemporary Art), February 1981, pp. 9–13.

Tsai, Eugenie. "A Tale of (at Least) Two Cities: Alice Aycock's 'Large Scale Dis/Integration of Microelectric Memories (A Newly Revised Shantytown).'" *Arts Magazine*, June 1980, pp. 134–41.

John Baldessari

Bruggen, Coosje van. *John Baldessari*. New York: Rizzoli, 1991.

New York. New Museum of Contemporary Art. *John Baldessari*, 1982. Texts by Marcia Tucker and Robert Pincus-Witten.

Santa Barbara. Santa Barbara Museum of Art. *John Baldessari: California Viewpoints*, 1986. Text by Hunter Drohojowska.

Baldessari, John. Statement, *Dialogue*, January-February 1982, pp. 38–39.

Collins, James. "Pointing, Hybrids, and Romanticism." *Artforum*, October 1973, pp. 53–58.

Davis, Susan A. "The Perennial Seed: Interview with John Baldessari." *C Magazine*, March 1988, pp. 34–37.

Drohojowska, Hunter. "No More Boring Art." *Art News*, January 1986, pp. 62–69.

Foote, Nancy. "John Baldessari." *Artforum*, January 1976, pp. 37–45.

Foster, Hal. "John Baldessari's 'Blasted Allegories.'" *Artforum*, October 1979, pp. 52–55.

Gardner, Colin. "A Systematic Bewildering." *Artforum*, December 1989, pp. 106–12.

Miller, John. "The Deepest Cut: Montage in the Work of John Baldessari." *Artscribe International*, May 1989, pp. 52–56.

Owens, Craig. "Telling Stories." *Art in America*, May 1981, pp. 129–35.

Siegel, Jeanne. "John Baldessari: Recalling Ideas," an interview. *Arts Magazine*, April 1988, pp. 86–89.

Jennifer Bartlett

Bartlett, Jennifer. *History of the Universe*. New York: Moyer Bell Limited and Nimbus Books, 1985.

Eisenberg, Deborah. *AIR: 24 Hours: Jennifer Bartlett*. New York: Harry N. Abrams, 1994. Includes a Bartlett interview with Eisenberg.

Russell, John. *In the Garden*. New York: Harry N. Abrams, 1982.

Smith, Roberta. *Rhapsody*. New York: Harry N. Abrams, 1985.

Cleveland. Cleveland Museum of Art. *Jennifer Bartlett: Recent Work*, 1986. Text by Tom E. Hinson.

Minneapolis. Walker Art Center. *Jennifer Bartlett*, 1985. Texts by Marge Goldwater, Roberta Smith, and Calvin Tomkins.

Amayo, Mario. "Artist's Dialogue: A Conversation with Jennifer Bartlett." *Architectural Digest*, December 1981, pp. 50, 54, 56, 58, 60.

Buck, Joan Juliet. "Brushing Up." *Vanity Fair*, April 1985, pp. 80–85, 107.

Buckley, Peter. "Jennifer Bartlett." *Horizon*, June 1985, pp. 41–48.

Cotter, Holland. "The Bartlett Variations." *Art in America*, May 1986, pp. 124–31.

Danto, Arthur. "Jennifer Bartlett." *Nation*, March 1, 1986, pp. 248–51.

Galligan, Gregory. "Jennifer Bartlett: In and Out of the Garden." *Arts Magazine*, November 1985, pp. 89–91.

Robertson, Nan. "In the Garden with Jennifer Bartlett." *Art News*, November 1983, pp. 72–77.

Smith, Roberta. "Bartlett's Swimmers." *Art in America*, November 1979, pp. 93–97.

Georg Baselitz

Dahlem, Franz. *Georg Baselitz*. Cologne: Taschen Verlag, 1984. With a text by Baselitz.

Franzke, Andreas. *Georg Baselitz*, trans. David Britt. Munich: Prestel Verlag, 1989.

Gohr, Siegfried. *Georg Baselitz: Prints 1963–1983*. Munich: Prestel Verlag, 1984.

Barcelona. Centre Cultural de la Fundacio Caixa de Pensions. *Georg Baselitz*, 1990. Texts by Antoni Mari, Rudi Fuchs, Kay Heymer, and Kevin Power.

Geneva. Musée d'Art d'Histoire. *Gerog Baselitz Gravures 1963–1983*, 1984. Texts by Georg Baselitz, Siegfried Gohr, and Rainer Michael Mason.

London. Whitechapel Art Gallery. *Baselitz Paintings 1960–83*, 1983. Texts by Richard Calvocoressi and Georg Baselitz.

New York. Solomon R. Guggenheim Museum. *Georg Baselitz*, 1995. Text by Diane Waldman.

Saarbrücken, Germany. Saarland Museum. *Georg Baselitz: Werke 1981–1993*, 1994. Texts by Ernst-Gerhard Güse, Georg Baselitz, Heinrich Heil, and Ernest W. Uthemann.

Caldwell, John. "Baselitz in the Seventies." *Parkett*, no. 11 (1986): 84–97.

Calvocoressi, Richard. "A Source for the Inverted Imagery in Georg Baselitz's Painting." *Burlington Magazine*, December 1985, pp. 89–99.

Collins, Matthew. "Georg Baselitz: Effluents and Inventions." *Artscribe*, October 1983, pp. 20–25.

Darragon, Eric. "Georg Baselitz." *Galeries Magazine*, February-March 1994, pp. 68–77.

Dornberg, John. "The Artist Who Came In from the Cold." *Art News*, October 1992, pp. 102–107.

Gohr, Siegfried. "Georg Baselitz: Paintings Don't Come with Guarantees." *Flash Art* (Summer 1993): 67–72.

_____. "In the Absence of Heroes: The Early Work of Georg Baselitz." *Artforum*, Summer 1982, pp. 67–69.

Kuspit, Donald B. "Pandemonium, The Root of Georg Baselitz's Imagery." *Arts Magazine*, Summer 1986, pp. 24–29.

Lloyd, Jill. "Georg Baselitz Comes Full Circle: The Art of Transgression and Restraint." *Art International*, Winter 1988, pp. 86–96.

Pincus-Witten, Robert. "Georg Baselitz: From Nolde to Kandinsky to Matisse, A Speculative History of Recent German Painting." *Arts Magazine*, Summer 1986, pp. 30–34.

Jean-Michel Basquiat

New York. Robert Miller Gallery. *Jean-Michel Basquiat: Drawings*, 1990. Text by Robert Storr.

New York. Whitney Museum of American Art. *Jean-Michel Basquiat*, 1993. Texts by Dick Hebdige, Klaus Kertess, Richard Marshall, Rene Ricard, Greg Tate, and Robert Farris Thompson.

Basquiat, Jean-Michel. "Tuxedo." *Paris Review*, Spring 1983, pp. 205–15.

Davvetas, Demosthenes. "Lines, Chapters, and Verses: The Art of Jean-Michel Basquiat." *Artforum*, April 1987, pp. 116–20.

Decker, Andrew. "The Price of Fame." *Art News*, January 1989, pp. 96–101.

Gopnik, Adam. "The Art World: Madison Avenue Primitive." *New Yorker*, November 9, 1992, pp. 137–39.

Lewis, Joe. "Basquiat: Shrewd as Well as Unruly, the Late Jean-Michel Basquiat Learned His Art from Both the Masters and the Streets." *Contemporanea*, July–August 1989, pp. 78–83.

Tate, Greg. "Nobody Loves a Genius Child." *Village Voice*, November 14, 1989, pp. 31–35.

Lynda Benglis

Atlanta. High Museum of Art. *Lynda Benglis: Dual Natures*, 1991. Text by Susan Krane.

Oneonta, N.Y. Fine Arts Center Gallery. *Physical and Psychological Moments in Time: A First Retrospective of the Video Work of Lynda Benglis*, 1975. Text by Robert Pincus-Witten.

Tampa, Fla. Teaching Gallery, University of South Florida. *Lynda Benglis: 1968–1978*, 1980. Text by Peter Schjeldahl.

Avgikos, Jan. "The Southern Artist: Lynda Benglis." *Southern Accents*, November-December 1988, pp. 168–71.

Benglis, Lynda. "Social Conditions Can Change," in "Eight Artists Reply: Why Have There Been No Great Women Artists?" *Art News*, January 1971, p. 43.

Pincus-Witten, Robert. "Lynda Benglis: The Frozen Gesture." *Artforum*, November 1974, pp. 54–59.

Vetrocq, Marcia E. "Knots, Glitter and Funk." *Art in America*, December 1991, pp. 92–97.

Joseph Beuys

Bastian, Heiner. *Joseph Beuys: Lightning with Stag in Its Glare*. Bielefeld, Germany: Benteli Verlag, 1986.

Götz, Adrian. Winfried Konnertz, and Karin Thomas, *Joseph Beuys: Life and Works*. Cologne: M. DuMont Schauberg, 1973.

Kuoni, Carin, compiler. *Emergency Plan for the Western Man: Joseph Beuys in America: Writings by and Interviews with the Artist*. New York: Four Walls and Eight Windows, 1990. Introductory texts by Kim Levin and Caroline Tisdall.

Stachelhaus, Heiner. *Joseph Beuys*, trans. David Britt. New York: Abbeville Press, 1991.

New York. Solomon R. Guggenheim Museum. *Joseph Beuys*, 1989. Text by Caroline Tisdall.

Adams, David "Joseph Beuys—Pioneer of a Radical Ecology." *Art Journal* (Summer 1992): 26–34.

Blumenthal, Lyn, and Kate Horsfield, "Joseph Beuys," an interview. *Profile*, January 1981, pp. 1–15.

Buchloh, Benjamin H.D. "Beuys: The Twilight of the Idol: Preliminary Notes for a Critique." *Artforum*, January 1980, pp. 35–43.

Buchloh, Benjamin H.D., Rosalind Krauss, and Annette Michelson, "Joseph Beuys at the Guggenheim." *October* 12 (Spring 1980): 3–21.

DeAk, Edit, and Walter Robinson, "Beuys: Art Encage." *Art in America*, November-December 1974, pp. 76–79.

Kuspit, Donald. "Beuys: Fat, Felt, and Alchemy." *Art in America*, May 1980, pp. 78–89.

Levin, Kim. "Joseph Beuys: The New Order." *Arts Magazine*, April 1980, pp. 154–57.

Meyer, Ursula. "How to Explain Pictures to a Dead Hare." *Art News*, January 1970, pp. 54–57, 71.

Sharp, Willoughby. "An Interview with Joseph Beuys." *Artforum*, December 1969, pp. 40–47.

Strauss, David Levi. "American Beuys: 'I Like America & America Likes Me.'" *Parkett*, no. 26 (1990): 124–29.

Tisdall, Caroline. "Beuys: Coyote." *Studio International*, July-August 1976, pp. 36–40.

Watson, Scott. "The Wound and the Instrument: Joseph Beuys." *Vanguard*, Summer 1988, pp. 18–23.

Ashley Bickerton

Bickerton, Ashley, and Aimee Rankin, "Fluid Mechanics: A Conversation Between Ashley Bickerton and Aimee Rankin." *Arts Magazine*, December 1987, pp. 82–85.

Jones, Ronald. "Protective Custody." *Artscribe International*, September-October 1988, pp. 50–53.

Leigh, Christian. "It's the End of the World and I Feel Fine." *Artforum*, Summer 1988, pp. 116–19.

Phillips, Richard. "Ashley Bickerton," an interview. *Journal of Contemporary Art* (Spring-Summer 1989): 79–90.

Ross Bleckner

Dennison, Lisa, with Tom Crow, Simon Watney, and Lisa Liebman, *Ross Bleckner*. New York: Harry N. Abrams, 1995.

London. Waddington Galleries. *Ross Bleckner*, 1988. Text by Peter Schjeldahl.

Milwaukee. Milwaukee Art Museum. *Ross Bleckner*, 1989. Text by Dean Sobel.

Bleckner, Ross. "Transcendent Anti-Fetishism." *Artforum*, March 1979, pp. 50–55.

Cameron, Dan. "On Ross Bleckner's 'Atmospheric' Paintings." *Arts Magazine*, February 1987, pp. 30–34.

Chua, Lawrence. "Ross Bleckner." *Flash Art* (November-December 1989): 122–25.

Halley, Peter. "Ross Bleckner: Painting at the End of History." *Arts Magazine*, May 1982, pp. 132–33.

Klein, Mason. "Past and Perpetuity in the Recent Paintings of Ross Bleckner." *Arts Magazine*, October 1986, pp. 74–77.

Liebman, Lisa. "Ross Bleckner: Mood Indigo." *Art News*, May 1988, pp. 129–33.

Melville, Stephen. "Dark Rooms: Allegory and History in the Paintings of Ross Bleckner." *Arts Magazine*, April 1987, pp. 56-58.

Morgan, Stuart. "Strange Days." *Artscribe International*, March-April 1988, pp. 48–51.

Steir, Pat. "Where the Birds Fly, What the Lines Whisper." *Artforum*, May 1987, pp. 107–10.

Zinsser, John. "Ross Bleckner's Architecture of the Sky." *Arts Magazine*, September 1988, pp. 41–43.

Christian Boltanski

Jennifer Flay, ed., *Christian Boltanski Catalogue: Books, Printed Matter, Ephemera 1966–1991*. Cologne and Frankfurt am Main: Verlag der Buchhandlung Walther König and Portikus, 1991.

Gumpert, Lynn. *"Christian Boltanski*. Paris: Flammarion, 1994.

Jerusalem. Israel Museum. *Christian Boltanski: Lessons of Darkness*, 1989. Text by Suzanne Landau. Boltanski interview with Bracha Ettinger.

Paris. Musée National d'Art Moderne, Centre Georges Pompidou. *Boltanski*, 1984. Texts by Bernard Blistène, Dominique Bozo, Klaus Honnef, Tadeusz Kantor, Gilbert Lascault, Serge Lemoine, Gunter Metken, Delphine Renard, and Dominique Vieville.

Lascaux, Gilbert. "Twelve Observations on Christian Boltanski's Shadows and Monuments." *Parkett*, no. 9 (June 1986): 12–15.

Marmer, Nancy. "Boltanski: The Uses of Contradiction." *Art in America*, October 1989, pp. 168–80, 233–35.

Svestka, Jiri. "Christian Boltanski." *Galeries Magazine*, April-May 1988, pp. 97–103.

Jonathan Borofsky

Basel, Switzerland. Kunsthalle Basel. *Jonathan Borofsky: Dreams 1973–1981*, 1981. Texts by Sandy Nairne, Jean-Christophe Ammann, and Joan Simon.

Houston. Contemporary Art Museum. *Jonathan Borofsky: An Environmental Installation*, 1981. Text by Linda L. Cathcart.

New York. Whitney Museum of American Art. Philadelphia. Philadelphia Museum of Art. *Jonathan

Borofsky, 1984. Texts by Mark Rosenthal and Richard Marshall.

Stockholm. Moderna Museet. *Jonathan Borofsky*, 1984. Texts by Olle Granath, Joan Simon, Dieter Koepplin, and Richard Armstrong.

Borofsky, Jonathan. "Prisoner." *Artforum*, March 1988, pp. 94–97.

_____. "STRIKE: A Project by Jonathan Borofsky." *Artforum*, February 1981, pp. 50–55.

_____. "Dreams." *Paris Review*, Winter 1981, pp. 89–101.

Cooke, Lynne. "Jonathan Borofsky." *Artscribe*, March–April 1985, pp. 53–55.

Howe, Katharine. "I Can Never Get Quite Too Direct . . . Jon Borofsky, an Interview." *Images and Issues*, May–June 1984, pp. 16–21.

Knight, Christopher. "The Visible Man." *Flash Art* (March 1985): 20–22.

Silverthorne, Jeanne. "Jonathan Borofsky: What Kind of Fool Is This?" *Artforum*, February 1985, pp. 52–54.

Simon, Joan. "An Interview with Jonathan Borofsky." *Art in America*, November 1981, pp. 157–67.

Soldaini, Antonella, and Vincent Todoli, "Borofsky," an interview. *Flash Art* (March 1985): 18–19.

Zelevansky, Lynn. "Borofsky's Dream Machine." *Art News*, May 1984, pp. 108–15.

Louise Bourgeois

Bernadac, Marie-Laure. *Louise Bourgeois*. New York: Flammarion, 1996.

Kuspit, Donald. *Bourgeois*. New York: Vintage Books, 1988. Bourgeois interview with Donald Kuspit.

Meyer-Thoss, Christiane. *Louise Bourgeois: Designing for Free Fall*. Zürich: Ammann Verlag, 1992. Bourgeois interview with Christiane Meyer-Thoss.

Weiermair, Peter, ed. *Louise Bourgeois*. Kilchberg/Zürich: Edition Stemmle, 1995. Texts by Lucy Lippard, Robert Storr, Rosalind Krauss, and Thomas McEvilley.

Cincinnati. Taft Museum. *Louise Bourgeois*, 1987. Text by Stuart Morgan.

New York. Brooklyn Museum. *Louise Bourgeois: The Locus of Memory, Works 1982–1993*, 1994. Texts by Charlotta Kotik, Terrie Sultan, and Christian Leigh.

New York. Museum of Modern Art. *Louise Bourgeois*, 1982. Text by Deborah Wye.

New York. Robert Miller Gallery. *Louise Bourgeois Drawings*, 1988. Text by Robert Storr.

_____. *Louise Bourgeois*, 1982. Text by Robert Pincus-Witten.

St. Louis. St. Louis Art Museum. *Louise Bourgeois: The Personages*, 1994. Text by Jeremy Strick. Bloch, Susi. "An Interview with Louise Bourgeois." *Art Journal* (Summer 1976): 370–73.

Bourgeois, Louise. "Louise Bourgeois." *Balcon*, nos. 8–9 (1992): 44–50.

Gardner, Paul. "Louise Bourgeois." *Contemporanea*, October 1989, pp. 65–69.

_____. "Louise Bourgeois Makes a Sculpture." *Art News*, Summer 1988, pp. 61–64.

_____. "The Discrete Charm of Louise Bourgeois." *Art News*, February 1980, pp. 80–86.

Kirili, Alain. "The Passion for Sculpture: A Conversation with Louise Bourgeois." *Arts Magazine*, March 1989, pp. 69–75.

Kuspit, Donald. "Louise Bourgeois—Where Angels Fear to Tread." *Artforum*, March 1987, pp. 115–20.

Leigh, Christian. "Rooms, Doors, Windows: Making Entrances & Exits (When Necessary). Louise Bourgeois's Theater of the Body." *Balcon*, nos. 8–9 (1992): 142–55.

Lippard, Lucy R. "Louise Bourgeois: From the Inside Out." *Artforum*, March 1975, pp. 26–33.

Morgan, Stuart. "Taking Cover," an interview. *Artscribe International*, January-February 1988, pp. 30–34.

Pels, Marsha. "Louise Bourgeois: A Search for Gravity." *Art International*, October 1979, pp. 46–54.

Rubin, William. "Some Reflections Prompted by the Recent Work of Louise Bourgeois." *Art International*, April 1969, pp. 17–20.

Steir, Pat. "Mortal Elements: Pat Steir Talks with Louise Bourgeois." *Artforum*, Summer 1993, pp. 86–87, 127.

Storr, Robert. "Louise Bourgeois: Gender & Possession." *Art in America*, April 1983, pp. 128–37.

Thurman, Judith. "Artist's Dialogue, Passionate Self-Expression—The Art of Louise Bourgeois." *Architectural Digest*, November 1984, pp. 234–46.

Marcel Broodthaers

Compton, Michael, and Marge Goldwater, *Marcel Broodthaers*. New York: Rizzoli, 1989, introduction by Marge Goldwater, essays by Michael Compton, Douglas Crimp, Bruce Jenkins, and Martin Mosebach.

Eindhoven, Netherlands. Stedelijk van Abbemuseum. *Marcel Broodthaers Projections*, 1992. Texts by Jan Debbaut, Frank Lubbers, and Anna Hakkens.

New York. Mary Boone Gallery. *Marcel Broodthaers*, 1984. Texts by Carter Ratcliff and Barbara Reise.

New York. Marion Goodman Gallery. *Marcel Broodthaers: Section Publicité du Musée d'Art Moderne DT des Aigles, 1995*. Text by Benjamin H.D. Buchloh.

New York. David Zwirner Gallery. *Marcel Broodthaers Correspondences*, 1995. Texts by Marcel Broodthaers and Dorothea Zwirner and Daniel Buren, Hans Haacke, Ilya Kabakov, Mike Kelley, and other artists.

Buchloh, Benjamin H.D. "Marcel Broodthaers: Allegories of the Avant-Garde." *Artforum*, May 1980, pp. 52–59.

Calas, Nicolas. "Marcel Broodthaers, 'Throw of the Dice.'" *Artforum*, May 1976, pp. 34–37.

Ratcliff, Carter. "The Mold, the Mussel and M. Broodthaers." *Art in America*, March 1983, pp. 134–37.

McEvilley, Thomas. "Another Alphabet: The Art of Marcel Broodthaers." *Artforum*, November 1989, pp. 106–15.

Chris Burden

Burden, Chris. *Chris Burden, 74–77*. Los Angeles: Author, 1978.

_____. *Chris Burden, 71–73*. Los Angeles: Author, 1974.

Newport Beach, Calif. Newport Harbor Art Museum. *Chris Burden: A Twenty-Year Survey*, 1988. Texts by Donald Kuspit, Tom Marioni, David A. Ross, and Howard Singerman.

Bear, Lisa, and Willoughby Sharp, "Chris Burden: The Church of Human Energy." *Avalanche*, Summer-Fall, 1973, pp. 64–71.

Butterfield, Jan, and Chris Burden, "Chris Burden: Through the Night Softly." *Arts Magazine*, March 1975, pp. 66–71.

Carr, C. "This Is Only a Test: Chris Burden." *Artforum*, September 1989, pp. 116–21.

Horvitz, Robert. "Chris Burden." *Artforum*, May 1976, pp. 24–31.

Hughes-Hallet, Lucy. "Peace on Earth? Chris Burden's Investigations." *Performance*, November 1990, pp. 16–25.

Larson, Kay. "Art: Best of Burden." *New York*, September 18, 1989, pp. 65–66.

Muchnic, Suzanne. "Wrestling the Dragon." *Art News*, December 1990, pp. 124–29.

Rubinfein, Leo. "Chris Burden," an interview. *Art in America*, September-October 1978, pp. 79–80.

Selwyn, Mark. "Chris Burden," an interview. *Flash Art* (January-February 1989): 90–94.

Daniel Buren

Buchloh, Benjamin H.D., ed. *Daniel Buren: Les Couleurs: Sculptures Les Formes: Peintures*. Halifax: Press of Nova Scotia College of Art and Design, 1981. Texts by Benjamin H. D. Buchloh, Jean-Francois Lyotard, and Jean-Hubert Martin.

Buren, Daniel. *Reboundings*, trans. Philippe Hunt. Brussels: Daled & Gevaert, 1970.

Fuchs, R.H., with Daniel Buren. *Discordance/Cohérence*. Eindhoven, Netherlands: Stedelijk van Abbemuseum, 1996. Texts by R.H. Fuchs, Daniel Buren, André Bompard, B.H.D. Buchloh, Douglas Crimp, and René Denizot.

Bordeaux, France. Cape Musee d'Art Contemporain, with the assistance of the Fondation Credit Lyonnaise. *Daniel Buren: Les Escrits, 1965–1990*, 1991. Text by Daniel Buren.

New York, John Weber Gallery, and London, John Wendler Gallery. *Five Texts*, 1973. Text by Daniel Buren.

Stuttgart, Germany. Staatsgalerie Stuttgart. *Daniel Buren: Hier und Da: Arbeiten vor Ort, 1990*. Text by Daniel Buren.

Apgar, Garry. "The Colonization of the Palais-Royal." *Art in America*, July 1986, pp. 31, 33, 35.

Ashton, Dore. "Paris Publicized and Privatized: Daniel Buren in the Palais-Royal." *Arts Magazine*, September 1986, pp. 18–20.

Baker, Elizabeth C. "Critics Choice: Daniel Buren." *Art News*, March 1971, pp. 25, 58.

Bickers, Patricia. "'Cabined, Cribbed, Confined . . . ,' Daniel Buren's *Cabanes Eclatees*." *Art Monthly*, March 1986, pp. 13–16.

Buren, Daniel. "Notes on Work and Installation, 1967–75." *Studio International*, September-October 1975, pp. 124–29.

_____. "Kunst Bleibt Politik," interview by Liza Baer. *Avalanche*, December 1974, pp. 18–19.

_____. "Function of the Museum." *Artforum*, September 1973, p. 69.

Deitch, Jeffrey. "Daniel Buren: Painting Degree Zero." *Arts Magazine*, October 1976, pp. 88–91.

Lyotard, Jean-Francois. "The Works and Writings of Daniel Buren: An Introduction to the Philosophy of Contemporary Art." *Artforum*, February 1981, pp. 56–64.

_____. "Preliminary Notes on the Pragmatic of Works: Daniel Buren." *October* 10 (Fall 1979): 59–67.

Dusinberre, Deke. "Working with Shadows, Working with Words," conversation between Daniel Buren, Seth Siegelaub, and Michel Claura. *Art Monthly*, December 1988-January 1989, pp. 3–7.

Smith, Roberta. "On Daniel Buren." *Artforum*, September 1973, pp. 66–67.

Victor Burgin

Burgin, Victor. *The End of Art Theory: Criticism and Postmodernity*. London: Macmillan, 1986.

_____. *Between*. Oxford, England: Basil Blackwell, 1986.

Eindhoven, Netherlands. Stedelijk van Abbemuseum. *Victor Burgin*, 1977. Text by Victor Burgin.

Lille, France. Musée d'Art Moderne de la Communauté Urbaine de Lille. *Victor Burgin Passages*, 1991. Texts by Joelle Pijaudier, Régis Durand, and Victor Burgin.

Godfrey, Tony. "Sex, Text, Politics: An Interview with Victor Burgin." *Block*, no. 7 (1982): 2–26.

Harrison, Charles. "A Very Abstract Context." *Studio International*, November 1970, pp. 194–98.

Iverson, Margaret, "Burgin Between Politics and Art." *Art History*, 1989, pp. 133–35.

Lewis, Mark, "Interview with Victor Burgin." *C Magazine*, Winter 1987–88, pp. 54–65.

Scott Burton

Baltimore. Baltimore Museum of Art. *Scott Burton*, 1986. Text by Brenda Richardson.

Cincinnati. Contemporary Art Center. *Scott Burton Chairs*, 1985. Text by Charles F. Stuckey.

London. Tate Gallery. *Scott Burton*, 1985. Text by Richard Francis.

New York. Solomon R. Guggenheim Museum. *Behavior Tableaux*, 1976. Text by Linda Shearer.

New York. Max Protetch Gallery. *Scott Burton: Early Work*, 1990. Text by Lynne Cooke.

Düsseldorf, Germany. Kunstverein fur die Rheinlande und Westfalen. *Scott Burton: Sculptures 1980–89*, 1989. Texts by Lynne Cooke, Richard Francis, Patricia C. Phillips, Nancy Princenthal, Brenda Richardson, Roberta Smith, Jiri Svestka, and Charles F. Stuckey.

Burton, Scott. "My Brancusi." *Art in America*, March 1990, pp. 149–58.

_____. Statement, in "Situation Esthetics: Impermanent Art and the Seventies Audience." *Artforum*, January 1980, p. 24.

_____. Statement, in Carrie Rickey, "Decoration, Ornament, Pattern and Utility: Four Tendencies in Search of a Movement." *Flash Art* (June-July 1979): 23.

Baker, Elizabeth C. "Scott Burton, 1939–1989." *Art in America*, February 1990, pp. 163, 199.

Cooke, Lynne. "Scott Burton." *Artscribe*, December 1985-January 1986, pp. 51–55.

Princenthal, Nancy. "Social Setting." *Art in America*, June 1987, pp. 130–37.

Smith, Roberta. "Scott Burton: Designs on Minimalism." *Art in America*, November-December 1978, pp. 138–40.

Cynthia Carlson

Buffalo, N.Y. Albright-Knox Art Gallery. *Cynthia Carlson: The Monument Series*, 1985. Text by Cheryl Brutvan.

Milwaukee. Milwaukee Art Museum. *Currents I: Cynthia Carlson*, 1982. Text by Russell Bowman.

New York. Queens Museum. *Activated Walls*, 1984. Text by Ileen Sheppard.

Oberlin, Ohio. Allen Memorial Art Gallery, Oberlin College. *New Voices I: Cynthia Carlson*, 1980. Text by William Olander.

Reading, Pa. Freedman Gallery, Albright College. *Cynthia Carlson: Installations 1979–1989 (A Decade, More or Less)*, 1989. Text by David S. Rubin.

Carlson, Cynthia. "A Couple of Cats by Cynthia Carlson." *Art Journal* (Fall 1994): 42–45.

_____. "Grassroots Art." *Ms. Magazine*, October 1977, pp. 64–68.

Upshaw, Reagan. "Cynthia Carlson: Memento Mori." *Art in America*, July 1986, pp. 101–11.

Sandro Chia

Frisa, Maria Luisa, ed. *Sandro Chia: Paintings and Recent Titles*. Milan: Arnolo Montadori Arte, 1991. Texts by Giuseppe Conte, Maria Luisa Frisa, Achille Bonito Oliva, Giorgio Franchetti, Lorand Hegy, Patricia Collins and Richard Milazzo, and Sandro Chia.

Amsterdam. Stedelijk Museum. *Sandro Chia*, 1983. Texts by Edy de Wilde, Sandro Chia, and Alexander van Grevenstein.

Berlin. Nationalgalerie Berlin. *Sandro Chia*, 1992. Texts by Dieter Honisch, Achille Bonito Oliva, and Wulf Herzogenrath.

London. Waddington Gallery. *Sandro Chia*, 1994. Text by Norman Rosenthal.

Salzburg. Edition Thaddaeus Ropac. *Sandro Chia*, 1989. Texts by Giovanni Carandente, Carl Haenlein, and Sandro Chia.

Chia, Sandro. "Art Should Be a Provocative Thing in the World." *Art International*, August 1990, pp. 50–51.

Marzorati, Gerald. "The Last Hero." *Art News*, April 1983, pp. 58–66.

Paparoni, Demetrio. "Art in the Belly of the Whale: Sandro Chia." *Tema Celeste*, January-February 1991, pp. 52–57.

Politi, Giancarlo. "Sandro Chia." *Flash Art* (Summer 1990): 53–59.

_____. "Sandro Chia." *Flash Art* (June 1984): 14–20.

Judy Chicago

Chicago, Judy. *The Birth Project*. Garden City, N.Y.: Doubleday, 1985.

_____. *The Dinner Party: A Symbol of Our Heritage*. Garden City, N.Y.: Anchor Books/Doubleday, 1979.

_____. *Through the Flower: My Struggle as a Woman Artist*. New York: Doubleday, 1973.

Chicago, Judy, with Susan Hill. *The Dinner Party Needlework: Embroidering Our Heritage*. Garden City, N.Y.: Anchor Books/Doubleday, 1980.

Withers, Josephine. "Judy Chicago's *Dinner Party*: A Personal Vision of Women's History," in Lucy Freeman Sandler and Moshe Barasch, eds., *Art the Ape of Nature: Essays in Honor of H.W. Janson*. New York: Harry N. Abrams, 1980.

Albright, Thomas. "Guess Who's Coming to Judy Chicago's Dinner." *Art News*, January 1979, pp. 60–64.

Lippard, Lucy R. "Judy Chicago's 'Dinner Party,'" *Art in America*, April 1980, pp. 115–26.

_____. "Judy Chicago, Talking to Lucy R. Lippard." *Artforum*, September 1974, pp. 60–65.

Christo and Jeanne-Claude

Alloway, Lawrence. *Christo*. New York: Harry N. Abrams, 1969.

Baal-Teshuva, Jacob, ed. *Christo: The Reichstag and Urban Projects*. Munich: Prestel Verlag, 1993. Texts by Tilmann Buddensieg, Michael S. Cullen, Wieland Schmied, Rita Süssmuth, and Masahiko Yanagi.

Bourdon, David. *Christo*. New York: Harry N. Abrams, 1971.

Christo: Complete Editions, 1964–1982. Munich: Schellman and Klüser, 1982. Text by Per Hovdenakk.

Goheen, Ellen R. *Christo: Wrapped Walk Ways: Loose Part, Kansas City, Missouri*. New York: Harry N. Abrams, 1978.

Hahn, Otto, and Pierre Restany, *Christo*. Milan: Editioni Appollinaire, 1966.

Laporte, Dominique G. *Christo*. New York: Pantheon Books, 1985.

Pavese, Edith M., ed. *Christo: Surrounded Islands: Biscayne Bay, Greater Miami, Florida, 1980–83*. New York: Harry N. Abrams, 1986. Texts by David Bourdon, Jonathan Fineberg, and Janet Mulholland.

Schellmann, Jörg, and Josephine Benecke, eds. *Christo and Jeanne-Claude: Prints and Objects 1963–95*. Munich: Edition Schellmann, 1995. Introduction by Werner Spies.

Yard, Sally. *Christo: Oceanfront*. Princeton, N.J.: Princeton University Press, 1975.

Chicago. Museum of Contemporary Art. *Christo: Wrap In, Wrap Out*, 1969. Text by Jan van der Marck.

Enright, Robert. "Now You See It, Now You Don't: The Legendary Art of Christo," an interview. *Border Crossings* (Canada), January 1992, pp. 31–37.

Fineberg, Jonathan. "Theater of the Real: Thoughts on Christo." *Art in America*, December 1979, pp. 93–99.

Nilson, Lisbet. "Christo's Blossoms in the Bay." *Art News*, January 1984, pp. 55–62.

Francesco Clemente

Auping, Michael. *Francesco Clemente*. New York: Harry N. Abrams, 1985.

Crone, Rainer, and Zdenek Felix, *Francesco Clemente Pastelle 1974–1983*. Munich: Prestel Verlag, 1984.

McClure, Michael. *Francesco Clemente Testa Coda*. New York: Rizzoli, 1991, with an introduction by Dieter Koepplin.

London. Whitechapel Art Gallery. *Francesco Clemente: The Fourteen Stations*, 1983. Texts by Nicholas Serota, Henry Geldzahler, and Mark Francis.

Madrid. Sala de Exposiciones de la Fundacion de Pensiones. *Francesco Clemente Affreschi: Pinturas al Fresco*, 1987. Texts by Henry Geldzahler, Rainer Crone, and Diego Cortez.

New York. Gagosian Gallery. *Francesco Clemente: Evening Raga and Paradiso*, 1992. Texts by Francesco Clemente, Allen Ginsberg, and Peter Orlovsky.

DeAk, Edit. "A Chameleon in a State of Grace." *Artforum*, February 1981, pp. 36–41.

Gardner, Paul. "Gargoyles, Goddesses and Faces in the Crowd." *Art News*, March 1985, pp. 52–59.

Kent, Sarah. "Turtles All the Way: Francesco Clemente Interviewed by Sarah Kent." *Artscribe International*, September-October 1989, pp. 54–59.

Pellizzi, Francesco. "Charon's Boat." *Artforum*, November 1988, pp. 112–17.

Perrone, Jeff. "Boy Do I Love Art or What?" *Arts Magazine*, September 1981, pp. 72–78.

Politi, Giancarlo. "Francesco Clemente." *Flash Art International* (April-May 1984): 12–21.

Storr, Robert. "Realm of the Senses." *Art in America*, November 1987, pp. 132–44, 194.

Robert Colescott

Charlotte, N.C. Knight Gallery, Spirit Square Arts Center. *Robert Colescott: Another Judgment*, 1985. Text by Kenneth Baker. Colescott interview with Ann Shengold.

Greenville, S.C. Greenville County Museum of Art. *Here and Now, Robert Colescott*, 1984. Text by Thomas W. Styron.

Philadelphia. Institute of Contemporary Art, University of Pennsylvania. *Investigations Robert Colescott: The Artist and the Model*, 1984. Text by Gerald Silk.

Richmond, Va. Marsh Gallery, University of Richmond. *The Eye of the Beholder: Recent Work by Robert Colescott*, 1988. Text by Susanne Arnold. Colescott interview with Katherine Weiss.

San Jose, Calif. San Jose Museum of Art. *Robert Colescott: A Retrospective 1975–1986*, 1987. Texts by Lowery S. Sims and Mitchell D. Kahan.

Douglas, Robert L. "Robert Colescott's Searing

Stereotypes." *New Art Examiner*, June 1989, pp. 34–37.

Hirsh, Faye. "L'Ecole de Paris Is Burning: Robert Colescott's Ironic Variations." *Arts Magazine*, September 1991, pp. 52–57.

Johnson, Ken. "Colescott on Black & White." *Art in America*, June 1989, pp. 148–53, 197.

Sims, Lowery S. "Bob Colescott Ain't Just Misbehaving." *Artforum*, March 1984, pp. 56–59.

John Coplans

Hartford, Conn. Wadsworth Atheneum. *John Coplans: Self Portraits*, 1991. Text by Andrea Miller-Keller.

Irvine, Calif. Fine Arts Gallery, University of California. *John Coplans: Photographs 1980–1985*, 1985. Texts by John Coplans and Melinda Wortz.

Paris. Centre Georges Pompidou. *John Coplans: Autoportraits*, 1987. Coplans interview with Jean de Loisy.

Rotterdam, Netherlands. Museum Boymans-van Beuningen. *John Coplans Self-Portrait: Hand/Foot*, 1990. Text by Jean-Francois Chevrier.

San Francisco. San Francisco Museum of Art. *A Body of Work: Photographs by John Coplans*, 1988. Text by Sandra Phillips.

Fraiberg, Elizabeth A. "John Coplans: The Aboriginal Man." *Q: A Journal of Art* (Cornell University) (May 1990): 27–30.

Lifson, Ben. "Image and Likeness: Thoughts on Some Recent Photographs by Bill Burke and John Coplans." *Polaroid Close-Up*, November 1982, pp. 13–19.

Tony Cragg

Cragg, Tony. *Ecrits/Writings/Geschriften*. Brussels: Editions Isy Brachot, 1992.

Bern, Switzerland. Kunsthalle. *Tony Cragg*, 1983. Texts by J-H Martin, Tony Cragg, and Germano Celant.

Brussels. Palais des Beaux-Arts. *Tony Cragg*, 1985. Texts by A.G. Buzzi, K.J. Geirlandt, S. Page, A. Pohlen, and Cragg interview with D. Davvatas.

Eindhoven, Netherlands. Stedelijk van Abbemuseum. *Tony Cragg*, 1991. Texts by D. Batchelor, Tony Cragg, and J. Debbaut.

London. Hayward Gallery. *Tony Cragg*, 1987. Texts by Joanna Drew, Catherine Lampert, and Lynne Cooke.

London. Tate Gallery. *Tony Cragg. Winner of the 1988 Turner Prize*, 1989. Texts by Nicholas Serota and Tony Cragg.

Newport Beach, Calif. Newport Harbor Art Museum. *Tony Cragg: Sculpture 1975–1990*, 1990. Texts by L. Barnes, M. Knode, M. Francis, Thomas McEvilley, and Peter Schjeldahl.

Celant, Germano. "Tony Cragg and Industrial Platonism." *Artforum*, November 1981, pp. 40–46.

Cooke, Lynne. "Tony Cragg: Darkling Light." *Parkett*, no. 18 (1988): 96–102.

Enzo Cucchi

Friedel, Helmut, ed. *Enzo Cucchi Testa*. Munich: Lenbachhaus, 1987. Texts by Helmut Friedel, Alberto Boatto, and Giovanni Testori.

Schwander, Martin. *Enzo Cucchi: L'ombra Vede*. Paris: Chantal Crousel, 1987.

Boston. Institute of Contemporary Art. *Currents: Enzo Cucchi*, 1984. Text by Elisabeth Sussman.

Madrid. Fundacion Caja de Pensiones. *Enzo Cucchi*, 1985. Texts by Carmen Bernardez, Bruno Cora, and Mario Diacono interview Cucchi.

New York. Mary Boone and Michael Werner Gallery. *Enzo Cucchi*, 1984. Text by Mario Diacono.

New York. Solomon R. Guggenheim Museum. *Enzo Cucchi*, 1986. Text by Diane Waldman.

Prato, Italy. Museo d'Arte Contemporanea. *Enzo Cucchi*, 1989. Text by Enzo Cucchi.

Berger, Danny. "Enzo Cucchi: An Interview." *Print Collector's Newsletter*, September-October 1982, pp. 118–20.

Politi, Giancarlo, and Helena Kontova, "*Flash Art* Interview: Enzo Cucchi." *Flash Art* (February-March 1984): 8–17.

_____. "Interview with Enzo Cucchi." *Flash Art* (November 1983): 12–21.

Turner, Jonathan. "Painting with Fire." *Art News*, December 1993, pp. 96–99.

Donna Dennis

Melrod, George. "Donna Dennis." *Art in America*, October 1993, pp. 125–26.

Lovelace, Carey. "Donna Dennis: Intimate Immensity." *Arts Magazine*, Summer 1988, pp. 71–73.

Westfall, Stephen. "Donna Dennis." *Art in America*, January 1988, pp. 131–32.

Jimmie Durham

London. Matt's Gallery. *Pocahantas and the Little Carpenter in London*, 1988. Text by Jimmie Durham.

New York. Alternative Museum. *Jimmie Durham*, 1988. Text by Jimmie Durham.

New York. Exit Art. *Jimmie Durham*, 1989. Texts by Jeanette Inberman, Papo Colo, Luis Camnitzer, Jean Fisher, and Lucy R. Lippard. Durham interview.

"Covert Operations," a discussion between Jimmie Durham, Michael Taussing, Miwon Kwon, and Helen Molesworth, *Documents*, Summer 1993, pp. 111–21.

Durham, Jimmie. "Those Dead Guys for a Hundred Years," in Brian Swann and Arnold Krupat, eds. *I Tell You Now. Autobiographical Essays by Native American Writers*. Lincoln: University of Nebraska Press, 1987.

_____. "On the Edge of Town." *Art Journal* (Summer 1992): 14–16.

_____. "Jimmie Durham on Collecting." *Artforum*, May 1991, p. 20.

Durham, Jimmie, and Jean Fisher, "The Ground Has Been Covered." *Artforum*, Summer 1988, pp. 99–105.

Fisher, Jean. "Attending to Words and Bones: An Interview with Jimmie Durham." *Art and Design*, nos. 7–8, 1995, pp. 46–55.

Gisbourne, Mark. "Jimmie Durham," an interview. *Art Monthly*, February 1994, pp. 7–9.

Irvine, Jaki. "Jimmy Durham's Original Re-runs." *Third Text* (Autumn-Winter 1994): 179–84.

Lippard, Lucy R. "Jimmy Durham: Postmodernist 'Savage.'" *Art in America*, February 1993, pp. 62–69.

Purdom, Judy. "Who Is Jimmy Durham?" *Third Text* (Autumn-Winter 1994): 173–78.

Schiff, Richard. "The Necessity of Jimmie Durham's Jokes." *Art Journal* (Fall 1992): 74–80.

Melvin Edwards

Montclair, N.J. Montclair State College Art Gallery. *Melvin Edwards: Fragments of a Decade: 1980–1990*, 1990. Text by Lorenzo Pace.

New York. New York Studio Museum of Harlem. *Mel Edwards: Sculptor*, 1978. Text by Mary Schmidt Campbell.

Paris. Maison d'UNESCO, *Melvin Edwards: Sculpture (1964–84)*, 1984. Texts by Mary Schmidt Campbell and April Kingsley.

Purchase, N.Y. Neuberger Museum of Art, State University of New York at Purchase. *Melvin Edwards: Sculpture: A Thirty Year Retrospective 1963–1993*, 1993. Texts by Lucinda H. Gedeon, Lowery Stokes Sims, Michael Brenson, and Josephine Gear.

Rapaport, Brooke Kamin. "Melvin Edwards: Lynch Fragments." *Art in America*, March 1993, pp. 60–65.

Jackie Ferrara

Amherst, Mass. University of Massachusetts Art Gallery. *Jackie Ferrara*, 1980. Text by Michael Klein.

Coral Gables, Fla. Lowe Art Museum. *Jackie Ferrara*, 1982. Text by Carter Ratcliff.

Sarasota, Fla. John and Mable Ringling Museum of Art. *Jackie Ferrara Sculpture: A Retrospective*, 1992. Texts by Jackie Ferrara, David Bourdon, and Nancy Princenthal. Ferrara interview with Ileen Sheppard-Gallager.

Linker, Kate. "Jackie Ferrara's Il-Lusions." *Artforum*, November 1979, pp. 57–61.

Martin, Mary Abbe. "Splendor in the Grass." *Art News*, October 1988, pp. 126–30.

Patton, Phil. "Jackie Ferrara: Sculpture the Mind Can Use." *Art News*, March 1982, pp. 108–12.

Pincus-Witten, Robert. "Jackie Ferrara: The Feathery Elevator." *Arts Magazine*, November 1976, 104–108.

Eric Fischl

Billeter, Erika, ed. *Eric Fischl: Paintings and Drawings*. Bern, Switzerland: Bentel Publishers, 1990. Texts by Jean-Christophe Ammann, Erika Billeter, and Elisabeth Schweeger.

Cuno, James, E. L. Doctorow, Richard S. Field, Elizabeth Armstrong, and Cora Zemel. *Scenes and Sequences: Recent Monographs by Eric Fischl*. New York: Harry N. Abrams, 1990.

Schjeldahl, Peter. *Eric Fischl*. New York: Stewart, Tabori and Chang, 1988.

Berkeley, Calif. University of California Art Museum. *Eric*

Fischl: Scenes Before the Eye, 1986. Text by Lucinda Barnes. Fischl interview with Constance W. Glenn.

East Hampton, N.Y. Guild Hall Museum. *Eric Fischl: A Cinematic View*, 1991. Text by Bruce W. Ferguson.

London. Waddington Galleries. *Eric Fischl*, 1989. Text by Frederic Tuten.

Saskatoon, Canada. Mendel Art Gallery. *Eric Fischl Paintings*, 1985. Essays by Jean-Christophe Ammann, Donald B. Kuspit, and Bruce W. Ferguson.

New York. Mary Boone Gallery. *Eric Fischl*, 1988. Text by Philip Roth.

Berman, Avis. "Artist's Dialogue: Eric Fischl." *Architectural Digest*, December 1985, pp. 72–79.

Curiger, Bice. "Eric Fischl," an interview. *Artscribe*, July-August 1985, pp. 24–28.

Danto, Arthur C. "Art: Eric Fischl." *Nation*, May 31, 1986, pp. 769–772.

Fischl, Eric. "Fischl About Fischl." *Border Crossings* (Canada), Fall 1985, pp. 84–86.

Grimes, Nancy. "Eric Fischl's Naked Truths." *Art News*, September 1986, pp. 70–78.

Liebman, Lisa. "Eric Fischl's Year of the Drowned Dog: Eight Characters in Search of an Autumn." *Artforum*, March 1984, pp. 67–69.

Pincus-Witten, Robert. "Entries: Palimsest and Pentimenti." *Arts Magazine*, June 1980, pp. 128–31.

_____. "Entries: Snatch and Snatching." *Arts Magazine*, September 1981, pp. 88–91.

Rosenblum, Robert. "Eric Fischl." *Contemporanea*, May 1988, pp. 62–65.

Schjeldahl, Peter. "Post-Innocence: Eric Fischl and the Social Fate of American Painting." *Parkett* (June 1985) 31–45.

_____. "Bad Boy of Brilliance." *Vanity Fair*, May 1984, pp. 67–72. Includes "Fischl Talks," p. 72.

Storr, Robert. "Desperate Pleasures." *Art in America*, November 1984, pp. 124–31.

Weschler, Lawrence. "The Art of Eric Fischl." *Interview*, May 1988, pp. 62–70.

Gilbert & George

Farson, Daniel. *With Gilbert & George in Moscow*. London: Bloomsbury, 1991.

Jahn, Wolf. *The Art of Gilbert & George or an Aesthetic of Existence*, trans. David Britt. London: Thames and Hudson, 1989.

Ratcliff, Carter. *Gilbert & George: The Complete Pictures 1971–1985*. London: Thames and Hudson, 1986.

Baltimore. Baltimore Museum of Art. *Gilbert & George*, 1984. Text by Brenda Richardson.

New York. Hirschl & Adler Modern. *Gilbert & George Postcard Sculptures and Ephemera, 1969–1981*, 1990. Text by Carter Ratcliff.

New York. Robert Miller Gallery. *Twenty-five Worlds by Gilbert and George*, 1990. Text by Robert Rosenblum.

Peking. National Art Gallery. *Gilbert & George China Exhibition*, 1993. Texts by James Birch, Richard Dorment, Jean-Louis Froment, Rudi Fuchs, Wolf Jahn, Robert Rosenblum, Nicholas Serota, Wojciech Markowski, and a Gilbert & George interview with Andrew Wilson.

Brooks, Rosetta. "Gilbert & George: Shake Hands with the Devil." *Artforum*, Summer 1984, pp. 56–60.

McEwen, John. "Life and Times: Gilbert & George." *Art in America*, May 1982, pp. 128–35.

Plagens, Peter. "Gilbert & George: How English Is It?" *Art in America*, October 1984, pp. 178–83.

Reise, Barbara. "Presenting Gilbert & George, the Living Sculptures." *Art News*, November 1971, pp. 62–65, 91–92.

Rosenblum, Robert. "Gilbert & George: The AIDS Pictures." *Art in America*, November 1989, pp. 153–54.

Wilson, Andrew. "We Always Say It Is What We 'Say' That Is Important: Gilbert and George Interviewed by Andrew Wilson 5 January 1990." *Art Monthly*, April 1990, pp. 6–13.

Leon Golub

Kuspit, Donald B. *Leon Golub: Existential/Activist Painter*. New Brunswick, N.J.: Rutgers University Press, 1985.

Marzorati, Gerald. *A Painter of Darkness: Leon Golub and Our Times*. New York: Viking Press, 1990.

Chicago. Museum of Contemporary Art. *Leon Golub: A Retrospective Exhibition of Paintings from 1947 to 1973*, 1974. Text by Lawrence Alloway.

London. Institute of Contemporary Art. *Leon Golub, Mercenaries and Interrogations*, 1982. Text by Jon Bird. Golub interview with Michael Newman.

Malmö, Sweden. Konsthall. *Leon Golub*, 1993. Texts by Thomas McEvilley and Leon Golub.

New York. New Museum of Contemporary Art. *Golub*, 1884. Texts by Ned Rifkin and Lynn Gumpert.

Philadelphia. Institute of Contemporary Art, University of Pennsylvania. *Leon Golub Paintings 1987–92*, 1992. Texts by Patrick T. Murphy and Carrie Rickey.

Alloway, Lawrence. "Leon Golub: Arts & Politics." *Artforum*, October 1974, pp. 66–71.

Baigell, Matthew. "'The Mercenaries': An Interview with Leon Golub." *Arts Magazine*, May 1981, pp. 167–73.

Bird, John. "The Imag(in)ing of Power," an interview with Leon Golub. *Art Monthly*, February 1985, pp. 10–14.

Brooks, Rosetta. "Leon Golub: Undercover Agent." *Artforum*, January 1990, pp. 114–21.

Golub, Leon. "What Works?" *Art Criticism* (Fall 1979): 29–48.

_____. "2D/3D." *Artforum*, March 1973, pp. 60–68.

_____. "Trends: The Artist as an Angry Artist." *Arts Magazine*, April 1967, pp. 48–49.

Horsfield, Kate. "Profile: Leon Golub." *Profile* 2, March 1982, entire issue.

Kozloff, Max. "The Late Roman Empire in the Light of Napalm." *Art News*, November 1970, pp. 58–60, 76–78.

Kuspit, Donald B. "Aggression, 'Ressentiment,' and the Artist's Will to Power." *Artforum*, May 1981, pp. 52–57.

_____. "Golub's Assassins: An Anatomy of Violence." *Art in America*, May-June 1975, pp. 62–65.

Marzorati, Gerald. "Leon Golub: Mean Streets." *Art News*, February 1985, pp. 74–87.

Ratcliff, Carter. "Theater of Power." *Art in America*, January 1984, pp. 74–82.

Robins, Corinne. "Leon Golub: In the Realm of Power." *Arts Magazine*, May 1981, pp. 170–73.

Sandler, Irving. "Interview: Leon Golub Talks with Irving Sandler." *Journal, Archives of American Art*, no. 18 (1978): 11–18.

_____. "Rhetoric and Violence: Interview with Leon Golub." *Arts Magazine*, February 1970, pp. 22–23.

Storr, Robert. "Review of Books: Monograph." *Art in America*, December 1990, pp. 55–59.

_____. "Riddled Sphinxes." *Art in America*, March 1989, pp. 126–31.

April Gornik

Enright, Robert. "Interview with April Gornik." *Border Crossings* (Canada), Winter 1993, pp. 29–32.

Grimes, Nancy. "April Gornik." *Art News*, January 1988, pp. 153–54.

Heartney, Eleanor. "April Gornik's Stormy Weather." *Art News*, May 1989, pp. 120–25.

Lewallen, Constance. "View: April Gornik." *Interview*, Fall 1988, pp. 1–24.

Shinoda, Tazmi. "The Landscape of April Gornik: Sensuality of the Anonymous." *Mizue*, Winter 1989, pp. 124–35.

Nancy Graves

The Sculpture of Nancy Graves: A Catalogue Raisonné. New York: Hudson Hills Press, 1987. Texts by E.A. Carmean Jr., Linda L. Cathcart, Robert Hughes, and Michael Edward Shapiro.

Buffalo, N.Y. Albright-Knox Art Gallery. *Nancy Graves: A Survey: 1969–1980*, 1980. Text by Linda Cathcart.

La Jolla, Calif. La Jolla Museum of Contemporary Art. *Nancy Graves*, 1973. Texts by Nancy Graves and Jay Belloli.

Poughkeepsie, N.Y. Vassar College Art Gallery. *Nancy Graves: Painting, Sculpture, Drawing, 1980–1985*, 1986. Text by Linda Nochlin and Graves interview with Debra Bricker Balken.

Amayo, Mario. "Artist's Dialogue: A Conversation with Nancy Graves." *Architectural Digest*, February 1982, pp. 146, 150–51, 154–55.

Berman, Avis. "Nancy Graves' New Age of Bronze." *Art News*, February 1986, pp. 56–64.

Collins, Amy Fine, and Bradley Collins, Jr., "The Sum of the Parts." *Art in America*, June 1988, pp. 112–19.

Frank, Elizabeth. "Her Own Way: The Daring and Inventive Sculptures of Nancy Graves." *Connoisseur*, February 1986, pp. 54–61.

Graves, Nancy. "Excerpts from Notebooks." *Artscribe*, 17, April 1979, pp. 39–40.

Heinemann, Susan. "Nancy Graves: The Painting Seen." *Arts Magazine*, March 1977, pp. 139–41.

Lippard, Lucy R. "Distancing: The Films of Nancy Graves." *Art in America*, November-December 1985, pp. 78–82.

Richardson, Brenda. "Nancy Graves: A New Way of Seeing." *Arts Magazine*, April 1972, pp. 57–61.

Rose, Barbara. "Nancy Graves." *Vogue*, June 1980, pp. 203, 235–236.

Shapiro, Michael Edward. "Nature into Sculpture: Nancy Graves and the Tradition of Direct Casting." *Arts Magazine*, November 1984, pp. 92–96.

Storr, Robert. "Natural Fictions." *Art in America*, March 1983, pp. 119–21.

Wasserman, Emily. "A Conversation with Nancy Graves." *Artforum*, October 1970, pp. 42–47.

Philip Guston

Ashton, Dore. *Yes, But . . .* New York: Viking Press, 1976.

Feld, Ross, and Henry T. Hopkins. *Philip Guston*. New York: George Braziller, 1980.

Mayer, Musa. *Night Studio: A Memoir of Philip Guston.* New York: Alfred A. Knopf, 1988.

Storr, Robert. *Philip Guston*. New York: Abbeville Press, 1986.

Boston. Boston University. *Philip Guston: New Paintings*, 1974. Text by Dore Ashton.

London. Whitechapel Art Gallery. *Philip Guston: Paintings, 1969–1980*, 1982. Texts by Nicholas Serota, Norbert Lynton, and Philip Guston.

Madrid. Centro de Arte Reina Sofia. *Philip Guston*, 1989. Texts by Mark Rosenthal, Robert Storr, Carrie Rickey, Francisco Serraller, and Dore Ashton.

New York. Museum of Modern Art. *The Drawings of Philip Guston*, 1988. Text by Magdalena Dabrowski.

Washington, D.C. Phillips Collection. *Philip Guston, 1980: The Last Works*, 1981. Text by Morton Feldman.

Ashton, Dore. "Philip Guston: Different Subjects." *Flash Art* (December 1981-January 1982): 20–25.

Berkson, Bill. "The New Gustons." *Art News*, October 1970, pp. 44–47.

Brach, Paul. "Looking at Guston." *Art in America*, November 1980, pp. 96–101.

Butterfield, Jan. "A Very Anxious Fix: Philip Guston," an interview. *Images and Issues*, Summer 1980, pp. 30–35.

Clark, John. "Philip Guston and Metaphysical Painting." *Artscribe*, August 1981, pp. 22–25.

Kingsley, April. "Philip Guston's Endgame." *Horizon*, June 1980, pp. 34–41.

Rickey, Carrie. "Gust, Gusto, Guston." *Artforum*, October 1980, pp. 32–39.

Rosenberg, Harold. "On Cave Art, Church Art, Ethnic Art and Art," conversation with Philip Guston. *Art News*, December 1974, pp. 36–41.

Smith, Roberta. "Philip Guston, 1913–1980." *Art in America*, September 1980, pp. 17–19.

_____. "The New Gustons." *Art in America*, January-February 1978, pp. 100–105.

Stevens, Mark. "A Talk with Philip Guston." *New Republic*, March 15, 1980, pp. 25–28.

Hans Haacke

Burnham, Jack, and Howard S. Becker and John Walton. *Hans Haacke: Framing and Being Framed: 7 Works*. New York: New York University Press, 1995.

London. Tate Gallery. *Hans Haacke*, 1984. Text by Hans Haacke. Haacke interview with Tony Brown and Walter Grasskamp.

New York. New Museum of Contemporary Art. *Hans Haacke: Unfinished Business*, 1986. Texts by Rosalyn Deutsche, Hans Haacke, Fredric Jameson, Leo Steinberg, and Brian Wallis.

Venice. Venice Biennale, German Pavilion. *Hans Haacke: Bodenlos*, 1993. Texts by Hans Haacke, Walter Grasskamp, and Grace Glueck.

Bois, Yve-Alain. "The Antidote." *October* 39 (Winter 1986): 128–44.

Bois, Yve-Alain, Douglas Crimp, and Rosalind Krauss, "A Conversation with Hans Haacke." *October* 30 (Fall 1984): 23–48.

Buchloh, Benjamin H.D. "Hans Haacke: Memory and Instrumental Reason." *Art in America*, February 1988, pp. 97–109, 157–59.

Burnham, Jack. "Meditations on a Bunch of Asparagus." *Arts Magazine*, February 1975, pp. 72–75.

_____. "Hans Haacke's Cancelled Show at the Guggenheim." *Artforum*, June 1971, pp. 68–71.

Haacke, Hans. "MetroMobiltan." *Impulse*, 1985, pp. 41–44.

_____. "Broadness and Diversity of the Ludwig Brigade." *October* 30 (Fall 1984): 9–22.

_____. "Issues & Commentary: Museums, Managers of Consciousness." *Art in America*, February 1984, pp. 9–17.

_____. "On Social Grease." *Art Journal* (Summer 1982): 137–43.

"Hans Haacke Profile." *Studio International*, February 1974, pp. 61–64.

Morgan, Robert C. "A Conversation with Hans Haacke." *Real Life Magazine*, Fall 1984, pp. 5–11.

Sheffield, Margaret. "Hans Haacke: Interview." *Studio International*, March-April 1976, pp. 117–23.

Siegel, Jeanne. "An Interview with Hans Haacke." *Arts Magazine*, May 1971, pp. 18–21.

Taylor, Paul. "An Interview with Hans Haacke." *Flash Art* (February-March 1986): 39–41.

White, Robin. "Hans Haacke," an interview. *View*, November 1987, entire issue.

Peter Halley

Halley, Peter. *Collected Essays 1981–1987*. Zurich: Galerie Bischofberger, 1988.

Des Moines, Iowa. Des Moines Art Center. *Peter Halley: Paintings 1989–1992*, 1993. Texts by Michael Danoff, Deborah Leveton, and Dan Cameron.

Cameron, Dan. "In the Path of Peter Halley." *Arts Magazine*, December 1987, pp. 70–74.

Cone, Michele. "Peter Halley." *Flash Art* (February-March 1986): 36–38.

Hart, Claudia. "Intuitive Sensitivity: An Interview with Peter Halley and Meyer Vaisman." *Artscribe International*, November-December 1988, pp. 36–39.

Miller, John. "Lecture Theatre: Peter Halley's 'Geometry and the Social.'" *Artscribe*, March-April 1989, pp. 64–65.

Politi, Giancarlo. "Peter Halley," an interview. *Flash Art* (January-February 1990): 81–87.

Schwartz, Michael. "Peter Halley." *Galeries Magazine*, December 1991, pp. 78–87.

Siegel, Jeanne. "The Artist/Critic of the Eighties: Peter Halley and Stephen Westfall." *Arts Magazine*, September 1985, pp. 72–76.

David Hammons

New York. P.S. 1 Museum. *David Hammons: Rousing the Rubble*, 1991. Texts by Alanna Heiss, Kellie Jones, Steve Cannon, and Tom Finkelpearl.

Springfield, Ill. Illinois State Museum. *David Hammons: In the Hood*, 1993. Texts by Kent Smith, Calvin Reid, and Ralph Rugoff.

Williamstown, Mass. Williams College Museum of Art. *Yardbird Suite: Hammons '93*, 1994. Texts by Deborah Menaker Rothschild.

Berger, Maurice. "Speaking Out: Some Distance to Go . . . Interviews with Mary Schmidt Campbell, Johnnetta B. Cole, David Hammons, Henry Louis Gates, Jr., Guy McElroy and Pat Ward Williams." *Art in America*, September 1990, pp. 78–85.

Cameron, Dan. "David Hammons: Coming In from the Cold." *Flash Art* (January 1993): 68–71.

Jones, Kellie. "Interview with David Hammons by Kellie Jones." *Real Life Magazine*, Autumn 1986, pp. 2–9.

Larson, Kay. "David Hammons." *Galeries Magazine*, February-March 1991, pp. 99–103.

Nesbitt, Lois E. "Nobody's Champion." *Artscribe*, Summer 1991, pp. 39–43.

Princenthal, Nancy. "The Art of the TopiCalif." *Art in America*, December 1991, pp. 78–83.

Reid, Calvin. "Kinky Black Hair and Barbecue Bones." *Arts Magazine*, April 1991, pp. 59–63.

_____. "Chasing the Blue Train." *Art in America*, September 1989, p. 197.

Keith Haring

Gruen, John. *Keith Haring: The Authorized Biography*. New York: Prentice-Hall, 1991.

Cameron, Dan. *Keith Haring 1988*. Van Nuys, Calif.: Martin Lawrence Limited Editions, 1988.

Keith Haring. New York: Abbeville Press, 1992. Texts by Barry Blinderman, William S. Burroughs, Timothy Leary, and Maarten van de Guchte.

Amsterdam. Stedelijk Museum. *Keith Haring 1986: Paintings, Drawings, and a Vellum*, 1986. Texts by Jeffrey Deitch and Paul Donker Duyvis.

Bordeaux, France. Musée d'Art Contemporain. *Keith Haring*, 1986. Texts by Brion Gysin and Sylvie Coudere.

New York. André Emmerich Gallery. *Keith Haring: Works on Paper 1989*, 1995. Text by Alexandra Anderson-Spivy.

Paris. La Galerie de Poche. *Keith Haring*, 1990. Text by David Galloway.

Alinovi, Francesca. "Twenty-first Century Slang: Keith Haring—Interview with the Artist." *Flash Art* (November 1983): 28–30.

Caley, Shaun. "Keith Haring," an interview. *Flash Art* (Summer 1990): 124–29.

Cummings, Paul. "Interview: Keith Haring Talks with Paul Cummings." *Drawing* 11 (May-June 1989): 7–12.

Galloway, David. "Keith Haring: Made in Germany." *Art in America*, March 1991, pp. 118–22, 163.

Haring, Keith. "Keith Haring." *Flash Art* (March 1984): 20–24.

Michael Kimmelman, "Art: A Look at Keith Haring, Especially on the Graffiti." *New York Times*, September 21, 1990, sec. C, p. 19.

Ricard, Rene. "The Radiant Child." *Artforum*, December 1981, pp. 35–43.

Rubell, Jason. "Keith Haring: The Last Interview." *Arts Magazine*, September 1990, pp. 52–59.

Sheff, David. "Keith Haring: An Intimate Conversation." *Rolling Stone*, August 10, 1989, pp. 58–66.

Thompson, Farris. "Requiem for the Degas of the B-Boys." *Artforum*, May 1990, pp. 135–41.

Newton and Helen Mayer Harrison

Baltimore. Decker Gallery, Maryland Institute. *Baltimore Promenade: A Work by Helen and Newton Harrison*, 1982. Text by Newton and Helen Mayer Harrison.

Ithaca, N.Y. Herbert F. Johnson Museum of Art. *The Lagoon Cycle: Helen Mayer Harrison/Newton Harrison*, 1985. Texts by Carter Ratcliff, Micel de Certeau, and Helen Mayer Harrison/Newton Harrison.

Long Beach, Calif. Long Beach Museum of Art. *Art Home*, 1983. Text by Arlene Raven.

San Francisco. San Francisco Art Institute. *From the Lagoon Cycle: From the Meditations: Newton Harrison/Helen Mayer Harrison*, 1977. Text by Newton and Helen Mayer Harrison.

Barrio-Garay, José Luis. "Newton Harrison's Fourth Lagoon: Strategy Against Entropy." *Arts Magazine*, November 1974, pp. 61–63.

Glueck, Grace. "Art People: The Earth Is Their Palette." *New York Times*, April 4, 1980, sec. C, p. 24.

Goldman, Judith. "Touching Moonlight." *Art News*, November 1978, pp. 60–65.

Harrison, Newton, and Helen Mayer Harrison. "Sea Grant Second Narrative and Two Precedent Works." *Studio International*, May 1974, pp. 234–37.

Levin, Kim. "Helen and Newton Harrison: New Grounds for Art." *Arts Magazine*, February 1978, pp. 126–29.

Russell, John. "London: Catfish Row." *Art News*, February 1972, pp. 36, 41.

Selz, Peter. "Helen and Newton Harrison: Art as Survival Instruction." *Arts Magazine*, February 1978, pp. 130–31.

Stiles, Kristine. "Helen and Newton Harrison: Questions." *Arts Magazine*, February 1978, pp. 131–33.

Eva Hesse

Barrette, Bill. *Eva Hesse Sculpture: Catalogue Raisonne*. New York: Timkin Publishers, 1989.

Lippard, Lucy R. *Eva Hesse*. New York: New York University Press, 1976.

Cooper, Helen A., ed. *Eva Hesse: A Retrospective*. New Haven, Conn.: Yale University Press, 1992. Texts by Helen Cooper, Maurice Berger, Anna C. Chave, Maria Kreutzer, Linda Norden, and Robert Storr.

London. Whitechapel Art Gallery. *Eva Hesse: Sculpture*, 1979. Text by Rosalind Krauss.

New York. Solomon R. Guggenheim Museum. *Eva Hesse: A Memorial Exhibition*, 1972. Texts by Linda Shearer and Robert Pincus-Witten.

Oberlin, Ohio. Allen Memorial Art Museum, Oberlin College. *Eva Hesse: A Retrospective of the Drawings*, 1982. Text by Ellen Johnson.

Ulm, Germany. Ulmer Museum. *Eva Hesse: Drawing in Space*, 1994. Texts by Grigitte Reinhardt, Naomi Spector, Erich Franz, Hanne Loveck, Helen Cooper, and Mel Bochner interview with Joan Simon.

Danto, Arthur C. "Growing Up Absurd." *Art News*, November 1989, pp. 118–21.

Hill, Andrea. "Eva Hesse." *Artscribe*, July 1979, pp. 41–44.

Levin, Kim. "Eva Hesse: Notes on New Beginnings." *Art News*, February 1973, pp. 71–73.

Lippard, Lucy R. "Eva Hesse—The Circle." *Art in America*, May-June 1971, pp. 68–73.

Nemser, Cindy. "An Interview with Eva Hesse." *Artforum*, May 1970, pp. 59–63.

Pincus-Witten, Robert. "Eva Hesse: Last Words." *Artforum*, November 1972, 74–75.

_____. Eva Hesse: Post Minimalism into Sublime." *Artforum*, November 1971, pp. 32–44.

Nancy Holt

Castle, Ted. "Nancy Holt, Site Seer." *Art in America*, March 1982, pp. 84–91.

Gardner, Colin. "An Ambiguous Environment." *Artweek*, January 26, 1985, p. 5.

Hess, Alan. "Technology Exposed." *Landscape Architecture*, May 1992, pp. 38–45.

Le Veque, Terry Ryan. "Art: Nancy Holt's Sky Mound." *Landscape Architecture*, April-May 1988, p. 82.

_____. "Nancy Holt's Dark State Park, Rosslyn, Virginia." *Landscape Architecture*, July-August 1985, pp. 80–82.

Lorber, R. "Nancy Holt." *Artforum*, December 1977, p. 71.

Marks, Ben. "On the Beach." *Artweek*, November 16, 1989, p. 3.

Marter, Joan. "Nancy Holt's Dark Star Park." *Arts Magazine*, October 1984, pp. 137–39.

Phillips, Deborah C. "Drawings by Sculptors." *Art News*, May 1985, pp. 122–23.

Rosen, N.D. "Sense of Place." *Studio*, March 1977, pp. 118–19.

Yau, John. "Deer Star Park, Rosslyn, Va." *Artforum*, April 1985, pp. 97–98.

Jenny Holzer

Holzer, Jenny. *Truisms and Essays*. Halifax: Press of Nova Scotia College of Art and Design Press, 1989.

Waldman, Diane. *Jenny Holzer*. New York: Harry N. Abrams, 1989.

Des Moines, Iowa. Des Moines Art Center. *Jenny Holzer: Signs*, 1986. Text by Joan Simon. Holzer interview with Bruce Ferguson.

Venice. 44th Venice Biennale, U.S. Pavilion. *Jenny Holzer, The Venice Installation*, 1990. Text by Michael Auping.

Howell, John. "The Message Is the Medium." *Art News*, Summer 1988, pp. 122–27.

Larson, Kay. "Sign of the Times: Jenny Holzer's Art Words Catch On." *New York Magazine*, September 5, 1988, pp. 49–53.

Ratcliff, Carter. "Jenny Holzer." *Print Collector's Newsletter*, November-December 1982, pp. 149–52.

Siegel, Jeanne. "Jenny Holzer's Language Games," an interview. *Arts Magazine*, December 1985, pp. 64–68.

Taylor, Paul. "Jenny Holzer." *Flash Art* (March-April 1990): 116–19

Bryan Hunt

Duisburg, Germany. Wilhelm-Lehmbruck-Museum der Stadt Duisburg. *Brian Hunt—Skulpturen und Zeichnungen*, 1987. Texts by Renate Heidt and Gerhard Graulich.

Ithaca, N.Y. *Bryan Hunt: Falls and Figures*, 1988. Text by Phyllis Tuchman.

Long Beach, Calif. University Art Museum, California State University. *Bryan Hunt: A Decade of Drawings*, 1983. Texts by C. Michelle Betty, Christie Collins, Jeff Matsuno, Shirley Pinard, Michelle Redlich, and Susan Taylor.

New York. Blum-Helman Gallery. *Bryan Hunt*, 1987. Text by Jerry Saltz.

_____. *Bryan Hunt*, 1983. Text by Carter Ratcliff.

Zurich. Knoedler Gallery. *Bryan Hunt: Skulpturen und Zeichnungen*, 1984. Text by Barbara Haskell. Becker, Robert. "Bryan Hunt." *Interview*, January 1982, pp. 52–54.

Cummings, Paul. "A Conversation About Drawing." September-October 1983, pp. 49–55.

Gibson, Eric. "Bryan Hunt at Cornell." *New Criterion*, October 1988, pp. 63–65.

Glenn, Constance W. "Artist's Dialogue: A Conversation with Bryan Hunt." *Architectural Digest*, March 1983, pp. 68–74.

Tuchman, Phyllis. "Bryan Hunt's Balancing Act." *Art News*, October 1985, pp. 64–73.

White, Robin. "Bryan Hunt," an interview. *View*, 1980, entire issue.

Jörg Immendorff

Bern, Switzerland. Kunsthalle Bern. *Jörg Immendorff: "Malermut Rundum,"* 1980. Texts by Johannes Gachnang and Max Wechsler.

Düsseldorf, Germany. Kunsthalle. *Jörg Immendorff: "Adlerhälfte,"* 1982. Texts by Jürgen Harten and Ulrich Krempel.

Eindhoven, Netherlands. Stedlijk van Abbemuseum. *Jörg Immendorff: "Pinselwiderstand,"* 1981. Text by R. H. Fuchs.

_____. *Jörg Immendorff: Lidl 1966–1970*, 1981. Text by Jörg Immendorff.

Esslingen, Germany. Galerie der Stadt. *Immendorff Malerie 1983–1990*, 1991. Texts by Alexander Tolney, Lorand Hegy, and Rudolf Schmitz.

New York. Mary Boone and Michael Werner Gallery. *Jörg Immendorff*, 1989. Text by Toni Stooss.

Oxford, England. Museum of Modern Art. *Jörg Immendorff*, 1984. Texts by David Elliott and Harald Szeemann.

Rotterdam, Netherlands. Museum Boymans-van Beuningen. *Immendorff*, 1992. Texts by Rudi Fuchs, Karel Schampers, David Elliott, Siegfried Gohr, Peter Gorsen, Johannes Gachnang, Fabrice Hergott, Pamela Kort, and Catherine Millet.

Zurich. Kunsthalle. *Jörg Immendorff*, 1983. Texts by Harald Szeemann, Toni Stoos, Jörg Huber, and Johannes Gachnang.

Diederichsen, Diedrich. "For What? For Whom? Jörg Immendorff, Painting and Politics." *Artscribe*, May 1990, pp. 56–61.

Robert Irwin

Irwin, Robert. *Being and Circumstance: Notes Toward a Conditional Art*. Larkspur Landing, Calif.: Lapis Press, 1985.

Weschler, Lawrence. *Seeing Is Forgetting the Name of the Thing One Sees: A Life of Contemporary Artist Robert Irwin*. Berkeley: University of California Press, 1982.

Chicago. Museum of Contemporary Art. *Robert Irwin*, 1975. Text by Ira Licht.

Los Angeles. Museum of Contemporary Art. *Robert Irwin*, 1993. Texts by Robert Irwin, Sally Yard, John Hallmark Neff, Jeremy Gilbert-Rolfe, Klaus Kertess, Arthur Danto, and Lawrence Weschler.

New York. Whitney Museum of American Art. *Notes Toward a Model*, 1977. Text by Robert Irwin.

Pasadena, Calif. Pasadena Art Museum. *Robert Irwin*, 1968. Text by John Coplans.

Albright, Thomas. "Robert Irwin: 'Everything I've Done in the Last Five Years Doesn't Exist,'" *Art News*, Summer 1977, pp. 49-54.

Butterfield, January. "Robert Irwin: On the Periphery of Knowing." *Arts Magazine*, February 1976, pp. 72–77.

_____. "Part 1. The State of the Real: Robert Irwin Discusses The Art of an Extended Consciousness." *Arts Magazine*, June 1972, pp. 47–49.

_____. "Part 2. Re-shaping the Shape of Things." *Arts Magazine*, September-October 1972, pp. 30–32.

Levine, Edward. "Robert Irwin: World Without Frame." *Arts Magazine*, February 1976, pp. 72–77.

Macintosh, Alistair. "Robert Irwin," an interview. *Arts and Artists*, March 1972, p. 24–27.

Smith, Roberta. "Robert Irwin: The Subject Is Sight." *Art in America*, March 1976, pp. 68–73.

Weschler, Lawrence. "In a Desert of Pure Feeling." *New Yorker*, June 7, 1993, pp. 80–91.

_____. "Lines of Inquiry." *Art in America*, March 1982, pp. 102–109.

_____. "Taking Art to Point Zero," parts 1 and 2. *New Yorker*, March 8, 1982, March 15, 1982.

_____. "Robert Irwin's Whitney Project: Retrospectives and Prospects." *LAICA Journal* (July-August 1977): 14–23.

Wortz, Melinda. "Surrendering to Presence: Robert Irwin's Esthetic Integration." *Artforum*, November 1981, pp. 63–69.

Valerie Jaudon

Bottrop, Germany. Quadrat Museum. Berlin. Amerika Haus. *Valerie Jaudon*, 1983. Text by Sam Hunter.

Jackson, Miss. Mississippi Museum of Art. *Valerie Jaudon*, 1996. Text by Anna Chave and Jaudon interview with Rene Paul Barrilleaux.

New York. Sidney Janis Gallery. *Valerie Jaudon*, 1996. Text by Saul Ostrow.

Johnson, Ken. "Valerie Jaudon." *Art in America*, May 1993, pp. 118–19.

Perreault, John. "Allusive Depths: Valerie Jaudon." *Art in America*, October 1983, pp. 161–65.

Neil Jenney

Berkeley, Calif. University Art Gallery. *Neil Jenney: Painting and Sculpture 1967–1980*, 1981. Texts by Mark Rosenthal and Neil Jenney.

DeAk, Edit, "Neil Jenney." *Art Rite* 9 (April 1975): 24–25.

Gardner, Paul. "Portrait of Neil Jenney." *Art News*, December 1983, pp. 68–74.

Simon, Joan. "Neil Jenney: Event & Evidence." *Art in America*, Summer 1982, pp. 98–106.

Stevens, Mark. "Neil Jenney: 'Art Is a Social Science.'" *Portfolio*, May-June 1982, pp. 74–79.

Bill Jensen

London. Grob Gallery. *Bill Jensen*, 1991. Text by John Russell Taylor.

New York. Museum of Modern Art. *Bill Jensen: First Etchings*, 1986. Text by Deborah Wye.

Jensen, Bill. "Ryder on the Storm." *Artforum*, December 1990, pp. 116–21.

Parks, Addison. "Bill Jensen and the Sound and Light Beneath the Lid." *Arts Magazine*, November 1981, pp. 152–56.

Smith, Roberta. "Bill Jensen's Abstraction." *Art in America*, November 1980, pp. 109–13.

Westfall, Stephen. "Into the Vortex." *Art in America*, April 1988, pp. 182–87.

Ilya Kabakov

Groys, Boris. *Ilya Kabakov: Das Leben der Fliegen*. Cologne: Edition Cantz, 1992.

_____. *Ilya Kabakov*. Munich: Carl Hamser Verlag, 1991.

Wallach, Amei. *Ilya Kabakov: The Man Who Never Threw Anything Away*. New York: Harry N. Abrams, 1996.

Bern, Switzerland. Kunsthalle Bern. *Ilya Kabakov, Am Rande*, 1985. Texts by Jean-Herbert Martin and Boris Groys.

Helsinki. Museum of Contemporary Art. *Ilya Kabakov: Five Albums*, 1994. Texts by Tuula Arkio, Boris Groys, and Ilya Kabakov.

London. Institute of Contemporary Art. *Ilya Kabakov: Ten Characters*, 1989. Text by Ilya Kabakov.

Washington, D.C. Hirshhorn Museum and Sculpture Garden. *Ten Characters*, 1990. Text by Ned Rifkin.

Bonami, Francesco. "Ilya Kabakov: Tales from the Dark Side." *Flash Art* (Summer 1994): 91–93, 142.

Cembalest, Robin. "The Man Who Flew into Space." *Art News*, May 1990, pp. 176–81.

Gambrell, Jamey. "Disappearing Kabakov." *Print Collector's Newsletter*, November-December 1995, pp. 171–74.

Groys, Boris. "'With Russia on Your Back': A Conversation between Ilya Kabakov and Boris Groys." *Parkett*, no. 34 (December 1992) 35–41.

Jolles, Claudia. "Kabakov's Twinkle." *Parkett*, no. 34 (December 1992): 66–72.

Solomon, Andrew. "Artist of the Soviet Wreckage." *New York Times Magazine*, September 20, 1992, pp. 54–55, 74, 80, 88–91.

Storr, Robert. "An Interview with Ilya Kabakov." *Art in America*, January 1995, pp. 60–69.

_____. "The Architect of Emptiness." *Parkett*, no. 34 (December 1992): 47–51.

Tupitsyn, Margarita. "Ilya Kabakov." *Flash Art* (February-March 1986): 67–69.

Tupitsyn, Victor. "From the Communal Kitchen: A Conversation with Ilya Kabakov." *Arts Magazine*, October 1991, pp. 49–55.

Mike Kelley

Miller, John. *Mike Kelley*. New York: A.R.T. Press, 1991. Kelley interview with John Miller.

Basel, Switzerland. Kunsthalle. *Mike Kelley*, 1992. Texts by Thomas Kellein, Christopher Knight, Colin Gardner, and Mike Kelley, and Kelley interviews with Paul Taylor and Ralph Rugoff.

Chicago. Renaissance Society at the University of Chicago. *Mike Kelley: Three Projects: Half a Man, From My Institution to Yours, Pay for Your Pleasure*, 1988. Texts by Howard Singerman and John Miller.

Hannover, Germany. Kestner-Gesellschaft. *Mike Kelley: Missing Time: Works on Paper 1974–1976 Reconsidered*, 1995. Texts by Carsten Ahrens, Timothy Martin, and Mike Kelley.

New York. Whitney Museum of American Art. *Mike Kelley: Catholic Tastes*, 1993. Texts by Richard Armstrong, Dennis Cooper and Casey McKinney, Diedrich Diederichsen, Jutta Koether and Martin Prinzhorn, Howard N. Fox, Colin Gardner, Kim Gordon, John

Hanhardt, David Marsh, Timothy Martin, John Miller, Ralph Rugoff, Paul Schimmel, and Howard Singerman.

Cameron, Dan. "Mike Kelley's Art of Violation." *Arts Magazine*, Summer 1986, pp. 14–17.

Chevrier, Jean Francois. "Mike Kelley." *Galeries Magazine*, October-November 1991, pp. 89–91, 153–55.

Diedrichsen, Diedrich. "America: Yet Another Discovery: Mike Kelley." *Parkett*, no. 31 (March 1992): 77–81.

Kelley, Mike. "Mike Talks to Mike About Mike." *High Performance*, no. 9 (1986): 28–34.

Koether, Jutta. "C-Culture and B-Culture." *Parkett*, no. 24 (1990): 102–106.

Miller, John. "Mike Kelley." *Bomb*, Winter 1992, pp. 26–31.

Nesbitt, Lois E. "Not a Pretty Sight: Mike Kelley Makes Us Pay for Our Pleasure." *Artscribe*, September-October 1990, pp. 64–67.

Taylor, Paul. "Mike Kelley," an interview. *Flash Art* (October 1990): 141–43.

Mary Kelly

Kelly, Mary. *Post-Partum Document*. London: Routledge and Kegan Paul, 1983. Foreword by Lucy R. Lippard.

New York. New Museum of Contemporary Art. *Mary Kelly Interim*, 1990. Texts by Marcia Tucker, Norman Bryson, Griselda Pollock, and Kelly interview with Hal Foster.

Cowie, Elizabeth. "Introduction to the Post-Partum Document." *M/F*, nos. 5–6 (1981): 116–23.

Fisher, Jennifer. "Interview with Mary Kelly." *Parachute*, July-September 1989, pp. 32–35.

Fraser, Andrea. "On the Post-Partum Document." *Afterimage*, March 1986, pp. 6–8.

Gagnon, Monika. "Mary Kelly's Corpus." *C Magazine*, Summer 1986, pp. 24–33.

Maloon, Terance. "Mary Kelly." *Artscribe*, August 1978, pp. 16–19.

Mulvey, Laura. "Mary Kelly and Laura Mulvey in Conversation." *Afterimage*, March 1986, pp. 6–8.

Paoletti, John. "Mary Kelly's Interim." *Arts Magazine*, October 1985, pp. 88–91.

Smith, Paul. "Mother as Site of Her Proceedings: Mary Kelly's Post-Partum Document." *Parachute*, Spring 1982, pp. 29–30.

Weinstock, Jane. "A Post-Partum Document." *Camera Obscura*, Spring-Summer 1985, pp. 159–61.

Anselm Kiefer

Gilmour, John C. *Fire on the Earth: Anselm Kiefer and the Postmodern World*. Philadelphia: Temple University Press, 1990.

_____. "Anselm Kiefer: Postmodern Art and the Question of Technology.'" in Gary Shapiro, ed., *After the Future: Postmodern Times and Places*. Albany: State University of New York Press, 1990.

Kiefer, Anselm. *A Book by Anselm Kiefer*. London: Thames and Hudson, 1988. Texts by Jürgen Harten, Theodore E. Stebbins, Jr., and Susan Cragg Ricci.

Amsterdam. Stedelijk Museum. *Anselm Kiefer*, 1986. Text by Wim Beeren.

Cologne. Paul Maenz Gallery. *Anselm Kiefer*, 1986. Text by Gudrun Inboden.

London. Whitechapel Art Gallery. *Anselm Kiefer*, 1981. Texts by Zdenek Felix and Nicholas Serota.

New York. Marian Goodman Gallery. *Anselm Kiefer: Bruch und Einung*, 1987. Text by John Hallmark Neff.

Philadelphia. Philadelphia Museum of Art. *Anselm Kiefer*, 1987. Texts by Mark Rosenthal.

Brooks, Linda M. "Kiefer Madness or How I Stopped Worrying and Learned to Love Postmodernism." *Art Papers*, January-February 1989, pp. 27–33.

Dietrich, Dorothea. "Anselm Kiefer's 'Johannisnacht II': A Textbook." *Print Collector's Newsletter*, May-June 1984, pp. 41–45.

Flam, Jack. "The Alchemist." *New York Review of Books*, February 13, 1992, pp. 31–36.

Fussman, Klaus. "The Colors of Dirt." *Artforum*, May 1986, pp. 106–9.

Gilmour, John C. "Original Representation and Anselm Kiefer's Postmodernism." *Journal of Aesthetics and Art Criticism* (Spring 1988): 341–50.

Kramer, Hilton. "The Anselm Kiefer Retrospective." *New Criterion*, February 1988, pp. 1–4.

Madoff, Steven Henry. "Anselm Kiefer: A Call to Memory." *Art News*, October 1987, pp. 125–30.

Marano, Lizbeth. "Anselm Kiefer: Culture as Hero." *Portfolio*, May-June 1983, pp. 102–105.

Martin, Rupert. "Anselm Kiefer's Ironic Vision." *Artscribe*, October 1983, pp. 26–30.

Robins, Corinne. "'Your Golden Hair, Margarete.'" *Arts Magazine*, January 1989, pp. 73–77.

Storr, Robert. "Anselm Kiefer." *Galeries Magazine*, December-January 1988, pp. 89–95.

Komar & Melamid

Nathanson, Melvyn B., ed. *Komar/Melamid: Two Soviet Dissident Artists*. Carbondale: Illinois University Press, 1979. Introduction by Jack Burnham.

Ratcliff, Carter. *Komar & Melamid*. New York: Abbeville Press, 1988. With texts by Vitaly Komar and Alexander Melamid.

Edinburgh. Fruitmarket Gallery. *Komar & Melamid*, 1985. Text by Peter Wollens.

Decter, Joshua. "Spotlight: Komar & Melamid." *Flash Art* (October 1989): 126–27.

Fields, Marc. "Komar and Melamid and the Luxury of Style." *Artforum*, December 1977, pp. 58–63.

Frazier, Ian. "Profiles: Partners." *New Yorker*, December 1986, pp. 33–64.

Gambrell, Jamey. "Komar and Melamid: From Behind the Ironic Curtain." *Artforum*, April 1982, pp. 58–63.

Indiana, Gary. "Komar & Melamid Confidential." *Art in America*, June 1985, pp. 94–101.

Komar & Melamid, "We Love N.J." *Artforum*, April 1989, pp. 133–35.

_____. "In Search of Religion." *Artforum*, May 1980, pp. 36–46.

_____. "The Barren Flowers of Evil." *Artforum*, March 1980, pp. 46–52.

Lawson, Thomas. "Komar & Melamid," an interview. *Real Life Magazine*, Winter 1983, pp. 19–21.

Newman, Amy. "'The Celebrated Artists of the End of the Second Millenium A.D.'" *Art News*, April 1976, pp. 43–46.

Schjeldahl, Peter. "Komar & Melamid." *Flash Art* (December 1985-January 1986): 64–65.

Woodward, Richard B. "Nobody's Fools." *Art News*, November 1987, pp. 172–78.

Jeff Koons

Koons, Jeff. *The Jeff Koons Handbook*. London: Thames and Hudson, 1992.

Muthesius, Angelika, ed. *Jeff Koons*. Cologne: Benedikt Taschen, 1992.

Amsterdam. Stedelijk Museum. *Jeff Koons*, 1992. Texts by Gudrun Inboden and Peter Schjeldahl.

Chicago. Art Institute of Chicago. *Jeff Koons*, 1988, Text by Michael Danoff.

San Francisco. Museum of Modern Art. *Jeff Koons*, 1992. Texts by John Caldwell, Jim Lewis, Daniela Salvioni, and Brian Wallis.

Collings, Matthew. "Matthew Collings Talks to Jeff Koons: 'You Are a White Man, Jeff . . . ,'" *Modern Painters*, Summer 1989, pp. 60–63.

Enright, Robert. "The Material Boy and the Femme Fidele," interviews with Jeff Koons and Ilona Stoller. *Border Crossings* (Canada), January 1991, pp. 34–47.

Gopnik, Adam. "The Art World: Lust for Life." *New Yorker*, May 18, 1992, pp. 76–78.

Kuspit, Donald. "Sincere Cynicism." *Arts Magazine*, December 1990, pp. 60–65.

Ottmann, Klaus. "Interview with Jeff Koons." *Journal of Contemporary Art* (Spring 1988): 19–23.

Pinchbeck, Daniel. "Kitsch and Rich." *Sunday Times Magazine*, January 12, 1992, pp. 28–34.

Ratcliff, Carter. "Not for Repro." *Artforum*, January-February 1992, pp. 82–87.

Renton, Andrew. "Jeff Koons and the Art of the Deal: Marketing (as) Sculpture." *Performance*, September 1990, pp. 18–29.

_____. "Jeff Koons," an interview. *Flash Art* (Summer 1990): 110–15.

Schjeldahl, Peter. "Jeff Koons." *Objectives*, May 8, 1990, pp. 82–99.

Schwartzman, Allan. "The Yippie-Yuppie Artist." *Manhattan, Inc.*, December 1987, pp. 137–43.

Siegel, Jeanne. "Jeff Koons: Unachieved States of Being." *Arts Magazine*, October 1986, pp. 66–71.

Smith, Roberta. "Rituals of Consumption." *Art in America*, May 1988, pp. 164–71.

Sprinkle, Annie. "Hard Core Heaven." *Arts Magazine*, March 1992, pp. 46–48.

Storr, Robert. "Jeff Koons: Gym Dandy." *Art Press*, October 1990, pp. 14–23.

Jannis Kounellis

Amsterdam. Stedelijk Museum. *Jannis Kounellis: Via del Mare*, 1991. Texts by Giuliano Briganti, and Kounellis interview with Wim Beeren.

Bordeaux, France. Musée d'Art Contemporain. *Jannis Kounellis*, 1985. Texts by Jean-Louis Froment and R. H. Fuchs.

Chicago. Museum of Contemporary Art. *Jannis Kounellis*, 1986. Texts by Mary Jane Jacob, and Thomas McEvilley.

Eindhoven, Netherlands. Stedelijk van Abbemuseum. *Jannis Kounellis*, 1981. Texts by Rudi H. Fuchs and Jannis Kounellis.

Lucerne, Switzerland. Kunstmuseum. *Jannis Kounellis*, 1977. Texts by Jean-Christophe Ammann and Marlis Gruterich.

Rivoli, Italy. Museo d'Arte Contemporanea. *Jannis Kounellis*, 1988. Texts by Rudi Fuchs, Johannes Gachnang, and Cristina Mundici.

Cameron, Dan. "A Culture Divided: Notes on the Jannis Kounellis Retrospective." *Arts Magazine*, December 1986, pp. 65–69.

Celant, Germano. "The Collision and the Cry: Jannis Kounellis." *Artforum*, October 1983, pp. 61–67.

Cora, Bruno. "Collaboration: Jannis Kounellis," an interview. *Parkett* 6 (September 1985): 3–5, 18–50.

Gambrell, Jamey. "Industrial Elegies." *Art in America*, February 1988, pp. 118–29.

Kuspit, Donald. "Alive in the Alchemical Emptiness: Jannis Kounellis' Art." *C Magazine*, March 1988, pp. 45–49.

Politi, Giancarlo, and Jannis Kounellis. "Interview." *Flash Art* (January 1985): 14–21.

Sharp, Willoughby. "Structure and Sensibility: An Interview with Jannis Kounellis." *Avalanche*, Summer 1972, pp. 16–26.

Thompson, Jon. "Jannis Kounellis: A Different Idea of the Image." *Artscribe*, September 1991, pp. 58–67.

White, Robin. "Jannis Kounellis," an interview. *View*. 1979, entire issue.

Joyce Kozloff

Boston. Boston University Art Gallery. *Joyce Kozloff: Visionary Ornament*, 1986. Text by Patricia Johnston.

New York. Tibor de Nagy Gallery. *Joyce Kozloff: An Interior Decorated*, 1979. Texts by Peg Weiss and Carrie Rickey with an artist's statement.

Kozloff, Joyce, and Jeff Perrone. "Two Ethnics Sitting Around Talking About Wasp Culture." *Arts Magazine*, March 1985, pp. 78–83.

White, Robin. "Joyce Kozloff," an interview. *View*. 1981, entire issue.

Barbara Kruger

Linker, Kate. *Love for Sale: The Words and Pictures of Barbara Kruger*. New York: Harry N. Abrams, 1990.

London. Institute of Contemporary Art. *Barbara Kruger: We Won't Play Nature to Your Culture*, 1983. Texts by

Iwona Blazwick and Sandy Nairne, Craig Owens, and Jane Weinstock.

Wellington, New Zealand. National Art Gallery. *Barbara Kruger*, 1988. Texts by Luis Bieringa, Jenny Harper, and Lita Barrie.

Courtney, Pat. "Interview with Barbara Kruger." *Art Papers*, September 1987, pp. 36–39.

Deitcher, David. "Barbara Kruger: Resisting Arrest." *Artforum*, February 1991, pp. 84–91.

Feinstein, Rochelle. "The Revenge of Capital: Barbara Kruger and the Fine Art of Selling." *Arts Magazine*, December 1988, pp. 46–49.

Foster, Hal. "Subversive Signs." *Art in America*, November 1982, pp. 88–92.

Gomez, David. "Barbara Kruger." *Splash*, May 1992, pp. 42–49.

Jacobs, Karrie. "Barbara Kruger." *Eye*, December 1991, pp. 8–16.

Johnson, Ken. "Theater of Dissent." *Art in America*, March 1991, pp. 128–31.

Kamimura, Masako. "Barbara Kruger: Art of Representation." *Woman's Art Journal* (Spring-Summer 1987): 40–43.

Lichtenstein, Therese. "Barbara Kruger's After-effects: The Politics of Mourning." *Art and Text* (July 1989): 81–85.

Nixon, Mignon. "You Thrive on Mistaken Identity." *October* 60 (Spring 1992): 58–81.

Owens, Craig. "The Medusa Effect on the Spectacular Ruse." *Art in America*, January 1984, pp. 97–105.

Roberts, John. "Barbara Kruger," an interview. *Art Monthly*, December 1983-January 1984, pp. 17–19.

Siegel, Jeanne. "Barbara Kruger: Pictures and Words." *Arts Magazine*, Summer 1987, pp. 17–21.

Squires, Carol. "Barbara Kruger." *Aperture*, February 1995, pp. 58–67.

_____. "Diversionary (Syn)tactics: Barbara Kruger Has Her Way with Words." *Art News*, February 1987, pp. 77–85.

Stephanson, Anders. "Barbara Kruger," an interview. *Flash Art* (October 1987): 55–59.

Sundell, Margaret, and Thomas Beller, "Barbara Kruger." *Splash*, October 1988, pp. 58–66.

Robert Kushner

New York. Holly Solomon Gallery. *Robert Kushner: New Bronze Sculpture*, 1987. Text by Richard Armstrong and a Kushner interview with Robin White.

Philadelphia. Institute of Contemporary Art, University of Pennsylvania. *Robert Kushner*, 1987. Texts by Janet Kardon and Donald Kuspit.

Becker, Robert. "Robert Kushner," an interview. *Flash Art* (November 1984): 34–38.

White, Robin. "Robert Kushner," an interview. *View*. February-March 1980, entire issue.

Suzanne Lacy

Burnham, Linda Frye. "Running Commentary: What Price Social Art?" *High Performance* 9, no. 3 (1986): 8–9.

Hankwitz, Molly. "Suzanne Lacy, Annice Jacoby, & Chris Johnson: The Roof Is on Fire." *Art Papers*, January-February 1995, pp. 39–40.

Kelley, Jeff. "The Body Politics of Suzanne Lacy," in Nina Felshin, ed. *But Is It Art? The Spirit of Art as Activism*. Seattle: Bay Press, 1995.

Lacy, Suzanne. "Name of the Game." *Art Journal* (Summer 1991): 64–68.

_____. "*In Mourning and Rage* (with Analysis Afterthought)." *IKON Magazine*, Fall-Winter 1982, pp. 60–67.

Lacy, Suzanne, and Lucy R. Lippard. "Political Performance Art," a discussion. *Heresies* 5, no. 1 (1984): 22–25.

Lacy, Suzanne, and Rachel Rosenthal. "Saving the World," a dialogue, *Artweek*, September 12, 1991, p. 1.

_____. "Evolution of Feminist Art: Public Forms and Social Issues." *Heresies* (Summer 1978): 76, 78–85.

_____. "*In Mourning and Rage*." *Frontiers* 3, no. 1 (1978): 52–55.

Lippard, Lucy R. "Give and Take Ideology in the Art of Suzanne Lacy and Jerry Kearns," in Fred Lonider and Allen Sekula, eds., *Art and Ideology*. New York: New Museum of Contemporary Art, 1984), pp. 28–38, 57.

Roth, Moira. "The Crystal Quilt." *High Performance* 10, no. 3 (1987): 72–73.

_____. "Suzanne Lacy's Dinner Parties." *Art in America*, April 1980, p. 126.

Thomas Lanigan-Schmidt

Lanigan-Schmidt, Thomas. "Thomas Lanigan-Schmidt: Incarnation and Art," in Peter Occhiogrosso, *Once a Catholic*. Boston: Houghton Mifflin, 1987.

New York. Holly Solomon Gallery. *Thomas Lanigan-Schmidt: Halfway to Paradise*, 1988. Text by Roger S. Wieck.

Boyce, Martin James. "Thomas Lanigan-Schmidt: Joy of Life, Predestination and Class-Clash Realism." *Flash Art* (November 1983): 66–67.

Putterman, Susan. "Thomas Lanigan-Schmidt's Testaments." *Arts Magazine*, March 1983, pp. 122–23.

Simon, Joan. "Thomas Lanigan-Schmidt at Holly Solomon." *Art in America*, May 1980, pp. 149–50.

Louise Lawler

Dent, Tony. "Alreadymade 'Female' Louise Lawler." *Parachute*, October-December 1994, pp. 20–24.

Fehlan, Fred. "Louise Lawler Doesn't Take Pictures." *Artscribe*, May 1990, pp. 62–65.

Joselit, David. "Investigating the Ordinary." *Art in America*, May 1988, pp. 46–52.

Lawler, Louise. "Arrangements of Pictures." *October* 26 (1984): 3–6.

Storr, Robert. "Louise Lawler: Unpacking the White Cube." *Parkett*, no. 22 (1989): 105–108.

Sherrie Levine

New York. Mary Boone Gallery. *Sherrie Levine*, 1989. Text by Rosalind Krauss.

_____. *Sherrie Levine*, 1987. Text by Donald Barthelme.

Philadelphia. Philadelphia Museum of Art. *Sherrie Levine Newborn*, 1993. Texts by Ann Temkin and Sherrie Levine.

Washington, D.C. Hirshhorn Museum and Sculpture Garden. *Sherrie Levine*, 1988. Texts by Phyllis Rosenzweig and Susan Krane.

Zurich. Kunsthalle Zurich. *Sherrie Levine*, 1991. Text by David Deitcher.

Cameron, Dan. "Absence and Allure: Sherrie Levine's Recent Work." *Arts Magazine*, December 1983, pp. 84–87.

Carr, Cindy. "What Is Political Now?" an interview. *Village Voice*, October 15, 1985, pp. 73–81.

Krauss, Rosalind. "Bachelors." *October* 52 (Spring 1990): 52–59.

Levine, Sherrie. "After Henri Matisse." *File*, no. 26 (1986): 13–33.

_____. "A Simple Heart (After Gustave Flaubert)." *New Observations*, no. 35 (1985): 15–19.

Marzorati, Gerald. "Art in the (Re)Making." *Art News*, May 1986, pp. 90–99.

Morgan, Robert C. "Sherrie Levine: Language Games." *Arts Magazine*, December 1987, pp. 86–88.

Siegel, Jeanne. "Uncanny Repetition: Sherrie Levine's Multiple Originals." *Arts Magazine*, September 1991, pp. 31–35.

_____. "After Sherrie Levine." *Arts Magazine*, June 1985, pp. 141–44.

Tatransky, Valentin. "Collage and the Problem of Representation: Sherrie Levine's New Work." *Real Life Magazine*, December 1979, pp. 91–102.

Taylor, Paul. "Sherrie Levine Plays with Paul Taylor," an interview. *Flash Art* (Summer 1987): 55–59.

Wei, Lilly. "Talking Abstract." *Art in America*, December 1987, pp. 112–29, 171.

Sol LeWitt

Amsterdam. Stedelijk Museum. *Sol LeWitt Wall Drawings, 1968–1984*, 1984. Texts by Alexander van Grevenstein, Jan Debbaut, and Michael Harvey.

Andover, Mass. Addison Museum of American Art, Phillips Academy. *Sol LeWitt: Twenty Five Years of Wall Drawings, 1968–1993*, 1993. Texts by Jock Reynolds and Andrea Miller-Keller.

Oxford, England. Museum of Modern Art. *Sol LeWitt*, 1993. Texts by David Batchelor, Rosalind Krauss, and David Elliott.

The Hague. Gemeentemuseum. *Sol LeWitt*, 1970. Texts by Enno Develing, Mel Bochner, John N. Chandler, Dan Graham, Coosje Kapteyn-van Bruggen, Lichael Kirby, Ira Licht, Rosalind Krauss, Barbara M. Reise, and others.

New York. Museum of Modern Art. *Sol LeWitt*, 1978. Texts by Lucy R. Lippard, Bernice Rose, and Robert Rosenblum.

Alloway, Lawrence. "Sol LeWitt: Modules, Walls, Books." *Artforum*, April 1975, pp. 38–45.

Baker, K. "Energy as Form." *Art in America*, May-June 1978, pp. 73–77.

Kuspit, Donald. "Sol LeWitt: The Look of Thought." *Art in America*, September-October 1975, pp. 42–49.

LeWitt, Sol. "All Wall Drawings." *Arts Magazine*, February 1972, pp. 39–44.

Liebman, Lisa. "Stubborn Ideas and LeWitty Walls." *Artforum*, October 1984, pp. 64–68.

Lippard, Lucy R. "Sol LeWitt: Non-Visual Structures." *Artforum*, April 1967, pp. 42–46.

Smith, Roberta. "Sol LeWitt." *Artforum*, January 1975, pp. 60–62.

Wooster, Ann Sargent. "LeWitt's Expanding Grid." *Art in America*, May 1980, pp. 143–47.

Richard Long

London. Hayward Gallery. *Richard Long: Walking in Circles*, 1991. Texts by Anne Seymour, Hamish Fulton, and a Long interview with Richard Cork.

New York. Solomon R. Guggenheim Museum. *Richard Long*, 1986. Text by R. H. Fuchs.

Rome. Oalazzo delle Esposizioni. *Richard Long*, 1994. Text by Mario Codognato.

Cook, Lynne. "Richard Long." *Art Monthly*, May 1983, pp. 8–10.

Greig, Geordie. "Circular Tours in the Name of Art." *Sunday Times Review* (London), June 16, 1991, sec. 5, p. 7.

Long, Richard. "Correspondence: Richard Long Replies to a Critic." *Art Monthly*, July-August 1983, pp. 20–21.

Martin, Tim. "Richard Long." *Art Monthly*, November 1990, pp. 20–21.

Robert Longo

Longo, Robert. *Robert Longo: Men in the Cities, 1979–1982*. New York: Harry N. Abrams, 1986. Introduction by Richard Prince and Longo interview with Prince.

Ratcliff, Carter. *Robert Longo*. New York: Rizzoli, 1985.

Iowa City. University of Iowa. *Robert Longo: Dis-illusion*, 1985. Text by Robert Hobbs.

Long Beach, Calif. California State University Art Museum. *Robert Long: Sequences: Men in the Cities*, 1986. Text by Lucinda Barnes.

Los Angeles. Los Angeles County Museum of Art. *Robert Longo*, 1989. Texts by Hal Foster, Katherine Dieckmann, and Brian Wallis.

Berger, Maurice. "The Dynamics of Power: An Interview with Robert Longo." *Arts Magazine*, January 1985, pp. 88–89.

Blinderman, Barry. "Robert Longo's 'Men in the Cities': Quotes and Documentary." *Arts Magazine*, March 1981, pp. 92–94.

Dika, Vera. "Robert Longo: Performance into Film." *Artscribe International*, Summer 1988, pp. 72–76.

Foster, Hal. "The Art of Spectacle." *Art in America*, April 1983, pp. 144–149, 195–99.

Fox, Howard N. "Desire for Pathos: The Art of Robert Longo." *Sun and Moon* (Washington, D.C.), Fall 1979, pp. 71–80.

Gardner, Paul. "Longo: Making Art for Brave Eyes." *Art News*, May 1985, pp. 56–65.

Lewis, Christopher. "Mondo Longo." *Art in America*, March 1989, pp. 35–39.

Mueller, Cookie. "Larger than Life: The World of Robert Longo." *Saturday Review*, November–December 1985, pp. 44–48, 90.

Owens, Craig. "Robert Longo at Metro Pictures." *Art in America*, March 1981, pp. 125–26.

Ratcliff, Carter. "Longo's Logos." *Artforum*, January 1990, pp. 105–110.

Smith, Roberta. "Art View/Once a Wunderkind, Now Robert 'Long Ago'?" *New York Times*, October 29, 1989, sec. 2, pp. 37, 41.

Mary Lucier

Dallas. Dallas Museum of Art. *Mary Lucier, Wilderness*, 1987. Text by Sue Graze.

Anderson, Phil. "Ohio at Giverny." *High Performance* 10, no. 3 (1987): 99–100.

Adams, Brooks. "Mary Lucier." *Art in America*, March 1990, pp. 197–98.

Barlow, Melinda. "Personal History, Cultural Memory: Mary Lucier's Ruminations on Body and Land." *Afterimage*, November 1993, pp. 8–12.

Borum, Jenifer P. "Mary Lucier." *Artforum*, October 1995, pp. 102–3.

Gever, Martha. "Mary Lucier's Elemental Investigations: 'Plant,'" *Afterimage*, February 1982, pp. 8–9.

Hagen, Charles. "Video Art: The Fabulous Chameleon." *Art News*, Summer 1989, pp. 118–23.

_____. "Mary Lucier." *Artforum*, Summer 1984, p. 90.

Lorber, Richard. "Mary Lucier, The Kitchen." *Artforum*, September 1978, p. 81.

Rice, Shelley, "Mary Lucier." *Women's Art Journal* (Fall-Winter 1984–85): 41–44.

Sturken, Marita. "Mary Lucier's Elemental Investigations: 'Denman's Col (Geometry).'" *Afterimage*, February 1982, pp. 10–11.

Upshaw, Regen. "Mary Lucier at Lennon, Weinberg." *Art in America*, September 1995, pp. 105–106.

Wooster, Ann Sargent. "Mary Lucier at the Whitney Museum." *Art in America*, April 1982, pp. 138–39.

Markus Lüpertz

Gohr, Siegfried. *Markus Lüpertz: Zeichnungen aus der Jahren 1964–1985*. Bern-Berlin: Verlag Gachnang & Springer, 1986.

Carandente, Giovanni. *Markus Lüpertz*. Milan: Fabbri Editori, 1994.

Eindhoven, Netherlands. Stedelijk van Abbemuseum. *Markus Lüpertz: Hölderlin*, 1981. Texts by Rudi Fuchs, Siegfried Gohr, and Marcus Lüpertz.

London. Whitechapel Art Gallery. *Markus Lüpertz: "Stil" Paintings 1977–1979*, 1979. Text by Siegfried Gohr.

Madrid. Museo Nacional Centro de Arte Reina Sofia. *Markus Lüpertz: Retrospectiva 1963–1990*, 1991. Texts by Maria de Corral, Johannes Gachnang, Theo Kneubühler, and Markus Lüpertz.

Vienna. Museum Moderner Kunst Stiftung Ludwig Wien. *Markus Lüpertz*, 1994. Texts by Lorand Hegy, Siegfried Gohr, Oswald Wiener, Rainer Fuchs, and Karl A. Irsigler.

Dietrich, Dorothea. "Allegories of Power: Markus Lüpertz's 'German Motifs.'" *Art Journal* (Summer 1989): 164–70.

Faust, Wolfgang Max. "Markus Lüpertz: Beyond Painting as Painting." *Artscribe*, May-June 1984, pp. 53–55.

Morgan, Stuart. "Interview with Markus Lüpertz." *Artscribe*, July-August 1985, pp. 40–45.

Paparoni, Demetrio. "Art in Wonderland: Markus Lüpertz." *Tema Celeste*, April-June 1990, pp. 30–34.

Patrick, Keith. "Markus Lüpertz: Nationalism Without Frontiers," an interview. *Art Line*, Summer 1991, pp. 10–16.

Kim MacConnel

Aspen, Col. Aspen Art Museum. *Kim MacConnel: Decoc Terrae Africano*, 1990. Text by Kenneth E. Silver.

New York. Holly Solomon Gallery. *Kim MacConnel*, 1991. Text by Thomas McEvilley.

_____. *Kim MacConnel: New Paintings on Stretched Canvas*, 1986. Text by Christopher Knight.

MacConnel, Kim. "Crepe du Chine." *LAICA Journal* (October-November 1977): 32–36.

Allan McCollum

Frankfurt am Main. Portikus. *Allan McCollum*, 1988. Texts by Allan McCollum, Andrea Fraser, and Ulrich Wilmes.

Eindhoven, Netherlands. Stedelijk van Abbemuseum. *Allan McCollum*, 1989. Texts by Anne Rorimer, Lynne Cooke, and Selma Klein Essink.

London. Lisson Gallery. *Allan McCollum: Surrogates*, 1985. Text by Craig Owens.

Philadelphia. Institute of Contemporary Art, University of Pennsylvania. *Allan McCollum: Investigations, 1986*, 1986. Text by Andrea Fraser.

Sarasota, Fla. John and Mable Ringling Museum of Art. *Allan McCollum: Perfect Vehicles*, 1988. Text by Joseph Jacobs.

Jones, Ronald. "Give and Take." *C Magazine*, Summer 1987, pp. 38–43. Project by McCollum.

McCollum, Allan. "In the Collection of . . . " *Wedge*, Winter–Spring 1985, pp. 62–67.

_____. "Painter's Reply." *Artforum*, September 1975, pp. 26–36.

Miller, John. "What You See Is What You Don't Get: Allan McCollum's Surrogates, Perpetual Photos, and Perfect Vehicles." *Artscribe*, January 1986-February 1987, pp. 32–36.

Owens, Craig. "Allan McCollum: Repetition & Difference." *Art in America*, September 1983, pp. 130–32.

Robbins, David A. "An Interview with Allan McCollum." *Arts Magazine*, October 1985, pp. 40–44.

Smith, Roberta. "Allan McCollum and Laurie Simmins." *Art in America*, January 1986, pp. 14–39.

George McNeil

Fort Lauderdale, Fla. Museum of Art. *George McNeil: The Past Twenty Years*, 1982. Text by Carter Ratcliff.

New York. Artists' Choice Museum. *George McNeil: Expressionism: 1954–1984*, 1984. Text by George McNeil.

New York. Hirschl & Adler Gallery. *George McNeil*, 1991. Text by Carter Ratcliff.

Berlind, Robert. "George McNeil." *Art Journal* (Spring 1994): 55–57.

_____. "George McNeil." *Art in America*, April 1991, pp. 165–66.

Higgins, Judith. "Heroes of Myth and the Morning After." *Art News*, September 1986, pp. 90–99.

Robert Mapplethorpe

Celant, Germano. *Mapplethorpe*. Barcelona: Fundació Miró, Electa, 1992.

Mapplethorpe, Robert. *Black Book*. New York: St. Martin's Press, 1986. Text by Ntozake Shange.

_____. *Lady, Lisa Lyon*. New York: Viking Press, 1983. Texts by Bruce Charwin and Sam Wagstaff.

Patti Smith. *Robert Mapplethorpe*. New York: Bellport Press, 1987.

Berlin. Raab Galerie. *Robert Mapplethorpe*, 1986. Mapplethorpe interview with Anne Horton.

London. Institute of Contemporary Art. *Robert Mapplethorpe 1970–1983*, 1983. Texts by Alan Hollinghurst, Stuart Morgan, and Sandy Nairne.

London. National Portrait Gallery. *Mapplethorpe Portraits*, 1988. Texts by Robin Gibson, Peter Conrad, and Terence Pepper.

New York. Whitney Museum of American Art. *Robert Mapplethorpe*, 1988. Texts by Richard Marshall, Ingrid Sischy, and Richard Howard.

Filler, Martin. "Robert Mapplethorpe." *House & Garden*, June 1988, pp. 158–63.

Indiana, Gary. "Robert Mapplethorpe." *Bomb*, Winter 1988, pp. 19–23.

Koch, Stephen. "Guilt, Grace and Robert Mapplethorpe." *Art in America*, November 1986, pp. 144–51.

Morgan, Stuart. "Something Magic." *Artforum*, May 1987, pp. 118–23.

Ripp, Allan, Carol Squiers, and Steven Koch, "Mapplethorpe." *American Photographer*, January 1988, pp. 44–55.

Sontag, Susan. "Sontag on Mapplethorpe." *Vanity Fair*, July 1985, pp. 68–72.

Weaver, Mike. "Mapplethorpe's Human Geometry: A Whole Other Realm." *Aperture*, Winter 1985, pp. 43–51.

Weiley, Susan. "Prince of Darkness, Angel of Light." *Art News*, December 1988, pp. 106–11.

Carlo Maria Mariani

Drammen, Norway. Drammen Kunstforening. *Carlo Maria Mariani*, 1990. Text by Jan Ake Pettersson.

Los Angeles. Los Angeles County Museum of Art. *Carlo Maria Mariani: Utopia Now!*, 1992. Texts by Maurizio Calvesi, Klaus Wolbert, and Howard N. Fox.

Milan. Studio d'Arte Cannaviello. *C.M. Mariani: Paradiso Riconquistato*, 1988. Text by Carlo Maria Mariani.

Christov-Bakargiev, Carolyn. "Interview with Carlo Maria Mariani." *Flash Art International* (April 1987): 60–63.

Derger, Doanny. "Carlo Maria Mariani in His Studio." *Print Collector's Newsletter*, July-August 1984, pp. 84–87.

Feaver, William. "Remembrance of Things Past." *Art News*, September 1984, pp. 135–37.

Hughes, Robert. "Gliding over a Dying Reef." *Time Magazine*, July 2, 1984, pp. 76–77.

Kohn, Michael. "Mannerism and Contemporary Art; the Style and Its Critics." *Arts Magazine*, March 1984, pp. 72–77.

_____. "Carlo Maria Mariani and Neoclassicism." *Arts Magazine*, January 1982, pp. 60–63.

Russell, John. "Art Spirit of 1700's Haunts a SoHo Gallery." *New York Times*, October 30, 1981, sec. C, p. 26.

New York. Hirshl & Adler Gallery. *Carlo Maria Mariani*, 1990. Text by Thomas McEvilley.

Gordon Matta-Clark

Matta-Clark, Gordon. *Splitting*. New York: 98 Greene Street Loft Press, 1974.

Chicago. Museum of Contemporary Art. *Gordon Matta-Clark: A Retrospective*, 1985. Texts by Mary Jane Jacobs, Robert Pincus-Witten, and interviews by Joan Simon.

New York. Holly Solomon Gallery. *Splitting: Gordon Matta-Clark*, 1990. Text by Mary Jane Jacobs.

Stockholm. Moderna Museet. *Flyktpunkter: Vanishing Points*, 1984. Text on Gordon Matta-Clark by Dan Graham.

Valencia, Spain. Centro Julio Gonzales. *Gordon Matta-Clark*, 1992. Texts by Corinne Diserens, Marianne Brouver, Judith Rossi Kirshner, and interviews with Matta Clark's friends and associates.

Anderson, Laurie. "Anarchitecture in Englewood." *Art Rite* 6 (Summer 1974): 4–5.

Baer, Liza. "Gordon Matta-Clark: Splitting (the Humphrey Street Building." *Avalanche*, December 1974, pp. 34–37.

Castle, Ted. "Gordon Matta-Clark." *Flash Art* (June-July 1979): 37–42.

Foote, Nancy, "Drawing the Line." *Artforum*, May 1976, pp. 54–57.

Graham, Dan. "Gordon Matta-Clark." *Parachute*, June-August 1986, pp. 21–25.

Kirshner, Judith Russi. "Non-uments." *Artforum*, October 1985.

Lavin, Maud. "Gordon Matta-Clark and Individualism." *Arts Magazine*, January 1984, pp. 138–41.

Wall, Donald. "Gordon Matta-Clark's Building Dissections," with an interview. *Arts Magazine*, May 1976, pp. 74–80.

Mario Merz

Buffalo, N.Y. Albright-Knox Art Gallery. *Mario Merz*, 1984. Text by Susan Krane.

New York. Solomon R. Guggenheim Museum. *Mario Merz*, 1989. Text by Germano Celant and Merz interviews and selected writings.

Trento, Italy. Galleriea Civico di Arte Contemporanea. *Mario Merz*, 1995. Texts by Danilo Eccher, Agnes Kohlmeyer, Mario Merz, Achille Bonito Oliva, Mario Diacono, Carl Haenlein, Zdenek Felix, Denys Zacharopoulos, Demosthenes Davvatas, Rudi Fuchs, Harald Szeemann, Marlis Grüterich, Suzanne Page, Jean-Christophe Ammann, Fumio Nanjo, and Bruna Cora.

Celant, Germano. "Mario Merz: The Artist as a Nomad." *Artforum*, December 1979, pp. 52–58.

Silverthorne, Jeanne. "Mario Merz's Future of an Illusion." *Parkett*, no. 15 (February 1988): 58–73.

Tisdall, Caroline. "Mario Merz: An Interview by Caroline Tisdall." *Studio International*, January-February 1976, pp. 11–17.

Mary Miss

Boston. Fogg Art Museum. *Mary Miss*, 1980. Text by Agnes Saalfield.

London. Architectural Association. *Mary Miss: Projects 1966–1987*, 1987. Text by Joseph Giovannini. Miss interview with Alvin Boyarsky.

London. Institute of Contemporary Art. *Mary Miss*, 1983. Text by Kate Linker.

Reading, Pa. Freedman Gallery, Albright College. *Mary Miss: Photo/Drawings*, 1991. Text by Nancy Princenthal.

Roslyn, N.Y. Nassau County Museum of Fine Art. *Mary Miss—Perimeters/Pavilions/Decoys*, 1979. Text by Ronald J. Onorato.

Berman, Avis. "Space Exploration." *Art News*, November 1989, pp. 130–35.

Gould, Claudia. "Mary Miss Covers the Waterfront," an interview. *Stroll*, October 1987, pp. 54–57.

Lippard, Lucy R. "Mary Miss: An Extremely Clear Situation." *Art in America*, March-April 1974, pp. 76–77.

Miss, Mary. "On a Redefinition of Public Sculpture." *Perspecta* 21, pp. 52–70.

Nevins, Deborah. "An Interview with Mary Miss." *Princeton Journal* (1985): 96–101.

Onorato, Ronald J. "Illusive Spaces: The Art of Mary Miss." *Artforum*, December 1988, pp. 28–33.

Malcolm Morley

Liverpool. Tate Gallery. *Malcolm Morley Watercolours*, 1991. Texts by Nicholas Serota, Klaus Kertess, and Richard Francis.

London. Whitechapel Art Gallery. *Malcolm Morley*, 1983. Text by Michael Compton.

Paris. Centre Georges Pompidou. *Malcolm Morley*, 1993. Texts by Klaus Kertess, Les Levine, and David Sylvester.

Alloway, Lawrence. "Morley Paints a Picture." *Art News*, Summer 1968, pp. 42–44, 69–71.

_____. "Malcolm Morley." *Unmuzzled OX* 4, no. 2 (1976): 48–55.

Collings, Matthew. "The Happy Return: Malcolm Morley," an interview. *Artscribe*, January-February 1985, pp. 17–21.

_____. "Malcolm Morley." *Artscribe*, August 1983, pp. 49–55.

Dimitrijevic, Nena. "Malcolm Morley." *Flash Art* (October 1988): 76–80.

Hayden-Guest, Anthony. "Daddy-O: The Wild Life and Art of Malcolm Morley." *New York Magazine*, February 1984, pp. 40–44.

Kertess, Klaus. "Malcolm Morley: Talking About Seeing." *Artforum*, Summer 1980, pp. 48–51.

Klein, Michael R. "Traveling in Styles." *Art News*, March 1983, pp. 91–97.

Kramer, Hilton. "The Malcolm Morley Retrospective." *New Criterion*, September 1983, pp. 71–74.

Levin, Kim. "Malcolm Morley: Post Style Illusionism." *Arts Magazine*, February 1973, pp. 60–63.

McFadden, Sarah. "Malcolm Morley," an interview. *Art in America*, December 1982, pp. 68–70.

Rubinfein, Leo. "Malcolm Morley." *Artforum*, December 1976, pp. 63–67.

Tatransky, Valentin. "Malcolm Morley: Toward Erotic Painting." *Arts Magazine*, April 1979, pp. 166–68.

Robert Morris

Krauss, Rosalind, Thomas Krens, David Antin, Maurice Berger, Jean-Pierre Criqui, Annette Michelson, and W. J. T. Mitchell. *Robert Morris: The Mind/Body Problem*. New York: Harry N. Abrams, 1994.

Morris, Robert. *Continuous Project Altered Daily: The Writings of Robert Morris*. Cambridge, Mass.: MIT Press, 1993.

Chicago. Museum of Contemporary Art. *Robert Morris: Works of the Eighties*, 1986. Texts by Edward F. Fry, Donald P. Kuspit, I. Michael Danoff, Mary Jane Jacob, and Paul Schimmel.

New York. Gray Art Gallery and Study Center, New York University. *Robert Morris: The Felt Works*, 1989. Texts by Thomas W. Sokolowski, Pepe Karmel, and Maurice Berger.

New York. Whitney Museum of American Art. *Robert Morris*, 1970. Text by Marcia Tucker.

Washington, D.C. Corcoran Gallery of Art. *Robert Morris: Inability to Endure or Deny the World: Representation and Text in the Work of Robert Morris*, 1990. Texts by Barbara Rose and Terrie Sultan.

_____. *Robert Morris*, 1969. Text by Annette Michelson.

Goossen, E. C. "The Artist Speaks: Robert Morris." *Art in America*, May-June 1970, pp. 104–11.

Marmer, Nancy. "Death in Black and White." *Art in America*, March 1983, pp. 129–33.

Morris, Robert. "Three Folds in the Fabric and Four Autobiographical Asides as Allegories (or

Interruptions)." *Art in America*, November 1942, pp. 142–51.

_____. "American Quartet." *Art in America*, December 1981, pp. 92–104.

_____. "The Present Tense of Space." *Art in America*, January-February 1978, pp. 70–81.

_____. "Some Notes on the Phenomenology of Making: The Search for the Motivated." *Artforum*, April 1970, pp. 62–66.

_____. "Notes on Sculpture," parts 1–4. *Artforum*, February 1966, pp. 42–44; October 1966, pp. 20–23; Summer 1967, pp. 24–29; April 1969, pp. 50–54.

_____. "Anti-Form." *Artforum*, April 1968, pp. 33–35.

Patton, Phil. "Robert Morris and the Fire Next Time." *Art News*, December 1983, pp. 84–91.

Wilson, William. "Hard Questions and Soft Answers." *Art News*, November 1969, pp. 26–28, 81–84.

Robert Moskowitz

New York. Blum Helman Gallery. *Robert Moskowitz Paintings and Drawings*, 1986. Text by Katy Kline.

_____. *Robert Moskowitz*, 1983. Text by Robert Rosenblum.

Washington, D.C. Hirshhorn Museum and Sculpture Garden, Smithsonian Institution. *Robert Moskowitz*, 1989. Text by Ned Rifkin and Moskowitz interview with Linda Shearer.

Carlson, Prudence. "Building, Statue, Cliff." *Art in America*, May 1983, pp. 144–47.

Gibson, Eric. "Art: Robert Moskowitz at MoMA." *New Criterion*, June 1990, pp. 68–71.

Elizabeth Murray

King, Elaine A. *Elizabeth Murray: Drawings*. Pittsburgh: Carnegie Mellon University Press, 1986. Texts by Ann Sutherland Harris and Paul Gardner.

Murray, Elizabeth. *Notes for Fire and Rain*. New York: Lapp Princess Press, 1981.

Smith, Roberta. *Elizabeth Murray: Paintings and Drawings*. New York: Harry N. Abrams, 1987. Poem by Robert Holman, artist's commentary and Murray interview with Sue Graze and Kathy Halbreich.

Dallas. Dallas Museum of Art. *Elizabeth Murray: Paintings and Drawings*, 1987. Texts by Roberta Smith and Clifford S. Ackley.

Brody, Jacqueline. "Elizabeth Murray, Thinking in Print: An Interview." *Print Collector's Newsletter*, July-August 1982, pp. 73–77.

Cohen, Ronny H. "Elizabeth Murray's Colored Space." *Artforum*, December 1982, pp. 51–55.

Galligan, Gregory. "Elizabeth Murray's New Paintings." *Arts Magazine*, September 1987, pp. 62–66.

Gardner, Paul. "Elizabeth Murray Shapes Up." *Art News*, September 1984, pp. 47–55.

Horsfield, Kate. "Elizabeth Murray." *Profile*, Summer 1986, entire issue.

Kuspit, Donald. "Elizabeth Murray's Dandyish Abstraction." *Artforum*, February 1978, pp. 28–31.

Murry, Jesse. "Quintet: The Romance of Order and Tension in Five Paintings by Elizabeth Murray." *Arts Magazine*, May 1981, pp. 102–105

Ratcliff, Carter. "The Paint Thickens." *Artforum*, June 1976, pp. 43–47.

Simon, Joan. "Mixing Metaphors: Elizabeth Murray." *Art in America*, April 1984, pp. 140–47.

Solomon, Deborah. "Celebrating Paint." *New York Times Magazine*, March 31, 1991, pp. 20–25, 40, 46.

Storr, Robert. "Shape Shifter." *Art in America*, April 1989, pp. 210–21, 275.

_____. "Added Dimension." *Parkett*, no. 8 (1986): 8–19.

Bruce Nauman

Bruggen, Coosje van. *Bruce Nauman*. New York: Rizzoli, 1988.

Baltimore. Baltimore Museum of Art. *Bruce Nauman: Neons*, 1982. Text by Brenda Richardson.

London. Whitechapel Gallery. *Bruce Nauman*, 1986. Texts by Joan Simon, Nicholas Serota, and Jean-Christophe Ammann.

Los Angeles. Los Angeles County Museum of Art. *Bruce Nauman: Works from 1965 to 1972*, 1972. Texts by Jane Livingston and Marcia Tucker.

Minneapolis. Walker Art Center. *Bruce Nauman*, 1994. Texts by Kathy Halbreich, Neal Benezra, Robert Storr, and Paul Schimmel.

New York. Castelli Graphics. *Bruce Nauman: Prints 1970–89*, 1989. Text by John Yau.

Adams, Brooks. "The Nauman Phenomenon." *Art and Auction*, December 1990, pp. 118–25.

Bruggen, Coosje van. "Entrance Entrapment Exit." *Artforum*, Summer 1986, pp. 88–96.

Butterfield, Jan. "Bruce Nauman: The Center of Yourself," an interview. *Arts Magazine*, February 1975, pp. 53–55.

Danieli, Fidel A. "The Art of Bruce Nauman." *Artforum*, December 1967, pp. 15–19.

Dercon, Chris. "Keep Taking It Apart: A Conversation with Bruce Nauman." *Parkett*, no. 10 (September 1986): 54–69.

Gopnik, Adam. "The Art World: Bits and Pieces." *New Yorker*, May 14, 1990, pp. 88–92.

Harten, Jürgen. "T for Technics, B for Body." *Art and Artists*, November 1973, pp. 28–33.

Nesbitt, Lois. "Lie Down, Roll Over; Bruce Nauman's Body Conscious Art Reawakens New York." *Artscribe*, Summer 1990, pp. 48–51.

Pincus-Witten, Robert. "Bruce Nauman: Another Kind of Reasoning." *Artforum*, February 1972, pp. 30–37.

Schjeldahl, Peter. "Profoundly Practical Jokes: The Art of Bruce Nauman." *Vanity Fair*, May 1983, pp. 88–93.

Sharp, Willoughby. "Nauman Interview." *Arts Magazine*, March 1970, pp. 22–27.

_____. "Bruce Nauman." *Avalanche*, Winter 1971, pp. 22–31.

Simon, Joan. "Breaking the Silence: An Interview with Bruce Nauman." *Art in America*, September 1988, pp. 140–49, 203.

Storr, Robert. "Nowhere Man." *Parkett*, no. 10 (September 1986): 70–90.

_____. "Bruce Nauman: The Not-So-Holy Fool." *Art Press*, February 1985, pp. 9–13.

Tucker, Marcia. "PreNAUMANology." *Artforum*, December 1970, pp. 38–44.

Dennis Oppenheim

Amsterdam. Stedelijk Museum. *Dennis Oppenheim*, 1974. Text by Dennis Oppenheim.

Montreal. Musée d'Art Contemporain. *Dennis Oppenheim: Retrospective Works, 1967–1977*, 1978. Texts by Alain Parent, Peter Frank, and Lisa Kahane, and Oppenheim interview with Alain Parent.

New York. Institute for Contemporary Art, P.S. 1 Museum. *Dennis Oppenheim: Selected Works 1967–90*, 1992. Text by Thomas McEvilley and Oppenheim interview by Alanna Heiss.

Baker, Kenneth. "Dennis Oppenheim: An Art with Nothing to Lose." *Arts Magazine*, April 1975, pp. 72–74.

Bourgeois, Jean-Louis. "Dennis Oppenheim: A Presence in the Countryside." *Artforum*, October 1969, pp. 34–38.

Braun, Emily. "The Factories." *Arts Magazine*, June 1981, pp. 138–41.

Crary, Jonathan. "Dennis Oppenheim's Delirious Operations." *Artforum*, November 1978, pp. 36–40.

Goldberg, Lenore. "Dennis Oppenheim: Myth and Ritual." *Art and Artist*, August 1972, pp. 22–27.

Levin, Kim. "Dennis Oppenheim: Post-Performance Works." *Arts Magazine*, September 1978, pp. 122–25.

Morgan, Stuart. "Dennis Oppenheim: Gut Reaction." *Artscribe*, February 1979, pp. 34–38.

Oppenheim, Dennis. "Recurring Aspects in Sculpture." *Cover* 2 (January 1980): 36–39.

_____. "Interactions: Forms-Energy-Subject." *Arts Magazine*, March 1972, pp. 36–39.

Sharp, Willoughby. "Interview with Dennis Oppenheim." *Studio International*, November 1971, pp. 183–93.

Wood, Steve. "An Interview with Dennis Oppenheim." *Arts Magazine*, June 1981, pp. 133–37.

Nam June Paik

Matzner, Florian, ed. *Nam June Paik: Baroque Laser*. Ostfildern, Germany: Cantz Verlag, 1995. Texts by Klaus Bussmann, Nam June Paik, Florian Matzner, and Ulrike Groos.

London. Hayward Gallery. *Nam June Paik Video Works, 1963–88*, 1988. Text by Wulf Herzogenrath.

New York. Whitney Museum of American Art. *Nam June Paik*, 1982. Texts by John G. Hanhardt, Dieter Tonter, Michael Nyman, and David A. Ross.

Venice. XLV Venice Biennale, German Pavilion. *Nam June Paik: eine data base*, 1993. Texts by Nam June Paik, Yongwoo Lee, Pierre Restany, John Canaday, Calvin Tomkins, Grace Glueck, David Bourdon, Otto Piene, Karl Ruhrberg, Irving Sandler, Vittorio Fagone, Jean-Paul Fargier, Wulf Herzogenrath, Achille Bonito Oliva, Edith Decker, Larry Litt, Hans Werner Schmidt, Otto Hahn, Florian Matzner, Anje Oswald, David Ross, Hilton Kramer, John J. O'Connor, Carol Brandenburg, and others.

Gardner, Paul. "Tuning in to Nam June Paik." *Art News*, May 1982, pp. 64–73.

Kurtz, Bruce. "Paikvision." *Artforum*, October 1982, pp. 52–55.

Paik, Nam June. "Random Access Information." *Artforum*, September 1980, pp. 46–49.

Tomkins, Calvin. "Profiles: Video Visionary." *New Yorker*, May 5, 1975, pp. 44–79.

A. R. Penck

Yau, John. *A.R. Penck*. New York: Harry N. Abrams, 1993. Text by Penck.

Basel, Switzerland. Galerie Beyeler. *A.R. Penck*, 1989. Penck interview with Andrea Schlieker.

Bern, Switzerland. Kunsthalle. *A.R. Penck*, 1975. Text by Dieter Koepplin.

New York. Mary Boone Gallery. *A.R. Penck*, 1989. Text by A.R. Penck.

Santa Monica, Calif. Fred Hoffman Gallery. *A.R. Penck: Venice Paintings*, 1989. Texts by Fred Hoffman and Pamela Kort.

Venice. Bienanale, German Pavilion. *A.R. Penck*, 1984. Text by Johannes Cladders.

Celant, Germano. "A.R. Penck." *Artforum*, March 1981, pp. 56–62.

Galligan, Gregory. "A.R. Penck." *Arts Magazine*, January 1986, pp. 139–49.

Gohr, Siegfried. "A.R. Penck: Expedition to the Holy Land." *Flash Art* (November 1983): 56–59.

Heinrich, T.A. "A.R. Penck: Documenta 6—Painting." *Arts Canada*, April-May 1978, pp. 35–62.

Koepplin, Dieter. "Experience in Reality: The Art of A.R. Penck." *Studio International*, March 1974, pp. 112–16.

Stich, Sidra. "Pictorial, Personal, and Political Expression in the Art of A. R. Penck." *Arts Magazine*, Summer 1984, pp. 121–25.

Judy Pfaff

Buffalo, N.Y. Albright-Knox Art Gallery. *Judy Pfaff*, 1989. Texts by William Currie and Susan Krane.

Charlotte, N.C. Knight Gallery, Spirit Square Center for the Arts. *Judy Pfaff: Autonomous Objects*, 1986. Text by Roberta Smith.

New York, Holly Solomon Gallery, and Washington, D.C., National Museum of Women in the Arts. *Judy Pfaff*, 1988–1989. Text by Linda Nochlin and Pfaff interview with Helaine Posner.

Sarasota, Fla. John and Mable Ringling Museum of Art. *Judy Pfaff*, 1981. Text by Michael Auping.

Auping, Michael. "Judy Pfaff: Turning Landscape Inside Out." *Arts Magazine*, September 1982, pp. 74–76.

Gardner, Paul. "Blissful Havoc." *Art News*, Summer 1983, pp. 68–74.

Adrian Piper

Birmingham, England Ikon Gallery. *Adrian Piper*, 1991. Texts by Claudia Barrow, Arlene Raven, and Adrian Piper.

New York. Alternative Museum. *Adrian Piper: Reflections 1967–1987*, 1987. Texts by Jane Farver, Clive Phillpot, and Adrian Piper in one edition, and in another, Lowery S. Sims and John T. Paoletti.

Seattle. University of Washington. *Adrian Piper: I Am Not a Token, I Am Not a Type*, 1989. Text by Lucy R. Lippard.

Berger, Maurice. "The Critique of Pure Reason: An Interview with Adrian Piper." *Afterimage*, October 1990, pp. 5–9.

Barber, Bruce. "Performance as Social Intervention: Interview with Adrian Piper." *Parachute*, Fall 1981, pp. 25–28.

Cottingham, Laura. "Adrian Piper." *Journal of Contemporary Art* 5 (Spring 1992): 88–136.

Hayt-Atkins, Elizabeth. "The Indexical Present: A Conversation with Adrian Piper." *Arts Magazine*, March 1991, pp. 48–51.

Kuspit, Donald. "Adrian Piper: Self-Healing Through Meta-Art." *Art Criticism* (September 1987): 9–16.

Piper, Adrian. "The Logic of Modernism." *Flash Art* (January-February 1993): 56–58, 118, 136.

_____. "Passing for White, Passing for Black." *Transition* 58 (1992): 4–32.

_____. "Cornered." *Balcon* 4 (1989): 122–35.

_____. "An Open Letter to Donald Kuspit." *Real Life Magazine* Winter 1987–88, pp. 2–11.

Sims, Lowery. "The Mirror the Other." *Artforum*, March 1990, pp. 111–15.

Thompson, Mildred. "Interview: Adrian Piper." *Art Papers*, March-April 1988, pp. 27–30.

Upsom, Nicola. "Adrian Piper: Smiling at Strangers," an interview. *Second Shift*, Spring 1993, pp. 6–9.

Judith Wilson, "'In Memory of the News and of Ourselves': The Art of Adrian Piper." *Third Text* 16-17 (Autumn-Winter 1991): 39–62.

Sigmar Polke

Liverpool, England. Tate Gallery Liverpool. *Sigmar Polke: Join the Dots*, 1995. Texts by Sean Rainbird, Judith Nesbitt, and Thomas McEvilley.

New York. David Nolan Gallery. *Sigmar Polke Drawings from the 1960's*, 1987. Text by Prudence Carlson.

Rotterdam, Netherlands. Museum Boymans-van Beuningen. *Sigmar Polke*, 1983. Texts by Wim Beeren, Sigmar Polke, Dierk Stemmler, and Hagen Lieberknecht.

San Francisco. San Francisco Museum of Art. *Sigmar Polke*, 1990. Texts by John Caldwell, Peter Schjeldahl, John Baldessari, Reiner Speck, Michael Oppitz, and Katharina Schmidt.

Buchloh, Benjamin. "Parody and Appropriation in Francis Picabia and Sigmar Polke." *Artforum*, March 1982. pp. 28–34.

Curiger, Bice. "Interview with Sigmar Polke." *Art Press*, April 1985, pp. 4–10.

_____. "Sigmar Polke." *Parkett*, no. 2 (1984): 36–55.

Drateln, Doris von. "Sigmar Polke." *Contemporanea*, January 1990, pp. 38–45.

Ferrari, Gabriella de. "Polke's Progress." *Vanity Fair*, November 1990, pp. 186, 250–51.

Frey, Patrick. "Sigmar Polke." *Flash Art* (Summer 1984): 44–47.

Gintz, Claude. "Polke's Slow Dissolve." *Art in America*, December 1985, pp. 102–109.

Groot, Paul. "Sigmar Polke." *Flash Art* (May-June 1988): 66–70.

Hickey, David. "Polke in America: The Non-Returnable Flounder and the Dime-Store Sublime, *Parkett*, no. 30 (1991): 86–91.

Kuspit, Donald. "At the Tomb of the Unknown Picture." *Artscribe*, March 1988, pp. 38–45.

McEvilley, Thomas. "Flower Power or Trying to Say the Obvious About Sigmar Polke." *Parkett*, no. 30 (1991): 32–40.

Marcadé, Bernard. "Sigmar Polke: La Droguerie de Polke." *Artstudio*, Autumn 1986, pp. 118–31.

Power, Kevin. "Sigmar Polke." *Frieze*, no. 4 (April-May 1992): 24–33.

Polke, Sigmar. "What Interests Me Is the Unforeseeable." *Flash Art* (May-June 1988): 68–70.

Reise, Barbara M. "Who, What Is 'Sigmar Polke.'" *Studio International*, July-August 1976, pp. 83–86; September-October 1976, pp. 207–10; January-February 1977, pp. 38–40.

Smith, Roberta. "Review/Art: Brooklyn Retrospective of the Mercurial Sigmar Polke." *New York Times*, October 11, 1991, sec. C, p. 26.

Storr, Robert. "Polke's Mind Tattoos." *Art in America*, December 1992, pp. 66–72, 134.

Richard Prince

Phillips, Lisa. "People Keep Asking: An Introduction." *Richard Prince*. New York: Harry N. Abrams, 1992. Additional texts by Jim Lewis, Rosetta Brooks, Glenn O'Brien, Larry Clark, and Richard Prince.

Prince, Richard. *Adult Comedy Action Drama*. New York: Scalo Publishers, 1995.

_____, ed. *Wild History*. New York: Tanam Press, 1985, pp. 116–27.

_____. *Why I Go to the Movies Alone*. New York: Tanam Press, 1983.

Hannover. Kestner-Gesellschaft. *Richard Prince Photographs 1977–1993*, 1993. Texts by Boris Groys, Carl Haenlein, and Noemi Smolik.

Villeurbanne, France. *Richard Prince*, 1983. Text by Kate Linker.

Halley, Peter. "Richard Prince: Interviewed by Peter Halley." *ZG* (Spring 1984): 5–7.

Hilty, Greg. "Diamonds and Dirt: Richard Prince's Latest Hits." *Frieze*, no. 1 (1991): 24–31.

Kruger, Barbara. "All Tomorrow's Parties," an interview. *Bomb*, Fall 1982, pp. 42–43.

Kuspit, Donald. "Tart Wit, Wise Humor." *Artforum*, January 1991, pp. 93–101.

Lewis, James. "Richard Prince: Notes Toward a Supreme Fiction." *Parkett*, no. 28 (June 1991): 6–15.

Morgan, Stuart. "Tell Me Everything: Richard Prince Interviewed by Stuart Morgan." *Artscribe International*, January-February 1989, pp. 46–51.

Prince, Richard. "Bringing It All Back Home." *Art in America*, September 1988, pp. 29–33.

_____. "Eleven Conversations." *Tracks, a Journal of Artists' Writings* (Fall 1976): 41–46.

Rian, Jeffrey. "Social Science Fiction: An Interview with Richard Prince." *Art in America*, March 1987, pp. 86–95.

Robbins, David. "Richard Prince: An Interview with David Robbins." *Aperture*, Fall 1985, pp. 7–13.

Saltz, Jerry. "Notes on a Drawing: Sleight/Slight of Hand: Richard Prince's *What a Business*, 1988." *Arts Magazine*, January 1990, pp. 13–14.

Smith, Roberta. "Review/Art: Richard Prince, Questioning the Definition of Originality." *New York Times*, May 6, 1992, sec. C, p. 32.

Taylor, Paul. "Richard Prince Interview." *Flash Art* (October 1988): 90–91, 121–23.

Wallis, Brian. "Mindless Pleasures: Richard Prince's Fictions." *Parkett*, no. 6 (September 1985): 61–66.

Martin Puryear

Benezra, Neal. *Martin Puryear*. New York: Thames and Hudson, 1991. With a text by Robert Storr.

Horsfield, Kate, and Lyn Blumenthal, eds. *Profile: Martin Puryear*. Chicago: Video Data Bank, School of the Art Institute of Chicago, 1977.

Amherst, Mass. University of Massachusetts, University Gallery. *Martin Puryear*, 1984. Puryear interview with Hugh M. Davies and Helaine Posner.

Chicago. Chicago Public Library Cultural Center. *Martin Puryear: Public and Personal*, 1987. Texts by Patricia Fuller and Judith Russi Kirshner.

Bois, Yve-Alain. "La Pensee Sauvage." *Art in America*, April 1985, pp. 178–98.

Calo, Carole Gold. "Martin Puryear: Private Objects, Evocative Visions." *Arts Magazine*, February 1988, pp. 90–93.

Crary, Jonathan. "Martin Puryear's Sculpture." *Artforum*, October 1979, pp. 28–31.

Morgan, Ann Lee. "Martin Puryear: Sculpture as Elemental Expression." *New Art Examiner*, May 1987, pp. 27–29.

David Reed

Hagen, Charles. *David Reed*. Los Angeles: A.R.T. Press, 1990. Interview with Stephen Ellis.

Cologne. Kunstverein. *David Reed*, 1995. Texts by David Reed, Arthur Danto, and Hanne Loreck.

San Francisco. San Francisco Art Institute. *Two Bedrooms in San Francisco*, 1992. Text by David Reed.

Bell, Tiffany. "Baroque Expressions." *Art in America*, February 1987, pp. 126–29, 161.

Carrier, David. "Artifice and Artificiality: David Reed's Recent Paintings." *Arts Magazine*, January 1986, pp. 30–33.

Carrier, David, with David Reed. "Tradition, Eclecticism, Self-Consciousness: Baroque Art and Abstract Painting." *Arts Magazine*, January 1991, pp. 44–49.

Hagen, Charles. "David Reed: The Anatomy of Autonomy." *Artforum*, November 1990, pp. 143–46.

Reed, David. "Media Baptisms." *M/E/A/N/I/N/G*, May 1993, pp. 31–33.

_____. "Reflected Light: In Siena with Beccafumi." *Arts Magazine*, March 1991, pp. 52–53.

Gerhard Richter

Bonn. Kunst und Ausstellunshalle der Bundesrepublik Deutschland. *Gerhard Richter*, 1993. Texts by Benjamin H. D. Buchloh, with a Richter interview.

London. Anthony d'Offay Gallery. *Gerhard Richter Mirrors*, 1991. Text by Richard Cork.

London, Tate Gallery. *Gerhard Richter*, 1991. Texts by Sean Rainbird, Stefan Germer and Neal Ascherson.

New York. Marian Goodman Gallery. *Gerhard Richter Paintings*, 1987. Texts by Anne Rorimer and Denys Zacharopoulos.

New York. Marian Goodman and Sperone Westwater Galleries. *Gerhard Richter*, 1985. Text by Benjamin H. Buchloh.

Rotterdam, Netherlands. Museum Boymans–van Beuningen. *Gerhard Richter 1988/89*, 1989. Texts by Karel Schampers, Anna Tilroe, and Benjamin H. Buchloh.

Venice. 36th Biennale, German Pavilion. *Gerhard Richter*, 1972. Texts by Dieter Honisch, Dietrich Helms, Klaus Honnef, Heinz Ohff, and a Richter interview with Gunther Dienst.

Blistène, Bernard. "Artistes: Mechanique et Manuel dans L'art de Gerhard Richter." *Galeries Magazine*, April–May 1988, pp. 91–95, 141.

Michael Brenson, "A Concern with Painting the Unpaintable." *New York Times*, March 25, 1990, sec. 2, pp. 35, 39.

Bruggen, Coosje van. "Gerhard Richter: Painting as a Moral Act." *Artforum*, May 1985, pp. 82–91.

Ellis, Stephen. "The Elusive Gerhard Richter." *Art in America*, November 1986, pp. 130–39.

Hübl, Michael. "The 'Melancholist' of Virtuosity." *Art News*, February 1989, pp. 121–25.

Kuspit, Donald B. "Gerhard Richter's Doubt and Hope." *C Magazine*, December 1988, pp. 18–24.

Schjeldahl, Peter. "Death and the Painter." *Art in America*, April 1990, pp. 248–57.

Magnani, Gregorio. "Interview with Gerhard Richter." *Flash Art* (May–June 1989): 94–97.

Stachelhaus, Heiner. "Doubts in the Face of Reality: The Paintings of Gerhard Richter." *Studio International*, September 1972, pp. 76–80.

Tim Rollins + K.O.S.

London. Riverside Studios. *Tim Rollins + K.O.S.*, 1988. Text by Jean Fisher, Marko Daniel, and Tim Rollins + K.O.S.

Brooks, Rosetta. "Tim Rollins + K.O.S. (Kids of Survival)." *Artscribe*, May 1987, pp. 40–47.

Cameron, Dan. "The Art of Survival: A Conversation with Tim Rollins & K.O.S." *Arts Magazine*, June 1988, pp. 80–83.

Decter, Joshua. "Tim Rollins & K.O.S.: The Workshop Has Survived Because We Love Each Other." *Flash Art* (January–February 1990): 89–93.

Koslow, Francine A. "Tim Rollins + K.O.S.: The Art of Survival." *Print Collector's Newsletter*, September–October 1988, pp. 139–42.

Lasswell, Mark. "True Colors: Tim Rollins's Odd Life With the Kids of Survival." *New York Magazine*, July 29, 1991, pp. 30–38.

Nilson, Lisbet. "From Dead End to Avant-Garde." *Art News*, December 1988, pp. 133–37.

Rollins, Tim. "Tim Rollins + K.O.S." *Parkett*, no. 20 (Summer 1989): 36–39, 56–71.

Tallman, Susan. "Cultural Literacy: Tim Rollins and K.O.S. on Flaubert." *Arts Magazine*, March 1990, pp. 17–18.

Susan Rothenberg

Auping, Michael. *Susan Rothenberg Paintings and Drawings*. New York: Rizzoli, 1992. Includes an interview with Rothenberg.

Maxwell, Rachel Robertson. *Susan Rothenberg, the Prints: A Catalogue Raisonne*. Philadelphia: Peter Maxwell, 1987.

Simon, Joan. *Susan Rothenberg*. New York: Harry N. Abrams, 1991.

Amsterdam. Stedlijk Museum. *Susan Rothenberg*, 1982. Texts by Edy de Wilde and Alexander von Gravenstein.

Basel, Switzerland. Kunsthalle Basel. *Susan Rothenberg*, 1981. Texts by Jean-Christophe Ammann and Peter Blum.

Los Angeles. Los Angeles Country Museum of Art. *Susan Rothenberg*, 1983. Text by Maurice Tuchman.

Malmö, Sweden. Rooseum Center for Contemporary Art. *Susan Rothenberg: 15 Years—A Survey*, 1990. Text by Robert Storr.

Washington, D.C. Phillips Collection. *Susan Rothenberg*, 1985. Text by Eliza Rathbone.

Handy, Ellen. "Mysteries of Motion: Recent Paintings by Susan Rothenberg." *Arts Magazine*, May 1990, pp. 70–74.

Herrera, Hayden. "In a Class by Herself." *Connoisseur*, April 1984, pp. 112–17.

Nilson, Lisbet. "Susan Rothenberg: 'Every Brushstroke Is a Surprise,'" *Art News*, February 1984, pp. 47–54.

Ratcliff, Carter. "Artist's Catalogue: Susan Rothenberg—Images on the Edge of Abstraction." *Architectural Digest*, December 1987, pp. 52–59.

Storr, Robert. "Spooks and Floats." *Art in America*, May 1983, pp. 153–59.

Tuchman, Phyllis. "Rothenberg's Dancers: Serial Image of Figures in Motion—The Subject of New Murals." *View: The Photojournal of Art* (June-July 1989): 72–75.

Ursula von Rydingsvard

Bloomfield Hills, Mich. Cranbrook Art Museum. *Ursula von Rydingsvard*, 1989. Text by Bruce Hartman.

Mountainville, N.Y. Storm King Art Center. *Ursula von Rydingsvard Sculpture*, 1992. Texts by Maureen Megerian and Michael Brenson.

New York. Exit Art. *Ursula von Rydingsvard*, 1988. Text by John Yau.

New York. Lorence Monk Gallery. *Ursula von Rydingsvard*, 1990. Text by Saul Ostrow.

New York. Bette Stoler Gallery. *Ursula von Rydingsvard*, 1984. Text by Lawrence Alloway.

Storrs, Conn. Jorgensen Gallery, University of Connecticut. *Ursula von Rydingsvard*, 1980. Text by Jean E. Feinberg.

Strauss, David Levi. "Sculpture as Refuge." *Art in America*, February 1993, pp. 89–92, 125.

Robert Ryman

Basel, Switzerland. Kunsthalle. *Robert Ryman*, 1975. Text by Carlo Huber.

London. Whitechapel Art Gallery. *Robert Ryman*, 1977. Texts by Naomi Spector and Robert Ryman.

New York. Dia Art Foundation. *Robert Ryman*, 1988. Texts by Gary Garrels and Robert Ryman and Ryman interview.

New York. Museum of Modern Art. *Robert Ryman*, 1993. Text by Robert Storr.

New York. Pace Gallery. *Robert Ryman: New Paintings*, 1990. Text by Yve-Alain Bois.

New York. Solomon R. Guggenheim Museum. *Robert Ryman*, 1972. Text by Diane Waldman.

Paris. Espace d'Art Contemporain. *Robert Ryman*, 1991. Texts by Christel Sauer, Urs Raussmüller, Robert Storr, and Robert Ryman.

Duve, Thierry de. "Ryman Irreproductible: Nonreproductible Ryman." *Parachute*, Fall 1980, pp. 18–27.

Gilbert-Rolfe, Jeremy. "Appreciating Ryman." *Arts Magazine*, December 1975, pp. 70–73.

Grimes, Nancy. "Robert Ryman's White Magic." *Art News*, Summer 1986, pp. 86–92.

McEvilley, Thomas. "Absence Made Visible." *Artforum*, Summer 1992, pp. 92–96.

Ratcliff, Carter. "Robert Ryman's Double Positive." *Art News*, March 1971, pp. 54–56, 71–72.

Reise, Barbara. "Robert Ryman: Unfinished II (Procedures)." *Studio International*, March 1974, pp. 122–28.

_____. "Robert Ryman: Unfinished I (Materials)." *Studio International*, February 1974, pp. 76–80.

Storr, Robert. "Robert Ryman: Making Distinctions." *Art in America*, June 1986, pp. 92–97.

Tuchman, Phyllis. "An Interview with Robert Ryman." *Artforum*, May 1971, pp. 70–73.

David Salle

David Salle. Zurich: Edition Gallery Bruno Bischofberger, 1986. Texts by Robert Rosenblum, Rainer Crone, and Dennis Cooper.

Liebman, Lisa. *David Salle*. New York: Rizzoli, 1994.

Schjeldahl, Peter. *Salle*. New York: Vintage Books, 1987.

Cologne. Michael Werner Gallery. *David Salle*, 1989. Text by Wilfried Dickhoff.

Madrid. Sala de Exposiciones de la Fundacion Caja de Pensiones. *David Salle*, 1988. Texts by Kevin Power and Carla Schulz-Hoffmann.

New York. Mary Boone Gallery. *David Salle*, 1988. Text by Frederic Tuten.

Philadelphia. Institute of Contemporary Art, University of Pennsylvania. *David Salle*, 1986–87. Texts by Janet Kardon and Lisa Phillips.

Rotterdam. Museum Boymans-van Beuningen. *David Salle*, 1983. Texts by W. A. L. Beeren and Carter Ratcliff.

Cameron, Dan. "The Salle Academy." *Arts Magazine*, November 1985, pp. 74–77.

"Complicities: A Conversation Between David Salle and John Hawkes." *Border Crossings* (Canada), October 1990, pp. 28–40.

Danto, Arthur. "Art: David Salle." *Nation*, March 7, 1987, pp. 302–4.

Feinstein, Roni. "David Salle's Art in 1985: Dead or Alive?" *Arts Magazine*, November 1985, pp. 86–88.

Heartney, Eleanor. "David Salle: Impersonal Effects." *Art in America*, June 1988, pp. 120–29, 175.

Levin, Kim. "The Salle Question." *Village Voice*, February 3, 1987, pp. 81–82.

Liebman, Lisa. "Harlequinade for an Empty Room: On David Salle." *Artforum*, February 1987, pp. 94–99.

Marsh, Georgia. "David Salle." *Bomb*, October 1985, pp. 20–25.

Marzorati, Gerald. "The Artful Dodger." *Art News*, Summer 1984, pp. 47–55.

Millet, Catherine. "David Salle." *Flash Art* (Summer 1985): 30–34.

Olive, Kirstin. "David Salle's Deconstructive Strategy." *Arts Magazine*, November 1985, pp. 82–85.

Pincus-Witten, Robert. "David Salle: Sightations (From the Theater of the Deaf to the Gericault Paintings)." *Arts Magazine*, October 1986, pp. 40–44.

_____. "Pure Pinter: An Interview with David Salle." *Arts Magazine*, November 1985, pp. 78–81.

_____. "Interview with David Salle." *Flash Art* (Summer 1985): 35–36.

_____. "David Salle: Holiday Glassware." *Arts Magazine*, April 1982, pp. 58–60.

Ratcliff, Carter. "David Salle." *Interview*, February 1982, pp. 64–66.

Roberts, John. "An Interview with David Salle." *Art Monthly*, March 1983, pp. 3–7.

Salle, David. "Post-Modernism." *Real Life Magazine*, Summer 1981, pp. 4–10.

_____. "Images That Understand Us." *LAICA Journal* (June-July 1980): 41–44.

Schjeldahl, Peter. "The Real Salle." *Art in America*, September 1984, pp. 180–87.

_____. "David Salle Interview." *LAICA Journal* (September-October 1981): 15–21.

Schwartz, Sanford. "David Salle: The Art World." *New Yorker*, April 30, 1984, pp. 104–11.

Storr, Robert. "Salle's Gender Machine." *Art in America*, June 1988, pp. 24–25.

Taylor, Paul. "How David Salle Mixes High Art and Trash." *New York Times Magazine*, January 11, 1987, pp. 26–28, 39.

Lucas Samaras

Levin, Kim. *Lucas Samaras*. New York: Harry N. Abrams, 1975.

Lifson, Ben. *Samaras: Photographs, 1969–1986*. New York: Aperture Foundation, 1988.

Samaras, Lucas, and Demosthenes Davvatas. *Dialogue*. Zurich: Elisabeth Kaufman, 1986.

Denver. Denver Art Museum. *Lucas Samaras: Objects and Subjects, 1969–1986*, 1988. Texts by Thomas McEvilley, Donald Kuspit, and Roberta Smith.

Long Beach, Calif. California State University. *Lucas Samaras: Photo-Transformations*, 1975. Text by Arnold B. Glimcher.

New York. Museum of Modern Art. *Samaras 1974*, 1975. Texts by William S. Lieberman and Lucas Samaras.

New York. Pace Gallery. *Lucas Samaras: Sitings 1979–1980*, 1980. Text by Carter Ratcliff.

_____. *Barbara Rose Interviews Lucas Samaras*, 1978.

_____. *Samaras: Selected Works 1960–1966*, 1966. Texts by Lawrence Alloway and Lucas Samaras.

New York. Whitney Museum of American Art. *Lucas Samaras*, 1972. Text by Robert Doty.

Paris. Musée National d'Art Moderne, Centre Georges Pompidou. *Lucas Samaras: Photos, Polaroid Photographs 1969–1983*, 1983. Text by Roger Marcel Mayou.

Yokohoma, Japan. Museum of Art. *Lucas Samaras [Self: 1961–1991]*, 1991. Texts by Kim Levin, Taro Amano, Sae Hayashi, Hiroshi Miyatake, and Shino Kuraishi.

Glimcher, Arnold. "Lucas Samaras." *Flash Art* (October-November 1985): 40–44.

Gruen, John. "The Apocalyptic Disguises of Lucas Samaras." *Art News*, April 1976, pp. 32–37.

Kuspit, Donald. "Exhibitionism." *Art in America*, March 1981, pp. 88–90.

Levin, Kim. "Eros, Samaras and Recent Art." *Arts Magazine*, December 1972, pp. 51–55.

Ratcliff, Carter. "Modernism Turned Inside Out: Lucas Samaras' 'Reconstructions.'" *Arts Magazine*, November 1979, pp. 92–95.

Rose, Barbara. "Lucas Samaras: The Self as Icon and Environment." *Arts Magazine*, February 1978, pp. 144–48.

Samaras, Lucas. "Autopolaroid." *Art in America*, November 1970, pp. 66–83.

Schwartz, B. "Interview with Lucas Samaras." *Craft Horizons*, December 1972, pp. 36–43.

Waldman, Diane. "Samaras: Reliquaries for St. Sade." *Art News*, October 1966, pp. 44–46, 72–75.

Miriam Schapiro

Schapiro, Miriam. *Art: A Woman's Sensibility*. Valencia, Calif.: Feminist Art Program, California Institute of the Arts, 1975.

_____. *Anonymous Was a Woman*. Valencia, Calif.: California Institute of the Arts, 1975.

La Jolla, Calif. Mandeville Art Gallery, University of California, San Diego. *Miriam Schapiro: The Shrine, the Computer and the Dollhouse*, 1975. Text by Linda Nochlin and Schapiro interview with Moira Roth.

Portland, Ore. Reed College FOB Gallery. *Miriam Schapiro: Anatomy of a Kimono*, 1978. Text by Miriam Schapiro.

Wooster, Ohio. College of Wooster Art Museum. *Miriam Schapiro: A Retrospective: 1953–1980*, 1980. Text by Thalia Gouma-Peterson; Schapiro interviews by Paula Bradley and Ruth A. Appelhof.

Avgikos, Jan. "The Decorative Politic: An Interview with Miriam Schapiro." *Art Papers*, November-December 1982, pp. 6–8.

Broude, Norma. "Miriam Schapiro and 'Femmage': Reflections Between Decoration and Abstraction in Twentieth-Century Art." *Arts Magazine*, February 1980, pp. 83–87.

Frank, Elizabeth. "Miriam Schapiro: Formal Sentiments." *Art in America*, May 1982, pp. 106–11.

Gill, Susan. "From 'Femmage' to Figuration." *Art News*, April 1986, pp. 95–101.

Gouma-Peterson, Thalia. "The Theater of Life and Illusion in Miriam Schapiro's Recent Work." *Arts Magazine*, March 1986, pp. 38–43.

Merrill, Patrick, and Gail Jacobs, "A Feminist Response: An Interview with Miriam Schapiro." *Newsprint: The Journal of the Los Angeles Printmaking Society* (1995): 4–10.

Nochlin, Linda. "Miriam Schapiro: Recent Work." *Arts Magazine*, November 1973, pp. 38–41.

Sanford, Christy Sheffild, and Enid Shorter. "An Interview with Miriam Schapiro." *Women Artists News*, Spring 1986, pp. 22–26.

Schapiro, Miriam. "Rembrandt and Me." *M/E/A/N/I/N/G*, November 1992, pp. 30–31.

_____. "Recalling Womanhouse." *Women's Studies Quarterly*, Spring-Summer 1987, pp. 25–30.

Schapiro, Miriam, and Faith Wilding. "Cunts/Quilts/Consciousness." *Heresies* (1989): 6–13.

Kenny Scharf

London. Edward Totah Gallery. *Kenny Scharf*, 1992. Text by Brooks Adams.

New York. Tony Shafrazi Gallery. *Kenny Scharf*, 1987. Text by Dan Cameron.

_____. *Kenny Scharf*, 1983. Scharf interview with Tony Schafrazi and Bruno Schmidt.

Alinovi, Francesca. "Interview with Kenny Scharf." *Flash Art* (November 1983): 30–31.

Marzorati, Gerald. "Kenny Scharf's Fun-House Big Bang." *Art News*, September 1985, pp. 72–81.

Julian Schnabel

Schnabel, Julian. *C.V.J. Nicknames of Maitre d's & Other Excerpts from Life*. New York: Random House, 1987.

Amsterdam. Stedelijk Museum. *Julian Schnabel*, 1982. Text by Rene Ricard.

London. Whitechapel Art Gallery. *Julian Schnabel: Paintings 1975–1987*, 1987. Texts by Thomas McEvilley, Lisa Phillips, and Julian Schnabel.

_____. *Julian Schnabel: Paintings 1975–1986*, 1986. Texts by Thomas McEvilley and Schnabel interview with Matthew Collings.

New York. Pace Gallery. *Julian Schnabel*, 1992. Text by Gabriella de Ferrari.

_____. *Julian Schnabel: Fox Farm Paintings*, 1989. Text by Thomas McEvilley.

_____. *Julian Schnabel*, 1984. Text by Gert Schiff.

New York. Whitney Museum of American Art. *Julian Schnabel: Paintings 1975–1987*, 1987. Text by Lisa Phillips.

Prato, Italy. Museo d'Arte Contemporanea. *Julian Schnabel*, 1982. Texts by Amnon Barzel, Julian Schnabel, Thomas McEvilley, and William Gaddis.

Collings, Matthew. "Julian Schnabel in Conversation with Matthew Collings." *Artscribe International*, September-October 1986, pp. 26–31.

Gablik, Suzi. "Julian Schnabel Paints a Portrait of God." *New Criterion*, January 1984, pp. 10–18.

Geelhaar, Christian. "Julian Schnabel's *Head (for Albert)*, *Arts Magazine*, October 1982, pp. 74–75.

Hughes, Robert. "Julian Schnabel: The Artist as an Entrepreneur." *Modern Painters*, Spring 1988, pp. 35–39.

Kuspit, Donald B. "The Rhetoric of Rawness: Its Effects on Meaning in Julian Schnabel's Paintings." *Arts Magazine*, March 1985, pp. 126–30.

Liebman, Lisa. "About Julian Schnabel." *Flash Art* (May-June 1988): 71–73.

McGuigan, Cathleen. "Julian Schnabel: 'I Always Knew It Would Be Like This.'" *Art News*, Summer 1982, pp. 88–94.

Marzorati, Gerald. "Julian Schnabel: Plate It as It Lays." *Art News*, April 1985, pp. 63–69.

Morgan, Stuart. "Julian Schnabel," an interview. *Artscribe*, December 1983, pp. 15–21.

_____. "Misunderstanding Schnabel." *Artscribe*, August 1982, pp. 44–49.

Pincus-Witten, Robert. "Julian Schnabel: Blind Faith." *Arts Magazine*, February 1982, pp. 152–55.

Politi, Giancarlo. "Julian Schnabel," an interview. *Flash Art* (October-November 1986): 45–53.

Reed, Dupuy Warrick. "Julian Schnabel: The Truth of the Moment." *Arts Magazine*, November 1979, pp. 86–95.

Ricard, Rene. "Not About Julian Schnabel." *Artforum*, Summer 1981, pp. 74–80.

Schnabel, Julian. "The Patients and the Doctors." *Artforum*, February 1984, pp. 54–60.

Stone, Michael. "Off the Canvas." *New York*, May 18, 1992, pp. 29–36.

Carolee Schneemann

Schneemann, Carolee. *Early & Recent Work*. New York: McPherson/Documentext, 1983.

_____. *More Than Meat Joy: Complete Performance Works and Selected Writings*. New York: McPherson/Documentext, 1979.

_____. *Cezanne, She Was a Great Painter*. New York: Trespass Press, 1976.

Juno, Andrea, and V. Vale, eds. "Carolee Schneemann," an interview, in *Research: Angry Women*. San Francisco: RE/search Publications, 1991.

New York. Max Hutchinson Gallery: A Documentext Publication. *Carolee Schneemann: I. Early Work 1960/70*, 1982. Text by Ted Castle.

New York. Penine Hart Gallery. *Carolee Schneemann: Mortal Coils*, 1994. Text by Johannes Birringer.

Alloway, Lawrence. "Carolee Schneemann: The Body as Object and Instrument." *Art in America*, March 1980, pp. 19–21.

Cameron, Dan. "Object vs. Person: The Early Work of Carolee Schneemann." *Arts Magazine*, May 1983, pp. 122–25.

Castle, Ted. "Carolee Schneemann: The Woman Who Uses Her Body for Her Art." *Artforum*, November 1980, pp. 64–70.

Constantinides, Kathy. "Carolee Schneemann: Invoking Politics." *Michigan Quarterly Review*, Winter 1991, pp. 127–45.

Rahmani, Aviva. "A Conversation on Censorship with Carolee Schneemann." *M/E/A/N/I/N/G*, November 1989, pp. 3–7.

Sean Scully

Poirier, Maurice. *Sean Scully*. New York: Hudson Hills Press, 1990.

Charleroi, Belgium. Palais des Beaux-Arts. *Sean Scully: The Catherine Paintings*, 1995.

Chicago. Art Institute of Chicago. *Sean Scully*, 1987. Text by Neal Benezra.

Fort Worth, Texas. Modern Art Museum of Fort Worth. *Sean Scully: The Catherine Paintings*, 1993. Texts by Carter Ratcliff, Arthur C. Danto, and Steven Henry Madoff.

London. Waddington Galleries. *Sean Scully*, 1995. Text by Enrique Juncosa.

_____. *Sean Scully*, 1992. Text by Paul Bonaventura.

London. Whitechapel Art Gallery. *Sean Scully*, 1989. Text by Carter Ratcliff.

New York. David McKee Gallery. *Sean Scully: Paintings 1985–86*, 1986. Scully interview with Joseph Masheck.

Pittsburgh. Museum of Art, Carnegie Institute. *Sean Scully*, 1985. Texts by John Caldwell, David Carrier, and Amy Lighthill.

Washington, D.C. Hirshorn Museum and Sculpture Garden. *Sean Scully: Twenty Years*, 1995. Texts by Ned Rifkin, Armin Zweite, Victoria Combalia, Lynne Cooke, and Scully interview with Ned Rifkin.

Adams, Brooks. "The Stripe Strikes Back." *Art in America*, October 1985, pp. 118–23.

Carrier, David. "Piet Mondrian and Sean Scully: Two Political Artists." *Art Journal* (Spring 1991): 67–70.

Cooke, Lynne. "Sean Scully." *Galeries Magazine*, August-September 1980, pp. 60–63.

Dixon, Glenn. "Sean Scully." *Artforum*, October 1995, pp. 96–97, 126.

Higgins, Judith. "Sean Scully and the Metamorphosis of the Stripe." *Art News*, November 1985, pp. 104–12.

Hunter, Sam. "Sean Scully's Absolute Paintings." *Artforum*, November 1979, pp. 30–34.

Zimmer, William. "Heart of Darkness: New Stripe Paintings by and an Interview with Sean Scully." *Arts Magazine*, December 1982, pp. 82–83.

Richard Serra

Güse, Ernst-Gerhard, ed. *Richard Serra*. New York: Rizzoli, 1987. Texts by Yve-Alain Bois, Douglas Crimp, Ernst-Gerhard Guse, Richard Serra, and Armin Zweite.

Serra, Richard. *Writings, Interviews*. Chicago: University of Chicago Press, 1994.

Weyergraf-Serra, Clara, and Martha Buskirk, eds. *The Destruction of the "Tilted Arc": Documents*. Cambridge, Mass.: MIT Press, 1991. Introduction by Richard Serra.

Duisburg, Germany. Wilhelm Lehmbruck Museum. *Richard Serra*, 1994. Texts by Manfred Schneckenburg, Richard Serra, and Rosalind E. Krauss.

Düsseldorf, Germany. Kunstsammlung Nordrhein-Westfalen. *Richard Serra: Running Arcs (for John Cage)*, 1992. Text by Armin Zweite.

London. Serpentine Gallery. *Richard Serra Drawings*, 1992. Serra interview with Lynne Cooke.

London. Tate Gallery. *Richard Serra: Weight and Measure*, 1992. Serra interview with Nicholas Serota and David Sylvester.

New York. Hudson River Museum. *Richard Serra: Interviews, Etc. 1970–1980*, 1980. Texts by Richard Serra, with Clara Weyergraf.

New York. Museum of Modern Art. *Richard Serra Sculpture*, 1986. Texts by Rosalind E. Krauss, Douglas Crimp, and Laura Rosenstock.

New York. Pace Gallery. *Richard Serra*, 1989. Text by Richard Serra.

Tübingen. Kunsthalle. *Richard Serra*, 1978. Texts by Clara Weyergraf, Max Imdahl, B. H. D. Buchloh, and Serra interview with Lizzie Borden.

Baker, Elizabeth C. "Critic's Choice: Richard Serra." *Art News*, February 1970, pp. 26–27.

Bois, Yve-Alain. "The Meteorite in the Garden." *Art in America*, Summer 1984, pp. 108–13.

_____. "A Picturesque Stroll Around *Clara-Clara*." *October* 29 (Summer 1984): 32–62.

Cornwell, Regina. "Three by Serra." *Artforum*, December 1979, pp. 28–32.

Crimp, Douglas. "Richard Serra: Sculpture Exceeded." *October* 18 (Fall 1981): 67–78.

Krauss, Rosalind. "Richard Serra: Shift." *Arts Magazine*, April 1973, pp. 49–55.

_____. "Richard Serra: Sculpture Redrawn." *Artforum*, May 1972, pp. 38–43.

Kuspit, Donald. "Richard Serra: Utopian Constructivist." *Arts Magazine*, November 1980, pp. 124–29.

Pincus-Witten, Robert. "Richard Serra: Slow

Information." *Artforum*, September 1969, pp. 34–39.

Ratcliff, Carter. "Adversary Spaces." *Artforum*, October 1972, pp. 40–44.

Schjeldahl, Peter. "Artistic Control." *Village Voice*, October 14, 1991, p. 100.

Senie, Harriet. "The Right Stuff." *Art News*, March 1984, pp. 50–59.

Storr, Robert. "'Tilted Arc': Enemy of the People?" *Art in America*, September 1985, pp. 90–97.

Joel Shapiro

Chicago. Museum of Contemporary Art. *Joel Shapiro*, 1976. Text by Rosalind E. Krauss.

Des Moines, Iowa. Des Moines Art Center. *Joel Shapiro: Tracing the Figure*, 1990. Text by Donald Kuspit, and Shapiro interview with Deborah Leveton.

London. Waddington Galleries. *Joel Shapiro*, 1989. Text by Lynne Cooke.

London. Whitechapel Art Gallery. *Joel Shapiro*, 1980. Text by Rosalind E. Krauss.

Los Angeles. PaceWildenstein. *Joel Shapiro Sculpture and Drawing*, 1996. Text by Michael Brenson.

Miami. Center for the Fine Arts. *Joel Shapiro: Selected Drawings 1968–1990*, 1991. Text by Mark Ormond and Shapiro interview with Paul Cummings.

Minneapolis. Walker Art Center. *Joel Shapiro: Outdoors*, 1995. Text by Deborah Emont Scott and Shapiro interview with Peter Boswell.

New York. Pace Gallery. *Joel Shapiro: Sculpture and Drawings*, 1993. Text by Peter Schjeldahl.

New York. Whitney Museum of American Art. *Joel Shapiro*, 1982. Texts by Richard Marshall and Roberta Smith.

Baer, Lisa. "Joel Shapiro Torquing: A Dialogue with Lisa Bear." *Avalanche*, Summer 1975, pp. 15–19.

Bass, Ruth. "Minimalism Made Human." *Art News*, March 1987, pp. 94–101.

Baker, Kenneth. "References to Breakdown: Joel Shapiro's Sculptures of the '80s." *Artforum*, February 1989, pp. 102–106.

Field, Marc. "On Joel Shapiro's Sculptures and Drawings." *Artforum*, Summer 1978, pp. 31–37.

Gilbert-Rolfe, Jeremy. "Joel Shapiro: Works in Progress." *Artforum*, December 1973, pp. 73–74.

Schwartz, Sanford. "Little Big Sculpture." *Art in America*, March-April 1976, pp. 53–55.

Judith Shea

Kansas City, Mo. *Judith Shea*, 1988. Text by Deborah Emont Scott.

La Jolla, Calif. La Jolla Museum of Contemporary Art. *Judith Shea*, 1988. Text by Lynda Forsha.

San Francisco. John Berggruen Gallery. *Judith Shea*, 1992. Texts by Peter Schjeldahl and Judith Shea.

Cohen, Ronny. "Reviews: Judith Shea." *Artforum*, February 1985, pp. 84–85.

Gill, Susan. "Judith Shea, Willard Gallery." *Art News*, January 1987, pp. 161, 163.

Haskell, Barbara. "Judith Shea at Willard." *Art in America*, October 1980, pp. 129–30.

Maricola, Paula. "Judith Shea's Contemporary Kore." *Artforum*, Summer 1990, pp. 134–39.

Rickey, Carrie. "Art of Whole Cloth." *Art in America*, November 1979, pp. 72–83.

Silverthorne, Jeanne. "Judith Shea: Willard Gallery." *Artforum*, October 1980, pp. 81–82.

Stein, Judith. "The Artist's New Clothes." *Portfolio*, January-February 1983, pp. 63–66.

Cindy Sherman

Barents, Els. *Cindy Sherman*. Munich: Schirmer/Mosel, 1982.

Cindy Sherman. Tokyo: Parco, 1987. Sherman interview with Laurie Simmons.

Danto, Arthur C. *Cindy Sherman History Portraits*. Munich: Schirmer/Mosel and New York: Rizzoli, 1991.

Krauss, Rosalind. *Cindy Sherman 1975–1993*. New York: Rizzoli, 1993. Additional text by Norman Bryson.

Schjeldahl, Peter, and I. Michael Danoff. *Cindy Sherman*. New York: Pantheon Books, 1984.

Amsterdam. Stedelijk Museum. *Cindy Sherman*, 1982. Text by Els Barents.

London. Whitechapel Art Gallery. *Cindy Sherman*, 1991. Text by Thomas Kellein.

New York. Whitney Museum of American Art. *Cindy Sherman*, 1987. Texts by Peter Schjeldahl and Lisa Phillips.

St. Louis. St. Louis Art Museum. *Currents 20: Cindy Sherman*, 1983. Text by Jack Cowart.

Avgikos, Jan. "Cindy Sherman: Burning Down the House." *Artforum*, January 1993, pp. 74–79.

Danto, Arthur C. "Cindy Sherman." *Nation*, August 15–22, 1987, pp. 134–37.

Dickhoff, Wilfried. "Untitled Nr. 179." *Parkett*, no. 29 (1991) 103–11.

Equi, Elaine. "Cindy Sherman." *Arts Magazine*, September 1989, p. 72.

Frascella, Larry. "Cindy Sherman's Tales of Terror." *Aperture*, Summer 1986, pp. 48–53.

Howell, John, and Shelley Rice. "Cindy Sherman's Seductive Surfaces." *Alive Magazine*, September-October 1982, pp. 20–25.

Jauch, Ursula Pia. "I Am Always the Other." *Parkett*, no. 29 (1991): 74–80.

Jeliner, Elfrieda. "Sidelines." *Parkett*, no. 29 (1991): 82–90.

Johnson, Ken. "Cindy Sherman and the Anti-Self: An Interpretation of Her Imagery." *Arts Magazine*, November 1987, pp. 47–53.

MacDonald, Erik. "Dis-seminating Cindy Sherman: The Body and the Photograph." *Art Criticism* (1989) 35–40.

Marzorati, Gerald. "Imitation of Life." *Art News*, September 1983, pp. 78–87.

Melville, Stephen W. "The Time of Exposure: Allegorical Self-Portraiture in Cindy Sherman." *Arts Magazine*, January 1986, pp. 17–21.

Mulvey, Laura. "A Phantasmagoria of the Female Body:

The Work of Cindy Sherman." *New Left Review*, July-August 1991, pp. 136–51.

Nilson, Lisbet. "Cindy Sherman: Interview." *American Photographer*, September 1983, pp. 70–77.

Perl, Jed. "Starring Cindy Sherman." *New Criterion*, January 1986, pp. 14–25.

Rhodes, Richard. "Cindy Sherman's 'Film Stills.'" *Parachute*, September-November 1982, pp. 4–7.

Robotham, Rosemary. "One-Woman Show: Cindy Sherman Puts Her Best Face Forward." *Life Magazine*, June 1984, pp. 14–22.

Schjeldahl, Peter. "Portrait: She Is a Camera." *7 Days*, March 28, 1990, pp. 16–20.

————. "Shermanettes." *Art in America*, March 1982, pp. 110–111.

Sischy, Ingrid. "Photography: Let's Pretend." *New Yorker*, May 6, 1991, pp. 86–96.

Solomon-Godeau, Abigail. "Suitable for Framing: The Critical Recasting of Cindy Sherman." *Parkett*, no. 29 (1991): 112–21.

Weiley, Susan. "The Darling of the Decade." *Art News*, April 1989, pp. 143–50.

Laurie Simmons

Bartman, William, and Rodney Sappington, eds. *Laurie Simmons*. New York: Artpress, 1994. Simmons interview with Sarah Charlesworth.

Cologne. Galerie Jablonka. *Laurie Simmons*, 1989. Text by Ronald Jones.

San Jose, Calif. San Jose Museum of Art. *Laurie Simmons*, 1990. Text by Dan Cameron.

Cameron, Dan. "Recent Work by Laurie Simmons." *Flash Art* (November-December 1989): 116–18.

Onorato, Ronald J. "The Photography of Laurie Simmons." *Arts Magazine*, April 1983, pp. 122–23.

Charles Simonds

Barcelona. Centre Cultural de la Fundacio Caixa de Pensions. *Charles Simonds*, 1994. Texts by Luis Monreal, Jacques Lambert, Germano Celant, and Daniel Abadie.

Chicago. Museum of Contemporary Art. *Charles Simonds*, 1981. Texts by John Hallmark Neff, John Beardsley, Daniel Abadie, and Charles Simonds.

Münster, Germany. Westfälischer Kunstverein. *Charles Simonds: Floating Cities and Other Architecture*, 1978. Text by Herbert Moldering. Simonds interview with Daniel Abadie and Lucy Lippard.

Beardsley, John. "Charles Simonds: Extending the Metaphor." *Art International*, February 1979, pp. 14–19, 34.

Castle, Ted. "Charles Simonds: The New Adam." *Art in America*, February 1983, pp. 95–103.

Linker, Kate. "Charles Simonds' Emblematic Architecture." *Artforum*, March 1979, pp. 32–37.

Lipsey, Roger. "The Little People's Work Microscopically Examined: Charles Simonds at the Museum of Contemporary Art, Chicago." *Arts Magazine*, February 1982, pp. 86–88.

Lyon, Christopher. "Charles Simonds: A Profile." *Images and Issues*, Spring 1982, pp. 56–61.

Patton, Phil. "The Lost Worlds of the 'Little People,'" *Art News*, February 1983, pp. 85–90.

Simonds, Charles. "Microcosm to Macrocosm/Fantasy World to Real World." *Artforum*, February 1974, pp. 36–39.

Robert Smithson

Flam, Jack, ed. *Robert Smithson: The Collected Writings*. Berkeley: University of California Press, 1996.

Hobbs, Robert. *Robert Smithson: Sculpture*. Ithaca, N.Y.: Cornell University Press, 1981. Essays by Hobbs, Lawrence Alloway, John Coplans, and Lucy R. Lippard.

Holt, Nancy, ed. *The Writings of Robert Smithson*. New York: New York University Press, 1979.

Shapiro, Gary. *Earthworks: Robert Smithson and Art After Babel*. Berkeley: University of California Press, 1995.

Tsai, Eugenie. *Robert Smithson Unearthed, Drawings, Collages, Writings*. New York: Columbia University Press, 1991.

Kent, Ohio. Kent State University School of Art. *Robert Smithson's Partially Buried Woodshed*, 1990. Text by Dorothy Shinn.

New York. New York Cultural Center. *Robert Smithson: Drawings*, 1974. Texts by Susan Ginsburg and Joseph Masheck.

New York. John Weber Gallery. *Robert Smithson: Sculpture 1968–69*, 1987. Text by Jeffrey Rian.

Alloway, Lawrence. "Robert Smithson's Development." *Artforum*, November 1972, pp. 54–61.

Childs, Elizabeth C. "Robert Smithson and Film: The Spiral Jetty Reconsidered." *Arts Magazine*, October 1981, pp. 68–81.

Coplans, John. "Robert Smithson, The Amarillo Ramp." *Artforum*, April 1974, pp. 36–45.

Craven, David. "Robert Smithson's 'Liquidating Intellect,'" *Art History*, December 1983, pp. 488–96.

Gilbert-Rolfe, Jeremy, and John Johnston. "Gravity's Rainbow and the Spiral Jetty." *October* 1 (Spring 1976): 65–85.

Gopnik, Adam. "Basic Stuff: Robert Smithson, Science, and Primitivism." *Arts Magazine*, March 1983, pp. 74–80.

Holt, Nancy, and Liza Bear. "Amarillo Ramp." *Avalanche*, Fall 1973, pp. 16–21.

Kuspit, Donald. "Robert Smithson's Drunken Boat." *Arts Magazine*, October 1981, pp. 82–88.

Leider, Philip, "For Robert Smithson." *Art in America*, November-December 1973, pp. 80–82.

Levin, Kim. "Robert Smithson No One Ever Noticed." *Art News*, September 1982, pp. 96–99.

————. "Reflections on Robert Smithson's *Spiral Jetty*." *Arts Magazine*, May 1978, pp. 136–37.

Müller, Gregoire. " . . . The Earth, Subject to Cataclysms, Is a Cruel Master." *Arts Magazine*, November 1971, pp. 179–85.

Ratcliff, Carter. "The Compleat Smithson." *Art in America*, January 1980, pp. 60–65.

Roth, Moira. "Robert Smithson on Duchamp: An Interview." *Artforum*, October 1969, pp. 197–99.

Smithson, Robert. "Incidents of Mirror-Travel in the Yucatan." *Artforum*, September 1967, pp. 28–33.

————. "The Monuments of Passaic." *Artforum*, December 1967, pp. 48–51.

————. "Toward the Development of an Air Terminal Site." *Artforum*, Summer 1967, pp. 37–40.

Ned Smyth

New York. Holly Solomon Gallery. *Ned Smyth*, 1985. Texts by Eric Frank and Donald W. Thalacker.

Coral Gables, Fla. Lowe Art Museum. *Ned Smyth: Three Installations; A Survey of the Artist's Work*, 1987. Text by Roberta Bernstein.

Blau, Douglas. "Ned Smyth." *Flash Art* (March-April 1980): 17–18.

Miller, Shari. "Sculptor Ned Smyth Creates Magical Spaces of Color." *Kenyon College Review*, Fall 1982, pp. 13–15.

Morgan, Susan, and Dena Shottenkirk. "Ned Smyth," an interview. *Real Life Magazine*, Spring-Summer 1982, pp. 25–28.

Alan Sonfist

Aachen, Germany. Neue Galerie—Sammlung Ludwig. *Alan Sonfist: Autobiography*, 1977. Text by Alan Sonfist.

Brookville, N.Y. Hillwood Art Museum, Long Island University. *Alan Sonfist 1969–1989*, 1989. Sonfist interview with Robert Rosenblum.

Ithaca, N.Y. Herbert F. Johnson Museum. *Autobiography of Alan Sonfist*, 1975. Text by Lawrence Alloway.

Washington, D.C. National Collection of Fine Arts. *Alan Sonfist/Trees*, 1978. Text by Peter Bermingham. Sonfist interview with Bermingham.

Frank, Peter. "Sonfist, Abandoned Animal Hole." *Art News*, January 1976, pp. 124–25.

Robins, Corinne. "Time as Aesthetic Dimension." *Arts Magazine*, October 1976, pp. 85–87.

Nancy Spero

London. Institute of Contemporary Art. *Nancy Spero: Retrospective*, 1987. Texts by Jon Bird and Lisa Tickner.

Malmö, Sweden. Kunsthall. *Nancy Spero*, 1994. Text by Susan Harris.

Philadelphia. Lawrence Oliver Gallery. *Nancy Spero*, 1986. Text by Rosetta Brooks.

Pittsburgh. Hewlett Gallery, Carnegie Mellon University. *Nancy Spero: The Black Paris Paintings*, 1985. Text by Elaine King.

Syracuse, N.Y. Everson Museum of Art. *Nancy Spero*, 1987. Texts by Jo Anna Isaak, Dominique Nahas, and Robert Storr.

Ulm, Germany. Ulmer Museum (Edition Cantz). *Nancy Spero*, 1990. Texts by Brigitte Reinhardt, Robert Storr, Noemi Smolik, Achille Bonito Oliva, Klaus Veirneisel, and Spero interview with Jon Bird.

Blumenthal, Lyn, and Kate Horsfield. "Interview with Nancy Spero." *Profile*, January 1983, entire issue.

Garb, Tamar. "Nancy Spero, Interviewed by Tamar Garb." *Artscribe International*, Summer 1987, pp. 58–62.

Golub, Leon. "Bombs and Helicopters: The Art of Nancy Spero." *Caterpillar*, no. 1, 1967, p. 52.

Jolicoeur, Nicole, and Nell Tenhaaf, "Defying the Death Machine," interview with Nancy Spero. *Parachute*, no. 39, June-July-August, pp. 50–55.

Jones, Alan. "The Writing on the Wall." *Arts Magazine*, October 1988, pp. 21–22.

Kuspit, Donald. "From Existence to Essence." *Art in America*, January 1984, pp. 88–96.

————. "Spero's Apocalypse." *Artforum*, April 1980, pp. 34–35.

Robins, Corinne. "Words and Images Through Time: The Art of Nancy Spero." *Arts Magazine*, December 1979, pp. 103–105.

Shottenkirk, Dena. "Dialogue: An Exchange of Ideas Between Dena Shottenkirk and Nancy Spero." *Arts Magazine*, May 1987, pp. 34–35.

Siegel, Jeanne. "Nancy Spero: Woman as Protagonist," an interview. *Arts Magazine*, September 1987, pp. 10–13.

Wye, Pamela. "Freedom of Movement: Nancy Spero's Site Paintings." *Arts Magazine*, October 1990, pp. 54–58.

————. "Nancy Spero: Speaking in Tongues." *M/E/A/N/I/N/G* 4, November 1988, pp. 33–41.

Doug and Mike Starn

Grundberg, Andy. *Mike and Doug Starn*. New York: Harry N. Abrams, 1990. Introduction by Robert Rosenblum.

Sarasota, Fla. John and Mable Ringling Museum of Art. *Doug & Mike Starn: The Christ Series*, 1987. Text by Joe Jacobs.

Gefter, Philip. "The Starn Twins," an interview. *Shift* 2, no. 4 (1988): 19–25.

Koslow, Francine A. "Doubling Photography: The Starn Twins." *Print Collector's Newsletter*, November-December 1986, pp. 163–66.

Masheck, Joseph. "Of One Mind: Photos by the Starn Twins of Boston." *Arts Magazine*, March 1986, pp. 69–71.

Ottmann, Klaus. "Interview with Doug and Mike Starn." *Journal of Contemporary Art* (Spring-Summer 1990): 66–79.

Pincus-Witten, Robert. "Being Twins: The Art of Doug and Mike Starn." *Arts Magazine*, October 1988, pp. 72–77.

Stapen, Nancy. "Still Rising Starns." *Art News*, February 1988, pp. 110–13.

Haim Steinbach

Bordeaux, France. Musée d'Art Contemporain. *Haim Steinbach*, 1988. Texts by Jean-Louis Froment, Germano Celant, Elizabeth Lebovici, and John Miller.

Castello di Rivoli, Italy. Museo d'Art Contemporanea. *Heim Steinbach*, 1995. Texts by Ida Gianelli, Mario Periola, Lynne Tillman, and Giorgio Verzotti.

Klagenfurt, Austria. Karntner Landesgalerie. *Haim Steinbach*, 1994. Texts by Arnulf Rohsmann, Jean Pierre Dubost, and Trevor Smith.

Celant, Germano. "Haim Steinbach's Wild, Wild, Wild West." *Artforum*, December 1987, pp. 75–79.

Collins, Tricia, and Richard Milazzo, "Double Talk: McDonald's in Moscow and the Shadow of Batman's Cape. Haim Steinbach." *Tema Celeste*, April-June 1990, pp. 35–38.

Cotter, Holland. "Haim Steinbach: Shelf Life." *Art in America*, May 1988, pp. 156–63, 201.

Decter, Joshua. "Haim Steinbach." *Journal of Contemporary Art* (Fall 1992): 114–122.

Taylor, Paul. "Haim Steinbach: An Easygoing Aesthetic that Appeals to the Flaneur in Many of Us." *Flash Art* (May-June 1989): 133–34.

Frank Stella

Axsom, Richard. *The Prints of Frank Stella, a Catalogue Raisonne, 1967–1982*. Ann Arbor: University of Michigan Press, 1983.

Guberman, Sidney. *Frank Stella: An Illustrated Biography*. New York: Rizzoli, 1995. Foreword by William Rubin, afterword by Richard Meier.

Pacquement, Alfred. *Frank Stella*. Paris: Flammarion, 1988.

Rosenblum, Robert. *Frank Stella*. Harmondsworth, England: Penguin Books, 1971.

Rubin, William S. *Frank Stella*. Greenwich, Conn.: New York Graphic Society, 1970.

Stella, Frank. *Working Space*. Cambridge, Mass.: Harvard University Press, 1986.

Baltimore. Baltimore Museum of Art. *Frank Stella: The Black Paintings*, 1976. Text by Brenda Richardson.

Fort Worth, Texas. Fort Worth Art Museum. *Frank Stella: The Swan Engravings*, 1984. Text by Robert Hughes.

_____. *Stella Since 1970*, 1978. Text by Philip Leider.

London. Hayward Gallery. *Frank Stella: A Retrospective Exhibition*, 1970. Text by John McLean.

New York. Museum of Modern Art. *Frank Stella, 1970–1987*, 1987. Text by William S. Rubin.

Pasadena, Calif. Pasadena Art Museum. *Frank Stella: An Exhibition of Recent Paintings*, 1966. Text by Michael Fried.

Ulm, Germany. Ulmer Museum. *Frank Stella, Moby Dick Series*, 1993. Texts by Brigitte Reinhardt, Robert K. Wallace, and David Galloway.

Waltham, Mass. Rose Art Museum, Brandeis University. *Recent Paintings by Frank Stella*, 1969. Text by William S. Seitz.

Baker, Elizabeth C. "Frank Stella's Perspectives." *Art News*, May 1970, pp. 46–49, 62–64.

Cone, Jane Harrison. "Frank Stella's New Paintings." *Artforum*, December 1967, pp. 34–41.

Creeley, Robert. "Frank Stella: A Way to Go." *Lugano Review*, Summer 1965, pp. 189–97.

Finkelstein, Louis. "Seeing Stella." *Artforum*, June 1973, pp. 67–70.

Halley, Peter. "Frank Stella and the Simulacrum." *Flash Art* (February-March 1986): 32–35.

Leider, Philip. "Shakespearean Fish." *Art in America*, October 1990, pp. 172–91.

_____. "Literalism and Abstraction: Frank Stella's Retrospective at the Modern." *Artforum*, April 1970, pp. 44–51.

Ratcliff, Carter. "Frank Stella: Portrait of the Artist as an Image Administrator." *Art in America*, February 1985, pp. 94–107.

Stella, Frank. "Frank Stella Talks About . . ." *Vanity Fair*, November 1983, pp. 94–95. Stella interview with April Bernard and Mimi Thompson.

Storr, Robert. "Issues and Commentary: Frank Stella's Norton Lectures: A Response." *Art in America*, February 1985, pp. 11–15.

Tomkins, Calvin. "Profiles (Frank Stella): The Space Around Real Things." *New Yorker*, September 1984, pp. 53–97.

Weschler, Lawrence. "Stella's Flying Ships." *Art News*, September 1987, pp. 92–99.

George Sugarman

Day, Holliday T. *Shape of Space: The Sculpture of George Sugarman*. New York: Arts Publishers, 1981. Additional texts by Irving Sandler and Brad Davis.

Castle, Wendell. "Wood: George Sugarman." *Craft Horizons*, March-April 1967, pp. 30–33.

Frank, Elizabeth. "Multiple Disjunctions: George Sugarman." *Art in America*, September 1983, pp. 145–49.

Goldin, Amy. "The Sculpture of George Sugarman." *Art in America*, September 1983, pp. 144–49.

Harper, Paula. "George Sugarman: The Fullness of Time." *Arts Magazine*, September 1980, pp. 158–60.

Rabinowitz, M. "George Sugarman's Sculpture." *Arts Magazine*, September 1985, pp. 98–101.

Sandler, Irving. "Sugarman Makes a Sculpture." *Art News*, May 1966, pp. 34–37.

Simon, Sidney. "George Sugarman." *Art International*, May 1967, pp. 22–26.

Szeemann, Harald. "George Sugarman." *Art International*, February 1970, pp. 50–51, 55.

James Surls

Kenne, Melvin, and James Surls. *From the Word*. New Waverly, Texas: Northern Hemisphere Press, 1979.

Dallas. Dallas Museum of Art. *Visions: James Surls, 1974–84*, 1984. Text by Sue Graze and Surls interview with Graze.

Choate, Pari Stave. "James Surls." *Flash Art* (Summer 1984): 68–69.

Fruedenheim, Susan. "James Surls: The Power of Singular Belief." *Artspace*, Spring 1985, pp. 10–13, 79.

Kutner, Janet. "Mocking Myths, Nachos, Nostalgia." *Art News*, December 1975, pp. 88, 90, 92.

Mayer, Susan. "Art Is Serious Play: An Interview with James Surls." *Texas Trends*, Fall 1986, pp. 30–37.

"James Surls." *Artefact*, Summer 1979, pp. 3–33.

Philip Taaffe

Cologne. Galerie Max Hetzler. *Philip Taaffe*, 1992. Text by Wilfried Dickhoff.

New York. Gagosian Gallery. *Philip Taaffe: Recent Paintings*, 1994. Taaffe interview with Oleg Grabar.

Adams, Brooks. "The Tabernacle of Philip Taaffe." *Print Collector's Newsletter*, January-February 1994, pp. 106–10.

Cameron, Dan. "The Other Philip Taaffe." *Arts Magazine*, October 1985, pp. 18–20.

Denson, G. Roger. "Flight into Egypt: The Islamic Reveries of Philip Taaffe." *Flash Art* (October 1990): 129–33.

_____. "Philip of Naples and the Evocative Geometry of History." *Parkett*, no. 26 (1990): 108–11.

Dickhoff, Wilfried. "We Are Not Afraid." *Parkett*, no. 26 (1990): 64–68.

Kaneda, Shirley. "Philip Taaffe." *Bomb*, Spring 1991, pp. 36–41.

McCormick, Carlo. "Poptometry." *Artforum*, November 1985, pp. 87–91.

Liebman, Lisa. "Taaffe's Temple." *Elle Decor*, December-January 1994, pp. 24–30.

Pellizzi, Francesco. "Fragment in Ornament." *Parkett*, no. 26 (1990): 98–101.

Perrone, Jeff. "History in the Making." *Parkett*, no. 26 (1990): 84–87.

White, Edmund. "A Propos: Philip Taaffe." *Parkett*, no. 26 1990): 91–93.

William Tucker

London. Annely Juda Gallery. *William Tucker*, 1987. Text by William Tucker.

Rome. Galleria L'Isola. *William Tucker "Horses,"* 1987. Text by William Tucker.

Venice. XXXVI Biennale, British Pavilion. *William Tucker*, 1972. Text by Andrew Forge.

Ashton, Dore. "William Tucker: New Sculpture." *Arts Magazine*, June 1987, pp. 84–85.

Gibson, Eric. "William Tucker's American Decade." *New Criterion*, September 1988, pp. 45–49.

Holst, Lise. "Mythopoeic Presences." *Art in America*, Spring 1989, pp. 231–33.

James Turrell

Adcock, Craig. *James Turrell: The Art of Light and Space*. Berkeley: University of California Press, 1990.

London. Hayward Gallery. *James Turrell, Air Mass*, 1993. Turrell interview with Mark Holborn.

Los Angeles. Museum of Contemporary Art. *Occluded Front, James Turrell*, 1985. Essays by Craig Adcock, John Coplans, Edy de Wilde, Craig Hodgetts, Count Giuseppe di Biumo, and Theodore Wolff, and Turrell interview with Julia Brown.

New York. Whitney Museum of American Art. *James Turrell: Light & Space*, 1980. Texts by Melinda Wortz and James Turrell.

Tucson, Ariz. University of Arizona Art Museum. *James Turrell: The Roden Crater Project*, 1986. Texts by Craig Adcock and John Russell.

Zurich. Turske & Turske Gallery, 1990. *James Turrell*, 1990. Texts by Oliver Wick, Jost Krippendorf, and James Turrell.

Adcock, Craig. "Light and Space at the Mendota Hotel: The Early Work of James Turrell." *Arts Magazine*, March 1987, pp. 48–55.

_____. "Perceptual Edges: The Psychology of James Turrell's Light and Space." *Arts Magazine*, February 1985, pp. 124–28.

_____. "Anticipating 19,084: James Turrell's *Roden Crater Project*." *Arts Magazine*, May 1984, pp. 76–85.

Failing, Patricia. "James Turrell's New Light on the Universe." *Art News*, April 1985, pp. 70–78.

Gopnik, Adam. "The Art World: Blue Skies." *New Yorker*, July 30, 1990, pp. 74–77.

Hammond, Pamela. "James Turrell: Light Itself," an interview. *Images and Issues*, Summer 1982, pp. 52–56.

Halbreich, Kathy, Lois Craig, and William Porter. "Powerful Places: An Interview with James Turrell." *Places* 1 (Fall 1983): 32–27.

Hapgood, Fred. "Roden's Eye." *Atlantic Monthly*, August 1987, pp. 46–52.

Larson, Kay. "Dividing the Light from the Darkness." *Artforum*, January 1981, pp. 30–33.

Marmer, Nancy. "James Turrell: The Art of Deception." *Art in America*, May 1981, pp. 89–98.

Ratcliff, Carter. "James Turrell's 'Deep Sky.'" *Print Collector's Newsletter*, May-June 1985, pp. 45–57.

Meyer Vaisman

Caracas. Centro Cultural Consolidada. *Meyer Vaisman: Obras Recientes*, 1993. Texts by Dan Cameron and Roberto Guevara.

Cologne. Jablonka Galerie. *Meyer Vaisman*, 1989. Text by Isabelle Grau.

London. Waddington Galleries. *Meyer Vaisman*, 1990. Text by James Lewis.

Cameron, Dan. "Spotlight: Meyer Vaisman: A Comedy of Ethics." *Flash Art* (Summer 1990): 137.

_____. "Who Is Meyer Vaisman?" *Arts Magazine*, February 1987, pp. 14–17.

Fairbrother, Trevor. "Meyer Vaisman and Andy Warhol: Inter/VIEW." *Parkett*, no. 24 (1990): 134–44.

Jones, Ronald. "Monkey Business; Francis, Meyer and Mary." *Artscribe*, May 1989, pp. 48–51.

Kent, Sarah. "On Meyer Vaisman." *Time Out* (London), November 1990, pp. 21–28.

Leigh, Christian. "Only When I Laugh: Bad Jokes and Joking Badly with Meyer Vaisman." *Bijutso Techo*, 1989, 143–59.

Lewis, Jim. "Meyer Vaisman." *Artstudio*, Winter 1991, pp. 128–37.

Andy Warhol

Bockris, Victor. *Warhol: The Biography*. London: Frederick Muller, 1989.

Bourdon, David. *Warhol*. New York: Harry N. Abrams, 1989.

Geldzahler, Henry, and Robert Rosenblum. *Andy Warhol: Portraits of the Seventies and Eighties*. London: Anthony d'Offay Gallery in association with Thames and Hudson, 1993. Additional texts by Vincent Fremont and Leon Paroissien.

Coplans, John. *Andy Warhol*. Greenwich, Conn.: New York Graphic Society, 1971.

Crone, Rainer. *Andy Warhol*. New York: Praeger Publishers, 1971.

Green, Samuel Adams. *Andy Warhol*. New York: Wittenborn, 1966.

Hackett, Pat. *The Andy Warhol Diaries*. New York: Simon and Schuster, 1989.

Koch, Stephen. *Stargazer: Andy Warhol's World and His Films*. New York: Praeger Publishers, 1973.

Kornbluth, Jesse. *Pre-Pop Warhol*. New York: Panache Press at Random House, 1988.

Ratcliff, Carter. *Andy Warhol*. New York: Abbeville Press, 1983.

Shanes, Eric. *Warhol: The Masterworks*. London: Studio Editions, 1991.

Smith, Patrick S. *Warhol: Conversations About the Artist*. Ann Arbor, Mich.: UMI Research Press, 1988.

_____. *Andy Warhol's Art and Films*. Ann Arbor, Mich.: UMI Research Press, 1986.

Stuckey, Charles. *Andy Warhol: Heaven and Hell Are Just One Breath Away! Late Paintings and Related Works, 1984–1986*. New York: Rizzoli, 1992. Foreword by Vincent Fremont and afterword by John Richardson.

Warhol, Andy. *America*. New York: Harper & Row, 1985.

_____. *The Philosophy of Andy Warhol (from A to B and Back Again)*. New York: Harcourt Brace Jovanovich, 1975.

Warhol, Andy, and Pat Hackett. *POPism: The Warhol Sixties*. New York: Harcourt Brace Jovanovich, 1980.

Boston. Institute of Contemporary Art. *Andy Warhol*, 1966. Text by Alan Solomon.

New York. Museum of Modern Art. *Andy Warhol: A Retrospective*, 1989. Texts by Kynaston McShine, Robert Rosenblum, Benjamin H. D. Buchloh, and Marco Livingston.

Pasadena, Calif. Pasadena Museum of Art. *Andy Warhol*, 1980. Texts by John Coplans, Jonas Mekas, and Calvin Tomkins.

Antin, David. "Warhol: The Silver Tenement." *Art News*, Summer 1966, pp. 47–49, 58–59.

Collins, Bradford R. "The Metaphysical Nosejob: The Remaking of Warhola, 1960–1968." *Arts Magazine*, February 1988, pp. 47–55.

Coplans, John. "Early Warhol: The Systematic Evolution of the Impersonal Style." *Artforum*, March 1970, pp. 52–59.

Danto, Arthur C. "Who Was Andy Warhol?" *Art News*, May 1987, pp. 128–32.

Deitch, Jeffrey. "The Warhol Product." *Art in America*, May 1980, pp. 9–13.

Gardner, Paul. "Gee, What's Happened to Andy Warhol?" *Art News*, November 1980, pp. 72–77.

Hughes, Robert. "The Rise of Andy Warhol." *New York Review of Books*, February 18, 1982, pp. 6–10.

Josephson, Mary. "The Medium as Cultural Artifact." *Art in America*, May-June 1971, pp. 40–46.

Leonard, John. "The Return of Andy Warhol." *New York Times Magazine*, November 10, 1968, pp. 32–33, 142–51.

McGuigan, Cathleen. "The Selling of Andy Warhol." *Newsweek*, April 18, 1988, pp. 58–64.

Marriner, Robin. "Missing Warhol." *Art Monthly*, October 1989, pp. 6–12.

Ratcliff, Carter. "Andy Warhol: Inflation Artist." *Artforum*, March 1985, pp. 69–75.

Schjeldahl, Peter. "Warhol and Class Content." *Art in America*, May 1980, pp. 112–19.

Taylor, John. "Andy's Empire: Big Money and Big Questions." *New York*, February 22, 1988, pp. 30–39.

Wallis, Brian. "Absolute Warhol." *Art in America*, March 1989, pp. 25–31.

"Andy Warhol, 1928–87: A Collage of Appreciations from the Artist's Colleagues, Critics, and Friends." *Art in America*, May 1987, pp. 137–43. Texts by Peter Schjeldahl, Philip Pearlstein, Lawrence Alloway, David Bourdon, Scott Burton, Kenneth E. Silver, Larry Rivers, John Coplans, Charles R. Stuckey, and Martin Filler.

William Wegman

Kunz, Martin, ed. *William Wegman: Paintings, Drawings, Photographs, Videotapes*. New York: Harry N. Abrams, 1990. Texts by Martin Kunz, Alain Sayag, Peter Schjeldahl, and Peter Weiermair.

Wegman, William, with Lawrence Wieder, *Man's Best Friend*. New York: Harry N. Abrams, 1982.

Minneapolis. Walker Art Center. *Wegman's World*, 1982. Texts by Lisa Lyons and Kim Levin.

Bear, Liza. "'Ray, Do You Want to . . .' Interview with William Wegman." *Avalanche*, Winter 1973, pp. 40–52.

Adams, Brooks. "Wegman Unleashed." *Art News*, January 1990, pp. 150–55.

Hempel, Amy. "William Wegman: The Artist and His Dog." *New York Times Magazine*, November 29, 1987, pp. 40–45.

Man Ray. "William Wegman: Man's Best Friend." *Camera Arts*, July-August 1981, pp. 76–83.

Lavin, Maud. "Notes on William Wegman." *Artforum*, March 1975, pp. 44–47.

Owens, Craig. "William Wegman's Psychoanalytic Vaudeville." *Art in America*, March 1983, pp. 101–109.

Robbins, D. A. "William Wegman's Pop Gun." *Arts Magazine*, March 1987, pp. 116–21.

Schjeldahl, Peter. "Le Wegman Nouveau." *Galeries Magazine*, February-March 1989, pp. 95–97, 138.

Trucco, Terry. "Man Ray's Best Friend." *Portfolio*, January-February 1982, pp. 24–28.

Wegman, William. "Shocked and Outraged as I Was, It

Was Nice Seeing You Again." *Avalanche*, Winter 1971, pp. 58–69.

Wegman, William, and Michael Smith, "The World of Photography." *Artforum*, October 1986, pp. 106–11.

Winer, Helene. "Scenarios/Documents/Images II." *Art in America*, May-June 1973, pp. 72–73.

Hannah Wilke

Frueh, Joanna. *Hannah Wilke: A Retrospective*. Columbia: University of Missouri Press, 1989. Statements by Hannah Wilke.

Iskin, Ruth. "Hannah Wilke: In Conversation with Ruth Iskin." *Visual Dialog* 2, no. 4 (1978): 17–20.

Savitt, Mark. "Hannah Wilke: The Pleasure Principle." *Arts*, September 1975, pp. 56–57.

Siegel, Judy. "Between the Censor and the Muse? Hannah Wilke: Censoring the Muse?" *Women Artists News*, Winter 1986, pp. 4, 46–48.

Jackie Winsor

Cincinnati. Contemporary Art Center. *Jackie Winsor/Sculpture*, 1976. Text by Jack Bolton and Winsor interview with Ellen Phalen.

New York. Museum of Modern Art. *Jackie Winsor*, 1979. Texts by Ellen H. Johnson, Jack Bolton and Kynaston McShine.

Milwaukee. Milwaukee Art Museum. *Jackie Winsor*, 1992. Texts by Peter Schjeldahl, Dean Sobel, and John Yau.

Baer, Lisa. "An Interview with Jackie Winsor." *Avalanche*, Spring 1972, pp. 10–17.

Gruen, John. "Jackie Winsor: Eloquence of a 'Yankee Pioneer.'" *Art News*, March 1979, pp. 57–60.

Lippard, Lucy R. "Jackie Winsor." *Artforum*, February 1974, pp. 202–09.

Terry Winters

London. Tate Gallery. *Terry Winters: Eight Paintings*, 1986. Text by Jeremy Lewison.

Lucerne, Switzerland. Kunstmuseum. *Terry Winters*, 1985. Texts by Klaus Kertess and Martin Kunz.

New York. Whitney Museum of American Art. *Terry Winters*, 1991. Text by Lisa Phillips.

Santa Barbara, Calif. University Art Museum, University of California. *Terry Winters: Paintings and Drawings*, 1987. Texts by Phyllis Plous and Christopher Knight.

Carlson, Prudence. "Terry Winters," an interview. *Galeries Magazine*, April-May 1987, pp. 74–79, 125.

_____. "Terry Winters' Earthly Anecdotes." *Artforum*, November 1984, pp. 65–68.

Cooke, Lynne. "Terry Winters' Poetic Conceits." *Artscribe International*, September-October 1986, pp. 62–64.

Holman, Bob. "Terry Winters." *Bomb*, Spring 1992, pp. 42–47.

Saltz, Jerry. "Terry Winters." *Tema Celeste*, May-June 1991, pp. 82–83.

Winters, Terry. "Waking Up and Warming Up." *Art News*, October 1992, pp. 114–17.

David Wojnarowicz

Wojnarowicz, David. *Close to the Knives*. New York: Vintage Books, 1991.

_____. *Sounds in the Distance*. London: Aloes Books, 1982. Foreword by William S. Burroughs.

Normal, Ill. University Galleries, Illinois State University. *David Wojnarowicz: Tongues of Flame*, 1990. Text by Barry Blinderman.

Deitcher, David. "Ideas and Emotions." *Artforum*, May 1989, pp. 122–27.

Lippard, Lucy R. "Out of the Safety Zone." *Art in America*, December 1990, pp. 130–39, 182, 186.

Rose, Matthew. "David Wojnarowicz: An Interview." *Arts Magazine*, May 1987, pp. 60–65.

Wojnarowicz, David. "Living Close to Knives, A Chapter from Self-Portrait in 23 Rounds: A Psychic Walkabout." *Journal of Contemporary Art* (Fall-Winter 1988): 68–84.

Robert Zakanitch

New York. Jason McCoy Gallery. *Robert Rahway Zakanitch: Big Bungalow Suite*, 1994. Text by Brooks Adams.

Philadelphia. Institute of Contemporary Art, University of Pennsylvania. *Robert S. Zakanitch*, 1981. Text by Janet Kardon.

Gallati, Barbara. "Robert S. Zakanitch." *Arts Magazine*, June 1981, pp. 125–27.

Perreault, John. "The Cultivated Canvas." *Art in America*, March 1982, pp. 96–101.

Elyn Zimmerman

Treib, Mark. "Place; Public; Perception; Presence: The Work of Elyn Zimmerman." *Elyn Zimmerman: A Decade of Projects*. New York: Rembrandt Press, 1988.

Chicago. Museum of Contemporary Art. *Options I: Elyn Zimmerman*, 1979. Text by John Neff.

New York. Gagosian Gallery. *Elyn Zimmerman*, 1996. Zimmerman interview with Robert Pincus-Witten.

_____. *Elyn Zimmerman*, 1993. Text by Sasha M. Newman.

Omaha. Joslyn Art Museum. *Elyn Zimmerman: Images of the City: Photographs and Sculpture*, 1985. Text by Holliday T. Day.

Tampa, Fla. Contemporary Art Museum, University of South Florida. *Elyn Zimmerman*, 1991. Texts by John Beardsley and Elyn Zimmerman.

Yonkers, N.Y. Hudson River Museum. *Palisades Project & Related Works*, 1982. Text by Charles Stuckey.

Feinberg, Jean E. "Terrain: Elyn Zimmerman's Garden Courtyard." *Landscape Architecture*, March-April 1988, pp. 84–88.

Gopnik, Adam. "Marabar." *Arts Magazine*, October 1984, pp. 78–79.

Tsai, Eugenie. "Elyn Zimmerman: Palisades." *Arts Magazine*, April 1982, pp. 138–39.

Varnedoe, Kirk. "Site Lines: Recent Work by Elyn Zimmerman." *Arts Magazine*, December 1978, pp. 154–55.

Joe Zucker

Baltimore. Baltimore Museum of Art. *Joe Zucker*, 1976. Text and Zucker interview by Brenda Richardson.

Buffalo, N.Y. Albright-Knox Art Gallery. *Surfacing Images: The Paintings of Joe Zucker, 1969–1982*, 1982. Text by Susan Krane.

Cologne. Aurel Scheibler. *Joe Zucker: Peg Men, Rubber Band Men*, 1991. Text by Klaus Kertess.

New York. Hirschl & Adler. *Joe Zucker*, 1989. Text by John Yau.

_____. *Joe Zucker*, 1987. Text by Lisa Liebman.

New York. Queens Museum. *Paintings by Joe Zucker*, 1985. Texts by Carolyn Fireside, Manuel E. Gonzales, and Ileen Sheppard.

Finch, Christopher. "Joe Zucker: The Fabric of the Painting." *Arts Magazine*, April 1976, pp. 97–99.

INDEX

Abakanowicz, Magdalena, 536–541
Abe, Shuya, 52
Ablutions (Chicago, Rahmani, Orgel, and Lacy), 128–129
Abs, Josef, 404
abstract expressionism, xxi– xxiii, 146–147, 168, 351
 American neoexpressionism and, 260, 268
 architectural sculpture of, 186
 East Village art and, 474
 German neoexpressionism and, 296, 306–307
 new image painting and, 194, 196–198
Abstract Paintings (Richter), 307–308
Accelerator for Evil Thoughts (Oppenheim), 44
Accession (Hesse), 30
Acconci, Vito, 17, 341, 396
 and art world of 1970s, 215
 deconstruction art and, 416
 feminism and, 124
 media art and, 325
 postminimalism and, 23, 35–40, 46–47, 50, 52–53, 70
Adam and Eve (Picabia), 285
Adelaide (Kiefer), 313
Adoration/Adornment (Smyth), 151
African art, 156, 310, 334
 East Village art and, 467–469
 new image painting and, 204–206
Africano, Nicholas, 198–199, 202–204, 217
Afrum (Turrell), 170
"After Abstract Expressionism" (Greenberg), 1
After Walker Evans: 7 (Levine), 387
Age of Catastrophe (Morley), 258
"Age of Mechanical Reproduction" (Benjamin), 388
Age Piece (Borofsky), 209
Ainslie, Michael, 426
Air Time (Acconci), 38
Albers, Joseph, 505
Albright-Knox Art Gallery, 212, 218
"Allegorical Impulse" (Owens), 343, 357–358
Allthorpe-Guyton, Marjorie, 50
Alsop, Joseph, xxii
American Art of the 1960s (Sandler), xxiii, xxv, 214
American Fine Arts gallery, 507
American neoexpressionism, 222–280, 452
 Applebroog and, 229, 251–254
 Bartlett and, 229, 247–248, 265–266, 268
 Bleckner and, 229, 260–263
 commodity art and, 482, 494
 diversity of, 229
 East Village art and, 461, 469, 517
 expressionism and, 223, 226–229, 248, 257–260, 269–270
 Fischl and, 222–224, 228–229, 236, 240–245, 248
 Golub and, 229, 252, 254–257
 Gornik and, 268–269
 Guston and, 229–230, 252, 260, 268
 historical influences on, 223
 Jensen and, 229, 268–270
 and Komar & Melamid, 229, 263–265
 Longo and, 229, 244–248
 Morley and, 229, 257–260
 Murray and, 222, 227–229, 241, 247–251
 neogeo and, 483
 new image painting and, 222, 224, 228, 230, 260, 265
 pitfalls of, 227
 Rothenberg and, 222, 229, 241, 248, 265–268
 Salle and, 222, 225, 227–229, 234–240, 248, 252, 260
 Schnabel and, 222, 226, 228–234, 236–238, 240, 246, 248, 260
 Scully and, 269–272
 Tucker and, 271–273
 von Rydingsvard and, 271–274
 Winters and, 268–269
American Painting of the 1970s, 212, 218
American Soldier, An, 244
Amerika (Tim Rollins + K.O.S.), 478–479
Ammann, Jean-Christophe, 282, 447
Ammann, Thomas, 216, 282
Anasta (Abakanowicz), 541
Andersen, Troels, 89
Anderson, Laurie, 35, 360, 416–419, 536, 548
and/or, 218
Andre, Carl, 2, 15, 98, 179, 341, 385, 433
Angel of Mercy, The (Antin), 125–126
Animal Pyramid (Nauman), 34
Anselmo, Giovanni, 22, 102
"Anti-Form" (Morris), 21
Antin, David, 4
Antin, Eleanor, 124–126
A-One gallery, 474, 516
Applebroog, Ida, 360, 445, 464
American neoexpressionism and, 229, 251–254
Appleyard, Bryan, 244
Arbus, Diane, 325
Architectural Digest, 426
architectural sculpture, 164–193
 Armajani and, 164, 172–174, 177, 189–190
 and art world of 1970s, 217
 Aycock and, 164, 175–177
 Burton and, 164, 182–185, 189–190
 Calder and, 187–188
 Christo and, 165–168
 Dennis and, 164–165, 174–175, 177, 185
 Ferrara and, 164, 178, 189
 Irwin and, 166, 168–171, 179
 Jeanne-Claude and, 166–168
 landmarks and, 186
 Miss and, 164, 174–175, 185, 189–191
 as public art, 185–191
 Serra and, 187–190
 Simonds and, 181–182
 Smithson and, 165, 179
 sources of, 164–166
 Turrell and, 166, 169–172, 179
 Zimmerman and, 164, 179–180
Architectural Sculpture (periodical), 217
architecture, 105, 230
 feminism and, 132
 international style of, 5, 69, 143, 505
 modernist vs. postmodernist, 5
 neogeo and, 505
 and pattern and decoration painting, 143, 145, 148, 150–151
 postminimalism and, 58, 67–70
 postmodernist art theory and, 339, 344, 365–367
Argument, An (Africano), 203
Armajani, Siah, 445
 architectural sculpture and, 164, 172–174, 177, 189–190
 public art and, 189–190
Armstrong, Richard, 445, 518–519
 and art world in first half of 1980s, 440, 443
Arp, Jean, 248, 390, 495
art and artists:
 as accidental, 240
 achieving recognition in, 214–215, 220
 -as-action, 89
 for the ages, 29
 alienation of, 13–16, 50, 186
 art as, 7, 9
 for art's sake, 2–3

art and artists *(cont.)*
 attempts to inflate reputations of, xxiv
 in becoming interdisciplinary, 72
 careerism in, 428–429, 440, 465, 486
 -as-commodity, xxiv, 12–13, 16, 50, 54, 62, 94–95, 97, 100, 102, 104, 225, 283, 302, 321, 353, 375, 384, 388, 390, 393, 427–428, 437–438, 441, 465, 485–488, 490, 492–493, 498, 507, 515, 519, 545, 549
 conception-as-, 71–72
 -as-creator, xxvi–xxvii, 342, 358
 decline of, xxii–xxiii
 -as-documentation, 12, 60
 end of, 506
 as expression of personality, 100
 forming judgments on, xxi–xxiv
 gap between life and, 6
 identifying tendencies in, xxv–xxvi
 immortality of, 168
 intentions in, xxvi–xxvii
 limits of, 7
 of location, 22
 of marginalized groups, 523–524
 materiality of, xxv
 as meeting places, 39
 misuse of, xxvii
 museum-as-frame-of-, 93–94
 negative and perverting influence on, xxiii–xxiv
 -as-nomad, 168
 -as-object, xxv, 10–12, 14, 56, 62, 104–105, 453
 as pathetic entertainer, 210
 in relation to art establishment, 43
 situation of, 23
 as source of exquisite sensations, 100
 specialness of, 233
 as stimulating, xxiii
Art & Auction, 426, 433
Art and Culture (Greenberg), 23–24
"Art and Objecthood" (Fried), 10
Art and Social Change, U.S.A., 455
Art and Technology show, 118, 169, 179
Art as Experience (Dewey), 174
Artaud, Antonin, 50, 130, 136, 233
art deco, 148–150, 486
arte povera, 22, 27, 281, 528
 and art world in first half of 1980s, 445–446
 and art world in 1970s, 215
 and European art after 1968, 87, 102–110
 transavantguardia and, 287–289, 291–292

Artforum, 60, 77, 103, 142, 350, 435–436, 454, 517, 541
 and art world in 1970s, 214
 commodity art and, 486
 consumer society and, 377
 feminism and, 128, 138
 postmodernist art theory and, 334–335, 354, 367
Art in America, 138, 216–217, 335, 435, 454, 517
"Art Is a Political Act" (Kozloff and Coplans), 335
Artist Is Not Merely a Slavish Announcer, An (Baldessari), 73
Artists Space, 218–219, 416, 420
 East Village art and, 461
 Pictures show at, 319, 325, 332, 379–380, 420, 453–454
 Witnesses show at, 551–552
Art News, 103, 426–427, 435–436, 446
Art of Bridgemaking #3, The (Armajani), 172
Art of Our Time, 432
Artschwager, Richard, 183, 491
 commodity art and, 483–484
 new image painting and, 195
Art Workers Coalition (AWC), 14–16, 114, 117
Art World Follies, 1981 (Krauss), 342
As Boring as Possible (Paik), 51
Ashbery, John, 365
Asparagus Still Life (Manet), 404
Aspects of International Art from the Early Seventies, 215
Attempt to Raise Hell (Oppenheim), 44–45
At the Bathers' Pool (Colescott), 206
Augeri, Lynne, 462
Au Moulin de la Galette (Renoir), 549
Auschwitz (Beuys), 89
Auto-Polaroids (Samaras), 46–47
Auvers-sur-Oise (Colescott), 206–207
"Avant-Garde and Kitsch" (Greenberg), 3, 5–6
Aycock, Alice, 67, 217, 344
 architectural sculpture and, 164, 175–177

Bad Boy (Fischl), 242–243
Bad Dream House #2 (Acconci), 39
Baer, Josh, 477
Baker, Elizabeth C., 54, 87, 100, 229, 435
Baker, Kenneth, 307–308, 438
Bakst, Leon, 143, 153–154
Baldessari, John, 12, 70
 and art of marginalized groups, 544–545

 and art world in first half of 1980s, 442, 444, 452–453
 and art world in 1970s, 215
 conceptual art and, 72–74
 deconstruction art and, 390
 media art and, 322–325
 postmodernist art theory and, 332, 354
Ball, Edward, 492
Baltimore Federal (Sugarman), 144
Banality Show, The (Koons), 497, 499, 518
Bannard, Walter Darby, 2
Barr, Alfred H., 362, 444–445
Barrie, Dennis, 551–552
Barry, Robert, 12, 395
Barthelme, Donald, 365
Barthes, Roland, xxvi, 454, 545
 deconstruction art and, 386
 postmodernist art theory and, 332, 336, 338–339, 358
Bartlett, Jennifer, 217, 360
 American neoexpressionism and, 229, 247–248, 265–266, 268
 new image painting and, 198–199, 207–208
Basel Art Fair, 216, 446
Baselitz, Georg, 222
 and art world in first half of 1980s, 446–450
 German neoexpressionism and, 281, 294–295, 297, 309–310
Basquiat, Jean Michel, 234
 and art world in first half of 1980s, 431, 445
 East Village art and, 466–469, 475–476, 514–516
Battcock, Gregory, 15
Battery Park, N.Y.:
 Miss's installation in, 174
 public art in, 190–191
Baudrillard, Jean, 332, 362, 377–379, 486, 505
 commodity art and, 484
 deconstruction art and, 378–379
 neogeo and, 484
Bauhaus, 8, 183–184, 298, 504
Bauruma, Ian, 299–300
Bayonne Rock Gardens (Komar & Melamid), 265
Baziotes, William, 268
Bear, 516
Beauty Is in the Eye of the Beholder (Colescott), 206
Beckmann, Max, 285
Beckwourth, Jim, 528–529
Beeren, Wim, 215
Beginner (Murray), 248
Belcher, Alan, 514
Belgium, art after 1968 in, 87, 93–98

Bell, Daniel, 377
Bell, Larry, 22, 58
Bender, Gretchen, 226–227
Benglis, Lynda, 128, 152–153, 159, 214, 360
Benjamin, Walter, 306, 388, 512
 postmodernist art theory and, 346–348
Bercovitch, Jacob, 340
Berlin, *Zeitgeist* show in, 210, 282, 298
Berman, Avis, 244
Bernard, Christian, 451
Beulahland (Applebroog), 254
Beuys, Joseph, 22, 27, 168, 281, 528
 and art of marginalized groups, 536
 and art world in first half of 1980s, 450–451
 and art world in 1970s, 215
 and criticisms of U.S. art, 283–284
 deconstruction art and, 390
 East Village art and, 477–478
 and European art after 1968, 87–93, 95, 98, 102, 104, 107–108, 110
 feminism and, 129–130
 German neoexpressionism and, 296–297, 301, 311–312
 Schnabel and, 230
"Beyond Objects" (Morris), 21–22
Bickerton, Ashley:
 commodity art and, 482–483, 487–490, 507
 East Village art and, 516–517
Bierstadt, Albert, 62
Big Wheel, The (Burden), 43
Bird in Space (Brancusi), 202
Bird of Paradise (Basquiat), 469
Birnbaum, Dara, 463
Birth (Simonds), 182
Birthday Boy (Fischl), 243
Bischofberger, Bruno, 282, 431
blacks, 244, 547, 550–551
 art of, 523–529, 532, 536
 AWC and, 15
 commodity art and, 495
 East Village art and, 466–470, 477–478
 feminism and, 135–136
 new image painting and, 204–206
 postmodernist art theory and, 334, 337
 stereotyping of, 205
Blasted Allegories (Baldessari), 322–323
Bleckner, Ross, 483, 512
 American neoexpressionism and, 229, 260–263
Blinks (Acconci), 36

Blistène, Bernard, 306
Block, René, 448
Bloom, Harold, 224
Blue U-Turn (Rothenberg), 267
Blum, Irving, 432
Boats (Bartlett), 266
Bodark Arc (Puryear), 529
Bode, Arnold, 296
body art, 345
 American neoexpressionism and, 236, 241, 267
 architectural sculpture and, 165, 183
 deconstruction art and, 384, 412
 and European art after 1968, 102–103
 feminism and, 125–128, 137
 postminimalism and, 11, 23–24, 31–38, 40–41, 44, 47, 50, 52–53, 70
body images, feminism and, 115, 122, 131–132, 134
Body Print (Kelley), 502
Boetti, Alighiero, 102
Bogosian, Eric, 244, 444, 536
 deconstruction art and, 416, 419
 East Village art and, 462
Boltanski, Christian, 215, 536–538
Bone Heads (Rothenberg), 267
Boone, Mary, 517
 and art world in first half of 1980s, 429, 431–432, 435, 440–442, 446, 447
 deconstruction art and, 390, 393–395
 East Village art scene, 513, 516–517
 Schnabel's paintings at, 230
Borofsky, Jonathan, 241, 282
 and art world in first half of 1980s, 445, 448
 new image painting and, 208–212
Bouncing Two Balls between the Floor and the Ceiling with Changing Rhythms (Nauman), 31
Bound Grid (Winsor), 29–30
Bound Square (Winsor), 29
Bourdon, David, 334
Bourgeois, Louise, 116, 120–124, 360
Brach, Paul, 452
Brancusi, Constantin, 183–184, 202, 390, 495
Brauntuch, Troy, 319–320
Brenson, Michael, 482
 on American neoexpressionism, 273–274
 and art of marginalized groups, 538

and art world in first half of 1980s, 443, 450
Bressler, Martin, 146
Breton, André, 285
Brody, Sherry, 146
Broken Circle/Spiral Hill (Smithson), 61
Broodthaers, Marcel, 362, 375
 and art world of 1970s, 215
 deconstruction art and, 401, 406
 and European art after 1968, 87, 93–98, 110
Brooklyn Museum, 117, 444, 469
Brooks, Diana, 426
Brooks, Peter, 366
Brooks, Rosetta, 136, 256, 326
Bruch der Gefässe (Kiefer), 314
Buchloh, Benjamin, 224, 309
 and art world in first half of 1980s, 453
 postmodernist art theory and, 335, 342–343, 352, 354, 362
Buck, Robert, 444
Buffalo subway station, Kozloff's installation in, 149–150
Bunting, Basil, 108
Burden, Chris, 17, 462
 postminimalism and, 40–47, 50, 52–53
Buren, Daniel, 341, 351–352, 354, 375
 and art world of 1970s, 215
 deconstruction art and, 376, 401, 404, 406
 and European art after 1968, 87, 98–102, 110
 postmodernist art theory and, 362–363
Burgin, Victor, 357
 deconstruction art and, 400–402
 media art and, 321
Burri, Alberto, 102
Burton, Scott, 445
 architectural sculpture and, 164, 182–185, 189–190
Butterfly (Rothenberg), 201
Byrne, David, 384
B.Z., 330

Cadillac/Chopsticks (Moskowitz), 202
Café Deutschland-III (Immendorff), 311–312
Cage (Bleckner), 260
Cage, John, 50–51, 74, 365
Calder, Alexander, 159, 187–188
California Institute of the Arts (CalArts), 118, 236, 240–241, 325, 452–453, 487–488
Calzolari, Pier Paolo, 102
Cameron, Dan, 440, 454, 518

Cameron, Dan *(cont.)*
 and art world in first half of 1980s,
 433–434
 commodity art and, 491
Cammitzer, Luis, 531
Camp (Polke), 303
Cantileve (Graves), 79
Caravaggio, Michelangelo Merisi,
 230–232, 234
Carlson, Cynthia, 150
Caro, Anthony, 62, 64
Carrier, David, 383
casa del giardiniere, La (Merz), 106
Castelli, Leo, 516
 and art world in first half of 1980s,
 428–429, 431–432
 and art world in 1970s, 214–215,
 218
Castelli Galleries, 429
 9 in a Warehouse show at, 22–23,
 26–27, 53, 214
Casting (Serra), 53
Cathcart, Linda, 212, 218
Caute, David, 86, 92–93
Ceci n'est pas une pipe (Magritte),
 95–96
Celant, Germano, 87, 288, 454
 on arte povera, 102–105
 commodity art and, 486, 493
Centre Pompidou, 284, 288
Cézanne, 349–350
Cézanne, Paul, 270, 357
Chagall, Marc, 285, 292
Champaigne, Philippe de, 511–512
Chandler, John, 70
Charles the First (Basquiat), 469
Charlesworth, Sarah, 546
Chave, Anna C., 29
Chia, Sandro, 222, 517
 and art world in first half of 1980s,
 432, 442, 446–447
 transavantguardia and, 281,
 287–289, 292–294
Chicago, Judy, 7, 400, 452
 feminism and, 115, 118–119, 124,
 128–129, 132–134
 and pattern and decoration paint-
 ing, 141, 145
 postmodernist art theory and,
 359–360
Child, Susan, 191
Choosing (Baldessari), 74
Chris Burden Deluxe Book (Burden),
 41
Christie's, 385, 427, 519
Christmas Tree (Morley), 258
Christo, 70, 94, 215, 344
 architectural sculpture and,
 165–168
Christov-Bakargiev, Carolyn, 103–104

Cincinnati Art Center, 551–552
Circuit (Serra), 56
City of Dreams (Daze, Daze), 474
Claim (Acconci), 36–37
Clark, Ron, 453
classicism, 293–294
Clemente, Francesco, 1, 222, 544
 and art world in first half of 1980s,
 430, 432, 446–447
 East Village art scene and, 515
 transavantguardia and, 281,
 287–293
Clocktower, 218–219
Close, Chuck, 195
Close-Up (Guston), 197
Clown Taking a Shit (Nauman), 34
Codex Artaud (Spero), 136
Cold War Zeitgeist, 462–463
Colescott, Robert, 195, 204–207
Collaborative Projects, Inc. (Colab),
 463, 465
combine-paintings, 230
*Coming of Post-Industrial Society,
 The* (Bell), 377
Commissioned Paintings
 (Baldessari), 73–74
commodity art, xxv, 482–503
 and art of marginalized groups,
 528
 and art world in late 1980s and
 1990s, 547
 Bickerton and, 482–483, 487–490,
 507
 East Village art and, 482, 494,
 516–518
 influences of, 484
 Kelley and, 500–503
 Koons and, 482–483, 493–500
 neogeo and, 483, 503, 507
 postminimalism and, 22
 Steinbach and, 482–483, 491–493,
 500, 507
 Vaisman and, 482–484, 490–491
 Warhol and, 482, 484–486,
 490–491, 493–494, 497–499
"Complexes" (Lippard), 217
*Complexity and Contradiction in
 Architecture* (Venturi), 5
Composition 3 (Mariani), 295
conceptual art, xxv–xxvi, 142, 281,
 303
 American neoexpressionism and,
 223, 225, 229, 234, 236, 238, 244
 and art world in first half of 1980s,
 441, 449, 452
 and art world in 1970s, 215
 and attacks on art-as-object, 11–12
 and commodification of art, 12
 commodity art and, 483, 487–489
 and criticisms of U.S. art, 284

deconstruction art and, 384, 386,
 395, 397, 400, 412, 416
 and European art after 1968, 95,
 100
 media art and, 322, 325, 330
 new image painting and, 194,
 199–200, 203–204, 207–209
 postminimalism and, 11–12,
 23–26, 32–33, 35, 59, 62, 65,
 70–74
 postmodernist art theory and, 338,
 345, 349, 351, 353–354, 361
 purpose of, 72
 rationales for, 71
 transavantguardia and, 288
*Concerning Diachronic/Synchronic
 Time* (Baldessari), 322
construction art, 62, 143, 161, 533
constructivism, 3–4
 architectural sculpture and, 173,
 183–184
 deconstruction art and, 399–400
 neogeo and, 504
 postmodernist art theory and, 336,
 366
 rationales of, 4
consumer society, 375–380, 428
 and art world in first half of 1980s,
 433–434, 452
 and art world in late 1980s and
 1990s, 545, 547–548
 commodity art and, 482–486,
 490–493, 498, 502
 deconstruction art and, 376,
 378–380, 383, 385–386, 391,
 394, 411–413
 East Village art and, 465, 515
 emergence of, 375–376
 marketing images in, 378–379
 media art and, 320–321, 325
 neogeo and, 483–484, 486, 507
Cooke, Lynne, 209, 227, 553
Cooney, Patrick, 426
Cooper, Paula, 218, 432
Paula Cooper Gallery, 71, 75,
 208–209, 211, 217
Coplans, John, 334–335, 534–535
Cornfield with Crows (Morley),
 257–258
Corporate Wars (Longo), 246–247
Cortez, Diego, 223, 225, 465
Cotter, Holland, 492
Cottingham, Laura, 353
Counting from 1 to Infinity
 (Borofsky), 208
Cowles, Charles, 335
*Cradle of Civilization with American
 Woman* (Morley), 259
Cragg, Tony, 64–65
Cremation Piece (Baldessari), 74

Crimp, Douglas, 11, 56–57, 224
 and art world in first half of 1980s,
 453–454
 on Buren, 100
 deconstruction art and, 379–380,
 384–387, 392, 420
 media art and, 319–320
 postmodernist art theory and, 332,
 335, 343, 346, 351, 354,
 362–363
 on *Tilted Arc*, 188
Crucifixion (Starn Twins), 511
Cubi (Smith), 77
cubism, 70, 248
Cucchi, Enzo, 222
 and art world in first half of 1980s,
 446–447
 transavantguardia and, 281,
 287–288, 291–292
*Cultural Contradictions of
 Capitalism, The* (Bell), 377
Cutouts (Sherman), 409
Cutting Device (Serra), 55
C.V.J. (Schnabel), 429

dadaism, 3–4, 8, 362
 commodity art and, 502–503
 and European art after 1968, 88
 German neoexpressionism and,
 305, 311
 and influences on European
 artists, 286
 postminimalism and, 21, 35, 54
 rationales of, 4
Dada Painters and Poets, The
 Motherland), 35
Daddy's Girl (Fischl), 243
Dalí, Salvador, 430
Dallas–Fort Worth airport,
 Smithson's proposal of, 59–60
Damjanovic, Maja, 309
Dance, The (Matisse), 206
Dance Aesea (Daze, Daze), 476
Dancing on the Bridge (Surls), 275
Danieli, Fidel, 30
Dannemeyer, William, 551
Danto, Arthur, 238, 441–442, 548
Darrow, Whitney, 328
Davis, Brad, 216
Davis, Douglas, 27, 385, 420
Davis, Gene, 100
Day of Glory Has Come..., The
 (Polke), 303
Days End (Matta-Clark), 69
Daze, Daze, 474, 476
Deacon, Richard, 64
DeAk, Edit, 4, 217, 222, 291, 442
 East Village art and, 473, 475
Debord, Guy, 16, 376, 378
de Chirico, Giorgio, 198, 223

new European painters influenced
 by, 285–287
transavantguardia and, 289, 292
deconstruction and deconstruction
 art, xxv, 378–423
 American neoexpressionism and,
 228, 238, 247
 Anderson and, 416–419
 and art of marginalized groups,
 523
 and art world in first half of 1980s,
 431, 445, 452–455
 and art world in late 1980s and
 1990s, 544–546
 Bogosian and, 416, 419
 Burgin and, 400–402
 commodity art and, 482–484
 consumer society and, 376,
 378–380, 383, 385–386, 391,
 394, 411–413
 East Village art and, 518
 and European art after 1968, 93,
 95, 97–98, 100
 Gray and, 416, 419–420
 Haacke and, 376, 381, 383, 385,
 401–407
 Holzer and, 394–399
 Kelly and, 399–401
 Kruger and, 390–395
 Levine and, 386–390, 393
 media art and, 319, 321
 and misuse of art, xxvii
 opponents of, 381–382
 politics and, 379–386, 391–393,
 399, 401–403, 405, 412, 418
 postmodernist art theory and,
 337–343, 345–346, 353, 356–357,
 359–362, 366
 primary mission of, 383
 Sherman and, 408–413, 416
 Simmons and, 412–414, 416
 timelessness of, 384
 venues for, 382–384
 Wegman and, 414–416
"Decoration, Ornament, Pattern and
 Utility" (Burton), 164
Decors (Broodthaers), 96
Deep Station (Holt), 178
Deepwater (Pfaff), 159
Deitch, Jeffrey, xxiv, 100–101, 378
 and art world in first half of 1980s,
 426, 431, 434, 450
 commodity art and, 489
 East Village art and, 462–463, 471,
 517–518
 neogeo and, 505
Déjeuner sur L'Herbe, Le (Manet), 466
de Kooning, Willem, xxv, 78, 425
 new image painting and, 194, 197,
 204–205

DeLillo, Don, 1
Dell, Floyd, 336
de Maria, Nicola, 287–288
de Maria, Walter, 12, 344
"Dematerialization of Art, The"
 (Lippard and Chandler), 21
*Demonstration for Capitalist Realism,
 A*, 301–302
Dennis, Donna, 164–165, 174–175,
 177, 185
Derrida, Jacques, 319, 377, 380, 386,
 454, 545
 deconstruction art and, 386
 postmodernist art theory and, 332,
 336–337, 339, 362
Description of Table (Artschwager),
 483
Destruction of the Father, The
 (Bourgeois), 121, 123
Deutsche, Rosalyn, 363
Deux Plateaux, Les (Buren), 101
*Device for Detecting, Entering, and
 Converting Past Lies Traveling
 Underground and in the Air, A*
 (Oppenheim), 44
Dewey, John, 174
Dibbets, Jan, 102–103
Dickstein, Morris, 339–340
Dictionary for Building (Armajani),
 173
Dimen, Muriel, 126–128
Dine, Jim, 35
Dinner Party, The (Chicago),
 132–134, 400
Disasters (Warhol), 309
Documenta shows, 215, 282, 296,
 299–300, 352, 448, 451, 516
D'Offay, Anthony, 431
Dollhouse (Shapiro and Brody), 146
Double Negative (Heizer), 22
Double Self-Portrait (Komar &
 Melamid), 263
Double Steel Cage Piece (Nauman),
 32
Double White Map (Johns), 220
Douglas, Kirk, 233
Dove, Arthur, 241, 268–269, 388
Dove of Tanna (Stella), 145
Dowd, Maureen, 514
Duchamp, Marcel, 2, 6, 35, 528
 architectural sculpture and, 177,
 183–184
 and art world in late 1980s and
 1990s, 546–547
 Borofsky and, 210
 commodity art and, 482, 491, 493,
 497
 conceptual art and, 70, 74
 deconstruction art and, 386,
 388–390

Duchamp, Marcel (cont.)
 and European art after 1968,
 92–94, 96, 98, 101
 feminism and, 126
 media art and, 321
 neogeo and, 512
 new European artists influenced
 by, 286
 new image painting and, 210
 postminimalism and, 44, 50
 postmodernist art theory and, 347,
 357, 362
 transavantguardia and, 294
Duchow, Achim, 303
Dufy, Raoul, 154
Dumb Luck (Puryear), 530
Durham, Jimmy, 530–531
Dwellings (Simonds), 181–182

Eagleton, Terry, 340
earth art, xxv, 2, 165, 441
 postminimalism and, 11, 22–25,
 60–66, 70, 78
 postmodernist art theory and, 345,
 349
 transavantguardia and, 288
 urban counterpart to, 66–70
East Village art and art scene, 363,
 461–481, 513–519
 and art world in first half of 1980s,
 454
 and Basquiat, 466–469, 475–476,
 514–516
 clubs in, 513–515
 and commodity art, 482, 494,
 516–518
 eclipse of, 516
 and Haring, 466, 470–472,
 475–477, 513–516
 and K.O.S., 477–479
 and Scharf, 466, 472–473,
 475–477, 513–514, 516, 518
 The Times Square Show and, 320,
 463–465, 473–474, 516
 wild style in, 474–475, 477
EAT/DEATH (Nauman), 33
Eat Them Taters (Colescott),
 204–205
Eckstut, Stanton, 191
Edelman, Asher, 433
Edelson, Gilbert S., 552
Edelson, Mary Beth, 130
Edwards, Melvin, 528–529
Eight Contemporary Artists (Licht),
 87
Einstein on the Beach (Glass and
 Wilson), 417–418
Ellis, Stephen, 307, 508
Ellora, India, cave temples in,
 179–180

Embarkation of the Doge on the
 Bucintoro, The (Guardi), 258
Emetic Fields (Applebroog), 254
Emmen, the Netherlands,
 Smithson's land reclamation
 project in, 61
Empty Places (Anderson), 419
"End of Painting, The" (Crimp), 224,
 351
Equator (Gornik), 271
Equi, Elaine, 411
Equilibrium (Koons), 494–495
Es Possible (Pfaff), 161
Estes, Richard, 195
Étude for Pianoforte (Paik), 50
Eurasia (Beuys), 89
European art, xxvi, 86–113
Evans, Walker, 347, 386, 388
Exit (Buren), 99
Exotic Bird Series (Stella), 145
expressionism, 282, 287
 American neoexpressionism and,
 223, 226–229, 248, 257–260,
 269–270
 and art world in first half of 1980s,
 448
 commodity art and, 489, 499
 deconstruction art and, 395
 East Village art and, 469
 German neoexpressionism and,
 297–299, 306–308
 neogeo and, 509
 new image painting and, 194,
 196–199, 201, 205–206, 209
 and pattern and decoration paint-
 ing, 146–147
 postminimalism and, 21
 postmodernist art theory and,
 352
Extended Armour (Oppenheim), 44
Eye Body (Schneemann), 130–131
Eyes in the Heat (Pollock), 274

Face of the Earth (Acconci), 39
Factories (Oppenheim), 44
Factum 1 (Rauschenberg), 226
Fallen Object (Bleckner), 262
False Start (Johns), 519
Fashion Moda, 516
Fassbinder, Rainer Werner, 244
Fat Chair (Beuys), 89
Faust, Wolfgang Max, 284, 297
Feaver, William, 448–449
Federal Plaza, Manhattan, Serra's
 sculpture in, 187–189
Feet of Clay (Nauman), 31
Felt (Morris), 26
feminism, 18, 428
 American neoexpressionism and,
 229, 239, 250

Antin and, 124–126
 architectural sculpture and, 164,
 175–177
 and art of marginalized groups,
 524, 536
 and art world in first half of 1980s,
 445, 452
 and art world in late 1980s and
 1990s, 551
 and art world in 1970s, 215–216,
 218
 Bourgeois and, 116, 120–124
 in celebrating Great Goddess,
 130–133
 Chicago and, 115, 118–119, 124,
 128–129, 132–134
 cooperative mission of, 116–117,
 133
 decline of, 138
 deconstruction art and, 391,
 393–395, 399–400, 406, 409–412
 essentialist, 115–116, 134, 177,
 359–360, 399–400
 first-generation, 114–141,
 359–360, 399
 first major historical survey of,
 117
 heroines of, 120–124
 Hesse and, 116, 120–121
 iconography and, 115–116, 128
 installation art and, 132–134
 Lacy and, 114, 116, 128–130
 legitimization of, 115
 materials and, 114–116, 121, 131,
 137
 new image painting and, 206
 and pattern and decoration paint-
 ing, 141, 145–147
 postminimalism and, 29–30, 117
 postmodernist art theory and, 334,
 337, 339, 353, 359–361, 366
 proliferation of, 137
 purpose of, 117
 in quest for subject and content,
 116, 118
 Schneemann and, 130–132
 second-generation, 359–361, 400
 sex and, 115–117, 120–121,
 125–128, 131–134, 136
 Spero and, 132, 134–137
 Wilding and, 120, 124–125
 Wilke and, 125–128
Ferguson, Bruce, 241
Ferrara, Jackie, 164, 178, 189
Festum Fluxorum Fluxus, 88
Fibonacci number system, 105–106
Fiedler, Leslie, 14
"Figures of Authority" (Buchloh),
 343, 352
Fillette (Little Girl) (Bourgeois), 121

"Fine Art of Gentrification, The"
(Deutsche and Ryan), 363
Fireworks (Oppenheim), 44–46
First Fan (Schapiro), 147
Fischer, Konrad, 301–302
Fischl, Eric, 325, 342, 544
American neoexpressionism and,
222–224, 228–229, 236, 240–245,
248
and art world in first half of 1980s,
436, 445, 441, 452
East Village art and, 465, 515
on narrative development,
242–243
Five-Day Locker Piece (Burden),
40–42
Fix (Ryman), 25
Flam, Jack, 313–315
Flash Art, xxvi, 287–288, 446–447,
517
Flavin, Dan, 2, 493
fluxus, 13, 35, 50–51, 74, 88, 281,
452
Fontana, Lucio, 102
Fooling with Your Hair (Salle), 238
Foote, Nancy, 24
For Paul (von Rydingsvard), 274
Foster, Hal, 454, 523
on American neoexpressionism,
224, 226
deconstruction art and, 387, 408
postmodernist art theory and, 335,
342, 354, 361
Foucault, Michel, 332, 454, 505, 545
Four Corners (Winsor), 30
Four Intruders Plus Alarm System
(Piper), 526
4 Kinds (Rothenberg), 268
France, 303, 448
art after 1968 in, 86–87, 94,
98–102
Francis, Mark, 542, 553
Frank, Patrick, 382
Frank, Peter, 513
Frankenthaler, Helen, 152
Freud, Sigmund, 243, 358
Fried, Michael, 2, 10–11, 23, 344
Friedberg, M. Paul, 190
Frohnmeyer, John, 552
From Hand to Mouth (Nauman), 31
From the Center (Lippard), 359
Fruit of Thy Loins (Kelley), 501
Fuchs, Rudi, 313
and art world in first half of 1980s,
447, 449
East Village art and, 516
German neoexpressionism and,
295–300
U.S. art criticized by, 282, 284
Fulton, Hamish, 344

Fuses (Schneemann), 131–132
Futura 2000 (Leonard McGurr), 476,
516

Gablik, Suzi, 429, 439–440
Gabo, Naum, 173
Gachnang, Johannes:
and art world in first half of 1980s,
447, 451
German neoexpressionism and,
295–296, 299–301
U.S. art criticized by, 282–284
Gagosian, Larry, 432, 438–439
Galleria Il Punto, 103
Galloway, David, 451
Gambrell, Jamey, 108–109
Garbage Wall (Matta-Clark), 66
Gaudí, Antonio, 230, 477
Geldzahler, Henry, 430, 515
Geller, Matthew, 463
General Services Administration
(GSA), 185–187, 189
*George Washington Carver Crossing
the Delaware* (Colescott), 205
Gericault's Arm (Salle), 237
German neoexpressionism, 110,
205–206, 260, 281–284, 287,
294–315
and art world in first half of 1980s,
447–452
Baselitz and, 281, 294–295, 297,
309–310
faux expressionism and, 295
Immendorff and, 281, 294–295,
297, 309, 311–312
Kiefer and, 281, 284, 294–295,
297, 299, 309, 311–315
Lüpertz and, 281, 294–295, 297
Penck and, 281, 284, 294–295, 297,
309–311
Polke and, 281, 294–297, 301–305,
308–309
Richter and, 281, 294–297,
301–302, 305–309
transavantguardia and, 291–292
Gesamtkunstwerk (Borofsky), 208
Giacometti, Alberto, 78, 238, 267,
538
Gigantomachies (Golub), 254
Gilbert & George, 375, 532
and art world of 1970s, 215
and postminimalism, 27, 47–50
Gilbert-Rolfe, Jeremy, 335, 382
Gintz, Claude, 303
Girl and Doll (Jenney), 199
Girouard, Tina, 216
Gladstone, Barbara, 432
Glass, Philip, 23, 417–418
Glastrinkerin (Baselitz), 310
Glier, Mike, 227

Glimcher, Arne, 432
Glueck, Grace, 478
God Save the Queen, 466
God's White Too (Applebroog),
252–254
Gohr, Siegfried, 451
Goldin, Amy, 334
and art world of 1970s, 216
on pattern and decoration paint-
ing, 141, 145–146, 152–153, 155
Goldin, Nan, 551
Gold Knots (Levine), 389
Goldstein, Jack, 319
Goldstein, Richard, 499
Golub, Leon, 465
American neoexpressionism and,
229, 252, 254–257
Gombrich, Ernst, 145
Goodman, Marion, 432
Goossen, E. C., 2
Gopnik, Adam, 6, 313, 546
commodity art and, 498–500
consumer society and, 486
deconstruction art and, 398
East Village art and, 469–470, 473,
477
on Turrell, 172
Gorky, Arshile, 268
Gorney, Jay, 516
Gornik, April, 268–269, 271
Grabbe, Christian Dietrich, 315
Grace and Original Sin (Lanigan-
Schmidt), 158
graffiti, 233, 445, 548
East Village art and, 464, 467–470,
472–479, 516
Graham, Dan, 69–70, 380
Grand Rapids, Mich., Calder's sculp-
ture in, 187
"Grand Rapids Queen Anne"
(Burton), 183
Gran Fury, 552–553
Graves, Nancy, 218, 360
and pattern and decoration paint-
ing, 142, 159
postminimalism and, 77–79, 110
Gray, Spalding, 244, 536
deconstruction art and, 416,
419–420
Gray Paintings (Richter), 305
Great Basin Desert, Utah, Holt's
sculpture in, 177–178
Green, Denise, 198
Greenberg, Clement, 1–8, 23–24
aesthetics of, 2–8, 10
criticisms of, 3–7
and end of avant-garde, 8
postmodernist art theory and,
333–334, 336, 341, 348
postmodernists' rejection of, 6–7

Green Coca-Cola Bottles (Warhol), 485

Greenspan, Stuart, 426, 433

Grey Art Gallery, 212, 218, 349

Grooms, Red, 35

Groot, Paul, 305

Grosz, George, 256

Group Material, 219–220, 377, 465, 477

Grundberg, Andy, 413, 439
 and art world in late 1980s and 1990s, 545–547

Guadalupe Meander, A Refugia for San Jose, The (Mayer and Harrison), 66

Guardi, Francesco, 258

Guerrilla Girls, 361, 363–364

Peggy Guggenheim Collection, 437

Solomon R. Guggenheim Museum, 106, 220
 Armajani's sculpture at, 173
 and art world in first half of 1980s, 437, 447
 feminism and, 121, 138
 Haacke's retrospective at, 402–403
 Holzer's works in, 399
 Italian Art Now show at, 447
 Refigured Painting show at, 451

Guilt and Innocence of Art, 405

Guston, Philip, xxi, 230, 286
 American neoexpressionism and, 229–230, 252, 260, 268
 new image painting and, 194, 196–198

Haacke, Hans, 13, 102, 341, 362, 375
 and art of marginalized groups, 544–545, 550
 deconstruction art and, 376, 381, 383, 385, 401–407

Hacklin, Allan, 452

Haftmann, Werner, 296

Halley, Peter, 228, 260, 330, 352, 544
 East Village art and, 516–517
 neogeo and, 482–484, 503–505, 508

Hammons, David, 6–7, 518, 547
 and art of marginalized groups, 526–528, 536

Hand Catching Lead (Serra), 35

Handy, Ellen, 117

Hang-Up (Hesse), 28–29

Hanhardt, John, 445

Haring, Keith:
 and art world in first half of 1980s, 430–431, 440, 445
 East Village art and, 466, 470–472, 475–477, 513–516

Harnett, William, 200

Harris, Ann Sutherland, 117

Harrison, Newton and Helen, 65–66

Hartley, Marsden, 241, 269

Haskell, Barbara, 220, 445

Hassan, Ihab, 11

Headrack (Mariani), 294

Heartfield, John, 391

Heartney, Eleanor, 445, 489, 519

Heizer, Michael, 22

Held, Al, xxiv, 159

Helen's Vest (Shea), 165

Helman, Joe, 432

Helms, Jesse, 551–552

Helmsboro Country (Haacke), 406–407

Hennessy, Richard, 350

Herriman, George, 196

Herron, Mary, 474

Hertz, Richard, 352

Hess, Elizabeth, 553–554

Hesse, Eva, 17, 102, 360
 and art world of 1970s, 214–215
 feminism and, 116, 120–121
 postminimalism and, 22, 27–31

Hieferman, Marvin, 321

Higher Goals (Hammons), 527–528

Hirshhorn Museum and Sculpture Garden:
 and art world of first half of 1980s, 444–446
 Content show at, 445–446, 455
 Directions 1983 show at, 445

Hitler, Adolf, 93, 404–405
 German neoexpressionism and, 296–298, 300, 311–313

Hockney, David, 532

Hodgkin, Rosalind, 146

Hofmann, Hans, 260

Hollywood Africans (Basquiat), 468

Holt, Nancy, 217, 344
 architectural sculpture and, 164, 177–178, 189

Holzer, Jenny, 6–7, 360, 383, 445
 and art of marginalized groups, 544, 550
 and art world in first half of 1980s, 454
 deconstruction art and, 394–399

Homem, Antonio, 517

Hommage à John Cage (Paik), 50

Honisch, Dieter, 284, 296

Hoover Dam (Hunt), 78

Hopper, Edward, 244

Horsing Around (III) (Golub), 257

Horvitz, Robert, 42

House of Cards (Acconci), 38–39

House of Cards (Serra), 53–54

House/Shield/Mask/Ladder (Fischl), 241

Hoving, Thomas, 437

Hoving, Walter, 403

How to Catch and Manufacture Ghosts (Aycock), 177

How to Explain Pictures to a Dead Hare (Beuys), 89

Hudson River pier, Matta-Clark's project on, 69–70

Huebler, Douglas, 12, 12, 70

Hughes, Robert, 519, 554
 and art world in first half of 1980s, 433–434, 437, 439–440
 on Salle, 238, 240

Hujar, Peter, 533

Human/Need/Desire (Nauman), 34

Humphrey Street Splitting (Matta-Clark), 66–68

Hunt, Bryan, 77–80, 110, 142

Hurson, Michael, 198

Hutchinson, Max, 218

Huxtable, Ada Louise, 8

Idleness of Sisyphus (Chia), 293–294

I dreamed I was taller than Picasso at 2,175,191 (Borofsky), 209–210

"*I dreamed that Salvador Dali wrote me a letter....*" (Borofsky), 209

I Like America and America Likes Me (Beuys), 89–92

Illimite (Broodthaers), 94

image painting, 234–236, 238–244, 248–260, 263, 265–267

Immendorff, Jörg, 93, 222
 and art world in first half of 1980s, 447–448, 450
 German neoexpressionism and, 281, 294–295, 297, 309, 311–312

Indiana, Gary, 486

Individual and the Nature of Mass Events, The, 211

Individual Works (McCollum), 508

infantilism, 502, 530

Infatuation (Bleckner), 260

Inflammatory Essays (Holzer), 397, 399

Inside Out (Fischl), 243

Installation (LeWitt), 71

installation art, 553
 architectural sculpture and, 166, 169, 173–182, 185
 and art of marginalized groups, 526, 536–541
 commodity art and, 502–503
 deconstruction art and, 395, 405–406
 East Village art and, 465
 and European art after 1968, 88, 93, 101–102, 107–109
 feminism and, 132–134
 German neoexpressionism and, 307–308

neogeo and, 507–508
new image painting and, 207–209, 211–212
and pattern and decoration painting, 149–151, 159–161
postminimalism and, 22–26, 32–33, 38, 70, 75
transavantguardia and, 287–289, 292
Institute of Contemporary Art at University of Pennsylvania, 216–217, 436, 454, 515
Interchange (de Kooning), 425
Interim (Kelly), 400–401
Interior Decorated, An (Kozloff), 148–149
Interior Scroll (Schneemann), 132
International with Monument Gallery, 494, 516–518
Interrogation II (Golub), 255
Iphigenie/Titus Andronicus (Beuys), 89
Irises (Van Gogh), 425, 519
Iron Curtain (Christo), 166
Irwin, Robert, 40, 344
architectural sculpture and, 166, 168–171, 179
Iskin, Ruth, 120
Islamic Art, 334
neogeo and, 510
and pattern and decoration painting, 143, 145, 148, 153–154
"Is Neo-Expressionism an Idea Whose Time Has Passed?" (Brenson), 482
I Still Get a Thrill When I See de Koo (Colescott), 204–205
Italian Art in the 20th Century, 105
Italian Trans-avantgarde, The (Oliva), 288
Italy:
art after 1968 in, 86–87, 102–109
see also transavantguardia
It Isn't True (Applebroog), 252
It's a Girl, Send It Back (Applebroog), 252–254

Jackson, Michael, 497, 499
Jacobs, Mary Jane, 220, 434
Jameson, Fredric, 358–359
Sidney Janis Gallery, 516
Japan and Japanese art, 63, 143
Japan Society, 143
Jaudon, Valerie, 164, 216
and pattern and decoration painting, 143, 146, 151–152
jazz, 469, 514, 527–528
Jeanne-Claude, 166–168
Jencks, Charles, 5, 335
Jenney, Neil, 222

and art world of 1970s, 214–215, 217–218
new image painting and, 194–195, 198–200, 203
Jensen, Bill, 218, 229, 268–270
Jewish Museum, 2, 214
Joachimides, Christos, 281–282, 284, 287, 298, 448–449
Joelson, Suzanne, 546
"John Mason and Post-Modernist Sculpture, New Experiences, New Worlds" (Krauss), 217
Johns, Jasper, xxv, 183, 214, 220, 350, 519
American neoexpressionism and, 226–227, 235–236
media art and, 321
Johnson, Philip, 365
Jonas, Joan, 130
Jones, Alan, 108
Jones, Ronald, 489
Judd, Donald, 2, 40, 493
Just Pathetic, 547

Kabakov, Ilya, 528
and art of marginalized groups, 536–540
postmodernist art theory and, 356–357
Kafka, Franz, 198, 478
Kalina, Richard, 413–414
Kant, Immanuel, 3, 7
Kapoor, Anish, 64
Kaprow, Allan, 35, 50, 130, 452
Kardon, Janet, 143, 154, 216
Karp, Ivan, 218
Katz, Alex, xxiv
Kaufman, Andy, 416
Kaufman, Jane, 164
Kelley, Mike, 6, 325, 518, 528
and art world in late 1980s and 1990s, 547
commodity art and, 500–503
Kelly, Ellsworth, 505
Kelly, Mary, 360, 399–401, 453
Kent, Corita (Sister Mary), 502
Kerr, Clark, 378
Kertess, Klaus, 260
Keystone Island (Zimmerman), 180
Kids of Survival (K.O.S.), 477–479
Kiefer, Anselm, 93, 104, 544
American neoexpressionism and, 222, 228
and art world in first half of 1980s, 427, 432, 446, 447–450
German neoexpressionism and, 281, 284, 294–295, 297, 299, 309, 311–315
transavantguardia and, 288, 291–292

Kimball, Roger, 366
Kimmelman, Michael, 268
Kismaric, Carole, 325
Kitchen (performance space), 153, 218–219, 416, 454
Kitchen, The (installation), 118–119
Klein, Yves, 94, 102–103, 502, 506
Kleist, Heinrich von, 315
K-Mart IV (Applebroog), 254
Knife Woman (Bourgeois), 121
Knight, Christopher, 502
Koenig, Kasper, 448–449
Kokoschka, Oskar, 232
Komar & Melamid, 229, 263–265
Koons, Jeff, 6, 528, 547
and art world in first half of 1980s, 442, 454
commodity art and, 482–483, 493–500
East Village art and, 516–518
Kosuth, Joseph, xxvii, 12, 72, 325, 395, 477
Kounellis, Jannis, 168
and art world of 1970s, 215
and criticisms of U.S. art, 284
and European art after 1968, 87, 102–104, 106–109
Kozloff, Joyce, 138, 164, 360
and pattern and decoration painting, 142–143, 148–151
Kozloff, Max, 142
on postminimalism, 26–27
postmodernist art theory and, 334–335
Kramer, Hilton, 223
and art world in first half of 1980s, 439–440
on AWC vs. MoMA, 15–16
postmodernist art theory and, 334, 364–365, 367–368
Krauss, Rosalind, 2, 165, 217, 224, 454, 546
deconstruction art and, 387
postmodernist art theory and, 335–336, 341–347, 349, 356–358
Krens, Thomas, 437, 451
Kruger, Barbara, 6–7, 234, 325, 355, 360, 445, 454
and art of marginalized groups, 544–545, 550
commodity art and, 482, 484
deconstruction art and, 390–395
on Salle, 239
Kubler, George, xxv, 384
Kunsthalle, 295, 447
Contemporary Italian Artists show at, 447
Live in Your Head show at, 215
wrapping of, 166

Kushner, Robert, 69, 164
 and art world of 1970s, 216
 and pattern and decoration paint-
 ing, 142–143, 145, 152–155, 194
Kuspit, Donald, 108, 299, 450

Laar (Turrell), 171
Labowitz, Leslie, 129–130
Lacan, Jacques, 332, 359, 400, 454,
 545
Lacy, Suzanne, 114, 116, 128–130,
 410
Lady Pink, 474
Lagoon Cycle, The (Harrison and
 Harrison), 65
Laments (Holzer), 398–399
Laminated Plywood (Winsor), 30
Land of Cotton (Zucker), 204
Landscape/Body/Dwelling (Simonds),
 182
Landscape #1 (Bickerton), 489
landscapes, 269, 282, 306, 344
 architectural sculpture and, 165,
 172, 174, 190
 commodity art and, 489, 500
 neogeo and, 513
 new image painting and, 200
 postminimalism and, 22, 56,
 59–61, 64
 transavantguardia and, 292
Lane, Lois, 198
Lanigan-Schmidt, Thomas, 157–159,
 216
Large Glass (Duchamp), 389–390
Larson, Kay, 223
 and art world in late 1980s and
 1990s, 550, 554
 on art world of 1970s, 218–219
"Last Exit" (Lawson), 354
*Last Painting of Vincent van Gogh,
 The* (Morley), 257–258
Latham, John, 23–24
Launching Structure #2
 (Oppenheim), 45
Lawler, Louise, 341, 406–407, 454,
 547
Lawson, Thomas, 142, 234, 377
 and art world in first half of 1980s,
 431, 453–454
 on consumer society, 379
 deconstruction art and, 381, 388,
 397, 407
 East Village art and, 461–462
 media art and, 320
 postmodernist art theory and,
 353–356, 367–368
 on Schnabel, 233
Leavin, Margo, 431
Le Compte, Elizabeth, 419
Lecture #1 (Oppenheim), 44

Lehman, David, 337
Leider, Philip, 53, 214
Leigh, Christian, 489
Lerner, Michael, 428
Let's Talk (Kelley), 503
Lettura, La (de Chirico), 286
Leutze, Emanuel, 205
Le Va, Barry, 152, 159
Levin, Kim, 9, 195
 deconstruction art and, 397
 East Village art and, 463–464, 474,
 518–519
 on Salle, 238, 240
Levine, Les, 444
Levine, Sherrie, 7, 234, 325, 341,
 347, 507, 518
 and art world in first half of 1980s,
 453–454
 and art world in late 1980s and
 1990s, 545–546
 deconstruction art and, 386–390,
 393
 media art and, 319–320
 neogeo and, 483
 postmodernist art theory and, 353,
 357–358, 360, 363
Levi-Strauss, David, 89–92, 412, 453
LeWitt, Sol, 12, 179
 and art world of 1970s, 215
 conceptual art and, 23, 35, 70–72
 new image painting and, 208
 postminimalism and, 23, 28, 35,
 70–72
 postmodernist art theory and, 341,
 344
Liberté, Égalité, Fraternité (Polke),
 303
Licht, Jennifer, 87
Lichtenstein, Roy, 1, 94, 103, 226,
 302, 434, 474, 495, 552
Liebmann, Lisa, 262, 465
"Lighting Out for the Territories"
 (Anderson), 418
Line Made By Walking, A (Long),
 62–63
Lipman, Samuel, 364
Lippard, Lucy R., 2, 217, 359, 400,
 524, 550
 architectural sculpture and,
 164–165
 and art of marginalized groups,
 533–534
 conceptual art and, 70, 72
 on European art after 1968, 87
 on feminism, 115–117, 128,
 134–135
 postminimalism and, 21, 24, 70,
 72
*Lissitzky's Neighborhood, Center
 House* (Armajani), 173

Little Red Cap, The (Baldessari),
 323–325
Living (Holzer), 397, 399
Lizard (Merz), 107
Lodge, David, 338
Long, Richard, 102, 168, 344
 and art world of 1970s, 215
 postminimalism and, 27, 62–65
Longo, Robert, 341, 517
 American neoexpressionism and,
 229, 244–248
 and art world in first half of 1980s,
 432, 436, 440, 443, 445, 454
 deconstruction art and, 409
 East Village art and, 461
 media art and, 319–320
Lord, Catherine, 453
Los Angeles Council of Women, 118
Los Angeles County Museum of Art,
 436
 Art and Technology show at, 118,
 169, 179
 Sculpture of the Sixties show at,
 214
 Women Artists show at, 117
Los Angeles Institute of
 Contemporary Art, 217–218, 466
Lotus (Kushner), 154
Louis, Morris, 1, 152
"Louis and Noland" (Greenberg), 1
"Love to Hanoi" (Spero), 135
Lower East Side, N.Y., Simond's pro-
 ject in, 182
Lowry, Bates, 15
Lucier, Mary, 512–513
Ludwig, Irene, 282, 296
Ludwig, Peter, 216, 282, 296
Ludwig Collection, 216–217
Lüpertz, Markus, 222
 and art world in first half of 1980s,
 447–450
 German neoexpressionism and,
 281, 294–295, 297
Luxury and Degradation (Koons),
 495
Lynch, David, 244
Lynch Fragments (Edwards), 528
Lynes, George Russell, 533
Lyotard, Jean-François, 9

McCollum, Alan, 518
 neogeo and, 482–483, 503,
 505–508
MacConnel, Kim, 164
 and art world of 1970s, 216
 and pattern and decoration paint-
 ing, 145, 155–157, 194
McCormick, Carlo, 514–515
McEvilley, Thomas, 44, 108,
 156–157, 358, 441, 541

Machine that Makes the World, The (Aycock), 176–177
Maciunas, George, 50
McLaren, Malcolm, 377, 465–466
McNeil, George, 260–261
McShine, Kynaston, 446, 451
 and art world of 1970s, 214–215
Made in Heaven (Koons), 499–500
Maenz, Paul, xxiv, 282, 446
Magdalena (Scully), 272
Magicians of the Earth, The, 541–542
Magnuson, Ann, 513
Magritte, René, 94–96
Magubane, Peter, 478
Mainardi, Patricia, 116
Making Their Mark, 360–361
Malevich, Kasimir, 292, 323, 506
Manet, Édouard, 466–467
 deconstruction art and, 400–401, 404
Mangold, Robert, 142, 195
mannerism, 289, 294, 451, 486
Man Ray (dog), 414–415
Mansion, Gracie, 513–514
Man Who Flew into Space from His Apartment, The (Kabakov), 538–540
Manzoni, Piero, 94, 102
Mao (Polke), 304
Mapplethorpe, Robert, 532–535, 551
Marabar (Zimmerman), 180
Marden, Brice, 142, 195
Mariani, Carlo Maria, 294–295
Marion, John, 425
Marmer, Nancy, 115, 301, 383–384
Marshall, Richard, 445, 518–519
 and art world in first half of 1980s, 440, 443
 East Village art and, 467
 new image painting and, 198–199
Martin, Jean-Hubert, 541
Martin, Richard, 439
Marzorati, Gerald, 292–293, 410
 East Village art scene and, 473, 513, 518
Masheck, Joseph, 335
Mason, John, 344
Mathews, Patricia, 115, 359–360
Matisse, Henri, xxii, 183, 206, 388, 467, 469
 and pattern and decoration painting, 144, 153–154
Matta-Clark, Gordon, 66–70, 165
Mayan art, 143, 310
Mayer, Helen, 66
Maze (Aycock), 175
Meat Joy (Schneemann), 131–132
media art, xxv, 319–332
 Baldessari and, 322–325
 commodity art and, 483

East Village art scene and, 518
postmodernist art theory and, 332, 336–337, 340–341, 343, 355, 358–359, 361–362, 365
Prince and, 322, 325–330
Meltdown Morning (Jenney), 200
Mendieta, Ana, 130
Men in the Cities (Longo), 244
Merlyn's Lab (Zucker), 204
Merz, Mario, 168, 215
 and European art after 1968, 87, 102–107
Merz, Marissa, 102
Messer, Thomas, 402
Metro Pictures, 432, 453–454, 518
Metropolitan Museum of Art, 292, 430, 487–488
 and art world in first half of 1980s, 436–437
 King's Book of Kings show at, 143, 146
 King Tut show at, 437
Mexican art, 143, 148, 174–175
Meyer, Ruth K., 216
Michael Jackson and Bubbles (Koons), 497
Michelson, Annette, 224, 368
 postmodernist art theory and, 335–337, 343, 346, 349
Miller, John, 382, 452, 493
Mills, Nicolaus, 425
Mimi (Schnabel), 232
minimalism, xxiii, 9–11
 aesthetics of, 11
 American neoexpressionism and, 230, 244, 248, 271
 architectural sculpture and, 165, 170, 174, 179, 183
 art-as-object in, xxv
 and art of marginalized groups, 526, 528
 and art world in first half of 1980s, 449, 451
 and art world in late 1980s and 1990s, 546–547
 and art world in 1970s, 214
 commodity art and, 482–483, 487, 491–493
 and criticisms of U.S. art, 281–283
 East Village art and, 478
 and European art after 1968, 87–88, 99, 103
 feminism and, 115, 117, 121
 formalism vs., 9–11, 23
 German neoexpressionism and, 296
 media art and, 328
 neogeo and, 508
 new image painting and, 194–195, 198–199, 208–209

and pattern and decoration painting, 141–143, 150
postminimalism and, 21–23, 25, 27, 40–41, 49, 54–63, 70–71, 75–77
postmodernist art theory and, 349, 351, 354
rationales of, 1–2, 9–11
self-contained objects vs. open-ended situation, 10
theatricality of, 10–11
transavantguardia and, 288
Mirror Displacements (Smithson), 60
Miss, Mary, 217, 344, 360
 architectural sculpture and, 164, 174–175, 185, 189–191
 public art and, 189–191
Mixed Blessing (Lippard), 550
Miyake, Issey, 486
Moderne Kunst (Polke), 303
modernism, 426, 529
 ambiguousness of, 4
 American neoexpressionism and, 223, 225, 229, 238, 246, 251, 260, 263, 268–271
 architectural sculpture and, 165, 184
 commodity art and, 489, 495
 consumer society and, 377
 and criticisms of U.S. art, 284
 death of, 115, 117
 deconstruction art and, 387–389, 406
 definitions of, 2–5, 7, 10
 East Village art and, 472
 end of, 7–9
 feminism and, 115
 German neoexpressionism and, 296, 298, 303
 Greenberg on, 2–4, 8, 10
 and influences on European artists, 285–286
 kitsch and, 6
 media art and, 321, 330
 and minimalism vs. formalism, 9–10
 neogeo and, 483, 503–505, 508
 and pattern and decoration painting, 141, 143, 154, 156
 postminimalism and, 24, 42, 69–70
 postmodernism vs., 4–5, 7, 9, 11–12
 postmodernist art theory and, 332, 337–338, 340–341, 343–349, 352–353, 356–359, 362, 364–366
 rationales, 504
 transavantguardia and, 287, 294
Mondrian (Rothenberg), 267
Mondrian, Piet, 267, 356, 503–504

Monet, Claude, 265, 513
Monet at Giverny, 350
Monster Roster, 254
Monte, James, 23–24, 214
Monument to Canada (Boltanski), 537
Moon (Clemente), 290
Moorman, Charlotte, 51
Moran, Thomas, 62
More Than You Know (Murray), 250
Morgan, Stuart, 233
Morgue Slab, The (Vaisman), 491
Morley, Malcolm, 229, 257–260
Morris, Robert, 2, 8, 10–12, 102
 and art world of 1970s, 215
 postminimalism and, 21–23, 25–26, 61
 postmodernist art theory and, 341, 344
"Moscow Diary" (Benjamin), 346
Moskowitz, Robert:
 and art world of 1970s, 217–218
 new image painting and, 194, 198–199, 202–203
Moss, Irene, 120
Mosset, Olivier, 98
Motherwell, Robert, 35, 234
Moules Casserole (Broodthaers), 97
Mourning and Rage (Lacy and Labowitz), 129–130
Mudd Club, 384, 419, 462, 467, 513
Mülheimer Freiheit group, 450
Mullarkey, Maureen, 133–134
multimedia art, 451, 462–463, 513
Munch, Edvard, 250
Murray, Elizabeth, 6, 218, 342, 360, 445, 544
 American neoexpressionism and, 222, 227–229, 241, 247–251
Museum Folkwang, 447, 450
Museum of Contemporary Art (MOCA) in Los Angeles, 420
 A Forest of Signs show at, 420, 455, 544–545
Museum of Modern Art (MoMA), 35, 284, 348
 and art of marginalized groups, 526, 541–542
 and art world in first half of 1980s, 444–445
 and art world in late 1980s and 1990s, 546, 553
 AWC vs., 15–16
 Aycock's work in, 177
 BerlinArt show at, 451
 DISlocations show at, 526, 553
 and European art after 1968, 87
 feminism and, 138
 From the Picture Press show at, 325

High & Low show at, 546
Information show at, 7, 13, 72, 215, 402
An International Survey of Recent Painting and Sculptural show at, 361, 446
The New American Painting show at, 296
 postmodernist art theory and, 362–363
 "*Primitivism*" show at, 541–542
Museum of Modern Art (Broodthaers), 95–96, 121, 286
"Mussel, The" (Broodthaers), 97
My Calling Card (Piper), 525
"*My Tour of Duty in the Crimea*" (Antin), 126

Nagy, Peter, 514
Nail Piece (Winsor), 30
N.A.M.E., 218
Namuth, Hans, 35, 53
Nassau County Museum, Miss's installation in, 174–175
National Educational Association (NEA), 185–187, 218–220, 386, 533, 551–552
Native Americans, 550
 architectural sculpture and, 174–177
 art of, 523, 530–531
 and pattern and decoration painting, 148–149
Nature Morte, 454, 514
Nature Study (Bourgeois), 122
Nauman, Bruce, 17, 102, 159, 165, 344, 395–396
 and art world of 1970s, 214–215
 feminism and, 124
 media art and, 325
 postminimalism and, 22–23, 30–36, 38, 52–53, 70
 project works of, 31–32
 video projects of, 34–35
 wax casts of, 33–34
"Negating the Negative" (Kozloff), 143
Neiman, LeRoy, 465–466
neogeo, 503–513, 495
 and art world in late 1980s and 1990s, 545, 547
 commodity art and, 483, 503, 507
 East Village art and, 516–519
 Halley and, 482–484, 503–505, 508
 McCollum and, 482–483, 503, 505–508
 Reed and, 508–510
 Starn Twins and, 511–512
 Taaffe and, 508, 510–511
 Warhol and, 486, 512

Neon Templates of the Left Half of My Body Taken at Ten-Inch Intervals (Nauman), 31
Netherlands, 61, 183–184
New Art Association, 332–333
New Criterion, 364–366, 368, 375
New Fauves, The, 216
New Hoover Convertible (Koons), 494
new image painting, xxv, 194–213
 Africano and, 198–199, 202–204
 American neoexpressionism and, 222, 224, 228, 230, 260, 265
 and art world in first half of 1980s, 445
 and art world in 1970s, 217–218
 badness of, 195, 198, 204, 206, 209, 212, 228
 Bartlett and, 198–199, 207–208
 Borofsky and, 208–212
 Colescott and, 195, 204–207
 conceptual art and, 194, 199–200, 203–204, 207–209
 deconstruction art and, 384
 definitions of, 198–199
 East Village art and, 461
 German neoexpressionism and, 302
 Guston and, 194, 196–198
 image-color field, 199, 202–204
 Jenney and, 194–195, 198–200, 203
 in rehabilitating painting, 212
 Zucker and, 198–199, 204
Newman, Barnett, 194, 230
New Museum, 466, 516
 "*Bad*" *Painting* show at, 194, 198, 251
 The Decade Show at, 550
New Museum of Contemporary Art, 219, 455
New Stones—Newton's Tones (Cragg), 64
Newsweek, 27, 420, 427, 429–430, 519
new wave, 461–464
New York, 1980s art in, 426–427
New York School, xxii, 141, 250
New York School, The (Sandler), xxii
New York Times, 333–334, 450, 465, 482
 and art world in first half of 1980s, 430–431, 438
 East Village art scene and, 515
NOC*167, 475, 516
Nochlin, Linda, 116–117, 159
Noland, Kenneth, 1, 100
Nolde, Emil, 298–299
Noon (Penck), 311
Nosei, Annina, 513, 518

"Notes on Sculpture" (Morris), 10, 21

"Notes on the Index" (Krauss), 343–345

Now Everybody (Longo), 246

No. 261 (Reed), 509

Nuremberg (Kiefer), 313

O'Connor, John, 551–552

October (film), 335

October (periodical), 217, 224, 375, 454

 and art world in late 1980s and 1990s, 544–546

 criticisms of, 342–343

 deconstruction art and, 387–388, 406

 founding of, 335

 neogeo and, 509–510

 postmodernist art theory and, 332, 335–337, 340–354, 356–358, 362–364, 368

October 18, 1977 (Richter), 309

O'Doherty, Brian, xxvi–xxvii, 12, 186–187

Ohio at Giverny (Lucier), 512–513

O'Keeffe, Georgia, 115, 241, 268, 474, 533

Oldenburg, Claes, 35, 94, 130, 165

Olitski, Jules, 1

Oliva, Achille Bonito, 92

 and art world in first half of 1980s, 446

 transavantguardia and, 287–289

 U.S. art criticized by, 282–284

Olympia (Manet), 401

One for Violin (Paik), 50

100 Boots (Antin), 124

198 Castle Clinton Tower and Bridge (Ferrara), 179

On Social Grease (Haacke), 385

Open House (Matta-Clark), 66

Opera Sextronique (Paik), 51

Oppenheim, Dennis, 177, 344

 and art world of 1970s, 215, 217

 postminimalism and, 44–46, 52–53, 66

Orgel, Sandra, 128–129

"Originality of the Avant Garde, The" (Krauss), 343, 357–358

Origins of Socialist Realism, The (Komar & Melamid), 263–264

O Superman (Anderson), 417

Outerspace Painting (NOC*167), 475

Owens, Craig, 224, 294, 308, 454

 consumer society and, 377

 deconstruction art and, 384–385, 387, 409, 411, 416

 German neoexpressionism and, 299–300

 media art and, 319

 postmodernist art theory and, 332, 335, 341–343, 345, 353–355, 357–358, 362

Oxidation Paintings (Warhol), 226, 352

Paesaggio Barbaro (Cucchi), 292

Page, Suzanne, 448

Paik, Nam June, 50–52

Painted Desert, Turrell's project in, 172

Painter's Forms (Guston), 196–197

Painters' Progress (Murray), 248–250

Painting of Depth (Vaisman), 491

Paisley/Leaf Vestituro (Schapiro), 147

Paladino, Mimmo, 287–288

Palladium, 515–516

Palms of Vai, The (Morley), 258

Panza di Biumo, Count Giuseppe, 215, 437

Paolini, Giulio, 102, 104

Parker, Charlie, 469

Parmentier, 98

Parsifal (Wagner), 299

Partially Buried Woodshed (Smithson), 344

Pascali, Pino, 102

Passmore, George, 47

Pastoral Chair Tableau (Burton), 183

pathetic art, 547–548

pattern and decoration painting, xxv, 141–164, 238

 and art world of 1970s, 216–217

 and Benglis, 152–153

 debating significance of, 143–145

 and Jaudon, 143, 146, 151–152

 and Kozloff, 142–143, 148–151

 and Kushner, 142–143, 145, 152–155, 194

 and Lanigan-Schmidt, 157–159

 and MacConnel, 145, 155–157, 194

 and minimalism, 141–143, 150

 and neogeo, 510

 and new image painting, 194–195

 and Pfaff, 157–161

 rationales for, 145–146

 and Schapiro, 141, 143, 145–147

 and Smyth, 150–151

 and Sugarman, 144, 159

 universality of, 145

 and Zakanitch, 142, 147–148, 194

Pay for Your Pleasure (Kelley), 502–503

Pearlstein, Philip, 183, 195, 241

Pelli, Cesar, 190

Penck, A. R., 222

 and art world in first half of 1980s, 447–450

 German neoexpressionism and, 281, 284, 294–295, 297, 309–311

Penone, Giuseppe, 102

"Perfect Tense, The" (Prince), 326

Perfect Vehicles (McCollum), 508

performance art, xxvi, 2, 11, 17, 312

 American neoexpressionism and, 244, 251–252, 263

 architectural sculpture and, 182–183

 and art of marginalized groups, 526, 530, 536

 and art world in first half of 1980s, 441, 454

 and art world in late 1980s and 1990s, 553

 and art world in 1970s, 215, 218

 commodity art and, 494, 502

 deconstruction art and, 384–385, 396, 409–410, 412, 416–419

 East Village art and, 462, 513

 and European art after 1968, 88–93, 95, 108–109

 feminism and, 115–117, 124–132

 furniture in, 183

 neogeo and, 507

 new image painting and, 211

 and pattern and decoration painting, 143, 153–154

 postminimalism and, 35–36, 38, 40, 42, 44–51, 66–69

 postmodernist art theory and, 345, 349, 351

 transavantguardia and, 288

Performances (Applebroog), 251

Perimeters/Pavilion/Decoys (Miss), 174–175

Perl, Jed, 271

Perpetual Photos (McCollum), 507–508

Perreault, John, 216

Perrone, Jeff, 141

Persian Line (Kushner), 153

Peto, John, 200

Pfaff, Judy, 216, 360

 American neoexpressionism and, 227, 229

 and pattern and decoration painting, 157–161

Phillips, Lisa, 6, 326–327, 445, 519, 544

 and art world in first half of 1980s, 440, 443

Phobos (Hunt), 78

Photo-Fry (Matta-Clark), 66

photography, xxv–xxvi, 11, 18

 American neoexpressionism and, 234–236, 240–241, 245–246, 254, 257, 267

photography *(cont.)*
architectural sculpture and, 168, 177
and art of marginalized groups, 526, 532–533, 535–536
and art world in late 1980s and 1990s, 544, 551
commodity art and, 490, 499–500
deconstruction art and, 379–380, 386–388, 390–391, 394, 400, 402, 406, 408–415, 420
East Village art and, 464–466, 478, 514
and European art after 1968, 96
feminism and, 124, 126–128, 135
German neoexpressionism and, 302, 305–308, 312–313
Greenberg on, 3
media art and, 322–327, 330
neogeo and, 483, 507–509, 511–512
new image painting and, 212
painting vs., 350, 353–355
and pattern and decoration painting, 146, 156
postminimalism and, 24, 27, 31, 35–36, 46–49, 53, 60, 63–66, 70–71, 73–74
postmodernist art theory and, 336, 338, 341, 344–355, 357, 362
pure vs. impure, 349
"Photography in the Age of Mechanical Reproduction" (Benjamin), 346
photorealism, xxv
American neoexpressionism and, 245, 257–258
and art world in 1970s, 215
German neoexpressionism and, 302–303, 305–306, 308
new image painting and, 195, 198
postmodernist art theory and, 345, 350
Photo-Transformations (Samaras), 46–47
Picabia, Francis, 177, 198, 303
American neoexpressionism and, 223, 235
new European painters influenced by, 285–286
Picasso, Pablo, xxii, 78, 183, 285, 292
Picture Painted According to the Commands of Higher Beings, The (Polke), 303
Picture That in Miami (Carlson), 150
Piero della Francesca, 288
Pincus-Witten, Robert, 21, 243
and art world in first half of 1980s, 430, 438–439

and art world in late 1980s and 1990s, 546, 549
East Village art and, 464, 515, 517
on German neoexpressionism, 297
neogeo and, 512
postmodernist art theory and, 342–343
on transavantguardia, 287
Piper, Adrian, 72, 360, 524–526
Pistoletto, Michelangelo, 102
Plagens, Peter, 225, 444
and art world in late 1980s and 1990s, 544, 554
deconstruction art and, 381–383
East Village art and, 466
media art and, 321
Plaster Surrogates (McCollum), 505–508
Platform Made Up of Spaces Between Two Rectilinear Boxes on the Floor (Nauman), 30
PLATO'S CAVE/ROTHKO'S CHAPEL/ LINCOLN'S PROFILE (Kelley), 502
Pocahantas's Panties (Durham), 531
Pohlen, Annelie, 298–299
Poiret, Paul, 153–154
Politi, Giancarlo, xxvi, 282, 287, 446–447
Politic, Giancarlo, 288
Polke, Sigmar, 93, 544
American neoexpressionism and, 222, 230, 235
and art world in first half of 1980s, 447–450
German neoexpressionism and, 281, 294–297, 301–305, 308–309
Picabia's influence on, 285–286
Pollack, Steve, 462–463
Pollock, Jackson, 35, 53, 152, 274, 296, 429
arte povera and, 102–103
new image painting and, 194, 197
Schnabel and, 230
pop art, xxv, 62, 153, 214, 220
American neoexpressionism and, 226, 247–248, 263
commodity art and, 482–486, 491
and criticisms of U.S. art, 282, 284
deconstruction art and, 409
East Village art and, 516
and European art after 1968, 87–88, 94
German neoexpressionism and, 296, 301–303
Greenberg on, 3
media art and, 321, 328, 330
new image painting and, 197
postmodernist art theory and, 355, 365

rationales for, 1–3, 6
Pope, Alexander, 439–440
Pope Clement of Rome (Schnabel), 234
Portable Fish Farm (Harrison), 65
Portrait of Dr. Gachet (van Gogh), 549
Portrait of God (Schnabel), 230
portraits:
American neoexpressionism and, 233, 263
and art world in late 1980s and 1990s, 546–547
commodity art and, 491
new image painting and, 196–197, 209–210
Portraits (Richter), 305
Portraits (Warhol), 226
posters, 336, 361, 524
commodity art and, 495
deconstruction art and, 396–397
East Village art and, 462, 465
postminimalism, xxv, 7, 21–85, 441, 553
Acconci and, 23, 35–40, 46–47, 50, 52–53, 70
American neoexpressionism and, 223–224, 230
antiform substance of, 24
appeal of, 27
architectural sculpture and, 165, 182
and art world in 1970s, 214–215
and attacks on art-as-object, 11–12, 56
Baldessari and, 72–74
Bell and, 22, 58
body art and, 11, 23–24, 31–38, 40–41, 44, 47, 50, 52–53, 70
Burden and, 40–47, 50, 52–53
conceptual art and, 11–12, 23–26, 32–33, 35, 59, 62, 65, 70–74
consumer society and, 375
Cragg and, 64–65
documentation of, 24, 31, 35, 37, 53, 60, 63–64, 70, 74
earth art and, 11, 22–25, 60–66, 70, 78
and European art after 1968, 87–88
evolution of, 17–18
feminism and, 29–30, 117
first museum show of, 23–25
and Gilbert & George, 27, 47–50
Graves and, 77–79, 110
Harrison and, 65–66
Hesse and, 22, 27–31
Hunt and, 77–80, 110
LeWitt and, 23, 28, 35, 70–72

Long and, 27, 62–65
Matta-Clark and, 66–70
Nauman and, 22–23, 30–36, 38, 52–53, 70
new image painting and, 194, 198–199, 209
objecthood and, 23–25, 27, 31, 36, 43, 46, 53, 56, 62, 70–72, 74, 77–78
Oppenheim and, 44–46, 52–53, 66
origins of, 21–27, 53
Paik and, 50–52
and pattern and decoration painting, 141–142, 159
postmodernist art theory and, 341, 344
radical aura of, 26–27
rationales of, 2–7, 9–12, 27
reaction against, 74, 110
reevaluation of, 74–75, 78
Samaras and, 46–47
Serra and, 22, 35, 53–58
Shapiro and, 75–78, 110
Smithson and, 21–22, 28, 58–62, 66, 70
Sonfist and, 65–67
theatricality and, 11
transformation of verbal texts in, 32–33
Tuttle and, 24, 58
viewer manipulation in, 31–33
Winsor and, 29–31
postmodernism, 12
 ambiguity of, 4
 birth of, 115
 and commodification of art, 12
 definitions of, 3–7
 emergence of, 9
 modernism vs., 4–5, 7, 9, 11–12
 "Postmodernism and the Consumer Society" (Jamison), 358–359
postmodernist art theory, 332–374
 deconstruction art and, 337–343, 345–346, 353, 356–357, 359–362, 366
 in demystifying modernism, 343–349, 356
 in elevating theory over art, 342–343
 feminism and, 334, 337, 339, 353, 359–361, 366
 of function of criticism, 339
 kitsch and, 364
 modernism and, 332, 337–338, 340–341, 343–349, 352–353, 356–359, 362, 364–366
 painting and, 333, 336, 338, 341, 345, 348–356, 362–363, 365
 photography and, 336, 338, 341, 344–355, 357, 362

poststructuralism and, 336, 339–341, 358, 366
 resistance to, 361–368
 and transformation of art criticism, 334–340
Post-Partum Document (Kelly), 399–400
poststructuralism, 132
 commodity art and, 484
 deconstruction art and, 397
 neogeo and, 484, 504
 postmodernist art theory and, 336, 339–341, 358, 366
Potato Eaters (van Gogh), 204–205
Pound, Ezra, 356
Pressure (Longo), 246
Preying Hands, The (Lanigan–Schmidt), 157
primitive art, 156, 227, 233
primitivism, 310
 and art of marginalized groups, 531, 541
 commodity art and, 487
 East Village art and, 466–469, 475–476
Prince, Richard, 245, 305, 332, 454, 507, 518
 and art of marginalized groups, 544, 546
 deconstruction art and, 386
 media art and, 322, 325–330
Prison with Conduit (Halley), 504
process art, xxv, 2, 152, 168
 and commodification of art, 12
 postminimalism and, 11, 21–22, 24–26, 28, 53, 62, 74
Proesch, Gilbert, 47
Project Entitled Studies for a Town (Aycock), 177
Projection Pieces (Turrell), 170
Prometheus (Tucker), 273
"Prospect Before Us, The" (Michelson), 343
P.S. 1, 218–219, 449, 465, 518, 527
 New York/New Wave show at, 465, 516
 A Painting Show show at, 212, 217
 Pattern Painting show at, 216–217
punk aesthetic, 461–462, 465–466
Puryear, Martin, 528–530

quilts, 116, 132, 146, 148
"Quilts" (Mainardi), 116
Quinones, Lee, 516

Rabbit (Koons), 495–496
Rahmani, Aviva, 128–129
Ramos, Mel, 204–205

Ratcliff, Carter, 220, 300, 342
 on American neoexpressionism, 227, 257, 260
 and art world in first half of 1980s, 438, 440, 442
 on deconstruction art, 383, 385–386
 new image painting and, 195
 on postminimalism, 46, 48
Rauschenberg, Robert, 6, 214–215, 349
 American neoexpressionism and, 226–227, 235, 238
 arte povera and, 102–103
 Burton and, 183–184
 East Village art and, 467
 German neoexpressionism and, 302–303
 media art and, 325
 Schnabel and, 230
Raven, Arlene, 119
RAW/WAR (Nauman), 33
Ray, Man, 35, 532–533
Ray Cat (Wegman), 415
Reading Garden #3 (Armajani), 173
Reagan, Ronald, 224, 382, 419, 425, 430, 433
Real Life, 352–354, 377, 454
Reason for the Neutron Bomb, The (Burden), 43–44
Recollections of My Life with Diaghilev (Antin), 125
reconstructionism, 255, 366
 deconstruction art and, 411
 media art and, 321, 323
 and misuse of art, xxvii
Red Skin (Cragg), 64–65
reductionism, 77, 143
 deconstruction art and, 382
 postmodernist art theory and, 332, 349
Reed, David, 443, 508–510, 544
Reich, Steve, 23
Reid, Calvin, 528
Reinhardt, Ad, 21, 506
Reiring, Janelle, 432, 453
Remember Me (Bleckner), 263
Renoir, Pierre Auguste, 549
Representational Painting (Antin), 124
Restany, Pierre, 283
Resumptio (Kiefer), 313
Rhapsody (Barlett), 207–208
Rhodes, Nick, 431
Rhyme (Winters), 269
Ricard, Rene, 476
Rich, Adrienne, 395
Richter, Gerhard, 93, 222, 544
 and art world in first half of 1980s, 447–450

Richter, Gerhard *(cont.)*
 German neoexpressionism and,
 281, 294–297, 301–302, 305–309
 neogeo and, 509
Rickey, Carrie, 146, 195
Rietveld, Gerrit, 183–184
Rifka, Judy, 463
Rimanelli, David, 513, 545
Risatti, Howard, 177
Rite of Passage, A (Lanigan–
 Schmidt), 157
Robbin, Tony, 146
Robert, Jean, 211
Robinson, Walter, 217, 514
Rock Chairs (Burton), 183–184
Rocked Circle—Fear (Oppenheim),
 44
Rodchenko, Alexander, 391
Rodin, Auguste, 78, 202, 271, 356,
 358, 467
Rollins, Tim, 219–220, 477–478
Tim Rollins + K.O.S., 478–479
romanticism, 287, 342
 American neoexpressionism and,
 222, 269
 commodity art and, 500–501
 deconstruction art and, 388
 German neoexpressionism and,
 297, 299–300, 306, 309, 313
Rose, Barbara, 2, 12–13, 212, 218,
 224
 and art world in first half of 1980s,
 439–440
 postmodernist art theory and,
 349–351
Rosen, Randy, 360–361
Rosenquist, James, 1, 103, 230, 235
Rosenthal, Norman, 281–282, 284,
 298
 and art world in first half of 1980s,
 448–449
Rosenzweig, Phyllis, 445
Roszak, Theodore, 14
Roth, Moira, 117–119, 124, 128, 130
Rothenberg, Susan, 281–282, 360,
 544
 American neoexpressionism and,
 222, 229, 241, 248, 265–268
 and art world in first half of 1980s,
 445, 448
 and art world in 1970s, 217–218
 new image painting and, 194,
 198–199, 201–202
Rothko, Mark, 172, 194, 268, 502
*Rothko's Blood Stain (Artist's
 Conception)* (Kelley), 502
Royal Academy in London, 105,
 281–282
 German Art of the 20th Century
 show at, 449

A New Spirit in Painting show at,
 429, 448–449
Rubell, Steve, 430
Rubin, William, 2, 286, 444–445, 541
Rugoff, Ralph, 547–548
Running Fence,... (Christo and
 Jeanne-Claude), 167–168
Running Man (Borofsky), 210
Ruscha, Edward, 325, 328
Ryan, Cara Gendel, 363
Ryder, Albert Pinkham, 269
Ryman, Robert, 24–25, 142, 195,
 214–215, 487

Saatchi, Charles, xxiv, 282, 383, 549
 and art world in first half of 1980s,
 432, 438, 442
Saatchi, Doris, 383, 432, 438, 442
Saatchi Collection (Simulations), The
 (Haacke), 404–405
Sacristy of the Hamptons, The
 (Lanigan-Schmidt), 157
Said, Edward W., 336
St. Joe Louis Surrounded by Snakes
 (Basquiat), 467
Salle, David, 194, 281–282, 305, 325,
 474, 544
 American neoexpressionism and,
 222, 225, 227–229, 234–240,
 248, 252, 260
 and art world in first half of 1980s,
 432, 436, 440–441, 443, 448, 452
 critics on, 238–240
 deconstruction art and, 409
 East Village art scene and, 515,
 517
 graphical ineptitude of, 240
 influences on, 236–237
 Picabia's influence on, 285–286
 postmodernist art theory and,
 353–355
 transavantguardia and, 287
Saltz, Jerry, 329, 435, 479, 546
Samaras, Lucas, 46–47
Sans II (Hesse), 28
Saret, Alan, 159
Saunders, Wade, 77
Saussure, Ferdinand de, 322, 337
Savinio, Alberto, 292
Saw and Sawed (Jenney), 200
Sayre, Henry M., 391, 397–398
 deconstruction art and, 414–415
 on Warhol, 486
Scarsdale (Fischl), 244
Schapiro, Miriam, 452
 feminism and, 115, 118–119
 and pattern and decoration paint-
 ing, 141, 143, 145–147
 postmodernist art theory and,
 359–360

Scharf, Kenny, 466, 472–473,
 475–477, 513–514, 516, 518
Scheuene (Richter), 306
Schiele, Egon, 388
Schjedahl, Peter, 198, 503
 American neoexpressionism and,
 228, 233–234
 and art world in first half of 1980s,
 430, 433, 439, 450
 and art world in late 1980s and
 1990s, 544–545, 549, 553–554
 on *Tilted Arc*, 188
Schlageter, Albert Leo, 315
Schnabel, Julian, 281–282, 305
 American neoexpressionism and,
 222, 226, 228–234, 236–238,
 240, 246, 248, 260
 and art of marginalized groups,
 544, 549
 and art world in first half of 1980s,
 427, 429–431, 436, 438–441,
 443, 445, 448–450
 East Village art and, 470
 on image and material selection,
 232–233
 influences on, 230–232
 Picabia's influence on, 285–286
 postmodernist art theory and, 353,
 355
 transavantguardia and, 287
Schneckenberger, Manfred, 215,
 451
Schneemann, Carolee, 130–132
Schor, Mira, 239, 252
Schunnemunk Fork (Serra), 57
Schwartz, Barbara and Eugene, 517
Schwartz, Estelle, 516, 518
Schwartz, Michael, 330, 517
Schwartzman, Allan, 435, 514,
 517–518
Scott-Brown, Denise, 5
Scream, The (Africano), 203
Scream, The (Munch), 250
Scrim Veil—Black Rectangle...
 (Irwin), 170
Scull, Robert and Ethel, 220
Scully, Sean, 269–272
Sculpture (Broodthaers), 97
"Sculpture in the Expanded Field"
 (Krauss), 217, 343–344
Seedbed (Acconci), 38
Segal, George, 94
Selavy, Rose, 390
Self-Portrait (Coplans), 535
Self-Portrait (Durham), 530–531
Self-Portrait (Mapplethorpe), 532
Self-Portrait (Piper), 524–525
Self-Portraits (Bickerton), 487–488
Sensation (Burgin), 402
Sense of Order, The (Gombrich), 145

"Sentences on Conceptual Art" (LeWitt), 12, 71–72, 208
Serota, Nicholas, 281–282, 284, 448
Serra, Richard, 102
 architectural sculpture and, 187–190
 and art world of 1970s, 214–216
 and pattern and decoration painting, 152, 159
 postminimalism and, 22, 35, 53–58
 postmodernist art theory and, 341, 344
SEX AND DEATH BY MURDER AND SUICIDE (Nauman), 33
Sex Pistols, 465–466
Shadow Puppets and Instructed Mime (Nauman), 34–35
Shafrazi, Tony, 513
Shaman (Graves), 78
Shanta (Turrell), 171
Shapiro, Joel, 165, 241, 247, 344
 and art world of 1970s, 214
 new image painting and, 195
 and pattern and decoration painting, 142, 150
 postminimalism and, 75–78, 110
Shapolsky et al Manhattan Real Estate Holdings (Haacke), 402
Shea, Judith, 164–165
Shearer, Linda, 39, 220
Sheldon, Jim, 463
Shelf Sinking into the Wall with Copper Painted Casts of the Spaces Underneath (Nauman), 30
Sherman, Cindy, 6, 360, 445, 532
 and art of marginalized groups, 544, 546–547
 and art world in first half of 1980s, 436, 454
 deconstruction art and, 408–413, 416
 neogeo and, 483
 postmodernist art theory and, 341–342, 348, 355
Shift (Serra), 56
Shift Falls (Hunt), 80
Shoot (Burden), 40–42
Shore, Michael, 461–462
Shredder (Bourgeois), 121
Siberian Symphony (Beuys), 88
Sight Point (Serra), 54–56
Silence of Marcel Duchamp Is Overrated, The (Beuys), 92
Simmons, Laurie, 454, 518
 and art world in late 1980s and 1990s, 546–547
 deconstruction art and, 412–414, 416

Simonds, Charles, 181–182, 344
Sims, Lowery, 206–207
Sims, Patterson, 220, 445
Simulations (Baudrillard), 378–379
Singer, Ann, 463
Singerman, Howard, 226, 347
Singing Sculpture, The (Gilbert & George), 47
Sironi, Mario, 285, 287
Sischy, Ingrid:
 and art world in first half of 1980s, 435–436, 454
 commodity art and, 486
 deconstruction art and, 409–410
situationism, 16, 69
 consumer society and, 375–378
 deconstruction art and, 401
 and European art after 1968, 98, 100, 102, 105
Skyspaces (Turrell), 171–172
Smith, Adam, 433
Smith, David, 77–78
Smith, Patti, 384
Smith, Paul, 401
Smith, Phillip, 319
Smith, Roberta, 282, 311, 554
 and art world in first half of 1980s, 435, 438, 443–445, 449
 commodity art and, 498
 deconstruction art and, 393–394
 on Longo, 247
 new image painting and, 194, 199
 postmodernist art theory and, 350–351
 on Salle, 238–240
Smith, Tony, 59
Smithson, Robert, 2, 102
 architectural sculpture and, 165, 179
 and art world in 1970s, 215
 postminimalism and, 21–22, 28, 58–62, 66, 70
 postmodernist art theory and, 341, 344
Smyth, Ned, 150–151, 190, 216
Snow, Michael, 23
Snyder, Joan, 115
socialist realism, 263, 296–297, 302, 311
Society of the Spectacle (Debord), 376, 378
SoHo, 20, 66, 215
Solomon, Deborah, 251
Solomon, Holly, 216, 432, 446
 and art world of 1970s, 216
 and pattern and decoration painting, 146, 153, 157
Solomon, Horace, 146, 216
Solomon-Godeau, Abigail, 346, 348

Somebody Else's Hand (Rothenberg), 267
Some Kind of Group (Cragg), 65
Sonfist, Alan, 62, 65–67, 215
Song of the Trumpeters (Zakanitch), 148
Ileana Sonnabend Gallery, 38, 94, 432, 495, 516–518
 The Banality show at, 497, 499, 518
 Kounellis's performance at, 109
Sotheby Parke-Bernet, 220, 425–427, 486, 519
South America Triangle (Nauman), 32–33
Soviet Union and Soviet art, 143, 462–463, 545
 American neoexpressionism and, 263–264
 architectural sculpture and, 173, 183–184
 and art of marginalized groups, 536–538
 postmodernist art theory and, 336, 347, 362
Spero, Nancy, 7, 359–360
 feminism and, 132, 134–137
Sperone, Gian Enzo, 103, 282, 288
 and art world in first half of 1980s, 446–447
Sperone-Westwater-Fischer Gallery, 432, 447
Spiral Jetty (Smithson), 22, 60–62, 70, 344
Splashing (Serra), 53
Spring Love (Kushner), 155
Starification Object Series (S.O.S.) (Wilke), 126–127
Starn, Mike and Doug (Starn Twins), 439, 511–512, 518, 547
Statuary (Koons), 495
Stay with Friends (Steinbach), 492
Stedelijk Museum:
 and art world in first half of 1980s, 429, 436, 447
 Square Pegs in Round Holes show at, 215
Steinbach, Haim, 518, 528
 commodity art and, 482–483, 491–493, 500, 507
Steir, Pat, 263
Stella, Frank, xxiii–xxiv, 356
 American neoexpressionism and, 227, 248
 neogeo and, 504–505
 and pattern and decoration painting, 144–145, 151
Stephan, Gary, 287
Stevens, Mark, 200, 554
Stiles, Kristine, 130

Still, Clyfford, 194
Still Life (Bickerton), 489–490
Stoller, Ilona (La Cicciolina), 499–500
Storr, Robert, 6–7, 343, 529
 and art world in late 1980s and 1990s, 546, 548–549, 553
 on Bourgeois, 122–124
 deconstruction art and, 380–381, 394
 East Village art and, 469
 on feminism, 137
 on Fischl, 241
 German neoexpressionism and, 304–305
 on Golub, 256
 on Salle, 238
 on *Tilted Arc*, 188–189
 on transavantguardia, 291
Strike (Serra), 56
Sugarman, George, 144, 159, 216
Summer Dress (McNeil), 261
Sun Tunnels (Holt), 177–178
Surls, James, 274–275
surrealism, 3–4
 American neoexpressionism and, 248, 274
 deconstruction art and, 386
 East Village art and, 473
 feminism and, 115
 postminimalism and, 21, 34
 rationales of, 4
Survival Series (Holzer), 397–399
Sussman, Elisabeth, 553
Swimmer (Moskowitz), 202
Swimmer Atlanta (Bartlett), 265
Syberberg, Hans-Jürgen, 299–300
Szarkowski, John, 325, 348
Szeemann, Harald, 96, 215, 446, 450–451

Taaffe, Philip, 508, 510–511, 544
Tale of Two Cities, A (Burden), 43
Tallman, Susan, 361
Tate Gallery, 429, 432, 436, 438
Taylor, Paul, 517
Ten Characters (Kabakov), 538
Terminal (Serra), 54–56
Theory of Universal Causality, A (Aycock), 177
Thinker, The (Rodin), 202
Thompson, Robert Farris, 469
3 D (Pfaff), 160
Three Elements (Jensen), 270
Three Women/Three Chairs Arranged By Mr. and Mrs. Burton Tremaine, Sr. (Lawler), 407
Through the Night Softly (Burden), 42–43
Thunderbomb (MacConnel), 156

Tiffany Cares (Haacke), 403
Tillim, Sidney, 347–348
Tilted Arc (Serra), 56–58, 187–190
Time, 430, 439, 463, 519
Time Landscape (Sonfist), 66–67
Times Square, N.Y. (Holzer), 398
Tinguely, Jean, 177
Tisdall, Caroline, 105
Toe-Touch (Acconci), 36
Tomorrow (Murray), 251
Tormented Self-Portrait (Bickerton), 488–489
Toroni, Niele, 98
Torture in Chile (Spero), 136
Torture of Women (Spero), 137
Tourism (Simmons), 413
Townscapes (Richter), 305
Trademarks (Acconci), 36–37
Train Art (A-One), 474
Train Wreck (Morley), 258
Trakas, George, 164, 344
transavantguardia, 106, 110, 281–284, 287–295
 arte povera and, 287–289, 291–292
 and art world in first half of 1980s, 446–449
 Chia and, 281, 287–289, 292–294
 Clemente and, 281, 287–293
 Cucchi and, 281, 287–288, 291–292
 Mariani and, 294–295
 Oliva and, 287–289
 Paladino and, 287–288
Transfixed (Burden), 42
Transparencies (Picabia), 235
Transparents (Polke), 303
Travelling (Kushner), 154
Trees and Lumber (Jenney), 199–200
Tremaine, Burton and Emily, 519
Triumph of American Painting, The (Sandler), xxi
TRUE ARTIST HELPS THE WORLD BY REVEALING MYSTIC TRUTHS, THE (Nauman), 32–33
Truisms (Holzer), 395–397, 399
Trump, Donald, 425, 430
Tuchman, Maurice, 214
Tucker, Marcia, 17, 550
 and art world of 1970s, 214, 216, 219
 deconstruction art and, 400
 new image painting and, 198–199
 postminimalism and, 23–24
Tucker, William, 271–273
Tudor, David, 50
Tunnel Tower (Dennis), 177
Turrell, James, 166, 169–172, 179
Tuttle, Richard, 159

and art world of 1970s, 214–215
postminimalism and, 24, 58
TV Bra for Living Sculpture (Paik), 51
TV Buddha (Paik), 51–52
Two-Cube Table (Burton), 185
Two Painters (Clemente), 291
Tzara, Tristan, 503

Uffizi Portrait, The (Vaisman), 491
Ultimate Anxiety, The (Morley), 258
Underneath the Arches (Gilbert & George), 47–48
Und Ihr Habt Doch Gesiegt (Haacke), 405–406
United States I–IV (Anderson), 418
Untitled, 1974 (Shapiro), 75
Untitled, 1980–1981 (Shapiro), 76
Untitled (Beuys), 90
Untitled (Hammons), 527
Untitled (Haring), 471
Untitled (Kounellis), 109
Untitled (Buy Me I'll Change Your Life) (Kruger), 391–392
Untitled (I Shop Therefore I Am) (Kruger), 391
Untitled (Your Gaze Hits the Side of My Face) (Kruger), 391, 393
Untitled (Levine), 389
Untitled (Longo), 246
Untitled (Miss, Eckstut, and Child), 191
Untitled (Polke), 302
Untitled (Prince), 327
Untitled (Sherman), 412
Untitled (Sherman), 413
Untitled Film Stills (Sherman), 408–410
Untitled (Taaffe), 510
Untitled (Man Ray) (Wegman), 415
Untitled (Wojnarowicz), 534
Untouchables, The, 463

Vaisman, Meyer:
 commodity art and, 482–484, 490–491
 East Village art and, 516–517
Valley Curtain, Rifle, Colorado (Christo and Jeanne-Claude), 166–167
Van Abbe Museum, 295, 447
van Bruggen, Coosje, 31
van Buren, Richard, 462–463
van Gogh, Vincent, 233, 425, 487–488, 519, 549
 Colescott and, 204–206
 Morley and, 257–258
 Murray and, 250
Variability of Similar Forms (Graves), 78

Varnedoe, Kirk, 6, 184, 347, 398, 473, 486, 499, 546
Vedova, Emilio, 102–103
Venice, Biennales in, 103, 214–215, 287, 446–448, 499–500, 528, 552
Venturi, Robert, 5
Venus Cushion (Wilke), 127
Vespers (Komar & Melamid), 265
video, 11, 102, 168, 454
 and art world of 1970s, 218
 deconstruction art and, 414
 East Village art and, 463
 feminism and, 124
 neogeo and, 512–513
 new image painting and, 209–210
 postminimalism and, 24, 27, 31–32, 34–36, 43
 postmodernist art theory and, 345, 349, 361
Video Corridor (Nauman), 32
Vietnam War, 13–18, 166, 418, 425, 428
 American neoexpressionism and, 254–255
 deconstruction art and, 402
 and European art after 1968, 86, 88, 93, 105
 feminism and, 114, 134–135
 new image painting and, 196
 postminimalism and, 31, 33, 35, 37, 42, 44, 54, 72, 74
 postmodernist art theory and, 333, 336, 340, 364, 368
Vine, Richard, 366–367
Violent Space Series (Baldessari), 323
Visit To/A Visit From/The Island, A (Fischl), 244–245
Vita (Schnabel), 231
Vitebsk-Harar (Cucchi), 292
Vogue, xxiii, 361, 430–431
Von Hier Aus, 449
von Rydingsvard, Ursula, 271–274
V-yramid (Paik), 52

Wagner, Richard, 299–300, 311, 313
Waiting (Wilding), 124–125
Waiting for Commercials (Paik), 51
Walking Cake (Simmons), 413–414
Walking Toilet (Simmons), 413
Wallis, Brian, 338
Wall of China (Hunt), 78
Wallraf-Richartz Museum, 215, 403–405
War Drawings (Spero), 134–136
War Games (Abakanowicz), 538
Warhol, Andy, xxiii, 1, 6, 13, 74
 American neoexpressionism and, 226–227

architectural sculpture and, 183
and art world in first half of 1980s, 430–431
and art world in late 1980s and 1990s, 547
commodity art and, 482, 484–486, 490–491, 493–494, 497–499
and criticisms of U.S. art, 283
deconstruction art and, 386, 388
East Village art and, 465–466, 470–471, 513, 515–516
and European art after 1968, 88, 93, 95, 103
German neoexpressionism and, 302, 309
media art and, 321, 325
neogeo and, 486, 512
postmodernist art theory and, 347, 349, 352, 365
Watchtower (Polke), 303
Watson, Peter, 426
Wave Length (Snow), 23
Way Station Launching an Obsolete Power (Oppenheim), 44
Wegman, William, 547
 deconstruction art and, 414–416
 media art and, 325
 new image painting and, 198
Weinberg, Dan, 431
Weiner, Lawrence, 72, 395
Weisgall, Deborah, 437
We'll Shake the Bag (Salle), 235
Werner, Michael, 282, 295, 431, 447–448
Weschler, Lawrence, 169
Wesselmann, Tom, 1
West, Cornel, 206
Westfall, Stephen, 5–6
Westkunst, 448–449
Weston, Edward, 357, 386–388
Westwater, Angela, 432
Weyergraf, Clara, 56, 351–352
What a Kid I Was (Prince), 329
"What's All This About Photography?" (Hennessy), 350
When the Worlds Collide (Scharf), 472
Where We Are Now? (Acconci), 38–39
Whispers (Edwards), 529
WHITE ANGER, RED DANGER, YELLOW PERIL, BLACK DEATH (Nauman), 33
White Columns Gallery, 477, 516–518
White Flag (Johns), 519
White Marble Circle (Long), 63
White Noise (DeLillo), 1
White Paintings (Prince), 329–330
Whitman, Robert, 35
Whitney Museum of American Art,

220
Anti-Illusion show at, 23–24, 214
Architectural Analogues show at, 217
and art world in first half of 1980s, 436, 440, 444–445, 453, 455
and art world in late 1980s and 1990s, 544–545, 553–554
Biennials at, 216–217, 220, 436, 440, 445, 465, 518–519, 553–554
feminism and, 117, 138
Image World show at, 320–321, 380, 383, 544–545
Independent Studies Program of, 453
Irwin's environment at, 170
Media World show at, 455
New Image Painting show at, 194, 198–199, 212, 217, 222, 251, 266, 349
postminimalism at, 25–26
Turrell's retrospective at, 171
Whole Public Thing, The (Vaisman), 490–491
"Why Have There Been No Great Women Artists?" (Nochlin), 117
Wieck, Roger S., 157
Wilde, Alan, 240
Wilde, Edy de, 282, 447
Wilding, Faith, 114, 120, 124–125
Wild Locusts Ride (Salle), 236
wild style painting, 474–475, 477
Wilke, Hannah, 125–128
Wilkin, Karen, 451
Willard Gallery, 217
Williams, Hugo, 411
Wilson, Robert, 417–418
Window Blowout (Matta-Clark), 69
Winer, Helene, 325, 432, 453
Winsor, Jackie, 29–31, 360
Winters, Terry, 268–269
Within and Beyond the Frame (Buren), 100
Wittgenstein, Ludwig, 72–73, 453
Wojnarowicz, David, 518, 533–534, 551
Woman (de Kooning), 204–205
Womanhouse, 118–120, 124, 146
Woodrow, Bill, 64
Woodward, Vivienne, 465
Woolworth, R. Frederick, 552
word paintings, 72–74
Worlds (Gilbert & George), 49
World War I, 8, 13, 315, 469
World War II, 13, 214, 258, 291–292, 309, 313, 446, 502, 536
consumer society and, 375
and European art after 1968, 107

Wortz, Ed, 169
Wyatt, Susan, 551

X-Ray (Benglis), 153

Yikes! (Murray), 250
Yohn, Tim, 377

Young Penis Symphony (Paik), 51
Yrissary, Mario, 146

Zakanitch, Robert Rahway, 142,
 147–148, 194, 216
Zakopane (von Rydingsvard), 273
Zama (Jaudon), 152

Zeitgeist, 448–449, 451
Zeitlos, 450–451
Zimmerman, Elyn, 164,
 179–180
Zorio, Gilberto, 22, 102
Zucker, Barbara, 138
Zucker, Joe, 198–199, 204, 217